PRAISE FOR *Van Gogh: The Life*

"An enormously compelling psychological study, one I savored long into the night—many nights—and could hardly wait to return to each day."
—*The Dallas Morning News*

"Captivating . . . [Naifeh and Smith] bring a booming authorial voice and boundless ingenuity to the task." —*The Wall Street Journal*

"*Van Gogh: The Life*, the intricate and panoramic biography by Steven Naifeh and Gregory White Smith, is a provocative work about the volcanic man and his art. . . . Naifeh and Smith treat 'the life' with remarkable detail. . . . This is an insightful and important work, unquestionably the essential biography for years to come." —*Newsday*

"How pleased we should be that [these authors] have rendered so exquisitely and respectfully Van Gogh's short, intense, and wholly interesting life."
—*The Boston Globe*

"[Naifeh and Smith's] biography enriches the eye. Its insight and vast information vault readers into the work of Van Gogh and the artists of his time. It deepens the experience of looking at art."
—*San Francisco Chronicle*

"The definitive biography for decades to come."
—LEO JANSEN, curator, Van Gogh Museum, and co-editor
of *Vincent van Gogh: The Complete Letters*

Van Gogh

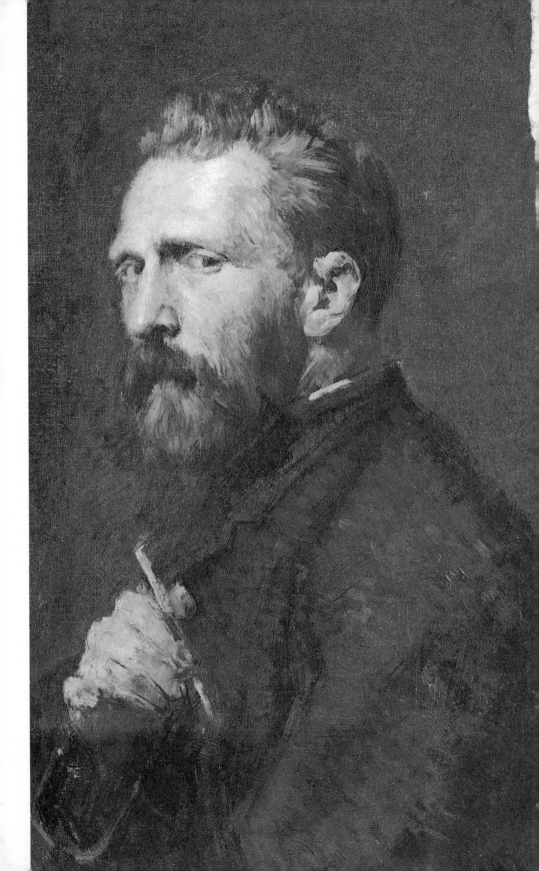

Van Gogh

THE LIFE

Steven Naifeh AND
Gregory White Smith

RANDOM HOUSE
TRADE PAPERBACKS
NEW YORK

Published in the United States by Random House Trade Paperbacks, an imprint of
The Random House Publishing Group, a division of Random House, Inc., New York.

RANDOM HOUSE TRADE PAPERBACKS and colophon are
registered trademarks of Random House, Inc.

Originally published in hardcover in the United States by Random House,
an imprint of The Random House Publishing Group, a division of Random House, Inc.,
and in the United Kingdom by Profile Books, London, in 2011.

Grateful acknowledgment is made to the following for permission
to reprint previously published material:

Ton de Brouwer: Excerpts from *Van Gogh en Nuenen,* 2nd edition, by Ton de Brouwer
(Venio, Netherlands: Van Spijk, 1998). Reprinted by permission of Ton de Brouwer,
founder of Vincente at Nuenen, www.vgvn.nl.

Fuller Technical Publications: Excerpts from *Vincent and Theo van Gogh:*
A Dual Biography by Jan Hulsker, edited by James M. Miller (Ann Arbor, MI: Fuller
Technical Publications, 1990). Reprinted by permission of Fuller Technical Publications.

Hachette Book Group: Excerpts from *The Complete Letters of Vincent van Gogh,* translated by
Johanna Bonger, originally published by The New York Graphic Society and subsequently
published by Little, Brown & Co. (second edition, 1978, third printing, 1988). Reprinted
by permission of Hachette Book Group.

Rizzoli International Publications, Inc.: Excerpts from *Van Gogh: A Retrospective,* edited by
Susan A. Stein (New York: Hugh Lauter Levin Associates, 1986). Reprinted by permission
of Rizzoli International Publications, Inc., 300 Park Avenue South, New York, NY 10010,
www.rizzoliusa.com.

Thames and Hudson Ltd.: Excerpts from *Taine's Notes on England* by Hippolyte Taine,
translated by Edward Hyams (London: Thames and Hudson, 1957). Reprinted by
permission of Thames and Hudson Ltd., London.

Ken Wilkie: Excerpts from *In Search of Van Gogh* by Ken Wilkie (Roseville, CA:
Prima Books, 1991). Quotes within the text attributed by Enid Dove-Meadows,
Piet van Hoorn, Baroness Bonger, and Madame Baize were made to Ken Wilkie.
Reprinted by permission of Ken Wilkie.

LIBRARY OF CONGRESS CATALOGING-IN-PUBLICATION DATA
Naifeh, Steven (Steven W.)
Van Gogh: The Life/Steven Naifeh and Gregory White Smith.
pages cm
ISBN 978-0-375-75897-3
1. Gogh, Vincent van, 1853–1890. 2. Artists—Netherlands—
Biography. 3. Gogh, Vincent van, 1853–1890.—Psychology.
I. Smith, Gregory White. II. Title.
N6953.G3N35 2011
759.9492—dc22
[B] 2010053005

Printed in the United States of America

www.atrandom.com

9 8 7 6 5 4

Frontispiece: John Peter Russell, *Portrait of Vincent van Gogh,* 1886

Book design by Barbara M. Bachman

To our mothers,

Marion Naifeh *and* Kathryn White Smith,

who first showed us the joy of art,

and to all the artists of THE JUILLIARD SCHOOL,

who have since brought so much joy into our lives,

this book is gratefully dedicated.

S. N.

G. W. S.

CONTENTS

ILLUSTRATIONS

COLOR PLATES
SECTION ONE (AFTER PAGE 268)

Van Gogh—Carbentus Family Tree

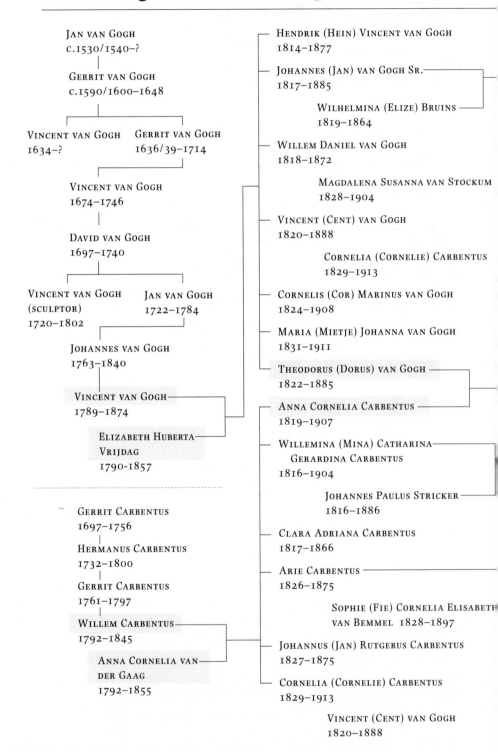

JAN VAN GOGH
c.1530/1540–?

GERRIT VAN GOGH
c.1590/1600–1648

VINCENT VAN GOGH
1634–?

GERRIT VAN GOGH
1636/39–1714

VINCENT VAN GOGH
1674–1746

DAVID VAN GOGH
1697–1740

VINCENT VAN GOGH
(SCULPTOR)
1720–1802

JAN VAN GOGH
1722–1784

JOHANNES VAN GOGH
1763–1840

VINCENT VAN GOGH
1789–1874

ELIZABETH HUBERTA
VRIJDAG
1790–1857

GERRIT CARBENTUS
1697–1756

HERMANUS CARBENTUS
1732–1800

GERRIT CARBENTUS
1761–1797

WILLEM CARBENTUS
1792–1845

ANNA CORNELIA VAN
DER GAAG
1792–1855

HENDRIK (HEIN) VINCENT VAN GOGH
1814–1877

JOHANNES (JAN) VAN GOGH SR.
1817–1885

WILHELMINA (ELIZE) BRUINS
1819–1864

WILLEM DANIEL VAN GOGH
1818–1872

MAGDALENA SUSANNA VAN STOCKUM
1828–1904

VINCENT (CENT) VAN GOGH
1820–1888

CORNELIA (CORNELIE) CARBENTUS
1829–1913

CORNELIS (COR) MARINUS VAN GOGH
1824–1908

MARIA (MIETJE) JOHANNA VAN GOGH
1831–1911

THEODORUS (DORUS) VAN GOGH
1822–1885

ANNA CORNELIA CARBENTUS
1819–1907

WILLEMINA (MINA) CATHARINA
GERARDINA CARBENTUS
1816–1904

JOHANNES PAULUS STRICKER
1816–1886

CLARA ADRIANA CARBENTUS
1817–1866

ARIE CARBENTUS
1826–1875

SOPHIE (FIE) CORNELIA ELISABETH
VAN BEMMEL 1828–1897

JOHANNUS (JAN) RUTGERUS CARBENTUS
1827–1875

CORNELIA (CORNELIE) CARBENTUS
1829–1913

VINCENT (CENT) VAN GOGH
1820–1888

HENDRIK JACOB EERLIGH VAN GOGH
1853–1886

JOHANNES VAN GOGH JR.
1854–1913

VINCENT VAN GOGH
1852–1852

Vincent Willem van Gogh
1853–1890

ANNA CORNELIA VAN GOGH
1855–1930

JOAN MARIUS VAN HOUTEN
1850–1945

THEO VAN GOGH
1857–1891

JOHANNA (JO) GEZINA BONGER
1862–1925

VINCENT WILLEM VAN GOGH
1890–1978

ELISABETH (LIES) HUBERTA VAN GOGH
1859-1936

JEAN PHILIPPE THEODORE DU QUESNE
VAN BRUCHEM
1840–1921

WILLEMINA (WIL) JACOBA VAN GOGH
1862–1941

CORNELIS (COR) VINCENT VAN GOGH
1867–1900

CORNELIA ADRIANA STRICKER ("KEE VOS")
1846–1918

CHRISTOFFEL MARTINUS VOS
1841–1878

JOHANNES (JAN) PAULUS VOS
1873–1928

ARIËTTE (JET) SOPHIA JEANETTE CARBENTUS
1856–1894

ANTON MAUVE
1838–1888

For the complete family tree, visit www.vangoghbiography.com.

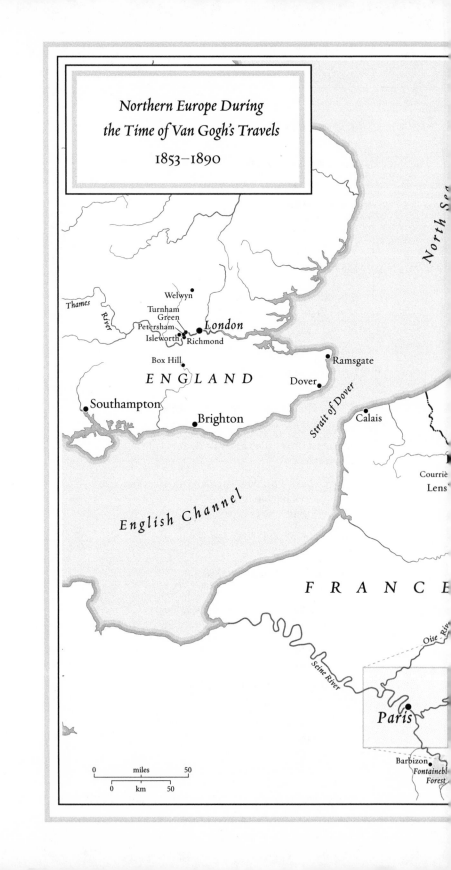

Northern Europe During
the Time of Van Gogh's Travels
1853–1890

North Sea

Thames
River

Welwyn
Turnham
Green
Petersham
Isleworth
Richmond
London

Box Hill

E N G L A N D

Ramsgate

Dover

Southampton

Brighton

Strait of Dover

Calais

Courriè
Lens

English Channel

F R A N C E

Oise Riv

Seine River

Paris

Barbizon
Fontainebl
Forest

0 miles 50
0 km 50

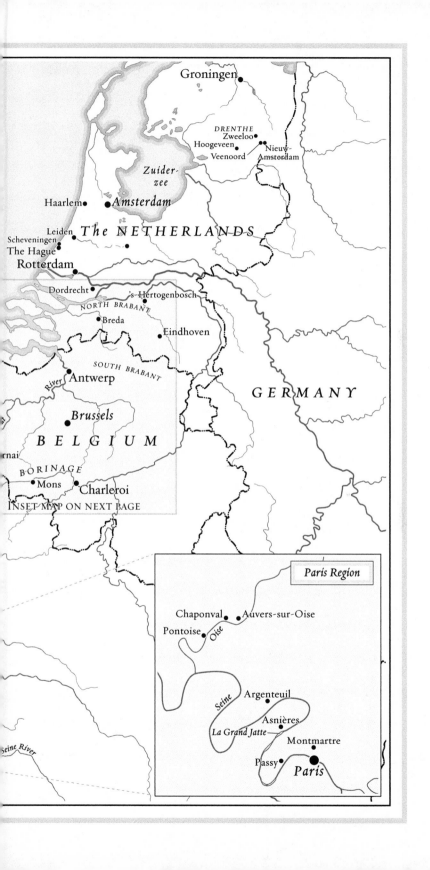

Groningen

DRENTHE
Zweeloo
Hoogeveen
Nieuw-
Veenoord
Amsterdam

*Zuider-
zee*

Haarlem • Amsterdam

Leiden
Scheveningen
The Hague
Rotterdam

The NETHERLANDS

Dordrecht
's-Hertogenbosch
NORTH BRABANT
Breda
Eindhoven

SOUTH BRABANT

River
Antwerp

GERMANY

Brussels

BELGIUM

rnai

BORINAGE
Mons • Charleroi

INSET MAP ON NEXT PAGE

Seine River

Paris Region

Chaponval • Auvers-sur-Oise
Pontoise *Oise*

Seine Argenteuil

Asnières
La Grand Jatte
Montmartre

Passy • Paris

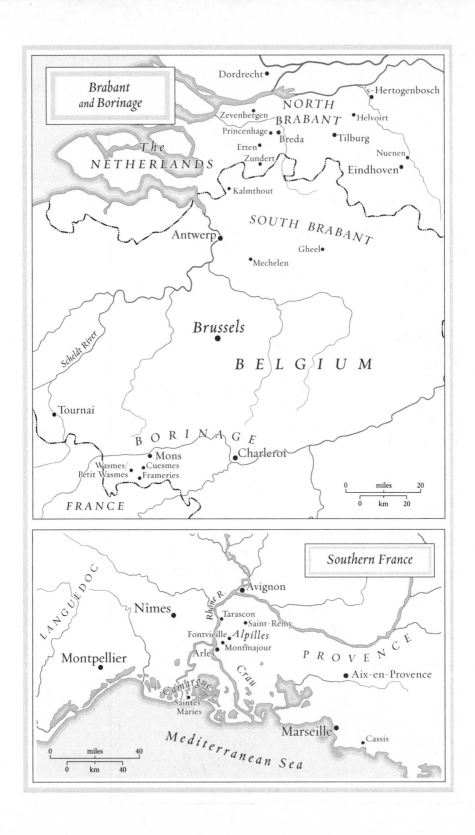

Brabant
and Borinage

Dordrecht•

's-Hertogenbosch•

NORTH
BRABANT

Zevenbergen• •Helvoirt
Princenhage• •Breda •Tilburg
The Etten• Nuenen•
NETHERLANDS Zundert• •Eindhoven

•Kalmthout

SOUTH BRABANT

Antwerp•
 Gheel•
 •Mechelen

Scheldt River

Brussels
•

BELGIUM

Tournai•

B O R I N A G E •Charleroi

•Mons
Wasmes/ •Cuesmes
Petit Wasmes •Frameries

0 miles 20
0 km 20

FRANCE

Southern France

LANGUEDOC

Avignon•
Rhône R.
Nîmes• Tarascon•
 •Saint-Remy
 Fontvieille• Alpilles
Montpellier• Arles• •Montmajour PROVENCE

Crau •Aix-en-Provence

Camargue
Saintes-
Maries

Marseille•
 •Cassis

Mediterranean Sea

0 miles 40
0 km 40

Van Gogh

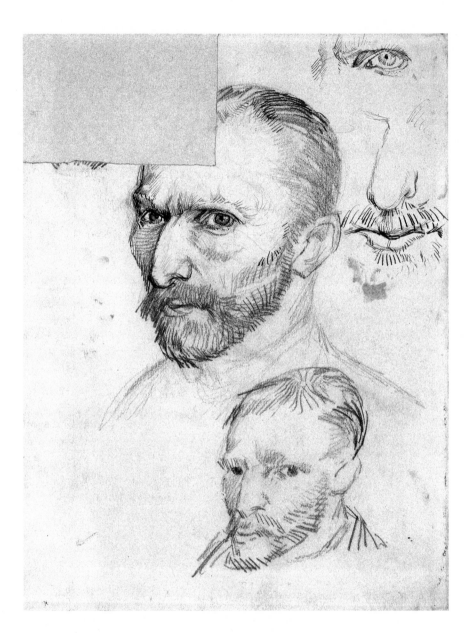

Self-Portraits, PENCIL AND INK ON PAPER, 1887, 12$\frac{1}{8}$ X 9$\frac{5}{8}$ IN.

A Fanatic Heart

*T*HEO IMAGINED THE WORST. THE MESSAGE SAID ONLY THAT VINCENT HAD "wounded himself." As Theo rushed to the station to catch the next train to Auvers, his mind raced both backward and forward. The last time he received a dire message like this one, it was a telegram from Paul Gauguin informing him that Vincent was "gravely ill." Theo had arrived in the southern city of Arles to find his brother in the fever ward of a hospital, his head swathed in bandages and his mind completely unmoored.

What would he find at the end of this train ride?

At times like these—and there had been many of them—Theo's mind wandered to the Vincent he had known once: an older brother of passion and restlessness, but also of boisterous jokes, infinite sympathy, and indefatigable wonder. On their childhood hikes in the fields and woods around the Dutch town of Zundert, where they were born, Vincent had introduced him to the beauties and mysteries of nature. In the winter, Vincent tutored him in skating and sledding. In summer, he showed him how to build castles in the sandy paths. In church on Sundays and at home by the parlor piano, he sang with a clear, confident voice. In the attic room that they shared, he talked until late at night, inspiring in his younger brother a bond that their siblings teasingly called "worship," but Theo proudly acknowledged, even decades later, as "adoration."

This was the Vincent that Theo had grown up with: adventurous guide, inspiration and scold, encyclopedic enthusiast, droll critic, playful companion, transfixing eye. How could *this* Vincent, his Vincent, have turned into such a tormented soul?

Theo thought he knew the answer: Vincent was the victim of his own fanatic heart. "There's something in the way he talks that makes people either love him or hate him," he tried to explain. "He spares nothing and no one."

Long after others had put away the breathless manias of youth, Vincent still lived by their unsparing rules. Titanic, unappeasable passions swept through his life. "I am a fanatic!" Vincent declared in 1881. "I feel a power within me . . . a fire that I may not quench, but must keep ablaze." Whether catching beetles on the Zundert creekbank, collecting and cataloguing prints, preaching the Christian gospel, consuming Shakespeare or Balzac in great fevers of reading, or mastering the interactions of color, he did everything with the urgent, blinding single-mindedness of a child. He even read the newspaper "in a fury."

These storms of zeal had transformed a boy of inexplicable fierceness into a wayward, battered soul: a stranger in the world, an exile in his own family, and an enemy to himself. No one knew better than Theo—who had followed his brother's tortured path through almost a thousand letters—the unbending demands that Vincent placed on himself, and others, and the unending problems he reaped as a consequence. No one understood better the price Vincent paid in loneliness and disappointment for his self-defeating, take-no-prisoners assaults on life; and no one knew better the futility of warning him against himself. "I get very cross when people tell me that it is dangerous to put out to sea," Vincent told Theo once when he tried to intervene. "There is safety in the very heart of danger."

How could anybody be surprised that such a fanatic heart produced such a fanatic art? Theo had heard the whispers and rumors about his brother. *"C'est un fou,"* they said. Even before the events in Arles eighteen months earlier, before the stints in hospitals and asylums, people dismissed Vincent's art as the work of a madman. One critic described its distorted forms and shocking colors as the "product of a sick mind." Theo himself had spent years trying, unsuccessfully, to tame the excesses of his brother's brush. If only he would use less paint—not slather it on so thickly. If only he would slow down—not slash out so many works so quickly. ("I have sometimes worked excessively fast," Vincent countered defiantly. "Is it a fault? I can't help it.") Collectors wanted care and finish, Theo told him again and again, not endless, furious, convulsive studies—what Vincent called *"pictures full of painting."*

With every lurch of the train that bore him to the scene of the latest catastrophe, Theo could hear the years of scorn and ridicule. For a long time, out of family pride or fraternal affection, Theo had resisted the accusations of madness. Vincent was merely "an exceptional person"—a Quixote-like tilter at windmills—a noble eccentric, perhaps—not a madman. But the events in Arles had changed all that. "Many painters have gone insane yet nevertheless started to produce true art," Theo wrote afterward. "Genius roams along such mysterious paths."

And no one had roamed a more mysterious path than Vincent: a brief, failed start as an art dealer, a misbegotten attempt to enter the clergy, a wandering

evangelical mission, a foray into magazine illustration, and, finally, a blazingly short career as a painter. Nowhere did Vincent's volcanic, defiant temperament show itself more spectacularly than in the sheer number of images that continued to pour forth from his ragged existence even as they piled up, hardly seen, in the closets, attics, and spare rooms of family, friends, and creditors.

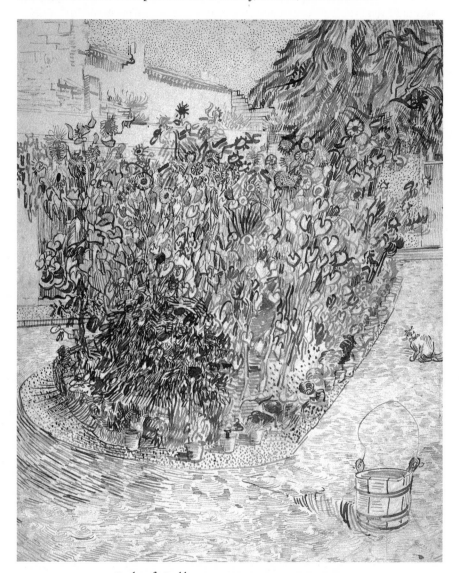

Garden of a Bathhouse, PENCIL AND INK ON PAPER,
AUGUST 1888, 23^7/$_8$ X 19^1/$_4$ IN.

Only by tracing this temperament and the trail of tears it left, Theo believed, could anyone truly understand his brother's stubbornly inner-driven art. This

was his answer to all those who dismissed Vincent's paintings—or his letters—as the rantings of the wretched, as most still did. Only by knowing Vincent "from the inside," he insisted, could anyone hope to see his art as Vincent saw it, or feel it as Vincent felt it. Just a few months before his fateful train trip, Theo had sent a grateful note to the first critic who dared to praise his brother's work: "You have read these pictures, and by doing so you very clearly saw the man."

Like Theo, the art world of the late nineteenth century was preoccupied with the role of biography in art. Émile Zola had opened the gates with his call for an art "of flesh and blood," in which painting and painter merged. "What I look for in a picture before anything else," Zola wrote, "is the man." No one believed in the importance of biography more fervently than Vincent van Gogh. "[Zola] says something beautiful about art," he wrote in 1885: " 'In the picture (the work of art), I look for, I love the man—the artist.' " No one collected artists' biographies more avidly than Vincent—everything from voluminous texts to "legends" and "chats" and scraps of rumor. Taking Zola at his word, he culled every painting for signs of "what kind of *man* stands *behind* the canvas." At the dawn of his career as an artist, in 1881, he told a friend: "In general, and more especially with artists, I pay as much attention to the man who does the work as to the work itself."

To Vincent, his art was a record of his life more true, more revealing ("how deep—how infinitely deep") even than the storm of letters that always accompanied it. Every wave of "serenity and happiness," as well as every shudder of pain and despair, he believed, found its way into paint; every heartbreak into heartbreaking imagery; every picture into self-portraiture. "I want to paint what I feel," he said, "and feel what I paint."

It was a conviction that guided him until his death—only hours after Theo arrived in Auvers. No one could truly see his paintings without knowing his story. "As my work is," he declared, "so am I."

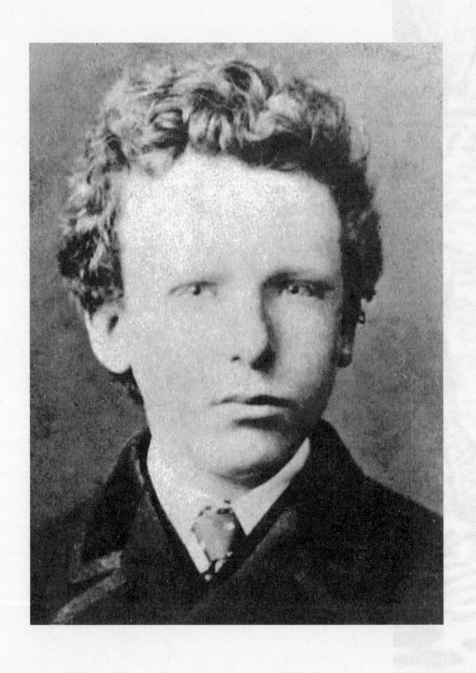

PART ONE

The Early Years
1853–1880

Dams and Dikes

~

O F THE THOUSANDS OF STORIES THAT VINCENT VAN GOGH CONSUMED in a lifetime of voracious reading, one stood out in his imagination: Hans Christian Andersen's "The Story of a Mother." Whenever he found himself with children, he told and retold Andersen's dark tale of a loving mother who chooses to let her child die rather than expose him to the risk of an unhappy life. Vincent knew the story by heart and could tell it in several languages, including a heavily accented English. For him, whose own life was filled with unhappiness, and who forever sought himself in literature and art, Andersen's tale of maternal love gone awry possessed a unique power, and his obsessive retellings protested both a unique longing and a unique injury.

Vincent's own mother, Anna, never understood her eldest son. His eccentricities, even from an early age, challenged her deeply conventional worldview. His roving intellect defied her limited range of insight and inquiry. He seemed to her filled with strange and "starry-eyed" notions; she seemed to him narrow-minded and unsympathetic. As time passed, she liked him less and less. Incomprehension gave way to impatience, impatience to shame, and shame to anger. By the time he was an adult, she had all but given up hope for him. She dismissed his religious and artistic ambitions as "futureless wanderings" and compared his errant life to a death in the family. She accused him of intentionally inflicting "pain and misery" on his parents. She systematically discarded any paintings and drawings that he left at home as if disposing of rubbish (she had already thrown out virtually all his childhood memorabilia), and treated works that he subsequently gave her with little regard.

After her death, only a few of the letters and works of art Vincent had sent her were found in her possession. In the final years of his life (she outlived him by seventeen years), she wrote to him less and less often, and, when he was hos-

pitalized toward the end, she never came to visit, despite frequent travels to see other family members. Even after his death, when fame belatedly found him, she never regretted or amended her verdict that his art was "ridiculous."

Vincent never understood his mother's rejection. At times, he lashed out angrily against it, calling her a "hard-hearted" woman "of a soured love." At times, he blamed himself for being a "half-strange, half-tiresome person . . . who brings only sorrow and loss." But he never stopped bidding for her approval. At the end of his life, he painted her portrait (from a photograph) and appended a poem with the plaintive question: "Who is the maid my spirits seek / Through cold reproof and slanders blight?"

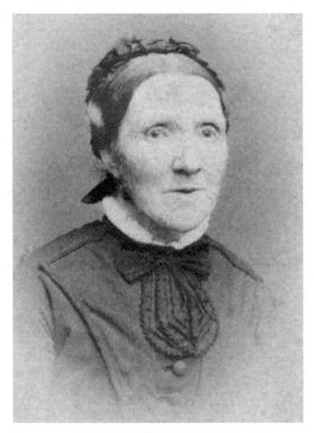

ANNA CARBENTUS

ANNA CORNELIA CARBENTUS married the Reverend Theodorus van Gogh on a cloudless day in May 1851 in The Hague, home of the Dutch monarchy and, by one account, "the most pleasant place in the world." Reclaimed from sea-bottom mud containing the perfect mix of sand and clay for growing flowers, The Hague in May was a veritable Eden: flowers bloomed in unrivaled abun-

dance on roadsides and canal banks, in parks and gardens, on balconies and verandas, in window boxes and doorstep pots, even on the barges that glided by. Perpetual moisture from tree-shaded ponds and canals "seemed every morning to paint with a newer and more intense green," wrote one enchanted visitor.

On the wedding day, Anna's family sprinkled flower petals in the newlyweds' path and festooned every stop on their route with garlands of greenery and blossoms. The bride made her way from the Carbentus house on Prinsengracht to the Kloosterkerk, a fifteenth-century jewel box on an avenue lined with linden trees and surrounded by magnificent townhouses in the royal heart of the city. Her carriage passed through streets that were the envy of a filthy continent: every windowpane freshly cleaned, every door recently painted or varnished, every copper pot on every stoop buffed, every lance on every bell tower newly gilded. "The roofs themselves seem to be washed each day," marveled one foreigner, and the streets were "clean as any chamber floor." Such a place, wrote another visitor, "may make all men envy the happiness of those who live in it."

Gratitude for idyllic days like these, in idyllic places like this—and the fear that they could all be lost in a moment—shaped Anna Carbentus's life. She knew that it had not always been this way, either for her family or for her country.

In 1697, the fate of the Carbentus clan hung by a single thread: Gerrit Carbentus, the only member of the family to come through the wars, floods, fires, and plagues of the previous hundred and fifty years alive. Gerrit's predecessors had been swept up in the panoramic bloodletting of the Eighty Years' War, a revolt by the Seventeen Provinces of the Low Countries against their brutal Spanish rulers. It began, according to one account, in 1568 when Protestant citizens in towns like The Hague rebelled "in a cataclysm of hysterical rage and destruction." Victims were tied together and heaved from high windows, drowned, decapitated, and burned. The Spanish Inquisition responded by condemning every man, woman, and child in the Netherlands, all three million of them, to death as heretics.

For eighty years, back and forth across the placid Dutch landscape, army fought army, religion fought religion, class fought class, militia fought militia, neighbor fought neighbor, idea fought idea. A visitor to Haarlem saw "many people hanging from trees, gallows and other horizontal beams in various places." Houses everywhere were burned to the ground, whole families burned at the stake, and the roads strewn with corpses.

Now and then the chaos subsided (as when the Dutch provinces declared their independence from the Spanish king in 1648 and the war was declared over), but soon enough a new wave of violence would wash over the land. In 1672, the so-called Rampjaar (Year of Catastrophe), little more than a generation after the end of the Eighty Years' War, another fury boiled up from the tran-

quil and impeccable streets of The Hague as crowds swept into the city center, hunted down the country's former leaders, and butchered them to pieces in the shadow of the same Kloosterkerk where Anna Carbentus would later celebrate her marriage.

But neither war nor these paroxysms of communal rage posed the greatest danger to the Carbentus family. Like many of his countrymen, Gerrit Carbentus lived his entire life on the edge of extinction by flood. It had been that way since the end of the Ice Age, when the lagoon at the mouth of the Rhine began to fill up with rich, silty soil that proved irresistible to the first settlers. Gradually, the settlers built dikes to keep the sea at bay and dug canals to drain the bogs behind the dikes. In the sixteenth and seventeenth centuries, when the invention of the windmill made it possible to drain vast areas, truly large-scale land reclamation began. Between 1590 and 1740, even as Dutch merchants conquered the world of commerce and established rich colonies in distant hemispheres, even as Dutch artists and scientists created a Golden Age to rival the Italian Renaissance, more than three hundred thousand acres were added to the Netherlands, increasing its arable landmass by almost a third.

But nothing stopped the sea. Despite a thousand years of stupendous effort—and in some cases because of it—floods remained as inevitable as death. With terrifying unpredictability, the waves would top the dikes or the dikes would crumble beneath the waves, or both, and the water would rush far inland across the flat countryside. Sometimes the sea would simply open up and take back the land. On a single night in 1530, twenty villages sank into the abyss, leaving only the tips of church spires and the carcasses of livestock visible on the surface of the water.

It was a precarious life, and Gerrit Carbentus, like all his countrymen, inherited an acute sense, a sailor's sense, of the imminence of disaster. Among the thousands who died in the battle with the sea in the last quarter of the seventeenth century was Gerrit Carbentus's uncle, who drowned in the River Lek. He joined Gerrit's father, mother, siblings, nieces, nephews, and first wife and her family, all of whom perished before Gerrit turned thirty.

Gerrit Carbentus had been born at the end of one cataclysmic upheaval; his grandson, also named Gerrit, arrived at the beginning of another. Starting in the middle of the eighteenth century, across the Continent, revolutionary demands for free elections, an expanded franchise, and the abolition of unfair taxes merged with the utopian spirit of the Enlightenment to create a force as unstoppable as war or wave.

It was only a matter of time before the revolutionary fervor hit the Carbentus family. When troops of the new French Republic entered Holland in 1795, they came as liberators. But they stayed as conquerors. Soldiers were billeted in every household (including the Carbentuses'); goods and capital (such as the

family's gold and silver coins) were confiscated; trade withered; profits disappeared; businesses closed; prices soared. Gerrit Carbentus, a leatherworker and father of three, lost his livelihood. But worse was yet to come. On the morning of January 23, 1797, Gerrit left his house in The Hague for work in a nearby town. At seven that evening he was found lying on the side of the road to Rijswijk, robbed, beaten, and dying. By the time he was carried home, he was dead. His mother "insanely hugged the lifeless body and let a stream of tears flow over him," according to the Carbentus family chronicle, a clan diary kept by generations of chroniclers. "This was the end of our dear son, who was a miracle in his own right."

Gerrit Carbentus left behind a pregnant wife and three small children. One of these was five-year-old Willem, grandfather of the painter Vincent Willem van Gogh.

In the first decades of the 1800s, as the Napoleonic tide receded, the Dutch emerged to repair the dikes of statehood. So widely shared was the fear of slipping back into the maelstrom that moderation became the rule of the day: in politics, in religion, in science, and in the arts. "Fear of revolution gave rise to growing reactionary sentiments," wrote one chronicler, and "self-satisfaction and national conceit" became the defining characteristics of the era.

Just as his country was emerging from the shadow of rebellion and upheaval, Willem Carbentus was rebuilding his life from the wreckage of personal tragedy. He married at twenty-three and fathered nine children over the next twelve years—amazingly, without a stillborn among them. Political stability and "national conceit" had other benefits as well. A sudden wave of interest in all things Dutch created a booming demand for books. From Amsterdam to the smallest village, groups were formed to promote the reading of everything from classics to instruction manuals. Seizing the opportunity, Willem turned his leatherworking skills to the art of binding books and opened a shop on the Spuistraat, in The Hague's main shopping district. Over the next three decades, he built the shop into a flourishing business, raising his large family in the rooms overhead. In 1840, when the government sought a binder for the latest version of the long-disputed constitution, it turned to Willem Carbentus, who thereafter advertised himself as "Royal Bookbinder."

Recovery through moderation and conformity worked for the country and for Willem, but not for everybody. Of Willem's children, the second, Clara, was considered "epileptic" at a time when that word was used to cover a dark universe of mental and emotional afflictions. Never married, she lived in the limbo of denial mandated by family dignity, her illness acknowledged only much later by her nephew, the painter Vincent van Gogh. Willem's son, Johannus, "did not follow the common road in life," his sister wrote cryptically, and later committed suicide. In the end, even Willem himself, despite his success, succumbed.

In 1845, at the age of fifty-three, he died "of a mental disease," says the family chronicle in a rare acknowledgment. The official record lists the cause of death more circumspectly as "catarrhal fever," a bovine plague that periodically affected livestock in rural areas but never spread to humans. Its symptoms, perhaps the basis for the official diagnosis, were overexcitement, followed by spasms, foaming at the mouth, and death.

Surrounded by lessons like these, Willem's middle daughter Anna grew up with a dark and fearful view of life. Everywhere forces threatened to cast the family back into the chaos from which it had just recently emerged, as suddenly and finally as the sea swallowing up a village. The result was a childhood hedged by fear and fatalism: by a sense that both life and happiness were precarious, and therefore could not be trusted. By her own telling, Anna's world was "a place full of troubles and worries [that] are inherent to it"; a place where "disappointments will never cease" and only the foolish "make heavy demands" on life. Instead, one must simply "learn to endure," she said, "realize that no one is perfect," that "there are always imperfections in the fulfillment of one's wishes," and that people must be loved "despite their shortcomings." Human nature especially was too chaotic to be trusted, forever in danger of running amok. "If we could do whatever we wanted," she warned her children, "unharmed, unseen, untroubled—wouldn't we stray further and further from the right path?"

Anna carried this dark vision into adulthood. Unremittingly humorless in her dealings with both family and friends, she grew melancholy easily and brooded ceaselessly over small matters, finding hazard or gloom at the end of every rainbow. Love was likely to disappear; loved ones to die. When left alone by her husband, even for short periods, she tormented herself with thoughts of his death. In Anna's own account of her wedding celebrations, amid descriptions of flower arrangements and carriage rides in the woods, her thoughts return again and again to a sick relative who could not attend. "The wedding days," she concluded, "were accompanied by a lot of sadness."

To hold the forces of darkness at bay, Anna kept herself frenetically busy. She learned to knit at an early age, and for the rest of her life, worked the needles with "terrifying speed," according to the family chronicle. She was an "indefatigable" writer whose letters—filled with hastily jumbled syntax and multiple insertions—betray the same headlong rush to nowhere. She played the piano. She read because "it keeps you busy [and] turns the mind in a different direction," she said. As a mother, she was obsessed with the benefits of preoccupation and urged it on her children at every opportunity. "Force your mind to keep itself occupied with other things," she advised one of them as a cure for being "down-hearted." (It was a lesson that her son Vincent, perhaps the most depressed and incandescently productive artist in history, learned almost too well.) When all else failed, Anna would clean furiously. "That dearest Ma is busy

cleaning," her husband wrote, casting doubt on the effectiveness of all her strategies, "but thinks about and worries about all."

Anna's busy hands also turned to art. Together with at least one of her sisters, Cornelia, she learned to draw and paint with watercolor, pastimes that had been taken up by the new bourgeois class as both a benefit and a badge of leisure. Her favorite subject was the common one for parlor artists at the time: flowers—nosegays of violets, pea blossoms, hyacinths, forget-me-nots. In this conventional pursuit, the Carbentus sisters may have been encouraged by their eccentric uncle, Hermanus, who, at one time at least, advertised himself as a painter. They also enjoyed the support and example of a very unconventional artistic family, the Bakhuyzens. Anna's visits to the Bakhuyzen house were immersions in the world of art. Father Hendrik, a respected landscape painter, gave lessons not only to his own children (two of whom went on to become prominent artists), and perhaps to the Carbentus sisters, but also to a changing cast of students who later founded a new, emphatically Dutch art movement, the Hague School. Thirty-five years after Anna's visits, the same movement would provide her son a port from which to launch his brief, tempest-tossed career as an artist.

As a fearful child, Anna was drawn naturally to religion.

Except for marriages and baptisms, religion makes a relatively late appearance in the Carbentus family record: When the French army arrived in The Hague in 1795, the chronicler blamed "God's trying hand" for the depredations of billeted soldiers and confiscated coins. Two years later, when the fury loose in the land found Gerrit Carbentus alone on the Rijswijk road, the chronicle suddenly erupts in plaintive piety: "May God grant us mercy to accept His decisions with an obedient heart." This was the essence of the religious sentiment that emerged from the years of turmoil—both in the Carbentus family and in the country: a trembling recognition of the consequences of chaos. Bloodied and exhausted, people turned from a religion that rallied the faithful to one that reassured the fearful. Anna herself summarized the milder goals of the new faith: to "preserve, support, and comfort."

Later in life, as the storms grew and multiplied, Anna sought refuge in religion with increasing desperation. The slightest sign of disruption in her own life, or errant behavior in her children's, triggered a rush of pieties. From school exams to job applications, every crisis prompted a sermon invoking His beneficence or His forbearance. "May the good God help you remain honest," she wrote her son Theo on the occasion of a promotion. She invoked God to shield her children against everything from sexual temptation to bad weather, insomnia, and creditors. But most of all, she invoked Him to shield herself from the dark forces within. Her relentless nostrums—so much like her son Vincent's more manic variations on both secular and religious themes—suggest a need

for reassurance that could never be satisfied. Despite repeated claims for the consoling power of her beliefs, these insistent incantations were clearly as close as Anna—or Vincent—ever came to being truly comforted by religion.

In every aspect of her life, not just religion, Anna sought the safe ground. "Learn the normal life more and more," she advised her children. "Make your paths in life even and straight." In a postrevolutionary, post-traumatic society— a society that always prized and often enforced conformity—it was an ideal to which virtually everyone aspired. Normality was the duty of every young Dutch woman, and none was more dutiful than Anna Carbentus.

Thus it was no surprise that when Anna turned thirty in 1849 and was still unmarried, she felt an urgent need to find a husband. All of her siblings, except for the epileptic Clara, the troubled Johannus, and her youngest sister, Cornelia, were already wed. Only a single cousin had waited longer than Anna—until she was thirty-one—and she ended up marrying a widower, a common fate for women who waited too long. Earnest, humorless, plain, redheaded, and thirty, Anna seemed destined for an even worse fate: spinsterhood.

The crushing blow came in March 1850 when Cornelia, ten years Anna's junior, announced her engagement to a prosperous print dealer in The Hague named Van Gogh. He lived over his gallery on the Spuistraat, not far from the Carbentus shop, and, like Cornelia, he had a sibling who was tardy in marriage: a twenty-eight-year-old brother named Theodorus, a preacher.* Three months later, a meeting was arranged between Theodorus and Anna. Theodorus (the family called him Dorus) was slight and handsome, with "finely chiseled features" and sandy-colored hair already starting to gray. He was quiet and hesitant, unlike his gregarious brother. He lived in Groot Zundert, a small village near the Belgian border, far from the royal sophistication of The Hague. But none of that mattered. The family was acceptable; the alternatives unthinkable. He seemed as eager as she to consummate an arrangement. Almost immediately after they met, an engagement was announced.

On May 21, 1851, Theodorus van Gogh and Anna Carbentus were married in the Kloosterkerk. After the ceremony, the newlyweds left for Groot Zundert in the Catholic south. Anna later recalled her feelings on the eve of her wedding: "The bride to be was not without worry about the future home."

* Dorus's character and family line are discussed in chapter 4, *God and Money.*

An Outpost on the Heath

~

*T*O THE EYE OF A NEWCOMER, ESPECIALLY ONE FROM SO PRINCELY A CITY as The Hague, the township of Zundert must have looked a wasteland. And, indeed, most of it was. More than half of the township—which stretched for miles in every direction from the small cluster of buildings that was the town of Groot Zundert ("Big Zundert," to distinguish it from nearby Klein Zundert, "Little Zundert")—consisted of swamp and heath: windswept, virtually treeless expanses of wild grass and scrub untouched by tilling or tending hand. Except for an occasional shepherd driving a flock of sheep, or peasants cutting peat or gathering heather for brushes, nothing broke the enormous silence that hung over the empty horizon. Contemporary chroniclers referred to the region as the "untouched territory."

Only the great highway built by Napoleon, the Napoleonsweg, tethered the town of Groot Zundert to the outside world. With its parade-straight double row of oak and beech trees leading to infinity, the road brought all the overland trade from Belgium and points south through the dusty little village. Inns, taverns, stables, and tradesmen's shops lined the famous road (the emperor himself had passed this way), almost outnumbering the 126 houses that sheltered the town's twelve hundred inhabitants.

The mêlée of commerce made Zundert a disproportionately dirty, disorderly place. Especially at festival time, when the newlywed Van Goghs arrived, the many inns and taverns around the town square, the Markt, were filled with raucous young men drinking, singing, dancing, and often brawling. Brueghelesque public debaucheries were common at these "fun fairs" (Brueghel had been born nearby), where alcoholic license, boorishness, and especially disregard of social rank and sexual mores, confirmed all the low stereotypes of the rustic Dutch character that polite society in urbane centers like Amsterdam and The Hague abhorred.

Off the main road, however, Groot Zundert remained virtually untouched by the comings and goings of commerce. When Anna arrived in 1851, almost four decades after Waterloo, the Napoleonsweg was still the town's only paved road, and tiny, home-based breweries and tanneries still its only industries. Most farmers still produced barely enough food to feed their own families—potatoes, mostly—and still used bullocks to pull their plows. Zundert's most profitable "crop" was still the fine white sand that was scooped from its infertile fields and used all over Holland to sand furniture and floors to a milky smoothness. Most families still shared their one-room houses with their livestock and dressed in the same clothes year-round. Only a tiny percentage of Zundert's citizens were rich enough to pay the poll tax and vote, while a quarter of its schoolchildren were poor enough to receive free education. In general, people from the rich cities of the north, like The Hague, came to Zundert only to exploit its most plentiful resource other than sand: cheap labor.

To proper Dutch townsfolk like Anna van Gogh, Zundert wasn't just a coarse, impoverished country village; it wasn't really Dutch. For centuries, Zundert and all of the townships around it had looked not north to the city-states of the Dutch Republic, but south—to Brussels and Rome—for leadership and identity. Together with most of northern Belgium, the townships of southern Holland belonged to Brabant, a medieval duchy that had enjoyed its own brief golden age in the thirteenth and fourteenth centuries before its power waned and its borders were submerged in the shifting empires of its neighbors. By 1581, when the Dutch declared their independence from Spanish rule, Brabant found itself separated from its northern neighbor by an economic, political, and, especially, religious gulf that would never be bridged. Overwhelmingly Catholic and monarchical, it remained on the opposite side of that gulf through all the bloody formative events of the seventeenth and eighteenth centuries.

Even after Napoleon was defeated at Waterloo in 1815 and all of Belgium was joined with the old Dutch provinces to form the Kingdom of the United Netherlands, animosities festered. Brabanters resented the political and economic hegemony of the north and resisted its cultural dominance, even its language; northerners looked down on the Brabanters as stupid, superstitious, and untrustworthy. In 1830, when the Belgians broke with the United Netherlands and declared Belgium an independent country, these mutual enmities boiled into the open. Brabanters on the Dutch side of the border allied with those on the Belgian side, and for almost a decade, it seemed to many in Holland that the whole lower third of the country might slide into rebellion.

A treaty in 1839 that split Brabant down the middle had devastating effects in border areas like Zundert. Farms and families were divided, roads were closed, congregations cut off from their churches. The Dutch government in The Hague treated Zundert and its fellow townships along the new border like occu-

pied enemy territory. A single crossing point served the whole trackless sweep of wasteland around the town. Farmers had to travel for miles to bring peat, their only source of fuel, home from the heath, and border guards imposed crushing tolls on all goods crossing the line. Military police monitored the new border and roamed the roads to prevent illegal migration. The Brabanters responded with a campaign of audacious smuggling greatly abetted by the wild landscape and desperate poverty.

The Belgian revolt and "occupation" that followed only deepened the bitter split between Catholics and Protestants. For two centuries, armies had swept back and forth over the sandy heaths of Zundert, installing one religion and chasing away the other. When Catholic forces approached from the south, or Protestant from the north, whole congregations would pull up stakes and flee. Churches were vandalized and appropriated. Then the political winds would shift: new authorities marched in, and old churches were reclaimed, scores settled, and new oppressive measures imposed on the unbelievers.

In the latest round, during the Belgian Revolt, after Catholics smashed the windows of the little church in Groot Zundert, Protestants had been slow to return. When the Van Goghs arrived twenty years later, the congregation stood at only fifty-six, a mere handful of families, outnumbered thirty to one in an

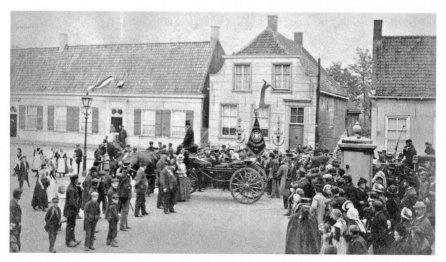

THE MARKT IN ZUNDERT; THE PARSONAGE WHERE
VINCENT WAS BORN IS AT CENTER

outpost of true faith on the papist heath. Protestants nursed dark suspicions of Catholic intentions and trod lightly to avoid conflicts with Catholic authorities. Catholics boycotted Protestant businesses and cursed Protestantism as "the faith of the invader."

Anna's new home, the Zundert parsonage, sat facing the Markt, right in the middle of this threatening frontier.

Virtually everything that happened in Zundert happened on the Markt: servants jostled and gossiped at the town water well, officials conducted public business surrounded by rowdy crowds, the stagecoaches and mail wagons rode in and changed teams at the big stables nearby. On Sundays, the news was read out in a booming voice from the steps of the town hall directly opposite the parsonage. So many carts or wagons passed through the Markt that residents had to keep their windows closed against the clouds of dust they kicked up. When it rained, unpaved sections of the square turned into impassable quagmires.

Spare and inconspicuous, the parsonage dated back to the early 1600s. In the two and a half centuries since, it had seen a long line of parsons' families and a few enlargements, but hardly any improvements. Hemmed in by larger neighbors on both sides, only its narrow brick façade enjoyed a view of the square. The door opened into a long, dark, narrow hall connecting a formal room at the front, used for church functions, to a single dark room at the back where the family actually lived. The hall ended at a small kitchen. Beyond that lay a washroom and a barn—all in one continuous, virtually lightless progression. The sole privy could be found behind a door in the corner of the barn. Unlike most people in Zundert, Anna did not have to venture outdoors to use the loo.

Putting the best face on the sudden change in her circumstances, Anna described the parsonage to her family back in The Hague as a "country place" where one could enjoy the pastoral simplicity of rural life. But pleasantries could not disguise the truth: After a prolonged maidenhood in the fine and proper world of The Hague, she had landed in a beleaguered religious outpost, in a wild and unfamiliar land, surrounded by townspeople who mostly resented her presence, whom she mostly distrusted, and whose dialect she could hardly understand. There was no disguising her loneliness, either. Unable to walk the streets of town unaccompanied, she hosted a succession of family visitors, and then, at the end of the summer, returned to The Hague for an extended stay.

As all the other distinctions of Anna's previous life fell away, one became increasingly important to her: respectability. She had always lived her life by the rules of convention. But now, under the battlefield discipline imposed by isolation and hostility, those rules took on a new significance. First and foremost, the rules demanded that parsons' wives, all wives, produce children—lots of children. Families of ten or more were not uncommon. It was a strategic and religious imperative to ensure the outpost's survival into the next generation—and Anna van Gogh was starting late. When she returned to The Hague at the end of the summer, she proudly announced "the future arrival of a little addition to the family, for which God had given us hope."

On March 30, 1852, Anna gave birth to a stillborn son. *"Levenloos"*—

lifeless—the town registrar noted in the margin of his book next to the nameless birth entry, "No. 29." Hardly a family in Zundert—or anywhere in Holland—rich or poor, was untouched by this most mysterious of all God's workings. The Carbentus family was typical, its chronicle littered with infant deaths and nameless stillborns.

In previous generations, the death of a child often passed without a funeral; the "birth" of a stillborn, without any mention at all. For the new bourgeoisie, however, no opportunity for self-affirmation and display went unseized. Mourning for an innocent child, in particular, caught the public imagination. One Dutch writer dubbed it "the most violent and profound of all sorrows." Sales of poetry albums devoted exclusively to the subject soared. Novels like Dickens's *The Old Curiosity Shop*, with its deathbed scene of Little Nell, transfixed a generation. When it came time for Anna to bury her son, she demanded all the trappings of the new fashion. A grave was dug in Zundert's little Protestant cemetery next to the church (the first for a stillborn) and covered with a handsome stone marker large enough for a biblical inscription, a favorite of the era's poetry albums: "Suffer little children to come unto me . . ." The marker bore only the year, 1852; and instead of the bereaved parents, it named the stillborn: Vincent van Gogh.

For Anna, naming children was only remotely a matter of personal preference. Like everything else in her life, it was governed by rules. Thus it was predetermined, when Anna gave birth to another son on March 30, 1853, exactly one year after the death of her first, that he would take the names of his grandfathers: Vincent and Willem.

The coincidence that Vincent Willem van Gogh was born a year to the day after the stillborn buried under a marker inscribed "Vincent van Gogh" would prove of far greater interest to later commentators than to the Van Goghs. Anna proceeded to produce a large family with clockwork discipline. In 1855, almost exactly two years after Vincent Willem's birth, a girl was born, Anna Cornelia. Two years after that (1857), another son, Theodorus. Two years after that (1859), another daughter, Elisabeth. In 1862, a third daughter, Willemina. Finally, five years later (1867), at forty-seven, Anna bore her last child, another son, Cornelis Vincent. So tightly did Anna control the process that six of her seven children had birthdays between mid-March and mid-May; three were born in May, and two were born one day apart (in addition to the two Vincents born on the same date).

This was Anna van Gogh's family. For the rest of the twenty years she lived in Zundert, Anna would pour most of her energy and all of her manic orderliness and fearful conformity into raising these six children. "We are shaped first by family," she wrote, "then by the world."

In concentrating so single-mindedly on home life, Anna not only fulfilled

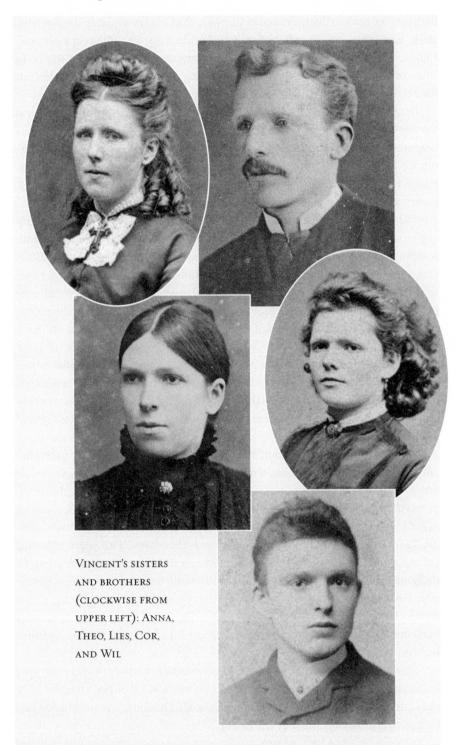

VINCENT'S SISTERS
AND BROTHERS
(CLOCKWISE FROM
UPPER LEFT): ANNA,
THEO, LIES, COR,
AND WIL

her duty as a wife and a Protestant, she upheld the conventions of her class. What historians would call "the era of the triumphant family" had dawned. Children were no longer just adults-in-waiting. Childhood had become a distinct and precious state of being—"holy youth," it was called—and parenthood a sacred calling. "One must make sure that [youth] shares as little as possible in the disasters of society," warned one of the most popular parenting instruction books of the era. "An entire following life cannot make up for a repressed youth." Hundreds of such books, and even more novels, embraced and instructed the new middle-class obsession. The message of such books was all too familiar to Anna: the outside world was a turbulent and dangerous place; family, the ultimate refuge.

Anna stamped this fearful, insular view on all her children. Neither physical nor affectionate by nature, she waged instead a relentless campaign of words: affirmations of family ties, invocations of filial duty, professions of parental love, and reminders of parental sacrifice, endlessly knitted into the fabric of everyday life. Not only was their family uniquely happy, she maintained, but a "happy home life" was essential to any happiness. Without it, the future could only be "lonely and uncertain." Her campaign echoed the mandate of family unity— what one historian called "family totalitarianism"—that filled the literature of the day, in which tender expressions of family devotion accompanied by uncontrollable sobbing were de rigueur. "We can't live without each other," Anna wrote to her seventeen-year-old son Theo. "We love each other too dearly to be separated or to refuse to open our hearts to one another."

In the claustrophobic emotional environment of the parsonage (a "strange, sensitive atmosphere," according to one account), Anna's campaign succeeded only too well. Her children grew up clinging to family like shipwreck survivors to a raft. "Oh! I cannot imagine what it would be like if one of us had to leave," wrote Elisabeth, her sixteen-year-old daughter, whom the family called Lies. "I feel that we all belong together, that we are one. . . . If there would be one missing now, I would feel as if this unity did not exist anymore." Separation from any member, emotional or physical, was painful for all. Reunions were greeted with joyful tears and invested with the power even to cure illness.

In later years, when separation became unavoidable, all of Anna's children suffered the pain of withdrawal. Letters (not just Vincent's) poured back and forth between them in an extraordinary effort to sustain the family bond. Gripped by spells of "inexpressible homesickness" throughout their adult lives, according to one in-law, they remained wary of the outside world, preferring the safe, vicarious life they found in books to the reality around them. For all of them, one of life's greatest joys would remain the family together in the shiplike parsonage; and one of life's greatest fears, being shut out of that joy. "The family feeling and our love for each other is so strong," Vincent wrote years later, "that

the heart is uplifted and the eye turns to God and prays, 'Do not let me stray too far from them, not *too* long, O Lord.' "

Not surprisingly, one of the most important books the young Vincent van Gogh was given to read was *Der schweizerische Robinson (The Swiss Family Robinson)*, the story of a parson's family shipwrecked on an uninhabited tropical island and forced to rely entirely on each other to survive in a hostile world.

ANNA VAN GOGH responded to the ordeal of her new life on the heath by imposing on her family, as zealously as on herself, the rigors of normality.

Every day, mother, father, children, and governess walked for an hour in and around the town, an area that included gardens and fields as well as the dusty streetscape. Anna believed these walks not only improved her family's health (their "color and brightness"), but also rejuvenated their spirits. The daily ritual both displayed the family's bourgeois status—working people could never take an hour off in the daylight—and stamped the family unit with the imprimatur of glorious Nature.

Anna planted a garden. Family gardens had been a Dutch institution for centuries, thanks both to the fecundity of the soil and the exemption from feudal taxes that the products of these gardens enjoyed. For the nineteenth-century bourgeoisie, who lived far beyond subsistence, flower gardens became a mark of leisure and plenty. The rich built country houses, the middle class lavished attention on tiny city plots, the poor planted window boxes and pots. In 1845, Alphonse Karr's *A Tour Round My Garden* touched the Dutch love affair with gardens to the heartstrings of Victorian sentimentality and instantly became a favorite of families like the Carbentuses and the Van Goghs. ("Love among flowers is not selfish," Karr instructed; "they are happy in loving and blooming.") For the rest of her life, Anna believed that "working in the garden and seeing the flowers grow" was essential to both health and happiness.

The garden in Zundert, which lay behind the barn, was large by Anna's city standards. Long and narrow, like the parsonage, it was neatly enclosed by a beech hedge and sloped gently downhill toward the fields of rye and wheat beyond. She carefully divided it into sections, putting flowers nearest the house. Eventually, flowers crowded out the more proletarian vegetables, which were banished to a plot adjacent to the nearby cemetery, where the parsonage grew crops, mowed hay, and cultivated trees for market. True to Victorian taste, Anna preferred delicate, small-bloomed flowers—marigolds, mignonettes, geraniums, golden rain—arranged in multicolored profusion. She maintained that scent was more important than color, but favored red and yellow. Beyond the flowerbeds lay rows of blackberry and raspberry bushes and fruit trees—apple, pear, plum, and peach—that dotted the garden with color in spring.

Cramped in the dark parsonage throughout the long winter, Anna's young family monitored every nuance of season and celebrated spring's first starling or daisy like freed prisoners. From that moment on, the family's center of gravity moved to the garden. Dorus studied and wrote sermons there. Anna read under a shade awning. The children played games in the harvested crops and built castles in the paths of fine Zundert sand. Every member of the Van Gogh family shared responsibility for the garden's cultivation. Dorus tended the trees and vines (grape and ivy); Anna, the flowers; and each child was given his or her own small plot to plant and harvest.

Inspired by Karr's elaborate plant and insect conceits, Anna used the garden to school her children in the "meanings" of nature. Not only did the cycle of seasons recapitulate the cycle of life, but that cycle could be marked out in the blooming and fading of certain plants: violets represented the courage of both spring and youth; ivy, the promise of life to come in both winter and death. Hope could rise from despair "even as the blossom falls from the tree and vigorous new life shoots up," Vincent later wrote. Trees—especially tree roots—affirmed the promise of life after death. (Karr claimed that certain trees, like the cypress, "grow in cemeteries more beautifully and vigorously than elsewhere.") In Anna's garden, the sun was the "Sweet Lord" whose light gave life to plants just as God gave "peace to our hearts"; and stars were the sun's promise to return in the morning to "make light out of darkness."

All the lessons in symbolism that Vincent eventually transformed into paint—from Christian mythology, from art and literature—all first took root in his mother's garden.

The Van Gogh family ate where they lived, in the back room of the parsonage. Like everything in Anna's life, food was subject to conventions. Modest and regular eating was considered crucial to both good health and moral wholeness. But with two cooks in the tiny kitchen, Anna could indulge her middle-class aspirations to larger, more elaborate repasts, especially on Sundays. If evening meals were the daily worship service of the "cult of the family," Sunday dinner was its high mass. These quiet extravagances of four- and five-course dinners left a deep impression on all her children, especially Vincent, whose lifelong obsession with food and sporadic attempts at self-starvation mirrored his turbulent family relations.

After dinner, everyone gathered around the stove for another ritual: instruction in family history. Father Dorus, who was "well informed on such matters" according to his daughter Lies, told tales of illustrious ancestors who had served their country through its many trials. These stories of past distinction consoled Anna's isolation on the heath by reconnecting her to the culture and class she had left behind. Like virtually everyone in their generation, Anna and Dorus van Gogh felt a profound nostalgia for their country's past—especially

its seventeenth-century "Golden Age" when the coastal city-states ruled the world's oceans, nurtured an empire, and mentored Western civilization in science and art. The stoveside lessons transmitted to their family not just a fascination with history, but also a vague longing for this lost Eden.

All of Anna and Dorus's children inherited their nostalgia for the past, both their country's and their family's. But none felt the bittersweet tug as sharply as their eldest son, Vincent, who later described himself as "enchanted by snatches of the past." As an adult, he would devour histories and novels set in previous eras—eras he always imagined as better, purer than his own. In everything from architecture to literature, he lamented the lost virtues of earlier times ("the difficult but noble days") and the inadequacies of the dull and "unfeeling" present. For Vincent, civilization would forever be "in decline," and society invariably "corrupt." "I feel more and more a kind of void," he later said, "which I cannot fill with the things of today."

In art, Vincent would cast himself repeatedly as the champion of neglected artists, archaic subject matter, and bygone movements. His commentaries on the art and artists of his own day would be filled with jeremiads, reactionary outbursts, and melancholy paeans to artistic Edens come and gone. Like his mother, he keenly felt the elusiveness and evanescence of happiness—"the desperately swift passing away of things in modern life"—and trusted only memory to capture and hold it. Throughout his life, his thoughts returned again and again to the places and events of his own past, and he rehearsed their lost joys with delusional intensity. He suffered fits of nostalgia that sometimes paralyzed him for weeks, and invested in certain memories the talismanic power of myth. "There are moments in life when everything, within us too, is full of peace," he later wrote, "and our whole life seems to be a path through the heath; but it is not always so."

EVERY EVENING AT THE parsonage ended the same way: with a book. Far from being a solitary, solipsistic exercise, reading aloud bound the family together and set them apart from the sea of rural Catholic illiteracy that surrounded them. Anna and Dorus read to each other and to their children; the older children read to the younger; and, later in life, the children read to their parents. Reading aloud was used to console the sick and distract the worried, as well as to educate and entertain. Whether in the shade of the garden awning or by the light of an oil lamp, reading was (and would always remain) the comforting voice of family unity. Long after the children had dispersed, they avidly exchanged books and reading recommendations as if no book was truly read until all had read it.

While the Bible was always considered "the best book," the parsonage book-

cases bowed with edifying classics: German Romantics like Schiller, Goethe, Uhland, and Heine; Shakespeare (in Dutch translation); and even a few French works by authors like Molière and Dumas. Excluded were books considered excessive or disturbing, like Goethe's *Faust*, as well as more modern works by Balzac, Byron, Sand, and, later, Zola, which Anna dismissed as "products of great minds but impure souls." The greatest Dutch book of the era, *Max Havelaar* (written by Eduard Dekker under the pseudonym Multatuli), was deplored for its blistering attack on the Dutch colonial presence in Indonesia and the "hypocritical goodness and self-glorification" of the Dutch middle class. More popular forms of children's entertainments, especially the cowboy-and-Indian stories coming out of America, were deemed "too rousing" for a proper upbringing.

Like most literate families across Victorian Europe, the Van Goghs reserved a special place in their heart for sentimental stories. Everyone clamored for the latest book by Dickens, or by his fellow Englishman Edward Bulwer-Lytton (who first wrote "It was a dark and stormy night . . ."). The Dutch translation of Harriet Beecher Stowe's *Uncle Tom's Cabin* arrived in Zundert just about the time Vincent was born, only a year after the final installment appeared in America, and was received in the parsonage with the same fervid acclaim it met everywhere else.

The Van Gogh children entered the world of approved literature through two doors: poetry and fairy tales. Poetry, memorized and recited, was the preferred method for teaching children to be virtuous and devout and to listen to their parents. Fairy tales meant only one thing in the parsonage: Hans Christian Andersen. Stories like "The Ugly Duckling," "The Princess and the Pea," "The Emperor's New Clothes," and "The Little Mermaid" had achieved worldwide acclaim by the time Anna started her family. Neither explicitly Christian nor bluntly didactic, Andersen's tales captured the new, more whimsical view of childhood that Victorian leisure had fostered. The subtle seditiousness of stories that highlighted human frailties and often lacked happy endings escaped the parsonage censors.

Vincent's reading would eventually range far beyond the books approved by his parents. But these early exposures set the trajectory. He read with demonic speed, consuming books at a breakneck pace that hardly let up until the day he died. He would start with one book by an author and then devour the entire oeuvre in a few weeks. He must have loved his early training in poetry, for he went on to commit volumes of it to memory, sprinkled it throughout his letters, and spent days transcribing it into neat, error-free albums. He kept his love of Hans Christian Andersen, too. Andersen's vividly imagined world of anthropomorphic plants and personified abstractions, of exaggerated sentiment and epigrammatic imagery, left a clear watermark on Vincent's imagination. Decades later, he called Andersen's tales "glorious . . . so beautiful and real."

—

HOLIDAYS AT THE PARSONAGE offered a special opportunity to display family solidarity in the face of isolation and adversity. Celebrations crowded the calendar of Zundert's model Protestant household: church holidays, national holidays, birthdays (including those of aunts, uncles, and servants), anniversaries, and "name days" (days set aside to celebrate common first names). Anna, who organized all the festivities at the parsonage, lavished all her nervous energy and anticipatory nostalgia on these set pieces of family unity. Ropes of greenery, flags, and bouquets of seasonal flowers festooned the dark rooms. Special cakes and cookies were laid out on a table decorated with bunches of fruits and branches of flowers. In later years, Anna's children would brave the hardships of travel, sometimes coming great distances, to attend these celebrations. When they couldn't, letters would fly to everyone, not just the honoree, congratulating all on the happy occasion—a Dutch custom that turned every holiday into a celebration of family.

In the long calendar of celebrations, nothing compared to Christmas. From Saint Nicholas Eve, December 5, when a visiting uncle dressed as Sinterklaas distributed candy and presents, to Boxing Day on the twenty-sixth, the Van Goghs celebrated the mystical union of the Holy Family and their family. For weeks, the front room of the parsonage rang with Bible readings, carols, and the clatter of coffee cups as the members of the tiny congregation gathered around the garlanded fireplace. Under Anna's direction, her children decorated a huge Christmas tree with gold and silver paper cutouts, balloons, fruit, nuts, candy, and dozens of candles. Presents for all the parsonage children, not just the parson's, were piled around the tree. "Christmas is the most beautiful time at home," Anna decreed. On Christmas Day, Dorus took Vincent and his brothers on holiday visits to sick congregants—"to bring St. Nicholas" to them.

Every Christmas, by the warmth of the back-room stove, the family concluded the annual reading of one of Dickens's five Christmas books. Two of them stayed in Vincent's imagination for the rest of his life: *A Christmas Carol* and *The Haunted Man.* Almost every year, he reread these stories, with their vivid images of Faustian visitations, children in jeopardy, and the magical reparative power of domesticity and the Christmas spirit. "They are new to me again every time," he said. By the end of his life, Dickens's tale of a man hounded by memories and "an alien from his mother's heart" would unsettle Vincent in ways he could never have imagined as a boy by the stove in Zundert. What he did feel then, and would feel more and more acutely in the years to come, was the indissoluble union of Christmas and family. "It seems to me," says Redlaw, the tormented Scrooge of *The Haunted Man,* "as if the birth-time of our Lord was the birth-time of all I have ever had affection for, or mourned for, or delighted in."

No celebration was complete without gift giving. From the earliest age, the Van Gogh children were expected to find or make their own presents for birthdays and anniversaries. All learned how to arrange bouquets of flowers and baskets of food. Eventually, every one of Anna's children developed a repertoire of crafts to satisfy the demand for holiday tokens. The girls learned embroidery, crochet, macramé, and knitting; the boys learned pottery and woodworking.

And everybody learned to draw. Under their mother's tutelage, all the Van Gogh children mastered the parlor arts of collage, sketching, and painting, in order to decorate and personalize the gifts and notes they relentlessly exchanged. A simple box might come adorned with a bouquet of painted flowers; a transcribed poem, with a cutout wreath. They illustrated favorite stories, marrying words to images in the manner of the emblem books widely used to teach children moral lessons. Although prints and other store-bought goods would eventually replace collage and embroidery at Van Gogh celebrations, handmade gifts would always be honored as the most authentic offering on the altar of family.

TO SURVIVE THE RIGORS of outpost life, Anna's children had to be as disciplined as frontier soldiers. All eyes were on them, both friendly and unfriendly. Behavior in the parsonage was governed by a single word: duty. "Duty above all other things," Anna declared.

Such exhortations carried the weight of centuries of both Calvinist doctrine and Dutch necessity. Calvin's cry, "Whatever is not a duty is a sin," had a particular resonance for inhabitants of a flood-threatened land. In the early days, if the seawalls were breached, everyone's duty was clear enough: they rushed to the break with spade in hand. Feuds were suspended, a "dike peace" was declared. Doubters and shirkers were driven into exile; violators, put to death. If a house caught fire, the owner had a duty to pull it down immediately to prevent the flames from spreading to his neighbors. The duty of cleanliness protected all from the spread of contagion. By the time of Anna's generation, duty had achieved the status of a religion, and Dutch families like the Van Goghs worshipped a domestic "holy trinity" of Duty, Decency, and Solidity.

First and foremost, duty meant upholding the family's position in society.

When Anna Carbentus traded her upper-middle-class maidenhood in The Hague for life as a parson's wife in Zundert, there was, according to a prominent historian of the period, "no country in Europe . . . where people [were] more class-conscious as to their manner of living, the circles to which they belong[ed] and the social category in which they [were] placed" than Holland. Upward mobility was virtually impossible—and viewed with deep disapproval. Downward mobility was the terror of all but those at the bottom. And at a time when deep

class divisions ran between city and country, a permanent move to a rural area like Zundert threatened just such a slide.

The parson and his wife stood at the apex of Zundert's tiny elite. For centuries, clergymen like Dorus van Gogh had been setting the country's moral and intellectual agenda, and entering the ministry was still one of only two ways to rise up the social ladder (going to sea was the other). Dorus earned only a modest salary, but the church provided the family with the perquisites of status—a house, a maid, two cooks, a gardener, a carriage, and a horse—that made them feel and appear richer than they were. The family's midday strolls enhanced the illusion: Dorus in his top hat and the children with their governess. Such emblems of status cushioned the fall from social grace that Zundert represented to Anna, and she clung to them with more than the usual worried tenacity. "We have no money," she summed up, "but we still have a good name."

To protect that good name, Anna instilled in her children a duty to associate only in "civilized good circles." Virtually all success and happiness in life, she believed, flowed from mixing in good company; all failure and sin, from falling into bad company. Throughout their lives, she relentlessly encouraged them to "mingle with the well-to-do" and warned them against the dangers of associating with those "not of our own class." She clucked with pleasure whenever one of them was invited to the home of a "distinguished family" and issued detailed instructions on cultivating such connections.

In Zundert, the "good circle" included only a few distinguished families who summered in the area and a handful of Protestant professionals. Beyond or beneath that tiny circle, Anna did not let her children venture. Beyond lay only Catholic families; beneath lay the working people of Zundert—those who filled the Markt (and the dreaded festivals) and whose company, Protestant or Catholic, Anna considered an invitation to every form of base behavior. "It is better to be around upper-class people," she advised, "for one is more easily exposed to temptations when dealing with the lower classes."

Even farther outside the circle, and absolutely untouchable, lay the unwashed mass of faceless, nameless, landless laborers and peasants that drifted by at the very periphery of polite consciousness. These were the cattle of humanity in the eyes of Anna's class, not only obstinately ignorant and immoral, but lacking the "heart's luxuries" (sensitivity and imagination), and indifferent to death. "[They] love and sorrow like people who are exhausted and live only on potatoes," instructed a parenting handbook that the Van Goghs read. "Their hearts are like their intellects; they have not progressed beyond primary school."

To ensure that they did not violate these social boundaries, the Van Gogh children were forbidden to play in the street. As a result, they spent most of their time isolated inside the parsonage or in the garden, as if on an island, with only each other for company.

To move in any good circle, even one as small and remote as Zundert's, one had to dress properly, of course. "To present [one]self pleasantly," Anna instructed, "is also a duty." Clothes had long been a peculiar obsession of the Dutch and a stage for the subtle class distinctions that preoccupied them. Gentlemen, like Dorus, wore hats; workers (and children) wore caps. Gentlemen wore long formal coats; workers wore smocks. Only a woman of leisure could be bothered with the awkward crinoline hooped skirts that Anna wore. Clothes, like the daily walks that displayed them to the community, marked Anna's family as members of the upper middle class.

Inevitably, clothes acquired talismanic significance among the Van Gogh children, the conferring of the first store-bought cap or grown-up suit or overcoat treated as milestones of family status and pride. In later years, both parents rained questions and advisories on their children in endless variation on the lesson of the midday walks in Zundert: "Always make sure that people see a gentleman when they look at you." Indeed, good clothes and a neat appearance signaled something even more important than class status: they signaled inner order. "What one wears on the outside," Anna and Dorus taught, reflects "what goes on in the heart." A stain on one's clothing was like a stain on one's soul; and an expensive hat could ensure that one "made a good impression by his exterior as well as his interior self."

This was the other lesson of the family walks in Zundert: clothes were a public covenant of good behavior and moral uprightness. For the rest of their lives, the Van Gogh children would view any walk in public as a kind of fashion parade for the soul. Years later, Anna told her son Theo that a stroll in a smart suit "will show people that you are the son of Reverend van Gogh." Twenty years after he left home, Vincent emerged from the hospital in Arles (where he had been confined for mental instability after cutting off part of his ear) with one overriding concern: "I have to have something new to go out in the street in."

In the Zundert parsonage, even the heart had its duty. The Dutch called it *degelijkheid.* Anna called it "the basis and source of a happy life." The last of the holy trinity of social deities, *degelijkheid* (often rendered inadequately in English as "solidity") summoned the Dutch heart to protect itself from the tides and storms of emotion that had proved so devastating in the past. History had taught that every triumph was followed by defeat, every plenty by want, every calm by upheaval, every Golden Age by apocalypse. The heart's only protection from the inexorable righting of fate was to seek the solid middle ground, whether in prosperity or adversity, elation or despair. In eating, in clothing, even in painting, the Dutch aimed for the golden mean: the prudent, sustainable balance between sumptuousness and frugality.

Degelijkheid fit perfectly with Victorian calls to repress unseemly emotions, as well as with the new Protestantism's rejection of Calvinist zeal. Once again,

Anna's fretful, defensive nature aligned with the zeitgeist. As an inveterate balancer of positives with negatives in her own gloomy calculations, Anna saw her role as keeping the ship of the parsonage on an even emotional keel. Good times would always be followed by "misfortune," she reminded her children; "troubles and worries," by "comfort and hope." Not a moment of joy passed in the Van Gogh household without Anna's calling attention to its inevitable cost—its "shadow side." But melancholy, too, was forbidden. "He who denies himself and is self-possessed," Anna summarized, "is a happy man."

The Van Gogh children grew up in a world drained of emotion as if of color; a world in which excesses on all sides—pride and passion on the one hand, self-reproach and indifference on the other—were leveled and centered in the service of *degelijkheid;* a world in which every positive had to be balanced by a negative; a world in which praise was always tempered with expectation, encouragement with foreboding, enthusiasm with caution. After leaving the island parsonage, all of Anna's children were buffeted by extremes of emotion with which they had no experience and for which they had no defense. All showed astonishing insensitivity or obtuseness in dealing with emotional crises—in some cases, with catastrophic results.

Duty, Decency, Solidity. These were the conventions of a happy life—the compasses of a moral life—without which "one cannot become a normal person," Anna warned. Failure to uphold them offended religion, class, and social order. Failure brought shame to the family. Or worse. The literature of the period bristled with cautionary tales of a "bad life" leading to a tumble down the social ladder. Closer to home, Dorus had a nephew whose shameful conduct had forced his widowed mother into exile, where she "died of a lot of misery," according to the family chronicler, "and cast a shadow on our house."

With nightmares like these in their thoughts, Anna and Dorus raised their children in an atmosphere of constant jeopardy and contingent love. A single wrong step could put one on "the slippery path," as Dorus called it, with devastating consequences for all. Inevitably, the Van Gogh children grew up deeply afraid of "falling short." The fear of failure "hung over [them] like a cloud," according to one account, instilling in all a sense of anticipatory self-reproach that would linger long after they left the parsonage. "How much do we have to love Pa and Ma?" one of them wrote another plaintively. "I am not nearly good enough for them."

Every New Year's Eve the Van Gogh children gathered and prayed together: "Preserve us from too much self-reproach." None prayed more fervently than the eldest, Vincent.

A Strange Boy

~

Avisitor approaching the zundert parsonage in the 1850s might have seen a small face in one of the second-story windows, eyeing the activity in the Markt. It would have been hard to miss the hair—a head full of thick, curly red locks. The face was odd: oblong, with a high brow and prominent chin, puffy cheeks, shallow-set eyes, and a wide nose. The lower lip protruded in a perpetual pout. Most visitors, if they saw him at all, would only have caught this fleeting glimpse of the parson's reclusive son Vincent.

Those who met him noticed immediately how much he favored his mother: the same red hair, the same broad features, the same compact frame. He had dense freckles, and small eyes of a pale, changeable blue-green color. They could seem piercing one minute, vacant the next. In meeting strangers, he was reticent and self-conscious. He tended to hang his head and shift in nervous unease. As his mother bustled about the visitor with tea and cookies and talk of the latest royal doings in The Hague, Vincent would slip awkwardly out of the room to return to his post at the attic window or resume some other solitary activity. The impression he left in many visitors' minds was *"een oarige"*—a strange boy.

Those who looked more closely, or knew them better, might have noticed other similarities between the proper mother and the strange son—similarities that ran deeper than red hair or blue eyes. He shared her fretful view of life, as well as her suspicious gaze. He shared her taste for creature comforts and the finer things—in flower arrangements, fabrics, and home décor (and, later in life, in brushes, pens, paper, and paint). He absorbed her obsession with the prerogatives of rank and status as well as her rigid expectations, of herself and of others, based on stereotypes of class and origin. Despite his restless, antisocial ways, he was as capable of pleasantries and indirections as she; and, already, a

bit of a snob. Like her, he often felt lonely and worried relentlessly, which made him a serious and anxious child—hardly a child at all.

He shared his mother's need for frantic, forward motion. From the time she taught him to write, his hands, like hers, never stopped. He learned to move a pencil over paper long before he understood the marks he was copying. For him, writing never lost that pure, calligraphic joy. Like his mother, he wrote with feverish speed—as if the greatest enemy was idleness ("Doing nothing is doing wrong," he warned), and the greatest fear, emptiness. What could be more "miserable" than "a life of inactivity?" he demanded. "Do a great deal or drop dead."

His busy hands followed hers into art. Anna wanted her children to have the same refined upbringing she did—a challenge in an outpost like Zundert. An indispensable part of that upbringing was exposure to the fine arts. Her daughters learned to play the piano, just as she had. Everyone took singing lessons. And, starting with Vincent, Anna introduced them all to drawing—not as a childhood craft, but as an artistic endeavor. For a while, she may have kept up her own amateur artwork, setting an example for her son as well as instructing him. At some point, the two Bakhuyzen sisters, Anna's artist friends from The Hague, visited Zundert, and the three went sketching in the town together.

Barn and Farmhouse, FEBRUARY 1864, PENCIL ON PAPER, $7^7/_8$ X $10^5/_8$ IN.

Vincent may or may not have tagged along that day, but in every other way he followed in his mother's artistic footsteps. As with poetry, he started by copy-

ing. Using instructional drawing books and prints, he painstakingly created his first images, including a farm scene that he made for his father's birthday in February 1864. Anna gave Vincent her own works to trace and color: flowers, mostly, in the decorative nosegays she favored. On a few occasions, he took pencil and sketchpad outside and attempted to render his own world. One of his earliest models was the family's black cat, which he drew scurrying up a leafless apple tree. But he turned out to be such a poor draftsman that he destroyed the sketch in frustration soon after making it, and, according to his mother, never made another freehand sketch as long as he lived at the parsonage. Later, Vincent would dismiss all of his childhood work with two words—"little scratches"—and argued, "It is really and truly not until later that the artistic sensibility develops and ripens."

Vincent's attachment to his mother was profound. Later in life, the sight of any mother and child could cause his eyes to "grow moist" and his "heart to melt," he confessed. Activities and imagery that he associated with motherhood—arranging flowers, sewing, rocking a cradle, even just sitting by the fire—preoccupied him both in life and in art. He clung to a childlike maternal affection, and its tokens, well into his twenties. He was periodically overtaken (stricken, really) by the need to win, or win back, his mother's favor. He felt intense affection for maternal figures and an equally intense desire to play a maternal role in others' lives. Two years before he died, when he painted a portrait of his mother "as I see her in my memory," he simultaneously painted a portrait of himself using exactly the same palette of colors.

Despite this special attachment, or perhaps because of its inevitable disappointment, Vincent hardened into an obstreperous, ill-tempered child. The process began early with fits of anger so remarkable that they merited a special mention in the family history. Driven to distraction by one such "insufferable" outburst, Vincent's paternal grandmother (who had raised eleven children of her own) summarily boxed his ears and threw him out of the room. Years later, Anna herself complained: "I never was busier than when we only had Vincent." A barrage of similar criticism found its way into family recollections that are otherwise bastions of circumspection. They call him "obstinate," "unruly," "self-willed," and "hard to deal with"; "a queer one" with "strange manners" and "a difficult temper." Sixty years later, even the family maid recalled vividly how "troublesome" and "contrary" Vincent had been, and branded him "the least pleasant" of the Van Gogh children.

He was noisy and quarrelsome and "never took the slightest notice of what the world calls 'form,'" one family member complained. He often skipped the outings his mother organized (to visit distinguished families in the area), while spending inordinate amounts of time with the family maids (with whom he shared the parsonage attic). In fact, much of Vincent's misbehavior seemed

aimed directly at his class-conscious, order-loving mother. When she praised a little clay elephant that he had made, Vincent smashed it to the ground. Anna and Dorus tried punishing their son—indeed, all the family chroniclers agree that Vincent was punished more often and more severely than any of his siblings. But to no apparent effect. "It is as if he purposely chooses the ways that lead to difficulties," Dorus lamented. "It is a vexation of our souls."

On his side, Vincent felt increasingly thwarted, alienated, and rejected—a knot of feelings that characterized his later life just as pious resignation characterized his parents'. "Family," he complained years after leaving Zundert, "is a fatal combination of persons with contrary interests, each of whom is opposed to the rest, and two or more are of the same opinion only when it is a question of combining together to obstruct another member."

Although he continued to embrace his family and its rituals with teary-eyed fervor, Vincent increasingly sought escape from it. Nature beckoned. Compared to the physical and emotional claustrophobia of the parsonage, the surrounding fields and heaths exerted an irresistible pull. Starting at an early age, Vincent began to wander out past the barn, past the rainwater well, down the hill, past the bleaching field where the family's linen was hung to dry, through the garden gate, and into the fields beyond. Most of Zundert's farms were relatively small, but to the Van Gogh children, penned in the narrow garden, the patchwork sea of rye and corn that surrounded the town looked immense: "the land of desire," they called it.

Vincent followed the path that led through the meadows to a sandy streambed, the Grote Beek, where the water ran cool even on the hottest summer day, and his feet left imprints in the fine, wet sand. His parents occasionally came this far on the family's daily walks—although the children were forbidden to go near the water. But Vincent went farther. He walked west and south to where the cultivated fields dissolved into wilderness: mile after mile of sandy moors carpeted in heather and gorse, marshy lowlands bristling with rushes, and stands of pine.

It may have been on these walks on the broad, deserted moors that Vincent discovered the special light and sky of his native country: the unique combination of sea moisture and morphing clouds that had transfixed artists for centuries. "The most harmonious of all countries," an American painter described Holland in 1887, "a sky of the purest turquoise [and] a soft sun throwing over everything a yellow saffroned light."

In addition to sky and light, the Dutch had long been famous for their curiosity and close looking (Dutchmen invented both the telescope and the microscope). The windy moors of Zundert provided endless scope for all of Vincent's powers of observation. The meticulous attention he had developed in copying his mother's drawings now focused on God's designs. He peered deeply into the fleeting vignettes of life on the heath: the blooming of a wildflower, the laboring

of an insect, the nesting of a bird. His days were spent "watching and studying the life of the underbrush," sister Lies recalled. He sat on the sandy banks of the Grote Beek for hours observing the transits of water bugs. He followed the flights of larks from church tower to corn sheaf to nests hidden in the rye. He could pick his way through the high grain "without even breaking one fine stalk," Lies said, and would perch beside the nest for hours, just watching. "His mind was given to watching and thinking." Years later, Vincent wrote Theo: "We share a liking for peering behind the scenes. . . . Perhaps we owe that to our boyhood in Brabant."

Even in these solitary sojourns, however, Vincent found means to defy and provoke his parents.

Anna and Dorus van Gogh loved nature, too—in the comfortable, consoling way typical of the nineteenth-century leisure class. "You will find in [nature] a very agreeable and conversable friend," promised one of their favorite books, "if you will cultivate her intimacy." They had spent their honeymoon in the Haarlemmerhout, a fifteen-hundred-year-old forest filled with birds and wildflowers and healing springs. In Zundert, they walked the meadow paths and pointed out picturesque tableaux to each other: a cloud formation, a reflection of trees in a pond, the play of light on water. They paused in their daily lives to enjoy sunsets, and occasionally went out in search of vistas from which to appreciate them more fully. They embraced the mystical union of nature and religion: the popular Victorian belief that beauty in nature sounded the "higher tones" of the eternal, and that appreciating nature's beauty qualified as "worship."

But none of that explained or justified Vincent's long, unaccompanied disappearances—in all seasons, in all weathers. To his parents' distress, he seemed especially to love walking in storms and at night. Nor did he stick to the meadow trails or the little garden byways in the village. Instead, he wandered far from the beaten path, into untracked regions where no decent person would dare to venture—godforsaken places where one would encounter only poor peasants cutting peat and gathering heather, or shepherds pasturing their flocks. Even the prospect of such contacts had to alarm Anna and Dorus. Once, he ended up near Kalmthout, a town six miles away on the Belgian side of the border—a route that only smugglers took—returning home late at night with his clothes dirty, his shoes muddy and battered.

But most worrisome of all was that he went alone. Anna, in particular, was deeply distrustful of solitude in all its forms. A popular parents' handbook of the time warned sternly that all "country outings" had to be closely supervised, otherwise "the young man disappears into the woods and finds . . . all that is capable of intoxicating his imagination." Vincent spent more and more of his time on these solitary cross-country treks, and less and less time "visiting" or playing with others. His schoolmates recalled him as "aloof" and "withdrawn":

a boy who "had little to do with other children." "Vincent went off on his own for most of the time," one of them said, "and wandered for hours . . . quite a long way from [town]."

His isolation extended even into the crowded parsonage.

Judging by his lifelong affection for babies and small children, Vincent must have found some pleasures at home during his time in Zundert—in the beginning, at least, when the parsonage was filled with both. He shared the attic rooms with them, played games with them, read to them, and undoubtedly played the parent to them in other ways, even as his own parental relationships deteriorated. As each grew up and began to assume an adult personality, however, the warm feelings faded. Anna, his oldest sister, looked and acted increasingly like their mother: humorless, judgmental, and cold (one brother described her as "a bit like the North Pole"). Sister Lies was six years younger and just developing into a poetic, fragile girl when Vincent's adolescent angst began to disrupt the household peace. A lover of music and nature whose moody letters were filled with plaintive "oh!"'s and weeping appreciations of family unity, Lies never fully forgave Vincent for threatening that unity. The last of the sisters, Willemina (called Wil), was born when Vincent was nine, during the tensest years in the parsonage. Unknown to Vincent at the time, the little girl running around under his feet was the only kindred spirit among his "siskins." Dutiful and serious as a child, Wil later developed an intellectual and artistic ambition that made her the only one of Vincent's sisters who ever appreciated his art.

Vincent's inevitable companion in his early years was his brother Theo. Born in 1857, a month after Vincent turned four, Theo arrived at exactly the right moment. He was the first sibling toward whom Vincent could feel a truly parental devotion. The pair played together inseparably. Vincent taught Theo boys' skills like shooting marbles and building sandcastles. In the winter, they skated, sledded, and played board games by the fire. In summer, they played "Jump the Ditch" and other "fun little games" that Vincent invented for his brother's delight.

In a family that otherwise strictly rationed displays of parental affection, Theo repaid Vincent's lavish attention with an attachment tantamount to "worship," according to sister Lies. He considered Vincent "more than just a normal human being." Writing decades later, Theo recalled, "I adored him more than anything imaginable." Starting very early, the two brothers shared a tiny second-floor bedroom, and probably a bed. In the privacy of this attic redoubt, covered in a blue wallpaper that he would remember vividly for the rest of his life, Vincent practiced his ripening skills as a talker—a fast and furious talker—on his adoring brother.

But no matter how hard he tried, Vincent could not make Theo into the same person. They looked less and less alike as the years went by. Theo had his father's

slight build and delicate features, while Vincent's body and face only thickened with age. Theo had blond hair to Vincent's fiery red. They shared the same pale eyes, but in Theo's refined face, they looked dreamy, not piercing. Theo did not share his older brother's iron constitution. From an early age, like all the Van Gogh children except Vincent, he frequently fell ill, suffered terribly from the cold, and was plagued by chronic ailments.

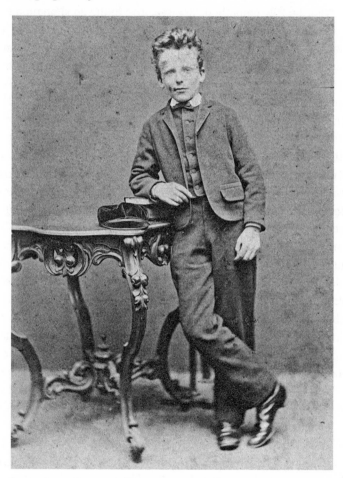

THEO VAN GOGH, AGE 13

But nowhere did the two brothers differ more than in disposition. While Vincent was dark and suspicious, Theo was bright and gregarious. While Vincent was shy, Theo was "warmhearted," like his father, according to Lies, "a friendly soul from the moment he was born." While Vincent brooded, Theo was ever "cheerful and pleased," even in adversity, according to his father—so cheerful that when he heard birds sing, he was "inclined to whistle along with them." With his good looks and sunny disposition, Theo fell naturally into company.

The same schoolmates who remembered Vincent as moody and aloof remembered his younger brother (Ted, they called him) as playful and garrulous. Vincent was "strange," recalled the Van Gogh family maid; Theo was "normal."

At home, in sharp contrast to his brother, Theo embraced the call to Duty. He quickly became his mother's special helper, whose "faithful hands" assisted both in the kitchen and in the garden. Anna referred to him as "my angelic Theo." Extraordinarily empathetic and sensitive to the good opinion of others, he played family peacemaker decades before Vincent tested the limits of that role. ("Don't you agree that we should [try] to please everyone?" said Theo—expressing a most un-Vincent-like sentiment.) Dorus, too, recognized the unique qualities in his namesake and undertook a lavish campaign of instruction that would continue until his death. He would later call Theo "our pride and joy," and would write to him fondly, "You have been like a spring flower to us."

The brothers' special relationship could not survive the contrast. Even as Vincent withdrew further and further into sullen isolation, Theo's star rose higher and higher within the family. ("Dear Theo," his mother later wrote, "just know that you are our most prized possession.") As he felt his brother slipping away, Vincent tried to draw him back into a conspiracy of disaffection against their parents—something he would do repeatedly in the years ahead. But to no avail. They bickered bitterly, setting schoolyard standards for debate that would color all their future arguments. ("*I'm* not conceited, *you're* conceited!" "Take it back!") The rising discord between them caught the attention of their father, who scoldingly compared them to Jacob and Esau, invoking the biblical story of a young brother who usurped his older brother's birthright.

By the time Vincent reached adolescence, he had begun his solitary trips into the countryside and the relationship between the brothers had changed. Now, whenever Vincent slipped out the garden gate on one of these expeditions, he passed his siblings "without a greeting," one of them recalled, and not even Theo asked, "May I come, too?" "His brother and sisters were strangers to him," said Lies. "[He was] a stranger to himself."

Loneliness defined Vincent van Gogh's childhood. "My youth was gloomy and cold and sterile," he later wrote. Increasingly alienated from his parents, his sisters, his schoolmates, and even Theo, he more and more sought the balm of nature, proclaiming by his absences what he would later proclaim in words: "I am going to refresh, to rejuvenate myself in nature." In this recourse, he found confirmation (as he always did) in literature. He began reading Romantic writers such as Heinrich Heine, Johann Uhland, and especially the Belgian Henri Conscience. "I fell in the abyss of the most bitter discouragement," wrote Conscience, in a passage that became one of Vincent's favorites, so "I spent three months on the moors . . . where the soul in the presence of God's immaculate

creation throws off the yoke of conventions, forgets society, and loosens its bonds, with the strength of renewed youth."

Like the Romantics he admired, however, Vincent found danger as well as comfort in the immense impassivity of nature. One could both lose oneself in the immensity and feel oneself diminished; be both inspired and overwhelmed. For Vincent, nature would always have this double edge: it both consoled him in his loneliness and reminded him of his alienation from the world—especially a world where nature and family were so intimately intertwined. Was he alone with God's creation, or just abandoned? Periodically throughout his life, he would seek comfort in his troubles by lurching into the wilderness, only to find more loneliness there and end up returning to the world in search of the human companionship that always eluded him, even in childhood, even in his own family.

To fill the emptiness, Vincent began to collect—an activity that would follow him, incongruously, throughout a vagabond life. As if trying to capture and bring home the companionship he found in nature, he began collecting and categorizing the wildflowers that grew along the creekbank and in the meadows. He used his knowledge of the fugitive birds to start a collection of their eggs. Then, when the birds flew south, he collected their nests. Beetles became his all-consuming passion—the first of many. He skimmed them off the creek and flushed them out of the bushes with a fishnet, then stored them in a bottle to take back to the parsonage, where his sisters squealed in horror at his trophies.

A lifetime of lonely, obsessive activity began in Vincent's attic room, where he spent evening after evening studying and categorizing his collections: identifying varieties of wildflowers and recording where the rarest ones grew; examining the differences between the nests of thrushes and blackbirds, finches and wrens ("Truly birds such as the wren and the golden oriole rank among artists, too," he concluded). He made little boxes to display his bug collection, carefully lining each box with paper, pinning the specimens inside, then neatly labeling each with its proper Latin name—"such horribly long names," Lies recalled, "yet [Vincent] knew them all."

On a rainy day in October 1864, Dorus and Anna van Gogh bundled their angry, alienated son into the family's yellow carriage and drove him thirteen miles north to the town of Zevenbergen. There, on the steps of a boarding school, they said good-bye to eleven-year-old Vincent and drove away.

ANNA AND DORUS'S EFFORTS to educate their eldest son in Zundert had ended in frustration and failure. When Vincent was seven, they had marched him off to the new public school just across the Markt from the parsonage. Prior to the building of the new school, the state of education in Zundert, as in all of

Brabant, had been "not worth a button," according to one angry parent. Most local families did not even bother to send their children to school (illiteracy was rampant); or, if they did, sent them to one of the many illegal schools run out of private homes where instruction was dominated by Catholic teachings and schedules more accommodating of chores and harvest times.

But Anna saw education as yet another privilege and duty of class—like promenading and dressing up—a display of status as well as a preparation for moving successfully in the right circles. Anna and Dorus had reason to believe that Vincent would succeed at school. He was smart and well prepared (he could probably read and write by the age of seven). But Vincent's obstreperousness soon ran afoul of the disciplinarian schoolmaster Jan Dirks, who had a reputation for "boxing the ears" of recalcitrant students. A classmate remembered that Vincent "got into mischief" and was "beaten from time to time," a development that undoubtedly contributed to his chronic truancy.

Anna and Dorus tried everything to salvage their son's foundering education: private tutorials, evening classes, even summer sessions. But nothing worked. At the end of October 1861—only four months into Vincent's second year of schooling—they withdrew him from the Zundert public school. Instead of providing structure and discipline, the classroom experience had only exacerbated his errant ways. He emerged from his brief exposure, if anything, even more insular and unruly than before. Anna blamed the school: "Intercourse with the peasant boys," she later insisted, had "coarsened" her son. The lower-class Catholic boys and the Catholic schoolmaster Dirks—all that "bad company," she concluded, was responsible for Vincent's increasingly rebellious behavior.

For the next three years, Vincent's frustrated parents tried homeschooling him. Despite the expense, they hired a governess and installed her on the second floor. Dorus, who taught daily religion classes for all the local Protestant children (and had himself been homeschooled), set the curriculum. Vincent spent a part of each day in his father's attic study learning gray lessons from the minister-poets (beloved of Dorus) who were fast losing their grip on Dutch education everywhere else. But even the all-suffering pastor could not cope with his troublesome son for long. In 1864, it was decided that Vincent would have to go to boarding school.

The Provily School commanded the narrow street that ran between the town hall and the Protestant church in Zevenbergen. The Zandweg was lined with mansions far finer than anything in Zundert, but none finer than number A40. Elaborate stained-glass panels crowned the front door and the lofty first-floor windows. Stone—a rare building material in Zundert—studded the brick façade: stone quoins, stone pilasters, stone garlands, stone fruit, a stone balcony. Six stone lion's heads peered down from a deep stone cornice. When

Anna and Dorus left their son in the school's grand parlor, they surely believed they were setting him on the right path at last.

Inside Vincent's palatial new home, a large staff tended to the needs of a relative handful of students: twenty-one boys and thirteen girls, sons and daughters of prominent Protestants from throughout Brabant—high government officials, gentlemen farmers, and prosperous local merchants and mill owners. In addition to the sixty-four-year-old founder, Jan Provily, his wife Christina, and his son Pieter, the faculty included two head teachers, four assistant teachers, and a governess imported from London. The school offered a formidable array of courses at both primary and secondary levels. All of this came at a price, of course. As a clergyman, Dorus may have received special consideration, but every guilder spent on Vincent's tuition represented a sacrifice for a parson with a growing family and an impoverished congregation.

But Vincent felt only abandonment. From the moment his parents drove away in their carriage, loneliness overwhelmed him. For the rest of his life, he would return to the memory of their good-bye at the school door as an emotional touchstone—a paradigm of tearful leave-taking. "I stood on the steps before Mr. Provily's school," he wrote Theo twelve years later. "One could see the little yellow carriage far down the road—wet with rain and with spare trees on either side—running through the meadows." At the time, however, no sentimental gloss could distract him from the obvious conclusion. After eleven years of relentless exhortations to family unity, he had been cast off the island parsonage, set adrift. Years later, he would compare his plight in Zevenbergen to that of the forsaken Christ in the Garden of Gethsemane, crying out for his father to rescue him.

The next two years at the Provily School only confirmed his darkest fears. Nothing could have been more paralyzing for a sensitive boy with habits of sullenness in public and temperament in private than the emotional exposure of boarding school. It didn't help that Vincent, at eleven, was the youngest student in the school. As the little redheaded newcomer with a country accent, short temper, and strange manners, Vincent withdrew deeper into his shell of preadolescent melancholy. At the end of his life, he compared his days at the Provily School to being locked in an insane asylum: "I feel every bit as out of place now," he wrote from the asylum at Saint-Rémy, "as I did when I was a twelve-year-old boy at boarding school."

Vincent waged a fierce campaign—as he would so often in the future—to reverse his exile. Within a few weeks, Dorus returned to the school to console and calm his unhappy son. "I flung my arms around Father's neck," Vincent later wrote of their tearful reunion. "It was a moment in which we both felt we had a Father in heaven." But Dorus did not take his son back to Zundert with him. Vincent had to wait until Christmas to see his family again. His jubilation

at returning to the parsonage for the holidays was recalled vividly by his sister Lies more than a decade later. "Do you remember how Vincent came home from Zevenbergen?" she wrote Theo in 1875. "What beautiful days those were. . . . we never thereafter had so much fun or spent such happy days together."

But eventually Vincent was forced to return to the stone lions on the Zandweg. Over the next two years, Dorus paid other visits and Vincent made the round-trip to Zundert for other family celebrations. Finally, in the summer of 1866, responding to what must have been a hail of homesick letters into which Vincent poured all his manic energy and injured loneliness (setting a pattern for the future), his parents relented. He could leave his palatial prison in Zevenbergen at last.

But not to come home.

IT IS NOT CLEAR why Anna and Dorus decided to move their forlorn son from the Provily School to the Rijksschool Willem II in Tilburg, even farther from home. As in Zevenbergen, Dorus probably found his way to the Tilburg School through family connections. Money appears to have been a factor as well. Unlike Provily's, Tilburg enjoyed the privileges of a Hogere Burgerschool (Higher Bourgeois School)—HBS for short—a state-supported school created under the mandate of a new law that encouraged public education as a way of spreading secular, bourgeois values.

Despite being cheaper, the Tilburg School was even more impressive than Mr. Provily's mansion on the Zandweg. In 1864, the Dutch king had donated the royal palace and gardens in the town center for use as a secondary school. The building itself was the stuff of schoolboy nightmares. A strange, squat, forbidding structure with corner towers and crenellated ramparts, it looked more like a prison than a palace. As a new HBS school, Tilburg had attracted a large and distinguished faculty. Because most members taught on a part-time basis, the curriculum offered a rich variety of courses—everything from astronomy to zoology—and drew on the talents of scholars and pedagogues from as far away as Leiden, Utrecht, and Amsterdam.

But all such distinctions were lost on Vincent. Zevenbergen or Tilburg, both were just extensions of his exile. If anything, he withdrew further into his protective shell and redirected the fire of bitterness into his schoolwork (as he would later direct it into his art). Despite his protest that he "learned absolutely nothing" at Provily's, he was admitted to Tilburg's first class without having to attend the preparatory program required of most applicants. Once classes began on September 3, 1866, the school's intensive curriculum absorbed all of his fanatic energy with long hours of instruction in Dutch, German, English, French, algebra, history, geography, botany, zoology, geometry, and gymnastics. The

last, taught by an infantry sergeant, included close-order drill and "instruction in the use of arms." But even as he marched on the Willemsplein in front of the castellated school shouldering his state-supplied cadet gun, he dreamed about the Grote Beek, heath bugs, and larks' nests hidden in the rye.

All of the Tilburg experience seems to have passed the same way: in a haze of mental absenteeism. In a lifetime of correspondence, he never once mentioned his time there. While most of his fellows struggled with the heavy course load, Vincent filled his lonely hours by memorizing great swaths of French, English, and German poetry. By July 1867, he had compiled the fourth-best record of any of his classmates, entitling him to advance to the next level (the second of five). Still, none of Vincent's course work, as successful as it was, seems to have interrupted his inner drama.

Not even art class.

The class's charismatic teacher, Constantin Huysmans, was the brightest star on the Tilburg faculty. The preeminent art pedagogue in Holland, Huysmans had virtually written the book on art education, championing the central role of drawing in preparing young people for the challenges of the new, industrial era. Fifty-five years old when he began teaching at Tilburg, Huysmans had been leading the fight for more and better art instruction in schools since long before Vincent's birth. What had started out as a simple drawing manual in 1840 had grown into a full-fledged popular movement. Huysmans argued that art education held the key to a new Dutch golden age: economic success through better design. A student who learned to draw well would not just acquire "a quick and sure eye," he promised, but also develop a mind "accustomed to steady attention" and alert to "impressions of beauty."

The classroom that Vincent entered for the first time in the fall of 1866 reflected Huysmans's lifetime of thinking about art education. Each student was assigned his own bench and drawing board grouped around a large table in the center of the room where the "model" of the day was displayed—a stuffed bird or squirrel, a plaster arm or foot. Huysmans moved around the room, giving each student, in turn, an exclusive share of his attention—a radical new way of teaching in an educational system just emerging from its dreary, lectern-dominated past. "The teacher himself must be the living method," Huysmans declared, "adapting himself to the subject and especially to the greater or lesser capacity of the pupil." Students hailed him as "stimulating" and "inspiring."

In his classroom, as in his writings, Huysmans made a galvanizing case for a new way of thinking about art—a new way of looking at it as well as creating it. He rejected the "tricks and techniques" that had been the staple of art schools for so long and urged his students instead to seek "power of expression." As a champion of practical art, he opened their eyes to the "art" in commonplace images such as botanical illustrations and atlases. He airily eschewed techni-

cal precision and encouraged his students to "sketch the impression the object makes rather than the object itself." In drawing a wall, he said, "the artist who must copy every small stone and each stroke of whitewash has missed his calling: he should have become a bricklayer."

Given his own love of landscape drawing, Huysmans inevitably led his students outside to sketch what he called "the source of all beauty, God's glorious nature." He was a spirited advocate of perspective, too. The first and foremost aim of art education, he said, was to "foster a keen power of observation." And nothing was more crucial to achieving that aim—to *seeing*—than perspective. Studying other works of art was another pillar of Huysmans's method. He lavished class time on a huge collection of reproductions that he used to illustrate his classroom lessons. He encouraged students to visit museums and exhibitions at every opportunity and develop their own "artistic sense." Without that sense, he argued, "one cannot bring forth anything beautiful or exalted."

Huysmans made himself readily available to students at his house not far from the school, which was filled with a vast collection of books and periodicals as well as his own paintings—primarily dark landscapes of the Brabant countryside and tenebrous farmhouse interiors. An aging, gregarious bachelor, Huysmans could easily be persuaded to reminisce about his youth as a landscape painter in Paris, about his successes at the Salon, his friendships with prominent artists, and his sojourn in southern France.

All this and more was available to any inquisitive student. But none of it mattered to Vincent. He never mentioned Huysmans or his class again. Years later, he complained bitterly: "If there had been someone then to tell me what perspective was, how much misery I should have been spared." Even when he set out to list his early artistic efforts, neither Huysmans's class nor any of the work he did there rated a mention.

With his extraordinary powers of retention, he no doubt tucked away some of what he heard and saw to be retrieved years later, unconsciously: the joy of cataloguing reproductions; the overlooked art of everyday imagery; the dark Brabant landscapes and interiors; the insistence that art have a practical value; the belief that expressiveness mattered more than technical skill; the conviction that true art, like any other craft, could be achieved by diligent application as well as by inspiration or gift. All of these would surface, or resurface, later in Vincent's life. But only after a sleep of almost two decades.

Vincent's few classmates (down to nine his second year) may have fitted Anna's ideal of "right company," but none was likely to befriend the strange country boy who kept to himself so much. All but one had grown up in the Tilburg area; all still lived with their families. When the last school bell rang, only Vincent trudged off through snow or rain to a home that wasn't his own. The family that boarded him, the Hannicks, treated him as well as could be expected

of a couple in their late fifties with a sulky thirteen-year-old boy thrust upon them. Vincent never mentioned them again.

Cut off from all emotional support, his spirits sank deeper and deeper into contrary feelings of homesickness and resentment. The twenty miles between Tilburg and Zundert—twice as far as Zevenbergen—discouraged both parental visits and trips home. When he arrived at the train station in Breda and the yellow carriage failed to appear—as it sometimes did—he had to walk the rest of the way to the parsonage, a trek of more than three hours. Even during his rare vacations, his siblings saw less and less of him as estrangement propelled him out the parsonage garden gate, or deep into a book.

Yet every time he returned to school, the homesickness swept over him again; the exile resumed. It was a bitter, hardening cycle that the visits home, with their inevitable leave-takings, only made worse. In a school photograph taken about this time, Vincent sits in the front row, his arms and legs crossed tightly, his shoulders hunched, his body bent forward as if folding in on itself. A military cap shields his lap. Other students relax, stretch out, spread their legs, lean back, look distractedly to the side. But not Vincent. With his drooping cheeks and perpetual pout, he hunkers within himself and glumly peers into the camera as if spying the world from a hidden, solitary redoubt.

VINCENT VAN GOGH ON THE STEPS OF THE TILBURG SCHOOL

In March 1868, only weeks before his fifteenth birthday, and two months before the end of term, Vincent walked out of the Tilburg School.

He may have walked all the way to Zundert—seven hours—instead of taking the train partway. If so, it would be the first of many long, lonely, self-punishing

walks that marked turning points in his life. What welcome he received when he showed up at the parsonage door, bags in hand, is not recorded. He had no convincing explanation to give his parents. No matter how much they bewailed the money already wasted on his education—the fees, the board, the travel—and the shame of such failure and waste in the eyes of others, Vincent remained unmoved. He had what he wanted. He was home.

FOR THE NEXT sixteen months, Vincent clung to his recovered life in the island parsonage, a reparative fantasy enhanced by a new baby brother in the house, one-year-old Cor. Defying the guilt that accumulated with each passing month of idleness, he resisted all suggestions for his future, preferring to spend his days at the Grote Beek, on the heath, and in his attic sanctuary. His rich uncle, an art dealer in The Hague, probably offered him a job. If he did, Vincent refused it, preferring his solitary pursuits.

He must have known that questions about his future, or the self-reproach they undoubtedly aroused, could not be put off forever. No matter how determinedly he trekked through the heath or lost himself in a book, or mounted his collections, sooner or later he would have to confront his family's frustrated expectations. Especially his father's.

God and Money

~

EVERY SUNDAY, THE VAN GOGH FAMILY, DRESSED IN BLACK, WALKED solemnly from the Zundert parsonage to the nearby church. There they took their place in a special pew at the front of the tall, spare little sanctuary. From his vantage point at the foot of the pulpit, Vincent could watch the ceremony unfold. The reedy chords of a harmonium summoned the forty or fifty worshippers to their feet. The music called forth the deacons, in their long dark coats and grim faces, measuring their steps as they came. Finally, the pastor emerged into view.

He was a short, slight man; hardly remarkable in most crowds. But here, the ceremony singled him out. The light reflected off his silver-sandy hair. His face shone against his full black robes, the inverted V of his starched collar singling him out like an arrow.

Then he ascended into the pulpit.

Thrust high into the air and overhung by a heavily carved sounding board, its tall parapets enclosing barely enough room for one man, the pulpit looked like a richly appointed box, just opening up to reveal its precious contents. Every Sunday, Dorus van Gogh ceremoniously climbed the steep stairs to the sacred enclosure and stepped inside. Vincent sat so close that he had to crane his neck to watch his father's ascent.

From this lofty position, Dorus directed the service: announcing each hymn, summoning music with a wave of his hand, leading the congregation in prayer and psalm. In his sermons—the soul of the service—he used High Dutch, a language rarely heard in the provincial depths of Brabant. If he followed the homiletic conventions of the era, the little church must have reverberated with the histrionic extremes of Victorian rhetoric: the ringing declamations, the exaggerated variations in speed and volume, the melodramatic cadences, the ac-

celerating repetitions, the thundering climaxes. His body, too, spoke in broad, larger-than-life gestures: every sweep of his arm or thrust of his finger dramatically elaborated by his billowing sleeves.

Dorus van Gogh was not only God's interlocutor to the Protestants of Zundert, he was their leader. Unlike parsons in other parts of the country, Dorus acted as both spiritual and temporal shepherd to his tiny band of Protestant pioneers in their outpost on the heath. Cut off from all but essential contact with the Catholic community around them, congregation members used the parsonage as both spiritual center and social club, filling the Van Goghs' front room almost every day of the week with readings, classes, or informal visits.

THEODORUS (DORUS) VAN GOGH

Dorus acted not only as the leader of his own community but also as ambassador to the larger Catholic community. His mission there was not to convert the papists of Zundert, but to deny them hegemony in this disputed region. At all public celebrations, Vincent would have seen his father among the town notables gathered on the dais, standing next to elected officials, as well as his Catholic counterpart. In public fund-raising drives, like a major one for flood victims,

Dorus always took a conspicuous leading role, matching the mayor's contributions guilder for guilder. These public acts, like his daily walks through town in his top hat with his family in tow, served notice to the Catholics of Zundert that the Protestants were there to stay.

For those parishioners who lived on isolated farms and in tiny hamlets spread throughout the vast township, Dorus played an even more critical role. Forbidden by custom to interact with their Catholic neighbors, these religious pioneers relied on the pastor's weekly visits for reassurance of God's favor, but also for something even more important: money. Successive waves of crop failure and blight had devastated the area's rural families. Farmers already living at subsistence level were thrown onto the church dole. As dispenser of these scarce funds, Dorus van Gogh held the power of life and death over his far-flung flock. When Vincent accompanied his father on trips into the countryside, he saw him greeted not just with reverence, but with kneeling gratitude.

With survival itself at stake, Dorus largely ignored the finer points of religious doctrine. Especially in an outpost like Zundert, what mattered was a man's mettle and a woman's fertility, not doctrinal purity. "We know that talking about religion and morality is of minor importance," Anna van Gogh wrote. The parsonage membership roll, which included Lutherans, Mennonites, and Remonstrants, testified to the parson's pragmatic ecumenism. But while dogma mattered little to Dorus, discipline meant everything. An unexplained absence from Sunday service invariably brought an angry visit from the parson that very week. He dealt with errant parishioners severely—"a real little Protestant Pope," one witness called him—and lashed out at those "scum" who challenged his authority. He hotly defended the prerogatives of his position, complaining bitterly to his church superiors when his meager salary made it difficult for him "to support his family in accordance with his rank."

Within the walls of the parsonage, Dorus's role as spiritual leader merged seamlessly with that of father. For the Van Goghs, the Sunday service never really ended; it just moved to the front parlor, where the cupboards were filled with communion plates and chalices, Bibles, hymnals, and psalm books. A statue of Christ stood on top of the chest, and a cross with twining roses hung in the hall. All week long, the Van Gogh children heard their father's distinctive church voice—preaching, praising, Bible reading—echoing from the parlor sanctuary throughout the narrow parsonage. And every night at the dinner table they heard the same voice praying: "Bind us, O Lord, closely to one another, and let our love for Thee strengthen these bonds ever more."

When not preaching or praying, Dorus remained aloof from his growing family. Moody and reclusive, he spent long hours in his attic study, reading and preparing his sermons, with only his cat for company. His indulgences complemented his solitude: he smoked pipes and cigars, and nipped a wide variety of

alcohols. His hours of seclusion were punctuated by "brisk, stimulating walks," which he considered "nourishment for the mind." When sick, which he often was, he grew even moodier and withdrew even further into seclusion, believing that "by making myself scarce it will end sooner." During these self-imposed confinements, he became "bored and cranky," and rejected all food, convinced that fasting would hasten his recovery.

Like most fathers of his generation, Dorus saw himself as "the delegate of God [who] exercised power akin to God" within the home. In his view, neither his outpost nor his family could brook "dissension," and he enforced unity in his family, just as he enforced it in his congregation, with uncompromising vehemence. He flew into "violent passions" of self-righteous anger when his authority—God's authority—was challenged. Vincent learned early that to disappoint his father was to disappoint God. "The love that honors the father," Dorus insisted, was the same love "that blesses the world." Offending one love offended the other; rejecting one rejected both. Later in life, when Vincent sought absolution for his sins, he hopelessly confused "father" and "Father," and found forgiveness in neither.

But there was another Dorus van Gogh. Rather than invoking "papal" authority, this Dorus used gentle persuasion and kind entreaties to keep his children on the straight and narrow. This Dorus did not "suspect" or "judge" them, he merely "provided support" and "encouraged them." This Dorus apologized when he hurt their feelings and rushed to their bedsides when they fell sick. This Dorus declared it his "goal in life . . . to live with and *for* our children."

Vincent had two fathers because, at the time, fatherhood itself was in crisis. By the middle of the nineteenth century, the French Revolution's challenge to all authority, both spiritual and temporal, had penetrated to the heart of the social contract: the family. The traditional patriarchal father figure who ruled his family "like the gods on Mount Olympus" had become just another relic of the ancien régime, according to the era's most popular instructional book on fathering. The modern family, like the modern state, should embrace "Democracy," it said, and be based on "respect for the other," not hierarchy and fear. Fathers should come down from their "thrones"—and pulpits—and get "more involved in their children's lives," it advised, "listen more to their opinions." In short, "a father must be a friend to his son."

Dorus van Gogh absorbed these lessons. "You know that you have a father who also wants to be like a brother to you," he wrote to his nineteen-year-old son, Theo.

Torn between the patriarchal father that the Zundert outpost demanded and the modern father that his social class expected, Dorus zigzagged his way through the successive crises of Vincent's childhood. Fierce criticisms were followed by protestations of love ("We can not breathe freely if there is a somber cloud over the face of one of our children"); thundering condemnations, by

elaborate claims of good intent ("I just point out things that you have to work out for yourself . . . It would be disloyal if we suppressed thoughts or held back remarks"). He professed deference to his sons' "freedom" but besieged them relentlessly with accusations of "making messes" and "bringing worry and sadness" into their parents' lives.

To a lonely, needful child, it was an irresistible trap. Vincent couldn't help but emulate the remote figure that ascended into the pulpit every Sunday. He adopted the same circuitous way of talking and metaphorical way of seeing. He developed the same emotional diffidence in public, and dissected his feelings with the same misguided rationalism in private. He approached the outside world with the same defensive suspiciousness. He treated those who challenged him with the same self-righteous inflexibility and reacted to perceived slights with the same paranoid anger. The son's introversion mirrored the father's reclusiveness; the son's brooding, his father's melancholy. Like his father, Vincent fasted to expiate his failings. In his collecting, and later his painting, Vincent mimicked Dorus's long hours of solitary activity in his attic study. The sight of his father helping the needy and consoling the grief-stricken—being welcomed and loved for the comfort he brought—became the central image of Vincent's adulthood, the image that drove all his subsequent ambitions in life and art. "How glorious it must be to have a life behind one like Pa's," he once said.

But at the end of all of Vincent's bids to win his father's blessing lay the other, inflexibly judgmental Dorus. For a man who considered cheerfulness "the fruit of a childlike faith," a gloomy son like Vincent must have seemed beyond the reach of God's favor. For a man who believed that "one becomes a person by meeting people," Vincent's introversion marked him indelibly as an outcast. For a father who urged his children to "work more and more for togetherness with each other," Vincent's contrariness was a continuing insult to family unity. For a man who exhorted his children to "always take an interest in life," Vincent's stubborn isolation at school and even within the parsonage must have seemed like a rejection of life itself.

In the end, no matter what the books told him, no matter how sincerely he wanted to help his son, Dorus could never bring himself to accept Vincent on his own terms. Despite his repeated promises to do so, he could never refrain from judging—and condemning—his willful, obdurate, eccentric son. These broken promises only drove father and son deeper into a spiral of provocation, rejection, and self-reproach from which Vincent, despite repeated attempts, could never escape.

IN A CHILDHOOD defined almost exclusively by family, only one other figure competed for Vincent's emulation: his uncle the art dealer Vincent van Gogh.

Other relatives visited more often or led more colorful lives (his uncle Jan had sailed the globe and fought in the East Indies). But "*Oom* [Uncle] Cent" had a double claim to his special place in Vincent's world. First, he had married Anna Carbentus's youngest sister, Cornelia, compounding the family ties between the Van Goghs and the Carbentuses. Second, for reasons that remained a mystery, he and his wife could not have children. The combination made Cent almost an alternate father to his brother's family—and it made young Vincent, the bearer of his name, as close to a son (and heir) as Cent would ever have.

UNCLE CENT VAN GOGH

During Vincent's early years, Uncle Cent lived in The Hague and visited Zundert with some frequency. Separated by only two years, the two brothers, Cent and Dorus, looked alike (the same slight build, the same salt-and-cinnamon hair). But the similarities ended there. Father Dorus was stern and humorless, Uncle Cent lighthearted and entertaining. Dorus quoted Bible verses, Cent told tales. They had chosen for wives two sisters as different as they were. Mother Anna frowned and admonished, while Aunt Cornelia lavished on her sister's

children the spoiled and spoiling attention of a woman who had been the baby of her family but had no prospects of a baby of her own.

The biggest difference, of course—the one that permeated every encounter—was money. Uncle Cent was rich. He dressed impeccably, as did his wife. His stories were peopled by kings and queens and barons of commerce, not farmers and tradesmen. He lived in a big gilded townhouse in The Hague, not in a narrow country parsonage. When Vincent was nine, Cent moved to Paris and occupied a succession of grand apartments and villas about which the family bragged tirelessly. Whereas his father seemed hardly ever to leave the barren isle of Zundert, Uncle Cent ranged the world. Through letters that his parents proudly read aloud, Vincent followed his uncle's trips to the ancient cities of Italy, the mountains of Switzerland (Vincent grew up longing to see mountains), and the beaches of southern France. Cent spent his winters on the Riviera and, every Christmas, sent greetings to the frosty parsonage from a "lovely" land where exotic fruits, grown only in greenhouses in Holland, "grow in the open here."

How could his look-alike uncle and father have ended up living such different lives, Vincent must have wondered; how could the same family have produced such different men?

THE CONTRADICTION RAN DEEP in Van Gogh family history. The first natives of the little Westphalian village of Goch who ventured out of the Rhine valley in the fifteenth century were drawn to God's work. Van Gochs and Van Goghs fanned out to monasteries across the Low Countries. A century later, some were preaching so militantly that they "gave offense," according to the family history—a serious charge in a century racked by religious wars.

These early missionaries encountered a society that was itself deeply conflicted about the roles of God and money. The newly arrived Calvinists' denunciations of "filthy lucre" sat uneasily in a land-poor country where money was the only way to keep score in the chief enterprise, trade. As always, the Dutch proved wondrously inventive in reconciling their acquisitive instincts with their spiritual aspirations: the rich were suitably "embarrassed" by their riches while simultaneously claiming them as a sign of divine grace; business failure and bankruptcy continued to rank high on the list of mortal sins.

By the time the Van Goghs showed up in The Hague in the seventeenth century, they, too, had caught the Dutch mercantile bug. First setting themselves up as tailors, they applied their skills to the burgeoning demand for luxury goods. In a race to show off their fabulous wealth while maintaining puritan modesty, the burghers of the Golden Age had turned to their tailors. The solemn black of Dutch propriety sprang to light with threads of silver and gold. By midcentury,

the Van Goghs were working precious metals instead of molding men's souls. Master tailors like Gerrit van Gogh were prized for the miles of spun gold they embroidered into waistcoats, capes, and jackets that sagged from the weight. By the time David van Gogh was born in 1697 (the same year as Gerrit Carbentus), the Van Goghs had made gold their sole business: they manufactured the gold wire that by now threaded its way into every corner of haut-bourgeois Dutch culture, from uniforms to draperies.

Some Van Goghs merged their spiritual and temporal ambitions: one served as a lawyer to monasteries and convents; another combined the callings of doctor and clergyman, healing both body and soul. More often, families split the duties between sons. David van Gogh's younger son Jan continued the family gold business; but his older son, Vincent, became an artist. Parisians probably first mangled the name "Van Gogh" when this Vincent arrived in the French capital sometime in the 1740s. Like his famous namesake, the painter, this Vincent van Gogh (there was one or more in every generation) led an incoherent, unconventional life. After wandering the Continent as a soldier-adventurer, he declared himself a sculptor. He married four times but died childless. His brother Jan's son Johannes inherited the family's lucrative gold wire business, but eventually he quit the trade and devoted himself exclusively to preaching the Gospel—bringing the family full circle back to its roots in Reformationist mission.

Johannes gave his only son the name of his childless artist-uncle: Vincent. Sixty-four years later, that Vincent would give the same name to his grandson, the painter Vincent van Gogh.

Johannes's son Vincent followed his father into the ministry. But he still could not escape the curse of ambivalence that had dogged his family for two centuries. Like his father, Vincent married a wealthy woman and applied for positions only in the richest congregations. In Breda, the ancient seat of the House of Nassau situated on the northern edge of Catholic Brabant, he found the ideal post for an up-and-coming clergyman with a taste for the material life. He installed his huge family (eventually thirteen) in a grand house on Catharina-straat, the town's main thoroughfare.

From this comfortable berth, he quickly rose to leadership in the "Society for Prosperity," the church's missionary initiative in the Catholic south. Far from a traditional charity, the Society saw its mission as investment. Secretly—to avoid conflict with Catholic authorities—it purchased farms and homesteads in Catholic areas and then relocated needy Protestants to work them. Like any investor, the Society expected a return on its money—both in lease payments and in large families to bolster Brabant's struggling Protestant congregations. For forty-two years, Vincent served as the Society's "cashier," recruiting hundreds of farmers with the Society's dual promise of financial reward and spiritual salvation.

Reverend van Gogh encouraged his children to a serious life of "work and

prayer," but he also instilled in them his own bourgeois aspirations. His family record is filled with loving descriptions of china, silver, furniture, and carpets; detailed reports of salary increases and prices paid; lamentations over missed promotions and squandered inheritances; and tributes to the advantages of owning over renting.

Thus, it was hardly surprising that none of the Reverend's six sons showed any interest in following him into the ministry. One by one, they embarked instead on socially and financially ambitious careers. The eldest, Hendrik (called Hein), saw opportunities in the book business and opened his own store in Rotterdam by the time he turned twenty-one. He, too, married a rich man's daughter. The second son, Johannes (called Jan), sought his fortune in the Dutch navy. The third son, Willem, joined the officer corps. The youngest, Cornelis (called Cor), entered the civil service.

The Reverend's hopes for a spiritual heir settled on his namesake, Vincent (called Cent). But Cent was soon struck down by scarlet fever and emerged too frail for the intense study required by the ministry. Or so he claimed. Whether because of his "terrible headaches," or because, like his brothers, he had no interest in his father's religious ambitions, he soon quit studying altogether. After a brief apprenticeship with brother Hein in Rotterdam, he moved to The Hague, where he worked in a paint store and lived a bachelor life of fencing, socializing, and womanizing.

That left only Theodorus.

IN FORTY YEARS of sermons, Dorus van Gogh preached thousands of images, verses, and parables. But one had special meaning for him: the sower. "For whatsoever a man soweth," Paul wrote to the Galatians, "that shall he also reap." To Dorus, Paul's words meant much more than a call to seek spiritual rewards rather than earthly pleasures. As he told the story to the farmers of Zundert working their sandy fields, the sower became a paragon of persistence in the face of adversity. His Sisyphean labors, like theirs, affirmed the power of perseverance to overcome any obstacle, triumph over any setback. "Think of all the fields that were turned down by shortsighted people," Dorus preached, "but through the sower's hard work finally produced good fruit."

If the story of the persistent sower had special meaning for Dorus van Gogh, it was because he had lived it.

Dorus's entire childhood had been a struggle. Declared by the family chronicler, his sister Mietje, "a very weak baby" from the moment of his birth in 1822, Dorus never fully recovered his health or his strength. He didn't learn to walk until he was well past two. He kept the short, slight body of a boy throughout his life. As the seventh of eleven children, the fifth of six sons, he barely knew

his parents. He inherited his father's "fine, delicate appearance" but not his easy intelligence. His modest academic success was the product of application, not aptitude. He was known for being "tidy" and diligent—"a good worker" who began his studies every morning at five.

Perhaps because illness was such a constant in his childhood, Dorus wanted to be a doctor. In 1840, medicine was an ideal career for a serious-minded, upwardly mobile parson's son with an appetite for hard work and a vague urge to do good while doing well. He even considered signing up to serve in the East Indies (where his brother Jan was stationed at the time), which would have made him eligible for free medical training. But when his father's disappointed ambitions belatedly fell on him, he could not refuse.

The ministry was by no means an obvious choice. Like his brother Cent, Dorus enjoyed the temporal pleasures that Paul had warned the Galatians against. Quoting a favorite poet, Dorus later referred to his youth in unmistakably lusty terms, comparing it to "a wheat field, delightful and beautiful for the eyes; howling, churning, and swelling in the early morning wind." By his own admission, his student years were filled with "intimate interactions" and "crazy things." Years later, when his own sons began to yield to the temptations of the flesh, Dorus admitted, "at your age I went through the same."

He found university life in Utrecht lonely and strange. But this was the field that fate had given him, and he was determined to make it bear fruit, no matter how barren and unpromising it seemed. "I am happy I have chosen to become a minister," he wrote soon after his arrival. "I find it to be a beautiful profession." He worked so hard at his studies that he repeatedly fell sick. One year, he almost died.

In Holland in the mid-nineteenth century, only someone with blind resolve could see the ministry as a "beautiful profession." In fact, by 1840, the Dutch Reformed Church was in upheaval. The simultaneous storms of revolution and science had loosened theology from its moorings in revealed truth. Only five years earlier, a German theologian had placed a bomb under Western Christianity with the publication of *Das Leben Jesu* (*The Life of Jesus*), a book that analyzed the Bible as history and Christ as a mortal man.

As Dorus began his studies, the clergy's long monopoly over Dutch thought was collapsing around him. The powerful new bourgeois classes were demanding a less punitive, more accommodating religion—a *modern* religion that would permit them to enjoy both God's favor and their newfound prosperity. In response, a new kind of Dutch Protestantism had emerged. Calling itself the Groningen Movement (after the university in northern Holland where most of its proponents taught), and claiming the biblical humanism of Erasmus as a model, it rejected not only the old dogmas, but the whole notion of dogma. Instead, it embraced a new idea of Christ that included both the historical Jesus

("as He lived on earth 1800 years ago") and the spiritual Jesus who came "to make humanity ever more conformed to the likeness of God." As a retort to *Das Leben Jesu*'s debunking of the Christ myth, the Groningers revived the Jesus of Thomas à Kempis's *Imitatio Christi* (*The Imitation of Christ*), a fifteenth-century vade mecum filled with down-to-earth guidance on living a Christlike life. "Make use of temporal things, but desire eternal things," Jesus advises in *Imitatio*, confirming that even a rich man could be blessed so long as he achieved a "union with Christ" in his heart.

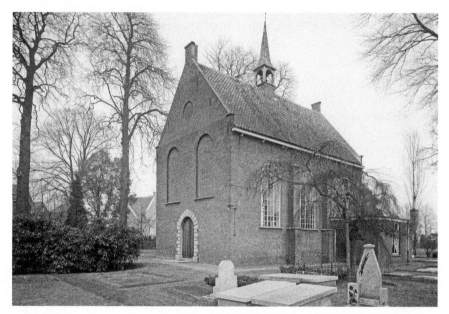

THE ZUNDERT CHURCH

Even Dorus's own family conceded that he was "not talented" as a public speaker. His sermons—long, convoluted affairs, filled with the leaden pedagogy typical of the Groningers—resembled his handwriting, described by his son Theo as "very fine but also very illegible." To make matters worse, his voice didn't carry well and his words often got lost or garbled. During one early sermon he tried to clear his throat by putting some candy in his mouth and rendered himself so unintelligible, according to a witness, that the congregation "feared something was amiss with his speech organs."

But Dorus persevered. Finally, in January 1849, after three years of rejections, he was offered a position in a remote township on the Belgian border called Zundert. The outgoing minister called his congregation "a well-prepared field." In fact, the persistent sower could not have found less fertile ground. The family chronicler, ever upbeat, described the new job as Dorus's "ideal posting,"

citing a popular poem about a quaint country parsonage on the moor. But the reality of Zundert, with its beleaguered band of Protestants set down in a sea of Catholic antagonism, bore no resemblance to the poet's romantic vision. And no excess of family enthusiasm could disguise the hard truth that the Zundert congregation, whose very existence hung by a thread, represented the lowest rung of the Dutch Reformed Church. "This little flock has been small from the beginning," Dorus noted ruefully, "and hasn't grown appreciably in the nearly two and a half centuries since."

And the future looked even grimmer. A succession of devastating potato blights and crop failures had plunged many farmers into destitution. Unable to feed their families for weeks at a time, they ate the food meant for cows, when they could get it. On their way to church, members risked encountering bands of desperate dispossessed farmers who roamed the countryside begging and stealing. The little congregation suffered severe losses as typhoid epidemics swept through the town, killing Protestants and Catholics indiscriminately. Between death and desertion, Zundert's tiny Protestant population shrank by half in a single decade.

This was the unpromising plot of moorland to which Dorus put his plow in April 1849. He set an example of faith in the future by marrying and bringing his bride, Anna Carbentus, from The Hague. He raised money from Zundert's handful of wealthy Protestants and bought an organ. In the spirit of self-help that animated the Society for Prosperity, he arranged with a carpet manufacturer in Breda to supply spinning wheels to widows in the congregation who were paid piece wages for the yarn they produced. Despite the hard times, he trimmed the church's welfare subsidies—a thankless task that required evicting farmers from church-owned lands, with force if necessary, often with catastrophic consequences.

Sowing and reaping were more than just metaphors to Dorus van Gogh. Like his father, he worked the farmland of Brabant in every way other than with his hands. As the local administrator of the Society, he identified farms and farmland to be purchased; he evaluated their soil, drainage, and pasturage; he negotiated the leases. He advised farmers on how to drain and plow, what and where to plant, and how to manure (all-important in Zundert's sandy soil). He was a demanding manager, grading each leaseholder on his skill, diligence, behavior, and cleanliness. Was his wife stupid, indiscreet, or disorderly? Did he have too many children to feed, or insufficient livestock for composting? For those who performed well, Dorus did what he could to shield them from the torments of poverty and debt. He pleaded their cases to the Society's board—the "Gentlemen in Breda," he called them—arguing that the church owed a special duty to "the handful of members who stand here, at the barricades."

But even soldiers at the barricades had a reckoning. The Dutch God was

an understanding landlord, but neither His patience nor His pocketbook was unlimited. If a farmer died and his wife could not carry on, Dorus evicted her and sold the family's possessions at public auction. Even the family of a typhoid victim was not immune. At the direction of the Society, Dorus evicted the dead man's wife and ten children. Another widow pleaded that eviction would leave her with no way to support her five children except prostitution. But the Gentlemen were unmoved. When the carpet manufacturer complained about the poor quality of yarn produced by the widows in Dorus's work-relief program, the Society terminated it. Soldiers and widows were not expected to be profitable, just to pay their own way. Otherwise, church support might be treated as charity, which, as the mayor of Zundert noted, "only feeds the laziness of people."

Whether in matters of God or money, this was the bottom line, the irreducible core of Dutch success: self-sufficiency. It was here, at this elemental level, that Dutch spiritual and temporal ambitions met. Neither piety nor pious labor—"the daily bread" that came from "the sweat of the brow"—was enough: not in this world, not in the next. There could be no true spiritual success without this minimum of temporal success.

This was the lesson Dorus taught his leasehold farmers—and his son Vincent: "Keep helping us by helping yourself." Without self-sufficiency there could be no self-respect. "Make sure that you can be independent," Theo van Gogh wrote his younger brother Cor, "for being dependent is a misery for yourself and for others." Decades later, when Vincent watched a sower at work outside the barred window of his cell at the insane asylum at Saint-Rémy—a sower he would immortalize in paint—he couldn't help deploring the laziness and waste he saw. In a letter home, he upbraided the farmer for living off the charity of an easy land. "The farms here would produce three times as much," he wrote, "if [they] were sufficiently manured."

For Vincent, as for Dorus, nothing existed in a temporal vacuum: not nature, not religion, not art. Everything, and everyone, had to succeed in *this* world to have any hope of success in the next.

WHILE DORUS VAN GOGH carried on his forebears' service to God, his brother Cent dedicated himself to the family's other traditional pursuit: money. After two years in The Hague, his bachelor high life had attracted the glowering attention of his parents. "There is much they don't like," the family chronicler hinted darkly. At their insistence, apparently, he left both the home and the employ of his dissolute cousin and, in 1841, opened a paint store a few blocks away on the Spuistraat selling paints and artists' supplies.

Most of the artists who patronized his new store were, like him, young men from good families, bon vivant sons of the bourgeois class with money and

the leisure to enjoy it. Charming and gregarious, with a quick wit and an easy laugh, Cent moved with equal comfort in the best drawing rooms of Hague society and in the smokiest artists' taverns. He fenced by day and partied by night. He dressed nattily; starred in amateur theatricals; and loved singing. "[We] were a very jolly, high-spirited group," one of his comrades recalled.

It was probably his active social life in this bourgeois milieu that led Cent to the discovery that would make him a very rich man. By the middle of the nineteenth century, the new Dutch middle class, indeed all of Europe, was buying art prints. Sales of everything from cheap wood engravings to expensive drypoint etchings skyrocketed as great swaths of Europe's population were introduced to the luxuries of disposable income and competitive acquisition. Classical and historical images, idealized nature scenes, still lifes, and religious subjects crowded the houses of the newly affluent.

In the Netherlands, the same wave of nostalgia that inspired hundreds of books on Dutch history also generated thousands of images of a quaint, picturesque, self-congratulatory Dutch past—so-called genre scenes. Images from the champions of the Golden Age, Rembrandt especially, flooded back into the public imagination and onto parlor walls. The Dutch, like the rest of Europe, also felt the fever of fashion radiating from the south. Newspapers and magazines trumpeted the prizewinning artists and paintings at the annual Paris Salon, fueling the demand for prints of mythological fantasies or costumed cavaliers as the bourgeoisie rushed to stake a claim in the latest style.

In the mid-1840s, Cent van Gogh's little paint store became one of the few places in The Hague that sold art prints. By 1846, business was booming. In May of that year, Cent traveled to Paris to visit the man who supplied many of the prints sold in his shop—indeed, most of the prints sold in Europe—Adolphe Goupil. The tall, starched Frenchman took an immediate liking to the slight, smooth-talking Dutchman, whose youth astonished him. Goupil, too, had started young. From a small store on the boulevard Montmartre in 1827, he had built an empire of images: a vertical monopoly that included not only several stores in Paris, a branch in London, and an agent in New York, but also a huge production facility where ranks of engravers and printers supplied his stores— and middlemen like Cent van Gogh throughout Europe—with thousands of prints in every conceivable format, subject, and price range.

Cent returned from his trip to Paris with a new determination. In the same year that Dorus became a candidate for the ministry, 1846, Cent van Gogh committed himself to becoming truly rich. Closing the door on his frivolous *flâneur* days, he finally married—at the extraordinarily belated age of thirty— choosing for his wife Cornelia Carbentus, youngest sister of another up-and-coming Hague merchant, bookbinder Gerrit Carbentus. When he discovered that his new wife could not bear children, he blithely enlisted her into the busi-

ness as a way to keep overhead down (always a concern for the penny-wise Cent).

With an energy that defied his always frail health and an impresario's acumen that nearly matched his French mentor's (a friend described him as "a careful . . . clever . . . calculating businessman"), Cent set out to replicate Adolphe Goupil's success in Holland. His motto: "Everything gets sold."

He quickly grasped the essence of Goupil's genius: images were commodities, not unique works of art. A successful print seller had only to assess the public taste and then find the images to suit it. Goupil's eye for popular imagery was legendary. Cent soon proved his equal. Before long, the traffic between Paris and The Hague went both ways: Goupil sent the latest fashionable prints adapted from French paintings; Cent forwarded to Goupil's reproduction factory images by Dutch artists that he judged "salable"—his signature word. Traveling ceaselessly, he scoured the Continent for images, artists, even whole schools of artists, to feed the insatiable demand for comforting, sentimental, fashionable, decorative art. Like Goupil, he sold images in every format and size, at every price point. In the mid-1850s, the development of photographic reproduction techniques made it possible for both men to add cheap and inexhaustible photogravures to their stock, opening up a vast new market of middle-class buyers. By the end of the decade, Goupil had built an entire factory dedicated to the new mass medium.

While he relentlessly showcased and spent lavishly on the artists and images that sold well—like Ary Scheffer's religious dramas and Rosa Bonheur's animal pictures—Cent also encouraged lesser-known Dutch, French, and German artists to create salable images by hanging their works in his store, and even, occasionally, buying them. He was known to provide materials, even cash, to young Hague artists whose works he judged promotable. But this was not charity. Like the "Gentlemen in Breda," Cent considered these subsidies investments. He never gave materials or cash to any artist without receiving work in exchange. He never bought, sold, or supported artists whose painting styles he considered unsalable. Ultimately, artists, like widows, had to support themselves.

The Dutch god of commerce smiled radiantly on Cent's efforts. In 1848, another revolution in France, combined with an explosion of railroad construction and the adrenaline of colonial empire, jolted the Continent's economy out of its long doldrums. Everyone, now, it seemed, wanted art. Encouraged by his brother's success, Hein van Gogh started selling prints at his bookstore in Rotterdam, and in 1849, youngest brother Cor opened a store for books and prints in Amsterdam, where his fortunes, too, rose with the tide. By the end of the decade, Cent's little store on the Spuistraat had been given a grand new title, the Internationale Kunsthandel Van Gogh, and the name Van Gogh had become virtually synonymous with art dealing throughout Holland and even beyond.

Given his company's phenomenal prosperity and expansion, it was inevitable that, sooner or later, Cent would have to either compete with Adolphe Goupil or partner with him. In February 1861, fifteen years after their first meeting, the two men sat down in the immense *hôtel* on the rue Chaptal that was Goupil's new Paris headquarters, and signed a partnership agreement. Much had changed in those years. Goupil, even more than Cent, had prospered extravagantly in the boom of the previous decade. Nothing trumpeted his success more loudly than the huge house at 9, rue Chaptal. Five floors of limestone in the grand empire-recherché style in which Baron Haussmann was then remaking Paris, it included galleries worthy of a king, studios for favored artists, printing facilities, and a palatial *appartement* for visiting dignitaries.

The deal was an extraordinary coup for the forty-year-old parson's son from Brabant. While technically a partnership (with Goupil holding a controlling 40 percent stake, Cent 30 percent, and Goupil's partner, Léon Boussod, 30 percent), the agreement relieved Cent of all managerial duties, creating for him a lifetime seigneury of privilege and influence that propelled him instantly into the aristocracy of the new age.

By the end of the year, the store in The Hague had moved from the narrow Spuistraat to sumptuous new quarters on the busy Plaats, and changed its name again—to Goupil & Cie. Still nominally under the management of a Van Gogh (Hein had sold his Rotterdam bookshop in 1858 and come to work for his successful brother), the new store began to stock more French paintings— Gérôme's orientalist fantasies and Bouguereau's sad-eyed girls—alongside the low-priced Dutch landscapes and genre paintings that had long been its mainstay. And, of course, it offered "a complete inventory of prints from the [Goupil] catalogue," Cent reassured his clients in a farewell letter. A few months after opening the new store, Cent and his wife left The Hague and moved into the grand Goupil *appartement* in Paris.

He still traveled, acting as ambassador-at-large for Goupil's international empire. When the company's reproductions won a gold medal at the 1867 World's Fair, Cent presented a copy of the winning prints to Willem III, King of the Netherlands. When Queen Victoria entertained the purchase of a painting, it was Cent van Gogh who traveled to Balmoral Castle to represent the Duchy of Goupil. Only his frail health prevented him from visiting the firm's busiest new branch, in New York. When business or family took him to Holland, he held court at the new store on the Plaats, which locals continued to refer to as "the house of Van Gogh." In 1863, he prevailed on his new partners to open another Goupil branch in Brussels and appointed his brother Hein its *gérant* (manager).

More and more, Cent occupied himself with the habits of wealth and leisure. True to the social class that had made him rich, he started an art collection.

Before, he had bought paintings to support artist friends, to secure reproduction rights, or just to add to stock. Now he bought for the sheer pleasure of owning and showing. He fussed endlessly over hanging his growing collection and changed its arrangement frequently in a succession of grand domiciles. In 1865 he found a palatial city house on the avenue de Malakoff, just off the grandest of Haussmann's grand new boulevards and the city's most fashionable promenade, the avenue de l'Impératrice. Located halfway between the towering Arc de Triomphe and the Bois de Boulogne, Cent's new home offered a front-row view of the famous *tour du lac,* the daily procession of all Paris's "finest people."

But even Paris wasn't perfect in every season. So in the winter of 1867–68, Cent went south—as his nephew would do exactly twenty years later—in search of a winter home, and relief from the respiratory problems that increasingly clouded his glittering leisure. He found both in the little coastal resort town of Menton, just beyond Nice, overlooking the blue waters of the Côte d'Azur. Over the next two decades, he and Cornelia would return there almost every winter, so enamored of the service at the town's grand hotels that they never bothered to buy a house.

For a summer place, Cent returned to the land of his childhood. In Prinsenhage, a wealthy enclave on the outskirts of Breda, he built a splendid villa as stout and solid as the nearby Zundert town hall, only bigger. With its huge English-style garden, conservatory, stables, coachman's house, and the latest baronial accessory, a "picture gallery," Huize Mertersem far outshone the country houses of the old aristocracy that it was designed to emulate.

In November 1867, prematurely frail and winded, but still only forty-seven, Cent received one of his country's highest honors. King Willem III, descendant of the Princes of Orange, conferred on Vincent van Gogh, descendent of gold thread-drawers, a Knighthood of the Order of the Eikenkroon (Oak Crown).

ONLY FOUR MONTHS after Cent was knighted, his nephew and namesake Vincent abandoned school in Tilburg and returned to the Zundert parsonage in defiant disgrace. For his parents, the contrast could not have been more crushing. If Vincent could not carry on the family's best name and highest purpose by serving God—as it increasingly appeared he could not, or would not—then the only face-saving alternative was to honor the family's newly gilded name in commerce.

Vincent himself dithered. "I had to choose a profession," he later wrote of this period, "but did not know which." He spent the rest of the year (1868) in obdurate paralysis ("moving is so horrible," he once said): clinging to the familiar parsonage from which his parents had tried repeatedly to oust him. He

wandered the moors, gathered bugs, and pored over his collections in his attic redoubt, ignoring the growing embarrassment as parishioners and townspeople began to talk about the parson's strange, indolent son.

Every success of his uncle Cent's only added to the weight of expectation and impatience. With each honor, the legacy of his childless uncle—long considered Vincent's to claim—grew richer, and Vincent's refusal to grasp it grew more and more confounding. No one doubted that Cent was prepared to be generous to his family. The point was driven home the year before Vincent's long idyll when the manager of the Hague store died unexpectedly and Cent bestowed the prize position on a twenty-three-year-old employee from outside the family. The appointment of the young, energetic outsider sent a clear message—to all, apparently, but Vincent: Uncle Cent was prepared to elevate, early and decisively, the first young Van Gogh to prove himself worthy.

Finally, in July 1869, sixteen months after he left school, Vincent relented. Whether it was the cumulative weight of embarrassment and enticement, or the intervention of the persuasive Cent himself (who visited Zundert frequently during those sixteen months), probably not even Vincent knew. Ensuring that his recalcitrant, unpredictable son did not have last-minute second thoughts, Dorus accompanied him on the train trip to The Hague. There, on July 30, he registered Vincent, just recently turned sixteen, as an "office clerk" at Goupil & Cie and left him with a blessing that no doubt mixed encouragement, admonition, and weary apprehension.

The Road to Rijswijk

~

ONCE THE DIE WAS CAST, VINCENT EMBRACED HIS NEW LIFE. AS IF to redeem himself for years of isolation and months of indolence, he seized his new role with the single-minded determination that would come to characterize all his endeavors. Overnight, the rough provincial boy with the battered shoes and fishnet full of bugs transformed himself into an up-and-coming business apprentice, a cosmopolite in the most cosmopolitan of all Dutch cities. He donned the summer wardrobe of a young gentleman (white socks, straw hat) and spent his Sundays not at the Grote Beek but with the other fashionable people strolling the beach at Scheveningen, a nearby bathing resort on the North Sea. At work, he submerged himself in his role as "protégé" (his word) of the firm's eminent founder, Uncle Cent, displaying "a certain proper pride," he confessed, in their shared name.

If Vincent needed a model to emulate—or a glimpse of what his future held—he had only to look to his boss, Hermanus Gijsbertus Tersteeg (known to all as H.G.). Handsome, hardworking, and poised far beyond his twenty-four years, Tersteeg was a new kind of man. He had risen to the top of his trade at such a young age not the old way, through family connections, but the new way: on his merits. Even as a teenage apprentice in an Amsterdam bookshop, Tersteeg had demonstrated the unsentimental pragmatism and levelheadedness so prized by the Dutch. And he dressed well. All of that, combined with a phenomenal memory, an eye for detail, and a "refined manner," had quickly won the confidence of Cent van Gogh, who no doubt recognized some of himself in the smooth, sharp-witted younger man. Only six years after starting, Tersteeg was promoted to *gérant* of the flagship store.

The young boss showed the firm's newest employee special solicitude. He invited Vincent to join him for coffee in the apartment over the store where he

lived with his young wife, Maria, and their infant daughter, Betsy. Vincent found much to admire in his new boss. Like Vincent, Tersteeg read voraciously in multiple languages. Already a leader in The Hague's bustling literary community, Tersteeg loved to talk about books—he "radiated poetry," Vincent said—and Vincent loved listening to him. "He made a strong impression on me," Vincent later recalled. "[I] looked upon him as a being of a higher order."

H. G. TERSTEEG

With Tersteeg as a model, Vincent threw himself into his new work. "I am very busy and glad of it," he wrote Theo, "for that is what I want." Most of his time was spent in the stockroom, out of the public eye, where the vast majority of the store's business was done and most of its money was made fulfilling orders for prints. After locating the requested images in the store's vast inventory, he carefully mounted, wrapped, and packed them for posting. Occasionally he helped box a painting in the shipping room or assisted a customer in the artists' supplies store (the sole remnant of Cent's original enterprise).

As a full-service "department store" of art, the house also included a resto-

ration studio, a framing department, and even an auction service, all of which might call on the services of an apprentice. In the store's sumptuous public gallery space, there were always exhibitions to be arranged, paintings to be hung or taken down or brought out for private viewing. To keep expenses down, Tersteeg (like Cent) operated the store with a minimum of staff. Vincent was one of only two apprentices on duty, working from daybreak until after dark most days, including Saturday. Of course, the store had servants (ubiquitous and invisible in this era) to do the menial chores like scrubbing and sweeping, but in the hubbub of a busy day, an apprentice like Vincent could be found doing everything from dusting picture frames to arranging window displays.

In his enthusiasm for his new job, Vincent took a characteristically sudden, feverish interest in a subject toward which he had shown no particular inclination before: art. He "devoured" books on artists, on art history, on art collections in Holland and elsewhere. He devoted himself to the latest art journals—available in abundance in The Hague's literate, international society. He paid frequent visits to the Dutch royal collection at the Mauritshuis, only steps from the Plaats, with its walls of Golden Age paintings like Vermeer's *View of Delft* and Rembrandt's *Anatomy Lesson.* He made pilgrimages to Amsterdam to see Frans Hals's *The Merry Drinker,* and, of course, Rembrandt's *Night Watch;* to Brussels to see the jewels of the great Flemish "primitives" (as Vincent called painters like Jan van Eyck and Hans Memling); and to Antwerp to see Rubens. "Go to the museum as often as you can," Vincent advised his brother; "it is a good thing to know the old painters."

He studied "new" painters, too—that is, contemporary Dutch artists such as Andreas Schelfhout and Cornelis Springer, whom his uncle favored. He found them not just on Goupil's walls, but in other galleries; in local art "bazaars," usually displayed amid a jumble of antiques and bric-a-brac; and in the just-opened Museum van Moderne Kunst (Museum of Modern Art) only a few blocks from the house where Vincent boarded.

It was probably at places like these that Vincent saw the first signs of a revolution coming in art. Here and there among the ranks of windmills, townscapes, storm-tossed boats, and idyllic skating scenes that had been the grist of Dutch artists for more than a century, he found a few paintings—landscapes, mostly—with vague forms, loose brushwork, muted colors, and gauzy light—paintings that looked nothing like the precisely detailed, intensely colored works around them. To Vincent's unaccustomed eye, they probably looked unfinished, as they did to so many at the time. Before long, however, Tersteeg began buying them, and the artists who painted them began coming into the store to purchase supplies and meet the new apprentice with the famous name. Over the first years of the 1870s, Vincent saw the work of, and almost certainly met, Jozef Israëls,

Jacob Maris, Hendrik Willem Mesdag, Jan Weissenbruch, and Anton Mauve, all of whom were painting in the new style—soon to be dubbed "the Hague School"—that would finally free Dutch art from the grip of the Golden Age.

Vincent undoubtedly heard stories about the new movement: its roots in shared outings in the Dutch countryside; the importance of *plein air* (outdoor) painting; and the new mandate to capture "the virgin impression of nature" that artists like Israëls had brought back from a distant woodland village in France called Barbizon. Vincent eagerly added the works of the "new" Dutch painters, and their French cousins such as Camille Corot and Charles Jacque, to the already crowded walls of his *musée imaginaire* (museum of the mind), while Tersteeg cautiously began testing the market for them.

Still, it would be another decade before the Barbizon painters found a prominent place on Goupil's brocaded walls. And with a revolution stirring in Dutch art, no one paid much attention to another group of French painters who had taken the Barbizon lessons about light and impressions in a very different direction. In the fall of 1871, the arrival in Holland of a young French painter named Claude Monet went virtually unnoticed on the Plaats.

Even as Vincent attended the birth of a new movement in art, his most important education was taking place in the Goupil stockroom, in the kaleidoscope of images that came across his desk every day—in woodcuts, engravings, etchings, lithographs, photogravures, photographs, artists' albums, illustrated books and magazines, catalogues, monographs, and special publications. Goupil had by now mastered the art of selling images across markets and using a painting's success to sell prints of it like stock in a booming company. Popular images came in all sizes and shapes, at every level of quality and cost—in some cases right up to the original painting itself.

The result was an explosion of imagery: everything from the richly detailed historical fantasies of Paul Delaroche to the domestic icons of Hugues Merle; from Rembrandt's chiaroscuro biblical scenes to Ary Scheffer's devotional images of Jesus (images that would define Christ for more than a century); from Bouguereau's fetching shepherdesses to Gérôme's oriental seductresses; from stirring battle scenes to sentimental vignettes of Italian peasant life; from romantic canalscapes of Venice to nostalgic visions of seventeenth-century Holland; from tiger hunts in Africa to the English parliament in session; from games of whist to vast sea battles; from New World magnolias to Egyptian palms; from bison on the American plain to Queen Victoria on her throne. All of these images crowded Vincent's keen and insatiable eye. "A continual spur for rousing the imagination," one observer called Goupil's huge catalogue of prints. "When we see them, how many voyages do we take in imagination, what adventures do we dream of, what pictures do we sketch!"

Vincent kept a salesman's open mind about the images passing across his

desktop. Indeed, for the rest of his life, he rarely singled out either a work or an artist for criticism. Rather than drowning in this sea of images, his enthusiasm seemed buoyed by it. *"Admire as much as you can,"* he advised Theo about this time; *"most people do not admire enough."* When he tried to write down his "favorites," the list grew to unwieldy proportions—sixty names of artists both famous and obscure. He included Dutch Romantics, French orientalists, Swiss landscapists, Belgian peasant painters, British Pre-Raphaelites, Hague School neighbors, Barbizon newcomers, Salon favorites, "[and] then there are the old masters." "I could go on like this for I don't know how long," he added in exasperation. Even so, it wasn't until a decade later that Vincent owned up to his liking for the gaudy, silly pictures of courtly life by Italian and Spanish painters of the era. "Those brilliant peacock's feathers," he recalled guiltily in 1882, "I thought them splendid."

For a while, it seemed that Vincent had truly turned a corner, that he had laid aside the brittle frustrations of his youth as surely as he had put down his fishnet and bottle. In some ways, the years of angry, self-imposed solitude had given him the perfect skills for his new job. The close observation and discernment he had practiced on birds' nests and beetle legs could now be applied to the subtle degradations of late impressions or the stylistic variations between different engravers' renderings of the same painting. His limitless energy for collecting and categorizing, combined with an astounding memory, helped him master everything from the stockroom's flood of images to the paint department's huge inventory of artists' supplies. The lonely, meticulous care he had lavished on his bug collection could now be put to use in the packing room or the display case.

A congenital arranger, Vincent excelled especially at seeing the relationships between images: not just in subject matter or artist, but in materials, style, and intangibles of mood and "weight." (A painting by Mesdag, he observed, had a "ponderous" effect beside a Corot.) He advised friends (and, no doubt, customers) on compiling the newly fashionable "scrapbooks"—blank books in which one could paste favorite images. "The advantage is that you can arrange [them] any way you like," he explained. He began a print collection of his own (starting with the "peacock feather" Italians) that he would add to and edit, arrange and rearrange for the rest of his life, honing ever more subtle notions of order and context.

Whether because of his knowledge and enthusiasm, or because of his family connections, Vincent was soon allowed to deal directly with the public in Goupil's plush, parlorlike gallery, where paintings in elaborate gilt frames filled the dark walls and gentlemen in top hats lounged on Turkish divans. Within a few years, Vincent was dealing with some of the firm's best clients. He demonstrated an instinctive savvy about value and rarity, fashion and demand, and no reticence whatsoever about the imperative to sell. By 1873, he had joined

the annual sales trips to Brussels, Antwerp, Amsterdam, and elsewhere to court clients and show the *nouveautés,* the latest additions to the Goupil catalogue. At some point, he learned accounting. So confident was Vincent in his new role that he reassured his parents he would never again have to look for a position.

GOUPIL GALLERY, THE HAGUE

But no success, or promise of success, could console his loneliness. A decade later, Vincent recalled his early years in The Hague as "a miserable time." At first he may have blamed his unhappiness on the trauma of leave-taking, which he always dreaded. "The beginning is perhaps more difficult than anything else," he warned Theo when he left home and started work in 1873. "I know so well how strange you must feel." But after two years, he had to recognize that the problem went deeper than homesickness. Despite the cosmopolitan distractions of the city; despite the familial comforts of a community planted thick with relations; despite the long hours of busy labor, Vincent had brought his unshakable isolation with him from the moors of Zundert.

At work, the demands of the understaffed store would have made socializing difficult even for a sociable person. As the only two apprentices, Vincent and Teunus van Iterson could not take breaks or vacations at the same time. Vincent's family connections, underscored in the beginning by his uncle's frequent visits to the store, also undoubtedly separated him from other employees, even if

his odd, prickly personality did not. By now, sickly and frustrated, Cent had become a nagging, oppressive overseer, whose departures for Paris or the Riviera were welcomed with relief by Tersteeg and no doubt others. "[He] was a difficult, cross-grained gentleman," Tersteeg later recalled, "harping on endlessly about the same subject."

In the winter of 1870, Cent was stricken by a near-fatal illness, and Tersteeg assumed full control on the Plaats. Almost immediately, his attitude toward his patron's nephew changed. From the beginning, the smooth, dignified Tersteeg had been bothered by Vincent's strange, unpolished manner, which he attributed to his rustic upbringing. (He compared Vincent's father unfavorably to the sophisticated Cent.) Now, that disdain began to show itself in angry words and sharp-witted disparagement. Vincent responded with the same bitter ambivalence that he felt toward his father: withdrawing into deference and "timidity" in his boss's presence ("I kept my distance," he recalled), while nursing a wound of rejection that would never heal.

As Christmas 1870 approached, after a year and a half in The Hague, Vincent was still miserable. The house where he lived, not far from the store, was crowded with members of the owner's family, the Rooses, along with several boarders Vincent's age (including his coworker, Iterson). But none, apparently, offered companionship. He retreated into old habits of solitude, preferring lonely walks in the nearby countryside to skating parties with his housemates. Both Vincent's parents and his uncle Cent complained bitterly that Vincent "failed to seek out good company" during his years in The Hague, despite multiple opportunities and relentless encouragements. But socializing required money, and Vincent's meager salary did not even cover the cost of his room and board at the Rooses'; his father had to supplement his wages. "Real poverty" is how he later described his condition. As for Christmas, the train trip to Zundert was expensive, and there was always a chance that Tersteeg would cancel his Christmas leave—as in fact he did—because the holiday season was the store's busiest.

Then, in November 1870, truly devastating news arrived from home: the family was leaving Zundert. After twenty-two years, Dorus had taken a position in Helvoirt, about twenty-five miles east of Breda, where another declining Brabant congregation needed the persistent sower. The Van Gogh family celebrated its last Zundert Christmas that year. By February 1871, they had left the parsonage, the garden, the creek, and the heath forever.

In a wave of nostalgia precipitated by the move, Vincent reached out to his only parsonage ally: Theo.

At first, his efforts to reconnect with the brother who once adored him met with failure. Theo's friends in Helvoirt, sons of the *junker* family that had persuaded Dorus and Anna to leave Zundert, saw in Vincent only what everyone

else saw: a strange and "difficult" young man—"good for nothing," in their estimation. When he came to visit, they made fun of him behind his back. Years later, they remembered that Theo shared their low opinion of his visiting brother—"and he spoke it out loud," one of them recalled. "There was not much closeness between them."

Then, in August 1872, probably after intense lobbying by Vincent, Theo came to visit him in The Hague. He was fifteen now, almost the same age as Vincent was when he left home. He stayed for some time—long enough for Vincent to grow accustomed to his companionship. They visited the Mauritshuis, where Vincent could show off his astonishing new knowledge. But mostly they just walked. One day, they struck out for the beach at Scheveningen. Vincent chose a route not along the fashionable, villa-lined boulevard but via a secret path through the woods. (He called them "my woods.") Another day, they headed in the opposite direction: east, toward Rijswijk, probably to attend a family celebration.

The two brothers walked the towpath that ran atop the dike beside the Rijswijk canal. Occasionally, a barge glided by under sail. On windless days, horses (and people) still used the towpath to pull their waterborne loads. They stopped at a seventeenth-century mill built to drain the meadows beyond the dike. A twenty-foot water wheel still carried on the Sisyphean labor. From a window at the base of the mill, the miller sold baked eel and milk from a cow on the premises for a penny a glass. They drank and walked on to the party at a house on the banks of the canal. They stood next to each other in the back as the assembled guests posed for a picture: Theo obediently still for the long exposure, Vincent almost as restless as the blur of children in the front row.

The walk to Rijswijk that day, like the rainy farewell in Zevenbergen, soon assumed mythic significance for Vincent. Years later, he would recall with aching nostalgia "that time long ago when . . . we walked together along the Rijswijk road and drank milk at the mill." He called the memory of that day "perhaps the most beautiful I have," and lamented that "it would have been impossible for me to put what I saw and felt on paper." For the rest of his life, he spoke of that day as a lost Eden of "sympathy" and sharing between two brothers "bound up in one . . . feeling, thinking and believing the same." Whether it was true—whether Theo had put aside his friends' mockery and low opinions of his brother—didn't matter. Lonely at work, estranged from his parents, evicted from his childhood home, Vincent needed to believe that he had found a companion at last.

Rijswijk set the pattern; and it would not change for the rest of his life: nostalgia as antidote for loneliness; the past as remedy for the present. Immediately after Theo's departure, Vincent began writing him: *"Waarde Theo"* (Dear Theo), "I missed you the first few days; it felt strange not to find you there when I came

home in the afternoons." It was the beginning of a correspondence that would grow into one of the great documents of the human experience.

ONE OF THE TOPICS almost certainly discussed on the road to Rijswijk was women—in particular, a pretty blond girl named Caroline Haanebeek, who also attended the party that day. Vincent had encountered her among the dense thicket of Van Gogh and Carbentus relatives in The Hague. The connection was close enough for family nicknames, but not too close for romantic aspirations. Caroline's father, Carl Adolph Haanebeek, ran a prosperous business and lived in a big townhouse just around the corner from the Spuistraat, long home to both Van Goghs and Carbentuses. All of which set Anna van Gogh's bourgeois heart racing. "Such good and solid people," she called the Haanebeeks, urging their company on her son. "It is good for your further development to associate yourself with people like that."

Vincent did not need his mother's encouragement to find nineteen-year-old Caroline Haanebeek attractive. Open, lighthearted, and unselfconscious (judging by her later letters), she was everything the dour young apprentice was not. She loved music—not the dreary parlor anthems of cultivated society, but cheerful popular tunes like *"Riez, riez, mes jeunes amours"* (Laugh, laugh, my young loves)—songs that flouted propriety just by the use of French. She enjoyed entertaining, and treated men with a simple directness that must have seemed flatteringly flirtatious in the corseted world of Hague society. Even Dorus van Gogh registered her charm: "the most delicate flower," he called her approvingly. In fact, she was wearing wildflowers in her hair at the family gathering that day on the banks of the Rijswijk canal.

Vincent may have been infatuated with Caroline, from afar, for some time. His later cryptic references to her suggest a first, great, chaste love. He describes his passion as "intellectual," not "physical." "One half of me fancied that I was in love," he wrote, "and with the other half I really was." If he ever declared that love, it was not a wooing, romantic voice that Caroline heard, but an insistent, contentious one—the voice that Vincent would always use to argue passions (his own and others') into submission. It was the voice of lonely desperation. "I wanted only to give," he recalled, "without asking anything in return." Vincent's infatuation may or may not have gone unexpressed, but it certainly went unrequited. By the time he and Theo arrived at the celebration that day, he must have known that Caroline Haanebeek was planning to marry their cousin Willem van Stockum. Caroline may even have chosen the party to announce her engagement. In the group photo, she stands next to Van Stockum and playfully flashes her hand to the camera, as if to show off a ring.

Vincent's reaction to the announcement was clear enough. "If I cannot get

a good woman," he told Theo, "I shall take a bad one . . . I would sooner be with a bad whore than be alone." Driven more by loneliness than libido ("my *physical passions* were very weak then," he later confessed), he began seeing prostitutes.

They were not hard to find in The Hague. Only a few blocks from the Goupil store, in a warren of medieval wooden buildings called the Geest, Vincent could find virtually anything he wanted, short of genuine affection. Despite a wave of reform in the 1860s and 1870s that required brothels to be registered and prostitutes to undergo regular medical exams, the ancient business of sex flourished uninterrupted on the street. For every brothel shuttered by regulatory burdens, a beer house or tobacconist shop "with female service" opened in its place. Later, when Theo moved to The Hague, Vincent warned him not to patronize such places "unless you can't do otherwise—then there is no harm in it for once."

Vincent's visits to the Geest, which began at least as early as the fall of 1872, when he was nineteen, were the first in a lifetime of trips down dark roads and dockside alleys in search of the intimacy he could not find elsewhere. Brothels were often his first stop in a new city. Sometimes he came merely to sit, to share a drink, to play cards, or to talk—"about life, about worries, about misery, about everything," he said. If the brothel keeper kicked him out, he would stand outside the entrance and just watch the customers come and go. When admitted, he engaged in the coarse whorehouse humor of his fellow patrons, and could fence in bawdy innuendo with the best of them. But his own interactions with "those women who are so damned and condemned" seemed always to be marked by empathy and the reticence of need. He confessed a "special affection" for them, and sagely advised Theo to see only those prostitutes "you can feel something for."

Vincent later recorded that, after the first miserable years, his time in The Hague became "much happier" around 1872. But the combination of a vulnerable heart and limited resources inevitably led to trouble. The exact nature of the trouble can only be inferred, but it was serious enough that Vincent reported being "frightened" of his parents' reaction, and "seized by a kind of panic." In desperation, he sought the advice of his young boss. Tersteeg responded in the bluntest terms: Vincent would have to abandon the forbidden activity—almost certainly a liaison or series of liaisons. To carry on would violate his "obligations towards [his] family." If he did not, Tersteeg apparently warned, the family could institute proceedings to place him under legal guardianship. Even a decade later, Vincent recalled Tersteeg's response as a bitter betrayal, writing "I have regretted ever since that I broached the matter with him."

By Christmas, "the matter" had reached Van Gogh ears. Vincent always suspected Tersteeg was responsible. "I am now almost certain," he wrote years later, "that long ago he said things about me which contributed not a little

toward putting me in a bad light." Whether or not Tersteeg reported it, the ugly news had immediate and devastating consequences. Questions about Vincent's job performance had already been raised at the highest level. In October 1872, the family chronicler, Uncle Cent's sister, noted doubts about their nephew Vincent—doubts that could only have come from Cent himself: "Sometimes one thinks he can become very suitable," she wrote, "then the other way around."

When those doubts reached the parsonage in Helvoirt, alarms sounded. Money was tighter than ever. The prospect that they might once again have to assume the financial burden of Vincent, plus the dread that his return might trigger another round of embarrassment in the eyes of their new community, made saving Vincent's job their highest priority. "You can imagine," Dorus wrote a family member, "that [Vincent's] case is keeping us very occupied."

Meanwhile, their exchanges with Vincent were increasingly marked by "unpleasant things," he later recalled. Dorus deluged his wayward son with admonitory and inspirational letters, poems, and pamphlets, urging him to "fight against [him]self," "confess [his] weakness," and "tear [his] heart away from the service of sin." Perhaps at Dorus's insistence, Vincent took Bible lessons, but made a show of indifference to them. To his fellow boarders at the Rooses' he presented himself as an atheist. Defying his father's urgings to guilt and repentance, he turned instead for consolation to the burgeoning secular literature of self-improvement books. He sat glumly for a photograph that even his mother couldn't like (she called his expression "sour").

The battle lines were drawn. It must have been a bitter, contentious Christmas—the first of many—as Vincent and his parents rehearsed their already-old antagonisms. By New Year's Eve, he was back at the Roos house in The Hague, where a fellow boarder saw him sitting by the open fireplace "calmly throwing the pages of a religious booklet his father had given him into the fire, one by one."

THE FIRST VICTIM of the turmoil in Vincent's life was his brother Theo. The financial pressures in Helvoirt were approaching a crisis. Not only was it increasingly likely that Vincent would be thrown back on the family dole, but he also risked drawing a low number in the draft lottery when he turned twenty in March 1873. Dorus would either have to let him sail off to fight a colonial uprising in Sumatra—an unspeakable shame and a virtual surrender of his future—or buy him out of service, an unspeakable expense. The family needed another source of income, and only Theo could provide it. After much discussion, Dorus and Cent found him an apprentice position—like Vincent's—at the Goupil branch in Brussels. Theo resisted at first. Unlike his older brother, he en-

joyed school, and he hated to leave his friends in Helvoirt. But duty came first. "God called you to this job," Dorus told him. In early January, 1873, still only fifteen, Theo took the train to Brussels and started work.

Anna and Dorus encouraged the new Goupil employee to "become really smart like Vincent." But behind the scenes they worked furiously to ensure that he did not follow his wayward brother's example in other ways. They boarded him with a pastor, who also gave him confirmation classes, and enrolled him in a "youth club" to fill his free time with the right kind of people (as a "safeguard against bad influences"). They inundated him with encouragements to attend church, obey his boss, dress well, and eat meat ("to become strong"). The direst warnings targeted sexual misadventures and religious laxity, the two traps into which Vincent had fallen. "Always stick to your principles," Dorus wrote. "Happiness is only to be found along the path of propriety and true piousness."

Despite early pangs of loneliness and dissatisfaction with his reverend landlord, Theo thrived in Brussels. Within a month, the store's reserved *gérant*, Tobias Victor Schmidt, was sending reports admiring Theo's "suitability" to the art trade and predicting his ultimate success. Dorus congratulated his son ("It is wonderful that you have made such a good start") and called him "plucky"— high praise from the persistent sower. Theo learned bookkeeping and studied French at night. *Gérant* Schmidt soon grew so fond of his youngest assistant that he invited him to move into his apartment above the store. The comparison to his struggling brother did not escape notice. "You do so well there," his mother wrote, "compared to Vincent's life."

Vincent had probably encouraged his brother to join him in the art trade, although not so soon and certainly not at such a distance; but the decision to send him to Brussels seemed to catch Vincent by surprise. "What good news I've just read in Father's letter," he wrote Theo around New Year's Day 1873. "I wish you luck with all my heart." Soon, jubilation overtook surprise. "I am very happy that you [now] work in the same firm," he wrote a couple of weeks later. Eventually, Vincent came to see the move as the consummation of the relationship the brothers had forged in The Hague the previous summer. "We *still* have a lot to talk about," he wrote euphorically. In a fierce assertion of fraternal solidarity, he flooded his brother with advice, instruction, and encouragement. He consoled Theo's early loneliness, hearing in it echoes of his own; congratulated his early successes; and commiserated over an apprentice's hellishly busy workday. He talked about artists and repeatedly demanded that Theo tell him "what pictures you see and which you like best."

For Vincent, Theo's new role fulfilled the promise of the Rijswijk road: two brothers "bound up in one . . . feeling, thinking and believing the same." Energized by that vision, Vincent launched into the new year with a surge of fresh enthusiasm. He traveled on business, visited clients, and never missed a chance

to see more paintings. He reconnected with family members and even joined in social events, like boating parties. After each new experience, he would rush to pen and paper to share it with Theo. At times, his newfound zeal for work bordered on exhilaration, as he played both cheerleader and example to his young protégé in Brussels: "[Goupil] is such a splendid house," he wrote. "The more one works there, the more ambition it gives you."

But the decision had already been made: Vincent would have to leave The Hague.

Cent and Tersteeg had probably come to that conclusion at Christmas, when they typically conferred and planned for the coming year. Dorus, who never hesitated to intervene with "the gentlemen" when his sons' interests were at stake, must have been involved in the decision. By the end of January, Tersteeg informed Vincent that he would be transferred "probably very soon" to the Goupil branch in London. No one recorded the reasons for the transfer. Vincent, apparently, either did not know them or did not want to share them with his brother. "It has been decided that I have to go away" was all he said.

But the connection between his misbehavior and his removal could not be denied. If he continued on his wayward path, he risked discrediting the family, the family's best name, and even the family business. Other factors may have contributed to the decision. Vincent's strained relations with his parents could only have reinforced Cent's doubts about the nephew who bore his name. In the photograph he had taken in December, Vincent appears rumpled and vexed—the opposite of his sprightly, dapper uncle and his gregarious younger brother. Vincent's sister Lies later recalled that his "awkwardness and shyness were a detriment to him in his business."

Dismissing him, however, was not an option. It would not only embarrass the family, it would throw a new burden on Dorus's strained finances. It would also waste Vincent's one undisputed asset: his astounding knowledge of Goupil's vast inventory of images. For both reasons, apparently, the transfer to London presented the perfect solution (and shows the hand of the shrewd Tersteeg): the London branch was wholesale only; it had no gallery. Because it sold only to dealers, not retail customers, Vincent would have only limited contact with the public—and, even then, only the English public. "They were sending him to London," his sister recalled, "to see [if] it might be easier for him to have dealings with the English."

But in a company built on selling, a company in which salesmanship determined advancement and defined success, the shame of a transfer to a distant stockroom could hardly be hidden. Still, the family tried. Almost as soon as the decision was made, everyone involved moved to disguise the truth. At the beginning of the year, even before being told of the transfer, Vincent was given a substantial raise—enough so he no longer needed subsidies from home—

and a bonus of one month's wages, fifty guilders, of which he forwarded the lion's share to his father, as surely he was expected to do. Anna professed to be "surprised" when she heard the news, but, in any event, she chose to treat it as a promotion. Dorus, who was more likely to know the full truth, clung to his faith in "God's blessing and guidance," but later confessed bleakly, "I can't tell what is desirable." Tersteeg consummated the conspiracy of denial with an after-the-fact, history-thwarting letter of appreciation. "He gives [Vincent] the highest praises," Dorus reported its contents to Theo, "and says that he will miss him terribly and that enthusiasts, buyers, painters and everyone else who visited the store liked to be around Vincent and that he will surely go a long way."

But nothing anyone said could fool or console Vincent. So bitter was the news of the transfer that he waited more than a month to tell his protégé in Brussels. "I suppose you have heard that I am going to London," he finally wrote Theo in mid-March—more than a month after Theo had heard the news. "I am sorry to leave this place." He took up smoking a pipe—his father's balm for melancholy—and advised Theo to do the same. "It is a remedy for the blues," he wrote, "which I happen to have had now and then lately." He put on a brave face for his brother, vowing "not to take things too hard"; and stoutly reassured his mother: "I plan to enjoy everything and take on everything." But his "blues" were exacerbated by the continuing vagaries of the transfer. Originally scheduled for summer, his departure was moved up to "very soon"—as if Cent and Tersteeg could not wait to remove him from their sight—then rescheduled for May, then sped up again. At first he was to go straight to London; then to London via Paris. It wasn't until the last week that the details were finally set: he would take a train to Paris on May 12.

The months of uncertainty were filled with lingering dread as Vincent anticipated the loneliness and homesickness to come. "I shall probably have to live alone," he speculated darkly. "Imagine how sorry I am to have to leave." He wandered through the city and into the countryside with a sketchpad, memorializing his "home" in anticipation of leaving it. He made quick pencil sketches that he later tenderly elaborated with pen lines and soft pencil shadings before giving them to his parents and brother. The ritual offerings no doubt comforted him: one showed the streetscape outside the Goupil store; another, a canal and towpath like the one he and Theo had walked that day to Rijswijk; another, a long road with a carriage in the distance—like his parents' carriage in Zevenbergen—heading away.

Vincent continued to work, with only a brief leave at Easter, right up until two days before his departure. Then he packed his single trunk (leaving much behind, as if hoping for a quick return) and traveled to Helvoirt for a final farewell with his family. But no consolation awaited him there. Only a shadow of the parsonage of memory remained. Sister Anna was away at boarding school;

Theo, in Brussels. He found his father staggering beneath a surfeit of cares. Dorus's worst nightmare had come true: Vincent had drawn a low number in the draft lottery, forcing the parson to dig deep into his meager nest egg to pay 625 florins—almost a year's salary—for a substitute, a bricklayer, to fight in his son's place.

By a strange coincidence, the Sunday that Vincent spent in Helvoirt was Saint Job's Day—the day that honored the much-suffering Old Testament patriarch. Dorus made time for a brief "chat" with his son; Anna asked only, "Did you leave everything behind in good order?" and seemed surprised when Vincent choked up with emotion and couldn't answer.

HE STAYED IN PARIS only a few days, barely long enough for the kaleidoscopic city to register. "Too large, too confused" were the only impressions he later recalled. He managed to cram the days with images: more than four thousand paintings at the recently opened Salon; a tempest of Rubens at the Luxembourg; and, of course, the Louvre, home to so many of the images that he had carefully wrapped and packed over the last four years. He toured Uncle Cent's world: the grand limestone *hôtel* on the rue Chaptal, the opulent gallery, the print shop, the huge stockroom; the old store on the boulevard Montmartre; and the vast new store ("much bigger than I had thought," he reported to Theo) in the shadow of Garnier's gargantuan new opera house. He dined at Cent's elegant townhouse, where he met artists and his uncle's fashionable friends.

Then he was gone. The only reason, apparently, for the trip to Paris was to ensure that Uncle Cent and his wife could accompany Vincent on the crossing to England—the family rallying yet again. So when they left, he left: a train to Dieppe, a boat to Brighton, a train to London.

For Vincent, it all went by in a blur—"pleasant" was the only thing he could think to say about the trip when he wrote Theo—all preempted by the drama of alienation and self-reproach that he had brought with him. "When I saw [Paris] for the first time," he later confessed, "I felt above all a dreary misery which [I] could not wave away." The more Cent showed him, the more glittering dinner parties he attended, the more artists he met, the more comments they made about his distinguished name, the more misery and regret he must have felt.

For it was surely clear by now, as Vincent looked around, that this was no longer his future. He would never be the son that Cent never had. The path to that life lay back in The Hague, or there in Paris, not at the order fulfillment desk in a London backroom. He had already been evicted from that path. His long exile had already begun.

The Exile

~

*I*N 1873, LONDON WAS THE BIGGEST CITY IN THE WORLD. WITH A POPU-
lation of four and a half million people, it was more than twice the size of Paris
and forty-five times bigger than The Hague. A contemporary critic described it
as an "immense black spot" spilling across the countryside in a cartographer's
nightmare of narrow, knotted streets. In The Hague, Vincent could find virgin
pastures only minutes from the doorstep of his boardinghouse; in London, a trip
to the country took " several days and a succession of cabs," according to one
visitor. Henry James reported being "crushed" by London when he arrived four
years earlier. Of course, Vincent had seen cities before: Amsterdam, Brussels,
and even Paris. But nothing in those brief excursions could have prepared the
country boy from Brabant for what James called the "inconceivable immensity"
of the capital of the world.

Where the streets of The Hague hummed with orderly activity, London
streets exploded in chaos. From the first day he reported for work at the Goupil
office on Southampton Street, just off the Strand, Vincent was thrown into a
roiling sea of humanity unlike anything he could have imagined. The roads
were so choked with traffic that a person could cross the street without touch-
ing the ground. Great winding columns of pedestrians filled the sidewalks,
clogged the bridges, and thronged the squares, especially at day's end. Here
and there the fast-moving currents were interrupted by beggars, shoeblacks,
prostitutes, mimes, crossing sweeps, barefoot street boys turning cartwheels
for a penny, and hawkers selling every kind of good or service in a bawling
language never heard in the schools of Holland.

But nothing would have struck Vincent as more alien than the filth. Com-
pared to The Hague with its polished windows and pristine streets, London was
one gigantic cesspit—"that great foul city," John Ruskin called it, "pouring out

poison at every pore." Greasy black soot coated everything—from the Victorian office fronts of Southampton Street to St. Paul's and the British Museum. Especially in summer, when Vincent arrived, a urinous stench wafted up from drains and gutters throughout the city, driving the rich to the country and everyone else to drink.

Like hundreds of thousands of other newcomers overwhelmed by the increasingly unlivable city, Vincent sought refuge in the ersatz country life of the suburbs. By the time he arrived, waves of "villas"—identical houses arranged in interminable rows—lapped at the city on every side. In one of these new communities (probably southeast, around Greenwich), Vincent found a boardinghouse. He described the neighborhood as "so peaceful and pleasant that you almost forget you are in London." The house, in the fashionable Gothic style, with a "lovely garden in front," was large enough to accommodate the landlady, her two daughters, and four boarders. In exchange for this facsimile of village life, Vincent had to begin his commute every morning at 6:30. He walked to a pier on the Thames, took an hour-long steamboat ride, then fought his way through the crowded streets to Goupil's doorstep.

Once in the city, he gravitated to the green spaces. "Everywhere you see charming parks," he wrote Theo. On lunch breaks and after work, he repaired to the quiet and relative solitude of these great fragments of countryside, especially Hyde Park, with its ancient trees, sheep meadows, and duck ponds, where he could imagine himself back on the banks of the Grote Beek.

CHASTENED BY HIS EXPULSION from The Hague, Vincent tried again to make a fresh start. With the scolding voices of his parents and uncle no doubt in his ear, he began his London stay with a flurry of socializing. Uncle Cent himself kicked it off by inviting Vincent to dinner with some of Goupil's most prominent London clients. He spent a "glorious" Saturday with his gallery colleagues boating on the Thames. He also reported "pleasant evenings"* with his fellow boarders—a hearty trio of Germans—singing at the parlor piano and taking long weekend walks in the country.

In June, Vincent's new boss, Carl Obach, invited his well-connected new employee on a Sunday outing to Box Hill, a soaring chalk escarpment south of the city. The view from the windy heights—on a clear day, the panorama em-

* Hereafter, all quotations from Vincent's letters are contemporaneous (i.e., within a year) of the events being described, unless otherwise noted. A quotation drawn from outside that window of contemporaneity is indicated in the text by the use of "later" or "earlier" or a similar term. Any quotation that is not otherwise attributed is from Vincent's letters. For more information on sourcing, see "A Note on Sources," p. 891.

braced all of southeast England, from London on one side to the Channel on the other—made it topographically clear just how far from his lowland home Vincent had been banished. "The country is beautiful here," he wrote Theo, "quite different from Holland."

Vincent set his parents' minds at ease by writing them that he had started attending church again. To prove it, he sent a small pen drawing of London's Dutch Reformed church, Austin Friars. But perhaps the most welcome bit of news at the Helvoirt parsonage was that Vincent had bought a top hat. "In London one could not do without it," Anna crowed.

In all these ways, Vincent was trying yet again to see himself in the class to which his mother aspired on his behalf. He reported breathlessly on his visit to "Rotten Row," Hyde Park's tree-lined royal bridle path, where every afternoon the equestrians of London turned out in their finest fashion and most splendid equipage. "One of the finest sights I have seen," Vincent wrote. His taste in art, too, seemed guided by new imperatives. After ranging virtually unchecked for four years, his critical eye narrowed to a tight, commercial focus. Of all the British artists he discovered, he found only two worthy of serious praise: George Boughton and John Everett Millais—both commercially successful painters squarely within the conventional taste. (Indeed, Boughton was under contract with Goupil.) He gave passing nods to a few other artists, expressing admiration for their sentimental appeal, nouveau riche display, and "value for money"—in short, their salability.

Controversial images, like the new social-realist depictions of homeless mothers, huddling poor, abandoned babies, and grieving widows, held no interest for him. Instead, the works he singled out in letters home celebrated the lifestyle and the values that lay at the heart of Goupil sales and Van Gogh expectations: a fashionable young couple caught in a moment of sweet boudoir intimacy in *The Honeymoon;* a well-dressed young mother tenderly carrying her new baby to church in *The Baptism;* two young women in elaborate party gowns stealing up a grand staircase to share a secret in *Devonshire House.* Images like these, Vincent maintained, show "modern life as it really is."

He attended the Summer Exhibition at the Royal Academy but came away in an uncharacteristically uncharitable mood, mocking several works specifically and dismissing English art in general as "very bad and uninteresting." The revolution in mass-produced woodcuts under way in magazines like *The Graphic* and *The Illustrated London News* did not register at all on Vincent's commercial scale, even though it was taking place virtually next door on the Strand. Every week he joined the crowd that gathered outside the papers' printing offices to get a first look at the new editions. But the stark black-and-white images he saw in the windows seemed "quite wrong," he later admitted. "I didn't like [them] at all."

After a tour of the National Gallery, he commented only on a Dutch landscape he saw there. In the Dulwich picture gallery some "splendid" Constables on display only reminded him of Barbizon favorites from The Hague. He seemed genuinely moved only by a traveling exhibition of familiar Belgian artists ("It was a real pleasure to see those Belgian pictures," he wrote), and he begged Theo impatiently for news of the Paris Salon.

But nothing was lost. The Leonardos and Raphaels at the National Gallery, the Gainsboroughs and Van Dykes at Dulwich, the Turners at the South Kensington museum (forerunner of the Victoria and Albert)—all were stored in the seemingly limitless museum of Vincent's memory, to be summoned up, often in astonishing detail, years later. The "crude" magazine illustrations of beggars and foundlings in *The Graphic*, for example, would resurface after a decade to become a defining obsession. At the time, however, the single image that seized Vincent's imagination that summer was a painting by Boughton of a young gentleman walking the family estate with a woman who looks to be his mother. It was called *The Heir.* He liked it so much that he made a sketch of it and sent it home.

Even as Vincent reached for reconciliation, his estrangement deepened. Everything reminded him of home. A Sunday walk made him think "with nostalgia" of Sunday walks in The Hague. His boardinghouse made him long for his former life at the Rooses'. "I do not forget [them]," he wrote, "and should very, very much like to spend an evening [there]." He hung the walls of his new room with exactly the same prints that had hung in the old. He ached for news from home, and marked every family holiday with plaintive requests for reports. A simple spell of good weather triggered waves of homesickness. "You must have had pleasant days at home," he wrote; "how I should like to see them all again."

All his initial attempts at socializing foundered. His early companions, even *gérant* Obach, quickly vanished from his correspondence. Language was partly to blame: by his own admission, Vincent understood English far better than he spoke it. When he first arrived, he joked that his landlady's parrot spoke better English than he did. Yet his better German did not stop his German housemates from abandoning him, too. To his parents, who always worried about his introversion, Vincent cast himself as shunning, not shunned. "[They] spent too much money" he explained the break to his parents.

But clearly other forces were at work. Old habits of isolation were reasserting themselves. "I never felt in my element there," Vincent later wrote about his time in London. As in The Hague, he avoided crowds (thus missing the usual tourist sights like the Tower of London and Madame Tussaud's). Instead, he spent more and more time in solitary pursuits—"taking walks, reading, and letter-writing." A former coworker from The Hague who visited him in August found Vincent filled with "world weariness" (*Weltschmerz*) and suffering from

"enormous loneliness." Years later, Vincent recalled his mood in London as "stony, arid . . . hardened instead of sensitive . . . toward people." His parents worried at his "pensive" letters. The word "strange" reappeared in their expressions of concern.

Rather than breaking down the walls of isolation and otherness, Vincent's job only raised them higher. The work—filling wholesale orders from print dealers—made him long for his more varied work in The Hague. "The house here is not so interesting as the one [there]," he complained to Theo. The London branch had no gallery, no window displays, no celebratory banners or holiday greenery. Its only customers were dealers and their minions on their hurried way in a hurried city. They had no time to talk about art. Nor was there a paint supply store where artists could browse, trade tips, and gossip. The stockroom was busy enough (processing more than a hundred prints a day), but the stock was limited, and Vincent had little affection for most of the images that flashed across his desk. "Good pictures [are] quite difficult to find," he grumbled to Theo. Everything reminded him of his removal from the vital art world on the Continent. "Tell me especially what pictures you have seen lately," he begged his brother, "or if any new etchings or lithographs have been published. Tell me all you can about these things, for I do not see much of them here."

Every day of this deadening tedium ("grubbing," he called it) was a reproach—a reminder of roads not taken, opportunities squandered. "Everything is not so beautiful as it seemed to me in the beginning," he wrote, in the first of many flashes of self-awareness. "Perhaps it is my own fault." He ventured a wistful hope that sometime—"later on"—"I shall perhaps be of use," but he must have known by now that his place in line was lost. His encounters in London hint at a faltering self-confidence and a rising sense of shame. He was so "overawed" by his new hero George Boughton that he "dared not speak" to him when they encountered each other. When the Dutch painter Matthijs Maris visited the Goupil office, Vincent was "too bashful to speak out."

Just as language exacerbated his isolation, money exacerbated his guilt—as it would for the rest of his life. Even though his salary had almost doubled when he moved to London, it still barely covered his expenses. "To save on pennies," he stopped taking the steamer into the city and instead walked the whole way, crossing the Thames on one of the madhouse bridges. He vowed to find a cheaper boardinghouse. His letters home were filled with promises to economize and exaggerated mea culpas over minor expenditures that betray a deeper, more implacable guilt. Meanwhile, his parents sent increasingly dire reports of financial hardship in Helvoirt and brave pledges of further sacrifice for their children. "We will try to live economically," Anna wrote, "and be happy when the money we invest in you proves to be well spent; that's the best interest rate one can hope for."

By August, homesickness, isolation, and self-reproach had deepened into melancholy. For months Vincent had tried to reassure his parents that he was "content," "doing fine," and "experiencing delightful satisfaction" in his new job. With Theo, he could be more open, though still stoic. In June, he wrote: "Considering the circumstances, I am doing pretty well." In July: "I shall probably get used to it." In August: "I shall bear with it a little longer."

Searching for an escape from the despondency that threatened to overtake him, Vincent opened an intimate correspondence with the now-married Caroline Haanebeek. In his manic way, he flooded her with flattering, suggestive images (some in poetry, some in prints) of blond young ladies and country maidens in coquettish poses. He copied out a poem by John Keats about a "maiden fair" with "bright drooping hair," and directed her to another, longer Keats poem ripe with erotic imagery. He sent her an extract from the popular French love manual *L'amour* by Jules Michelet, describing a man haunted by the portrait of a woman "who took my heart, so ingenuous, so honest . . . This woman has remained in my mind." He invoked their past relationship in language more appropriate to separated lovers than distant friends, and recommended that she read Longfellow's *Evangeline*, the story of a young Acadian torn from his true love.

What did Vincent expect to gain from this seduction by words and images of the happily married Caroline? It was, in fact, the first in a lifetime of hopeless campaigns to remold hearts by persuasion. It shows his capacity for illusory attachments and the extremes to which such illusions could carry him. It also reveals the extent to which he had already begun to find consolation—that is, mediation between a hostile reality and aspirations to happiness—in literature and art. He told Caroline of his search for "a homeland . . . a small spot in the world where we are sent to stay." "[I] have not got there yet," he wrote, "though I am straining after it, and perhaps may yet grasp it."

In the fall of 1873, Vincent's parents heard a new voice coming from their eldest son in London. "We are getting cheerful letters," Dorus reported with some surprise. But the reason was not Caroline Haanebeek, who had rejected his strange suit.

Vincent had found a new family.

OVER THE SEVENTEEN YEARS of life remaining to him, Vincent would try repeatedly to attach himself to other families as he grew increasingly estranged from his own. He had already tried at least once in The Hague, assiduously cultivating the devotion of little Betsy Tersteeg in the hope of making a place for himself in his boss's close-knit young family. He may have tried again in London with his new boss, Obach, whose wife and children Vincent visited at home. Over the coming years, he would be especially drawn to inchoate families: fam-

ilies that had lost a father-husband, or never had one, leaving a void that he could readily fill; families in which he could feel, for a change, welcome.

To Vincent, Ursula Loyer and her daughter Eugenie must have looked like such a family. He came as a boarder to the house at 87 Hackford Road in Brixton, where mother and daughter ran a small day-school for boys. The rent was cheaper and the walk to work shorter (less than an hour). From early on, Vincent must have seen the fifty-eight-year-old widow Ursula and the nineteen-year-old Eugenie as kindred spirits: wounded, errant, in search of a "homeland." Even the name, Loyer, seemed uprooted—a lovely French word ("loy-*yay*") displaced by a sour English pronunciation: "lawyer."

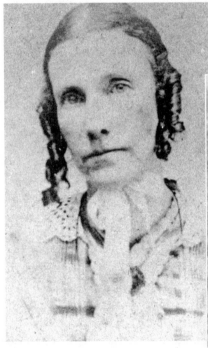
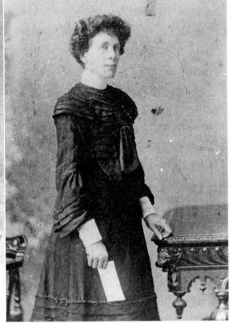

URSULA AND
EUGENIE LOYER

Born to a ship's captain, Ursula had the seen-it-all stoicism of sailors' women. "Her name is written in the book of life," Vincent observed. Small and bony, with oversized features, Ursula had been battered by life but not beaten. A grandchild later described her as "a kindly old soul" with "not one hint of misery." Eugenie, on the other hand, was already a formidable woman. With her large head, broad features, and stocky frame, she could have been Vincent's sister (favoring his mother), right down to the shock of red hair that she wore

pulled up in a flaming tousle. As a girl who had spent most of her life without father or siblings, she carried herself more like a man than a woman: willful, withholding, "domineering [and] difficult," according to her daughter, with a "sharp wit" and an explosive temper.

The missing member, who marked the family with its mongrel name, had been dead for more than a decade. Jean-Baptiste Loyer was also a man without a home. A native of Provence, Loyer had been driven into exile by family problems. He arrived in London as a stranger, married Ursula, and fathered only one child, Eugenie, before falling mortally ill from "consumption." According to family legend, Loyer's last wish was to die in his homeland. With his wife and young daughter, he returned to France and took a cabin by the sea, where every evening friends carried him to the shore to watch the sun set. When the moment of death arrived, he made his confession, and "all who were present wept when they heard of his pure and righteous life." A document recounting these events eventually found its way into Vincent's hands. True or not, the story of exile and homecoming so moved him that for years afterward he kept a copy, which he transcribed and sent to family members. "He loved nature and he saw God," the account concluded, "this stranger on the earth."

Inevitably, Vincent saw Ursula and Eugenie through the gauze of this sentimental tale. Instead of a wizened landlady and her headstrong daughter (he never wrote a word about either of them to Theo), Vincent saw a brave little family carrying on in the wake of great sorrow. "I never heard or dreamed of anything like the love between [them]," he wrote his sister Anna. From the moment he settled into his tiny third-floor room, Vincent saw this broken but loving family as the perfect fit to his broken-off fragment. "I now have a bedroom such as I always longed for," he wrote, comparing his new accommodations to his attic room in Zundert. To complete the reverie, he summoned Theo to join him: "Oh! Old man, I so want you to come here."

He found reprises of his childhood everywhere: in the garden where the Loyers grew flowers and vegetables; in the collections of butterflies and birds' eggs that filled the house; in the daily bustle of children coming and going to class. He made drawings of his new home and presented them to both his new family and his old one. At Christmastime 1873, he helped decorate the house with holly and celebrated "in the English way," with pudding and carols. His first Christmas away from home passed without the pangs of homesickness that crippled him in later life. "I hope you had as happy a Christmas as I had," he bragged to Theo.

Emboldened by this newfound sense of belonging, Vincent began the new year determined to reclaim his place in his true family. He wrote home faithfully, always in a cheerful voice. He applied himself to the drudgery of work with a diligence that brought commendations all the way up to Paris (and thence to Helvoirt). Flush with a New Year's raise, he sent so much money home that his

parents worried he was "denying himself." He even reached out to his former boss and family favorite, H. G. Tersteeg.

The centerpiece of this new campaign of rehabilitation was a plan to bring his sister Anna to England. By finding her a paying position as a governess in an English family, he could relieve the financial pressures on the parsonage and earn his way back into favor. In January, he began his two-pronged campaign. To his parents, he relentlessly argued the practicalities of the venture: Anna could interview in person, more offers would be open to her, and she could practice her English. He placed advertisements in newspapers, sought out suitable positions, and drafted letters of inquiry. He even offered to come home and accompany his sister on the trip across the North Sea. "Such a dear [Vincent]," his mother wrote, "so willing to help."

To Anna, however, Vincent wove a different narrative, one designed to appeal to her lonely teenage heart. He emphasized the warmth and welcome of the Loyers—so different from the cold formality of her boarding school. They would be for her, as they were for him, a second family, he promised. Eugenie and Vincent had agreed to be "like brother and sister to each other," Vincent wrote; and Anna "should consider her a sister, too." "Be kind to her for my sake," he summed up. Ursula wrote Anna a warm letter urging her to think of the house on Hackford Road "as her own home," and inviting her to come join the celebration of Eugenie's engagement "to a good-natured youth who will know how to appreciate her."

Weighed down by continuing money woes, Vincent's parents reluctantly agreed to his plan. In June, he would come to Helvoirt and escort Anna to England, where he would help her find work (and support her in the meantime). Vincent was ecstatic. "Our Anna will come here," he wrote Theo. "How wonderful that will be for me. It is almost too good to be true."

Even as Vincent's campaign to regain his place in the family appeared headed for success, however, that place was being taken. In November, only six months after Vincent was removed, Theo was transferred to the Hague branch of Goupil. He moved into Vincent's boardinghouse and took up most of his brother's duties at the store. *Gérant* Tersteeg invited Theo to the apartment upstairs for coffee and enlightenment, just as he had Vincent.

The contrast between the two brothers could not have been starker. With his pleasing looks and mild manner, Theo mixed effortlessly in any company. Clients called him "tactful" and "attentive"—two words never heard about Vincent. Theo not only looked more like his famous uncle than Vincent did, he also had Cent's famous "golden tongue." Even at sixteen, Theo "knew how to handle" customers, according to one account: how to "help them to a better discernment," so that "they always thought it was their own choice." He soon won praise not only from his demanding boss ("How well suited you are for this busi-

ness," Tersteeg marveled), but also from his all-seeing Uncle Cent, who would hear "not a word spoken against" *this* nephew.

After the disappointment of Vincent, Theo's successes were celebrated at the parsonage in Helvoirt with joy and relief. Not only had he renewed the family hopes of providing an heir to Uncle Cent, he had already (by age seventeen) achieved a measure of self-sufficiency that had taken Vincent years to reach. "It's a privilege that you are making so much money already," Dorus wrote. "That means something!" In The Hague, Theo upheld family obligations that Vincent had often ignored. For setting such an admirable example, his parents showered him with gratitude, encouragement, and undisguised favor. "Be well and always remain our joy and crown!" they wrote to him.

News of Theo's success, broadcast in letters to all the family, did not go unnoticed in London. Vincent had already heard from Tersteeg at Christmastime about his brother's quick ascent. He professed to be "pleased" at the news, but did not show it. Despite a busy correspondence with others, his letters to Theo slowed to a grudging crawl. When he did write, the letters were short and perfunctory. Breaking a two-month silence, Vincent explained brusquely, "[I] am very busy." The insistent inquiries to "tell me what you see" came to an end. Instead, Vincent loftily suggested that Theo "think it over and perhaps you will have some questions [about art] to put to me." Theo quickly assumed the role of the more desultory correspondent, often waiting weeks to reply to his brother's letters; unlike Vincent, who typically fired off responses to Theo within a day or two—an asymmetrical embrace in which they would remain locked for the rest of their lives.

By June, when Vincent returned to Helvoirt to escort Anna to London, the relationship between the brothers had cooled. Nor did Vincent receive the warm, grateful welcome he expected. Instead of enthusiasm for his new life and new family, he found only suspicion. The fault may have been Anna's. Vincent's attempt to enlist her in his campaign with talk of love had backfired. A relentless matchmaker, Anna began to spin webs of schoolgirl fantasy as soon as she received his first letter about the Loyers. Only days after Vincent cautioned her, "Old girl, you must not think there is anything more to this than what I have written," Anna speculated to Theo that there was "more than a brother's love" between Vincent and Eugenie. No matter how many times Vincent denied it and enjoined her "do not mention this at home," Anna doubtless spread the innuendo of nascent love to her parents just as she did to Theo. Subsequent "corrections" reporting Eugenie's engagement to another man just added to the puzzlement and concern at the parsonage, where Vincent's motives were always in doubt and where news of his odd epistolary courtship of Caroline Haanebeek may already have reached.

As usual, the Van Goghs blamed the company Vincent kept. The contradic-

tory stories about Eugenie's availability cast an unfavorable light on her mother, Ursula, whom Anna referred to disdainfully as "that old lady." What kind of mother would expose her daughter's reputation to such damaging ambiguities? The very inchoateness of the Loyer family that so attracted Vincent struck his parents as worrisomely "unnatural." "They are no family like ordinary people," Anna warned Theo. Dorus, of course, questioned the moral compass of any enterprise touched by French immorality. The possibility that Eugenie was a fatherless "love child" must have lurked in their darkest fears. They complained of "too many secrets" at the house on Hackford Road, and worried that the Loyers "were not doing [Vincent] any good."

The more Vincent insisted on the joys of his new family—"wonderful," he called it, "an escape from life's troubles and problems"—the more his parents feared that it was just another of their strange son's strange "illusions . . . sure to be disappointed." The more he detailed the loving embrace he found there, the more they worried about "his life being too lonely and secluded" in the house on Hackford Road. Anna took umbrage at Vincent's glowing descriptions of familial love far from home. His ardent claims of new "brother-sister" relationships and calls to treat these distant strangers as family members had no place in Anna's world, where family ties were unique and inviolable. Dorus shared his wife's misgivings.

And then Theo appeared.

News of his latest triumph had preceded him to Helvoirt. In mid-June, he had met the queen of the Netherlands, Sophie, when she paid a visit to the store on the Plaats. Not long after that, Uncle Cent had introduced him to royalty of a different kind: Adolphe Goupil. Theo's time and talents were in such demand that he almost had to cancel his trip to Helvoirt for Vincent's homecoming. The reunion between the two brothers after a year apart was, at best, polite. They talked shop but apparently little else. When Theo rushed back to The Hague the next morning, Vincent, in a fit of pique, refused to accompany him.

The more his family distrusted and marginalized him, the more Vincent withdrew. He spent most of his stay in Helvoirt filling a little sketchbook with "snapshots" of his life in London. After Theo left, he continued the work of self-documentation. He made drawings of the Helvoirt parsonage and gave them to his sisters Lies and Wil. For his parents, he made a big drawing of the view from his window on Hackford Road—an image intended either to reassure them about Anna's visit there, or to defy them about his future there, or both. In words that Vincent had not heard from home in a long time, his mother roundly approved his turn to drawing as a constructive pastime. "We are all very happy with it," she wrote Theo. "It is a delightful gift that can be of good use to him."

Vincent resisted leaving, as he always resisted leaving home. As his departure approached, he grew more irritable and alienated. When the subject of

London came up, he only groused about the fog. "He wasn't himself," Anna later complained to Theo. Dorus, physically sick following his father's death in May, withdrew from parsonage life into the moody seclusion that was his habit. Vincent barely saw him during the last week of his visit. Despite already having overstayed the ten days originally allotted for the trip, Vincent wrote his boss Obach at the last minute requesting more time. He also canceled a side trip to The Hague to see his brother, using the extra time in a last frantic rush of drawing—as if one more image might soften the hearts that seemed set against him.

But nothing worked. His campaign had failed. By the time Vincent and his sister left from the Helvoirt train station on July 14, his parents had come to see Anna as Vincent's salvation, not the other way around.

LESS THAN A MONTH after returning to London, Vincent left the house on Hackford Road. He never explained why. His relationship with the Loyers resumed amicably after he returned from Helvoirt. Ursula and Eugenie embraced Anna. "They are good people," she reported home. "They try to make things as comfortable as possible for us." At first, Vincent seemed deliriously happy to have his sister's company. "You can imagine how pleasant it is to be here together," he wrote Theo. Anna accompanied him partway on his walk to work every morning, then practiced the piano in the Loyers' parlor. She visited his workplace and dined with his boss Obach. On weekends, they toured museums and took picnics in the parks. Vincent learned to swim.

What brought this brief summer idyll to such an abrupt end? In the absence of any explanation, Vincent's parents saw only vindication of their dark forebodings. "It turns out things weren't so wonderful at the Loyers'," Dorus wrote. "I'm glad of it because I had an uneasy feeling about them staying there." "I'm glad he isn't there anymore," Anna agreed. "Real life is different from what one imagines." Years later, a family legend of unrequited love grew up around Vincent's sudden departure. In her early account, Johanna Bonger, Theo's future wife, speculated that Vincent had fallen in love with Eugenie Loyer—a story that compounded Anna's schoolgirl romanticism with Bonger's own and launched scores of biographers into speculative seas. "He tried everything to make her break [her] engagement," Bonger wrote, "but he did not succeed." It was this "first great sorrow," Bonger maintained, that changed Vincent forever; that made him, in the words of her tale's most successful retailer, Irving Stone, "sensitive to the pain of others."

Undoubtedly, the reality was both more prosaic and more profound. Vincent's patchwork family on Hackford Road could not hold together for long. He barely knew his sister Anna, whom adolescence had transformed into a suspicious and censorious nineteen-year-old. Perhaps more important, she did not

know him. After weeks of job hunting without success, Anna's prospects of employment dimmed. "I think it will be very difficult," Vincent explained to Theo. "They say everywhere that she is too young." Having promised to support his sister until she found work, Vincent faced his own financial crisis as the August rent came due—always, for him, a time of special volatility. The combination of his guilty sensitivity, Anna's demanding impatience, and Eugenie's quick temper made a falling-out virtually inevitable.

By August 15, Vincent had found new lodgings less than a mile away, bringing an end to his year with the Loyers—the first in a lifetime of intense attachments ending in sudden, traumatic breakups as his surrogate families proved inadequate to his reparative designs. "He has illusions about people," wrote Anna in her only comment about the month she spent with Vincent and the Loyers. "When they don't live up to his too-quick judgment, he's so disappointed that they become like a bouquet of withered flowers to him."

Whatever the cause, Vincent's expulsion (or flight) from the Hackford Road house marked the beginning of another of the long depressions that scarred his life. Within days, as fate would have it, Anna found a job in Welwyn, a small town five hours by train from London, and moved out of the new lodgings on Kennington Road. Alone for the first time in a year, Vincent quickly reverted to childhood habits of brooding and solitude. He stopped drawing and sought the old balms of literature and art. He ate poorly and ignored his appearance. He withdrew from social contacts and neglected his duties at work, drawing a sharp rebuke from as far away as Prinsenhage, where Uncle Cent "wished [Vincent] would get out and see people," his mother reported; "it is necessary for his future." As if to punish his old family for the failure of his new one, he stopped writing home. "It pains us that he does not write," Dorus worried to Theo, "and it is proof that he is not in good spirits."

London had no heath into which Vincent could escape. But it offered distractions and consolations nowhere available on the Grote Beek, with wildlife far more varied and strange. Especially at night, after the long workdays, Vincent "roamed around a lot there in the backstreets," he later told a friend.

Socially inept, craving human contact, and long since stripped of any compunction, Vincent found himself in the world capital of paid companionship. More than eighty thousand prostitutes, many of them barely teenagers, plied their trade in a city where the age of consent was only twelve. In the parts of London that Vincent frequented, opportunities abounded. "You cannot walk a hundred steps without knocking into twenty streetwalkers," one visitor complained about a walk along the Strand. The trade was serviced by three thousand official brothels, and half again as many coffee shops, cigar divans, dancing saloons, and "night houses," all peddling the same wares. In addition, prostitutes gathered in "swarms" at designated locations (Oxford Street, St. James's Square,

Covent Garden), many of them within steps of the Goupil store. They accosted passersby with a fearlessness that unnerved the unwary. They went by many names: drabs, Cyprians, fallen sisters, *lorettes*, harlots, whores, and "degraded creatures."

Vincent called them "girls who love so much."

In a letter to Theo in August, Vincent boldly announced his new life in London: "Virginity of soul and impurity of body *can* go together." With that salvo, Vincent launched a furious new campaign to end his exile. If he could not regain his parents' favor, he could at least reclaim his brother's allegiance. And what better way to do it than with the lure of sexual license?

As Vincent no doubt knew, Dorus had been waging a battle against Theo's darker angels since he left home at fifteen. The big city of Brussels held special temptations, but even Theo's transfer to the relative safety of The Hague (probably engineered by his father) did not curb the distraught admonitions from Helvoirt—"be on your guard," "steer clear of the rocks," "don't be known as a gadabout"—all coded warnings about the dangers of sex. When an unrequited infatuation sent Theo searching for sex in the dark alleys of the Geest, Vincent seized the moment.

While Dorus urged propriety and purity, Vincent preached tolerance and the pleasures of the flesh. "The animal must get out," he explained. When Dorus advised Theo to buy a biblical almanac and start each morning with an appropriate verse, Vincent countered with Bible lessons of his own: "Ye judge after the flesh; I judge no man," and "He that is without sin among you, let him cast a stone at her." He urged Theo to stand firm in defiance of their father ("Keep to your own ideas"), and instead of Christ, quoted Jules Michelet, author of that other gospel of the human heart, *L'amour.* While Dorus tried to terrify Theo with "ghastly" foreboding dreams of "wild goings-on" in the city, Vincent tempted him with images like *Margaret at the Fountain,* Goethe's vision of comely maidenhood helpless before temptation.

In his Faustian battle for Theo's heart, as in his campaign for Caroline Haanebeek's, Vincent enlisted every means of persuasion at his command. He sent Theo prints of alluring young peasant girls (the era's icon of guilt-free sex) and a portrait of Camille Corot (as famous for his mistress as for his paintings) with instructions to "put these up in your room." He recommended Corot's painting of voluptuous female woodcutters (*Les bûcheronnes*) and Jules Breton's of peasant girls dancing around a fire in a delirium of sensuous innocence (*St. John's Eve*). Of all the works in the Royal Academy show that year, he praised only the fashionable, available young women of James Tissot.

From literature, he recruited not only German Romantics like Goethe and Heine (who famously kept a shopgirl as a mistress), but also Frenchmen like Charles Sainte-Beuve, whose sonnets combined awe before nature with lecher-

ous longing for the feminine ideal; Armand Silvestre, who painted word portraits of peasant women with "souls as deep as the sea" and "blouses molded to their breasts"; Émile Souvestre, novelist laureate of the lovelorn ("This year I shall have a broken heart, for she whom I loved did not love me"); and Alfred de Musset, avatar of romantic angst, well known for his tempestuous love affair with George Sand.

Vincent's impassioned argument soon escalated into a full-scale, obsessive assault on his younger brother—the first of many in the years to come. The defense of sexual license was only the cutting edge. His exhortations eventually broadened to include love and belonging, melancholy and longing—subjects that clearly haunted him in his deepening alienation. So intense was his passion to persuade that letters alone could not contain it. By early 1875, he had bought an album for Theo and began filling its blank pages with long transcriptions from the works by these and other writers, all in a tiny, neat, error-free script. When he had filled every page of the first album, he bought another one and filled it, too, copying by gaslight late into the night.

How much of this fevered chorus found its way into Vincent's letters is not known. For the six months between August 1874 and February 1875, no letters from Vincent to Theo are known to survive, despite clear evidence that some were written. All that remains of Vincent's campaign are two little albums, bound in colored paper. The seventy-three entries, filling more than a hundred pages, testify to the depth and desperation of his pleas during the winter of 1874 to reclaim the special alliance that, in his imagination, had been pledged on the road to Rijswijk—even as he slipped farther and farther away from the rest of the world.

In October, Vincent's battle with his parents broke into the open. He had not written home for almost two months—an unprecedented breach of family duty. When he failed to write even on his mother's birthday in September, the hostility of his silence could no longer be denied. "Vincent won't write, not even on important days," Anna despaired. "Oh Theo! You don't know how much pain this is causing us." In the absence of any news, his parents imagined the worst. They had a dozen theories about what was wrong: Vincent wasn't eating properly, he wasn't getting out enough (he needed to "mingle with the well-to-do" more), he spent too much time alone, the London air had "adverse effects." They even suggested, improbably, that he needed to read more ("it turns the mind to other things"). They worried that he had stopped going to church, leading Anna to accuse him of "not cooperating" in God's plan for his happiness.

As the silence dragged into October, their worried speculations grew darker as they confronted, for the first time on record, the possibility that the problem went deeper. "Poor boy," they wrote, "he doesn't make things easy on him-

self . . . We experience unhappy times when we cannot be satisfied with who we are." When Uncle Cent visited Helvoirt sometime in September, Dorus and Anna's accumulated anxieties spilled out. Soon after that, Vincent received word from "the gentlemen" at Goupil that he was being temporarily transferred to Paris.

Vincent was infuriated by the intrusion. He fired off an angry letter that shattered family conventions of euphemism, repression of negative emotion, and parental infallibility. He accused his father, in particular, of interfering in his life, a charge that Dorus could deny only with a lawyerly quibble ("I didn't talk to Uncle [about Paris]," he insisted; "Uncle talked to me"). In fact, Dorus had met with Cent and his partner Léon Boussod just two weeks before the transfer was announced, and he had informed Theo about it even before Vincent heard the news. Vincent tried to credit his father's argument that Uncle Cent "wanted him to work at 'headquarters' and become more familiar with everything the Paris store contains." But he continued to seethe, confirming that older, deeper grievances were at work. Instead of paying a farewell visit to his sister in Welwyn, he sent a curt note demanding the return of his suitcase. He pointedly refused to send his parents his address in Paris, or even the date of his departure, forcing them to beg the information from Theo.

Vincent sailed for France on October 26. In Helvoirt, Dorus and Anna assumed the familiar posture of waiting and hoping. "We don't want to despair," they insisted. Instead, they prayed fervently that "God's involvement in this transfer will lead [Vincent] back to us and to Him and to himself and to become happy again." In their darker moments, however, as the winter descended and Vincent remained steadfast in his silence, the whole family began to entertain the unthinkable. Sister Lies worried that Vincent might never again be "the way he used to be," and predicted "it will be a long time before we see him again." Dorus called his son's behavior "unnatural" and warned, "it can hardly have positive consequences." Anna's judgment was hardest of all: "He has withdrawn himself from the world and society," she wrote. "He pretends not to know us . . . He is a stranger."

THIS WAS THE PATTERN of Vincent's fall from family grace—a pattern that would be repeated again and again in the years to come. His campaign to find employment for Anna was only the first of many bids to regain his rightful place in the lost paradise of the Zundert parsonage—a memory that loomed larger as he drifted farther from it. His lonely withdrawal into London's nocturnal world was the first of many descents into guilt and self-abusive excess; his exhortations of literature and art, the first of many efforts to reverse his isolation (and strike

back at his parents) by wresting Theo away from them; his fury at his father over the temporary transfer to Paris, the first of many explosions of wounded anger that only deepened his estrangement.

The pattern replayed almost immediately.

Overcome once again by family feeling as Christmas approached, Vincent eventually broke his silence. His parents responded in kind, dismissing the recent storm as "that mood," and eagerly planned for the family's holiday reunion. Delayed by work and weather, Vincent made a dramatic last-minute dash from Paris to arrive home on a storybook Christmas Eve. "How wonderful Helvoirt looked that evening [with] the lights in the village and the steeple amidst the snow-covered poplars," he recalled later. His return home on a starry, moonlit night, riding in an open wagon, soon became another of Vincent's talismanic memories—so quickly had the wheel of family longing come round since his bitter departure from London only a few months before.

Returning to England in January, he rededicated himself to work and duty. His correspondence emerges from its six-month sulk brimming with excitement over the store's new gallery (opened while he was in Paris) and the prospect of selling paintings, not just prints. "Our gallery is ready now and is very beautiful," he boasted to Theo; "we have some splendid pictures." He wrote his parents "good letters," too, letters "full of ambition." After seeing Vincent in London, sister Anna reported that he "looked very good" and reassured her parents that he was eating well and tending to his clothes.

He didn't miss his father's birthday in February (as he had missed his mother's), and his birthday congratulations overflowed with "deep emotion," Dorus noted. As a present, Vincent sent his parents money so they could have their photographs taken and give copies to their children. The plan marked not only the culmination of a running family preoccupation with portrait swapping, but also the first hint of an obsession with portraiture that would eventually carry Vincent to the frontiers of artistic expression.

In March he tried, unsuccessfully, to persuade his bosses at Goupil to transfer Theo from The Hague to London so they could be together. "How I should like to have you here," he wrote with a glint of determination; "we must manage that someday."

But neither Vincent nor his family could so easily escape the past. Their perfect Christmas was shadowed by Dorus's announcement that the final payment for Vincent's draft replacement was due, casting the family back into financial jeopardy. Sister Lies recalled that her father turned a deaf ear to Vincent's kind words and "pure thoughts" when he was home. "If, for once, Pa had listened," Lies lamented, "how differently he would think of [Vincent]." And for all his ardent rededication to family and duty as the new year began, Vincent continued to torment his parents with short letters at erratic intervals.

At work, Vincent's new enthusiasm could not mask the problems that had plagued him since The Hague: his lack of "social graces" and the temperament for sales. As the new gallery slowly moved toward its inaugural exhibition, these shortcomings must have become increasingly glaring to *gérant* Obach. The relationship between the two grew so acrimonious that they may have argued openly. (Vincent later angrily derided Obach's "materialism" and closed-mindedness, calling him "out of his mind.") Once again, complaints about Vincent's unsuitability began to circulate around Goupil, complaints that he acknowledged with a preemptive denial: "I am not what many people think I am just now."

In mid-May, only days before the opening of the new gallery, Vincent received word that he was being transferred to Paris immediately. The transfer was again labeled "temporary," but this time the message was unmistakable: "the Gentlemen" had lost all confidence in him. He could not be trusted with a position of responsibility. He was being replaced by another apprentice, an Englishman. He would not be returning.

In Helvoirt, his parents braced for the worst. "I hope it will not hurt him too much," Dorus fretted. Theo worried that "nobody close to [Vincent] has any sympathy for him"; "[nobody] knows what's going on in his heart"; "nobody trusts him, despite his good intentions." How would a man with his brother's "sensitivity" respond to such a crushing reversal?

Finally, a letter arrived from Paris. Dorus described it as a "strange letter," without explaining why. It may have been the letter in which Vincent enclosed a poem, "L'exile," translated into Dutch for his parents:

> *What use is there in banishing him*
> *From one shore and then another . . .*
> *He is the desolate son*
> *Of a beloved land.*
> *Let us give a homeland*
> > *A homeland*
> *To the poor exile.*

After reading the letter, Dorus suggested hopefully that perhaps the "heat and exertions" had "overstimulated" Vincent. But he couldn't shut out a darker explanation. "Just between us," he confided to Theo, "I believe it is a sickness, either of the body or of the mind."

Imitation of Christ

~

PARIS WAS IN AN UPROAR. IT WAS THE WINTER OF 1875 AND THE ART world was under attack by a rebellious cadre of young painters who styled themselves the Société anonyme (Anonymous Society), but whose enemies had stuck them with a range of dismissive labels including "Impressionalists," "Impressionists," and "lunatics." They claimed to see the world in a new way: making the improbable argument that their bright colors and loose brushwork captured images in a more scientific way—so that "even the most astute physicist could find no fault with their analysis," wrote one of the few critics who supported them. They even claimed to "paint" light—although they rejected the use of dark shadows, the traditional means of rendering the play of light on objects. They called their cheerful, airy paintings "little fragments of the mirror of universal life," or simply "impressions."

Claims that Impressionism represented the "next wave" in art were met with catcalls and guffaws from most of the Paris art world, still deeply invested in the Renaissance academics of drawing and modeling, and the commercial hegemony of the Salon. They called the new works "crimes," "absurdities," and "mud-splashes," and accused radicals like Claude Monet of conducting a "war on beauty." Outraged editorialists compared the new work to that of "a monkey who might have got hold of a box of paints." "Sheer lunacy," huffed *Le Figaro*, "a horrifying spectacle."

The storm finally broke in March 1875. Desperate for money, a group of the upstarts (including Monet and Renoir) arranged to sell some of their controversial works at the city's central auction house, the Hôtel Drouot. The event sparked a near riot of outrage. Spectators howled insults at the art and at the artists. As each work came on the block, they mocked it; and then when it

sold for pennies—fifty francs for a Monet landscape—they cheered in derision. "That's for the frame!" one yelled. The auctioneer feared that the frenzied crowd "would take me off to a lunatic asylum," he recalled. "They treated us like imbeciles!" So ugly did the event become that the organizers had to call the police to prevent the mêlée from breaking out into fistfights.

Two months later, Vincent arrived in Paris.

By then, the firestorm had spread to every corner of the insular, gossipy art world. The young artists and gallery workers who filled the brasseries of Montmartre, where Vincent found an apartment, could talk of nothing else. The artists at the center of the storm gathered almost nightly at cafés—first the Guerbois, then the Nouvelle-Athènes—only blocks from the Goupil gallery on the rue Chaptal, where Vincent worked. At the Moulin de la Galette, not far from Vincent's apartment, Renoir set up his easel to paint couples waltzing in the dappled light under the trees. On any given night, in any of the scores of music halls and nightclubs within a few minutes' walk of Vincent's room, or in any of the cheap local cafés frequented by young dancers, Degas could be seen with sketchpad in hand.

Vincent's frequent route to the other Goupil stores passed the studios of Renoir and Manet. When the Salon of 1875 rejected one of Manet's works, he invited the public to come to his studio and see it for themselves—and thousands did. Near the Goupil store on the avenue de l'Opéra, who could have missed the banners of the Durand-Ruel gallery beckoning the public to view the Impressionists' latest scandals: Degas's strangely informal portrait of workaday life, *Cotton Exchange*, and Monet's startling image of his wife in a bright red Japanese kimono? In June, Vincent visited the site of the infamous auction debacle, the Hôtel Drouot, not far from the Goupil store on the boulevard Montmartre. On one of his many trips to the area he no doubt passed a young stockbroker (and early Impressionist collector) named Paul Gauguin, who worked at the nearby Bourse and painted in his spare time.

But none of it registered with Vincent. Despite the controversy that crackled all around him, despite the lunchtime chatter and the barroom debates, despite the indignant reviews and the impassioned defenses, despite the furor—to say nothing of the arresting, unsettling images—Vincent never mentioned a word about Impressionism or any of its proponents during the time he spent in Paris. A decade later, when his brother tried to interest him in the "new artists," he could only respond, "I have seen absolutely *nothing* of them." "From what you told me about 'impressionism,' " he wrote in 1884, putting the unfamiliar term in quotation marks, "it's not quite clear to me what it really is."

Where was Vincent? How could he have ignored the war of words and images being waged in the galleries where he worked, the cafés where he ate, the

papers that he read, the streets that he walked? How could he have been so disconnected? The answer was as simple as the "strange" letter he sent his parents after arriving in Paris: Vincent had found religion.

EVERY THURSDAY EVENING and twice on Sunday, pilgrims thronged the Metropolitan Tabernacle in south London. They came by the thousands, blocking the streets in every direction. They filled the cavernous music-hall auditorium, packing it until the crowd spilled into the yard and spread as far as sound could reach. They came from everywhere: from London, from the countryside, from as far away as California and Australia. They came mostly from the ranks of the newly prosperous: clerks and shopkeepers, bureaucrats and housewives—alienated bourgeoisie longing for an escape from the oppressive matter-of-factness of modern life. Some came out of fervor, some out of disillusion, some out of curiosity. But they all came for one reason: to hear Charles Haddon Spurgeon preach.

Among the pilgrims in the winter of 1874–75 was a lone Dutchman, Vincent van Gogh.

After leaving the Loyers, Vincent had moved into a boardinghouse only a few blocks away from the immense Corinthian portico of Spurgeon's palace of worship. The Baptist preacher held all Victorian England in his thrall (there were rumors that Victoria herself attended services in disguise). Long in the public eye, Spurgeon had grown from a sensational "boy preacher" at twenty to a religious mogul at forty. His empire included a college, an orphanage, and a vast library of publications. But the soul of his success was still the thrice-weekly performance on the grand one-man stage that he had built for himself in Newington. From a railed platform the size of a boxing ring set in the middle of an adoring sea of more than four thousand worshippers, Spurgeon preached the promise of redemption: of "lifting men from the lowest degradation" and "bringing joy where there is sorrow."

A stout, comfortable man with a broad, bearded face, Spurgeon moved around the stage offering what he called "common sense" with the ease and animation of a favorite uncle. He addressed the deity with an intimacy many found shocking. He preached "the real humanity" of Christ. "Feel him to be near of kin to you," he said, "bone of your bone, flesh of your flesh." He "piled metaphor on metaphor," using the same parables of mustard seeds and sowers and "sheep gone astray" that Vincent's father used. He talked often about families and spoke of Christ as the paradigm of unconditional parental love. He used the example of his own misspent youth to prove that no one was beyond his Father's—or his father's—forgiveness.

It was a message perfectly tuned to a wayward, self-reproachful youth far from home.

Meanwhile, in his little room not far away on Kennington Road, Vincent set out on another pilgrimage—an inner pilgrimage through the only country in which he felt completely at home: books. It was the "age of advice," as the historian Peter Gay has dubbed it, an era when the "anguished bourgeois," seeking refuge from the century's social, scientific, and economic upheavals, turned to books to "re-enchant their world." Vincent was one of them. "I am reading a great deal just now," he wrote Theo. Hungry for belief, but alienated from his childhood sources of belief, he reached out in every direction: to collections of poetry and philosophical tomes; to nature guides and self-improvement books; to George Eliot novels and silly romances; to ponderous histories and, the latest craze, biographies—searching for new sources of mystery in an increasingly literal world.

His first guide was Jules Michelet, a master of many of the new genres. Michelet first gripped Vincent's imagination with his highly personalized books on natural history and the animal world, enthralling the childhood collector of birds' nests and beetles with books like *L'oiseau* (*The Bird*) and *L'insecte* (*The Insect*). Michelet had only tightened that grip with his chauvinistic and eccentric instructional books on sex and love (exploring, among other things, a fetishistic obsession with blood) that had helped Vincent through the romantic and sexual vicissitudes of the previous years.

But Michelet was primarily a historian, and it was through the Frenchman's sweeping, multivolume histories that Vincent ventured into the deeper and more perilous waters of faith. Michelet wrote history the way his friend Victor Hugo wrote fiction: with forceful narrative, soaring rhetoric, and a grand vision. In Michelet's histories, Vincent encountered for the first time a world unyoked from Christianity: a world in which *le peuple* (the people), not God, made history; a world in which the only true determinism was the determinism of the human spirit. In a message ideally pitched to an anxious but atheistic age, Michelet championed the French Revolution over the life of Christ as the seminal event in human history, the ultimate triumph of freedom over fatality, of life over death.

With religious fervor, Vincent threw himself into the study of the events of 1789. In addition to historical accounts, he read novels inspired by "those unforgettable days." The combination of Michelet's vivid evocations and melodramatic fictions like Dickens's *A Tale of Two Cities* struck the chord of Vincent's nostalgic imagination. For the rest of his life, he both pined for this lost paradise of freedom and fraternity, and believed it could be regained.

During his first transfer to Paris at the end of 1874, he had added paintings to his celebration of the glories of the Revolution. One painting in particular, a

portrait of a revolutionary youth wearing the *bonnet rouge*, struck him as "indescribably beautiful and unforgettable." He saw in it a face like Christ's: "marked by those cataclysmic times." When he returned to London in 1875, he hung a print of the painting in his room on Kennington Road like a devotional icon. In the years ahead, he would invoke it again and again as a symbol of hope and a promise of redemption. "There is something of the spirit of the resurrection and the life in it," he said.

He read Hippolyte Taine, another French historian whose efforts to reconcile science and religion threatened to carry Vincent even further from the reassuring verities of the Zundert parsonage. To Taine, religion was nothing more than the childish projection of human frailties onto the unseen and unknowable. Because one could only truly know what could be observed and experienced, Taine argued, the only valid mode of thought was the scientific mode. Humans could never do more than witness and classify. Vincent, who always craved the comfort of the infinite and never lost his taste for the poetic excesses and moralistic sentimentality of Romantic literature, seems to have resisted Taine's contempt for transcendental truth. But in another way, Taine's ideas offered something like salvation to a bookish, introverted, social misfit like Vincent. "Inner realities" mattered more than mere appearances, Taine argued; and only "private reflection"—an intense personal struggle with the unknowable—could lead to a true understanding of the ultimate mysteries of life. All conceptions of truth and beauty, all "intimations of the infinite" derived from this exquisite loneliness.

Vincent also found balm in the dense arguments and brilliant dicta of Thomas Carlyle, yet another lapsed romantic rebuilding his faith. For Carlyle, it was man's fate to be a pilgrim, to wrestle with doubt, to reject old creeds and seek new insights into the "Unseen World." In a conceit that must have had special resonance for Vincent, Carlyle compared the discarding of old beliefs to the shedding of threadbare clothes. Like Vincent, the hero of Carlyle's *Sartor Resartus* was ejected from his idyllic childhood home, estranged from his family, unsuccessful in friendship, spurned in love, and forced to face the world alone ("one lone Soul among those grinding millions"). After undergoing a crisis of suffering and self-doubt, he emerges, Christlike, reborn in a new faith.

In his book *On Heroes*, which Vincent also eagerly consumed, Carlyle explored more fully what it meant to lead a Christlike life. Jesus may have been "the greatest of all Heroes," he said, but only one of many. Heroes could be prophets (like Mohammed or Luther) or potentates (like Napoleon), but they could also be poets like Dante or Shakespeare or Goethe. They could even be artists. What made them heroes was not their effect on the world, according to Carlyle, it was their way of seeing the world. In passages that must have warmed the heart of the creekbank gazer from Zundert, Carlyle claimed for all hero-poets a special

vision: the power to "discern the loveliness of things," to appreciate their "inner harmony." "Through every star, through every blade of grass," he argued, "is not a God made visible, if we will open our minds and eyes?"

Carlyle's heroes were no paragons, either. Like Vincent, they had struggled with self-doubt and discouragement. His Dante was "an unimportant, wandering, sorrow-stricken man"; his Shakespeare, a sad soul who spent years "wading in deep waters" and "swimming for his life." His heroes cared not at all for the "smooth-shaven respectabilities" of conventional behavior, and their oddness blinded others, even their families, to their true worth. With nothing more than "sincerity of heart" and a "clear, all-seeing eye," Carlyle promised, even a flawed, unconventional youth, estranged from his family and spurned by the world, could find the "divinity" within himself.

For Vincent, this was the ultimate consolation: an identification with Christ. It not only sanctified his pain and heroized his loneliness, it trumped his father's sanctimonious condemnations. It also held out the promise of forgiveness and redemption—an end to his wandering exile.

But it was another book he read that winter that truly sealed Vincent's messianic identification—sealed it so tightly that, in later years, it would spring from his fevered mind with delusional force. The book was *Vie de Jésus*, Ernest Renan's *verité* account of the birth of Christianity. Such was the impact of Renan's biography on Vincent's imagination that in February 1875 he sent a copy to his brother alongside the poetry album over which he had slaved all winter. In Catholic France especially, Renan's claims that Christ was a mere mortal, the Eucharist just "a metaphor," and miracles merely the delusions of superstitious minds ignited a firestorm of controversy. But as a Dutch Protestant raised in the shadow of *Das Leben Jesu* and the Groningers' biblical humanism, Vincent would have found nothing shocking in such claims. What transfixed him was Renan's vivid portrait of a man in search of himself.

Like Vincent, Renan's Jesus was a "provincial," a Galilean, with "an exquisite sympathy" for nature, in which he often sought solace. The eldest of many brothers and sisters, but never married, Renan's Jesus shunned his family and came to value "the bond of thought" more than "ties of blood." Like Vincent, Renan's Jesus was a man of volatile moods: alternately rent by anger, possessed by rapturous enthusiasms, and paralyzed by melancholy. He was a deeply flawed *man*. Obstacles irritated him. He argued incessantly, and saw his life increasingly as a battle with the forces of hypocrisy and narrow-mindedness. Isolated and ostracized, he disdained convention and delighted in flouting the social niceties of his day. "Contact with the world pained and revolted him," according to Renan. By the end, he had altogether "forgotten the pleasure of living, of loving, of seeing, and of feeling."

Yet these torments and trials were merely the necessary passage to ultimate

redemption: not in a literal resurrection (Vincent never showed any interest in Christ's Passion), but in pointing the way to a new life, a journey's end. For humanity, that destination was the promised utopia, the consummation of Michelet's apocalyptic revolutions. For Jesus' fellow outcasts, like Vincent, it was a place in the soul where they could finally find comfort and belonging.

THROUGHOUT THE WINTER and spring of 1874–75, these ideas simmered in the solitude of the little room on Kennington Road. Vincent's parents heard only hints of them in his rare, brief letters. At Christmas, his sister Lies admired Vincent's "pure ideas." In February, even Dorus noticed some "good thoughts" in his son's birthday greeting. Vincent almost certainly poured out these "thoughts" to Theo in the six months of missing letters. He eagerly added passages from his readings in Taine, Carlyle, and Renan to the poetry albums he was preparing for his brother, creating an incongruous pastiche of swooning love poetry and ponderous philosophizing that perfectly reflected his manic mind. Equally comfortable with the deepest ideas and the shallowest sentimental notions (a versatility later critical to his art) he was moved by Spurgeon's avuncular exhortations to simple faith even as he embraced Carlyle's abstruse "divine infinite" and Renan's controversial Christ.

By the time Vincent arrived in Paris, however, his search for answers had resolved into a single mandate: "Fear God and keep his commandments," he enjoined his brother in the summer of 1875, "for this is the whole duty of man."

The triumph of evangelical ardor over existential angst—of Spurgeon over Carlyle—in Vincent's flailing thoughts may have been the result of a pilgrimage he made that spring to Brighton, the resort town on the south coast where, in May and June, evangelicals from across Europe gathered for one of the great "conventions" that marked the spiritual revival of the 1870s. Although he missed the convention itself, Vincent later recalled how "moving" it always was to see "the thousands of people now flocking to hear the evangelists."

Whatever the cause, the transformation was complete. In Paris, he launched into a paroxysm of piety. He read the Bible fervently every night and filled his letters with its wisdom. He imposed monastic self-discipline on his routine: rising at dawn and going to bed early (in contravention of long habit). He summarized his day to Theo with the ancient monastic motto *ora et labora* (prayer and work). He eschewed the pleasures of the flesh and took a new, sacramental interest in bread ("the staff of life")—both ominous portents of the self-punishments to come. Writing at a furious pace, he deluged his family and friends with exhortatory letters: letters fat with scripture, hymns, inspirational verses, and homiletic aphorisms. So overwhelming was the outpouring that even the pious Dorus expressed unease. "[Vincent] is always in such a serious mood," he com-

plained to Theo. Ever distrustful of excess, Dorus may have recognized in his son's newfound passion not the ardor of a man embracing new angels, but the desperation of a man fleeing old demons. "This morning I heard a beautiful sermon," Vincent reported to Theo in September. " 'Forget what is behind you,' the preacher said. 'Have more hope than memories.' "

In his rush to put the past behind him, Vincent renounced almost everything that he had once held precious—in some cases only months before. After years of encouraging his brother's romantic adventures, he warned Theo to "keep your heart against all attention." After years of lurching toward success as an art dealer, he disavowed the whole notion of worldly success and now wished only to become "rich in God." He came close to renouncing art itself. "You need not exaggerate . . . the feeling for art," he cautioned Theo. "Don't give yourself *utterly* to that." After a winter of wrestling with the brave new ideas of Carlyle and Taine, he now dismissed them all as "deviations" and discouraged Theo from thinking "too deeply" lest his intellect imperil his faith. Repudiating a childhood of defiant noncomformity, he repeatedly enjoined his brother to aim always for "the narrow road" (a phrase he borrowed from his father). And after years of desultory attendance, he sternly instructed Theo in imperative terms to "go to church every Sunday; even if the preaching is not good."

Perhaps the most astonishing reversal—surely the most surprising to Theo—was Vincent's rejection of his longtime hero Michelet. In September, Theo sent a letter with a favorable mention of *L'amour,* a book that his brother had been pressing on him only the year before. Vincent scrawled an alarmed response onto Theo's letter—"Do not read Michelet any longer"—and shot it back by return post. A few weeks later, he sent another anxious warning: "I am going to destroy all my books by Michelet, etc. I wish you would do the same." He followed up a month later: "Did you do what I advised you to do, get rid of the works of Michelet?" And again a week after that: "I advised you to destroy your books, and do so now; yes, do so."

Why this hounding? In Vincent's guilt-obsessed mind, Michelet had become synonymous with sexuality. Avoiding the Frenchman's erotic writings was an essential part of the regimen Vincent proposed to ward off the temptations of sex—temptations that clearly, for Vincent, lurked in every unguarded moment. (His regimen included Bible reading and visiting friends in the evening as often as possible.) Soon Vincent's moralistic fervor extended to other books as well. With a certitude that could only have reflected his own precarious grip on certainty, he commanded his brother not to read anything at all but the Bible, dismissing everything else as "disgusting." Romantics like Heine and Uhland were "dangerous traps," he warned Theo. "Be on guard . . . do not abandon yourself to them." As for Renan's *Vie de Jésus:* "Throw [it] away," Vincent thundered.

In place of Michelet and Renan and all the other books banished in the fall

of 1875, Vincent pressed a new favorite on his brother: Thomas à Kempis's *Imitatio Christi* (*Imitation of Christ*). Even more than the Bible, this fifteenth-century spiritual guide for monastic novices brought Christ vividly to life—not as a biographical figure, but as an intimate friend. Unlike the "hero" of Carlyle and Renan—a remote figure on a millenarian mission—Kempis's Jesus speaks directly to the reader in "the language of the heart": with sincerity, common sense, and an exquisite sympathy for human weakness. He counsels, exhorts, chides, and cajoles. With its unique combination of classical wisdom and medieval sweetness, *Imitatio* proved the perfect comfort to Vincent's estranged soul. Kempis's Jesus reassures his followers that "God loves us as much in our failings as in our successes," and that loneliness is a badge of devotion, not a curse. All true believers live as "strangers and pilgrims in the world," he says, and "gladly endure the heart's interior exile."

In letter after letter that fall, Vincent tried to play the part of Kempis's consoling Christ to his eighteen-year-old brother. Melancholic from the deaths of several friends, disgruntled at work, and bedridden by an injury, Theo presented an ideal test for the new, beatific Vincent. Instead of the usual exhortations and incitements, he sent his brother quiet urgings to see the storms of adolescence as "nothing but vanity"; not to take setbacks "*too* much to heart"; not to put too much stock in the things of the world; even "not to dream" too much. "All things work together for good to them that love God," he wrote about Theo's sprained ankle. "Courage, old son," he concluded philosophically, "rain and good weather alternate on the road that goes uphill all the way—yes to the very end." For a volatile young man whose life so far had been riven by wild enthusiasms and bitter disappointments, it was a bold leap of imagination—a desperate grab for the serenity that had always eluded him in reality.

Vincent sent copies of *Imitatio* not just to Theo but to his sisters Wil and Anna as well, and everyone reported receiving "good letters" from him. But the person who felt the full force of Vincent's ardor that fall wasn't Theo or any other Van Gogh. It was Vincent's housemate, Harry Gladwell.

Vincent met the young Englishman at the Goupil office on the rue Chaptal where he, like so many Goupil apprentices, had been sent for training by his art dealer father. With his provincial ways, poor French, and jug ears, Gladwell cut an almost comic figure in cosmopolitan Paris. "At first everybody laughed at [him]," Vincent reported, "even I." But religion brought them together. By October they not only shared a boardinghouse, they shared a joint discipleship. Every night, they read aloud from the Bible, intending to "read it from one end to the other," Vincent said. Every Sunday, they visited "as many churches as possible," leaving early in the morning and returning late at night. Vincent ardently preached Kempis's *Imitatio* to his young companion, chastising the homesick eighteen-year-old for "sighing after" his family too much—a violation of Kem-

pis's instruction to withdraw from the world and seek solitude. Gladwell's close relationship with his father drew an especially sharp rebuke from Vincent, who called it "dangerous" and "unwholesome"—"idolatry, not love." According to Kempis, parental love should be marked by sadness and regret, Vincent insisted— at least in this life.

When it came to Harry Gladwell, however, Vincent ignored Kempis's warning to "shut the door" on emotional ties. Starved of companionship for so long, he found in the awkward outcast Gladwell both a mirror of himself and a new slate to write upon. He quickly expanded their nightly readings to include his favorite poetry (a true familial intimacy). He tutored Gladwell's eating habits, introduced him to the joys of print collecting, and guided him through museums, pointing out "the pictures that I like the most." The friendless Gladwell, who was exactly Theo's age, gladly accepted the role of pliant, attentive younger brother that Theo himself had long since abandoned. He came to Vincent's room every morning to wake him and make him breakfast. They walked to and from work together, ate dinner together around the little stove in Vincent's room ("*our* room," Vincent called it), and took long soulful treks together through the streets of Paris. "I should like to walk again with [Harry] in the twilight, along the Seine," Vincent recalled fondly years later. "I'm longing to see his brown eyes, which could sparkle so."

The unfamiliar passion of friendship, combined with the new passion of piety, crowded out everything else. Even as the Paris art world burned with controversy; even as young artists plotted insurrection in brasseries and traditionalists retaliated in furious editorials; even as Monet's and Renoir's riverbank scenes of Argenteuil were scorned and derided—or championed—all around him, Vincent holed up in his little Montmartre "cabin" (his word) with his young acolyte, reading the Bible and following the example of Kempis's Christ: "Withdraw your heart from the love of things visible, and turn yourself to things invisible."

But Vincent could not surrender his vicarious life in images any more than he could resist the balm of Gladwell's companionship. Instead, he enlisted art in the service of his newest obsession. Already in London the previous year, he had begun adding explicitly religious images to his storehouse of favorites. He made a special trip to the British Museum in August 1874 to see one of Rembrandt's drawings of the life of Christ. Over the winter, as his thought-pilgrimage led from Spurgeon to Michelet to Carlyle to Renan, the gallery of images nailed to his wall tracked its progress. Scenes of provocative women and bourgeois life came down; scenes of Bible readings, christenings, religious heroes, and pious ceremonies went up. Carlyle's view of divinity in Nature brought a rush of images of serene sunrises, glimmering twilights, turbulent skies, and lowering clouds (especially by the French landscapist Georges Michel)—cementing a bond between nature and religion that would never be broken.

But the divine Nature of Carlyle soon yielded to the triumphant Christ of Renan. From a memorial exhibition of works by the most soulful of all Barbizon landscapists, Camille Corot, Vincent singled out one work, *The Garden of Olives.* From a show of old masters, he picked Rembrandt's *Descent from the Cross* for praise. From the vast riches of the Louvre and Luxembourg galleries, he recommended that Theo see Rembrandt's *Supper at Emmaus,* another scene from the life of Jesus. For his mother's birthday in September, he sent two engravings: *Good Friday* and *St. Augustine.* Within a few months after his arrival in Paris, he had added to the images on his cabin wall a nativity scene, a picture of a monk, and a print entitled *The Imitation of Jesus Christ.*

Vincent's otherworldly obsessions only compounded his problems at work. The fresh wave of enthusiasm with which he began the job in May was quickly dashed when he learned in June that he would not be returning to London as he had hoped and expected. His devotion to Christ may have consoled his disappointment, but it earned him no friends, other than Gladwell, among his fellow employees on the rue Chaptal. Nothing could have been more ill-suited to Adolphe Goupil's bastion of cosmopolitan commercialism than Kempis's *Imitatio,* with its exhortations to disengagement and asceticism. What were Vincent's fellow apprentices, merchant sons in training, to make of Kempis's injunction: "Do not flatter the rich, nor desire to be in the presence of those who are important in the eyes of the world"? If Vincent tried to convert them—as he surely did—he no doubt received the same impatient rebuff he did from his Uncle Cent: "I know nothing of supernatural things."

Vincent later dismissively described his job in the salesroom at Goupil as "entertaining visitors," suggesting both the dreaded social demands of the work and his poor track record of sales. His inborn shortcomings as a salesman— rough appearance, unsettling gaze, awkward manner—must have stood out even more jarringly on the rue Chaptal than they did on the Plaats. The ladies of Paris who came to shop at Goupil's limestone palace of parlor-art called him *"ce Hollandais rustre"* (that Dutch rube) and stiffened with disdain when he waited on them. He treated them not as customers to be wooed, but as novices to be educated—recruited to his latest enthusiasm—or sometimes as philistines to be chastened. The "stupidity" of some customers "exasperated" him, according to one account. And when someone defended a purchase by saying *"C'est la mode"* (That's the fashion), he would recoil in astonishment and anger. The customers responded in kind, indignant that this strange clerk "dared to question their taste." In such confrontations, Kempis's call to honesty in word and deed could only have emboldened Vincent's natural obstinacy. On more than one occasion, his *impolitesse* so alarmed his superiors that they were forced to take disciplinary action against him for setting a "bad example" to his coworkers.

To make matters worse, Kempis's call to embrace the "simple and humble"

sent Vincent's taste in art wandering in ever more contrarian and idiosyncratic directions. He developed a special obsession for the strange, somber works of the Dutch artist Matthijs Maris, a former Communard who lived not far from Vincent's boardinghouse in Montmartre. Maris was another fallen son of the bourgeoisie. He had once worked for Goupil and painted in the same conventional style as his successful artist brothers, Jacob and Willem. But he had turned his back on all that. Dismissing his previous works as nothing but "potboilers," he began painting in an eerie symbolist style and took up the life of an exile and recluse. When Vincent championed Maris's "genius" to his parents, they responded warily: "[He] is so enthused about the bleakly-colored paintings of Maris," Dorus lamented. "I wish that his tastes would prefer the expressions of a more energetic life, something done in strong and bright color."

Despite their proximity, Vincent never reported visiting the misanthropic Maris. But in every way that mattered, he had found a kindred spirit. They shared the same otherworldly concerns; the same history of family alienation and revolutionary ardor; the same trajectory of eccentricity, rejection, and withdrawal. Sometime that fall, Vincent began preparing a poetry album for the older man. He invoked Kempis in the very first entry: "When you are a stranger everywhere," he wrote, "how fortunate it is to have the truest friend in your heart."

The combination of Kempis's lessons, Maris's example, and the continuing troubles at Goupil gradually reshaped Vincent's world. Old attitudes were swept away—not just toward his uncle's profession, but toward wealth and privilege in general. He developed a lifelong antipathy to the class he had once aspired to join—the class that, like his family, would not have him. According to his sister Lies, he came to see bargaining as nothing more than "seeking to get the better of another," and art dealing as "simply legitimate stealing." "Everything, everything," Vincent later wrote, "is in the clutches of the moneychangers." Angry and adrift, he complained of depression and took up again his cure for the "blues," pipe smoking. He endlessly wandered the streets of Paris, avoiding museums but lingering over cemeteries. He referred dismissively to his life at Goupil as "that other world" and spurned familial duties to his patron Cent. In perhaps the clearest sign of his inward revolt, he began defying the strict dress code of both family and profession. Godliness, said Kempis, "does not avoid what is shabby, and does not mind wearing clothes old and tattered."

The one vanity that Vincent could not give up, regardless of Christ's example, was his longing for family. As always, the approach of Christmas fanned that longing into a blaze of anticipation. Because his father had accepted a new position, the family would celebrate the holiday in Etten, a little town on the outskirts of Breda, only four miles from Zundert. So Christmas would be a double homecoming. As early as August, Vincent started laying holiday plans. In Sep-

tember, he wrote to Theo, "How I am longing for Christmas," and instructed his paymaster to withhold something from his salary checks each month because "I shall want a lot of money around Christmas." December began with a rush of letters and a flurry of shifting plans for his departure from Paris. When a painting arrived at the gallery showing a snow-covered village scene, Vincent imagined it as his own Christmas reunion to come. "It tells us that winter is cold," he wrote hopefully, "but that human hearts are warm."

But the months of longing and anticipation only added to the burden of failure and guilt that he carried home with him on the overnight train that left Paris on December 23. The news he had to tell his parents would blacken his family's brightest, most cherished holiday: he could not stay at Goupil.

THE ACCOUNTS OF VINCENT'S final humiliation are incomplete and confusing, but on one point they agree: he saw the ax coming. In a subsequent letter to Theo, he called his dismissal "not entirely unforeseen" and admitted vaguely to having "done things that in a certain sense have been very wrong." One of those things surely was his unauthorized trip home for the holidays. In fact, it appears that Vincent's holiday leave had been canceled, probably at the last minute—not an unusual occurrence during the store's busiest season. But after months of planning and longing, Vincent defied his bosses and left anyway. It may have been during a confrontation over the last-minute cancellation that Vincent "flew into a rage and walked out," as he confessed to Theo years later. He told his family none of this at first. Only after the celebrations were finished and Theo had returned to The Hague did Vincent sit down for a "heart-to-heart talk" with his father.

Even then, he never mentioned his unauthorized departure or the dismissal he must have known was coming, but instead portrayed his predicament in more general and sympathetic terms. "He is definitely *not* happy," Dorus reported to Theo after the conversation. "I believe he is not in the right place there . . . It may be necessary to change his position." Even as his train left Breda for Paris on January 3, Vincent had still not told his parents the truth. At their farewell, "[Vincent] was of the opinion that he should stay [at Goupil]," Dorus reported to Theo. Anna recorded her son's parting words: "I am looking forward to my work."

As Vincent feared, the dismissal was, in fact, the first item of business when he returned to work on January 4. Léon Boussod, one of Cent's partners, delivered the news in an encounter that Vincent described as "very unpleasant." Confronted with his unauthorized leave, coming on top of a litany of customer complaints, disciplinary actions, and admonitory transfers, Vincent retreated into silence. "I never made a big thing to answer back," he told Theo. He must

have known that he had no choice but to accept a decision that had clearly been approved at the highest level. In January, the Van Gogh family chronicler noted tersely: "Vincent received word that he was no longer employed in the house of Goupil. . . . The gentlemen had noticed long ago that he was not fit for business, yet they had let him stay as long as possible for Uncle [Cent]'s sake."

Vincent tried to salvage what he could from the wreckage. In a letter to his father the same day, he finally admitted the unauthorized leave, but described his summary dismissal as if it had been a dignified resignation. To Theo, he compared himself poetically to a "ripe apple," which even "a soft breeze will make fall from the tree." For the rest of his life, Vincent would replay this humiliating episode in his head, regretting his Christlike "passivity," and insisting that he could have defended himself against Boussod's accusations but chose not to. "I could have said a lot of things in reply if I had cared to," he explained to Theo, unprompted, years later, "such things as I believe would have made it possible for me to stay."

But nothing Vincent might have said or done, then or ever, could mitigate the shame. "What a mess he has made!" Dorus wailed. "What a scandal and shame! . . . It hurts us so much." "It is so terribly sad," Anna lamented, "who would have expected this ending? . . . We don't see any light . . . it is so very dark." Abandoning all reticence, his parents poured out their "bitter disappointment" and "indescribable sorrow" in letter after letter to Theo. They called Vincent's humiliation "a cross put upon us by our Heavenly Father," and hoped only that word of the scandal might not reach Etten.

Any sympathy they felt for Vincent was snuffed out by the conviction that he had brought this catastrophe on himself—and on his family. Dorus blamed Vincent's lack of ambition, his inability to "take charge of himself," and his "sick outlook on life." Anna, whose brother Johannus had committed suicide only a few months before (over some unmentionable miscreance), located Vincent's fate in his rejection of class and family duties. "Such a pity that Vincent did not get involved more in the family life according to our station in society," she wrote. "Without that, one cannot become a normal person." Even Theo agreed, offering his parents the cold comfort that Vincent "will find his troubles wherever he goes." The family chronicler summed up the consensus view: "[Vincent] was always strange."

The parson and his wife did everything they could to contain the damage. They instructed Theo, and no doubt others, not to talk about the events in Paris. Everyone should "act as if nothing has happened," they wrote. If asked, he should say only that "Vincent wants to change jobs." In the meantime, Dorus asked his brother Cor to arrange a position at Cor's bookstore in Amsterdam. If Vincent transferred from one Van Gogh enterprise to another before his final termination date (Boussod had given him until April 1), the worst humiliation

might still be avoided. For a while, Dorus even thought he might overturn the sentence of the "gentlemen" in Paris. In a series of tortured letters, he urged Vincent in the strongest terms to go back to Boussod, apologize, regret his error, and ask for his job back.

But it was no use. Boussod stood firm. Uncle Cor expressed sympathy for the family's dilemma but would not offer a job to his troublesome nephew. And not a word of condolence or mitigation was heard from Uncle Cent—although his feelings eventually found their way into the family chronicle. "Great disappointment for Uncle," the chronicler, Aunt Mietje, wrote, "who had hoped for a good future for [Vincent] for the sake of the name."

In Etten, Dorus mourned as if his son had died. He retreated into his study and wrote a sermon for the next Sunday: "Blessed are those who mourn, they will be consoled."

Desperate to preserve their one remaining tie to Cent's favor, Dorus and Anna launched a campaign to insulate Theo from the shame of his brother's scandalous fall. They urged him to maintain his own good relations at Goupil (especially with Tersteeg). "Remember that Vincent neglected to do that," they cautioned. Anna sent pointed advice that sounded nothing at all like the mother of the Zundert parsonage: "Let us all be independent and not depend too much on each other." If Theo showed any sign of fraternal sympathy, they moved quickly to dispel it. Vincent should have learned his lessons, they wrote, "never mind how solid and good he is." And lest Theo forget the damage his brother had wrought, they signed their letters, "your sad Pa and Ma."

In his Montmartre room, paralyzed with remorse, Vincent surveyed the shipwreck of his life. He later described the events of January as "a calamity"— "the ground gave way under my feet"—"everything that I had built up tumbled down." Six years of work at Goupil had come to nothing. He had blackened the name he wore so proudly; embarrassed the brother whose admiration he craved; and disgraced the family he longed to rejoin. In a belated effort to check the damage, he sent a flurry of letters and gifts to family and friends, but received back only polite replies—or, in the case of Uncle Cent, no reply at all. Theo wrote so sparingly that Vincent had to plead for news: "I long to hear from you . . . speak to me of your daily life." What he did hear about Theo, mostly by other routes, only sharpened the pain: a new promotion, a successful spring sales trip, another volley of praise from Uncle Cent, and a substantial salary increase. Overwhelmed by guilt, Vincent returned forty florins that his father had sent him.

At the end of January, Harry Gladwell moved out of Vincent's boarding-house, adding isolation to shame. Vincent clearly suspected the timing, only weeks after the debacle with Boussod. In a flash of the paranoia that would later engulf him, he blamed Gladwell's abandonment on a conspiracy against him.

The Englishman's occasional visits after that could not prevent him from lapsing into old patterns of solitude and self-pity. "We feel lonely now and then and long for friends," he wrote Theo (distancing himself from the hurt, as he often did, with the plural pronoun). "We would be quite different and happier if we found a friend of whom we might say: 'He is the one.' " Within days of Gladwell's departure, Vincent attached himself to another employee at work, another troubled young Dutchman, Frans Soek. Vincent invited Soek back to his room and read to him from Andersen. He visited Soek's Paris apartment where he lived with his wife and mother-in-law. Vincent described them as "two sympathetic souls," and may have briefly imagined making them into his next family.

BUT HE HAD TO LEAVE. The shame was too great for him to remain in Paris. His parents dutifully invited him to stay in Etten, but disgrace no doubt awaited him there as well. For reasons he never revealed, Vincent was "firmly resolved" to return to England. To live on his own, however, he had to have a job. Dorus's strained finances could never subsidize his wanderings—even if Vincent were willing to take his father's money. But Vincent could think of nothing he wanted to do. The sudden "uprooting" (his word) from Goupil had left him demoralized, adrift, and deeply mortified at the prospect of hunting for another job. "One is simply 'someone out of work,' " he despaired, "a suspicious character." His parents suggested that he take up accounting, or perhaps build on his indisputable strength (and only experience) by working in an art museum. Or, if he still had a "love for his profession," why not set up as an art dealer on his own, just as both his uncles had done?

But Vincent showed no interest in art. He cared only about the reparative drama playing out in his cabin with Frans Soek and Harry Gladwell, who still came for weekly poetry readings. He felt he had "an inclination for instruction," he wrote his father vaguely, and hoped that "the enthusiasm would follow." He had read George Eliot's *Felix Holt*, in which the hero supports himself and his widowed mother by instructing young boys. He imagined doing the same. With no more consideration than that, Vincent began responding to advertisements in English papers seeking teachers and private tutors. His parents despaired of his chances. "It will take a lot of study and effort to acquire the necessary tact and ability," they worried, "and it's not clear that he wants to prepare himself."

All Vincent's inquiries were either rejected or went unanswered. As his termination date approached, he grew increasingly anxious. April 1 loomed like Judgment Day. "My hour approaches," he wrote Theo. Defying his parents, he determined to go to London—with or without a job—as soon as he left Goupil; he would stop in Etten only briefly on his way to England. In the meantime, he struggled to stem the rising tide of anxiety and self-reproach by turning again

to Kempis's Christ. "You will feel great comfort in time of trial . . . when men despise you," Kempis promised. Was not Christ, too, "abandoned by friends and acquaintances"?

But as his departure neared, Vincent turned to older, deeper consolations. Despite his impending poverty, he bought more prints for his growing collection. He spent his final weeks in Paris not bidding farewell to friends or revisiting favorite sites, but filling out the album he had begun for Matthijs Maris. With the art world in upheaval around him and his own life in collapse, he sat alone in his garret feverishly copying entry after entry from the voices of his youth—Andersen, Heine, Uhland, Goethe—summoning up his truest friends with ink and pen; busying his hands with page after page of tight, flawless script; calming his head with mantric repetitions of their familiar images—evening mists and silvery moonlight, dead lovers and lonely wanderers—and comforting his heart with their insistent assurances of a higher love.

ON FRIDAY, MARCH 31, the day after his twenty-third birthday, Vincent left Paris. It was an uncharacteristically orderly leave-taking for Vincent, who hated good-byes and would spend the rest of his life preempting them with precipitous flights. Gladwell, who saw him off at the train station, took Vincent's job at Goupil and moved into his room in Montmartre—exactly reprising Theo's role three years earlier in The Hague. At the last minute, a letter arrived offering a position at a small boys' school in Ramsgate, a resort community on the English coast. The news gave Vincent's departure the air of a fresh start rather than an ignominious end. It wasn't much (the job paid nothing initially), but at least it provided room and board and a place far away to hide his shame.

The brief stay in Etten rekindled old longings. Vincent made a pencil drawing of the family's new home, the Etten church and parsonage, with every fence picket and window sash lovingly detailed and every contour meticulously emphasized in pen. He took a train trip to Brussels to see his sick Uncle Hein. He may have revisited Zundert. His parents called the days he spent in Etten "good days," and insisted hopefully, "He *is* a good man." Vincent seemed to want to linger. A trip originally scheduled for only "a few days" gradually extended to several weeks. On April 8, Theo arrived, detouring to Etten on his spring sales trip.

But Vincent could not stay. Every time the subject of art came up, as it inevitably did, his parents could not hide their disappointment that he was leaving a profession he knew so well for one that he knew not at all. "It's incredible how much he loves art and how deeply it touches him having to leave it all behind," Anna lamented. "We hope that he will find a good vocation [but] 24 boys in a boarding school is no small thing." Theo's arrival only threw Vincent's failure into higher relief. Instead of setting off into the unknown, Theo would be re-

turning to The Hague to help with Goupil's move to a new and even grander gallery on the Plaats.

Vicarage and Church at Etten, APRIL 1876, PENCIL AND INK ON PAPER, $3^1/_2$ X $6^7/_8$ IN.

Vincent's train left at four in the afternoon on April 14, two days before Easter, bound for the port at Rotterdam. Not until that moment, alone on the platform, did Vincent seem finally to realize what he had done: he had banished himself. Suddenly overcome with second thoughts, he took a piece of paper and began to scratch a plaintive note. "We have often parted before," he began, "[but] this time there was more sorrow in it than there used to be." After he boarded the train, he continued writing, setting out the argument for his return. "But now [there is] also more courage because of the firmer hope, the stronger desire, for God's blessing." It was the argument that he would make for the next five years, in words and deeds (and after that, in images): if he loved God enough, his family would have to take him back.

Only a few months before, Vincent had found a poem that perfectly expressed the knot of homesickness, self-reproach, and resentment he felt as the train left behind the meadows and creekbanks of his childhood. He sent it to Theo, saying that "it struck me in particular":

How impetuously a wounded heart rushes . . .
Towards the first refuge where, young and at peace,
He used to listen to himself singing amidst the silence.

With what bitter zeal, my soul, do you revel
In the house where you were born . . .
And yet, O chimera, you were deceiving us!

For in your beautiful illusion a superb future
Was opening out its rich sheaves like a glorious summer,
Its fluttering ears like real suns.

You lied. But what irresistible charms they have,
These ghosts one sees in the ruby-red distance
Shimmering iridescently through the great prism of one's tears!

CHAPTER 8

Pilgrim's Progress

~

TWELVE YEARS LATER IN ARLES, WAITING SLEEPLESSLY FOR THE ARRIVAL of Paul Gauguin, Vincent van Gogh spent many late nights at a café frequented by the homeless and the vagabond—"night prowlers," he called them. He considered himself one of them—condemned to wander forever in the yellow gaslight of all-night cafés, pursuing a mirage of "family and native land" that existed only in the yearning imaginations of those without them. "I am a traveler," he wrote, "going somewhere and to some destination . . . [only] the somewhere and the destination do not exist."

When he left for England in April 1876, Vincent set out on that journey.

For the next eight months, he hardly stopped. Ricocheting from place to place, from job to job, he traveled hundreds of miles back and forth across the English countryside, "going somewhere." He took boats and trains and buses and carts and even a subway. But mostly he walked. At a time when rail travel was so cheap that even shopgirls could afford third-class tickets, Vincent walked. He walked in all weathers, at all times of day and night, sleeping in the open, foraging in the fields, eating in public houses or not at all. He walked until his face was sunburned, his clothes tattered, and his shoes worn thin. He walked at a deliberate pace—three miles an hour by his own reckoning—as if the destination didn't matter; as if walking itself—the sheer accumulation of miles, the wearing down of shoe leather, the fraying of laces, the raising of blisters—was the measure of a man's devotion.

In Ramsgate, he walked the beaches dotted with "bathing machines." He walked the dockside and the huge jetties that reached out toward his homeland. He walked the paths along the tops of the chalk cliffs with their "gnarled hawthorn bushes" and brave wind-bent trees. He walked the fields of corn that floated above the sea right up to the cliff edge, as inviting as the Zundert heath

and only minutes from the school where he taught. He walked to coves and inlets up and down the coast.

Only two months later, when his school moved from Ramsgate to London, he followed on foot—a trek of fifty miles in the punishing summer heat, the longest single journey of his time in England. "That is quite a stroll," he bragged to Theo. A steamboat up the Thames could have taken him as far in a few hours for only a handful of pennies. He slept one night on the steps of a church, and stayed for only two restless days before setting off again to see his sister Anna in Welwyn, thirty miles farther on. The next day he walked the final twenty-five miles to Isleworth, the small town on the far side of London where his school had relocated.

Picturesquely sited on a bend in the Thames, Isleworth would have been the ideal place for Vincent to settle. Instead, he used it as a base from which to launch repeated expeditions into the city, ten miles downriver. Largely ignoring the frequent trains, he walked the route again and again, in all weathers, day and night, leaving early and returning late, sometimes two or three times in a single day. Every trip to London justified a dozen lesser trips: endless walks crisscrossing the city's mad traffic and labyrinthine streets to see his old workplace, visit a former associate, investigate a job prospect, even view a landmark church—anything, it seemed, to keep moving.

In July, he changed jobs. The new position, at another school in Isleworth, *required* him to travel to London and elsewhere to visit sick students and parents who had fallen behind in their school fees—duties that took him to some of the city's remotest neighborhoods. In September, he considered going to Liverpool or Hull—to find another job, he said. At other times, he talked of sailing to South America. "One sometimes asks, 'how shall I ever reach my destination?' " he wrote Theo.

What was propelling Vincent down these rough country roads and busy city streets, pushing him perhaps even to the far side of the world? Partly, it was the same urge to escape that had rushed him out of Paris and Etten. During the summer and fall, his letters spoke about breaking chains and flying to "safety," about escaping from the sin and "deceitful tranquility" of his previous life. He read books about criminals on the run and consoled himself with daydreams about the ultimate escape of death.

No doubt he was striking back at his parents as well. His letters alternately kept them elaborately informed of his grueling travels or lapsed into ominous silence—a combination perfectly designed, if not intended, to punish them with worry. "He keeps making hours-long treks," Dorus wrote Theo, "which I fear will affect his appearance, so that he will become even less presentable . . . those are excesses that aren't right . . . We suffer because of this."

But no one suffered more on account of Vincent's "excesses" than Vincent

himself. "In those years," he wrote later, "I was abroad without friends or help, suffering great misery." Indeed, self-punishment may have been the true purpose of his ordeal. Clearly, a huge burden of guilt weighed on every step. "Keep me from being a son that maketh ashamed," he wrote soon after his arrival in England. In letter after letter, he confessed to feelings of "great inadequacy," "imperfection," and "unworthiness." He admitted to "hating his own life," and longed for the day when he could "forget the sins of my youth." "Who shall deliver me completely and forever from the body of this deed," he asked plaintively, "and how long shall I have to fight against myself?"

The months of self-punishing flight were accompanied by a flood of reparative imagery. Images of travelers and traveling, leave-takings and homecomings, lovesick wanderings and moral questings, had always excited Vincent's imagination. Now they became his lifeline. He returned to old favorites like Longfellow's *Evangeline* and *The Courtship of Miles Standish*, both tales of transformative exile, and took up the same author's *Hyperion*, the story of a melancholy young poet wandering the apocalyptic landscape of post-Napoleonic Europe in search of himself. Longfellow's *Tales of a Wayside Inn*, a wanderer's storybook, became his new gospel. The homeless heroine of Elizabeth Wetherell's sentimental blockbuster *The Wide, Wide World* touched him so deeply that he read the book to his students and sent a copy to Theo.

He collected scenes of tearful farewells and ecstatic reunions: scenes like the opening of Henri Conscience's *Le conscrit* (*The Conscript*), which he copied out in pages of careful script. ("The hour of leavetaking has struck! . . . Squeezing his mother's hand . . . he covers his face in his hand to hide the tears streaming down his cheeks and says in an almost unintelligible voice: 'Adieu.' ") He found the same heartbreaking image in Gustave Brion's picture *Les adieux*, showing a young man bidding his parents good-bye amid copious tears. For a while, the image attained devotional status in his collection of prints, which he somehow managed to keep with him through all the peregrinations of the summer and fall. In May, he sent a version of it to his parents for their anniversary.

Roads figured as prominently in Vincent's imagination as they did in his daily life. He was raised in a country filled with rail-straight lanes lined to the vanishing point with trees. His mother had taught him early about "the road of life," and his father treasured a print showing a funeral procession making its way along a path through a cornfield. Not surprisingly, Vincent grew up seeing a journey in every road and a life in every journey. In looking at landscapes, his eye always searched for the path. He hung in his room a print like his father's showing a rough country road leading into the distance. One of his favorite stanzas of poetry pleaded in the voice of a weary traveler: "Does the road go uphill all the way? / Yes, to the very end. / Will the journey take the whole long day? / From morn till night, my friend."

Just as he saw a journey in every road, he saw a pilgrim in every traveler. "If you want to persevere and make spiritual progress," Kempis advised, "look upon yourself as an exile and a pilgrim on this earth." Now embarked on his own lonely journey, Vincent found new solace in stories of pious travelers trekking earthly routes toward otherworldly destinations. In the album he prepared for Matthijs Maris in Paris, he copied out the opening stanzas of Uhland's "Der Pilger," about a pilgrim setting off for the Holy City. In a book of Dutch poetry that his father sent him, Vincent singled out (and copied into a letter for Theo) only one poem: "De pelgrimstogt" ("The Pilgrimage"), another story about the "uphill road to a better life."

But no pilgrim made a deeper impression on his imagination than the one he discovered in John Bunyan's *The Pilgrim's Progress.* "If you ever have an opportunity to read [it]," he told his brother, "you will find it greatly worthwhile." Like Vincent, Bunyan's pilgrim, Christian, abandons home and family to undertake a dangerous journey, encountering on his way every form of human frailty, folly, and temptation. Much like Vincent's later art, Bunyan's story infuses the cartoon world of allegory with an emotional urgency that startled and endeared readers when it was first published in 1678, and had earned it an honored place beside the Bible in every literate English household in the two centuries since. "For my part," Vincent wrote, "I am exceedingly fond of it."

But Bunyan's Christian had to compete with a different traveler in Vincent's imagination. In another book, he found the story of the *pillawer*—the "rag and bone man"—who scratched out a life wandering the byways, collecting rags to be used in making paper. The story so touched him that he copied it out, at length, in an album: "People close their doors when they see him. . . . He is a stranger in the village where he was baptised. . . . He does not know what is happening in his own family."

As the miles accumulated and his shoes wore out, this was the image that increasingly haunted Vincent's journey. "He walks, he walks, the rag and bone man, like a wandering Jew. Nobody likes him."

VINCENT'S JOURNEY BEGAN in an unkempt, bug-infested house in Ramsgate. He must have thought he had wandered into one of his beloved Dickens stories—one of the dark ones. The school run by William Post Stokes was nothing like the formal, well-funded institutions of Vincent's own experience. Twenty-four boys between the ages of ten and fourteen crowded into the narrow townhouse at 6 Royal Road, only a hundred yards from the edge of a cliff that dropped vertiginously to the sea. Vincent complained about the building's rotten floors, broken windows, dim light, and dark passages. "A rather melancholy sight," he called

it. Dinner consisted of bread and tea, but so dreary was the rest of their day that the boys looked forward to it eagerly, he wrote.

In these miserable conditions, Vincent staggered like a Dickens hero under onerous and unrelenting duties. From six in the morning until eight at night, he and a fellow "assistant teacher" bore full responsibility for all the school's students. He taught them "a little of everything," he said: French, German, math, recitation, and "dictation." He led them on walks and took them to church; he oversaw their flea-ridden dormitory and put them to bed at night. Once, at least, he bathed them. In his spare hours, he did maintenance work and odd jobs. "It's a heavy task," he said stoically.

Stokes himself completed the Dickensian picture. A big man with a bald pate and bushy side-whiskers, Stokes ran his school like the business it was. With the government school system overwhelmed by the demand for education from the new middle class, anybody with a house and pretense of erudition could start a school. Stokes had "but one goal," Vincent later wrote, "money." He conducted his business "mysteriously," according to Vincent; never talked about the past; and kept everyone off guard with his odd comings and goings. Too many secrets made Stokes a moody master: one minute playing marbles with his students, the next minute flying into fits of rage at their rowdiness and ordering them to bed without dinner. A fortnight after Vincent's arrival, Stokes abruptly announced that the school would be moving to Isleworth, where his mother ran a similar enterprise.

Vincent's letters soon fell silent on the subject of his job and focused instead on the view of the town in a battering rainstorm or the "spectacle of the sea" as seen from the school's front window ("unforgettable," he called it). No doubt his limited, heavily accented English made a hard job even harder. "It is not easy to see that what they are learning is what we are teaching them," he wrote candidly. Vincent also found Stokes's miserliness "disgusting." When Vincent asked for the small salary that Stokes had promised him after a one-month trial, Stokes refused to pay it. "[I] can get teachers enough for just board and lodging," he said brusquely.

By the time the school moved in mid-June, Vincent was already looking for something else, someplace else. That, after all, was the pilgrim's lot. "We must continue quietly on our way," he wrote.

After a mere two months as a teacher, he had decided to become a missionary.

THE AMBITION TO BRING others to the Truth was deeply rooted in Vincent's nature. Years of alienation and lonely, self-righteous brooding had left him with

an irrepressible urge to persuade. For him, enthusiasms had to be shared to be fully enjoyed. Successful persuasion, even over trivial matters, brought vindication at the most visceral level. Failure to persuade amounted to absolute rejection. In this regard, the outbreak of missionary zeal in the summer of 1876 followed inevitably on the poetry albums for Theo and the joint discipleship with Gladwell—another in an endless series of life-and-death campaigns to right unnamable wrongs.

In his new calling, Vincent found encouragement, even inspiration, in the novels of George Eliot. Books such as *Felix Holt, Adam Bede, Silas Marner,* and *Scenes of a Clerical Life,* all of which he sent to his parents that winter, offered the perfect bridge from Kempis's insular piety back to the world of fiction that Vincent always loved. *Felix Holt* tells the story of a "rough" young man who repudiates his family's legacy to pursue a life of political and religious fervor among the working class and, in doing so, redefines "failure." In both *Adam Bede* and *Scenes of a Clerical Life,* flawed, guilt-racked men achieve heroic martyrdom by ministering to the poor and living a life of utter self-abnegation. Freely ignoring Eliot's cynical view of religion in general and evangelism in particular, Vincent found inspiration even in her devastating portrait of the fundamentalist sect Lantern Yard in *Silas Marner.* "There is such a longing for religion among the people in the big cities," he wrote, that groups like Lantern Yard offered "the kingdom of God on earth, no more, no less."

In response to this perceived "longing," Vincent began looking for a new position. He described his ideal job to Theo in terms that closely tracked his reading: "[It] should tend toward something between a clergyman and a missionary," he wrote; should involve preaching "mainly to the working class population"; and should be located "in the suburbs of London." In what was surely a painful exercise, he prepared a brief autobiography (a *levensschets,* or "life sketch") that combined guilty half-truths, hopeful inflations, and abject pleas: "Father . . . make me as one of thy hired servants. Be merciful to me a sinner." In June, while still in Ramsgate, he sent the statement to a preacher in London. "When I lived in London I often attended your church," he wrote. "Now I would ask for your recommendation as I look for a position."

In fact, London was swarming with missions. In a backwash from the tide of secularization that had swept over Victorian England earlier in the century, religion was once again seen as the solution to society's every ill. By the 1870s, a consensus had emerged among the bourgeoisie that rising crime rates and intractable poverty did not reflect underlying flaws in their bright new world, but rather ominous signs of a spiritual deficit. Restive workers lacked faith, not rights; and no social problem could long resist the beneficial effects of charity and religious instruction. As a result, money poured into new sects, revivalist

preachers (like Charles Spurgeon), and evangelical missions—especially those aimed at the poor and working classes. More than five hundred charitable societies doled out more than seven million pounds annually, a fabulous sum. Bible societies distributed more than half a million free copies of the Gospels every year.

So fanatic was the belief in the benefits of Bible distribution that it was recognized as a new religious "calling": *colportage.* Spurgeon established an entire school just to train colporteurs—men and women who took Bibles from door to door "among classes almost inaccessible to such influences." So-called "Bible carriages" roamed the busy streets carrying big-voiced men reading scripture and loaded with stacks of the Good Book. On crowded street corners, members of the Society for Open-Air Preaching enlightened passersby. In railway stations, foreign travelers were astonished to find large Bibles chained in waiting rooms; while in the parks, dozens of lay preachers stood reading with a Bible in one hand and an umbrella in the other.

At the same time, more than a thousand paid missionaries fanned out across London—from the hellishly overcrowded City to the farthest and newest working-class suburbs. Evangelical churches, like Spurgeon's, spearheaded the offensive, but vast nondenominational organizations such as the London City Mission provided many of the troops needed to fight the new war on destitution and damnation. Dozens of specialized aid societies competed with each other to mitigate the suffering and save the souls of drinkers, penitent prostitutes, wayward servants, and abused children. In 1875, the year before Vincent returned to London, a former lay preacher named William Booth led a new ministry to "win back" the hearts of the working class with a combination of street-corner evangelism, missionary assistance, and soul-rousing music. He called his group the Salvation Army.

Despite the storm of missionary activity going on all around him, Vincent could not find a job. Or would not. After his initial visit in mid-June, he returned to London several more times "to find out if there was a chance of becoming" a missionary, he reported to Theo. In support of his application, he claimed that he had "mixed with people of the lower classes" in Paris and London, and that as a foreigner, he could better assist other foreigners "looking for work [or] in difficulties." But to no avail. That his search proved unsuccessful may suggest how limited his language skills were or how unpersuasive and off-putting his approach. Even Vincent's pessimistic parents were taken aback by his lack of success. "One would think that it would be easy to find a position in such a big world," Anna wrote.

On the other hand, his failure may have betrayed his doubts about the way forward. "I see a light in the distance so clearly," he admitted to Theo, "[but] that

light disappears now and then." Vincent offered only a single improbable expla-
nation for his failure to find any kind of suitable position: "one must be at least
twenty-four years old," he wrote both Theo and his parents. It was the unassail-
able excuse of a man afraid to risk further rejection. "It is very doubtful whether
I shall make great progress in this profession," he concluded only weeks after his
initial foray.

Instead of persisting or exploring serious alternatives, his mind quickly
drifted to exotic and unlikely scenarios. Inspired perhaps by melodramatic news-
paper accounts of poverty and suffering in the coal fields (often accompanied by
graphic black-and-white illustrations), he considered going off to the mining
districts in western England to minister to the miners. He even briefly contem-
plated joining a mission to South America. But all of those ideas, too, came to
nothing. His ambition to be a missionary lasted barely more than a month.

By the beginning of July, he had retreated to his room in Isleworth, claim-
ing a martyrdom of rejection and still looking for the "light in the distance." He
dismissed his teaching job as frustrating and "humiliating." After a final round
of broken promises and futile bargaining, he left Stokes's school. (He told his
parents that he resigned, but later hinted that Stokes had fired him—or was
about to.) Meanwhile, he drifted into an almost identical position at another
boys' school only a few hundred yards away. By July 8, he had moved into Holme
Court, the school run by the Reverend Thomas Slade-Jones, while continuing to
work part-time for Stokes. The halting transition confused his parents, who had
initially welcomed the move because Vincent advertised Slade-Jones's school as
"more fashionable." "Oh! nothing is clear yet," Dorus protested.

One thing *was* clear, however: Vincent was not happy. He wrote his parents
melancholy letters complaining about the job, the school, and his loneliness (the
students were on their summer break). "He is going through a difficult time,"
they reported to Theo; "his life is not easy." "I think it's a matter of dreading his
work among the boys," Anna concluded. "I think he is afraid that he will fail."
She flatly predicted that Vincent "will not be able to stay in that profession." He
needed a new direction that would "mold him for everyday life" and "make his
life happier and calmer." She even offered a suggestion: "I wish he could work in
nature or art—that would be grounds for hope."

It wasn't until August that Vincent found his direction again, and it wasn't
the one his mother suggested. Only two days before a planned visit to see Harry
Gladwell, who was spending the summer holidays with his family outside Lon-
don, Vincent received word that Harry's seventeen-year-old sister had died in a
riding accident. He immediately set out on the six-hour walk, crossing London
"from one end to the other." He arrived just as the mourning family returned
from the funeral. The "spectacle of pain" overwhelmed him. He felt "something
truly holy" in the house and longed to connect with it, but couldn't. "I felt a kind

of shyness and shame," he confessed to Theo the next day. "I wanted to console [them], but I felt embarrassed."

Only with his old friend Harry could Vincent play the role that burned inside him. On a long walk, they talked "about everything," Vincent wrote, "the kingdom of God, the Bible," just as they had in Paris. As they paced up and down the train platform, Vincent poured forth a manic, sermonlike stream of consolation. In that moment, he said, he felt "the ordinary world" suddenly "animated by thoughts that were not ordinary."

Soon after that, he decided to become a preacher.

FOR VINCENT, PREACHING meant only one thing: consolation. At the core of its theology, where Catholicism put sin and punishment, the Dutch Reformed Church put solace. The "unspeakable consolation" of a watchful, caring God filled the church's founding documents, the Formularies of Unity. In the embattled religious outpost of Zundert, a preacher's first duty was to comfort, not to convert. Dorus van Gogh provided spiritual consolation and financial support to his precarious flock. At times of sickness and death, he brought them proof against loneliness in this life and affirmation of a higher love in the next. In ordinary times, he calmed their worries and quieted their fears. His sermons did not educate or illuminate so much as weave warm blankets of "healing words" from familiar strands of scripture and anecdote.

No one, of course, needed the balm of religion more than Vincent. From childhood, he fixed on the image of Christ as both sorrowing and comforter of sorrows. This was the image enshrined forever in his imagination by an engraving of Ary Scheffer's *Christus Consolator* that hung in the Zundert parsonage. Illustrating a passage from the Bible ("I have come to heal those who are of a broken heart"), it became one of the favorite religious images of a century fixated on images of innocent suffering: a radiant but sad Christ sits surrounded by supplicants prostrated by pain, sadness, oppression, and despair. He opens his hand to reveal the stigmata, a reminder of his own suffering. The message was clear: suffering brings one closer to God. "Sadness does no harm," Dorus wrote, "but makes us see things with a holier eye." Melancholy, said Vincent, is "fine gold."

His reading of the Romantics added new layers of imagery and meaning to Scheffer's icon, introducing Vincent to new forms of suffering, new myths of salvation, new paradoxes of hope, and new windows on the sublime—all of which filled his albums and papered his walls. Long before he preached the Gospel, Vincent preached the "quiet melancholy" of nature and consoled himself with its images in poetry and pictures. He followed Christ's shadow through the writings of Carlyle and Eliot, who transposed the theme of redemption through

suffering into a modern, internalized world. "Deep, unspeakable suffering," wrote Eliot in *Adam Bede*, "may well be called a baptism, a regeneration, the initiation into a new state."

ARY SCHEFFER, *Christus Consolator*, 1836–37, OIL ON CANVAS, 72¼ X 97⅝ IN.

When an exiled Vincent rediscovered Jesus in 1875 in his little room on Kennington Road, he turned first to the comforting Christ of his childhood. Renan described Him as "the great consoler of life," who "filled souls with joy in the midst of this vale of tears." Kempis's Christ promised, "Your acts of penance will be transformed into joy." A fragment of scripture from Corinthians quickly became Vincent's mantra of consolation: "sorrowful, yet always rejoicing." In these four words, Vincent discovered a perfect expression of the alchemy of happiness that he always expected from religion (and would later expect from art). "I've found a joy in sorrow," he wrote. "Sorrow is better than laughter."

This new vision of a life spinning heartbreak into happiness so excited him that he bought a new pair of boots—"to get myself ready for new wanderings"—and persuaded his employer, Reverend Slade-Jones, to let him assist at the Methodist church in Richmond, just across the Thames from Isleworth. At the weekly prayer meeting that Slade-Jones conducted there, Vincent began "visiting the people [and] talking with them." Before long, he was invited to "speak a few words" to the group. At school, Slade-Jones agreed to let Vincent spend more of his time on religious devotions and less on academic instruction. Vincent led

the twenty-one boys in their Bible study and prayed with them every morning and evening. At night, he sat between their beds in the dark dormitories and told inspirational stories from the Bible and literature.

Impressed by Vincent's ardor, Slade-Jones invited him to assist at the Congregational church in Turnham Green, a small community three miles downriver from Isleworth, where he preached. Vincent prepared the little iron church for meetings and services, and taught Sunday school. The other teachers welcomed the strange young Dutchman as a coworker, although they continued to mangle his name ("Mr. van Gof") until Vincent persuaded them to call him by his first name: "Mr. Vincent." In addition to Sunday classes, he organized a Thursday evening service for youths and was given responsibility for visiting sick and absent students. Soon afterward, Slade-Jones sent his eager young assistant to yet another church, a tiny Methodist chapel in Petersham, two miles upriver from Isleworth, to lead a Sunday evening service.

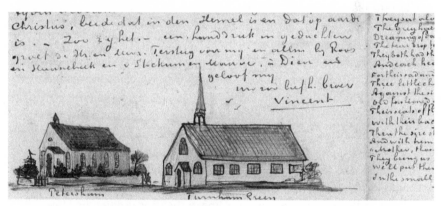

Churches at Petersham and Turnham Green, LETTER SKETCH, NOVEMBER 1876, INK ON PAPER, 1⅝ X 3⅞ IN.

At some point in this shuttle of pious activity, Vincent won Slade-Jones's consent to preach a sermon of his own. Elated at the prospect, he began feverish preparations. He practiced his delivery at the weekly prayer meetings in Richmond and with the boys in his Bible study class. (They sometimes fell asleep in the middle of a story, he admitted.) He made lists of his favorite verses, stories, hymns, and poetry and transcribed them into a "sermon book." Judging by the long letters he wrote to Theo that fall, which undoubtedly drew from it, the book must have been a frenetic fantasia of consolation, far exceeding any of his previous albums—a perfect reflection of his frenzied imagination as he prepared for his new life as a preacher. "Whoever wants to preach the Gospel must carry it in his own heart first," he said. "Oh! May I find it." At the end of each day, he would climb to his room on the third floor of Holme Court and fall asleep with

a Bible still gripped in his hands and a print of *Christus Consolator* looking down from the wall.

Finally, on Sunday, October 29, Vincent stepped into the pulpit of the Richmond Methodist church to give his first sermon. He described the event in rapturous detail in a letter to Theo two days later, painting the scene like the opening of an Eliot novel:

> It was a clear autumn day and a beautiful walk from here to Richmond along the Thames, in which the great chestnut trees with their load of yellow leaves and the clear blue sky were mirrored. Through the tops of the trees one could see that part of Richmond which lies on the hill: the houses with their red roofs, uncurtained windows and green gardens; and the gray spire high above them; and below, the long gray bridge with the tall poplars on either side, over which the people passed like little black figures.

At the foot of the pulpit, he paused, bowed his head, and prayed: "Abba, Father, in Thy name be our beginning." As he ascended, he felt as if he were "emerging from a dark cave underground," he said, and was overcome by a vision of his future "preaching the Gospel wherever I go."

He chose his text from Psalms: "I am a stranger on the earth . . ."

"It is an old belief," he began, "and it is a good belief, that our life is a pilgrim's progress."

It is impossible to know what churchgoers thought of the sermon that day, or even how much of it they understood. Vincent spoke English accurately, but with great speed and a heavy accent. Some in the congregation had heard him talk before at prayer meetings, and no doubt had learned to cope with his grapplings in an unfamiliar language. But none could have been prepared for the eruption of fervor they heard that morning.

> But though to be born again to eternal life, to the life of Faith, Hope and Charity—and to an evergreen life—to the life of a Christian and a Christian workman, be a gift of God, a work of God—and of God alone, yet let us put the hand to the plough on the field of our heart, let us cast out our net once more . . .

In his fever to console, Vincent piled scripture on scripture, verse on verse, aphorism on aphorism in a deluge of earnest, obscure pieties. He lurched from bold exhortations to muddled exegeses, from bland bromides to odd analogies ("Have we not often felt as a widow and an orphan—in joy and prosperity as well and even more than under grief—because of the thought of Thee"). Meta-

phors mixed and morphed under the strain of his ardor. Strange confessional pleas burst from the dull rhetoric with an urgency that surely alarmed his listeners: "We want to know that we are Thine and that Thou art ours, we want to be Thine—to be Christians—we want a Father, a Father's love and a Father's approval."

Vincent had said that his goal was to preach in "simplicity" and "fullness of heart." No one who heard him could have doubted his heart. But even his father, whose sermons were hardly a model of concision or clarity, criticized Vincent's convoluted and obscure way with scripture. After receiving one of the long letters that Vincent wrote rehearsing his sermon, Dorus complained to Theo: "If only he learned to remain simple as a child, and not always go on filling his letter with Bible texts in such an exaggerated and overwrought manner." Whether or not Vincent accepted the criticism, he recognized the problem. "I do not speak without difficulty," he admitted. "How it sounds to English ears, I do not know." A few weeks later, he felt compelled to warn his congregation: "You are going to hear bad English."

But he pressed ahead anyway, haunted by the prospect of yet another setback on his journey. "I shall be unlucky if I cannot preach the Gospel," he wrote ominously in early November. "If my lot is not to preach . . . well, *misery* is truly my lot."

THERE WAS ONE PLACE, however, where Vincent found the simple comfort that he sought, but could not give.

He had felt the tug of hymns since childhood. Every Sunday, their solemn drone filled the little Zundert church, often accompanied by his mother playing the reedy harmonium. From the moment he arrived in London in 1873, he seemed, according to his sister-in-law, "intoxicated with the sweet, melodious words" of English church music, so different from the penitent hymns of his Calvinist youth. "[He] likes the organ and the singing most of all," Dorus reported after Vincent had been in England only a month. At Spurgeon's Metropolitan Tabernacle, Vincent surely added his voice to the chorus of thousands—an experience that one participant likened to floating on "a huge sea of melody which rises and falls and surges and floods the place." He asked Theo to send him a Dutch hymn book and sent him in return two English hymnals. He carried a popular hymnal with him everywhere he went, and knew it so well that he referred to his favorites by number.

By the time Vincent reached Isleworth, hymns had become his heart's chief solace. He sang them every morning and evening with his students in Bible study. Walking through the halls of Holme Court, he would hear a boy "hum a snatch of some hymn," he said, and feel "the old faith" well up inside him. In his

room at night, he heard hymns drifting up from the piano in the school below and felt a rush of sublime comfort that could move him to inexplicable tears. On his endless journeys that fall, through gaslit city streets and empty country roads, he would sing them softly to himself, he confessed, when "nobody is about."

Over and over, verse after verse, mile after mile, hymn after hymn. "There are so many beautiful ones," he wrote.

He loved their words: by turns touching and stoic, tender and ecstatic, imploring and serene, sorrowful and rejoicing. Taking his cue from the hymnbooks of the era, which printed only words, not music, he treated their lyrics as poetry, copying out verses in letters and albums. But it was music that gave them their hypnotic power. With melodies tailored to untrained voices and harmonies easy enough for street-corner bands, they cast their spell through simplicity and familiarity. "Especially when heard often," Vincent wrote, "one grows so fond of them." Many of them spoke in the same pleading, imperative voice as Vincent himself. His favorite, "Tell me the old, old story," pleads like a persistent child for the ultimate comfort of a bedtime tale:

Tell me the story simply, as to a little child,
For I am weak and weary, and helpless and defiled.

Tell me the story always, if you would really be,
In any time of trouble, a comforter to me.

Tell me the old, old story, tell me the old, old story,
Tell me the old, old story, of Jesus and His love.

When Vincent wrote, more than ten years later, that he wanted his paintings "to say something comforting as music is comforting . . . something of the eternal," this is what he meant. One can search Vincent's childhood and youth for the first signs of the new art that would soon burst on the world, but nowhere is the future clearer than here in the deep feelings, simple means, and immortal longings of the hymns that drifted upward from the third-floor room at Holme Court.

IN OCTOBER, VINCENT'S PARENTS wrote that Theo had fallen seriously ill. Dorus rushed to his son's bedside in The Hague; Anna followed close behind and settled in for a long convalescence. Vincent responded at first with an avalanche of consoling words and images. "How I long to see you again," he wrote his feverish, prostrate brother. "Oh! my longing is sometimes so strong." Overcome

with nostalgia, he begged Reverend Slade-Jones for a three-day leave so he could return to Holland. "Besides longing to sit at Theo's bedside," he said, "I should like so much to see my mother again and, if possible, also go to Etten to see Father and speak with him."

Vincent had suffered many such swoons of homesickness since leaving Etten in April. The sea crossing in 1876 brought back painful memories of his ill-fated return to England with Anna in 1874. The view from the school's bay window in Ramsgate made him think of his homeland across the water. From the same window, he watched the students wave good-bye to their parents and his heart ached with theirs. To share his pain, he made a drawing of the "melancholy" scene and sent it home with a sad note: "None of us will ever forget the view from that window."

In the schools in Ramsgate and Isleworth, every student reminded him of Theo. Whenever he walked with them, made sand castles with them, showed them prints, or put them to bed, "I would have preferred to have you with me," he wrote his brother. On a trip to the beach, he saved two sprigs of beach moss and sent them to Theo as a memento. On a visit to Hampton Court in June, he retrieved a feather from a rook's nest and enclosed it in his next letter. In July, he briefly entertained a fantasy of joining his brother in The Hague, and even asked Theo to help him find a job there "in connection with the church."

He showered letters on other family members including sister Anna in Welwyn, on family friends (even Tersteeg), and on old acquaintances like Frans Soek and Harry Gladwell in Paris. On his frequent trips into London, he sought out the people and places that evoked his previous life there: his boss Obach and former Goupil colleagues like Elbert Jan van Wisselingh, George Reid, and Henry Wallis. He tried particularly hard to cultivate a new family in the Gladwells, who still grieved over the loss of their daughter. "I love those people," he proclaimed. "I can sympathize with them." When in London, he never missed a chance to visit Harry's father at his store, or walk the extra miles out of his way to see the family in Lee. He may even have transcribed an album for them, the ultimate token of familial bonding.

Vincent appears to have tried the same sleight of heart with the family of his employer, the Reverend Thomas Slade-Jones, and his wife, Annie. With their six children and parson's lifestyle, the Slade-Joneses seemed perfectly suited to fill the void in Vincent's life. Like the Zundert parsonage, Holme Court was a self-sustaining island, with great trees shading its courtyard, vines overgrowing its walls, and a contingent of barnyard animals. Vincent did his best to make a place for himself there, just as he had at the Loyer house on Hackford Road. He worked in the garden, gave lessons to the Slade-Jones children, and read to them at bedtime. In a nostalgic ritual, he decorated the house with greenery for the holidays. He poured days of painstaking labor into the visitors' book that Annie

maintained. Filling page after page from edge to edge with tiny script, he transcribed his favorite hymns, Bible verses, poetry and prose—in French, German, and Dutch as well as English—in a manic bid for belonging.

His search for family even took him back to the Loyers. In November, braving certain awkwardness and a long walk in a bitter London winter, he returned to the house on Hackford Road to wish Ursula a happy birthday.

In the end, however, neither the Gladwells nor the Slade-Joneses nor the Loyers could fill the void. Only one family could do that. In October, the news of Theo's illness and the coming of Christmas combined to create a fresh surge of nostalgia and homesickness. "O Zundert!" he cried. "Memories of you are sometimes almost overpowering." Everywhere he went, he saw images of home. On visits to London galleries, he lingered with "intense delight" over paintings of Holland. He told his students stories about "the land without hills," where "houses and streets were as clean and spotless as the play-toys of the giants in *Gulliver's Travels.*" He rehearsed the journey again and again in his imagination: "How delightful it will be to sail down the Thames and across the sea," he wrote, "to see those friendly Dutch shores and church spires in the distance." He reread the poetry of his childhood and copied out old favorites, like Longfellow, bathed in memory and longing:

> *I see the lights of the village,*
> *Gleam through the rain and the mist,*
> *And a feeling of sadness comes o'er me,*
> *That my soul cannot resist.*

It was visions like these that led Vincent to beg Reverend Slade-Jones for time off to visit his sick brother in The Hague. His first request was rejected, but Vincent pleaded and cajoled so pitifully that Slade-Jones finally relented. "Write to your mother," he said. "If she approves, I will too."

But she did not approve. In a devastating blow, Anna van Gogh wrote back that Vincent should wait until Christmas to come home—"and may God give us a happy meeting then." Vincent said nothing in his letters to Theo (which he knew his mother read), but poured his heartbreak into the sermon he preached a week later: "The journey of our life goes from the loving breast of our Mother on earth to the arms of our Father in heaven . . . Has any one of us forgotten the golden hours of our early days at home, and since we left that home—for many of us have had to leave that home."

Once his mother rejected his bid to return, Vincent lost enthusiasm for everything else. His round-robin of duties between Holme Court, Petersham chapel, and the iron church in Turnham Green now seemed nothing but a burden. Even his beloved walks became cause for complaint in his letters home. Instead of a

pilgrim, he described himself as Slade-Jones's "walking boy," trekking about the countryside on senseless "superhuman journeys." It didn't help that the schoolmaster had assigned Vincent the miserable task of collecting unpaid tuition bills on his visits to students' parents, many of them poor. (Slade-Jones himself was slow to pay Vincent's meager wages, serenely maintaining that "God takes care of those who work for Him.")

For Vincent, obsessed with the coming of Christmas and the prospect of reuniting with his family, the crowded days could not pass fast enough. "How I am longing for Christmas and for you all," he wrote Theo; "it seems to me I have grown years older in these few months." In the evenings, he sat exhausted in his room, stared at photographs of his parents pinned on the wall, and relived fond memories of Christmases past: especially his last-minute return to Helvoirt two years earlier (before the disgrace in Paris), when the moon shone on snow-covered poplars and the lights of the village twinkled in the darkness.

Images like this—drawn from literature, scripture, art, and hymns as well as from his own past—increasingly provided Vincent with his only true comfort. Spurned by his family and haunted by regrets, he withdrew into the tumultuous solitude of his own imagination, where all these images were "breathed on variously by multitudinous forces," as Eliot wrote in *Silas Marner*, "forever moving and crossing each other with incalculable results."

The image that obsessed him most that fall and winter was that of the Prodigal Son. More than once, he preached the story of the wastrel, wandering child who "was no more worthy to be called thy son," but was welcomed home by his father: "For this my son was dead, and is alive again; he was lost, and is found." The story appeared in Vincent's autobiographical *levensschets*, and it echoes throughout his first sermon. In his room, he hung a print of Ary Scheffer's *L'enfant prodigue*, showing a godlike father embracing a penitent, dewy-eyed youth. He sent a copy of the same image to his mother for her birthday. With his usual monomania, he pursued this icon of reconciliation and redemption through literature and poetry as well as art. He studied it, preached it, and included it in his bedtime lessons.

In his hunger for comforting images, Vincent increasingly blurred the line between real and imagined. His letters filled up with "word paintings"—inspired by Eliot's brilliant descriptive passages—that transformed the everyday into the eternal. A sunrise seen from a passing train became "a real Easter sun"; a sexton's house in the rain became a refuge of faith; a quiet riverbank became a promise of redemption: "The chestnut trees and the clear blue sky and the morning sun mirrored in the water of the Thames; the grass was sparkling green and one heard the sound of church bells all around." In images like these, Vincent combined observation and imagination to create a better, more consoling reality. He introduced contradictions and impossibilities, compressed

time, embellished with favorite tropes, and freely omitted anything that did not suit his purpose. His description of a London slum included no mention of poverty, crime, overcrowding, or filth, but only the pious, picturesque poor bustling about in the gaslight on a Saturday evening, eagerly anticipating the Sabbath to come—"which is such a comfort for those poor districts."

The consoling images that Vincent took from literature and art underwent a similar transformation as he reimagined them—simplified and intensified them—in pursuit of his heart's elusive comfort. He changed the names of poems and paintings. He disregarded dissonant characters and authorial views. Like the illustrated books of his childhood, he grafted words to images and images to words, insistently reshaping both to his narrative of reassurance. He paired pictures with poetry, sometimes transcribing lines from literature and scripture directly onto his prints to create collages of consolation. This process of layering words and images so gratified his manic imagination and his search for comfort that it would become his principal way of seeing and coping with the world.

Churchgoers at the Richmond Methodist church got an early, and no doubt disorienting, glimpse of this process at work. To conclude his first sermon, Vincent told them about "a very beautiful picture" he had seen once. It was called *The Pilgrim's Progress.* But the image he described looked nothing at all like the painting by George Boughton that Vincent had seen at the Royal Academy two years before, in 1874. Vincent's telling transformed Boughton's flat horizon and hazy sky into a dazzling vista of hills and mountains glimpsed in the "splendor" of a Romantic sunset ("the gray clouds with their linings of silver and gold and purple"). Vincent replaced Boughton's low fortified town with Bunyan's Celestial City—high atop a mountain "whereon the setting sun casts a glory." In Boughton's painting, a girl in a white tunic pours water for the pilgrims on their dusty journey. In Vincent's vision, the girl becomes an angel in black, a figure from an Andersen tale.

Onto this mix of art, literature, and scripture, Vincent added one final layer: himself. In his vision, the angel offers consolation not to a group, but to a single lonely pilgrim who "has been walking for a good long while and he is very tired." They converse in the words of Vincent's favorite poetry, and the pilgrim goes on his way "sorrowful yet always rejoicing."

Only by combining the real, the depicted, and the imagined could Vincent approach the true source of his hurt, as well as the only source of true consolation: his family. Just as he cast himself as the pilgrim in Boughton's painting, he could cast himself as the Prodigal Son repeatedly embraced by his father in Scheffer's print, in sermons, and in bedtime stories. Layering allowed Vincent to superimpose his family as well as himself onto images in art and literature, whether it was Theo as a young revolutionary hero, Uncle Cent as a Golden

Age burgher, or his mother and father as the tender, caring parents in a poem by George Eliot. It allowed him to see the Zundert parsonage in every image of happy home life and to see himself as Conscience's conscript, ripped from the bosom of a loving family, or as Eliot's flawed but exemplary clergyman in *Felix Holt*, or as Bunyan's pilgrim Christian.

Ultimately, this was the consoling power that art shared with religion in Vincent's imagination: both offered an imagery of reconciliation and redemption with which he could reimagine his own life of failure and remorse. It was an extraordinary power. The imploring intimacy of Vincent's religious visions must have startled his listeners. "Can a woman forget her sucking child," he cried out in the words of Isaiah, "that she should not have compassion on the son of her womb?" The relentless interweaving of Father and father, Son and son, in Vincent's imagination transformed all of Christianity into a canvas for autobiography. "The nature of every true son," he wrote, "does indeed bear some resemblance to that of the son who was dead and came back to life."

The connection between religion and family would hereafter haunt his imagination, his art, and finally his sanity. He took the Bible's offer of redemption as a promise of forgiveness and reconciliation in his own family. "Those who are above," he assured Theo, "can make us father's brothers." The consolation of that promise formed the emotional core of his experience of the sublime. When Vincent was moved to tears, as he often was, by religion or literature or art, this, ultimately, was the pedal note of love and longing that sounded beneath all the layers and layers of allusions. "Love of this sort," wrote Eliot in *Adam Bede*,

> is hardly distinguishable from religious feeling. What deep and worthy love is so? whether of woman or child, or art or music. Our caresses, our tender words, our still rapture under the influence of autumn sunsets, or pillared vistas, or calm majestic statues, or Beethoven symphonies, all bring with them the consciousness that they are mere waves and ripples in an unfathomable ocean of love and beauty: our emotion in its keenest moment passes from expression into silence; our love at its highest flood rushes beyond its object, and loses itself in the sense of divine mystery.

The danger, of course, was that Vincent would confuse these pentimenti of love: mistake the imagined for the real. Already at times, both his despair and his enthusiasm approached the delusional, and events he reported as real took on the gloss of fantasy. As Christmas approached, he seemed increasingly unable to distinguish between images in his head and events in his life. He stared at the photographs of his parents on the wall and recited over and over the prayer from the Zundert parsonage: "Unite us, O Lord, firmly together and may the love for

Thee strengthen that bond more and more." For one of his last sermons before leaving, he again chose his text from the story of the Prodigal Son: "But when he was yet a great way off, his father saw him, and had compassion."

On the eve of Christmas, that image took hold of him—as if it were, in fact, the reception that awaited him in Etten. "We shall be moved when we hear the name of God pronounced," he intoned, "yea, even as we are moved when we see our father again after having been away from home for a long time." Compared to such visions, the real world no longer held any interest. He could only think about returning home to become his "father's brother." And he could hear his parents' voices singing the words of the hymn he carried with him:

> *Come home, come home! You are weary at heart,*
> *For the way has been dark, and so lonely and wild;*
> *O prodigal child!*
> *Come home; oh come home!*
> *Come home, come home! From the sorrow and blame,*
> *From the sin and the shame, and the tempter that smiled;*
> *O prodigal child!*
> *Come home; oh come home!*

O Jerusalem, O Zundert

~

T HE RECEPTION THAT AWAITED VINCENT IN ETTEN DID NOT MATCH any of the prints on his wall or the verses in his hymnbook. His wanderings had not mitigated his shame, only worsened it. Months of intermittent and uninformative letters had left his parents even less sympathetic than when he fled in April. Every time he moved from one unpaid, "futureless" job to the next, he reopened the wounds. "We are more and more worried with time," Dorus wrote Theo in September, "and we fear that he will become unfit for practical life. It is bitterly sad." They tried to talk sense to him. If he really wanted to be a preacher, they said, he should study for it—and find a paying job in the meantime. But their proposals were always met with "woolly" answers or ignored altogether. They took his evasiveness as a lack of conviction—or, worse, cowardice. "He doesn't seem to have the courage to take up a course of study," Anna concluded. "I cannot imagine him as a preacher," Dorus added. "He will never find a living in it."

In the absence of progress, they brooded over what had gone wrong in Vincent's life—in Vincent—to bring this trial upon them. As always, they blamed his failure to socialize in the right circles and his neglect of appearances. But mostly they blamed his attitude: his "morbid nature," his "inclination to melancholy." "Seriousness is all right," his father wrote, "but seriousness must ever be linked with freshness and strength." If only he had "a jolly heart," Anna lamented, he would not be so prone to "excesses"; he would "become a more normal and practical person."

Not even their bleakest assessments, however, had prepared them for Vincent's proposal to sail to South America as a missionary. His father denounced it as "foolhardy" and "sheer folly"—"a very costly undertaking which would certainly come to nothing." Before, they had questioned Vincent's dedication; now, they doubted his compass. "One must first and foremost use common sense,"

Dorus said bitterly. "I cannot *begin* to tell you how much we suffer because of this."

When Vincent arrived in Etten on December 21, he was greeted not with open arms and tears of joy, but with what he later described as a "torrent of reproaches."

Christmas unfolded exactly according to parsonage ritual: the usual cakes and cookies, red tablecloth and ropes of greenery. Anna played the organ; Dorus visited the sick. But the mood was nothing like that of past Christmases. "How much worry this boy is causing Pa and Ma," Vincent's sister Lies wrote. "You can really see it in their faces." Lies blamed Vincent for his fecklessness, his failure to find a job, and especially his religious fervor ("I believe his piety clouds his brain," she said). To these accusations, it seems, only Theo offered a defense. He told his siblings that Vincent was not like a "normal man"—to which Lies responded that everyone, including Vincent, would be better off if he were. But Theo's late arrival and early return to work in The Hague were a form of chastisement, too. And one can only imagine the censure Vincent felt at Uncle Cent's house in Prinsenhage, where the Van Goghs spent Christmas Day.

He had come home seeking redemption, like the Prodigal Son, but found only reproaches. "All one does is wrong," he wailed. An acquaintance who saw him after Christmas recalled that "he looked as if he were suffering from a sense of injury—there was something lonely about him." He complained of feeling "weary" and "tired of everything." In the unmistakable code of gospel verse, he confessed to "weeping" at night. A long, long walk in the snow, despite the harsh weather and a rare cold, hinted at the self-punishments to come. In a moment of heartrending honesty, he admitted to Theo feeling "heavy depression because everything I undertook failed."

Only the pain of guilt can explain Vincent's agreement in late December to give up his religious calling. With uncharacteristic meekness, he accepted the arguments his parents had been making throughout his months of exile: he needed to "stop following [his] own desires" and put himself "back on the road to a normal existence." He agreed to find a job and find it nearby—in his own country. He might still pursue a religious life sometime in the future, Dorus allowed, but only if he were "really serious about it" and willing to spend "at least eight years of study" preparing for it. But Dorus did not encourage such hopes. Instead, he reminded Vincent that he could lead a "useful and virtuous" life no matter what profession he entered, because "religion is not separate from real life."

In fact, Dorus had already arranged a job for him. Probably at the behest of Uncle Cent, a bookseller in Dordrecht, less than twenty miles from Etten, had offered Vincent a position as a bookkeeper and sales clerk. Only a few days after agreeing to his father's plan, Vincent took the train to Dordrecht and was in-

terviewed by Pieter Braat, a longtime Goupil customer. On his return, Dorus dispatched him to Prinsenhage to perform a final act of penance: reassuring Uncle Cent of his gratitude for this new opportunity. On the trip to his uncle's house, Vincent projected his own feelings onto nature's canvas: "It was a stormy night," he recalled, "with the dark clouds and their silver linings."

In a wave of dutifulness, Vincent—now twenty-four—threw himself into his new job at Blussé and Van Braam Booksellers on the market square in Dordrecht. He started work immediately after the new year, and virtually ignored the end of a one-week "trial period" that, theoretically, would have allowed him to reconsider. Even before his trunk arrived from England, he moved into a boardinghouse just across the square from the store. After only a few weeks of "wistful" letters, he seemed to put his previous life behind him. He wrote a long letter to the Slade-Joneses to tell them he would not be returning. "I wished them to remember me," he told Theo, "and asked them to wrap my recollection in the cloak of charity."

SCHEFFERSPLEIN, THE MARKET SQUARE IN DORDRECHT; THE BOOKSTORE BLUSSÉ
AND VAN BRAAM WHERE VINCENT WORKED IS AT CENTER

Coming out of its busiest sales season, the store generated a vast amount of bookkeeping work that kept him busy until late at night. "But I like it that way," he wrote. "The feeling of duty sanctifies and unifies everything, making one large duty out of the many little ones." He seemed to accept the logic of his new course, telling his parents "how much he enjoyed being back in his own country," and explaining to Theo how "duty" demanded that he choose a book-

keeper's salary over a preacher's "because later in life a man needs more." He told a coworker that he was "so glad not to be a burden to his parents anymore."

FOR A JOB THAT constituted a hopeful step backward in time, Vincent could not have found a town better suited than Dordrecht. The oldest city in Holland, it sat at the confluence of four rivers. Since the great flood of 1421, it had been completely surrounded by water. From that tollhouse position, it had reaped centuries of fabulous wealth by taxing the materials and merchandise that flowed to and from the sea. Merchants built gilded, top-heavy houses along its canals and around its perimeter where they fêted royalty and incubated Dutch independence. Golden Age artists like Cuyp, Van Goyen, Maes, and Ruisdael flocked to its "delicious landscape"—its forested quays, glittering shoreline, and magical rivers.

By the time Vincent arrived, however, Dordt (as everyone called it) had declined into picturesque poverty, its former splendors preserved in the amber of neglect and nostalgia. But the golden images from a previous era and the quirky glories of its faded remnants had earned Dordt a special place in the Dutch imagination. So when Vincent walked the winding streets and saw everywhere vignettes of rickety staircases, black balustrades, red roofs, and silvery water— images that had brought tears of homesickness in Paris and London—he must have felt at home: at home in a way he could never feel in the unfamiliar Etten; at home in a way only one other place, another island out of time, could make him feel: Zundert.

But it wasn't enough. A homecoming in imagery, even in Vincent's powerful imagination, was not a real homecoming; and simply doing his father's bidding could never satisfy his yearning for a Prodigal Son embrace. He soon reverted to old habits of brooding and reclusiveness. After a few desultory attempts at socializing, he withdrew into an almost absolute solitude. "He had no intercourse with anybody," recalled Dirk Braat, the storeowner's son. "He hardly spoke a word. . . . I do not believe there is anybody in Dordrecht who knew him." At his boardinghouse, he was "singularly silent," according to his landlord, and "always wanted to be alone."

He spent his spare daylight hours on long walks—"always alone," according to Braat—and his long nights reading. His landlord, Rijken, a grain merchant, arose at three every morning to check the grain loft and often noticed "spooky business" in Vincent's room: shuffling and a light under the door. When Rijken refused to pay for the extra oil he needed for his lucubrations, Vincent bought candles—a fire hazard that terrified the nervous Rijken. During the day, a different sound coming from Vincent's room alarmed the landlord: the hammering of nails. "I could not stand this Van Gogh covering the walls with those [prints],"

Rijken told an interviewer decades later, "driving nails ruthlessly into the good wallpaper."

Among his coworkers and fellow boarders, Vincent was both shunning and shunned. Like all clerks, he worked standing at his desk, typically from eight in the morning until midnight (with two hours off for lunch). But much of that time was spent "puttering," according to Braat, or "drowsy" from his short, sleepless nights. Braat quickly realized that Vincent was only there because his family "did not really know what to do with the boy." As in Paris, Vincent could not be trusted with customers. "When he had to give ladies and other customers information about the prints," a bookstore coworker recalled, "he paid no attention to his employer's interests, but said explicitly and unreservedly what he thought of their artistic value." Eventually, he was only allowed to sell halfpenny prints to children and blank paper to adults. "He was really next to useless," said Braat. "For he had not the slightest knowledge of the book trade, and he did not make any attempt to learn." Despite six years of experience at Goupil, he struck his coworkers as "a novice in business."

Only once, when the town flooded in the middle of the night and everyone rushed in timeless Dutch fashion to rescue what they could from the rising waters, did Vincent feel connected to the people around him. "There was no little noise and bustle," he reported excitedly to Theo: "on all the ground floors people were busy carrying things upstairs, and a little boat came floating through the street." The next day, at the store, he lugged load after load of soaked books and records to higher ground, earning the admiration of coworkers for his diligence and physical stamina. "Working with one's hands for a day is a rather agreeable diversion," he wrote in a rare flash of contentment; "if only it had been for another reason."

To outsiders who, unlike his family, had not followed his slow unwinding from the real world, or who could not dismiss his strangeness as merely foreign, or who did not speak his language of religious fervor, Vincent's eccentric inwardness could be disturbing. They found his looks odd and off-putting. Years later, they recalled his "homely, freckled face," his "crooked" mouth, his "narrowed, peering eyes," and his vivid hair cropped so close that it "stood up on end." "No, he was not an attractive boy," said Dirk Braat. It didn't help that Vincent insisted on wearing a frayed top hat—a sad relic of former days as a young cosmopolite in London. "Such a hat!" Braat exclaimed. "You were afraid you might tear its brim off if you took hold of it."

With his strange appearance and moody, solitary ways, Vincent invited scorn. His housemates mocked his serious manner and made noises to disturb his interminable reading, driving him off into the night in search of quiet. They called him a "queer fish," a "queer chap," and "cracked." The torments came not just from the group of rowdy young gentlemen who boarded with him, but

also from the landlord's wife, who berated him for his strange habits, and from Rijken himself, who later summed up Vincent's behavior: "It was as if the fellow was out of his mind."

Only one person, his roommate, Paulus Görlitz, offered Vincent friendship. A teaching assistant (as Vincent had been in England) who also worked part-time at the bookstore, Görlitz could not have known what he was getting into when he agreed to share his room with the newcomer. Fortunately for both, Görlitz, who was studying to earn a teaching certificate, shared Vincent's bookish, insular ways. "In the evening, when [Vincent] came home," Görlitz recalled, "he used to find me studying . . . and then, after an encouraging word to me, he would start working, too." They took occasional walks together, and Vincent shared with Görlitz, who was teaching in a school for the poor, his own "poignant stories" of the Reverend Thomas Slade-Jones and his "boys from the London slums." But mostly Görlitz listened to his roommate's relentless monologues. When Vincent talked, said Görlitz, "he warmed into enthusiasm," and his face "changed and brightened wonderfully."

More and more, Vincent talked about religion.

It was inevitable that Vincent's loneliness and longing would soon retake a religious shape. For a while after he arrived in Dordrecht, he seemed to forswear his evangelical ardor and accept his father's argument that one could do "religious work" without necessarily pursuing a religious calling. But that middle course could not long withstand Vincent's eccentric habits and his tendency to steer for the horizon. Eventually, according to everyone who lived with him or worked with him in Dordrecht, he reverted to the religious fanaticism that had defined his pilgrimage in England. "Strict piety was the core of his being," wrote Görlitz. "He was excessively interested in religion," recalled Dirk Braat. As in Paris, Vincent dedicated himself to the Bible, this time with even more feverish single-mindedness. "The Bible is my solace, my support in life," he told Görlitz. "It is the most beautiful book I know." He reaffirmed the vow he had made in Montmartre: to "read it daily [until] I know it by heart."

At work, he copied out long passages of scripture in Dutch, then translated them into French, German, and English, separated into four neat columns like accounting entries. "If a beautiful text or a pious thought came to him," Görlitz recalled, "he wrote it down; he could not resist doing so." The sight of Vincent in a reverie of transcription became a regular irritant to Braat senior, the owner. "Good heavens!" he complained, "that boy's standing there translating the Bible again." At home, Vincent read his big Bible late into the night, copying out passages and memorizing them. Many nights he read himself to sleep, and Görlitz found him "on his bed in the morning with his 'life-book' on the pillow." He hung biblical illustrations on every wall, image after image, mostly of Jesus, until "the whole room was decorated with biblical images and *ecce homo*'s," Görlitz recalled.

On each image he wrote the same inscription: "Sorrowful yet always rejoicing." At Easter, he framed every print of Christ in palm branches. "I was not a pious person," said Görlitz, "but I was moved when I observed *his* piety."

The surge of religious feeling brought a return to the monastic lifestyle Vincent had shared with Harry Gladwell in Montmartre. According to Görlitz, Vincent "lived like a saint," was "frugal like a hermit," and "ate like a penitent friar." He took meat only on Sundays, and then only in small amounts, telling his mocking housemates: "To men the physical life should be a small secondary matter; food from plants is sufficient, the rest is luxury." When the landlord complained about his unhealthful habits, he replied with Kempian indifference, "I don't want food, I don't want a night's rest." He mended his own clothes, and sometimes skipped meals so he could buy food for stray dogs. He allowed himself only one luxury: his pipe, which he smoked almost incessantly while working over his Bible in the hours before dawn.

As in Paris, Vincent spent every Sunday going from church to church in a marathon of devotion, ignoring differences between Lutheran and Reformed, Dutch and French, even between Catholic and Protestant, sometimes logging three or four sermons in a day. When Görlitz expressed surprise at his ecumenism, Vincent replied, "I see God in each church . . . the dogma is not important, but the spirit of the Gospel is, and I find that spirit in all churches." For Vincent, only the preaching mattered. In letters to Theo, he described how the Catholic priest lifted up the poor, cheerless peasants in his flock, while the Protestant preacher used "fire and enthusiasm" to sober the smug burghers in his.

Inevitably, these Sunday tours rekindled Vincent's ambition to preach. At home, he began studying the works of the most inspiring preacher he had ever heard, Charles Spurgeon, and drafting sermons during his late-night study sessions. He regaled his scornful fellow boarders with impromptu inspirational readings, even as they laughed and made faces at him. He tested everyone's patience, even Görlitz's, with interminable dinnertime prayers. When Görlitz urged him not to waste his time on his housemates' souls, Vincent snapped, "Let them laugh . . . someday they will learn to appreciate it."

Only one congregation received Vincent's ministrations warmly that winter—but it was the most important congregation of all.

THEO HAD BEEN brought to grief by a woman. He had fallen in love with "a girl from a lower class" (as Vincent later described her). He may have gotten her pregnant. Dutiful both to the woman and to his family, Theo reported his predicament to his parents and proposed to marry the girl. The prospect of yet another family shame was devastating in Etten, where the stain of Vincent's dishonor had yet to be erased. But Anna and Dorus responded differently than

they had with their eldest son. Calmly dismissing Theo's love for the girl as an "illusion," they offered only a gentle rebuke ("Our sweet Lord doesn't condemn, but forgives mildly") and extracted a promise that he would stop seeing her.

When Theo broke that promise three months later, Dorus exploded. He called the relationship "miserable and detestable"—a godless liaison "based only on cupidity and sensual lust" that could only bring Theo to ruin and damnation if he persisted in it. "Open your eyes," Anna pleaded. "Resist the danger of giving in. . . . God can help you find a decent girl . . . a girl we will gladly call our child." Torn between love and duty, Theo collapsed in despair. He considered leaving the country, convinced that if he stayed he would only continue to bring pain and misery to everyone he loved. "I am so lonely and sad," he wrote to his brother. "I wish I could go far away from everything. I am the cause of it all, and bring only sorrow to everybody."

Theo's cry for help galvanized Vincent's preaching ambitions and set him again on the journey that had begun in England.

As he did the previous fall when Theo fell sick, Vincent launched a manic campaign of consolation, expending all the coiled-up energy of long obsession on his congregation of one. In passages that evoke, and sometimes exactly echo, his sermon in Richmond, he urged Theo to seek comfort in Christ. Only through Him, he said, could tears of remorse be changed into "grateful tears," and "vital strength" be made to spring from "the weary heart." In his breathless rush to comfort Theo, Vincent freely mixed his own guilt and loneliness with his brother's. In places, it is hard to tell who is the consoler and who is the consoled. "There is a time in life," he wrote, "when one is tired of everything and feels, perhaps correctly, as if all one does is wrong."

Vincent sent long letters to his suffering brother filled with poetry, scripture, hymns, catechisms, and exhortations. As in his sermon, with its relentless invocations of Father and Mother and the idyll of youth, Vincent sought to comfort Theo by invoking their shared past. He urged him to read the poets of their childhood like De Génestet and Longfellow. He used the shorthand of imagery— a magazine illustration showing a churchyard at twilight—to summon up the ultimate balm of the Zundert parsonage. And when images created by others proved insufficient, he created his own. Only days after one of Theo's visits, he reimagined their time together, layering it with all the vivid, sentimental detail he had used to transform a Boughton painting into *The Pilgrim's Progress:*

> The hours that we spent together slipped by too quickly. I think of the little path behind the station where we watched the sunset behind the fields and the evening sky reflected in the ditches, where those old trunks covered in moss stand and, in the distance, the little windmill and I feel I shall often walk there, thinking of you.

The resurgence of Vincent's religious fervor was not welcomed in Etten. Dorus and Anna worried that it presaged another round of "excesses"—more futureless wanderings while the possibility of a normal life slipped further and further out of reach. To them, a religious calling required years of patient, dedicated study. Without that, Vincent would never be qualified for anything but marginal missionary work in a strange land under the banner of some fringe sect, like Methodism. "I truly hope he will not have to go abroad again," Anna fretted. "I wish he would stay with his present work," said Dorus, who worried himself sleepless over Vincent's prospects.

Determined to prevent any further straying from the path of self-sufficiency, and probably alerted to his son's increasingly eccentric behavior in Dordrecht, Dorus arranged for Vincent to visit his uncle Cor in Amsterdam. If Vincent were working in a family business like Cor's bookstore, he might become more firmly attached to the trade, and also he could be more closely monitored for signs of trouble. Amsterdam offered a safety net of relatives, including the family's other distinguished uncle, Jan, a rear admiral and commandant of the naval dockyards there. At his father's insistence, Vincent wrote to Uncle Cor in advance of his visit, vaguely apologizing for the "relative failures" of the past and discreetly inquiring about a position.

But if Dorus expected the meeting on March 18 to quell Vincent's religious ambitions, he must have been bitterly disappointed. Vincent went to Amsterdam riding a fresh wave of pious fervor. Theo had just been ordered to abandon the girl he loved, prompting Vincent to an outburst of consolation that capped a winter of clandestine meetings, confessional letters, and earnest pledges of undying brotherhood, all of which had brought his ardor, both fraternal and religious, to a fever pitch. Rather than acquiesce to his father's plan, Vincent adamantly reasserted his desire "to become a Christian and a Christian laborer." A contentious meeting with Uncle Cor left the issue unresolved.

The next day, in a move that seems to have caught everyone by surprise, Vincent hastily arranged to visit his uncle by marriage, the prominent preacher Johannes Stricker, apparently hoping to plead his case to a more sympathetic ear. Despite another round of discouragements, Vincent left Amsterdam on March 19 in a buoyant, if delusional, mood of eager anticipation. Rather than setting him more securely on a path to a normal life, the visit had crystallized his resolve to return to God's service.

Only this time, his ambition took a new form. "It is my fervent prayer and desire," he announced to Theo only days after his departure from Amsterdam, "that the spirit of my father and grandfather may rest upon me."

Vincent had decided he wanted to be a parson like his father. "If I one day have the joy to become a pastor and to acquit my task like our father," he wrote, "I will thank God."

—

VINCENT HAD COME a long way from the lonely room on Kennington Road; a long way from the swelling masses at the Metropolitan Tabernacle and the born-again fervor in Brighton; a long way from the apocalyptic ardor of Michelet and the shadow Christianity of Carlyle. Nothing in *Imitatio Christi*—for so long Vincent's other Bible—pointed the way to a parsonage in the Dutch countryside. Kempis urged disengagement from the world—just the opposite of Dorus's political, social, and financial interventions in the lives of his parishioners. What would Kempis's Jesus have thought of evicting widows for failure to make lease payments? What place was there in his father's church for the evangelism of the Methodists in Richmond or the Congregationalists in Turnham Green? What place for the kind of messianic zeal that sent missionaries to South America or into coal mines in search of souls to save? Vincent's road had led him to churches that valued the heart over the head, ardor over education; churches where a young foreigner with an unpronounceable name and a passion, but not much else, could speak his heart—a long way from his father's church, where centuries of bloodshed had bred a calmer, more measured piety.

In fact, despite the detours and setbacks, Vincent's pilgrim path had always led this way. From the moment he burned his father's inspirational pamphlets in the wake of his first disgrace in The Hague, Vincent ensured that religion would be the only route to reconciliation. Even in his early fanaticism, even as he renounced Michelet's *L'amour* and condemned Gladwell for his "idolatrous" paternal fondness, Vincent filled his letters with aching professions of love and admiration for his own father. "We would have to strive and hope to become men like our father," he wrote Theo soon after arriving in Paris. He prayed that he might one day have his father's "wings" of faith, so he, too, could "glide above life, above the grave and death!" Even as he horrified his parents with plans for a mission to the far side of the world, he sat in his little room in Holme Court and prayed that God might "make me my father's brother."

Dordrecht brought Vincent closer to his father than he had been since childhood; perhaps ever. Dorus had promoted the bookselling job in Dordrecht by promising Vincent that he could make frequent Sunday trips to nearby Etten. Only days after moving, Vincent was already planning his first visit. "He spent such an enjoyable Sunday at home," Anna reported afterward, "very cozy." Only a few days later, his father stopped in Dordrecht on a trip to The Hague. Crowding years of longing into four breathless hours on a "glorious" winter day, Vincent walked with his father, drank beer with him, showed him his room, and took him to see Scheffer's *Christus Consolator.* Dorus marveled at Vincent's knowledge of art ("he was so much in his element at the museum") and probably urged him again toward a job with Uncle Cor and away from a religious

career. "He better not immerse himself too deeply in that," he wrote Theo. But Vincent could hear only the longed-for words of paternal approval: "He is such a fine fellow," Dorus said of him after the visit.

For the rest of the winter, Vincent reveled in this vision of reconciliation. He took up again his father's love of birds and exchanged sightings with him. Dorus saw the first starling; Vincent, the first stork. They watched together for the first lark of spring. He echoed his father's interest in plants—especially the ivy vines that had always been Dorus's responsibility at the Zundert parsonage. He reread his father's favorite poetry and added to the prints on his wall a copy of Paul Delaroche's *Mater Dolorosa,* an image that had always hung in his father's study in Zundert. In his consoling letters to Theo, he adopted his father's warm, patronizing tone—"Let us not have any secrets"—and instructed him solemnly that a father's love "is fine gold": "For who is dearer than the father, In the kingdom of God or on Earth."

To celebrate their new shared identity, he gave his father a copy of Eliot's *Scenes of Clerical Life* for his birthday—and arranged for Theo to give him *Adam Bede,* another clergyman's story. When Dirk Braat dared to criticize the Reverend van Gogh as a country parson who would never advance beyond small-town parishes like Etten, Vincent flared with indignation. "This was the only time I ever saw Van Gogh angry," Braat recalled. "His father was absolutely in the right place; a true shepherd." It may have been in Dordrecht that Vincent began wearing a long clergyman's coat that had belonged to Dorus.

By the time he met with Uncle Cor in Amsterdam, Vincent's determination to *become* his father bordered on delusion. "As far as one can remember in our family," he wrote Theo, "which is a Christian family in every sense, there has always been, from generation to generation, one who preached the Gospel." Now *he* was being "called to that service," he said, so that "my life may resemble more and more" Father's life. Despite the clear contrary signals from Etten, he declared that his father wanted him to be a preacher. "I know his heart is yearning that something may happen to enable me to follow his profession," Vincent insisted to Theo, and no doubt to his uncles; "Father always expected it of me." Almost at the same moment, however, Dorus wrote to Theo: "I wish he would stay with his present work; it worries us."

To the outside world, and certainly to his parents, Vincent's defiance of reality, his determination to persist in the face of overwhelming opposition, smacked of sheer contrariness—a willful, often self-destructive perversity. The more firmly his parents pushed him toward the art business, it seemed, the more firmly he planted his feet in his father's footsteps. Even when a prominent Dordrecht preacher tried to redirect his zeal back into missionary work, Vincent refused, insisting, "I want to be a shepherd like my father." What no one understood, except perhaps Theo, was how high the stakes had risen. "Oh! Theo, Theo

boy, if I might only succeed in this," Vincent wrote from the throes of his new obsession. "I hope and believe that my life will be changed somehow, and that this longing for Him will be satisfied." If he could "persevere in this course," he imagined, the "heavy depression" of his past failures would be lifted from his shoulders and the reproaches that burned in his ear could finally stop. For that, he said, "[both] my father and I would thank the Lord so fervently."

While Vincent could be gallingly contentious and even dangerously confrontational at times, the contrariness that others saw was really just the persistence of longings too important to let go of: images in his head kept alive by a fierce imagination that overruled an increasingly contrary world.

Just how fierce soon became clear. In early April, Vincent returned to Zundert.

THE TRIP WAS SPARKED by a letter from home with news that Dorus had gone to visit an old farmer in Zundert, a former parishioner, who was on his deathbed. "He asked for me," Dorus wrote. "We drove across the heather to him. The poor man is truly in pain. I wish he could be released from his suffering!" As soon as he read the letter, Vincent flew out of the bookstore, pausing only long enough to borrow money from Görlitz. "I love that man so much," he told Görlitz breathlessly about the dying farmer, "I would like so much to see him one more time. I want to close his eyes."

In truth, the trip to Zundert had been planned for years—played out repeatedly in Vincent's imagination every time nostalgia overwhelmed him. "O Zundert!" he cried out from England. "Memories of you are sometimes almost overpowering." He had planned a pilgrimage there at Christmas—the perfect time—only to be thwarted by the reproaches of his family and the search for a job. Since then, the proximity to home and the unprecedented intimacy with his father had brought these persistent longings to a boil. In complex reveries layered with vivid memories and newly minted hopes, he summoned up the Zundert of his imagination:

> The memory of old times came back to me . . . how we used to walk with Father . . . and heard the lark above the black fields with young green corn, beheld the sparkling blue sky with the white clouds above, and then the paved path with the beech trees. O, Jerusalem, Jerusalem! Or rather, O, Zundert! O, Zundert!

More than the illness of a farmer he had barely known (and who had been sick for more than a year), it was this vision of Zundert, this imagined promise of returning to an imagined home, that brought Vincent racing in the darkness

back to the site of his original exile. "My heart was drawn so strongly towards Zundert," he explained to Theo, "that I longed to go there also."

He took the train, but walked the last twelve miles. "It was so beautiful on the heath," he reported to Theo the next day; "though it was dark, one could distinguish the heath and the pine woods and moors extending far and wide." He burnished that image with a hopeful Romantic flourish in anticipation of his new life about to begin: "The sky was overcast, but the evening star was shining through the clouds, and now and then more stars appeared." He was returning not just to the heaths of his childhood, but to the roads that his father had walked, the hamlets his father had visited, the farmers he had consoled, and, finally, the church where he had preached. "It was very early when I arrived at the churchyard in Zundert," he recorded; "everything was so quiet. I went over all the dear old spots." Then he sat down in the graveyard next to the church and waited for the sun to rise.

Later that morning, he learned that the sick man had died during the night.

But Vincent had come to console the living. He had come to do what he had seen his father do hundreds of times—in this town, for these people. "They were so grieved, and their hearts were so full," he recounted, "I was glad to be with them, and I shared their feelings." No longer the reticent novice he had been at Susannah Gladwell's funeral, he prayed with them and read to them from the Bible—just as his father would have done. He visited the dead man's family and viewed the body.

Vincent was never more alive than in the presence of death. "Oh! It was so beautiful," he recalled the scene. "I shall never forget that noble head lying on the pillow: the face showed signs of suffering, but wore an expression of peace and a certain holiness." Later he commented on how "the calmness and dignity and solemn silence of death contrasted with us, who still live." Filling out his reverie of the past, he visited the servants who had attended his childhood in the parsonage: a gardener and a maid. "The memories of all we have loved stay and come back to us," he wrote soon after this visit. "They are not dead but sleep, and it is well to gather a treasure of them."

The same day, Vincent continued on to the parsonage in Etten, a final four miles, completing the backward journey he had begun exactly one year before. He had banished himself on a Good Friday. He returned only a week after Easter; nine days after his twenty-fourth birthday. Vincent clearly saw his trip to Zundert as a new beginning. In the account he sent to Theo the same day, he had already layered onto it the most compelling image of rebirth he knew. "You know the story of the Resurrection," he wrote; "everything reminded me of it that morning in the quiet graveyard."

—

VINCENT EMERGED FROM his trip to Zundert infatuated with the image of himself as a pastor like his father. In the heat of this newest passion, all remaining obstacles melted away. The most intractable of these was his parents' long-standing insistence that he devote seven or eight years to theological studies, as his father and grandfather had done. Vincent had always resisted—partly out of self-righteous impatience and partly out of horror at the expense it would impose on his family's ever-strained finances. Only a few weeks earlier he had restated his resistance in the most vivid terms. "I have such a fervent longing for it," he wrote Theo about his new ambition, "but how can I reach it? If only I could be through with this long and difficult study to become a preacher of the Gospel."

Now, however, in the afterglow of Zundert, the prospect of years of study became a point of stubborn pride. A clergyman in Dordrecht tried to persuade him that "the preliminary study [was] too hard for him," Dirk Braat later reported, "[because] he had never been to a grammar school." But Vincent was determined to endure the same trials his father had endured, his roommate Görlitz recalled. It had become "an obsession with him."

Vincent's strange moonlight pilgrimage to Zundert had had exactly the opposite effect on his parents. Over the previous weeks, moved by his ardor, they had begun to set aside their long-held doubts. In late March, Görlitz had visited Etten and given them a sympathetic inside look at their son's pain. When Anna inquired, "How is Vincent doing? Does he adjust?" Görlitz answered plainly: "Madam, to tell you the truth, Vincent does not do well in his profession. He has only one ardent desire: to become a preacher." Soon afterward, Dorus asked his brother-in-law, Johannes Stricker, to investigate what Vincent would have to do to prepare for university examinations—the first step to being admitted for theological studies in Amsterdam. But when Vincent showed up at the door a week after Easter, tired and disheveled from his long walk home and solitary night in the Zundert graveyard, all of Dorus's reservations flooded back. "Theo, what do you say about Vincent's surprising us again?" he wrote warily. "He ought to be more careful."

But once Vincent agreed to his parents' conditions about preparatory study, they had no choice but to support him. The rest of the family responded in much the same way—doubtful but dutiful—when Dorus called on them for help. Uncle Stricker, who knew the least about Vincent's past, stepped forward with the most enthusiasm, not only identifying the best tutor to prepare Vincent for the exams (especially in Latin and Greek), but also volunteering to monitor his progress and guide his religious study. A learned, influential preacher, Stricker could also introduce Vincent to the mostly liberal clerical world of Amsterdam, in which he was highly respected, despite his comparatively conservative views.

Having himself failed his own ordination exam, Stricker was prepared to

give Vincent's ambitions the benefit of the doubt. "Our good Lord loves surprises," he said cheerfully. Uncle Jan, the rear admiral, offered Vincent a room in his commodious house in a large complex of military buildings overlooking the Amsterdam harbor. Widowed and with no children at home, Jan could offer not only meals and accommodations (with servants), but also entrée to society—a prospect that truly excited Anna. "If Vincent wants to become a vicar," she wrote, "he has to be able to deal with people from the higher society as well as with those who live a simple life." Although he refused to assume any kind of supervisory role over his troublesome nephew, Jan did manage to find Vincent "a decent job" to help defray his expenses. "At least that's a ray of hope in this matter," Anna wrote. Uncle Cor, the print dealer, offered money to help pay for Vincent's lessons, and a bundle of good paper to write them on, but little else.

Of all the relatives, only Uncle Cent, who knew the most about the past, refused to help. In a brutally businesslike rejection sent both to Vincent and to his parents, Cent "did not agree with Vincent's views," Anna reported to Theo. "Uncle doesn't think his plans will lead to good prospects and *that* is what he believes Vincent really needs." He also cut off any further discussion, virtually washing his hands of his feckless namesake. "He did not think that carrying on the correspondence served any purpose," Vincent told Theo, "because in this case he could not be of any assistance to me at all." Theo offered a benign view of Cent's refusal to his parents—"Uncle can't see that Vincent really means well"—but his sympathy for his brother triggered an alarmed response from Etten: "[Uncle] knows very well that Vincent is a good man," Anna insisted, "he just doesn't agree; and I expect he has been frank about it to Vincent." Then she added, in a moment of glum candor, "Neither we nor you are feeling comfortable about it either."

In the end, however, the family struck a familiar pose of guarded hopefulness, preferring to imagine—once again—that Vincent had finally come in from the heath. "How wonderful it will be," wrote Lies, "if he can see his illusion turn into reality." Anna did what she had done many times before: she put the matter in God's hands. "We would be so happy if we could see all of you reach your destiny and become good people," she wrote Theo, "starting with the eldest." Dorus, like his son, consoled himself by preaching a sermon. His subject: "Man is born to suffer"—"how troubles and worries form the heart and make it susceptible to comfort and hope." As a going-away present, they gave Vincent the ultimate symbol of their persistent hope: a new suit.

Vincent plunged ahead, seemingly unbothered by the doubts lapping around him. He began studying his catechisms immediately, furiously copying out page after page to occupy his thoughts and keep his own doubts at bay. Years later, he confessed to deep skepticism about the plan on which he was about to embark. But now, carried on a swift tide of obsession and identification, he only offered

more prayers ("Lord, I long so much to be earnest"), scribbled more reassuring texts in the margins of his prints, and redoubled his sermon-going. He consoled himself with one last trip to see the *Christus Consolator,* as well as with paintings of his own creation: word pictures featuring churchyards, meadow paths, and evening light. He fought second thoughts with anesthetizing repetitions of scripture and aphorisms. "I am striving for favor in the eyes of some I love," he explained to Theo in a moment of heartbreaking clarity. "If God wills it, I shall find it."

After leaving Dordrecht on May 2, Vincent lingered in Etten for a week in a last reverie of family. On his way to Amsterdam, he stopped in The Hague, where Theo, at his parents' insistence, took his brother for a haircut. ("Do a deed of mercy," Dorus instructed. "I would think that a barber in the Hague might make something of it yet.") Then Vincent left for Amsterdam, vowing to "put my hand to the plow."

IMAGES OF SOWING and reaping haunted Vincent's imagination as he began his new life. In one of his last letters from Dordrecht, he told Theo that he hoped to become a "sower of the Word"—"as one that sows wheat in the fields." On the Sunday before his son's departure, Dorus, who preached his life just as Vincent would later paint his, had chosen for his text the passage from Galatians that was his favorite: "For whatsoever a man soweth, that shall he also reap." "God's work," he said, "so closely connected to that of mankind, brings about solutions, unexpected and blessed. We sow and we reap, [but] it is not just us who are doing our best; God supports and blesses and opens up ways for our help and happiness."

For the persistent sower Dorus van Gogh, this was the most consoling message he could give his son as he put his hand to the plow yet again. And surely it was no coincidence that it echoed a passage from one of Vincent's favorite books, Eliot's *Scenes of Clerical Life,* which both father and son had recently read:

> She tried to have hope and trust, though it was hard to believe that the future would be anything else than the harvest of the seed that was being sown before her eyes. But always there is seed being sown silently and unseen, and everywhere there come sweet flowers without our foresight or labour. We reap what we sow, but Nature has love over and above that justice, and gives us shadow and blossom and fruit that spring from no planting of ours.

Head to the Wind

~

DAY AFTER DAY, FROM HIS UNCLE'S HOUSE OVERLOOKING THE AMSTERDAM harbor, Vincent saw the great labor unfold. Every morning, an army of workers poured through the gate of the naval dockyards—so many that the report of their boots on the pavement sounded "like the roaring of the sea," Vincent wrote. They worked from first light (as early as five in the summer) until the lamplighters started their rounds. Some went to the boatyards, building everything from ironclad warships to high-masted schooners. But most reported to the dockworks, where steam shovels, wooden cranes, and bare backs fought a grinding battle against the intractable sea bottom and the relentless sea.

Vincent called their daily struggle "a magnificent spectacle," and followed keenly the slow drama of their labors. "He who must learn to work must watch the workers," he wrote. Only with their "patient persistence" and faith in "God's help," he said, could any great work be completed. He saw them battle not only the spongy Amsterdam "soil"—more water than dirt, requiring mountains of sand fill—but also the unpredictable elements. With the treacherous North Sea only twenty miles to the west and the surly Zuider Zee just to the east, storms sprang to lethal life without notice, flooding dikeworks, snapping lines, dashing temporary docks, sweeping away the sand, and setting back the work by weeks. But the next day, the workers returned to undo the damage, refill the dikes, rerope the booms, rebuild the scaffolding, and then, God willing, nudge the sea a little farther back and raise the walls a little higher.

This was the history of Amsterdam, reenacted before Vincent's eyes. From the building of the first dam across the Amstel River in the thirteenth century, the civic enterprise called Amsterdam had been a struggle against nature. "The impossible city," historians called it. In the Golden Age, when it seemed as though no problem could withstand Dutch ingenuity, Amsterdam embarked

on a program of canal digging that gave the city its distinctive configuration of waterways in concentric half circles, like nesting bowls. The rich merchants of Amsterdam drove wooden piles into the soft ground to support their grand new townhouses. But no matter how many ditches and canals they dug, the boggy bottomland never truly drained. No matter how much sand and topsoil they dumped behind the dikes, buildings continued to sink: pavement parted, foundations cracked, and façades leaned perilously.

The harbor, too, defied both logic and the elements. Not directly accessible from the sea, it could be approached only through a maze of islands and shallows that quickly filled with silt and debris as land was reclaimed on either side of the channel. Shifting sandbanks and headwinds meant ships often had to lie offshore for days awaiting the right conditions for a dash to the harbor. Amsterdamers seemed to understand the improbability of their city, and the impermanence of its triumphs. Unlike the proud citizens of Europe's other great cities, they never took the trouble to build monuments: no grand boulevards, no great public spaces, no towering memorials to bygone glories. Critics accused them of lacking faith in symbols, of caring only about the material. But clearly it was neither good business nor good symbolism to build grandly on sand.

But build they did. And when the new canal to the North Sea opened in 1876, Amsterdam experienced yet another explosion of unlikely success. The pharaonic labor that Vincent witnessed from his uncle's window was only one of hundreds of such projects that had begun to roust the sleepy seventeenth-century city into the new industrial era. The IJ riverbank, Amsterdam's port, roared with the sounds of iron, steel, and steam engines as the harbor was enlarged, new docks built, and new islands raised. Railroads muscled their way to preeminence with plans for a vast new dockside train station. Canal after canal disappeared and new neighborhoods appeared. Amsterdamers had even begun to think about monuments: a great new museum to celebrate—what else— their Golden Age. Everywhere Vincent walked he saw the telltale mountains of sand—symbols of both impermanence and eternal effort—that accompanied every construction project, each one bearing witness to the power of hope over experience, of imagination over reality.

WITH INSPIRATION ON virtually every street corner, Vincent launched into his own great new labor. "Sometimes it is right to carry a thing through and to do it with a will," he declared, *"coûte que coûte"* (whatever it costs). Undistracted by employment (he did not take the job his uncle had arranged), he could devote himself unreservedly to the task ahead. And a formidable task it was. Before he could begin any theological studies, he first had to be admitted to a university. That was a challenge even for high school students with all the necessary pre-

paratory classes (especially Latin, which was still the language of instruction for all advanced study). Only a small fraction of high school graduates qualified to enter one of the country's three universities. For Vincent, who had walked away from the Tilburg School as a sophomore nine years earlier, the matriculation examinations presented an almost insuperable barrier. It would take at least two years to prepare for them, he was warned.

Vincent was determined to do it in less. "May God grant me the necessary wisdom to end my studies as early as possible," he wrote impatiently, "so that I can perform the duties of a clergyman." He embarked on a relentless study schedule that began at dawn with Latin and Greek and ended after dark with mathematics and algebra. In between, he crammed everything else: literature, history, geography. He studied with a pen in hand, writing out lengthy summaries of the vast tracts that filled his nights and strained his eyes. He copied out great swaths of text, sometimes whole books. "I know no better way to study," he insisted. Most nights, he worked in the sitting room, scribbling furiously by the gaslight until his uncle (as a sailor, a lifetime early riser) chased him to bed. He tried to continue in his attic room, but found "the temptation to sleep when it is getting late is too strong."

Religion was not a part of his matriculation exam study, but he could not resist it for long. Soon he was studying the Bible straight through yet again, somehow finding time in his busy schedule to make long lists of parables and miracles and arrange them in chronological order, in English and French as well as Dutch. "After all," he explained to Theo, "it is the Bible that is essential."

Vincent pursued all these studies with an intensity that exceeded even his usual fervor for new endeavors, applying himself "with the tenacity of a dog that gnaws a bone," as he put it. He filled his letters with proud pledges of "steadfastness" and "perseverance," and promises to "fight the good fight" "with God's help." Against his uncle's curfew, he "stretched" the day at both ends—from before dawn until "deep in the night." "I must sit up as long as I can keep my eyes open," he told Theo. On a rare visit to relatives, he stood in a corner reading while the others played cards. He read while walking the maze of Amsterdam's streets and canals. He never left town, even when Theo sent him money to come to The Hague to see an exhibition of drawings.

Only once a week did he break from his studies. But not to rest. As in Dordrecht, he set Sundays aside for sermons—as many as he could fit into the day (by one count, as many as "six or seven"). He left the admiral's house at six to attend an early service at the nearest church, the Oosterkerk (East Church), where Uncle Jan had an assigned seat. From there, he walked a mile along the riverfront to the Oudezijds Chapel, a fifteenth-century church tucked into a warren of streets in the oldest part of the city. With its shiplike lattice of beams and carved pagan faces grimacing down from the rafters, the Oudezijds had been

largely abandoned in favor of new churches in more fashionable neighborhoods. Often Vincent's only company in the ancient pews were old sailors, sailing cadets, and children from the nearby orphanage. But Uncle Stricker often preached there, and Vincent visited him at his house nearby. Vincent admired the "warmth and true feeling" of his uncle's sermons, and sometimes walked great distances to hear him preach at other churches as well.

From the Oudezijds, he headed west another mile to the Westerkerk (West Church), one of the largest Reformed churches in the Netherlands, with a looming bell tower that tolled the hour to all of Amsterdam. There Vincent could hear another preacher he admired, Jeremias Posthumus Meyjes. Dorus had given Vincent an introduction to Meyjes's father, who was also a preacher. When Vincent saw the "tall, noble figure" of the younger Meyjes, he saw his own future: both preacher and preacher's son. From the Westerkerk, he might head north, just a half mile up the townhouse-lined Prinsengracht, to the Norderkerk (North Church), where both Stricker and the elder Meyjes preached occasionally.

These four churches—East, West, North, and Oudezijds—were the compass points, the stations, of Vincent's weekly progress. From departure to return, he could cover seven or eight miles in a single Sunday, undeterred by heat or wind or darkness or the punishing rainstorms that swept in, unexpected and unobstructed, from every direction. Even Vincent, not usually one for self-deprecating humor, seemed to mock himself in reporting to Theo "the frightful number of stone thresholds and church floors under my eyes and feet."

The one person who saw Vincent's ardor close-up was his tutor, Maurits Benjamin Mendes da Costa. Vincent called him just "Mendes." A Portuguese Jew, Mendes lived with several dependent relatives on the edge of the old Jewish quarter in eastern Amsterdam, only a half mile from the naval docks. He was twenty-six but looked far younger, a slight figure with soulful Sephardic features and a blur of a mustache. In early May, having been "forewarned" by Stricker about Vincent's "unusual behavior," Mendes received him apprehensively in his room overlooking the Jonas Daniel Meyer Square. He found his new student surprisingly "reticent," given the small difference in their ages. "His appearance was by no means unpleasant," Mendes wrote in a reminiscence thirty years later. Where others saw a country "roughness" in Vincent's red hair and freckles, "homely face," and "nervous hands," Mendes saw a "charming strangeness."

Vincent responded to his teacher's sympathy with extravagant admiration. To Theo, he called Mendes "a very remarkable person," and added, "one must not talk too lightly about genius, even though one believes there is more of it in the world than many suppose." He brought gifts of books and prints and flowers to their morning lessons "because you are so good to me," he told Mendes. He lavished attention on his teacher's blind brother and retarded aunt. In an appar-

ent effort to distance himself from the social prejudice that Jews, even in Amsterdam, still suffered, he inscribed on the flyleaf of one book he gave Mendes: "In him there is neither Jew nor Greek, nor servant nor master, nor man nor woman." He eagerly reported Mendes's early encouragements to his parents. "Mendes has told [Vincent] that he is pretty confident that he will complete his studies," Anna reported with relief in July.

The need to vindicate his teacher's confidence only made Vincent redouble his already fanatic efforts. Mendes vividly recalled watching from his study window as Vincent approached for his lesson with grim determination in every step. "I still see him . . . without an overcoat . . . crossing the wide square . . . with books under his right arm, pressed closely against his body . . . his head to the wind."

But there were signs of trouble right from the start. The work did not yield readily to Vincent's ardor. "It does not come to me so easily and quickly as I could wish," he admitted. He tried to reassure himself that "one should get used to it," and that "practice makes perfect." He searched for excuses. "To persevere in simple regular study after all those emotional years is not always easy," he explained to Theo. But within a few weeks of starting, his reports shifted from the language of optimism to the language of obligation. Doubts began to cloud his determination. He prayed for a lightning bolt to restore his conviction. "After a period of disappointment and pain," he imagined, "one gets to a time of life where our fervent desires and wishes are fulfilled *at a stroke.*" Without that lightning, however, Vincent saw less and less hope of success. "Humanly speaking," he conceded, "one would say it cannot happen." He compared himself to the prophet Elijah, waiting for the "small, still voice" of God to speak from the cave. "What is impossible to man," he reassured Theo, and himself, "is possible to Him."

But months passed and lightning did not strike. No voice spoke. With his low threshold for frustration and his peripatetic mind, Vincent found distractions increasingly irresistible. His trips to Mendes for lessons turned into meandering excursions through the picturesque Jewish Quarter. His walks grew longer and took him farther and farther afield. He walked to the sea at Zeeburg, to the Jewish cemeteries at the fringes of the city, to the "farms and meadows" farther still. His visits to booksellers offered shopping opportunities for books not on any reading list. "I invent some errand to go there whenever possible," he admitted, because bookshops "always remind me that there are good things in the world." In a startling hint of disaffection, he complained to Theo about his nightly Bible reading: "When that is finished I will move on to something worthwhile." His letters, both to Theo and to his parents, grew longer and more frequent (sometimes two a day) and betray a restive mind held in check only by increasingly defensive vows of dedication and self-discipline.

By midsummer, with a heat wave scorching the city and bringing its canals to a stinking boil, Vincent's great enthusiasm had been rendered down to a series of growling complaints. What could be more "oppressive," he wrote bitterly, than "Greek lessons in the heart of Amsterdam, in the heart of the Jewish quarter, on a hot and stifling summer afternoon, with the feeling that many difficult examinations await you, arranged by very learned and shrewd professors." He complained that his "continuous plodding" produced only "meager satisfaction" and "no results." He began to blame others for his misery and pronounced a bold judgment on his work: "I do not like it." For the first time, he even allowed himself to imagine failure. "When I think the eyes of so many are fixed on me," he wrote,

> who will know where the fault is if I do not succeed . . . [who] will say by the expression of their faces: "We have helped you and have been a light unto you, we have done for you what we could. Have you tried honestly? What is now our reward and the fruit of our labor?"

Now when he asked himself why he should go on, "notwithstanding everything that seems against me," the answer came back filled with desperation: "so that I shall know what to answer to those reproaches that threaten me."

Nevertheless, when the time came in August for Vincent's first review by Uncle Stricker, it was agreed that he should be allowed to continue. As Vincent put it, with something less than his former enthusiasm, Stricker and Mendes "did not seem to be dissatisfied."

Dorus had only one complaint about Vincent's new life in Amsterdam: his son's persistent habits of brooding and withdrawal. "I wish that he would find a little more cheerfulness," Dorus wrote, "that he would not remain on the outside of everyday life so much." Within mere weeks of beginning his studies, Vincent complained of "despondent moods." "The soul sometimes sinks within us and is fearful," he confessed. Thoughts of the struggle ahead filled him with such "weariness" that his head ached. "My head is sometimes heavy and often it burns and my thoughts are confused," he wrote, recording the first ominous signs of the maelstrom to come in the years ahead.

In the house that he shared with his uncle, Vincent felt increasingly a stranger. Rear Admiral Johannes van Gogh was an erect, square-jawed man with long gray hair and "an inordinate love for order," according to one family member. "His public as well as his private life was lived with military precision." A veteran of wars on the far side of the world, the hardships of long voyages, and separations from his family that lasted as long as five years, Uncle Jan had little patience for the tempest in his nephew's head. He had commanded men and ships in war; he had navigated unknown seas; he had sailed the navy's first

steamships at a time when steam was still a wild and fickle force. Renowned as a dead-on navigator in the worst of storms, and "calm and brave" in adversity, he had earned the admiration of his men, the respect of his superiors, and the honor of his country.

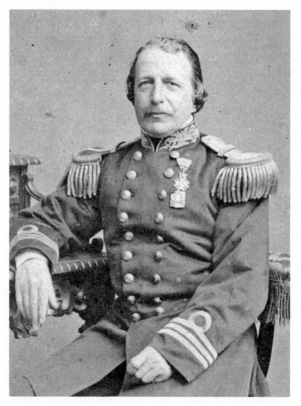

REAR ADMIRAL JOHANNES VAN GOGH (UNCLE JAN)

Now sixty and ending a distinguished career, Jan had taken Vincent into his house "only to please the latter's parents," according to sister Lies. Although he occasionally took his nephew on official outings and family visits, the two ate separately, and for the most part, he noticed his nephew only when Vincent's strange behavior disturbed the commandant's household. ("I cannot sit up so late in the night any more," Vincent wrote Theo in October, "Uncle has strictly forbidden it.") As for Vincent's growing self-doubts and wavering purpose, nothing could have been more anathema to the stalwart, self-confident Jan, described by the family chronicler as "always sure of what he was doing." Indeed, the only advice that he apparently ever offered his despondent nephew was a soldierly "Push on."

Everywhere Vincent turned that fall, he found the same guarded indulgence

and pious exhortations to greater effort. Uncle Stricker took his role as counselor and shepherd seriously. He invited his nephew to dine or to visit with him in his study, where Vincent could enjoy the preacher's large collection of fine books and a portrait of Calvin by Ary Scheffer. The sixty-year-old Stricker was a witty, amiable man with sad eyes, an under-chin beard like a hairbrush, and an eccentric taste in biblical verses. (He once collected all the passages in which the word "manure," or "dung," appeared.) Although known as a popularizer of the "new" theology, his conservative inclinations in matters of both head and heart made him an unreceptive audience for either Vincent's evangelical enthusiasm or his tortured self-examination. Stricker also held the purse strings: Dorus had deposited with him the money for Vincent's expenses—a failure of trust that had to rankle Vincent, however justified.

For a while, it seemed that Reverend Meyjes of the Westerkerk might fill the vacuum of sympathy and companionship. Vincent described the forty-six-year-old preacher as "a very gifted man [of] great talent and great faith. . . . He made a deep impression upon me." He visited Meyjes's study, where they talked about England and the older man's experiences ministering to "workmen and their wives." At Meyjes's house near the church, Vincent met the preacher's family. "They are such nice people," he reported to Theo. But, for reasons that are not clear, the relationship with Meyjes soon petered out. Alarmed perhaps by the onslaught of attention that always accompanied Vincent's admiration, Meyjes began to withdraw: first through neglect, then through outright avoidance.

One family came closer than any other to filling the persistent void. Uncle Stricker had a daughter named Cornelia Vos, known to the family as Kee. She lived with her husband and their four-year-old son near the Westerkerk, where Vincent often visited on his Sunday rounds. Homely and bookish, but possessed of a serene disposition, the thirty-one-year-old Kee was fiercely devoted to her sickly husband Cristoffel, who had been forced to abandon his career as a preacher because of a lung disease, and to her son, Jan. Vincent came away from an early visit intoxicated, as he always was, by the image of perfect family life. "They love each other truly," he wrote. "When one sees them side by side in the evening, in the kindly lamplight of their little living room, quite close to the bedroom of their boy, who wakes up every now and then and asks his mother for something, it is an idyll."

Like most of the families to which Vincent was drawn, the Voses had been touched—and ennobled—by tragedy. Only two months before Vincent's arrival, their younger son, a one-year-old, had died. An air of suffering and grief still suffused the family tableau, and Vincent breathed it in. "They have known days of anxiety and sleepless nights and fears and troubles, too," he wrote, referring both to the ghost of the dead infant and to the father's illness. But the same drama that attracted Vincent also excluded him. With the onset of winter

weather, Cristoffel's condition worsened and his wounded family closed around him. Eventually, the Voses, like the Meyjeses, faded out of Vincent's letters. Unlike the latter, however, the Voses would reappear in his life years later to wreak unimaginable havoc.

The only break in the gathering clouds came in September when Harry Gladwell visited. "It was a delightful sensation to hear Gladwell's voice in the hall," Vincent wrote. It had been only a year since their soulful adieu at the train station outside London. Gladwell was still working at Goupil in Paris. He had come to The Hague on business and, at Theo's request, extended his trip to Amsterdam to see Vincent. They spent two whirlwind days together visiting churches and meeting preachers. At night, they had soul-baring talks and shared Bible readings (Vincent chose the parable of the sower). Vincent urged his friend to follow him into the clergy: to quit Goupil and choose "the love of Christ and poverty." But the nineteen-year-old Gladwell ignored his pleadings. Soon after his departure, Gladwell stopped answering Vincent's letters, and within six months he had disappeared altogether from Vincent's life.

By winter 1877, loneliness forced Vincent to seek companionship in the only place left to him: the past. When walking his uncle's dogs along the docks on a starry evening, the smell of tar from the shipworks would remind him of "the pine woods" of home, and memories would overwhelm him. "I see it all again before me," he wrote in a reverie of nostalgia remarkable for a twenty-four-year-old. "I have loved so many things." Every place he had ever lived began to look like a lost Eden to him. Not just Zundert ("I shall never forget that last visit there"), but also London and Paris ("I often recall them with tender melancholy"). Even The Hague, site of his first and decisive failure, was transformed by longing into a memory of innocent, carefree youth.

But no place excited his nostalgia more than England. Everything reminded him of it: every rainy day; every patch of ivy; every narrow, medieval street. He read English books and magazines and frequented places where he could hear English spoken. One of those places was the English Church. Tucked away in a hidden courtyard on the far side of the city, this seventeenth-century building had been used as a Catholic redoubt at a time when Amsterdam's famous tolerance allowed other religions to be practiced but not seen. Set in its secret greensward like a vision out of Eliot, the English Church offered Vincent, too, a perfect retreat—an island of escape as complete and idyllic as a memory. "In the evening it lies so peacefully in that quiet courtyard between the hawthorn hedges," he wrote. "It seems to say, '*In loco isto dabo pacem*' . . . in this place, I will give peace." Here, in this fragment of another country, in a clandestine church walled off from his homeland, in the company of other outsiders, speaking a language not his own, Vincent found something like belonging. "I love that little church," he told Theo.

—

AS THE TIME FOR his second review approached, it took all of Vincent's imaginative power to escape the inevitability of failure. He somehow recast Gladwell's rebuff as a triumph of his plan to follow in his father's footsteps. "Oh, boy, how glorious it must be to have a life behind one like Pa's," he wrote Theo soon after Harry left; "may God grant us to be, and to become increasingly, sons after the spirit and his heart." He read a novel based on Homer's *Odyssey* and cast himself as the famously wandering king, with his discontents, his rough manners, his agitated thoughts, his history of trials and survival, and his heart "like a deep well." He pictured himself, like Ulysses, coming to the end of his long journey and "seeing again the place so fervently longed for."

But the review in late October exploded any such fantasies. Mendes reported to Stricker that his student appeared incapable of mastering Greek. "No matter how I approached it," Mendes recalled later, "whatever means I invented to make the task less tedious, it was to no avail." Stricker summoned Vincent for a "long talk" in which Vincent acknowledged that he found the work "very difficult," but protested that he was trying his best "in every possible way." Moved once again by Vincent's earnestness, Stricker and Dorus decided that he "should give it another try." A final decision would be made at the next review in January.

For Vincent, the stakes were now clear. *"It is a race and a fight for my life,"** he wrote, "no more, no less."

Vincent later described the next few months as "the worst time I have ever lived through." Alternately terrified of failing and desperate to succeed, he spiraled into despair and delusion. Somehow, he redoubled his efforts—staying up all night in defiance of his uncle's curfew, turning the gas down low, drinking endless amounts of coffee, and spending so much on pipe tobacco that Theo had to send him money for the Sunday collection plates. He redoubled his prayers, too, more convinced than ever that only God could give him "the wisdom I need." He fortified himself with a frantic campaign of poetry, scripture, and nostrums ("When I am weak, then I am strong"; "Set your face as a flint"; "What cannot be cured must be endured")—all addressed to Theo, but directed at the storm in his own head. "I never despair," he repeated again and again—even though, many years later, Mendes remembered Vincent walking into his lessons with a look of "indescribable sad despair."

His past failures hounded him like Furies. He confessed to bringing "sorrow and misery on myself and others." He regretted both the shame of his fall from

* Except where otherwise noted, italics in quotations from Vincent's letters indicate Vincent's own emphasis.

Goupil and his flailing indecision since. "If I had only given all my strength to it before," he lamented, "yes, I should have been further now." The prospect, now imminent, of yet another failure overwhelmed him with guilt. His parents had stretched their meager budget to help pay for his lessons and board, adding hundreds more guilders to a lifetime of expenditures. Failure would mean it had all been wasted. "Money does not grow on trees," Dorus pointed out. "The education of our children has been expensive—one more than the others." On one of Vincent's Sunday pilgrimages, in what may have been a desperate act of penance, he placed his silver watch in the collection plate. "When I think of all this," he wrote, "of the sorrow, the disappointment, the disgrace . . . I wish I were far away from everything!" He begged God to "let me complete one significant work in my life."

His letters reveal a mind suddenly gone dark with remorse and self-reproach. "There is much evil in the world," he warned, "and in ourselves, terrible things." He talked of "the dark side of life," and of his own "evil self" that shirked work and yielded to temptation. He chastised himself for mysterious "days of darkness." He insisted that "to know oneself [is] to despise oneself"—a doctrine of self-loathing that he attributed to both Christ and Kempis. When Mendes disputed this interpretation as too harsh, Vincent argued back vehemently: "When we look at others who have done more than we, and are better than we, we very soon begin to hate our own life because it is not as good as others."

So much guilt could not go unpunished. During the day, he returned to the self-mortifications of his earliest ardor. He ate only bread—a "crust of black rye bread"—invoking the example of Elijah and Christ's instruction in the Sermon on the Mount: "Take no thought, saying, what shall we eat, or what shall we drink." In rain and cold, he went without an overcoat. At night, he deprived himself of sleep with abusive amounts of tobacco and coffee ("it is a good thing to soak oneself in coffee," he said), then tortured his short rests by sleeping on his walking stick.

Some nights, he slipped out of the house before the doors were locked and slept on the ground in a nearby shed "without bed or blanket," according to Mendes, to whom Vincent confessed this ritual of self-abuse, because "he felt that he had forfeited the privilege of spending that night in bed." The winter of 1877–78 was filled with storms and bitter weather, but "he preferred to do it in the winter," according to Mendes, "so that the punishment . . . would be more severe." When an even harsher penance was called for, Mendes recalled, Vincent would take his walking stick to bed and beat himself across the back with it.

The combination of pressure and deprivation took a terrible toll. According to one family account, Vincent suffered a "mental breakdown" that winter. His parents and siblings watched in horror as the handwriting in his letters deteriorated along with his mind. "It became mere pen-strokes without rhyme or

reason," one of them recalled, "nothing more." His letters to Theo ranted and raved and wandered incoherently—a sign, perhaps, that he had already begun drinking, or the early eruptions of a deeper, as yet undiagnosed illness. His headaches grew worse as the inner voices of self-doubt and self-damning grew stronger. "When one has many things to think of and to do," he complained, "one sometimes gets the feeling, 'Where am I? What am I doing? Where am I going?' And one's brain reels."

For the first time on record, he flirted with suicide. "I breakfasted on a piece of dry bread and a glass of beer," he joked darkly in August; "that is what Dickens advises for those who are on the point of committing suicide, as being a good way to keep them from their purpose, at least for a while." By December, black humor gave way to an obsession with graveyards and an intense longing for the day when "God shall wipe away all tears." Throughout the winter, he kept a book of funeral orations in his pocket, and read from it so often that he wore it out. He spoke enviously of the dead farmer in Zundert: "He is freed from the burden of life, which we have to go on bearing."

Not even Christmas could break the downward spiral. In his embattled state, Vincent longed for it more vividly than ever. To Theo he described it as "the kindly light from the houses" on a stormy night: "The dark days before Christmas are as a long procession at the end of which shines such a light." He had not been home since his studies began, and he had not seen his father since before the unfavorable review in October. With the third and decisive review less than a month away, he clearly hoped the magic of the season might soften hearts in his favor. "I cannot tell you how I long for Christmas," he told Theo. "I do hope Father will be satisfied with what I have done."

To Theo and his other siblings, he pretended all was well. On the eve of his return, he reassured them: "I am now over the beginnings of Latin and Greek," and claimed his studies had been "on the whole, [a] good thing." He came early to Etten and lingered for weeks after Christmas, enacting the role of pious, dutiful son. He took long walks with his parents and went sledding with ten-year-old Cor. He visited his mother's sewing class ("it is really lovely," he said, "one would like to have a painting of it"), and shadowed his father on his busy holiday rounds. As a final act of atonement, he made a pilgrimage to Prinsenhage to visit his ailing Uncle Cent.

But his parents were neither fooled nor appeased. "If only I had some reason to be somewhat at ease about Vincent's future," Dorus lamented after Vincent finally left in January. Anna offered a despairing New Year's prayer for her ever-wayward son: "May he become more and more normal. . . . The worry about him is still with us: He has been and continues to be strange." As for Vincent's brave pretensions to fill his father's shoes, it was left to his plainspoken sister Lies to deliver the family's unforgiving verdict. She called him "daffy with

piety," and dismissed his religious ambitions with a single word, *kerkdraver,* a Dutch term for a fanatic churchgoer of showy but shallow faith. "Now that he is so heavenly," she wrote scornfully after the holidays, "I hope not to become like that."

The Christmas debacle could have left no doubt in Vincent's mind what message his father brought when he arrived in Amsterdam in early February for the third and final review. In addition to chastising him for his continuing antisocial habits and "unhealthy existence," Dorus accused his son of lacking true commitment to his work. To underscore the point, he sat with Vincent in his little study and corrected some of his papers, scolding him for their "manifold mistakes." After he left, he reported to Theo, "I am afraid that [Vincent] is not of a mind to study."

There was only one solution. In order to avoid bringing dishonor, yet again, on himself and his family, Vincent would have to work harder. He was "no longer a child," Dorus said sternly: he had set the goal; now it was his duty to reach it. Dorus laid down a new, stricter regimen for Vincent's studies; and to ensure compliance, he arranged for Uncle Stricker to supervise his lessons twice a week. Finally, he touched Vincent's most sensitive nerve. Money had become a "terrible problem," Dorus said, and from now on Vincent would have to contribute to his own support. He would have to get a job.

Before leaving, Dorus took Vincent around to all the people whom he had disappointed or alienated in his short eight months in Amsterdam: Mendes, Stricker, Uncle Cor, Reverend Meyjes. Then, four days after arriving, still "uneasy" about the future, he left. Vincent, who always dreaded departures, watched as his father's train pulled out of the station. He stood on the platform, paralyzed, until the last wisp of smoke disappeared from view. When he returned to his uncle's house, he went to his study and surveyed the books and papers still on his desk where his father had been reviewing them. He looked at the empty chair where his father had sat and burst into tears. "I cried like a child," he admitted to Theo.

LESS THAN TWO WEEKS after his father left Amsterdam, Vincent van Gogh exhibited his first work of art. Drawn "with red chalk on heavy brown paper," it hung in a basement Sunday school classroom so dark that it needed gaslight to be seen, even at midday. "I want to do such things now and then," Vincent wrote, "for it certainly is very doubtful that I shall ever succeed. . . . [And] if I fail, I want to leave my mark here and there behind me."

"Dat Is Het"

~

V INCENT ALWAYS NEEDED ART: BOTH TO ESCAPE THE WORLD, AND TO reshape it. Despite his protestations of undeviating purpose and piety, religion never preempted that need. From his monastic seclusion in Paris in 1876, he wrote a letter to his parents "only about paintings." On his Bunyanesque wanderings on the country roads of England, he visited the royal collection at Hampton Court, with its portraits by Holbein and Rembrandt and its galleries of Italians, including a Leonardo. "It was a pleasure to see pictures again," he confessed to Theo. In Dordrecht, at the very moment he was recapturing his ardor and resolving to follow in his father's footsteps, he repeatedly visited the art museum there. Within just a few days of arriving in Amsterdam, he began making side trips to the city's treasure house of the Golden Age, the Trippenhuis.

Everywhere he went, Vincent filled his solitude with images. Prints covered the walls of every room he inhabited. He had begun his studies in Amsterdam with a brave vow to curtail his obsession with collecting prints. But before long he was frequenting the bookstalls and printsellers that lined the route to Mendes's apartment in the Jewish Quarter. "I have the chance of picking up prints cheaply," he rationalized to Theo. He needed them to "give my little room some atmosphere," he said, "to get new ideas and freshen my mind." He bought prints with "Latin and Greek themes," claiming they would advance his studies, along with images of evangelists, vicars, vestries, and baptisms. He rechristened old secular favorites with religious titles so they, too, would fit the new mission.

But religious images never displaced the sentimental images that sustained Vincent's vision of an alternate, better reality. His pictures of idealized sufferers and biblical tales, of Christs in the Garden and Mater Dolorosas with dewy, upturned eyes, shared the walls of his study with little boys marching to school,

little girls skipping home from church, old men trudging through snow, and stoic mothers fetching coals for the family fire.

Even as his father and Uncle Stricker berated him for his slack effort and "manifold mistakes," Vincent's mind increasingly sought refuge in this other world. In church, an old woman dozing in a pew nearby made him think of a Rembrandt etching. In his studies, the battle of Waterloo took the form of a painting he had once seen depicting the siege of Leiden. He read books and imagined the illustrations that should accompany them, and which artist should paint them.

For inspiration, he propped portraits of historical figures on his desk as he studied. A book called *Old Testament Legends* led him to another by the same author, *Legends of Artists.* On his walks along the wharves, he saw not topics for sermons, but subjects for paintings. He brought prints to his lessons with Mendes and often stayed afterward to "discuss his former occupation, the art trade," Mendes recalled. The only new acquaintance he mentions in all the Amsterdam letters was a clerk at Uncle Cor's gallery. Even as he pledged himself yet again to unremitting study and imposed on himself a brutal regimen of long days and punishing nights, he escaped to his uncle's store to immerse himself in back issues of art magazines, in which, he confessed, "I found many old friends."

In the summer of 1877, two events made it possible for Vincent to combine, finally, the great consuming passion of his life: family reconciliation through religion; and the great consoling preoccupation of his life: art.

One was a sermon Vincent attended in the Oudezijds Chapel early on the morning of Sunday, June 10. The preacher that day was not Uncle Stricker but a sprightly younger man with a bald pate and bushy side-whiskers. Eliza Laurillard represented a new generation of Dutch preachers willing to engage the new bourgeois culture on its own terms. Better known for his popular books than for recondite sermons, Laurillard brought a message that was at once reassuringly familiar and startlingly new. His text: the parable of the sower. "Jesus walked in the newly sown field," he began.

It was a common theme of the "nature sermons" that had made Laurillard one of the most sought-after preachers in Holland. Using simple, vivid images, he portrayed a Christ not only *in* nature, but also intimate with the processes of nature (plowing, sowing, reaping), and inseparable from the beauty of nature. Both Dorus van Gogh and Charles Spurgeon had preached the gospel of fertile seeds, fruitful vineyards, and "healing" sunbeams. Karr and Michelet had found God in flower beds and on tree branches. Carlyle had declared the "divineness of Nature." But Laurillard and others went further. Finding beauty in nature was not just one way of knowing God, they proposed; it was the only way. And those who could see that beauty and express it—writers, musicians, artists—were God's truest intermediaries.

For Vincent, this was an electrifying new ideal of art and artists. Before, art had always *served* religion: from the ubiquitous emblem books that taught children moral lessons, to the devotional prints that hung in every Van Gogh room. But Laurillard preached a "religion of beauty" in which God was nature, nature was beauty, art was worship, and artists were preachers. In short, art *was* religion. "He made a deep impression on me," Vincent wrote as he returned again and again to hear Laurillard preach. "It is as if he paints, and his work is at the same time high and noble art." He compared Laurillard to two giants of his imagination, Andersen and Michelet. "He has the feelings of an artist in the true sense of the word," he wrote Theo.

The comparisons to Andersen and Michelet, both objects of shared passion with his brother, were carefully chosen. Vincent was responding to the other seminal event of the summer of 1877: Theo's announcement that he wanted to be an artist.

ONLY JUST TURNED TWENTY and already afflicted by bouts of depression that would eventually cripple him, Theo had been thrown into an existential crisis the previous winter after his third disastrous love affair in as many years. In May, after his refusal to end the affair triggered his father's wrath, he saw no choice but to leave The Hague and start a new career and a new life someplace else. But that plan set off even louder alarms in Etten. A private scandal was abhorrent, but another family shame would be a catastrophe. "These are new worries and very big ones," Dorus wrote as he hastily arranged an emergency trip to The Hague to head off Theo's "crazy" plan. "I beg you not to take any rash steps . . . I beg you to wait until we have talked."

Theo had already shared with Vincent his plan to quit Goupil, probably earlier that spring before his parents knew that he had resumed the affair. At the same time, no doubt, he broached the idea of becoming an artist. Elated that his brother would spurn the firm that had spurned him, Vincent rallied to Theo's cause. He sent the usual flood of support: paeans to the admirable "life and work" of artists they both loved (Breton, Millet, Rembrandt) and a copy of *Legends of Artists*. In mid-May, on his way to Amsterdam, he stopped in The Hague so the two brothers could visit Anton Mauve, their cousin by marriage, who was a widely admired and successful painter.

Theo had recently begun seeing Mauve often, both at his home in the city and at his studio near the shore at Scheveningen. Charming and accomplished, with a young family and a comfortable bourgeois lifestyle, Mauve offered a perfect model of the successful artistic career that Theo no doubt imagined for himself. Vincent's visit provided the final push. Soon after he left for Amsterdam, Theo informed his parents of his intention to quit Goupil. Vincent reveled at

the thought of his brother breaking with convention and setting off on a new path—just as he had done. The vindication of it thrilled him. "My past comes to life again when I think of your future," he wrote.

Seeing fulfillment of his vision on the Rijswijk road within his grasp—two brothers "bound up in one . . . feeling, thinking and believing the same"—Vincent proclaimed the brotherhood of preachers and artists even more boldly than Laurillard did. He found "a resemblance" between the works of artists like Millet and Rembrandt and "the work and life of Father." And he claimed for Theo's new calling the same transformative power he claimed for his own: "When I see a painting by Ruysdael [or] Van Goyen," he wrote, "I am reminded again and again of the words, 'Sorrowful, yet always rejoicing.' "

But Theo could not go through with it. Within only a few days of making his momentous announcement, he rushed to Etten to retract it, not even waiting for his father to come to him. Whether from failure of conviction or excess of duty, he would stay at Goupil. At first, he asked to be transferred someplace else—to Paris or London. But Dorus talked him out of even that. Uncle Cent advised his ambitious, "golden-tongued" nephew not to "spoil his future with haste." Instead, Theo should "concentrate on making himself indispensable," Cent counseled. Both flattered and chastened, Theo quietly let the matter drop, bringing to a quick close the first in a career filled with similar periodic feints of rebellion.

Vincent, on the other hand, could not let go so easily. Emboldened by Laurillard's ideas and driven by the image of perfect brotherhood, he continued to encourage Theo's artistic ambitions long after Theo had retreated from them. For the rest of his life, Vincent would taunt his brother and torture himself with the vision of brotherly solidarity that he enjoyed for barely a week in the summer of 1877.

Obsessed by that vision and guided by Laurillard, Vincent's powerful imagination continued to shape new connections between art and religion, binding them together in an ever tighter unity. They shared not just common roots in Nature, he said, but a whole catalogue of Romantic imagery: from starry skies to "overflowing eyes." To Vincent, those images now spoke not just of lost love, but of "the Love of God." They shared a common source—"a deeper source in our souls," he said—a source beyond the conscious mind or the clever hand. Both promised renewal, whether through revolution or apocalypse, and both offered "something of the spirit of the resurrection and the life."

Like Carlyle's divinity, both resided in the particularity of this world, not in the perfection of the next: in a swaybacked draft horse patiently awaiting its next burden; in the corkscrew twist of a tree branch, or a battered pair of walking boots. All were "noble and beautiful," he maintained, "with a peculiar, weird beauty." They shared a common language, too. Not just the symbolism of suns

and sowers, but a common mode of expression—a "simplicity of heart and simpleness of mind" that Vincent found in works as different as Michelet and the Book of Kings. Nor was this a language that required years of study to master. "It could be understood by everyone," he insisted, because "it has an eloquence which wins the heart because it comes from the heart."

Finally, art and religion shared the signature power of Vincent's imagination, the power to console—the power to "bring light into darkness," to transform suffering into solace, sorrow into rejoicing. "For this is what great art does," he declared: "cheer you and feed your inner life." This was the power that brought tears to Vincent's eyes over a passage of scripture, an Andersen story, or the sight of "the sun shining through the leaves in the evening." When Vincent felt this power—for it was more a feeling than a perception—he recognized it instantly. *"Dat is het,"* he would exclaim. *"That is it."*

Vincent had first heard the phrase from Mauve, years before in The Hague. Then, it applied only to art—a painter's eureka of tribute to the rightness of an image, the successful capture of a subject's ineffable essence. Now he applied it to anything that evoked this new and mysterious conjunction of art and religion. "You will find *it* everywhere," he said; "the world is full of *it*." He found *it* in a group of old houses on a little square behind the Oosterkerk—a vignette of humble persistence just waiting for an artist to see. He found *it* in a sermon on the death of a child—"This was *it*," too, he said. Whether encountered in a painting or a sermon, *it* evoked feelings of joyful consolation. *It* both illuminated the human condition—the way art had always done—and, like religion, gave life meaning in the face of inevitable suffering and inescapable death. Preachers and artists alike could provide the consolation of *it*, Vincent argued, as long as they "applied themselves heart, mind and soul." His father had *it*, of course. But in Vincent's union of art and religion, Uncle Cent had *it*, too: "something indescribably charming and, I should say, something good and spiritual."

He found *it* in everyday experience. "There are moments when the common everyday things make an extraordinary impression," he wrote, "and have a deep significance and a different aspect." A little girl he saw in the flower market, knitting while her peasant father sold pots, had *it*: "so simple in her little black bonnet, and with a pair of bright, smiling eyes." Old people, like the wizened sexton at the Oosterkerk, had *it*. What they had in common, he observed, was "soul"—a term he used to refer to any burden, affliction, or sadness (such as poverty or age) that separated them from the soulless beauty found both in Salon paintings and in church pews. Always sensitive to his own rough appearance, he increasingly saw outward ugliness as a sign of "spirituality" within. "I would rather see a homely woman," he argued after seeing a voluptuous Gérôme nude, "for what does a beautiful body really matter?"

In Vincent's relentlessly visual imagination, *it* also had a face. Years of deep, obsessive immersion in the Bible had imprinted on him an image that could not be erased: the image of an angel. "It is also good to believe that now, just as in olden days, an angel is not far from those who are sad," he wrote Theo in the midst of his crisis. In England, he swore he saw the "countenance of an angel" when his father preached. In Amsterdam, he fixated on the story of Elijah being "touched by an angel" as he lay sleeping, alone in the wilderness. He wrote Theo about the angel who told Paul, "Fear not," and about the angel that visited Christ in the Garden of Gethsemane and "gave strength unto Him Whose soul was sorrowful even unto death." He bought an engraving of Rembrandt's *The Angel Leaving the Family of Tobias*, a dramatic depiction of the moment when the archangel Raphael, after restoring sight to the blind Tobias, reveals himself and rises into the air in a burst of light and a swirl of weightless robes.

For Vincent, angels would always be the instruments of God's consolation, the messengers of His comfort: hovering, always hovering "not far away from us—not far from those who are broken-hearted and dejected in spirit." Despite the encroachments of an increasingly skeptical world and modern notions of a godless universe, despite his own bold and desperate straining to create an embracing *it* that superseded his father's demanding faith, Vincent clung to these earlier incarnations of divine possibility, these nuncios of the sublime. Till the end of his life, they continued to hover over his imagination, embodying his last delusional hope for reconciliation with a Father both abandoned and abandoning. In the asylum at Saint-Rémy, between images of sowers and cypresses and starry nights, he painted a radiant portrait of the archangel Raphael.

In Amsterdam, Vincent immediately began experimenting with the new ideas he was formulating. "Happy the one who is taught by truth," he argued, "not by fleeting words but by *it*self, showing *it*self as *it* is." In addition to collecting prints, copying out passages, and recording examples on his walks, he tried to capture *it* in the medium he knew best: words. Going beyond the simple word paintings that had long filled his letters to Theo, he tried to evoke not just images, but complete moments: fragments of experience suffused with deeper significance—with *it*. His new vision was at work in December when he described the dockyards outside his window:

> Twilight is falling . . . That little avenue of poplars—their slender forms and thin branches stand out so delicately against the grey evening sky; . . . Farther down is the little garden and the fence around it with the rosebushes, and everywhere in the yard the black figures of the workmen, and also the little dog . . . In the distance the masts of the ships in the dock can be seen . . . and just now here and there the lamps

are being lit. At this moment the bell is ringing and the whole stream of workmen is pouring toward the gate.

Vincent clearly saw creations like this as something new and significant. Later that month, he collected "a few writings" that he had done, and took them to a bookseller to have them bound.

Vincent had already learned to layer words and images in the pursuit of what he called "the finest expression." A dense thicket of Bible verses, hymns, and poetry filled the margins of his print collection. But the search for *it*—for "deep significance and different aspect"—transformed these composite images, just as it did his word paintings, into deeply creative explorations.

In his description of a twilight walk along the bank of the IJ River, he struggled to express—for the first of many times—the solace he found in the night sky. He began with the "shining moon" and "that deep silence." He added poetry ("God's voice is heard under the stars"), literature (Dickens's "blessed twilight"), and scripture ("twilight, when two or three are gathered together in His name"). Recalling a drawing he had seen, he reimagined the night sky as a backdrop for a Rembrandt biblical scene in which "the figure of our Lord, noble and impressive, stands out serious and dark against the window through which the evening twilight radiates." For Vincent, this promise of redemption was the comforting Truth—the *it*—in every moonlit night or starry sky.

> I hope never to forget what that drawing seems to tell me: "I am the light of the world, he that followeth me shall not walk in darkness, but shall have the light of life." . . . Such things twilight tells to those who have ears to hear and a heart to understand.

Portraits, too, were transformed by the search for *it*. The "stormy, thundery expression" in an old engraving of a seventeenth-century Dutch admiral reminded him of his religious hero, Oliver Cromwell. A noble portrait of Anne of Brittany summoned up images "of the sea and rocky coasts." The portrait of a young boy from the French Revolution, *Citizen of the Year V*, that had hung on his wall for years, suddenly resurfaced in his imagination, carrying in its resigned young face all the passion and adversity of Vincent's own religious coming of age. ("He is astonished to find that he is still alive after so many catastrophes.") Vincent's synthesizing eye combined the "splendid" portrait of the boy in the *bonnet rouge* with Michelet, Carlyle, Dickens, and all his reading on the Revolution so that it made "a good and beautiful whole."

But no composite portrait he "painted" that winter was more vivid than the one he painted of himself. Looking through old art magazines at his uncle's

bookstore, he ran across an etching entitled *A Cup of Coffee*, which he described to Theo:

> A young man with rather severe, sharp features and a serious expression who looks just as if he were pondering over a fragment from *Imitation* [*of Christ*] or planning some difficult but good work, as only *une âme en peine* [a soul in pain] can do.

Vincent added to this unblinking self-portrait his own prescient postscript: "Such work is not always the worst; for what is wrought in sorrow, lives for all time."

At some point, he took the final step. Instead of layering his words on others' drawings, he layered his drawings on their words. It was an easy line to cross. Vincent had grown up making drawings as gifts and as records. After leaving home, he made them as a way of sharing with his family and others his life away from them: his room, his house, his church. Whenever his parents moved, he made a drawing of each new parsonage. When he left a place, he invariably made drawings as mementos, to interleave with his memories.

The Cave of Machpelah, MAY 1877, INK ON PAPER, $2^7/_8$ X $6^1/_8$ IN.

The first drawings he did in the summer of 1877 were no different from these. Only now, the home that he wanted to share was not on any map. "Last week, I got as far as Genesis 23," he reported to Theo on the progress of his Bible studies, "where Abraham buries Sarah in the cave of Machpelah; and I spontaneously made a little drawing of how I imagined the place." The drawing he enclosed was small (less than six by three inches) but it contained a world. With tiny strokes from a fine pen, he drew the dark cave opening in the center and, above it, a marker stone with an infinitesimal inscription. On the right, a path

wanders by, discernible by its weedy border, and a disappearing trio of knotty, crooked trees; on the left, a flock of birds alights from a distant field. Next to the marker he drew a tiny bush, each of its rangy limbs defined by a stroke as fine as a hair and topped with a straggle of blossoms drawn with a conviction that suggests he knew exactly what kind of bush it was.

After hearing Laurillard preach, Vincent's ambitions for these drawings changed. They were no longer merely records of places, whether real or imagined; they became *expressions*. "What I draw, I see clearly," he wrote. "In these [drawings], I can talk with enthusiasm. I have found a voice." He immediately tried his new voice on a biblical image that always obsessed him: the wandering, Christlike Elijah. "I did [a drawing] this morning, representing Elijah in the desert under a stormy sky," he reported to Theo.

In his quest for "complete expression," these early efforts were soon replaced by another form of imaginary landscape: maps. Vincent's fascination with geography and maps must have begun with his childhood in a stopover town on a busy transcontinental road, with one uncle who sent reports from places as distant as the beaches of southern France and the Alps of Switzerland, and another uncle who explored corners of the planet as impossibly exotic as Borneo and Java. The same fascination made him a ready audience throughout his life for pseudoreligions and science fictions that promised different worlds on distant planets; and stayed with him to the end, when he looked into the night sky and saw a map of eternity.

In Amsterdam, despite the heavy workload, he produced maps with the profligate energy that marked all his great obsessions. He spent his precious extra money on "penny" maps, and made special trips to Stricker, Reverend Meyjes, Mendes, and Uncle Cor's bookstore to see and copy the magnificent volumes of hand-colored maps produced by the century's great mapmakers, Spruner and Stieler, with their panoramic formats, evocative topography, and meticulous lettering. "The work of *real artists*," he called them.

The distinction between map making and art making had never really been recognized in Holland, with its simultaneous mandates to explore and describe. In the Golden Age, Johannes Vermeer's *Art of Painting* had included a map so precise that one could set sail by it. Vincent added maps to the prints on his wall and recommended that Theo do the same. He used maps, like prints, to create composite images. He made elaborate maps of the countries he studied, then copied long extracts from his texts onto the same sheet, "thus making a whole of the two." A map of Normandy called for a page of Michelet. To a map of France he added "a list of everything I can remember concerning the French Revolution." He embellished a map of Paul's route across Asia Minor with excerpts from the saint's letters. Despite the increasingly intense pressure of his stud-

ies, he labored painstakingly over each map, copying it again and again until it "finally has the quality I want," he said, "namely that it has been made with feeling and love."

One map preoccupied him more than any other that winter. Borrowing a book on the geography of Palestine from Uncle Stricker, he set out to create a map of the Holy Land. On a huge sheet of paper, almost three by five feet, he carefully drew all the cities and regions, rivers and mountains, valleys and oases, of this unseeable world. He shaded in their contours and washed their borders with color. In one corner, he set a plan of Jerusalem, with its jagged city walls and citadel, its Mount of Olives, its Golgotha—the landmarks of his last three years—all drawn in an eager, naïve hand—all "made with loving devotion," he explained.

When his father came to Amsterdam in February 1878 for his third review, Vincent had the map ready to give him—as proof of his dedication, perhaps, or a plea for patience. But in his tortured retelling of the events of those days, Vincent never mentioned presenting it to him. Ten days later, he took a copy of the same map, drawn in red crayon, to the dark basement classroom of a little chapel near the Jewish Quarter and hung it there. "I thought that little room would be a nice place for it," he wrote Theo. "It is only a very small light . . . but let me keep it burning."

AFTER THE DISASTROUS MEETING with his father, Vincent clearly knew he would never succeed in his studies. "It is very doubtful that I shall ever pass all the examinations," he wrote Theo in what had to be a painful admission. But he could not give up. Nor, despite his relentless exhortations to Theo and his increasingly elaborate invocations of *it*, did he consider becoming an artist himself. Instead, he vowed fresh determination and spun new delusions of success. "I must push on," he said. "There is no remedy but to set to work again, since it is clearly my duty to do this, whatever it costs."

And then a different path opened up. On February 17, only days after his father left, Vincent broke from his usual Sunday routine and visited the Waalse Kerk (French Church). In the lofty pulpit stood a visiting clergyman "from the vicinity of Lyon" who delivered a sermon unlike any Vincent had heard before.

The same industrial revolution that had brought great wealth to some, like Uncle Cent, had thrown hundreds of thousands of others into unimaginable poverty. As the center of French industry, especially the weaving industry, Lyon had suffered more than most places with inhuman working conditions, sub-human living conditions, child labor, and unchecked disease. This pandemic of exploitation and suffering, which had inflamed a workers' movement that was

already the most militant in France, was the subject of the sermon delivered in the Waalse Kerk that morning. The preacher spoke of the workers' plight using "stories from the lives of the working people in the factories," Vincent recalled.

Vincent responded not only to the heartbreaking imagery, which he always found more vivid than reality, but also to the messenger: an awkward, earnest foreigner struggling with his words. "One could hear that he spoke with some difficulty and effort," he reported to Theo, "but his words were still effective because they came from the heart—only such are powerful enough to touch other hearts."

Vincent grasped his example like a lifeline. In the Frenchman's tales of evangelical outreach to the poor workers of Lyon, Vincent found a new model for his foundering enterprise to become "a real Christian": He would do "good works." Almost overnight, references to his studies virtually disappeared from his letters. So did the endless philosophical ruminations, dense knots of scripture, and flights of homily and rhetoric. "Better to say but a few words, but filled with meaning," he corrected himself. He argued with his tutor about the value and relevance of his lessons. "Mendes," he said, "do you really think such horrors are necessary for someone who wants what I want?" In place of sermons and studies, he proposed work as the ultimate expression of spirituality, and exalted the "natural wisdom" of the peasants over book learning. Instead of a scholarly parson like his father, Vincent now aspired to be a "laborer" for the Lord. "Laborers, your life is full of suffering," he wrote to Theo, echoing a French evangelical pamphlet. "Laborers, you are blessed."

Vincent began preaching the apotheosis of "the simple people" (as he called them) in the winter of 1878. But the idea already had deep roots in his imagination. In his childhood, of course, real peasants were rarely seen and never discussed. Vincent had little contact with the yeoman farmers that his father supervised; even less contact with the invisible and often landless peasants who stood at the bottom of Anna van Gogh's social ladder; and no contact whatsoever with the emerging class of workers in sparsely industrialized Brabant. He lacked any actual experience to contradict either his parents' view of peasants as "rough, uncivilized, sensual, churlish, and aggressive," or the new, romanticized Victorian view scornfully summarized by George Eliot: "Idyllic ploughmen . . . jocund when they drive their team afield; idyllic shepherds mak[ing] bashful love under the hawthorn bushes; idyllic villagers danc[ing] in the chequered shade." Like most sons of the bourgeoisie, Vincent often conflated these conflicting narratives—noble farmer, beast of burden, libertine fantasy—so that his imagination could be equally engaged by reverential portrayals of peasants at prayer and by leering depictions of country girls in come-hither poses, while remaining indifferent to the horrifying plight of actual peasants.

Vincent had been fired by evangelical ardor toward the underclasses once

before, in England, largely on the basis of reading Eliot's *Silas Marner* and *Adam Bede*. But that zeal had since faded in the white heat of his identification with his father. As recently as the previous summer, his only requirement for a future parish was that it should be "picturesque." But the vision that suddenly seized him in Amsterdam that winter went far beyond the romantic idealization of the prints on his wall, or the homesteading mandate of his father's ministry, or even Eliot's empathetic rustic realism. Now he imagined peasants and workers not just as icons of Romantic sentiment or paragons of religious piety, but as objects of emulation. "It is right to try to become *like* [them]," he said: they hold fast to their faith despite unending toil and utter hopelessness; they bear their labors with patience and dignity; and they die, like the old farmer in Zundert, serene in their ultimate redemption. In short, they had *it*.

Vincent's new vision of blessed labor was accompanied by a blaze of new imagery. Dressmakers, coopers, woodcutters, and diggers crowded baptisms and benedictions off his walls. Works by the patron saint of peasant painters, Jean-François Millet, returned to their "Holy Ground" in the pantheon of his imagination. These images had "soul," he argued. Their subjects' hard work and humble appearance proved them "richer in spirit," and therefore "more beautiful." *"Dat is het,"* he declared.

This was a definition of *it* that went far beyond the merits of a painting, beyond the synthesis of artistic perfection and divine inspiration, beyond the "cheer and feeding of the inner life." In Vincent's flailing imagination, *it* had become a way of life—a calling higher than his father's piety or his brother's aesthetics—a summons to apply himself without reservation or compromise to the creation of "truthful work." "It must be good to die in the knowledge that one has done some truthful work," he wrote, "and to know that, as a result, one will live on in the memory of at least a few and leave a good example for those who come after."

It was, of course, an impossibly demanding standard for an awkward, alienated young man who confessed to feeling "like Robinson Crusoe." Nevertheless, Vincent embraced the new calling with all his singular intensity. After hearing the French preacher at the Waalse Kerk, he sought out the church's regular minister, Ferdinand Henri Gagnebin. Considered a "radical" in Amsterdam's staid clerical community, the Swiss Gagnebin encouraged Vincent to pursue his new calling. "Forget yourself completely and throw yourself into your work without reservation," he advised. Vincent found similar encouragement at the cloistered English Church, where he spent more and more of his Sundays as his devotion to his lessons and to his own church waned. The minister there, William Macfarlane, introduced him to another in Amsterdam's circle of evangelical preachers, an Englishman named August Charles Adler. His mission was converting Jews to Christianity.

A converted Jew himself, the forty-two-year-old Adler had recently come to Amsterdam under the auspices of the British Society for the Propagation of the Gospel Among the Jews, a radical offshoot of the Church of England. With its large and mostly impoverished Jewish population, Amsterdam had long been one of the continental centers for "the fight with Jewish ignorance and darkness," as one account referred to it. Despite fierce and sometimes violent resistance from the local rabbinate, the Society had built a mission church on Barndesteeg, at the edge of the Jewish Quarter.

On February 17, 1878, Vincent began teaching Sunday school in the basement of the Zionskapel. The extent to which he participated in the church's larger evangelizing mission—as measured every year by an announcement of the number of Jews baptized—is not known, as his letters to Theo slowed to a concealing trickle. He may have accompanied Adler on his frequent evangelizing trips into Jewish neighborhoods, or joined the church's crew of colporteurs who delivered the Gospels door to door in the warrenlike Quarter. Adler shared Vincent's love of George Eliot and recommended that he read *Romola*, Eliot's novel based on the great firebrand preacher Savonarola. Vincent admired the bald, bearlike Englishman and no doubt confided in him his new dream of a life serving the needy, of which he considered the Sunday school class the first "small light." "Adler is not the man to let [that light] go out," he told Theo.

The weeks following Vincent's start at the Zionskapel saw a burst of missionary activity and enthusiasm. He proselytized to distant relatives and even at Roman Catholic churches. By the beginning of March, flush with new zeal, he seemed poised to shake loose from his studies and embrace his new mission as a catechist: a simple teacher of the Bible. He would spend his life as a bringer of comfort, an annotator of prints, a maker of maps—as a disciple of *it*.

But Vincent's parents did not share his vision. "A Catechist!" Dorus wailed. "That does not put bread on the table." This was the final indignity. Catechists occupied the lowest rung on the ladder of religious work; they were low-status, low-paid readers of rote and reciters of syllogisms to children. Years of effort and worry, thousands of guilders, sleepless nights, wearying travel, appeals for family support, for what? For a *catechist*? Not that the news was unexpected. Dorus had returned from the February review discouraged about his son's prospects for success. Soon afterward, Vincent wrote a "strange, contradictory letter" complaining about his studies and probably mentioning the dreaded word "catechist" for the first time. That was followed by a letter from Uncle Jan "concerned about [Vincent's] study," At some point, Uncle Stricker, who met with Vincent regularly, added his voice to the rising chorus of worry.

"It is a torment for our souls," Dorus wrote Theo. Anna compared it to a death in the family. "He wants a job in the church but without studying," she wrote in horror; "what a prospect for his honor—and ours!" They blamed this latest

catastrophe on the new company Vincent was keeping—"ultra-orthodox" ministers like Adler, Gagnebin, and Macfarlane—whose radical ideas had led him into "an even higher number of mistakes in his work," according to Dorus. But mostly they blamed Vincent. "There is such a close connection between human errors and sad results," Dorus wrote. "He knows no joy of living." They wrung their hands in exasperation. "We did all we could to set him on an honorable course!" they said. "It is as if he chooses on purpose what leads to difficulties."

Vincent's failure to write on his birthday (March 30) was the last straw. In a stern letter, Dorus demanded that he quit his job at Adler's Sunday school. Vincent objected in a long plaintive reply, but Dorus stood firm, citing "the danger that [Vincent] would give his heart to the lesser thing and that the main thing would be neglected because of it." The dispute seemed headed inexorably toward open defiance. "*Enfin*, we just sit and wait," Dorus wrote with weary resignation. "It is like the stillness that comes before the storm."

In early April, trying one last time to broker a family peace, Theo traveled to Amsterdam to see his brother. Dorus and Anna had kept him vividly informed of their ordeal. But the relationship between brothers no longer had the reparative power it once did. The events of the previous summer had left a bitter aftertaste. Despite continuing protestations of fraternal devotion, Vincent never fully forgave Theo for abandoning his plan to quit Goupil and join Vincent in the pursuit of *it*. Nor did it help that Theo and Dorus had visited each other frequently during the intervening months. Inevitably, Vincent began to question his brother's ultimate loyalty.

In mid-March, his most paranoid suspicions seemed confirmed by the news that Theo would be transferred to Goupil in Paris. After his rebellious episode the previous year, Theo had applied to work in one of Goupil's other branches. He had even learned English in case he was sent to London. But Paris was still the capital of the Goupil empire, and was now also the site of the 1878 Exposition Universelle, an extravaganza of art, science, and technology from five continents. "It is truly an extraordinary chance to cast your eye over that colossal world around you," Dorus wrote proudly. To Vincent, however, Paris was the site of his most painful failure, the family disgrace from which he seemed unable to escape. Now Theo would go to Paris to take Vincent's job—and his legacy—in a devastating rejection not just of Vincent's relentless advice and of their perfect brotherhood, but also of *it*.

If Theo's announcement did not open the floodgates of self-reproach and resentment, the jubilation in Etten surely did. "Dear Theo, remain the pride and joy of the parents who are being shaken so often," they wrote. "It's a ray of sunshine in these uneasy days."

Barely two weeks later, Theo came to Vincent on his peacemaking mission. By all indications, the brothers fought bitterly. The arguments spilled into Vin-

cent's letters in the weeks that followed, as he tried to have the last word against the seemingly irrefutable argument of his brother's success. He lashed out at Theo's easy, superficial life. He mocked his "polite circles" and "fine surroundings." He called him "narrow-minded and over-cautious," and accused him of "straying from all that is natural" and thereby losing his "real and inner life." He contrasted his brother's smooth road to success with his own rocky path, and he dismissed Theo's coming adventure in Paris with an ominous warning: "Though there may be a bright dawn, there is also a dark midnight and a burning, oppressive heat at noon."

As for his career, he had no choice but to go forward as a catechist, Vincent insisted; anything else would be "backsliding." Just turned twenty-five, he needed to "become accomplished" in something: to establish a "way of thinking and acting" independent of his father and his past. He defended Adler and his Sunday-school work with dewy-eyed passion. In response to the inevitable question "What will you do for money?" Vincent turned to a higher authority. "Happy is he who has faith in God," he declared, making an argument that he would spend the rest of his life trying to prove, "for he will in the end be tided over all life's difficulties, albeit not without trouble and sorrow."

If anything, Theo's opposition, like his father's, only stiffened Vincent's resolve. Through page after page of convoluted argument and frantic self-encouragement, he reaffirmed his commitment to *it* in an ecstasy of fervor. "The need is for nothing less than the infinite and the miraculous," he declared, "and a man does well to be satisfied with nothing less." He marshaled long lists of books and poetry and images, in addition to the Bible, to which he intended to dedicate his life as *"un homme intérieur et spirituel."* He would join the ranks of authors, poets, and artists who had "thought a little more deeply and searched and worked and loved a little more than the rest, who [had] plumbed the depths of the sea of life."

When Theo spoke of Vincent's duty to family, Vincent proclaimed a higher duty to *it*—"that divine spark," that "fire in one's soul"—a duty to "keep loving faithfully what is truly worth loving." Of course, he would "encounter genuine sadness and real disappointments," he said, but for love to be true, it must be tested by life—"as gold is tested by fire."

Propelled by this vision of the *"rayon d'en haut"* (light from above), Vincent finally broke openly with his father. In early June, after Dorus's deadline for quitting the Zionskapel had passed, Vincent wrote that he intended to remain a catechist and put off his studies until some later date. Dorus immediately offered a compromise: if Vincent would continue his lessons for at least three months ("to become more enlightened and to give him the patience for reflection"), Dorus would try to find a position for him somewhere. Vincent summarily rejected the

offer. He would not return to his studies, but instead would look for missionary work on his own.

By summer, a battle that began with the feints and retreats typical of Van Gogh family disputes had turned into a bitter confrontation—the "explosion" that Dorus had long anticipated. Vincent later described the break and its aftermath in the bitterest terms: "miserable," "ridiculous," and "utterly foolish. I still shudder when I think of it," he wrote. "*Everybody* I had formerly relied upon changed completely, and left me high and dry." Years later, he would recall ruefully that "a lasting, deep-rooted misunderstanding between Father and myself" began "when I declared that I would not continue with my study in Amsterdam."

And then, suddenly, on July 5, he came home.

AFTER MONTHS OF DECLARING his independence in sweeping, defiant terms, and only a little more than a year after embarking on a seven-year program of study, Vincent's return to Etten marked an abject admission of failure. In later years, he would maintain that he had been railroaded into university study ("I was very skeptical about the plan," he said). He even claimed that he had purposely failed in his language lessons "so that the shame of giving it up fell on me, and on nobody else."

But none of that explains his sudden return home. He could have stayed and pursued his new calling in Amsterdam, a city with poverty and oppression of its own, teeming with missions and missionaries. Or he could have carried out his threat to seek a position elsewhere with one of the "ultra-orthodox" churches scorned by his father, like Adler's, which had missions throughout Jewish communities in Europe and the Middle East. Instead, he agreed to come home and wait for his father to find him the "suitable" position he had defiantly rejected. He would abjure radical evangelism and the pursuit of *it*. He would return to a "respectable" path for preaching the Gospel in exchange for one more chance at reconciliation.

The surrender was complete. Even before he came home, all of his independent activity ceased, from teaching Sunday school to writing Theo. When Dorus determined that Belgium was the best place to find a position, Vincent stopped looking anywhere else. The requirements for preaching in Catholic Belgium were far less rigorous than in Holland. "Respectable, clever people should certainly do well there," Anna reported hopefully, "even without diplomas." While still in Amsterdam, Vincent dutifully wrote long letters following up on his father's inquiries and offered to travel to Brussels to plead his case face-to-face. In mid-July, Dorus arranged an interview for Vincent with an evangelical school in

Brussels. Father and son traveled there together, accompanied by the Reverend Thomas Slade-Jones from Isleworth, who mysteriously materialized just in time to give Vincent a good recommendation in person.

While waiting to hear from the school, Vincent did his best to play the good son. He took long walks with his brother Cor, an ebullient eleven-year-old who loved to draw and wanted to be a cavalry officer when he grew up. On a hot summer day, they sat in the shade and drew "a little map of Etten and surroundings," Vincent reported. He helped with preparations for the big event of the summer: the wedding of his eldest sister Anna to Joan van Houten, a proper, prosperous burgher from Leyden, by making arrangements of flowers and greenery. He followed his father like a shadow, often accompanying him on his parish rounds during the week and his preaching duties on Sundays. When Dorus was away, Vincent sat in his room overlooking the garden and composed sermon after sermon in preparation for his life to come.

In July, Vincent accompanied his father to Zundert, where Dorus preached in the little church and afterward visited the sick. On the way home, Dorus stopped the carriage and they walked the heath together in the evening light. This was as close as Vincent would ever come to the reconciliation he so desperately sought. He recorded the moment in an image fraught with *it:*

> The sun was setting red behind the pine trees, and the evening sky was reflected in the pools; the heath and the yellow and white and grey sand were so full of harmony and sentiment—see, there are moments in life when everything, within us too, is full of peace and sentiment, and our whole life seems to be a path through the heath.

The days leading up to his departure were filled with public cheer but private turmoil. He fought with the bride ("Vincent is more obstinate than ever," Anna complained) and shrank from his social duties. "He is more withdrawn than ever," his mother wrote on the eve of the wedding. The appearance of Uncle Cent and Uncle Stricker at the ceremony on a beautiful August day could only have added to the aura of failure and rejection, as he prepared once again to leave the only life that he truly longed for.

Four days after the wedding, Vincent set out for the evangelical school in Brussels that his father had chosen for him. He would begin with a three-month "trial." If he successfully completed that, he would be allowed to enroll in the school's full three-year program. As they saw him off at the train station, his parents' thoughts were filled with dread. "We see him leave with worry," Anna wrote Theo. "His ideas about daily life are so unhealthy that I think he will not be able to teach it to people." (Sister Anna put it more bluntly: "I fear that his pig-headedness [will] be an obstacle in his new position.") Dorus cloaked his

fears in resignation. "I have no illusions about Vincent," he wrote; "I cannot escape the fear that we will be disappointed again."

IN FACT, THE BRUSSELS "school" was a mirage. Launched only two years earlier, it consisted of one room, five students (three full-time and two part-time), and one teacher. The lessons were taught by Dirk Bokma, a one-legged former elementary school principal, assisted by a handful of like-minded local evangelical preachers who occasionally dropped by and taught for free. Otherwise, the school had no permanent faculty, no administration, and no funding.

Buffeted by fierce sectarian rivalries within Belgium's tiny evangelical community, the school never found an institutional anchorage and survived only on the passion and energy of its founder, Nicolaas de Jonge, an "unorthodox" young preacher, and the indulgence of a few wealthy sponsors. In a country where evangelism had long been dominated by foreign missionaries—especially Dutch and British—De Jonge preached a radical religious nativism. The only way to reach the people with the Gospel, he insisted, was to speak to them in their language, Flemish, not the "posh Dutch" of Reformed preachers like Dorus van Gogh. "Flemish is for Flanders!" was his rallying cry.

That Dorus sent his son to De Jonge's crusading, quixotic school, or that Vincent went, is the clearest sign of their mutual desperation. Like any Dutch speaker, Vincent could understand and converse in Flemish. But his father's formal preaching style marked him as an outsider in a school dedicated to "the dialect of the masses" and opposed to "dutchification." The unfamiliar idiom, combined with his tendency to overload his talks with allusions and complex rhetoric, forced Vincent to read rather than preach his sermons—a violation of the school's mandate "to give popular and attractive lectures, more short and interesting than long and learned." On Sundays when he gave Bible lessons in nearby Mechelen and Lier, he felt "like a cat in unfamiliar surroundings," Vincent confessed—a long way from the "popular orator" he aspired to be, "[with] the ability to speak to the people with seriousness and feeling, fluency and ease." The rest of the week, he spent as much as fourteen hours a day in the little classroom laboring yet again through history, Latin, and the Bible, all taught in Flemish.

The prospect of another failure drove Vincent into a spiral of depression and self-abuse. At his boardinghouse in Laeken, north of the city, he refused food and slept on the floor rather than in his bed. Through a cold autumn, he went without adequate clothing on his long walks into the city along the Charleroi canal. At school, he disdained to use his desk, choosing instead to keep his copybook on his knees in a way that reminded his scornful classmates of "a scribe from the Middle Ages." As in Amsterdam, he sought solace in graveyards and

in long wandering walks to the margins of the city where, he said, "one gets a peculiar pristine feeling like that of homesickness, in which bitter melancholy plays some part."

Years later, Vincent's classmates recalled him as a surly, wounded, volatile student who could be defiant and disrespectful one minute—"Och teacher, I really don't care"—and "furiously indignant" the next. "He did not know what submission was," one of them said. Once when a fellow student teased him, Vincent struck out at his tormenter with "such a blow that he did not come back for more," according to a witness. "Oh! that face blazing with indignation and wrath! . . . I shall never forget it. How deplorable that [a man] so devoted to God could so forget himself." A visit by Theo on November 15 must only have made failure more intolerable. Returning triumphantly from Paris, where he had manned Goupil's booth at the Exposition Universelle, Theo had unequivocally assumed the mantle of his uncle's heir and his family's pride. He even looked like a new man, with a smart, reddish beard. The contrast with his lost, despondent, and increasingly embittered brother could not have been more stark.

No one could have been surprised when Vincent failed his three-month trial. He would not be allowed to continue in the school's program. His teacher-ministers found "no signs of [his] being a diligent student." Out of deference to his father, no doubt, they agreed to allow Vincent to continue attending classes, but they could not support him in any way. To Theo, Vincent explained the setback matter-of-factly: "I cannot attend the school on the same conditions as they allow to the native Flemish pupils," he wrote. But nothing could conceal the shame in Etten. Dorus and Anna despaired at the latest debacle. "We have not told anybody about this," they wrote Theo, "don't you, either . . . What is going to happen?"

Vincent was devastated. He had failed yet again, this time on the very lowest rung of religious training. Where could he go from here? After the final verdict, he could not eat or sleep. He fell ill and lost weight so precipitously that his landlord felt compelled to write his parents and ask them to "come and take Vincent home." "He does not sleep and seems to be in a nervous state of mind," Dorus told Theo at the end of November. "We are very worried." Without telling Vincent, Dorus laid plans to come to Brussels. In the meantime, however, Vincent resolved to leave. "In order to stay here longer I ought to have more financial means than I have at my disposal," he wrote Theo, "for they are nil." In fact, his father had offered to continue paying for his board in Brussels while he looked for other employment. But Vincent rejected the offer.

THE DEEPER VINCENT SANK, the more tightly he clung to *it*. Only weeks before leaving Etten, he had written Theo, "*It* has been a remarkable feature in

art and will continue to have a great influence on many people." At least once during his short stay in Brussels he went to the Musées Royaux des Beaux-Arts. His sole surviving letter from Brussels brims with talk of art and artists. He saw *it* everywhere: in an old house covered with vines "like a picture by Thijs Maris"; in a "Gothic" alley of linden trees with the gnarled stumps and twisted roots of a "fantastical Albrecht Dürer print." When Theo visited, the brothers spent almost all their time looking at paintings and browsing prints. "How rich art is," Vincent wrote afterward; "if one can only remember what one has seen, one is never empty of thoughts or truly lonely, never alone."

He continued to search for "whole expressions"—composite images that "speak in their own way, if we only listen to them." At the evangelical school, he drew pictures on the blackboard to "complete" his answers to teachers' questions. On his wandering walks through the city's "Quartier de l'Industrie," he transformed glimpses of "picturesque" workshops into meditations on mortality ("They say: 'Work while it is day, the night cometh when no man can work' "). The sight of old horses pulling their ash carts "utterly alone and desolate" became for him both a lesson in the meaning of life, and a reflection of his own bleak fate: "The poor horse . . . standing there patiently and meekly, yet bravely and unflinchingly . . . awaits its last hour."

But no image was more complete than the one Vincent created on the eve of his departure from Brussels. He began with a description that he found in "a little handbook of geography" of a region in southern Belgium called the Borinage. Like his beloved prints, the handbook painted a portrait of the region's inhabitants, the Borins, both endearing and suffused with deeper significance:

> [They] find their work exclusively in the coal mines. . . . The miner is a special Borinage type, for him daylight does not exist, and except on Sunday he never sees the sunshine. He works laboriously by a lamp whose light is pale and dim, in a narrow tunnel . . . he works in the midst of thousands of ever-recurring dangers; but the Belgium miner has a happy disposition, he is used to that kind of life, and when he descends the shaft, carrying on his hat a little lamp that is destined to guide him in the darkness, he trusts himself to God.

Onto this moving description of labor and faith Vincent layered a reverie of scripture: Isaiah's prophecy that "the people who walked in darkness have seen a great light" and the Psalms' promise that "Unto the upright there ariseth light in the darkness." To this he added from his own life both a memory of applying for missionary work in the coal mines of England, and a wish for the future: that he, too, might someday find a light in the darkness of failure and shame. "It always strikes me," he wrote, "that when we see the image of indescribable

and unutterable desolation—of loneliness, of poverty and misery, the end of all things, or their extreme—then rises in our mind the thought of God."

To complete this image, Vincent made a drawing.

He took as his subject a little café that he saw on one of his frequent walks along the Charleroi canal, the spine of industrial Brussels. The café was attached to a big shed where coal was brought from the mines in the south of the country by canal barge. With the coal came the people who mined it, driven from their homes by unemployment and economic crises in hopes of finding work in the foundries and factories that lined the canal. "One sees here so many people that work in the coal mines," Vincent reported, "and they are rather a characteristic kind of people."

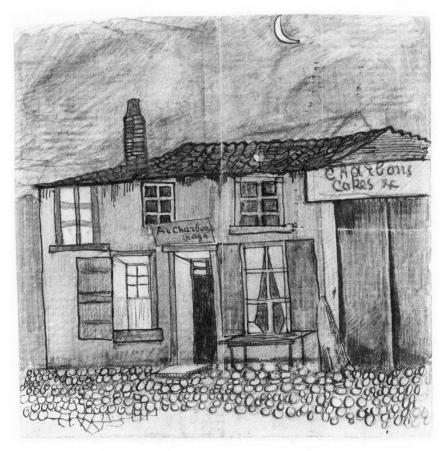

The "Au Charbonnage" Café, NOVEMBER 1878,
PENCIL AND INK ON PAPER, $15^1/_2$ x $15^1/_2$ IN.

These were the miners from the Borinage that he had read about in his geography book. They congregated every day in the welcome of this little café,

called Au Charbonnage [to the coal fields]. "The workmen come there to eat their bread and drink their glass of beer during the lunch hour," he wrote.

He drew the café, lavishing all the facility at his command on this "scratch," as he called it, barely bigger than a postcard: the shallow, sagging roof; the sad, stained stucco; the little sign over the door (in his own handwriting); the hard cobblestones outside and the soft curtains inside. He added a benevolent crescent moon and shaded the whole image to a twilight gray with a touch so soft that the pencil strokes were barely visible. He left unshaded only the welcoming gaslight from two windows and a transom over the door—the "light from within." When he was finished, he carefully folded the drawing and put it in a letter to Theo as an announcement: He, too, was headed *au charbonnage*—to the coal fields.

A WEEK LATER, he was gone. In a weakened condition, in the dead of winter, with no means of support, no plans, and no prospects, he left for the Borinage to pursue the chimera of *it* that he had created. He left so quickly that he may have been gone by the time his father arrived to take him home. "I shall make myself scarce," Vincent admitted later, was the thought that drove him out of Brussels. If their paths did cross, Dorus no doubt tried to console his wayward son with the same message he had preached to his congregation on the eve of leaving Etten: "I am the sower. Shortsighted people have rejected many fields that through the sower's hard work produced good fruit. That same sower will not abandon any of his children."

But Vincent had a different Bible verse on his mind, and only days before leaving Brussels he began writing a sermon on the parable of the "barren fig tree" about a man who waited season after season for his fig tree to bear fruit, until finally, in despair, he cut it down.

Vincent later told Theo that he went to the Borinage to prove "that I did not lack courage." At the time, he justified it to himself (and, no doubt, to his parents) as yet another proof of his devotion. He promised he would "learn and observe" and come back "having something to say that was really worth hearing"—a "better and riper" man. More than a year earlier, however, in one of his rare flashes of electrifying candor, he had confessed the true reasons for his headlong rush to nowhere:

> When I think the eyes of so many are fixed on me, who will know where the fault is if I do not succeed, who will make me reproaches . . . the fear of failure, of disgrace—then I also have the longing: I wish I were far away from everything!

The Black Country

~

T HE TRAIN TOOK VINCENT TO A PLACE NOT SHOWN IN ANY GUIDEBOOK. To a boy who grew up on the unspoiled heath of Zundert, the surface of the moon could not have appeared stranger. Here and there across a flat horizon rose huge black cones: abrupt, singular, featureless; too stark to be natural, too big to be man-made. On some, grass had begun to grow; others still steamed from inexhaustible inner fires, like great boils on the landscape. "The whole region seems to have been eaten away by an enormous ulcer," wrote another visitor to the Borinage;

> the air is smudged the color of soot beneath the slow and relentless outpouring of coal; the soot that belches endlessly from the tall chimneys covers the countryside and it seems sickly, laid to waste in the eddying smoke, as if convulsed, ravaged and swollen with the abscesses of the slagheaps of the coal mines.

Barely a tree interrupted this desolate vista. Except for a few small gardens, cultivation of any kind had retreated from the black assault of the huge, exhaling slagheaps. Even in summer, one visitor noted, the land was so stripped of greenery that "it stirred one's heart to see the dusty leaves of a dried-up geranium on a window-ledge." In the winter, snow turned gray as it fell. When it melted, the gray soil turned black, roads turned into tarlike mud so thick it sucked the shoes off travelers' feet, and water ran black in the streams. Even on days that should have been clear, gray vapor from the slagheaps and soot from the smokestacks hung in the air, blurring the boundary between ground and sky. Nights descended into a starless, netherworldly darkness. Locals called it *le pays noir*—the black country.

In the featureless brick and stucco towns that punctuated every mile of sunken roads, Vincent met the real Borins: the black people of the black country. "The people are quite black when they come out of the dark mines," he reported to Theo; "they look exactly like chimney sweeps." Not just the men, but whole families wore the stain of the mines. Children worked because only their tiny bodies could squeeze through the fissures in the earth where the coal hid; wives, because their families needed the money. After work, the men squatted on the doorsteps of their tumbledown cottages and smoked, while the women— "artificial negresses," one observer called them—dragged children "with the faces of old people" to fetch water for the daily *dénoircissement*—unblackening.

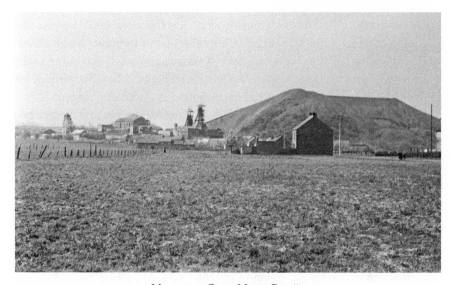

MARCASSE COAL MINE, PIT #7

For the men the *dénoircissement* no longer worked. Most bore the permanent marks of scratches and grazes in the mines, the white skin of their arms and chests tattooed "like blue-veined marble." Indeed, they bore all the scars of their labor: tired, bent-over bodies (life expectancy averaged forty-five years); emaciated, weather-beaten faces; the memory of loved ones lost to the mines; and the knowledge that their children would follow them into the earth because, as Émile Zola wrote, "nobody had yet invented a way of living without food." Every morning, as husbands, sons, and daughters said good-bye to wives and mothers, they wept, according to another account, "as though they were never going to return."

In a "vast, dismal human herd" they headed to the mines. In the winter, they set out before the first gray of dawn, by lamplight, toward the ominous beacons of the blue-flamed blast furnaces and the coke ovens' red glare. In every coal town in the Borinage, the mine overshadowed all else. With its mountain of

slag, its towering chimney and fantastical metal scaffolding, the mine could be seen and smelt for miles around. And heard. The earsplitting sound of its great turning wheel, the panting exhaust of its massive engine, the thundering of its ironworks, and the incessant ringing of bells that marked its every heaving movement spread across the landscape almost as far as its choking cinders. Surrounded by high brick walls indistinguishable from fortifications, and a moat of cinder and stinking gas, the mine swallowed thousands of workers every morning "like some evil beast," wrote Zola in *Germinal,* his novel set in a French coal mine just across the border, "struggling to digest its meal of human flesh."

SOMEHOW, VINCENT FOUND new energy for the new task. Despite the self-inflicted rigors of his life in Brussels, he arrived in the Borinage "well-dressed" and "display[ing] all the characteristics of Dutch cleanliness," according to the minister who greeted him. To spare the French-speaking Borins the perils of his difficult Dutch name, he presented himself simply as "Monsieur Vincent."

Armed with his father's recommendation, passable French, and replenished ardor, he soon found a position in Petit Wasmes, one of a cluster of small towns that cowered together in the shadow of the Marcasse and Frameries mines. There a small congregation had just started its own church and was, by law, entitled to a state-paid preacher. While that position was being finalized, the regional evangelical committee agreed to give Vincent a six-month trial as a "lay preacher and teacher of catechism." They offered him a small salary and, after a brief stay with a colporteur in nearby Pâturages, installed him with one of their most prosperous members, Jean-Baptiste Denis, a farmer who lived with his five sons in a "rather fine house" in Petit Wasmes.

Vincent immediately started a catechism class for the children of the congregation. He read to them, led them in hymns, and taught them Bible stories using maps of the Holy Land that he drew. In the evenings, he visited members' houses, where small groups gathered for devotional "classes." He also visited the sick, "since there are so many of them here," he told Theo. "I have just visited a little old woman [who] is terribly ill, but full of faith and patience. I read a chapter with her and prayed with them all." His initial letters home were filled with enthusiastic reports of his new ministry. "It's the kind of work he likes to do," Anna wrote, entertaining yet another cautious hope. "He is so content there." These early reports impressed even his wary father. "He seems to work with success and ambition," Dorus wrote Theo in January. "We are so glad for him. "

Because it had only recently split from the church in Wasmes, Vincent's new congregation had to meet in an old dance hall, the Salon du Bébé. The hall, which seated almost a hundred, had already been adapted for religious use in a region awash in evangelical missions. In his attic room at the Denis house,

Vincent prepared sermons for the workmen and farmers who shuffled into the Bébé every Sunday. He took up again the message of the preacher from Lyon: "We should think of [Christ] as a workman," he preached, "with lines of sorrow and suffering and fatigue on his face." Who could better understand the life of a "workman and laborer whose life is hard," he asked, "than the son of a carpenter . . . who labored for thirty years in a humble carpenter's shop to fulfill God's will"?

For inspiration, Vincent had only to look outside at the dreary procession of miners that passed under his window every morning: men and women dressed in identical "pit rags," their clogs clattering in the predawn darkness. Or every night, fourteen hours later, when they returned—"just the same as yesterday, and just the same as tomorrow," according to one account, "as it has been for hundreds of years. Like true slaves."

It was only a matter of time before Vincent's fervor drove him to join the gray line filing into the earth.

"It is a gloomy spot," he wrote about his visit to the Marcasse mine, one of the oldest, grimmest, and most dangerous in the area: "poor miners' huts, a few dead trees black from smoke, thorn hedges, dunghills, ash dumps, heaps of useless coal." He made his way to the pit-head through the vast, surreal townscape of the mine complex: the tarpaulin-covered screening shed, the winding house, the drainage pump tower, the coke ovens and blast furnaces. In the distance, slag horses made their slow way up the sides of the black mountain dragging tub after tub of cinder and refuse coal. He probably passed through the locker room, where a huge coal-fired stove gave miners what Zola called "a good skin-full of warmth" before they headed down.

But nothing could have prepared him for the pit-head, a cavernous brick building palled in grimy windows and furious with motion: the shiver of the big copper engine, the churning of its steel arms, the ceaseless throbbing of its exhaust; the thunder of heavy tubs rumbling across the iron floor; the whining of inky cables flying overhead. The cables passed from the engine's great wheel through greasy pulleys suspended from an iron framework that towered over the pit-head like a skeletal steeple. The screeching of the pulleys announced the arrival and departure of the cages as they appeared from the depths with loads of coal and then dived down again filled with miners—"swallowing men as though the pit were a mouth gulping them down," wrote Zola.

The cage plunged 635 meters, dropping "like a stone" more than a third of a mile. Miners stood barefoot, lamps in hand, huddled together in empty coal tubs, as the guide beams in the shaft "flew past like a rail under an express train." The air turned intensely cold and water began to rain down on the cage from the shaft walls: first a trickle, then a deluge. They flew past three abandoned levels: so deep that the miners referred to the world above as "up in Hell"; so deep that

the daylight visible at the top of the shaft dwindled to a spot as small as a star in the sky.

From the hewn "hall" at the bottom of the shaft, galleries radiated out in every direction in search of the elusive coal seams, some only inches thick, folded like loose drapery throughout the rocky underworld. As Vincent stumbled down one of these dark alleys toward the distant din of picks, the timbered roof and plank walls lowered and narrowed—he compared the tunnels to "big chimneys." Puddles of water on the floor spread into a seamless pool. The temperature quickly rose from the freezing hurricane at the shaft, where ventilation was best, to the warmer, windless air of the galleries. Eventually, he was walking bent over through ankle-deep water in "suffocating heat, as heavy as lead."

Now and then he heard a dull roar in the tunnel ahead "like the rumbling of a storm." Seconds later an apparition would materialize in the darkness: a horse pulling a train of full tubs. He had to flatten himself against the jagged, slippery walls to let it pass. The miners envied the well-fed horses, who lived their entire lives underground in comfortable warmth and the "good smell of fresh straw kept clean." Deeper still, where the horses couldn't go, pit-boys and haulage girls dragged the tubs: the boys shouting foul language as loudly as they could, the girls "snorting and steaming like overloaded mares," as Zola described them.

Finally, he came to the miners. The gallery did not end so much as fray— dissolving into an ambiguity of tiny chimneys and impossibly narrow tunnels that "seemed to go on forever," he said. At the end of each one, a miner toiled alone in the darkness. Vincent called these tiny niches *"des caches"*: "hiding places, places where men search." He compared them to cells in "an underground prison," or "partitions in a crypt." "In each of those cells," he explained to Theo, "a miner in a coarse linen suit, filthy and black as a chimney sweep, is busy hewing coal by the pale light of a small lamp."

Vincent's trip into the Marcasse mine in January 1879 represented the high point of his two years in the Borinage. He would descend into the earth at least once more during his stay (in March of that year), but by then he had begun a much more perilous descent: a descent into depths that he would not visit again until ten years later when he was confined in a hospital in Arles for insanity: a descent into the blackest country of all.

THE DROP BEGAN almost immediately. "We are beginning to worry about him again," Dorus wrote only weeks after Vincent began his ministry at the Bébé; "troubles show on the horizon." The Borins did not take to their new preacher, nor he to them. Vincent's geography-book vision of devout miners confronting darkness and death with a "happy disposition" quickly foundered on the reality of a reticent, clannish people. When he first arrived, he described them to

Theo as "simple and good-natured." Before long, they had become "ignorant and untaught"—"nervous," "sensitive," and "mistrustful."

He puzzled over their strange regional dialect "which comes out with amazing speed," he complained. He tried to keep up by speaking his Parisian French as fast as possible—a strategy that only resulted in more misunderstandings and at least one angry altercation. He seemed surprised to discover that most of his congregation could not read, and soon lamented that, as "a man of culture and decency," he could not find "companionship" in such "uncivilized surroundings." The miners, too, recognized their new preacher for a stranger. Attendance at his sermons, which he gave in French, started "haphazardly" and soon fell off. Lacking "a miner's character and temperament," Vincent lamented, he would "never get along with them or gain their confidence."

As he always did when reality threatened, Vincent withdrew deeper and deeper into delusion. He stoutly defended the "picturesqueness" of the blighted landscape and the "charm" of the Borins. He compared the black slagheaps to the lovely dunes of Scheveningen. "One has a homelike feeling here," he maintained, "like on the heath." Even his trip into the mine could not break his hold on the vision of *it* that had summoned him to the Borinage. He called his six-hour visit to the hellish Marcasse mine "a very interesting expedition." His account of it reads like a naturalist's report on the habitat of bugs or birds: filled with technical terms (*maintenages, gredins, accrochage, tailles à droit, tailles à plat*), but not a word of outrage or empathy. While acknowledging the mine's "bad reputation"—"because many perish in it, either going down or coming up, or through poisoned air, firedamp explosion, water seepage, cave-ins, etc."—he insisted that life in the mines was better than life in the desolate villages above; and that the miners preferred the permanent night of their work to the "dead and forsaken life" of the upper world, "[just] as mariners ashore are homesick for the sea, notwithstanding all the dangers and hardships which threaten them."

Vincent barricaded his delusion with images. Everything from the desolate landscape to the sight of injured miners reminded him of a favorite print. The deadly fog created "a fantastic chiaroscuro effect" like "pictures by Rembrandt." He thought Matthijs Maris might make a "wonderful picture" of the "emaciated, weather-beaten" miners. And if any artist could paint the miners at work in their Stygian cells, he imagined, "[that] would be something new and unheard of."

Rather than recognize the pandemic of real suffering all around him, he returned to the images of suffering in his favorite books. "There is still so much slavery in the world," he wrote about *Uncle Tom's Cabin*, "and in this remarkably wonderful book that important question is treated with so much wisdom, so much love, and such zeal and interest in the true welfare of the poor oppressed." Although he never recorded a disapproving word about the treatment of the

miners in the Borinage—a region notorious even in an insensitive era for its horrendous working conditions—he hailed Dickens's *Hard Times* as "a masterpiece," for its "moving and sympathetic portrait of a working man." At one point, he seemed to admit preferring the facsimile of the poor and oppressed that he found in prints and books to the reality outside his window. "A picture by Mauve or Maris or Israëls," he insisted, "says more and says it more clearly, than nature herself."

He preached his delusion. Vincent had come to a region boiling with labor unrest. In the thirty years since Marx and Engels wrote *The Communist Manifesto* in nearby Brussels, the coal miners of the Borinage had spearheaded a socialist workers' movement that would eventually sweep across the Continent. Wave after wave of bloody strikes and brutal suppressions had spawned a militant union movement supported in communities like Wasmes by a network of clubs, cooperatives, and *mutualités,* all determined to redress the cruelty and injustice of the new capitalist order.

But Vincent's vision of the miners as Christian heroes did not admit of victimhood. Their misery, like his own, brought them closer to God. They needed Thomas à Kempis, not Karl Marx. Rather than rebel, he exhorted them to celebrate their suffering—rejoice in their sorrow. "God wills that in imitation of Christ, man should live and walk humbly on earth," he preached, "not reaching for the sky, but bowing to humble things, learning from the Gospel to be meek and humble of heart." He had come expecting the miners, as the people who "walked in darkness," to embrace this Kempian message of serene resignation—for him, the ultimate comfort for the wretched and oppressed, just as it was for the ash-cart horse.

Through strikes and work stoppages and "rebellious speeches," some of which he attended, Vincent clung to that vision. "Child of God, exiled on the earth," he underlined in the dog-eared psalmbook that he used at the Bébé, "raise your eyes, a little patience, and you will be consoled, going toward God." But in a community seething with grievances, where wages had fallen by a third in the previous three years and people died by the hundreds in explosions and cave-ins and unchecked epidemics, Vincent's message only separated him further from the "poor creatures" that he longed to comfort.

Only one path to consolation remained to him: ministering to the sick. The mines of the Borinage discarded hundreds of broken workers every year, burned and crushed, poisoned by gas or cinders or horrific hygiene. The diseased and the dying did not question Vincent's delusions or parse his sermons. They welcomed the strange Dutchman for the help he offered when so few others did. "There have been many cases of typhoid and malignant fever," he reported to Theo. "In one house they are all ill with fever and have little or no help, so that the patients have to nurse the patients."

Vincent threw himself into this tide of suffering with selfless abandon. He visited households quarantined for typhus, offered to do chores, and sat vigil for days. After mine accidents and explosions, he rushed to help care for the injured, including one man who was "burnt from head to toe." He ripped linen bandages and applied them with wax and olive oil that he sometimes paid for himself. He worked "day and night," according to one account, sitting beside sickbeds praying and evangelizing, and "fell to his knees with fatigue and joy" when patients recovered.

But it wasn't enough. Before long, Vincent returned to the familiar dark spiral of self-blame and self-abuse. He refused all food except for bread—no butter—and a gruel of rice and sugar water. He neglected his clothes, washed infrequently, and often walked in the bitter winter weather without a coat. As in Amsterdam and Brussels, he found his accommodations "too luxurious," and soon moved from the Denis house in Petit Wasmes to a tiny abandoned thatch-roofed hut nearby. He rejected the comfort of a bed and sought out "the hardest wood" from which to make a plank for sleeping. He hung his prints on the hut walls and withdrew deeper and deeper into his private world: tending the sick and injured by day; reading, smoking, studying the Bible, and underlining his psalmbook by night. He lost weight until Denis's wife feared that in his weakened condition, exposed in his little hut, he would fall victim to the typhoid epidemic that raged all around.

Denis and others in the congregation considered the shack unbefitting a preacher and complained angrily about Vincent's *"folie religieuse."* Vincent defended himself by citing Kempis—"the Lord had nowhere to lay *his* head"— but his accusers took that as blasphemy. The combination of dissatisfaction with his preaching, the bizarre self-abasement of his new home, his stubborn refusal to heed advice, and even his manic ministrations to the sick prompted church members to summon an inspector from the Evangelical Committee in Brussels to review their new preacher's appointment—a clear threat to dismiss him. Only a month after starting his new life, Vincent once again faced imminent failure.

The news came as no surprise in Etten. His letters, with their tales of horrible injuries, rampant disease, and journeys into coal mines, had only fueled his parents' anxieties. Dorus feared that "being so absorbed in taking care of and watching over the sick and wounded" might distract Vincent from his religious duties. Anna fretted over his appearance because "it must be so dirty there." They had also received a letter from Madame Denis detailing "the miserable life [Vincent] was leading" in his thatched hovel; as well as one from Vincent himself "confirming our worry that he had no bed, no bedclothes, and no laundry facilities," Anna reported. In response to the uproar among his congregation, he defied his accusers—"it's none of their business"—and again defended his

actions by invoking Kempis: "Jesus also acted calmly in the storm," he wrote, "and the tide might turn."

But Dorus knew better than to wait. Dodging winter storms, he set out for the Borinage on February 26. By the time he arrived, the inspector, Reverend Rochedieu, had already come and heard the grievances against the new preacher. Rochedieu concluded that Vincent had shown "a regrettable excess of missionary zeal" and delivered a "vigorous lecture" to the wayward young preacher. But apparently it had not been enough to dislodge Vincent from his hut, because that is where his father found him, "lying on a straw-filled sack, and looking appallingly weak and emaciated," according to an eyewitness account.

Vincent "suffered himself to be led away like a child," according to the same account, and the next day Dorus took him on a penance trip through the gray snow to visit the three local clergymen in whose hands his fate now precariously rested. In the spirit of the persistent sower, he talked with Vincent about "plans for improvement and change and generating energy." He extracted vows that Vincent would look after his appearance, obey his church superiors, and only use the little hut "as a workshop or study."

But no one was fooled. "He is too obstinate and stubborn to take any advice," Anna despaired. To Theo, Vincent painted a delusional picture of his father's visit: "He will not easily forget the Borinage," he wrote the next day; "no one who visits this curious, remarkable and picturesque region can." But soon after Dorus left, Vincent was seen spitting on the Denis house. "Perhaps," he wrote his parents defiantly, "things should get worse before they can get better."

THE EXPLOSION CAME without warning. The invasion of picks, lamps, and air released forces that had been locked in the earth since its formation. Colorless and odorless, the gas built up in the mine with each blow of the pick, each fall of rock, each load of coal. It took only a single spark—from a malfunctioning lamp or friction on the tub rails—to set it off. That is what happened on April 17, 1879, at the Agrappe mine in Frameries, only two miles from Wasmes.

A flash of methane's distinctive blue flame began the chain reaction. The explosion sent a wall of pressure down the narrow corridor strong enough to hurl men the length of the gallery and jam them into cracks in the coal face. Veteran miners knew when they heard the rush of gas—"firedamp," they called it—to dive to the floor, for it was followed instantly by a flame like a blowtorch— the flash—at head height. The wind sucked coal dust from every crevice and suspended it in the air just long enough for the flash to ignite it. Coal dust could turn even a small firedamp flash into a runaway inferno as wind and then fire roared through the mine as if through the barrel of a gun. The pressure wave lifted roof beams off their props, causing new falls; it twisted rails, and hurled

empty tubs through the galleries like bullets. The fire raced through the tunnels at a thousand miles an hour, charring everything in its path—tools, horses, men, children—with the ferocity of a blast furnace.

The disaster underground announced itself to the world when the wind and fire found the shaft and exploded out of the pit-head with a stupendous roar—"like the report of a gigantic cannon," according to one account. The hoist man who operated the cages was incinerated instantly. Soon afterward, a huge bubble of unignited gas rushed up the ventilation shaft nearby and burst into a great ball of flame in the middle of the mine complex. Young girls working in the sorting shed were burned beyond recognition. The pit-head exploded again and again, hurling hundreds of tons of coal and rock into the air. One explosion threw up clothes that the updraft had stripped from dead miners.

An immense "column of fire," visible for miles, and huge clouds of black smoke soon signaled to the surrounding countryside the cataclysm under way deep in the earth. Women and children streamed onto the roads, hurrying toward the spreading black stain in the sky. As the first of them neared the mine, they could hear the terrifying sound of the muffled explosions still going on, hours later, and feel the ground shake. They quickly filled the mine courtyard, where they watched with "gasping hope" as survivors stumbled out with black, puffed faces and stretcher after stretcher was borne either to the infirmary or to the chapel. Shouts of anger and curses soon mixed with wails of grief as the charred bodies piled up and the magnitude of the tragedy became clear. (One hundred and twenty-one miners died.) The police eventually had to close the gates to prevent a riot of anguish and outrage.

It is impossible to imagine that Vincent van Gogh did not participate in the panorama of suffering and solace that filled the courtyard of the Agrappe mine that day and in the following days. While fatherless children and childless mothers wept inconsolably, others waited in an agony of uncertainty to hear the fate of family members still unaccounted for (it took five days to bring the last survivors up). Word spread that almost a hundred miners were trapped behind a rock fall. Rescuers could hear the howls of the injured. Every mining family knew the horror of "afterdamp," unexploded gas still in the mine that could suffocate a man in minutes. Trapped miners sang to keep themselves from "falling into the gas." Vincent had to be moved by the image of the imprisoned miners, fearing death at any moment, raising a hymn of hope from the total darkness.

Soon after the disaster, the funeral processions began. Part mourning, part protest, they wound through the shrouded landscape in black trains by the score, a grim multiple of the icon from Vincent's childhood, *Funeral Procession Through the Cornfields*. The grieving extended beyond the Borinage to all of Belgium, where the worst mine accident in a decade ignited labor protests and stirred a moribund government to demand improvements in mine safety. It

extended even to Etten. "It is awful, that terrible accident," Dorus wrote Theo. "What a situation for those people—buried alive and almost no hope of being saved in time." But Dorus also saw the potential danger for his sensitive, unstable son. "I hope it will not cause difficulties for Vincent," he added. "With all his strange quirks, he shows true interest in those miserable people. And God will surely notice that. Oh, if things would only go well for him!"

But they did not go well. Almost as soon as his father left the Borinage, Vincent returned to his defiant, delusional mission. In what one witness called a "frenzy of self-sacrifice," he gave away almost all his clothes as well as the little money he made; even the silver watch that he had tried once before to disown. He tore up his underclothes for bandages. In March, he returned the money his father sent for his board, an indication that he had moved back into the hut. In response to Rochedieu's demands that he curb his excessive zeal, Vincent pursued his medieval vision of piety even more intently, denying himself the pleasures of food, warmth, and bed. He went barefoot in the winter and donned the sackcloth garments the miners wore. He stopped bathing altogether, dismissing soap as a "sinful luxury." He spent more and more time with the sick and injured and declared himself "prepared to make any sacrifice to ease their suffering."

After the mine explosion in April, Dorus and Anna briefly entertained a hope that Vincent might make himself "useful" in the recovery efforts, about which he kept them suspensefully informed. But if anything, the disaster at Frameries only accelerated the downward spiral.

In July, the Evangelical Committee decided to terminate Vincent's ministry. The Committee's formal report cited only his poor preaching as the reason for his dismissal. "A talent for speaking [is] indispensable to anyone placed at the head of a congregation," it read. "The absence of that quality renders the exercise of an evangelist's principal function wholly impossible." But his parents—and probably Vincent himself—knew the real reason. "He does not yield to the wishes of the Committee," Dorus wrote. "Nothing will change him. It is a bitter trial."

The Committee gave him three months to find another situation, but continuing his ministry in Wasmes until then was unthinkable. The constant warnings and rebukes from his superiors, and his own increasingly eccentric behavior, had turned his congregation against him. In meetings, they insulted him and openly mocked his strange ways. The children in his beloved catechism class rebelled against him. No doubt echoing their parents, they called him *"fou"*—crazy—the first time that that word appears in the record. Nor could he go home; the prospect of another early return from a failed mission clearly overwhelmed him with guilt and shame. "We invite him to come home," Dorus wrote, "but he does not want that at all."

In a last-ditch effort to salvage his Belgian mission, Vincent went in search of Abraham Pieterszen, the preacher who had helped Dorus arrange Vincent's admission to the evangelical school in Brussels. While a student there, Vincent had assisted several times at Pieterszen's church in Mechelen. On August 1, dressed in miner's sackcloth, he set out on another of the long, wandering, self-punishing journeys that often accompanied crises in his life. After two nights of sleeping in the open, he arrived with bleeding feet at the house in Brussels where Pieterszen was staying. The girl who answered the door shrieked and ran when she saw him because "he looked so neglected and dangerous." Pieterszen urged Vincent to return to his parents' home in Etten, but he adamantly refused. "He was determined," Pieterszen reported to Dorus. "He is his own worst enemy."

Unable to dissuade him, Pieterszen reluctantly gave Vincent a letter of introduction to a preacher in the Borinage who went by the single name of Frank. He lived in Cuesmes, a mining town only four miles from Wasmes. As an "independent evangelist," Frank had no church, no congregation, and no way of paying Vincent a salary. He was little more than a lonely man in the wilderness preaching the word of God to anyone who would listen. Vincent would serve as Frank's "assistant." It was an ignominious end to his great ambition. The next day, he returned to the black country and reported to the house of "Frank the Evangelist," whose address he gave only as *"au Marais"*—in the swamp.

Vincent had only one person left to ask for help. Immediately after arriving in Cuesmes, he scribbled a short letter begging Theo to visit.

THE MORE DEEPLY Vincent fell into delusion and despair, the more he longed for his brother. "[I] am not made of stone or iron like a pump or a lamppost," he wrote. "Like everyone else, I need friendly or affectionate relationships or intimate companionship . . . I cannot do without these things and not feel a void." He compared himself to a prisoner in solitary confinement and called Theo his *"compagnon de voyage"*—his sole "reason for living." Only their brotherhood made him feel that his life was "perhaps good for something," he said, and not "utterly worthless and expendable."

But Vincent's longing could not bridge the growing gap between them. They had not seen each other since Theo's triumphant return from Paris the previous November—almost at the same moment Vincent fled Brussels in desperation. For the first time in six years, they had missed each other at Christmas, as Vincent stayed at his post in Petit Wasmes. Their correspondence had faded to an erratic formality, with months passing between letters that gave no hint of the upheavals in the Borinage—except for the repeated calls for Theo to visit. To

his brother, Vincent continued to portray himself as a missionary of *it*, and the black country as a "peculiar" and "picturesque" land filled with sentiment and character.

But Theo knew the true story. He had heard his parents' worried cries as Vincent dragged them deeper and deeper into disappointment and shame. By the time Vincent was dismissed from his position in Petit Wasmes, Theo's sympathy, too, had been largely exhausted. "[Vincent] has made his own choice," he told his mother coldly.

When he arrived at the train station in Mons in the second week of August, he came prepared to tell Vincent the hard truths that his father had shrunk from telling him for fear of another explosion. On a long walk, he told Vincent that he had been "going down-hill" for too long; that the time had come for him to "improve his life"; that he needed to stop living off their father's money and start supporting himself. Perhaps he could return to the bookkeeping work he had done in Dordrecht, Theo suggested, or apprentice himself to a carpenter. He could be a barber, or a librarian. Sister Anna thought he would make a good baker. If he wanted to return to the world of art, he could "become an engraver of invoice headings and visiting cards." Whatever path he chose, Theo said, his days of idle wandering—his "feeble," "do-nothing" existence—had to come to an end.

He rejected Vincent's claims (citing Kempis) of a mandate to poverty and sacrifice as "impossible religious notions and idiotic scruples" that only prevented Vincent from "seeing things straight." And when Vincent tried to invoke their pledge of brotherhood on the Rijswijk canal eight years earlier, Theo shot back: "You have changed since then, you are no longer the same." Finally, clearly speaking for his parents, Theo lodged what was for him the most serious charge against his brother: that he had caused "so much discord, misery and sorrow amongst us and in our house."

It was this last accusation, apparently, that struck home. Vincent could parry and dodge the others, as he did immediately after Theo left, in a letter that combined patronizing sophistry, indignant posturing, and fraternal seduction in a tour de force of denial. But the charge that he had brought his parents to grief ignited flames of guilt that not all Vincent's powers of self-justification and self-pity could extinguish. "It may well be," he allowed in a flash of confession, "that it was all my own fault."

There was only one way to put out that fire. As soon as he had mailed his rebuttal to Theo, he walked to Mons and took the first train north. After more than a year of steadfastly resisting it, the hunger for it having finally overwhelmed the shame of it, Vincent went home.

"All of a sudden he was at our door," Anna reported to Theo. "We heard 'Hi Pa, hi Ma' and it was him." They gave him clothes and food, but after that,

only skeptical glances and complaining silence. "He looks skinny," Anna wrote, "[and] his face has a weird expression." It was not the prodigal-son welcome that Vincent had always longed for. Wounded and wary after so many plans and so many disappointments, his parents kept a careful distance. But Vincent took their caution as indifference, and soon sank into a churlish solitude that must have raised, on both sides, all the darkest memories of the Zundert parsonage. "He's reading books by Dickens all day long," Anna reported, "and doesn't do anything else. He doesn't talk, he only answers our questions. . . . He often gives strange answers, too. . . . He doesn't say a word about anything else; nothing about his work from the past, nothing about his future work."

Determined to break through the silence, Dorus took Vincent for a walk to Prinsenhage to visit his uncle Cent. "Maybe [Vincent] will open up then," Anna said hopefully. But the five-mile journey led only to catastrophe. Dorus brought to the encounter a paternal duty worn thin by years of injury and disappointment. "Tomorrow it will be ten years ago that [Vincent] left our home and I brought him to The Hague to work at Goupil," he wrote Theo only a week before Vincent's unexpected arrival in Etten. "We are tired and disheartened." But Vincent carried a weight of resentment, too, having convinced himself that his religious ambitions had been betrayed by his father's demands. At almost the same moment that Dorus was bemoaning his son's intransigence, Vincent was complaining ruefully to Theo: "You know how things were planned and discussed, argued and considered, talked over with wisdom, and yet how miserable the result was . . . I fear a similar result if I follow wise advice given with the best intentions."

It took only a single flash of "hot temper"—whether from Vincent or from his father is not recorded—to spark an explosion so fierce that Vincent had to flee the house.

After that, he descended into total darkness. He did not write Theo again for a year; or, if he did, the letters disappeared. Virtually all of his family's letters from the period met the same fate. Whether banished by his father or by his own self-loathing, he returned to the black country. He had entered his worst nightmare. On the eve of his trip to Etten, he had written to Theo,

> If ever I came to believe seriously that I was being a nuisance or a burden to you or those at home, so that it would be better if I were not there at all, . . . were I really to think that, then I should be overwhelmed by a feeling of sadness and should have to wrestle with despair [and] I might wish it were granted me not to have much longer to live.

For the next six months, Vincent punished himself with a ferocity that appalled even the wretched Borins. Rejecting the relative comfort of the house in

Cuesmes where Evangelist Frank lodged, he returned with new fervor to the self-mortifications of the past: going without food, without shelter, without bathing, without rest, without warmth, without companionship, for impossibly long periods. When he allowed himself to sleep, he found a barn, or just lay down in the open. He lived on crusts of bread and "frostbitten potatoes."

He found no work and no comfort from Frank (whom he never mentioned again). No church in Cuesmes would give him duties, paid or voluntary; his reputation had followed him from the Bébé. His father apparently sent small amounts of money, but Vincent gave whatever he received to the poor, or spent it on Bibles that he distributed, or sent it back. When he went to the mines to evangelize, the miners insulted and mocked him. They denounced his strange behavior as "outrageous" and "shocking." For longer and longer periods, he avoided people altogether, or they avoided him. "Everyone considers me worthless," one villager remembered him muttering.

Vincent's imagination followed him into the darkness. He "cast aside" not only his letter-writing pen but also the pencil he used for sketching. He must have denied himself the pleasure of his print collection, for which there was hardly a place in his bare, beggarly existence. His imaginative life was reduced to the little pocket-sized books that he apparently carried with him everywhere. But even these seemed chosen for the pall they cast. From Dickens's dystopian *Hard Times* to Stowe's *Uncle Tom's Cabin*, Vincent revisited the bleakest visions from his past. A year before, he had read Michelet's sweeping account of the French Revolution. Now, he turned to Hugo's *The Last Day of a Condemned Man*, a claustrophobic tale of injustice and indiscriminate death during the Terror. "[We] are all condemned to death," Hugo concludes, "though the stay of execution varies." Vincent found an even bleaker vision in Aeschylus' *Oresteia*, tracing the terrible fate of the victors at Troy. In this blackest and most barbaric of Greek tragedies, the world is defined by family crimes—infanticide, patricide, matricide—and a guilty son flees his home pursued by the Furies of remorse.

Finally, Vincent ventured down into the comfortless, nihilistic depths of Shakespeare's *King Lear.* "My God, how beautiful Shakespeare is," he exclaimed in the first letter after his long silence; "who else is as mysterious as he is?"

For a reader like Vincent who shared his era's addiction to stories of suffering redeemed and love triumphant, *Lear* represented an unendurable mortification of hope. The death of Cordelia, especially, violated every convention of the Victorian heart, and productions of the play often substituted a happy ending for Shakespeare's unbearable one. Vincent must have found some strange consolation in this dark tale of a father brought to grief by his own mistakes and the defiant suffering of a man "more sinn'd against than sinning." He expressed special admiration for the "noble and distinguished" character of Kent, the duke who disguises himself as a servant and is punished for his plainspoken-

ness. But as the winter wore on, he began to resemble more and more the play's self-negating protagonist, Edgar, the betrayed eldest son. Banished by Lear, invisible to his blinded father, living in a cave on the heath disguised as a madman, a "poor naked wretch . . . houseless . . . unfed . . . loop'd and window'd [in] raggedness," Edgar runs in terror from unseen tormenters and, like the rag and bone man, "drinks the green mantle of the standing pool."

Vincent was seen that winter with his face blackened, barefoot and clothed in rags, wandering the bleak landscape through snow and thunderstorms. Former acquaintances, including Denis, warned him, "You are not in a normal frame of mind." Peasants who encountered him on the heath called him simply "mad." "The Lord Jesus was also crazy," he would answer—a defense that some took as proof of his fevered mind. He rubbed his hands together incessantly, as if trying to remove an indelible stain, and neighbors who passed the barn where he slept often heard the sounds of weeping. According to one account, he "subjected himself to the ultimate indignity" by stripping off his clothes and, like Edgar, "answering with [his] uncovered body the extremity of the skies." "Thou art the thing itself," Lear tells Edgar: "unaccommodated man is no more but such a poor bare, forked animal as thou art." In his own moment of Lear-like compassion, Vincent saw a workman who had made a shirt out of a sack with the word "Fragile" stenciled across it. "He did not laugh," recalled a villager, "but spoke of it for days afterwards in tones of pity." In his psalmbook, he underlined in short, exclamatory strokes:

> *My soul is in agony . . .*
> *My God, my God why have you forsaken me,*
> *Far from your comfort in my deep distress . . .*
> *Night and day I fearfully invoke your name*
> *But your holy voice does not answer my cries;*
> *Finally I feel my life almost extinguished by pain.*

Dark thoughts of suicide threaded through the months of self-torment. After seeing his mother off at the train station in July, Vincent had been overcome by "melancholy," he reported to her afterward, "as if he were saying goodbye for the last time." Only a month later, when the Committee finally formalized his failure in Petit Wasmes, he wrote Theo even more abjectly: "My life has gradually become less precious, much less important and more a matter of indifference to me."

Vincent may not have attempted suicide, but before the winter was over, he set out on a punishing journey that amounted to the same thing. Around the beginning of March, malnourished, weak, and inadequately clothed, he once again left the Borinage and headed west. He rode the train as far as the few francs

in his pocket would take him. When he reached the French border, he started to walk. He may have been headed for Calais, one hundred miles northwest, where the England of his memory lay only twenty miles across the Channel. Earlier, in his desperation, he had written Reverend Slade-Jones in Isleworth, site of his only mission that had not failed. Slade-Jones had responded with rare encouragement, proposing to build a series of "little wooden churches" in the Borinage. Vincent's great ambition to preach the Gospel had faded to this delusive glimmer.

Whether or not this was the star he followed out of the black country, the trip soon proved beyond even Vincent's capacity for self-punishment. Whipped by freezing rain and wind, with no money for food or lodging, he "wandered and wandered forever like a tramp," he later recalled, "without finding either rest or food or covering anywhere." He slept in abandoned wagons, woodpiles, and haystacks, and awoke covered with frost. He looked for work—"I would have accepted anything," he said—but no one would hire the strange vagabond. "I was abroad without friends or help," he recalled, "suffering great misery." He persevered until he reached Lens, only forty miles from his starting point, before turning around. On the return trip, he stopped briefly in the town of Courrières, near Lens, where Jules Breton had a studio. Vincent had long loved Breton's poetry and paintings. During his Goupil days, he had even met the artist. But that was a previous life. Now, he just stood outside the studio, too paralyzed with self-loathing to knock.

After only three days, crushed in body and in spirit, he returned to the black country. "That trip," he later admitted, "nearly killed me."

This was Vincent's condition when his parents saw him only a week or two later in Etten. He may have limped there on his own (he complained of "crippled feet" after the aborted journey), but it is more likely that Dorus, alerted again by someone in the community, traveled to the Borinage and brought his son home—as he had often threatened to do. After years of "despairing" over Vincent's fate, lamenting it as "the cross we must bear," Dorus had finally decided to take matters into his own hands.

He had decided to commit his son to an asylum.

THE TOWN OF GHEEL lay only forty miles south of Etten, just across the Belgian border. Since the fourteenth century, pilgrims had come to Gheel in search of miraculous cures for mental problems thought to be the work of the devil. Like all pilgrims, they boarded with local families, often staying for years and assuming roles in village life. By 1879, centuries of pilgrims had reshaped the town into a single open-air asylum: "the City of the Simple." Except for a small clinic, there were no cells, no wards, no walls. One thousand "lunatics"—as they were

invariably called—lived among the ten thousand sane inhabitants, placed in the homes of paid householders, where they undertook chores and even trades "uncontradicted in their caprices [and] unnoticed for their peculiarities," according to the advertisements Dorus would have read.

In an era of horrific public asylums, where inmates were routinely chained for long periods or humiliated by visitors who paid to mock them, the availability of Gheel made Dorus's agonizing decision a little easier. It was close enough for regular visits, but safely out of public view. Like all Victorian families, the Van Goghs feared most the unspeakable stigma of insanity—a stigma undiminished by recent advances in the understanding and treatment of mental illness. Everything from Theo's chances for advancement at Goupil to the marriageability of their two young daughters, even Dorus's ability to stand unashamed before his congregation, depended on absolute secrecy.

To commit Vincent to any asylum, however, Dorus needed a "certificate of insanity" from a medical expert who had examined the patient. Sometime after Vincent arrived home in March, Dorus made an appointment for him to see Professor Johannes Nicolaas Ramaer, a prominent "alienist" in The Hague and an inspector of lunatic asylums. According to his mother's much later recollection, Vincent at first agreed to visit Ramaer in order to "ask for medicine." But at the last minute, perhaps alerted to his father's intentions, he refused to go. "I resisted with all my might," he later recalled.

The only way Dorus could commit his son without a certificate, as Vincent probably knew, was to convene a *"conseil de famille"* (family council) to support the petition for commitment—something his father would have been loath to do.

But by now Dorus was determined. "My father called the family together for a meeting," Vincent told a friend years later, "in order to have me locked away as a madman." To assert guardianship over his son—who had just turned twenty-seven—Dorus sought to have him declared incompetent "on *physical* grounds"—because of his inability to take care of himself. He called Vincent "deranged" and "dangerous," and dismissed his Kempian fantasies of "choosing a life of poverty" as proof of his madness.

Sometime that spring, in a bitter rage, Vincent left Etten again. He told his parents he "didn't want to know [them] any more," and defiantly returned to the site of his undoing, the Borinage. He may have been escaping the campaign to commit him, or he may have been driven out by his father's demand that he stay, convinced that Dorus just wanted to keep him out of sight to avoid bringing more shame on the family. As soon as he arrived back in Cuesmes, he sent his parents a copy of *The Last Day of a Condemned Man*, which struck exactly the blow he must have intended. "Hugo is on the side of *criminals*," his mother wrote in horror. "What would become of the world if bad things were considered to be good? For the love of God, that can't be right."

After only a short time alone in the black country, however, Vincent's anger hardened into despair. All his missions had failed. His congregations had rejected him; their God had betrayed him. His family had renounced him long before he renounced them. The battle over Gheel had dashed even the hope of reconciliation—the hope that had sustained him through all the loneliness and hardship of the previous three years. Homeless, penniless, friendless, faithless, he had reached the bottom of his long descent. Guilt and self-loathing overwhelmed him. He branded himself as "an objectionable and shady sort of character . . . a bad lot . . . a ne'er-do-well." He complained of feeling "dreadful disappointment gnawing" at his spirit, and "a wave of disgust welling up inside." "How can I be of use to anyone?" he concluded bitterly. "The best and most sensible solution all round would be for me to go away . . . to cease to be."

From the depths of this blackest country, after almost a year of silence, he reached out to his "*waarde* Theo." "I have kept silent for such a long time," he wrote in July. "[Now] I have reached a sort of impasse, am in trouble, what else can I do?"

It was the beginning of a deluge: a pent-up storm of protest, self-pity, confession, and supplication in the longest letter he had yet written. He staunchly defended his bizarre excesses of behavior, arguing simply, "I am a man of passions." If he seemed "good for nothing," a "*fainéant*" (idler), it was because his "hands were tied." If he appeared angry, it was because he was "maddened by pain"—like a captive bird that "bangs his head against the bars of his cage." Amid the pages and pages of defensive posturing and convoluted casuistry, however, stood one genuine cri de coeur: "One does not always know what he can do," Vincent wrote, using the veiled constructions that always guarded his most painful confessions, "but he nevertheless instinctively feels, I am good for something! My existence is not without reason! . . . How can I be of use, how can I be of service? There is something inside me, but what can it be?"

Theo heard his brother's plea. The next time Vincent wrote, his question had been answered. "I am busy drawing," he announced in a brief letter a month later, "and I am in a hurry to go back to it."

CHAPTER 13

The Land of Pictures

~

THEO HAD ALWAYS ENCOURAGED VINCENT'S DRAWING, IN THE SAME way their parents encouraged it: as one of Vincent's few remaining social graces, a connection to the bourgeois world that he seemed determined to reject in every other way. In fact, as he headed off to the Borinage, Vincent was prepared to jettison even this last remnant of his former life. "I should like to begin making rough sketches of some of the things I encounter," he wrote on the eve of his departure from Brussels, "but as it would probably keep me from my real work, it is better not to begin." The prohibition did not apply, apparently, to four maps of the Holy Land that his father asked him to make soon after his arrival in Petit Wasmes. But after that, he stuck to his vow of artistic abstinence through all the crises of the winter and spring of 1878–79. It was only after his world began to fall apart in May that he promised his parents "he would do his best" to take up drawing again.

Theo joined in encouraging him. "I should have some drawings to show you," Vincent reported on the eve of his brother's visit in August 1879, clearly responding to inquiries. "Often I draw far into the night." He made drawings of the miners' "costumes and tools" and tiny panoramas of the coal mines—his new home. Probably at Theo's prompting, Tersteeg sent Vincent a set of watercolors with which he could wash his maps and sketches with a thin glaze of color. He called the results "souvenirs." They captured "the aspect of things here," he said. On his trip to see Reverend Pieterszen, he took some of his drawings to show the preacher, a recreational watercolorist himself.

But neither Vincent nor Theo thought much of these scraps. "It wouldn't be worthwhile for you to leave the train for those alone," Vincent wrote defensively before his brother's arrival. After seeing them, Theo apparently agreed. Throughout their detailed conversation about Vincent's future—a talk that

touched on bookkeeping and carpentry as possible career choices—Theo apparently never broached the idea that his brother might become an artist. In the months of darkness that followed, Vincent easily "cast aside" his sketchpad and watercolors, along with all the other undeserved bourgeois comforts of food, bed, and clothes.

When Vincent emerged the following July with his long, pleading letter, Theo urged him to resume drawing as a "handicraft"—a healthy preoccupation to keep his mind and his hands busy, prevent him from obsessing over his problems, and reconnect him to the world. He might even sell his maps, sketches, and watercolors to help support himself, Theo suggested.

At first, Vincent rejected the idea. "I thought it very impractical and would not hear of it," he recalled. But the proposal sounded far more plausible and attractive than it would have the previous summer. Vincent had, in fact, sold some of his drawings in the meantime. His father had paid ten francs apiece for his maps of the Holy Land, and Pieterszen had bought one or more of his miner sketches. (Unbeknownst to Vincent, Dorus had sent the purchase money to Pieterszen with instructions to use it to "nurse [Vincent] back to health without letting him know it came from me.") It wasn't much, but it was enough to stir ambitions to self-sufficiency. "I have wasted time when it comes to earning a living," he admitted in his July letter.

In addition, Vincent had discovered new pleasures in drawing. After months of eliciting only insults and mockery in public, he could now go out with a sketchpad, not a Bible, and draw unmolested. "He made pictures of women picking up coal," one local recalled, "but no importance was attached to it. We didn't take it seriously." For a man fearful of people yet starving for human companionship, the opportunity to quietly observe others proved exhilarating. And the chance to dominate a social encounter—by recruiting and posing models—proved intoxicating. Within weeks, he had begun the search for "models with some character . . . male and female."

After the bitter trials of the winter, the former pastime of drawing now satisfied deeper needs as well. The final collapse of Vincent's evangelical ambitions left art as his sole remaining claim to a higher calling. He immediately resumed the arguments of Amsterdam, trumpeting the unity of art and religion. "It is the same with evangelists as it is with artists," he insisted. "Try to grasp the essence of what the great artists, the serious masters, say in their masterpieces, and you will again find God in them." "Everything that is really good and beautiful . . . comes from God." By taking up drawing, Vincent could continue his work as a missionary of "inner, moral, spiritual and sublime beauty." He had not abandoned his ambitions. He had not changed course. He had not failed. His troubles had been the fault of "odious and tyrannical" evangelists, he main-

tained, who, like the "old academic schools" of artists, "exclude the man with an open mind."

Declaring himself an artist also sustained another hope for reconciliation: the dream of the Rijswijk road—two brothers "bound up in one . . . feeling, thinking and believing the same." Once the long winter of estrangement was broken, old feelings of solidarity flooded back. Only the "magic force" of brotherhood could unlock the cage in which he felt imprisoned, Vincent said. Protesting his "homesickness for the land of pictures," he insisted that his enthusiasm for art had not waned during his wandering in the Borinage. He framed his new artistic ambitions emphatically as a response to Theo's guidance ("I think you would rather see me doing something good than doing nothing") and called for the restoration of their fraternal *"entente cordiale"* in order to "make us of some use to one another."

Vincent even chose to resume their correspondence in French, as a tribute to his brother's successful new life in Paris, and to their shared citizenship in the francophone "land of pictures."

In the service of this new mission, Vincent's powerful imagination, which had lured him to the black country, and kept him alive there, now began to reshape his experience there. When Theo wrote about the inspiration many French artists had found in Barbizon, a village in the Fontainebleau Forest south of Paris, Vincent recast his grueling trip the previous winter into a parallel artistic quest. "I haven't been to Barbizon," he wrote, "[but] I did go to Courrières last winter." In Vincent's imagination, the hellish, hopeless, wandering trek six months earlier was transformed into a pilgrimage in search of *it*—an inspirational "walking tour" as well as a chance to visit the great Barbizon painter Breton, for whom Theo shared his brother's reverence.

In Vincent's vision, an idyllic countryside of haystacks, thatched-roof farmhouses, and "marled earth, almost coffee-colored" erased the smoking slagheaps that dominated the French mining district around Courrières no less than the Belgian one around Cuesmes; and a "fine, bright" French sky replaced the choking smog of the Borinage, only a few miles away. He peopled his fantasy with picturesque peasants right out of the prints on both brothers' walls: "all manner of workmen, diggers, woodcutters, a farmhand driving his wagon and a silhouette of a woman in a white cap." Vincent even reimagined his ordeals of hunger and cold as the transformative trials of Bunyan's Christian. "I do not regret it," he said, passing revised judgment not just on the trip but on his whole time in the black country, "because I saw some interesting things and the terrible ordeals of suffering are what teach you to look at things through different eyes."

Despite the winter of deprivations, he seized his new calling with furious new energy, combining his usual cyclonic enthusiasm for fresh starts with a des-

perate determination to put the past behind him. From the house in Cuesmes, he dunned Theo and others with demands for "models" from which to learn his new gospel. He especially wanted Charles Bargue's two-part home study course on figure drawing, *Exercices au fusain* (*Charcoal Exercises*) and *Cours de dessin* (*Drawing Course*), and Armand Cassagne's *Guide de l'alphabet du dessin* (*Guide to the ABCs of Drawing*), a similar how-to manual on perspective drawing. He devoured these big books, with their graduated exercises and promise of sure success to the diligent—page by page, over and over. "I have now finished all sixty sheets," he reported after the first of many times he completed the *Exercices au fusain.* "I worked almost a whole fortnight on [it], from early morning until night . . . it invigorates my pencil."

He worked with astonishing intensity, squatting on a camp stool in the little second-floor room that he shared with the landlord's children, hunched over a large sketchpad balanced on his knees, with the full-sized Bargue and Cassagne propped next to him. He worked as long as the light allowed—outside in the garden if the weather permitted. In a single two-week period, he reported finishing a hundred and twenty drawings. "My hand and my mind are growing daily more supple and strong as a result," he reported. He found the exercises "demanding" and sometimes "extremely tedious," but dared not slacken his frantic pace. "If I cease searching, then, woe is me, I am lost," he wrote. "That is how I look at it—keep going, keep going come what may." He told Theo of a "great fire" that burned within him.

To feed that fire, he needed more than exercises. He sent Theo sweeping calls for other images to copy, starting with Millet's iconic *Les quatre heures de la journée* (*Four Hours of the Day*) and *Les travaux des champs* (*Workers in the Fields*), images that had hung on his walls for years and that he would continue to copy for the rest of his life. At first, laboring tirelessly over his course books, he requested only etchings by "masters" of figure drawing like Millet and Breton. "These are the things I want to study," he insisted. But soon he demanded landscapes, too: from Golden Age giants like Ruisdael to Barbizon heroes like Charles Daubigny and Théodore Rousseau.

No matter how many images Theo sent, however, Vincent could not resist the impulse to leave his cramped "studio" and find images of his own. Despite repeated pledges to complete his exercises before attempting to draw "from nature," he wandered the town sketching portraits and vignettes: women carrying sacks of coal, a family harvesting potatoes, cows in a pasture. He even persuaded some locals, including his former landlady, Esther Denis, to pose for him.

He took his folding stool to the mine entrance and made crude, childlike records of what he saw—unschooled attempts that even he dismissed as "clumsy." (He later admitted destroying all his work from this period.) Still, he laid elaborate plans for a pair of large drawings: one, of the miners going to work in the morn-

ing ("passing shadows, dimly visible in the twilight"), and the other, the pendant, showing their return (with "an effect of brown silhouettes, just touched by light, against a mottled sky at sunset"). Long before he had finished the *Cours de dessin*, he committed the first of these images to paper. "I could not keep from sketching in a rather large size the drawing of the miners going to the shaft," he confessed to Theo.

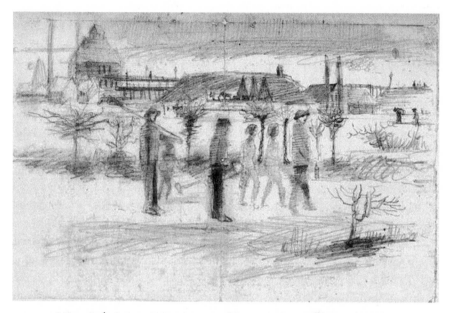

Miners in the Snow at Dawn, AUGUST 1880, PENCIL ON PAPER, 5⅛ X 8 IN.

But in this fury of work, this resurrection of hopeful enthusiasm, he returned again and again to one image in particular. "I have already drawn 'The Sower' five times," he wrote in September, "and I will take it up again, I am so entirely absorbed in that figure."

IN OCTOBER 1880, only two months after declaring himself an artist, Vincent abandoned the Borinage. He had slightly less than a decade—just one-quarter of his life—left to live. He departed for Brussels from the train station in Mons where, almost two years before, he had arrived from Brussels. Only now, instead of a portfolio of sermons, he carried a portfolio of drawings. He complained that he had "undergone some misery in the Belgian 'black country,' " and needed a better studio, the company of other artists, and "good things to look at" in order to forget those miseries and "make good things myself."

In fact, the trajectory of Vincent's brief, incandescent artistic enterprise had already been set. Figure drawing would always energize him, even as success

at it always eluded him. As a way of touching the sentiments he prized and of making the human connections he longed for, he never found any subject as satisfying as figures, even as he created some of the most sublime landscapes in Western art. The same deep belief in the transformative power of work—his mother's religion of "keeping busy"—that had propelled him through the impossible hardships of England, Amsterdam, Brussels, and the Borinage would now be turned on the virtual impossibility of artistic success. The friction of this blind push would continue to produce the same self-inflicted anguish that it did on the blighted heaths of the black country.

He would continue to alternate between ambitious pledges to learn the fundamentals of his new craft and cries of exasperation when progress proved slow. He repeatedly laid grand plans for self-improvement that, like his pursuit of a religious calling, quickly foundered on his impatience, peripatetic interests, and fears of failing. Just as he started far more drawings than he completed (he found the process of turning a sketch into a finished drawing difficult as well as deadening) he littered his career with half-completed projects undertaken in fevers of enthusiasm that always rejected half-measures.

This flight from reckoning allowed him to be both mercilessly self-critical and endlessly hopeful: forever promising, and expecting, improvement; forever waiting for lightning to strike, or God's voice to speak, or an angel to appear. "I am working away hard, though for the moment it is not yielding particularly gratifying results," he wrote for the first of many times in a letter from the Borinage. "But I have every hope that these thorns will bear white blossoms in due course and that these apparently fruitless struggles are nothing but labor pains." His sudden departure for Brussels—only days after assuring Theo, "the best thing is for me to stay here and work as hard as I can"—was the first of many preemptive flights to keep hope alive.

In his emotional life, too, Vincent would never leave the Borinage. When Theo sent him fifty francs in June, it not only revived their relationship, it began a financial dependence that would last the rest of Vincent's life. Within a few months, he was advancing the first of the plaintive, coercive arguments for further subsidies that would become the corrosive hallmark of their correspondence. "Honestly, to be able to work properly I need at least a hundred francs a month," he wrote in September, along with a warning: "Poverty stops the best minds in their tracks." Money made vivid and undeniable the reversal of the brothers' relative positions in the family—"if I have come down in the world," Vincent conceded, "you have in a different way come up in it"—ushering in a new world of suspicion and reserve. Yet, at the same time, money brought a new edge of desperation to Vincent's old craving for fraternal solidarity. The "magic force" of brotherhood would no longer be sufficient; Vincent now needed Theo's absolute commitment to the joint enterprise of his art. His work, Vincent

claimed, was *their* progeny, fathered forever by Theo's decisive encouragement in the summer of 1880.

But Vincent's "depressing dependence" (his term) brought new waves of guilt and resentment. The guilt expressed itself in relentless protests of hard work, apologetic pleas for patience, and pathetic promises to pay his brother back. ("Someday or other I shall earn a few pennies with some drawings," he wrote in his very first letter as an artist.) The resentment found its voice in manipulative schemes, escalating claims of entitlement, and fits of moral indignation when Theo, inevitably, failed to live up to Vincent's vision of a joint enterprise. By the time Vincent left the Borinage, Theo had stepped fully into their father's shoes in this vicious spiral of guilt and anger: a spiral in which resentment sometimes overruled gratitude, no support was ever sufficient, and gestures of generosity were often answered by spasms of defiance. In September, Theo invited Vincent to come to Paris. Vincent responded with a veiled request for money to visit Barbizon, and then, without advance notice, moved to Brussels instead.

Finally, through the sheer power of his imagination, Vincent emerged from the Borinage with his vision of *"it"* intact, undimmed by the years of setbacks and suffering. "My inner self," he told Theo, "has not changed. . . . I think, believe, and love more seriously now what I thought, believed, and loved then." Consolation remained the ultimate goal; truth the ultimate medium; and sorrow the ultimate, redemptive sentiment. His imagination was already busy transforming his years of exile and misery into the stuff of *it*—the "inner sorrow" that he found in the works of all the artists he admired. He vowed to seek in his own work "a nobler, worthier, and if you will allow me, more evangelical tone." He spoke of the challenge ahead in biblical cadences ("Narrow is the way and strait the gate and there are only a few who find it"), and of his rebirth in the black country as a resurrection. "Even in that deep misery," he wrote, "I felt my energy revive, and I said to myself: In spite of everything I shall rise again. I will take up my pencil."

The Dutch Years
1880–1886

Hearts of Ice

~

*I*T LOOMED OVER BRUSSELS LIKE A FANTASY OF EMPIRES LONG PAST. Even in a century infatuated with itself, the Palais de Justice would stand as a high-water mark of grandiosity. "A little Michelangelo, a little Piranesi, and a little madness," said the poet Verlaine of the Babel-like structure nearing completion when Vincent arrived in October 1880.

But, of course, it had to be huge (the biggest single-building construction project in the nineteenth century), because Brussels was a city with something to prove. Emboldened by the fiftieth anniversary of its independence and enriched by its African colonies, the young country of Belgium had set out to transform its ancient capital into a world-class city—to reverse centuries of domination by either French or Dutch and make Brussels a center of prestige and splendor to rival even Paris. What Baron Haussmann had done to the French capital, King Léopold II was doing to Brussels: leveling great swaths of medieval city to make room for grand new boulevards of bourgeois *appartements* and great new palaces of commerce, government, and art. Outside the old city, Léopold built a vast countryside park to match Paris's Bois de Boulogne and a huge fairground where, in 1880, the country celebrated its anniversary with a jubilee that echoed Paris's Exposition Universelle.

But Brussels had also benefited from its long eclipse in Paris's shadow. Successive political convulsions had sent waves of artistic and intellectual refugees to this French-speaking safe haven. Karl Marx and other founders of socialism wrote and published here with impunity. The anarchist Paul Proudhon ("Property is theft!") escaped imprisonment here. As Vincent must have known, Victor Hugo began his twenty-year exile here—the most productive years of his hugely productive life. Charles Baudelaire fled persecution for the "perversities" of Symbolism here. Verlaine brought his forbidden lover Arthur Rimbaud and

sketched the first drafts of *Romances sans paroles* (*Songs Without Words*) here. By the time Vincent arrived, Brussels had solidified its reputation as a place where people of uncommon mind, estranged from their homelands, could come to reset their destinies.

To this city of new ambitions and second chances, Vincent brought his own desperate bid for a new life. The troubles of the past disappeared from his correspondence. Only the name of the café-inn where he lodged, Aux Amis de Charleroi, hinted of his black time in the black country. (Charleroi was the capital of the coal mining region.) In his little room above the café at 72, boulevard du Midi, overlooking the train station, the fever of work resumed. "I am pushing ahead with a will," he assured Theo after his arrival. "We must make the same efforts as lost, desperate beings."

Living on the free bread and coffee available around the clock in the café downstairs, he threw himself into the last part of the Bargue course, which showed him how to make copies after the great line portraits of Raphael and Holbein. But at the same time, he returned to the more elementary charcoal exercises and raced through them yet again. He made still more copies of his favorite Millet prints, experimenting with a pen, which he found frustrating. ("It is not as easy as it seems," he complained.) He labored over a big anatomy book, copying its large-scale illustrations of grimacing skulls and muscled limbs until he had traversed "the whole of the human body," front, back, and side. Then he sought out veterinary sources for illustrations of horses, cows, and sheep, to master animal anatomy as well. He even ventured into the pseudosciences of physiognomy and phrenology, convinced that an artist had to know "how character is expressed in the features and in the shape of the skull."

Vincent dutifully reported these Herculean efforts to his parents and to Theo, working as hard to reverse the family judgment against him as to master the mysteries of the figure. "[If] I make progress and my drawing becomes stronger," he wrote his parents, "then everything will come right sooner or later." He sent them drawings ("so [they] might see I am working") accompanied by plaintive protests of his diligence and sincerity. Scarcely a letter went by without a reminder of the difficulty of the task before him or a promise of ultimate success. "On the whole I can say I have made progress," he wrote on New Year's Day 1881. "[Now] I ought to be able to get along more quickly."

He bought new shoes and new clothes. "[They] are well cut and look better on me than any others that I can remember," he reported proudly. He even enclosed a swatch of suit fabric for his parents' approval, noting with a newfound sense of style, "this material is often worn, in studios especially." "I also replenished my underwear with three pairs of drawers," he added reassuringly, and went to the public bathhouse "two or three times a week."

Responding to another of his parents' complaints, Vincent resumed the

quest for "good company." Almost as soon as he arrived in Brussels, he reported meeting "several young men who were also beginning to study drawing." He dunned Theo for introductions in a city where his brother had worked for almost a year. One of his first stops after arriving was the Goupil gallery at 58, rue Montagne de la Cour, in the shadow of Léopold's grand new showplace, the Musées Royaux des Beaux-Arts. He hoped that Theo's old boss, *gérant* Schmidt, could help him "make the acquaintance of some of the young artists here," he said. When Theo wrote back with introductions, Vincent promptly pursued them. He presented himself to Willem Roelofs, the dean of expatriate Dutch painters in Brussels, and probably met Victor Horta, a young Belgian architect who had just returned from Paris to enroll in the Brussels Academy. Theo may also have provided an introduction to another expatriate Dutch painter, Adriaan Jan Madiol. Vincent eagerly advertised these social forays to his parents and pledged to renew relations with family favorites like Tersteeg and Schmidt and, by extension, Uncle Cent.

Of all Vincent's new acquaintances, none pleased his parents more, or played a larger role in his life, than Anthon Gerard Alexander Ridder van Rappard. (In writing and in speech, Vincent always referred to him simply as Rappard.) Like almost everyone Vincent met in Brussels, Rappard knew Theo first. They had met not long before in Paris, during Rappard's apprenticeship in the studio of Jean-Léon Gérôme, a leading Salon artist as well as Adolphe Goupil's son-in-law. Like so many of Theo's friends, Rappard personified Anna Carbentus's ideal of "civilized company." The youngest son of a prosperous Utrecht lawyer from a noble family, he had attended the proper bourgeois schools; socialized in the proper circles; and summered in proper style, whether sailing on the lake at Loosdrecht or going to fashionable spas like Baden-Baden.

When Vincent arrived one morning in late October 1880 at Rappard's well-appointed studio on the rue Traversière on Brussels's north side, he found a handsome, affluent, self-possessed young man of twenty-two, one year younger than Theo. Even beyond the obvious differences of wealth, looks, and social standing, the two artists could not have been more different. Rappard was phlegmatic, good-hearted, and amiable, qualities honed from a lifetime of being well liked. An inveterate joiner of clubs, he moved with the ease of long experience in social gatherings, prized by his many friends for a level head and a steady heart. Vincent was confrontational, prickly, and self-righteous; never fully at ease in company; prone to outbursts of vehemence that could derail any conversation. After years of living inside his own head, he had lost almost all sense of social grace and approached every interaction as a choice between assaulting or being assaulted.

Rappard's impeccable manners extended to his intellect, which was neither especially inquisitive nor overly colorful. He read newspapers "carelessly" and

spoke loosely on intellectual subjects, always favoring the conventional wisdom of his class. Nothing could have been more different from Vincent's ravenous, contrarian intellect and volcanic explosions of enthusiasm.

ANTHON RIDDER VAN RAPPARD

Years later, looking back on their first meeting, Rappard recalled Vincent as "violent" and "fanatical." Vincent called Rappard "elegant" and "superficial" (the same accusations he leveled at Theo). Rappard complained that Vincent "was not easy to get along with." Vincent called Rappard "*abominably* arrogant." Nevertheless, by the time they parted that first day, Vincent had set his mind—and staked his larger ambitions to a new life—on winning the friendship of his young countryman. "I do not know whether he is the person with whom someone like me could live and work," he ventured coyly. "But I certainly shall go and see him again."

Over the next months, he took his new friend—the first since Harry Gladwell—on long walks in the countryside and made himself a frequent guest in Rappard's spacious, well-lighted studio. Together, they explored the pleasures of the Marolles, Brussels's red-light district, where Vincent apparently renounced the last self-mortifications of his previous life. Although reticent at first, Rappard eventually warmed to his strange new companion. The same wandering timidity that had led him from an early ambition to join the navy, through four different art schools without completing any of them, found a safe harbor in Vincent's tyrannical enthusiasm. Inchoate and "ever dissatisfied with

himself," according to a friend, he yielded willingly to Vincent's passion, sitting quietly during his outbursts: avoiding him at times, but never challenging him.

In another bow to his parents, whose faith in schooling never wavered, Vincent applied for admission to the Académie Royale des Beaux-Arts. He had resisted the idea when *gérant* Schmidt first proposed it soon after his arrival, arguing implausibly that he could skip the first step of Academic training because of his work on the Bargue course. No doubt he found the prospect of more schooling, after so many failed attempts, daunting. What he really needed, he said, was to work directly with an experienced artist in a studio setting. But the subsequent recommendation of Roelofs and, undoubtedly, the lure of solidarity with Rappard, who was a student at the Academy, soon brought him around.

He applied for the class in *Dessin d'après l'antique* (drawing after plaster casts of antique statues), and consoled himself that it would at least provide "a well-heated and well-lighted room" through the nasty Brussels winter. The Academy charged no fees, but it did screen candidates. While impatiently awaiting a decision on his application, Vincent found a "poor painter" who would give him lessons in perspective for one and a half francs per two-hour session. "I cannot get on without some instruction," he said. Even this pleased his parents so much that they immediately agreed to pay for the lessons.

No issue defined Vincent's reincarnation in 1881 more than money. Of all the accusations leveled against him over the previous years, none weighed more heavily on his new life than the charge that he could not support himself. This was, after all, the accusation on which his father had launched the effort to have him committed. The pain and humiliation of those memories had driven Thomas à Kempis completely out of his thoughts. From the moment he arrived in Brussels, he could not protest loudly enough his single-minded determination to earn a living. "My aim must be to learn to make some drawings that are presentable and saleable as soon as possible," he declared in his first letter from the Aux Amis, "so that I can begin to earn something directly through my work." His first stop in Brussels had been at Goupil for a symbolic re-embrace of the family's mercantile heritage—"[I] have now returned to the art field," he proclaimed. To Theo, he confided his hope that "if only I work hard . . . possibly Uncle Vincent or Uncle Cor will do something—if not to help me, at least to help Father."

Over the winter, he continued to insist to his parents, "I *shall* make a living by it . . . A good draftsman can certainly find work nowadays . . . Such persons are in great demand, and there are positions that are very well paid." He called their attention to the hefty fees that draftsmen earned in Paris ("from 10 to 15 francs a day"), in London, and "elsewhere the same and even more." To Theo as well as to his parents, he justified every effort, every expense, as essential to this single goal. Pen drawing served as "good preparation, in case one should

later want to learn etching." Perspective lessons and animal anatomy would help him "become a better draftsman and get some regular work." As if to prove his new bourgeois bona fides, he filled his correspondence with the language of business: about the "fair return" he would earn on the cost of his materials, the "capital" of his training, and the high "interest" it would eventually yield.

At some point, he even mustered the courage to make a "sales call." With his portfolio in hand, he visited a former evangelical school classmate, Jozef Chrispeels, who had since entered the military. Heedlessly barging into parade ground exercises at the fort where Chrispeels was stationed, Vincent demanded to see his former friend. "A sergeant called me, saying: 'There is a man to speak with you,'" Chrispeels recalled decades later. "It was Van Gogh with a large portfolio under his arm." Vincent showed him the only finished drawings he had, the mine workers that he continued to draw and redraw after leaving the Borinage. Chrispeels's reaction, if he shared it, could not have been encouraging: "How queer those stiff little figures looked!" he recalled thinking.

But Vincent was both impervious to skepticism and incapable of half measures. Before long, his new aspirations to bourgeois status led to new excesses. In an effort to accelerate his career and keep up with young artists like Rappard (he was acutely aware of his late start), he quickly began to spend more money than his parents could afford. Dorus had agreed to send him sixty francs a month, but his rent at the Aux Amis was fifty. Despite vociferous claims of frugality—"You must not imagine that I live richly here"—he in fact spared no expense. In the first few months, he bought four suits (one made of veloutine—"a material you can wear everywhere"). He restarted his print collection with another dozen Millet engravings, calling them "useful" because "it is quite possible that I shall work from wood engravings sometime." He tore through drawing materials at a furious rate, filling dozens of sheets of expensive paper in a single session. For this prodigious consumption, he developed a justification that he would invoke for the rest of his life: "When I spend more, I get on quicker and make more progress."

Nothing consumed his scarce resources like models. Vincent's serendipitous encounters in the Borinage, where unmindful villagers allowed him to eavesdrop on their labors, had left him with an insatiable appetite for this perquisite of his artistic calling. Other art students waited a year or more to sketch from life; Vincent was still working on the *Exercices au fusain* when he brought his first model to the little room over the Aux Amis. "I have a model almost every day," he reported happily, only a few months after declaring himself an artist, "an old porter, or some working man, or some boy, who poses for me." He coached them into the poses he wanted—sitting, walking, shoveling, carrying a lantern—scolded them for their awkwardness, then sketched them again and again. In Brussels, however, unlike the Borinage, models had to be paid. "Models

are expensive," he complained, even as he argued for yet more models in order to "be able to work much better."

Models also had to be dressed. In February, with his parents already fretting over his rising expenditures, Vincent reported that he was putting together a collection of clothes "in which to dress the models for my drawings." He made a long list of the costumes he required, including "workmen's clothes," wooden clogs, Brabant bonnets, miners' hats, fishermen's sou'westers—"and also a few women's dresses." Preempting his parents' objections to the expense, he insisted that "drawing the model *with the necessary costumes* is the only true way to succeed." Models also required a studio, he added. His badly lit little room above the Aux Amis (for which he did not have the money to pay the rent that month) would no longer suffice. "I shall only be able to manage," he said, "when I have some kind of studio of my own."

His parents reeled under these spiraling demands. The sixty francs Dorus sent every month represented more than a third of his pastoral salary. When they raised the issue with Vincent, he vehemently denied any extravagance and reminded them pointedly of his opposite excesses in the past. Once again, Theo heard the familiar lament rising from Etten: "A melancholy has taken hold of us because of the pain concerning Vincent."

This time, Theo was in a position to do something about the pain. Because of a recent promotion, he was finally earning enough to make a commitment to his parents: from now on, *he* would support his brother. "It is so very nice that you want to help us out with the expenditures for Vincent," Dorus wrote. "I assure you this is not a small relief for us." It was a promise that would have unimaginable consequences.

Theo's largesse sprang more from duty than from fraternal feeling, however. Despite his decisive intervention the previous summer, or perhaps because of it, his relationship with Vincent had since fallen into a deep chill. The unannounced move to Brussels surely rankled the cautious planner Theo, and Vincent's early visit to *gérant* Schmidt at Goupil raised new fears of family embarrassment. Theo immediately wrote back asking his brother to avoid the gallery (using a pending legal dispute as the excuse) and studiously ignored Vincent's request that he pressure Schmidt into helping Vincent launch his new career. The last two months of 1880 passed without a letter between the brothers, not even at Christmas, when, for the second year in a row, their paths did not cross.

In January, Vincent fired off a scolding New Year's greeting: "As I have not heard from you for so long . . . nor even had the slightest answer to my last letter, perhaps it will not be out of place to ask you for some sign of life." Calling his brother's silence "strange and rather unaccountable," he speculated on its cause: "Is he afraid of compromising himself in the eyes of Messrs. Goupil & Co. by keeping in touch with me? . . . Or is it that he is afraid I will ask him for

money?" After an awkward attempt at levity ("you might at least have waited until I tried to squeeze something out of you"), he tried to repair the damage with a retraction ("I wrote my last letter in a moment of spleen . . . let us drop it"). But the defensive, resentful, conflicted tone of the next ten years had been set, months before the first franc or guilder changed hands.

Sometime in late March, the torch was formally passed. Dorus came to Brussels to give Vincent the news. In the meantime, Theo laid out the terms of his benevolence. Echoing their last, disastrous encounter in Mons, he called again for Vincent to find a job and emphasized that he had to live within his means until then. He urged Vincent to think of financial hardship as an opportunity, not a "handicap." To reduce the expense of models, he offered to send a second-hand mannequin with adjustable limbs for posing. He repeated the invitation for Vincent to join him in Paris, where they could live together more cheaply, and sweetened the offer with the prospect that Vincent could receive "guidance and teaching" from Hans Heyerdahl, a young Norwegian painter who had recently débuted at the Salon. "That is just what I need," conceded Vincent, who had long expressed the desire for just such a mentor arrangement.

But Theo resisted his brother's demands for more money—specifically, his insistence that living on less than one hundred francs a month was "impossible." Meanwhile, the gap between Vincent's new bourgeois ambitions and his chronic money shortage only grew more obvious. Friends like Van Rappard, whose opinion mattered dearly to him, began to ask questions about the "strange and unaccountable fact" that he was so "hard up," despite his famous name and rich uncles—questions that threatened to undo all his hard work to put the past behind him. "[They think] there must be something wrong with me . . . and will have nothing to do with me," he complained. The pressure of these questions eventually drove him to the indignity of a job search. He applied for work at printing houses, hoping to practice his drawing skills and perhaps learn lithography. But he was "rebuffed everywhere," he later recalled. "They said there was no work, business was slow." Eventually he did find one job: drawing stoves for a blacksmith.

Vincent's ambitions to a new life were under assault from every direction. His experience at the Brussels Academy proved so unsatisfactory that he never mentioned a word about it again, nor saved a scrap of his work there. He may have been refused admission, or dropped out soon after starting. In any event, the companionship of his fellow students eluded him. He apparently made not a single friend among the Academy's nearly a thousand students, one of whom later recalled avoiding Vincent "because we would end up in a hefty row in no time."

Vincent's strange ways and persona non grata status at Goupil quickly threatened to become "the subject of gossip in the studios," which in turn fed

his paranoia. He blamed the coldness of people like the Dutch painter Roelofs on the false position into which his family, and Theo, had thrust him. He complained that people "accuse [me] of many bad intentions and villainies which have never entered [my] head," and that bystanders who watched him work "think that I have gone mad and, of course, laugh at me." In his defense, he could say only, "Few people know why an artist acts as he does."

The failure of his family, especially his uncles, to come to his aid rankled more and more with each new indignity. Why wouldn't his omnipotent uncle Cent at least "smooth the way" for him? Why wouldn't his rich uncle Cor, who so often supported other draftsmen, help *him*? Shouldn't they show their own family the same "good will"? He and Cor had argued three years before in Amsterdam when Vincent quit his studies, "but is that any reason to remain my enemy forever?" he demanded. He considered writing to them, but feared they would not read his letters. He considered going to see them, but feared they would not receive him cordially. When his father visited in March, Vincent begged him to intervene on his behalf: to make them "see me with new eyes."

At some point, he worked up the courage to write Tersteeg. Vincent had been hoping for months that he could come to The Hague in the summer to repair relations with his old boss, renew his relationship with his successful artist cousin Anton Mauve, and "have some intercourse with painters." But Tersteeg responded to Vincent's overture with a fierce rejection that seemed to speak for the whole family. He accused Vincent of trying "to live off the bounty of his uncles," and said he had "no right to do such a thing." In response to Vincent's request to come to The Hague, Tersteeg answered categorically: "No, certainly not, you have lost your rights." As for his artistic ambitions, Tersteeg snidely suggested he would be better off "giving lessons in English and French." "Of one thing he was sure," Vincent reported bitterly: "I was no artist."

Finally, Vincent decided to take his faltering campaign of rehabilitation to the place where all his campaigns led: home. His decision was helped, no doubt, by Rappard's plan to go home for the summer. By now, Vincent did almost all his work in the studio on the rue Traversière, so when Rappard left Brussels, Vincent would have to go, too. Vincent had also come to see his young friend as a model of the gentleman-artist he wanted to be. If Rappard could spend the summer boating and sketching in the bosom of his family, why couldn't Vincent? He briefly entertained a fantasy of going to some genteel summer resort (which he called "the country") and setting up housekeeping with another painter. But there was no one but Rappard to join him, and the costs of going alone were prohibitive. "The cheapest way," he concluded, "would perhaps be for me to spend this summer at Etten."

In fact, his destination was never really in doubt. The hard and lonely winter in Brussels had brought new urgency to his old and still unfulfilled longing

for reconciliation. On the eve of his return, he wrote Theo: "It is necessary for good relations between myself and the family to be re-established." He was determined to reverse the bitter judgment of the black country—what he called the "sufferings and shame" of the past. He imagined that once he had reclaimed his place in Etten, he could reach out to his uncles again, and that they, in turn, would reach out to him.

But going home was not easy. He had not been there since the previous winter, when his father tried to commit him to the asylum in Gheel. He had stayed in the Borinage the previous summer rather than come home because he believed his parents preferred him to keep out of the way. Even now, he asked Theo to intercede with their father and calm his parents' fears of another cycle of shame. "I am willing to give in about dress," he said, "or anything else to suit them."

He originally intended to stay in Brussels until Rappard left in May, but the pull of home proved too strong to wait. As soon as he heard that Theo would go to Etten for Easter (April 17), he abruptly abandoned his room at the Aux Amis and took the train north. (He departed so precipitously that he had to return after the holiday to retrieve the rest of his belongings.) As always, Vincent layered his life onto the images that he saw—and, now, the images that he made. On the trip to Etten, one image in particular transfixed his imagination once again: the sower. As soon as he arrived, he sat down and made yet another copy of Millet's icon of new life: his father's icon of persistence in the face of failure. As if to demonstrate his new skills under his parents' watchful eyes, he labored over the familiar figure, imitating the appearance of an etching with thousands of tiny pen strokes, endlessly hatching and cross-hatching, shading and shading again, in a manic proof of dedication.

VINCENT BARELY PAUSED to savor his return home, saying only, "I am very glad things have been arranged so that I shall be able to work here quietly for a while." Instead, he plunged with renewed energy into the project that had made his return possible. Every day that it didn't rain—not many in Etten's wet spring—he struck out across the woods and heaths in search of a place to set his folding chair. He wore a uniform befitting a young artist summering in the country: a blousy shirt shorn of its stiff collar, and a stylish felt hat. On cold days, he wore a coat.

He carried his chair, a portfolio of paper, and a plank of wood. He worked so intensely—holding the big carpenter's pencil in his fist like a knife—that he needed the heavy plank to prevent tearing the paper. He planted himself in front of trees and shrubs, outside farmers' cottages and barns, overlooking mills and meadows, along roadsides and churchyards. He sketched animals as they fed, and implements—plows, harrows, wheelbarrows—where they lay. In the vil-

lage of Etten (twice the size of Zundert, but poorer), he invaded the shops of tradesmen to practice his perspective drawing. In bad weather, and sometimes even in good, he stayed inside and worked furiously at his "exercises": copying more Millets and racing yet again through Bargue "with a tremendous zeal," according to one visitor that summer. "I hope to make as many studies as I can," he pledged to Theo. Years later, the Etten parsonage maid recalled that Vincent sometimes spent the whole night drawing, "and when his mother came down in the morning she would sometimes find him still at work."

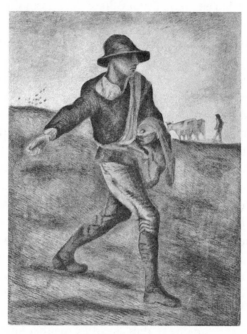

Sower (after Millet), APRIL 1881,
INK ON PAPER, $18^7/_8$ X $14^1/_4$ IN.

But to achieve his ambition of self-sufficiency, Vincent argued, he needed more than anything else to draw from models. "Anyone who has learned to master a figure," he wrote, "can earn quite a bit." If he mastered figure drawing, he could make the kinds of images that often appeared in illustrated magazines—especially images of picturesque country life. Championed by artists like Millet and Breton, these images had become a staple of popular culture—favorites of a rootless bourgeoisie seeking comforting myths to replace the consolation of religion. Vincent's studies of landscapes and interiors, farmyards and tools, copies of Millet and the *Exercices,* all served this larger ambition. "I must draw diggers, sowers, men and women at the plow, without cease," he explained to Theo: "scrutinize and draw everything that is part of country life."

In single-minded pursuit of this goal, Vincent roamed across the country-

side around Etten in search of models. At first, as in the Borinage, he drew laborers in the fields where they worked. He barged fearlessly into farmhouses to draw women at their chores. But neither quick nor dexterous enough to capture their activities as they happened, he needed them to pose. Sometimes he persuaded them to do so on the spot—in the field or yard or farmhouse—freezing in place with shovel poised or plow stayed. If he could, he took them back to the parsonage where he set up a studio in an abandoned outbuilding. Here, in the ample light of a big, arched window, he posed them standing, stooping, bending, kneeling. He usually drew them from the side to avoid the challenges of foreshortening. He gave them props: a rake, a broom, a shovel, a shepherd's crook, a sower's bag. He might start by asking them to re-create the positions in which he had sketched them earlier in the field, allowing him to clarify lines and correct proportions. But he often went on to pose the same model in multiple roles. He used the same big sheets of paper that the Bargue exercises required and consumed them at the same furious rate.

He recruited models with a combination of money and intimidating enthusiasm. "He forced people to pose for him," one villager remembered; "they were afraid of him." Locals began to avoid the "peculiar" parson's son when they saw him coming down the road, "always looking straight ahead," intent on his new mission. "It was unpleasant to be with him," one of them recalled. In the studio, he drove his models as tirelessly as he drove himself. He drew the same poses over and over and scolded his amateur sitters for their restlessness. He "would work on a drawing for hours," according to the account of one of his models, "until he had caught the expression he was aiming at." On his side, Vincent complained "what a tough job it is to make people understand how to pose." He called his models "desperately obstinate" and mocked their bumpkin insistence on posing in their stiff Sunday clothes "in which neither knees, elbows, shoulder blades, nor any other part of the body have left their characteristic dents or bumps."

For a while, it looked like the world might yield to this hurricane of effort. In striking contrast to his previous stay there, the Etten parsonage began to seem like home; its occupants, like family. The house was big and square. Behind its impressive façade, the rooms were spare but lofty and comfortable, with an abundance of windows that welcomed every summer breeze. In back, a cozy garden filled with rosebushes nestled between the house and a vine-covered wall. Against the wall stood a wooden arbor. By the middle of summer, it was canopied in blooming greenery. Here, the family often sat in the shade and took sandwiches in the evening. On rainy days, they gathered at a round table in the living room under the light of a hanging oil lamp.

Over the summer, Cor came home from school in Breda, sister Lies visited from Soesterberg, and sister Wil, now nineteen and returned from England, sat

for one of Vincent's first portraits. "She poses very well," he reported. To replace the companionship of the missing Theo, Vincent found two young men, Jan and Willem Kam, sons of the pastor in neighboring Leur. Both amateur artists, the Kam brothers followed Vincent on his sketching expeditions and watched him at work in his studio. "He wanted his drawings to be precise—and profitable," Willem recalled years later. "He talked about Maris and Mauve," Jan remembered, "but most of all about Millet."

Reassured by the brothers' good company, and by Vincent's repeated pledges to "make a living," even Dorus and Anna began to relax from their long despair. Not a word of criticism or concern made its way to Theo that summer. They willingly offered the parsonage outbuilding, a former Sunday school, for Vincent's strange ritual with the local peasantry, taking on faith (and his forceful protests) that it constituted an essential step in the long ascent out of the black country—the safe return of their eldest son to the "normal life" for which they had never stopped praying.

All those prayers seemed answered when Anthon van Rappard arrived in June. For both Vincent and his parents, the visit of the young gentleman with the noble name crowned the fantasy of a new life. On the day of his arrival, the Van Goghs took their distinguished guest on a long walk to display him to the neighbors. He accompanied them to church on Sunday and sat at the front of the big medieval sanctuary in the side pew reserved for the preacher's family, where the whole congregation could see him. He received the ultimate imprimatur of family approval when Vincent took him to Prinsenhage to meet the ailing Cent (who was too sick to receive them).

Vincent exulted in his parents' approbation as much as his new friend's attentions. "Van Gogh was in very high spirits then," Jan Kam recalled of Rappard's visit, "more cheerful than I would ever see him again." With camp stool and sketchpad in hand, Vincent led his new "fellow traveler" (the same term he applied to Theo) on a tour of all his favorite spots in the countryside around Etten: the deep, mysterious woods of Liesbosch to the east; the "notorious" village of Heike to the south (home to "gypsy-like" refugees and other "riff-raff" where Vincent often recruited models); and the strange swampland, called the Passievaart, to the west.

At various points along the way, in a celebration of artistic fraternity that Vincent would try for the rest of his life to reenact (most memorably in the Yellow House in Arles), the two men set their rickety stools side by side and shared the act of making art.

Once the drawing began, their roles reversed: Rappard led and Vincent followed. The more warmly his parents embraced the handsome young gentleman-artist, the more eagerly Vincent embraced his friend's genteel art. While still in Brussels, he had admired Rappard's pencil-and-pen drawings of

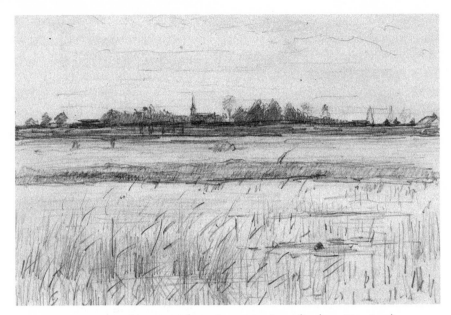

ANTHON VAN RAPPARD, *The Passievaart Near Seppe (Landscape Near Seppe)*,
JUNE 1881, PENCIL ON PAPER, $4^5/_8$ X $6^3/_4$ IN.

trees, vistas, and scenic vignettes, calling them "very witty and charming." He
had adopted Rappard's favored métier, reed pen and ink, and his characteris-
tic short, quick pen strokes to render the infinite variety of nature's textures.
Indeed, Vincent had come to the Etten heaths partly in imitation of his young
companion, who, like many beginning artists, had made sketching trips into the
countryside every summer since adolescence.

Once Rappard joined him, Vincent set aside his long obsession with figure
drawing and turned his full attention, for the first time, to landscape. Both drew
views of the road to Leur, with its rows of stunted pollard willows on either side;
both drew the forest's edge at Liesbosch. Both drew the Passievaart swamp with
the town of Seppe on the horizon.

Despite their shared subjects, shared métier, and even shared vantage
points, the images that emerged from these joint sessions differed as much as
the two men who created them. From the spot they had picked on the edge of
the Passievaart, Van Rappard looked across the watery marshland and drew the
distant town as an island of heavy pencil shadings floating in the middle of a
sheet of white paper barely bigger than a postcard. He suggested the marsh with
just a few random pencil strokes of reeds and weeds, and clouds with the lightest
grazing of gray. Vincent looked out across the same swampy vista and cast his
eyes downward. Pushing the horizon almost to the top of his much larger sheet,
he relegated the town to insignificance and fixed his gaze on the teeming water

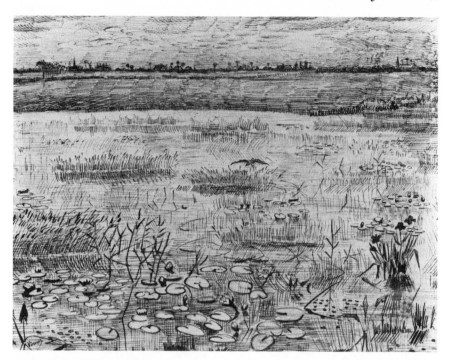

Marsh with Water Lillies, JUNE 1881, PENCIL AND INK ON PAPER, $9^3/_8$ X $12^1/_8$ IN.

at his feet: a tangled world of reeds, flowers, lily pads, and leaves, each with its own slant or arc, its own shape and shade, its own cross-hatched reflection on the still surface of the sunlit bog. With a manic vehemence not taught in any exercise book, he filled the bottom of the sheet with clusters of dots, random dark spots, floating circles, and meandering lines in an effort to render the bottomless fecundity that he knew so well from the banks of the Grote Beek. He added a bird, a visitor from his childhood, swooping low over the water in search of the life squirming unmistakably beneath the pencil marks.

In another drawing that summer—while Rappard continued to make spare, correct renderings of tree-lined country roads and vistas of heath—Vincent explored an even more exotic, unexpected landscape. Probably after his companion had left, he wandered into the garden behind the parsonage and focused his intense gaze on the wooden arbor against the back wall. He had often done drawings of his family's houses, or details of them, to give as mementos or keep as aides-mémoires. The sketch that he started that summer day may have begun that way, as a gift for Rappard or for his sister Wil, who left Etten around the same time.

The wooden bench against the vine-covered wall looks recently deserted, its curvilinear sides drooping as if downcast. Facing it, a metal chair is pushed far away, beyond the shade of the overhanging pergola, where it sits in unnatu-

ral isolation. On the ground between them, a basket and gardening glove lie abruptly abandoned. Around this drama of ghosts, Vincent's manic imagination spun a web of life even more dizzying than the swampy margins of the Passievaart—as if, by looking intensely enough, he could mitigate the pain of loneliness. Vines vein the wall like cracks, grasses bristle underfoot, flowers spring from dense thickets of spiky leaves, pine bushes explode, leaves blot out the sky in a blizzard of dots and dashes. But instead of comforting the observer, the skein of boisterous, indifferent life only intensifies the emptiness of the abandoned pergola. It was a painful contradiction in nature to which Vincent would return again and again in the years to come.

The end of Rappard's twelve-day visit left Vincent lonelier than before, and hungrier than ever for the reconciliation due the Prodigal Son. After so much searching and suffering, did he not deserve the unreserved embrace that Rappard enjoyed from his patrician family—especially his lawyer father? In his renewed ambition to win the hearts so long set against him, Vincent must have drawn strength from the portrait of unstinting paternal solicitude and forgiveness he found in Balzac's *Le père Goriot,* which he read that summer. Theo's visit in July—for which Anna, Wil, and Lies all returned to Etten—demonstrated the joys of family favor in such unbearable contrast that Vincent claimed illness and took to his bed. On leave from his new job as *gérant* of one of Goupil's three Paris stores, Theo, in his elegant suits and Parisian manners, served as a vivid reminder of the distance Vincent had yet to travel to recover what he had lost.

Then, only weeks after Theo left, Vincent thought he saw an opportunity to close that gap and end his years of loneliness in a single stroke. In August, he asked Kee Vos to marry him.

Aimer Encore

~

VINCENT HAD NOT SEEN HIS COUSIN SINCE THE LAST TIME HE VISITED the Vos house in Amsterdam in 1878. In the three years since, both their lives had changed irreversibly. Kee's sick husband, Christoffel, had died later that same year—right before Vincent failed at evangelical school and headed for the black country. They may have just missed each other when Kee visited Etten in the late summer of 1879—about the time Vincent showed up unexpectedly from the Borinage for the fateful confrontation with his father. Apparently, they had not corresponded.

When she arrived at the parsonage for an extended visit in August 1881, thirty-five-year-old Kee was no longer the brave, beleaguered mother of the house "where love dwells" that Vincent remembered from Amsterdam. Still bitterly sad over a death she considered unjust, she remained locked in mourning: a severe, unsmiling figure in high-buttoned black satin, forever sealed to her dead husband by grief; and to her timid son Jan, now eight, by their shared loss.

If anything, the death of Kee's husband only perfected the image that had so enraptured Vincent in Amsterdam. "That deep grief of hers touches and moves me," he wrote. Now, as then, her sadness cried out for consolation—for Vincent, still the heart's highest calling—and her tiny, twice-wounded family seemed even more in need of the completion he longed to provide. But he saw her in another way, too. As part of his new ambition to throw off Kempian self-denial and reclaim his family's favor, Vincent had decided that he needed a wife. "I was set against being alone," he later recalled. His parents had often expressed their desire to see all their children married, and for Vincent in particular, they believed marriage would both anchor him and "spur him to acquire a social position."

Vincent had discussed his new ambition with Theo in July before Kee's arrival, expressing both his long frustration ("Women are the grief of the righ-

teous") and his new determination. "A man cannot stick it out in the open sea," he argued; "he must have a little cottage on the shore with a bit of fire on the hearth—with a wife and children around that hearth." He bolstered this new imperative with a frenzy of reading in the vast Victorian literature on love and marriage. He consumed Charlotte Brontë's *Shirley,* an eight-hundred-page novel of courtship and connubial advantage, in three days. He read the same author's *Jane Eyre,* a story of love (and marriage) triumphing over self-denial, and two novels by Harriet Beecher Stowe, *My Wife and I* and *We and Our Neighbors,* both lengthy testaments to the sanctity of home and family.

KEE VOS-STRICKER AND SON JAN, C. 1881

By the time Kee arrived in August, Vincent must have worked himself into a fever of anticipatory infatuation. Within a mere week or two, without waiting for any indication that his feelings were reciprocated—or not caring that they weren't—he declared his love to Kee. "I love you as myself," he told her,

and asked if she "would risk marrying me." The proposal apparently caught his shy, serious cousin off guard—or perhaps Vincent's fervor offended her. She responded with uncharacteristic "coldness and rudeness." "Never," she huffed over his heedless arguments, "never, no, never!"

Soon thereafter, Kee left Etten and returned to Amsterdam with her son.

But Vincent refused to let go. Not even such a vehement rebuff could dislodge the image now in his head. Just as he had come to see marriage with Kee as essential to his bid for a new life, he inevitably saw her rejection as one with the rejections of the past. Over the next months, his obsessive, defensive imagination would combine all his longings into a single, powerful new delusion of redemption: if he could reverse Kee's "never, no, never," he could not only comfort the bereaved widow, father her fatherless child, fulfill his parents' expectations, end his loneliness, and enjoy the reparative union celebrated in books; he could finally overturn the terrible judgment of the past.

As soon as Kee left, Vincent launched yet another manic campaign of letters to prove himself worthy of her hand. More than anything else, that meant proving that he could make money by creating salable art. "You must be sure that I try very hard to change many things in myself," he wrote Theo, "especially the sad state of my money affairs." He convinced himself that if he could only make a thousand guilders a year, he could "change minds."

In pursuit of that goal, he collected his best drawings and set out for The Hague—a trip he had been threatening to make for almost a year. In a whirlwind two days, he saw anyone he thought might help sell his work or make it more salable. No one was more important to that effort than H. G. Tersteeg. Despite their rancorous exchange the previous spring, Vincent braved a call on his former boss at the Goupil store on the Plaats. "Mr. Tersteeg was very kind," he wrote Theo with evident relief. In response to Vincent's drawings after the old masters—but *not* his original work—Tersteeg allowed that they showed "some progress." "He at least attaches some value to my making them," Vincent reported brightly.

With an introduction from Theo, Vincent visited the studio of Théophile de Bock, a protégé of the most commercially successful of all Hague artists, Hendrik Mesdag. De Bock had returned from Barbizon to assist on Mesdag's magnum opus, the *Panorama maritime,* a four-hundred-foot-long, 360-degree depiction of the nearby seashore at Scheveningen, housed in its own specially built pavilion. Other artists dismissed the just-opened *Panorama* as commercial and "inartistic," but when De Bock took him to see it, Vincent praised The Hague's newest tourist attraction. "It is a work that deserves all respect," he wrote Theo.

On his round of visits to studios and exhibitions, Vincent also met Willem Maris, youngest of the painting Maris brothers, whose watercolors of misty Dutch farm scenes earned him a handsome income, and Johannes Bosboom,

an éminence grise of the Hague School. At sixty-four, Bosboom had long made a comfortable living by selling his nostalgic images of church interiors to an increasingly secularized public. With his portfolio ever ready, Vincent plied the elderly Bosboom (a favorite of Uncle Cent's) for "hints" to improve his drawing. "I only wish I had more opportunity to receive such hints," he lamented.

But Vincent had come to The Hague primarily to see one person: his cousin by marriage Anton Mauve. He had often recalled fondly his trip with Theo to Mauve's studio in Scheveningen in the early summer of 1877, and had set his mind to return there almost from the moment he declared himself an artist. In the intervening four years, Mauve had established himself as one of Holland's most commercially successful painters. Collectors prized his moody images of farmers and fishermen in muted tones and soft light. Equally adept with watercolor and oil, he could transform the most prosaic vignette (a solitary rider or cow) into a poignant tone poem in the brushy idiom made fashionable by the French Barbizon painters. At Scheveningen, he turned his eye both on the picturesque fishing boats that had to be hauled by horses onto the harborless beach, and on the fashionable gentry who went down to the sea in top hats and bathing machines, thus offering bourgeois buyers both an idealized past and a flattering present.

Mauve's likable images and affable, if moody, personality had made him a favorite not only of collectors, but of fellow artists in The Hague, where he helped found a drawing society and served on the board of the city's leading artists' association, the Pulchri Studio. Since marrying Anna Carbentus's niece in 1874, Mauve had also become a favorite of the Van Gogh family. In addition to providing Theo with a home in The Hague, the Mauves had hosted Vincent's parents at their house in the dunes at Scheveningen, and the two families regularly exchanged presents at holidays.

This was the artist Vincent wanted to be. With his handsome, well-stocked studio, his happy marriage and growing family of four children, his commercial success and social standing, the forty-two-year-old Mauve represented the ideal of accomplishment and approval that had become Vincent's consuming ambition. In the short time he spent in Scheveningen, Vincent saw "many beautiful things," he reported. He and Mauve shared an admiration for Millet—the icon of commercial and artistic success combined—and Mauve gave him "a great many hints" on his own drawings. As they parted, he invited Vincent to return in a few months to review his progress. This was exactly the blessing Vincent had come to The Hague hoping for: a show of support from his successful cousin for his new mission to reverse the past. "Mauve gave me courage when I needed it," he reported to Rappard. "He is a man of genius."

Vincent returned to Etten bursting with new energy: so much that he couldn't wait until he arrived to express it. On the train ride home, he got off

in Dordrecht and braved a rainstorm to draw a group of windmills that he had seen on the outbound trip, setting a precedent for a lifetime of Lear-like defiance of the elements in pursuit of an image. Back at the parsonage, he resumed his summer-long attack on figure drawing, scouring the countryside for models and filling sheet after sheet with stiff, posed studies of diggers, sowers, and shepherds; of girls sweeping and peeling potatoes; and of "an old, sick peasant sitting on a chair by the hearth with his head in his hands"—a pose that would haunt

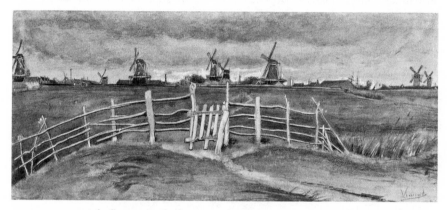

Windmills Near Dordrecht, AUGUST 1881, WATERCOLOR, PENCIL, AND CHALK ON PAPER, $10^1/_8$ X $23^5/_8$ IN.

him to the end of his life. He filled his letters with long lists of figure painters he admired, and page after page of quick sketches of his studies: a catalogue of his hard work every bit as manic and defensive as the letters he had once filled with scripture to prove his piety.

He tried the new materials Mauve had recommended: charcoal and chalk of various colors, sometimes reduced to blunt stumps; watercolor, ranging from the transparency of a wash to the opacity of oil paint; and conté crayon, a soft, oil-based medium in pencil form. As if arguing the images into submission (he talked of "tackling" a figure and "hanging onto it"), he used all of these on the same sheet, applying them with such force that nothing less than the thickest paper could stand up to the onslaught. "I had the devil of a job working with that new material," he later admitted. "I grew so impatient at times that I would stamp on my charcoal and become utterly dejected." Despite setbacks and frustration, he clung tenaciously to his missionary optimism. "What seemed utterly impossible to me before," he said, "is gradually becoming possible now." When Theo wrote that he saw progress in the latest sketches, Vincent responded with a solemn vow: "I shall do my very best not to let you down."

Vincent did his very best for his parents, too. In a rare show of restraint, he hid his disappointment that they had failed to support his suit of Kee Vos that

summer. His mother had offered "many comforting words" after his proposal was rejected, but kept Kee away from him for the remainder of her visit. "She might have taken my part with a little more sympathy," he complained to Theo. His father had offered only a puzzling parable about "somebody who had eaten too much and another who had eaten too little" (a reference, apparently, to their being mismatched). Still, Vincent set these slights aside in the pursuit of his larger goal of winning minds and hearts. After returning from The Hague, he also made a pilgrimage to Prinsenhage to see his uncle Cent, hoping to set right a relationship critical to the new life he envisioned. To his surprise, the aging Cent received him warmly and told him "there really might be a chance for me if I worked hard and made progress." After the visit, Cent gave him a paint box, an encouragement that Vincent found unexpectedly touching. "I am very glad to have it," he said.

The reconciliation with Cent, the endorsement of Mauve, the relentless work effort, the repeated promises of financial self-sufficiency, the vows to "cast out despondency and gloom" and "take a more cheerful view of life," eventually raised yet another flicker of hope in the parsonage. Vincent reported that his parents "are very good to me and kinder than ever," and boasted enigmatically that he had "made rather good progress . . . not only in drawing but also in other things."

Nothing gave the Van Goghs more confidence in the future than their son's fledgling friendship with Anthon van Rappard. Soon after his trip to Prinsenhage, Vincent invited Rappard to return to Etten. "We should all be very happy to have you with us once more," he wrote in a long letter precariously balanced between shameless flattery and patronizing advice. "My friend Rappard has taken a great step forward," he began, using the same lofty third-person shorthand he used with Theo. "I have my reasons for believing that you have reached a point of revolution and reform. *Ça ira!* [So be it]." Vincent sweetened the invitation with intimations of career advancement through his cousin Mauve, through his *gérant* brother in Paris, and especially through his famous uncle Cent in Prinsenhage. He even claimed to have shown some of his friend's letter sketches to his uncle. "[He] thought them very good," Vincent reported, "and noticed with pleasure that you are making progress."

In late October, Rappard stopped on his way back to Brussels, where he had enrolled in yet another academy in order to paint from nude models. Vincent had advised against this plan from the moment he heard of it. He argued repeatedly that Rappard should stay in Holland and draw "ordinary people with their clothes on"—exactly what Vincent was doing. "In no case shall *I* go abroad," he said sharply, "for *I* have made rather good progress since I came back to Holland." He summoned his friend's patriotism as a way of pleading for his fraternity. "As I see it, both you and I cannot do better than work after nature in

Holland," he wrote. "Then we are *ourselves,* then we feel *at home . . .* we have our roots in the Dutch soil." But it didn't work. With Vincent still arguing for a "spiritual kinship," Rappard departed for Brussels, leaving Vincent with yet another embarrassment of spurned ardor.

A FAR MORE DEVASTATING failure loomed in Amsterdam: his suit of Kee Vos had hit an impasse. After months of inundating Kee with plaintive letters, Vincent had received a stern warning from her father. "Her 'no' is quite decisive," Reverend Stricker wrote. He demanded that Vincent stop all efforts to contact his daughter. To continue them, he warned, risked "severing friendly relationships and old ties." Vincent responded defiantly with yet another wave of combative supplications—addressed to both Kee and her parents—demanding one full year of unrestricted access to Kee to convince her that they were indeed "suited to one another."

Both sides soon appealed the dispute to the family's highest court in Prinsenhage. The cagey Uncle Cent tried to placate his ever-troublesome nephew by offering sympathy in exchange for a promise not to "speak or write anything more about this business." But Vincent refused the offer. "No one in the world should in fairness demand such a thing of me," he protested. "A lark cannot help singing in the spring." He accused his uncles, both Cent and Stricker, of "trying to put a spoke in my wheel."

Inevitably, Vincent's defiance of Uncle Cent drew his parents into the fray. After their casual condolences that summer, Anna and Dorus had largely stepped away from their son's strange, unwelcomed courtship—fearing, no doubt, that any opposition would only fan the flames. But eventually they could not withstand the pressure from Amsterdam and Prinsenhage to rein in Vincent's embarrassing persistence. They condemned his proposal (which had taken them completely by surprise) as "untimely and indelicate," and urged him to drop the matter, calling it "settled and done." But when persuasion failed, they had no choice but to intervene. In early November, they insisted that Vincent cease all correspondence.

Only when the confrontation with his parents had reached this impasse did Vincent finally write to his brother about Kee Vos. In a letter incandescent with frustration, he recounted the events of the previous two months. "There is something on my mind that I want to tell you about," he began. "This summer a deep love grew in my heart." Why had he waited so long to report this deep love? "I should like it very much if you could persuade Father and Mother to be less pessimistic," he wrote, enlisting Theo in the brewing family feud. "A word from you perhaps influences them more than anything I can say."

With that, Vincent brought his brother fully into what would become the

most furious campaign of persuasion he had ever mounted—in a life already filled with furious campaigns. After averaging only one letter a month for a year, he would write Theo nine long letters in the next three weeks, sometimes separated only by a day—the next day's letter taking up where yesterday's left off, his thoughts crowding the paper so manically that as soon as he folded a sheet and mailed it, he grabbed another sheet and filled it, so that his letters formed one continuous torrent of words.

He cast himself as a champion and a martyr for love. He vowed to "throw myself into" and "commit myself totally and with all my heart, utterly and forever" to love. He had never really known love before Kee, he declared, only "fancied that I was in love." True love had rescued him from a life "withered, blighted and stricken through all kinds of great misery." And if he could not make her love him? Then "I should probably stay a bachelor always."

Each letter reached for new heights of ardor, bursting again and again into French, the language of the heart. He reread Michelet's *L'amour* and *La femme* and filled his letters with verses from these gospels for the lovelorn. "Father Michelet says to all young men: 'A woman must breathe on you for you to become a man.' " His new passion slipped easily into the homiletic cadences of the old. "My soul's anguish will not have been in vain," he said of his frustrated courtship. "Though I fall ninety-nine times, the hundredth time I shall stand." "For, indeed, of all powers, Love is the most powerful."

Through maniacal repetition, Vincent transformed Kee's devastating "never, no, never" into a caption for all the forces thwarting him—both Kee's reluctance and his family's interference. To express his unyielding rejection of those forces, he invented his own devotional catchphrases: "She, and no other"; and especially *"aimer encore"* (to love again or "Love on!"). "What is the opposite of 'never, no, never'?" he explained to Theo. *"Aimer encore!* . . . I will sing no other song but *aimer encore!"*

Lost in this swirl of metaphor and melodrama, of missionary fervor and Gallic romance, was the woman at the eye of the storm: Kee Vos. In the thousands and thousands of words that poured out of his pen, Vincent devoted hardly a single one to his beloved: no fond descriptions, no happy recollections, no paeans to her brave widowhood or to her tender motherhood, no laments over their parting. Whole pages, even whole letters, went by without a mention of her name. When she does appear, he describes her like a figure in one of his prints, or a character in an Andersen tale: "Oh, Theo, there is so much depth in her character . . . She [has] an outer bark of lightheartedness, but inside is a trunk of firmer wood, and hers is of a fine grain!" Even Theo couldn't help but remark on the absence of "intimate and tender feelings" in his brother's letters.

During the same weeks that he flooded Theo with fevered declarations of irrepressible passion, Vincent did not mention a word about the crisis over Kee Vos

in the four long letters he wrote to Anthon van Rappard. Instead, he engaged in a second, almost equally fanatic campaign to bend a different heart to his will. Vincent's effort to cajole and browbeat his new friend into fraternal submission continued even after Rappard left Etten in late October. If anything, his campaign against academic art (in particular, drawing from the nude) caught the gale-force winds of the Kee Vos storm. Rattled by the densely argued, emotionally charged letters that began to bombard him after he arrived in Brussels, the decorous Rappard accused Vincent of "a lust for argument."

Unlike the defiant polemics to Theo, however, the letters to Rappard were filled with courtesies, apologies, expressions of humility, and concessions of doubt, as Vincent threaded his way through the unfamiliar cordons of friendship. "Let me be very careful, for I am just the kind of man to spoil things for myself when they seem good," he wrote, in a confession unthinkable in his other campaign. Even as he wrenched his family apart with intransigence and incendiary rhetoric, he wooed his friend with elaborate mock syllogisms, sexual innuendos, and playful word games. To Theo, he pleaded the purity and chastity of his love for Kee. To Rappard, he argued the vapidity of romantic love and the imperative of carnal fulfillment.

If the volcano of emotion that erupted in November 1881 was not about Kee Vos or romantic love, then what was it about? The answer was buried everywhere in the ash of words. "Father and Mother do not understand anything of the '*aimer encore*,' " Vincent wrote. "[They] cannot feel for or sympathize with me." "[They] completely lack warm, live sympathy." "They are creating a desert around themselves." "[They] have hardened their hearts." "[They] are harder than stone."

Vincent had staked his new life, his return from the black country, on Kee Vos. By marrying her, he imagined, he could wipe away the sins of the past and catapult his fledgling career into the comfortable world of friends like Anthon van Rappard. By not supporting his suit, however quixotic, his parents betrayed that vision and consigned him to the judgments of the past. "They think me a weak character, a man of butter," he wrote Theo bitterly. "I have become little more than a half strange, half tiresome person to Father and Mother . . . When I'm at home, I have a lonesome, empty feeling."

Even when his parents tried to distance themselves ("Father and Mother have promised not to oppose this if only I leave them out of the matter"), Vincent refused to release them. He expressed astonishment at their claim that the matter didn't "concern" them. Their approval was, after all, the real goal; their "never, no, never," the real obstacle. If they had actively backed his cause, Kee's refusal would hardly have mattered. It was their cold hearts, not hers, that needed to thaw and "*aimer encore*"—love again.

By mid-November, Vincent had come to see his pursuit of Kee as nothing

less than a fight for his "right to exist." He had spent too long underground, he argued, and refused to "go back into the abyss." All he was asking, he said sadly, was "to love and to be lovable—to live." Driven increasingly by paranoia and memories of the effort to commit him to Gheel, he accused his parents of plotting to get rid of him. When they warned him against severing family ties by his perverse persistence, he took it as a threat, and retaliated by pretending to be invisible—not speaking and not responding when spoken to. "For a few days I said not a word and took no notice at all of Father and Mother," he reported to an aghast Theo. "I wanted them to see what it would be like if ties really had been severed."

Day by day, he spun deeper and deeper into delusion. He proudly claimed the title of "sublime fool" and came to see his blind, mad bid for Kee's affection as a spiritual statement. "All in exchange for all is the real true thing," he declared. "That is *it*." In a fever of invention, he imagined Kee's heart softening toward him. "She is beginning to understand that I am neither a thief nor a criminal," he asserted, "but, on the contrary, am inwardly more quiet and sensible than I appear outwardly." He pictured their future together—"I count on her joining in many artistic campaigns with me"—and polished the delusion with the most hopeful image he knew: "While the sky becomes clouded and overcast with quarrels and curses, a light rises on her side."

Finally, surrendering in full to the illusion he had created, he resolved to go to Amsterdam and "rescue" his beloved. "I must do it someday quite unexpectedly," he decided, "and take her unawares."

To go to Amsterdam, however, he needed money. And for that, he needed Theo. Through the hurricane of words, Theo had struggled to remain neutral. Always the peacemaker, he had advised caution from the very start. "Take care not to build too many castles in the air *before* you are sure the work is not in vain," he wrote. His equivocation prompted a predictable take-no-prisoners response from Vincent: "From the very beginning of this love, I have felt that unless I threw myself into it *sans arrière pensée* [without second thoughts], committing myself totally and with all my heart, utterly and forever, I had absolutely no chance." As if trying to slow the speed of his brother's spinning, Theo delayed his replies to each urgent missive, causing Vincent no end of frustration and even suspicion. "You will not betray me, brother?" he inquired after a letter for his parents arrived from Theo, but not one for him.

Despite this uncertain reception, Vincent began lobbying his brother for money almost as soon as he informed him of the "affair." He insisted that his love for Kee actually made him a better artist, and he sent Theo drawings with the reassurance that "since I really love, there is more reality in [them]." When Theo still criticized the drawings as harsh and severe, Vincent argued that only Kee could soften them. He promised his brother to "make lots of draw-

ings . . . whatever you want," and assured him that "*aimer encore* is also the best recipe for *dessiner encore* [to go on drawing]." But when Theo still resisted, Vincent was forced to resort to dark threats of family disruption. "If I do not [go] soon, something will happen . . . which would perhaps do me great harm. Don't ask me to go into it."

Before Theo could respond, events in Etten derailed Vincent's plan for a final confrontation. On November 18, after a furious argument, Dorus threatened to throw his unrulable son out of the house. The immediate provocation, apparently, was Vincent's bizarre effort to make himself "invisible." ("They were amazed at my behavior," he reported proudly.) But, in fact, the explosion had been building for some time. Despite Dorus's early reluctance to take sides, he had been thrust into the thick of the battle by both parties. Once engaged, father and son quickly remounted the barricades of antagonism built up during the long struggle over Vincent's schooling and the Gheel episode. Dorus accused Vincent of intentionally "embittering" his parents' lives, and decried his unconventional behavior and immoral French ideas. Vincent responded by waving the "infected" works of Michelet in his father's face and taunting him, "I attach more value to Michelet's advice than to [yours]." He decried his father's "infuriating" obstinacy and hinted menacingly that if his parents continued to obstruct love's course, "I should not be able to contain myself." Dorus told his son, "You're killing me."

In this war of escalating injuries, it was inevitable that Vincent would denounce his father's religion. The *real* God, he argued, "urges us toward *aimer encore* with irresistible force." Religion would "ring hollow," he declared, "if one had to hide one's love and were not allowed to follow the dictates of one's heart." He sweepingly condemned those like his father who opposed *aimer encore* as "*bégueules dévotes collet monté*" (bigoted, genteel prudes) and dismissed their ideas on morality and virtue as "nonsense." In an astounding about-face clearly pitched to elicit maximum outrage, he repudiated the special authority of the Bible. "I too read the Bible occasionally," he said, "just as I sometimes read Michelet or Balzac or Eliot. . . . But I really don't care for all that twaddle about good and evil, morality and immorality."

With provocations like these filling the air, the parsonage was primed for an explosion. In an enormous rage that evoked memories of the Borinage and Gheel, Dorus lashed out at his son's intolerable persistence in pursuing Kee Vos and "making trouble between us." But Vincent refused to back down. "There are things a man simply *cannot* let pass," he told Theo, things that "anyone with a heart in his body will protest with all his might." The mutual tirade ended only when Dorus hurled the ultimate curse—"God damn you"—and ordered Vincent to "move away somewhere else."

The prospect of leaving Etten and finding a new home and new studio on

his own threw Vincent into a panic. "No, no, it is not the way!" he wrote Theo the same day, begging him to intervene with their father. "If I were suddenly taken out of these surroundings, I should have to start anew on something else." "This must not be!" he protested. "No, no, no, it cannot be right that they want to put me out of the house just at this moment." But not even the threat of banishment could dislodge the delusion on which he had staked everything. "I would rather give up the work just begun and all the comforts of this home," he declared, "than resign myself to not writing her or her parents." He pleaded again for Theo to send him money for the trip to Amsterdam so "I can at least see her face once more."

Within days, Theo met both of his brother's demands: he wrote their parents a letter defusing the crisis and sent Vincent money for the trip. Vincent immediately sent the Strickers a furious letter designed, he said, to elicit from the Reverend "a certain expletive which he certainly would not use in a sermon." Then he rushed off to Amsterdam *plus vite que ça* (quicker than that) for the confrontation he had no doubt played out a thousand times in his imagination.

To get past Kee's gatekeeper father, he would stage a dramatic surprise confrontation so that the poor pastor would "have no alternative but to turn a blind eye for the sake of peace." He waited until the dinner hour and then rang the doorbell at the family's townhouse on the Keizersgracht. When a servant ushered him into the dining room, however, Kee was nowhere to be seen. Her son Jan was there, but not Kee. Vincent checked the plates. "There was a plate in front of each diner, but no extra plate," he recalled. "This detail struck me. They wanted to make me think that Kee wasn't there and had taken away her plate. But I knew that she was there."

When Vincent demanded to see Kee, Reverend Stricker told him she was out. "She left the house the moment she heard you were here," he said. But Vincent refused to believe it. He immediately "squared up" to the Reverend and launched into the fiery arguments he had been rehearsing for weeks. "I got a bit steamed up," he admitted to Theo. "I did not pull my punches." Stricker, too, had been storing up his anger for this moment. "He did not pull his punches either," Vincent recounted, "going as far as a clergyman could. And although he did not exactly say 'God damn you,' anyone other than a clergyman in Uncle Stricker's mood would have expressed himself thus."

Vincent returned the next night, and again Kee disappeared. Her parents and brother accused Vincent of "trying to coerce her." They told him again and again, "the matter [is] over and done with" and he should "put it out of [his] mind." They mocked his pretensions as a suitor, saying that unless his financial prospects improved, "there wasn't the slightest chance of winning her." They ridiculed his "she, and no other," telling him that her answer was "Certainly, not him." To his pleas of *aimer encore*, they delivered a devastating rebuff: "Your

persistence is *disgusting."* He demanded again and again to see her, to have just a few minutes to plead his case directly to her. At one point, he put his hand over a gas-lamp flame and demanded, "Let me see her for as long as I can keep my hand in this flame." Someone eventually blew out the lamp, but weeks later his burned flesh was still visible from a distance.

He came again a third day, but again they told him, *"You will not see her."* "[She] spirited herself away every time," he moaned. As he walked out the door for the last time, he wanly vowed, "the present case is not over." But, of course, it was. "[My] love for her received a death blow," he admitted later. He left Amsterdam feeling "an inexpressible melancholy . . . emptiness, [and] unutterable misery within me," he wrote. The image that had driven him to such self-destructive extremes, the image of a new life, of "a little cottage on the shore with a wife and children around the hearth," was lost forever, just as the dream of following in his father's footsteps had died on the black heaths of the Borinage.

As then, he contemplated suicide. "Yes, I can understand people drowning themselves," he said. But he remembered a line of Millet's: *"Il m'a toujours semblé que le suicide était une action de malhonnête homme"* (It has always seemed to me that suicide was the deed of a dishonest man). "I found strength in [this] saying," he wrote, "and thought it much better to take heart and find a remedy in work."

VINCENT COULD NEVER go home again. He would try many times, but always with disastrous results. The rejection in Amsterdam had been complete, final, and permanent. In Kee's "Certainly, not him," and the Strickers' "Your persistence is disgusting," Vincent heard the voices of his entire family and all of his past. After Amsterdam, only two people still inhabited his darkling world: his brother Theo and his cousin Anton Mauve. "Father is not someone for whom I can feel what I feel for, say, you or Mauve," he wrote Theo as Christmas 1881 approached. "I really do love Father and Mother, but it is quite a different feeling from the one I have for you or Mauve. Father cannot feel for or sympathize with me, and I cannot settle into Father's and Mother's system, it is too stifling and would suffocate me."

As if gasping for air, Vincent arrived unannounced at Mauve's house in The Hague in late November, straight from the catastrophe in Amsterdam. He did not return home or even tell his parents where he was going. Mauve had promised to visit Etten that winter to initiate Vincent into the "mysteries of the palette." Now, instead, Vincent had come to Mauve. With his heart "beating quite hard" for fear of another rejection, he begged his cousin to let him stay "for a month or so" and allow Vincent to "occasionally trouble [him] for some help and advice." By way of explanation, he offered only a cryptic French expression,

to convey the urgency of his distress: *"J'ai l'épée dans les reins"* (literally, I have a sword in my gut).

He stayed at an inn nearby and walked every day to Mauve's comfortable canalside studio on the city's east side. Because Vincent insisted on making salable works, Mauve introduced him to watercolor, a lucrative but difficult medium at which Mauve excelled. "What a splendid thing watercolor is," Vincent exulted after making a portrait of a peasant girl with only a few strokes of muted color. "[It] expresses atmosphere and distance so that the figure is surrounded by air and can breathe." Under his cousin's guidance, Vincent began to sense progress almost immediately—"a glimmering of real light," he called it. "I wish you could see [my] watercolors," he wrote Theo in yet another cautious surge of hope. "I reckon that I am now at the beginning of the beginning of doing something serious."

As Vincent recovered his artistic confidence, his imagination began to repair the damage wrought by the storms of the previous months. To save face with Theo, he said almost nothing about the debacle in Amsterdam except that "Uncle Stricker was rather angry." He blamed Kee for the failure of his mission. Her silly notions of "mystical love" had proved to him that he needed a *real* woman, he said—that is, a prostitute.

He sent his brother a detailed report of his encounter with just such a woman immediately after leaving the Stricker house in Amsterdam. In a narrative as "realistic" as any of the French novels his father rejected, he described her "modest, little room" and her "perfectly simple bed." She was "coarse, not common," he said, and "no longer young, perhaps the same age as Kee Vos." Like Kee, she had a child, and "life had left its mark on her." But unlike Kee, "she was strong and healthy"—not imprisoned by "frozen" devotion to a dead husband.

To revenge himself on his father, Vincent renounced religion as well as romantic love. "There is no God!' " he proclaimed. "For me, the God of the clergymen is as dead as a doornail." He boasted to Theo that his father and Uncle Stricker "consider me an atheist," and blithely dismissed their accusations with Sarah Bernhardt's famous quip: *"Que soit"* (so what). In religion, as in love, Vincent imagined himself as spurning, not spurned. He compared his long enthrallment to Kee to "leaning too long against a cold, hard whitewashed church wall," and now declared himself liberated from the debilitating detentions of both heart and soul.

In these sweeping renunciations, Vincent imagined reversing all the bitter defeats of the winter in a single stroke—and escaping the judgments of the past a little longer. "You cannot imagine the feeling of liberation I am beginning to have," he wrote. Through the first weeks of December, he bolstered this new

myth of redemption through "realism" with pledges to "become more realistic in everything," and with page after page of "realistic" images of Dutch peasants and vignettes of country life.

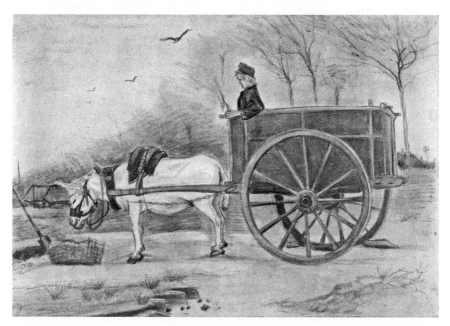

Donkey and Cart, OCTOBER 1881, CHARCOAL AND CHALK ON PAPER, 16³/₈ X 23³/₄ IN.

No doubt sensing the delusiveness of this resolution, he mightily resisted returning to Etten, where it would be tested against reality. "I should like to stay here longer," he wrote from The Hague, "even renting a room here . . . for a few months (and perhaps even longer)." He pleaded with Theo to send more money and defended his heavy expenses for models and materials with one simple explanation: "It is a little risky to remain a realist."

A week before Christmas, alarmed by Vincent's prodigal spending, Dorus came to The Hague to retrieve his troublesome son yet again. Vincent appealed in vain to Mauve, who appeased him with a promise to visit Etten and a vague commitment to continue his apprenticeship in the spring. With Mauve's support, Vincent extracted from his father a promise that he could rent a separate studio in Etten and an agreement not to interfere with his artistic project. "Father must stay out of it," he wrote Theo. "I must be free and independent, that goes without saying."

But it was no use. The end was determined from the moment Vincent set foot back in the parsonage. For a few days he tried the usual tonics of enthusiasm and work to distract him from the inevitability of what followed. He even

located a possible studio, a shed in nearby Heike, where he had often sketched and recruited models. But on Christmas Day, less than a week after his return, the whole precarious delusion came crashing down.

It started when Vincent refused to attend holiday church services. "I naturally told them that it was completely out of the question," he told Theo, "that I thought their whole system of religion horrible." The flames quickly spread from God to Kee Vos to Gheel and beyond, until the entire landscape of the previous four years was engulfed in a firestorm of guilt and recrimination. "I do not remember ever having been in such a rage in my life," Vincent admitted.

In the "violent scene" that followed, Vincent unleashed all his pent-up frustration in a fury of righteous indignation and profane curses. He had spared his father's feelings and weathered his intolerable insults for too long, he said. "I could no longer contain my anger."

It ended only when Dorus cried "Enough!" He ordered his son to leave the parsonage and not to return. "Get out of my house," he thundered, "the sooner the better, in half an hour rather than an hour." This time there would be no delay and no appeal. It was the banishment that Vincent had long feared. As he left, he heard the door lock behind him.

VINCENT NEVER RECOVERED from the events of Christmas Day 1881. "It is and remains a wound which I carry with me," he wrote two years later. "It lies deep and cannot be healed. After years it will be the same as it was the first day." To him, it represented the culmination of all the injuries and injustices of the years that preceded it, many of which had plunged him into self-consuming throes of despair. This time, however, he did not wander into the black country. This time, he had a new light to follow: a new religion, realism; and a new preacher, Anton Mauve.

When Vincent was still in The Hague, Mauve had taken him into the studio and set up a still life of a pot, a bottle, and a pair of clogs. "This is how you must hold your palette," he said as he showed him the oval of colors.

"With painting," Vincent wrote his brother excitedly, "my real career begins."

A Draftsman's Fist

~

VINCENT HEADED STRAIGHT BACK TO THE HAGUE, CONSUMED IN BITTER-ness and rage. The fiery trials of the previous years—the repeated clashes with his father, the months of doing battle over Kee Vos, both climaxing in the events of Christmas Day—had brought his ardor to a boil of indignation and hardened his defensiveness into an armor of resentment. "I used to have many regrets and be very sad and reproach myself because things between Father and Mother and me were going so badly," he wrote. "[But] that's over and done with, once and for all."

Brazenly violating his agreement not to return to Mauve for at least three months, he went directly to his cousin's house and begged to resume his apprenticeship immediately. In a move clearly intended to appall and alarm his family, he borrowed enough money from Mauve to rent a room nearby. Defying his father's accusations of profligacy, he spent extravagantly on decorating it. In a brazen declaration of his intent to stay, he filled it with furniture he had purchased, not rented. He bought a raft of new prints to ornament the walls, and flowers for the table. Within a week of his arrival, his last penny was gone. Then he sat down and wrote to his parents, proudly announcing what he had done, declaring their relationship ended, and caustically wishing them a happy new year.

He wrote Theo, too, unapologetically detailing his new life ("I have a real studio of my own, and I am so glad") and hinting darkly that he might be forced to borrow again from Mauve if Theo did not replenish his empty pockets—or even go to Tersteeg for money. Fearing another family embarrassment, Theo sent the money, but not without blistering his brother for behaving so badly toward their parents. "What the devil made you so childish and so shameless?" he scolded. "One day you will be extremely sorry for having been so callous in this mat-

ter." Vincent exploded at the rebuke, responding to his brother's accusations in a long and furious rebuttal. "I offer no apology," he declared. To Theo's charge that such bickering threatened their aging father's health, Vincent replied acidly: "The murderer has left the house." Instead of softening his demands, he complained that Theo had not sent *enough* money, and insisted that Theo guarantee further payments because "I must know with some certainty what to expect."

This was the spirit of anger and defiance in which Vincent launched his artistic enterprise. Art was not just a calling, it was a call to arms. He compared his career to "a military campaign, a battle or a war," and he vowed to "fight my battle, and sell my life dearly, and try to win." "Persistence," he cried, "is better than surrender." He raged against his critics—"the persons who suspect me of amateurism, of idleness, of sponging on others"—and promised to fight them even "more fiercely and savagely" until he vanquished them with his "draftsman's fist."

Only one person seemed immune from Vincent's reflexive, indiscriminate belligerence: Anton Mauve. A sensitive, decorous man, struggling to maintain family decorum without being dragged into the family's darkest melodrama, Mauve opened both his house and his studio to his homeless cousin. "He helped and encouraged me in all sorts of practical and friendly ways," Vincent wrote. Despite their obvious differences in age (fifteen years) and disposition, Mauve may have seen in the younger man a dim reflection of his own past. The estranged son of a preacher, he had left home at fourteen to become an artist, dashing the family's plan for him to succeed his father in the ministry.

Like Vincent, Mauve had spent his early years as an impoverished artist set on achieving commercial success by making copable, conventional images. Like Vincent, Mauve threw himself into his work with an industry that verged on mania. In order to finish a painting, he sometimes locked himself in his studio for days at a time. "He gives each picture and drawing some small part of his life," Vincent observed admiringly. Outside of work, Mauve, too, found consolation in nature. He shared Vincent's love of long walks, especially in the evening, as well as his keen sensitivity to the sublime. Although he preferred music to literature (he often hummed Bach while working), Mauve, too, admired the fairy tales of Andersen, which he often recited to his children in a tableau of family intimacy that surely tugged at Vincent's exiled heart.

Mauve's generosity to Vincent represented an extraordinary sacrifice for the one and an unprecedented opportunity for the other. An intensely private man, Mauve rarely admitted guests to his family circle and even more rarely allowed visitors into his studio. He did not take students. Although active and widely admired in the art world of The Hague, he remained generally aloof from social activities. He entertained guests one at a time, choosing his friends for their refined

tastes and "gifts of good sense and humor." Crowds and "empty chatter" made him nervous. Despite his love of music, he refused to attend concerts because he found the rustle of the audience upsetting. He resented any disturbance or "violence" in taste or temperament that might jar what he called the "lyric" quality of his sensibilities.

ANTON MAUVE, 1878

By opening up the cherished serenity of his life to Vincent, Mauve was offering him not just a surrogate family, but an opportunity for advancement that other young artists in Holland could only dream about. For Mauve was more than just a cultivated teacher, he was one of the leading figures of the Hague School, a movement in Dutch art that had risen to the heights of critical and commercial success in the decade since Vincent first encountered it as an apprentice at Goupil. The painters of the Hague School not only claimed the mantle of the Golden Age, but also commanded a growing audience of collectors, especially in England and America, eager to pay dearly for the moody colors, deft brushwork, and picturesque subjects of the new Dutch art. By 1880, Hague School paintings dominated sales at the Goupil store on the Plaats, and its most popular artists—especially Anton Mauve—could not produce enough new work to keep up with the demand both at home and abroad.

Like the movement he championed, Mauve stood near the zenith of his success when Vincent arrived in The Hague in the last days of 1881. Critics applauded and collectors clamored for his appealing images of life among the dunes and meadows, whether in oil or in watercolor. His fellow artists had already begun to surround him with what was later called a "nimbus of devout veneration," lauding him as a "poet-painter," a "genius," and a "magician." In 1878, they honored him by electing him to the board of their most prestigious society, the Pulchri Studio.

Only a week after Vincent arrived, in a first hint of what the future might hold, Mauve nominated his young cousin to become an associate member of the Pulchri, an unprecedented honor for a late-arriving novice. "As soon as possible after that," Vincent wrote Theo in a rush of ambition, "I shall become a full member."

In his comfortable studio on Uileboomen, Mauve offered his young protégé an even more important head start on his new career. Vincent came almost every day to watch and learn—his first opportunity to study a mature painter at his easel. Working with lightning speed, Mauve exercised absolute control over the brush, rendering even the smallest details and most evanescent effects with precise, unhesitating strokes. Experience and endless sketching trips had finely tuned his innate facility until his eye and his hand seemed to work in perfect unison.

At the time Vincent arrived, Mauve had just begun work on a large painting of a fishing boat being hauled onto the beach at Scheveningen by a team of horses, a theme on which he had painted many variations. The scene's foamy water and wet sand gave Vincent a chance to watch his teacher create the pearly atmosphere for which he was most famous. All the Hague School painters were praised (or criticized) for their distinctive muted palette. Instead of bright, contrasting colors, they used a limited range of subdued colors to create moody tone poems of suffused light. Ridiculed at first as "the gray school," they believed that "tonal" painting better captured the "fragrant, warm gray" of their watery homeland.

No one rendered this silvery saltwater light better than Anton Mauve. In the painting that Vincent saw emerging in the studio, Mauve drenched the scene in it: from the mist-laden clouds hanging over the sea, to the puddles of water left by the receding tide, to the slippery sand, to the ink-black boat. "Theo, what a great thing tone and color are," Vincent wrote, entranced. "Mauve has taught me to see so many things that I used not to see."

Despite his commitments to work and family, Mauve made time for his "greenhorn" cousin. He pointed out Vincent's mistakes, offered suggestions, and corrected details of proportion and perspective, sometimes directly on Vincent's sheet. He dispensed his advice with a combination of authority and def-

erence that perfectly suited Vincent's vulnerable state. "If he says to me, 'This or that is no good,' " Vincent reported to Theo, "he immediately adds, 'but just try it this way or that.' " A meticulous craftsman, Mauve extolled the virtues of good materials and good technique ("use the wrist, not the fingers"), and offered "lessons" in common problems, such as how to draw hands and faces—just the kind of practical advice that Vincent craved most: the inside information he felt deprived of by his late start.

Responding to his pupil's most pressing concern—how to make salable works—Mauve continued to urge him toward watercolor. Impatient and forceful, Vincent had always struggled with this fragile medium (he called it "diabolical"), using it mostly just to highlight and fill in drawings. But Mauve, a master watercolorist, showed him how to *draw* using only the luminous daubs and washes of color. "Mauve has shown me a new way to make something," Vincent exulted. "I am getting to like it more and more . . . it is different and has more power and freshness."

Hungry for approval after years of reproaches, Vincent grasped at the attentions of his celebrated cousin. "Mauve's sympathy," he said, "was like water to a parched plant to me." In a fever of gratitude, he lavished praise on his new mentor. "I love Mauve," he wrote. "I love his work—and I count myself fortunate to be learning from him." He bought him gifts, mimicked his speech, cherished his compliments, yielded to his criticisms, and faithfully relayed to Theo every word of his wisdom. "Mauve says that I shall spoil at least ten drawings before I know how to handle the brush well," he wrote, "so [I] am not disheartened even by my mistakes."

Vincent was so enamored of his new mentor that he abjured all other company. "I do not wish to associate much with other painters," he said, "[because] each day I find Mauve cleverer and more trustworthy, and what more can I want?" He begged Theo for more money so that his penury would not embarrass him in front of his genteel cousin, and vowed to "dress a little better" now that he was a regular visitor to the studio on Uileboomen. "I know now the direction in which I have to go," he wrote solemnly, "and need not hide myself." Because of Mauve, he said, "the light is beginning to dawn [and] the sun is rising."

But it couldn't last. No one could satisfy the demands of Vincent's admiration for long, especially not the prickly, introverted Mauve. And Vincent's wild flights of enthusiasm were always doomed to crash in disillusionment. The relationship had already begun to fray when Mauve came to visit Vincent on January 26 in his second-floor flat on the outskirts of town. While he was there, one of Vincent's "models" showed up: an old woman he had recruited on the street—the only place he could find people willing to pose for the little money he could pay.

Vincent tried to cover the awkward encounter by posing the hapless woman

and showing Mauve his sketching skills. But the effort collapsed in embarrassment, sparking an argument between student and teacher. Vincent tried to dismiss the discord as the inevitable friction of artistic temperaments—"we are equally nervous," he explained to Theo—but the episode upset him so much that he took to his bed with "fever and nerves."

Over the next few weeks, in a series of furious letters, Vincent inflated the dispute into a preemptive casus belli. Mauve, apparently, had been dismayed by the scene in Vincent's studio, seeing it as the worst kind of amateur posturing. If Vincent truly wanted to learn to draw the figure, Mauve insisted, he should start by drawing from plaster casts—the traditional method—rather than waste his time (and his brother's money) on playacting with street people. "He spoke to me . . . in a way such as the worst teacher at the academy would not have spoken," Vincent fumed.

The battle lines were drawn. Rather than wait for the inevitable rejection, Vincent sprang to the attack. He accused Mauve of being "narrow-minded," "unfriendly," "moody and rather unkind." He cast the dispute as a veiled assault on his whole artistic project, claiming that Mauve secretly disliked his work and harbored a wish "that I should give it up." He escalated the argument into a contest not just between live models and plaster casts, but between drawing and watercolor; then, between realism and academism. Calling watercolor "exasperating" and "hopeless," he virtually gave up trying to master the medium—a ringing repudiation of his teacher.

On the other hand, he defiantly continued working with his model, arguing that he was "getting more used to [her], and for that very reason I must continue with her." As if determined to push the dispute into a confrontation, he persisted in demanding his cousin's attention. He seemed shocked when Mauve withdrew further ("Mauve has done very little for me lately," he complained) and genuinely wounded when the older man lashed out at him in exasperation: "I am not always in a mood to show you things, [and] you will damn well have to wait for the right moment."

When Vincent still pressed his case, Mauve turned on him. In a poisonous pique, he "spitefully" mimicked his student's "nervous and flurried" speech, and mocked his earnest, grimacing expression. "He is very clever at those things," Vincent later recalled painfully. "It was a striking caricature of me, but drawn with hatred." Vincent tried to defend himself: "If you had spent rainy nights in the streets of London or cold nights in the Borinage," he told Mauve, "you would also have such ugly lines in your face and perhaps a husky voice, too."

But his real response came later when he returned to his room and hurled the plaster casts he had into the coalbin, smashing them to pieces. "I will draw from those casts only when they become whole and white again," he vowed in a fury of hurt, "when there are no more hands and feet of living beings to draw

from." Then, in a final provocation, he returned to Mauve and flaunted his defiant act. "Don't mention plaster to me again," he raged. "I can't stand it." Mauve immediately banished Vincent from his studio and vowed "not to have anything to do with him" for the rest of the winter.

It had lasted barely a month.

WITH H. G. TERSTEEG, the break came even more quickly. The precocious Goupil *gérant*, now thirty-six, stood at the epicenter of the Hague art world, his star rising ever higher with the success of the Hague School painters whom he had long supported. No one, not even Mauve, could have done more to further Vincent's career.

At first, Tersteeg welcomed his former apprentice to The Hague, apparently setting aside their rancorous exchange the previous spring when he accused Vincent of sponging off his uncles and advised him to be a teacher, not an artist. Vincent joined in the show of reconciliation, saying "all had been forgiven and forgotten," and suggesting "let bygones be bygones." But of course nothing had changed. Just as he could leave no slight unchallenged, Vincent could leave no courtesy untested. Less than two weeks after his arrival, he went to Tersteeg and borrowed twenty-five guilders, not a trivial amount. Tersteeg retaliated by waiting three weeks to make his first visit to Vincent's apartment.

When he finally did visit, the dispute erupted into the open. Shrewd and imperious, and unrestrained by family ties, Tersteeg did not mince words. He called Vincent's pen drawings—his pride—"charmless" and "unsalable," and reproached him for persisting in the clumsy, amateur sketches that filled his studio. He disparaged Vincent's prized models with a haughty "There are no models in The Hague." If Vincent really wanted to make a living as an artist, said Tersteeg, he had to abandon figure drawing and apply himself to watercolor—landscapes, preferably. He also had to give up the large Bargue-sized images he favored and make smaller works. He scoffed at Vincent's defense that his drawings had "character," and when Vincent brought out his fat portfolios to prove how hard he worked, the *gérant* dismissed their contents as "a waste of time." Figure drawing, he told Vincent, "is a kind of narcotic which you take in order not to feel the pain caused by being unable to make watercolors."

Even by the standards of their difficult past, it was a shattering indictment. Tersteeg had always had a perverse instinct for Vincent's weaknesses; and Vincent, always a special sensitivity to his former boss's rebukes. Deeply wounded, Vincent unleashed a storm of protest. The violence of it would tear him away from beliefs he had professed only weeks before and cast him on a new and perilous course. Calling Tersteeg "thoughtless" and "superficial," he vehemently defended his drawings, insisting "[they] have a great deal of good in them." He

argued that figure drawing from the model was both more difficult than water-color, and more "serious"—that is, more capable of expressing deeper truths.

Soon the arguments escalated into a sweeping rejection of the goal that had guided him since he emerged from the Borinage: to support himself by selling his work. "I shall not run after the art lovers or dealers," he vowed; "let them come to me." Rather than "flatter the public," he wanted only "to be true to myself"— even if that meant expressing "rough things in a rough manner." Where only a month before he had confessed himself an eager novice, hungry for instruction, now he cast himself as a persecuted artist defending his integrity. "Since when can they force or try to force an artist to change either his technique or his point of view?" he demanded indignantly. "I think it very impertinent to attempt such a thing." "I will not let myself be forced to produce work that does not show my own character."

In February, the arguments exploded into personal vitriol. Vincent set the fuse by sending Tersteeg a letter accusing him of being complicit in the blowup with Mauve. After Theo missed a monthly payment, he also suspected that the sly *gérant*, just returned from a trip to Paris, had poisoned his brother against him. "Is it possible that you have heard something from Tersteeg that has influenced you?" Vincent inquired afterward. When the payment still did not come, Vincent marched to Goupil and confronted "His Honor." He demanded that Tersteeg make good on his brother's obligation by giving him ten guilders. Tersteeg responded with "so many reproaches—I might almost say insults," Vincent sputtered, "that I could hardly control myself."

Tersteeg renewed his charge of the previous spring that Vincent's artistic "calling" was nothing more than fakery and laziness, and that he should give it up. "You must earn your own living," he said: get a job and stop "taking money" from Theo. He told him point-blank, "You started too late." As for his chances of ultimate success, Tersteeg vehemently restated his opinion of the previous spring: "Of one thing I am sure, you are no artist." He dismissed Vincent's efforts since then with a blithe *"ni fait ni à faire"* (neither done nor to be done). But this time, he went further, using his unique position as a family friend who had known Vincent since Zundert to pronounce a devastating judgment: "You failed before and now you will fail again . . . This painting of yours will be like all the other things you started, it will come to nothing."

Vincent was crushed. Tersteeg had said "such things [as] pierce the heart and grieve the soul," he wrote Theo bitterly. He accused Tersteeg of an unreasoning personal antipathy going back to their earliest days. "For years he has considered me a kind of incompetent dreamer," he wrote. "[He] always starts with the fixed idea that I can do nothing and am good for nothing." Although he fiercely rejected Tersteeg's judgment about his future as an artist—"I do in-

deed have the artistic sense in the very marrow of my bones," he insisted—he also wondered plaintively why the *gérant* didn't "ask for things that *I* can *make*, instead of asking for impossible things." But then the anger returned and he longed for the good old days when men like Tersteeg could be sent to the guillotine with the other villains of the ancien régime.

When Theo tried to calm the tempest by urging Vincent to "remain on good terms with Tersteeg [because] he is almost like an elder brother to us," Vincent exploded in a rage of sibling rivalry. The thought of his younger brother making common cause with the dandy parvenu usurper propelled him to new heights of antipathy. He listed in obsessive detail all the ways in which Tersteeg had betrayed him over the years. When Theo demanded that he take back his harsh words, Vincent flatly refused. Instead, he escalated his attacks to include *all* art dealers, and strove relentlessly to drive a wedge between his brother and the "Satan" Tersteeg. For a few delusional weeks, he even tried again to persuade Theo to quit his job and become an artist, challenging him to renounce the perfidious *gérant* and declare his solidarity with his true brother. "Remain something better than H.G.T.!" he exhorted. "Be a painter!"

At one point, Vincent agreed to stay away from Tersteeg for six months. At another time, he claimed utter indifference to him ("Tersteeg is Tersteeg, and I am I") and pledged to "absolutely forget him." Only days after Vincent assured Theo he was "done with him for good and all," Tersteeg paid an unannounced visit to Vincent's studio that set off yet another frenzy of anger and defiance. "I must make him understand that he judges me too superficially," Vincent fumed.

This was the pattern that would mark Vincent's relationship with Tersteeg for the rest of his life: periodic fits of rage, followed by grudging efforts at reconciliation, followed by meaningless vows of indifference, in a rondo of obsession that never stopped. After years of rancor, the events of the winter and spring had transformed the elegant *gérant* into Vincent's implacable nemesis—as unappeasable in art as his father was in life. His letters would return again and again to this unhealing wound, drawn by the irresistible desire to make salable art, to which Tersteeg seemed always to hold the key; or by the inevitable but intolerable alliance between Tersteeg and Theo, siblings in the Goupil family from which Vincent had been expelled; or by the echo he heard in Tersteeg's criticism of his own secret self-doubts.

MAUVE AND TERSTEEG were hardly the exceptions. Vincent fought with everyone. He rarely reported his fights to Theo, but they echo throughout his letters in the names of fellow artists who appear briefly then are never mentioned again, leaving the traces of a quarrel only in their sudden and unexplained disappear-

ance. Names like Jules Bakhuyzen, Bernard Blommers, Piet van der Velden, and Marinus Boks, often introduced with a burst of hopeful enthusiasm, bear witness to the doomed project of friendship.

Claiming that he did not need friends, Vincent dismissed his fellow artists as tedious, lazy, stupid, and "inveterate liars." Even those he admired could not withstand his attentions for long. In February, he visited the studio of Jan Hendrik Weissenbruch, a senior member of the Hague School whom he had met almost a decade earlier as a Goupil apprentice. An affable, elderly eccentric (known as the Merry Weiss), Weissenbruch offered some welcome encouragement to mitigate the pain of Mauve's withdrawal. He thought Vincent drew "confoundedly well," he said (according to Vincent), and offered to take Mauve's place as Vincent's tutor and guide. "I think it a great privilege to visit such clever people," Vincent wrote Theo after the visit. "That is just what I want." But he never reported another trip to the Merry Weiss and, by summer, talked about him only in fond recollection.

The friendship with Théophile de Bock, which Theo had tried to spark the previous summer, also flamed out quickly. The two had much in common: both were late starters in their art careers (the thirty-year-old De Bock had been a railroad clerk); both worshipped Millet. But from the very start, Vincent doubted the other's true commitment. When De Bock expressed admiration for the Barbizon landscapist Camille Corot, Vincent attacked him for betraying Millet and accused him of "having no backbone." He complained that De Bock refused to accept his advice. "He gets angry when one says some things which are only the ABCs," Vincent wrote. "Every time I go and see him I get the same feeling: the fellow's too weak." After one visit, Vincent concluded bitterly: "He'll never make good—unless he changes." Thereafter, the two saw each other only by accident in the street.

For the first half of 1882, Vincent even declared himself *"en froid"* (in a chill) with the distant Anthon van Rappard, who had refused to concede defeat in their epistolary battle over academic drawing. When Rappard wrote him a stout rebuttal around New Year's Day, Vincent promptly terminated their correspondence. "Nothing, or hardly anything, in your letter holds water," Vincent huffed. "I have more serious things to do than write letters." Only the insulation of distance and silence kept the name Van Rappard off the growing list of friendships failed or forgone.

Besides, Vincent had found a replacement. George Hendrik Breitner was twenty-four, exactly Theo's age, when he and Vincent began to make joint late-night forays into the Geest, The Hague's red-light district, in early 1882. Expelled from art school two years earlier, Breitner was already developing into a Hague School iconoclast, despite his friendships with both Willem Maris and the powerful Mesdag, for whom he had worked on the *Panorama*. He had noth-

ing to lose from associating with the outcast Van Gogh. (Like Rappard, Breitner had previously known Theo.)

As with Rappard, Vincent immediately launched an extravagant campaign of comradeship. Within the first week or two, they went on multiple sketching trips and exchanged several studio visits, while continuing their nocturnal outings. As with Rappard, Vincent put fraternal solidarity ahead of artistic imperative and followed the younger man's lead. Breitner had largely shaken off his classical training and embraced the gritty naturalism of French writers like Zola and the Goncourt brothers. Whereas Vincent went to the Geest to recruit models that he could pose for his Millet scenes of country life, Breitner went because the city itself was his subject. Modern artists should find their inspiration not in some mythic rural past, he argued, but in the dark immediacy of contemporary urban life. He fashioned himself a "painter of the people."

Vincent eagerly followed his young companion into soup kitchens, train station waiting rooms, peat markets, lottery offices, and pawn banks. At first, he used these expeditions only as a way to find new subjects for figure studies to be done later, in his studio, with a model. But soon he joined Breitner in directly sketching vignettes of street life—a bakery storefront, a chaotic road excavation, a lonely sidewalk—all subjects in which he had never before shown any interest. The results were hardly encouraging. Eager to capture the bustle of city life that fascinated Breitner, but unable to abandon his own fixation on solitary figures, Vincent produced at least one bizarre street scene showing a toddler crawling beside an open trench and an old woman with a cane colliding with a ditch digger.

All Vincent's efforts at friendship were similarly doomed. By the time Breitner entered the hospital in early April (for venereal disease), Vincent was already chastising him for being "afraid to take models." Vincent visited his sickbed, but when Vincent was hospitalized two months later, Breitner felt no obligation to return the favor. In fact, they did not speak again for a year. Admitting that Breitner had "broken contact completely," Vincent burst into wounded recriminations, dismissing his paintings as "tedious," "dull," and "haphazardly smeared," and insinuating that his failure to take more models showed a lack of virility.

What was it like to fight with Vincent van Gogh? His uncle Cor found out when he visited in early March. Vincent had not seen his other art-dealer uncle since they argued over Vincent's decision to quit his studies in Amsterdam. After a year of bitterly denouncing Cor's failure to support his fledgling career, Vincent had swallowed his pride and invited his rich uncle to see his new studio. He dreaded the visit, and steeled himself against another debacle like those with Mauve and Tersteeg, vowing in advance to stop "running after" dealers, "no matter who they are."

By the appointed day, this reservoir of resentment was poised to break.

When Cor mentioned that Vincent needed to "earn his own bread," he reaped the flood. "Earn bread?" Vincent demanded.

> How do you mean? Earn bread, or deserve bread? Not to deserve one's bread—that is, to be unworthy of it—is certainly a crime, for every honest man is worthy of his bread; but unluckily, not being able to earn it, though deserving it, is a misfortune, and a great misfortune. So if you say to me, "You are unworthy of your bread," you insult me. But if you make the rather just remark that I do not always earn it—for sometimes I have none—well, that may be true, but what's the use of making the remark? It does not get me any further if that's all you say.

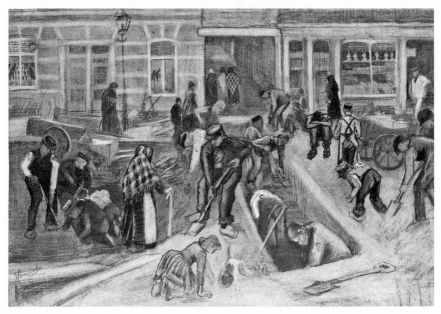

Torn-Up Street with Diggers, APRIL 1882, PENCIL AND INK ON PAPER, 16⁷/₈ X 24³/₄ IN.

When friends and family complained about Vincent's quick temper, this is what they meant. Arguments seemed to materialize out of nothing. By Vincent's own account, he could walk into another artist's studio and "immediately, sometimes in less than five minutes," burst into a dispute so intense that "neither party can go forward or back." A word, a gesture, even a look could set off a storm of heated words, leaving listeners like Uncle Cor startled and speechless, feeling as if they had interrupted a fierce internal debate. Disagreements quickly escalated, as Vincent's proselytizing fervor and open-wound defensiveness merged into a frenzy of argument that knew neither reason nor restraint.

"I do not always speak justly," he admitted later, "but let my imagination roam without regard to reality, and see things in a very fantastic way." Swept up in these delusions of rhetoric, he pursued his positions to absurd extremes, reduced all relatives to absolutes, conceded nothing, and lashed out bitterly at his attackers in language he often regretted later.

No one understood this self-defeating vehemence better than Vincent himself. Sometimes he attributed it to "nervous excitement" or "passion aggravated by temperament." "I am a fanatic!" he explained. "I am going in a definite direction, and I want others to go along with me!" He protested that "those who are serious at heart . . . often have something disagreeable about them." But in a moment of candor—rare for this period—he acknowledged the truth. "I am often terribly melancholy, irritable, hungering and thirsting, as it were, for sympathy; and when I do not get it, I try to act indifferently, speak sharply, and often even pour oil on the fire."

This time, however, Uncle Cor did not let Vincent's tantrum deter him from his benevolent purpose. Browsing through his nephew's thick portfolios of drawings, he stopped at one of the street scenes Vincent had sketched with Breitner. "Could you make some more of these?" he asked. Thrilled by his first commission—"a ray of hope," he called it—Vincent set aside his uncompromising arguments with Tersteeg about artistic integrity and eagerly agreed to make twelve views of the city for two and a half guilders each. Although clearly stung that Cor had passed over his hundreds of figure drawings without a single comment, Vincent spared him the furious counterattacks that he had mounted against both Mauve and Tersteeg in defense of drawing from the model.

That is, until after he left. When payment did not arrive promptly once he sent the drawings, Vincent immediately suspected an insult. Even after receiving a second order for six more drawings in April, he continued to question his patron's motives. In May, paralyzed by suspicion, he threatened to stop work on the new commission altogether. "I don't deserve having to consider it charity," he protested. Theo finally cajoled him into finishing the drawings, but when Cor paid him less than he expected, *and* sent the payment "without one written word," Vincent exploded in indignation.

In his uncle's silence, he thought he heard a contemptuous question: "Do you really think that such drawings have the slightest commercial value?" To this imagined scolding, he formulated a brave retort:

> I do not pretend to be acquainted with the commercial value of things . . . I personally attach more importance to the artistic value, and prefer to interest myself in nature instead of calculating prices . . . [If] I cannot give my things gratis for nothing, this is because, like all other

human beings, I have my human needs, wanting food and a roof over my head.

Anticipating that such an argument would be considered "ungrateful, rude and impertinent," Vincent imagined his uncle's response: "Your uncle in Amsterdam, who means so well by you, and is so kind to you, and gives you such help reproaches you for your pretentiousness and obstinacy . . . You treated him so ungratefully that it is your own fault." To this imagined upbraiding, Vincent formulated a proud and defiant reply: "I am willing to reconcile myself to losing your patronage."

It was the kind of argument Vincent would have again and again for the rest of his life—made only more vivid, not less, by the fact that it took place entirely in his own head.

EVEN AS VINCENT fought his mentors, patrons, and fellow artists, he waged an ongoing battle with his art. His draftsman's fist "does not quite obey my will," he complained. The problems he had experienced since declaring himself an artist continued to frustrate and oppose him. In his figure drawings, bodies stretched and bent in impossible ways; faces disappeared in a blur of uncertainty. In his watercolors, daubs missed and colors muddied. In perspective drawings, lines skewed out of true, shadows fell at contradictory angles, and figures floated out of relation to ground or proportion.

Vincent responded to these repeated setbacks with a combination of brave optimism for Theo's benefit and quiet anguish that he revealed only later. "The way they turned out made me desperate," he said the following year about these early drawings. "I made an absolute mess of it." As if disputing the evidence of his own eyes, he redoubled his efforts, just as he had done when his studies in Amsterdam faltered. He rallied himself with the language of combat, vowing to overpower the images and triumph in the "hand-to-hand struggle" with nature.

Rather than slow down and take more care with each drawing, he defiantly pushed himself to go faster, arguing that speed and quantity would produce successful images as surely as precision or facility. "Things like this are difficult and do not always work straight away," he explained. "When they do work, it's sometimes the end result of a whole series of failures." He calculated that if only one out of twenty drawings was successful, he could produce at least one good drawing every week—one "more characteristic, more deeply felt," a drawing of which he could say, "This will last."

When such a drawing emerged from the blizzard of failures, he made copy after copy, sometimes ten in a row, as if unsure of when, or if, another would follow. ("Later one hardly knows how one tossed it off.") Vincent admitted that

he worked this way partly because he could work no other way: "There is something in my make-up that does not want to be too careful," he said. But it was clearly a method perfectly suited to his manic, missionary imagination—a relentless argument with the images in his head—and Vincent sealed it with the most encouraging example of persistence in the face of failure that he knew: "the more one sows," he wrote, "the more one may hope to reap."

Vincent also enlisted his art in his ongoing battles with the world. The increasingly bitter antagonisms with Mauve and Tersteeg drove him even more deeply into his obsession with figure drawing, despite his persistent inability to render the human form convincingly. "The figure takes more time and is more complicated," he claimed, "but I think in the long run it is more worthwhile." He made forays into other kinds of imagery—streetscapes with Breitner, cityscapes for Cor—but always returned to figures, disputing the judgment not only of Mauve and Tersteeg, but also of his own unruly hand. All artistic endeavors began and ended with figure drawing, he argued—even landscape. "[One must] draw a pollard willow as if it were a living being," he wrote, "then the surroundings follow almost by themselves." He bolstered this militant devotion to the figure by reading Alfred Sensier's biography of Millet ("What a giant!"), and defended it with a campaign of words and images rallied by Millet's battle cry: "*L'art c'est un combat.*"

To counter Mauve's and Tersteeg's arguments for watercolor—and against his beloved pen drawings—Vincent set out to prove that his black-and-white images could achieve the same moody tonality as the daubs of watery color that the world was pushing him to make. He worked over drawings again and again, relentlessly shading, rubbing, and erasing, using big carpenter's pencils, ink from a reed pen, ink on a brush, charcoal, chalk, and crayon, trying to achieve the subtle modulations of gray that would match the "drowsy dusk" tone of Mauve's watercolors. "This little drawing has caused me more trouble than has been expended on many a watercolor," he claimed of one such effort. Of another he said, "I have brushed it in with lead pencil . . . as I would if I were painting."

But it was a process that brought him into fresh conflict with both his images and his materials. Pencil marks could be erased or even scraped off (as long as he didn't tear the paper, which he often did); some charcoal could be brushed off with a handkerchief or feather. But the images grew darker and darker as he reworked them in pursuit of a "warmer and deeper" atmosphere, and he had to fight to prevent them from turning "heavy, thick, black and dull." Many of the drawings he made for his uncle show the strains of this struggle: skies lower menacingly, dark rivers pass through darker fields, shadows veil buildings even in broad daylight. When Mauve saw drawings like these, he recognized their defiant ambition to create the mood of color without the means. "When you draw," he told Vincent, "you are a painter."

In April, Vincent sent Theo a figure drawing that announced a new offensive in his battle of images against a disapproving world. It was a naked woman, seen from the side, her legs drawn up to her breasts and her head buried in her crossed arms.

Vincent had begun drawing from the nude.

BY APRIL 1882, only three months after his arrival, Vincent's relentless combativeness had left him virtually friendless in a city his family had called home for three centuries. As an associate member of the Pulchri Studio, he had the right to draw from models two nights a week at the society's imposing home on Prinsengracht, but he never wrote a word or left a drawing to suggest that he took advantage of the privilege. After only two recorded attempts, he gave up on social visits there as well. "I cannot stand the close air of a crowded hall," he explained. "I do not like to be in company."

Nevertheless, in late March, Vincent tried to mount a showing of his favorite black-and-white prints in the Pulchri's popular exhibition series. Although supported by Bernard Blommers, a successful Hague School painter, the proposal met with opposition, even ridicule, from most Pulchri members. They dismissed Vincent's cherished images as mere "illustrations": too superficial, too sentimental, and too commercial for serious artistic consideration. Vincent, who saw even minor disagreements as personal attacks, took their rejection as a declaration of war. He dismissed their opinions as "humbug" and told them acidly to "hold their tongues until they learned to draw better themselves."

After that, he withdrew completely, choking on bitter denunciations of his fellow artists' "pedantic self-conceit," and fantasies of ultimate vindication. "In a year—or I don't know how long—I shall be able to draw," he vowed, "then they will hear me thunder, 'Go to hell'; . . . 'Go away, you're standing in my light.' . . . To hell with anyone who wants to hinder me."

The more attacks he fended off, the more attacks he suspected. Gripped by paranoia, he accused people of laughing at him behind his back, of plotting to "obstruct" him, of "trying to devour" him. Despite his early unearned access to luminaries like Mauve and Tersteeg, he expressed shock at the "jealousy" and "intrigues" he imagined directed against him. He tried to explain the opposition as artistic and inevitable: "The better my drawings become, the more difficulty and opposition I shall meet." But he heard Mauve's cruel taunts of the previous winter echoed everywhere. "If remarks are made about my habits—meaning dress, face, manner of speech, what answer shall I make?" he asked Theo. "Am I really so *ill-mannered*, insolent and indelicate? Could I be such a monster of insolence and impoliteness? [Do I] deserve to be cut off from society?"

In May, Mauve reappeared in Vincent's life just long enough to confirm all

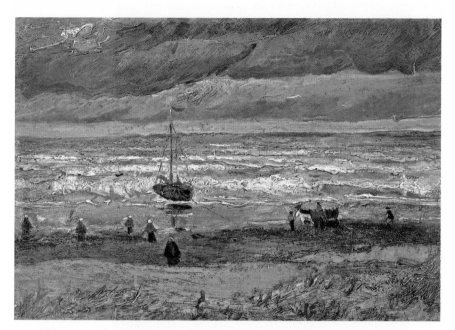

View of the Sea at Scheveningen, AUGUST 1882, OIL ON CANVAS, 13 ⅝ X 20 IN.

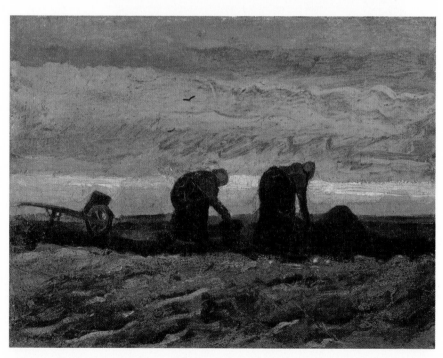

Two Women in the Moor, OCTOBER 1883, OIL ON CANVAS, 10 ⅝ X 13 ⅞ IN.

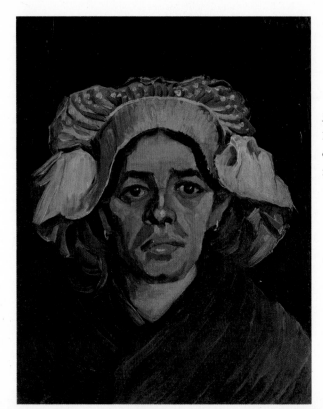

Head of a Woman,
MARCH 1885,
OIL ON CANVAS,
16 ⁷⁄₈ X 13 ¹⁄₈ IN.

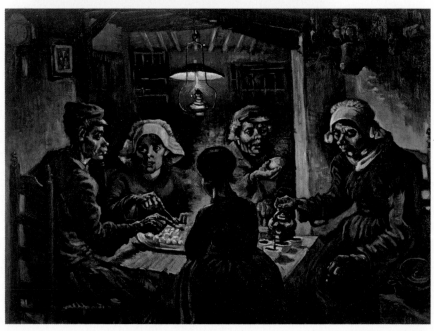

The Potato Eaters, APRIL–MAY 1885, OIL ON CANVAS, 32 ³⁄₈ X 44 ⁷⁄₈ IN.

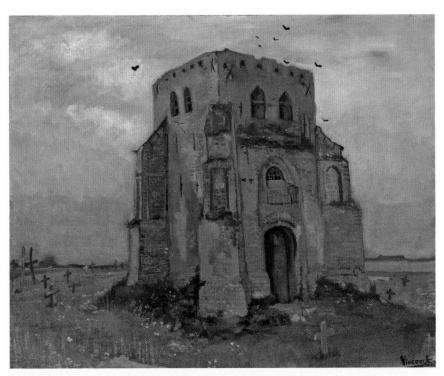

The Old Church Tower at Nuenen ("The Peasants' Churchyard"), MAY–JUNE 1885,
OIL ON CANVAS, 25 ⅝ X 34 ⅝ IN.

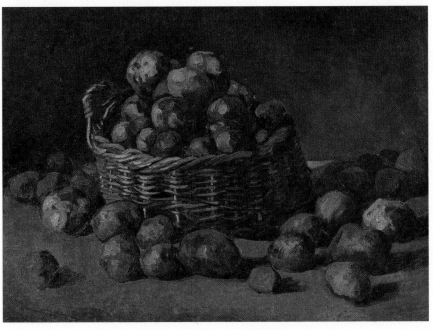

Basket of Potatoes, SEPTEMBER 1885, OIL ON CANVAS, 17 ½ X 23 ⅝ IN.

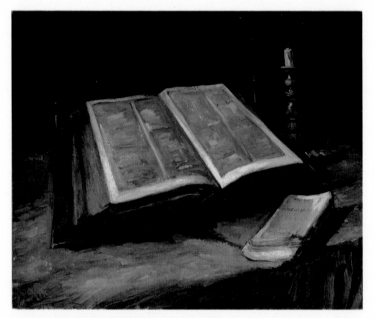

Still Life with Bible, October 1885, oil on canvas, 25 5/8 x 30 3/4 in.

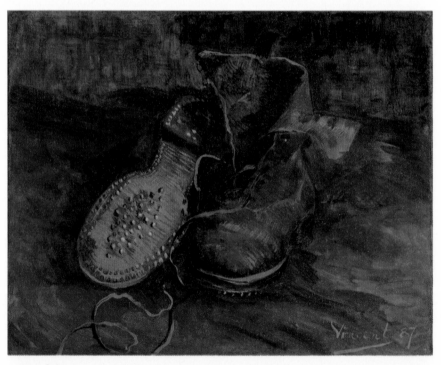

A Pair of Shoes, Early 1887, oil on canvas, 13 3/8 x 16 3/8 in.

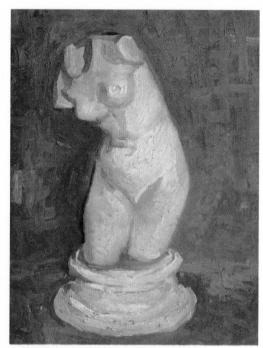

Torso of Venus,
JUNE 1886,
OIL ON CARDBOARD,
13 7/8 X 10 5/8 IN.

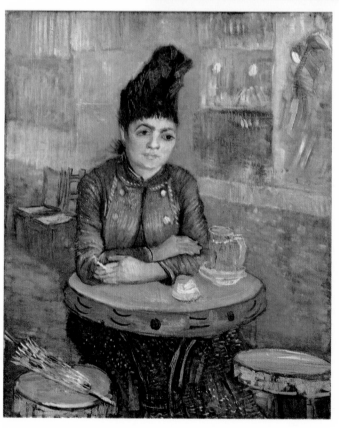

In the Café:
Agostina Segatori
in Le Tambourin,
JANUARY–MARCH
1887,
OIL ON CANVAS,
21 7/8 X 18 3/8 IN.

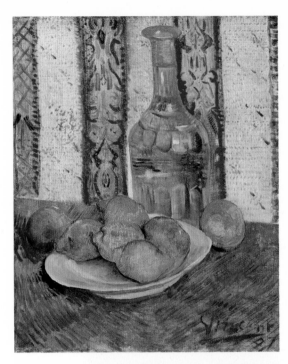

Caraf and Dish with Citrus Fruit, FEBRUARY–MARCH 1887, OIL ON CANVAS, 18 ⅛ X 15 IN.

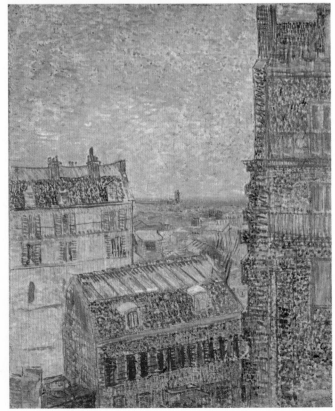

View from Theo's Apartment, MARCH–APRIL 1887, OIL ON CANVAS, 18 ⅛ X 15 IN.

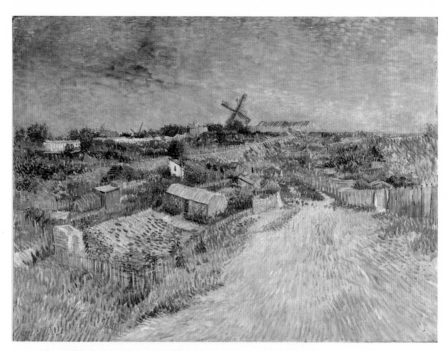

Vegetable Gardens in Montmartre: La butte Montmartre, June–July 1887, oil on canvas,
37 ⁷/₈ x 47 ¹/₈ in.

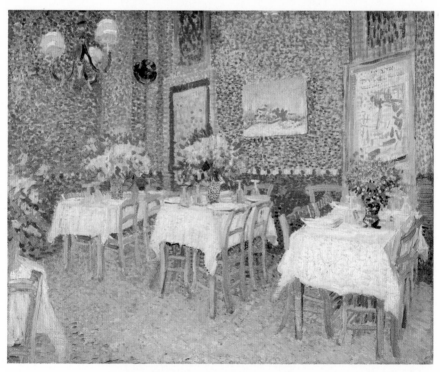

Interior of a Restaurant, June–July 1887, oil on canvas, 17 ⁷/₈ x 22 ¹/₈ in.

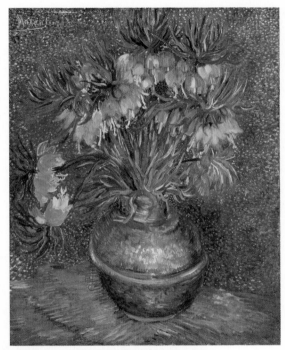

Fritillaries in a Copper Vase, APRIL–MAY 1887, OIL ON CANVAS, 28 7/8 X 23 7/8 IN.

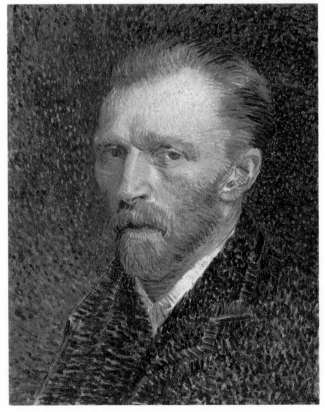

Self-Portrait, SPRING 1887, OIL ON CARDBOARD, 16 1/2 X 13 1/2 IN.

Wheatfield with Partridge,
JUNE–JULY 1887,
OIL ON CANVAS,
21 ³/₈ X 25 ¹/₄ IN.

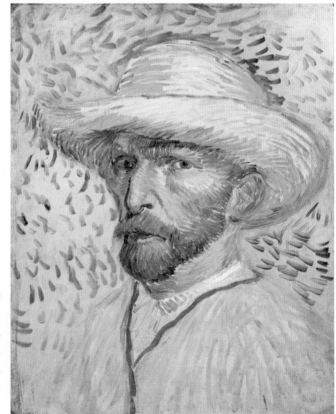

Self-Portrait with Straw Hat,
AUGUST–SEPTEMBER 1887,
OIL ON CARDBOARD,
16 ¹/₈ X 13 IN.

Flowering Plum Tree:
after Hiroshige,
OCTOBER–NOVEMBER
1887, OIL ON CANVAS,
21 ³/₄ X 18 ¹/₈ IN.

Portrait of
Père Tanguy,
1887, OIL ON CANVAS,
36 ¹/₈ X 29 ¹/₂ IN.

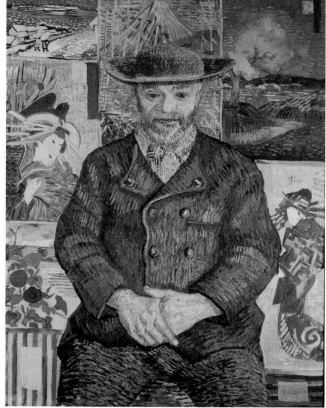

Self-Portrait as a Painter,
DECEMBER 1887–
FEBRUARY 1888,
OIL ON CANVAS,
25 $^5/_8$ X 19 $^7/_8$ IN.

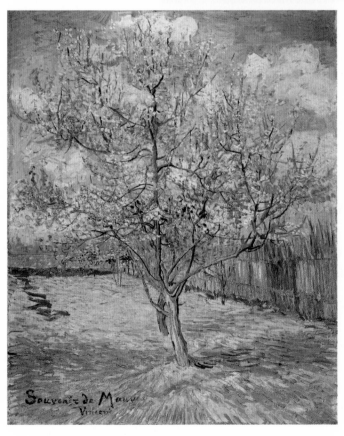

*Pink Peach
Tree in Blossom
(Reminiscence
of Mauve),*
MARCH 1888,
OIL ON CANVAS,
28 $^3/_4$ X 23 $^1/_4$ IN.

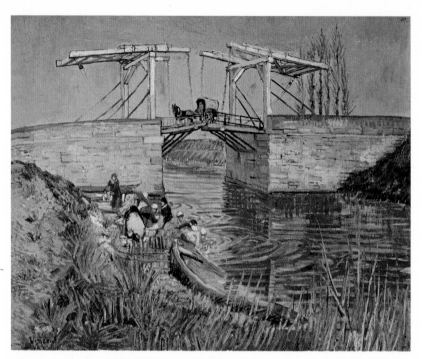

The Langlois Bridge at Arles with Women Washing, MARCH 1888, OIL ON CANVAS, 21 3/8 X 25 5/8 IN.

The Harvest, JUNE 1888, OIL ON CANVAS, 28 3/4 X 36 1/8 IN.

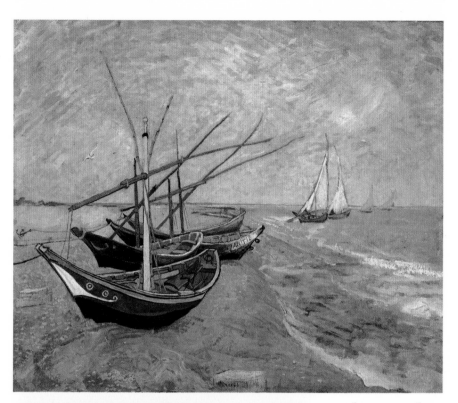

*Fishing Boats on the
Beach at Saintes-
Maries-de-la-Mer,*
LATE JUNE 1888,
OIL ON CANVAS,
25 1/4 x 31 7/8 IN.

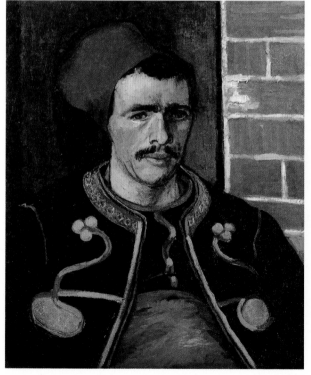

The Zouave,
JUNE 1888,
OIL ON CANVAS,
25 5/8 x 21 3/8 IN.

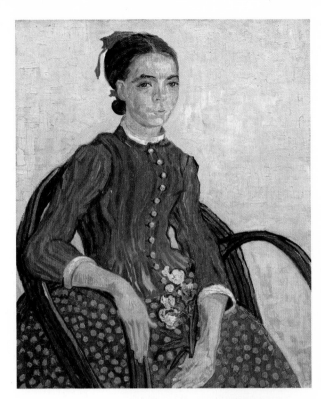

La mousmé, Sitting,
July 1888,
oil on canvas,
29 1/8 x 23 5/8 in.

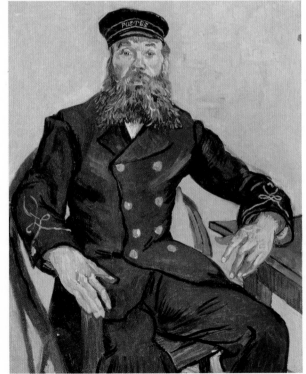

*Portrait of the Postman
Joseph Roulin,*
early August 1888,
oil on canvas,
31 7/8 x 25 5/8 in.

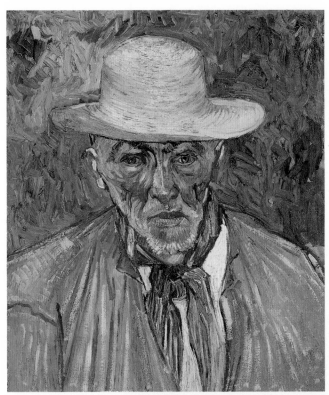

*Portrait of
Patience Escalier,*
AUGUST 1888,
OIL ON CANVAS,
25 $\frac{1}{8}$ X 21 $\frac{1}{4}$ IN.

*Still Life: Vase with
Oleanders and Books,*
AUGUST 1888,
OIL ON CANVAS,
23 $\frac{5}{8}$ X 28 $\frac{3}{4}$ IN.

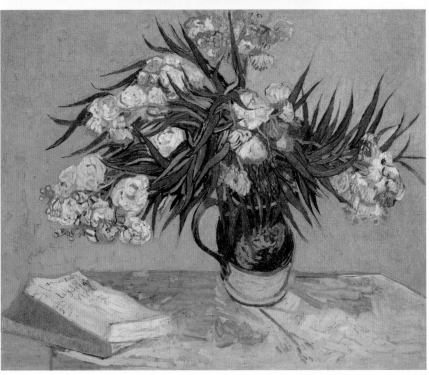

*The Café Terrace on
the Place du Forum,
Arles, at Night,*
SEPTEMBER 1888,
OIL ON CANVAS,
31 $^{7}/_{8}$ X 25 $^{7}/_{8}$ IN.

*The Night Café
in the Place
Lamartine in Arles,*
SEPTEMBER 1888,
OIL ON CANVAS,
27 $^{5}/_{8}$ X 35 IN.

the paranoid voices in his head. Even after his banishment expired in April, Mauve had successfully avoided any further contact with his former student. "One day he is ill, then he needs rest, then he is too busy," Vincent complained. He had written Mauve a pitiful letter, but Mauve ignored it. They spoke only once, briefly, in the street. Angered by this continued coldness, Vincent had written him yet another letter, bitter this time, reopening their final argument (about drawing from plaster casts) in a desperate bid to end their relationship on his terms, not Mauve's. "It is too difficult for you to guide me," he wrote, "and it is too difficult for me to be guided by you if you require 'strict obedience' to all you say—I cannot give that. So that's the end of the guiding and being guided." When Mauve still did not reply, Vincent felt "choked" by his indifference. He complained that the shock of Mauve's desertion made it impossible for him to work. "I cannot look at a brush," he said, "it makes me nervous."

But a few weeks later, when he encountered Mauve by accident in Scheveningen, he found his draftsman's fist again. He demanded that Mauve come see his work and "talk things over." Mauve refused. "I will certainly not come to see you," he said flatly, "that's all over." When Vincent reminded him that Uncle Cor had seen his work and even given him a commission, Mauve scoffed: "That doesn't mean anything; [it] will be the first and last, and then nobody will take an interest in you." When Vincent stood his ground, insisting, "I am an artist," Mauve repeated his accusation of amateurism and added venomously, "You have a vicious character."

Vincent later compared the encounter to being tortured.

In Mauve's betrayal, as in every calamity that spring, Vincent thought he saw the gloved hand of H. G. Tersteeg. Ever since their falling-out in February, Vincent had suspected the *gérant* of plotting against him. He lived in constant fear that Tersteeg's implacable skepticism would infect distant family members, especially Uncle Cent, and no doubt attributed the hostility of the Pulchri members to Tersteeg's ubiquitous influence. When Mauve's attitude toward him "changed suddenly," Vincent immediately accused Tersteeg of poisoning his mentor's ear. In a reverie of paranoia, he imagined Tersteeg whispering to Mauve: "Be careful, you can't trust him with money. Let him go, don't help him any longer; as a dealer I see no good coming of it." Driven by such visions, Vincent imagined Tersteeg as the architect of a relentless conspiracy—a "poisonous wind"—intended to drive him out of The Hague. He accused him of slander and betrayal, and damned him as "an enemy who begrudges me the very light of my eyes."

By April, Vincent imagined that the conspiratorial *gérant* had set his sights on Theo. "[Tersteeg] told me he would see to it that you stopped sending me money," he wrote, frantic with worry. "[He said], 'Mauve and I will see to it that there is an end to this.'"

—

SO FAR, THEO HAD BEEN spared the blunt force of the draftsman's fist. Compared to the rhetorical fireworks and bitter recriminations directed at Mauve and Tersteeg, Vincent's letters to his brother, although tense at times and furious with others, had never veered into open hostility. After Theo's scolding letter in January, and Vincent's defiant reply, their exchanges settled into a wary intimacy—a volatile mix of pleading and threatening on Vincent's side; encouraging and warning on Theo's. Beneath the surface, however, a battle raged.

They fought over money. For Vincent, no subject was more sensitive or incendiary. Since the Christmas expulsion from Etten, his war with the world had made money the defining issue between the brothers. Vincent had spurned his parents' (astonishing) offer to lend him money after his flight to The Hague ("I hate to have to account to Father for every cent I spend," he said brusquely), and Uncle Cent had long since recused himself from his nephew's sad tale. That left only Theo. But his support was by no means assured. In December, he had refused to send Vincent the money he needed to extend his earlier stay in The Hague, after fleeing the Strickers' house.

No doubt with that refusal in mind, Vincent struck a defiant note in his very first request for money from his new home. After spending all one hundred guilders that Mauve had lent him on furniture and "ornaments" for his apartment, he laid his predicament at his brother's feet. "I am in for it now, and the die is cast," he wrote unapologetically. "Of course I must ask you, Theo, if you will occasionally send me what you can spare without inconveniencing yourself." Within a week, the mask of deference was ripped away, and Vincent's tone turned demanding: "Theo, what's the matter with you? . . . I have not received *anything* . . . send me at least part of [the money] by return mail."

Theo's delay in sending a second payment in February sealed Vincent's anxiety and condemned their relationship to an unending cycle of resentful pleading and guilty scheming. Buffeted by a dependence that he loathed and an indebtedness that he could not deny, Vincent careered back and forth between petulant demands and grudging gratitude. He appeased his brother with pledges to dress better, to socialize more, and, most of all, to make salable art—in Vincent's assurances, always just around the corner. He placated Theo with promises of hard work and harsh economies, and charades of financial acumen (calculating down to the day when he would next be "absolutely penniless"). He spun vivid, Camille-like tales of fainting spells brought on by "scarcity of funds." He complained of being harassed and feverish with worry when Theo's money failed to arrive on time. He protested that every franc Theo withheld was a detriment to his art, reminding him again and again in endless variations that "the

success or failure of a drawing also depends greatly on the mood and condition of the painter."

He also threatened. With increasing directness, he warned Theo of the calamities that would befall him if more money were not forthcoming: the embarrassment, the discouragement, the sickness (headache and fever), the depression—and especially the mental problems. "Don't forget that I shall break down if I have too many cares and anxieties," he wrote, waving the red shirt of the Borinage and the family upheaval over Gheel. "All the worry and troubling over my drawings is hard enough," he hinted heavily. "If I had too many other cares . . . I should lose my head."

Meanwhile, he continued to spend money with a defiant disregard for the limits of Theo's purse. Vincent had always been a spendthrift, never budgeting and never saving. He cited the aristocratic Van Rappard as his example. "I see again in Rappard how practical it is to use good stuff," he explained. "Rappard's studio is very good and looks very comfortable." Even so, he should have been able to get by on the hundred francs that Theo sent every month. The average workman earned about twenty francs a week and often supported a whole family on that. While Vincent had expenses no workman did, he also received shipments of his favorite (expensive) paper from Theo, and extra income from his "sales" to Uncle Cor and Tersteeg. No, when Vincent pleaded poverty or missed rent payments, it was because he had spent his last pennies on books, or "special" penholders, or a new easel, or more models, or improvements to his apartment, or additions to his growing collection of prints and illustrations. (Five months after arriving in The Hague, he had more than a thousand of them.) And through it all, he never did without the little girl he paid to sweep his studio.

The problem went beyond simple profligacy. Vincent had come to believe that he deserved to be supported. Whether as an angry challenge or a desperate self-justification, or both, he argued that his hard work and noble purpose entitled him to his brother's money. Thus when Theo pressed him to make more salable works so that he could earn his own living, he countered airily: "It seems to me that it is much less a matter of *earning* than of *deserving*." Armed with this delusional sense of entitlement, Vincent loudly asserted his artistic prerogative; eschewed formal training; disdained taking a job to help defray expenses; and demanded a large, well-stocked studio, prodigious supplies of materials, and a steady flow of private models—all while he was still little more than an unpromising novice. He passed his mounting debts on to Theo with only the faintest expressions of regret ("I see no other way") while covering the indignity of his dependence with a flood of self-justifying letters that argued his right to even more money. He mocked the "poor wretches" who bought lottery tickets "paid for with their last pennies, money that should have gone on food," even as he

undertook projects and purchased luxuries without a cent in his pocket, on the expectation of Theo's next letter.

Tersteeg's threat—"I will see to it that there is an end to this"—threw Vincent into a self-righteous panic. "How is it possible, and what's got into him?" he wrote, frozen by the fear that Tersteeg and Mauve might conspire with his like-minded brother to cut off his funding—"to try and take my bread away from me." He sought reassurances of Theo's support with pleas for sympathy ("I have struggled through this winter as best I could") and with howls of pain: "Sometimes it seems as if my heart would break."

But also with defiance. Rather than moderating his claims of entitlement, Vincent escalated them. Instead of one hundred francs a month, he now wanted one hundred and fifty—almost half of Theo's salary. And he wanted a new studio—bigger, because "it is much better for posing." And, most of all, he wanted a guarantee. "I insist upon its being arranged so that I no longer need be afraid that what is strictly necessary will be taken from me," he dictated, "nor always feel as if it were the bread of charity." No matter what Vincent did—or refused to do—the money should continue to flow, because, he declared, "a workman is worthy of his wages." It was a demand for nothing less than financial independence without financial means, an unprecedented arrangement, and Vincent argued his brother to paralysis over it.

Theo had arrived at the same bitter impasse as Mauve and Tersteeg: Vincent refused to give up, or even moderate, his obsession with figure drawing. With religious absolutism, he had declared himself a disciple of the human body, banishing all compromises as surrender and answering all challenges with indignant defiance. Even the failure to match his passion constituted an act of intolerable moral cowardice, as Breitner and De Bock and the artists of the Pulchri had learned.

Why was drawing figures so important that Vincent was prepared to antagonize two of the most influential figures in Dutch art and even defy his benevolent brother? Why would he sacrifice his best chances for success, collegiality, and even survival on an art form for which he had demonstrated no talent and resisted all efforts at instruction? Was it purely his contrarian nature: his draftsman's fist, still shaking angrily at the world after the twin blows in Amsterdam and Etten? Or was something more at stake?

The answer had to be apparent to anyone who visited the little apartment off the Schenkweg.

It wasn't much: a single room with a potbellied stove flued into a fake fireplace, an alcove for a bed, and a window looking out on a cluttered carpenter's yard and the neighbor's laundry lines. The building, nondescript and cheaply built, sat in a sparsely developed new area on the outskirts of The Hague just beyond the Rijnspoor station: an area of garden plots and cinder paths and the

ceaseless belch and scream of trains only a few steps from the front door. Not really city, not really country, it was a no-man's-land where "nice" people rarely ventured, and never settled.

Still, the neighbors must have wondered at the strange parade of visitors who made their way to the second-floor rear apartment at Schenkweg no. 138. Sometimes Vincent brought them; sometimes they arrived unaccompanied. They came and went throughout the day, from morning until evening: boys and girls, sometimes with their mothers, sometimes without; old men and young men, old women and young women—but never ladies. None was dressed for visiting. They all wore "everyday clothes"; many clearly had nothing else.

These were Vincent's models. He recruited them wherever he could: in soup kitchens and train stations, in orphanages and old people's homes, or just off the street. At first, he tried hiring experienced models like the ones Mauve used, but they cost far more than he could afford. Besides, he seemed to find an odd pleasure in accosting strangers and asking them to pose for him. With its combination of persuasion and intimidation, the "hunt" (his word) for models perfectly suited his missionary mind-set. But it was far harder in The Hague than it had been in rural Etten, where he could convincingly claim a *droit d'artiste*. "I have great trouble [finding] models," he complained soon after arriving.

Some refused to make the long trek to his outlying studio; some promised to come but never showed up. Some came once but never returned. Some refused because they feared "they would have to strip naked"; some could come only on Sundays. Some spurned him because he wore shabby, paint-spattered clothes, others because he wore a fine coat. Money weighed on every encounter. Parents demanded exorbitant sums for children to pose, forcing Vincent to recruit orphans; returning models demanded extra payment for the long commute. He tried saving money by asking people just to freeze in place while he sketched them, but he found these attempts deeply unfulfilling. "The result was always a great longing in me for a longer pose," he said, "the mere standing still of a man or a horse doesn't satisfy me."

Once Vincent managed to pay, plead, or cajole someone into his studio, he took possession of them. "He was anything but meek," one of his models recalled. Somewhere in the one-room apartment, he redressed them in the clothes he provided and then shuffled them into position. He re-created poses from the Bargue *Exercices*, from his print collection, and from his own previous drawings. He reworked favorite poses again and again with the same models in different clothes, or with different models. He re-created scenes he had sketched in the street: a boy pulling a tow rope along a canal; a woman wandering near a madhouse. He wrung as many poses as possible from each model, as if he feared it was his last. He drew each pose from the front, back, and side.

Even though he worked quickly, a drawing usually took at least half an

hour—and that was after the long and tedious business of finding the right light and adjusting the pose until it was exactly what he wanted. When he ran out of poses, he drew studies of heads, necks, breasts, shoulders, hands, feet—devouring each model with his tireless pencil and charcoal until the sunlight disappeared from his south-facing window. When the winter weather warmed even a little, he took them outside or instructed them to meet him at a particular time and place so he could fix the position of a figure in a drawing, or see where the light touched it. It was "hard work" for the models as well as for him, he admitted, and when the light or the pose or the pencil frustrated him, he would "fly into a rage" and leap from his chair screaming "Damn it, it's all wrong!" or worse. His models often complained, and sometimes they simply walked out on him—just as friends did in his other life.

Despite the problems, Vincent could never get enough of models. In Etten, he could have models every day because most were uninitiated rustics who cost him only four francs a week. Even then, he complained it was not enough. In The Hague, professional models charged the same amount *per day*, but still he hired them until his money ran out. Soon he began tapping The Hague's demimonde of poor and homeless willing to do almost anything for pennies. (Mothers on public assistance received only three francs a week.) But the lower expense of amateur models only prompted him to hire more of them, more often. Within a month, he had models "every day from morning until evening." When he found models he liked, he nervously offered inducements to keep them coming back, including regular pay (whether or not he used them), raises, and advances. By March, he had at least three models "under contract" in this way, for a promised payment of two francs a day: a total of sixty francs a month—almost two-thirds of what Theo sent him. And he was already planning an elaborate summer campaign of drawing from the nude.

To justify this extraordinary expenditure, Vincent hammered his brother with every imaginable argument. The more he spent on models, he insisted, the better his work would become. He warned that working without a model would be his "ruin," and that trying to draw a figure from memory was "too risky." He argued that his models gave him the courage he needed to succeed. Because of them, he said later, he "feared nothing." He vowed to sacrifice everything else, from food to art supplies, in order to spend more on models. The desperation of his arguments unmoored him from the principles he had recently espoused so furiously to Mauve and Tersteeg. On the one hand, he proclaimed the moral superiority of figure drawing as "the surest way to penetrate deep into nature." On the other hand, he argued for drawing from the model as the surest way to guarantee commercial success, citing popular magazine illustrators who "have models almost every day."

These muddled justifications masked a single, far deeper one: in his studio,

Vincent was master. By his own account, he dominated his models, or tried to, approaching every encounter as a struggle for control with only two possible outcomes: to submit, or to force submission. The quality he admired most in models was "willingness," he said, and he spoke longingly of "getting my own way with the models" and "making those I want to pose for me do so, wherever I want them, and as long as I want them." He repeatedly compared models to whores, extolling submissiveness as the ultimate virtue in both. He often posed his models in the posture of submission—knees bent, heads bowed, faces buried—and his accounts of models are filled with the language of coercion and domination. "*Take* the model," he advised. "Do not become the slave of your model."

Woman Sitting on a Basket with Head in Hands,
MARCH 1883, CHALK ON PAPER, $18^3/_4$ X $11^5/_8$ IN.

He held up as his ideal the power that a doctor exercised over his patients. "How well he knows how to banish their scruples," he wrote enviously, "and to make them do exactly as he wishes." He expressed special admiration for physicians who were "abrupt" in their handling of patients, and "less afraid to hurt [them] a little." "In the future," he vowed after observing one such doctor at work, "I shall try to handle my models the way he does his patients, namely by getting a firm hold on them and putting them straightway into the required

position." One of his favorite images at the time depicted a group of policemen wrestling a criminal into a chair for a photograph, straining to keep the struggling suspect still. It was called *The Bashful Model.*

Vincent's struggle with models echoed his struggle with materials (some of them "listen with intelligence and obey," he said, while others are "indifferent and unwilling") and ultimately the larger battle of art itself. "The artist always comes up against resistance from nature in the beginning," he explained,

> but if he really takes her seriously he will not be put off by that opposition . . . one must come to grips with her, and do so with a firm hand . . . And having wrestled and struggled with nature for some time now, I find her more yielding and submissive . . . [It] is sometimes a bit like what Shakespeare calls "taming the shrew."

Only in his studio, with his models, could Vincent claim any advance in this mortal struggle. Everywhere else, victory eluded him: in his family, in his friendships, in his relations with his mentors, even in his endlessly compromised love for Theo. Only in his studio could he simulate the control that the world denied him elsewhere. Only here, directing his poor compliant models, could he make life submit to the images in his head. "If only one had to deal with people only inside the studio!" he exclaimed. "But personally I cannot get on well with people outside of it, and cannot get them to do anything."

In this little world ruled by the draftsman's fist, Vincent found a new family. Powerless and homeless everywhere else (the thought of going to Etten "gives me the shudders," he said), Vincent found in the rituals of domination and submission enacted each day in the Schenkweg studio a facsimile of the ideal family that he had tried and failed so often to impose on his own parents and siblings. He chose what they wore and cast them in the roles they played. He posed them with a firm paternal hand: as a mother sewing by the window, as a sister doing chores, as a father quiescent by the stove. At mealtimes, they ate together around the heavy kitchen table. He gave parties for the children; and, at night, he almost certainly gave them shelter sometimes, too.

Although protective of his dominion, he worried endlessly about his models' emotional well-being and longed to strengthen their pretend ties with the genuine bonds of affection. "I can draw the models better when I have come to know them well," he argued. To flesh out this fantasy, he leaped at the opportunity to hire members of the same family to pose for him. Within the first few months, he had recruited a woman along with her young daughter and her aging mother. "They are poor people," Vincent exulted, "and splendidly willing."

—

IT WAS ONLY a matter of time before Vincent longed to complete this flawed fragment of a family. In early May, he wrote to Theo declaring his love for the woman, a prostitute, who was pregnant. He revealed that he had been secretly supporting her and her family for months.

And he said he was going to marry her.

My Little Window

~

*B*EYOND A REASONABLE DOUBT, THEO KNEW OF HIS BROTHER'S
relationship with the prostitute Sien Hoornik long before Vincent confessed it.
Always torn between concealment and defiance, Vincent had made only spo-
radic efforts to hide the affair after it began, probably in late January 1882—a
remarkable act of hubris given the scandals of his own past, as well as the pry-
ing eyes and attentive ears of a city filled with family. Yet every time a family
emissary visited the Schenkweg studio and found him at work with his "model,"
he anguished for weeks that his secret might be revealed to Theo. Hints of dis-
pleasure from Paris prompted anxious, disingenuous queries ("Do you perhaps
know something that I do not?") and strange, abstract arguments about an in-
violable "barrier between artistic and personal matters."

Even without firsthand reports, Theo surely suspected something. At a time
when the door between modeling and prostitution swung freely, and amorous
liaisons between artists and their models were already a hoary art-world cli-
ché, Vincent's incessant talk of models could never avoid a sexual subtext. Both
brothers had long traded in stories of whores and mistresses. Even during his
religious years, Vincent obsessed over "fallen women" and "carnal man" and
the dangers of "violent desire." When he visited a prostitute in Amsterdam after
the debacle at the Strickers', he wrote Theo of his special affection for "those
women who are so damned and condemned and despised."

In late January 1882, he sent Theo another paean to prostitutes, along with
this forthright instruction:

> One must not hesitate to go to a prostitute occasionally if there is one
> you can trust and feel something for, as there really are many. For one

who has a strenuous life it is necessary, absolutely necessary, in order to keep sane and well.

The very same week, Vincent reported triumphantly: "I have had a model regularly, every day from morning until evening, and she is good." Soon after that, he announced that he had begun to draw from the nude.

Not until three months later did the truth come out. Squeezed between the fear that Mauve or Tersteeg would expose his deception, and the increasing financial demands of his new "family," Vincent decided in April that he had to tell his brother about Sien. Instead of an outright confession, however, with its uncertain consequences, he chose to launch another campaign of persuasion. In eight letters over four weeks, he laid out his arguments with equal measures of calculation and ardor—part legal brief, part cri de coeur—in a bid to frame the coming revelation as sympathetically as possible.

First, he escalated his attacks on Tersteeg and Mauve, casting himself as a martyr to their implacable enmity. The one opposed his art and the other resented his peculiarities of manner and dress, he insisted, clearly aiming to undermine the credibility of both as unbiased commentators on his private life.

Then he recast his art. Invoking for the first time the rhetoric of Breitner's "painter of the people," he said that his art *demanded* that he lower himself to the level of the "laborers and poor people" who posed for him. He claimed as his true inspiration the social-realist illustrations of English magazines that he had seen eight years earlier in London—images that had made no apparent impression on him at the time. "Where do the draftsmen who work for the *Graphic, Punch,* etc., get their models?" he asked, in a question so loaded that Theo may have taken it as confirmation of any suspicions he had. "Do they not personally hunt for them in the poorest alleys of London—yes or no?"

If he did not mix well in the dandified company of Hague artists, if his manner did not please the bourgeois Mauve or the honorable *gérant*, it was because he belonged to a "different sphere from most artists," Vincent argued. His art demanded something deeper, something truer to nature. "I do not want the beauty to come from the material," he said, dismissing all complaints about the crudity of his drawings, "but from within myself." That truth, that beauty, of course, was love. Not just any love, but love for a woman who *also* belonged to that other sphere—a "woman of the people."

To conclude his brief, Vincent reminded Theo of his unrequited love for Kee Vos, and of the storm that descended on their family when he was denied the object of that desire. "Last year I wrote you a great many letters full of reflections on love," he said. "Now I no longer do so because I am too busy putting those same things into practice . . . Would it have been better to have kept thinking

of her always and to have overlooked what else came my way?" In a scarcely veiled hypothetical, he asked what else he could do if a model said to him, "I will come not just today, but tomorrow and the day after tomorrow; I understand what you want. *Do as you like.*" If that happened—*when* that happened—Vincent claimed that all his problems would be solved: his drawings would improve, they would start to sell, and (most important to Theo) family peace would be restored: "Father and Mother will come to see me," he promised, "and on both sides this will produce a change in our feelings."

Sorrow, APRIL 1882, PENCIL AND INK ON PAPER, 17$^1/_2$ X 10$^1/_2$ IN.

As always, Vincent's arguments found their fullest expression in images. In mid-April, he sent Theo a drawing that summarized all his earnest pleadings. It showed a naked woman, her legs pulled up to her chest, arms crossed, head bowed—a knot of angular limbs rendered in the bold outline of the Bargue *académie* on which her pose was based. Her folded figure almost fills the 17½-by-10½-inch sheet, as if she is trapped in a box. Her drooping breasts and bulging stomach announce her pregnancy.

Onto this image of stark vulnerability, Vincent layered all his arguments on behalf of the still-hidden relationship. He invoked not only the graphic magazine illustrations of homeless, victimized mothers that he had seen in London, but also Michelet, whose embracing view of love excused all; and Millet, whose woodcut of a shepherdess offered another icon of vulnerable womanhood. He filled in the background with a profusion of carefully chosen symbolic plants—lilies for innocence, snowdrops for purity, ivy for fidelity—and added a budding tree to represent renewal of hope and redemption by love. He raised again the unhealed wound of Kee Vos—"the void in the heart that nothing will fill." Finally, he wrote a single English word at the bottom of the image—"Sorrow"—as a caption for all his pleas.

Vincent called it "the best figure I have drawn yet."

At the last minute, with exposure imminent, he sent another drawing surrounded by another frame of words. It showed a skeletal black tree with its mangled roots exposed by a storm—another study in vulnerability and tenacity in the face of hardship. "I tried to put the same sentiment into this landscape as I put into [*Sorrow*]," he explained: "the convulsive, passionate clinging to the earth, and yet being half torn up by the storm. I wanted to express something of the struggle for life in that pale, slender woman's figure, as well as in the black, gnarled and knotty roots."

By early May, time had run out. Convinced that his secret was no longer safe, Vincent finally confessed the truth. Adopting a tone of righteous indignation, he laced his confession with all the previous month's defenses: "I am suspected of something . . . it is in the air . . . I am keeping something back, Vincent is concealing something that mustn't see the light of day," he began, addressing his offstage enemies Mauve and Tersteeg as well as Theo:

> Well, gentlemen, I ask you, you who prize manners and culture . . . which is more cultured, more sensitive, more manly: to desert a woman or to concern oneself with one who has been deserted? Last winter I met a pregnant woman, deserted by the man whose child she was carrying. A pregnant woman who walked the streets in the winter—she had her bread to earn, you'll know how. I took that woman on as a model and have worked with her all winter.

WHO WAS THIS WOMAN?

Clasina Maria Hoornik grew up in a Hague invisible to Van Gogh eyes. Her father, Pieter, a porter, may have carried Van Gogh packages or delivered letters to a Carbentus townhouse. Pieter's brother, a carriage driver, could have ferried a Van Gogh guest or taken a Carbentus to shop. Pieter's mother, also Cla-

sina, might well have bedded a randy Van Gogh uncle slumming in the Geest in the sixteen years between Pieter's birth and her marriage to a blacksmith, who probably shod a Van Gogh horse. The skeletal public record suggests a vivid tale of illegitimacy, forced marriages, infant mortality, divorces, remarriages, and making do.

Pieter Hoornik fathered eleven children by his wife, Maria Wilhelmina Pellers, and then struggled unsuccessfully to support them until the effort killed him in 1875, at the age of fifty-two. By that time, three of his children had already died. The three oldest boys were set loose to fend for themselves, and the other three (all younger than ten) were sent to an orphanage. Only the eldest and the youngest children, both daughters, stayed with their mother, Maria. By that time, the eldest, twenty-five-year-old Clasina, had already borne her first illegitimate child. It died a week later.

Clasina (called "Sien"), along with her three-year-old sister and her forty-six-year-old mother, did what had to be done. Her brothers could drift between menial jobs—thatching roofs, cleaning stores, repairing furniture— earning just enough to pay for their alcohol and tobacco, while fathering the next generation of illegitimate children in the dense warren of the Geest. But the new era offered no such mercies to poor women on their own. Capitalism brought a flood of new jobs to commercial centers like Amsterdam, but few factories had been built in the harborless Hague. Unregulated workshops paid pennies for long hours in horrendous conditions; and piecework that could be done at home, mostly sewing, was unreliable, underpaid, and underlit (often leading to blindness). Not even benevolent employers thought to pay a living wage to women, whose incomes were always considered merely supplementary.

Both Sien and her mother claimed at various times to work as seamstresses or charwomen, but such terms were used loosely, by both victims and officials, to cover the shame of destitution and its inevitable concomitants. (In England, "milliner" became a euphemism for streetwalker.) On the birth certificate of her second illegitimate child, who was born in 1877, Sien was described politely as *"zonder beroep"*—without profession. Church charity and public assistance provided the thinnest possible insulation from catastrophe, but for anything more, a woman had no choice but to find a man—whether for life, or for the night.

Prostitution offered money, but hardly security. Competition was fierce. Work that required no training and minimal speaking drew women not just from the countryside but from other countries. Most prostitutes lived a nomadic existence, moving from neighborhood to neighborhood, city to city, or even country to country, every few months. To find security for her mother, sister, and newborn, Sien could have applied to one of the city's official brothels—legacies of Napoleon's "French system" of state-regulated prostitution. But that meant the humiliation of registering with the authorities as a "public woman"—a

"woman of the people"—carrying the notorious red card and subjecting herself to regular health exams. The paperwork and public opprobrium (this was Holland, not France) kept most women, like Sien, off the official books.

But a resourceful woman could find plenty of opportunities for sponsorship, if not security, in the scores of beer halls, bars, cafés, and cabarets that lined the narrow streets of the Geest. Outside the official system, prostitution flourished. Engorged on the same new money and bourgeois consumerism as the booming print market, prostitution had become more lucrative and ubiquitous than ever. Repeated campaigns for public health and decency, popular in conservative rural areas, had succeeded only in pushing both prostitutes and their patrons into fewer and larger enclaves in cities like The Hague, creating a busy underworld of carnal sweatshops and piecework every bit as crushing and inescapable as its daytime counterpart.

Survival in this world had taken its toll on Sien Hoornik. In 1879, she bore her third illegitimate child, a boy who died after four months. When she met Vincent less than two years later, she looked a decade older than her thirty-two years. Pale and gaunt, with sunken cheeks and impassive eyes, she had long since lost whatever attractions she once held for wayward husbands and adventurous young men. In *Sorrow*, Vincent had done her a favor by posing her with her head buried, hiding her faceful of smallpox scars. "This ugly, faded woman" is how he himself described her at the time, "no longer handsome, no longer young, no longer coquettish, no longer foolish." Years of rough clients, public humiliation, and official indifference had wrung the last refinements from her. Ill-tempered and prone to fits of anger, she swore like a sailor, bathed rarely, smoked cigars, and drank like a man. A persistent throat affliction had left her with a strange, husky voice.

Vincent reported that other people found Sien "repulsive" and "unbearable." A creature of café and sidewalk by night, soup kitchen and railroad station by day, she had little time left for her sister or her daughter ("a sickly, neglected chit of a girl," Vincent called her). Years of drinking and smoking, malnutrition, multiple pregnancies, at least one miscarriage, and the wear of her nightly work had reduced her body to a "miserable condition," according to Vincent, "a worthless rag," racked by pain, anemia, and the "ugly symptoms" of consumption. Her only apparent joy in life, other than gin and cigars, was a weary, streetwise cleverness in securing advantage. Almost certainly she could not read, and, although nominally Roman Catholic, she could not afford the luxury of religious convictions—or any other enthusiasms that might handicap her daily struggle. Even motherhood. Within a few years of meeting Vincent, she gave away both her surviving children to relatives.

To Vincent, however, she was "an angel."

Where others saw a sinner and temptress—a cautionary example of unbri-

dled female lust, justly "damned" for her wanton lifestyle—Vincent saw a wife and mother. "I have a feeling of being *at home* when I am with her," he said. "She gives me my own '*hearth and home.*' " He listed her domestic virtues—quiet, thrifty, adaptable, helpful, useful—and wrote proudly about the way she mended his clothes and cleaned his studio. He counted her cooking among "things that make life worth living," and compared her favorably to a nurse who had cared for him and Theo in Zundert. "She knows how to quiet me," he wrote, "and that is something I am not able to do for myself."

Where others saw a canny, scheming survivor, Vincent saw a passive and unquestioning "lass," too helpless to make her own bed. He called her a "poor creature"—"as meek as a tame dove." He compared her to the innocent stray animal in the parable of the "poor man who had but one single little ewe lamb." "It had been raised in his house—it ate from his bread and drank from his cup and slept in his arms, and it was like a daughter to him." In Sien's blank, impenetrable gaze, Vincent saw an expression like that of "a sheep that would say, 'If I must be slaughtered, I won't try to defend myself.' "

Rather than an angry and vulgar whore, Vincent saw a Madonna. "It is wonderful how pure she is," he said. He praised her delicacy of feeling and good heart, and told her that no matter what she had done in the past, "you will always be *good* in my eyes." He cast her as a heroine in peril and himself as her rescuer. The more depraved her story, the stronger the fantasy of rescue and redemption grew, until finally he invoked the greatest of all reclamations through love. Quoting Christ's pledge in the Garden of Gethsemane—"*Fiat voluntas*" (Thy will be done)—he promised to save Sien just as he had saved the injured miners in the Borinage.

Vincent saw her face everywhere: in a Mater Dolorosa by Eugène Delacroix, in the idealized dark ladies of Ary Scheffer (painter of the *Christus Consolator*), in the heroine of a Victor Hugo novel. When he leafed through his portfolio of prints, he saw her as the brave matriarch defending her family from deportation in *Irish Emigrants;* as the desperate woman forced to choose between selling her body and starving her children in *Her Poverty but Not Her Will Consents;* as the heartbroken mother surrendering her infant at an orphanage door in *The Foundling;* and as the desperate wife watching as her husband is seized by police and marched away in manacles in *The Deserter.* "She looks just like that," he said of each one.

Finally, he saw in her pockmarked face an image of Christ—"a sorrowful look like an *Ecce Homo*," he said, "only in this case it is on a woman's face."

VINCENT DID NOT just see images, he inhabited them. With his boundless curiosity, obsessive ardor, exquisite receptivity, and astounding recall, he wove them

into his consciousness as deeply as reflexes. Emerging from a childhood defined by images—images that preached, cajoled, cautioned, inspired—he continued to order and describe the real world by reference to the depicted one.

He judged people by the prints that hung in their rooms, or the images they most resembled. He used images to woo, and to chastise; and limned his own tortuous progress by reference to the changing gallery on his walls. In his letters to Theo, he invoked images to support his arguments or express his feelings until the brothers spoke a virtual private language of imagery: tree roots and shepherdesses, meadow paths and churchyards, innkeepers' daughters and revolutionary youths. Every time either brother fell in love with a lower-class woman, the mere mention of a Mater Dolorosa sufficed to explain all. He dreamed in Andersen, he said, and had nightmares in Goya.

As he reeled from crisis to crisis, Vincent placed greater and greater demands on images: altering, combining, and layering them into increasingly sophisticated "expressions," like the *Pilgrim's Progress* of his Richmond sermon. In his effort to console (and be consoled), his eye turned more and more to his imagined world of prodigal sons, persistent sowers, and little boats on stormy seas, and less to the real world around him.

The succession of disasters that began in 1879—Borinage, Gheel, Kee Vos, and now Sien—drove him fully into the embrace of this comforting alternative reality. He looked at the blighted landscape of the Borinage and saw "the medieval paintings of Brueghel." A wagon full of injured miners reminded him of a print by Jozef Israëls; an aging prostitute registered as "some quaint figure by Chardin or Jan Steen." A wood engraving of a coal miners' strike, perused in the comfort of his studio in The Hague, seemed more real—more moving, more inspiring—than his actual experience of such a strike three years earlier. Any poverty or suffering was best glimpsed through the correcting lens of art, and all love's real lessons could be learned from his portfolio of prints. Even as he loudly protested his "feeling for things themselves, for reality," Vincent insisted that the "reality" of Millet or Maris "is more real than reality itself." "Art," he declared, "is the essence of life."

In Vincent's reality, images told stories. For him, coming out of a tradition of children's emblem books and illustrated lessons, images could never shirk their narrative duties. In England, he taught lessons from prints. Preparing for his university exams in Amsterdam, he used images as study aids and conjured illustrations for texts that didn't have them. As a preacher, he filled the margins of his religious prints with bits of scripture and poetry in a running narration of piety. He was always fascinated by episodic sequences of images ("The Life of a Horse," "The Five Ages of a Drinker") and would later ponder interminably over arrangements of his own works in an effort to create a whole more eloquent than its parts.

He described pictures to Theo with a storyteller's delight in unfolding a narrative:

> [An old man] is sitting in a corner near the hearth, on which a small piece of peat is faintly glowing in the twilight. For it is a dark little cottage where that old man sits, an old cottage with a small white-curtained window. His dog, which has grown old with him, sits beside his chair—those two old friends look at each other, they look into each other's eyes, the dog and the man. And meanwhile the old man takes his tobacco pouch out of his pocket and lights his pipe in the twilight.

Vincent's portfolios of prints were filled with images like this one (Israëls's *Silent Dialogue*) that distilled their narratives into titles, legends, or captions: "At Death's Door," "A Helping Hand," "Hopes and Fears," "The Light of Other Days," "Home Again." In his own early works, like *Sorrow*, Vincent observed the Victorian fashion for art that told stories and taught lessons. The very first nude drawing he sent Theo in April 1882, showing a woman sitting bolt upright in bed, came with an explanatory narrative:

> There is a poem by Thomas Hood telling of a rich lady who cannot sleep at night because she went out to buy a dress during the day [and] saw the poor seamstress—pale, consumptive, emaciated—sitting at work in a close room. And now she is conscience-stricken about her wealth, and starts up anxiously in the night.

He gave it a title, too: *The Great Lady.* For Vincent, no image was complete without a bold or suggestive caption—whether or not it was written at the bottom—and he soundly rejected works that defied this narrative imperative, such as the murky, "mystical" visions of his friend Breitner.

In Vincent's reality, images also had to have "significance." Any image that did not reach beyond its immediate subject in search of a deeper meaning, a broader relevance, he dismissed as a mere "impression"—an ephemeral artifact, like a sketch, useful only to the artist in his continuing quest for something more "noble and serious." To achieve significance, an image had to strip away the specifics of the observed world and "concentrate on what makes us sit up and think." An image that "rises *above* nature," he said, "is the highest thing in art."

In an imagination steeped in metaphor and medieval notions of immanence, any subject could aspire to significance. Even the old horses in Mauve's beach painting preached to Vincent "a mighty, deep, practical, silent philosophy": "Patient, submissive, willing . . . They are resigned to living and working somewhat longer, but if they have to go to the butcher tomorrow, well, so be it,

they are ready." Vincent's world was filled with "significant" images like these "ill-treated old nags": wayfaring pilgrims, tree-lined roads, cottages in the wilderness, church steeples on the horizon, old women stoically sewing by the fire, old men despairing, families at dinner, and legions of laborers. "There is more soul in Millet's *Sower*," he proclaimed, "than in an ordinary sower in the field."

In Vincent's reality, images evoked emotions. Born into a family and an era awash in sentimentality, Vincent looked to images not just to be instructed and inspired, but, most of all, to be moved. Art should be "personal and intimate," he said, and concern itself with "what touches us as human beings." He shared the Victorian love not only for scenes of melodramatic emotion—deathbed vigils, tearful farewells, joyful reunions—but also for the sweet ubiquitous vignettes of little girls with baskets, grandparents with children, flirting young lovers, families at prayer, flowers and kittens—nosegays of imagery so popular that they spawned an entire new industry: greeting cards. He hailed "sentiment" as the sine qua non of all great art, and set for his own art the highest goal: "to make drawings that *touch* some people."

In Vincent's reality, even landscapes had to speak to the heart. "The secret of beautiful landscape," he wrote, "lies mainly in truth and sincere sentiment." He praised the Barbizon painters for their "heartbreaking" intimacy with nature. But nature had always been a wellspring of both imagery and emotion for Vincent: from the consolations of creekbank and heath, to the conceits of Karr and Michelet. The landscape images that he began collecting from an early age reflected both the Romantics' awe before sublime Nature and the Victorian code of Nature's sentiments. Every season, every time of day, every meteorological condition was thought to have its own specific emotional effect. Pictures were called simply "Autumn Effect," "Evening Effect," "Sunrise Effect," or "Snow Effect." Each provided an emotional cue, like the caption on a print, as certain and comforting as a children's story: sunrise for hope, sunset for serenity, autumn for melancholy, twilight for longing.

In Vincent's reality, both the search for significance and the search for sentiment demanded simplicity. In his own work, he pledged to seek images "that almost everybody will understand"—to simplify each image "to the essentials, with a deliberate disregard of those details that do not belong." Despite his subtle and far-ranging intellect, he preferred images that did not puzzle or prevaricate. Far too earnest for irony, he drew from the densest Carlyle and deepest Eliot only the most forthright lessons. In huge novels, he sometimes saw only a single character, often a minor one, reflecting back his view of himself and the world. His childhood love of fables and parables, especially Andersen's, and his taste for vivid imagery and simple narratives never left him. He treated the grown-up fables of Dickens as true accounts, only occasionally allowing himself to look into the Englishman's dark heart. Just as he read Dickens as if it were Zola, he

read Zola as if it were Dickens, drawing these very different authors into his reductive imaginary world.

The search for simple truths dominated Vincent's visual world. He loved cartoons—everything from the political send-ups of the British magazine *Punch* to the caricatures of the two great French illustrators of the century, Paul Gavarni and Honoré Daumier, whose droll, sometimes hilarious drawings of bourgeois vanity and official buffoonery carried a weight of humanity as heavy as Millet's toiling peasants. "There is pith and a sober depth in [them]," he wrote. Like Daumier and Millet, Vincent shared the Victorian fascination with "types." The notion that human behavior could be explained through physical appearances was only one of the many comforting pseudosciences spun off by the century's social, economic, and spiritual upheavals. It permeated popular culture: from the sideshow quackery of phrenology to the high art of Balzac's *La comédie humaine.* The work of Vincent's beloved Dickens represented a virtual bible for believers in types, with its unbreakable correlations between outward and inward behavior, between surface and essence.

Raised in a culture of unmistakable distinctions—Catholic-Protestant, rich-poor, city-country, served-serving—Vincent became an ardent disciple of typology long before he took up drawing the figure. If bugs and birds' nests could be catalogued and labeled, why not people? "I am in the habit of observing very accurately the physical exteriors of people in order to get at their real mental make-up," he wrote. From his mother, no doubt, he learned early how to read character as well as class in the clothes people wore. He also inherited her abiding faith in stereotypes. For Vincent, Jews sold books or lent money and "Negroes" (any nonwhites) worked hard. Americans ("Yankees") were coarse and dull; Scandinavians, orderly; Middle Easterners (all "Egyptians"), enigmatic; southerners, temperamental; northerners, phlegmatic.

These were the simple images that peopled Vincent's world: "unpolished" laborers with faces "broad and rough"; fine-featured young ladies and solemn preachers; bent old men and sturdy peasants. Onto this childhood template, the new gospels of physiognomy and phrenology, the *"tournure"* of Daumier and Gavarni, the icons of Millet and the English illustrators, only added layers of refinement and confirmation.

This was the "reality" that Vincent increasingly imposed on the world around him. "I see a world," he said, "which is quite different from what most painters see." It was a reality that demanded "significance." When he saw a group of poor people gathered expectantly outside a lottery office, he dubbed the scene "The Poor and Money." That way, he explained, "it assumed a greater and deeper significance for me than it had at first sight." On his walks, he recognized only effects. ("All nature is an indescribably beautiful 'Black and White' exhibition during those snow effects.") It was a reality tender with emotion. News of a

friend's death could pass with barely a mention, but seeing his portrait opened up floodgates of grief.

It was a reality of uncompromising simplicity. Even his greatest passions had to conform to simple formulae, like the captions on his prints, whether "sorrowful yet always rejoicing" or *"aimer encore."* Through this lens, everyday irritations appeared as *"petites misères de la vie humaine"* (little miseries of human life), and the deepest mysteries as *"quelque chose là-haut"* (something on high). For the rest of his life, no crisis or enthusiasm could avoid the relentless reduction of a motto. From *foi de charbonnier* to *rayon blanc,* he forced the world into categories, as if pinning bugs in a box or arranging prints in a portfolio. He eschewed ambiguity and saw cartoons of metaphor where others saw only harsh reality.

When he looked at people, he saw only types. From the handsome, aristocratic Van Rappard to the lowly streetwalker Sien, they were never more real than characters in a book or figures on a page—drawn indelibly by fate in the broad outlines of their type. ("I *see* things as pen drawings," he said.) Except for Sien, not one of the models who drifted through his studio in two years on the Schenkweg ever merited a personal word or any observation beyond a physical description. He drew orphans repeatedly, but never commented on their circumstance or condition. Of a disabled model he wrote only, "One little fellow, with a long thin neck, in a wheel chair, was splendid."

He treated people according to type, expected them to act according to type, and judged them according to type. Rich men like his uncle Cent *should* think only of money, he said. "One could not expect anything else." But clergymen, like his father, "ought to be humble and contented with simple things." The poor should help each other; women and children (but not men) should "learn thrift." Bourgeois women should be cultured, but not intellectual; lower-class women, neither. Workers should never go on strike, but only "work on to the utmost." Why? Because, like characters in a novel, he said, "it was impossible [for them] to act differently."

Most of all, artists should act like artists. Again and again in Vincent's defiant standoff with the world, he invoked the destiny of "type" to define and justify himself. If he did not seek out good company, it was because, "as a painter, one must *leave aside* other social ambitions." If he suffered from "temporary fits of weakness, nervousness, and melancholy," it was the result of "something peculiar in the constitution of every painter." If he led a troubled, unconventional life, it was because "it fits in with my profession . . . I am a poor painter." Even his "ugly face and shabby coat" he claimed as badges of his type. And if he refused to change his mind about loving Kee Vos or drawing figures or using models or marrying Sien, it was because he was who he was, and an artist could not be any other way. "I do not intend to think and live less passionately than I do," he declared. "I am myself."

In this world of pen drawings, Sien Hoornik had her place, too. For Vincent, as for his era, no typology was stricter than the typology of women (a strait-jacket laid out benevolently in Michelet's treatise on womanhood, *La femme*). In their purest form, they were delicate, inchoate creatures, inherently weak and frail-willed, designed by God for love. Without love, a woman became an icon of pity—"she loses her spirits and the charm is gone," Vincent said. Images of sad, helpless, unloved women preoccupied the Victorian mind in a kind of por-nography of pathos: wives of departing soldiers, homeless maidens, husband-less mothers, grieving widows. The sight of lonely, unloved women, whether in a print or in a church pew, touched Vincent deeply. "Even as a boy," he told Theo, "I would often look up with infinite sympathy, indeed with respect, at a woman's face past its prime, inscribed as it were with the words: here life and reality have left their mark." Mothers were the other icon of womanhood that could move Vincent to tears. His collections had always included this staple of nineteenth-century sentimentalism, and he spun vivid images of motherhood from the threads of his own experience long before he put pencil to paper.

A pregnant prostitute combined the helplessness of all women, the pathos of unloved women, and the dewy sentiments of Mother Love. In Vincent's ty-pology, only a few "temptresses" actually chose prostitution. The vast major-ity of fallen women were merely victims of unloving men and their own weak natures. All women were easily deceived and readily deserted, he believed, but poor women especially, if not taken care of by a man, were always "in great, im-mediate danger of being drowned in the pool of prostitution" and lost forever. An older prostitute mother, like Sien, touched all these talismans of pity. *"My poor, weak, ill-used little wife,"* Vincent called her, "an unhappy, forsaken, lonely creature." Not to help this thrice-damned creature would be "monstrous," he protested. "She has," he said, "something of the sublime for me."

In drawing after drawing, he situated Sien in this intimate typology. He drew her as the "bare, forked animal" of *Sorrow;* as a young widow, dressed in black and lost in melancholy; as a matron sewing serenely for her family. He posed her as a mother, using both her sister and her daughter as children. Suggesting her features with only the most cursory strokes, he depicted her contented in the safe embrace of domesticity: sweeping the floor, saying grace, carrying a kettle, going to church. Rough as they are, these pencil and charcoal drawings, taken together, represent Vincent's first effort at portraiture—the first of many efforts over the coming years that would, like these, reveal far more about the artist and his inner world than about the sitter or the real world.

HOLED UP IN HIS Schenkweg studio, surrounded by prostitutes posing as maternal icons, orphans as shoeblacks, vagrants as Millet farmers, and pen-

sioners as fishermen, Vincent could keep the real world at bay. The studio itself became by turns an almshouse, a peasant's hovel, a fisherman's hut, a village inn, a soup kitchen. Vincent adjusted the light flooding in his window by adding shutters and muslin shades—not just to re-create the mysterious contrasts of a *Graphic* illustration, or the warm, tempered light of a Rembrandt print, but also to shut out the world.

Windows had always played a special role in Vincent's life. As both an observer and an outsider, he had staked his place early at the parsonage window overlooking the Zundert Markt. Twenty-nine years later, he was still there. Whenever he arrived in a new home, he lovingly recorded the view from his window and sometimes drew it, as in Brixton and Ramsgate. His descriptions of the scenes outside his windows, often filled with longing and nostalgia, are indistinguishable from his descriptions of the prints on his wall.

From these frequent, detailed accounts, it is clear that Vincent spent long hours, day and night, gazing from his window, observing unobserved the distant ebb and flow of other lives: from the dockworkers in Amsterdam to the diggers in the railroad coalyards outside his Hague studio. In any interior, whether depicted or real, he was preoccupied by the window arrangement, and the view through windows would return again and again to obsess his own imagery. From the time he began to create studios for himself in 1881, he complained relentlessly about the inadequacy of the windows and lavished far more of his precious funds on window treatments than his artistic requirements could justify.

Among the very first images Vincent drew after arriving in The Hague was the view from his window: a cluttered patchwork of backyards, each fenced off from the others, but all visible from Vincent's second-floor vantage. In May, when his uncle Cor commissioned a second set of city scenes, he returned to his window and drew the scene in loving, longing detail: the laundry yard of his own building in the foreground and a busy carpenter's yard beyond—all rendered with a combination of intense looking and voyeuristic detachment that rehearsed a lifetime of seeing unseen. "One can look around it and through it," Vincent wrote proudly of this drawing, "in every nook and cranny." The laundresses and carpenters pass through the scene's meticulous clutter like ghosts, unaware of being watched, leaving barely a trace of life.

Vincent clearly found something deeply satisfying about this eavesdropping perspective. When he went to the almshouse in search of models, he secreted himself in front of a window looking out and made sketches of the activities he spied on the grounds. In the hustle and bustle of the Geest, he yearned to withdraw to a safe distance and observe unobserved. "I wish one could have free access to the houses," he wrote, "and sit down by the windows without ceremony." In summer, when he moved to a new apartment in the building next door, he immediately went to its higher window and drew the same scene again.

"You must picture me sitting in my attic window as early as four o'clock in the morning," he reported to Theo, "studying the meadows and the carpenter's yard with my perspective frame."

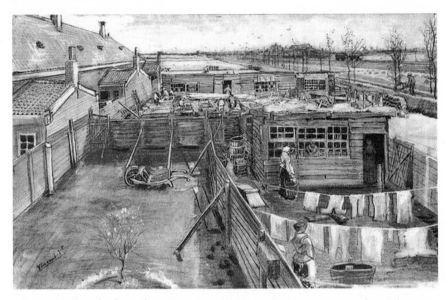

Carpenter's Yard and Laundry, MAY 1882, PENCIL AND INK ON PAPER, $11^1/_8$ X $18^1/_2$ IN.

When he left his studio and went out into the world, Vincent took his window with him. He had first heard about perspective frames in the writings of Armand Cassagne, a French draftsman who authored a number of books for both artists and amateurs. Vincent had read Cassagne's book for children, *Guide de l'alphabet du dessin* (*Guide to the ABCs of Drawing*), when he first emerged from the Borinage. Cassagne recommended the use of a *"cadre rectificateur"* (correcting frame), consisting of a small rectangular frame of cardboard or wood divided by threads into four equal rectangles. By holding the frame up to a view, a draftsman could isolate the image to be drawn and better gauge its proportions.

It wasn't until Vincent arrived in The Hague more than a year later, however, that he arranged for a carpenter to make such a device for him. Always eager for simple solutions and long frustrated by the "witchcraft" of proportion, he saw in Cassagne's suggestion the key to taming his unruly hand and unlocking the mysteries of salable art. The frame he had made was still small ($11\frac{1}{2}$ inches by 7 inches), but hardly Cassagne's pocket-sized *cadre rectificateur.* And instead of two intersecting wires, Vincent's had ten or eleven, creating a grid of little squares like windowpanes through which he could peer and peer and painstakingly transfer every contour onto the same grid traced on his paper.

Despite the balancing act required to simultaneously secure the frame, a sketchpad, and himself, Vincent took his little rectangle everywhere: around his

Schenkweg neighborhood, onto the city streets, into the dunes at Scheveningen, and throughout the countryside in between. Everywhere, he held up his frame and "corrected" the world. He called it his "spy-hole." "I think you can imagine how delightful it is to focus my spy-hole on the sea, on the green meadows," he exulted. "One can look through it *like a window*" (his emphasis). To shut out the world beyond the frame, he squinted his eyes—a trick Mauve may have taught him—until only the blurry, crisscrossed scene in his spy-hole was visible.

In drawing after drawing, the results thrilled him. "The lines of the roofs and gutters shoot away into the distance like arrows from a bow," he boasted to Theo of one successful effort. He took his frame into the attic to draw the view of the busy yards out back and the "infinity of delicate, soft green, miles and miles of flat meadow" beyond. He liked it so much that he had two more frames made, larger and sturdier, the last one a deluxe affair with iron corners and special legs for uneven ground—"a fine piece of workmanship," he called it. He even took it into his studio where he peered through it at Sien and his other models, drawing them "faithfully and with love," he said, "by calmly looking through my little window."

IN THE MONTHS BEFORE the birth of Sien's baby, Vincent saw only one image: family. After years of trying—with his own family and others—he had finally found a family that would have him. "*She* sees that I am not rough," he wrote of Sien, almost in amazement, "and she wants to stay with me." Images of motherhood had riddled his letters to Theo, even as he continued to withhold the key that would have unlocked their meaning. Every day in the studio, he posed his models in a preenactment of the vision in his head: Michelet's "triple and absolute tie" of man, woman, and child.

With that vision firmly in his spy-hole, Vincent shut out everything else. Even as the feuds with Mauve and Tersteeg threatened to undo Theo's support, he spent lavishly on his imaginary family: medicine for Sien, rent for Sien's mother, clothes for the coming baby. He used the rent money Theo sent to pay Sien's doctor, precipitating a desperate crisis when the landlord threatened to evict him. Even before that storm had passed, he began lobbying Theo to move to a bigger apartment next door, deepening the deception with each letter.

Gripped by the same fever of caring as in the Borinage, Vincent threw himself into "rescuing" the fallen woman on whom he had staked everything. He made her take baths and long walks. He administered "restoratives." He ensured that she ate "simple food" and got plenty of fresh air and rest. "I have taken her up and have given her all the love, all the tenderness, all the care that was in me," he wrote, framing their relationship as a model of Christian charity. When she went to register at the maternity hospital in Leiden, he accompanied her. A

frustrated doctor, like his father, Vincent represented Sien in discussions with the hospital staff and acted in every other way like a husband.

So single-mindedly did he focus on bringing "the poor creature" back to life that he neglected his own deteriorating health. After complaining ominously in January about headaches, fever, and weakness (lamenting, "my youth is gone"), he barely mentioned his condition through a flood of letters that spring and dismissed any problem with a defiant "I haven't given in to it."

Theo must have been surprised when a letter arrived in early June announcing, "I am in the hospital . . . I have what they call the 'clap.' "

But not even illness could shake Vincent's life in images or his new vision of family. Despite Sien's likely role in putting him there, he entered the hospital in extraordinarily good spirits for a twenty-nine-year-old man who had never been seriously ill in his life. The indignities of a common ward with ten beds, overflowing chamber pots, and abrupt male nurses struck him as "no less interesting than a third-class waiting room," he said. "How I should love to make some studies of [it]." The doctors assured him that his gonorrhea was a mild case that would require only a few weeks of treatment (quinine pills for fever and sulfate irrigations to quell the infection). Although confined to bed, he had brought Dickens novels and his books on perspective to study. When the nurses left the ward, however, he sneaked from his bed to look out the window. "The whole is a bird's-eye view," he wrote.

Vincent always found pleasure in the company of doctors. (Years later, in Arles, he said that painting "consoles me up to a certain point for not being a doctor.") At first, he also had visitors to buoy his spirits: his old Goupil colleague Iterson; his cousin Johan; even the gallingly proper Tersteeg. But the visits that truly sustained him were Sien's. "She came to visit me regularly," he told Theo proudly, "and brought me some smoked beef and sugar or bread." On one such visit, on June 13, while waiting in the hospital lobby for visiting hours to begin, Sien crossed paths with a short, silver-haired preacher striding toward the wards on clerical privilege. It was Vincent's father.

Dorus van Gogh no doubt looked past the humble pregnant woman waiting in the lobby as he went to see Vincent for the first time since their fateful Christmas Day argument. He had traveled from Etten as soon as he heard of Vincent's hospitalization, to make peace with his sick son. "I invited Vincent to come stay with us for a while after he leaves the hospital," he reported to Theo, "so he can regain some strength." At an earlier time, Vincent would surely have succumbed to yet another hope for reconciliation. Or a misplaced word might have reignited the bitter antagonisms that had scorched so many previous encounters. But now his vision was firmly fixed on his new family, not the old one.

Throughout their conversation, Dorus noticed that Vincent kept "restlessly

looking at the door, as if he expected a visitor that he would rather not have me meet." Vincent declined the invitation to return home, saying only, "I want to go back to work." Afterward, he dismissed his father's surprise visit as an unwelcome spectral visitation out of a Dickens tale. "It was very strange to me," he told Theo, "more or less like a dream."

But Sien could not continue to visit. On June 22, she herself checked in to a different hospital, in Leiden, preparing for a delivery that the doctors predicted would be difficult and dangerous. Almost as soon as she stopped visiting, Vincent suffered a relapse. Overcome by sentiment, he attributed his worsening condition to their separation. He was moved to a different ward for more intensive care and put on a new regimen to fight the resurgent infection. To drain his bladder and irrigate the inflamed canal, doctors inserted catheters of increasing size into his penis. Infection and irritation made the insertion difficult and painful. The process of "stretching" the canal was so excruciating that it left him lame with soreness for days.

Still, he barely uttered a complaint. His imagination was obsessed with a much more vivid pain. "What are the sufferings of us men," he wrote from his hospital bed, "compared to that terrible pain which women have to bear during childbirth."

Soon, the image of Sien giving birth overwhelmed him. In late June, he received a melancholy letter on the eve of her final confinement. "She has not been delivered yet," Vincent reported to Theo; "the waiting has lasted for days. I am very anxious about it." Her bravery and patient suffering only inflamed him more. He had to go to her. On July 1, still uncured, still "faint and feeble" from his own treatments, he left his sickbed and went to Leiden. Leading Sien's mother and nine-year-old sister, he arrived just in time for the weekly visiting hour. "You can imagine how very anxious we were," he wrote Theo the same day,

> not knowing what we should hear when we asked the orderlies in the hospital about her. And how tremendously glad we were when we heard: "Confined last night . . . but you mustn't talk to her for long" . . . I shall not easily forget that "you mustn't talk to her for long"; for it meant "you can still talk to her," when it could easily have been, "you will never talk to her again."

Sien lay in the old maternity ward of the University Hospital in Leiden, a bleak Dickensian building that shared a lightless, airless courtyard with the hospital's autopsy room. Now and then, an autopsy helper would empty a bucket of dark effluvia into the courtyard drain. Even in daylight, the maternity ward was gloomy, with its high ceiling and heavy drapes. In July, the tall windows were

pivoted open, but breezes were rare. Beds lined the walls on both sides—two patients to a bed: a pregnant woman and a new mother. A crib for dirty linens hung beside each bed; a baby crib sat at the foot.

It was not an easy place to enter life. According to one earlier account, "the nurses were rough and indifferent; they only helped new mothers if they got a tip; and they often kept back drugs and extra food. The food was slop." Some conditions had improved. Better understanding of bacteria and antiseptics had at least eliminated the kind of epidemics that used to sweep through the ward unchecked, killing one out of every ten new mothers. Still, horrendous conditions continued to keep "good women" at home with their midwives, leaving maternity wards like this one filled with the "unmarried, ignorant, and shamed," according to the hospital's director, "[those] exhausted by poverty and deprivation."

By the time Vincent arrived, the baby had finally appeared in the birth canal after a long labor complicated by uterine infection and nervous exhaustion. For the next four and a half hours, it remained there, "stuck fast," according to Vincent's account, as five doctors in succession tried to dislodge it with forceps, while Sien writhed in pain. They gave her chloroform, but she never lost consciousness. Finally, the baby emerged: a seven-and-a-half-pound boy, "shriveled" and suffering from jaundice. Twelve hours after the delivery, Sien was still disoriented with pain and "mortally weak." The shock to her system had been so great, her doctor reported, "it will take years before she completely recovers her health." The baby's survival remained in doubt.

But Vincent's euphoric account paints a very different picture. Instead of a grim autopsy courtyard, he saw "a garden full of sunshine and greenery" outside the ward window, and Sien's pain seemed like nothing more than a touching "drowsy state between sleeping and waking." Her suffering had "refined her," he said, given her "more spirit and sensitivity"; and the sick, jaundiced baby at the foot of her bed had a "worldly-wise air" that enchanted him. In Vincent's eyes, everything—the bleak room, the pale mother and yellow child, the tortured past, the hellish night—were all transformed into an image of love triumphant. "When she saw me, she sat up in bed and became as cheerful and lively as if nothing had happened," he wrote, confirming the success of his mission of rescue. "Her eyes were radiant with love of life and with gratitude."

Whether out of gratitude or calculation, Sien chose to give her new son a name that had no precedents in her own family: Willem—Vincent's middle name. The events of the day, he wrote Theo, "made me so happy that I cried."

He returned to The Hague in a rapture. He saw nothing but the image of family now framed in his imagination: "a household of my own." In twenty-nine years of blinding enthusiasms, none had rivaled this one. While Sien and the baby recovered in Leiden, Vincent set out to create a home for his new family. Without a word to Theo, he rented the apartment next door that he had long coveted. In

a frenzy of decorating (famously reprised six years later at the Yellow House in Arles), he filled it with furniture, including a wicker easy chair for the convalescing patient, a big bedstead for the parents, and an iron cradle for the baby.

He bought linens for the beds, cutlery for the kitchen, and flowers for the window, curtly dismissing Theo's concerns about the expense: "It cost what it cost." He bought a new mattress for the attic bedroom that he would share with Sien and carefully stuffed it himself. He decorated his big north-facing studio "like a comfortable barge" ("I love my studio the way a sailor loves his ship," he said), then papered it with his own studies and a selection of his most precious prints: Scheffer's *Christ,* Holl's *Foundling,* and Millet's *Sower.* Over the crib, he hung Rembrandt's *Reading the Bible.*

"Now, thank God," he announced, "this little nest is ready."

Alone in a new home, anxiously awaiting Sien's return, Vincent's imagination finally slipped its strained moorings. On a stormy night in early July, he looked around the empty apartment and the image of domesticity overwhelmed him. The sight of the empty iron cradle, especially, "gripped" him in a reverie of family feeling. "I cannot look at it without emotion," he wrote Theo later that night. He pictured himself "sitting down next to the woman I love with a baby in the cradle beside us," and that vision triggered a rush of treasured images of motherhood and the "eternal poetry" of Christmas. In all of them, he saw hope—"a light in the darkness, a brightness in the middle of a dark night."

He ended his letter to Theo that night with a question: "Do you think that Father would go on being cold and finding fault—beside a cradle?"

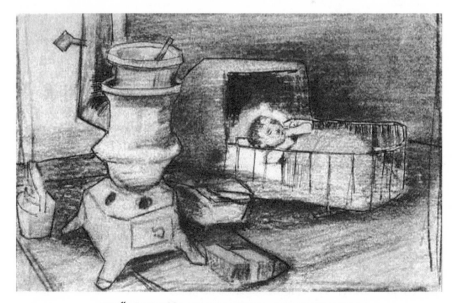

Cradle, JULY 1882, LETTER SKETCH, CHALK ON PAPER

—

THROUGHOUT THE SPRING and summer, in a fury of letter writing, Vincent fought to make Theo share his vision of domestic bliss.

Theo had telegraphed his displeasure early on by refusing to make any comment on the centerpiece of Vincent's argument, the drawing *Sorrow*, despite his brother's repeated promptings. A letter in mid-May with fifty francs enclosed—enough for Vincent to avoid eviction for a few more weeks—signaled at least that Theo had not deserted him. In the accompanying note, however, Theo unequivocally rejected Vincent's illusion of family. He accused Sien of duplicity and Vincent of gullibility: she had "tricked him" and he had "allowed himself to be taken in," Theo said. Vincent had no choice but to "give her up." Putting aside what must have been a deep sense of betrayal (all those plaintive letters and cries of desperate need—all deceptions), Theo urged a simple solution: "Pay her off." If Vincent wanted to save Sien from returning to the street, he could give her money or set her up in his will, Theo advised, but under no circumstances should he marry her. He warned his brother against "obstinacy" in this matter. "[Do not] wantonly insist on having your own way."

But Vincent's vision would not be denied. "It is my decided intention to marry her as soon as possible," he wrote back defiantly the same day. One long letter followed another, sometimes two in a single day, as he fought furiously to reverse his brother's judgment. He piled argument on argument in a constantly shifting mix of honesty and deception, confession and manipulation, passion and polemic.

Expressions of tenderness and devotion ("I feel a great calm and brightness and cheerfulness at the thought of her") were followed by sober pledges of economy and pragmatism ("I can't tell you how useful she is to me"). In one letter, he boldly seized the moral high ground ("First and foremost for me is this: *I will not deceive or forsake a woman*") and loftily dismissed *"l'opinion publique."* But in another letter the same day, he argued that marrying Sien was "the only means of stopping the world talking," and worried instead about being "reproached with an illicit relationship." He claimed a religious mandate to marry Sien ("It is God's will that man does not live alone but with a wife and child") but also defended marriage as the obvious solution to the need for safe, dependable sex.

He fought fiercely on behalf of the images in his head. He painted in increasingly vivid strokes the cartoon of fallen womanhood and rescue by love that he so cherished. "She would die if she had to walk the streets again," he pleaded. By marrying her he could "save Sien's life" and prevent her from "falling back into that terrible state of illness and misery in which I found her." He bolstered that image with reports from her doctors detailing how delicate her health remained, and warned darkly that Theo's rejection could trigger "a prolapse of the

womb that might be incurable." At one point, he even claimed that the doctor had *prescribed* marriage: "Her first remedy, the most important medicine, was to have a home of her own; that is what he kept insisting on." To refuse her that now, Vincent pronounced, "would be murder."

He invoked both the heartbreaking tableau of Sien and her baby ("so quiet, so delicate, so touching, just like an etching"), and his prerogatives as The Artist ("My profession allows me to undertake this marriage"). He and Sien would live together "like real Bohemians," Vincent imagined; and because of her, he would "become a better artist." Revealing new details of the cold reception he received at the Stricker house in Amsterdam ("I felt that my love—so true, so honest and strong—had literally been *beaten to death*"), he claimed a Christlike martyrdom for love: "After death there is resurrection. *Resurgam* [I will rise again]."

In support of these images, Vincent recruited a new and formidable ally, Émile Zola. He had only recently been introduced to the novels of the great French writer, probably by his brief friend Breitner. Originally impressed by Zola's vivid descriptions of Paris as if seen from a high window, Vincent was quickly drawn into the alternate reality of Zola's multivolume Rougon-Macquart saga: a world of thwarted ambition, falls from grace, and impossible loves; a world in which, again and again, typology is fate. "This Émile Zola is a glorious artist," he wrote Theo in July, as he devoured one novel after another. "Read as much of [him] as you can."

In particular, he cited *Le ventre de Paris* (*The Belly of Paris*), Zola's celebration of the triumph of bohemian humanity over bourgeois orthodoxy. Vincent cast himself not as Claude Lantier, the book's ne'er-do-well artist, but as Madame François, a kindly woman who rescues the book's forlorn hero, Florent. It was an image of salvation that reverberated past differences of class and sex to the core of Vincent's relationship with both Sien and his brother—as both rescuer and rescued. "What do you think of Mme. François, who lifted poor Florent into her cart and took him home when he was lying unconscious in the middle of the road?" he asked Theo pointedly. "I think Mme. François is truly humane; and I have done, and will do, for Sien what I think someone like Mme. François would have done for Florent."

In Paris, this torrent of hyperventilating rhetoric and delusional imagery backfired. Instead of winning approval for the marriage, Vincent's arguments prompted Theo to question his brother's sanity. Raising the ghost of Gheel, he warned Vincent that their parents might again seek guardianship over him when they heard about the proposed marriage. At this, Vincent erupted in a fury of indignation that spilled over weeks of letters. Coming at a time when Mauve and Tersteeg were already attacking him, and the threat of eviction left him open to charges of "incompetence in financial affairs" (another basis for guardianship), talk of committal only deepened his paranoia. If his parents had

the "will and the temerity" to try to commit him, he warned Theo, he would subject them to the high costs and "public disgrace" of a protracted court fight. Or worse. He menacingly reported the case of a man who had been unjustly placed in guardianship by his parents, "then bashed his guardian's brains in with a poker." According to Vincent, the killer was acquitted on a claim of "self-defense."

Vincent's dire warnings and desperate pleadings did succeed in wresting from his brother a raise in his stipend: from one hundred to one hundred and fifty francs a month. (Ever skeptical of Vincent's budgeting, Theo insisted on sending the money in three installments, on the first, tenth, and twentieth of each month.) But on the crucial issue, Theo remained resolute: he would not condone the marriage to Sien. Nor would he agree to continue supporting Vincent if he chose to marry her anyway. He did, however, agree to come and visit his brother's new "household" in early August. For Vincent, with his unshakable faith in the power of images, this was enough to keep hope alive. "I wonder what you will say about the new house," he wrote anxiously, "and also what you will think of Sien when you see her and the new little baby. I hope with all my heart that you will feel some sympathy."

With his entire fantasy of house, wife, and family now dependent on Theo's sympathy, Vincent's letters underwent a radical shift in tone: from self-destructive defiance to flattery, affection, and appeasement. "Brother, I think of you a very great deal these days," he wrote in early July, "because everything that I have is really from you: my lust for life and my energy, too." He reaffirmed his oft-broken promise to "save and economize in all respects," renounced his melancholic disposition, and repledged himself to "dogged work" despite continuing ill health.

In his sketchpad and on his easel, too, Vincent tried to make amends for his winter of defiance. After months of angrily championing figure drawing to the exclusion of all else, he embraced the landscape imagery that Theo had long urged on him. He quietly dropped his plans for a summer of drawing from the nude and instead undertook sketching trips to Scheveningen and made images of pollard willows, meadowed vistas, and bleaching grounds "[with] a real Dutch character and sentiment." "I am quite taken up by landscape," he assured his brother.

In an even more dramatic reversal, he relaxed his draftsman's fist and returned to the delicate challenges of watercolor, long pressed on him in vain by Mauve and Tersteeg, as well as Theo. "I have a great urge to start *painting* again," he announced, implausibly attributing the sudden volte-face to his larger studio, better light, and a cupboard to store his paints "so they will not make too much dirt and mess." As if apologizing for the past, he revisited earlier images and reworked them in color, then informed Theo: "I think you will like them now."

Knowing that no truce would please Theo more than a family truce, Vincent even reached out to his parents, setting aside weeks of bitter denunciations over guardianship and Gheel to reopen a cordial correspondence (without a word about Sien). He laid plans to invite his father to The Hague so that he, too, could see Vincent's new home and feel the power of its imagery. "I shall beg Father to make another trip here," he reported his plan to Theo.

> Then I shall show him Sien and her little baby . . . and the neat house and studio full of the things I am working on . . . [and] all this will make a better and deeper and more favorable impression on Father. . . . And as to what Father will say about my marrying, I think he will say, "Marry her."

Only two weeks before Theo's visit, this image of reconciliation was put to the test. On the morning of July 18, H. G. Tersteeg appeared in the doorway of Schenkweg no. 136. There he encountered the magical tableau that Vincent hoped would change hearts: Sien with the baby at her breast.

"What is the meaning of that woman and that child?" Tersteeg demanded. "Is this your model or is she something else?" Vincent, caught by surprise, stammered a defense, but Tersteeg dismissed his claims of family as "ridiculous." "Have you gone mad?" he exclaimed. "This is certainly the product of an unsound mind and temperament." He threatened to write Vincent's parents to inform them of the new travesty and humiliation their son had visited on his family. He called Vincent "as foolish as a man who wants to drown himself." But he saved the cruelest cut for last. On his way out, as he passed Sien, he told Vincent, "You will make that woman unhappy."

As soon as he left, Vincent seized pen and paper and wrote Theo a letter bursting with belated indignation. He called Tersteeg "unsympathetic, domineering, indelicate, indiscreet," and railed against his "meddling in my most intimate affairs" and his "policeman-like mood." "I believe he would look on quite cold-bloodedly while Sien was drowning," Vincent wrote acidly, "not lifting a finger, and call it a boon to society." Tersteeg's accusation that Vincent must have gone mad to take a wife and children triggered an especially fierce paroxysm of denial:

> *Never* has a doctor told me that there was something abnormal about me in the way and sense Tersteeg dared to tell me this morning. That I was not able to think or that my mind was deranged. No *doctor* has told me this, neither in the past nor in the present; certainly I have a nervous constitution, but there is definitely no real harm in that. So those

were serious insults on Tersteeg's part, just as they were on Pa's, but even worse, when he wanted to send me to Gheel. I cannot take such things lying down.

Beneath the incandescent rage and vows of retribution, however, Vincent had suffered a crushing blow. Recognizing that Tersteeg's "untimely interference" in Etten could "spoil everything again," he abruptly withdrew his demand to marry Sien. "[I] propose to let the whole question of civil marriage rest for an indefinite time," he wrote in a second letter the next day, "until my drawing has progressed so far that I am independent." After months of repeated resolutions to tell his parents about his new family, damn the consequences, he quietly agreed that "the matter need not be discussed for the time being." His plan for reconciliation would have to wait.

That left only Theo. In the weeks between Tersteeg's visit and his brother's, Vincent fell into a deep reverie of fraternal longing. He filled his letters with plaintive pleas for understanding and the most heartbreaking hopes of ultimate vindication. "I want people to say of my work: that man feels deeply, that man feels keenly," he wrote. "In spite of my so-called coarseness—do you understand?—perhaps even because of it . . . I should one day like to show by my work what such an eccentric, such a nobody, has in his heart."

On the eve of Theo's arrival in early August, Vincent reaffirmed the image on which, he said, "my whole future depends." "Sien and the baby are well and are getting stronger, and I love them both," he wrote. "I shall draw the little cradle another hundred times."

Inevitably, reality disappointed him.

The two brothers, who had not seen each other in a year, both made efforts to recapture their elusive bond. Theo brought presents from their parents, as well as drawing paper and crayon from Paris. Vincent took his brother for a walk on the dunes at Scheveningen to enjoy the "sand, sea and sky"—just as they had at their last reunion in The Hague five years earlier. Theo came to the Schenkweg to see his brother's new home.

But nothing, not even the sight of Vincent's beloved cradle, moved him. "Do not marry her," he told Vincent. Forever seeking a balance between fraternal and familial duty, Theo did promise to continue his support for another year regardless of Sien, thus averting his brother's worst nightmare. In return, however, he demanded an end to Vincent's campaign for acceptance of his new family—not only with their parents but even with Theo himself. (For the next six months, neither Sien's name nor any discussion of her appears in Vincent's letters.) She was to be banished from the public record as well as from the family's reputation.

But silence was not all that Theo demanded. Vincent's art would also have

to change. Despite his last-minute conversion to landscape and color, Vincent had continued to resist Theo's pressure to make salable art. Only a few days before, he had argued in a letter that "to work for the market is in my opinion not exactly the right way," and dismissed "speculation" in art as nothing more than "deceiving amateurs." Theo came determined to set Vincent straight. He reiterated his demand that Vincent turn his attention away from black-and-white figure drawing and concentrate on landscape and color—that is, on *painting.*

Because Vincent had often used the expense of painting as an excuse for inaction, Theo gave him extra money for the necessary supplies. To ensure faithful compliance, he insisted that Vincent send him proof of his "progress in a direction that is reasonable" in the near future.

This was the full price Theo demanded for his continued support; this was his response to *Sorrow*: Vincent would have to erase Sien not just from his public life, but from his art as well.

WHEN VINCENT COULDN'T SLEEP, as he often couldn't after Sien and her baby returned from the hospital, he went to the studio downstairs where he pulled from the cupboard his big portfolios of illustrations and, by gaslight, pored over the familiar images for the hundredth time. "Every time I feel a little out of sorts," he said, "I find in my collection of wood engravings a stimulus to set to work with renewed zest." Unlike reality, these images stayed within their neat white borders. "I always regret," he wrote later, "that the statue and the picture are not alive."

For months, years even, he had tried every conceivable way of forcing reality to conform to the sentimental, cliché-driven world between the covers of his portfolios: isolating it in fragments, cloaking it in imagery, distilling it into images; surrounding it in a relentless frame of words. The friction of that effort had produced nothing but heat: with his fellow artists, with his mentors, with his parents, with his brother.

In the summer of 1882, out of that same friction, after so much heat, some light finally began to emerge.

Orphan Man

~

THE FISHERMEN ON THE BEACH MUST HAVE WONDERED ABOUT THE strange, lone figure standing on top of a dune thirty yards away, watching their struggle with the sea. He could not be a tourist; the weather was far too brutal for sightseeing. Rain and gale-force winds of up to fifty miles an hour lashed the dunes where the stranger stood. The city dwellers who overran the little fishing village of Scheveningen every summer, with their bathing machines and saltwater cures, would be watching nature's fury from the safety of their hotel porches and parlors. Fighting to beach their little flat-bottomed shrimpers before the worst of the storm arrived, the fishermen probably never imagined that the lonely figure watching them from the windswept horizon was, in fact, a painter.

Vincent had come prepared to do battle with the elements. Despite the warm August weather, he wore a pair of thick trousers to protect his legs from the bristly dune grass and from the coarse fish basket he used as a chair. Sometimes, he kicked the basket aside and knelt to paint, or sat, or even lay prone in the sand. He had brought sturdy shoes, too, in expectation of days like this one. With his linen smock soaked and clinging to him, he imagined that he looked "like Robinson Crusoe."

He carried so much painting gear with him that he couldn't fit on the tram from The Hague and ended up walking to the beach. Immediately after Theo's visit, with a wad of Theo's money in his pocket, he had bought a new paint box, palette, brushes, and dozens of tin tubes of paint (an innovation that had only recently liberated painters from their studios). He also bought a new watercolor kit—a huge improvement over the awkward saucers on which he used to mix his colors. Loaded with all this, plus his large perspective frame, a stretched canvas with paper affixed to it, and provisions of bread and coffee, he plodded his

way from the Schenkweg to the sea, an arduous three-mile journey even in fair weather.

In the storm, none of it mattered. Wind and blowing sand played havoc with all the equipage and rituals of art making, blotting out the view in his perspective frame and covering his paints and brushes with a crust of grit every time he opened his box. The stretched canvas threatened to sail away with each blast of wind. More than once, the impossible conditions drove him to seek shelter in a little inn behind the dunes. Eventually, he left most of his materials there. When the next calm came, he loaded his palette with more color and his pockets with extra tubes and rushed out again. He scrambled up the wet, windswept dune, gripping his canvas tightly in one hand, his palette and a few brushes in the other. "The wind blew so hard that I could scarcely stay on my feet," he described the scene to Theo, "and could hardly see for the sand that was flying around."

He seemed invigorated by the storm: fully alive in defiance of it. With his smock snapping wildly at each gust, he somehow managed to brush the roiling gray clouds and the murky, furrowed sea, working as quickly as his hand could move from palette to paper. He laid the paint on "thick and sticky" and "quick as lightning" in a spontaneous frenzy that made his inexperience as irrelevant as his perspective frame. It was a burst of direct image making that suited his manic imagination far better than the still lifes of Mauve's quiet studio, his only previous experience with oil paints. At least twice the storm drove him back inside, where he found the painting "so covered with a thick layer of sand" that he had to scrape it clean and repaint the image from memory. Eventually, he left the canvas behind and ran back out into the storm just "to refresh the impression."

In this extremity of art and nature, Vincent made an astonishing discovery: he could paint.

"When I paint," he wrote Theo, "I feel a power of color in me that I did not possess before, things of broadness and strength." After some initial hesitation, he "plunged headlong" into the new medium with all his characteristic fervor and abandon. Within just a month after Theo's visit, he had painted at least two dozen scenes of beach, woods, fields, and gardens. He "painted from early in the morning until late at night," he reported, "scarcely taking time even to eat or drink."

He took a boyish pleasure in the license that his painting "adventures" conferred. Insisting that everything looked more beautiful when it was wet, he rushed into every rainstorm in search of subjects, covering himself in mud as he knelt to work. In one painting, he depicted a girl in a white dress clinging to a tree surrounded by a sea of forest floor muck, painted in thick strokes of brown and black with such voluptuous verisimilitude that "you [can] smell the

fragrance of the woods," he claimed. He reveled in the tactile docility of the oil paint—so unlike watercolor. From the first, he spread it on the canvas or paper without reserve—"one must not spare the tube," he cried—and scraped it off without remorse. He squeezed it from the tube and then worked it with a brush, eschewing glazes and mixing colors directly on the surface, as if afraid of too much deliberation.

The results amazed him. "I am sure no one could tell that they are my first painted studies," he wrote proudly. "To tell you the truth, it surprises me a little. I had expected the first things to be a failure [but] they are not bad at all." "*I don't know myself* how I paint [them]," he confessed. "I just sit down with a white board in front of the spot that appeals to me [and] look at what is in front of my eyes." Nevertheless, he considered them so good that he tacked them up on his studio walls, displacing his treasured figure drawings. In his letters, he described their colors and subjects in extravagant detail. He spoke of "something infinite in painting," of "hidden harmonies" and "tender things," and even uttered the unthinkable: "[Painting] is more gratifying than drawing." "It is so delightful just for expressing one's feelings," he marveled, as if experiencing it for the first time, "[and] so sympathetic to me that it will be very difficult for me not to go on painting *forever*." "I have a painter's heart," he proclaimed. "Painting is in the very marrow of my bones."

And then he stopped. After barely a month of heroic exertions, prodigious consumption of paint, and repeated pledges to go "full speed ahead" and "strike while the iron is hot," he quit painting entirely. To cover his hasty retreat, he raised a host of arguments. The most emphatic and least convincing of these was the cost. "Though I myself love doing it," he protested, "for the present I shall not paint as much as my ambition and desire demand because of the heavy expenses."

The reality, of course, was far less simple and far more painful.

VINCENT HAD GOTTEN his wish. His fantasy of a family unto itself, an island removed from the real world, had come true. No one visited him and he had no one to visit. The all-day painting expeditions meant that even his bedraggled band of models had no reason to make the long trek to his studio. His fellow artists and acquaintances, starting with Mauve and Tersteeg, had completely abandoned him. They "consider me an outcast," he acknowledged. "They look down upon me, and consider me a nonentity." When they saw him on the street, they jeered. When he saw them first, he slunk away to avoid a confrontation. "I purposely avoided those who I thought would be ashamed of me," he later admitted.

At first, he pretended not to care that the world had abandoned him, and

claimed not to understand why its "good will" had been "as short-lived as a straw-fire." At times he blamed his rough appearance, his social ineptitude, or his sensitive nerves. At other times, he succumbed to paranoia, imagining all the "eccentric and bad things [that] are thought and said about me" and decrying the failure of artists to support each other out of fraternal esprit. Sometimes, however, the truth proved too obvious to deny: "They think my own actions foolish."

Gradually, the price he had paid for his illusions became clear. "One would like to go and see some friend or would like a friend to come to the house," he wrote. "One has an empty feeling when one can go nowhere and nobody comes." Especially as he ventured into new artistic territory, he felt keenly the absence of both mentors and colleagues. He brooded endlessly over the loss of Mauve's guidance, alternating between anger and regret. "I often feel the longing and need to ask someone's advice," he admitted. "It stabs me to the heart whenever I think of it." He longed to watch other artists at work and wished wistfully that "they would just take me as I am."

Sometimes the brooding took him to the darkest possible places, as his reading in Zola's saga of family degeneration planted thoughts of genetic curses and inescapable fates. "What am I in the eyes of most people," he lamented, "a nonentity, an eccentric or an unpleasant person—somebody who has no position in society and never will have, in short, the lowest of the low." Again and again, his thoughts returned for consolation to the story of Robinson Crusoe, the shipwrecked mariner, "who did not lose courage in his isolation."

Even when he walked the narrow streets of his beloved Geest, away from the bourgeois sensitivities of family and fellow artists, Vincent could not find belonging. With his shabby clothes, odd manner, and strange burden of equipment, he attracted unwanted attention, not just from the fearless street urchins who harassed him relentlessly, but even from passersby, who freely offered their judgments. "That's a queer sort of painter," Vincent heard one of them say. In public places like soup kitchens and train stations, he often created such a scene, with his big sheets of paper and "vehement scratching," that he was asked to leave. Once, on a visit to the potato market, someone in the jostling crowd "spat his quid of tobacco onto my paper," Vincent reported miserably. "[They] probably think I am a lunatic when they see me making a drawing with large hooks and crooks which don't mean anything to them."

Eventually, the mere proximity of people unnerved him. "You cannot imagine how irritating and tiring it is when people always stand so close to you," he wrote. "Sometimes it makes me so nervous that I have to give up." Eventually, he did give up: avoiding public places except in the very early morning hours (as early as four in the summer) when he shared the streets only with the sweepers.

His own family offered no comfort. Cast adrift on a raft of lies, Vincent saw

his hope for reconciliation with his parents fade with each passing day. "This is worse than having no home at all, no father, no mother," he wrote. "It is a great sorrow." In August, the family moved to Nuenen, a town forty miles east of Etten where Dorus had accepted a new position—putting even more distance between Vincent and his dream of returning to the Zundert parsonage. He tried to reopen a correspondence with them, but his secret weighed on every exchange of pleasantries. Nor could he talk with them about his work. "I am afraid that Father and Mother may never really appreciate my art," he concluded forlornly. "It will always be a disappointment to them."

The gulf only widened when Vincent's father paid a surprise visit to the Schenkweg in late September. Unable to hide Sien and the baby, Vincent pretended that she was merely a poor, sick, pitiful mother whom he felt duty-bound to help. No talk of love or marriage—just Christian obligation. When he returned to Nuenen, Dorus sent a parcel that included a woman's coat—an apparent show of support for Vincent's latest charitable project. But neither father nor son was fooled. Almost a year later, Vincent admitted that the visit had left no doubt about his parents' attitude: "They were more or less ashamed of me."

Vincent's pledge of silence about Sien not only delegitimized his life with her, it alienated him from the only person who cared: Theo. Weighed down by prohibitions, his letters lapsed into superficiality, coded references, and unfathomable circumlocutions. Or he simply wrote less often. Every unaccounted guilder that he spent on Sien (or her baby, her daughter, her sister, her mother) only added to the burden of guilt he always felt in taking Theo's money. To that unseen debt, Vincent now added the costs of oil painting, a frightening new level of expenditure far exceeding the paper, pencils, and charcoal he was used to. "Everything is so expensive," he complained soon after starting, "and is so quickly used up." It didn't help that he brought the same manic, trial-and-error method to painting that he had come to rely on in drawing. "So many things that I start turn out wrong," he explained, "and then one has to begin anew, and all the trouble has been in vain."

The final blow came in late September when Theo asked to see one of the new oil studies for which Vincent had expressed such enthusiasm. At first he refused to send anything, cloaking his refusal in a vague argument about the difference between studies and finished pictures. "Making studies is like sowing," he said, "and making pictures like reaping."

But no argument could conceal the truth: his confidence had collapsed. When he finally relented and sent Theo a study (of tree roots), it came accompanied by a letter filled with apology and self-criticism. Only five weeks after boasting "no one would guess that these really are my first painted studies," Vincent desperately pleaded his inexperience. "I have been handling the brush for too short a time," he wrote. "If it is a disappointment to you, you must remember

that it is such a short time since I began painting." He begged Theo "not to judge the future from the one" and ended with a pathetic plea for continued indulgence: "If when looking at it . . . you do not regret having enabled me to make it, then I shall be satisfied and shall continue with good courage."

Mocked in public, scorned by his fellow artists, alienated from his brother, and facing the challenges of a new family and a new medium, Vincent escaped into the past on a wave of nostalgia. He blamed his ostracism on the "skepticism, indifference, and coolness" of modern life: its decadence, its dullness, its lack of passion. With a poignancy striking for a twenty-nine-year-old man, he mourned his lost youth and cursed the factories, railways, and agricultural combines that were robbing the Brabant countryside of its "stern poetry." "My life," he wrote Theo, "is not as sunny now as it was then."

As always, his imagination followed his longing into the past. He reread Andersen's fairy tales, the lodestar of his childhood. He put aside his Zola and returned to the Romantic potboilers of Erkmann-Chatrian, a leap backward of a hundred years in time and even further in sensibility. The French Revolution had always loomed in Vincent's imagination as a lost paradise of heroic men and noble ideas, and once again he seized on it as his true home in time. "There was definitely something warmer about those days," he wrote, "more light-hearted and alive than today."

In art, too, he surveyed the previous century and concluded that he had arrived too late; that the parade had passed. Even as Impressionists like Monet, Renoir, and Pissarro were celebrating their seventh group show in Paris, even as Gauguin was laying plans to best them and Manet was nearing death, Vincent pined for the days of Millet, Corot, and Breton. Art had gone into a "sharp decline," he said; "capriciousness and satiety" had replaced passion. Artists had betrayed the spirit of the Revolution—"the honesty, the naïveté," and especially the *fraternité.* "I had imagined that the painters formed a kind of circle or society in which warmth and cordiality and a certain kind of harmony reigned," he wrote. As a result, art would never again rise to such heights. "Higher than the top of the mountain one cannot climb . . . The summit has been reached."

To recover this lost Eden of passion and solidarity, Vincent turned inevitably to his portfolios of prints. Just as they had long defined his reality, now they defined his ambitions. In these carefully organized, lovingly mounted, and comforting black-and-white images, he found a community of artists that welcomed him, even if only in his imagination. His collection ranged from Dürer's Renaissance allegories to modern surrealist cityscapes, but the campaigns and tribulations of the previous months had conferred a special status on one group of artists in particular: the English illustrators.

—

AS EARLY AS THE 1840S, London newspaper publishers began recruiting artists to enliven their pages with eye-catching imagery. The same newly affluent public that made art prints a huge business also eagerly consumed illustrations of current events, public figures, exotic locales, and the latest fashions. By the time Vincent arrived in London in 1873, weekly illustrated magazines had become the rage. As the audience for them grew bigger and more sophisticated, so did the images. Thanks to the same advances in printmaking that made Adolphe Goupil and Cent van Gogh rich, publishers could achieve a subtlety of detail and tone unthinkable in the early years when drawings had to be painstakingly carved, in reverse, onto boxwood boards. Better printing techniques also made it possible to insert two-page foldout images—a startling visual experience in an era weaned on tiny books and stamp-sized illustrations.

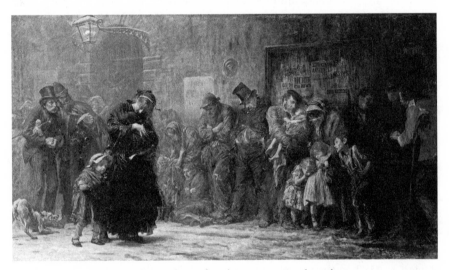

LUKE FILDES, *Applicants for Admission to a Casual Ward,* 1874,
OIL ON CANVAS, 53^7/$_8$ X 95^7/$_8$ IN.

As the social cost of bourgeois affluence began to make itself felt, the illustrated magazines also recorded the sins and shames of the new economic order, as well as the easy Victorian remedies of charity and faith. When working as an apprentice at Goupil, Vincent had witnessed the massive public interest generated by these images of society's castaways, but he rejected them as art. At the Royal Academy show in 1874, he saw Luke Fildes's painting *Applicants for Admission to a Casual Ward,* a somber, dark-hearted depiction of London's poor lining up outside a shelter on a freezing night. *Applicants* stirred such a public sensation that barricades had to be erected to control the crowds clamoring to see it. But Vincent's only comment on the show concerned some paintings of young girls that he thought "beautiful."

Now, a decade later, alienated and abandoned himself, Vincent proclaimed these dramatic images, and their creators, the true heirs to the spirit of 1793: "For me the English black-and-white artists are to art what Dickens is to literature. They have exactly the same noble and healthy sentiment." He called them "artists of the people" and praised their work in the same moralistic terms that he used to defend his own work—and, indeed, himself: "solid and substantial," "rough and audacious," "full of feeling and character," "unpolished." "These are pictures," he said, "in which there is nothing, *and yet everything.*" The fact that art-world sophisticates like Mauve and Tersteeg (and Theo) considered them crass and passé, or that his fellow artists at the Pulchri Studio dismissed them as café *divertissement,* only inflamed Vincent's passion for them. He would rescue them from cruel neglect and unjust condemnation just as he had rescued Sien. Who better to champion a rough, repudiated art than a rough, repudiated artist?

Vincent began collecting the work of English illustrators almost as soon as he arrived in The Hague in January 1882, after years of ignoring them in favor of French and Dutch prints. They were not only affordable, they also embodied an attainable artistic goal. Certainly nothing else in his experience remotely resembled the "clumsy and awkward" sketches that he brought with him from Etten and the Borinage. In The Hague, he quickly found booksellers who provided him with a bottomless supply of both individual prints and old copies of magazines such as *The Graphic, Punch,* and *The Illustrated London News* from which he could cut and mount the illustrations.

By the summer of 1882, the search for works by these artists had turned into a full-scale obsession, temporarily supplanting even Millet and Breton in the gallery of Vincent's autobiographical manias. "They are great artists, these Englishmen," he explained in terms that amounted to a plea on his own behalf. "They have quite another way of feeling, conceiving, and expressing themselves, if only you take the time to understand them." Eventually, Vincent bought an entire decade's worth of *The Graphic*—1870 to 1880—more than five hundred issues in twenty-one volumes. He called them "something solid and substantial that one can hang onto in days when one feels weak."

In May, Vincent's old friend Anthon van Rappard stopped in The Hague prior to his annual summer sketching expedition. The two had always shared an interest in engravings; both had long collected prints and illustrations. But much had changed in the five months since Vincent summarily broke off contact, officially declaring himself *"en froid"* with his friend. He had been rejected by Kee Vos, expelled by his parents, estranged from his powerful uncles, excommunicated by Mauve, and denounced by the influential Tersteeg. After so much humiliation and rejection, the possibility of renewed friendship with Rappard offered a lifeline of good repute. And it came at precisely the right moment: only weeks

before Vincent planned to confess to Theo his long, secret affair with Sien—a confession that threatened to unravel his sole remaining tie to the world.

After Rappard's visit, Vincent was overcome by feelings of solidarity unequaled since his Bible-reading sessions with Harry Gladwell in Paris seven years before. This time, the shared gospel was black-and-white; the saints, illustrators. He sent long lists of his favorite images and artists, and begged his friend to respond in kind. He labored over encyclopedic letters showing off his astounding knowledge of engravers, periods, styles, and schools. He invited Rappard to test his knowledge with aficionado games of identifying prints and deciphering signatures. They exchanged books by and about draftsmen. Vincent repeatedly searched his portfolios for duplicates that he could send his confrère. When he ran out of duplicates, he combed through bins of old magazines hoping to find more. He wanted their collections to match exactly.

In Rappard, Vincent found not just a second to his obsessions, but a lone voice of sympathy and support for a mission that must have seemed increasingly hopeless. "He is a man who understands my intentions, and who appreciates all the difficulties," Vincent wrote to Theo after Rappard's visit in May. When Rappard spoke kindly of his drawings, Vincent melted with gratitude:

> What I most want is for people to find some sympathy for my work; that gives me such pleasure . . . For it is so disheartening and dispiriting and crushing if one never hears, This or that is right . . . It is so exhilarating when you realize that others really do feel something of what one has tried to express.

Onto his absent friend, Vincent could project all the frustrations, angers, disillusionments, and fears that had accumulated through the long winter of battles and brooding: his astonishment at the abusive behavior of his fellow Hague artists; his paranoia that Mauve and Tersteeg might still "play tricks" on him; and, of course, his martyrdom of thankless toil.

In his favorite martial cadences, Vincent enlisted Rappard in his battle not just with their community, but with their era. "I believe it would be a good thing for us to focus our attention on the men and works of former days," he wrote, "so it will not be said of us, 'Rappard and Vincent may also be reckoned among the *decadent* fellows.' " In passages that must have puzzled and amused the conventional, congenial Rappard, Vincent lamented their shared fate as artistic pariahs and social outcasts. "They look upon you and me as unpleasant, quarrelsome nonentities," he wrote in a delusion of solidarity. "They consider us ponderous and boring in our work and in our persons." "Prepare to be misunderstood, despised, and slandered." Even as Rappard enjoyed the comforts of his parents' home in Utrecht, socialized with a large circle of friends, and eagerly joined an

array of artists' clubs, Vincent rallied him to a lonely, priestlike life of artistic devotion. "One feels weaker as an artist the more one associates with other artists," he wrote. "I believe Thomas à Kempis says somewhere, 'I never mingled with human beings without feeling less human.' "

Against this tide of nostalgia and obsession, self-vindication and fraternal longing, painting did not stand a chance. In mid-August, Vincent learned that Rappard had returned from his expedition with sketchbooks full of figure drawings. By then Sien had recovered enough to start posing again. The retreat began soon after that, announced by a figure study done in both charcoal and oil with "very little color."

In mid-September, Vincent announced a new ambition: "I want to make groups of people," he said, "at the soup kitchen, in the waiting room of the station, the hospital, the pawnshop . . . talking in the street or walking around." Images like these, which had been staples of *The Graphic* and other magazines, would require "innumerable separate studies and sketches of each figure"— in other words, more models. Within a few weeks, however, the new initiative foundered, undone by the hostility he encountered whenever he went out to sketch in a crowd, and by his decision to use watercolor—probably to satisfy Theo—a medium that he found especially frustrating in attempting to render the elusive human form.

Vincent never explicitly renounced painting. But the proof of his retreat filled the studio. By late September, he was back ensconced in his Schenkweg world, with his charcoals and pencils and his family of models, churning out figure drawings at the rate of a dozen a day. He still occasionally protested his love for painting or color or landscape—primarily to parry Theo's concerns about salability—but his work returned almost exclusively to the black-and-white of his prints and his *fraternité* with Rappard. He took all the canvas left over from his few weeks of painting and used it to cover the studio windows in order to create a more sympathetic light for his models.

AFTER THE FAILURE of his crowd scenes, Vincent turned for inspiration to another famous *Graphic* image, Hubert Herkomer's *Sunday at Chelsea Hospital.* The depiction of an ancient war veteran slumped dead in his chair at a meeting of old comrades was so well received when it first appeared in 1871 that Herkomer made a painted version, which went on to win international acclaim under a more sentimental title, *The Last Muster* (another painting that Vincent had seen in London in 1874 but not commented on).

In September, Rappard began a series of drawings at the institute for the blind in Utrecht, a project that promised many similar heart-tugging images. At almost exactly the same moment, as if responding to a shared initiative, Vincent

began recruiting models at the almshouse in the Geest. He approached many of the elderly pensioners with his strange request, but only one came back again and again. His name was Adrianus Jacobus Zuyderland.

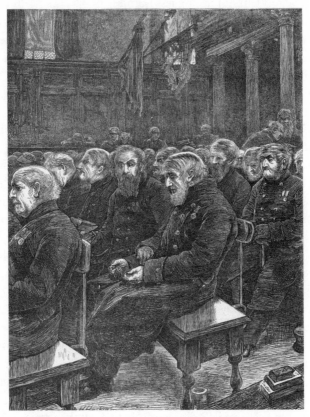

HUBERT VON HERKOMER, *The Last Muster: Sunday at Chelsea Hospital* (detail), 1871, ENGRAVING, $11^{1}/_{2}$ X $8^{7}/_{8}$ IN.

Vincent may have known his name, but he never mentioned it. Nor could Zuyderland have responded if Vincent had called him by name: he was deaf. Like all the pensioners at the Dutch Reformed Old People's Home, he wore a number on his sleeve for identification; his was 199. He also wore the uniform of all male pensioners: tailcoat and top hat—a frayed faux gentility that marked him everywhere as a charity case. On cold days, Zuyderland wore a long double-breasted overcoat like the ones worn by the veterans in Herkomer's *Chelsea Hospital*. Despite the military-style coat and the medal pinned to his lapel, the seventy-two-year-old Zuyderland would never be mistaken for either a soldier or a gentleman. His unruly white hair stuck out from under his hat and cascaded over his collar. The hat covered a perfectly bald pate. Dense mutton-chop whis-

kers hung on his cheeks. He had a broad, hooked nose; large, protruding ears; and small, heavy-lidded eyes. Vincent called him *"echt"*—the real thing.

Over the next year, Zuyderland came to the apartment on the Schenkweg often—probably as often as he could, given that pensioners were only allowed out three days a week and had to return by sundown. For fifty cents a day (all of which Zuyderland was obliged to surrender to the home), Vincent finally had a model commensurate to his capacity for drawing. With the patience of Job, Zuyderland stood frozen for hours while Vincent drew him in every conceivable position: standing, sitting, bending, kneeling—front, back, side. Sometimes he appears frail and stooped, sometimes erect as a soldier. He posed with a cane, with a stick, with an umbrella; with a top hat, with a cap, hat in hand, bareheaded. Vincent gave him props—a handkerchief, a glass, a cup, a book, a pipe, a broom, a rake—and posed him eating, drinking, reading, and doing chores. He joined with Sien, her mother, her daughter, and her baby for "family portraits."

Despite the almshouse prohibition on pensioners' wearing "any outer clothing outside the home other than that supplied by the governors," Zuyderland compliantly donned the costumes and carried the attributes of the "types" that peopled Vincent's imagination. A smock, a cap, and a peat basket transformed him into a peasant; a shovel, into a digger; a sou'wester, into a fisherman; a pickax, into a miner; a pipe and blouse, into an artist. Vincent sat him at a table, posed him praying, and drew him as a paterfamilias saying the mealtime benediction. He draped a bag over the old man's sloped shoulder and drew him again and again as The Sower.

Zuyderland endured every pose with the stoicism of the dray horses that Vincent admired so much. For Vincent, who rarely could get models for more than one or two sessions and even then had to plead for their indulgence and race their impatience, Zuyderland's patience amounted to a gift from the gods. It freed him not only to try more poses, but to do and redo each one until the correct outline emerged—a crucial condition for success given Vincent's lottery-like approach to studies. It also allowed him to take more time with each successful outline, to focus his extraordinary powers of observation on the play of shadows in the folds of a coat or the creases in a shoe. He returned to the larger size and bold strokes of *Sorrow*—which he still considered his best drawing—but added to it the vigorous hatching of the English engravings that filled his portfolios.

Over the long winter months in the Schenkweg studio, Vincent grew attached to his patient, compliant, stone-deaf model. Like the old pensioners in Herkomer's *Last Muster*, Zuyderland must have looked to Vincent like a castaway from the past, one of the disappearing "faithful veterans" from the era of Millet and Dickens. Homeless, wifeless, childless, friendless, and penniless, Zuyderland, too, was a Robinson Crusoe in the world, marooned in the passionless

present. Vincent often referred to him using a name given to all the "poor old fellows from the workhouse." He called him *"weesman"*—orphan man.

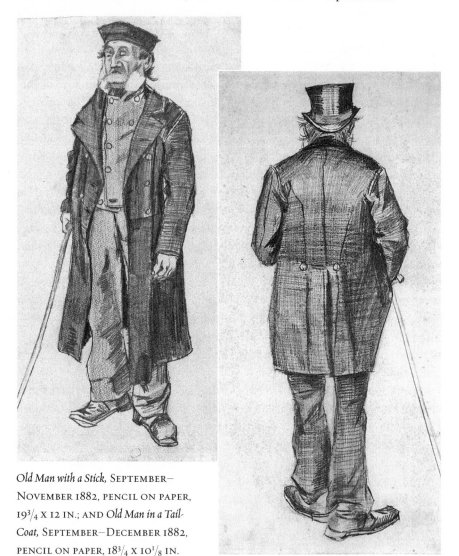

Old Man with a Stick, SEPTEMBER–
NOVEMBER 1882, PENCIL ON PAPER,
19³/₄ X 12 IN.; AND *Old Man in a Tail-
Coat,* SEPTEMBER–DECEMBER 1882,
PENCIL ON PAPER, 18³/₄ X 10¹/₈ IN.

IT WAS ONLY a matter of time before Vincent's new enthusiasm for drawing, for Van Rappard, and for the past coalesced into one of the driving manias that inevitably overtook him. In late October, a letter arrived from Rappard that fanned all these fires of ardor into a single, perfect flame of obsession. It contained a summary of an article by Hubert Herkomer that had appeared in an English magazine. In language as emotional as *The Last Muster,* Herkomer championed black-and-white imagery and celebrated the English illustrators (himself

included) for bringing the form to its highest expression. In words that must have seemed to have jumped directly from Vincent's thoughts onto the page, Herkomer hailed the bygone glories of wood engraving, and made the astonishing claim that the illustrations that appeared in a single magazine, *The Graphic*, represented as "true and complete" an artistic expression as all the paintings on all the walls of all the museums in the world.

In Herkomer's "energetic words," Vincent found vindication for all the impassioned arguments he had made on behalf of his repudiated art. An artist's sincere heart mattered more than his agile hand, Herkomer argued; his bravery more than his expertise; his mettle more than his training. He extolled the "moral advantages" of drawing over other art forms and exalted draftsmen above all other artists. He praised tone over color and vigor over care. In words that transformed Vincent's alienation and nostalgia into badges of courage, Herkomer warned against the dangers of "morbid conventionalism" and bewailed the decadence of recent trends in art (even at *The Graphic*), taking particular aim at the "foolish school" of Impressionism, founded by "half-formed minds" who painted "anything [and] everything they see in Nature, irrespective of all claims to beauty, or interest in [the] subject."

As a German-born, American-raised outsider in the closed club of English art, Herkomer painted a picture of his early career (he was only four years older than Vincent) that consoled Vincent's darkest fears. Herkomer, too, had experienced poverty and neglect. He, too, had been unable to pay the rent, scrounged for models, and suffered persecution. Even Herkomer's dense, overwrought English, so much like Vincent's, seemed to speak on Vincent's behalf. "The whole thing is thoroughly sound, strong, honest," Vincent wrote of the article. "To me it is an inspiration, and it does my heart good to hear someone talk this way."

Herkomer's polemic, by turns stirring and consoling, fired Vincent's ministry of black-and-white drawing to an evangelical fervor. As in Amsterdam five years earlier, earnest devotion gave way to fanatic zeal. After a long absence, religious images reappeared in his letters, along with sonorous biblical cadences and actual scripture. He described his collection of prints as "a kind of Bible" that put him in a "devotional mood." Like a latter-day Savonarola, he railed against the decadence and decay of the new art and "today's deteriorating society"; against the onrushing tide of superficiality and conventionality; against the elevation of "material grandeur" over "moral grandeur."

In the studio, Vincent pursued his new vision of salvation with a frenzy of drawing. Throughout the fall, he drew not only Sien and her family and the orphan man Zuyderland, but others from the almshouse and orphanage, and workmen from the carpenter's yard nearby. He made drawings of horses on the street, paying owners to still their beasts while he scribbled madly. "I am working with all my strength," he wrote, as he reported completing stack after stack

of studies. "The more one makes the more one wants to make." As an homage to his new Kempis, he started a series of portraits like those that Herkomer had done for *The Graphic*'s "Heads of the People" series. These images, drawn from models but intended to represent broad, identifiable types (The Miner, The Fisherman, The Field Worker), had attracted Vincent's attention even before the summons of Herkomer's article. He had sent copies of the *Graphic* illustrations to Theo in June.

In mid-October, Vincent began moving the perspective frame closer to his models, creating multiple large-scale, head-and-shoulder portraits of Sien, her mother, and Zuyderland. He posed them each in distinctive headgear (hat, cap, bonnet, sou'wester), the shorthand of typology that he hoped would render them universal. Freed from the constraints of portraiture ("*the type* [is] distilled from many *individuals,*" he instructed Theo), he let his pencil obsess over the rough paper, working the bold outlines into moody, deeply shadowed cartoons of character. Of the scores of portraits he made that winter, only a few—one of Sien's ten-year-old sister with her hair shorn for lice and a suspicious look in her eye; another of the bookseller Jozef Blok, with his intense brow and impatient gaze—hint at something deeper than Herkomer's impassive secular icons.

In November, Vincent produced the truest testament to his new gospel. Again inspired by Herkomer's *Sunday at Chelsea Hospital,* he set out to capture the same pathos of inexorable death. The burden of mortality had haunted him since his own dark journey in the Borinage. He pulled from his portfolios a drawing he had done the previous year in Etten of an old man sitting with his head buried in his hands, weighed down by the trouble and futility of life. It was titled *Worn Out.* He carefully posed Zuyderland in the same position, set up his perspective frame, and traced the outline of this wounded, woeful figure. Not since *Sorrow* had he lavished more care on an image or invested it with more meaning. "I have tried to express . . . what seems to me one of the strongest proofs of the existence of '*quelque chose là-haut*' [something on high]," he explained in a lengthy sermon of commentary. "In the infinitely touching expression of such a little old man . . . there is something noble, something great that cannot be destined for the worms."

For Vincent, however, no vision of salvation was complete without the promise of reconciliation with his family—the wellspring from which all his manias flowed. Here, too, Herkomer offered hope. Not only was he himself a successful, wealthy illustrator, but he preached a message of opportunity and plenty to win the heart of any Van Gogh. "[In] an age of quick recognition and reward," Herkomer promised in the same article, an artist who specialized in wood engravings could readily earn a living and be free from the anxiety of sales. Why? Because in the new era of bourgeois consumerism (an era of "utility and haste," he called it), wood engravings would be more in demand than any

other art form. Cheap, reproducible, and "reasonably comprehensible to most minds," wood engravings offered "pleasure and edification" to the masses, and the masses would always "clamour loudly for good work."

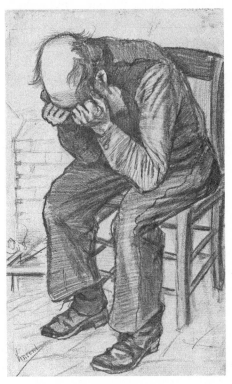

Worn Out, NOVEMBER 1882, PENCIL ON PAPER, 19³/₄ X 12¹/₈ IN.

Such reassurances fell like manna on Vincent's faltering artistic enterprise. Despite the rhetorical battles with Mauve and Tersteeg, Vincent still clung to the ambition he had brought out of the Borinage: self-sufficiency. His letters to Theo zigzagged between lofty claims of artistic integrity and solemn rededications to commercial success. Herkomer's words promised release from this whiplash of ambivalence. Through the medium of mass-produced wood engravings, a simple, sincere art could touch people directly, he argued, bypassing the "poisonous influence" of dealers like Tersteeg; and a simple, sincere artist could reap the rewards of success without sacrificing his soul.

Within days of reading Herkomer's article, Vincent set out to create an image that struck this perfect balance. Using the phenomenally popular *Chelsea Hospital* as his model, he announced his plan to "produce a work of Art in black and white of a striking subject that would attract attention and fix a reputation." By doing so, he imagined, he, like Herkomer, could reverse the disdain of his peers, the rejection of his family, and the indifference of the world.

In late October, Theo inadvertently enabled his brother's great new ambition. In a letter, he described some recent developments in lithography, a traditional method for mass-producing images that had been largely eclipsed by more modern printing techniques like photoengraving. Because it involved drawing directly on a lithographic stone (from which copies were made), lithography was widely admired for its faithfulness to the artist's vision as well as the expressive moodiness of its velvety blacks. But the practical challenges (and expense) of working with a grease crayon on a limestone block limited lithography's popularity, especially among younger artists. Theo's letter reported on a new technique that allowed artists to draw an image with lithographic crayon on a special paper, which could be transferred mechanically to a stone, thus bypassing the most difficult and expensive step in the process. "If this is true," Vincent wrote back instantly, "send me all the information you can pick up about the way in which one has to work on this paper, and try to get me some of it, so that I can give it a trial." When Theo failed to respond immediately, Vincent marched to an art supply store, Smulders, and bought some of the new paper on his own. With no idea how to use it, he took the paper home, copied onto it one of his drawings of the orphan man Zuyderland, and returned it to the astonished clerk at Smulders for printing, all within a few hours. The resulting print so excited him that, without waiting for Theo's reaction, he laid elaborate plans for a whole series of similar prints—"not too elaborate, but *vigorously done*"—and reserved six stones at Smulders. He chose as his model Millet's *Les Travaux des Champs*, the icons of redemptive toil that had guided him out of the black country. He started with an image of "a woman with a bag of coals on her head"—yet another variation of *Worn Out*—and laid plans for the next image in the series, a "small caravan" of women miners.

IN A RAPTURE of enthusiasm, he imagined that his album of prints would surely secure him a job as an illustrator, or at least give him "prestige in the eyes of . . . the magazines." He proposed going to England to apply for work, convincing himself that the magazines there would experience a shortage of competent draftsmen once the revival of lithography got under way—which he expected to happen any day. In London, he planned on meeting with Herkomer himself, as well as the editors of the fabled *Graphic*. "I don't think it's every day that [they] find somebody who considers making illustrations his speciality," he wrote. Among the first drawings he recreated for his new stones were two with English titles, including *Sorrow*.

So strong was Vincent's vision of success that setbacks only prompted him to greater leaps of fantasy. From the outset, he had hoped that the album would

bind him even more closely to Anthon van Rappard and planned for his friend to contribute drawings to it. But as soon as Rappard expressed reservations about the project, Vincent proposed a new and even grander conception: he would recruit a community of artists, all of whom would contribute to the great effort—with both illustrations and money—working together just as the English illustrators had cooperated in the glory days of *The Graphic.*

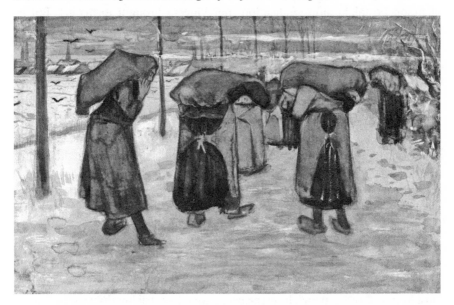

Women Miners, NOVEMBER 1882, WATERCOLOR ON PAPER, 12⅝ X 19¾ IN.

Through every leap of unreality, Vincent argued his cause with the same combination of delusional invention and earnest calculation, of inspiration and cerebration, that would ultimately shape his art. He cast the project as nothing less than a moral duty and rallied his brother with the revolutionary rhetoric of 1793: One should "act, not deliberate . . . Great things can be done. . . . *En avant et plus vite que ça* [Move on, quick as possible]." He drew up a detailed contract for the revolutionary artists' group he envisioned, a manifesto that dictated not just the artistic program (materials, subject matter, and price), but also profit shares, voting rights, shareholder duties, and distribution of assets.

All to no avail. Yet again, his grand plans fell victim to his overheated expectations. Theo, who had learned to speak to his volatile brother on certain subjects only in measured silences, never responded directly to the album proposal. In truth, not even Vincent seemed persuaded by the promises of commercial success he repeatedly made and retracted, sometimes in the same letter. His attitude toward popularity also took a series of abrupt U-turns. At first, he

dismissed public recognition, saying, "[it] leaves me absolutely cold." But when he heard that the workmen at Smulders had asked to hang one of his prints on the shop wall, he hailed the discernment of "the man in the street" and set himself the goal of hanging his prints in "every workman's house and farm." Only weeks later, however, he was again expressing contempt for the public taste.

The images, too, betrayed him. No medium could bear for long the weight of ardor, nostalgia, and vindication that Vincent brought to his art. But lithography proved especially intractable. The results disappointed him at every turn. The double transfer—from drawing to stone and from stone to print—introduced a host of vagaries into the creative process. The loss of control gave him fits of frustration. In the printing process, ink ran and blotted, spotting some images and blurring others. In its own way, transfer lithography was as unforgiving as watercolor: once the greasy crayon touched the paper, there was no going back. He tried erasing the crayon with the scraper intended for the stone, but that reduced even the heaviest paper to shreds. He tried "touching up" the drawings themselves with autographic ink—yet another "treacherous" medium. But when the drawing was wetted during transfer, the ink dissolved—leaving "nothing but a black blot instead of your drawing," he moaned. Then he tried making changes directly on the stone, using his pocketknife as an eraser. Finally, he took finished prints and treated them as drawings in gestation, using a pen to elaborate details and add background.

He complained endlessly to Theo about how much of the drawings was "lost in transferring them"; how the prints were less striking than the originals, drained of "animation" and "diversity of tone." He reported impressions that turned out "spoiled" and "misprinted." Even the best ones he found unsatisfactory; the worst he declared (to Rappard) "failures" and "sorry abortions." He sent copies to Theo with hand-wringing apologies. At the end of November, after only four weeks and six images, he pronounced the project's epitaph: "I tell you that dissatisfaction about bad work, the failure of things, the difficulties of technique can make one dreadfully melancholy."

The final blow came from the most unexpected source: *The Graphic.* In the 1882 Christmas issue, the editors of the magazine directly challenged Herkomer's jeremiad. They denied the charges of artistic decline and dismissed Herkomer's dire warnings of a shortage of competent draftsmen. "Besides our professional artists," they boasted, "we have no less than *two thousand seven hundred and thirty* friends scattered all over the world, sending us sketches or elaborate drawings." The editorial exploded Vincent's remaining arguments for his project's commercial viability. In an apparent attempt to limit the damage, he sent Theo a copy of the magazine accompanied by a furious denunciation.

But the words struck at his sole remaining hope. "It makes me sad, it takes

away my pleasure, it upsets me, and personally I am absolutely at a loss about what to do," he wrote in a moment of utter candor. "When I started, I used to think, 'If only I make such and such progress . . . I shall be on a straight road and find my way through life.' "

MEANWHILE, ALL WAS NOT well in the apartment off the Schenkweg.

The storms of summer had given way to a bitter winter. The effects of hospitalization followed Vincent deep into the fall. He complained of feeling "indescribably weak," "faint," and "thoroughly miserable." He tired easily, caught cold frequently, and slept fitfully. He was tortured by severe toothaches that migrated to his eyes and ears. Sometimes his eyes hurt so much "that even simply looking at things bothered me," he wrote. Every affliction, compounded by too little food and probably too much alcohol, took a visible toll. Acquaintances who encountered him on the icy streets saw his bloodshot eyes and sunken cheeks and thought he looked "as if [he] had been on a bender . . . obviously on the road to dissipation."

No sooner had the euphoria of the baby's birth in August passed than Vincent began sending hints of trouble with his new family—distress signals from behind his vow of silence. Life on the Schenkweg had lost its "light-heartedness," he said. It was becoming more and more difficult "to preserve some freshness." He wrote of his disillusionment in carefully coded abstractions: "Even though things should turn out differently from what one originally intended, one must rally and take courage again." He quietly withdrew his plan to "draw the little cradle another hundred times."

With unconvincing vows to push on, he fought off increasingly serious attacks of depression—days when "life is the color of dishwater." "My heart gets heavy when I think of the way things are going," he admitted. At times, he seemed to lose interest in his own work, bemoaning the incessant drudgery of it. He looked at his piles of studies and complained: "They don't interest me . . . I find them all bad." Even his precious collection of illustrations lost its consoling power. After painstakingly mounting a batch of new prints, he reported being overcome by "a rather melancholy feeling of 'what's the use?' "

The coming of Christmas brought a fresh wave of determination to make his new family fill the void left by the old, an effort made plausible by his fondness for the infant Willem. He thought he saw "something deep, infinite, and eternal . . . in the expression in the child's eyes." He recruited Sien and her baby for a matching series of sketches in an effort to draw them into the fantasy of redemption that was for Vincent, as for Dickens, the heart and soul of the Christmas story. He posed the orphan man Zuyderland reading a Bible and say-

ing grace. His intention in these drawings, he said, was "to express the peculiar sentiment of Christmas." He sat by the "cozy Christmas fire" and read Dickens's *A Christmas Carol.*

But Dickens wrote another Christmas story that Vincent also reread that year: *The Haunted Man.* As the first anniversary of the fight with his father and the expulsion from Etten approached, Vincent resembled more and more that book's lonely protagonist, craving forgetfulness from the "sorrow, wrong, and trouble" of his past.

The disgrace of repeated failures haunted him. "One gets a feeling of guilt, of shortcoming, of not keeping one's promises," he wrote. "One has a feeling that one may strike a rock at any moment." When his defenses slipped, he saw in the mirror a "leper" of incompetence and misfortune. "One would like to call from afar to the people: 'Don't come too near me, for intercourse with me brings you sorrow and loss.' " As the year ended, he surveyed the wreckage of his artistic project and offered Theo a humbling apology: "I am sorry that I have not succeeded in making a saleable drawing this year. I really do not know where the fault lies."

On New Year's Day 1883, an unexpected revelation from Paris threw back the curtain on Vincent's private struggle to fashion a family on the Schenkweg. Theo had taken a mistress. In a thrill of solidarity, Vincent wrote of their shared dilemma: "To you and me there appeared on the cold cruel pavement a sad pitiful woman's figure, and neither you nor I passed it by." Seizing on the news to reassert his older-brother prerogatives, he lectured Theo on the challenges, and especially the changeability, of love: on the cycles of "withering and budding . . . ebbing and flowing . . . exhaustion and impotence" that he knew so well. But wisdom soon bled into confession as Theo's plight licensed Vincent to reveal all the grievances he had held back for so long.

"I have had some unpleasant experiences," he wrote of his life with the Hoornik clan, "some of them very nasty indeed." Little Willem's incessant wailing roiled his already troubled sleep. Sien's daughter roamed the house like the street urchin she was: anxious and suspicious, a lightning rod for angry confrontations. Sien's sister ranked as "an unbearable, stupid, vicious creature." Together they "eat me out of house and home," he complained. Sien herself had grown fatter and lazier in her long convalescence. Even after she returned to posing, she would do so only for short periods. She insisted on being paid in cash and still left the chores to Vincent. Her recalcitrance may have extended to other wifely duties as well: Vincent confessed that he no longer felt "passion" for her, only "fathomless pity."

He assailed her humorlessness and indelicacy of manners—the same badges of victimhood he had celebrated six months before. He criticized her narrow-mindedness and her lack of appreciation for books or art—a failing that

only grew more acute as the rest of the world fell away. "If I did not look for art in reality," he said in a moment of brutal clarity, "I should probably find her stupid." He referred darkly to something he had learned about her past that did cruel injury to his love—even killed it. "When Love is dead," he wondered, "is it impossible for Charity to be alive and awake still?" And he hinted pathetically at the gulf he had discovered between them: "There is not a soul here in whom I can confide."

In the midst of this melodrama, Anthon van Rappard began to slip out of Vincent's grip. It began with yet another squabble over the faulty drawing in Vincent's lithographs. Desperate to maintain his friend's involvement in his album project as proof of its viability, Vincent held his fire through the Christmas season. If anything, his increasing isolation in The Hague only exacerbated the adhesiveness he brought to every friendship. He sent Rappard books and poetry, drawing tips, effusive flattery, and fervent pledges of brotherhood. In the most urgent terms, he proposed reciprocal studio visits and planned joint sketching trips to the countryside, even to the Borinage. "I regard love—as I do friendship—not only as a feeling," he wrote, challenging Rappard to match his fervor, "but chiefly as an *action.*"

Grandly invoking their "spiritual unity," he imagined a bond that went beyond mere friendship. "Whenever different people love the same thing and work at it together," he said, "their union makes strength . . . a whole is formed." It was the bond to which he had summoned Theo again and again—the vision of the Rijswijk Road—two brothers "bound up in one: feeling, thinking and believing the same"—an artistic marriage of *"two* good people . . . with the same intentions and object in life, actuated by the same serious purpose." Even as his dream of a noble combination of artists—a reincarnation of the *The Graphic*—withered in the winter of his disrepute, Vincent imagined a perfect pairing of "human hearts who search for and feel the same things." "What couldn't they accomplish!" he exclaimed.

It was the same vision that he would fix on Paul Gauguin six years later, with disastrous results.

Vincent's utopian visions, whether of family or friendship, left no room for compromise. In his tyrannical mirror, Rappard could not differ from or surpass him in any way. "We are both on just about the same level," he told Theo. "I don't try to compete with him as a painter, but I won't let him beat me in drawing." "I would despise a friendship which did not call for some exertion on both sides to maintain the same level," he said—but only in a perfect and eternal marriage of equals.

No friendship could bear such a burden for long. In March 1883, when Rappard announced his intention to submit a painting to an exhibition in Amsterdam, the inevitable unraveling began. Vincent responded with a storm of

protest. He lashed out with the fury of a betrayed lover at the very concept of exhibiting. Claiming an insider's knowledge from his days at Goupil, he denounced exhibitions as nothing but fakery—a sham of unity and cooperation at a time when artists desperately needed *real* "mutual sympathy, warm friendship and loyalty."

Rappard responded to this tirade in the most cutting way of all—he ignored it. His painting, *Tile Painters*, appeared in the International Exhibition that opened in Amsterdam two months later. Vincent, of course, immediately set to work to try to repair the breach he had opened between them. In May, he finally succeeded in arranging the reciprocal visits he had pined for. But the damage had been done. Vincent would have other chances, but within two years it would be over completely. After that, he and Van Rappard would never speak to each other again.

As Rappard balked, Vincent turned to other, more pliable companions like Herman van der Weele, the son-in-law of the manager of a paint store where Vincent often ran up debts. As a teacher at the local secondary school, Van der Weele had mastered the classroom art of encouraging without approving—an absence of criticism that Vincent eagerly construed as praise. "In looking over my studies," he reported after one of Van der Weele's visits to his studio, "he wasn't so quick to say, 'This or that isn't right.' " That spring, after months of encouragement from Van der Weele, Vincent finally abandoned the austere, single figures and "heads of the people" that had obsessed him all winter long.

In May, Vincent agreed to give drawing lessons to the son of another paint-store owner, again probably working off his invariably overdue bills. Twenty-year-old Antoine Furnée, who was studying for an examination in land surveying, caught the brunt of Vincent's bitterness toward a community of artists that he now denounced as "inveterate liars." As stern a master as he was a rebellious student, Vincent condemned Furnée's amateur watercolors as "hideous," "horrible daubs" and put him on a strict regimen of drawing only. "I made him draw many things which he did not like at all," Vincent reported proudly to Theo. On their joint sketching trips, according to Furnée, Vincent never stopped talking: filling his student's captive ears with all the pent-up arguments for which he had no other audience.

But Vincent found no comfort in these occasional contacts. "I should like to find and keep up a *real* friendship," he lamented, "[but] it is difficult for me . . . Where it is conventional, bitterness is almost unavoidable." He called himself a *"sentinelle perdue"* (lost sentinel)—"a poor struggler of a sick painter"—and compared himself to the tattered prints that he pulled from trash bins: "ignored and looked down upon as worthless rubbish, garbage, wastepaper." He saw in his loneliness a martyrdom for art, succeeding his martyrdom

for love. His imagination poured out images of lonely martyrs to console his soli-
tude, from Christ in the Garden to Andersen's Ugly Duckling. He cast himself as
Quasimodo, Hugo's despised, bandy-legged hunchback in *Notre Dame de Paris*.
From the depths of self-loathing, he rallied himself with the hunchback's pitiful
cry: *"Noble lame, vil fourreau / Dans mon âme je suis beau"* (A noble blade, a vile
sheath / Within my soul I am beautiful).

On March 30, Vincent passed his thirtieth birthday alone, rereading Hugo's
tale of hounded exile, *Les misérables*. "Sometimes I cannot believe that I am only
thirty years old," he wrote. "I feel so much older when I think that most people
who know me consider me a failure, and how it really might be so."

To escape such thoughts, Vincent took long walks. Abandoning the troubled
Schenkweg apartment, he strolled the familiar alleyways of the Geest, and hiked
to the distant sea at Scheveningen, calling the seashore a great antidote "for a
man who is downcast and dejected!" He walked in storm and snow. He walked
past the lavish house of Jozef Israëls—still the paragon of Millet piety and bour-
geois prosperity—and peered longingly in the open door. ("I have never been
inside," he noted ruefully.) His considered going farther—lighting out for the
country, for the Borinage, or for England.

To avoid encountering former acquaintances, especially Tersteeg, Vincent
walked the cobblestone streets of the city center only at night. In the empty
Plaats, he often stopped at Goupil's gaslit window and stared at the works dis-
played there. One evening in April, he stood for a long time gazing at a small
marine by Jules Dupré. He had given a print of the same or a similar image to
his father seven years before, after being fired from Goupil. It was a dark paint-
ing—especially in the low, fluttering gaslight—so he came back many evenings
in order to truly *see* it. "What an almightily beautiful impression it makes," he
wrote Theo. In moody tones and agitated brushwork, it showed a small sailboat
caught between a roiling sea and an angry sky. In the distance, an opening in
the clouds defined an island of sunlight where the water was green and smooth.
The boat's fragile prow pointed the way to the distant light. "When my worries
become too great," he wrote, "I feel as if I were a ship in a hurricane."

There were times, however, when no ray of light appeared in the distance,
when life seemed "something like an ash heap," he said; and it took all his ef-
fort to avoid "staring into the unfathomable." He talked openly of regret ("some
things will never return") and obliquely of suicide—and what might lie beyond.
"One begins to see more and more clearly," he wrote, "that life is only a kind of
sowing time, and the harvest is not here."

ON THE SCHENKWEG, the only escape was illusion. Pressured by Theo for
salable work, cut off from outsiders, and hounded by creditors, Vincent spun

further and further into unreality. In early spring, he launched yet another am-
bitious plan to create an iconic image like *Chelsea Hospital*—a *manifestation* that
would answer Herkomer's mandate to "attract attention and fix a reputation."
With Van der Weele's encouragements in his ear and Rappard's paintings of tile
painters in his competitive eye, he returned to an old subject: soup kitchens. He
had visited the *établissements de bouillon* in Brussels with Rappard. He had also
sketched the municipal kitchen in The Hague with Breitner. The subject had lin-
gered in his imagination throughout the winter, sustained by numerous prints
in his collection, surviving even the failed effort at watercolor group scenes in
September.

But this time, he did not have to face the hostile crowds in the Geest or the
scorn of the soup kitchen patrons. This time, he re-created the entire scene in
his studio.

In an extravaganza of unaffordable expenditures, he remade the front room
of the apartment into a replica of the soup kitchen he knew. He hired workmen
to install multipart shutters in each of the studio's three big north-facing win-
dows, "so that the light falls exactly as in the place itself." Using the canvas that
had served as blinds, he made a partition across one end of the room and drew
on it the small double opening through which the soup was served in the actual
kitchen. He painted the entire room with the gray wainscoting of the original.
"By paying attention to those things," he explained to Theo, "one gets the local
color so much more correctly."

Vincent sent him lengthy descriptions of the mise-en-scène, complete with
elaborate drawings that labeled each feature and explained its function. No de-
tail was left unattended to; no expense forgone. He hired a crowd of models and
bought "*real* clothes" for all of them—"picturesque" patched smocks and coarse
linens like the ones in his illustrations. "Tomorrow," he wrote in a fever of an-
ticipation, "I'll have the house full of people."

The next day, Vincent sketched from dawn until dusk, moving his models
from one position to another, opening and closing the shutters to get the high-
lights on the heads of the figures just right and "render the character most com-
pletely and strongly." He was so delighted with the results that he immediately
planned more alterations, more expenses, more models, and many, many more
drawings. "I just go on drawing," he said of his plans for the future, "that's all."
He told Theo that he felt "at home and content" with the models together in his
studio. The scene reminded him of a print in his collection depicting a corridor
in the offices of *The Graphic* at Christmastime when all the models who had ap-
peared in the magazine throughout the year came to offer their Yuletide greet-
ings. It showed a procession of invalids, beggars, and blind men hanging onto
each other's coattails, all united by the redemptive spirit of Christmas.

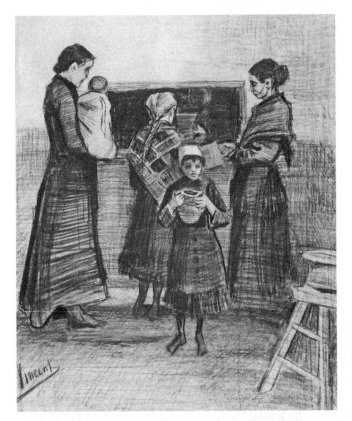

Soup Distribution in a Public Soup Kitchen, MARCH 1883,
CHALK ON PAPER, $22^{1}/_{4}$ X $17^{1}/_{2}$ IN.

Now he could live in that print. He imagined not just a series of soup kitchen drawings, not just a series of group scenes, but a permanent Christmas on the Schenkweg—a "place where the models could meet every day, as in the old days of the *Graphic*":

> My ideal is to work with more and more models, quite a herd of poor peoples to whom the studio would be a kind of harbor of refuge on winter days, or when they are out of work or in great need. Where they would know that there was fire, food and drink for them, and a little money to be earned. At present this is so only on a very small scale, but . . .

Jacob and Esau

~

*I*N PARIS, THEO READ HIS BROTHER'S LETTER WITH A FRESH WAVE OF dismay and alarm. The bizarre plan to transform the Schenkweg apartment into a private soup kitchen summarized all the excesses and misdirections of Vincent's flawed and faltering career as an artist—a career that increasingly seemed destined to end, as all the others had, in failure.

Theo had tried dutifully to steer Vincent in the right direction—with little success. Indeed, as he looked back over the previous two years, it must have seemed that he had spent the entire time arguing with his brother about the direction of his art. Beginning in the fall of 1880, the two had sparred repeatedly over artistic issues great and small. Theo called Vincent's early drawings, with their Puritan simplicity and recherché sentiment, old-fashioned—a direct assault on his brother's exaggerated nostalgic enthusiasms. He complained that they were not only too big to attract buyers, but also "too dry" (a rebuke of Vincent's preference for pencil), too dark, and too meager—charges that embraced Vincent's whole beloved canon of black-and-white. He urged Vincent to find more cheerful subjects than the dreary workers and pitiful old men he favored. Buyers wanted "pleasant and attractive" images, he said, not "things of a more gloomy sentiment."

He sent repeated exhortations for Vincent to do more landscapes—for which he seemed to have an innate talent—and lobbied relentlessly for more color and more elaboration. He said again and again that those endless solitary figures against blank backgrounds would never sell. If Theo knew one thing from his ten years in the art business, it was that people bought art because they *liked* it, because they found it pleasing and charming. They didn't give a fig about Vincent's fervent principles or tiresome rhetoric; they wanted "details," they wanted "finish."

Vincent had responded to all these suggestions with an unceasing stream of arguments. Over the winter, the stream had turned into a torrent as he struggled to justify his rising expenditures and unchanging art. At least twice a week, a fat letter appeared in Theo's Goupil mailbox filled with Vincent's hyperventilating justifications and promises of future progress. After long experience, Theo no doubt knew that any frank criticism might trigger an eruption of defensiveness that could last for weeks, even months. So, like his father before him, he avoided direct confrontations, veiling his persuasion in generalities about "vivid" palettes and the beauties of nature. He wrote lengthy descriptions of colorful scenes that would make wonderful paintings, and sang the praises of successful colorists and landscapists.

But Vincent matched his brother's missives description for description, artist for artist, hint for hint, in a battle of indirection as rancorous as any open debate. He repeatedly solicited advice, often in the most affectionate terms, but almost always refused to follow it. He repledged his love for watercolor and landscape, but pushed any return to painting into the indefinite future. In an especially clever parry, he praised the vivid word paintings that Theo sent as proof of his brother's true vocation and renewed his call for Theo to become a painter—essentially shifting the burden of unrealized potential back onto his brother.

He deflected accusations of "dryness" with complaints about Theo's stingy stipend ("my life is too cramped and meager") and protests that all beginners suffered the same problems. He responded to Theo's call for more pleasing imagery by drawing one of his models pushing "a wheelbarrow full of manure." When Theo encouraged more elaboration, Vincent answered with a paean to the "honesty, naïveté, and truth" of his unembellished images. Despite intense pressure to make smaller works (from Mauve and Tersteeg as well as Theo), he vehemently defended his continued use of the large, Bargue-sized sheets, dismissing the arguments against them as "preposterous" and vowing never to change. Finally, he rejected Theo's right to make *any* comments about his drawings before he had seen them all together in the studio.

Much of Theo's advice seemed designed to coach his obstreperous brother toward the new art of Impressionism. In his five years in Paris, Theo had seen the stock of artists like Manet, Degas, and Monet rise from the humiliating depths of the Hôtel Drouot auction in 1876. Their colorful, challenging images had not yet unseated commercial giants like Bouguereau and Gérôme, whose works still lined Goupil's lush galleries, but the winds of fashion and capitalism were clearly at their backs. Only the year before, in 1882, the French state had withdrawn its official support from the Salon, leaving all artists at the mercy of the market. The Impressionists, who had by then mounted seven annual group shows, were already masters of the new rules of success. As a junior *gérant* in a bastion of the old order, Theo himself would not begin to deal in

the works of artists like Monet and Degas for several more years, but he had already come to see their commercial success as inevitable. "To me it seems quite natural," he wrote his brother about the revolution in the air, "that the desired change will occur." Recognizing that Vincent would never master the sharp rendering and deft modeling of his heroes like Millet and Breton, Theo must have seen in Impressionism's brusque, unfinished images a perfect home for his brother's impatient eye and unruly hand.

But Vincent resisted every effort to coax him from the grip of the past. In his opinion, the change brought by the Impressionists was neither natural nor desirable. He especially resented Theo's suggestion that they would eclipse his eternal favorites Millet and Breton. He linked the Impressionists to the forces of decadence about which Herkomer had "sounded the alarm bell." "The changes that the moderns have made in art are not always for the better," he cautioned his brother, "neither in the works nor in the artists themselves." He accused the Impressionists of "losing sight of the origin and the goal" of art. He associated their confectionary colors and unfocused forms with the "hurry and bustle" of modern life, with the ugly summer houses of Scheveningen, the disappearing moors of Brabant, and everything else that had "taken the joy out of life." He rejected their loose *"à peu près"* (approximate) way of rendering reality, and dismissed their pretensions to scientific color as mere "cleverness." Cleverness, he warned, would never save art; only earnestness could do that.

So strong was Vincent's antagonism to Impressionism that not even Zola could appease it. Indeed, he recruited Zola's decadent avant-garde painter, Claude Lantier, in his attacks on the new art. "One would like to see another kind of painter depicted by Zola than Lantier," he wrote in November 1882, at the height of his argument with Theo. Vincent had heard that Zola based the figure of Lantier on the pioneer Impressionist Édouard Manet—"not the worst example of that school, which I think is called impressionist," Vincent allowed, using the term for the first time. While conceding that Manet was clever, he railed against Zola's modern ideas of art as "superficial," "wrong," "inaccurate and unjustified"; and he dismissed Manet and his ilk as "not part of the nucleus of the artistic corps." Far from following in the path of past masters, the new style "utterly contradicted the style of these masters." "Have you noticed," Vincent pointed out in horror and disbelief, "that Zola doesn't mention Millet at all?"

The brothers' debate focused especially on one central tenet of Impressionism: that true black does not exist in nature. For an artist who had staked his whole precarious enterprise on black-and-white imagery, such a claim posed an existential challenge. While airily conceding the point in principle, Vincent insisted that Theo and the Impressionists had it exactly backward. While they claimed that all blacks were made up of color, Vincent argued that all colors

were, in fact, made up of black and white. "Scarcely any color is not gray," he explained. "In nature one really sees nothing else but those tones or shades." The highest duty of the colorist, he declared, was "to find the grays of nature on his palette." To prove his point, he sent elaborate descriptions filled with shades and shadows: fields with "brown-gray soil"; horizons of "grayish streaks"; and vistas with "a somewhat yellowish yet gray sky."

In the studio, as if to defy his brother's cautious encouragements to Impressionism's light and color, Vincent threw himself into an obsessive, winter-long campaign in search of the blackest black.

Theo had begun hearing about this contrarian quest as early as April 1882—at exactly the moment Vincent acknowledged his break with Mauve and forswore his enthusiasm for watercolor. Determined to prove his chosen medium, black-and-white, the equal of the rejected one, he cast about for ways to combine the saturated black of his beloved pen drawings with the vigorous modeling and varied tones of his pencil sketches. He loved the coal-dust black of charcoal, but in his frenzied working style he almost always smeared or overworked images before he could fix them. Then he tried making the pencil drawings look more like charcoal—blacker—by washing the shine off them with drenchings of fixative. "[I] just pour a large glass of milk, or water and milk, over it," he described his unorthodox procedure. "It gives a peculiar saturated black, much more effective than is generally seen in a pencil drawing." A visitor to the Schenkweg studio in 1882 was surprised to find Vincent "continuously sponging off his studies from buckets full of dirty water."

The austere allure of lithography—which he undertook just as Theo began to apply serious pressure for more color—recharged Vincent's obsession with black. He convinced himself that his previous attempts to make reproducible drawings had failed because the blacks he used—whether pencil, charcoal, or chalk—were not black enough. For a few months, the lithographic crayon, a dense bar of greasy black the consistency of soap, seemed to Vincent the grail of blackness he had long sought. Unlike regular crayon, the lithographic crayon also adhered to pencil marks, so that he could complete a drawing in pencil, fix it with milk, and then rework the image with the crayon, achieving the "glorious black" he craved. He also discovered that if he soaked the drawing in water, the crayon marks softened enough that he could work them with a brush, like paint, achieving deep, velvety blacks that reminded him of English illustrations. He called this strange and risky procedure *"painting in black."*

Even after the lithography project faltered, he continued to use the lithographic crayon, arguing that it "gives the same depth of effect, the same richness of tone value as in a painting." But before long, he found an even blacker black. Rummaging around his cluttered studio, he discovered a few pieces of "natural" black chalk that Theo had brought from Paris the previous sum-

mer. "I was struck by its beautiful black color [and] *beautifully warm tone*," he reported to Rappard. Perhaps because he admired its rugged authenticity (at a time when most chalks were fabricated), Vincent dubbed it *"bergkrijt"*— mountain chalk. "There's soul and life in that stuff," he declared. "I like nothing better than to work with it."

With this five-inch-long stick of black, sharpened to a point, Vincent fended off all Theo's calls for cheerfulness, for color, for light, and for Impressionism. The drawings that Theo received after the elaborate soup kitchen preparations in March 1883 summed up his brother's long preoccupation with black almost categorically: combining mountain chalk, lithographic crayon, black water-color, and ink. From Theo's point of view, these unbudging images must have looked virtually indistinguishable from the drawings he had seen in Vincent's studio the previous summer, or even the summer before that in Etten: dark, cheerless, charmless images—exercises in defiance and denial.

THE SQUABBLES OVER ART only rehearsed the deeper antagonisms over Vincent's utter dependence on his brother. His pleas for money grew increasingly shrill. "I need it as much as a meadow needs the rain after a long drought," he wrote. And no matter how much Theo sent, he always needed more. He spent with a blitheness that surely appalled his brother, he often bought on credit, and he never stopped making improvements to his studio. As always, Vincent attributed his high expenses to his hard work and the demands of his art, but when he alluded cryptically to "household costs" and "heavy cares," Theo must have suspected other, unwelcome claims on his largesse.

When Theo reported in May that business at Goupil had been slack and his own finances were "rather straitened," Vincent retreated not an inch. "Let us redouble our energy," he instructed. "I will be doubly intent on my drawings, but you must be doubly intent on sending the money." Calling the money absolutely indispensable, he warned Theo that "cutting it down would be something like choking or drowning me. I mean, I can do as little without it now as I can do without air." He brushed aside Theo's pleas for patience and sacrifice with calls for more models, and turned back every demand that he find a paying job.

The combination of profligacy and laxness in the pursuit of self-sufficiency brought a sharp rebuke from Paris. But instead of withdrawing in the face of Theo's disapproval, Vincent was emboldened by it. He openly rejected the prospect of a job as a "nightmare" and testily reminded Theo that his fraternal duty was to "comfort" his brother, not to "distress or dishearten" him.

More and more, Vincent seemed pulled by hidden, contrary currents of animus: answering generosity with ingratitude, devotion with resentment. He compared his dependence on his younger brother to a kind of captivity—"like

the beetle which is bound to a thread and can fly a little way, but is inevitably stopped." While he still offered occasional appeasements and declarations of fraternal love, his counterattacks grew sharper. He refused Theo's repeated requests to pay professional calls and to dress better (arguing that his art would suffer if he improved his appearance). When Theo dared to intimate that Vincent had not advanced very far in his two years as an artist, Vincent blamed Theo's inattention and inadequate funding for his slow progress. His comments about dealers grew increasingly venomous; not just in his conspiratorial rants to Rappard but directly to Theo.

The more Theo pushed him to make salable works, the more bitterly Vincent resisted, until, in the summer of 1883, he tried to end the argument once and for all with an ominous threat: "If you should *insist* on my going to ask people to buy from me, *I would do so,*" he wrote, "but *in that case* I should perhaps get melancholy . . . Brother dear, human brains cannot bear everything; there is a limit. . . . Trying to go and speak to people about my work makes me more nervous than is good for me."

With all these tensions hanging fire between them, Theo made plans to visit The Hague on his annual leave in August 1883. The two brothers had not seen each other since the previous summer, when Theo had tried unsuccessfully to oust Sien from the Schenkweg apartment. A year later, the topic still shadowed all their arguments. The prospect of another confrontation filled Vincent's letters with anxiety for the future and with memories of past betrayals running in an unbroken line back to the Zundert parsonage. "Father used to ponder over the story of Jacob and Esau with regard to you and me," he wrote a few months later, recalling the biblical story of another usurping younger brother, "not quite wrongly."

ONLY ONE ISSUE brought the feuding brothers together in absolute agreement: Theo's mistress.

Women had always been Theo's weakness. In a life otherwise bounded by duty and an almost monastic selflessness, excursions of the heart offered the only escape. As an attractive, sociable twenty-five-year-old bachelor in the most sociable of all cities, he did not have to look far. Paris was teeming with women in search of advantageous entanglements. Economic dislocations all over Europe, but especially in rural France, had swept tens of thousands of unmarried women toward the City of Light. Many were educated, even cultivated: the daughters of provincial tradesmen and shopkeepers. Not all were bound for prostitution—at least not in the traditional sense. Often with the blessings of their families, they eagerly volunteered in the great upswelling of social mobility that drew everything, even love, into the new bourgeois equation. They came to

Paris hoping to find marriage and money, although not necessarily together and not necessarily in that order.

Among them was a girl from Brittany named Marie.

Marie's last name, like so much of her story, is missing from the record. She and Theo met, apparently, in late 1882 under what Vincent described tantalizingly as "dramatic circumstances." Given Theo's cosmopolitan circuit of galleries and deluxe shops by day, fashionable restaurants and cafés by night, this is no hint at all. In Paris, ablaze with the glamour of money and new electric lights, every encounter held out the promise of "dramatic circumstances." Vincent may have been referring to the melodramatic dilemma in which Marie presented herself for Theo's rescue: abandoned by a feckless lover, penniless from paying his debts, stricken by a cruel but unspecified affliction.

Not a word about her appearance survives, but Theo clearly found her charming and attractive. The childless daughter of a Catholic family that Vincent described as decent and middle class, she must have been young. She could read, and was "not without culture." Theo spoke lovingly of her provincial *"je ne sais quoi"* even as he fretted fondly over her naïveté. He pictured her to Vincent as a fresh country girl, with the salt air of the Brittany coast still in her hair, a gamboling maiden from a painting by both brothers' favorite, Jules Breton, caught up in a sordid urban misadventure out of a Zola novel. With his usual dutiful resolve, Theo committed himself not just to a sexual liaison, but to a complete rehabilitation. He lobbied bureaucrats on her behalf, put her up in a hotel room, and tried to find her employment. As impetuous in love as he was cautious in everything else, he considered marrying her almost immediately.

Vincent responded to every detail of his brother's amorous confessions with almost delirious enthusiasm. Arguments over art and money were swept aside by heartfelt expressions of solicitude and even offers of sacrifice. "To save a life is a great and beautiful thing," Vincent wrote. "Do not deprive *her* for my sake." When Theo's joy succumbed, as it always did, to brooding over the future, Vincent launched a campaign of consolation that echoed the poetry album campaigns of previous years, filling letter after letter with advice and comfort for his lovesick brother. Asserting his superior knowledge in affairs of the heart, he offered everything from practical guidance on keeping a mistress ("It would be desirable for her to be elsewhere than in a dreary hotel room") to detailed instructions on wooing ("Show her unmistakably that you cannot live without her"). He sent lists of romantic readings (especially Michelet) and a lover's gallery of images, including the inevitable Mater Dolorosa.

Freed from his vow of silence by Theo's new romantic dilemma, Vincent relentlessly drew parallels between Marie and Sien ("We both stopped and followed the human impulse of our hearts"). When Marie was hospitalized for an operation in February, Vincent saw it as a reprise of Sien's medical crisis and

used it to right old wrongs and reclaim old prerogatives. He listed the similarities to Sien's case in numbered paragraphs and lectured Theo on the curative powers of "love and loyalty." "Yes, I truly think her life may depend on it," he said.

In May, Theo finally worked up the courage to ask his parents for permission to marry Marie. When they refused ("There is something immoral in a relation with a woman of a lower station in life," Dorus explained), Vincent's fantasy of vindication seemed complete. He rained condemnation on the parson and his wife, calling them "unutterably pretentious and downright ungodly." In the direst terms, he urged his brother to break with their parents and join him in open rebellion. After months of wavering, he began lobbying clamorously for marriage, insisting it was the right thing to do "even if one does not know beforehand how this woman will turn out later." He even urged Theo to make the ultimate commitment—the surest, most irrevocable break with their parents: "I think it *desirable* that there be a child."

Vincent made a special effort to drive the wedge deeper between his brother and his father. He railed against the inhumanity and wickedness of Dorus's behavior. "Thwarting the interests of such a woman, *preventing* her rescue, is *monstrous*," he wrote. "You and I also sometimes do things which are perhaps sinful; but for all that, we are not merciless, and we feel pity." Vincent drew only the thinnest curtain over his divisive intentions, calling the argument over Marie "a crisis that may cause some to become more firmly attached to each other, whereas on the other hand, it may cause others to become estranged."

Yet even as he raged against his father, another contrary current pulled Vincent closer to him and widened the rift with Theo. Dorus traveled to The Hague in May, and Vincent reported the most amicable visit between the two since 1877, when Dorus had spent "a glorious day" with him in Dordrecht. Despite the irrepressible rancor filling Vincent's letters, they spoke only briefly about Sien, and not at all about Marie. Afterward, Vincent laid plans to draw his father's portrait, and described him in warm, forgiving terms unprecedented in the long history of their antagonism. In the ultimate role reversal, Vincent cast himself as family peacemaker. "I should be glad," he wrote Theo, in words that surely left his brother blinking in disbelief, "if, with a little good will, peace might be preserved."

But it was no use. In the end, Theo chose duty over love; family over fraternity. As he always did. No doubt offended by Vincent's attacks on their parents and probably uneasy under his brother's militant tutelage (and perhaps alert to his designs), Theo arranged to keep Marie at arm's length, setting her up financially, making discreet arrangements with her parents, while continuing to see her—exactly contrary to Vincent's advice.

By the end of July, less than a month before his planned visit to The Hague, Theo had regained his parents' favor and shattered Vincent's illusions of cor-

recting what he called a "false position" with his brother. Theo would arrive at the Schenkweg studio newly emboldened by his own sacrifices to demand the same of Vincent.

AS THE DAY of reckoning approached, Vincent rushed to make amends for the year of dissension and disappointment since Theo's last visit. In a campaign driven by ever-shifting combinations of fraternal love, guilt, and resentment, he sought to appease his brother in images and words. In May and June, he created a series of drawings that he billed as evidence of his dedication to doing the more elaborate work that Theo urged on him. These big scenes, crowded with figures, all portrayed groups engaged in a common labor: digging potatoes, hauling coal, cutting peat, moving sand. He bragged to Theo about the complication and variety of these images, and assured him, "[They] will please you more than those single studies."

In June, Vincent promised Theo that he would return to watercolor again in the near future—"probably before your arrival." It wasn't until a month later, however, that he took his rarely used paint box into the countryside and managed "a few watercolors by way of a change." Even then, he put off any further attempts until his brother's visit, "when we shall decide together whether I shall make a number of small watercolors for you—just as an experiment." Oil painting, too, made a sudden reappearance in the months before Theo's visit. Vincent identified some "splendid things to paint" and professed to being "just in the mood for [painting] now." He reported doing some landscapes, his brother's favorite, on sketching trips to the country and to the beach at Scheveningen.

In July, using black ink, he painted a potato field nestled between dunes, its rows of plants converging toward a layered horizon of fields, brakes, and hills— as serene and embracing a vision of nature as he had ever rendered. In another painting, known only by a hasty sketch in a letter to Theo, he drew a line of bushes "tangled by the sea wind" along a path by the shore. The six battered bushes almost fill the image, bending and trembling like flames in a wind. Freed by the inconsequence of this "scratch," Vincent captured the scene in swirling pen strokes that lacked only the color of the brushstrokes to come.

On the eve of Theo's arrival, Vincent announced elaborate plans to stockpile paint supplies, and hurriedly rehung his studio, replacing the ubiquitous figure studies with some of his painted sketches from the previous summer's fervor. "It struck me there was something in them after all," he reassured his brother.

In lieu of the agreeable images that Theo wanted, Vincent flooded his brother with agreeable words. His letters accelerated from one a week in April to one a day in the weeks leading up to the fateful visit, as Vincent hurried to frame his modest images in gilded rhetoric. "A revolution has taken place in me," he

claimed; "the time is ripe . . . I have loosened the reins." He assured Theo again and again that he was only a few days, a few models, a few sketches away from "something broad and audacious," "something comforting, something that makes one think."

Path to the Beach, JULY 1883, LETTER SKETCH, INK ON PAPER, 3 X 5¼ IN.

He pointed to his latest group drawings as proof that "the moment" when he would produce a salable image was close at hand, and he predicted confidently that "people will alter their opinion about my doing or planning absurd things." In addition to promising a bright future if Theo showed patience, he warned of dire consequences if he did not. "I don't care for anything but the work," he said, waving again the red flag of mental instability. "I become melancholy when I can't go on with my work." The prospect of having to quit, Vincent hinted leadenly as Theo's visit approached, "makes me sorry that I didn't fall ill and die in the Borinage that time, instead of taking up painting."

The looming visit also roused Vincent to the one activity he hated most: socializing. After more than a year of Robinson Crusoe isolation on the Schenkweg, he reported friendly encounters with dealers and other artists. He exchanged books and studio visits with Breitner, who had returned to The Hague for the

summer. On a trip to Scheveningen, he called on Bernard Blommers, the successful Hague School painter who had disappeared from Vincent's life about the same time as Anton Mauve. In July, Vincent braved those memories to show Blommers his recent work and reported brightly afterward, "He wants me to keep it up."

He also paid a visit to Théophile de Bock, the Mesdag protégé with whom he had already fallen out several times. De Bock had rented a house just off the road that ran from The Hague to Scheveningen. In his report to Theo, instead of mocking De Bock's bourgeois pretensions (as he had often done), or criticizing his failure to use models more, Vincent pointedly admired the artist's "pretty," "blondly brushed" landscapes and retreated somewhat from his fierce attacks on Impressionism. "I don't mind its being unfinished," he said of one De Bock work. "[It's] half romantic, half realistic—a combination of styles that I don't dislike." He even arranged to use a room in De Bock's house as a pied-à-terre where he could store his materials, making trips to the beach much easier—an arrangement he presented to Theo as a virtual guarantee of more landscapes.

To demonstrate his commitment to selling his work, Vincent reversed months of rhetoric and reached out yet again to his estranged family. He sent Uncle Cor in Amsterdam two of his group drawings accompanied by a wan hope that "they might be the means of finding new connections, and perhaps of reestablishing relations." He reassured Theo that he was "very anxious to be on good terms with Mauve again." In an especially delusional moment, he asked Theo to persuade Mauve to offer him "a helping hand" again.

The road to Uncle Cent's favor, however, ran through the Plaats, Goupil & Cie, and the little back office of H. G. Tersteeg. This was a much harder reversal to negotiate. Only the month before, Vincent had laid all the tribulations of the previous year at Tersteeg's feet and vowed "I will not cross his path again." Initially, Vincent hoped that Theo would "write a little word" and "make some arrangement" with the implacable *gérant*. He proposed that his brother broker a rapprochement.

After a month passed without a response, emboldened by his new drawings and desperate to "thaw the ice" between them, Vincent returned to the Goupil gallery for the first time in more than a year and confronted his nemesis face-to-face. Tersteeg received him formally. Quick to take offense, Vincent read in his manner a frigid greeting: "Here you are, bothering me again—do leave me alone." He had brought one of his drawings of group labor showing a row of diggers, and he offered it to Tersteeg as a gift. "I understand perfectly well that this sketch could not be anything for you," he said as he spread the big drawing out on Tersteeg's desk , "but I came to show it to you because it has been so long since you have seen any of my work and because I wanted to prove that I do not feel any ill will about what happened last year."

"I do not hold a grudge, either," Tersteeg said wearily, barely looking at the image laid before him. "As to the drawing, I told you last year that you ought to make watercolors . . . This is not saleable and saleability must come first." Again, Vincent read in the *gérant*'s manner a far sterner message: "You are a mediocrity and you are arrogant because you don't give in and you make mediocre little things: you are making yourself ridiculous with your so-called 'seeking.' "

Fighting despondency, Vincent ran home and spent the rest of the day redrawing the image "to finish the figures better." He wrote his brother a detailed account of the debacle: a tale torn between fury, pain, and despair, spread over several long, plaintive letters. "Sometimes one is depressed by it and feels miserable and almost stunned," he wrote. "Life sometimes becomes gloomy, and the future, dark." He cursed Tersteeg and all those like him—"the fatuous-minded, the impotent, the cynics, the idiotic and *stupid scoffers*." "He persists in thinking everything I do is wrong. . . . I should not be in the least surprised if he considered my work crazy."

Stoically, he vowed to ignore the doubt that swirled around him and work on steadily—to "take it in stride and go my own way." But in all of the brave rhetoric, one can hear a single rising fear: that Tersteeg's poisonous words might be only a foretaste of the bitter medicine Theo would bring in August.

EVEN AS VINCENT protested Tersteeg's "*everlasting* no," his case for a viable life in The Hague—the case he would put to Theo—was falling to pieces around him.

His debts continued to mount. By the end of July, creditors were pounding at the door. Vincent reported one especially nasty "skirmish" with a debt collector—by now a common occurrence on the Schenkweg:

> I told him that I would pay him as soon as I received money but that for the moment I was absolutely without a cent . . . I begged him to leave the house, and at last I pushed him out the door; but he, perhaps having waited for this, seized me by the neck, threw me against the wall, and then flat on the floor.

Vincent had also ignored months of tax summonses. When the assessors came to collect, he told them defiantly: "I lit my pipe with your summonses." But when they returned and threatened to seize all his possessions for auction, he protested with howls of righteous indignation ("Millet and the other masters worked on till writs were served on them, or some have been in prison") and pleas of poverty. But at the same time, he rushed to confirm Theo's ownership

of all his work (putting it beyond his creditors' reach) and considered declaring bankruptcy with his feet: first by hiding out at his pied-à-terre in Scheveningen; then, if necessary, by moving to the country.

After months of resisting his brother's pleas for more money, Theo finally sent an extra fifty francs to help tide Vincent over until their reunion in August. Only days later, Vincent announced that he had bought a new easel.

At the same time his debts mounted, he fell deeper and deeper into isolation. In June, he was refused permission to draw in the almshouse, cutting him off from Zuyderland and the other almshouse residents. Soon after that, he broke off with another source of models, the neighborhood carpenter. His friend Van der Weele left for the country in mid-July, and his ambitious promises to visit De Bock and Blommers evaporated in the heavy summer air, leaving him alone on his long walks through the dunes.

Meanwhile, on the Schenkweg, Vincent's "family" spiraled toward the inevitable break. Under the strain of isolation and scarcity, Sien increasingly rebelled at the bargain she had struck. "At times her temper is such that it is almost unbearable," Vincent admitted. "I am sometimes in despair." Desperate to preserve his fantasy of rescue, he cast everywhere for villains to explain Sien's laziness, slovenliness, and increasingly violent fits of temper. Chief among them was her mother, Maria Wilhelmina Hoornik, who had moved into the Schenkweg apartment during the winter and almost immediately begun to make trouble.

In his paranoia, Vincent saw treachery everywhere. Maria did not act alone, he insisted, but as the instrument of a "meddlesome, slandering, aggravating family"—"*wolves,*" he called them. He accused them of sowing discontent and distrust; of "trying to draw [Sien] away" and drag her back to her former life. He imagined them whispering in her ear: "He earns too little," "He is not good for you," "He will certainly leave you someday." Even after Maria departed in May, Vincent continued to blame the family for Sien's "backsliding." He pleaded with Sien to cut off contact with them. But she never did. "She prefers to listen to and believe people who told her that I would desert her," he lamented. But still Vincent clung to her—and especially to her infant son, Willem. "He often sits with me in the studio, and crows at the drawings," he wrote in yet another reverie of family. "[When he] comes crawling toward me on all fours, crowing for joy, I haven't the slightest doubt that everything is right."

While both his finances and his family life fell apart, his physical health also continued to deteriorate.

Vincent's ailments seemed never to subside, only to accumulate. Reports of nervousness, feverishness, faintness, and dizziness continued throughout the spring and summer, rising in a defensive crescendo—as they always did—in advance of his brother's arrival. The complaints ranged from the specific (upset stomach, "a pain between the shoulders") to the general ("a feeling of prostra-

tion," or simply "I feel miserable"). Most came down to money, as Vincent turned his suffering into yet another indictment of his brother's stinginess. "I have a faint feeling in my stomach because there isn't enough to eat," he wrote—at a time when he had enough money for models' costumes and studio improvements. Yet the ailments were real enough. Even when he ate properly, his stomach rebelled, triggering headaches and dizzy spells that lingered for long periods.

For Vincent who, like his father, believed in a link between physical and mental health, these persistent ills stirred the darkest fears. Half in threat and half in dread, he began to speculate about the effects of "overwrought nerves," the danger of melancholy, and the fatality of madness. Such forebodings sprang to terrifying life in July when Vincent visited the studio of George Breitner. From the moment he entered Breitner's garret room, furnished only "with a razor and a box with a bed in it," Vincent sensed a soul in torment. Around the walls, he saw paintings in various states of completion—tenebrous images painted in broad, hurried strokes—looking, he said, "like patches of faded color on a bleached, moldering and mildewy wallpaper."

In a rare fit of criticism, he dismissed all of Breitner's paintings as "absurd," "ridiculous," "clumsy," and "weird"—"impossible and meaningless as in the most preposterous dream." To produce such images, he declared, an artist would have to be "in a fever"—if not outright insane. He speculated that Breitner had "strayed far from a composed and rational view of things," and that nervous exhaustion had rendered him "unable to produce a single composed, sensible line or brushstroke." He layered onto this vision of artistic and mental breakdown a painting by Émile Wauters, *La folie d'Hugues van der Goes* (*The Madness of Hugo van der Goes*), a chilling depiction of the famously insane fifteenth-century painter sitting coiled and wide-eyed, seized by invisible demons.

Vincent returned from Breitner's studio "overcome by a depression I cannot exactly explain," and immediately wrote Theo a detailed account, as both a cautionary tale and a cry of fear on the eve of his brother's visit. It was all he could do, he protested, to fight off the "difficulties [that] rise like a tidal wave," and "the doubt that overwhelms me." Should he lose that battle—or be discouraged from it—the consequences could be devastating. "One must not believe that things are really as gloomy as one supposes," he warned. "If one did, it would make one mad."

As the day of Theo's visit neared, Vincent approached the reckoning with such anxiety that he feared putting his head down at night. Instead, he worked straight through past sunrise, smoking his pipe, drawing and redrawing the familiar images in a fury of distraction until he "dropped with exhaustion." He repeatedly claimed "serenity" in his work, but his letters bristled with defensiveness. When a painting by his friend Van der Weele won a silver medal, he rushed to reassure Theo, "I, too, shall be able to make something of the kind in the

future." When Theo suggested that Vincent spend a few weeks recuperating in the countryside to improve his health, Vincent immediately suspected a slackening of support and brusquely dismissed the idea: "Taking a rest is out of the question."

Yet nothing could discourage Vincent's fantasy of perfect brotherhood. The vision that he and Theo had shared on the Rijswijk road ran in perpetual counterpoint to the rancor and resentment of their quotidian battles. He had only to walk alone in the dunes of Scheveningen, where the brothers had walked together so often in the past, to feel that tug again, and the welling of hope it always brought. "I shouldn't be surprised if you also remember the spot," he wrote after one such walk. "I think if we were together on that spot again, it would put you and me into a mood such that we would not hesitate about the work, but feel decisive about what we have to do."

But Theo's feelings toward his brother were also subject to wide swings of emotion (Vincent called them "oscillations"). And the years of relentless argument and thankless sacrifice had worn his fraternal feelings to a threadbare duty. In late July, on the eve of a mission he undoubtedly dreaded, Theo sent his brother a cruel preview of the message he would bring: "I can give you little hope for the future," he wrote. Whether the product of carelessness or impatience or unchecked anger, the words struck Vincent a devastating blow. "They hit me unexpectedly right in the heart," he wrote back immediately. "I feel my ardor vanishing . . . It sounds to me as if you yourself have no confidence in me. Is this true?" In a second letter the same day, he poured out all the self-doubt and self-reproach that had been dammed up through the months of defiant posturing:

> All my troubles crowd together to overwhelm me, and it becomes too much for me because I can no longer look clearly into the future. I can't put it any other way, and I can't understand why I shouldn't succeed in my work. I have put all my heart into it, and, for the moment at least, that seems to me a mistake. . . . Sometimes it becomes too hard, and one feels miserable against one's will. . . . I am only a burden to you.

Only days before Theo's arrival, he took a solitary walk through the dunes. Thoughts of death crowded into the silence. The lonely beach and "gloomy mood" set him to thinking about a magazine profile of an artist who had died at the age of thirty-eight, he told Theo, and that led inexorably to a series of morbid calculations. "Not only did I start drawing relatively late in life, but it may well be that I shall not be able to count on many more years of life either." Transforming a frisson of mortality into a plea for sympathy and patience, he carefully drew the lesson for his brother:

I would like to leave some memento in the form of drawings and paintings . . . I have to accomplish in a few years something full of heart and love, and to do it with a will. Should I live longer, *tant mieux*, but I put that out of my mind. *Something must be accomplished* in these few years.

Month upon month of tireless arguments had come down to this simple plea: "The only thing I want is to make some good work."

THEO'S TRAIN ARRIVED late in the afternoon on Friday, August 17. Nothing that happened in the next few hours played out according to the wishful scenarios Vincent had spun in the preceding months. Instead of staying for the weekend, Theo only stopped between trains. Instead of giving Vincent's work a detailed review, Theo may not have visited the Schenkweg studio at all (probably to avoid Sien). His only comment about his brother's art was a vague tribute to its "manliness." Instead of a trip to Scheveningen for a "nice long walk" in the dunes, the brothers made a circuit of the city streets as the day waned and the lamplighters came out. Instead of Vincent's fantasy of fraternal solidarity, they fought bitterly.

Throwing aside the careful circumspection of their letters, they reopened every wound inflicted in the year since they had last met, provoking each other to towering rages and fuming silences. This time Theo *insisted* that Vincent find a job and make more efforts to sell his own work. Business at Goupil had fallen off (as it had everywhere in the recession of 1882–83) and Theo's finances were strained to the breaking point. His salary had to be divided six ways—among parents, siblings, and mistress—and he could not promise to continue sending a hundred and fifty francs each month.

Stung by the indictment he heard in Theo's woes, Vincent attacked his brother's shallow, superficial life in Paris. He flatly refused to take a job on the side and haughtily rejected selling his own work (he likened it to "begging"). "It is so painful for me to speak to other people," he countered. "The best thing would be to work on till art lovers feel drawn toward my work of their own accord." Flinging the accusation of laziness back at his brother, he blamed Theo for not doing enough to sell his drawings or to heal the rifts with Tersteeg, Mauve, and their powerful uncles.

Theo revealed that he had, in fact, recently spoken to Uncle Cor in Amsterdam, and he had agreed to commission another set of drawings from Vincent. Uncle was even prepared to pay him a substantial advance. But on one condition: Vincent would have to leave Sien.

That propelled the argument to new heights of rancor on the most sensitive subject of all. Vincent accused his brother and father of cruelty for denying him his one true love, Kee Vos—"a wound that I carry with me"—and forcing

him into the embrace of "a faded whore" and her "bastards." Theo argued that Sien had driven away the very people Vincent needed most, like Tersteeg. Finally, Theo leveled his most incendiary charge: that Vincent had fathered Sien's child.

The rage that followed ("*I decidedly* lost my temper," Vincent confessed) shattered any remaining fragments of fraternal feeling. In his brother's accusation, true or not, Vincent must have heard again his father's reproving voice. When Theo's train pulled away from the station that night, Vincent's parting thought was that his brother had *become* his father.

BY THE TIME Theo departed, it was clear that Vincent would leave Sien. He would choose his old family over the new one. The only question was when and how he would justify leaving. "Do not hurry me in the various things we could not settle at once," he wrote his brother in a fit of regret immediately after returning from the train station, "for I need some time to decide."

Over the next three weeks, he wrestled with the inevitable through almost a dozen long, agonized letters. Professions of undying fealty and pleas for understanding battled outbursts of self-righteousness and bitter denunciations of Theo's oversight, as Vincent foundered in crosscurrents of love and resentment, acquiescence and resistance. Chest-beating confessions were freighted with long, defiant postscripts taking back every concession. Vows of cooperation ("I am at your disposal") vied with demands to "let me go my own way, just as I am"—sometimes in the same paragraph. One day he offered to take a lowly job as a delivery boy "rather than put too heavy a burden" on Theo's shoulders; but the next day he defiantly declared himself "dead to anything except my work."

Rather than resolve this conflict, this "struggle in my very depths," Vincent's first instinct was to escape it. Only two days after Theo's visit, he proposed leaving The Hague. "I should like to be alone with nature for a time," he announced, "far away from the city."

The idea of traveling to the country had been percolating for more than a year, as Vincent sought to emulate affluent artists who, like Mauve, retreated every year to country houses or, like Anthon van Rappard, took leisurely sketching trips to remote regions. As recently as early August, Theo had suggested that Vincent take a holiday from the heat and closeness of the city by going to the polders, the Dutch lowlands, for a few weeks. But now the pressure of creditors and assessors had given practical urgency to this bourgeois indulgence. Now, Vincent proposed a permanent stay "in that country of heath and moorland," where, he imagined, "I could do what I want." He advertised the move to Theo as an economic measure—a cheaper, healthier alternative to city life, a source of both better (more salable) subjects and more affordable models, thus guaranteeing Theo both the landscapes he loved and the economies he demanded.

Vincent's first choice of destination was, of course, home. Only the month before, he had worked himself into a thrall of nostalgia for the heath and pine trees of Brabant. Yet again he pictured a perfect homecoming, with his father and mother not just welcoming him, but posing for him in the same way as his make-believe family on the Schenkweg. "What I should tremendously like to do is [to draw] the small figure of Father on a path across the heath . . . In addition, Father and Mother arm in arm, let's say." But they would have to pose patiently, Vincent added firmly. "They will have to understand that it is a serious matter . . . And so they will have to be gently warned that they must adopt the pose I choose and not change it."

In the real world, however, Theo had put Nuenen—indeed, all of Brabant—off-limits as long as Vincent clung to his scandalous "family." He must have reaffirmed that judgment at the brothers' meeting, for when Vincent announced his plan for moving to the country soon thereafter, he had chosen a new destination: Drenthe.

A remote province reaching almost to the northernmost border of the Netherlands, Drenthe had long since earned a place in Vincent's intimate geography of art and family. Mauve had gone there in the fall of 1881 and invited Vincent to join him, before he fell sick and the trip was abandoned. Rappard had traveled there in 1882 and again in 1883, returning with glowing reports of "being on the road," as well as drawings and paintings that Vincent pored over in his friend's studio in Utrecht. Based only on these, Vincent had pictured the distant Drenthe as "something like Brabant when I was young." In fact, it was Rappard's reappearance in The Hague—on his way to Drenthe again—at exactly this moment that fixed Vincent's decision. Grasping at the last remaining tie to his family's favor, he imagined Rappard visiting him more often in Drenthe and counted the ways they "could profit from each other's company." He envisioned the two of them founding a kind of colony where other artists could come and "saturate [themselves] in nature's serenity on the heath."

And he imagined taking Sien with him. "I should like to live with her someplace in a little village where she could see nothing of the town and could live a more natural life," he said, incorporating his old vision of rescue into his new vision of escape to the country. In a storm of arguments, he fought to save his fantasy of family from Theo's cruel logic. "If I deserted the woman, she would perhaps go mad," he said; and besides, "the little boy really dotes on me." In a fever of self-justification, he even offered, again, to marry her.

But Vincent had thrown his lot with Theo, and Theo was unyielding. Vincent, of course, put all the blame for their final undoing on Sien: her perfidy, her backsliding, her refusal to sever relations with her scoundrel family. On Sunday, September 2, he sat her down in the living room of the Schenkweg apartment and spoke to her the same hard truths that Theo had spoken to him. "It is impos-

sible for us to stay together," he said. "We make each other unhappy." He urged her to "go straight," but doubted she would. As to her future, he gave her the same solemn advice that Theo had so often given him: "Find a job."

Up to the moment that Vincent's train left The Hague on Sunday, September 11, doubts and regrets tormented him. He entertained fantasies that Sien would join him, or that he might stay, even as he settled his debts with the money from Uncle Cor and arranged to store his possessions in his landlord's attic. He sped through preparations, convinced that each day of delay "took [him] deeper into the labyrinth" of Sien's "wretchedness." In a fever to leave, he dismissed Theo's suggestion that he learn more about his destination. He took it as all the confirmation he needed that Rappard had written from Drenthe: "The country has a very serious character; the figures often remind me of your studies." He begged Theo to send extra money so he could set out "as soon as possible . . . the sooner the better." If he could not send enough for Drenthe, Vincent offered to go *anywhere*, as long as it was "far, far, away" and he could leave immediately.

When the money finally arrived, he left the next day. He had tried to keep his leaving a secret from Sien until the last minute, but she showed up at the station to see him off carrying one-year-old Willem in her arms, a sight he feared would break his heart. "The little boy was very fond of me," he wrote Theo of his farewell, "and when I was already on the train, I still had him on my lap. On both sides, I think, we parted with inexpressible sadness."

Vincent claimed the mantle of "duty" to cover his humiliating exit from The Hague. "My work is my duty," he wrote on his last night there, "even more immediate than the woman, and the former must not suffer because of the latter." But the currents that moved him had not changed. The foundering of his adopted family had driven him, yet again, back toward his real one. Yearning for Theo suffuses the last letters from The Hague. He promised to return from Drenthe in time for Theo's next visit and then to join a society for watercolorists to which both Mauve and Tersteeg belonged, and after that to go to London to find paying work. He imagined his uncles rallying to yet another resurrection of favor. "The main thing now is to paint a great deal," he declared. "*That*, and nature's serenity will bring us victory in the end—do not doubt it."

Vincent left The Hague in search of Theo. On the moors of Drenthe, he seemed to imagine, the brothers might finally find the mythic union they had pledged each other on the road to Rijswijk. It was a redemption second only to the one that always beckoned him from an even more distant moor. Vincent had sacrificed everything—wife, family, home, art—to this elusive vision of perfect brotherhood. Soon it would be Theo's turn to do the same.

Castles in the Air

~

O N THE SEVEN-HOUR TRAIN TRIP INTO THE DARKNESS, VINCENT
kept a map of Drenthe at his side. In the weeks leading up to his departure, his
imagination had wandered over it many times. He had picked as his destination
"a large white space devoid of any village names" where canals and roads came
to an end. Near it was a body of water called the Zwarte Meer (Black Lake)—
"a name to conjure with," he sighed. Across it was written only one word:
Veenen—peat moors.

He awoke the next morning to a landscape of unremitting bleakness. The
moors—dense, damp, alluvial—stretched to the horizon in every direction.
"What kind of attraction could there be in this land of moors as far as one can
see," wrote another visitor to the area three years earlier. "What else can one
expect but exhausting monotony?" These were not the sandy heaths of Zundert
or the playful dunes of Scheveningen. On these highland bogs, the only trees
that survived were the ones planted along the roads—tall, spindly aliens cling-
ing to the high ground. Little but water-loving mosses, like peat, thrived in the
dense, sooty soil—a stew of long-dead vegetation as dark and impervious as its
ancient cousin, coal. Like coal, peat could be burned—crucial in a treeless land
of long, cold winters—and years of harvesting the precious fuel had robbed the
landscape of even its desolate grandeur. Everywhere Vincent looked, the moor
had been stripped of its layers of peat and scored with a grid of canals (ditches,
really) for transporting the bounty away—a process that flayed the high heaths
of Drenthe as surely as coal mining had disemboweled the Borinage.

Both the ditches and the bleakness drained into the little town of Hoogeveen,
where Vincent stepped off the train. He picked it because it was marked by a red
dot on his map: "[It] is classed as a town on the map," he wrote, "but in real-
ity it doesn't even have a tower." A makeshift frontier town on the edge of a

watery wilderness, Hoogeveen was made up almost entirely of the simple modern brick houses that Vincent loathed. A widening in the main canal, grandly dubbed a "harbor," had been dug when Hoogeveen was still at the center of the peat industry. But by now the surrounding bogs had been stripped bare and the big extraction operations had moved their armies of impoverished cutters and dredgers farther east. The few residents who remained eked out a living transporting dried peat from moor to market. Barge after barge mounded with the stuff arrived at the harbor every day—some drawn by horses, some by people. Women and children in mud-caked rags waded out to unload them. At the canal's edge, emaciated cows drank from the foul water, while on the sandy paths above them, old men led delivery carts pulled by even more emaciated dogs.

So extreme was the poverty that Dutch order had begun to lose its grip. Years of economic depression, especially in agricultural goods, brutal working conditions, and official indifference (even the dogs were taxed) had stripped civility nearly to the bone of anarchy. "The people are left to fend for themselves too much," complained a local evangelist. "They are almost wild." Drenthe had paid a heavy price for the government's policy of relocating criminals and paupers to the country's most inhospitable regions to serve as cheap labor for Amsterdam investors. Barren earth and barren hearts had combined to produce not just a desolate, lonely landscape, but a country within a country: a Siberia of high infant mortality, rampant alcohol abuse, and unrepentant criminality; a wilderness still wild in a country that had been settled for five thousand years.

"The heath is magnificent," Vincent exclaimed. "Everything is beautiful here, wherever one goes."

Vincent had promised his brother, and himself, the Drenthe of his dreams: a land of autumnal beauty and moral authenticity, a place as perfect as their shared memories of Brabant. Nothing less than a vision of paradise could justify abandoning the fiction of family in which he had invested so much. Whether or not that was the Drenthe he saw, that was the Drenthe he reported: "splendid" and "inexpressibly lovely" peat fields; weather as "splendid" and "bracing" as Brabant's; scenery of "so much nobility, so much dignity, so much gravity" it tempted him to stay forever. "I am very glad that I am here," he wrote, "for, boy, it is very beautiful."

He looked at the wretched sod houses that peasants shared with their livestock and pronounced them, too, "very beautiful." He compared the quaint barges loaded with peat to those the brothers had seen on the Rijswijk canal, and the miserable women unloading them to the picturesque farm laborers of Millet. He described the innkeeper at his lodging house near the station as "a real coolie." He delighted in the creased, careworn faces he saw everywhere among the townspeople, calling them "physiognomies that put one in mind of pigs or crows." In their plodding sullenness, he saw "melancholy of a healthy kind."

"The more I walk around here," he insisted, "the better I like Hoogeveen. . . . It is more and more beautiful here . . . it is so beautiful here."

So beautiful, in fact, that only a day after arriving, he announced plans to take a barge trip into the heart of the great labor, where the peat operations were just winding down for the season. He would traverse the entire breadth of the peat country right up to the Prussian frontier, he declared, because "Further into the country it will be even more beautiful."

Vincent bolstered this idyllic vision with images by all the brothers' favorite landscape painters, from the Golden Age to the Barbizon School. He described the heath as nothing but "miles and miles" of Jan van Goyen, Philips Koninck, Georges Michel, Jules Dupré, and Théodore Rousseau. Through repeated mentions of Michel, in particular, whose stormy skyscapes had long made him a hero to both Van Gogh brothers, Vincent proclaimed the Romantic allure of his new home. He filled his letters with elaborate word paintings, as poetic as any he ever wrote, depicting everything from the voluptuousness of the women to the austere beauty of the moors:

> That vast sun-scorched earth stands out darkly against the delicate lilac hues of the evening sky, and the very last little dark-blue line at the horizon separates the earth from the sky. . . . The dark stretch of pine wood border separates a shimmering sky from the rugged earth, which has a generally reddish hue—tawny—brownish, yellowish, but everywhere with lilac tones.

Then he translated these visions into paint. After a year of resistance, he capitulated completely to Theo's pleas and took up his oil brushes again. "You know quite well," he wrote, "that painting must be the main thing as much as possible." Vowing to paint "a hundred serious studies," he ventured into the countryside with his easel and paint box in search of picturesque subjects to convince Theo of his Drenthe. He painted peat cutters' houses (little more than piles of sod held together by sticks) silhouetted against a hazy dusk; red sunsets over birch groves and marshy meadows; vistas of heath and bog with vast, boldly brushed skies, empty horizons, and not a figure in sight. He praised the "serious, sober character" of the country and explained how it demanded the very light, color, and elaboration that Theo had been calling for in his art.

In this Eden of imagery, real or not, Vincent found hope for yet another new beginning. Within a few weeks, he sent some of his paintings to Paris and boldly recommended that Theo show them to dealers. He imagined returning to The Hague in triumph with portfolios full of "characteristic bits of nature" that were sure to "find sympathy" among buyers, especially in England. He compared himself to a character in a Daudet novel, a "simple fellow . . . absorbed in his

work . . . careless and shortsighted, wanting little for himself," who nevertheless finds fortune in the end. On his easel, he crowned this newest vision of redemption with a very old image: a sower striding improbably over the peat bogs of Drenthe, flinging his seeds on the barren moor.

NOT EVEN VINCENT could sustain this delusion for long. Loneliness—"that particular torture"—soon overwhelmed him. In the immense emptiness of the high heaths, "one could wander for hours without seeing a living soul," wrote a visitor to Drenthe in 1880, "except perhaps a shepherd, his dog and his sheep, of which the dog is still the most interesting creature." Mail arrived slowly and intermittently, underscoring the remoteness of the place. "I am so out of everything," he complained. Nature, no matter how "stimulating and beautiful," was not enough, he confessed. "There must also be human hearts who search for and feel the same things." He found no such hearts in Hoogeveen. The clannish townspeople regarded the odd stranger from the west with suspicion, or contempt. On the street, they stopped and stared, taking him for a "poor peddler." When he knocked on strangers' doors in search of picturesque subject matter— as he had done in Etten—town gossips began to whisper about the "lunatic" in their midst. Vincent rued his estrangement ("I take it so much to heart that I do not get on better with people"), but responded in kind. He called the town "wretched" and the locals "primitives" who did not behave "as reasonably as, for instance, their pigs."

The mounting antagonism cut Vincent off from the only intimacy he had known in The Hague: his models. He had come to Drenthe with high hopes for more and cheaper models, convinced that he could impress the local peasants just as he had in Etten. But Vincent was no longer the aspiring gentleman artist of that summer two years earlier. The battles with Mauve and Tersteeg, the insulation of the Schenkweg studio, the fevers of both body and mind, had changed him. Sharper, more brittle, more bitter, quicker to anger, closer to panic, Vincent now lived at the limit of his tolerances. Nor were the peat laborers and bargemen of Hoogeveen the naïve peasants of Brabant. As rumors about his strange behavior spread, the people were emboldened in their rejection. "They laughed at me, and made fun of me," he reported dismally to Theo less than two weeks after arriving. "I could not finish some studies of the figure I had started because of the unwillingness of the models."

He blamed his humiliations on the lack of a decent studio or unfavorable light and assailed the locals for not "listening to reasonable, rational demands." As in The Hague, he burned with frustration over "the people whom one would love to have as models, but cannot get." That frustration led him to the only other form of paid intimacy he knew: prostitutes. In a long and plaintive letter,

he extolled the virtues of these "sisters of charity" and defended his persistent need for their companionship. "I see nothing wrong in them," he explained; "I feel something human in them."

He missed Sien and the boy. The second thoughts that had dogged his departure from The Hague followed him to Drenthe like Furies. The memory of her "cuts right through me," he confessed only days after arriving. "I think of her with such tender regret." He saw her everywhere, like a "phantom." At the sight of a poor woman on the heath, or a mother and child traveling by barge, or an empty cradle at an inn, his "heart melted" and his "eyes grew moist." He wrestled yet again with his justifications for leaving and the possibility of her salvation. "Women of her kind are infinitely—oh, infinitely—more to be pitied than censured," he wrote. "Poor, poor, poor creature." He longed for her company on the companionless moors and bitterly regretted that he had not pressed harder to marry her. "It might have saved her," he imagined, "and also put an end to my own great mental anguish, which has now unfortunately been doubled." He waited each day for a letter from her, until the anxiety almost crushed him. "The fate of the woman and the fate of my poor little boy and the other child cuts my heart to shreds," he wailed. "There must be something wrong." In a panic of guilt and dread, he sent her money.

Vincent never told Theo how much money he gave Sien when he left (and afterward). But all of it was money he could not afford. As a result, less than a week after his arrival in Drenthe, a familiar lament arose: "My money is almost gone . . . I don't know how I shall manage." The rent was due; the locals refused to extend credit. He couldn't repay a loan from Rappard—an embarrassment that stymied his plan for a reunion in the far north. As his money ran out, so did his supplies. He had left The Hague provisioned for only a week or two of painting, even though he knew nothing would be available in Drenthe and any replacements would have to be ordered from The Hague. But he had left the city with many bills unpaid, and no one there would extend him credit either. In the meantime, the approaching winter drained the landscape of color, foreclosing important subjects. "I have found so much beauty here," he cried out in frustration. "Losing time is the greatest expense." Without sufficient supplies, he had to put off his deeper excursions into the moorlands—the arduous forays that had preoccupied his first days in this alien country. "It would be too reckless to undertake [them] if one did so without a stock of materials," he conceded bitterly.

By the third week of September, his paint box was nearly empty. For the first time since the Borinage, he faced the terrifying prospect of idleness. "I feel inexpressibly melancholy without my work to distract me," he warned. "I *must* work and work hard, I must *forget myself in my work,* otherwise it will crush me."

He lashed out at his uncle Cor for not responding to the raft of drawings he had sent from The Hague. Into that silence, Vincent read all the slights and

betrayals of the past. "He seems to have certain unshakable opinions about me," he wrote of the only family member other than Theo who had actually supported his art. "I certainly need not put up with insults, and it *is* a decided insult that he did not even acknowledge that he had received the last packet of studies. Not a syllable." In an explosion of bile, he threatened to "attack" his fifty-nine-year-old uncle, "have it out with His Honor," and "get satisfaction."

> It would be *cowardly* to let the matter rest. I shall and must demand an explanation . . . If he should refuse, then I shall tell him to give me— and *I* have a right to tell him so—an eye for an eye and a tooth for a tooth, and then in my turn I shall insult him without restraint, quite cold-bloodedly . . . I cannot endure being treated as a reprobate, being judged or accused of things without being heard myself.

Eventually, Vincent turned the painful memories of the Borinage on the real target of his anger: Theo. He accused his brother of cruelly giving him only enough money to perpetuate his misery, and insisted that not only his career but his relationship with Sien, too, would have succeeded if only Theo had been more generous. "I would rather have stayed with the woman," he wrote, "[but] I did not have the means to act toward her as I should have wished." He blamed his brother for the "dark future" that lay ahead, for his "bleeding heart," for the "feeling of disappointment and melancholy" that haunted him, and for the "void" at the center of his life.

Recalling the self-punishing hardships of the winter of 1880 ("wandering forever like a tramp"), Vincent warned that he was once again nearing his limits. "You remember, perhaps, how it was with me in the Borinage," he wrote. "Well, I am rather afraid it might be the same thing here all over again." The only way to avoid that terrible fate, he argued, was for Theo to provide "proof of sincerity": first by sending enough cash immediately for Vincent to lay in a fresh stock of materials; second, by giving an ironclad guarantee (a "definite fixed arrangement") that he would continue sending one hundred and fifty francs a month *no matter what*. At a time when he knew his brother to be financially distressed, Vincent threw down the gauntlet: without more money, he threatened, "I must be prepared for anything," including "madness."

THE BARGAIN VINCENT had struck in The Hague was unraveling. In choosing Theo over Sien, he had given up too much and gotten too little. The thought of his mistake pushed him deeper and deeper into depression—"discouragement and despair greater than I can describe"—even as he squeezed his paint tubes harder and harder to eke out another day's work. Without money, materials,

models, companionship, or comfort—without "confidence and warmth"—he confessed miserably, "I am absolutely at a loss . . . I cannot shake off a feeling of deep melancholy."

Only two weeks after it began, the expedition to Drenthe seemed on the verge of collapse. *"Everything is prose,"* he lamented, "which, after all, has poetry for its end." He saw the bleak moors with new eyes, describing them as monotonous and aggravating—a "perpetually rotting" carrion of landscape that yielded only mold as crop. Everywhere he looked, he found death and dying: in a local graveyard where he painted and sketched; in the figure of a mourning woman wrapped in crepe; in the decayed remains of old tree stumps exhumed after centuries under the bog. He sent Theo a detailed description of a funeral barge gliding mysteriously across the heath, the women mourners seated in the boat while the men pulled from the canal bank.

Landscape with Bog-Oak Trunks, OCTOBER 1883,
PENCIL AND INK ON PAPER, $12^1/_8$ X $14^7/_8$ IN.

Reminders of mortality dragged Vincent into a "morass of thoughts and insoluble problems." Describing himself as "absolutely beaten," he spent his idle days grinding the failures of the past yet again through the millstones of guilt and self-reproach. Yet again he imagined solving his problems by escap-

ing them. He laid elaborate plans for "pushing on deeper into the country, not-withstanding the bad season," or perhaps finding a new home "even farther out on the heath." But without his brother's money, these were nothing more than fantasies. "I see more clearly how I have got stuck here," he admitted, "and how handicapped I am."

Just when the future seemed too gloomy and hopeless to bear, the rains came. Dark clouds filled the sky over the moors and it poured incessantly. As bogs filled up, canals topped their banks, and roads returned to swamp, Vincent sat in his dark garret turning over and over in his mind a poem by Longfellow:

> My life is cold, and dark, and dreary;
> It rains, and the wind is never weary;
> My thoughts still cling to the mouldering Past,
> But the hopes of youth fall thick in the blast,
> And the days are dark and dreary.
>
> Be still, sad heart! and cease repining;
> Behind the clouds is the sun still shining;
> Thy fate is the common fate of all,
> Into each life some rain must fall,
> Some days must be dark and dreary.

He quoted only the last two lines in a letter to Theo, then added bleakly, "Isn't the number of dark and dreary days sometimes too great?"

On one dreary day in late September, Vincent finally reached his breaking point. It did not take a new calamity to trigger what may have been his first recorded psychotic episode. After the crisis of conscience in The Hague and the unfolding disaster in Drenthe, his mental state was so precarious that it took only the humblest of provocations to bring on the storm. Returning to his room, he looked across the gloomy attic space and saw his paint box illuminated in the darkness by a spot of light from a single pane of glass. The sight of the empty box, the dry palette, the discarded curls of paint tubes, the "bundle of worn-out brushes," spoke to him in a way only metaphors could.

"Everything is too miserable, too insufficient, too worn out," he cried on be-half of himself as well as his pitiful kit. The great gap between his endless plans and his pathetic reality opened before him and he saw "how hopeless everything is." A wave of dread, long kept at bay by furious work, threatened to drown him. "I have been overwhelmed by forebodings about the future," he reported to Theo in a letter he called "a cry for more breath." Choking on guilt and regret, he con-templated surrendering to failure, even to self-extinction. "Leave me to my fate,"

he begged his brother. "There is no help for it; it is too much for one person, and there is no chance of getting help from any other side. Isn't that proof enough that we must give it up?"

To escape the demons let loose in his garret room that day, Vincent fled into his imagination—as he always did. The obsession that emerged only days later would outstrip all the great obsessions of his life.

"COME, BROTHER, COME and paint with me on the heath."

This was the cry that arose from the desolate moors of Drenthe in early October 1883. For the next two months, Vincent strained every fiber of his intelligence, passion, and imagination in an effort to persuade his brother to quit Goupil, abandon Paris, and join him on the heath. "Come and walk with me behind the plow and the shepherd," he pleaded. "Let the storm that blows across the heath blow through you."

In a hail of letters, he argued Theo insensate over this latest in a lifetime of desperate, delusional schemes for happiness. "I cannot help imagining a future when I no longer work alone," he wrote in an ecstasy of longing, "but instead you and I, painters, working together as comrades here in this moorland." Not his ministry in the Borinage, not his pursuit of Kee Vos, not even his rescue of Sien Hoornik had inspired Vincent to more manic fantasies of logic or more incandescent flights of yearning. Like all of those past campaigns, this new one set an unreachable goal and marshaled all his powers of self-delusion to achieve it. Even as he insisted defensively, "I am not living in a dream . . . or in a castle in the air," he knew that Theo had rejected this same invitation many times already. As recently as the previous summer (1883), he had turned a deaf ear to Vincent's pleas that he should "move to the country" and "Be a painter."

Why did Vincent revive so soon a proposal that his brother had rejected so often and so recently? Especially a proposal so preposterous on its face? Only the money Theo sent each month stood between Vincent and utter destitution. The same Goupil salary also helped support his brother, sister, and parents. All would be subjected to hardship, not to say humiliation, if the family's most dutiful son abandoned its most distinguished enterprise to join its most disreputable slacker in the country's most desolate region. But Vincent's needs outran rationality. Alone on the moors of Drenthe, just as in the Borinage, he simply had no place else to turn. The events of late September had filled him with fears he could neither acknowledge to himself nor admit to his brother. At almost exactly the same moment, Theo began to complain moodily about his situation in Paris and talked loosely of leaving Goupil. These periodic fits of melancholy and discontent always drew Vincent into raptures of solidarity, as he saw in them

confirmation of his own errant path. But this time, Theo went further than he had ever gone before—literally. He threatened not just to quit Goupil, but to leave Europe altogether and sail for America.

Faced with absolute abandonment at a time of overwhelming need, Vincent launched his desperate, impossible campaign. Not until five years later, when he lured Paul Gauguin to Provence, would it be equaled.

He had often bragged to his brother about the "manliness" of an artist's work. Now he redoubled his charge of effeminacy against dealers and "men who live on their income." "As a painter," he promised, "one feels more a man among other men." Not to become a painter, he warned, could only lead Theo to "deterioration as a man"; while, as an artist, he could "roam about freely" among Zola's libidinous natives. He urged on Theo the virile kinship between artists and other "craftsmen"—like blacksmiths—who "can make something with their own hands." Taking an argument that Theo had first made to him in the Borinage, he extolled the simplicity and honesty of art as a "handicraft," calling it "a delightful thing" that would make Theo "a better and deeper human being." He invoked the Spirit of 1793 to call for a revolution in Theo's life and cited a print from his portfolio that showed, he claimed, a physical resemblance between Theo and the heroes of an earlier revolution, the Puritans. His brother had "exactly, exactly the same physiognomy" as the *Mayflower* pilgrims, he concluded triumphantly, the same "reddish-hair" and "square forehead." What more convincing proof could there be that he was destined to follow in the footsteps of these "men of action" who struck out for a brave new world in search of "simple lives" and the "straightforward path"?

But not for America. In a blur of conflicting signals, Vincent attacked his brother's plan to cross the ocean (the only truly "revolutionary" ambition Theo ever expressed). Without a glimmer of irony, he dismissed it as the figment of overwrought nerves—the product of a "miserable, gloomy moment, when one is overwhelmed by things." He compared it to a suicide wish and chastened his brother for even considering such an "unbecoming" notion. "Look here," he exclaimed, "making oneself scarce or disappearing, neither you nor I should *ever* do that, no more than commit suicide." He answered Theo's threat with a threat of his own—a hint of the extremes to which he would go to prevent being abandoned by his brother: "Those moments when you think of going to America," he warned, "I think of enlisting for the East Indies."

In Vincent's fevered summons, no place on earth compared to the moors of Drenthe. Only days after seeing death everywhere, he rediscovered the vision of paradise in his head—"my little kingdom," he called it. "It is so absolutely and entirely what I think beautiful . . . The heath speaks to you . . . the still voice of nature . . . beautiful and calm." Other times, the heath reverberated with a

symphony of "heart-rending music" and the days passed "like dreams." Scenery so "unutterably beautiful" could not only dazzle, Vincent promised; it could also heal. Citing his own calmness as proof, he wooed his sickly, nervous brother with the heath's reparative powers. Only its serenity could save Theo from nervous exhaustion—"your constant enemy and mine"—or even breakdown. After several years of furiously denouncing all religion, Vincent beckoned his brother to a spiritual renewal on the heath, summoning him to something higher than nature, higher than art, something "inconceivable" and "unnamable." "Put your trust in the same thing I put my trust in," he wrote, resurrecting the brothers' code name for the unnamable: *"It."*

As if to illustrate his arguments with actual experience, Vincent left Hoogeveen and headed deeper into peat country. Flush with a payment from Theo, a loan from his father, and a fresh supply of painting materials wangled on credit from The Hague, he took a slow barge sixteen miles due east to the little town of Veenoord—"the remotest corner of Drenthe," he called it. Along with its twin settlement, Nieuw-Amsterdam, Veenoord sat at the heart of the peat country. Throughout the summer, thousands of cutters and dredgers swarmed across the treeless expanses in every direction, throwing up huge mounds of peat alongside their temporary shelters. By the time Vincent arrived in early October, most of the piles had been hauled away and the laborers had settled into their wretched winter lives, cooped in the same stinking hovels with their animals, bound like serfs by the hated "truck system." The peat bosses who paid their subsistence wage all summer now began taking it back through inflated prices at the company-owned stores all winter, so that most laborers emerged in the spring shackled to the land by debt. So great was the hardship inflicted by this vicious circle of exploitation that the peat workers had already resorted to the unthinkable *boljagen*—going on strike.

As in the Borinage, however, Vincent's vision of a rustic paradise overruled the reality of injustice and anger that surrounded him. From the balcony of his room overlooking the canal, he saw only "fantastic silhouettes of Don Quixote–like mills" and "curious monsters of drawbridges profiled against the vibrant evening sky." The surrounding villages looked "wonderfully cozy," he reported; the peat workers' hovels, "peaceful and naïve."

In late October, Vincent mounted the most ambitious of all his expeditions-as-arguments, a trip to the ancient village of Zweeloo, ten miles northwest of Veenoord. Just as he did three years earlier when he traveled from the Borinage to Jules Breton's studio in Courrières, Vincent claimed an artistic inspiration for this latest punishing trek ("Imagine a trip across the heath at three o'clock in the morning in a small open cart"). Based on nothing more than an approving comment from Theo, he set out in pursuit of the Alsatian artist Max Lieber-

mann, who had visited Zweeloo some months earlier and, according to Vincent, was rumored to still be there. Upon his return, he wrote Theo an account of his trip that is among the most elaborate and poetic word paintings in all his letters.

He describes a journey into a landscape by Corot ("a stillness, a mystery, a peace as only he has painted it"), under Ruisdaelean skies ("nothing but that infinite earth [and] infinite sky"), suffused with Mauve's "misty atmosphere," and filled with Millet plowmen, "shaggy" Jacque shepherds, and old Israëls spinsters. In a trance of invention, he piled image on image, transforming the drab, inhospitable Drenthe winter into a beckoning fantasy of the Garden of Eden. "Now you can see what it is like here," he concluded his pictorial brief. "What does one bring back from such a day? Merely a number of rough sketches. Yet there is something else one brings back—a quiet delight in one's work."

If Drenthe was paradise, Goupil was the serpent that invaded it. Vincent had often taken advantage of Theo's chronic disenchantment to criticize his employer, but never in language this harsh and uncompromising. "Odious, wanton, capricious, and reckless," he called it, an institution that had "outlived its fame" and was headed for "deserved ruin." It had turned the honorable profession of art dealing, as their uncles had once practiced it, into "nothing more than gambling," he said. As for the gentlemen of Goupil who had made Theo's situation impossible, Vincent accused them of "insupportable arrogance," "horrible unfairness," and "doing mean things." He brushed aside any possibility of compromise ("do not flatter yourself with the belief in reconciliation") and urged his brother to follow in his own defiant footsteps—"stand your ground . . . don't give in." To dissuade Theo from jumping to another dealer or setting up a gallery on his own, Vincent expanded his denunciations beyond Goupil and railed against all dealers everywhere. "It is Tweedledum and Tweedledee," he argued; "the whole art business is rotten." He hurled at the whole enterprise Zola's ringing denunciation of bourgeois taste: "a triumph of mediocrity, nullity, and absurdity."

But that still left one question unanswered. If Theo quit his job, what would the brothers do for money? Vincent made all the usual arguments about life being cheaper in Drenthe and two being able to live for the price of one. Painters didn't need much to live on, he reminded Theo; "money leaves us cold." Besides, any deprivations would be short-lived because "my work will probably yield *some* profit soon," he added. And in any case, God would provide. Yet again claiming the entitlements of a higher calling, he reassured his brother that "an infinitely powerful force" would protect them in their new mission of perfect brotherhood. "If one will only set about things with love, with a certain understanding of each other and cooperation and mutual helpfulness," he wrote, "many things which would otherwise be insupportable would be made supportable."

Vincent "calculated" that the two of them would need two hundred francs

a month for a period of two years before they could support themselves entirely on their painting. He suggested that Theo raise the necessary stake from one of their rich uncles, solemnly pledging his own work as collateral. Such guarantees proved that "we do not build castles in the air," he said. He sent Theo elaborate projected budgets ("I do not know where and how to get the money, [but] I will work out for you how we should use it"). Yet even as he steadfastly defended the rationality of his arguments, he asked for more money and proposed a fallback plan—both brothers could return home to live with their parents—that must have struck Theo dumb with disbelief.

In fact, this seemingly offhand suggestion betrayed the fantasy at the core of Vincent's furious campaign. Merging his vision of perfect brotherhood with yet another reverie of family reconciliation, he imagined a reunion of the Zundert parsonage. He, Vincent, would lead the family in rallying around his younger brother. Together, they would support Theo's quest to be a painter—in all the ways they had never supported Vincent's. They would bravely bear the hardships of poverty and the storms of disrepute. They would cooperate in the great new artistic "phenomenon of two brothers being painters." In Vincent's dream of a parsonage, he and Theo would no longer have to "obey." Their father would have to subordinate his authority to the *"force majeur"* of Theo's calling—as he had never done for Vincent's—and treat *both* of his sons with "cordiality and love."

Seized by this new fantasy of redemption, Vincent demanded that Theo reverse his opposition to Vincent's returning to Brabant, and wrote their father in a tone that both invited him to join this new incarnation of family and warned him against yet again spoiling it: "If I should have to live at home for a while, I hope, for myself as much as for you, that we shall possess the wisdom *not* to make a mess of things by discord, and that, ignoring the past, we shall resign ourselves to what the new circumstances may bring." Convinced that the realization of his dream now rested entirely on Theo's coming, Vincent raised his entreaties to a giddy fever of longing. "Living together . . . how delightful it would be. So delightful that I hardly dare to think of it, yet cannot help doing so, though that happiness seems too great." He imagined the two of them renting a peasant's cottage and decorating it together. Increasingly, his pleas strained with the ardor of a marriage proposal:

> Neither of us would be alone, our work would merge. In the beginning we should have to live through anxious moments, we should have to prepare ourselves for them, and take measures to overcome them; we should not be able to go back, we should not look back nor be able to look back; on the contrary, we should force ourselves to look ahead. . . . We shall be far removed from all our friends and acquaintances, we shall fight this fight without anybody seeing us, and this will be the best thing

that can happen, for then nobody will hinder us. We shall look forward to victory—we feel it in our very bones. We shall be so busy working that we shall be absolutely unable to think of anything else but our work.

Argument gave way to mindless exhortation ("[We] must, must, must go forward and win"), yet more salvoes of French (*"la patience d'un boeuf"* [the patience of an ox]), and mottoes drawn from his reading (Dickens's "How-*not*-to-do-it system"). In pleas as repetitious as a drunkard's, he insisted that Theo had the soul and stuff of a true painter. He predicted that Theo would find painting far easier and make faster progress than he had. "You will be an artist as soon as you take up a brush or a piece of crayon," he boldly promised. *"You can do it* if only you want to." He even told Theo exactly what kind of art he should make. Holding out the brothers' great favorite, Michel, as a model within Theo's grasp, he urged his brother to "try your hand at landscape at once." The vast moorlands and dramatic skies of Drenthe presented endless vistas virtually authored by the French master. "It is absolutely Michel," he wrote, "*that* is absolutely what it is here." "These are the kinds of studies which I should like you to try at once. . . . I have thought it over so long."

"One becomes a painter by painting," he declared, mixing self-justification with inspiration. "If one wants to become a painter, if one delights in it, . . . one can do it."

Indeed, in Vincent's desperate pleadings, he and Theo had already merged. Claiming a special insight into his brother's heart, Vincent saw only his own reflection. Oscillating between first and second person, he both coached Theo and consoled himself:

> They will tell you that you are a fanatic, but most certainly you—after having undergone so many mental trials—will know that it is *impossible* for you to be fanatical . . . Don't let them try to turn things upside down, that won't do for me!

At every opportunity, he urged on Theo his own gospel of recklessness ("My plan is always to risk too much rather than too little") and defiance ("If you hear a voice within you saying, 'You are not a painter,' *then by all means paint,* boy, and that voice will be silenced"). "My aim in life is to make pictures and drawings, as many and as well as I can," he both explained and entreated; "then, at the end of my life, I hope to pass away, looking back with love and tender regret, and thinking, 'Oh, the pictures I might have made!' . . . Do you object to this, either for me or for yourself?"

All of these arguments, and more, found their ultimate expression in images. In the letter that launched his campaign, Vincent enclosed a sheet of

drawings on which he had labored heroically: a half dozen vignettes of Drenthe life—peasants in the fields, canal banks, village roads—all carefully arranged in a montage exactly like those he had seen in *The Graphic* introducing readers to quaint industries or picturesque locales. When he summoned Theo to paint the moorland skies just as Michel had painted the Montmartre skies, he accompanied the summons with drawings and paintings "in the spirit of Michel": vistas of brown earth and slate-gray sky. He translated his cries of delight—"What tranquility, what expanse, what calmness in this landscape"—into swirling strokes of clouds and boldly brushed furrows of earth. With nothing more than a pencil, pen, and ink, he showed his brother the serenity that awaited him in a way words never could: a long canal, a barge under sail, a vast pearly dusk.

His straining invitations to a life of simplicity on the heath—"Come and sit with me, looking into the fire"—took their tenderest, most plaintive form in image after image of lone cottages under twilight skies brushed in broad strokes of translucent gray. And to enact the noble labor he beckoned Theo to join— "something good, an honest enterprise"—Vincent conjured a procession of Millet peasants: a shepherd driving his flock past a village church; a plowman silhouetted against a sky as big as the American West; two women stooped in unison on a stormy moor; a broad-shouldered farmer pulling a harrow behind him, leaning against the drag with the patience of an ox, his gaze fixed on an infinite horizon.

In Drenthe, Vincent finally, fully recruited his art to the service of his larger quest. Since the Borinage, art had been the fixed star around which his arguments swirled: an eye of Victorian convention in a vast storm of angst and pain. The dream of merging with Theo, furious and insuppressible, uprooted all that. It wrenched him from the great unifying passion of The Hague—figure drawing—and left the defiant preoccupations of the last three years scattered behind. He would return to figure drawing from time to time, both for love of the work of its greatest masters, and for the warmth and control that he found only with models. But he would no longer be bound by it.

His single-minded devotion to pencil and pen and ink and the black-and-white images they produced was another victim of the storms of October and November 1883. He discovered in Drenthe how persuasive paint could be; and color and brushstroke. "Painting comes more easily to me," he wrote Theo from Veenoord, in a turning point for Vincent and for Western art. "I am eager to try all kinds of things which I have left undone till now." And this time he meant it. In Drenthe, painting became not just a defensive posture, an appeasement to his brother, but his most eloquent argument—a new and powerful language of persuasion that he could recruit to the great missionary zeals that ruled his life. In Drenthe, Vincent discovered that he could do more than just dream or argue these castles in the air—he could paint them.

Landscape in Drenthe, SEPTEMBER–OCTOBER 1883,
PENCIL AND INK ON PAPER, $12^{1}/_{8}$ X $16^{1}/_{2}$ IN.

Man Pulling a Harrow, OCTOBER 1883, LETTER SKETCH,
PENCIL AND INK ON PAPER, $3^{1}/_{2}$ X $5^{1}/_{4}$ IN.

—

AT FIRST THEO dismissed his brother's pleas with breezy objections (the family depended on him) and polite demurrals (painters are born, not made). But resistance only stoked the fire. Before long, Vincent's furious attacks on Goupil and art dealing jolted Theo out of his disillusionment. Choosing duty over solidarity, as he always did, he chided his brother as a dreamer, and confessed that his heart was still in the art business. "I will have to stick it out for all our sakes," he wrote in a refusal that only Vincent could have taken as equivocal. "All that [is] rubbish," Vincent retorted, dismissing his brother's arguments. Pleading letter followed pleading letter. But the longer and more baroque Vincent's missives, the shorter and more summary Theo's eventual replies; the more sweeping and passionate Vincent's arguments, the more immovable Theo's refusals.

Vincent eventually placed much of the blame for his predicament on Theo's mistress, Marie. Early on, Vincent had encouraged his brother to enter into a formal engagement with his companion of a year, imagining her to be an ally in the campaign to lure Theo away from Paris. Overcome by the vision of a family of painters on the heath, Vincent had even recommended that Theo bring Marie with him to Drenthe. "The more the merrier," he exclaimed, adding, "If the woman came, of course she would have to paint, too." But Theo's silence changed all that. As he would five years later when Theo proposed marriage to another woman, Vincent turned against the intruder. "This woman of yours, is she good? Is she honest?" he probed. Perhaps Marie had "bewitched" him, Vincent suggested, planting doubts with words like "poison" and "enchantment." He compared Marie to Lady Macbeth—a wicked woman with a "dangerous craving for 'greatness' "—and warned Theo that he, like that lady's infamous husband, risked losing his "sense of right and wrong."

In this contest of escalating rhetoric and contrary motion, it was inevitable that Vincent would turn to darker threats. Defying Theo's repeated objections, he reiterated his plan to flee to Brabant and impose himself on their aging parents if Theo chose to stay at Goupil. He even threatened to renew his ties to Sien. "I should not stop seeing her to please anybody," he warned pointedly. "Let people think and say what they like." Theo parried every provocation with a combination of delay and courtesy and cleverly invited Vincent to come to Paris instead, dangling the possibility of a role for him in a future business venture. The unexpected counterinvitation briefly threw Vincent off his fiery stride ("there are things for me to learn in Paris as well as here on the moor," he conceded), but he quickly recovered, dismissing the plan as "too much in the air for my taste" and discouraging his brother from any new ventures other than painting in Drenthe.

In early November, Theo tried yet again to cut off the exchange with an especially curt note. "For the present," he wrote, "things will remain as they are." It had exactly the opposite effect. Enraged, Vincent shot back an ultimatum that exposed the raw need beneath his exhausted arguments. If Theo did not quit Goupil, he warned, "it is my intention to refuse your financial help." As hard as Vincent tried to portray this threat of self-destruction as an offer of self-sacrifice ("I don't want my needs to be a reason for your staying [at Goupil]"), he could not hide its dark, coercive heart. He vowed to throw himself headlong into "the tempest," sternly setting a deadline for Theo's final decision, and solemnly granting his brother permission "to have nothing more to do with me." He promised to look for work, any work, to support himself, but despaired of finding it, and warned of "enervation" if he did. He enclosed some studies "as a small sign of life," but added miserably, "Of course I do not suppose they will be considered saleable."

Even before he posted it, Vincent regretted the letter's threatening message and petulant tone. He added two postscripts of qualifiers and mollifiers ("Please don't take what I tell you amiss"), but sent the letter nevertheless. When Theo failed to respond, or to send the next fifty-franc payment when it was due, Vincent panicked, fearing that his brother had accepted the apocalyptic offer. *"It made me crazy when your letter did not come,"* he confessed, as he flooded Theo with explanations and equivocations.

Theo eventually sent more money, as he always did, but Vincent's arguments had so incensed him, apparently, that he refused to make up the missing payment. In a stinging rebuke, he insisted that he took "renewed pleasure" in his work at Goupil, and compared Vincent to the wild-eyed, peasant-loving Nihilists who had recently assassinated the Russian czar—icons of ruinous fanaticism and contempt for civilized norms.

It was enough, finally, to snuff out the last traces of hope—"the last straw," Vincent called it. "Differences of opinion are *no* reason to overlook the fact that we are brothers," he wrote dejectedly. "One must not blame the other or become hostile, or spiteful, or throw obstacles in each other's way."

Only a few days later, Vincent left Drenthe. He had intended to stay a year, but debt and despair drove him out after less than three months. He left abruptly, without a word to the innkeeper in Veenoord, or to Theo. In a final humiliation, he had to walk the sixteen miles back to the train station in Hoogeveen. Dressed in tattered clothes, suffering from a rare cold, and reviled by locals as "a murderer and a tramp," he walked for six hours across the featureless moor, carrying what he could through a storm of freezing rain and snow. By his own telling, he cried most of the way. With every step, he thought of Theo: one minute burning with anger over his brother's refusal and bitterly rehearsing yet another round of arguments; the next minute staggering under a new weight

of guilt and remorse. Later, he summed up the arduous journey with the most consoling of all images: "a sowing of tears."

He was headed home, of course: partly in order to save money, partly in defiance of Theo, partly in imitation of Rappard (who had left Drenthe to live with his parents), partly because he had no place else to go. But mostly because all his roads led that way. He brought with him an impossible burden of old grievances and fresh injuries, borne with the resignation of a prisoner returning to his jailer. "We must live on until our hearts break within us," he wrote Theo. "We are what we are." He came pursuing yet another vision of rebirth—"the gnarled old apple tree that bears the most delicate and virginal blossoms under the sun"—and packing, in his paint box, a new means of expressing that vision.

He arrived just in time for Christmas.

The Prisoner

~

THE SUN BEATS DOWN ON A MUDDY NILE. HEAT RISES FROM THE SURFACE in sulfurous fumes. On the distant riverbank, barely visible through the haze, minarets and lotus-column ruins drift past. The boat cuts through the still water leaving barely a ripple. The air is so windless and heavy with heat that the boat's forward motion barely stirs the muslin blouses of the five men on board. The two oarsmen—one brown, one black—grope forward to the next stroke. At the prow, a man in a tall fez, with a dagger slung across his chest, watches their labor, grimly impervious to the heat. At the stern, a man with a pistol tucked in his tunic strums a *buzuq*. Grinning in mockery, he sings a poem of ridicule to the defeated enemy at his feet. Crammed crosswise in the narrow boat, tightly bound and gagged, the captive clenches his jaw in frustration and struggles to free himself, but he can only watch helplessly as the oarsmen bear him to his dreadful fate and the singer tortures his final hours, trapped in a drama he is powerless to alter, carried on a river he cannot see.

Gérôme's *The Prisoner* enchanted the nineteenth century. With its deliciously exotic imagery and mysterious narrative spiced with oriental intrigue, it became one of the most popular images of a popular artist working in the era's most popular genre. Even if Vincent never saw the painting when he lived in Paris, he saw the image again and again in the stockrooms of Goupil, where thousands of copies were packed and mailed to a cosseted bourgeoisie hungry for vicarious jeopardy.

To Vincent, however, the image spoke in far more personal terms. He had always seen himself as a prisoner, bound by captors both seen and unseen. The language of bondage and confinement—"cramped," "thwarted," "hampered," "hindered"—fills his letters with jaw-clenching frustration. He described himself as a man "consumed by a great longing for action" who could do nothing

"because his hands are tied . . . because he is imprisoned somewhere." In the Borinage, he compared himself to a caged bird, and confided to a housemate: "Since I entered the world, I have felt myself in a prison." He complained bitterly that the failures of the past bound him more surely than any ropes:

A justly or unjustly ruined reputation, poverty, disastrous circum-stances, misfortune, they all turn you into a prisoner. You cannot always tell what keeps you confined, what immures you, what seems to bury you, and yet you can feel those elusive bars, railings, walls.

JEAN-LÉON GÉRÔME, *The Prisoner*, 1861, OIL ON CANVAS, $17^3/_4$ X $30^3/_4$ IN.

After the Christmas expulsion from Etten two years earlier, he lashed out at the captivity of exile: "One feels as if one were lying bound hand and foot at the bottom of a deep, dark well, utterly helpless." He kept a special place in his inner gallery for images of confinement, starting with the shackled, prostrate figure at Christ's feet in Scheffer's *Christus Consolator.* "I am bound in different ways," he wrote from Isleworth in 1876, "but the words engraved above that image of [Christ] are true to this day, 'He has come to proclaim liberty to the *captives.*' "

His portfolios overflowed with depictions of imprisonment: from catalogues of famous prisons to scenes of convict life. To his parents' horror, he celebrated as heroes the criminals he found in literature, from the petty crooks of Zola's *Pot-Bouille* to the magnificent martyrs of Hugo's *Histoire d'un crime, Le dernier jour d'un condamné,* and *Les misérables.* Only months before leaving The Hague, he had bragged to Theo that he modeled his defiant behavior on *Ut mine Festungstid* (*During My Incarceration*), Fritz Reuter's autobiographical account of rebellious prison life in a Prussian fortress.

The train pulled into Eindhoven on December 5 and Vincent trudged the last five miles to Nuenen, just as he had trudged the first sixteen from Drenthe, through bitter winter weather. He bore an intolerable weight of grievances, each one a heavy link in a chain that reached back to the Zundert parsonage. His parents had never "given me freedom," he wrote, "nor have they ever approved of my desire for freedom." Everywhere he turned, they had opposed him, obstructed him, thwarted him. Their implacable disapproval had brought him to tears of indignation. "I am no criminal," he cried. "I don't deserve to be treated in such an inhuman way." In his love for Kee Vos, in his artistic ambitions, in his rescue of Sien, they had "closed their ears and eyes" and "hardened their hearts" against him. They had mocked him with their absurd gossip and laughed at his delusions—"thinking me a person who is always dreaming and incapable of action." He compared himself to Gérôme's prisoner lying bound and taunted in the bottom of a boat. "I am chained to misfortune and failure," he cried.

Now he had come to break free of his long imprisonment.

But not through forgiveness. For the first time, Vincent's homeward footsteps were not accompanied by images of prodigal sons or family reconciliation. Instead, each step brought a fresh surge of defiance—the defiance of a condemned man led to the gallows: a wronged innocent seeking vindication not in acquittal or forgiveness, but in martyrdom. Like Gérôme's prisoner being ferried to his oriental Golgotha, Vincent came home seeking victory in victimhood. "To my way of thinking," he explained Gérôme's painting, "the man lying fettered is in a better position than the fellow who has the upper hand and is taunting him." Why? Because "it is better to provoke a blow," he declared, "even if it is a hard blow, than to be indebted to the world for *sparing* you."

LESS THAN AN HOUR after he arrived, Vincent provoked the first blow. He demanded that his father admit that banishing him at Christmastime two years earlier had been a grievous error. Blaming all of his troubles since then on this single offense, Vincent shouted the litany of injuries at his sixty-year-old father, who had grown hard of hearing: how it had brought him financial trouble; how it had driven him to extremes of behavior; how it had forced him into "a much more stubborn attitude than I would have adopted of my own free will"; how it "made things ten times more difficult—almost impossible," and doomed all his efforts to failure. When Dorus refused to take back anything he had said or done, Vincent exploded into accusations no doubt rehearsed a thousand times in the loneliness of the heath, calling his father "unjust . . . arbitrary . . . reprehensible . . . implacable . . . blind . . . ignorant." His father's self-righteousness

was an insurmountable barrier that continued to separate them, he said—and would inevitably prove "fatal" for them both.

When Dorus responded scornfully, "Do you expect me to kneel before you?" Vincent stormed out of the room, vowing "not to waste my breath on the subject any longer."

But, of course, he immediately seized pen and paper and wrote Theo a furious letter, heaping blame on his father for his "narrow-mindedness" and "clergyman's vanity." He was always "carrying things to extremes" and "causing disasters," Vincent charged, just as he had two years before in Etten. "Basically there has been no change whatever, not the slightest, he sputtered. "In Father's mind there was not then, there is not now, the faintest shadow of a doubt that what he did was the right thing."

Throughout a sleepless night, the accusations hurtled back and forth in Vincent's head. Now and then he sprang from the bed to add the latest to his letter, or scrawl an indignant marginal note: "They think they did no harm at the time, this is too bad." He railed against his father's "hardness, like iron"; "icy coldness"; and dryness like "sand or glass or tinplate." "Father does not know remorse like you or me," he wrote, "or any man who is human." He also recorded his own desperate state, simultaneously agitated and captive:

> I again feel almost unbearably disturbed and perplexed. . . . Now I am again in an almost unbearable state of wavering and inner struggle. . . . I feel in everything a hesitation and delay which paralyze my own ardor and energy. . . . There is a *je ne sais quoi* in Father which I am beginning to look upon as incurable and which makes me listless and powerless.

Declaring himself and his father "irreconcilable down to the depths of our souls," Vincent surrendered to despair after only one day. He had come to Nuenen, he said, searching for clearer insight and found only the torment of false cordiality and good intentions. He had spent two years, "every day of which was a day of distress to me," only to find that, for his parents, it had been two years of "everyday life—as if nothing had happened." To live with them again would be impossible, he told Theo; they remained as obstinate and stupid as ever. Nothing had changed—"Nothing, nothing at all." As the Zundert parsonage seemed to slip away forever, he cried out in exasperation, "I am *not* a 'Van Gogh.' " Rejecting any possibility of compromise as unutterably hopeless, he laid plans to leave immediately—for The Hague, for Utrecht (where Rappard lived happily with *his* parents), wherever. Even the barren heaths of Drenthe seemed preferable to the bound hearts and strangling indifference of Nuenen. "Old fellow," he begged his brother, "help me get away from here if you can."

Yet he stayed.

He stayed for almost two years.

Day after day, he returned to his father's study to refight the battle. Dorus always began by calmly insisting he had nothing to regret. But Vincent's relentless accusations of "hypocrite" and "Jesuit" almost invariably incited him to "violent passions." They fought about Vincent's past failures and dismal prospects. They fought about his duty to Sien and the cruelty of his father's disapproval. They fought about the family's lack of support for his art, with Vincent repeatedly citing the example of his gentleman friend Anthon van Rappard, whose parents paid all his bills so he could "face the world in a dignified manner."

THE PARSONAGE IN NUENEN

Vincent launched attack after attack on his father's closed mind, while rejecting any resolution short of complete capitulation. "I am *not content* with a *sham* or a too *half-hearted* reconciliation," he said. "Bah! It just won't do." Dorus steadfastly refused to acknowledge any fault, while torturing his son with fresh claims of innocence. "We have always been good to you," he insisted. (To Theo, he complained: "I don't think [Vincent] ever feels any self-reproach, only spite against others.") Between the father's well-meaning self-righteousness and the son's paralyzed vulnerability, there could be no common ground.

On both sides, loftier causes intensified the stalemate. Vincent saw himself battling not just a single old man, but a vast, corrupt system of repression and conformity at the center of which stood a God as "capricious and despotic" as

his father. He railed against the religion that had once hypnotized him, calling it "grim" and "dreary" and "damnably icy cold." He condemned his father and all the forces of darkness he represented as the *"rayon noir"* (black light), a phrase taken from Hugo, because "the light within them is black and spreads darkness, obscurity around them." To help him fight the epic battle playing out almost daily in his father's study, Vincent recruited all the heroes of his imaginative world: a pantheon of writers and painters, almost all of them French—an obvious incitement to the Francophobe Dorus. To complete his Manichean vision, Vincent claimed for these advocates, and for himself, the label *"rayon blanc"* (white light).

In his arguments, he adopted the uncompromising vehemence of Zola's attack on bourgeois convention in *Mes haines,* as well as the remorseless anticlericalism of Daudet's *L'évangéliste* (*The Evangelist*), both of which he read around this time. He demanded his freedom in the militant pieties of Eliot's *Felix Holt* and denounced his imprisonment in the logical imperatives of Mill's *On Liberty.* Mill's mandate to "break the fetters" of conformity and his championing of eccentricity ("one should not complain of the Niagara river for not flowing smoothly between its banks like a Dutch canal") echo through Vincent's letters like a call to arms. "I am *entitled* to do anything which does not hurt anyone else," he declared, "and it is my duty to live up to the liberty which not only I myself but every human being has an unlimited and natural right to."

For Dorus, such arguments represented far more than just the lashing out of an obstreperous, ungrateful son who had long grieved his parents. In almost forty years as a pastor, Dorus had watched the Dutch Reformed Church retreat under the relentless assault of godless science on one side and bourgeois sentimentality on the other. In the last two decades of the century, the number of Netherlanders who claimed to have no religious affiliation increased tenfold. The French writers that Vincent upbraided him with—and Dutch ones, too—had battered and defiled the once-proud *"dominocratie,"* ending its three-hundred-year monopoly on the Dutch mind and threatening to undo Dorus's lifetime of labor on the frontiers of his faith. For his son to bring their arguments and accusations into his parsonage, into his study, constituted an offense against God, church, and family.

Their clashes sometimes lasted three or four hours, according to one witness. Even when they ended—when Vincent stormed out—they didn't end. Every shouting match was followed by long stretches of silence in the parsonage, a darkness of recrimination far more threatening than the fireworks of temper. Just as he had in Etten two years earlier, Vincent spent days pretending to be "invisible"—enacting the very judgment that he protested against. Rather than speak to his parents, he wrote them notes. At meals, he pulled his chair to the corner of the room, placed his plate on his lap, and sat in utter silence.

He ate with one hand, using the other to shield his face, as if hiding. When his behavior attracted reproving stares, he accused his parents of treating him like "a big, rough dog" that "runs into the room with wet paws," barks too loud, and "gets in everybody's way." Possessed by this conceit, he spun it into a long, bitter indictment that hints at an even more bizarre playing-out of the judgments against him.

> He is a foul beast. All right—but the beast has a human history, and though only a dog, he has a human soul, and even a very sensitive one, that makes him feel what people think of him . . . The dog feels that if they keep him, it will only mean putting up with him and tolerating him *"in this house,"* so he will try to find another kennel. The dog is in fact Father's son, and has been left rather too much in the streets, where he could not but become rougher and rougher. . . . The dog might bite, he might become rabid, and the constable would have to come to shoot him. . . . The dog is only sorry that he did not stay away, for it was less lonely on the heath than in this house, notwithstanding all the kindness. . . . I have found myself—*I am that dog.*

Trapped in this cycle of abuse and escalating outrages, Dorus and Anna van Gogh coped in the only ways they knew how. They offered the universal panaceas of new clothes and earnest prayers. They offered to lend Vincent money to pay off his debts. They complimented his drawings ("He is doing several that we think are beautiful," Dorus reported to Theo). They made hopeful excuses. "When he looks back and recalls how he has broken with all former relations," Dorus explained, "it must be very painful to him." Whenever possible, they surrendered to the storms of his moods. When he demanded a studio—like Rappard's—they set aside their objections and cleared a room in the parsonage that had been used for a laundry, spending precious funds to install a stove and a wooden floor "to make it nice and warm and dry." They offered to put in a window for more light.

In perhaps the hardest concession of all, they capitulated to the immutability of their son's strangeness. "We are undertaking this experiment with real confidence," they wrote Theo soon after Vincent's arrival, "and we intend to leave him perfectly free in his peculiarities of dress, etc. . . . There is simply no changing the fact that he is eccentric."

But Vincent could not be satisfied. Every attempt at appeasement was met with greater and greater provocation as he focused the anger of a lifetime on his captive captors. He saw only criticism in their gifts ("my clothes were not good enough") and condescending indulgence in their courtesies. "Their cordial re-

ception grieves me," he complained. "Their indulgence without acknowledging their error is, for me, perhaps worse than the error itself." He referred to the laundry room dismissively as an "apology of a studio" and almost immediately began demanding a better one. He answered every offer of accommodation with more rigid demands and fiercer rhetoric. "I cannot stand the least appearance of being in agreement with [Father]," he wrote two weeks after arriving. "I am dead against him, absolutely in opposition to him." When his parents expressed doubts about his remaining in Nuenen, Vincent resolved to stay; when they re-affirmed their welcome, he threatened to leave. The gift of the laundry room studio triggered wails of martyrdom ("you people do not understand me, and I fear you *never* will") and melodramatic vows to make himself scarce. "I must try to find a way not to '*bother*' you or Father any longer," he wrote Theo. "Let me go on my own way."

Indeed, just as the new studio was being completed in time for Christmas, Vincent retaliated against his parents' kindness in the most hurtful way possible. On the eve of a trip to see Rappard in Utrecht, in a scene that reenacted the expulsion from Etten two years earlier, he incited yet another argument over Kee Vos. Still unable to force his father to yield (he blamed it on Dorus's "petty-minded pride"), he fled the parsonage, vowing to extend his trip to include The Hague—the one place his parents had begged him not to go. He spent the Christmas holiday with Sien and her children. When he returned, he announced that he was once again considering marrying the woman, even as he confided to Theo that he and Sien had "decided more definitely than ever to live apart."

Predictably, Dorus threatened to block the marriage with yet another guardianship petition—a threat that launched Vincent into yet another round of bitter denunciations and furious defiance just as the new year began.

IT WAS INEVITABLE that Vincent would take the fight with his father to the unpaved streets and garden paths of Nuenen. With a population smaller than Zundert, the little town on the sandy heaths of East Brabant was also a prisoner of its past. Bound to ancient methods of farming and a cottage weaving industry barely changed from the Middle Ages, Nuenen had fallen deeper and deeper into poverty and irrelevance as the rest of Holland, and Europe, raced toward a new century. Better cloth could be made more cheaply in big steam-powered factories all over the Continent, and better transportation had already triggered a worldwide agricultural depression that hit small farmers, like Nuenen's, hardest. Without Zundert's Napoleonsweg, the town had remained geographically isolated and ethnically inbred for most of its history. The railroad came too late.

By the time Dorus van Gogh arrived in 1882, Nuenen was a dying town, with low birth rates, high death rates, and a net outflow of the working-age population.

Only a summons from his beloved Society for Prosperity could have compelled Dorus to leave his comfortable semiretirement in Etten for one more tour of duty in another embattled outpost on the heath. A controversy over the Society's stern treatment of tenant farmers (evicting a tenant with an incurable disease for nonpayment of rent) had opened an ugly rift with Society officials and bitterly divided the tiny congregation (a mere thirty-five souls in a town of fewer than two thousand inhabitants). Dorus had been sent to subdue the dissenters and quiet the seditious gossip that threatened to undermine the Society's mission in East Brabant. The enemies of Protestantism would seize on any sign of weakness, any hint of scandal, to discredit the Society and the faith it served.

Prior to his arrival on Saint Nicholas Day in 1883, no one in Nuenen—not even the elders of Dorus's church—had known that Vincent existed. The pastor had spoken not a word about his eldest son. The reason for his silence soon became obvious. In a campaign that seemed intended to mortify and embarrass his parents, Vincent boldly advertised his atheism to visitors, and bragged of his role as the family's black sheep. His mysterious flight to The Hague on Christmas Eve—a time when every Protestant eye in Nuenen was fixed on the parson—announced to all the discord at the core of their congregation.

Although still capable of exquisite propriety with distant friends like Rappard and Furnée, Vincent gave no quarter to his parents' circle. He confronted visitors to the parsonage with either brooding taciturnity or bristling challenges, or else avoided them altogether. He ostentatiously rejected social courtesies, dismissing them as "absurd" and "disgusting." He decried the "narrow conventionality" of the town's gentility—"prim, self-righteous prigs," like his father—and subjected their polite opinions to withering assaults of what he called "honest observation." Eventually, the Van Goghs had to discourage friends from visiting for fear of their son's unpredictable reception. "How is it possible to behave so unkindly?" Anna wondered bitterly.

On his long walks through the village and into the surrounding countryside, Vincent did not have to make an effort to draw disapproving stares. Most residents of Nuenen and its tiny satellite hamlets had never seen a painter before, much less a painting parson's son who swore vehemently, wore strange clothes, refused to eat meat, smoked a pipe incessantly, drank cognac from a flask, and lashed out sarcastically when challenged. "He was not friendly," one villager recalled fifty years later. "He was strange. . . . He got angry. He scowled." Another remembered that even Vincent's ruddy beard seemed subversive of Dutch order: "One bristle stuck out this way and the other bristle that way. . . . He was extremely ugly." The docile peasants of Nuenen had no place in their experi-

ence, or in their language, for such a strange, insubordinate man. They called him simply *"schildermenneke"*—little painter fellow—or just "Red." He called them "clodhoppers." As he did in so many places, Vincent attracted knots of small boys who followed and mocked him everywhere he went, a torment that he claimed to relish. He dismissed his tormentors, as he dismissed the whisperers and the gossips, with a curled lip. "I cannot bother about what people think of me," he said. "I go my own way."

More and more, Vincent pursued one path in particular that mortified and embarrassed his parents more than any other.

THEIR ROOMS WERE as dark and close as prison cells. On sunny days, a few shafts of dusty light angled across the darkness. But sunny days were rare in Nuenen, especially in winter. "The rains, the fogs drown it in a constant moisture," one traveler complained. "The inhabitants search with all their eyes for a sun that scarcely shines here." On most days, dawn brought nothing more than a twilight gray to their airless rooms. After sunset, their work was illuminated by the faint red glow of fires kept low to conserve precious fuel, and the heatless yellow light of gas lamps suspended from the smoke-blackened beams.

Whether in shadow or in light, however, the work proceeded. From the packed-earth floor to the thatched-roof rafters, the rooms shuddered with the labor of the loom. It sat huge in its tiny cell, like a trapped insect, too big to crawl out the airhole windows or the stooping door. Its legs and arms, posts and beams, reached out in every direction, some as thick as a ship's timbers, showing the sinewy distortions of the huge trees from which they were hewn, and big black knots where great limbs once hung. At its filigree center, two skeins of warp moved up and down, merging and unmerging in ghostly rhythm, as the shuttle flew between them trailing its weft, back and forth in endless escape.

Vincent had imagined drawing weavers for as long as he had been an artist. In 1880, he claimed to have seen "weavers' villages" on one of his ill-fated sojourns out of the Borinage, and immediately compared their pale faces and dark workplaces to those of the miners he lived among. He found in their labors an artisanal kinship with his own new "handicraft," he said, as well as a deeper connection with weavers he had seen as a child in Brabant. The combination of solidarity and nostalgia inspired him to a vision of weavers as otherworldly heroes ("that faraway look, almost daydreaming, almost a sleepwalker") drawn from sources as diverse as the rural fantasies of Golden Age painters, the "mystic weavers" of Michelet's histories, and the "disinherited race" of Eliot's *Silas Marner.* In The Hague, he recruited this idealized image in the relentless arguments over Sien, praising the weavers as men of action, not contemplation. "[The weaver] is so absorbed in his work that he doesn't think, he acts," he

wrote in defense of his own reckless course. "It's nothing he can explain, he just *feels* how things should go." By the time he left The Hague, weavers had assumed a place beside peasant funerals and church graveyards in Vincent's iconography of home. While in Drenthe, he may have heard rumors about Max Liebermann painting a weaver family in Zweeloo, and when he visited Rappard's studio in December he no doubt saw his friend's depictions of spinners, weavers, and looms.

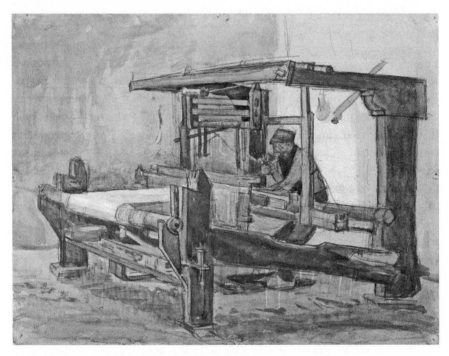

Weaver, 1884, WATERCOLOR ON PAPER, 13 X 17³/₈ IN.

In Nuenen, Vincent found weavers at the end of virtually every street. One in four of the town's adult males made some part of his meager living working at a loom. They worked the way they always had, at home, with the monstrous black looms filling their tumbledown cottages, and wives and children winding their bobbins. Nuenen's brief experiment with modern factories had failed years before Vincent arrived, throwing the destitute weavers on the mercy of the entrepreneurs who supplied their yarn (hand spinning had all but disappeared) and a marketplace stalled in a Continent-wide depression. Most of Nuenen's weavers used the same looms their great-grandfathers had used, their beams grimy with the sweat of generations. Most still rented their looms. They made what they had always made: brightly striped and checked material called *bontjes.* Some made kitchen towels; a few made linen for diapers. The work came

fitfully and paid miserably—pennies a day for numbing treadmill labor. Many weavers made ends meet by farming their small plots or taking odd jobs. One of these was Adriaan Rijken, who tended the garden of Parson van Gogh and cleaned the studio of his strange son, the painter. It was probably Rijken who first took Vincent down one of the sandy paths that led to the outskirts of town, to fulfill his long ambition to draw weavers.

But Vincent must have been drawn to the gloomy cottages at the ends of these paths for reasons more compelling than the competition with Rappard or the search for yet another icon of noble labor. In his first months in Nuenen, he spent hour after hour in the low, soot-stained workshops, sitting against the wall, only feet from the infernal machines and their relentless clattering. He came in the morning and stayed late into the night—far longer than he needed to make the rough, preliminary sketches that he took back to his studio. Yet despite these long hours, his finished works show a surprising inattention to the rudiments of how the looms actually worked—a failure of engagement uncharacteristic of Zundert's obsessive creekbank collector and categorizer.

Nor did he look long or hard at the weavers themselves. In image after image, they sit impassively in their elaborate machines like birds in their cages, without distinctive features or visible expressions of emotion. Vincent rarely depicted their nimble, indefatigable hands, or the endless journey of their feet on the treadle. In some works, he admitted adding the figure of the weaver last, as an afterthought. He dismissed it as a mere "apparition"—a ghost in the machine hardly worth his notice. (In Nuenen, as in The Hague, Vincent never named or described his models.)

Yet clearly Vincent was drawn to these dens of noise and distraction, with their caged denizens isolated from him by the deafening clatter as surely as the orphan man Zuyderland was isolated by deafness. Like Eliot's hermit weaver Silas Marner, Vincent seems to have found in the "monotonous response" of the loom an escape from the torments of memory and reflection, and from the furious, unwinnable battle with his father. It was the same escape he found in his art. "Every man's work," wrote Eliot, "pursued steadily, tends in this way to become an end in itself, and so to bridge over the loveless chasms of his life."

As subjects, the weavers and their looms could not have been more ill-suited to Vincent's uncertain art. The complex cages of the looms presented insoluble problems in perspective. His efforts to use a perspective frame proved futile: the looms were too big, the rooms too small. "One must sit so close," he complained, "that it is difficult to take measurements." As a result, the images often collapsed in conflicting angles, especially when he added figures, or tried to depict the looms in their settings. Eventually he found a larger room with two looms, but he had to retreat to the hall to get a clear view.

The addition of the weavers only compounded the problem. Despite years

of trying, Vincent had yet to master the human figure. In The Hague, he had used the controlled environment of his studio, the perspective frame, tricks of posing, and endless trial and error to overcome the halting awkwardness of his earliest attempts. But in the cramped weavers' cottages, his ineptitude was fully exposed. As the failures piled up, he tried posing the weavers beside their looms, with their backs to him, or revealed only in profile. He positioned them in front of windows, reducing them to simple silhouettes; or cast the whole room in such gloominess that their features were barely distinguishable—solutions that forced him to render the images darker and darker.

Still he persisted. With his usual monomaniacal zeal, he produced dozens of nearly identical drawings in the months after his arrival, lavishing extraordinary care on every cross-hatched knob, hook, beam, strut, and spindle. He labored over the same scenes in watercolor, always an agony for him. He even expended precious oil paints on the recalcitrant looms, filling big, expensive canvases with tentative, tenebrous images that gave him so little satisfaction he didn't bother to sign them.

Why this effort?

The weavers may not have suited Vincent's artistic struggle, but they perfectly suited his larger struggle. In Dorus and Anna's book of bourgeois bogeymen, weavers ranked with peddlers and grinders as rootless men of unconventional habits and unaccountable means. "[One] was not quite sure," wrote Eliot in *Silas Marner*, "that this trade of weaving, indispensable though it was, could be carried on entirely without the help of the Evil One." Within the Van Gogh family, weaving was considered "unhealthy" and "harmful," according to sister Lies. Weavers in Nuenen were seen abroad only at Sunday dusk— not a time for decent people to be out—when they came to exchange the past week's linen for the next week's yarn. Pale, spectral figures (Eliot called them "alien-looking men"), they usually traveled alone. Dogs barked at them. Rumor and legend attached to them. By the 1880s, labor militancy among weavers all over Europe had reinforced these old superstitions with new suspicions of political agitation and social insurgency.

Vincent no doubt taunted his parents, just as he taunted Theo, with descriptions of his daily visits to the homes of these disruptive agents: of their "miserable little rooms with the loam floors" and the strange, "disgusting" apparatus that filled their houses with noise day and night. "They are but poor creatures, those weavers." If Dorus and Anna raised objections, he no doubt shouted them down, as he did Theo: "I consider myself absolutely free to consort with the so-called lower orders." As if to underscore the argument, at mealtimes he brought his paintings into the parsonage dining room and propped them on the chair opposite, defiantly inviting the weavers to his parents' table. "Vincent is

still working with weavers," Dorus lamented after months of such incitements. "It's a shame that he wouldn't rather do landscapes."

ON JANUARY 17, 1884, fate gave Vincent one last chance to break free from the lockstep of provocation and rejection. On a shopping trip to Helmond, his mother slipped and fell as she stepped off the train. The sixty-four-year-old Anna had fallen the previous winter, but escaped without serious injury. This time, she was not as lucky; she broke her hip. Accompanied by son Cor, she was rushed by carriage back to Nuenen, where the bone was set and encased in a huge plaster cast. Her bed was moved to Dorus's downstairs study and she was given chloral hydrate to help her sleep.

Then the vigil began.

For the next two months, Vincent found a home in his mother's helplessness. He threw himself into the healing work with abandon, just as he had for the injured coal miners of the Borinage and the sickly prostitute Sien. He fretted over every symptom and second-guessed every diagnosis. He worried endlessly over the dangers of long-term immobility. He put himself entirely at her disposal. "My mother will require a lot of nursing," he explained solemnly to Rappard. "I have to stay at home most of the time these days." He advised Theo of the necessary slowdown in his work. "I'll be able to work only half time for a while," he wrote, "on account of the unfortunate event, which has resulted in a lot of other things that *have* to be done."

When her bed needed changing, he lent his back to a bierlike stretcher the doctor devised to move the patient without disturbing her stricken leg. Later, when the break began to heal, Vincent carried her in an improvised sedan chair into the living room and eventually into the parsonage garden. He took his turn with other family members reading to her, or otherwise distracting her from the pain. He searched the garden for winter blossoms—primroses, violets, snowdrops—and arranged them on trays that he brought to her bedside. Even when there was nothing to do for her, he lingered about the house waiting for any chance to "lend a helping hand."

Gradually, the grip of the past seemed to loosen. The accident "pushed some questions entirely into the background," Vincent reported, allowing him to "get on pretty well" with his parents. His eagerness to help drew rare praise from the Reverend van Gogh, who called Vincent "exemplary in his caring," and even elicited some sympathy for his artistic efforts ("he works with tremendous ambition")—if not for the art itself. "I so hope that his work will meet with some approval," Dorus wrote Theo.

Vincent responded in kind. After more than a month of remorseless criticism,

he reembraced his father's conventional values, amiably greeting well-wishers to the parsonage ("getting on better with people is of great importance to me," he declared) and worrying over his sisters' marital prospects. ("Without capital," he warned, "the inclination to marry a penniless girl is not great.") On Dorus's birthday in early February, Vincent gave him a copy of *Uit de cel* (*From the Cell*) by Eliza Laurillard, a leading light of the same *dominocratie* he had so furiously denounced only weeks before. When two hundred florins in doctor bills arrived in the first weeks after the accident, Vincent handed his father all of his most recent payment from Theo (putting off his debts in The Hague still longer). So keen was his desire to help his parents through their financial difficulties that he pressed Theo once again to help him find paying work, "so that you could give Mother what you would otherwise give me." Finally, in a bid that surely brought a smile to his mother's face, he tried to broker a match between his sister Wil and the aristocrat Rappard.

In his art, too, Vincent turned from provocation to appeasement. Seized by the sudden and unexpected possibility of favor, his imagination returned to its earliest ambition: pleasing his parents. "I am glad to say Mother's spirits are very even and bright," he reported proudly to Theo. "She is amused by trifles. The other day I painted for her a little church with a hedge and trees."

Vincent had already briefly explored this nostalgic imagery in a series of drawings he did immediately upon his arrival in Nuenen, in the first flush of homecoming. After a heavy snowfall, he took his sketchpad into the cold and recorded the Brabant winter of his childhood: the parsonage garden with its bare trees and snowy vistas; a couple walking the tree-lined route to church, leaving their twined footprints in the snow; a peasant woman forking manure against a vast, white horizon; children building a snowman; crooked crosses etched in a churchyard cemetery. He had come home with many of these images already in his imagination—prepared, as always, to see what he most needed to see. Done in delicate pen and pencil shadings, with the exquisite care that he always lavished on "portraits" of his family's homes, these notebook-sized mementos earned the admiration even of his skeptical father, in the brief interval before the storm descended on the parsonage. "Don't you think those pen drawings of Vincent's are beautiful?" he wrote Theo. "It comes so easily to him."

The chance to win his mother's approval revived those first hopeful images. After the defiance and subversion of the weavers, Vincent returned to the comforting imagery of his father's little church and the nearby parsonage. Rather than wandering down unknown paths, he took his sketchpad no farther than his mother's garden behind the parsonage, where he lovingly recorded its ghostly winter pall and its promise of spring: saplings and rose bushes wrapped in straw against the frost; skeletal fruit trees gesticulating crazily; an old bell tower, long since stripped of its church, standing alone on the horizon, the ul-

timate reminder of rebirth. He took these sketches into his little laundry-studio and transferred them to big sheets of smooth paper, tirelessly hatching every change in texture, every twisted branch, every picket of hedge, every leaf or tuft or blade that braved the winter's wrath. He broke out his paint box and displayed his new skill to his parents for the first time by painting his father's church with the congregation assembled outside, as if for a group portrait. When he was done, he gave the painting to his mother, enacting a childhood ritual of offer and acceptance from which he had long felt barred.

Freed from the need to prove or persuade, wanting only to please, Vincent began a series of images that would become the first indisputable masterpieces of his slow-igniting, fast-burning career. Retreating from the unfamiliar challenges of oil painting, he chose instead the instruments that felt most comfortable in his hand: pencil and pen. Black-and-white drawing had sustained him since the dark days in the Borinage, and through all the crises since. It was the only medium that had ever earned him compliments from his family. It was also the medium on which he had built his friendship with Anthon van Rappard. Now, with the possibility of reconciliation at home revived, Vincent launched yet another campaign of solidarity with this parental favorite, of which matchmaking was only a part.

For subjects, he chose places as familiar and comforting to his parents as the rooms of the parsonage: a pond on the margins of the parsonage garden, swollen with winter runoff and fringed in wild grasses; a sandy road just outside the garden gate; and a stand of bare birches at the edge of town, only a short distance away. If his mother could not walk the garden paths she loved, Vincent would bring them to her in images.

He captured the stillness and anticipation on the banks of the pond in the first days of spring. Pouring a lifetime of intense, meticulous observation into a single image, he filled the sixteen-by-twenty-one-inch sheet with an exquisitely detailed record of the devastation wrought by winter: the tortured stumps and twisted branches of unpruned bushes, the spindly bareness of unplanned trees competing upward to form a single lacy canopy that he traced in finer and finer lines to the top of the sheet. He filled the foreground with the lambent pond, its still waters mirroring its unkempt margins and the stand of trees in glowing grays. He caught even the reflection of the sky in endless modulations of fine hatching that left no part of the wove paper untouched by his pen. With his perspective frame, he laid in an empty road lined by a grizzled hedge. It enters from the left and vanishes on the horizon beyond the trees, its arrow straightness a rebuke to the amoebic pond. In the distance, dead center, ever present, is the faint gray ghost of a church tower.

Against this frozen tableau of winter, Vincent set the tiny drama of a bird hovering over the motionless water in search of a meal. In a few careful dabs

of white paint against the pond's dark reflections, he evoked a childhood of bird-watching with his father, the shared gospel of Michelet's *L'oiseau,* and the solitary rewards of waiting patiently by a creekbank for the thrilling surprises of nature. He decided to name the drawing after the bird: *The Kingfisher.*

The Kingfisher, MARCH 1883, PENCIL ON PAPER, 15⅜ X 20⅞ IN.

In another drawing, Vincent focused all his extraordinary powers of observation on a small stand of pollard birches. About a dozen of the stout, stunted trees stood in motley formation on the banks of a drainage ditch separating the town from the flat pastureland beyond. Anna van Gogh knew the sight well. Vincent set his perspective frame so close that the two trees in front almost filled his big sheet, both top to bottom and side to side. Behind each one, he drew a row of trees shooting to the distant horizon, converging almost at the center of the image—a dramatic perspective that thrust the front trees forward. Vincent had often drawn pollard trees before: their distinctive gnarled trunks and crown of new growth attracted him just as they had attracted generations of Dutch artists. Along many of the roads, canals, and fields he walked, trees of all kinds—willows, oaks, birches—were subjected to the annual pruning, called pollarding, that left them looking abused and forsaken, especially in winter— roadside grotesques, half tended, half natural.

On these dozen birches, veterans bearing the scars of many spring mayhems, Vincent focused his unblinking eye. One should draw a pollard tree "as if

it were a living being," he had once told Rappard; "focus all one's attention on that particular tree and not rest until there is some life in it." But until now, Vincent had never followed this advice. In previous efforts, his pen had wandered to the mise-en-scène of landscape or farmhouse, cloudy sky or vanishing road. Or to figures. In drawing after drawing, he used pollard trees to frame a solitary figure tramping a lonely road, their tortured forms reduced to symbolic echoes as he labored fruitlessly over the figures that he loved and the feelings he longed to share.

In the brief clearing of his mother's favor, however, Vincent could just *look*. His eye found and probed every knotty wound, every stump of severed limb, every pitiful deformation. It captured the shiny white crinkles of bark as well as each tree's slightly different, asymmetrical lean. And from the black knots that marked the most recent cuts, it caught the upward exultation of new growth— the slender, sun-seeking branches that sprang heavenward from the battered ruin beneath. In row after row of receding trees, he repeated the triumphant gesture, filling the top of the sheet with layer upon layer of vertical lines, and then echoed it everywhere across the bottom in a thousand vertical pen strokes of grass and reeds and distant stalks.

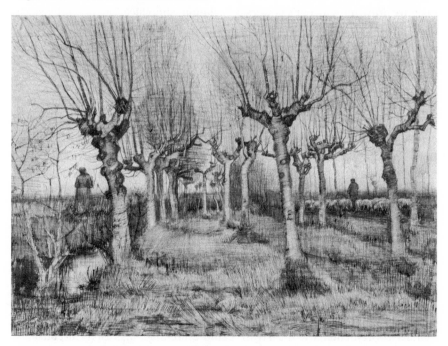

Pollard Birches, MARCH 1883, PENCIL ON PAPER, 15³/₈ X 21¹/₄ IN.

Only once before had Vincent allowed himself to look as long and deeply at a single subject as he looked at the pollard birches. In his fanatical pursuit of the

figure, he had subjected the ever-patient orphan man Zuyderland to his relentless gaze, only to be frustrated by the unique challenges of the human form. Even now, in the spring of 1884, mastery of the figure was a quest that he could neither succeed in nor completely surrender. In another drawing that March, he lavished his pen on a ditchside foursome of pollard trees just outside the garden gate. But beside them he added a man dragging a wheelbarrow—a stiff, faceless straggler from the Schenkweg studio, a time when his loneliness overruled his eyes. He eventually added figures to his drawing of the pollard birches as well— on the right, a shepherd with his flock; on the left, a woman with a rake over her shoulder—but they turn their distant backs and almost disappear beside the great thrusting vitality of the mangled trees.

In the pollard birches, for the first time, Vincent found life beyond figures. He had always had an inexhaustible eye for nature, for the infinite incident and soulful escape of *The Kingfisher,* and all the gardens and wheat fields it adumbrated. But now he added to that intimacy with nature the fanatic eye he had always reserved for his models: the immediacy of purpose, the unity of vision, the boldness of expression. "A row of pollard willows," he had written, "sometimes resembles a procession of almshouse men." Freed from their long enslavement to figure drawing, Vincent's powers of isolation, simplification, and intensification—honed on years of letter sketches—could now explore the latent life in virtually any object: a chair, a pair of shoes, a sunflower.

BUT VINCENT'S ESCAPE from the past was doomed to failure. The prospect of regaining his rightful place in the family, however dim, put him on a collision course with the person who had assumed that place. By January 1884, his relationship with Theo had already fallen into a stalemate of acrimony. Vincent had arrived in Nuenen bursting with rancor—over Theo's opposition to Sien, over his refusal to quit Goupil—all of it pent up during the long, fruitless campaign on behalf of Drenthe. Describing himself as "disillusioned" and "disenchanted," he held Theo accountable for the "bitterly, bitterly sad" end to his dream of perfect brotherhood.

Theo, too, felt betrayed. In going to Nuenen, Vincent had done the very thing Theo had worked hardest to prevent. Up to the last minute, he had tried to persuade Vincent to come to Paris instead of going home. He had even found a job for him at a magazine there, *Le Moniteur Universel.* Vincent's refusal, postmarked from Nuenen, was filled with yet more jeremiads against the art business ("within relatively few years a number of great art enterprises, like *Le Moniteur Universel . . .* will dwindle down [and] fall into decadence") and nose-thumbing expressions of confidence in his ultimate vindication: "I say it is possible that a revulsion of feeling will come about in your mind, either gradually or suddenly,

and that this will force you to adopt a new conception of life, which perhaps will finally result in your becoming a painter."

Theo's efforts to defend their father (Vincent boasted of his "savagery" in argument) revived Vincent's old fears of a conspiracy against him. He accused Theo of joining the laughter he always heard behind his back and demanded that his brother declare his true loyalty: "I ask you point-blank how we stand— are you a 'Van Gogh,' or are you the 'Theo' I used to know?" Theo's answer came in the form of a scolding letter that called Vincent a "coward" for bullying their aging father, and insisted that he take back his harsh criticisms. Vincent responded with a fury of defensive letters—bitter, petulant, snide letters that simultaneously lamented the loss of their former closeness and blamed Theo for all his problems. No sooner was the ink dry on that storm of protest than Vincent added a new provocation: the Christmas trip to The Hague. When he returned, he blamed his brother for the wretched state of Sien and her family, and he openly vowed to continue supporting them in flagrant violation of Theo's demand that he renounce the woman once and for all. "Whatever your financial power," he wrote, declaring his freedom in bold underlining, "*you will not be able to force me to renounce her.*"

But real freedom proved harder to win. In his campaign to reclaim favor after Anna's accident, his dependence on Theo continued to thwart him. He tried to escape his reputation as a "ne'er-do-well" by openly embracing the Goupil gospel of salability and making more commercial works like watercolors (borrowing both the subject matter and gauzy tonality of Mauve). He linked his weaver paintings to successful Hague School artists like Jozef Israëls and added dreamy French titles to some of his drawings from December (*Jardin d'hiver, Mélancolie*), as if they were bound directly for the Paris market. But every time he presented himself to his parents' friends—"the respectable natives of these regions," he called them now—he opened himself up to a torment of questions: "Why is it that you never sell your work?" "Why do others sell and you don't?" "How strange that you don't do any business with your brother or with Goupil." He catalogued these injuries to Theo in increasingly rueful tones. "Everywhere I go, especially at home, a constant watch is being kept on whether I get anything for my work," he wrote. "In our society virtually everybody looks out all the time for that sort of thing."

Inevitably, guilt and paranoia magnified every polite inquiry, every askance look, into a stinging rebuke. "I have to put up with being reproached with idling away my time—or even being *absolutely* looked upon as '*having NO means of subsistence,*' " he keened. "One hears that drivel day in, day out, and one gets angry with oneself for taking it to heart." He complained bitterly about the unflattering impression created by his financial dependence on his brother and how it trapped him in a "false position"—a coded reference to the deeper injuries long

inflicted by Theo's ascendancy. It wasn't long before he lashed out at his distant but ever-present brother. "On my coming home, I was struck by the fact that the money I was in the habit of receiving from you was looked upon . . . as charity for a poor fool," he wrote, betraying the accusations in his own head. "I am feeling more and more cramped."

In February, inflamed by these accumulating slights, Vincent mailed his brother two parcels of drawings and watercolors, accompanied by a "proposal for the future." In language that strained to sound businesslike, he offered yet another plan for their troubled relationship: Vincent would occasionally send his work; Theo would choose what he liked. Any money that Theo sent would be considered payment for the selected works ("money I have earned"); any works Theo rejected, Vincent could take to other dealers. As always, he framed his proposal in fond blandishments, calls to fraternal solidarity, and solemn assurances that it would keep their relations on "a straight course." But nothing could disguise the angry demand at its core. "After March, I will accept no money from you," he wrote, reviving the deadline he had imposed in Drenthe, "[unless] I give you some work in return." It was the same threat of self-destruction he had made so often before: if Theo refused to "buy" his work, Vincent would refuse to take his money—casting himself, and his family, into yet another crisis of uncertainty.

He waited weeks for a reply, alternately fretful and fuming, as Theo again punished him with silence. He sent plangent reminders comparing himself to a convict awaiting the judgment that would set him free. He placated his brother with poetry and protests of good faith, as he battled a wave of second thoughts and the pendulum swung back toward fraternal devotion. "Whatever the difference in feelings may be, and the difference over this or that," he wrote, "we are brothers, and I certainly hope that we shall go on behaving like brothers."

It wasn't until early March that Theo responded. In language as unequivocal as Vincent's was oblique, he told his brother that his work was "not good enough" to sell; that he had "not yet made enough progress" since his first clumsy efforts in Etten. Whether as a dealer or as a patron, Theo said, he could do nothing to advance Vincent's career until his work "improved a great deal." If anything, Vincent's baroque appeasements only seemed to clarify his brother's rejection. He ridiculed the notion that Vincent could find other dealers for his art, and reminded him that no one else would advance him money on dreams and rhetoric. It would be "a good many years" before his work would have any real commercial value, Theo predicted—and even longer before he could support himself on it. He criticized the crude technique of Vincent's drawings (the public would "take offense" at their imperfections), the superficiality of his painted studies, and the drabness of his colors. In a slight that amounted almost to a repudiation of their shared past, he accused Vincent of being "too obsessed"

with the French landscapist Georges Michel, the brothers' lifelong favorite, and in particular dismissed Vincent's Michel-inspired paintings from Drenthe as simply "no good."

In proposing his plan, Vincent had reassured his brother that "if [my work] should not please you and you should not want to have anything to do with it, then I should not be able to say anything about it." "*I want you to feel free with me*," he had written in bold underline, "just as I want to feel free with you." But, of course, there was no such freedom. On either side. Vincent's rage followed as inevitably as Theo's scolding. In the most furious letter he ever wrote his brother, he raised the pitch of their dispute to new heights of rawness and ferocity. He blamed Theo for virtually every setback he had ever suffered. If his work didn't sell, it was because Theo had done nothing to sell it. He had "put it away in a dark corner" and "not lifted a finger" to find buyers. His indifference to Vincent's art only mirrored his insincerity, even dishonesty, in their relationship. He was a "wretched" brother, who put "feathering his own nest" above love of art or bonds of fraternity. "You couldn't care less about me," Vincent raged. A *true* brother would not have held him hostage to need. He would have given freely—without oversight or obligation—instead of "tugging at the purse strings" and forcing him to "knuckle under." Reopening the freshest wound of all, he decried again the betrayal on the Schenkweg. In opposing Sien, Theo had deprived him of "*a wife . . . a child . . .* a home of [his] own." What a fool he had been to invite Theo to Drenthe. What a vain hope it was that his brother had the heart or spine or spleen to be a painter.

What was left but to break it off? Only cowardice could explain their failure to part company sooner—Theo's cowardice. Vincent had put up with his meaningless encouragements, his refusal to "soil his hands," long enough. The only "manly action" was to put an end to the "wretched business" into which their perfect brotherhood had degenerated. The time had come to break free. "It is perfectly natural to kick when one knows for certain that one is being kept dangling, being kept in the dark," he said. "If one goes from bad to worse . . . what difference does it make?" It was the ultimatum that had hung over their relationship since The Hague, only this time stripped of its conditions. "I cannot leave matters as they are," he declared. "I have resolved on a separation."

He vowed to find a new dealer, flatly rejecting Theo's verdict that none would treat him any better. Furthermore, he would pursue every opportunity to develop new contacts and to exhibit his work—tasks he had always disdained in the past. He talked of going to Antwerp to find buyers. He and Rappard had discussed it. Perhaps he would even move there. Or perhaps he would return to The Hague. In what could only have been meant as a threat, he proposed returning to the site of his previous disaster and renewing his relations at Goupil. "After all," he protested, "I have never misbehaved myself toward them."

To underscore his determination to go his own way, he contracted with a local carpenter to build some frames for his paintings, a requirement for selling them (he thought they looked best in black ones). The first works he planned to frame were some Drenthe studies—just like the ones Theo criticized. He also packed up the best of his recent drawings, including *The Kingfisher* and *Pollard Birches*, and sent them to Rappard with a request that he "show them to people." To Paris, he sent not landscape drawings—the imagery Theo had long urged on him—but yet another batch of weavers, as if daring his brother to reject them again.

Not even in the midst of this, his greatest fury, could Vincent escape the torment of second thoughts. When Theo wrote reporting the final breakup of his affair with Marie, Vincent scrambled to "unsay" some of his harshest words. ("You see it is not my aim to break off relations with you.") But when Theo retaliated by delaying his next payment, Vincent sprang back to the attack, his rage redoubled. He accused Theo of not merely failing him in his time of need, but of intentionally sabotaging him. "You commit this negligence *on purpose* in order to make life more difficult for me," he railed. In the bitter, helpless language of a frustrated child, he lashed out at his brother, summoning all the injuries of the past year—and long before that—in one great explosion of abuse. The "high and mighty" *gérant* had tortured him for too long with his "conceited" condescension, his "dear little Van Goghish tricks," and his "silly, insipid" criticisms. Vincent could not suffer for another day such "narrow-mindedness" and "self-righteousness." Theo had become their father, he wrote, hurling his most devastating bolt, and the outrage of it had finally grown absolutely unbearable. "It would be *stupid* to go on *in this way*," he thundered. *"Stupid!"*

BUT THEO WAS a prisoner, too. In early April, he agreed to all of Vincent's demands. He would send one hundred and fifty francs every month, as he had been doing. In return, Vincent would send him all his work. Theo could do anything he wanted with it (even "tear it to pieces," Vincent agreed). Vincent could tell people in Nuenen that his brother had bought his work. The money would be "*earned*," Vincent emphasized; "that way I have something to justify myself in the eyes of the world." Theo would impose no conditions on his support. Vincent would make no additional demands on his brother. Theo would tell no one, not even their parents, about the terms of the agreement. Despite his own financial straits, Theo sealed the deal with a special payment of two hundred and fifty francs to placate his implacable brother. Vincent finally had his "definite arrangement."

But it resolved nothing. Vincent immediately began demanding revisions to the agreement. Within a few weeks, he issued yet another ultimatum that Theo

accept his revisions *"or else we're finished."* He accused his brother of not show-ing sufficient enthusiasm for his work—of treating it "too frivolously." He repu-diated the images that Theo admired and embraced those he rejected, returning to the contrarian paralysis of The Hague. After showing Theo some of the great penned landscapes from the spring, Vincent never did another. "I have some-what changed my technique," he reported without explanation.

Despite Vincent's repeated claims of "freedom," the months of intimate bat-tle with Theo had left him even more hopelessly trapped in a downward spiral of provocation and defiance—a spiral that would capture both his emotional life and his artistic life over the next year in Nuenen, undoing the promise of his mother's recovery as surely as it disowned the art that comforted her. Even in the flush of his victory over securing an arrangement, Vincent himself saw the darkness ahead. In a passage meant as a warning to his brother, he com-pared himself to his hero Millet, betrayed by faithless backers who gave him only money—not respect, or enthusiasm, or love. "He clasped his head with both hands," Vincent recounted a story about Millet, "in a gesture as if once again he were overwhelmed by huge darkness and unutterable melancholy."

La Joie de Vivre

~

IN MAY 1884, WOMEN IN NUENEN WERE SURPRISED TO FIND A HANDSOME stranger at their door—a young man with both the title and the manners of a noble lineage: Anthon Ridder van Rappard. Even more surprising was his companion: the Protestant pastor's odd and annoying son, the *schildermenneke*, Vincent van Gogh. With their sketchpads under their arms, the mismatched pair were ranging across the spring landscape, knocking at the doors of weavers and farmers in search of subjects—or, better yet, models.

Vincent had campaigned furiously for his friend's visit. To lure Rappard from his busy bourgeois life in Utrecht, he dangled every kind of bait, from the beauty of the Brabant countryside to the availability of his sister. Replaying many of the same arguments he made to Theo from Drenthe, he promised a paradise of picturesque subjects and plein air painting. In addition to almost a dozen of his own drawings, like *The Kingfisher*, he sent page after page of transcribed poetry to fill out this enticing vision. He fawned shamelessly over Rappard's work ("Your brushstroke often has an individual, distinctive, reasoned, deliberate touch") and hinted heavily that he could enlist his brother's assistance to further his friend's career. He even interrupted his fierce feud with Theo to plead Rappard's case as "one of the people who will count." "If you should feel personal sympathy for Rappard's work," he wrote, "he would certainly not feel indifferent toward you either." Shrugging off Rappard's harsh criticism of his weaver drawings, he cast himself as a good-natured bohemian Puck willing to poke fun at himself as well as at the pretensions of others. Giving no hint of the winter's many trials, he summoned his friend to an artists' May Day on the heaths of Brabant.

Despite their similar blue blouses and felt hats, the two men made an odd couple indeed on the sandy streets and country byways of Nuenen. Rappard,

who was accustomed to frequent, extended sketching trips, traveled light, carrying only his sketchpad, a tiny tripod easel (knee-height when unfolded), and a book-sized paint box—a burden so light he had one hand free for a stylish walking stick. Vincent, on the other hand, brought his studio with him: a folding chair, a heavy combination paint box, larger sketchbooks, and the cumbersome perspective frame. Even inattentive field workers must have marked the difference in their gaits: the one, brisk and self-assured, with a straight back and outthrust chest; the other, plodding and round-shouldered under his burden. The villagers and farmers they approached would have found the contrast even more striking close up: Rappard's thick, dark hair and finely trimmed beard, Vincent's bristly, short-cropped hair and wild whiskers; Rappard's soft, slightly crossed eyes, Vincent's crystalline blue-green glare.

For ten days, Vincent did everything in his power to erase the differences between the two men. After introducing Rappard to the weavers who had obsessed his imagination for so long, he indulged his friend's interest in more picturesque subject matter. He led expeditions to some of the ancient mills that dotted the countryside around Nuenen—exactly the kind of conventional imagery that Vincent had spurned in the past. (He had to ask directions to find some of them.) The two spent hours in the town tavern, where Vincent entertained the cosmopolitan Anthon with jokes about the locals, and no doubt pleaded anew all the arguments for solidarity that had filled his letters over the previous months: the brotherhood of painters, the dangers of "studio style," the mystery of "present-day trends" like Impressionism, and especially the loneliness of the artist's life—complaints that must have sounded sad and strange to Rappard, who had just celebrated his twenty-sixth birthday by founding yet another social club for his fellow artists in Utrecht.

But one subject never failed to bring them closer: women.

Even before his friend's arrival, the topic was much on Vincent's mind. The final breakup with Sien had left him without any prospect of physical intimacy. "I have always lived with a certain warmth," he told Theo in despondent euphemisms. "Now everything is getting grimmer and colder and more dreary around me. . . . I *will* not stand it." He turned first, as always, to prostitutes (which he probably found in Eindhoven, a larger commercial center, where he also bought his paints). He sent his brother elaborate rationalizations and a bitter lament: "I have not yet had enough experience with women." He claimed as his new example their womanizing uncle Cent, whose motto, according to Vincent, was this winking license: "One may be as good as one likes." In the very same breath, he began demanding more money for models and bemoaning the difficulty of finding them. He may have signaled his ultimate intention by complimenting the Impressionist Édouard Manet (whose work he barely knew)—especially Manet's paintings of nude women.

Rappard's impending visit only stoked the fire. Ever since their joint expeditions to the Marolles, Brussels's red-light district, in 1881, sex had been the *other* passion the two men shared. Vincent set the tone for the coming encounter by sending not only sheaves of his drawings, but also a little "Arabian fable" from which he teased images of erotic abandon and even suicide by sex. The subject of models carried both these torches at once. After returning from Utrecht in December, where he had admired Rappard's painting of a woman spinning, Vincent bought a spinning wheel, apparently in hopes of luring women to pose privately rather than having to draw them in their own houses at their own wheels.

But even if a woman succumbed to such inducements, Vincent had no place to take her. For unknown reasons, he had moved his studio out of the parsonage's windowless laundry, with its prying eyes and prisonlike spareness, and into a shed-roofed outbuilding that, according to Vincent, "adjoined the coal hole, sewers, and dung pit." (Dark and wet when it rained, dark and dusty when it didn't, the cramped space would later be used as a chicken coop.) Immediately after Rappard wrote in April telling of his work with models, Vincent began an all-out push for a better studio. "I need [it] in order to work from the model," he announced. No doubt eager to put distance between Vincent and the parsonage, Theo sent extra money for the move, but with a warning to avoid the mistakes of the past, to which Vincent responded blithely: "One may try one's best, or act carelessly, the result is always different from what one really wanted."

But rather than pick an isolated shed far from town—as he had in Etten right before the Christmas expulsion in 1881—Vincent found a studio close to home. The little two-room apartment sat on the main road, the Kerkstraat, only a thousand feet south of the parsonage, literally in the shadow of the big new Catholic church, St. Clements. Indeed, the space had been used as a "prayer and knitting school" by the church before Vincent moved in that May. Even more awkward for the Protestant parson Van Gogh, the house was owned (and occupied) by the sexton of St. Clements, Johannes Schafrat. Vincent told Theo nothing about the studio's high visibility or his Catholic landlord, but described it only as "large and quite dry." Rather than apologize for the added expense, he boldly announced his plans for the new studio: "I again have space enough to be able to work with a model," he wrote. "There's absolutely no saying how long it will last."

By the time Rappard arrived in late May, Vincent had decked out the front room of the handsome, brick-faced house on the Kerkstraat exactly like the Schenkweg apartment, filling the walls with his drawings and paintings and the other "ornaments" of a proper artist's studio. He had retrieved all his models' costumes and attributes from storage in The Hague and organized them for the coming campaign of figure drawing. The new spinning wheel was positioned in

the middle of the room. He hung his prized drawing of Sien, *Sorrow*, in a place of honor. Everything was ready for the "hunt" (his word) to begin.

"Rappard and I have made long excursions," he reported to Theo, "visited house after house and discovered new models. . . . I get back my high spirits, *as if I were twenty.*" In approaching a house, even one where he was known, Vincent pushed the younger man forward. Rappard's good looks and ingratiating manner found willing subjects almost everywhere—especially among the women—even without the incentives of money, liquor, tobacco, and coffee that Vincent had to offer.

It was probably on one of these hunting expeditions with Rappard that Vincent first secured Gordina de Groot as a model. As a neighbor of Pieter Dekkers, a weaver whom Vincent had drawn at his loom, Gordina no doubt knew the *schildermenneke*, at least by reputation, by the time he appeared at her door with his handsome companion. Vincent probably knew just enough about the twenty-nine-year-old Gordina, too. Her father had recently died and she lived with her mother, two younger brothers, and a strange extended family of aging unmarried relatives, all crowded together in a little hut on the road to Gerwen. Over the next year, she made many trips to the studio on the Kerkstraat, posing at the spinning wheel and elsewhere for Vincent's relentless hand. Her name was Gordina. Locals called her Stien. Vincent, for reasons he never shared, called her Sien.

But this was not the same Victorian fantasy of rescue as in The Hague. In response to the bitter disappointments of the previous year, Vincent had fashioned a new vision of happiness—a new vision of himself. "Fortune favors the bold," he declared, "and whatever may be true about fortune or *'la joie de vivre,'* as it is called, one must work and dare if one really wants to live." In a fever of self-reinvention, he renounced a lifetime of anguished introspection and proclaimed himself a man free of scruples or regrets—a man of action, not contemplation; instinct, not reflection. He would take from life what he wanted—in women, in business, in art—without concern for the consequences. "Whether the result be better or worse, fortunate or unfortunate," he declared, "it is better to do *something* than to do *nothing*. . . . Many people think that they will become good just by *doing no harm*—but that's a lie."

For this new life, Vincent had a new vision. Instead of the solicitous policeman of English illustrations or Michelet's enlightened suitor or Dickens's humble goodheart, he saw his new example in the cynical, streetwise antiheroes of his favorite French authors, especially Zola.

Increasingly, he imagined himself as one character in particular.

Vincent had first encountered Octave Mouret in Zola's *Pot-Bouille* (*Pot Luck*). A provincial pitchman and roué, come to Paris to make his fortune, Mouret was Zola's ultimate modern man: the feral product of the new era's freedom from

traditional restraints—moral, entrepreneurial, and amorous. He hawks and woos his way to success (marrying a rich widow) in a novel seething with scorn for the "nullity" of bourgeois convention. In the dark winter of 1882, isolated on the Schenkweg with only his high principles and abused love for consolation, Vincent had condemned Zola's apartment-house Don Juan as crass and shallow. "He doesn't seem to have any other aspiration except the conquest of women," he marveled disapprovingly, "and yet he does not really love them." He saw Mouret, as he saw everything modern, as an insult to his beloved bucolic past and sublime aspirations—in short, "a product of his time." A year later, in Drenthe, he warned his brother away from Mouret's example: "You are deeper than that," he implored, "not really a man of business, [but] an artist at heart, a true artist."

But in the long months since then, Vincent had picked up *Au Bonheur des Dames*, the latest installment in Zola's Rougon-Macquart saga of the human condition, and seen Octave Mouret with new eyes. In this sweeping socioeconomic allegory, the scheming street-salesman of *Pot-Bouille* has ridden the wealth of his now-dead wife to the heights of *haut-monde* Paris. As the captain of a huge department store called Au Bonheur des Dames (The Ladies' Delight), Mouret conquers women shoppers by the thousands and seduces an entire city with the aphrodisiac of consumerism. After the claustrophobic *Pot-Bouille*, Zola gives the tawdry Provençal a stage as grand as a Haussmann boulevard to ply his marketing prowess, both commercial and sexual, and parade the earthly rewards of *la joie de vivre*.

This time, Vincent found much to admire. "I like him much better than I did in the first book," he wrote of Zola's predator protagonist. Instead of pitying Mouret's cynical, opportunistic view of life, Vincent envied his manliness and passion. He lauded his unapologetic egoism, boundless enthusiasm, and take-no-prisoners boldness. He cited approvingly Mouret's determination to "*live intensely,*" and copied out his carpe diem philosophy: "Action is its own reward—to act, to create, to fight against the facts, *to conquer them or be conquered by them,* is the source of all human joy." The test was simply this, said Mouret: "Are you enjoying yourself?"

Rather than disparage Mouret to his brother, Vincent now emphatically urged Theo to emulate him. "I wish we had Mourets in the *art trade*," he wrote. "[They] would know how to create a *new and larger* buying public. . . . If you are no artist, then try to be a *dealer* like Mouret." Finally, completely reversing his earlier indignation, he embraced Mouret's shameless exploitation of women ("I want her, I will have her"), maintaining that any other attitude led only to emasculation and mediocrity. Transcribing long passages from the book, he urged Theo to "read your Mouret over again"—just as he had read Michelet—and he adopted as his own motto Mouret's leering slogan: "*Chez nous on aime la clientèle*"

(Here, we *love* our customers). He proclaimed himself the Mouret of the heaths, worshipping the sturdy, somber peasant women of Millet just as Zola's hero worshipped the bourgeois housewives of Paris. "The two passions are one and the same," he declared.

Through the summer and fall of 1884, Vincent played out his new fantasy of self. In addition to "flattening the corn" with Gordina and no doubt others, he took up Mouret's injunction to "act": to take charge of one's own fate. *"Do a great deal or drop dead,"* he proclaimed. Redoubling his campaign of the spring to make more salable works, he turned almost entirely to painting and to commercial subjects like peasant vignettes and country churches, "splendid sunsets," and, in fall, the *"chûte des feuilles"* (fall of leaves). He returned to the water mills without Rappard and painted them repeatedly in both oil and watercolor.

But it was no longer enough just to *make* more salable works. Mouret enjoined Vincent to *sell* them. Building on the frustration he felt toward Theo's long inaction, he revived his scheme from two years before for a "combination" of artists—an art market run by and for artists—and continued to plan a trip to Antwerp, or even a move, in order to "get some connections" and "find my own way for my work." At the end of the summer, he took a few of his paintings to a photographer in Eindhoven and had reproductions made in several sizes, with the intention of "sending them to some illustrated papers, to try to get some work, or at least to become known." He probably also displayed his pictures at the store in Eindhoven, Baijens's, where he bought his paints.

Using his frequent trips into town for supplies, Vincent also began a concerted campaign to establish himself in Eindhoven's tiny community of amateur artists and art lovers. Through the owner, Jan Baijens, he solicited introductions to the store's bourgeois clientèle, no doubt advertising his connections to the house of Goupil and his training with Anton Mauve. Other times, he hung around the store "abundantly volunteering his insights," according to one patron, holding forth on the sins of "chicness" (referring to Impressionism) and the joys of plein air painting. Baijens's had a framing service, too, and Vincent monitored the paintings being brought in, searching for prospective students. On a visit to a printing shop, he saw some works by the owner's son and persuaded the boy's parents to send him to Nuenen for lessons. Twenty-two-year-old Dimmen Gestel was the first "student" to make the trek to the sexton's house on the Kerkstraat. "There he stood," Gestel recalled,

> the short square little fellow, who was called the little painter man by the farmers. His weather-beaten and tanned face was defined by a somewhat red and bristly little beard. Probably because of his painting in the sun his eyes were slightly inflamed. While he talked about his work, he mostly held his arms crossed in front of his chest.

Others followed. Over the course of the fall and winter, Vincent successfully sold his services to several amateur painters in search of mentoring, although most took their lessons at their homes in Eindhoven and only rarely visited the studio in Nuenen. Unlike Gestel, these were not art students but "Sunday painters"—men who had grown up with the same bourgeois pastimes as Vincent himself. Willem van de Wakker often crossed paths with Vincent going from his boardinghouse in Eindhoven to his job as a telegrapher in Nuenen. "He was by no means an easy master," Van de Wakker later recalled. Anton Kerssemakers, at forty-two, ran a successful leather tanning business and spent his leisure time painting. He had already begun to redecorate his office with a series of landscape murals when Vincent heard about the project through Baijens. Vincent marched straight to the tanner's shop and offered his services. "There is indeed some good in this," he told Kerssemakers after surveying his plans for the murals,

> but I advise you to make still-lifes first, not landscapes. You will learn a lot more from that. When you have painted about fifty of those, then you will see some progress, and I am prepared to help you with it and to paint the same objects with you.

Vincent directed all his new students to the easier execution of still lifes, rather than the devilish figure drawing he had championed for so long. "Painting still-lifes is the beginning of everything," he told Van de Wakker, reversing years of fervent rhetoric on behalf of both drawing and figures. He himself painted dozens of still lifes that winter, filling canvas after canvas with the comfortable, conventional imagery that he had long eschewed: bottles and jugs, mugs and bowls, and even flowers.

But two Mouret-like projects, in particular, dominated the summer of 1884: one artistic, one amorous.

Antoon Hermans was a rich man—no doubt the richest of Baijens's customers. He had built his fortune on the new bourgeoisie's taste for the oldest form of wealth: gold. With a goldsmith's skills and a trader's instincts, he had made enough to retire in opulence by the age of fifty-seven. A jovial, enthusiastic man, he wore his wealth lightly, but openly. No one could miss the big new house he built on the Keizersgracht in the shadow of Eindhoven's equally ambitious new church, St. Catharina. In fact, he had so admired the spiky-towered church that he hired its architect, Pierre Cuypers (the architect of the new Rijksmuseum nearing completion in Amsterdam), to design his retirement palazzo. Hermans fancied himself both a pious man and an art patron, and the new Gothic style perfectly suited his twin tastes for richness and spirituality. He traveled exten-

sively in search of art and antiques to fill his new house, and took a personal role in finishing its lavish interiors. At sixty, he turned his artisan's hands to a new craft, painting, and immediately set to work on an ambitious plan to cover the walls of his dining room with religious images "in a modern Gothic style."

As soon as Vincent heard of Hermans's project, he hurried to the house on the Keizersgracht to offer his services. Instead of the mock-medieval *cabinet* of saints that Hermans had envisioned, Vincent urged him to undertake a more modern theme: peasants at work. "I told him that the appetites of those sitting at the table would be considerably more stimulated," he wrote Rappard, "if they saw scenes from the rural life of the district on the walls instead of mystical Last Suppers." He proposed a series of scenes symbolizing the four seasons: sowing in autumn, wood gathering in winter, herding in spring, and harvesting in summer. Hadn't "medieval" painters like "Peasant Breughel" taken up just such subject matter? he asked.

As was his habit, Vincent argued vehemently on behalf of his vision, even offending the pious Hermans with his antireligious rhetoric. But for the new Vincent, commerce trumped conscience. When Hermans hired him, but demanded that he fill six spaces instead of four, Vincent revised his scheme to fit. When Hermans wanted more figures in each image, not just two or three, Vincent added them. When Hermans decided to paint the panels himself, Vincent agreed to make scaled-down preliminary sketches—cartoons—to help guide him. When Hermans asked for full-scale oil sketches so that he could copy them more easily, Vincent obliged. After years of excoriating Rappard for debasing his talent with "undignified" projects—and only a few months after declaring "seriousness" his only standard—Vincent reveled in the success of his "decorations" for Hermans's house, explaining to Theo how his designs "harmonized with the woodwork and the style of the room."

At times, Vincent expressed a certain condescending fondness for his aging patron, who was almost exactly his father's age. "It is really touching," he wrote Theo, "to see how a man of sixty tries hard to learn to paint with the same *youthful* enthusiasm as if he were twenty." At other times, he disparaged Hermans's abilities ("What he makes is not beautiful"), criticized his color choices, called his antiques "ugly," and referred to him belittlingly as "my art lover." But he continued to meet Hermans's every request, working long days to curry and keep the old man's favor—working so hard, in fact, that Pastor Dorus complained of Vincent becoming "irritable and over-excited" because of "the exertion of going back and forth in the heat to Mr. Hermans and talking about the work."

Vincent never said how much Hermans paid for these extraordinary efforts. Indeed, he staunchly maintained to his brother that the affable goldsmith was, in reality, "stingy rather than generous," and, as a result, he ultimately made

"a whole lot less than nothing" on the project. He boasted to Rappard, however, that Hermans agreed to pay not just for his materials, a considerable expense, but also for his models—a very lucrative arrangement for a man with Vincent's voracious eye.

Margot Begemann was a spinster daughter of Nuenen's richest Protestant family. She and her two older sisters, also spinsters, lived next door to the parsonage. Their father, a previous pastor in Nuenen, had built the grand brick house called Nuneville on the eve of his retirement, assuming, no doubt, that his three daughters (out of a total of eleven children) would never marry. He died two years later, his wife a year after that, leaving the three middle-aged sisters alone in a grandeur of disappointment on the town's main thoroughfare. At forty-three, Margot was the youngest of the three. Born in Nuenen and never educated outside her home, she hardly knew the world. Her parents' punitive piety and her own homely appearance had condemned her to a life of private pleasures and earnest helpfulness. Within her extended family, she was known for her "sensitive spirit and good heart," according to her niece, and for her tireless attentions to sick friends and relatives. A single romantic injury in the distant past and decades of withdrawal had left her in a permanent state of fragility, high-strung and histrionic, her sole emotional attachment the sympathy she felt for the afflicted in her care.

It was on one of her missions of mercy that Margot first met the neighbors' unknown son, Vincent. She had flown to Anna van Gogh's bedside as soon as she heard of her accident in January. She returned again and again over the next six months, tending to Anna's wardrobe, reading to her, assuming her parsonage duties. "We have such precious help in Margot Begemann," Dorus wrote to Theo. Margot no doubt admired Vincent's like devotion to his mother's recovery, and she immediately took a schoolgirl's interest in the enigmatic painter thirteen years her junior. And in his art. Indeed, it may have been Margot's well-meaning but unwelcome curiosity—about his sales, about his relations with Goupil, about "why others sell and you don't"—that triggered Vincent's demand in March for a new, face-saving arrangement with Theo. ("A constant watch is being kept on what I do with my work," he had written, "trying to find out everything about it.") According to her niece, Margot rose every morning "before the crack of dawn" to watch from the big windows of Nuneville as Vincent set out on his sketching trips, "bashful and deep in thought, and always dressed the same." In his odd burden and lonely labor, his seriousness and solicitude, she had finally found a kindred spirit.

For the first seven months after he met her, Vincent said nothing to his brother about Margot Begemann. By the time Rappard arrived in May, Margot was visiting the studio on the Kerkstraat, but Vincent apparently did not intro-

duce her to his friend, nor did he refer to her in any subsequent letter. He and Rappard made a sketching trip to a linen mill owned by the Begemann family, but Vincent either kept his connection secret or considered it not worth mentioning. As Margot joined him more and more often on walks, Vincent began to take some pleasure in her self-abasing attentions. "Recently I have been getting on better with people here than I did at first," he reported to Theo, without mentioning names. "One decidedly needs some distraction; if one feels too lonely, the work always suffers."

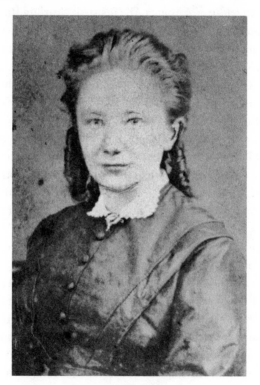

MARGOT BEGEMANN

Sometime that summer, the advantages of a liaison entered his thoughts. Margot was not just the youngest Begemann sister, she was a part owner of the family business, having used her own legacy to rescue her brother Louis from bankruptcy in 1879. Vincent's family was struggling financially, with medical bills to pay and daughters to dower. In July, his youngest brother Cor, now seventeen, had to withdraw from school and take a job at another nearby factory owned by the Begemann family. At about the same time, Vincent began to encourage Margot's affections with gifts of books and flowers and, of course, his own art. They hid their relationship from both their families (although Dorus

suspected something). Both would have disapproved: the Begemanns for fear of Vincent's ultimate intentions; the Van Goghs for fear of the inevitable embarrassment.

Even with such dim prospects, Vincent plunged ahead. "The man of faith, of energy, of warmth . . . will not be put off so easily," he wrote Theo, quoting Octave Mouret. "He wades in and does something and stays with it, in short, he violates, he 'defiles.' " Vincent would later describe the months of his clandestine courtship in terms taken directly from Mouret's manual. He was merely *"disturbing the tranquility of a woman,"* he insisted; "hurling [her] back into life, into love." He compared Margot to "a Cremona violin that has been spoiled by bad, bungling repairers"—"a rare specimen of great value" that was "rather too damaged," but could still be played upon. Vincent may not have wooed Margot for her money, as Mouret would have done; but her money, like her wounded spinsterhood, no doubt played a role in his Mouret fantasy of advantageous conquest. "I had her in my power," he boasted.

Unlike Zola's cad, however, Vincent had no experience with the power of being loved. While he clung blithely to his fantasy, the relationship rushed toward inevitable catastrophe. On their long walks, Margot would confide, "I too have loved at last," and profess her readiness to die for him. But Vincent "never paid any attention," he later admitted. Not until mid-September did her pleading vows of love unto death and other unspecified "symptoms" begin to unsettle him. Fearing that she might be developing "brain fever," he consulted a doctor and quietly alerted her brother Louis.

But the warnings didn't alter the image of amorous daring in his head. Only a day or two later, he maneuvered himself onto a sofa with Margot when her sisters were out of the house. A niece, come to pick blackberries in the garden, saw them together and reported their shocking intimacy to her mother. The alarm sounded throughout the Begemann clan, according to the niece's later account. "That degenerate son of the minister" who "fancies himself a painter" and "is always broke" had compromised Margot's maidenhood and "sullied the good name of the family Begemann." Vincent and Margot were immediately summoned to a Begemann family council, where the sisters excoriated Margot for her indiscretion and mocked her protestations of love. Vincent listened with rising fury until he finally exploded. "I will marry her," he announced, pounding the table, "I want to marry her. I *must* marry her."

The assembled Begemanns took his surprise proposal as a confession that Margot was pregnant. The council erupted in reproach. One of the sisters leaped into Vincent's face and screamed "Cad!" Marriage was unthinkable. Margot was too old, they insisted: too old to marry, too old to bear children, too old to be so foolish. She must be sent away immediately. To avoid scandal, a friendly, discreet doctor must be found to take her in and deal with the consequences of her

indiscretion, whatever they might be. Vincent protested mightily, according to his later account, defending his actions and Margot's honor, denouncing the charges against them as *"groundless and malicious."* "I gave as good as I got," he claimed. He repeated his proposal of marriage, only this time as an angry ultimatum: "It has to be now or not at all."

But nothing he said could reverse his banishment, or hers. A few days later, on the eve of her departure for Utrecht, Margot met Vincent in a field on the outskirts of town—a furtive and surely forbidden final encounter. In a letter to Theo, Vincent described what happened next. It was his very first mention of Margot Begemann:

> She slipped to the ground. At first I only thought it was weakness. But it got worse and worse. Spasms, she lost her power of speech and mumbled all kinds of things that were only half intelligible, and sank to the ground with many jerks and convulsions . . . I grew suspicious and said, "Did you swallow something?" She screamed "Yes."

Like Madame Bovary, she had taken strychnine. But not enough to kill her. Vincent forced her to vomit and rushed her to a doctor in Eindhoven, who administered an antidote. Family honor immediately closed over the incident and Margot left for Utrecht amid private opprobrium and public suspicion. It was given out that she had "gone abroad."

The "terrible" events of September poisoned Vincent's fantasy of *la joie de vivre*. In a flurry of letters, he tried desperately to save it. He decried Margot's mistreatment at the hands of her family, heaping special blame on her sisters for their false accusations that drove *"so many nails into the patient's coffin."* He broadened his indictment to include all "respectable people" with their bourgeois small-mindedness and their "damnable icy cold" religion. "They are perfectly *absurd*," he fulminated, "making society a kind of lunatic asylum, a perfectly topsy-turvy world." He even invoked the Revolution's call for "a change in the social position of women . . . with equal rights, equal freedom."

But at the same time he invoked his special rights as a partisan of Octave Mouret to "break the stagnation" of women, and continued to maintain that he had done Margot a favor by rescuing her from the melancholy of a loveless life. ("She had never really loved before," he explained.) His own actions may have been impulsive, even foolish, he said, but they were at least *manly actions*. "Aren't those who never do anything foolish," he challenged, "even more foolish in my eyes than I am in theirs?"

Unlike Mouret, Vincent insisted that he really did love Margot. "I believe without question," he declared, "that she loves me [and] I love her." But in his belated protestations, as in all his claims of injury and injustice, one can hear

Vincent fending off the persistent inner voice of self-reproach. He steadfastly withheld the details of his involvement from his parents, and ordered Theo to do the same. He invented elaborate deceptions to hide the full, humiliating truth from his brother. Instead of admitting that the Begemann family had roundly rejected his proposal, he led Theo to believe that marriage remained a viable option, dependent only on Margot's health and the permission of her doctor—a sad echo of his earlier claim that Sien's doctor had "prescribed" marriage. And while he vehemently proclaimed his love and defended the propriety of his actions to his brother, he never said a word about Margot to Anthon van Rappard. Reporting on a trip to Utrecht in late September, Vincent told Theo that he spent "almost the whole day with [Margot]." But to Rappard he claimed that he spent the day shopping for prints.

By the beginning of October, Vincent had arranged for Rappard to visit Nuenen again later that month, and Margot Begemann's name had virtually disappeared from his letters.

But not even Vincent's stoutest denials could stop the events of September from resonating backward through the pains and failures of the past. "Domestic happiness," he wrote Theo bitterly, "is a beautiful promise society makes, but doesn't keep." His furious arguments could put off the guilt he felt over Margot's "sad story" for a time, at least (it would resurface at the end of his life), but they could not protect him from fear. In Vincent's relentless dissection of Margot's "critical nerve disease"—her "neuritis," her "encephalitis," her "melancholia," her "religious mania"—he was already exploring the dark place into which he felt himself slipping. "There are things in the depths of our souls," he confessed in a moment of introspection unknown to Octave Mouret, "that would cut us to the quick if we knew about them."

BY THE TIME he arrived in mid-October, Rappard must barely have recognized his hale companion of the previous spring. Vincent stood on the platform of the Eindhoven train station pale and gaunt as a ghost. He had not slept a full night or eaten a full meal in a month. He complained of weakness, melancholy, and "anguish." "There are many days when I am almost paralyzed," he wrote. Vincent's parents, who had lobbied for Rappard's visit in hopes of providing their "feverish" son with some distraction, may have written him in advance, as they wrote Theo, preparing him for what to expect. "We have had difficult days again with Vincent. . . . He is very irritable and over-excited . . . sad and unhappy." Melancholy had led to drink and drink had led to "violence," Dorus warned. "There is a question whether we can go on living together."

Forewarned or not, Rappard yielded to yet another campaign of invitation, this one even more frantic than the last. It had begun the day his previous visit

ended and continued through the summer with exchanges of books, declarations of solidarity, and promises of models. Vincent painted version after version of the painting he had seen in Rappard's studio in December, of a woman spinning, and advertised them to his friend. The tone of desperation was set early, in August, when Vincent scolded Rappard for his desultory correspondence. The next month, the two scuffled over Vincent's intrusive artistic advice. "Remember, *I* am making the painting, not you!" Rappard wrote, in a rare show of spleen that sent Vincent into a fit of defensiveness. Rappard had no idea why Vincent's pleas for him to visit reached a new pitch of intensity in late September.

They spent the cool days just as they always had, making long excursions into the countryside, knocking on doors and "discovering new models." They visited Vincent's art lover, Hermans, so Vincent could show off his lone commission. They sketched and painted outside when they could ("there are splendid autumn effects"), but they also spent many hours in the Kerkstraat studio, where Rappard busied himself at his easel ("he is up to his ears in work," Vincent reported to Theo) while Vincent basked in rare companionship and fantasized that Rappard would be the first of many artists to visit his Brabant studio.

But nothing was the same as before. In the previous six months, Rappard's *Old Woman at the Spinning Wheel* had been awarded a silver medal at the International and Universal Exhibition in London, and another of his works had been shown at the National Exhibition in Utrecht. "[He] is doing very well," Vincent acknowledged to Theo, comparing his friend's work to Courbet's. "It is damned well done." Rappard had journeyed to Drenthe again and returned, not in disgrace and despair, but with "a good crop of studies." As if to remind Vincent of their diverging paths, Rappard insisted they take a trip to Heeze, a small town southeast of Eindhoven, to visit a friend from Utrecht, Willem Wenckebach, another dapper artist-aristocrat, fellow medal winner, and Rappard's regular companion on sketching trips. Afterward, Vincent muttered to one of his students, "I do not like these highborn people."

It was inevitable that they fought. After almost two weeks of short days and claustrophobic nights, Rappard bristled at Vincent's bullying criticism and complained about his "manner of working"—an accusation that could have embraced everything from his crude technique to his unconventional work habits to his rough treatment of models, but surely rang with class distinction and disapproval. At some point, they may both have realized that this was the last time they would see each other.

After the stinging rebuke from the Begemanns, Rappard's withdrawal—and his successes—combined to loose the demons of guilt and self-reproach that Vincent had kept at bay with visions of *la joie de vivre*. When he finally lashed out, he chose as his target not his guileless friend, or even his distant brother,

but the original source of all his grief and pain. At a family dinner, with Rappard looking on in horror, Vincent provoked a fierce argument with his father. "Suddenly the son got so furious," Rappard recorded in a rare surviving account of his time with Vincent, "that he rose from his place with the carving knife from the tray in his hand and threatened the bewildered old man."

CHAPTER 23

The Waternix

~

FROM PARIS, THEO WATCHED HIS BROTHER'S LATEST UNRAVELING WITH
desperate dismay. Every letter from his parents brought hints of fresh outrages
and new fears. "Vincent is very irritable . . . His actions are increasingly unac-
countable. . . . He is sad and finds no peace . . . We hope for Higher Help." Theo
had seen the crisis coming the year before when he pleaded with Vincent to
come to Paris from Drenthe rather than continue his torturous homeward trek.
Even after Vincent arrived in Nuenen, Theo had done everything in his power to
mediate with money and words an antipathy well beyond either's reach. Despite
a busy year at the gallery and even a trip to London in August, he had found
time to make two visits to Nuenen that summer: twice the usual burden of over-
sight and worry. Now, despite his efforts, it had come to this: public scandal and
reports of domestic violence.

Vincent had written, too; but since the brothers' fierce argument that spring,
his correspondence had dried to a grudging trickle. Once or twice a month, a
curt letter arrived in Theo's mailbox, suspiciously devoid of personal news and
often missing the customary affectionate closing, *"met een handdruk"* (with a
handshake). Even in this wary summer lull, however, the brothers continued to
wage the battle over Vincent's art that had begun in March. They argued about
technique, with Vincent defending his drawings (and himself) from Theo's
charges of crudeness by invoking the "stately simplicity" of Golden Age masters
like Ruisdael as well as recent favorites like Jozef Israëls and Charles de Groux.
When Theo pointed out that Vincent had not yet submitted a watercolor to the
Society of Draftsmen in The Hague (as he had promised to do after his trip to
Drenthe), Vincent launched into a guilty fit of rebuttal. "I quite forgot it . . . I
am not very keen on it . . . I have not one watercolor on hand . . . [It is] already

too late for this year . . . I am in no mood for it." Instead, he announced yet more paintings and drawings of weavers directly defying Theo's disapproval.

But mostly, they argued about color.

Vincent had long felt insecure about using color. The debacle with Mauve, the expense of paint, the intractability of watercolor, and his huge psychic investment in black-and-white imagery had combined to delay any real progress in color for almost two years. "I have sometimes wondered why I was not more of a colorist," he mused in August 1883. "My temperament decidedly seems to indicate it—but up till now it has developed very little." Except for a few glorious experiments in the late summer of 1882, he had little to show for all his chronically unpaid bills for tubes of color.

Even when he tried, as in Drenthe, he could not leave the *grisaille* world of the Schenkweg studio behind. Just as he "painted" with charcoal and pencil—relentlessly hatching, shading, and smudging to imitate the vibrancy of color—he subdued his palette to a rainbow of grays, rarely using hue to do more than distinguish one object from another. He invented elaborate justifications for this reticence, arguing that he had to keep his colors in "a lower key"—"below the intensity of nature"—in order to preserve the "delicate gray harmonious color" of the whole. In his vast gallery, he found many champions (from the ubiquitous favorite Georges Michel to the elusive Max Liebermann); and, as always, he framed his muted images in a kaleidoscope of color-filled descriptions.

For all these reasons, Theo's criticism of the Drenthe watercolors in March ("not any good") had struck Vincent a wounding blow. When his brother visited Nuenen in May and repeated the criticism standing in the Kerkstraat studio, Vincent's response was immediate and galvanic. "As to drab color," he declared as soon as Theo left in a letter filled with underlining, "one must not judge the colors of a painting separately. . . . Colors can be very *luminous in a picture* that, when considered *separately,* are in fact of *a rather dark, grayish tone.*" It was the opening salvo in a debate that would propel his art on a defiant, yearlong descent into darkness.

Throughout the summer, in a series of unusually monothematic letters, Vincent channeled all his anger over past slights and all his fears about coming revelations into this single argument. He copied out pages of his recent reading from Charles Blanc's *Les artistes de mon temps* (*The Artists of My Time*), summoning no less an authority than the titan Delacroix in his defense of "gray and dirty tones." When Theo recommended the French artist Pierre Puvis de Chavannes, whose luminous, pastel vision of Arcadia, *The Sacred Wood,* had captivated the 1884 Salon, Vincent shot back with the wisdom of Jozef Israëls ("start with a deep color scheme, thus making even relatively dark colors seem light") and a storm of contrary models: from the chiaroscuro of Velázquez (whose "shadows and half-tones consist mostly of *colorless, cool grays*") to the cloudy skies of the Barbizon.

Nothing could have been further from Vincent's turgid, tenebrous views of life on the heath than Puvis's idealized depictions of the *"doux pays"* (pleasant land), with their classical figures and chalky, serene color. No doubt sensing this, Vincent roundly rejected Theo's advocacy of Puvis's "silvery tones" and passionately defended his two favorite oil colors, "bistre and bitumen"—both browns—lodging the same complaints of neglect and pleas for patience on their behalf that he had made so often on his own:

> They possess such very remarkable and peculiar qualities . . . They require some effort in learning to use them, for they must be used differently from the ordinary colors . . . Many are discouraged by the experiments one must make first and which, of course, do not succeed on the very first day one begins to use them. . . . At first I was awfully disappointed in them, but I could not forget the beautiful things I had seen made with them.

When Theo tried to reopen consideration of the Impressionists, Vincent recoiled even more sharply. Claiming both ignorance ("I have seen absolutely *nothing* of them") and indifference ("I am little curious about or desirous for other or newer things"), he dismissed Impressionism as nothing more than the elevation of charm over substance. "I do not disdain [it]," he said disdainfully, "but it does not add *very* much to the beauty of what is true."

When Theo continued to press Impressionist arguments about avoiding black and capturing the effects of sunlight, Vincent's opposition only hardened. He challenged the manliness of the Impressionists and invoked everything from the "unutterably beautiful" laws of color to the "infinitely deep" music of Beethoven in defense of his "dingy" art. Far from avoiding black, he announced yet another search, in paint this time, for an even blacker black—"stronger effects [and] deeper tones than pure black itself." And he airily rejected as "impossible or ugly" any attempt to capture sunlight in paint. Only four years before setting his easel under the brilliant sun of Provence, he condemned all such "summer sun effects" and reaffirmed his devotion to shadows, silhouettes, and twilight.

AS IF IN TANDEM, Vincent's life followed his art into the darkness. The dramatic events of September swept aside the summer debate over color (it would return with a fury the following year) as Vincent once again provoked the world into near-universal condemnation. No one, not even his amorous brother, accepted Vincent's elaborate Mouret justifications for leading Margot Begemann astray ("I would sooner perish of passion than die of boredom"). As word of the

kindhearted spinster's fate at the hands of the pastor's degenerate son leaked into the community, Vincent withdrew into surly isolation.

His letters to Theo sank into a slough of despondence ("I know well enough that the future will always remain very difficult for me") punctuated by fierce eruptions of vitriol, often in long postscripts, as guilt condensed into anger. "I cannot swallow everything," he wrote. "[It is] really too outrageous . . . Things can't go on like this." He cast Theo in the most damning role he could imagine— an enemy of the Revolution—and spun an elaborate conceit about two brothers fighting each other, perhaps killing each other, atop the barricades of the most heroic of all struggles. The stirring imagery briefly revived the dream of Drenthe ("try to know for yourself where you *really* belong"), but his thoughts always returned to the present—the "infinitely *meaningless*, discouraging, hopeless" present. His plans for the future, too, ricocheted between defiant threats to return to The Hague and despairing nostalgia for the black country.

Rappard's visit the next month plunged Vincent into a different hell. He had always felt intensely competitive with his aristocratic friend, repeatedly insisting that "we are just about on the same level" and vowing to "keep up with him." But two weeks of working together had exposed all that as delusion. In fact, a huge gap had opened between them. Rappard's silver medal, his exhibitions, his social life, his suave friends and supportive family, all had conspired to shut Vincent out. The pain of that exclusion had suffused all the bickering over technique that filled their correspondence the previous spring. In October, the sight of his friend producing "beautiful" painted studies, one after another, all "damned well done," sent Vincent into a paroxysm of competitiveness, part despair and part determination. "One comes to a dead end," he declared, "and must renew oneself." He wrote Theo letters filled with hyperventilating defenses of the past and breathless, almost babbling, impatience for the future: "I *must* strike while the iron is *hot* . . . not lose a moment . . . work must be done at *full* speed . . . I must show *very* shortly that I have again accomplished something."

In a frenzy of ambition, he pledged himself anew to the conventional goals that had always eluded him. "I warrant you," he wrote immediately after Rappard's departure, "something will happen before long—either I shall exhibit or I shall sell." With Rappard as his inspiration, he took his easel and paint box into the cold November countryside and painted a series of pleasant, conventional landscapes: a poplar lane in golden autumn hues, a country road, multiple views of the local mills.

To show his new resolve, he bought new clothes ("I am more particular about my clothes than before," he assured Theo), and offered "facts and figures" to prove that he would soon start earning a 20 percent return on Theo's money ("taking a sound view of business matters"). No doubt recognizing that he could never catch up to Rappard without Theo's help, he sued for peace, or at least a

pause, in the brothers' escalating feud. "We must make progress," he wrote, reviving the fraternal "we" of fonder days. "We must get a move on. . . . Side with me—not in a neutral way, but in an energetic, positive way. . . . Dear brother and friend, *stir up the fire.*"

As in Drenthe, Vincent filled the void between longing and dread with delusion. Without telling Theo, he wrote forceful letters to both Mauve and Tersteeg summoning their cooperation in his desperate new initiative. "Give me another opportunity to paint some studies in [your] studio," he demanded of Mauve. In exchange for owning up to past errors, Vincent imagined, Tersteeg would "renew old relations," and Mauve would give him "hints for correcting and improving my work." He envisioned himself again as a successful young artist, like Anthon van Rappard, apprenticed to a solid, serious painter and reconnected to the art world of the formidable *gérant*. "I am just taking steps to promote the direct progress of my work," he explained to Theo, who must have been both dumbfounded and appalled by his brother's overtures. "I will harp on it till Mauve gives in."

Even a quick, stinging rebuff from The Hague ("they have refused to have anything to do with me," he reported) could not shake Vincent's fantasy of vindication and advancement. "I am almost glad that Mauve and Tersteeg have refused me," he wrote. "I feel within me the power to win them over *in the end.*" In fact, he had just begun work on a series of images that he *knew* would make them see the error of their ways, he told Theo. "I see a chance of giving them convincing proof."

By early December, his studio was already filling up with the new imagery. From every wall, portrait heads peered out of the darkness. Whether on his easel or in his piles of sketches, visitors saw nothing but the solemn visages of Nuenen's anonymous underclass—peasants and poldermen, weavers and their womenfolk—captured in endless variations of bistre and bitumen. This was Vincent's grand new plan for commercial success, for winning over Mauve and Tersteeg, for ending his dependence on Theo, and for reclaiming his place beside Rappard. In fact, the series was inspired by his nobleman friend, who had spent much of his visit in October painting portrait heads—mostly women— that Vincent had enviously admired. "His visit has given me new ideas for my own work," he wrote Theo immediately after Rappard left. "I can hardly put off starting work on them."

Even the name that Vincent chose for these new images—"heads of the people"—betrayed his new commercial and competitive fever. Just as *The Graphic*'s famous series of illustrations had showcased the invisible "real people" of the working class, his series of peasant types would introduce the world to "the old Brabant race." At the same time, he claimed for his new works the commercial cachet of portraits. (In his fervor, he cast aside the doubts about his ability to

render "likenesses" that had long paralyzed his attempts at portraiture.) Surely even Mauve and Tersteeg would see the sales potential of "heads with character," he insisted. "Portraits are more and more in demand, and there are not so very many who can do them."

Gripped by this chimera of success, Vincent launched yet another manic campaign of work. His initial plan was to paint thirty heads by the end of January 1885—ten a month—and then take them on the long-delayed sales trip to Antwerp. But within a few weeks, he had raised his goal to fifty heads—almost one a day—"as soon as possible, and one after the other." Why? "Because right now I am hitting my stride," he explained to Theo. "I cannot spare a day." Convinced, as always, that Herculean labor could compensate for meager results, he hedged furiously against yet another failure. Models arrived almost every morning at the Kerkstraat studio: men and women, old and young, anyone he could pay or persuade to undergo the ordeal of his attention. He seemed to pick them for their "ugliness," one of his students remarked: flat faces, low foreheads, thick lips, weak chins, dented or turned-up noses, protruding cheekbones, big ears. He posed them in the gray winter light of his studio: men in hats, visored work caps, or fashionable Zeeland bowlers; women in elaborate Brabant bonnets, morning caps, day caps, night caps, even bareheaded. As each one sat down, he pulled his chair up very close and peered through his perspective frame.

Then he painted. Racing the early dusk, he laid his brush directly on the blank one-and-a-half-by-one-foot canvases. There was no time for drawing or blocking in the shapes. He relied entirely on his squinting eye and any sketches he might have made the night before in the gaslight. True to his arguments with Theo, he brushed on the darkest colors first—the almost-black folds of jackets and smocks and shawls, the bitumen background, the bistre faces. He couldn't wait for the paint to dry, so he added lighter colors wet-in-wet, eagerly soiling whites and ochers into grays and browns. With every errant stroke, he risked mud, as dabs of color disappeared quickly in the darkness that preceded them.

The risk demanded speed. Painting image after image, he learned an extraordinary economy of brushstrokes—a perfect match to his furious pace. Shawls and collars could be suggested in a few bold streaks; lips and chins and dimples and brows in short single strokes. Any lingering contact with the canvas could only spell disaster, so he fell back inevitably on the parallel hatching of his pen drawings and the shorthand of letter sketches, motions that came as naturally to him as writing. On the women's convoluted white bonnets especially, he worked as if the canvas were hot to the touch, fragmenting their interplays of light and shadow into fewer and fewer sorties of paint in order to save the delicate tones on which he had staked his latest bid for success. "At last my color is becoming more solid, and more correct," he reassured his brother. "I have a notion of, and sentiment for, color."

Pushing himself to go faster and faster ("I must paint a lot"), Vincent learned to complete an entire portrait in a single morning. He reached his goal of fifty heads by the end of February 1885 and still continued doing them—a record of monomaniacal labor unmatched since the orphan man Zuyderland stepped before his relentless pencil in The Hague.

Not since The Hague, either, had he found such a compliant family of models. They came not only in the mornings for painting in the precious daylight, but in the afternoons and evenings, too, to sit in the lamplight for a parallel campaign of drawn heads. To satisfy this ravenous demand, Vincent cast his net as widely as possible. Respectable people like Adriana Schafrat, wife of the sexton from whom he rented his studio, found the invitation to model "inappropriate." And nobody would sit for the strange *schildermenneke* without pay. "People do not like to pose," Vincent complained. "If it weren't for the money, *nobody* would." In Nuenen's long, cold winter, however, the single guilder Vincent spent each day on models found many takers: idled farm workers, unemployed tradesmen, weavers out of work.

As in The Hague, however, Vincent preferred to attack the same problems over and over rather than seek out new ones. More and more, he focused his manic attentions, and his money, on a small group of regular visitors to the studio, and on one model in particular: Gordina de Groot—the one he called Sien.

His letters soon rang with familiar cries: "I must have a model," "I am continually in want of models," "I wish I could take even more models." He sent leering descriptions of "peasant girls" in "dusty blue bodices," and hints of entanglements well beyond the range of his perspective frame. He spoke of "getting on a sufficiently intimate footing" with his models, "finding compensation for hussies that won't have me," and country girls "as fair and clean as some whores." He composed a fond disquisition on "the subject of women's heads": from the proper girls of Whistler, Millais, and Boughton ("girls such as our sister") to the lusty peasant women of Chardin, *"sale, grossier, boueux, puant"* (nasty, crude, filthy, stinking). He talked longingly of drawing from the nude. In the studio, he painted Gordina again and again, lavishing on her simple features the thick, dark, darting strokes perfected through a winter of ceaseless work.

She stares directly at him, her turned-up nose and thick lips relaxed in familiarity, her bonnet a voluptuous halo brushed in radiant crenellations of gray. She was the crowning achievement of Vincent's dark new art, a Mater Dolorosa in bistre and bitumen, and he defended her in the same passionate, desperate terms he had summoned to defend the masterwork of a previous delusion, *Sorrow*: "One must paint peasants as if one were one of them," he declared, "as if one felt and thought as they do, being unable to help what one actually is."

Defiance, obsession, and delusion had carried Vincent back to the Schenkweg.

—

ONCE AGAIN, the unseen marriage of emotional need and artistic ambition sent the brothers' relationship spiraling into acrimony. To support his new family of models, Vincent needed money. Theo had reduced his monthly allowance from one hundred and fifty to one hundred francs during his visit in August, so the stage was already set for a confrontation when Vincent launched his "heads of the people" series, with its extravagant calls for both models and paint. Once again, he sent pleas on behalf of his new life disguised as demands for more money and more sympathy for his art. In the panic that followed Rappard's visit, he begged his brother to send "something extra," brushing aside Theo's complaints of economic hardship with exhortations to "push on"—"What one must have, can be found." He repeatedly pressed for supplemental payments in the same near-hysterical terms that had masked his commitment to Sien: "I must manage to get an extra 100 francs . . . Is it absolutely impossible for you to let me have it now? . . . I must insist, decidedly insist."

When Theo balked—when he withheld support from Vincent's application to Mauve and Tersteeg, when he urged Vincent to give up his studio and rent a room in Eindhoven, or when he simply failed to respond promptly—Vincent unleashed a torrent of abuse. "Personally you *aren't of the slightest use to me,*" he wrote, relentlessly blurring personal and professional injuries. Once again, he accused Theo of sabotaging his art (money without sympathy was mere "protection," he scoffed) and of joining with their father in a conspiracy against him. He compared Theo to a "hussy" spurning his advances and vowed "not to force you to be affectionate toward me." Instead, he would throw himself on the sympathies of a world that had never shown him the slightest sympathy. "You have made it clear and unmistakable," he wrote bitterly in December, "that you are not going to take notice of me personally or of my work except by way of protection. Well, this I utterly refuse to put up with."

Inevitably, Vincent's parents were dragged once again into the vortex of anger and abuse. When he lived in The Hague, distance had insulated them from the worst of their son's outrages. But in Nuenen, there was no escape. Every man, woman, and child in the pews of Dorus's church on Sunday morning knew something of the pastor's aberrant son: his studio in the Catholic sexton's house, his circle of unpresentable models, his inexplicable art. They knew that Margot Begemann had been forced to flee their village on account of the strange, redheaded *schildermenneke.*

Vincent, of course, adamantly denied that his behavior had scandalized their parents. He even argued incredibly that their relations with the Begemanns had not been disrupted at all by the events of September. But Anna and Dorus's letters to their son in Paris tell a different story. "Because of Vincent

and Margot, our relationship with the people has changed," Dorus wrote. "They don't come by to see us because they don't want to run into him. Our neighbors at least. And we must say that they are right." Only days after Margot was taken to Utrecht, Dorus gloomily contemplated the possibility of being forced to leave Nuenen. "It would be difficult," he said, "but if our relationships with people become too difficult, it may come to that. These days, there is more and more chance of it."

While invoking God's ultimate protection, the parson and his wife did everything they could to shield their family from the contagion of scandal. Immediately after Vincent's affair with Margot came to light, they sent twenty-two-year-old Wil to stay with relatives in distant Middelharnis because "it will be good for her to be in different surroundings." They kept Cor, seventeen, safely in Helmond, where his apprenticeship at the Begemann factory and his friendship with a Begemann cousin might remain unsullied by his brother's miscreance. They fretted over the effects of Vincent's troubles on faraway Theo, "who [had] done so much" to prevent just the kind of family embarrassment that now befell them. Theo and all the family worried, in turn, about their parents, especially their frail father, now sixty-two.

Even before his wife's injury in January, Dorus's fragile health had begun to fail. In May, he had to resign from his position with the Society for Prosperity for health reasons, severing a Van Gogh tie that traced back to the organization's founding. Anna's slow recovery had taxed him in ways both seen and unseen as he coached her from standing in March, to walking in July, to traveling in September. Now, in addition to the worries over his wife of thirty-three years and the indignities of age, Dorus had to manage Vincent's increasingly unmanageable temper and unpredictable behavior—all within the confines of his own home. "We do our best to calm him down," he wrote Theo, barely concealing his despair. "But his outlook on life and his forms are so different from ours, that it is a question whether living together in the same place can continue in the long run."

Still, Dorus resisted for as long as possible the inevitable solution: asking Vincent to leave. He knew better than anyone his son's wounded, obstreperous heart. "We follow, and we don't want to show the way," he wrote helplessly. "One simply has to let some things happen as they may." So he waited for Vincent to follow through on his oft-discussed plan to move to Antwerp and stoically pledged to "endure and try everything" in the meantime. Too weak to risk a fight, Dorus seriously considered leaving Nuenen himself if Vincent would not. In November, when a call came from his former congregation in Helvoirt, he entered into negotiations—quietly, in order not to alarm his volatile son. "What troubles could have been spared," he lamented, "if [Vincent] had been more normal. But that is not the way it is."

As Dorus expected, when Vincent caught wind of the plan to oust or abandon him, he hunkered down in the parsonage and banished any talk of moving. He dismissed as "downright nonsense" Theo's cautious suggestion that he take rooms in Eindhoven. After almost a year of breathless anticipation, he abruptly dropped his plans to move to Antwerp, even for part of the year. He claimed that Rappard had advised him against it (a complete reversal, if true), and flooded his brother with desperate, defensive, delusive arguments that betrayed how high the stakes had risen (they continued long after Dorus declined the Helvoirt offer). The Kerkstraat studio had been the key to his success, he maintained. Without it, his career "would have been a failure." "It is certainly not for my *pleasure* that I live here at home," he protested, "only for my painting." He warned Theo that it would be a great mistake if the family "robbed" him of this idyllic workplace. "*For my painting,*" he insisted, "I *must* stay here somewhat longer still." When asked how long, he answered vaguely, "Until I have made more definite progress."

The more Theo pressed his parents' case, the more fiercely Vincent resisted it: "I *cannot* give up the studio . . . and in no event can they demand that I leave the village." He hurled his brother's careful, indirect arguments back at him, transforming them into demands for more money and, of course, more models. "I must paint a large number of heads [before leaving]," he wrote, "which will go more smoothly the better I can pay the models." He escalated their dispute into yet another clash between city (Theo) and country (Vincent), portraying his brother as an effete connoisseur out of touch with the source of all true inspiration, nature. Finally, he struck at his brother's most sensitive nerve by threatening to take their battle to its source, their father. "My situation here is a bit too tense," he hinted darkly, "and I do not find it easy to possess my soul in patience."

> Be so kind as to take this into consideration. And if you should be willing to do your best on the financial side, so that things will be somewhat easier for me, I believe there will be a chance of keeping the *peace* in the future, though it will be far from real *harmony.*

Provoked to honesty, Theo finally let slip the doubts he had long harbored about his brother's enterprise. "I am suspicious," he wrote. Whatever he meant by it—suspicious of Vincent's spending, of his reasons for staying in Nuenen, of his intentions at home, of his ultimate success—Vincent took it to mean all these and more: a sweeping indictment of his entire raison d'être. In the charged aftermath of the Begemann affair and Rappard's visit, this single word— "suspicious"—touched a spark to the dry tinder of Vincent's sensitivities.

"I don't give a damn whether you are suspicious or not," he exploded. Brand-

ing the insinuation *"vicious,"* he charged Theo with "purposely acting this way in order to get rid of me." His indignation flamed through months of letters as the word burned its way into Vincent's lexicon of guilt and grievance:

> Just because you are in an elevated position, that is no reason to be suspicious of those who are standing on low ground—where I stand . . . [If] you are suspicious of me, you yourself are the cause of this . . . You will have to take back what you said about your suspiciousness. . . . The ugliest misunderstandings are caused by suspicion. . . . Your being suspicious of me is positively improper. . . . Withdraw the word or explain it, for I will not tolerate such a thing being said to me.

The coming of Christmas, with its cruel promise of family harmony and universal joy, pushed Vincent fully into despair. The traditional Saint Nicholas Day festivities, with a Sinterklaas skit and thoughtfully chosen presents from an absent Theo, only mocked the collapse of all his family relations. He fought now even with his sisters, and withdrew almost completely from parsonage life. "He becomes more and more a stranger to us," Dorus wrote after the holidays.

Both the Van Gogh family and the world were fraught with woes at Christmastime 1884. The new global economy remained stalled, destroying businesses and sending a plague of economic refugees into cities everywhere, including Amsterdam. News of a cholera epidemic that swept through France prompted worried letters over Theo's safety. Even Uncle Cent, seeking relief from perpetual ill health in a hotel on the Riviera, was not immune from the alarm. Closer to home, another uncle, Jan the admiral, saw his feckless son Hendrik finally hospitalized for "epileptic seizures" after squandering the family's fortune and good name and driving his proud father toward an early grave. In the parsonage itself, Anna could walk, but now could not lie still in bed, condemning both her and her attendant husband to long, sleepless nights. Dorus suffered another holiday cold, the bane of the pastor's busiest season. "It is a very depressed situation everywhere," he summed up.

To this bleak background, Vincent added all his own unseasonal woes. Estranged from Theo, alienated within the parsonage, and ostracized everywhere else, he saw only loneliness ahead. Distant friends like Kerssemakers never visited. By Christmas, the liaison with Hermans had already ended in a fight and the friendship with Rappard had slipped into yet another *froideur.* On Christmas Eve, Vincent closed himself up in the cold studio to work rather than join his brother Cor skating. "[Vincent] asks no advice and seeks no intimacy," Dorus lamented. In his dealings with Theo, Vincent faced humiliation. A year of pleading, demanding, wheedling, and thundering had brought him not a single step closer to independence. He spent the entire month of December begging his brother

for a mere twenty extra francs—an effort that left him feeling "wretched" and "handicapped," he said. Worst of all, the future seemed to hold nothing better. "I have hardly ever begun a year with a gloomier aspect, in a gloomier mood," he wrote as he emerged from the holidays, "and I do not expect any future of success." As the failures mounted, he felt his courage "oozing away," he said, and the year of family turmoil taking its toll. "I cannot endure life without more peace and cordiality," he wrote on Saint Nicholas Day.

In the Kerkstraat studio, short days and bitter cold combined to deprive Vincent of his one escape and only solace: work. "I would wish for Vincent that the winter would be over," Dorus wrote fretfully. "Painting outside is of course not possible. And the long evenings do not help his work either." Whether or not Vincent was warming the darkness with alcohol, as Dorus suspected, his art remained frozen in the past. In his letters to Theo, he resurrected the heroes of the Schenkweg—Daumier and Gavarni, De Groux and Matthijs Maris—and resumed his mania for magazine illustrations, types, and figure drawing. "Perhaps it would be wise to concentrate more exclusively on the figure," he wrote, specifically citing his Hague work as his best. "By constantly studying the model, I shall keep a straight course."

In the short bursts of work that he could manage, he continued to produce dark, caricatured portrait heads, heedlessly pursuing his goal of fifty heads by February. "It will help me with the figure in general," he insisted, brushing aside his brother's repeated pleas for landscape and light. When the weather permitted, he painted from the model; when it didn't, he made drawings of his studies (he had sent a dozen to Theo at Christmas). In the winter half-light, his palette turned darker and darker as he argued furiously, in both images and words, on behalf of a world drained of color. "It will be proved beyond a doubt," he declared, hinting at the tsunami of justification to come, "that, exactly in the matter of color, I have achieved something."

Surrounded by the broken promises of home and family and Christmas, Vincent began to doubt the delusions that had brought him to Nuenen in the first place. "I have always had the impression that in Zundert there was generally a better atmosphere in the house," he wrote. "What I don't know is whether the feeling that things were better in Zundert is only my imagination. That may easily be the case."

For a man who had always coped with failure by clinging to illusions of future success and former happiness, such a frank look in the mirror held grave dangers. Vincent had approached the subject of mental illness before, but always warily and unwillingly. "I am terribly sensitive," he allowed in The Hague, "physically as well as morally." He confessed only to "nervousness" and blamed it on the "miserable years" in the black country. When people called him crazy, or treated him like a madman, as they did in Drenthe, he claimed ultimate con-

trol of the "tricks nerves play"—an inner "serenity" that kept the demons at bay. "I felt my own disease very deep within me," he wrote from the peat moors,

> and tried to remedy it. I exhausted myself with hopeless, unsuccessful efforts, it is true, but because of that *idée fixe* of getting back to a normal point of view again, I never mistook my own desperate doings, worryings and drudgings for my real innermost self. At least I always felt, "Just let me do something, be somewhere, and it *must* get better. I will rise above it, let me have the patience to recover.

But the repeated disasters of the fall had shaken his confidence in "reaching a normal point of view again." Instead, they had opened up a bleak vista on an infinity of failures, a permanent winter of "empty stupidity and pointless torture," as Zola described it in a passage Vincent copied out. And only his work prevented him from plunging into the abyss. "I think that painting can prevent worse things," he wrote, "and that otherwise it would be even worse." Steeped in Zola's world of degenerate seeds and inherited fates, Vincent imagined a Van Gogh "family failing" that had stained his soul indelibly. "I am a black sheep," he cried out in December, "a *mauvais coucheur* [ill-natured malingerer]."

Now, when his imagination ranged over the miseries of the past, it fixed on an image not of rebirth, but of damnation. Instead of the Christlike Dante, crossing the Styx to witness the torments and suffering of *Inferno*—"a sober, severe figure full of indignation . . . sad and melancholy"—Vincent imagined himself as a permanent inhabitant of that netherworld of pain: the Waternix. This demon of Scandinavian folklore lurked in lakes and rivers and tempted unwary travelers to a watery death. Vincent called it "an evil spirit luring people into the abyss." The Waternix did not just suffer eternal torment, Vincent pointed out, it dragged others down to share its terrible fate. And unlike Dante, who "went to Hell and came back," the Waternix always returned there.

Theo watched with mounting alarm as Vincent's despair played out in ever-angrier cycles of abuse. No doubt he had come to discount the periodic outbursts—one in January and another in February—when Vincent demanded an immediate, definitive separation, then added, often in the same letter, a plea for additional funds. But he must have noticed a different tone in the letters after New Year's 1885. "If it gives you any satisfaction to know that what you call 'my plans for the future' have practically fallen through," he responded acidly to Theo's New Year's greeting, "*thrive* on the thought." He talked of death—"If I should drop dead . . . you would be standing on a skeleton"—striking a note of glib fatalism unusual for Theo's eternally earnest and combative brother. Out of concern for Vincent's reaction, Theo withheld the news in January that Goupil had recorded a good sales year in 1884, an unexpected boost to his end-of-year

bonus. He also kept secret from his brother a job offer from a client who was prepared to pay him the astronomical sum of a thousand francs per month—almost ten times his father's wage. (He refused the offer after Dorus weighed in against it.)

When Vincent found out anyway, as predicted, he subjected Theo to a storm of protest and a drama of penury. Recalling Theo's recent appearance at the Nuenen parsonage, in August, wearing the latest must-have accessories for a "plush gentleman" from the big city, Vincent summoned up a bitter image of his brother. "I cannot help seeing you in my mind's eye wearing a pince-nez with sunglasses," he wrote, circling back on the accusation that rankled most. "In a sense other than the literal one, in your actions and thoughts, you are looking through dark glasses—suspiciousness for instance." His frustration at Theo for not doing more to sell his art hardened from shrill protests into bitter sarcasm. He recommended that they "leave the matter of mutual sympathy out of the question," and just "try to be *inoffensive* to each other."

On the subject of his art, especially, Vincent's tone changed. After years of accepting his brother's bland encouragements to "go on painting," Vincent posed the question to which he had always before avoided the answer: What did Theo think of his chances as an artist? "If I do *better* work later on, I certainly shall not work *differently* than now," he wrote, cutting off Theo's usual escape, baring his own doubts, and risking everything. "I mean it will be the same apple, though riper . . . If I am no good now, I shall be no good later on either. But if later on, then now too. Corn is corn."

Under different circumstances, Theo might have braved his brother's wrath and urged him to accept the inevitable—to embrace art as an ennobling pastime, not as a path to self-sufficiency. After four years of thankless sacrifice and unceasing abuse, he had finally begun to lose patience with Vincent and his contrary art. Just in the previous few months, he had finally complained about his brother's "particularly unpleasant" letters, his excesses of rhetoric, his manipulative threats, and his stubborn nostalgia for passé art. "You make me think of old people who are always saying that in their young days everything was better," Theo wrote in early 1885, after years of vainly pushing Vincent toward more modern painters, "meanwhile forgetting that they themselves have changed."

But now, more than ever, Theo dared not abandon his volatile brother. Every time a letter arrived from his parents, he heard the reticent plaints of a parsonage in turmoil. "His quick temper prevents any conversation," Dorus wrote in February. "It certainly is not easy for me to be passive." Father and son had fought over Margot Begemann and over the proposed move to Helvoirt. Dorus complained of Vincent's "unpleasant tone" ("you really cannot have a discussion with him"); Vincent, of his father's arrogance ("the man really thought he

was in the right"). Dorus compared his son's strangeness to his wife's injury, calling Vincent "the other pain I carry"; Vincent denounced his father as "my worst enemy" and angrily regretted that he had not rebelled against him sooner.

Feelings only hardened when some members of Dorus's congregation in Geldrop openly accused the parson of lax discipline—a charge no doubt illustrated by, if not provoked by, his disruptive son. For a man who prized unity above all else, the combination of defiance in his house and division in his flock sapped both spirit and health, in the depths of a bitterly cold winter. Given Vincent's erratic, even threatening behavior, his talk of death, his delusions of conspiracy, and his canteen of cognac, what would be the consequences of a real separation? Or even just discouragement?

In a desperate bid to calm his brother, save his aging father from further aggravation, and defuse the looming crisis in the parsonage, Theo made a bold conciliatory gesture. He offered to submit a painting of Vincent's to the most important annual exhibition in all of Europe: the Paris Salon.

Only a few weeks later, on March 27, 1885, he received a telegram from Nuenen. His father was dead.

DORUS HAD SPENT the whole day in Geldrop, mending fences. After dinner with friends and a piano recital, he headed back to Nuenen, a five-mile walk across the windswept heath on a freezing night. About 7:30, a passing maid heard the parsonage front door rattle. As she unlatched it, the weight of his body pushed the door open and he sank against her in his heavy overcoat. Except for his hobbled mother, Vincent was the only family member who could have been home. Someone carried the motionless preacher into the living room and laid him on the sofa. Wil rushed back from a neighbor's house—"oh it was so terrible," she described the scene she found there. She fell on her father's body in a futile effort to "restore life to it," according to one family account. "But it was ended." Dorus was pronounced dead of a massive stroke.

Four days later, Theodorus van Gogh was buried. The black procession moved from the parsonage to the little Nuenen church where the entire congregation waited with friends, church dignitaries, and fellow preachers from outposts all across Brabant. Mourners followed the black-draped bier to the Oude Toren, the ancient church tower that Vincent had often drawn and painted on his horizons. It was a short trip—only a third of a mile along a rutted road through the green winter wheat. With her bad leg, Anna may have ridden with the casket. Whether she walked or rode, Theo no doubt accompanied her. He had taken the train from Paris the same day the telegram arrived with the incomprehensible news. "He had gotten a letter from his father only the previous day," recalled the friend who took him to the station, "saying he was in perfect health. [Theo]

himself is not very strong: so you can imagine the state he was in when he left." The slender twenty-seven-year-old at his mother's side, the image of his father, was now his family's sole support.

A grave had been dug among the crooked crosses at the tower's base. The neglected little graveyard, bound in snow, had been one of Vincent's first subjects in Nuenen. Above this scene loomed the dark symbolism of the ruined church—only a few months away from scheduled demolition. The mourners at the graveside included Uncle Cor from Amsterdam and Uncle Jan, the admiral. Anna's sister Willemina Stricker, Kee Vos's mother, had come from The Hague. Devastated by the news but too sick to leave his hotel, Uncle Cent had locked himself in his room and refused to come out, even to eat.

It may have been the presence of so many witnesses to his past failures that kept Vincent in the shadows on his family's day of mourning. Funerals, even of strangers, usually moved him to heroic feats of consolation. But not this one. Uncle Jan, hardly a man of demonstrative passions, thought Vincent showed an odd "tendency to cool rationalization" in the midst of so much grief. "[He is] a bit withdrawn," Jan noted. At the viewing of the body, Vincent admonished one mourner: "Dying is hard, but living is harder still." Even afterward, in his letters, Vincent never referred to the dramatic events of March 26, nor ever expended a single word of his profligate descriptive powers on the day of his father's funeral procession through the wheat fields.

That day, March 30, was also Vincent's birthday: his thirty-second. The awkward coincidence only underscored the connection between the two events—the son's birth and the father's death—that weighed on many of the mourners. Most knew something of the pastor's long, sad struggle with his eldest son. Many had heard, or heard of, the battles in Dorus's study: the father's exasperated cries—"I cannot bear it," "it's killing me," "you will be the death of me"; and the son's unrepentant provocations. "I do not much care for deathbed reconciliations," Vincent had once said, brushing aside Theo's pleas for compromise. His last recorded conversation with his father had ended in yet another bitter stalemate. "He seems not to be able to tolerate any hints at all," the pastor had written afterward, a week before his death, "and that proves again that he is not normal." That was the judgment Dorus took to his grave unreconciled.

Whether those same memories haunted Vincent's thoughts as he watched the persistent sower finally laid to rest, he never revealed. But he no doubt heard the accusation in every pious tribute, every expression of shock, and every awkward silence. Only his plainspoken sister Anna dared to say to his face what the others were whispering: that Vincent had killed his father.

A Grain of Madness

~

VINCENT WAS TOO BUSY TO MOURN. THEO'S OFFER TO SUBMIT A PAINTING to the Salon had thrown down a gauntlet that propelled him into a panic of work in the weeks preceding his father's death. The prospect of a public reckoning so terrified him that he tried at first to escape it, protesting that he had nothing suitable to show. "Had I known about it six weeks ago," he demurred, "I should have tried to send you something."

After years of fiery demands for more exposure, he retreated into lawyerly distinctions between "pictures" fit for showing and "studies" meant only for the studio. He included all of his recent painted works (about which he had so often boasted) in the latter category, saying "only one out of ten or twenty is worth seeing." And even those "may be worth *nothing now.*" When Theo visited the Kerkstraat studio at the time of their father's funeral, Vincent gave him two of his "heads of the people" portraits and meekly suggested that he show them *privately* to Salon-goers. "It might be useful," he apologized, "even though they're only studies."

He also showed his brother the first sketches of a new work—something "larger and more elaborate . . . a more important composition." This was Vincent's *other* response to Theo's unexpected challenge, and to his father's sudden death—not guilt, but defiance. "After more than a year of devoting myself almost exclusively to painting," he declared, "it's safe to say that [this will be] something quite different." For the next month, in a fury of work, Vincent silenced the whispers and filled the emptiness with his newest fantasy of vindication. "People will speak of unfinished, or ugly," he wrote, defending himself as well as his art, "but my idea is to *show them by all means.*"

—

THE IDEA FIRST touched paper sometime in March, before his father's death, with a loose, blowsy sketch of peasants seated around a table. At the time, Vincent was spending many evenings at Gordina de Groot's tumbledown cottage on the road to Gerwen, and he later claimed as his inspiration the sight of Gordina and her family at the dinner table. But the image that took shape in April, in a torrent of drawings and painted studies, tapped much deeper and more tangled roots.

From the start of his artistic enterprise, Vincent had longed to portray people in groups. Whether miners trekking to their labors, lottery ticket buyers, peat cutters, sand diggers, potato grubbers, or funeral mourners, he had always seen his relentless figure studies as only a means to an end: preparation for something more elaborate that would both consummate and redeem his years of drudgery. Even as his studio and sketchbooks filled up with hundreds of images of lonely figures and empty landscapes, depictions of people *connecting*— through labor, through leisure, through love—continued to haunt Vincent's art and preoccupy his ambitions. Indeed, he had come to Nuenen from the lonely heaths of Drenthe with a dream of painting his own family, just as he had drawn his ersatz family in the Schenkweg soup kitchen.

JOZEF ISRAËLS, *Peasant Family at Table,* 1882, OIL ON CANVAS, 28 X 41³/₈ IN.

No doubt, Vincent saw the tableau of the De Groots at their table through a kaleidoscope of other images. From the monumental laborers of Millet to the idealized rustics of Breton to the bathetic simplefolk of Israëls, he had memo-

rized the era's narcissistic fascination with its own humble past. He had also absorbed scores of images of families at table, sharing both food and prayer. Since the seventeenth century, when English and Dutch Pietists put mealtime "grace" at the center of domestic religious life, artists from Jan Steen to Hubert Herkomer had celebrated this daily ritual in paintings and prints. Vincent ardently admired Charles de Groux's *Le bénédicité* (*The Benediction*), a solemn, *Last Supper*–like panorama of a peasant family giving thanks; and he hung Gustave Brion's version of the same scene in his room in Amsterdam. Masters of nostalgia like Israëls had revived the subject, with and without prayer, for the new, backward-looking bourgeois class.

In The Hague, in 1882, Vincent had seen one of the many variations on Israëls's hugely successful *The Frugal Meal,* and proclaimed Israëls "the equal of Millet." Younger artists, inspired by Israëls, had taken up the subject, too, until heartwarming dinner table scenes had become ubiquitous. To find examples, Vincent had to look no farther than his portfolios of magazine illustrations, or the studio of his friend Anthon van Rappard, whose paintings of institutional "families" gathered around tables had impressed him on his visits to Utrecht.

In the storm of argument to come, Vincent would claim all these, and more, as godfathers to his new work. But for a man who could still recite his father's dinnertime blessing, no mere image could match the resonance of the empty chair at the head of the parsonage table. When Vincent looked at the strange, extended De Groot family gathered in the yellow lamplight, he could not help but see the oil lamp that lighted every dinner of his childhood, and the table at which he was no longer welcome.

In the first week after the funeral, Vincent worked furiously to bring forth the image in his head. He made drawing after drawing of figures around a table, experimenting with their placement, their posture, the way they perched on their chairs. He returned again and again to the house on the Gerwen road to check his vision against Gordina's ever-willing and seemingly oblivious clan. He sketched the cottage's gloomy interior, with its beamed ceiling, its broken glass transom, and its yawning, soot-stained hearth. He peered into the darkness to make detailed studies of everything from the clock on the wall to the kettle on the fire to the knobs on the chairs.

Back in the studio, the denizens of this world took form. Vincent may have started with life sketches of the De Groots and their housemates, the Van Rooijses, but his eager ambition soon transformed them into something new and strange. For all his practice, Vincent had never mastered the casual precision required to render the human face, especially on a small scale. His hand fell naturally into the exaggerations and shortcuts of caricature. In an era addicted to stereotypes, he found encouragement for his weakness everywhere. His hero Millet had portrayed peasants as simple beasts. Like Millet, Vincent had learned

from the pseudosciences of physiognomy and phrenology that a peasant's features should echo those of his bestial cousins: the low forehead and broad shoulders of an ox, the sharp beak and small eyes of a rooster, the thick lips and saucer eyes of a cow. "You know what a peasant is," he later wrote, "how strongly he reminds one of a wild beast, when you have found one of the true race."

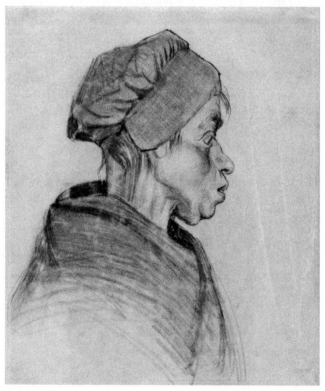

Head of a Woman, 1884—85, CHALK ON PAPER, 15³/₄ X 13 IN.

Like Millet, Vincent wanted his depictions to celebrate not just the peasants' oneness with nature (their "harmony" with the countryside) but also their stolid resignation in the face of crushing labor—the same noble resignation he had admired in the old cab horses of London, Paris, and Brussels, hauling dung or ashes through the streets "patiently and meekly . . . await[ing their] last hour." Throughout the winter, in his endless portrait heads, Vincent had worked to endow his models' faces and hands with the immortality of toil. Now he brought all those lessons to bear on a final flurry of preparatory studies, both drawn and painted, for the figures around the table.

To give these humble beasts the solemnity and significance they deserved, he set them in their natural habitat: darkness. He had long been fascinated with the gloomy cottages—"caves," he called them—in which families like the De

Groots lived. But not even his darkest palette could penetrate the almost total obscurity of these thatch-roofed hovels. In the past, he had solved the problem by placing his figures against the bright light of a window, or by carving them out of the darkness in a woodcutter's economy of highlights. Even before he became an artist, his imagination had been seized by the drama of objects emerging from shadows, or silhouetted against coronas of backlight. To him, "effects" like these revealed an immortal dimension, and as early as Etten he had begun experimenting with them. "I want something broad and audacious, with silhouette and relief in it," he said of his group drawings in The Hague. In his images of weavers, he enlisted both shadow and silhouette to confer sublimity on his simple subjects, as well as to conceal his awkward drawing.

For his new tableau of peasants around a table, he sketched the scene both ways: at a midday meal in front of a window, and at supper in the chiaroscuro of lamplight. He quickly decided on the latter, darker vision: he would portray his diners in the blackness of their night meal, revealed only by the yellow light of the oil lamp over the table. He had already practiced this Stygian palette in several paintings in March, creating elaborate mixes of hues to achieve a narrow range of brown-green, green-blue, and blue-black—what he called "the color of dark soft soap."

Almost no pigment traveled from tube to canvas untouched, uncut, unbroken by his relentless pursuit of these minute variations in tone. Pleats in a skirt or objects on a wall were differentiated with only the slightest lightening or darkening. Highlights on the table or the hands engaged a host of hues—Prussian blue, Naples yellow, organic red, brown ocher, chrome orange—to achieve an unnamably neutral gray. Vincent had recently steeped himself in color theory, reading books by Eugène Fromentin and Charles Blanc (he copied out long passages from the latter). Following Millet's example, he had even started taking piano lessons, convinced that musical tones could teach him more about color tones. But he subordinated all these "scientific" lessons to his poetic vision of the cavelike cottage ("a glimpse into a very gray interior") and months of championing "a low scale of colors."

Only days after completing the portrait-sized study, he attacked a larger canvas (two and a half by three feet) with his broad, dark brush. In the week after Easter, working "continually from morning till night," he struggled to find a new and better expression of the scene he imagined. Frustrated, as always, with the mysteries of the human body and the complications of modeling in such a limited range of colors, he fought a "tremendous battle" with his materials, he reported, working and reworking the figures until the paint became too dry to manipulate, but too wet to paint over. Although he trudged many nights to the De Groot house to refresh his imagination in the lamplight, he relied increasingly on his portrait studies of the winter for the faces and hands around

the table. To emphasize the claustrophobia of the little cottage, he lowered the beamed ceiling, crammed more of the room into the picture frame, and crowded it with more and more domestic details: a mirror, a clog filled with utensils, a devotional print of the Crucifixion.

Finally, responding to an unknown mandate, he radically reimagined the characters in his narrative. Instead of four hungry peasants hovering over their meager meal, as remote from each other as livestock at a trough, Vincent painted a family. Instead of Gordina's anarchic in-law household, with its coarse manners and strange relationships, he created a scene as familiar as a memory: at a table set with a tablecloth, a marital couple politely share a dish of potatoes, a matriarch pours coffee for all, and a child waits obediently to be served.

Lastly, Vincent added a new figure, a fifth person, seated in the back, a newcomer at this family ritual. He is an odd-looking man with an open, plaintive face and a hint of red hair.

FOR VINCENT, THE BOUNDARY between life and art had always been porous. At some point during the winter of 1884–85, he crossed that line. Between his evenings at the De Groot house, his unwelcome nights at the parsonage, and his open estrangement everywhere else, he found in the verities and comforts of his art an irresistible haven.

Since Etten in 1881, Vincent had claimed the mantle of "a painter of peasants." It was a fashionable designation. Like an entire generation of young artists, like Rappard, weaned on Romantic notions of nature, encouraged by governments to flatter an increasingly politicized peasantry, and lured by the commercial success of painters like Millet, Breton, Israëls, and Mauve, Vincent had answered the summons of *le doux pays*. The mandates of art, commerce, and camaraderie mixed with his burning nostalgia for the Zundert heath (where all the peasants were "simple and good-natured," he imagined) to carry him past the actual frustration and hostility he encountered whenever he ventured into the countryside. "I see paintings or drawings in the poorest cottages," he wrote on the eve of his departure for Drenthe (where the peasants regarded him as a "lunatic" and a "tramp"). "My mind is driven towards these things with an irresistible momentum."

Years of rejection by his bourgeois family and friends had only driven him deeper into the fantasy of a home among the peasants as "a painter of rural life." To support this mirage of happiness, he drew heavily on another fiction: Alfred Sensier's bestselling biography of Millet. "It interests me so much that I wake up at night and light the lamp and sit up to read," he wrote in 1882. "What a big man Millet was!"

But Sensier was more than just Millet's Boswell; he was his patron, collector,

and dealer as well. In order to provide iconic images like *The Sower* and *The Angelus* with a marketable creator legend, Sensier had dressed his subject's provincial past in a self-serving finery of sentiment and cliché. Sensier's Millet spent his childhood in the fields, sharing the "hard toil" and "rough farm-work [that] makes the daily life of the peasant." The real Millet was a sensitive son of faded gentry, a studious boy who grew up as close to Virgil's *Aeneid* as to the rocky soil of his native Normandy. If he experienced sowing and reaping at all, it was probably only in tending the family garden for a doting grandmother. With a state stipend arranged by well-connected relatives, he eagerly exchanged the *pays* of his birthplace for an apprenticeship in Paris with Goupil star Paul Delaroche, a favorite of Vincent's uncle Cent.

Sensier's Millet lived a life of solidarity with the impoverished subjects of his art. "He always had in his heart compassion and pity for the miserable poor of the country," Sensier maintained. "He was a peasant himself." In 1849, Millet escaped from city life in Paris to live among the simple people he loved, according to Sensier: to share their life of self-abnegation and poverty. He even wore their gray jersey and *sabots* (clogs)—the "livery of poverty"—so that an unsuspecting traveler might easily mistake the heavy-set, bearded man trudging through the fields for "one of those enthusiastic peasants." The real Millet, a reckless spender, knew only indebtedness, not poverty. Endowed with a keen eye for the market and great skill with a brush, he painted strategically—from society portraits to nubile young women in teasing vignettes—and in his whole career, rarely lacked for patrons, commissions, or sales.

When he "escaped" to the fashionably rustic hamlet of Barbizon in the Fontainebleau woods near Paris, the real Millet entertained a wide circle of sophisticated Parisian friends, not peasants, piling up debt and girth as amply as honorifics. Like other landed gentry, he often wore simple clothes, but he always insisted on being photographed in the splendid attire of a gentleman, and spent lavishly on tailors. In the company of artists like Charles Jacque and Théodore Rousseau and writers like George Sand, he rode the great wave of artistic discontent that rolled forward from the Revolution of 1848, with paintings like *The Sower* in 1850 and *Harvesters Resting* in 1853, the year of Vincent's birth. Soon afterward, the same wave swept Millet and the rest of the Barbizon artists to triumph at the Universal Exhibition and the Salon of 1855.

But Vincent saw only Sensier's Millet: a sentimental man-child with a vivid, maverick imagination; misunderstood by the public, spurned by critics, and hounded by creditors; a melancholic loner given to uncontrollable fits of weeping and suicidal musings; an artist filled with defiant passion and inexplicable guilt. "I don't want to stop feeling pain," Sensier quoted his subject. "Pain is what makes the artist express himself most distinctly." From the moment he first read Sensier's "great work," Vincent began layering autobiography onto hagi-

ography in his search for consolation and direction. Despite having seen little of Millet's art except in prints, he imagined himself as a satellite to his "sun," and claimed the Frenchman as inspiration for his return home from The Hague in 1883. "[When] all the influences of the past dragged me more and more out of nature," Vincent wrote, "it was [Millet] who took me back into nature."

After his own father's death, Vincent fully entered into a delusion of solidarity with the man—or the image of a man—he had always referred to as "Father Millet." He imagined his hero—and himself—living lives of tireless labor and selfless dedication to the "truth" of peasant painting. He cast Millet as both a Christlike martyr for the suffering of his noble, neglected subjects, and a prophet calling every errant, luxury-loving artist back to the humble and the infinite in art. By mid-April 1885, as his drawings and paintings of a group of peasants around a table began piling up and filling the walls in the Kerkstraat studio, Vincent had found a new father, a new faith, and a new mission. "Millet is *father Millet*," he declared, "a leader and mentor in *everything* [and] an example to painters as a human being."

In the spring that year, after the weather warmed and planting began, Vincent rose early every morning to join his flock in the fields. He dressed himself in a coarse blue linen blouse, stiff with sweat and faded by the sun to the color of a robin's egg. He always wore a hat—straw in fair weather, black felt in damp—but his face was still "weathered and tanned," according to one witness, the distinctive leather color that marked all those who worked the land. As he left the parsonage, he stepped into a pair of heavy, rough-hewn Brabant clogs, their insteps polished by use. Early-rising neighbors would have seen him clomping hurriedly toward the outskirts of Nuenen, sketchbook in hand, to catch the first furrow of the day. He planted himself in the fields and farmyards, beside whatever labor he could find. "I attack the very first thing I see people do," he wrote: pitching winter rye, chopping beanstalks, drawing water. When the fields were idle, he watched the cows being milked or the sheep being shorn, or knocked on cottage doors hoping for a chance to sketch their "splendid interiors." He wandered miles out into the heath, "traipsing and trudging" from sunup to sundown, "out in the fields just like the peasants," he boasted. He returned at twilight, "dog-tired" but uncomplaining. He assured his brother that "through exposure to the elements," his "constitution [had] become virtually like that of a peasant."

Sometimes he didn't come home at all, but stayed the night with peasant families far out on the heath where rumors of Nuenen's strange *schildermenneke* had not yet reached. "I have made some friends there among the people," he reported gleefully, "with whom I am always welcome." He shared their black bread and straw beds, and reassured himself that there would always be other strangers' houses, other fields "where nothing will be expected of me, as a stranger

among strangers." Claiming to be "sick of the boredom of civilization," he saw less and less of his family, and devoted himself entirely to "observing peasant life at all hours of the day." He studied them in their silent "musing by the fire" and in their superstitious gossip. Dispensing both money and liquor to earn their confidence, he learned how they "sniffed the wind" to foretell the weather, and where the local witches lived. (He boldly paid a call on one of them, only to find "she was up to nothing more mysterious than digging her potatoes.")

On Sundays, he took long scouting trips "far, far across the heath," looking for new subjects, "beautiful hovels," and, of course, models. Unencumbered by anything but the smallest sketchpad, he struck off from the rutted roads and beaten paths, through country so remote that he compared it to the American West. These expeditions often attracted the attention of local boys, bored and restless after Mass. Vincent still suffered their torment and mockery when he went out to paint, with his strange load of gear and even stranger images; but he welcomed them on these Sunday sojourns. He had learned to co-opt their ridicule with coins. He would pay five or ten cents for every birds' nest they brought him, depending on the rarity of the bird and the condition of the nest. "I told him I knew where there was a longtail golden oriole," one of the boys remembered years later,

a very unusual little bird. "Let's go to the tree and keep a watch out," he said. We went and waited but no bird came out. "I don't see anything," Van Gogh said. I said, "There, there." "That's a knot," he said. So I kicked the tree and the little bird flew out and startled him. Oh, that was something. He fetched a ladder and neatly cut out the nest.

He recruited boys everywhere he went, and often accompanied them on long, elaborate hunts across the heath, for birds as well as nests. He hung nets between hedges and sent his helpers to flush the birds from their redoubts. He used slingshots, too, that he made himself. He gave one to a mischievous young companion who used it to shoot out the windows of the school.

Before long, Vincent had attracted a cadre of searchers, happy to be paid for a walk on the heath, even in the company of the "ugly" and "eccentric" gentleman with the "scruffy red beard." He "was always dressed so poorly," one of them recalled, "that you wanted to give *him* something rather than accept something from him." On these long rambles in the company of peasant boys, Millet's mandate from the past fused with Vincent's longing for his own lost childhood of birds' nests and creekbanks. "I wish you had been with me," he wrote Theo after one of his Sunday adventures. "We had to wade through a brook for half an hour, so I came home quite covered with mud." He compared his needs and pleasures to those of other "peasant boys" and, in a reverie of

regression, complained of the "everlasting drivel" he had suffered from "my parents and my teachers."

As a peasant boy, Vincent felt entitled to another prerogative of his humble class: sex. He had long subscribed to the bourgeois myth that peasants fornicated just as their beasts did: at will in the barnyard and the field, free of guilt or inhibition or entanglement, whenever instinct overtook them. Now these schoolboy fantasies merged in Vincent's wishful imagination with Millet's call to "immerse himself *personally* in peasant life." By April, Gordina de Groot came to the Kerkstraat studio almost every evening, alone. Local tongues were already beginning to wag about the parson's son and his peasant "Dulcinea." Many suspected that he was drawing her in the nude.

WHEN HE READ ZOLA'S *Germinal* in May, Vincent found a new testament for his libidinous mission. Set in a workers' hell that Vincent knew well—a coal mine in northern France—*Germinal* seethes with outrage at the brutality of the capitalist system and the suffering of its victims. But Vincent's zeal looked right past Zola's scathing indictment. In a novel filled with sympathetic workers led by a failed Romantic hero, Vincent fixed his autobiographical eye on the mine's bourgeois manager, M. Hennebeau. It was Hennebeau's envious fantasies of panting, steaming sex among the underclass that Vincent copied out for his brother as confirmation of his new calling, from the highest possible source:

> Oh, that he could not let them sit down at his table and stuff them with his pheasant, while he went out to fornicate behind the hedges, tumbling the girls without caring a rap about those who had tumbled them before him! He would have given everything . . . if only he could have been for a single day the least of the wretches who obeyed him, master of his flesh . . . Ah! Live like a beast, having no possessions of his own, flattening the corn with the ugliest, dirtiest female coal trammer, and being able to find contentment in it.

But Vincent's fanatic heart demanded pain more than pleasure. He found in Millet's call to a simple life the same summons to self-mortification that he had found in Kempis's or Christ's. He dressed in rags that even the peasants pitied; he denied himself cover in the rain, and shade from the sun. When he stayed in the Kerkstraat studio, he insisted on sleeping in the attic with the dust and the spiders, rather than in his more comfortable room downstairs. "To have slept anywhere else," his landlady recalled, "would have been pampering himself." As if to deny himself the "luxury" of the studio itself, he never cleaned or tidied it. According to one horrified visitor, "great piles of ashes surrounded the stove,

which had never seen a brush or polish." Cane chairseats were left frayed and broken. Clothes and clogs, caps and hats for his models, tools and farm implements, specimens of moss and plants from his endless forays into the heath, all lay scattered about, gathering dust where they fell, disappearing under sheaf after sheaf of drawings as numberless and neglected as leaves.

He ate only the "black bread" sanctified by Millet, supplemented occasionally by morsels of cheese and always by coffee. When offered meats and cakes by friends like Kerssemakers and Van der Wakker, he would request a crust of dry bread instead. "I don't eat fancy food," he said, refusing meals that the De Groots would have devoured. "That would be pampering myself too much." But moderation soon led to starvation, as it always did when ardor gripped him. As if to out-Millet Millet ("I consider myself *below* the peasants," he said later), Vincent began to eat even less than his impoverished subjects. "I never saw a human being as skinny as Van Gogh," recalled one of the boys who hunted nests with him in a countryside filled with people who survived on potatoes. Friends like Kerssemakers blamed Vincent's strange self-abuses on his unaccountable poverty, but there was always money for cognac and tobacco. Vincent defended himself with another of Hennebeau's fantasies in *Germinal*: "He also wanted to starve, to enjoy an empty belly, his stomach twisted by cramps that staggered his brains by fits of dizziness; perhaps this would have killed the eternal pain."

Not even rejection by the peasants themselves could alter Vincent's vision of a life spent toiling and sacrificing in their name. By all accounts, people like the De Groots and the Van Rooijses considered Vincent's daily visits, at best, a profitable nuisance; at worst, a menace. The boys who brought him nests were both fascinated and repulsed by his bizarre excesses in a community that punished any hint of deviation. They took his money but mocked him mercilessly behind his back. One of them recalled venturing into the Kerkstraat studio to find Vincent at work on a painting, dressed in long woolen underwear and a straw hat, furiously smoking his pipe:

> It was a strange sight. I had never seen anyone like him. He stood some distance from the easel with his hands folded over his chest—he often did that—and stared at the painting for a long time. Suddenly he would leap up as if to attack the canvas, paint two or three strokes quickly, then scramble back to his chair, narrow his eyes, wipe his forehead and rub his hands . . . They said in the village that he was mad.

Another boy recalled Vincent in the fields, searching for a spot to place his easel. "He stood here, and then there, and then over there, and then back again, and then ahead again, until the people said, 'that nut is at it again.' " His piano teacher in Eindhoven abruptly discontinued his lessons, according to Kersse-

makers, because Vincent spent so much time "comparing the tones of the piano with Prussian blue and dark green, or dark ochre with bright cadmium that the teacher thought that he was dealing with a madman." Even those who knew him only by sight, like the customers in Baijens's paint store, referred to him simply as "that crazy little man from Nuenen."

Vincent heard the scoffs and the giggles, but pushed himself on with claims of persecution and vows of even greater effort. Millet had turned a "deaf ear to such taunts," he said, "so it would be a disgrace should one so much as waver." He would just go *deeper* into the heath—"go and live in a peasant's cottage so as not to hear or see educated people—as they call themselves—any longer." He defended what he called his "enthusiasm" and "impulsiveness" against the fears and ennui of the world, and claimed, for all artists, a *duty* of madness: *"Le grain de folie qui est le meilleur de l'art"*—the grain of madness that is the best of art.

By the beginning of May, the delusion was complete. In the evenings, he imagined himself not as a painter returning to his studio with the day's studies, but as a laborer coming in from the fields to exchange his hoe for a brush— "I am ploughing on my canvases as they do on their fields," he wrote— transforming himself from a peasant painter into a painting peasant. (He emphatically defined a masterpiece as a painting *"made by a peasant who can paint."*) Railing against the "so-called civilized world" that "banished [me] because of my clogs," he claimed a martyrdom of solidarity with all the *"common people"*— not just the potato eaters of Nuenen, but also the groundlings of Zundert, and the miners of the Borinage. He laid plans to return to the black country and "bring home about thirty studies in a month." In a fantasy of denial, he begged Theo to join him in his new life as a painter-peasant: to seize Sensier and *Germinal* as his twin gospels; to *"go about in clogs,"* eat black bread, and "live like a beast." "What pictures you could make then!" he exclaimed.

This was no delusion, Vincent insisted. The *world* was delusion. Millet's "enchanted land"—a place "where one is free"—did indeed exist, he assured Theo. The promise of it filled his head with images:

> It is a *good thing* in winter to be deep in the snow, in the autumn deep in the yellow leaves, in summer among the ripe corn, in spring amid the grass; it is a *good thing* to be always with the mowers and the peasant girls, in summer with a big sky overhead, in winter by the fireside, and to feel that it always has been and always will be so.

His mother and sisters watched in horror as Vincent disintegrated before their eyes. They had certainly heard about his previous breakdowns—in London, in Paris, in Amsterdam, in The Hague—but had never before seen one unfolding under the same roof. More than her husband, Anna van Gogh had al-

ways treasured the social distinctions and privileges of a parson's life. From the moment he arrived, Vincent had laid siege to that special status: in his strange behavior and dress, in his Catholic models and Catholic studio, in his relentless public rebellion against her husband, in his never-ending dependency, in his embarrassing art. Now, after driving her beloved Dorus to his grave, Vincent had declared himself a *peasant*! Every day that he left the parsonage and struck off toward the fields—just as he had done as a boy in Zundert—to wander aimlessly and alone among the temptations of the heath, and every night that he returned from his strange doings in the filthy hovels of the potato-eating papists, Anna must have seen God's fulfillment of all her darkest maternal prophecies.

Perhaps at his mother's instigation, perhaps in anticipation of it, Theo had recommended that Vincent leave the parsonage—leave Nuenen altogether—immediately after Dorus's funeral. Vincent had often threatened to go elsewhere, and only a few months earlier had contemplated moving into his studio. But Theo's suggestion froze him in place. "I personally see no good in moving," he wrote. "I have a good studio here and the scenery is very beautiful." Millet had regretted leaving his homeland; Vincent would not make the same mistake by abandoning Brabant. "I have no other wish than to live deep, deep in the heart of the country," he wrote, vowing defiantly to "stay here the rest of my days."

But Vincent had not reckoned on his sister Anna, who had remained in Nuenen after the funeral to help her stricken mother. Already the formidable matron of her own household, thirty-year-old Anna quickly took charge of the parsonage. Her first order of business was to eject her brother Vincent. "He had made himself impossible," she recalled years later. "He gave in to every urge, sparing nobody. How Pa must have suffered from all that." Vincent argued furiously with his sister, defending his "way of life." But Anna had inherited her mother's iron will. With the support of her sisters, she made his life in the parsonage a daily misery. Even Wil, Vincent's favorite, sided against him—an especially bitter betrayal. Still, it wasn't until Anna accused him of trying to kill their mother, just as he had killed their father, that Vincent's resistance finally collapsed. Wounded and bitter, he packed his bags and left home for the last time.

To Theo, he covered his retreat in a veil of charity. "It is *so* much for the better this way," he wrote, pretending it had been his choice. "I think those at home very, very far from sincere." He cast their dispute as solely artistic and blamed his departure on the fundamental incompatibility between "people who seek to maintain a certain social standing and a painter of peasant life who gives the matter no thought." In the same spirit of martyrdom for his art, and hoping to placate his mother and sisters, he renounced any claim to his father's modest estate. "Inasmuch as during the last years I had lived in great discord with my father," he grandly informed Rappard, "I relinquished my share in the inheritance."

But neither the living nor the dead were appeased. When the day came for the estate to be inventoried, Vincent returned to the parsonage to find his uncle Stricker, Kee Vos's father, representing the interests of his absent siblings, including Theo. Nobody other than his father had been witness to so many of Vincent's past failures. When the probate official arrived, he took one look at Vincent—with his "wild appearance and farmer's clothing," according to sister Lies—and demanded, "Shouldn't that man leave?" Anna van Gogh replied: "That is my eldest son." Whether because of the shame in his mother's voice, or the haunting presence of his disapproving uncle, or the slow tallying of his father's life, Vincent fled the house in the middle of the inventory—"without giving reasons therefor," the official noted in his report.

Vincent may have offered a glimpse of his reasons in a rare, Lear-like moment of clarity in April. Lamenting that his mother, like his father, was "unable to grasp the fact that painting is a faith," he heard the pastor's damning judgment from the grave. "This is exactly what is the matter between her and me—as it was between Father and me, and remained so. Oh dear."

By early May, he had moved everything into the cluttered Kerkstraat studio, a few blocks from the parsonage. On the easel sat a third and final attempt to paint *The Potato Eaters*, wet with endless reworkings. In the furor of his battle with his own family, he had begun an even bigger canvas, almost three by four feet, trying again to capture the phantom of familyhood in his head. He had painted and drawn and imagined the figures at the table so often that he didn't need to refer to his sketches or studies any longer. "I paint it *by heart*," he said.

Vincent had been obsessed with the image throughout his slow, painful expulsion from the parsonage. After he finished the second attempt in mid-April, he immediately announced his intention to make a lithograph of it. Without waiting for Theo's opinion of the image or the venture, he went to Eindhoven and contracted to print fifty copies. As his own home life fell apart, he reworked the image again on the stone and laid ambitious plans for an entire series of lithographs based on the same theme: *"les paysans chez eux"*—peasants at home. He sent Theo repeated sketches of the image, urging him to show it to friends and fellow dealers. He wondered if the editor of *Le Chat Noir,* a chic Parisian art magazine, "might want a rough drawing of those potato eaters," and offered to make one in any size.

Ignoring his brother's repeated discouragement, he seized triumphantly on the report that one of Theo's colleagues, a minor dealer named Arsène Portier, had "seen something" in his earlier work. He immediately wrote Portier a long letter "giving him arguments for his own instinctive feelings" and exhorting him to stand fast in his opinion. Portier's polite compliment (he said Vincent's work had "personality") whipped Vincent into a froth of anticipation in the last weeks of April. When the lithographs came back from the printer, he sent cop-

ies to Theo, Rappard, Portier, even his old Goupil colleague Elbert Jan van Wis-selingh—giving them out like cigars at a birth, celebrating not just the image, which continued to change with every iteration, but the new mission that it represented. "It is a subject that I have felt," he said. "There is a certain *life* in it."

Even as he passed out copies of the lithograph and made plans for another, Vincent returned again and again to the canvas on his easel. For the last three weeks of April, as he fought for his place at the parsonage table, he endlessly reworked his vision of a peasant family dinner. He painted and repainted the heads, exaggerating their coarse features, aging and scarifying their faces and hands. Only Gordina and the "fifth man" escaped his cruel revisions. He fussed over the finest gradations of tone, hewing to his claim that "the best way to express form is with an almost monochrome coloring." He would leap to the canvas to tame an overeager highlight, and spent hours mixing shades of gray on his palette.

From each reworking, the image emerged, if anything, even darker. After laboring for weeks on the heads, he determined that his formula for flesh color was *"much, much too light"* and *"decidedly wrong,"* so he repainted the faces yet again; this time *"in the color of a very dusty potato,"* he said, *"unpeeled of course."* He fought to keep his dark colors as dark as possible. He tinted his varnishes with bitumen and mixed his paints with balsam, a natural resin that prevented oil in the paint from sinking into the canvas, thus leaching the gloss out of dark colors and turning them matte. The balsam also kept his paint softer longer—making it a more suitable medium for his restless vision. But the softer paint dulled the bravura brushstrokes he had developed on the portrait heads over the winter, and forced him to wait even longer to make the inevitable alterations.

Vincent kept at it, week after week, working at all hours: doing in the morning, redoing in the afternoon, undoing at night, in an endless argument with himself. He claimed for all these hairsplitting revisions the loftiest possible purpose: "to put *life* into it." But as April ran out and the gloomy scene in the De Groot hovel barely changed under his manic ministrations, even Vincent realized he had a problem: he couldn't stop.

He had always tended to overwork images, especially the ones that mattered to him ("I couldn't keep my hands off them," he confessed about some spoiled drawings in The Hague). And no image mattered more than this one. He may have successfully avoided Theo's Salon challenge, but the aura of high stakes and last chances still hung over the unfinished painting. Vincent himself continued to raise the stakes with promises of "something more important," and assurances that Portier, or Theo, could send it to an exhibition when it was done. *"I know for sure* there is *something in it,"* he assured Theo, something "completely different than you have ever seen in my work." The fever fed on itself. The more he raised expectations, the more he revised, the more he delayed.

Eventually, he had to physically wrest it away from himself. At the very end of April, he carted the big canvas, still wet, to Eindhoven and placed it in the custody of Anton Kerssemakers with the instruction to "make certain I don't spoil it." Nevertheless, a few days later, he returned to his friend's studio and attacked it again with a small brush, laying down a welter of "finishing touches" on top of yet another (fourth) layer of varnish. Before those changes had a chance to dry, he hauled the painting back to Nuenen, hoping to send it to Theo for his birthday, May 1. But it sat in the Kerkstraat studio only a day or two before he loaded it up again and carried it through the dusty streets to the little house on the Gerwen road, determined "to give it some last touches from nature." He arrived to find the De Groots and Van Rooijses at dinner in front of a window rather than under the hanging lamp. The sight of them silhouetted in the waning daylight so moved him—"Oh, it was splendid!" he exclaimed—that he immediately fell on the painting again, making the hands and faces darker still ("the color of dull brass") and adding touches of "the most tender faded blue." He wrote Theo afterward in despair, "I shall never think my own work ready or finished."

Even as he tormented the painting with alterations, he covered it in a relentless varnish of words, desperately trying to shape Theo's reaction before sending it off. "I've held the threads of this fabric in my hands all winter long and searched for the definitive pattern," he wrote, "and although it is now a fabric of rough and coarse appearance, the threads have nonetheless been chosen with care." He complimented its lively color and "originality." He framed its flaws in the pathos of its subjects ("It comes from the heart of the peasant's life") and the righteousness of his purpose. "I wanted to convey a picture of a way of life quite different from ours, from that of civilized people," he explained, cutting off objections to its crudeness.

On the eve of sending it off, a last wave of panic swept over him. He worried about the painting's size, and nervously suggested painting it all over again on a much smaller canvas. He worried about its darkness, and invoked a pantheon of masters to support the desperate notion that light paintings were not as light as they looked and dark paintings, like his, not as dark. He worried that Theo would reject the work outright, and entertained not sending it to him at all. He fretted miserably over the correct freight charges, imagining that if any were due on arrival, the painting would be more likely to disappoint. Always convinced that his work looked best when viewed in the context of quantity, he sent a package of ten painted studies to prepare Theo's eye, and soften his heart, for the long-promised picture.

Finally, on May 6, he shipped the painting to Paris, packed in a cheap crate that he boldly marked "V1."

—

THERE HAD NEVER BEEN the slightest chance that Theo would like *The Potato Eaters*. Vincent had labored for a month—indeed, for a winter—on a painting that defied years of gentle urgings to light, color, and charm. How Vincent could have argued so vehemently for and invested so much hope in such an image must have mystified Theo as much as the image itself did. He had openly criticized his brother's messy, slapdash technique the year before. They had been engaged in an on-and-off argument about his "drab" palette since Vincent took up a brush. Was it reasonable—was it rational?—to respond to Theo's Salon offer with a painting so determined to displease?

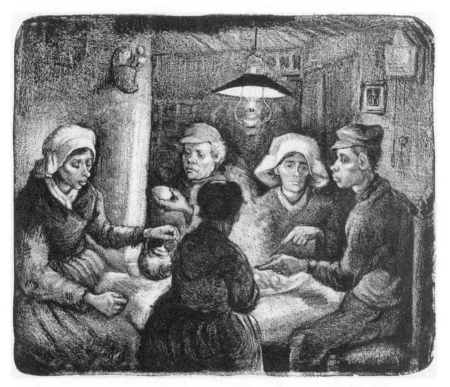

The Potato Eaters, APRIL 1885, LITHOGRAPH, $10^{1}/_{4}$ X $12^{5}/_{8}$ IN.

As usual, Theo dared not speak his mind. Worried about his widowed mother and her continued vulnerability to Vincent's misbehavior, he put family peace far above personal candor. Tactful from birth, subtle by disposition, and trained in the rarified diplomacy of Parisian retail, Theo had negotiated the perils of his brother's enthusiasm for this strange image with typical finesse throughout its long gestation. When he first heard about it at their father's funeral, he said

little, if anything, but signaled his displeasure by neglecting to take any of the preparatory drawings home with him. Once back in Paris, he relayed discouraging news about the public's (not his) indifference to Millet's (not Vincent's) work. He followed Vincent's absurd instruction to show the image to *Le Chat Noir* and reported the editor's refusal with studied neutrality. He objected to the high cost of making a lithograph of the image (not to the image itself); and after seeing a copy, criticized it only on technical grounds ("the effect is wooly"). He had balanced his own conspicuous coolness with Portier's tepid comment about "personality," and sent pacifying reports to their mother, which he knew Vincent would read. "I was happy that I could give Vincent good news recently," he wrote her in April. "He has not sold anything yet, but that will come. In any case it is certain that when someone like [Portier] sees something in it, there will be others who will think likewise."

When he received the painting, Theo promptly sent his brother a letter that both flattered his peasant subjects ("One can hear the clogs of the guests clacking") and called him to task for lapses in draftsmanship and murky colors. To soften even those glancing blows, he enclosed an extra payment of fifty francs and sent their mother another inflated reassurance. "Several people have seen his work," he wrote, "and especially the painters think it is highly promising. Some find a lot of beauty in it, especially because his figures are so true." (Theo only ever mentioned showing *The Potato Eaters* to one painter, Charles Serret, an aging genre painter of his acquaintance. "[Serret] could see that it was done by someone who has not been working long," he reported to his mother, "but he found much in it that was good.")

Theo preferred to convey his harshest critique through indirection and example. He had already tried several times to steer his brother toward the art of Léon Lhermitte, a Salon artist renowned, both as a painter and as an illustrator, for his images of peasants at work. He had sent Vincent some Lhermitte prints in response to the lithograph of *The Potato Eaters*, hoping no doubt to discipline his brother's heavy-handed drawing and awkward figures with the example of Lhermitte's meticulous draftsmanship and dynamic poses. Vincent lavished praise on the prints ("full of sentiment . . . superb"), but ignored the lesson. Theo tried again after receiving the finished painting, enclosing a review of the 1885 Salon that hailed Lhermitte as "Millet's successor" and praised both artists for the light and color of their work.

In the same letter, Theo recommended to Vincent Fritz von Uhde's *Suffer the Little Children to Come Unto Me.* He could hardly have found an image more a rebuke to Vincent's bestial cave dwellers than Uhde's delicate, sweet updating of the Gospel story, showing a line of ragged peasant children shuffling toward a seated Christ. Each is individualized in gesture and expression, without a hint of exaggeration or caricature. Although rendered in the same "green soap" pal-

ette as *The Potato Eaters*, Uhde's scene is bathed in a soft light that both reveals the dark interior and touches the towheaded children with golden highlights. Despite its impeccable technique, the painting glows with emotion—what Vincent would call "true sentiment." Like Millet, Uhde had managed to convey the sublime nobility of his humble subjects without resort to drab color or coarse drawing.

Vincent found in his brother's suave scoldings all the provocation he needed to join the battle he always sought. He would not be denied his martyrdom for art. "I believe the fuller of sentiment a thing one makes is," he wrote, further equating art and artist, "the more it is criticized and the more animosity it rouses." With his peasant fantasy and Millet messianism, he had raised the stakes so high that concession was unthinkable. Rebuffing all of Theo's examples as "cold" and "orthodox," he insisted on the uniqueness of his art and the individuality of its creator. "Let us paint," he pleaded, "and, with all our faults and qualities, *be ourselves.*" For the rest of the summer, he battered Theo with rebuttals and new outbursts of argument, each bent on the delusional goal of reversing his brother's judgment on *The Potato Eaters;* and thus on him.

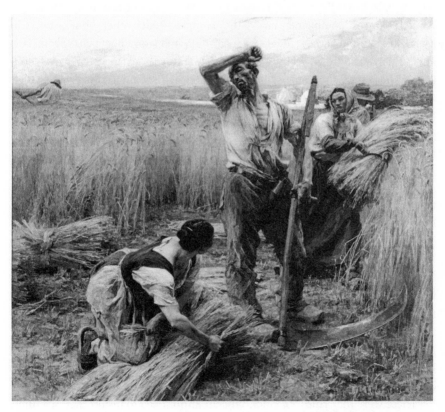

LÉON LHERMITTE, *La moisson (The Harvest)*, 1883, OIL ON CANVAS, 92 X 104³/₈ IN.

—

THEO'S CRITICISM OF the painting's colors triggered an especially fierce storm of dispute. No subject had been more worked over in their arguments, and no objection was more predictable. But Vincent addressed his brother like a schoolmaster on the first day of class, drilling him on the basics of "scientific" color theory that he had been studying all winter in books like Charles Blanc's *Les artistes de mon temps* and *Grammaire des arts du dessin* (*Grammar of the Visual Arts*), also by Blanc, the Michelet of color. He had sent Theo lengthy transcriptions from both books in April, as if preparing for this very battle.

All of nature was composed of only three "truly elementary" colors, according to Blanc: red, yellow, and blue. Combining any two of these "primary" colors produced one of three "secondary" colors: orange (red + yellow); green (yellow + blue); or violet (blue + red). Drawing on the work of the French chemist Michel-Eugène Chevreul, Blanc peered deep into the relationships among these six interlocking hues. He attached great significance to the fact that each secondary color was *missing* one of the primary colors: orange lacked blue; green lacked red; violet lacked yellow. He referred to the relationship between these pairs of unrelated colors as "complementary"—they completed each other—but he found in their interaction a fierce struggle for separation and supremacy: blue against orange, red against green, yellow against violet. The eye read their struggle as "contrast." The starker their opposition—the closer their proximity, the brighter their tone—the more violent the struggle, the more intense the contrast. Blue never looked bluer than when set next to orange; red never looked redder than next to green; yellow never yellower than when opposed by violet. At their most vivid, Blanc warned, these juxtapositions could heighten the contrast "to such a violent intensity that the human eye can hardly bear the sight of it."

Blanc offered corollaries for controlling these fierce clashes of complementary colors. (Blanc framed all his "rules" in the language of battle, no doubt another attraction to Vincent.) One could mix them in unequal proportions so that "they only partially destroy each other," producing a grayish *ton rompu* (broken tone) that favored one or the other of the constituent hues. The *ton rompu* (gray-green, for example) could then be juxtaposed to its complementary (red) to create a less intense contrast (an "unequal fight"), or to a *ton entier* (pure tone), like blue, to create a tonal harmony. Thus even the subtlest variations of tone could, theoretically, create distinct contrasts (gray-green and red-gray) or unifying sympathies (green and green-gray), and all the shades of conflict in between. Following Chevreul, Blanc called these rules about the interactions of colors "the law of simultaneous contrast."

These were the "rules" of color, Vincent announced to his brother: scientific, unchanging, unchallengeable. Blanc had done for color "what Newton did for

gravitation," he said. "Those laws of color are a ray of light . . . absolutely certain." To prove it, he cited everything from the colorful works of Blanc's hero, Delacroix, to the bright plaids of Scottish tartans. "[They] get the most vivid colors to balance each other," Vincent explained, "so that instead of the fabric being a jumble, the overall effect of the pattern looks harmonious from a distance." He insisted again and again that *The Potato Eaters* observed all of Blanc's rules and therefore any criticism of its color was necessarily "arbitrary" and "superficial." Where Theo and others saw monotone darkness, Vincent claimed a cornucopia of colors—broken but still vibrant—waging little guerrilla wars of contrast. For his impenetrable browns and grays, he claimed skeins of delicately modulated broken tones, juxtaposed in ways that untutored eyes simply could not appreciate. The painting's "green soap" tone was, in fact, a multicolored cheviot of hues, he insisted, "woven" by his brushstrokes "into a harmonious whole."

In response to Theo's criticism of the drawing in *The Potato Eaters*, Vincent made exactly the opposite argument. Instead of championing the rules, he furiously railed against them. Consistency was always an early casualty in Vincent's persuasive terrors, but his defense of *The Potato Eaters* cracked open a rift of contradiction that had run through his artistic ambitions from the start. Deprived of natural facility, he had always clung to the faith that hard work and mastery of the rules, from Bargue to Blanc, would be rewarded with success. He defensively ridiculed the notions of "innate genius" and "inspiration," while exalting his own meager tools: "drudgery," "science," and most of all, energy. But in the face of continuing frustration and failure, he had always left open another way of defining success. If an artist had sufficient *passion,* he argued whenever self-doubt overwhelmed him, nothing else mattered: not ability, not technique, not sales, not even the art itself. Criticizing the pictures in the 1885 Salon, Vincent wrote: "They give me neither food for the heart nor for the mind, because they have obviously been made without a certain passion."

The Potato Eaters had been borne on yet another wave of optimism about labor's just rewards. Vincent had approached the painting like an Academy chef d'oeuvre, with months of arduous preparatory sketches. In the weeks leading up to its completion, he had reaffirmed his faith in the "fundamental truths of drawing . . . which the ancient Greeks already knew, and which will continue to apply till the end of the world." He had fretted ceaselessly over correcting every detail of the painting "in order to make it exact." He pointed out how his drawing had improved in the final version, and assured Theo repeatedly that the figures had been drawn "with care and according to certain rules." Indeed, he insisted on their correctness and blamed Theo for seeing the subjects wrongly. "Don't forget those people do not sit on chairs like those in Café Duval," he admonished.

Only after Portier and Serret added their voices to Theo's criticism (Serret had pointed out "certain faults in the structure of the figures") did Vincent abandon

his claim to "lifelike" figures and fall back on his last line of defense: passion. In a furious about-face, he dismissed conventionally correct drawing and correct figures as "*superfluous*—even if drawn by Ingres himself"—and declared defiantly: "*I should be in despair if my figures were good.*" He praised the "almost *arbitrary*" proportions of caricature and scoured the vast gallery in his head for examples of "inaccuracies, aberrations, reworkings, transformations of reality—lies, if you like" that marked the work of "true artists." Art demanded more than correctness, he intoned. It demanded a truth "truer than the literal truth." It demanded authenticity, honesty, intimacy, modernity—"in short, life."

To Vincent, still in thrall to Sensier's Millet, "life" meant only one thing. Whatever its technical shortcomings, *The Potato Eaters* expressed peasant life *as it really was:* peasant life, not "perfumed" with color or "polished" with correctness, but "smelling of bacon smoke and potato steam" and "reeking of manure"; peasant life as he, and Millet, had actually *lived* it—not as imagined by city-dwelling painters whose "*splendidly* done figures . . . cannot but remind one of the suburbs of Paris." He schooled Theo with a passage from Sensier's book about Millet's masterwork, *The Sower:* "There is something great, and of the grand style in this figure, with its violent gesture, its proud raggedness, which seems to be painted with the very earth that the sower is planting." In his fever of justification, Vincent grasped this poetic metaphor as a universal principle. "How perfect that saying of Millet's about the peasants is," he wrote. "*These peasants seem to be painted with the soil they sow.*"

He repeated this mantra again and again, using it to exempt both his colors and his figures from all the "ordinary rules" imposed by "dupes of convention." *His* paintings had the "dust of the cottages" on them, he bragged, as well as the flies of the field:

> I had to pick off a good hundred or more flies from the four canvases you're about to receive, not to mention dust and sand, etc., not to mention the fact that if one carries them through heath and hedgerows for a couple of hours, a branch or two is likely to scratch them.

Throwing Theo's sly hints back in his face, Vincent derided the notion that "bright painters"—Impressionists with their confectionary colors and floods of light—could ever express the "filthy, stinking" reality of peasant life; or that academically correct draftsmen could show "diggers that dig, peasants that are peasants, or peasant women that are peasant women." Only the dark palette and coarse figures of *The Potato Eaters* could honestly express the "truer truth" of the peasants' meager existence. And only a painter who lived and suffered among them could bear witness to that truth. "*Everything,*" he insisted, "depends on how much life and passion an artist is able to express."

In every howling defense of his abused image, one can hear Vincent pleading an even more urgent cause. "What kind of man, what kind of visionary, or thinker, observer, what kind of human character stands *behind* canvases extolled for their technique?" he demanded to know. "Were [they] made with a *will*, with *feeling*, with *passion*, with *love*"? He reminded Theo of Zola's injunction to "*cherchez l'homme*" (look for the man) in the work—to "*aimez l'artiste*" (love the artist) more than the painting.

As always, Vincent's art followed where his arguments led. Throughout the summer of 1885, in an outpouring of work that matched the outpouring of words, he hectored his brother with images in support of *The Potato Eaters*. He seconded its dark colors with a series of even darker paintings: a landscape "under a starless night, dark and thick like ink"; a churchyard "in the evening"; and a peasant cottage like the De Groots' "by night." The thatch-roofed cottage, of a type already disappearing from the Brabant countryside, offered Vincent not only an appropriate subject for his nocturnal palette (with the last rays of sunset instead of lamplight), but also a chance to demonstrate his special feeling for the lives of its inhabitants. "Those 'peasants' nests' remind me so much of the wren's nest," he wrote Theo, vowing to paint a whole series of similar images and to find "more beautiful hovels far away on the heath," like a peasant boy searching for birds' nests.

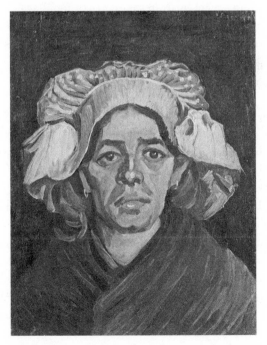

Head of a Woman, MARCH 1885, OIL ON CANVAS, 16⁷/₈ X 13¹/₈ IN.

At the same time, he painted more "heads," some even darker than the dusty diners at the De Groot table; some even more caricatured and coarsely rendered. He sent Theo yet another portrait of Gordina, slashed out by heart in bold, unhesitant strokes, and claimed it as proof of his Millet gospel: "I haven't yet made a head so much *'peint avec de la terre'* [painted with soil]," he wrote, "and more will follow." Soon afterward, another crate arrived in Paris, crammed with dark paintings and proudly labeled "V2."

In response to the unanimous criticism of the figures in *The Potato Eaters*, Vincent launched a campaign of drawing that both answered the objections and defied them. He pledged allegiance to a new technique that would render his figures "fuller and broader" and promised to make fifty drawings, a hundred, or "even more, until I have exactly what I want, namely that everything is round and . . . makes one harmonious lifelike whole." He sent Theo elaborate explanations of the new technique, filled with sonorous French phrases and the wisdom of eminences like Delacroix and Hébert.

But the drawings themselves hardly changed. Whether out of stubbornness, or a shortage of models as the July harvest approached, Vincent returned to the same poses he had been practicing since Etten: women bending over to glean corn or dig carrots, thrusting their bottoms in the air; men digging with spades, or raking, or reaping. He defiantly chose the large sheets and single subjects that Theo had been discouraging since Etten. His promises of roundness and wholeness added nothing except girth to the scores of familiar figures that piled up in the studio that summer. He claimed for all these bulging, unbudging images the same "character," "life," and "dust" that he claimed for his maligned potato eaters.

WHEN ANTHON VAN RAPPARD sent a letter critical of the *Potato Eaters* lithograph in late May, Vincent unleashed a fury of rebuttal that brought their five-year friendship to a tumultuous end. Rappard had dared to specify, in pitiless detail, all the imperfections that Theo would only hint at:

> You will agree with me that such work is not meant seriously. . . . Why did you see and treat everything so superficially? . . . How far from true is that coquettish little hand of the woman in the background . . . And why isn't that man to the right allowed to have a knee, a belly and lungs? Or are they located in his back? And why must his arm be a yard too short? And why must he do without one half of his nose? And why must that woman on the left have some sort of little tobacco-pipe stem with a little cube at the end for a nose?

The image had "terrified" him, Rappard wrote, and he castigated Vincent in the harshest terms for betraying the artistic ideals he had thought they shared: "While working in such a manner, how dare you invoke the names of Millet and Breton? Come on! In my opinion art is too sublime a thing to be treated so nonchalantly."

Vincent immediately sent the letter back, adding only a curt, scribbled note. But within a week, his indignation exploded in wounded protest. For the next month, he spat out page after page of desperate argument, as if all the disputes of a lifetime hung in the balance. He ricocheted between angry counterattacks and self-pitying pleas on behalf of his art and himself. Repeated claims of indifference ("I leave you to your delusions") were followed by long paragraphs of academic justification. Elaborate encouragements shared the page with half-mad accusations. He offered defenses from the most technical ("I used corrosives on the stone") to the most sweeping ("We seek our subjects in the heart of the people"). He declared himself the truer disciple of Millet and predicted his friend's ruin if they parted ways.

The more he argued, the angrier he grew, until his tirades regressed to the helpless frustration and hurt of a child's tantrum. When Rappard suggested that Vincent needed someone to tell him "some home truths," Vincent flailed back, "I *myself* am the one to tell myself some home truths."

In Rappard's disapproval, Vincent saw the same dark forces that had always thwarted and persecuted him. "I have had the very same kind of trouble for a great number of years with a great number of people," he wrote, including "my parents and my whole family." In his paranoia, Vincent suspected that Rappard's betrayal had been part of an *actual* conspiracy against him—a conspiracy orchestrated, of course, by his old Goupil nemesis, H. G. Tersteeg. "What is the *real* reason you have broken with me?" he demanded. He speculated that Rappard had met secretly with Tersteeg on his recent visits to The Hague and agreed to trade his good opinion of *The Potato Eaters* for favors from the implacable *gérant*. Hadn't Millet been betrayed in just the same way by those attempting to "suppress and refuse" him? Driven by his own escalating suspicions, Vincent had no choice but to demand a full retraction. "This is my last word," he announced. "I want you to take back, frankly and without reservation, what you wrote."

Concerned by Vincent's unhinged letters, but antagonized by his "despotic" demands, Rappard retracted nothing. Instead, he apparently asked his friend Willem Wenckebach, who was summering again in nearby Heeze, to look in on his distraught friend in Nuenen. The dapper, urbane Wenckebach sought Vincent out among the birds' nests, broken furniture, and dirty clothes of the Kerkstraat studio. Vincent responded to this gentlemanly outreach with the

same unkempt passions that filled his letters, careening between polite small talk and fits of violent rage. Kicking his easel to punctuate his arguments, he railed against the so-called "decent" bourgeoisie one minute and cursed the uncooperative peasants the next.

When Wenckebach reached to pick up a drawing from the floor, Vincent caught the glint of a gold cufflink. "He looked at me in a contemptuous manner," Wenckebach recalled later, "and said furiously: 'I can't stand people who wear such luxuries!' This unusual, unkind, and rude remark made me feel most uncomfortable." On the subject of Rappard, Vincent was unyielding. He would "never admit the justice of [Rappard's] reproaches," he told his visitor. Therefore, nothing but a full retraction would suffice to "erase" his friend's "unmanly" insults. When Wenckebach wondered why he would take such an uncompromising and ultimately self-destructive stand, Vincent answered simply: "It is not good to take the smooth path in one's life! I never do!"

Vincent waited for Rappard's reply. And waited. Finally, Vincent himself broke the silence. "I am willing to look upon the whole business as a misunderstanding," he wrote, "provided that you realize yourself that you were mistaken." If Rappard did not retract everything within a week, Vincent added, "I shall personally not be at all sorry to be done with you." It was the same ultimatum he had issued so often to Theo. But his friend chose the option Theo never could. He found in Vincent's unreasoning defense of *The Potato Eaters* the final excuse he needed to walk away from his odd, oppressive correspondent.

At some point that summer, Vincent took a penciled self-portrait that Rappard had given him and tore it in half. "You are ahead of me in many things," he wrote; "still I think you went too far."

That left only Theo.

LIKE RAPPARD, Theo bristled under Vincent's manic onslaught. He had tried every way possible to coax his uncoaxable brother from his fixation on dark colors and dreary subjects. Vincent had recoiled from even the most diplomatic and indirect hints with storms of defense as well as fresh attacks on Goupil, on dealers, on the Salon, on the Impressionists, and on Theo himself. To avoid raising his brother's ire, Theo had recruited acquaintances like Portier and Serret to beard the unwelcome truth. But Vincent had responded by drawing them, too, into his mania of persuasion, deluging them with the same pleading, bullying letters that filled Theo's mailbox that summer.

Far from being grateful for Theo's exertions, Vincent had rallied his brother to more and greater efforts on behalf of his neglected art. After years of dismissing exhibitions, and one-man shows in particular, he pushed Theo to mount a solo show for him. He demanded that Theo show his work to other dealers: not

nonentities like Portier, but prominent dealers like Henry Wallis and Elbert Jan van Wisselingh, his old Goupil colleague. He had begged Theo to approach Paul Durand-Ruel, one of Paris's most celebrated dealers and an early champion of the very Impressionists that Vincent so often derided. "Let him think it ugly," Vincent snapped, ignoring the delicacy of his brother's position. "I don't mind." In his fever, he had even suggested that Theo enlist the help of his eternal antagonist, Tersteeg ("he is a man who dares, once he is convinced")—a notion of breathtaking folly.

Ever suspicious of Theo's resolve, Vincent hinted threateningly that if Theo failed in his duties, he might come to Paris himself and take the promotion of *The Potato Eaters* into his own hands—a prospect that surely alarmed his discreet, circumspect brother.

And at the end of every month, as regular as rent, the same cry erupted: "I am *absolutely* without money," "I am absolutely cleaned out," "I am literally without a penny." At a time when Theo's own finances were strained by the expenses of his father's burial and the burdens of an entire family, Vincent's allowance continued to disappear faster than Theo could send it. "I cannot and may not do otherwise than spend relatively much on models," Vincent responded defiantly to his brother's repeated pleas for forbearance. "Far from cutting down on the expenses for models, I think spending a little more is called for, very much called for." The terrifying risks of Vincent's profligacy were made clear to Theo in August when his uncle Jan, the distinguished admiral, died penniless and disgraced at the age of sixty-seven after his feckless, epileptic son squandered the family fortune and ran off to America.

In fact, the situation in Nuenen was far worse than Theo knew. Vincent had lavished money as heedlessly as words in advocating for *The Potato Eaters*. Rent money, paint money, food money—almost all had gone to his ragged fantasy of a peasant family. Since settling his debts in April with an extra payment from Theo, Vincent had resumed buying everything he could on credit. By the end of July, the dogs were at the door again, especially the paint sellers in The Hague, whose bills he had put off repeatedly. At least one of them had threatened to seize the contents of Vincent's studio and sell the lot as junk. It was all he could do to fend them off with protests and lies until the end of the month when Theo would visit Nuenen again and Vincent could plead his case face-to-face.

But Theo had already set his mind against his brother. He signaled his new resolve in advance by refusing to send Vincent an extra few guilders to prepay the freight on a third crate of paintings. He failed to take any of Vincent's work with him on his stop in Antwerp, as Vincent had urged him to do. And finally, most piercingly, he brought with him to Nuenen a new friend, a colleague at Goupil and fellow Dutchman, Andries Bonger. With his gentle manner, self-effacing intelligence, and guileless affection, "Dries" represented a repudiation, in every

way, of the overweaning brother Theo had grown up with. Vincent, who had always resented his brother's friends, sent pouting, scornful notes to the parsonage from which he was banished. "I am rather busy, as they are reaping the corn in the fields," he wrote, putting off their reunion a little longer. "You must not be offended when I go on with my work."

But nothing could temper or delay the inevitable explosion when they finally confronted each other. It was sparked when Vincent warned Theo about the family embarrassment that would result if his paint bills were not paid. Unable to contain the resentments that had built up through all the months of dunning arguments on behalf of *The Potato Eaters,* Theo not only rejected outright Vincent's request for extra funds, he told him he could no longer count on the same level of support. Indeed, he warned that his subsidies might end altogether. "Bear in mind," he said gravely, "that under the pressure of certain circumstances I may feel obliged to cut the towrope." Vincent raged in defense, rearguing a whole summer's worth of letters. He scoffed at his brother's financial woes and ridiculed his bourgeois pretensions, saying, "In my opinion you don't in the least belong among the rising men." He took the opportunity to launch yet another doomsaying assault on Goupil and the "tulip mania" of art dealing.

Rather than shy from Vincent's attacks, as he had all summer, Theo rose for the first time to meet them, blow for blow. As if responding to years of unanswered arguments—against painting, against color, against light, against convention, against Goupil, against their father—he lashed out at the "selfishness" of Vincent's relentless offensives against the world. He was fed up with his brother's righteous reproaches and cruel "truths." He accused Vincent of trying to discourage him, of wanting to see him fail, of being more his "enemy" than his friend. Resurrecting the incendiary charge from the previous year, he challenged Vincent's good faith, and told him bluntly that he did not trust him in the battles that lay ahead. "I see quite clearly that I cannot count on you," he said. No matter what he did for Vincent in the future, no matter how much money he sent, no matter how hard he worked to sell his paintings, Theo concluded, Vincent would reward him only with "stinking ingratitude."

Vincent wrote afterward that the conversation "made me utterly disconsolate."

Theo left Nuenen early so he could stop in Amsterdam to meet Andries Bonger's family members. Among them was Dries's twenty-two-year-old sister, Johanna.

BLINDING HONESTY and the threat of abandonment drove Vincent only deeper into delusion. As if the argument with Theo had never happened, he

casually laid plans to take even more models ("always the best policy") and sent his brother an elaborate budget that called for an *increase* in his regular allowance from one hundred back to one hundred and fifty francs a month. "Let's keep that little painting business of mine in good shape," he wrote cheerfully. As if Anthon van Rappard were still a friend, he resumed their correspondence: first with a joking letter that dismissed their dispute as a silly theological spat; then with the opposite: a long, barbed, petulant brief for a return to the status quo ante ("I deem it desirable for us to remain friends") that stood steadfastly by *The Potato Eaters* ("I render what I see"). His entreaties pried one last letter out of Rappard before the friendship lapsed into total and permanent silence.

As if the summer had never happened, Vincent imagined a welcoming audience for his paintings somewhere. He saw a "reaction setting in" among both artists and public against the tyranny of fashion. More and more, they would demand "modern" pictures, by which he meant paintings that "show the peasant figure in action . . . *That* is the very essence of modern art." He predicted a "peasant uprising" against Salon juries, and claimed a mandate from Millet to follow on the successes of the summer. "I cannot stop working at the height I have risen to now," he announced. "I must push on." He rallied Theo to work with more animation on behalf of his art, urging "now is just the moment to try to do something with my work." He planned showings in Antwerp and Holland as well as Paris. "One must not call it a hopeless struggle," he exhorted. "Others have won, and we shall win too."

He summoned his brother to this fantasy of past and future with an image as charming as a child's parable. Comparing his career as a painter to a lifeboat being towed behind the "big ship" of Theo's career as a dealer, Vincent envisioned a day when their roles—rescuer and rescued—would be reversed:

> At present I am a tiny vessel which you have in tow, and which at times will seem to you so much ballast . . . But I, who am the skipper of my tiny vessel, ask in this case that—far from having the towrope cut—that my little boat be kept trim and well provisioned, in order that I may do better service in times of need.

In September 1885, Vincent van Gogh had his first public show—in the shop window of his most relentless creditor, a paint store in The Hague called Leurs. Vincent claimed his shameful place in Leurs's window as a career coup and imagined it as a victory for all his months of argument. "I am too firmly convinced of being on the right road," he declared one week after Theo's visit. "I want to paint what I feel and feel what I paint."

In One Rush

~

*I*N HIS MONTHS OF TENDENTIOUS ARGUMENTS ON BEHALF OF *THE POTATO Eaters*, Vincent had talked himself into a new art. Extremities of temperament and rhetoric had flung him far from the course on which he had originally set out five years earlier in the Borinage, when art seemed the only point of reentry into the bourgeois world that had expelled him. Instead, his fevered defenses had landed him on a distant, unknown shore: a place without "true" color or line; a place where hues clashed and objects took shape unhindered by nature's narrow-mindedness.

The art that Vincent described did not exist yet: not in his books or portfolios of prints, not on the walls of any galleries or museums, and certainly not on Vincent's easel. Nothing could have been further from it than the turgid, tenebrous image that set the storm in motion, or the scores of paintings and drawings with which he had tried to justify it. Hardened in opposition to his brother's advisements to bright colors and mired in yet another fantasy of family, Vincent clung to the aggrieved palette and rejected subjects of *The Potato Eaters* long after his Odyssean vision had left them behind.

In the fall of 1885, two events, impossibly different—a trip to a museum and a sex scandal—combined to finally break the grip of the past. Together—one pulling, the other pushing—they drove Vincent out of Brabant, freeing him to explore, for the rest of his brief life, the strange new art he had already defiantly imagined.

VISITORS TO AMSTERDAM'S Rijksmuseum on October 7, 1885, expected to encounter slow-moving crowds. The grand new building on the Stadhouderskade had opened less than three months before with a spectacular ceremony

featuring chorus, orchestra, and fireworks. For years before that, the whole country had buzzed with controversy as Pierre Cuypers's fantastical master- piece slowly rose at the edge of the old city. Many Protestants (including the king, who boycotted the opening ceremony) saw in its cathedral windows and Gothic echoes yet another Roman conspiracy (led by the Catholic Cuypers)—an affront in iron filigree and variegated brick to the pious dignity of the Dutch Republic. Others, like Dries Bonger, thought it merely vulgar. "It is such a pity that this great building turned out to be such a disappointment," he wrote after seeing it with Theo in August. "There it stands for all eternity, to the annoyance of future generations."

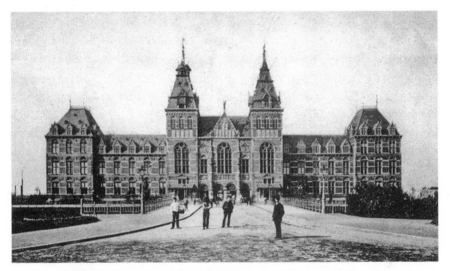

RIJKSMUSEUM, AMSTERDAM, SOON AFTER COMPLETION IN 1885

The controversy only inflamed public curiosity. In the first three months after the building opened in July, a quarter million visitors reportedly shuffled through its vaulted halls—an astonishing figure in a country of only four mil- lion inhabitants. Thus, even on a rainy Wednesday in early October, crowds still clogged the museum's twin entrances and surrendered their soaking umbrellas to see Cuypers's extravagant celebration of Dutch culture.

Viewing paintings was always a slow and arduous process in nineteenth- century galleries, with their frame-to-frame, floor-to-ceiling honeycombs of im- ages, and the Rijksmuseum was worse than most, both for the density of its hangings and the distracting profusion of its decoration. But progress that day was disrupted even more than usual by an odd-looking man who planted him- self, like an island in the stream, in front of a single painting and would not budge. He wore a wet, hairy ulster and a fur cap that he refused to take off. "He looked like a drowned tomcat," one visitor recalled. Underneath his sodden cap,

he had the sun-beaten face of a sailor and a wiry red beard. At least one local thought he looked "like an ironworker."

The painting that had transfixed Vincent was Rembrandt's *The Jewish Bride*, a portrait of a merchant and his new wife, long famous for its fiery red-and-gold palette, ineffably tender gestures, and gorgeous brushwork. "What an intimate, what an infinitely sympathetic picture it is," Vincent wrote afterward. Anton Kerssemakers, who had joined Vincent for part of the Amsterdam trip, continued through the museum without him. "He could not be torn away from it," Kerssemakers recalled. When he returned to the spot later, he found Vincent still there: now sitting, now standing, now clasping his hands in prayerlike reverie, now staring intently only inches from the canvas, now stepping back and shooing people out of his sightline.

Vincent had seen hardly any paintings, real paintings, since leaving The Hague two years before. He had not seen *these* paintings, some of his country's greatest treasures, since the dark and stony days of studying for the clergy, when visits to the Trippenhuis or the Van der Hoop collection (the Rijksmuseum's predecessors) had to be secreted between sermons. But even the paintings he knew well he was seeing with new eyes. For the first time, he pored over their surfaces not as a dealer or draftsman, but as a *painter.* He drank so deeply of their imagery that years later he could still recall every detail—the sheen of a fabric, the expression on a face, the fathom of a tone. He didn't hesitate to feel a canvas, to follow a brushstroke with his thumb, or to lick his finger and touch it to the surface to deepen the color.

The Jewish Bride was only one of dozens of images Vincent consumed that day. He and Kerssemakers would enter a gallery, and Vincent's eyes would immediately light on a particular picture—an old favorite or a new discovery—singling it out from the cacophony of competing images. "My God, look at that," he would exclaim as he rushed through the crowd toward it. "Look!" Ignoring the museum's prescribed tour, he ran from gallery to gallery by an inner routing. "He knew precisely where to find what interested him most," Kerssemakers recalled: here, a billowing skyscape by Ruisdael; there, two leafless oaks spotlighted against a stormbank by Van Goyen; there, Vermeer's intimate, eavesdropping glimpse of a woman reading a letter. But of all the giants of the Golden Age on display, he sought out two with special fervor. "[I am] longing most of all for Rembrandt and Frans Hals," he had written Theo when he first laid plans for the trip.

The Rijksmuseum offered a feast of images to sate even Vincent's insatiable longing: from Rembrandt's *Night Watch*, an image so famous that Cuypers had built a special room for it, which he placed at the end of the navelike Honor Gallery like an altar; to Hals's *The Lean Company*, a panoramic tour de force of brilliant portraiture and magical brushwork. Unfamiliar to Vincent until he en-

tered the gallery where it hung, Hals's huge painting of a proud company of Amsterdam militiamen struck him dumb. "I was literally rooted to the spot," he reported to Theo. "That alone—that one picture—is worth the trip to Amsterdam."

But there were many others. The walls were studded with dark windows into both masters' imaginations: Rembrandt's veiled and deeply mysterious explorations of the sublime, and of himself; Hals's delighted documentation of the human condition: roguish soldiers and red-cheeked drinkers, love-struck grooms and their bemused brides, self-satisfied burghers and their world-weary wives. Still, it wasn't enough for Vincent. He dragged Kerssemakers directly from the Rijksmuseum to another museum, the Fodor, and from there to Uncle Cor's gallery on the Keizersgracht, where, at the last minute, he balked at going inside. "I must not show myself to such a proper, rich family," he told his puzzled companion. Kerssemakers left Amsterdam that same evening, but Vincent delayed his return to Nuenen for another day, spending precious pennies on a hotel so he could spend yet another day in the Rijksmuseum.

The frantic three-day trip to Amsterdam was one of two trips Vincent took that fall. Sometime after Theo's departure in August, he and Kerssemakers also traveled to Antwerp, in another reprise of his brother's tour with Dries Bonger. Why this sudden restlessness after years of abjuring city life and threatening to disappear deeper into the heath? Despite repeatedly vowing to seek out buyers for his work in cities like Antwerp, Vincent had successfully resisted leaving Nuenen for almost two years, making only a single day trip to Utrecht (to visit Margot Begemann) since Christmas 1883. Even after his patron Hermans offered to give him the money for a journey of his choice, Vincent preferred the verities of his life on the Kerkstraat to the vagaries of travel. In announcing his new wanderlust in September 1885, Vincent claimed a long-suppressed urge to "see pictures again," and explained that he needed to "take a trip now and then" in order to "find buyers for my own work." But when he finally did leave, he took no paintings to show, either to Antwerp or to Amsterdam.

In fact, Vincent had other, more compelling reasons to absent himself from Nuenen.

BY THE END OF July 1885, Gordina de Groot's pregnancy could no longer be hidden. The sight of the unmarried thirty-year-old Gordina big with child brought months of festering rumors to a boil. Combined with unanswered questions over Margot Begemann's misfortune and general suspicion of Vincent's strange, godless ways, the gossip soon reached toxic levels. Vincent's vehement denials fell on deaf ears. This was the same *schildermenneke*, after all, who drank publicly, quarreled with passersby, consorted outside his class

and religion, invited unmarried women to his room, and, it was rumored, drew them naked.

Eventually, the condemnation grew so pervasive that Vincent reported feeling "a dose of malice" every time he left the studio. Only months after lionizing them, Vincent lashed out bitterly at the "God-fearing natives in the village who persist in suspecting me." Rather than retreat from the accusations, he defiantly pressed his hunt for models in the teeth of communal hostility, offering larger and larger baits of money to peasants idled after the summer harvest, even as he cursed their mercenary ingratitude. "They do *nothing* for *nothing* here," he fumed.

Vincent's persistence soon brought a visit from the local Catholic priest, Andreas Pauwels, as both spokesman for and guardian of his outraged parishioners. He cautioned Vincent against fraternizing with "people of lower station," according to Vincent's account, and instructed his flock not to allow themselves to be painted, no matter how much money they were offered. Far from being chastened, Vincent erupted in a defensive rage. (He later admitted that in Pauwels's scolding he heard the voice of his dead father.) Fueled by these unburied antagonisms, he launched a furious assault on all clergymen for not "sticking to their own sphere of more abstract concerns." Rather than resolve the scandal discreetly, as both his family and Gordina's would surely have preferred, Vincent took the matter directly to the most public forum, the town Burgomaster.

In his letters, he absolved himself of any blame for "the accident" of Gordina's pregnancy and excused the peasants for their complicity in his persecution by heaping blame on the ancient common enemy in Rome. Just as he had accused a meddlesome priest in The Hague of sabotaging his relationship with Sien, Vincent came to see Pauwels as the source of all his woes. In arguments tinged with paranoia, he accused the priest of fomenting the peasants' hostility against him. If they refused to pose, it was because the priest had promised them money to stay away, he told Theo. If they blamed him for Gordina's pregnancy, it was because Pauwels was harboring the real father in his own congregation. Vincent foresaw a popular insurrection on his behalf against Pauwels's edict and vowed to fight the forces arrayed against him "an eye for an eye, and a tooth for a tooth," confident that his models would return by winter.

Inevitably, the battle extended into the studio. Deprived of models, Vincent defiantly reaffirmed his devotion to Millet's peasants in a series of still lifes. Instead of posing figures digging or picking, he arranged baskets of the potatoes they dug and the apples they picked, and lavished on them the dark, missionary vision of *The Potato Eaters*. In a challenge to Theo every bit as bitter as his challenge to Pauwels, Vincent made the new works even darker and pressed his claims for their color using the same strident tones in which he argued his innocence to the Burgomaster. Summoning the authority of yet another book

on color, Félix Bracquemond's *Du dessin et de la couleur* (*On Drawing and Color*), he sent his brother elaborate inventories of the calculations that had gone into his impenetrable grays, and ringing defenses of his "dull" imagery. He took his big, dark brush and painted a sulfurous basket of apples over a bright still life of flowers that he had painted as a memento mori after his father's death—an act of vandalism directed at all the "reverend gentlemen of the clergy" who had hounded him, and hounded him still.

Looking around his studio, Vincent found another perfect subject to protest his solidarity with the peasants who shunned him. On the branches of a fallen tree limb, he had arranged more than thirty of the birds' nests that he and his young recruits had collected since his arrival in Nuenen. On these childhood talismans of home and heath, Vincent now focused all his frustrated powers of depiction. In a palette even more *"de terre"* than his apples and potatoes, he traced with his muddy brush every feature of their fragile domesticity: the skirling straw of the wren's nest; the mossy lining of the sparrow's; the woolly bowl of the golden oriole, still attached to its web of lofty branches. Vincent's obsessive eye and indefatigable hand transformed these aerial hovels into monuments of nature, symbols of his abiding kinship with the natives of the heath. They argued, more persuasively than his reassuring words ever could, that Father Millet would ultimately triumph over Father Pauwels, and that his errant family of peasants would return to their nest in the end.

But they did not return. As autumn came to a close, Vincent remained alone in his studio, surrounded by the detritus of his Millet fantasy. By the time he left for Amsterdam and the Rijksmuseum, the peasants who peopled that fantasy had abandoned him altogether. They no longer dared come to the Kerkstraat studio, they barred him from their homes, and in the fields they ran away "frightened" at his approach.

NOT EVEN HALS and Rembrandt could dethrone the noble peasant in Vincent's imagination all at one time in a brief three days. His obsessions were rooted far too deep for a road-to-Tarsus conversion. Despite the months of ostracism and abuse, despite the confrontation with Theo, despite the collapse of his friendship with Rappard, despite the distant criticism of Portier and Serret, Vincent returned from Cuypers's temple to the gods of Dutch art seemingly reconfirmed in his defense of *The Potato Eaters* and rearmed for his battles with the world. Another artist might have been crushed by the contrast between the ignominy of his own misfortune (the threat of a forced sale by creditors) and the glories of the Golden Age. But not Vincent.

Instead, he read the Rijksmuseum the way he read a book: autobiographically.

He looked at the ranks of famous images and found his favored "deep tones" everywhere: from the chiaroscuro of Rembrandt's portraits to the dark clouds of Ruisdael's skies. "The more I see of those pictures," he wrote Theo in a long report of his visit, "the more I am glad that my studies are found too black." In Hals's bravura brushwork and Rembrandt's scumbled surfaces, he saw his own imprecision. The "great masters" did not "polish faces, hands and eyes," he pointed out, but were guided instead "by that conscience which is called sentiment." He celebrated the peasant subjects of Brouwer and Van Ostade and praised Hals's mastery of gray. He recruited virtually the entire museum as an endorsement of his artistic godfather Israëls (who was nowhere on view), and as a rebuff to "bright" painters like Theo's beloved Impressionists. "Every day I hate more and more those pictures which are light all over," he wrote, dismissing the style as "that fashionable impotency."

But even as he defiantly girded himself for another round of defenses, Vincent began remodeling the vast architecture of arguments that propped up his claims for *The Potato Eaters.* His trip to the Rijksmuseum had exposed—even to Vincent's stubborn eyes—the yawning gap between his rhetoric and his art. He could bridge that gap only in the labyrinths of obsession. He had justified his dreary browns and dull grays as the only colors befitting the meager life of the De Groot household. But in Amsterdam, he celebrated Millet's earthy palette in subjects as far from the dusty heath as Hals's cavaliers and Rembrandt's cadavers. He imagined even the exotic, voluptuous nudes of the Italian Renaissance painted in "a color like mud." As surely as the peasants of Nuenen had disowned him, Vincent began to dissociate them from his quest for expressive color.

Freed from the oppression of metaphor, he saw nothing in his tubes of paint but color. "Just now my palette is thawing," he noted in late October, almost bewildered by the change. "Colors follow of their own accord, and taking one color as a starting-point, I have clearly before my mind what must follow . . . Colors indeed have something to say for themselves."

In a letter written after returning from Amsterdam, Vincent marked his changed mission with an extraordinary description of a painting he had not seen in a decade: Paolo Veronese's *The Marriage at Cana.* This enormous canvas, which hung in the Louvre, depicted the Gospel story of Jesus attending a wedding feast. But in Veronese's vision, the humble ceremony is transformed into a lavish imperial banquet staged on a palace plaza overlooked by marble colonnades and gilded balconies filled with spectators. Scores of wedding guests in bright, bejeweled garments drink from great jugs of wine and eat from barges of food carried by servants in turbans and red slippers, while musicians play, courtesans jape, and well-fed dogs doze contentedly. No place, real or imagined, could have been further from the dirty hovels of Brabant and their potato-eating denizens. But Vincent's imagination recalled in this unlikely image a single

patch of gray that released him from the *de terre* literalism of Millet—a gray that simultaneously reaffirmed the palette of *The Potato Eaters* and opened up a new world of color for its own sake:

> When Veronese had painted the portraits of his *beau-monde* in the *Marriage at Cana*, he had spent on it all the richness of his palette in somber violets, in splendid golden tones. Then—he thought still of a faint azure and a pearly-white—which does not appear in the foreground. He detonated it on the background—and it was right . . . So beautiful is that background that it arose spontaneously from a calculation of colors. Am I wrong in this? . . . Surely *that* is real painting, and the result is more beautiful than the exact imitation of the things themselves.

On his easel, Vincent's art could finally match his arguments. Almost as soon as he returned from Amsterdam, in the waning days of autumn, he dragged his paint gear into the deserted landscape and set a big canvas where a curving alley of oaks ended in a clearing. He squeezed tube after tube of carmine and cobalt onto his gray-caked palette and applied them fearlessly: swaths of red-orange for the dusty clearing, dapples of pure yellow and orange for the sun-struck trees; bright blue sky, luxurious lavender clouds. Not a soul and hardly a shadow darkens the vivid contrasts of blue and orange, yellow and violet.

As if reimagining the previous two years in color, he returned to the parsonage garden and painted its autumnal spareness in his bright new palette. The great pen drawings of the spring of 1884 were reborn in the vivid oranges and ochers of *The Jewish Bride.* He robed the naked pollard trees beyond the garden gate in a golden cloak of leaves set against a lavender winter sky. In the studio, he rejected the dusty apples and potatoes of the previous month with a large still life of brightly colored fruit and vegetables rendered in bold complementary contrasts. "A painter does better to start from the colors on his palette," he wrote, announcing his altered gospel, "than to start from the colors in nature."

In these and a dozen more paintings he tore through in the first weeks after returning from Amsterdam, Vincent displayed another new freedom he had learned at the Rijksmuseum: speed. In this, too, his arguments had long outpaced his art. From the very beginning of his career, he had worked like a man possessed, running through reams of paper in siege after siege of the Bargue exercises, working and reworking the same drawing, scraping and rescraping the same canvas. Easily frustrated and desperate for signs of progress, he justified his manic (and expensive) work habits by arguing that quantity would yield quality in the end, and therefore speed mattered more than the precision he could never master. As a draftsman, he declared his ultimate goal "to draw quick as lightning." When he took up painting, he pledged "to *paint* quick as

lightning," and "to get more brio into my brush." The only "healthy and virile" way to apply paint to canvas, he maintained, was to "dash it on without hesitation." By the spring of 1885, in his endless preparatory heads for *The Potato Eaters*, Vincent had sharpened this argument to an obsessive mantra, bragging that he could complete a study in a single morning and vowing to work "even more quickly." "You must set it all down at once," he instructed Kerssemakers, "and then leave it alone." "Paint in one rush," he coached himself, "as much as possible in one rush."

But the creation of his magnum opus had been nothing at all like that. An agony of starts and stops and doubling back, *The Potato Eaters* had been calculated and adjusted innumerable times in a painstaking process that stretched over several canvases and as many months. Paint built up in thick layers as he waited for previous "mistakes" to dry so he could cover them with varnish and try again. The preparatory heads, with their swirling bonnets and dashed-off faces, may have been done at a breakneck pace, but those were mere *études*— studies to be hoarded in the studio or sent en masse to Paris to prove his work effort—certainly not to show or sell. No matter how many times he urged on himself, and others, the virtues of working boldly "in one rush," Vincent had never been able to break from the ideal of *tableaux*—well-painted pictures of flawless finish and mystifying means—as an artist's truest expression.

The Rijksmuseum changed all that. "What struck me most on seeing the old Dutch pictures again," he wrote, "is that most of them were painted quickly; that these great masters . . . *dashed off a thing from the 'premier coup'* [first stroke] and did not retouch it so very much." Looking at these familiar images for the first time as products of labor rather than objects of admiration, Vincent could unwind each passage and replay each stroke: the attack, the finish, the angle of the brush, the weight of the hand. He could track every gesture and revisit every decision in the light of his own experience.

He found in the happy fire of Hals's brushwork, in particular, the fulfillment of all his calls to "paint in one rush." For a moment, the thrill of it even jolted him out of his defense of *The Potato Eaters*. "What joy to see a Frans Hals," he wrote, seeming to forget his own painting's endless groomings. "How different it is from those pictures where everything has been carefully smoothed down in the same way." Vincent found the same license everywhere he looked, in images as different as a Rubens sketch and a Rembrandt portrait—passages "done with a single stroke of the brush without any retouching whatever." And he found them not pinned on a studio wall but framed in gold and enshrined in Cuypers's cathedral of *tableaux*.

Vincent couldn't even wait until he left Amsterdam to test the new freedom. On three eight-by-ten-inch panels he had brought in a small paint box, he finally gave his hand the courage of his arguments. In a blur of brushstrokes, he

captured three snapshots of the rainy city: its river skyline, its forested quays, its vast new rail station. He caught them "on the wing," as he put it, working on his lap or at a café table. When Kerssemakers arrived at the station on October 7, he found Vincent sitting at the window in the third-class waiting room "fervently working" on one of his little pictures, "surrounded by a crowd of conductors, workmen, tourists, etc."

Forced by the small scale to use smaller brushes, he fell naturally into the blazing shorthand of his letter sketches, dashing off images like glimpses from a moving train. But they were no longer just *études*. Vincent called them "souvenirs"—a word he had reserved in the past for his most meticulous renderings—and he treated them like *tableaux*. As soon as he returned to Nuenen, he packed up two of them, barely dry, and sent them to Paris in a crate marked "V4," accompanied by a proud boast: "If in an hour's time I want to dash off an impression somewhere, I am learning to do so in the same way as others who analyze their impressions . . . It is pleasant work to dash something off in a rush."

Back in the Kerkstraat studio, he took his broad brush and carried the argument even further. Emboldened by his visit to the Rijksmuseum, and by a newfound passion for eighteenth-century art, Vincent gave himself over to the sheer materiality of paint. His new heroes—artists like Boucher and Fragonard—championed painting, not peasants. Their airy, pastel-colored works celebrated nothing more profound than the frolicsome fantasies of the ancien régime, but they applied paint with a combination of daring economy and *presto* brushwork that Vincent vowed to emulate. He found in their "brusqueness of touch" and "spontaneity of impression" a new defense of both his rough art and its rough author. Others might call their summary image-making "foolishness," he argued, but "it cannot be *imitated* by cowards and weaklings." In a leap of imagination, he linked their rococo facility to the volcanic creativity of another hero, the great Delacroix. The ideal, said Vincent, was to paint "*comme le lion qui dévore le morceau*" (like a lion devouring its meat).

He especially admired their mastery of *enlever* (literally, "to lift up"), a maneuver of the brush—a flick of the wrist—that leaves sharp peaks of paint at the ends or edges of a stroke. At the Rijksmuseum, he had seen the distinctive reflection and felt the rippled contour of *enlever* strokes in the works of Golden Age painters like Hals. Now he began practicing the technique in his own studio, loading his brush with more and more paint, running it back and forth to coax the color into higher and higher ridges, trying to make it do what the thinned, muddy paint of *The Potato Eaters* would never do.

Eventually, he turned his new skills to an image—a different kind of still life. From his studio collection of stuffed animals, he took a bat, frozen in flight, and placed it in front of a light so that the thin membrane of its wings glowed like

a Chinese lantern. Using a broad brush loaded with bright orange and yellow, he distilled the subtle shadings of the illuminated wings into a fabric of distinct brushstrokes, woven spontaneously in a single pass. "At present it comes quite easily to me to paint a given subject unhesitatingly," he wrote to his brother, "whatever its form or color may be."

But bold color and dashing technique were not the only changes forced on Vincent by the events of 1885. In his defense of *The Potato Eaters,* he had advanced another radical claim for his art that fate now demanded he make good. By relentlessly equating his art and himself, he had seized the high ground of modernism staked out by Zola: the singularity and primacy of artistic temperament. But he had delivered mostly untutored echoes of nostalgic favorites like Israëls and Millet. For all his demands to "paint what I feel and feel what I paint," he had steadfastly refused to put himself under the lens of his own art. When his peasant models fled, they took with them his only escape from the self-accounting that he always dreaded. He continued to resist the most obvious form of introspection—self-portraits—but the lack of models set him inexorably on that inward path.

His search for new subject matter had led him only briefly to traditional still life subjects (jugs, bowls, tankards) before he moved on to objects that held special meaning for him, like potatoes, apples, and birds' nests. In landscapes, too, he quickly abandoned generic vistas and returned to the parsonage, his mother's garden, the stand of pollard trees—all *places* with meaning. He had already risked this kind of intimate imagery once, under duress, in early June, when he painted the old churchyard where his father was buried. Immediately after the pastor's death, Theo had suggested it as the perfect subject for a memento mori. Despite having drawn and painted the graveyard and its condemned tower many times already, Vincent at first resisted the suggestion, pursuing instead his single-minded vision of peasants around a table. Not until the last minute, with demolition imminent, did he finally set his easel in front of the stripped stone husk and allow himself to peer deeply at this scene of extraordinary personal significance.

When he did, he saw both his father's funeral ("I wanted to express what a simple thing death and burial is") and his own fall from grace. "Those ruins tell me how a faith and a religion moldered away," he explained, "strongly founded though they were." But his brush told a deeper story than his words. The old tower looms massively in the foreground, almost filling the canvas, its great masonry corner buttresses rooting it to the earth like a granite outcropping. This is no temporary structure. No demolition will erase it from the treeless field in which it sits, or release its grip on the graves at its feet. Despite the clichés of lowering skies and circling birds, Vincent had created not an epitaph, but a premonition: a portrait of a stone ghost that would always haunt his horizons.

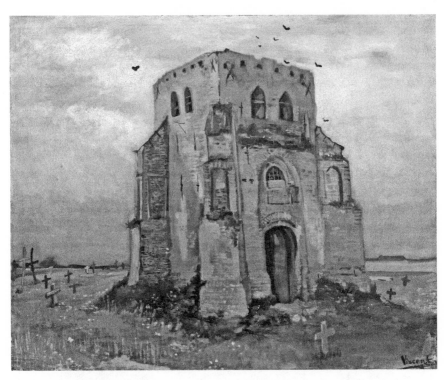

The Old Church Tower at Nuenen, JUNE–JULY 1885, OIL ON CANVAS, 25⅝ X 34⅝ IN.

Looking around his studio in November for a subject to replace the faithless peasants, Vincent found an object that invited him to probe the unhealed wound only touched in *The Old Church Tower at Nuenen.* A huge Bible sat amid the discarded clothes and dried-up specimens. It had belonged to his father. Because the church kept the pulpit Bible and his widow kept the family Bible, this magnificent tome, with its copper-reinforced corners and double brass clasps, was the only Bible passed down when Dorus van Gogh died. And it passed not to Vincent, but to Theo. It came to be in Vincent's studio only because his mother, in an act of wanton insensitivity, had asked him to mail it to his brother in Paris. Clearing an open place in the clutter, Vincent spread a cloth over a table, set the Bible on it, and unhooked the clasps. The huge book fell open in the middle, to Chapter 53 of Isaiah. He pulled his easel up close, so that the open book almost filled his perspective frame. He propped up the spine to show more of the linen pages with their dense double columns of text. At some point, he decided to enliven the composition with another object. Sifting through his piles of books, he selected one of the bright yellow paperback Charpentier editions of the French novels he loved, and placed it on the edge of the table, at the foot of the giant Bible.

Then he began to paint.

Vincent's fanatic brush found significance everywhere. He designated the yellow novel as Zola's *La joie de vivre* and with provocative care lettered in its title, author, and place of publication—Paris. In a few strokes, he captured its dog-eared cover and well-worn pages—a challenge to his father's flawless, formal Bible. The yellow defiance of Zola elicited a violet response. Vincent mixed and mixed the two complementaries on his palette in search of a gray to express the narrow-mindedness of Dorus's gospel. When he finally achieved the color he was looking for—a deep, pearly lavender gray, equal parts Veronese's wedding banquet, Hals's bourgeois militiaman, and the dead flesh of Rembrandt's corpses—he "detonated" it on the canvas in a hail of vandalizing brushstrokes in place of the neat blocks of text.

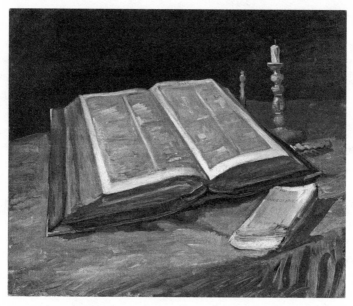

Still Life with Bible, October 1885, oil on canvas, 25⅝ x 30¾ in.

But the text answered back. The words of Isaiah in front of him were well known to Vincent: "He is despised and rejected of men; a man of sorrows and acquainted with grief." The painfully resonant scripture, combined with the defiant juxtaposition of gospels, opened up the entire landscape of the previous two years, and Vincent's brush recorded it with a candor that he hardly ever allowed himself in words: the fights with his father, sex with the peasant girls like Gordina, the Mouret-like pursuit of Margot Begemann in the shadow of the parsonage, his persecution by the priests, the betrayal of the peasants. Onto the pages of fathomless gray, he introduced accents of blue and orange—another contest of opposites summoned up from somewhere other than the table in front of him. He executed the identical clasps in opposite ways: one, lying to the

side in a tremulous ripple, the other standing bolt upright in a single menacing stroke. As he finished the book and the draped table, the clash of complementaries played itself out in an argument of broken tones applied with an increasingly broad and confrontational brush. To complete this chronicle of rejection, grief, self-reproach, and defiance, Vincent added at the last minute a new object—an extinguished candle—the final snuffing out of the *rayon noir*, and a confession that he could never make any other way.

He immediately reported the new painting to his brother, accompanied by a proud boast: "I painted it in one rush, during a single day."

Through this seamless, spontaneous interweaving of personal preoccupations and artistic calculations, private demons and creative passions, Vincent had achieved an entirely new kind of art. And he knew it. His letters churn with the false bravado of uncertainty—of a man who finds himself suddenly either on the edge of a new world or at the end of a long limb. He could not invoke Zola often enough to make the doubts go away. "Zola creates, but does not hold up a mirror to things, he creates wonderfully, but creates, poetizes, that is why it is so beautiful." He wreathed his new liberties in the science of Blanc, as well as in medieval notions of immanence. His goal, he said, was to find *"ce qui ne passe pas dans ce qui passe"* (that which endures in that which fades). "To think of one thing and to let the surroundings belong to it and proceed from it," he argued, "surely that is real painting." Even as he advertised the modernity of his new, personal "symbolism," he imagined it as a rebirth of the Romanticism on which he was weaned. "Romance and romanticism are of our time," he insisted, "and painters must have imagination and sentiment—which lead to poetry."

Indeed, Vincent was the most reluctant of pioneers—more shunned than shunning; ostracized from the art he loved by the shortcomings of his hand just as he was ostracized from his families, both real and adopted, for the nonconformity of his behavior. He spoke of the new poetry in his brush in mixed tones of anticipation and resignation. "As I have been working absolutely alone for years," he wrote in November, "I shall always see with my own eyes, and render things originally." He wanly consoled himself that Millet, too, was a "symbolist" in this new way, but he knew that he had left the safety and reassurance of all his former favorites behind. He defended his years of drudgery in the mines of verisimilitude with unrepentant nostalgia, even as he acknowledged his ultimate failure there. "One can never study and toil too much from nature," he wrote after completing *The Bible*. "For years and years I myself have been so engaged, almost fruitlessly and with all kinds of sad results, [but] I should not like to have missed that error." In a poignant farewell to Realism, he conceded almost wistfully that "the greatest, most powerful imaginations have made things directly from nature that strike one dumb."

One of the few authorities from his past that Vincent did not invoke to comfort his leap into the unknown was also the most eloquent. In an 1872 essay on poetry that both Vincent and Zola read, the philosopher Hippolyte Taine had described with astonishing prescience the imagery at the end of Vincent's tortuous journey:

> Less a style, indeed, than a system of notation, superlatively bold, sincere and faithful, created from instant to instant, out of anything and everything in such a fashion that one never thinks of the words but seems to be in direct touch with the gush of vital thought, with all its palpitations and starts, with its suddenly checked flights and the mighty beating of its wings. . . . It is queer language, yet true even in its least details, and the only one capable of conveying the peaks and troughs of the inner life, the flow and tumult of inspiration, the sudden concentration of ideas, too crowded to find vent, the unexpected explosion into imagery and those almost limitless blazes of enlightenment which, like the northern lights, burst out and flame in a lyrical mind . . .
>
> Trust the spirit, as sovereign nature does, to make the form; for otherwise we only imprison spirit, and not embody. Inward evermore to outward—so in life, and so in art, which still is life . . . Poetry, thus conceived, has only one protagonist, the soul and mind of the poet; and only one style—a suffering and triumphant cry from the heart.

AT THE END of November, only a week before Saint Nicholas Day, Vincent left Nuenen. It was, by all accounts, a bitter, acrimonious, and unwilling departure. Defying all his reassurances to Theo, the scandal over Gordina's baby did not die down. The townspeople never stopped believing he was the father. If anything, the clamor for his departure only grew louder, as Vincent battled his accusers with bellicose taunts and new provocations. (After one of his trips to the city, he brought back a supply of condoms and distributed them among the "country lads.") To the end, he blamed his troubles solely on clerical intrigue and public hysteria. "I am greatly handicapped by the neighbors," he complained; "people are still afraid of the priest."

Nor could he find succor at the parsonage. The new scandal had pushed his mother from a chill of animosity into a freeze of hostility. Despite often lingering nearby to draw or paint, he was never invited inside to share a hot meal, even as the winter drew on and the holidays approached. Vincent exacted his bizarre revenge with a premonition that his mother would soon follow her husband to the grave. With all the vehemence of a curse, he predicted that "death will come

unexpectedly and softly, just as it came to Father," and warned Theo insistently, "there are many cases of a wife's not outliving her husband by long."

The crisis came to a head when Vincent's landlord, the sexton Schafrat, refused to renew his lease on the Kerkstraat studio. "In this studio, just next door to the priest and the sexton, the trouble would never end," Vincent wrote, "that is clear, so I am going to change this." At first, he planned just to rent another room nearby and wait for the controversy to blow over—a fantasy that lasted only a few days. He thought of returning to Drenthe—a sure sign that the pressure to leave Nuenen had become unbearable. Finally, he proposed to take the sales trip to Antwerp that he had so often postponed, and perhaps stay and work there for a while. But only for a few months. "I know the country and the people here too well and love them too much," he said, "to be positively leaving them for good."

He filled his letters with plans to make connections and promises to learn from pictures again, as he had in Amsterdam. But no words could cover the disgrace of his departure. Despite the long drought of models, he left destitute and in debt. He had to wait for Theo's next letter to buy a train ticket, and he stole out of town to avoid paying Schafrat the last month's rent. That meant having to leave his collection of prints and almost all his paintings and drawings behind in the studio—years of labor left to the equal mercies of his creditors and his mother.

His final leave-taking from the parsonage played out in an ugly scene that echoed bitterly for months afterward: "I am not going to write home," he told Theo in December. "I told them that quite simply when I went away. . . . They got what they wanted; for the rest, I think of them extremely, extremely little, and I do not desire them to think of me." In a parting blow on the eve of his departure, a letter arrived from the paint dealer in The Hague who had hung his pictures in the window. "He wrote that Tersteeg and Wisselingh had seen them," Vincent reported miserably, "but did not care for them."

Still, he left Nuenen undefeated. His new art had given him a new surge of courage. "My power has ripened," he claimed, even as he conceded that he might have to "begin all over again from the very beginning." In a farewell visit to Kerssemakers in Eindhoven, he encouraged his friend's artistic ambitions in terms that surely reflected his own stubborn hope: "One doesn't become a painter in one year," he said, "nor is it necessary. But there is already one good thing among the lot, and one feels hopeful, instead of feeling helpless before a stone wall."

For the first time, he expressed a sense of urgency—a sense of limited time, closing doors, and evanescent opportunity. Only days before his departure, he vowed to take up an entirely new medium, pastels, suddenly enchanted with the

vivid, gossamer creations of the great French pastellists Chardin and La Tour—images as distant from the lumpen peasants of *The Potato Eaters* as Paris from Nuenen; images rendered not in dirt, but in light and air; images, he marveled, that "express life with pastel which one could almost blow away."

"I don't know what I shall do and how I shall fare," he wrote as he left Nuenen, Brabant, and Holland for the last time, "but I hope not to forget the lessons which I am thus learning these days: in one stroke—but with absolutely complete exertion of one's whole spirit and being."

Lost Illusions

~

*L*ESS THAN A DAY AFTER LEAVING THE HEATHS OF NUENEN, VINCENT sat at the window of a sailors' bar in Antwerp and watched the city explode with life. Not since his exile to London ten years earlier had he suffered such a shock of dislocation. In every direction, as far as he could see, carts and wagons choked the narrow streets, inching toward the docks where they massed in a calamity of commerce. "More tangled and fantastic than a thorn hedge," he described the scene to Theo, "so chaotic that one finds no rest for the eye and grows giddy." Herds of cattle snorted impatiently, steamship whistles screamed, sailors with "ruddy faces and broad shoulders, lusty and tipsy" staggered from bar to brothel. Loads of strange wares moved in and out of the maelstrom, wrestled on their way by "docker types as ugly as sin." Vincent was especially struck by the mounds of hides and buffalo horns from America.

Here and there, arguments broke into scuffles, creating little whirlpools of commotion in the turbulent flow of commerce. Soon after his arrival, Vincent was caught in one of these eruptions. "A sailor is being thrown out of a brothel by the girls in broad daylight," he recorded from his window seat, "pursued by a furious fellow and a string of prostitutes, of whom he seems to be terrified." In the distance, the great black ships bobbed and creaked in their slips like restless beasts. The forest of their masts winked in the winter sun, almost obscuring the far shore of the Schelde. "It's all an impenetrable confusion," Vincent wrote.

Although only twenty-five miles from the Zundert parsonage, Antwerp might as well have been an island in the middle of the ocean. Perched on the edge of the vast Rhine delta, the city had been one of Europe's busiest ports for half a millennium—a place as distant from the rural countryside beyond its fortified walls as the exotic destinations of its ships or the homelands of its sailors.

Another visitor in 1885 catalogued the city's polyglot of strangers: "the silent, serious Norwegian; the square Dutchman; the red-haired Scotch; the quick Portuguese; the boisterous, talkative Frenchman; the slender, irritable Spaniard; the Ethiopian with his blue-black skin." From every corner of the world, they brought their wares and their indulgences. A babel of shops lined the medieval streets leading to the docks, catering to every worldly whim. Brothels advertised prostitutes from every nation. Bars served everything from Lambiek, a local beer, to sake. A saloon filled with rowdy Flemish sailors eating mussels stood next to a quiet English pub, which stood next to a vast *café-concert:* a French concoction of music hall, dance hall, bar, and brothel.

Like centuries of vagabonds and exiles passing through Antwerp before him, Vincent drank the beer and plied the whores, torn between visions of new beginnings and dreams of homecoming. He introduced himself to barmaids as a "bargee"—an inland sailor. Once inside, he sat, like other lone sailors, at the end of the bar, or on the edge of the brothel sofa, or beside the dance floor as couples whirled nearby. He smuggled in a pocket-sized sketchpad and captured glimpses where he could—lightning drawings hidden in his lap, made to the accompaniment of a husky dance hall organ. He drew spectators shouting and singing from the balcony, and maidservants dancing together in giddy pairs. Vincent never reported dancing himself; only watching. After attending "a popular sailors' ball at the docks," he wrote Theo: "It does one good to see folks actually enjoy themselves."

—

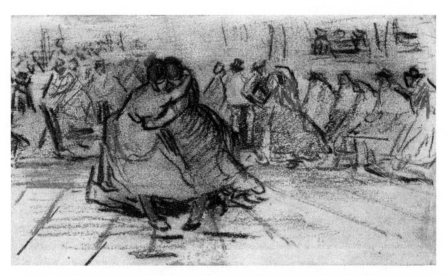

Couple Dancing, DECEMBER 1885, CHALK ON PAPER, $3^1/_2$ X $6^3/_8$ IN.

VINCENT FILLED HIS first letters from Antwerp with desperate enthusiasm. "I feel a power within me to do something," he wrote soon after his arrival. "I am very glad I came here." Whether out of genuine optimism or as cover for his hasty, ignominious exit from Nuenen, he mounted yet another campaign for bourgeois respectability. Instead of sermons on Millet and treatises on color, he regaled his brother with strategies for showing and selling his work. After years of vehemently resisting, he offered to find a "job on the side"—making decorations for restaurants or painting signboards ("for instance, for a fishmonger, still life of fishes"). "One thing is certain," he declared, "I want my things to be seen."

Abandoning his rhetoric on the joys of the heath and solidarity with the peasants, he hailed the "bustle" of Antwerp's chaotic commercial life, claiming "I needed it badly." He bought new clothes and began to eat regularly, arguing the new mandate of success. "One must not look too hungry or shabby," he wrote. "On the contrary, one must try to make things hum." He rented a room in an impressive apartment block on the city's burgeoning east side—a new but respectable neighborhood—and outfitted it with the trappings of an artist's studio, including a stock of new canvases, better brushes, and more expensive pigments. To replace his beloved illustrations abandoned in Nuenen, he papered the walls with the cheap, colorful Japanese prints available in every dockside shop. "My little room has turned out better than I expected," he crowed. "[This] is a splendid place for a painter."

He charged fearlessly into Antwerp's parochial art market, carrying under his arm the only three major paintings he had brought from Nuenen: an avenue of poplars, a moody view of a mill at twilight, and *The Bible.* Rather than bludgeoning dealers with endless arguments on behalf of these images, as he had Theo, he immediately set out to diversify his portfolio. In the first weeks after his arrival, he tried painting some of the tourist fare that he saw at many of the galleries he visited—picturesque street scenes and vistas of the old city from the opposite bank of the Schelde; romantic views of Antwerp's medieval landmarks such as the cathedral, the Grote Markt, and the ninth-century castle Het Steen. Such images, he assured Theo, were "just the thing for foreigners who want to have a souvenir."

Even as city life tempered some of the obsessions of the heath, it inflamed others. Like a sailor too long at sea, Vincent came to Antwerp with one overriding mandate: women.

Since leaving The Hague two years before, his quest for female companionship had never really abated. He continued to patronize prostitutes in Eindhoven throughout his time in Nuenen, and no doubt availed himself of their services on his trips to Utrecht, Antwerp, and Amsterdam. The liaison with Gordina de Groot had proved more tantalizing than satisfying. Although she probably suc-

cumbed to his pleading (and payment) to pose naked, it was never enough. In his letters to Theo, he continued to fantasize about a more systematic and intensive study of the female nude.

Stymied by the prudery of the Brabant peasants and their meddlesome priest, he increasingly saw Antwerp, with its large population of prostitutes, as the answer to all his longings, both artistic and sexual. He argued an urgent need to "get good models, *as many as I like* and *good* ones," and imagined apprenticing to an artist "who takes models for the nude." "I need it for many reasons," he explained cryptically. Based on his reading of a passage in Sensier's biography, he convinced himself that he could recruit prostitutes to model for him by offering to paint their portraits—as Millet had done in another port town, Le Havre. By insistently conflating modeling and prostitution, and eliding the difference between modeling for portraits and modeling nude, Vincent managed to transform Sensier's salacious hints into a virtual guarantee of both sexual and artistic fulfillment among Antwerp's legion of whores.

By the time he arrived, these strands of obsession and desire had combined into a mania that propelled him through the tangled streets day and night. Every place people gathered—public dances, cafés, music halls—he scanned the crowds for women, alternately admiring their "splendid heads" and assessing their availability. "What they say about Antwerp is true," he reported; "the women are all handsome." He sent Theo elaborate catalogues of the women he observed: some "splendidly healthy-looking," others with "dull, grey little eyes." He preferred "common girls" for their "power and vitality" and for their "ugly and irregular faces . . . lively and piquant à la Frans Hals." He admired Scandinavian girls for their blond hair, which he preferred, but German girls left him "quite cold," he said, because "they are all manufactured from a single model." He compared English girls ("very fair, very delicate") to Chinese girls ("quiet as a mouse, stealthy, small, naturally bedbug-like"). Their variety and plentitude almost overwhelmed him. "There's no denying that they can be damned beautiful . . . If only I had my choice of models!"

When the dances ended, that frustration led him inevitably to the city's ubiquitous brothels. To Theo, he admitted "roaming through quite a number of streets and alleyways" in order to "make acquaintances among the prostitutes." Even during the day, he frequented the quays, where streetwalkers catered around the clock to sailors' timeless urges. He sought out a local procuress—"a washerwoman who knows a lot of women"—and rendezvoused with a shadowy man who offered him "a couple of very beautiful hussies" to paint. "I suppose they are kept women," he speculated. He stationed himself outside whorehouses "in broad daylight" to watch the traffic and assay the women on offer. He called these vigils "model-hunting" but confessed to Theo that he wanted not just to paint the girls he saw, but to "have them."

Whenever an opening presented itself, he approached and made his strange proposal. Unable to pay the wages of sex for hours of modeling, he undoubtedly plied them with the same arguments he rehearsed to Theo: that portraits were not only fashionable ("in keeping with the times"), but also useful. They could be hung in cafés and restaurants to attract clients, given as keepsakes, or even sold at a profit. Noting that the local photography studios did a brisk business in portraits, Vincent pressed the advantages of painting over photography. "Painted portraits have a life of their own," he argued, "coming straight from the painter's soul, which the [camera] cannot express." He offered not only to pay his sitters a modeling fee but also to give them their portraits in exchange for posing—a lopsided proposition that scarcely veiled the sexual advance at its core. Even when he succeeded—when a woman came to his studio—he faced the further hurdle of persuading her to take off her clothes. Still, he persisted, convinced that, "if only I could come by a good model for a song, I'd be afraid of nothing."

Vincent's obsessive eye singled out women even in the pictures he saw. In a city filled with masterworks in every genre and every style for five hundred years, he saw only portraits—specifically, women's portraits—everywhere. From Henri Leys's panorama of Antwerp's medieval street life, to museums filled with the jewels of Flemish art, he remarked only on depictions of women: a blond Mary Magdalene by Quentin Matsys, a winsome Saint Barbara by Van Eyck. He especially liked Rembrandt's portrait of a prostitute. "[That] whore's head by Rembrandt struck me so forcefully," he wrote, "because he had caught that mysterious smile in such an infinitely beautiful way."

Scenes of peasants or workers or figural vignettes no longer registered in his letters to Theo. Of all the "modern" art he saw, he talked only about the painters of women—Alfred Stevens, James Tissot, Octave Tassaert, Charles Chaplin. He praised their "delicate intuition of the female form," and compared them to the great eighteenth-century French sensualists Greuze and Prud'hon. Portraits by the giants of academism Ingres and David elicited not the damning polemics of the previous summer, but envious appreciation of the beautiful sitters they could command. "Oh, if only one could get the models one wants!!!" he wailed. In a country forested in sculpture, from the baroque fantasies of the Quellinus family to the noble laborers of Meunier, Vincent found only one work—Jef Lambeaux's *The Kiss*—worthy of comment. ("*Superb,*" he pronounced it.) Lambeaux's figure of a naked young girl coyly fending off the advances of a suitor only confirmed his envious suspicion that sculptors enjoyed easier access to nude models than painters did.

Vincent's new obsession led him inexorably to perhaps the greatest painter of women in all of Western art, Peter Paul Rubens. As Antwerp's most famous artist, Rubens would have been unavoidable under any circumstances. His he-

roic, oratorical canvases of curvaceous women and straining men peopled the city's artistic landscape. From the voluptuous horrors of martyrdom to the bacchanalian pleasures of the flesh, Rubens had marked the walls of his adopted hometown indelibly with his vision. Even before setting out from Nuenen, Vincent had cast his trip to Antwerp as a journey into Rubens's exuberant imaginative world—as far from the dark, claustrophobic world of *The Potato Eaters* as it was possible to go. On the eve of his departure, he wrote Theo: "As for Rubens, I am looking forward to him very much." Not for his religious paintings, which Vincent dismissed as "theatrical, often even badly theatrical in the worst sense of the word"; nor for the seriousness of his subjects; nor for the persuasiveness of his brush. "What he can paint is *women*," Vincent emphasized. "There especially he gives one most to think about and there he is at his deepest."

True to his word, Vincent arrived in Antwerp and immediately sought out Rubens's women. He described in rapturous detail two bare-breasted blondes in the foreground of the artist's vast *Christ with St. Theresa in Purgatory*. He called them "very beautiful, finer than the rest . . . Rubens at his best." He returned to the museum many times to examine these and other Rubens women "repeatedly and at my ease." He studied especially the Flemish master's rendering of female flesh, which he praised as "*so alive*," and conveyed to Theo the lessons learned in lascivious terms far removed from the pious metaphors of Millet.

He visited the Cathedral and stood before Rubens's great triptych centerpieces, *The Elevation of the Cross* and *The Deposition from the Cross*. With their astounding scale, daring compositions, and operatic lighting, the two images filled the vast cathedral with a drama in paint that had mesmerized visitors for two hundred years. But Vincent was disappointed, especially by the *Elevation.* "[It] has a peculiarity that struck me at once," he complained. "There is no female figure in it." He professed to "love" the *Deposition,* on the other hand, for the "blonde hair, fair faces and necks" of the two Marys at the foot of the cross, receiving the limp body of Christ. Nothing else about the picture moved him— not the slender grace of the pale, pliant figure gliding lifelessly on its winding sheet; not the tender brush of its foot against the Magdalen's bare shoulder; and especially not the vivid depiction of inconsolable grief. "Nothing touches me *less* than Rubens expressing human sorrow," Vincent snapped. "Even his most beautiful weeping Magdalenes or Mater Dolorosas always simply remind me of the tears of a beautiful prostitute who has caught a venereal disease or some such small misery of human life."

When Vincent himself took up a brush, the same obsessions guided his hand. The same powerful fusion of artistic and sexual imperatives preempted all the hard-won freedoms of Nuenen—enlisting some and discarding others. His brief, promising ventures into landscape and still life ended almost as soon as he arrived. Except for the early attempts at tourist fare, all his thoughts and

efforts turned to portraits. In the rare breaks from model hunting, he found time to paint only two urban landscapes—both views of snowy rooftops out the rear window of his apartment building, images that harked all the way back to the Schenkweg. As in The Hague, he was seized by a frantic conviction that his art could not progress at all without models ("Above all, above all, I still haven't enough models"), compounded by a convenient certainty that portraits held the key to commercial success.

But the new mission made a new demand on Vincent's art: accuracy. The women he wooed wanted portraits that pleased and flattered—idealized but identifiable records of their unique allure—not expressions of the artist's unique temperament. Vincent had long despaired over his inability to create such "likenesses" (as he called them dismissively), and had always taken care to exempt his portrayals from the particularity required of portraiture. They were "types" or "heads of the people," he insisted, not portraits: an old fisherman, not the orphan man Zuyderland wearing a sou'wester; "a poor woman with a swollen belly," not the pregnant Sien Hoornik; "peasant heads," not the De Groot family.

Even as he planned his campaign of portrait painting in Antwerp, he dreaded the expectations of his sitters: "I know it is difficult to satisfy people as to the 'likeness,' " he wrote on the eve of his arrival, "and I dare not say beforehand that I feel sure of myself on that point." Every time a woman sat for him, he struggled with the mandate of reality. He worked and reworked profiles, noses, eyes, and hairlines, searching for the elusive correctness. The need to please overwhelmed the brave rhetoric of *"premier coup"* and "in one rush" that he had brought back from the Rijksmuseum in October. Only on the margins of an image—in the billowing folds of a blouse or the crenellations of a bonnet or a sweep of hair—could the broad, impetuous brush of Nuenen reassert itself.

Vincent's libidinous new mission may have stymied his brush, but it emboldened his palette. The models he wanted most would never have tolerated the *"de terre"* tones endured by Gordina de Groot. Only once, when an old man wandered into his studio soon after his arrival, did Vincent fall back on the familiar bistre and bitumen of his Nuenen heads. The very first time a woman sat for him, in mid-December, he courted her with bright colors and floods of light. He described the results to Theo: "I have brought lighter tones into the flesh, white tinted with carmine, vermilion, yellow . . . Lilac tones in the dress." He placed her not in a Stygian darkness but against "a light background of gray-yellow."

To make his colors even brighter and more pleasing, he sought out better paints, convinced that color "is what gives [a portrait] life." He discovered cobalt blue ("a divine color"), carmine red ("warm and lively like wine"), cadmium yellow ("brilliant"), and emerald green. Instead of mixing them endlessly into grays, he deployed them boldly: a jade green dress with a scarlet bow. He applied the lessons of Blanc and Chevreul to the new mission of flattery: heightening

a rouged cheek with a bright green background, or the yellow thrust of a neck with a lavender blouse. In place of fine gradations of tone, he called for "less far-fetched, less difficult color. More simplicity." He cited as his new goals both the luminous flesh of Rubens's women and the saturated colors of stained-glass windows. Among the modern works he saw, he singled out the bright, brusque canvases of Henri de Braekeleer, an Antwerp artist who painted women (including prostitutes) in vivid dashes of light-drenched color.

No matter how enthusiastically he embraced the new hues, new paints, new palette, and new heroes of Antwerp, however, he never lost sight of his ultimate goal. "We must carry things to such a height," he wrote, rallying Theo to the new mission, "that the girls will begin to like having their portraits painted— I am sure that there are some who want them."

BUT FEW DID. Despite his Herculean efforts, the models did not come. In the first month, Vincent reported only a trickle of visitors to his studio: the old man, an old lady, one young woman, and "half a promise" from another. By late December, he was desperate. Using some extra money Theo had sent, he paid a chorus girl from the Café-concert Scala, a Folies Bergères–like revue, to come to his studio and pose. For several weeks, he had watched her perform in the Scala's tacky Moorish splendor and, he suspected, pleasure select patrons afterward. When she arrived at his studio with her luxuriant black hair, pouty cheeks, and bee-sting lips, Vincent found her "beautiful" and "witty," but also impatient. Restless from too many late nights, she could not sit still. She refused an offer of champagne ("it doesn't cheer me up," she said, "it makes me sad") and breezily declined his invitation to take her clothes off.

Unnerved by the rebuffs, Vincent worked feverishly to produce "something voluptuous" to appease his *ennuyée* sitter: a stark, Rubenesque contrast of "jet-black" hair against a white jacket with a "flame-colored bow," surrounded by a halolike "golden glimmer" of radiant yellow "much lighter than white." She left his studio that night with the painting and a flirtatious promise to pose for him again (in her dressing room next time). *"Sacrebleu,"* he exclaimed to Theo as soon as she left. "I feel the infinite beauty of the study of women . . . in the very marrow of my bones." But there is no evidence that they ever saw each other again.

By the start of the new year, all of Vincent's bold new plans had come to similar dead ends. Nothing sold: not the big paintings he had brought from Nuenen like *The Bible*, not his beloved portraits, not even the little city views he had done for that reason only. After a month of trekking through the "chilly and gloomy" streets carrying his wares of castles and cathedrals, he had not found a single dealer who would even show his work, much less buy it. His vows to

paint signboards or design menus or find students evaporated in the heat of his passion for prostitutes and portraits. Coveting the success of portrait photographers, he imagined he could ensure more accurate likenesses in his own work by applying paint directly to photographs ("one could get a much better coloring that way"), or simply by repackaging his portraits and selling them as "fantasy heads." When schemes like these failed, as they invariably did, he blamed tight-fisted buyers, out-of-touch dealers, a moribund market, or the decline of modern art in general. "If they showed more and better things," he complained, "more would sell. . . . The prices, the public, everything needs renovation."

Next, his body betrayed him. After years of bragging about his hardy "peasant" constitution, Vincent began to complain about feeling faint, "overstrained," and "far from well." The proud rigors of his Millet diet in Nuenen came to seem more like deprivations in Antwerp's bitter, wet winter; but his stomach rebelled against richer fare. He smoked a pipe to calm his digestion, but his gums grew sore and his teeth loosened. He developed a hacking cough. For the first time, he reported losing weight. At some point, he must have suffered rashes, cankers, or lesions—as if all his vague afflictions were manifesting themselves on his flesh. In a port city filled with sailors and whores, Vincent sought treatment for the scourge of sailors and whores everywhere: syphilis.

Fearing, no doubt, that Theo would see the disease as the wages of his obsession with prostitutes and question his entire portrait project, Vincent hid both the symptoms and the treatments from his brother. He wrote nothing about his visits to Dr. Amadeus Cavenaille on the rue de Holland only a few blocks from his studio; nothing about his treatments at the big Stuyvenberg hospital nearby; nothing about his shame or dread in the face of an uncertain prognosis. But in an era that reflexively linked syphilis and gonorrhea (which Vincent had already contracted in The Hague), and that condemned both equally as "monstrosities" of nature, the diagnosis was inevitable and the treatment certain: mercury.

Whether administered in the famous blue pills, as a foul-smelling ointment, or in "fumigations" of toxic vapor (Vincent jotted one name for such treatments, *"bain de siège"* [seated bath], in his sketchbook, along with appointment times), mercury could only ameliorate the disease but not cure it. Meanwhile, it inflicted on its victims a Job-like litany of suffering to rival the disease itself: from hair loss and sexual asthenia to insanity and death. Even in moderate doses, it could cause stomach cramps, diarrhea, anemia, depression, organ failure, and impairment of sight or hearing. Mercury's signature side effect was salivation—not just unsightly drooling, but buckets of sputum ("liquefied wastes from the sickness"), all of it carrying the unseen spirochete, bathing throat and mouth and gums in new infections until the entire orifice erupted in one huge, fetid ulcer.

Although he never admitted to the disease or the treatment, Vincent

couldn't keep from his brother the ruin that followed in their wake. His already ailing stomach revolted. His energy drained. For the first time in his life, he complained of "feeling physically weak." Running constantly with a strange "grayish phlegm," his mouth and throat filled with sores so that he couldn't chew or swallow food. Within a few months, his loose teeth began to rot and break off. Before leaving Antwerp in February, he paid a precious fifty francs to have a dentist remove up to a third of his teeth—a horrific ordeal at a time when extractions were done with ratchet wrenches and liquor was often the only anesthetic.

Christmas 1885 brought a different kind of torment. The ghost of Pastor van Gogh haunted the holiday that he had dominated for so long. Vincent complained that "certain recollections [of the way] Father spoke and behaved toward me" hounded him—just as memories hounded Redlaw in his favorite Dickens Christmas story, *The Haunted Man.* To escape the voices from the past, he took long walks through the snowy streets to the city's edge. But he found no consolation in the countryside, either; only "immense melancholy." He turned inevitably to taverns and brothels for some facsimile of seasonal cheer. Despite Theo's pleadings, he adamantly refused to write to his mother or sisters, even on Saint Nicholas Day—a blasphemy against faith and family aimed straight at the heart of his dead father. He considered himself doomed to "a perpetual state of exile"—condemned forever to "a family stranger than strangers."

The despondency spread to every corner of his life. As Christmas processions made their way through the streets outside his window and skaters filled the flooded Grote Markt, Vincent sat in his empty studio and cursed the world. He cursed the dealers, like Portier, who had failed him; he cursed the models who harried and hurried him; he cursed the prostitutes who refused his money, and the creditors who demanded it. He cursed all those who scorned his claim to being a "*real* painter." And, of course, he cursed Theo. In an acid holiday "greeting," he chastised his brother for his "frigid and unkind slighting and keeping me at a distance," and lashed out at him for having so often "taken the wrong side"—their father's side—against him. "Again and again," he complained to Theo just as he had to Dorus, "you lapse into the old evil with regard to me." Looking back over the year just ending, he admitted bitterly: "I am not the least bit, literally not the least bit, better off than I was years ago."

The bleaker his reality, the more tightly Vincent clung to the fantasy of artistic and sexual fulfillment through portraits. At the very end of December, when he persuaded the girl from the Scala to pose for him, his obsession revived like a phoenix. Against all the weight of failures, that single "success" with a chorus girl rejuvenated his mission. Calling it his "greatest craving" and an "absolute necessity," he vowed to continue his quest among the prostitutes of Antwerp for a genuine "whore's expression." He summoned Theo to yet another ante of patience and sacrifice ("I must be able to spread my wings a little") and redou-

bled his promises of financial breakthrough and artistic triumph. "One should aim at something lofty, genuine, and distinguished," he challenged his brother, "shouldn't one?"

But Theo had other ideas.

IN JANUARY 1886, Theo told Vincent he had to leave Antwerp.

The brothers had been heading toward a showdown from the moment Vincent arrived. His insatiable demands for more models and more money had thrown them into yet another pitched battle almost immediately. His relentless sexual innuendoes and unblushing accounts of model hunting among the city's brothels had set off alarm bells from the past. At every hint of concern or displeasure, of course, Vincent flew into rages of protest, accusing his brother of neglecting him, stifling his art, hampering his career, and sabotaging his efforts to "regain some credit." In some of the most strident language he had used in years, he warned Theo against interfering with his newest obsession. "*À tout prix* [at all costs]," he wrote menacingly, "I want to be myself. I am feeling obstinate, too, and no longer care what people say about me or about my work."

The dispute had come to a head right after New Year's when Theo threatened to withdraw his support if Vincent did not abandon his absurd and appalling plan to pay prostitutes to pose. The plan not only made no business sense (by giving the portraits to the sitters, Vincent was essentially paying them twice), but also raised the ghost of Sien Hoornik and the possibility of yet another scandal. "We cannot do it," Theo wrote in early January. "We have no money—there is nothing doing. I tell you 'No.' " But Vincent was undeterred. Exploding in indignation, he called Theo an "impotent dullard and blockhead," and in a moment of surreal defiance, forbade him from vetoing the plan.

Vincent's health was the last straw. More than the furious accusations of meddling or the bitter Christmas denunciations, his vague reports of sickness and boasts of starvation sounded an ominous note. When he wrote that he would use any extra money not to buy food but to "immediately go on a hunt for models and continue until all the money was gone," Theo had no choice but to intervene. No doubt foreseeing another self-destructive spiral of excess, he called for Vincent to leave the city for his health's sake. "If you fell ill," he wrote, "we should be worse off." Convinced of the reparative powers of nature and unaware of the full scope of his brother's expulsion from Nuenen, he insisted that Vincent return to the country.

The demand triggered a fierce storm of protest. Up until then, Vincent had maintained that his stay in Antwerp would be a short one—"a couple of months," at most. Theo's directive changed all that. "I do not think you can reasonably expect me to go back to the country," he fired back immediately, "see-

ing that the whole series of future years will depend so much on the relations I must establish [in Antwerp]." Frantic to preserve the life of portraits, models, and prostitutes that he still envisioned, he accused Theo of "slackening" and "losing courage," and cast his staying in Antwerp as both a financial and an artistic imperative. "It would be by far the best thing for me to stay here *for a long time*," he now insisted, "for the models are good. . . . Going back to the country now would end in stagnation."

Desperate straits called for desperate measures. In mid-January, Vincent did something he had vowed he would never do again: he enrolled in art school. Not just any art school, but the ancient and prestigious Royal Academy of Art, Antwerp's answer to Paris's legendary École des Beaux-Arts. As recently as November 1885, only days before arriving in Antwerp, Vincent had dismissed the idea of Academic training: "They would not want me at the academy," he said, "nor would I want to go there." After his humiliation at the Brussels Academy in 1881 and years of bitter arguments with Rappard over Academic technique, his attacks on schools like Antwerp's Royal Academy had only grown more heated. He vehemently condemned their students as *"plaster-of-Paris artists"* and ridiculed their teaching as "superfluous" to modern art. "No matter how academically correct a figure may be," he wrote only six months before enrolling at the Antwerp Academy, "it lacks that essential modern aspect, the intimate character, the real action."

But that gospel had been overwritten by a new one. The student of the heath had become the student of female flesh; the disciple of Millet, the disciple of Rubens. Vincent would do anything to protect his mission among the prostitutes of Antwerp. Besides, he might learn something about painting accurate, appealing "likenesses" that would make his search for models easier. To explain this sudden volte-face, he filled his letters to Theo with passionate, pleading, and sometimes conflicting arguments, all of them adding up to a single, simple plea: "Let me stay."

Enrolling in the Academy would open up a world of "new friends and new relations," he wrote, promising an end to years of artistic solitude. "It is a good thing to see many others paint . . . One must live in the artists' world." Rejoining that world would require him to dress better, he assured his brother, and would revive his "high spirits." Living in the city would allow him to put both the melancholy of Christmas and the obsessions of the heath behind him, he argued, and living as a student would mean savings on rent (he would drop his demand for a larger studio), on painting materials, and, especially, on models. "I hope that I shall be allowed to paint from the model all day at the academy, which will make things easier for me, as the models are so awfully expensive that my purse cannot stand the strain." With his "self-confidence and serenity"

restored, could success be far behind? "I could not take a shorter cut to make progress," he assured Theo yet again. "This is the way."

In his fever of persuasion, Vincent led his brother to believe that the Academy offered the ultimate prize, nude female models, and hinted that he might abandon his expensive, unhealthy, and unwise search among the brothels of Antwerp if only Theo relented. (In fact, only men posed nude at the Academy, as Vincent surely knew, and beginning students were not permitted to work from models at all.)

On January 18, 1886, Vincent began classes in the Academy's distinctive building on the Mutsaertstraat—a Palladian façade affixed to a medieval friars' church. He told Theo he had enrolled in two courses: an afternoon painting class with Charles (Karel) Verlat, the school's director, and an evening drawing class, called *"antiek,"* in which students drew only from plaster casts of antique sculptures. Brushing past his long history of antagonism to schooling of any sort, he sent glowing reports of success and satisfaction ("I am very pleased that I came"). He portrayed himself as a changed man: no longer a belligerent, melancholic loner, but a dutiful student surrounded by artistic colleagues and even friends. He joined two drawing clubs: informal, student-organized groups that met late at night to draw from models, criticize each other's work, and socialize. "It is an attempt to come into contact with people," he assured Theo.

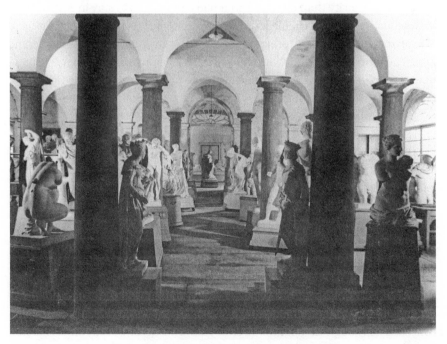

PLASTER ROOM AT THE ANTWERP ACADEMY

Banished, too, was the angry iconoclast who had alienated family and friends with his odd, tyrannical ideas about art. When instructors gave him "severe" advice, Vincent reported, or criticized his efforts, he took it not as a provocation, but as an opportunity. "I get a fresh look at my own work," he wrote sunnily. "I can judge better where the weak points are, which enables me to correct them." Not even the academy's intense concentration on drawing from plaster casts (the very issue that had caused his final break with Mauve) could darken Vincent's narrative of contentment. "On looking at them carefully again," he wrote of the school's vast gallery of plasters, "I am amazed at the ancients' wonderful knowledge and the correctness of their sentiment."

His point could not have been clearer, but he underlined it for his wary brother: "Maybe I shall feel at home here after all." Less than two weeks after his first class, he wrote Theo a long, pleading letter:

> I most urgently beg you, for the sake of a good result, to lose neither your patience nor your good spirits; it would be fouling our own nest if we lost courage at the very moment that might give us a certain influence if we show that we know what we want, and dare to do something and to carry it through.

No less an authority than director Verlat had advised him to stay in Antwerp for at least a year, Vincent claimed, drawing nothing but plaster casts and nudes. "I shall then go back to my other outdoor work or my portraits quite a different man," he pledged. More than anything, he needed practice, and "that is a question of time," he wrote. "It is to my advantage to stay here for some time. . . . I repeat, we are on the right track."

In fact, catastrophe was already upon him.

CHARLES VERLAT INTERVIEWED every student who was admitted to his painting class. His decisions were not easy to predict. He had a vigorous, inquiring mind and "a taste for the new and unknown," according to one biographer, but also strong convictions and an irascible temperament. He saw himself both as a champion of Flemish culture and as a shepherd of young artists everywhere—he admitted legions of foreigners, especially Englishmen, to the Academy's classes. Although schooled in Paris and steeped in the rigid academism inherited from previous centuries, he believed in nurturing talent of all kinds and understood the limits of artistic training. "Artists are born, not made," he conceded. Although he admired Ingres, Flandrin, Gérome, and other stars of the French Academic firmament, he had befriended the rogue Courbet in his

youth, and even exhibited with him. His career had been marked by controversy and failure as well as success and eminence. He eschewed "fashion" in artistic movements but accepted the lesson of the new art: that artists should be allowed freedom to find their own creative styles. Polish mattered less, he said, than the ability to "breathe life into something and clearly render [its] character and feeling."

With his portfolio full of crude drawings and roughly brushed portraits, all of them rendered with "character and feeling" but little polish, Vincent might have presented the director with a genuine dilemma. The previous fall, a vast overhaul of the Academy's rules had thrown many of the old standards into disarray, opening up admission to a wider range of candidates. The Anglophile Verlat might have looked favorably on Vincent's accomplished English; and the names Van Gogh, Goupil, Mauve, and Tersteeg would have stood out on any résumé. Even if Verlat had been disposed to take a chance on Vincent's earnestness and pledges of hard work, however, he hardly ever permitted new applicants to enter his class directly. He routinely sent artists with far more training for at least a few weeks in *antiek* to prove their mastery of drawing, which he considered "more useful" to a painter "than knowing how to read and write." It would have been truly extraordinary for a newcomer like Vincent to be admitted immediately into the master's life painting class.

And, indeed, he wasn't. Contrary to Vincent's repeated claims to Theo, he never did gain admission to Verlat's class. Whether he was rejected, or he never applied (the school term would end soon), Vincent had begun his Academy career with a desperate deception. He *was* allowed to register for the evening *antiek* drawing class, a decision in which Verlat may have had a hand, but he would not be allowed to paint at the Academy, nor could he work from a live model. Yet his letters continued to ply Theo with boasts of hard work in "painting class," the joys of "seeing the nude again," and the challenges of "getting along with" his demanding new instructor. "I have now been painting at the academy for a few days," he wrote, "and I must say that I like it quite well."

According to one eyewitness account, Verlat's first encounter with the strange new Dutch student came quite suddenly and unexpectedly, sometime after that reassuring report. In what must have been a last-ditch effort to make good his story to Theo, Vincent appeared one day with his paints and palette in the Academy's painting studio just after Verlat had posed two male models, naked to the waist, in the position of wrestlers. In a room crowded with sixty painters behind their easels and canvases, the teacher did not at first notice the interloper among them. But others did. "Van Gogh arrived one morning, dressed in a sort of blue smock," recalled a fellow student, interviewed several decades later.

[He] began painting feverishly, furiously, with a speed that stupefied [us]. He had laid on his impasto so thickly that his colors literally dripped from the canvas onto the floor.

When Verlat saw this work and its extraordinary creator, he asked in Flemish, somewhat bewilderedly, "Who are you?"

Van Gogh answered quietly, *"Wel, ik ben Vincent, Hollandsch."* ["Well, I am Vincent, a Dutchman."]

Then, the very academic director, while pointing to the newcomer's canvas, proclaimed disdainfully, "I cannot correct such putrid dogs. My boy, go quickly to the drawing class."

Cheeks flushed, Van Gogh contained his rage and fled the classroom.

Whether at Verlat's order or not, Vincent did enroll in a second drawing course immediately after the scene in the painting studio. It was yet another *antiek* class that confined him to the Academy's collection of plaster casts. (The course he had initially enrolled in was also finishing the term, and Vincent had already clashed bitterly with its instructor, François Vinck.) The new class, which met in the afternoon rather than the evening, took up where Vinck's left off. Only, for Vincent, the stakes had doubled. If he could not succeed there, he would have nothing to tell Theo but lies.

But the same problems that had dogged him for years followed him into the big sculpture court. The monumental milky-white plaster models that stood in the center of the room, carved into high relief by the brilliant light of a gas reflector lamp, frustrated his hand as surely as the restless poor of The Hague and the peasants of Nuenen. And on the Schenkweg and the Kerkstraat he didn't have Eugène Siberdt looking over his shoulder. A fastidious martinet in pince-nez and pompadour, Siberdt didn't know what to make of the "disheveled, nervous, and restless man" who, according to a classmate, "fell like a bomb" in his showcase of classical perfection. They approached each other cautiously at first, but a collision was inevitable. "I irritate him," Vincent grumbled, "and he, me."

Siberdt gave his students an entire week of classes—sixteen hours—to finish a single drawing. Vincent worked with a fury that startled and distracted the room, filling up sheet after sheet without retouching, tearing up drawings that frustrated him or just tossing them over his shoulder. Siberdt circulated through the class encouraging students to study the plaster models intently and *"prendre par le contour"* (seize the contour)—that is, find the lines that perfectly expressed the profile, proportion, and form from which all else sprang. He forbade the use of any fudges that might interfere with the search for the perfect line: no maul sticks, no hatching, no stippling, no tinting with stumps or chalk. "First make a contour," he directed. "I won't correct it if you do your modeling before having seriously fixed your contour."

But Vincent knew only fudges. All of his figures emerged from the fire of trying—from relentless attempts, using every means and material available, to create a convincing image. Where Siberdt demanded simplicity—black lines against a white background—Vincent could give him only shadows. Where Siberdt demanded perfection, Vincent could produce only approximation. Confronted with the smooth anatomy and elegant torque of a fifth-century B.C. discus thrower, Vincent drew a fleshy, big-hipped sower, its musculature drawn with folds as deep as an orphan man's overcoat, set against a background hatched and shaded from gray to almost black. When Siberdt tried to correct his strange ways, Vincent objected so vehemently that Siberdt thought he was "mocking his teacher." Vincent escalated the confrontation by spreading his heresy of "vigorous modeling" among his classmates and calling Siberdt's methods "absolutely wrong."

Within weeks, if not days, the dispute came to a head. When the class was presented with a plaster of the Venus de Milo as a model, Vincent took his pencil

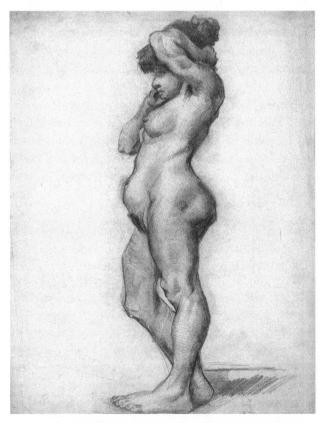

Standing Female Nude (Seen from the Side), JANUARY 1886,
PENCIL ON PAPER, 19³/₄ X 15⁵/₈ IN.

and drew the limbless, naked torso of a Brabant peasant woman. "I can still see it before me," recalled a fellow student, "that thickset Venus with an enormous pelvis . . . an extraordinary, fat-buttocked figure." Another student remarked that Vincent had transformed a "beautiful Greek goddess" into "a robust Flemish matron." When Siberdt saw this defiant provocation, he attacked Vincent's sheet with his crayon, making corrections so furiously that he tore the paper. Vincent rose to the challenge. "[He] flew into a violent rage," according to a witness, "and shouted at the horrified professor: 'You clearly don't know what a young woman is like, *God damn it!* A woman must have hips, buttocks, a pelvis in which she can carry a baby!' "

By some accounts, that was Vincent's last class at the Academy.

Still, he labored on, trudging every night to the two drawing clubs that met until the early hours of the morning, one of them in a historic old house on the Grote Markt. Students had formed these loose, roving workshops-cum-socials precisely in order to escape the oppressive restrictions of the Academy system. Members chipped in to pay for models and pints of beer all around. Women were not only permitted to pose nude, they were boisterously encouraged (although they could not become members), but more often the crowd had to settle for a man, or even one of their own number. Lubricated by drink, talk, and tobacco, club gatherings were rowdy, friendly, and unstructured—a perfect medium for artistic experiment.

But even here, far from the "spiteful" rigidity of his teachers, Vincent found only failure and rejection. From the moment he burst through the Academy doors carrying his roll of odd paintings and drawings under his arm, his fellow students shunned his company and amused themselves over his "unbelievably peculiar" ways. Years later, one of them could still recall his first startled impression of the strange visitor from the heath.

> He came rushing in like a bull in a china shop and spread his roll of studies out all over the floor. . . . Everyone crowded around the newly arrived Dutchman, who gave more of an impression of an itinerant oil-cloth dealer, unrolling and unfolding at a flea market his marked-down samples of easily foldable tablecloths. . . .
>
> Indeed, what a funny spectacle! And what an effect it had! The majority of the young chaps laughed their heads off.
>
> Soon, the news that a wild man had surfaced spread like wildfire throughout the building, and people looked on Vincent as if he were a rare specimen from the "human wonders" collection in a traveling circus.

Vincent tried at first to win over his tormentors, most of them a decade or more his junior. In a year of labor strife that would spark the first general strike

in Belgium's history, he eagerly shared with them his experiences among the miners of the Borinage and rallied them to a similar artistic solidarity. Rebuffed as a "freak," he turned inevitably to the clubs' other outsiders, especially the large contingent of Englishmen with whom he shared both a language and an exile. Like him, they had left the severities of their home academies for the looser rules and naked models of Antwerp. One evening, he even sat for a quick water-color portrait by a young English student named Horace Mann Livens.

But it wasn't clear whether Livens intended to record his weathered face or mock it. Other clubmates later recalled gleefully how Livens's portrait perfectly captured Vincent's "flat, pink head, yellow hair, angular mask, pointed nose, and ill-cut beard." Of all his fellow students, Livens was the only one with whom Vincent ever corresponded after leaving Antwerp. From Paris, six months later, he sent a single, plaintive missive ("You will remember that I liked your color, your ideas on art and literature," he wrote, "and I add, most of all your personality"). The letter to the twenty-three-year-old Livens opened not with "Dear Horace" or "Amice," but with a stiff greeting: "My dear Mr. Livens."

Recoiling from the impatience of his teachers and the intolerance of his fellow students, Vincent increasingly withdrew into silence. He still came to the clubs every night, clinging to the last remnant of the artistic life that he had promised Theo. But he mostly sat in the corner furiously scratching out his defiance in pencil and charcoal. Whether drawing a bored workman or a haughty fellow student, Vincent made his arguments in energetic strokes, jagged contours, deep shadings, free hatching, and multiple materials—a proud reclothing of the peasants of Nuenen. When he finally got a chance to draw a naked woman, he avenged himself on teachers and classmates alike with an angular, muscular monument of flesh and fertility.

Far from winning converts, these provocative images only drove the wedge deeper between Vincent and his fellows. They read enmity in his silence; arrogance in his persistence. "He pretended not to notice [us]," one of them recalled, "but only withdrew further into that stoic silence which soon earned him a reputation for self-centeredness."

By early February 1886, Vincent's fiction of life in Antwerp was collapsing on all sides. He had been ejected from one class, humiliated in another, and angrily awaited the ax in a third. His fellow students spurned his company and mocked his art. He had found no sympathetic dealers, no connections, no amateurs willing to pay him for lessons. He went through the motions of submitting a drawing to the competition, the *concours,* that concluded the term, but mocked himself for trying ("I am sure I shall place last"). Still, he could not have been prepared for the judges' recommendation that he be sent down to an "elementary level" course to draw with ten-year-olds.

Meanwhile, Theo grew more and more impatient with his lack of progress.

He began to question everything from the difficulty of Vincent's courses to the mettle of his resolve. Their exchanges over money grew sharper as Vincent's unaccounted expenses (medicine, treatments, alcohol, tobacco, prostitutes) mounted, and the possibility of sales faded. At the same time, the object of all Vincent's efforts, and much of his money, slipped further and further from his grasp. He never heard from the Scala girl again, nor did any of his plans for portraits of "hussies" or other "intercourse with women" materialize. His deteriorating health and shrinking purse combined to put every sexual outlet out of reach save one.

The teeth that he had often cited as symbols of his virility rotted and broke off. His cheeks sank, his stomach ached, his indestructible body went weak and feverish. But he couldn't tell Theo why. Instead, his letters continued to brag of "keeping courage," "making progress," and "avoiding a real illness." Torn between reassuring his brother and preparing him for the looming collapse, he sent a flood of conflicted letters: bitter complaints about the abuses he suffered wrapped in claims of calmness and serenity and confidence in the future. "I keep feeling satisfied with having come here," he insisted. "There is something of resurrection in the atmosphere."

As the gap between his real life and his imagined life grew wider, the deception grew deeper. As in Drenthe, when the paradise in his letters fought the hell in his head, something had to give.

"It is an *absolute* breakdown," he reported in early February. "It overtook me so unexpectedly."

What triggered this collapse? Was it another ambush of metaphor, as in Drenthe? Or perhaps something more dramatic? At least once that winter, Vincent was seen drunk in public. Another time, for unknown reasons, he jotted the address of a local police station in his notebook. He may have been caught off guard by a hint in one of Theo's letters about a possible courtship of Johanna Bonger. In the context of the brothers' estrangement, news like that would have raised the direst threat of all: abandonment. Or perhaps it was something simple and quotidian, like a too-long look at the cadaverous, gap-toothed face in the mirror. "I look as if I had been in prison for ten years," Vincent wailed, as if seeing himself for the first time. "There is something stiff and awkward about me."

For weeks afterward, the image of decay haunted him. He tried to blame the breakdown on poor food, too much smoking, and delicate nerves. "Nervous people are more sensitive and refined," he protested. But in more unguarded moments, talk of nervousness yielded to fears of insanity. What else could be expected of a man who had "dined for years on *la vache enragée* [mad cow]," he wondered. At times, he pretended to believe that improving his outward appearance would solve all his problems. But at other times he conceded that the strange visage in the mirror betrayed "a difficult and harassed life, much care

and sorrow and no friends," and that nothing could "cure or save" him. He wandered the winter streets hounded by images of death and dying: from the graceful exits of great artists ("they die the way women die . . . hurt by life") to the preemptive suicide of a young girl racked by consumption. Death hovered over his easel as well. Sometime that winter, somewhere in Antwerp, he placed a canvas in front of a skeleton, put a cigarette between its teeth, and slashed out his first self-portrait.

As in Drenthe—the last time Vincent feared he had "lost all chance for happiness . . . fatally and irrevocably"—he turned to Theo. This time, the cry arose not from the lonely heath but from the crowded streets of Antwerp. And instead of an exhorting demand—"Join me"—it was a plaintive, heartbreaking plea: "Let me join you."

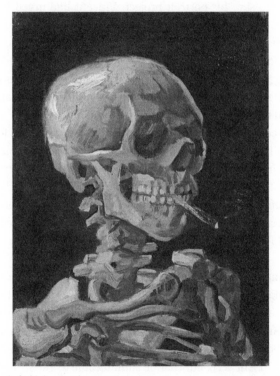

Head of a Skeleton with Burning Cigarette, JANUARY–FEBRUARY 1886,
OIL ON CANVAS, $12^7/_8$ X $9^1/_4$ IN.

THE TWO BROTHERS had been fighting over Vincent's coming to Paris since 1880—even though neither one wanted it to happen. Theo had issued invitations on and off, invariably when Vincent's art or spending careened out of control and consolidating their living expenses seemed the only hope of stretching his salary to support them both. But his invitations were always issued with a

sigh of resignation and an edge of reprimand, never in a spirit of genuine wel-
come. And for that very reason, Vincent had never accepted them. Instead, he
invariably waited until Theo withheld money or support, then used the threat of
coming to Paris to maneuver him into concessions.

Round and round they went—in the Borinage, in Brussels, in Drenthe, in
Nuenen—daring and bluffing each other to stalemate each time, until Paris had
assumed a significance far beyond its place as the mecca of artists everywhere.
To Theo it had come to represent the frustration of his long effort to guide Vin-
cent toward self-sufficiency; to Vincent, it meant the surrender not just of his
independence, but of all his heated claims of artistic principle and ultimate suc-
cess. To both, it had become an admission of failure.

The latest round had been fought as recently as January. In his delusional
determination to save his portrait project, Vincent had urged his brother yet
again to quit Goupil and open a gallery in Antwerp. When Theo responded by
demanding that Vincent return to Holland instead, Vincent immediately threat-
ened to descend on Paris—"without any hesitation." And it would not be cheap,
he warned. He would need to "work regularly from the model as much as pos-
sible"—and the models would not be free, as they were at the Academy. In addi-
tion, he would need "a rather good studio where one can receive people."

Theo offered a compromise: if Vincent went to Nuenen for a few months to
help their mother pack for a move to Breda, he could then come to Paris and
perhaps work in a prominent studio. He dangled the name of Fernand Cormon,
an atelier master long known to Vincent for his loose rules and nude models.
But Vincent refused the bait. He angrily dismissed Theo's objections to Antwerp,
reaffirmed his satisfaction with his life there, and defiantly declared his intention
to stay "for at least a year." As for Paris, he said tauntingly, "we aren't that far
yet."

But all that changed in early February. As in Drenthe, Vincent emerged
from his breakdown a different man. After months of the dutiful drip-drip of
weekly letters, he flooded his brother with seven long, pleading missives in just
two weeks. Gone were the scolding defenses and strident demands for money.
Instead, he filled page after page with dense, imploring arguments—not that
he should stay in Antwerp, but that he should come to Paris. "If it could be ar-
ranged so that we lived in the same city," he wrote in a complete reversal, "it
would certainly be by far the best."

He not only approved of Theo's plan for the Cormon studio, he penned long
paragraphs proclaiming it "critical" to his artistic project. His barbed demands
for a separate studio were replaced by calls for caution and savings. A single
room would be sufficient, he assured Theo. "Anything will do." As for Antwerp,
he apologized for not making more progress and humbly conceded "disappoint-

ment" in his time there—another complete reversal. Although he never admitted to the debacle at the Academy (he led Theo to believe he was still registered), he retreated from the fiction of success he had spun and offered his brother a rare glimpse of his true world. "If I did not go [to Paris]," he confessed, "I am afraid I should get into a mess, and continue to go in the same circle and keep on making the same mistakes."

Now, nothing mattered more than reuniting with Theo. "Union is strength," he cried, resurrecting the call from Drenthe. He summoned the vision of the Rijswijk road ("It is such a splendid idea that, working and thinking together"), and tearfully cited other brother pairs who had "joined hands." He pictured their life together in Paris in yearning images of domesticity, just as he had in Drenthe. "I do not think it would do you any harm to come home to a studio in the evening," he wrote Theo. "I have wanted it to be this way between us for a long time already." He promised his brother everything from better health to a better chance at happiness, if only he would agree.

Not even marriage—to Jo Bonger or anyone else—could daunt Vincent's vision of perfect solidarity. "I wish we *both* might find a wife before long," he imagined, "for it is high time." As in Drenthe, he sealed his plea with vows of hard work, improved health, and good behavior, punctuated by outbursts of desperate longing. "After so many lost illusions we *must* feel sure that we can carry it through," he wrote, "we *must* know our own minds perfectly, we *must* have a certain confidence after all."

Theo surely foresaw, in Vincent's fevered pleas themselves, the disaster that loomed. He had spent the last five years suffering his brother's fanatic heart, his wild swings of weeping nostalgia and cautionless zeal, his alternating spirals of anger and self-abuse. Already old at twenty-eight, Theo could not have held out any hope for real change. Their bitter, unending contest would soon come to his city, his job, his friends, his home. All he could do was delay. He threw up excuses—his lease did not expire until June, there was no room in his apartment, it was too expensive to rent a second apartment—and pushed again for Vincent to go to Nuenen, at least until June.

"Brabant is a useless detour," Vincent scoffed, in a worrisome reminder of his changeability.

When Theo suggested that Vincent could use his time in the country to paint landscapes, Vincent claimed the absolute necessity of drawing from plaster casts "without interruption"—an ominous reminder of his intransigence.

Finally, Theo did what he always resisted doing: he told Vincent no. He could *not* come to Paris immediately. He would have to wait until summer.

But Vincent could not wait. Only days after receiving Theo's answer, he boarded the night train to Paris. He left his rent, his paint bills, and his dentist

492 The Dutch Years, 1880—1886

unpaid. He told his brother nothing of his plan. The first Theo heard of it was a hand-delivered note he received at his office the next day. *"Mon cher Theo,"* it began.

> Don't be angry with me for arriving out of the blue. I've given it so much thought and I'm sure we'll gain time this way. Shall be at the Louvre from midday onwards, or earlier if you like. . . . Come as soon as you can.
> We'll sort everything out, you'll see.

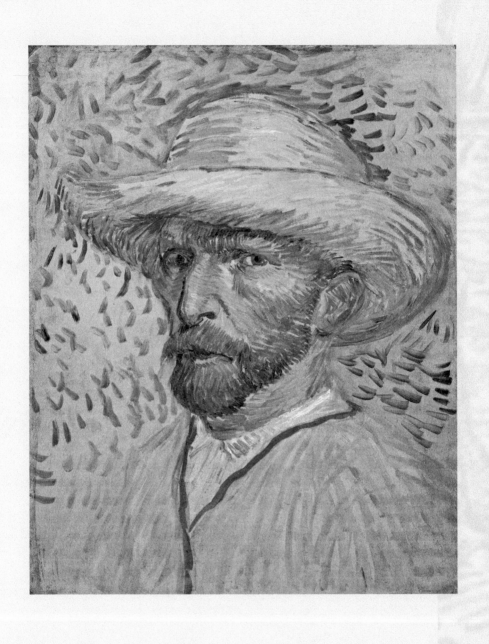

The French Years
1886–1890

Against the Grain

~

VINCENT WENT DIRECTLY FROM THE GARE DU NORD TO THE LOUVRE. He had told Theo to meet him in the Salon Carré, the gilded wedding cake of a room that had given birth to the vast institution called the Salon. In this one room were displayed as many of the museum's greatest masterpieces as would fit on the walls—Leonardo's *Mona Lisa*, Rembrandt's *Holy Family*, Holbein's *Erasmus*, Veronese's giant *Marriage at Cana*, and scores more—all stacked and tightly fitted together like bits in a mosaic.

Only nine months earlier, the room had echoed with the wails and moans of mourners making their way to the Arc de Triomphe, where a huge black catafalque had been erected under Napoleon's great arch. Victor Hugo was dead. Over two million people filled the streets that day, more than the entire population of the city. From the Louvre's west-facing windows, a river of humanity stretched as far as the eye could see, flowing past the ruins of the Tuileries and pooling in the Place de la Concorde, site of the Revolution's razor. As the funeral cortège passed through the vast square, the crowd swelled like a tide, climbing up every tree, fountain, lamppost, and kiosk to get a glimpse of the grand procession that climaxed in a simple pauper's hearse—Hugo's parting provocation.

The old socialist lion had achieved a new kind of divinity by debunking the old. Through the better part of a century of bourgeois consumerism and contentment, he had kept the torch of idealism—the flame of the Revolution—alight and aloft. He had battled backsliding governments and resurgent religion, outraging everyone from Louis Napoleon to Dorus and Anna van Gogh with his celebrations of godlessness and criminality. Indeed, he had proudly staked out his place as a noble outlaw at war with society, a prophet of doom to the prosperous and a Moses to the dispossessed, clinging to his vision of truth in a dark and doubting era.

By 1885, when Hugo was laid to rest in a deconsecrated Pantheon accompanied by a twenty-one-gun artillery salute, the world had changed. While his outcast-as-hero status lived on as a model to artists of all kinds, including Vincent van Gogh, his confidence in the ultimate triumph of the human spirit did not. The senseless slaughter of the Franco-Prussian War, the chaos of the Commune, the dislocation of technological changes, the buffeting of economic cycles, and the bafflement of scientific advances, all combined to make any ambitions to higher truth seem like mere bourgeois vanity. Who could maintain Hugo's idealism in the face of Poincaré's proof that time and space were not fixed (overturning Newton's comfortable universe); Pasteur's discovery of deadly unseen agents; or Flammarion's mapping of unseen worlds in the night sky—to say nothing of capitalism's incalculable barbarism?

Uncertainty bred fear. As the end of the century loomed, Hugo's utopian optimism had turned to apocalyptic dread. His funeral itself struck many as a millennial marker: the huge black-draped Arc, a fitting metaphor on which to close a century that seemed doomed to end badly. The pervasive fatalism expressed itself in a desperate, demagogic politics. A military strongman, General Georges Boulanger, made promises of stability and security that were greeted with wild and menacing public acclaim. A newly empowered popular press alternately stirred the "patriotic" frenzy and pandered to readers' fears with alarming reports of criminality and corruption. Anarchists' bombs, both verbal and incendiary, provided the final proof that the end of civilization was near.

By 1885, most writers and poets had fled the high ground that Hugo had defended so stoutly—spooked, like everyone else, by the specter of meaninglessness. Some, like Zola, made a separate peace with the dark forces of modernism. Embracing the positivist promise of salvation through science, they marshaled the "facts" of everyday life into searing indictments of bourgeois complacency—the same enemy that Hugo had long battled with gripping fictions and soaring rhetoric. But a younger generation of writers found cold comfort in the naturalists' limited world of observable phenomena. How could note-taking, even the brilliant note-taking of Zola, capture the roiling stew of human emotions or the mystery of existence? Wasn't the ultimate reality not the observable one but the *felt* one; not the "real" world but the *perception* of the real world? If there was meaning to be found in life—and that "if" was crucial—then surely it could only be found in the tortured labyrinth of the psyche. Surely art's truest mandate was to map that labyrinth: to express directly, unvarnished and untempered, the elemental reality of human consciousness.

But how to fulfill that mandate? How could one express in words a reality that was both unobservable and individual? Everyone agreed on the question, but no one agreed on the answer—thus proving the dilemma. Some, like Mallarmé, continued to believe that traditional words and forms, the stuff of Hugo,

could meet the challenge of exploring this new dreamlike inner world. Others insisted that the new reality demanded a new language. The old precision of words was a chimera, they claimed. Words were, in fact, more like scents, or tones, or colors. Using them to inform or describe, as Zola did, was a fool's errand. Their real purpose could only be to stimulate the senses, engage the heart, or stir the soul. Sensation, emotion, inspiration. These were the elusive "essences" of life—art's only deserving subject.

In 1884, J. K. Huysmans, a former Zola acolyte (and nephew of Vincent's high school art teacher), published a manifesto of the new ideas: a thinly veiled autobiographical tale of a reclusive aesthete engorging his senses on every strange and forbidden indulgence. In the year before Vincent arrived, *À rebours* (*Against the Grain*) rocked the literary world of Paris. To some writers, however, like the poet Paul Verlaine, *any* words, even autobiographical words, seemed pitifully insufficient. An estranged son of the bourgeoisie, Verlaine wandered from dissolution to scandal to self-destruction in a tortured living out of his inner life. At the moment of Vincent's arrival, not far from the Louvre, Verlaine lay sickly, drunk, and dissipated in a prostitute's flat in the Latin Quarter. But in the new, inverted world of Parisian letters, he was acclaimed a hero.

Critics coined a new term for these avatars of excess, whether real or fictionalized: "Decadents." The writers themselves couldn't agree on a better name. In 1886, someone proposed "Symbolists"—the label history would ultimately attach to them—but that was rejected as too literate, too literal. What bound them together was not a word—feckless, faithless words—but a common contempt for convention, a love of scandal, and a shared belief that only the eccentric outcast—whether aesthete, criminal, or madman—pursuing his own inner path, could express the deepest mysteries of life.

Artists, too, had peered into the abyss and come away with divided minds. The nostalgic naïveté of Barbizon pastorals and Millet peasants had long since lost its allure to young painters impatient for the future. In the decade since Vincent left Paris in disgrace after his fall from Goupil, the Impressionists' long struggle for legitimacy (and sales) had moved from insurgency to vindication to eclipse. Their relentless descriptions of sunlight and bourgeois ephemera seemed more and more a confectioner's art—pretty, optimistic, and meaningless—to artists and critics hungering for expressions of the fin-de-siècle darkness.

Driven by the fractious literary world, with its chaos of competing ideologies each supported by its own partisan critics and mouthpiece reviews, progressive artists splintered into shifting, bickering factions.

Some attacked the Impressionists for not going far enough in embracing the scientism of the future. Led by Georges Seurat, the son of a customs official and a disenchanted Beaux-Arts student, they argued that color could be divided up into its constituent elements and then reassembled by the observer's eye as it

reacted to a work of art. Drawing on positivist philosophers as well as the scientific color theories of Blanc and Chevreul, they rejected the old way of mixing colors on the palette and claimed that a more vivid effect could be achieved by dividing each stroke into smaller "points" of purer color and applying each one separately.

Seurat had spent most of 1885 eagerly preparing a great "manifestation" to prove this theory of divided color. He went again and again to make preparatory drawings at an island in the Seine called La Grande Jatte, a favorite Parisian spot for recreation and promenading. He advertised these preparations to his followers as an elaborate scientific project, involving precise measurements of color and light, and he gave the huge painting that took shape slowly, point by point, in his studio, a suitably descriptive title: *Un dimanche après-midi à l'Île de la Grande Jatte* (*A Sunday Afternoon on the Island of La Grande Jatte*). Seurat dubbed his new method "chromoluminarism," but even his own followers preferred simpler names like "divisionism" or "pointillism."

Another group attacked Impressionism for the opposite reason: because it relied *too much* on science. No rules, no matter how scientifically formulated or applied, could express the elusive meanings and deep mysteries of life— art's ultimate subject. Their leaders were not young: Odilon Redon was a forty-five-year-old provincial aristocrat when Huysmans's *À rebours* brought the art world's attention to his eccentric charcoal *Noirs*—disturbing, hallucinatory images that eschewed color altogether in their pursuit of mystery and meaning. Gustave Moreau had turned sixty by the time young disillusioned artists—again alerted by *À rebours*—began seeing in his mysterious renderings of Greek myths, Bible tales, and children's fables an escape from the literalness of modernism.

Encouraged by these and other examples, and urged on by Symbolist writers and critics, artists began rummaging in the attic of the culture's collective unconscious for the "reality" in otherworldly images, and for pictorial devices that conveyed the essential otherworldliness of real life. They wrapped their subjects in gauzy, dreamlike atmosphere or bathed them in theatrical light in order to transform the everyday into the monumental; the natural into the supernatural; the specific into the mythic. By refocusing Impressionism's view of reality from surfaces to essences, these artists (whom history would also label Symbolists) hoped to reenchant both art and life—to fill the hole left by religion and unfilled by science.

Still another group of artists, especially younger ones, had given up on both science and enchantment. Instead of compromising with or transcending the absurdity of modern life, they embraced it. Children of the postwar malaise, artists in their twenties, especially, found the entire artistic enterprise unconvincing and irrelevant. They entertained each other with ferocious mockery of the Academic system and irreverent skepticism of all art's claims to higher truth.

Their anarchic cynicism expressed itself less in art than in actions. They formed mock-solemn societies that ridiculed not just the usual bourgeois enemy but any attempt to enlighten or reform it. They lampooned the Impressionists with an exhibition of "drawings made by people who don't know how to draw" and derisively dubbed themselves "the Incoherents."

Their art relied heavily on words, especially wordplay, as if they no longer trusted images alone. What little work they produced mixed parody, provocation, adolescent humor, profanity, and polemics into images as randomly explosive as anarchists' bombs: drawings made with the artist's foot; paintings of nudes described as *"léchée"* (licked); all-white and all-black paintings with winking titles (*Negroes Fighting in a Cellar at Night*); constructions that combined traditional images with actual objects affixed to them (a worn shoe stuck to the portrait of a postman). One artist repainted the *Mona Lisa* with a pipe in her mouth and wreathed in smoke (anticipating by several generations Marcel Duchamp's similar defacement after the next great war).

They found many ways to vandalize the old pretensions of "high" art. They incorporated into their work the tawdry subjects, garish colors, and unrefined sensibilities of commercial advertising (in which some of them were employed). They borrowed imagery from "low" aesthetic genres like fashion magazines, street posters, calendars, and cartoons, as well as the cheap but colorful prints sold by the thousands to working people and plastered everywhere in cafés, wine shops, and public urinals. Artists like the Incoherents proudly acknowledged the meaninglessness of their endeavors ("the subject is nothing," Paul Signac explained) and gave their subversive approach to art—and life—a name that perfectly reflected both its origins in café badinage and its blithe insubstantiality. They called it *fumisme*—roughly, blowing smoke.

In a culture defined by consumerism and self-contempt, the *fumistes'* nihilist aesthetic quickly became all the rage. Artists' clubs that began as little more than café conclaves mutated into popular entertainments (*cabarets artistiques*) where impresarios like Rodolphe Salis and Aristide Bruant marketed the outré bohemianism of avant-garde art to the *haut monde* of Paris society and gaping tourists. They took names like Café des Assassins, Cabaret des Truands (criminals), and Cabaret de l'Enfer (hell). At the most famous of them, Le Chat Noir (The Black Cat, an obscene pun on a slang term for the female genitalia), the fashionable clientèle sat in cramped rooms decorated in "atelier clutter" attended by waiters dressed in the green-and-gold livery of the French Academy. The proprietor, Salis, insulted his guests with Republican *égalité*, favoring even the most genteel with a frisson of the artistic life by "treating them like pimps and whores," according to one account.

The artists themselves eagerly played their part in this self-annihilating parody. It was the era of publicity and self-promotion; an era when even a tarty

actress could rise to unheard-of celebrity as "the divine" Sarah Bernhardt (a Chat Noir patron); an era when any artist with a scandalous story or an outrageous image, and a critic or publicist to flak it, could aspire to a level of conspicuity unimagined by Salon favorites of the past. With so much to gain, and the future of art—and everything else—so much in doubt, the new generation of artist-entertainers barely noticed or cared that they had succumbed to the same bourgeois ethos they so mercilessly pilloried every night at Le Chat Noir. Of only one thing were they certain: if art was to have a future—and that "if" was crucial—it would have to travel by a new road, as they had blown up all the old ones.

This was the art world that awaited Vincent van Gogh in Paris. Only a few years after the Impressionists drove the first wedge into it, the great monolith of the Salon—with its hegemony over public taste and intellectual discourse— had shattered into a kaleidoscope of noisy, competing partisans, fueled by ideas noble and mean, existential and commercial, evangelical and self-serving: a world sustained on the oxygen of café arguments, clamorous reviews, and the certainty that history would lavishly reward the art and ideas that triumphed, and ruthlessly discard the rest.

The disintegration of the artistic avant-garde horrified and disgusted Émile Zola. He saw in it the frustration of his great naturalism project. In *L'oeuvre* (*The Masterpiece*), which Vincent began reading in serialized form on the eve of his arrival in Paris, Zola chastised all artists, even the Impressionists he had once championed, for their failure to find a single, emblematic art for the new era. Using the fictional story of Claude Lantier, a near-mad painter obsessed with the creation of a perfect work, Zola rejected both the Symbolists' surrender to the supernatural and Seurat's impersonal science. To create a *true* modern masterpiece, he argued, an artist would have to give more of himself ("What was Art, after all, if not simply giving out what you have inside you?")—even if, as in Lantier's case, that meant insanity and certain death. He challenged artists of every stripe to meet his challenge. The entire century had been and would remain "a failure," he thundered, until the mandate of modern art had been fulfilled—until someone, somewhere, found inside himself an art at once literal and poetic, real and symbolic, personal and enchanted.

VINCENT ARRIVED IN Paris with only one mandate: to please Theo. He had come unannounced, unexpected, and unwelcome. For years he had pictured the brothers' reunion as a perfect and inevitable fulfillment—increasingly, the only one possible. Now that it was upon him, he was terrified of disappointment. "What I am not sure of is whether we shall get on personally," he confessed to

Theo only weeks before his departure from Antwerp. "If we were together soon, I might disappoint you in many things."

To avoid that fate, Vincent immediately rededicated himself to the goal that he had so often abandoned: bourgeois respectability. He sought out a barber to give his beard the smartest new trim and a tailor to fit him for a new suit to match his dapper brother. He finished the arduous task of fixing his teeth, and had a modern Paris dentist fit him out with the latest in wooden dentures. Casting aside the last self-abnegation of the heath, he indulged in a regular Parisian diet of restaurant fare. In these and other ways, he did his best to blend in with the fashionable crowds that bustled outside Theo's little apartment on the rue Laval. Situated just off the grand boulevard de Clichy in a busy theatrical district, the street was well known to all of Paris society. Only a few doors away, Le Chat Noir filled the neighborhood with stylish revelers until well past midnight.

But Vincent's renewed ambition also brought renewed demands. Theo's cramped flat not only posed a threat to the brothers' comity, it also proved completely unsuitable to Vincent's vision of "a rather good studio where one can receive people if need be." He may have been forced to stop painting altogether for lack of space. Before arriving in Paris, eager to join his brother, Vincent had temporarily dropped his demand for a studio. He even offered to live by himself in a garret for the first few months and wait a year before securing a separate workspace. But Paris's lures and Theo's cosmopolitan lifestyle soon rekindled old longings. He probably began militating for a bigger apartment as soon as he arrived, and without doubt he took the lead in finding one—a process that he had rehearsed often in his fantasies. "If one wants to start a studio," he wrote from Antwerp, "one must consider well where to rent it, where one has the greatest chance of getting visitors, and making friends, and getting known."

The spacious fourth-floor apartment at 54, rue Lepic fit these specifications like a tailored suit.

First, it was located in Montmartre, the community where Vincent had lived during his last stay in Paris. Rising from the boulevard de Clichy, Montmartre spread up and over the famous butte of the same name, a limestone promontory that thrust into the Seine valley from the east, forcing the river to take a great westward loop around it. From the crest of the butte, with its crenellation of windmills, one could see the Seine on three sides—slicing through the dense city to the south; washing the river playgrounds of Asnières and La Grande Jatte to the west; then disappearing into a wasteland of factories and *banlieues* to the north.

In the ten years since Vincent lived there, Montmartre had kept its reputation as an artistic refuge from the big city—a marginal place where people came to indulge in marginal activities, a "half-wild" quarry town where rich men se-

creted their mistresses, and artists enjoyed a special liberty in their studios and in their habits. But now, like the rest of bohemia, Montmartre had acquired a new bourgeois cachet. Now, the margins had become the new fashion, as artists and intellectuals flocked to the knowing fringes. Zola and the Goncourts set novels here (and later chose to be buried here); Salon painters like Alfred Stevens brought their clients here ("society women [were] highly excited at the thought of going up to Montmartre," according to one account); and popular *chansonniers* like Bruant sang the praises of the "martyr's hill" to packed houses here.

The building that Vincent chose, on a bend in the rue Lepic, was perfectly poised at the intersection of old and new Montmartre, village and city, fringe and fashion. It sat just below the butte's final steep rise—before the streets turned to stairs and the sidewalks ended in chalky paths. Beyond the bend, the bright new limestone buildings yielded to wind-beaten old shacks and ragged greenery, and the paths led sightseers to the few surviving windmills, now stripped of their sails and reduced to tourist attractions by the coming of steam.

Built in 1882, the nondescript five-story apartment house had been designed specifically to exploit the same demand for boundary-hopping that filled the seats of Le Chat Noir every night. It repackaged the old bohemian Montmartre for the new boulevard taste. Great oak outer doors led to a quiet passage and a view of the garden in back. Guests entered the vestibule through the elaborate iron-and-glass inner doors, where a concierge greeted them. The apartments—only two to a landing—boasted huge rooms (by Paris standards), herringbone parquet floors, black Belgian-marble mantles, and tin tubs. Modern conveniences included gas heat and light in every room and, most astonishing in a city where even good buildings offered only a single outdoor tap, *two* faucets—one in the kitchen and one in the bathroom. (Chamber pots remained a standard feature in all but the richest households.)

Theo and Vincent's apartment had the special advantages of a high floor, far removed from the smells of the street, washed with sunlight and open to Montmartre's famous breeze. Everywhere in Paris, height signaled status: the higher one's floor, the higher one's social standing. The builders of 54, rue Lepic shared their renters' disregard for the lower classes, too. The "kitchen" consisted of a tiny room at the back with a single gas burner on a wooden table. But Vincent didn't care: Theo had agreed to hire a full-time kitchen maid, enviously described by a friend as "a cook *in optima forma.*"

In June, as soon as the rue Laval lease expired, Vincent moved the brothers into their fashionable new aerie. He took the smallest of the three bedrooms for his own, saving a larger one for his studio. Fulfilling fantasies of fraternal domesticity he had harbored since Drenthe, he doubtless took charge of the decorating—not just arranging the furniture and planning window treatments, but

also hanging Theo's collection of paintings, prints from both their portfolios, and some of his own work.

As soon as the move was complete, as if to celebrate his new home and new life, Vincent took up Guy de Maupassant's *Bel-Ami*, the story of another ambitious outsider who climbed to the heights of Paris society from a humble start in Montmartre. Like Octave Mouret, Georges Duroy charms and dares his way into the hearts of men and the beds of women (thus earning his nickname, Bel-Ami—a winning fellow). Vincent found comfort in Maupassant's "light-hearted" vision of the uphill road ahead—and, no doubt, inspiration in Duroy's ultimate, dizzying success. He pronounced *Bel-Ami* "a masterpiece" and recommended it as an antidote to all "civilized people [who] suffer melancholy and pessimism"—including himself:

> I, for instance, who can count so many years of my life during which I lost any inclination to laugh—leaving aside whether or not this was my own fault—I, for one, feel the need for a really good laugh above all else. I've found it in *Guy de Maupassant.*

A winning new life demanded a winning art. Gripped yet again by the vision of a successful joint enterprise with Theo, and desperate to justify his unbidden arrival, Vincent threw himself into the task of creating works that would sell. He started by illustrating menus for restaurants, fulfilling a pledge he had made in Antwerp. For one upscale establishment, he transcribed the entire bill of fare (*"Cervelle Beurre noir," "veau marengo," "gâteau de riz au Kirsch"*), and bordered it with a scene straight out of *Bel-Ami*: fashionable Parisians strolling through a park.

Reviving his ambitions from The Hague, he peddled illustrations to the myriad magazines and illustrated papers that filled the newsstands of Paris, many of them published by cafés and cabarets like Le Chat Noir. He carefully calculated the subject matter, size, setting, and mood of each drawing, gauging it to a specific potential client. For Le Mirliton, Aristide Bruant's popular club not far from the rue Laval, he chose as his subject a denizen of the very demimonde that Bruant celebrated in his songs and in his magazine: a grotesquely obese woman walking her little dog. He set her on the sidewalk just outside Le Mirliton, with landmarks carefully drawn in, and, for good measure, inscribed the drawing with a verse from one of Bruant's own songs. For Le Chat Noir itself, he created a tiny illustration the size of a calling card—perfect for menus, napkins, stationery, or their famous magazine—showing a dangling skeleton and a crouching black cat locked in a macabre stare.

The move to a studio of his own in June opened up another money-making

possibility: tourist pictures. Every day a steady stream of sightseers made their way up the rue Lepic, the primary route to the summit of Butte Montmartre, to see the famous view of Paris from its crest. Only a block uphill from the brothers'

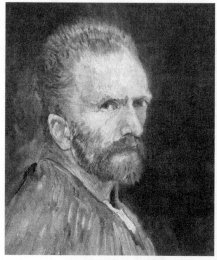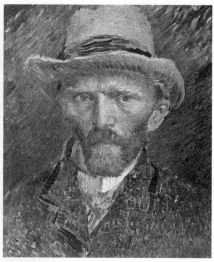

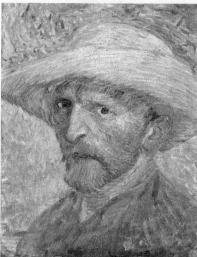

Self-Portrait, 1887, OIL ON CANVAS, $16^1/_8$ X $13^1/_8$ IN.; *Self-Portrait with Grey Felt Hat*, 1886–87, OIL ON CARDBOARD, $16^1/_8$ X $12^5/_8$ IN.; AND *Self-Portrait with Straw Hat*, 1887, OIL ON PANEL, 14 X $10^5/_8$ IN.

apartment, the Moulin de la Galette—a bustling entertainment complex of restaurant, dance hall, and park—attracted crowds day and night with food, drink, and the *cahut*, a lewd variant of the cancan. The complex incorporated two of the three remaining windmills on the mount, the Radet and the Blute-Fin. The latter's precarious belvedere offered the most spectacular view of all: a panoramic metropolitan vista unlike anything anybody had seen in an era when flight was still an exotic rarity.

The view was Montmartre's signature landmark, as closely linked to it in the public imagination as Antwerp was to its cathedral, and Vincent attacked it with the same mercenary fervor. Many streets in his neighborhood afforded spectacular views from their higher reaches, as did the windows of the rue Lepic apartment. From the windy lookout of Blute-Fin to the noisy construction site of Sacré Coeur, he carried his easel up and down the mount in search of fresh angles on the vast vista.

At some point, Vincent turned around and fixed his perspective frame on the butte itself. He saw in its sentinel windmills and seedy clutter more to interest his searching eye than in the smoky, unchanging panoramas. Even more important, he saw the potential for sales. Tourists snapped up prints of Montmartre's unique country-in-city landscape—not just the windmills, but the old quarry, the twisted streets, and the shantytown on the ridge. Dedicated magazines ran page after page of such illustrations. Vincent repeatedly drew and painted the picturesque mills (both from a distance and close-up); the street outside the Moulin de la Galette (with its signage carefully lettered in); and the crazed patchwork of huts and gardens at the crest of the butte. He painted them in the muted tones of Mauve and the Hague School—the most salable images he knew. He even tried them in watercolor—an ever-frustrating but affordable medium. "One must sell cheap to rise," he said, "or even at cost. Paris is Paris."

Sometime that spring, Vincent celebrated his new incarnation in a new way: he looked in the mirror. Instead of a convict with broken teeth and sunken cheeks, he saw an artist Bel-Ami—a young man still, but not unseasoned (his hairline receding), dressed not in the loose blue smock of Millet but in a sturdy wool jacket, high-buttoned vest, and silk cravat. Here was a man who cared for himself properly: beard barbered, hair curled, teeth tended; a man who carried himself with dignity: chin up, chest thrust out. Without the telltale brushes and palette, he could have been a businessman, a Paris art dealer perhaps, distractedly smoking his Prince of Wales pipe, looking back with a skeptical gaze.

Only then, and for the first time, Vincent painted what he saw in the mirror.

He liked what he saw so much, in fact, that he painted at least four more versions of the image in the mirror over the next few months, each one bigger, better attired, and more prosperous-looking than the last.

But the centerpiece of Vincent's bourgeois rebirth in Paris wasn't his salable art, his new clothes, his new teeth, or even the bright new apartment on the rue Lepic. It was his enrollment in the atelier of Fernand Piestre, the artist known as Cormon.

THE SALON SYSTEM may have lost its hegemony by 1886, but not its popularity. A vast industry, with Goupil still in the lead, churned out thousands upon thou-

sands of genre scenes, rural idylls, oriental fantasies, and historical vignettes for a larger and richer audience of collectors than ever before. The demand for these polished, pleasing images had overwhelmed the old state-sponsored Académie system for training artists, with its competitive elitism and aristocratic bias. Meanwhile, the same prosperity that drove the booming art market had also produced a surplus of young men (and a very few women) with the money, education, and leisure to pursue their artistic ambitions.

To address both these unmet demands, an alternate form of art schooling had sprung up in major cities across the Continent, but especially in Paris, the birthplace of the Salon. Called *ateliers* (for the skylighted attics where artists often worked), or simply studios, these private schools varied in size, in prestige, in rigor, and, of course, in fees. But they were all children of the École des Beaux-Arts—employing the same time-honored teaching methods and pledged to the same goal of proficiency as their more exalted parent. Almost all their founders and instructors had graduated from the École. Many were former Salon stars who parlayed their prize medals, sometimes even just a single *succès d'estime*, into the franchise of an atelier. Cormon was one of these.

His career had peaked in 1880 when his huge painting *The Flight of Cain* caused a sensation at the Salon. By casting the biblical fratricide as a slack-jawed Neanderthal, Cormon succeeded in inflaming both defenders of religion and champions of the new science of evolution, thus reaping a whirlwind of notoriety. Two years later, he opened an atelier. Despite his own checkered history as an École student and a taste for nontraditional subject matter (he painted Hindu kings and Wagner heroes as well as cavemen), Cormon fully embraced the meticulous craftsmanship of the classical tradition. Like most atelier masters, he saw himself working in concert with the Salon to train the next generation of artists, and his school mimicked the École model right down to its annual competition or *concours*. In 1884, he was appointed to the Salon jury—making his atelier even more attractive to ambitious young artists.

Cormon also embraced the expensive lifestyle of a successful Salon painter. In addition to the atelier, he maintained a large private studio and an apartment. He entertained extravagantly and traveled exotically. The son of a stage manager at the Paris Opera, he loved to dress up in theatrical costumes. At one point, he was keeping three mistresses simultaneously—a feat that earned him more acclaim among his atelier acolytes than either his Salon medals or his stupendous canvases.

By the time Vincent arrived in 1886, however, Cormon's star had already begun to fade. In the fast-changing universe of Paris art, his Stone Age scenes had become just another bizarre sideshow in the great quest for a "modern" art. Dealers and collectors moved on. The turn of fortune may explain why Cormon agreed to admit Theo van Gogh's brother Vincent into his exclusive atelier de-

spite his lack of credentials or accomplishments. As a junior *gérant* at Goupil, Theo was well positioned to return the favor. How quickly arrangements were made after Vincent's sudden arrival is not certain. Given the setbacks in Antwerp, he probably took some time to collect himself—recover his health and repair his teeth—before starting. But sometime that spring, he made his first trip to Cormon's atelier on the boulevard de Clichy, mounting yet another assault on the formal training that he could neither master nor forswear.

Cormon must have seemed to Theo the perfect choice for this thankless mission. Although sought after for his Academic eminence, the forty-year-old Lyon native was also known as a distracted, indulgent teacher who rarely imposed his view of art on paying students. Like Charles Verlat, the director of the Antwerp Academy, Cormon had shown himself "more sympathetic to novelties than most of his kind," according to one account. The antics of the Incoherents no doubt appealed to his theatricality; the esoteric subjects of the Symbolists echoed his own fondness for legends and folklore. Only the scientific pretensions of the "spot" painters, like Seurat, elicited his contempt. When he visited the atelier, he would pass quietly among his students offering "only a few well-chosen words of instruction as he paused beside each easel," one of them later recalled. "He looked at everything with a solicitude that surprised us."

Between Cormon's *laissez-passer* reputation and Vincent's renewed pledges of hard work (he promised to stay at Cormon's for "three years at least"), Theo had good reason to hope that after so many failed attempts to find his brother an artistic home, this one might actually succeed.

In fact, it was as doomed as all the others.

Unfortunately for Vincent, the Atelier Cormon did not reflect its founder's open-mindedness. Because he came so rarely (only once or twice a week) and commented with such restraint, it was left to Cormon's students to pass judgment on each other's work, and on each other. For Vincent, as ever, fellow artists proved the most demanding and least forgiving audience. Far more than in Brussels or Antwerp, his classmates at Cormon's formed a cohesive, exclusionary unit. Most were French. While other commercial ateliers openly catered to rich foreigners, Cormon's rigorous selection process guaranteed an overwhelming majority of Frenchmen among the school's thirty or so students. Vincent's accented French, unpolished after ten years of disuse, marked him more plainly than ever as an outsider.

Most were young. Students under eighteen were not unknown, and those over twenty-five were rare. As a group, they clung to the antics and intolerance of adolescence. New students—called *nouveaux*—were mercilessly teased and humiliated in ways that Vincent's odd manner surely invited, but his prickly dignity could never have tolerated. *Nouveaux* were forced to do menial chores and endure meaningless trials. They were stripped naked and made to fence with

paint-loaded brushes; or trussed up on poles, like pigs on a spit, and carried to the local café, where they often ended up paying the bar tab.

Most of the students were rich, too: sons of the old aristocracy of breeding or the new one of business. The atelier's two student leaders perfectly reflected the bifurcation of the French elite, and thus of French art. Louis Anquetin's father made his fortune as a butcher in Normandy, after marrying into a wealthy family. Twenty-five-year-old Louis would have stood out in any class. A tall, robust Zeus of a man, with a lustrous crown of curls and thick beard, he had learned to ride and draw by age ten, like any gentleman's son. He kept an apartment and a redheaded mistress on the avenue Clichy, not far from the atelier that he ruled over with innate nobility.

His fellow student leader represented exactly the opposite sort of evolution. Henri Marie Raymond de Toulouse-Lautrec-Monfa was both the beneficiary of an ancient lineage—Counts of Toulouse back to 1196—and a victim of its curse: inbreeding. His parents, first cousins, lived in "an aristocratic floating world of hunting and riding," according to one biographer. But they begat a child with fragile bones and a misshapen body. Young Henri broke both legs in childhood and never reached five feet as an adult. He would never *ride* horses—he could barely walk without a cane—but he could draw them. His tremendous facility, combined with an ebullient spirit and a razor wit ("my family has done nothing for centuries," he remarked; "without wit, I'd be an utter fool"), might have

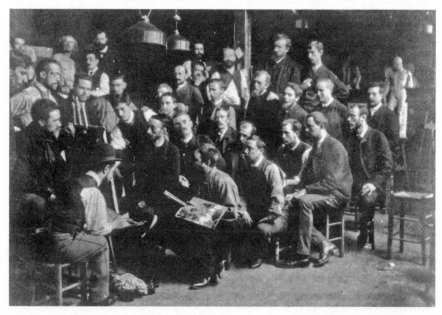

ATELIER OF FERNAND CORMON (C. 1885): CORMON AT EASEL, TOULOUSE-LAUTREC WEARING BOWLER HAT WITH BACK TO CAMERA, ÉMILE BERNARD AT UPPER RIGHT

won him a place in the Paris art world even without his freakish appearance or distinguished name. When he met Louis Anquetin at the age of seventeen, he barely rose above the other man's belt. But the two recognized each other as a breed apart. Lautrec (as Vincent invariably called him) referred to his towering friend as "my great man," and, after that, rarely left his side.

This unlikely pair ran the Cormon studio as their own personal social club. Anquetin commanded the respect of his fellow students with his Jovian countenance and masterful brush. (He was named one of the "most promising younger painters" at the Salon des Indépendants.) Lautrec exercised both the official power of a *massier* (the student responsible for recruiting and posing models, collecting fees, and maintaining order) and the unofficial power of a teacher's favorite. He and Cormon worked together on outside commissions and he always took the place of honor, front row center, when the master paid a visit to the atelier.

The two enjoyed a liberty with each other that shocked and delighted Lautrec's classmates. A fixture at Cormon's open houses, Lautrec also hosted weekly get-togethers at his own studio on the rue Caulaincourt, just around the corner from the rue Lepic, where debates over the new ideas in art flowed as freely as wine. In class or out, he played master of ceremonies, whether leading the boisterous ragging of the *nouveaux*, teaching his classmates Bruant's latest song in his booming baritone, or clownishly inspecting the *"partes naturales"* of potential models from his unique perspective.

Cormon's students rallied to the leadership of their "Velasquez dwarf" and his Michelangelesque partner. Young men from good families all, veterans of many social clubs at *lycée* or university, they fell easily into the classroom raillery and hazing rituals of the atelier.

Not so Vincent. Prone to anger, quick to take offense, menacingly intense, and untuned to the irony and irreverence of youth, Vincent descended on the atelier like a leaden thundercloud from the North Sea. At the least provocation he would burst into storms of vehement protest and lip-quivering passion. Shouting and gesticulating, he would plunge heedlessly into arguments, pouring out sentences in a wild mix of Dutch, English, and French, according to one witness, "then glance back at you over his shoulder and hiss through his teeth." Nothing could have been less suited to the sly, carefree atmosphere cultivated by Lautrec in the teacher's absence than Vincent's humorless intensity. Lautrec himself, while never cruel to his charges, could have found little of interest in the dour Dutchman. In the right company (especially among his countrymen), Vincent could be sociable, even jovial. But his sense of humor favored broad mimicry and bawdy innuendo—a universe apart from Lautrec's cynical drollery and self-mocking flamboyance.

No doubt taking their cue from their *massier*, Vincent's classmates responded to the volatile stranger in their midst with a combination of haughty tolerance

(dismissing him as "a man of the north [who] didn't appreciate the Parisian spirit") and surreptitious ridicule. "What laughter behind his back," one of them recalled. Whether out of fear, or indifference, or deference to his well-placed brother, they spared him the worst abuses of the *nouveaux* and simply ignored him as "not interesting enough to bother much about."

As in Antwerp, Vincent was forced to seek companionship at the margins of the class, among the handful of foreign students. Fortunately for him, the leader of this tiny band was a genial English speaker a long way from home: an Australian painter named John Peter Russell. Son of a South Seas adventurer and arms manufacturer, Russell had everything Vincent envied: money, friends, leisure, standing, and a striking blond Italian girlfriend, Marianna. (Rodin, for whom she modeled, called her "the most beautiful woman in Paris.") A tireless reveler, Russell frequented fashionable nightspots like Le Chat Noir and Le Mirliton, often driving his own horse and carriage. On weekends, he promenaded in the Bois de Boulogne with the rest of high society, or sailed his yacht on the Seine. He summered in Brittany and wintered in Spain. A steady stream of visitors (including Rodin, a personal friend, and Robert Louis Stevenson) climbed the grand staircase to Russell's studio on the impasse Hélène, where the door was always open. He entertained them all with a boisterous, indiscriminate bonhomie that was often mistaken for American.

Vincent joined the crowd drawn to Russell's easy hospitality. Brandishing his family connections to Goupil—a real attraction to the commercially ambitious Australian, who still painted in the High Victorian style showcased at Goupil—Vincent visited Russell's studio on the far side of the Montmartre cemetery. Russell shared the general opinion of Vincent as "cracked, but harmless," and their relationship never merited a mention in his letters at the time or in his later writings. But he was an indulgent host with a taste for artistic eccentricity—a taste that puzzled his friends (who considered Vincent a "weedy little man") and dismayed Marianna (who complained that Vincent's eyes "glittered frighteningly").

Vincent imposed on the open-door policy at the impasse Hélène often enough that Russell eventually invited him to sit for a portrait. It was hardly a singular honor. Russell was a talented portraitist who, unlike Vincent, could capture a likeness quickly and surely with pencil or paint, and he practiced his skills at every opportunity. Using the same flattering brush that he often used on society matrons, Russell portrayed Vincent the way Vincent wanted the world to see him: not as a bohemian aesthete, but as an artist-businessman: prosperous and contented as a banker in his dark suit, stiff collar, and stern expression. Only in the eyes—caught in a suspicious, almost menacing sidelong glance—did Russell hint at a darker reality.

—

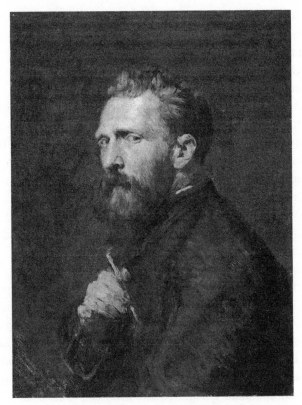

JOHN PETER RUSSELL, *Portrait of Vincent van Gogh,*
1886, OIL ON CANVAS, 23⅝ X 17¾ IN.

NOTHING SET VINCENT apart from his fellow students more than his lack of facility. If he had wielded a pencil as wittily as Lautrec or a brush as winningly as Anquetin, his strange appearance might have been overlooked, his blunt manner forgiven. Led by Anquetin, who had drawn exquisitely since his schoolboy days in Normandy, and Lautrec, a precocious illustrator, Cormon's acolytes put a high premium on drawing, just as their master did. Although tolerant of individuality in painting styles, Cormon, like Verlat in Antwerp, saw draftsmanship as above the to-and-fro of artistic fashion. "If one doesn't measure," he said, "one draws like a pig." His students, no matter what daring new images they admired, all aspired to "draw like the old masters in the Louvre," according to one of them.

Eschewing the cumbersome perspective frame that he had come to rely on—and that no doubt embarrassed him in a room filled with freehand draftsmen—Vincent focused with immense intensity on the old challenges of line and proportion. Although nude models were a regular feature of the atelier, he still found himself working mostly from the plaster casts that lined the studio walls.

Like Siberdt, Cormon emphasized contour over shading and hatching, and discouraged his students from improvising. "They were to copy strictly what they had in front of them," one student recalled Cormon's instructions, "without changing anything."

Submitting yet again to the tyranny of reality, Vincent drew, erased, and redrew until a firm, accurate outline appeared, then delicately modeled with chalk and stump and more erasing in an effort to create the kind of precise, polished study that students like Lautrec could produce effortlessly. But his hand still would not, could not, obey. Even his most polished images, whether drawn from the plaster or the nude, emerged from his easel with broadened buttocks, misaligned limbs, enlarged feet, crooked faces, or quivering contours. "We considered his work too unskillful," recalled a fellow Cormon student; "there were many who could surpass him from that point of view." Another said, "His drawings had nothing remarkable about them."

Painting, too, brought ridicule and rejection. Like the Academy students in Antwerp, Vincent's Cormon classmates were astonished by the speed and appalled by the disorder of his working methods. He painted three studies to every one of theirs, completing multiple angles on the same pose in a single, relentless assault, not even pausing during the model's rest period. "He worked in a chaotic fury," one of his classmates recalled, "throwing all the colors on the canvas in feverish haste. He picked color up as if by the shovelful and the paint ran back along the brush and made his fingers sticky. . . . The violence of his study surprised the studio; the classical artists were horrified by it."

When Vincent wasn't looking, the other students mocked his flailing strokes. When Cormon stopped at his easel, they fell silent with anticipation and leaned in to hear how the placid master would react to the Dutchman's latest provocation. But Cormon only criticized Vincent's draftsmanship and advised him to work more carefully in the future. For a while, at least, Vincent tried to heed the advice. He came to the studio in the afternoons, when all the others had left, and practiced his drawing on the familiar plaster casts, struggling to capture their elusive contours until his eraser wore holes in his paper. Someone who chanced upon him alone in the big studio, locked in his furtive labors, thought he looked "like a prisoner in his cell."

By summer, he was gone. He had promised to study at Cormon's for three years; he stayed less than three months. He may have continued to make occasional trips to the studio on the boulevard de Clichy as late as the fall; but, if he did, he timed his visits carefully to avoid his former classmates. When pressed to describe his brief experience at Cormon's, Vincent would say only, "I did not find it as useful as I had expected it to be." After leaving Paris, he never wrote another word about it. So decisive was his failure at the prestigious atelier that the subject never came up in a letter Theo wrote to his mother in June summa-

rizing Vincent's first few months in Paris. Instead, he spun a farrago of reassurance that Vincent had finally turned a corner, and that life with him was not the burden it had been in Nuenen. "He is much more cheerful than in the past and people like him here," Theo reported brightly. "If we can keep it up I think his difficult times are over and he will be able to make it by himself."

In reality, Vincent had found failure around every corner. Despite all his efforts that spring, he had not sold a single painting. None of the hundreds of magazines circulating in Paris would pay him for an illustration. Worse still, his attempts to win dealers to his cause had all foundered, despite his brother's connections in the business. A Cormon classmate remembered how Vincent "used to rage from time to time that though connected with the picture trade no one would buy anything he did."

Only Theo's old colleague Arsène Portier, the same minor dealer who had abruptly withdrew his support for *The Potato Eaters* the previous year, paid Vincent the respect of taking some works on consignment. But what else could he do? Living downstairs in the same building, Portier not only saw both brothers every day, but no doubt suffered a relentless haranguing—in person this time, not by letter. When pressed to *show* the paintings to buyers (he worked out of his apartment), Portier demurred, promising vaguely to mount an exhibition sometime in the future. The only place Vincent had found to actually display his work was a nearby paint supply store called Tanguy's—described by a contemporary as "a small and shabby boutique"—where they hung unlighted amid the retail clutter with dozens of other customers' canvases. Even when he tried to exchange his paintings with fellow artists (an old student tradition encouraged by Theo), he met with little success. Only those as obscure and marginalized as he was were tempted by his offers to swap. Better-known painters like Charles Angrand, a friend of Seurat's, simply ignored his overtures.

Vincent might have made more exchanges if he had made more friends. But Theo's assurance to his mother that "people like him here" was only a comforting fiction. The letters and journals of other artists in Paris at the time betray not a hint of Vincent's presence, despite numerous opportunities for their paths to cross. He began the summer of 1886 as alone in Paris as he had been on the heath. Russell had left for the season, lending his apartment to two Englishmen who proved far less sympathetic hosts. A. S. Hartrick thought Vincent "more than a little mad"; and Henry Ryland reacted to his visits with horror. ("That terrible man has been here for two hours," Ryland once complained to Hartrick. "I can't stand it any more.") Still, desperate to preserve some semblance of professional connection, Vincent continued to visit Russell's studio until a row over Ryland's watercolors (Vincent called them "anaemic and useless") extinguished his welcome on the impasse Hélène forever.

By the fall, he was reduced to writing Horace Livens, the classmate in

Antwerp whom he barely knew, to report poignantly, "I work alone," and to complain, "I am struggling for life and progress in art." Only six months after arriving, he begged the distant Livens to join him in Paris, or, barring that, to help him escape. "In spring, or even sooner, I may be going to the South of France," he wrote, anticipating by a year his flight to Provence. "And look here, if I knew you had longings for the same, we might combine."

AFTER THE COLLAPSE of his plan for Cormon, without friends or colleagues or direction, Vincent quickly retreated into the obsessions he had brought with him to Paris.

The portrait project that had preoccupied him in Antwerp resumed almost without interruption. Among his earliest paintings in Paris were two portraits of the same sitter: a raven-haired matron whose bourgeois dress and fancy bonnet betray the artist's new bid for respectability. But once he started at Cormon's, his mania returned to its deeper roots in sex. The atelier sessions provided a steady diet of nudes for Vincent's voracious hand. Better yet, the studio attracted an almost unbroken stream of models in search of work. They paraded around the atelier for the inspection of all the students, who often voted on their favorites. Because auditions required disrobing, and students were free to poke and prod (to test musculature), such tryouts often dissolved into leering, snickering gauntlets of mutual arousal.

But Vincent wanted more. Long accustomed to the prerogatives of his own studio, he immediately set out to arrange private modeling sessions, only to encounter the same frustrations that had dogged all his previous campaigns. None of the professional models who lined up every day for the atelier's auditions would accept an invitation to his studio. "[They] did not want to pose for him," Theo recalled—either for portraits or for figure studies. And certainly not for nudes. Even the women Vincent knew personally, such as Russell's mistress, Marianna, refused the strange Dutchman's advances.

Soon enough, he was forced to take his hunt to more familiar regions.

Prostitutes swarmed the broad boulevards and café bars of Haussmann's new city. The combination of wealth, license, and the opportunity for display made Paris the capital of sexual gratification—and venereal disease—on a randy continent in a libertine era. They went by many names—*pierreuse, lorette, grisette, gigolette, apéritive*—and serviced almost three-quarters of the city's adult males. Virtually every artist in Cormon's atelier not only kept a mistress but also made nightly forays into Paris's libidinous underworld. Even Russell would leave the beautiful (and pregnant) Marianna to enjoy the end-of-empire decadence available on almost every street corner.

Surrounded by so much opportunity, Vincent could hardly contain himself.

Books like Zola's *Nana* and the Goncourts' *La fille Élisa* (both chronicles of prostitution) had filled his head with visions of erotic freedom and sexual athleticism. Even Maupassant's Bel-Ami, for all his amorous conquests, couldn't resist the particular pleasures of Parisian whores. In later years, Vincent recalled fondly his model-hunting escapades not just in the city's bustling brothels but also in the seedy walk-up back rooms where lonely women "screw 5 or 6 times a day." He spoke knowingly about the relationships between prostitutes and their *"maquereaux"* (pimps), and described himself as merely a hungry consumer in search of the best cut of beef. "The whore is like meat in a butcher's shop," he wrote in 1888, "and I sink back into my brutish state."

It was probably in his relentless search for models that Vincent first encountered Agostina Segatori. Although too old (about forty-five) to be active in the trade herself, Agostina knew where to find what Vincent was looking for. Since her teens on the streets of Naples, she had lived on the slippery border between modeling and prostitution. By 1860, her seductive look and voluptuous body had earned her passage to Paris, where she posed for a pantheon of the era's greatest painters, including Gérôme, Corot, and Manet. All of Europe hungered for the easy sensuality of dark-haired Italian girls, often portrayed in fetching native costumes and carrying the symbol of their "gypsy" spirit: a tambourine. Like many former models, Agostina found a sponsor and, in 1885, capitalized on her fading celebrity by opening a café called simply Le Tambourin.

By the time Vincent met her in 1886, she had aged into a savvy, bosomy, bohemian *signora*, entouraged by a young lover, a thuggish manager, and two blond Great Danes. She presided over her café domain with languorous authority and "imposing charm," according to one of her legion of admirers. Everything in the big establishment on the boulevard de Clichy, from the tambourine-shaped tables to the waitresses in Italian peasant dresses, played out the theme of exotic, erotic allure that had made her famous. But the allure was more than just stagecraft. Theme cafés like Le Tambourin typically did a booming side business in prostitution. In return for providing a safe environment and a steady stream of customers, owners took a cut of their servers' after-work earnings. Like the procuress Vincent met in Antwerp, Agostina Segatori "knew a lot of women, and could always supply some."

Even with Segatori's help, Vincent's excursions into Paris's sordid underbelly produced only a few hasty, eavesdropping sketches. One shows a woman lying naked in bed, her arms behind her head, comfortably advertising her full availability. Another depicts a woman sitting on the edge of a bed languidly pulling up her stockings after sex. Another shows a woman squatting over a basin, cleaning herself. At one of the many erotic theatricals that filled the smoky basements of the boulevards, he captured in furtive pencil and chalk the peep-show scene of a couple copulating on stage, as shameless as a circus act.

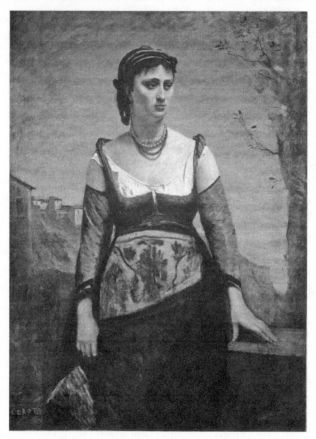

JEAN-BAPTISTE COROT, *Agostina*, 1866, OIL ON CANVAS, 51¹/₈ X 37¹/₄ IN.

When one particularly homely *pierreuse* agreed to pose for him, Vincent lavished his art on her overripe body and coarse face. He both drew and painted her as a grotesque odalisque, then celebrated her bestial features in a portrait done in the same earthy hues as his Nuenen peasants—a proud boast of her country-girl sexual prowess. He even sketched her in the same submissive position that Sien had assumed for *Sorrow*.

But no one, apparently, not even his *belle laide* Beatrice, would come to the rue Lepic as Sien had come to the Schenkweg. After leaving Cormon's, Vincent was reduced to painting studies of the little nude statuettes the brothers collected, and, as in Nuenen, forlornly sifting through the contents of his studio for still-life subjects that refracted his frustrations and regrets. He found the perfect metaphor in a battered pair of walking shoes, which he painted in the moody tones and meditative strokes of the Kerkstraat birds' nests, as if longing for the lost liberties of the heath.

The failure of his hunt for models drove Vincent even deeper into the *other*

burning obsession he had brought with him to Paris: color. His unique witness to the gospels of Blanc and Chevreul, developed in the wilderness of Nuenen only to be swept aside in the commercial and sexual fevers of Antwerp, re-emerged in the summer of 1886 in a fresh burst of evangelical zeal. "Color drove him mad," a classmate at Cormon's recalled. Taking up the banner of "simultaneous contrast" where his rhetoric had left off the previous winter, Vincent startled his fellow atelier students by painting a nude model—the most prosaic of color subjects—against "an intense, unexpected blue" instead of the studio's drab brown backdrop. The result, according to one witness, was an explosion of complementaries "with violent new tones, one inflaming the other." And every vehement image came accompanied by a storm of vehement words. "He never stopped talking about his ideas about color," recalled another Paris acquaintance.

But this time Vincent found himself preaching to a city already ablaze with arguments about color. What was it? How was it perceived? What did it express? Even as Paris celebrated the centenary of Michel Chevreul, the patriarch of color theory, with a torchlight parade (which Vincent undoubtedly attended), artists squabbled over his legacy. The divisionists, led by Seurat and championed by a powerful young critic, Félix Fénéon, wrestled the mantle of optical science away from Impressionism. They recruited scientists to validate their art and hailed the *Grande Jatte*, which débuted in April 1886, for its "exactitude of atmosphere." Meanwhile, acolytes of Huysmans's *À rebours* declared war on all forms of objectivity, including optics, and claimed for themselves the true grail of color: the power of suggestion. The arguments reached into every corner of the art world, even the Atelier Cormon. In the same year as Vincent's brief attendance, according to one account, the studio erupted in a dispute over color so intense that the complacent master was forced to expel the troublemakers and temporarily close his school.

Through all the rancor and upheaval around him, Vincent remained true to the gospel of color that he learned on the heath. Through a spring and summer crowded with opportunities to see the images roiling the art world, his devotion never wavered. At the eighth and final Impressionists' show in May, where he could finally study the works that had triggered the uproar a decade before (except for Monet and Renoir, who boycotted the show—a sign of the turbulent times), Vincent found only confirmation of the verdict he had argued to Theo for years. "When one sees them for the first time," he later recalled his introduction to Impressionist images, "one is bitterly, bitterly disappointed, and thinks them slovenly, ugly, badly painted, badly drawn, bad in color, everything that's miserable." After seeing them, he wrote Livens reassuringly, "Neither your color nor mine relates to their theories." He explained the difference this way: "*I* have faith in color."

At the same exhibition he also saw Seurat's *Grande Jatte,* the symbolic meditations of Redon, and dozens of works by young artists unknown to him, including Paul Gauguin. But he commented favorably only on a suite of nude women, in pastel, by Degas. Through the Exhibition Internationale in June (where the works of Monet and Renoir *were* on display), and the equally huge Salon des Indépendants in August (in which almost 350 artists took part), and the exhibition of the Incoherents, Vincent commented favorably on only one work in his letter to Livens that fall: a Monet landscape.

What he missed in the shows, he could see every day in scores of galleries and dealers' dens: from the storied salesroom of Durand-Ruel, Impressionism's first champion, where a visitor could spend days viewing the nearly bankrupt dealer's unsold stock, to the apartment of Arsène Portier, just downstairs, where Manets and Cézannes were available for close inspection. For more exotic fare, any night, he had only to visit one of the many cabarets like Le Chat Noir or Le Mirliton, where the walls were filled with the latest *fumiste* concoctions (including some by Lautrec), or just walk the streets where frame dealers and paint stores like Tanguy's offered a babel of imagery in their windows.

Through the blizzard of sectarian reviews and fire-breathing rhetoric, through atelier debates and café chatter, Vincent clung to the view he had brought to Paris from the heath: complementary color was the one true gospel and Delacroix its truest prophet. "Delacroix was his god," a fellow Cormon student recalled; "when he spoke of this painter, his lips would quiver with emotion." In his studio, he kept a lacquered box containing balls of brightly colored yarn that he endlessly twined and untwined to test the interaction of colors—exactly the procedure described by Chevreul, who had developed his theories as director of dyes for the royal looms at Gobelins.

Instead of seeking out the *Grande Jatte,* Vincent returned again and again to the Louvre to view works like *The Bark of Dante,* Delacroix's great vision of artistic determination, a painting mythologized in Charles Blanc's writings. In the same galleries where he ignored so much, he sought out lesser-known images by the Romantic master. Dismissing those, like Anquetin, who considered Monet and the Impressionists the keepers of Delacroix's palette, Vincent celebrated his own private pantheon of true heirs—painters like the Belgian Henri de Braekeleer and the long-dead Barbizon master Narcisse Virgile Diaz de la Peña—and anointed a little-known Marseille painter, Adolphe Monticelli, as the truest disciple of all.

In the charged atmosphere, Vincent's contrary certainty riled partisans on every side. "He was always quarreling," wrote Theo's friend Andries Bonger, whose comments on Vincent's work were always met with the same fierce defense: "He persists in replying, 'but I wanted to introduce this or that color contrast,'" Bonger complained, adding tartly, "as if I give a damn about what he

wanted to do!" When he visited Tanguy's to buy paints—a rare opportunity to engage fellow painters—Vincent would linger for hours arguing color theory with the other customers.

He clashed spectacularly with the shop's owner, Julien Tanguy (known to everyone as Père Tanguy), over the Impressionists' cheerful palette. Tanguy had not only mixed color for some of the giants of the revolution (including Monet and Renoir), he had appointed himself personal champion for one of their number in particular: Paul Cézanne. The dingy shop's storage rooms were stocked to the rafters with the unpopular works of the hermetic Provençal master, who had left them there to rot or sell, he didn't care which. Tanguy, a grizzled old socialist with a sentimental streak, defended both the Impressionists and Cézanne with the fierceness of a Communard, which only incited Vincent to greater storms of vehemence. A customer once saw Vincent emerging from Tanguy's back room after an argument looking as if "he would erupt into flames."

Deprived of models but determined to make his case for color, Vincent turned to a new subject: flowers. The choice was both rhetorical and commercial. Theo, too, admired the work of Monticelli, whose brashly colored, heavily encrusted little images of flowers and festive parties (*fêtes galantes*) had attracted a small but avid following in Paris and elsewhere. Theo not only dealt in Monticelli's works, he kept several of them for his own collection—conferring on the Marseille artist both the stamp of salability and the lure of fraternal solidarity. When Monticelli died suddenly in June under strange circumstances (it was said he drank himself into insanity and suicide), Vincent's fervor transformed him into a hero: a *L'oeuvre*-like martyr for color. He rushed to his studio and began a series of small, impacted still lifes showing flowers in scumbles of pungent reds and yellows. He painted orange lilies on a cobalt field, and ocher chrysanthemums, like suns, jumbled in a ginger jar of unfathomably deep green. Like Monticelli, he rendered even the brightest flowers in craggy impastos and draped them in Rembrandt's darkest shadows. Every image served both as an homage to Monticelli (and Delacroix) and a rebuke—in rich hues, dramatic highlights, dark backgrounds, and prodigal paint—to all the so-called "modern" colorists.

Determined to prove that his contrary images could also be salable, Vincent took some of them to Agostina Segatori, hoping she might either buy them or at least show them at Le Tambourin. Segatori, who showcased other artists' works and pitched her establishment as "more museum than café," took pity on the ardent Dutchman and agreed to hang some of his paintings with the other "works of masters" on her walls. She also began accepting them as payment for meals, and may even have sent him flowers to suggest future subjects—giving Vincent all the proof of commercial viability he needed.

Fueled by the prospect of more "sales," by the enthusiasm for Monticelli that he shared with Theo, and by his own devotion to Delacroix, Vincent launched

a furious campaign of persuasion in paint. As if illustrating Chevreul's voluminous studies, he worked his way through the full range of complementary contrasts and tonal harmonies, using blossoms, vases, and backgrounds in ever-shifting combinations: red gladioli in a green bottle; orange coleus leaves against a blue field; purple asters and yellow salvia. From meditations in red with asters and phlox, to harmonies of green and blue with peonies and forget-me-nots, to red-green riots of contrast with carnations and roses, he argued his case with insistent thoroughness. To Livens, he boasted of his color "gymnastics." Over the course of the summer, he exhausted the greenhouses of Paris: lilacs and zinnias, geraniums and hollyhocks, daisies and dahlias.

He worked with the lightning speed of the Nuenen peasant "heads"—faster than the flowers could wilt in the stifling city heat—turning out a score of images each month. Perhaps encouraged by Segatori's continued support, he moved to bigger and bigger canvases, but he kept the saturated color, deep chiaroscuro, and sculptural brushstrokes of the unsung Monticelli rather than the all-over light and airy strokes—even dashes and dots—that marked the new art all around him.

Throughout the fall and into the winter, Vincent grew increasingly isolated and defiant. If anything, he built the barricades of mania even higher as the weather grew colder and the flowers fled south. He returned to the subjects of the spring: still lifes of boots, scenes of Montmartre, even the little plaster nudes in his studio. Only now he wrung them through the gospel of complementary color: painting some in vivid contrasts, some in tonal harmonies, some in both. He defied the Impressionists' sunlight by painting his vignettes of city life under cloudy skies, and rejected their frivolous obsessions with yet more images of Nuenen diggers—only now dressed in blue and orange.

He turned again and again to the mirror, portraying himself always as the bourgeois Bel-Ami artist in satin-trimmed collar—only now with a bright orange beard and blue ascot, or wearing a deep green coat against a flaming-red field. He painted still lifes in vehement strokes and colors so "fierce," according to a fellow Cormon student, that Tambourin patrons and Tanguy customers were "scared of them."

In these and other works, Vincent shouted out his different vision with an uncompromising contrariness that could only have sprung from other sources, and could only be appeased by other means.

The Zemganno Brothers

~

*E*VERYWHERE THEY PITCHED THEIR TENT, CROWDS GASPED. DEFYING both gravity and death high above the sawdust ring, they flung themselves toward each other, and then away again, in a spinning, whirling pas de deux of jeopardy and rescue. Release and catch. Release and catch. Their flying bodies seemed connected by hidden ties; their spines fused, even as they hurtled in opposite directions. Gianni, the older—urgent and questing—had pushed their act to the limits of possibility, forever straining at the bonds of endurance and nature. Nello, the younger—beautiful and soulful—flew like a bird to please his brother. Together they twirled and spiraled, twisted and tumbled in their midair ballet, now clutching each other, now casting each other off, leaping further and further into peril, in higher and higher swings, testing the invisible ligaments, tempting the logic of release and catch.

Vincent read Edmond de Goncourt's *The Zemganno Brothers,* as he read so many novels, like a self-portrait. In his endless search for brother pairs who merged their lives, he seized early on the story of the "twin spirits" Edmond and Jules de Goncourt. "They had such a splendid idea, working and thinking together," he wrote Theo from Antwerp, sending along a summary of the Goncourts' accomplishments and noting pointedly how "joining hands" had allowed them to face the future "with the simplicity of grown-up children."

Vincent undoubtedly knew—everyone knew—that Edmond had written his tale of gypsy acrobats as a loosely autobiographical tribute to his dead younger brother, Jules, a vision of artist-brothers feeling and creating as one—"the effusion of a single ego, of a single *I."* It was the same vision Vincent had brought to Paris from the lonely heaths and docksides. "I wish that we too might work together somewhere at the end of our lives," he wrote Theo on the eve of his ar-

rival. "If we have the wish and the courage to do that, won't we have something to talk about then?"

But it didn't work out that way. The euphoria of reunion soon succumbed to the reality of cohabitation. It had been twenty years since Vincent lived with his brother in the attic of the Zundert parsonage. Since then, he had shared a room only once, briefly, with the prostitute Sien Hoornik. He treated the whole rue Lepic apartment as if it were the Kerkstraat studio: spreading his paints and apparatus everywhere until "it began to look more like a paint shop than an apartment," according to one visitor. "Everything was topsy turvy," another recalled. "[Vincent] spread his taste for disorder into every room."

He freely mixed discarded clothes and wet canvases (even using Theo's socks to clean his brushes) and cleared away swaths of domesticity to make room for a still life (or, on rare occasions, a model). An overnight guest recalled "stepping out of bed in the morning into a pot of color Vincent had left lying around." After the debacle at Cormon's, Vincent immediately reverted to the personal habits of the heath as well, neglecting both bathing and clothing. "He always looks so dirty and unappetizing," Theo complained to their sister Wil. Within a month or two of moving into the new apartment, Theo fell sick with an unidentified illness, and Lucie, the housekeeper-cook, fled.

Vincent had a similar influence on Theo's social life. Prior to his brother's arrival in March, Theo had enjoyed a glittering circuit of boat trips on the Seine, promenades in the Tuileries, official receptions, evenings at the theater, nights at the opera, weekends in the country, and splendid candlelight soirées in white tie, with celebrity performances, dancing, and suppers at 2:00 A.M. Although often lonely in a crowd, Theo made an attractive, amusing guest, and his reticent charms earned him more than a few invitations to his clients' houses.

Vincent's arrival changed all that. Social outings, an important part of Theo's work, were no longer possible unless he left his unpredictable brother behind—an option increasingly foreclosed by Vincent's demanding notions of fraternal solidarity. Nor, apparently, did Theo trust his brother's behavior enough to introduce him to many of the prominent artists, collectors, and dealers whose names filled his address book. For the same reasons, he had to take care what guests he invited to the rue Lepic apartment (where, he confessed, "the situation is anything but attractive"). Only a select few, mostly fellow Dutchmen, could be trusted not to take offense at Vincent's unconventional ways.

Even then, friends often refused his invitations. "Nobody wants to come to our home anymore," he complained. "Because it always results in arguments." Those who did come suffered the gauntlet of Vincent's attentions. "That man has no manners whatsoever," Andries Bonger summed up the newcomer who had robbed him of his closest companion. "He is always quarreling with everybody." Another visitor found Vincent "troublesome" and filled with strange,

fervent talk. Even Theo himself, in a letter to Andries's sister Johanna, later admitted that Vincent was "impossible to get along with . . . since he spares nothing and nobody." The judgment of the past had followed Vincent to Paris, Theo revealed: "Everyone who sees him has said: '*C'est un fou*' [he's a madman]."

As in the past, Theo's relations with women, in particular, roused Vincent to extremes of fraternal solicitude. In addition to all the other upsets, the new living arrangements had seriously disrupted Theo's romantic life. His mistress of a year, a woman known only as S, had flown into a spiral of jealous, self-destructive rages at the intrusion into what was, no doubt, a plan to marry the attractive young art dealer. "You have cast a spell on her," Dries Bonger warned Theo regarding S. "Morally she is seriously ill." Vincent, too, considered the woman "deranged," but nevertheless offered to "take her off [Theo's] hands." "An amicable arrangement could be reached," he assured his brother, "by your passing her on to me." After all, the Goncourt brothers had shared a mistress.

Like Gianni Zemganno, Vincent believed that relationships with women—other than sexual relations—sapped the brothers' joint creative energy. Inviting a woman into their lives not only betrayed the sacred bond of brotherhood (neither Goncourt brother ever married), it risked even more grievous injury. Hadn't the Zemganno brothers been undone—and ultimately destroyed—by an interloping woman in love with the handsome young Nello?

But the woman in Theo's life was not the hapless S—the last in a virtually unbroken chain of mischosen mistresses. She was the distant Jo Bonger. Theo had pined for his friend's twenty-three-year-old sister since meeting her in Amsterdam the previous summer. The two had not communicated since, but Andries continued to encourage the match on both sides. He himself became engaged that winter, and he urged Theo to follow suit: "It would be so nice if we were both happily married in Paris," he wrote. Theo's sister Lies, always eager to bring her brother's luckless love life to a happy conclusion, took up the cause as well. She maintained an active correspondence with Jo, acting both as Theo's go-between and as family ambassador. (Contingents of Van Gogh and Bonger womenfolk met in Amsterdam in January.)

The separation only whetted Theo's ardor. Like Vincent, he found obsession easier to nurture at a distance. All winter, despite the whirl of social events and the attentions of S, he wrote to his sister about the loneliness of Paris ("one feels lonelier than one would in a village") and the void at the center of his life. The unexpected arrival of his troubled brother at the end of February, far from filling that void, only confirmed it. "There was something in you that I had sought in others, but to no avail," Theo later wrote Jo, recalling his winter of pining. "I sensed that I was on the threshold of an entirely new life."

But to enter that new life, Theo needed money. In his world of duty first, an honorable young man would never ask for a young woman's hand unless

he could be sure of supporting her properly. Before he would even explore an engagement with Jo, he had to have a plan for financial security. Inevitably, the lure of marital bliss combined with the duty of fiscal responsibility to revive an old fantasy: a business of his own. Fitfully discontent, Theo had often imagined setting up as an independent dealer. Only two years before, feeling abused by his bosses, he had developed an elaborate plan to start a "modern business" involving directors and capital and "an apparatus for reproductions." Like his uncle Cent, he would strike off on his own and find his fortune. Eventually he abandoned that plan, as he did many others over the years, as the risks loomed larger and his melancholy ebbed.

But this time was different. This time his ambitions were fueled by longing ("I envisaged my work and my love going together hand in hand," he wrote), and his father was no longer there to advise caution. Joining with his friend Andries, now married and eager to build his own nest, Theo prepared yet again to approach his uncle for financial backing. After years of ignoring his brother's passionate entreaties and suicidal threats, two years after rejecting the desperate pleas from Drenthe, Theo laid plans to leave Goupil—all for a woman he barely knew, and with a partner other than Vincent.

In August 1886, Theo left for Holland on his summer vacation. He had two destinations, but only one goal. In Breda, he would ask Uncle Cent to invest in his future. In Amsterdam, at the Bonger house, he would claim that future.

Vincent sent words of encouragement from the rue Lepic, where he awaited Theo's return along with Andries (whom Theo had asked to sleep in the apartment for fear of leaving Vincent alone) and S (whom Vincent had rashly invited to join them after Theo's departure). But how could he genuinely support any plan that brought his brother closer to the uncle who had spurned him—any plan, that is, that didn't end with Theo's becoming a painter? In anticipation of the verdict from Breda, Vincent fell ill. When news finally arrived that Cent had refused to back Theo's proposal (he "fobbed me off," Theo reported), Vincent responded not with the usual calls for defiance, but with rare counsels of patience and resignation: "In any case the subject is broached," he wrote, sounding unmistakably relieved.

After the "bitter disappointment" in Breda, Theo's mission to Amsterdam brought only more frustration. Without a plan for financial security, he withheld the declaration of love he had prepared. He returned to Paris at the end of August without having asked even for permission to write, but with his infatuation redoubled.

In Jo Bonger, still only twenty-four, Theo saw everything he thought his own life had lost. In her girlish manner and guileless enthusiasm he found a refuge of cheerful innocence far from the vulgarity and mendacity of Paris. (On first meeting Jo, one of Theo's sisters described her as "smart and tender, not know-

ing anything about the everyday, narrow-minded, annoying, prosaic world full of worries and misery.") The fifth of ten children, Johanna Gezina Bonger shared with Theodorus van Gogh the dutifulness and passivity of a middle child. Like him, she read and listened with exquisite sensitivity, eager to be moved by the passions of others in lieu of surrendering to her own.

JOHANNA BONGER, 1888

Jo's intellectual ambitions reached far beyond the limited schooling afforded to women in the Bonger family. She had acquired a formidable command of English (having already translated at least two novels by the time she and Theo met), and used it to support herself as a teacher—a mark of the Dutch steadiness that set her so much apart from histrionic French girls like S. Her sentimental earnestness and romantic delusions about the real world (she loved Shelley and dismissed French novels as "silly") promised Theo exactly the untroubled domestic escape he had always imagined. Convinced that she and she alone could give him the "love and understanding my heart thirsted for," he later wrote, he returned to the rue Lepic apartment buoyant with hope, possessed by the thought—"call it a dream," he said—"that sooner or later our lives would be joined together."

The more Theo dreamed of a future with Jo Bonger, the more his life with Vincent descended into nightmare. As if punishing his brother for his long ab-

sence and wandering heart, Vincent turned their rue Lepic aerie into a hell of argument and recrimination. They fought about money—the inevitable surrogate for deeper conflicts—as Theo saw his brother's spendthrift ways close-up and Vincent saw the actual account book where Theo tracked every franc that went unrepaid, documenting his intolerable dependence. They fought about family (Vincent was invited to join Theo on the trip to Breda, but didn't), and about Vincent's antisocial behavior, which Theo called "unbearable." Vincent not only wreaked havoc on their private lives, he showered Theo with contempt in public. "Vincent always tries to dominate his brother," reported Andries Bonger, who often accompanied them to cafés and restaurants, "blaming him for all kinds of things of which he is quite innocent." Theo himself described his tyrannical brother as "selfish," "heartless," and "reproachful." In short, he concluded, "[Vincent] is his old self again, and you can't reason with him."

But mostly they argued about art—a subject that avoided the forbidden paths of fraternal resentment and provided Vincent with his most potent weapon: a brush. The great wave of defensive contrariness that swept through his studio in the summer, fall, and winter of 1886 was accompanied by an equal wave of words—a storm of arguments as fierce and relentless as any from the heath. Only these could not be put aside in a drawer to be read another day. "When [Theo] came home tired out in the evening, he found no rest," Jo Bonger recounted; "the impetuous, violent Vincent would begin to expound his own theories about art and art dealing . . . This lasted till far into the night; indeed, sometimes he sat down on a chair beside Theo's bed to spin out his last arguments."

When Theo defended his proposal to sell some work by new artists, including Impressionists, as an independent dealer, Vincent assailed their plein air frillery. "It will never amount to much," he scoffed. But when Theo retreated from that plan and recommitted to Goupil, Vincent ridiculed him as a wage slave and rehearsed the arguments that had embittered their letters for years. In his unreasoning vehemence, he often ended up arguing both sides of an issue, as if the fight were all that mattered. "One hears him talk first in one way, then in the other," Theo exclaimed in exasperation, "with arguments which are now all for, now all against the same point."

Vincent's antagonism over art, implacable and unreasoning, whether in words or in images, carried the weight of other grievances. "[He] would begin interminable discussions about Impressionism," Dries Bonger recalled, "during which he would touch on all possible subjects." For Vincent, all the brothers' differences—over art, money, the plan for Breda and Amsterdam, the bid for independence, the dream of marriage—had merged into a single deep and inexpressible injury. "We sympathize so little any more," Theo confided to their sister. "He never misses an opportunity to show me that he despises me and that I am repugnant to him."

Not even the nostalgic magic of Christmas—the brothers' first together in nine years—could stop Vincent's relentless assaults. By Saint Nicholas Day, the bitterness had reached such intolerable levels that Theo invited a third person to move into the rue Lepic apartment. Alexander Reid, an impish thirty-three-year-old Scotsman, had only recently come to Paris as a Goupil trainee. Because of his interest in Hague School artists, who sold well in his native Glasgow, Reid had been assigned to the young Dutch *gérant*. It was sheer coincidence that the two men looked like brothers: the same russet hair and reddish beard, the same slight build, sparkling blue eyes, and delicate artistic sensibilities. Theo and his new protégé shared the same tastes in art, too: a love for the masters of the Barbizon and the Hague School, matched by an equal enthusiasm for the new art. Both admired especially the eccentric work of the Frenchman Monticelli.

Vincent briefly tolerated the holiday imposter. Reid even sat in the frigid apartment and submitted to several portraits. But within only a month or two, Reid was forced to flee: driven out, he said, by Vincent's threats of violence and hints of insanity.

The months of rancor took a terrible toll on Theo's always fragile health. The strange affliction that had gripped him for months after Vincent's arrival returned with a vengeance at Christmastime. His joints stiffened until he could hardly move; he lost weight from his slender frame and felt inexplicably weak. His face swelled up until his features were barely distinguishable—"He literally has no face left," Andries Bonger reported in alarm. But in the embittered atmosphere of the apartment, even such serious symptoms were denied or dismissed as "nerves." If Theo had secrets about his health—as Vincent did—he must have chosen not to share them with his pitiless brother.

A true son of Dorus van Gogh, Theo believed illness represented a mental as much as a physical failing (he called it "decidedly improper" to be sick), and he searched for ways to correct the lapse of self-discipline that afflicted him. He did not have to look far. "He is determined to part from Vincent," Dries Bonger told his parents on New Year's Eve; "living together is impossible."

It took another three months of abuse for Theo to act. "There was a time that I loved Vincent and that he was my best friend," he wrote to sister Wil in March, "but that is now in the past. I wish he would go and live by himself, and I will do my best to make that happen." Even then, he resisted Wil's call for him to cut the cord completely. "If I told him he must leave," Theo despaired, "it would only be a reason for him to stay." He may have chosen to move out temporarily himself, rather than confront his brother. But eventually the message was received. In April, Vincent applied to the Dutch consulate in Paris for a permit to return to Antwerp.

—

ONLY WHEN THE invisible ties had been stretched to the breaking point did Vincent spring to repair them.

As in the past, he reached out with art. Theo had always pushed his brother to do landscapes, adamant about both the reparative power and the commercial appeal of nature's beauty. But those calls had rung hollow to Vincent ever since Theo had rejected the heathscapes from Drenthe as too derivative of the brothers' childhood favorite, Georges Michel. In the thrall of Millet and the fervor of *The Potato Eaters,* Theo's advocacy had come to look increasingly like obstructionism—designed merely to frustrate Vincent's passion for figure painting. That impression seemed confirmed in Antwerp when Theo pushed him to return to Brabant and paint landscapes rather than come to Paris to gratify his craving for nude models. In response, Vincent dismissed plein air painting as unchic ("[Parisians] care little for outdoor studies," he insisted) and claimed that working outdoors was bad for his health.

In the year since, he had hardly ventured beyond the precincts of the rue Lepic apartment. He documented his neighborhood and the view from his window (just as he did in every new home), but rarely visited even a park. In a city obsessed with escaping itself in the summer heat, he spent the entire summer holed up in his studio, painting bowl after bowl of withering flowers.

But all that changed in early 1887. Before the trees had even budded, Vincent lugged his paint box and equipment over the butte, past Montmartre's ramshackle margins, past the crumbling fortifications that girdled the old city, and through the ring of factories and warehouses that circled the new one. Finally, about three and a half miles out, he hit the banks of the Seine—not far from the Île de la Grande Jatte, the summer playground immortalized by Seurat.

Over the next months, at points all along this route, he marshaled his paints and brushes and his conciliatory eye in an all-out campaign to reclaim his brother's favor. Forsaking years of strident rhetoric and uncompromising images, he embraced the art that Theo had advocated so long in vain: Impressionism. It was a reversal abrupt and dramatic even by Vincent's volatile standards. He planted his easel on the broad boulevards and suburban highways, beside industrial monuments and *banlieue* vistas—all subjects favored by the new art but long ignored by him—and painted them in the bright colors and drenching sunlight that had been the subject of so many heated debates on the rue Lepic.

Especially on the banks of the distant Seine, where spring came early, he made amends for his years of obstinacy. He filled canvas after canvas with the Impressionists' signature images of bourgeois leisure: a Sunday rower on a glistening river, timid waders at the water's shallow edge, a straw-hatted stroller on the grassy riverbank, a boatman resting in the shore's dappled shade. He painted tourist landmarks like the Restaurant de la Sirène, a Victorian pleasure palace that loomed over the little riverside town of Asnières, just downriver from

La Grande Jatte. During the high season, the Sirène's long verandas filled with spectators for river regattas and day-trippers fleeing the stifling city. He painted the huge bathing barges anchored just offshore and the fashionable waterside restaurants set with linen and crystal and bouquets of flowers—scenes as far from the hovels of Nuenen as imagination could take him—all rendered in the pastel tones and shadowless, silvery light he had decried so vehemently, in words and images, only months before.

Throughout the spring and into the summer, he returned again and again to the same area around Asnières—outings that had the added benefit, if not the intention, of absenting him from the apartment. Theo "look[ed] forward to the days when Vincent would wander off into the country," Dries Bonger recalled. "He would get peace then." Liberated from his long resistance, and desperate to find the key to his brother's favor, Vincent tried virtually every technique in the Impressionists' repertoire, all of which he had studied carefully, even in rejection.

His experiments with Impressionist brushwork had already begun earlier that winter in still lifes and portraits, like the ones of the Scotsman Reid. Because the gospels of Millet and Blanc were relatively silent on the application of paint, his brush was free to test the new art's texture even as he continued to attack its fainthearted palette. Already in Antwerp, the dense, featureless surface of *The Potato Eaters* had given way to the *enlever* contours of his portraits, and these in turn to the scumbled encrustations of the previous summer's flowers. As early as January 1887, he experimented with both the thinner paint and the more open compositions of Impressionists like Monet and Degas. In the spring, he abandoned altogether the heavy impastos and compacted surfaces of the past and set out to try his hand at the whole complex calligraphy of brushstrokes that distinguished the new art as much as its color or light.

The paintings of spring and summer were filled with the fashionable shorthand of dashes and dots. He tried them in every size and shape: from bricklike rectangles to comma-like curls to bits of color no bigger than flies. He arranged them in neat parallel ranks, in interlocking basketweaves, and in elaborate, changing patterns. Sometimes they followed the contours of the landscape; sometimes they radiated outward; sometimes they all swept across the canvas in the same direction, as if blown by an unseen wind. He applied them in tight, overlapping thickets; in complex confederations of color; and in loose, latticelike skeins that revealed the underlayers of paint or ground. His dots clotted and clustered, filled large areas with perfect regularity or exploded in erratic swarms.

In his race to make up for lost time, he jumped back and forth over ideological chasms that brought other artists to blows, often combining Divisionist dots and Impressionist brushwork in the same image. Eschewing or ignoring Seurat's optical claims, he mixed the colors on his palette exactly as he had always

done, rather than apply them "pure" and trust the viewer's eye to blend them. His *pointille* came and went, faded in and out from painting to painting, even within paintings, as his patience for the painstaking method waxed and waned.

On days too cold or wet for the trip to Asnières, he practiced all these new liberties on an old and elusive subject: himself. Risking only cheap sheets of cardboard or scraps of paper not much bigger than postcards, he painted the dapper, chapeauxed image in the mirror in every combination of palette and brush: from monochrome scrawls to delicate cameos in pastel pinks and blues; from sketches in broad slashes to mosaics of brushwork in every pattern, density, and dilution. Finally, he committed himself to a real canvas and rendered the familiar visage in a hail of tiny brushmarks that barely touched the canvas, using paint almost as insubstantial as watercolor, and hurtling to finish it so fast that the last flicks of background blue fly off the vibrating figure like sparks off a flame.

In all these experiments, Vincent had an advantage he could not have anticipated. Years of seeing with an etcher's eye had prepared him unknowingly for the fractured image making of the new art. He had long since mastered the interweaving of solids and voids: rendering contour and texture through hatching and stippling; manipulating form through the density and direction of markings. To school his hand in the new styles, he had only to recruit these old skills in the service of his new understanding of color—to substitute Blanc's matrix of simultaneous contrasts and kindred hues for the binary interplay of his beloved black-and-whites.

By connecting these two wellsprings of picture making, the jabbing images of that spring and summer finally freed Vincent from the unforgiving linearity of realism and opened up his paintings to the spontaneity and intensity of his best drawings.

As if celebrating this triumphant synthesis, he took a huge canvas (at three feet by four feet, as big as *The Potato Eaters*) and filled it with a drawing in paint: a view of the Montmartre butte that he passed every day on his route to Asnières. As closely observed as the carpenter's yard on the Schenkweg or the pollard birches in Nuenen, the ragged patchwork of vegetable gardens brings the chalky hillside to exuberant life. Color breaks in everywhere—green hedgerows, red rooftops, boards weathered lavender by the sun, pink sheds and powder-blue pickets, the radiant yellow stubble of harvested plots—rendered in thousands of unique marks by Vincent's tireless brush, from the vivid stipples of rosebushes to the tiny hatching of distant fences to the broad strokes of hazy blue sky. A lime-white road, glaring in the summer sun, fills the bottom of the picture, then winds dramatically to the distant crest of the butte where a mill without sails stands alone on the horizon, stripped to its violet bones.

For Vincent, everything about the picture was a repudiation of the past: the absence of figures and shadows; the relentlessly bright, clear colors; the pe-

remptory brushwork; the paint so thinned that it lies on the canvas like pastel, showing the white undercoat between every stroke, as ubiquitous and blinding as the chalky ground. If *The Potato Eaters* was a meditation on darkness, *La butte Montmartre* was a reverie of light.

In his explorations of the new art (a self-education that telescoped ten years of artistic innovation into a few frantic months), Vincent had help from another unexpected source. At twenty-three, Paul Signac was a decade younger than Vincent—younger even than Theo—but already fluent in all the many dialects of imagery that competed for the allegiance of young artists in Paris. He had made Manet a hero as a teenager; seen the light of Impressionism in high school (while Vincent was still laboring in the mines of the Borinage); and written for *Le Chat Noir* by the time he turned twenty. An inexhaustible reader, he had consumed not only the Naturalist literature that Vincent loved, but great swaths of philosophy and art theory, and could converse on them with a precocious facility that admitted him to virtually any intellectual or artistic circle he set his sights on. As a founder of the juryless Salon des Indépendants—a refuge for all artists neglected by officialdom, not just Impressionists—Signac created a vast network of friends that he cultivated with proselytic fervor.

He and Vincent had lived only a few blocks apart for a year, but never met. Vincent certainly knew of Signac by reputation: he had seen his work at the Indépendants' show the previous summer, and probably again at their next exhibition in April 1887, which included almost a dozen of Signac's canvases. By all accounts, though, their first real encounter came quite by accident on one of Vincent's day trips to Asnières. Signac, the son of a wealthy shopkeeper, kept a studio at his family's house there (in addition to both an apartment and a studio in Montmartre), and the return of spring lured him to the riverbank just as it did so many Parisians. Two painters, both working on the same short stretch of riverfront, could hardly help but meet.

Despite his gregarious nature, however, Signac did not pursue the connection with any apparent vigor. By his own account, he saw Vincent only "several times" over the rest of the spring: a morning of painting outdoors, lunch at a local bistro, perhaps, and at least once a long walk back to the city. His brief reminiscence portrays Vincent as a somewhat clownish and not necessarily welcome companion on his country excursions. "He shouted, gesticulated and brandished his big canvas which was still quite wet," Signac recalled, "smothering himself and passers-by with paint." Once they reached the city, their paths parted. Signac never introduced Vincent to any of his wide circle of friends nor invited him to the soirées he hosted every Monday night at his residence, just a short walk from the rue Lepic apartment.

Of course, Vincent didn't need the young Signac to show him the "new" Impressionism. He had seen it scores of times, starting with the *Grande Jatte* it-

self, probably at both its exhibitions in 1886. Like many young artists, Vincent's Cormon classmates Anquetin and Lautrec had fallen under Seurat's Pointillist spell that same summer. Their works, as well as those by Signac and other acolytes, were on view throughout the following winter and spring. Even those who resisted the new style, like John Peter Russell, argued about it endlessly.

So Vincent had undoubtedly seen the art and heard the ideas many times before he encountered the cocky young painter on the banks of the Seine. But Signac was a charismatic spokesman, an incorrigible explainer, and Vincent was a man bereft of companionship for whom a hands-on demonstration, a word of encouragement, or a cordial compliment could work wonders. Their interaction, however brief or awkward, touched his imagination in a way no exhibition could. Vincent expressed his gratitude in paint. Whether in Signac's company or merely for his approval, he painted at all the Neo-Impressionists' favorite spots along the Seine, including the Île de la Grande Jatte itself, eagerly mimicking the dense *pointille,* strict color rules, and radiant light of his young mentor. Finally, he sealed their connection with a self-portrait done exactly as Signac would have done it—all disciplined dots and color juxtapositions.

But as soon as his occasional companion left Paris at the end of May, Vincent's brush abandoned the strictures of Pointillism and returned to the goal that had driven him out of the city and into the countryside in the first place. In a series of shady, close-up vignettes of forest floor and rural path, he cast aside Signac's rules, Monet's subjects, even Blanc's complementaries, and returned to the intimacies of his earliest landscapes—the cozy glimpses of nature that had always pleased his brother most: a lush carpet of undergrowth at the base of an ivy-laced tree; a sunlit clearing seen through a dense latticework of young saplings; a field of summer wheat at the moment when a gust of wind churns the stalks into waves and startles a partridge from its hiding place.

After the silk cravats and smart felt hats of his self-portraits, after the glowing reports of advantageous relations with the young gentleman Signac, these affirmations of nature's reparative powers touched the final talisman of Van Gogh family amends, capping Vincent's months-long push to win back his brother's lost devotion.

But it wasn't enough. Theo certainly recognized the change in his brother's art and welcomed his long-overdue embrace of Impressionism. "[Vincent's] paintings are becoming lighter," he reported to sister Lies in May; "he is trying hard to put more sunlight in them." And the images of nature worked their parsonage-garden magic, moving Theo to flights of poetic appreciation for "nature's vast magnificence." Vincent's long absences from the apartment, combined with the ministrations of a new doctor, had also revived Theo's health, at least temporarily. Whether because of the changes in Vincent's art, or the improvements in his spirits, or just the coming of spring ("man, just as nature,

thaws out sometimes when the sun shines," he wrote), Theo reached out to his brother. "We have made our peace," he reported to sister Wil in April. "I hope it will last . . . I have asked him to stay."

But on the most important judgment of all, Vincent had failed to win a reprieve. If anything, the trials of the winter had only redoubled Theo's determination to marry. The months of ominous illness and battles with Vincent had turned his natural melancholy into a deep dread of living out his remaining years deprived of "interaction with sympathizing souls." In letters to his sisters, he poured out his loneliness and desperation. He complained of "difficult days" when it would "mean so much to know that there is somebody who wants to help"; of times when he felt "all alone," facing impossible challenges with "no way out." He exhorted them, and himself, to "find what your heart desires so that you may always feel warmth around you." He warned them, and himself, that "perfect happiness is not of this earth." For him the answer was plain enough. "I intend to ask for Jo Bonger's hand," he declared. He had not seen her since the previous summer—had not even written her—but "she could mean oh so much to me," he imagined. "I could trust her in a very special way, like nobody else."

In May, just after his thirtieth birthday, Theo announced his intentions. He would go to Amsterdam "as soon as possible" and beg Jo Bonger to marry him.

The news, expected though it was, plunged Vincent into despair. Even as his palette and brush continued to capture the bursting sunshine of the Paris summer, his spirits sank into darkness and depression. He talked of suicide, and suffered paralyzing nightmares. He ruminated on death in two painted studies of a stark, Yorick-like skull. As in Nuenen, where he never left the studio without a flask of cognac, he found solace in drink. The route to and from Asnières was lined with cafés and bistros where he could end the long, hot workdays, as so many Parisians did, in the cool, sweet-green oblivion of absinthe.

Like Theo, he had only his sisters to tell his misery. In a letter so bitter and cynical that it must have alarmed the naïve twenty-five-year-old Wil, he lamented his "lost youth" and cursed the "diseases" of "melancholy and pessimism" that tormented him. He responded to some poetry she had sent for his review with a coruscating denunciation of all artistic aspirations. Down that road, he warned, lay nothing "sacred or good," but only futility and disillusionment. As if on cue, word arrived from Nuenen that everything he had left behind in the Kerkstraat studio, including studies and drawings and even his precious portfolios of prints, were to be sold at auction to pay the debts he had also abandoned.

He agonized over the source of his misfortune and misery. He claimed his plight as the curse of neglected artists everywhere, doomed to suffer the fate of "a grain between the millstones"—a seed snatched from the soil before it could

ripen or germinate, or a flower "trampled underfoot, frozen or scorched." He brooded on his own culpability, invoking Zola's theories of degeneracy and determinism to defend himself from unspoken reproaches. "Evil lies in our own nature," he protested, "which we have not created ourselves. . . . Vice and virtue are the products of chemistry, like sugar and bile." But ultimately he couldn't hide the true source of his terror. "If I didn't have Theo," he wrote, "it would not be possible for me to achieve with my work what I ought to achieve."

If the brilliant landscapes of summer masked his despair, the self-portraits unmasked it. In quick succession, he produced another series of confessions in paint, all full-sized and all on canvas—as if the smaller, paper images of spring couldn't contain his guilt or his grievances. Stripped of silks and satins, the figure in the mirror appears in the limp, tattered smock of an artist, his hair cropped short, his cheeks sunken, his gaze colorless, unfocused, affectless. For all the sun flooding into his Montmartre studio, he stands against the dark, murky background of a prison cell. The hollow-eyed criminal of Antwerp had returned. In his letter to Wil, Vincent, now thirty-four, reported "making swift progress toward growing into a little old man—you know, with wrinkles, a tough beard, a number of false teeth, and so on." To Theo, he put it even more bluntly: "I already feel old and broken."

Vincent had dealt with the threat of a woman disrupting their perfect brotherhood before. In Drenthe, he proposed that Theo's mistress Marie join the two painter-brothers in their cottage on the heath. "Of course she would have to paint too," he encouraged; "the more the merrier." In Antwerp, he responded to Theo's talk of marriage by declaring, "I wish both of us might find a wife." The following summer (1886), when Theo left for Amsterdam with engagement on his mind, Vincent had offered not just to take the mistress S "off his hands," but to *marry* her—"if worse comes to worse." In Vincent's estimation, these were the only two circumstances in which marriage was thinkable, for him or Theo: either one woman married them both, or they both married. Anything else would upset the perfect balance of their brotherhood.

But Vincent had not yet even met Jo Bonger, the woman of whom Theo said, "I cannot put her out of my mind; she is always with me." Jo was still a stranger to Vincent; and she to him. In fact, as Vincent either knew or suspected, Theo had not yet told his inamorata *anything* about his troubled brother—a hint of the shame he felt and a preview of the inevitable exclusion to come.

If they could not both marry Jo Bonger, then Vincent would have to find a wife of his own. And indeed, the ghosts of failed attempts to do so haunt his letters that summer. "I still continue to have the most impossible and highly unsuitable love affairs," he wrote sister Wil, "from which as a rule I come away with little more than shame and disgrace." One such "unsuitable" affair may have been with an older woman that he met in Asnières. He called her "the

countess" and he courted her with repeated gifts of paintings. "I cannot help thinking of [her]," he later admitted, even as he wondered if their liaison was just "an illusion." He tried to explain his sad record of similar illusions as the inevitable fate of an artist. "I blame it all on this damned painting," he wrote. "The love of art is the undoing of true love." And, as always, he compensated with images for the inadequacies of life. Setting his easel in a lovers' lane, he painted happy couples strolling arm in arm and embracing on a bench, as if painting it could make it come true for him.

But as the moment of Theo's departure for Amsterdam approached, a sense of urgency gripped him. Reviving past fantasies, he inquired after the status of Margot Begemann and asked his sister unabashedly, "Did Sien de Groot marry her cousin?" The distorted version of family that he had briefly enjoyed on the heath came back to him in a wave of regret and he acclaimed *The Potato Eaters*, the icon of that time, "the best picture I have done." He lived in terror that he had waited too long: that love was destined to be the last and greatest in a litany of failures. "In years gone by," he lamented, "when I ought to have been in love, I gave myself up to religious and socialist affairs, and considered art holier than I do now." Desperately reassessing the verities of a lifetime, he wondered if "people who only fall in love are more saintly than those who sacrifice their hearts to an idea."

Only desperation could explain Vincent's amorous advances on Agostina Segatori.

The two had continued to see each other over the winter. Vincent painted a portrait of the bored-looking *signora* fashionably attired, sitting at one of her distinctive tambourine tables. He continued to patronize Le Tambourin, too, occasionally bringing along the old paint dealer Tanguy, to the horror of his shrewish wife. When Vincent needed money—perhaps to ransom his treasured portfolios in Nuenen—Segatori let him display some of his recently acquired prints on her café walls, alongside his paintings, in hopes of raising quick cash. The relationship seemed cordial enough—she was a professional hostess, after all—but hardly intimate.

Meanwhile, her situation, like his, grew increasingly complicated and untenable. After its auspicious opening, Le Tambourin had fallen under a cloud of disrepute. The manager—whose relationship to Agostina remained suspiciously unclear—had attracted a circle of menacing thugs and pimps. The restaurant's aura went from fashionably outré to genuinely sinister. At a time of widespread xenophobia directed against immigrant Italians, dark rumors swirled around "La Segatori's" erotic eatery. Every sensational murder, it seemed, involved Italian villains who had been seen plotting at a tambourine table. Brawls and police raids were common. A Tambourin regular rumored to be one of Agostina's ex-lovers was convicted of murder and executed. Alarmed customers fled, pushing the café inexorably toward bankruptcy.

But Vincent didn't care. He needed a woman. And in his limited social circle, Segatori's flattering sensuality and Neapolitan warmth were no doubt as close as he had come to reciprocity. If the rumors reached him at all, he either ignored them or cast the hapless beauty as the victim of those around her ("she is neither a free agent nor mistress in her own house," he explained to Theo). With his usual heedless ardor, he courted the aging beauty using the same means of persuasion he always used: art. Reviving the bond of the previous year, he started painting flowers again, filling large canvases with elaborate bouquets, brighter and bolder than ever, brushed in the pure, dappled colors he had practiced all spring in Asnières. Wooing image followed wooing image, including one of a basket of violets, the flower of requited love, set on one of her tambourine tables—an unmistakable gesture of seduction.

After Theo left on his mission of marriage in July, rejection became unthinkable. Even when Segatori refused to accept his courtship bouquet of violets, Vincent persisted. "She didn't tread all over my heart," he noted optimistically in a letter to his absent brother. When he heard that she had fallen in love with another man, he condemned the gossipmongers. "I know her well enough to trust her," he insisted. When she told him to "go away," he imagined she was only protecting him from the dangerous men who surrounded her. "Appalling things would be done to her if she took my side," he explained.

Despite the banishment, despite the danger, despite a threatening visit to the rue Lepic apartment by a restaurant employee, Vincent returned to Le Tambourin—convinced, no doubt, as he always was, that he could still persuade her to love him. What happened next is unclear. Secondhand accounts vary, and Vincent's is unreliable. One thing is certain: there was a fight. Someone, the manager or one of his henchmen, tried to throw Vincent out. He resisted. They exchanged blows. The assailant may have thrown a beer glass in Vincent's face, cutting him on the cheek, or perhaps smashed one of his flower still lifes over his head. Either way, Vincent fled the scene, bleeding, shamed, and in despair.

Nursing his wounds and waiting anxiously for the verdict from Amsterdam, he took paper and pen and struggled to explain this latest catastrophe to befall him. He recast it as a business deal gone sour. He had returned to Le Tambourin merely to reclaim his paintings and prints, he protested, concerned about their fate at a threatened bankruptcy auction. It was the manager who had "picked a quarrel," he said, not him. "You can be sure of one thing," he assured Theo. "I shan't be doing any more work for the Tambourin." As for Segatori herself, he struggled manfully to excuse her role in the debacle, casting her, like Sien Hoornik, as yet another guiltless Mater Dolorosa, more to be pitied than censured. "She's in pain and unwell," he explained. "I don't hold it against her." As with Sien, only exoneration could keep the delusion alive. "I still feel affection

for her," he insisted, "and I hope that she, too, still feels some for me." In a few months, he imagined, she might even thank him.

When he wasn't entertaining delusions of reconciliation with Segatori, he constructed fantasies of a place for himself in his brother's new married life. Theo might buy a country house "like so many other art dealers," he suggested, where Vincent could decorate the walls with his paintings and the three of them—Theo, Jo, and Vincent—could live together, "looking rich" and "enjoying life." Beyond that, he could see only one other alternative, which he pointedly shared with Theo: "to do away with oneself."

Pondering the same dark thoughts in images, he painted a coda to the flower offerings begun for Agostina. He chose a particular late-summer-blooming flower and painted a trio of pictures. Taken together, they present—and in Vincent's metaphorical mind, surely were intended to present—a narrative of the disastrous summer. His subject, for the first time: sunflowers. He brooded on these huge blossoms with the same lingering, introspective eye that saw abandonment in empty birds' nests and fruitless journeys in worn-out shoes.

For the first image, he cut just two aging flower heads from their stems and laid them, already wilting, on a tabletop. He faced them both forward and enlarged them to fill the whole canvas so his obsessive brush could explore every detail of their dying: the wasted burden of seeds, the shriveling fringe of petals, the drying leaves. Rendered in sallow yellows, acidic greens, and a rain of red dashes, they summarize in morose close-up the evanescence of perfection. In the next image, he brought one of the flowers back to life. Its swirling center bursts with color and fertility. Its fresh yellow petals are still edged in green, bending and curling voluptuously against a background of brilliant cobalt blue. But this time he tucked the second blossom demurely behind the first: its face turned away, upstaged by its exuberant partner.

Finally, he painted four huge blossoms arrayed across the biggest canvas of all (two feet by three and a half feet). Three of them explode like suns, each with its own writhing corona of yellow petals; its own teeming, radiant bounty of seeds; its own long, green stem—recently cut but still full of life. Only the fourth flower turns away, hiding its face, revealing its short, closely cropped stalk, betraying the brief, dismal end to come.

Alone, afraid, broke, unable to work, anxiously awaiting his brother's return, Vincent could only watch as his paintings and prints at Le Tambourin were auctioned off as junk—"in a pile . . . for a laughable sum." It was his first "exhibition," other than in a creditor's window. Afterward, one fellow artist dubbed it a *"succès de rire"*—a triumph of laughter.

But none of that mattered anymore. All that mattered now was the announcement Theo brought from Amsterdam.

Catch and Release

~

J O HAD TOLD THEO NO. WORSE THAN THAT: SHE HAD HUMILIATED HIM. Marveling at the forwardness of a man she felt she hardly knew, she recorded the scene in her diary:

> At two o'clock in the afternoon the doorbell rang: Van Gogh from Paris. I was pleased he was coming, I pictured myself talking to him about literature and art, I gave him a warm welcome—and then suddenly he started to declare his love for me. If it had happened in a novel it would sound implausible—but it actually happened; after only three encounters, he wants to spend his whole life with me, he wants to allow his happiness to be dependent on me. It is quite inconceivable. . . . My heart feels numb when I think of him!

Arguing over her refusal—just as Vincent had done with Kee Vos—Theo offered her "a rich life full of variation, full of intellectual stimulation, [and] a circle of friends who are working for a good cause, who want to do something for the world." But Jo stood firm. *"I don't know you,"* she protested, rejecting not just his impetuous proposal, but his whole sad, unilateral delusion of love. "I am so terribly sorry that I had to cause him such sorrow," she concluded. "How depressed he will be when he returns to Paris."

Jo's unequivocal rebuff brought Theo reeling back to the rue Lepic apartment, where Vincent welcomed him like a prodigal son. Spurned himself—both in love and in art—Vincent saw in his brother's misfortune a chance to revive his Goncourt fantasy of "working and thinking together." Always eager for reconciliation, and crushed by Jo's refusal, Theo fell into the waiting embrace.

Only a few months earlier, he had resolved to banish Vincent from his apart-

ment. But even then he had confided to his sister that he, too, still clung to the vision of the Rijswijk Road. "It is a pity," he wrote about his difficult brother, "for if we had worked together it would have been better for both of us." Now Vincent's familiar entreaties to "join hands" offered not just consolation for his broken heart, but a recall to duty. When Anna van Gogh heard the news about Jo, she warned Theo against the dangers of despondency by invoking her dead husband's favorite image, the persistent sower: "Have faith that there will be good things after times of sadness," she wrote, "for the sadness often yields fruit that makes us grateful in the end."

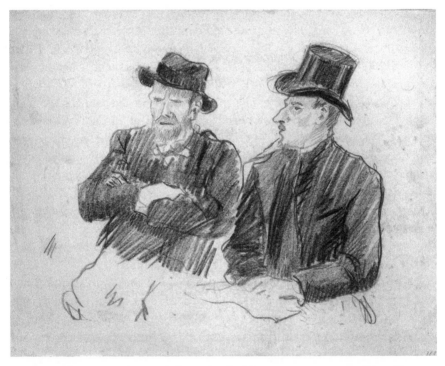

LUCIEN PISSARRO, *Vincent and Theo van Gogh,* 1887, CRAYON ON PAPER, $8^3/_4$ X $6^7/_8$ IN.

In that spirit, Theo returned to Paris and put the plow once again to the field of his fraternal bond. He described the task ahead in terms both resigned and determined:

> I think it is far more important, knowing that we are what we are, to extend a hand to one another &, in the faith that we are stronger together than alone, to hope and strive, by living together, to reach a point where we see each other's faults & forgive them & try to nurture whatever is good and noble in one another.

Retreating into the solace of brotherhood, Theo lifted the restrictions of the past. After more than a year in which their joint social life consisted largely of dinners at home or at neighborhood restaurants, with perhaps a single Dutch friend, he and Vincent began frequenting concerts, cafés, and cabarets together. They heard the music of Richard Wagner for the first time (still a controversial novelty in Paris) and saw the famous "shadow theater" at Le Chat Noir, a pre-cinematic extravaganza of puppets, lights, music, and special effects.

At home, too, Theo admitted Vincent into regions of his life from which he had long been barred. It was at this time, apparently, that the brothers finally, fully revealed their health secrets to each other. Soon they were sharing doctors and treatments for the syphilis from which they both suffered. They endured together the latest "scientific" remedies of Louis Rivet, a young doctor who specialized in "nervous disorders" (a catchall euphemism for secret afflictions); as well as the idiosyncratic regimens of Dr. David Gruby, an eccentric health guru renowned for his celebrity clientèle.

Theo also brought his brother fully into the obsession and pain of his love for Jo Bonger. Soon after his return to Paris, undoubtedly at Vincent's prompting, he sent Jo a pleading, combative letter that simply pretended her "no" had never been uttered. ("I am writing in the hope of hastening [your] decision, whatever it may turn out to be.") In the patronizing, defensive tones that had marked all Vincent's failed loves, Theo accused Jo of naïveté and dismissed her adolescent notions of love as "only a dream . . . bound to be followed by a rude awakening." True love, he declared, could only be achieved through faith and forgiveness. She must *learn* to love him, he insisted. (Like so many of Vincent's demanding missives, the letter brought all correspondence to an end.)

The renewed grip of brotherhood extended even into Theo's work. Until now, their reconciliations had always stopped at the doors of the Goupil branch on the boulevard Montmartre—the scene of Vincent's humiliating dismissal ten years earlier. If Theo didn't ban his brother from the premises outright, Vincent surely felt unwelcome there. No evidence survives that he ever set foot in Theo's workplace during his two years in Paris. The mere mention of Goupil could ignite arguments over Theo's allegiances and "true self" every bit as bitter as the furious letters from Drenthe. Vincent browbeat his brother late into the night over the corruption of the art market in general and Goupil in particular. Thus it was hurtful, though hardly surprising, when Theo chose to partner with Andries Bonger in his abortive bid for an independent dealership in 1886. Theo never stopped admiring Vincent's extraordinary knowledge of art and artists, but the life of a Goupil *gérant* was filled with delicate negotiations and diplomatic compromises, and there had never been a suitable place in it for his volatile, vehement brother.

Until now.

In fact, when Theo returned from his failed mission to Amsterdam, Goupil was no longer Goupil. The firm had officially changed its name. Starting in 1884, with the imminent retirement of its founder, Adolphe Goupil, the gallery had begun to rechristen itself. By the time Vincent came to Paris, the sign over the door of Theo's gallery read "Boussod, Valadon & Cie" (after Goupil's partner Léon Boussod and the company's manager, René Valadon, Boussod's son-in-law). For decades, however, people continued to refer to it simply as "Goupil."

But the sign wasn't the only thing that had changed. A whole new generation of management had taken charge. In addition to the thirty-eight-year-old Valadon, Boussod brought into the company his sons Étienne, twenty-nine, and Jean, twenty-seven. Together, they set out to bring Goupil's huge but aging business into the new era. They severed longstanding ties with Salon stars like Bouguereau (whose fetching women had been a virtual industry within an industry), and dropped many of the École artists who supplied the firm's staples of academic genre scenes and history paintings. They revamped the printing and photography divisions to take advantage of new technologies and new media, especially magazines. In May 1887, they staged a huge auction of inventory, both to raise capital for new ventures and to dispose of old, unsalable stock.

Finally, they decided to enter the market for new art. Ten years after the disastrous auction at Drouot, the success of the Impressionists had convinced them that Goupil, too, had to embrace the changing tastes of its audience. In 1887, they signed a contract with Léon Lhermitte, a forty-three-year-old artist whose reputation was just ripening into acclaim. Lhermitte's colorful oils and pastels perfectly combined the rural imagery of the Barbizon School (a perennial seller) with the light and brushwork of the Impressionists. (Lhermitte had in fact been invited to exhibit with the Impressionists, but never did.) They also approved a plan to deal directly with some of the original Impressionists, especially artists like Claude Monet and Edgar Degas, whose works had begun to sell at impressive prices that promised only to rise.

But they ventured further still. Having learned the *real* lesson of the previous decade—that there was money to be made, serious money, in marginal, even controversial art—they approved an initiative to seek out and support unproven artists. Goupil would risk its money and its reputation in a search for the *next* Impressionists, whoever they might be.

Finally, they chose the man to lead the search: Theo van Gogh.

History would later give Theo full credit for Goupil's initiative in the new art. But, if anything, his standing in the firm had only been diminished by his attempt to break away the previous summer. The overhaul also reached far beyond his gallery on the boulevard Montmartre, and many of its aspects were managed entirely from Adolphe's limestone palace on the rue Chaptal. Theo surely supported the plan; he may even have lobbied for it. For years, he had

been following and admiring the new trends (and pressing them on Vincent). He had even dabbled in their market a few times. And events had certainly proven him right.

But others at the firm, including his new bosses, shared his enthusiasm. In the end, the fateful decision to give Theo van Gogh the mandate to deal in the new art on behalf of Goupil may have hinged on an accident of architecture: only the Montmartre branch offered a discreetly separate display area—a small, ill-lit mezzanine, or *entresol*—where the controversial new images could be quarantined from the firm's less adventurous clientèle.

In April, a month before Goupil's massive sale, Theo launched his part of the companywide initiative with a coup that caught the attention of the entire vanguard art world. In a single stroke, he bought three paintings by Claude Monet and agreed to give over much of the *entresol* to show at least a dozen of the painter's recent works—mostly views of the Brittany coast at Belle-Île. The deal represented not just a rich triumph for Monet (by the end of the year, Theo had bought fourteen of his canvases for almost twenty thousand francs, an astounding sum), but a milestone in the ascendance of Impressionism from avant-garde to investment-grade. Almost simultaneously, Theo paid an eye-opening four thousand francs for a large painting by Degas.

In accepting Theo's offer, Monet abandoned Paul Durand-Ruel, the dealer who had built Monet's success out of the ashes of the Drouot sale. It was a betrayal that both spotlighted the works on view on the *entresol*, and underscored the changing of the old order. Even more than the companywide fire sale of old stock, Theo's Monet coup (and the money that followed) signaled to the art world that Goupil, the Salon fortress built on costume vignettes and martial scenes, pretty girls and picturesque peasants—Goupil, with its international network of stores, acres of printing presses, and armies of loyal collectors—had entered the market for "modern" art.

Inside the limestone walls of the boulevard Montmartre gallery, the momentous events of the spring and summer hardly altered Theo's busy workday. He still spent most of his time on the main floor selling Goupil "evergreens" like Camille Corot and Charles Daubigny (both Barbizon landscapists) and managing relations with fashionable painters like Vittorio Corcos (another painter of women), whose works continued to pay the gallery's bills. He still carefully appraised collector sentiment before committing company money or taking a painting on consignment, and dropped artists who didn't sell, no matter how much he personally admired their work.

On the *entresol*, where the mandate of the spring brought a parade of new art and artists into Goupil's sanctum, the same rules applied. He heavily favored artists, such as Raffaëlli and Monet, with established reputations and ready, if erratic, markets. Seemingly impervious to the ideological battles that filled art-

ists' cafés and partisan reviews, he assessed the work of lesser-known painters by the same commercial standards he had always used—the same standards that had long frustrated Vincent: Was it colorful? Was it done with "vigor"? Was the subject matter pleasant? Was it pleasing to the eye? In short: Would it sell?

Beyond the gallery walls, however, everything in Theo's life changed. Goupil's new initiative caused a sensation among the legions of unknown, upcoming painters struggling for recognition in Paris's crowded art world. Most of them, young or old, came from middle-class backgrounds. However dissonant their theories or fractious their rhetoric, they, like Vincent, brought to their artistic pursuits the same middle-class aspirations to comfort and repute. Opportunities to show their works (except to fellow partisans) were rare; buyers, even rarer. Like Vincent, they filled the mailboxes of friends and family with bitter letters, howling the injustices of penury and neglect. Goupil's commitment to open its doors, and its purse, offered not just the possibility of income, but, even more important, the promise of legitimacy—the chance to hang their work under the same roof as Delacroix and Millet. Toulouse-Lautrec's aristocratic family, who otherwise frowned on the "low-life naturalism" of their son's art, beamed with pride when they heard that his pictures would be exhibited "at the big art dealer, Goupil's."

For all these reasons, Theo enjoyed a power in the contemporary art world far out of proportion to the modest funds and timid initiatives he deployed starting in the fall of 1887. Artists of every stripe deluged him with pleas to show their works on the *entresol*. They offered to slash their prices, or even make gifts of paintings, in exchange for a treasured place in Goupil's out-of-the-way mezzanine. They entreated him to visit their studios and attend the unpublicized shows they staged in whatever café, cabaret, or office lobby would have them. They plied him with personal gifts and favors as well: drinks, invitations, introductions—looking for any wedge of advantage.

Like any dealer, Theo had always reaped the benefits of inside information and artists' gratitude. But as a junior Goupil *gérant* selling the expensive works of dead masters and prominent living artists, he had managed to collect only a few small gifts from illustrious clients like Corcos, and a scattering of sentimental favorites bought at bargain prices. All of that changed when he entered the fraught world of unproven art, where paintings often sold for the price of a good meal, if they sold at all. Theo apparently never transacted personal business on Goupil's premises, but real separation was impossible, and the artists knew it. Nothing prevented him from using the *entresol* to build the reputations of painters he favored (and invested in), or from showing works to gauge public interest in particular artists before investing in them, or from just dropping a few flattering words into the large pool of collectors who relied on his discernment.

To help him find his way through this clamor of advocacy and chaos of im-

agery, Theo turned to the one person whose eye and allegiance he trusted: his brother. Over the previous year, the chasm between their tastes in modern art had almost closed. From Monticelli's palette the previous summer to the Impressionists' light and subject matter that spring, one by one Vincent had abandoned the defensive barricades of *The Potato Eaters* and returned to the natural consonance of eyes trained on virtually identical imagery. The brothers had always shared a fondness for naturalism, especially in landscapes, as well as a suspicion of artifice (pictures "premeditated forcedly") and a distaste for vulgarity.

They both saw the new art as a "regeneration" of the old, not a rejection— a gradual evolution, not the revolution plotted by some—and they relentlessly looked for continuities between the new images that attracted them and the old ones they had long revered. From their shared mentor H. G. Tersteeg, they had both learned to see the new art *"dans le ventre"*—in the gut—as well as in the eye; and never to confuse admiration with popularity. "Never denounce a movement in the arts," Tersteeg warned, "[for] what you denounce today, in ten years may make you kneel."

While Theo had never fully trusted his brother's business sense—there is no evidence that he ever bought or sold a painting entirely on Vincent's recommendation—there were practical as well as artistic arguments for bringing him into this new venture (and Vincent undoubtedly made them). With his already frantic schedule, Theo needed help keeping track of the bewildering array of art and artists who, unanchored by regular dealers, showed somewhere in the city almost every day. With his keen eye, vast knowledge, and vivid descriptive powers, Vincent could double Theo's presence. Unproven, marginal artists would treat him not as an outsider, but as one of their own. He could preach to them in their shared language of aspiration, and reassure them that Theo, unlike other dealers, understood their craft as well as their predicament. He could solicit "exchanges" with his own work, using the implied promise of Theo's attention to build the brothers' personal collection.

Vincent marked his new place in Theo's business world the same way he marked all the twists and tumbles of the brothers' relationship in Paris: with self-portraits. In the fall of 1887, he painted himself in both of the roles Theo had assigned him: as the modern plein air painter in straw sun hat and smock, championing the art of the future; and as the ambitious dealer, decked out for business in gray felt homburg, stiff collar, silk cravat, and velvet-trimmed coat. Finally, it seemed, by a coincidence of heartbreak and entrepreneurship, they had found the joint enterprise that Vincent had dreamed of for so long, the perfect union of mind and heart that Theo had tried and failed to find elsewhere: "a rich life full of variation, full of intellectual stimulation, a circle of friends around us, working for a good cause."

—

IN THE SUPERCHARGED competitive atmosphere, such a circle formed quickly around *les frères* Van Gogh. Like everything else in the Paris art world, it was a shifting, ephemeral group—not a circle so much as a loose network, held together by the "good cause" of mutual self-interest: namely, the commercial promise of Theo's foray into what he neutrally referred to as "the new school" of art.

Some artists, like Camille Pissarro, were drawn simply by the potential for income. A veteran of the very earliest Impressionist shows, Pissarro had watched enviously as fellow pioneers Manet, Degas, and now Monet flourished while his own fortunes languished. By the summer of 1887, desperate for money, distrustful of his longtime dealer Durand-Ruel, and harassed by a wife frantic to maintain her middle-class identity, Pissarro saw the young Goupil *gérant* as the only alternative to "complete disaster." From the moment Theo made his first purchase in August, the garrulous, often cranky Pissarro became a regular visitor to the rue Lepic apartment. While his paintings sold sluggishly at first, he did manage, through Theo, to secure a job for his son Lucien at the Goupil printworks—a valuable perquisite that could not have gone unnoticed among the other contenders for Theo's favor.

While Pissarro and his son (also an aspiring artist) depended on that favor for years, other artists came and went like comets through the new enterprise. In the fever of enthusiasm for "original" Impressionists that followed the deal with Monet, Theo bought three paintings by another aging, passed-over member of the movement's founding generation, Alfred Sisley. Although a decade younger than Monet, Sisley had clung to Impressionist subjects and principles through all the "neo" temptations and Symbolist distractions of the decade. His cautious, colorful landscapes perfectly suited Theo's cautious new initiative. (Vincent later called Sisley "the most tactful and sensitive of the impressionists.") But when none of the three canvases he bought had sold by the end of 1887, Theo parted ways with the impoverished artist.

The work of Armand Guillaumin—a bolder, brighter version of Monet—had come to Theo's attention that spring when he attended a "fringe" exhibition at the offices of the avant-garde periodical the *Revue Indépendante*—one of his earliest known forays into the demimonde of vanguard art. The polite dealer and the politic artist exchanged friendly letters at the time and may have mingled socially, but did no business. When Theo launched his new initiative in the fall, however, a work by Guillaumin was among his first purchases. The forty-six-year-old Guillaumin, like his friend Pissarro, circulated widely among other, better-known artists such as Monet, Degas, Renoir, Seurat, and Cézanne

(who kept a studio next to Guillaumin's on the quai d'Anjou). He also enjoyed a steady income and good relations with a circle of loyal avant-garde dealers and collectors who supported his work. The combination made him a potentially valuable ally in the Van Gogh brothers' venture, both as an artist and as a broker.

From gray eminences like Monet and Pissarro to yeoman disciples like Guillaumin, it was a guarded start. In an art world filled with young lions desperate for attention, Theo and Vincent never wandered far from the proven path of Impressionism.

Until they encountered the youngest lion of all: Émile Bernard.

From the moment he arrived at the Cormon atelier as a boy of sixteen, fresh from the vulgar provincialism of Lille and the incomprehension of his merchant father, Bernard fashioned himself the *wunderkind* of the Paris art world. Tall and slender, with fine, brooding features, an omnivorous intellect, and the fearlessness of youth, he pursued his vision of inevitable notoriety. At Cormon's in 1884, he immediately cast himself as the *maître*'s gifted young protégé and ingratiated himself into a triumvirate with the studio's undisputed leaders, Anquetin and Toulouse-Lautrec. When, in early 1886, Cormon soured on his arrogance and dismissed him, Bernard wrapped himself in the flag of artistic freedom ("a breath of revolt had blown through the theories of the place as soon as I entered the studio," he later boasted) and declared himself a martyr for the new art.

Vincent and Bernard just missed each other at Cormon's. But in the year that followed, they had many opportunities to meet. Both frequented Tanguy's store. Both may have made return trips to Cormon's studio in the fall of 1886, where their paths could have crossed. They both surely visited the nightclubs and cafés favored by artists, such as Le Chat Noir and Le Mirliton. Bernard is known to have patronized Agostina Segatori's Le Tambourin and later claimed to have noticed some of Vincent's paintings and prints among the clutter on the walls there. The two artists certainly had acquaintances in common— Lautrec, Anquetin, and Signac, for example. But none, apparently, bothered to make the necessary introductions or, if they did, to record the fact. This was hardly surprising. In Bernard's vision of meteoric ascent, there was no place for the strange, peripheral Dutchman—or even for his junior, Salon-dealer brother.

But all that changed in the summer of 1887. When Bernard returned from his summer trip to Brittany in July, the world of vanguard art had a new venue, Goupil's *entresol*; and a new dealer, Theo van Gogh. With his unfailing instinct for advantage, Bernard soon made his way to the rue Lepic, where he immediately recognized the long-neglected Vincent as a promising route to Theo's favor. Within weeks (before the end of the summer), he invited Vincent to visit him at his parents' new home in Asnières, where a small wooden studio had been built for him on the grounds.

In this plank-sided clubhouse, the friendless thirty-four-year-old Vincent fell immediately under the spell of the suave nineteen-year-old Bernard. They exchanged enthusiasms and perhaps canvases. They may have painted together on the nearby banks of the Seine in the waning days of summer. For Vincent, the offer of friendship and the difference in ages triggered old, unalterable habits of heart. He treated Bernard with the same mix of solicitude and superciliousness, fraternal solidarity and tyrannical viscosity, that Theo and Rappard had endured in their turns. The coltish Bernard may have been pleased that the older artist took his ambition seriously. But Vincent surely entered the relationship blind to the implications of that ambition. Instead, he rushed headlong into yet another cordial or convenient alliance mistaken for a deep friendship and destined to flame out in a long, lopsided correspondence.

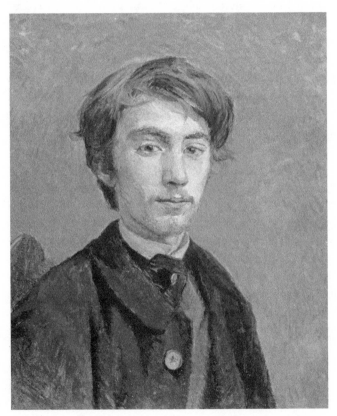

HENRI DE TOULOUSE-LAUTREC, *Portrait of Émile Bernard,* 1886, OIL ON CANVAS, $21^3/_8$ X $17^1/_2$ IN.

Bernard brought with him into Vincent's orbit his two colleagues from Cormon's: Anquetin and Lautrec. Although both lived relatively close to the rue Lepic apartment, Vincent had seen neither of his former classmates except in

passing since leaving the atelier the previous summer. Theo, on the other hand, had begun corresponding with Lautrec by the spring of that year, drawn to the artist's vibrant, Degas-like glimpses of "modern" life, just as he was drawn to Pissarro's Monet-like glimpses of rural France. In reconnoitering for his coming push into vanguard art, Theo found reassurance in Lautrec's proven salability, and, no doubt, in his family credentials—just as Lautrec found reassurance in Goupil's gilt-edged reputation. With the announcement of the new initiative that summer, the status-conscious Lautrec eagerly followed his young friend Bernard into the circle around *les frères* Van Gogh.

Other artists were drawn to the borning flame of enterprise on the rue Lepic and the *entresol,* but only Bernard bid for Theo's favor by directly courting his strange and difficult brother. The rest, like the students at the Antwerp Academy or Cormon's studio, merely tolerated him, out of deference or fear of a bad report. When they congregated at a café or at someone's studio (Guillaumin's and Lautrec's were favorites; never Vincent's), they seldom included him in their conversations. "[Vincent] arrived carrying a heavy canvas under his arm," recalled a participant in one such gathering, "and waited for us to pay some attention to it. No one took notice." In direct encounters, they scoffed at his naïve enthusiasms and chaffed at his prickly self-righteousness, but feared his volatile temper. They rarely visited his studio and dreaded his visits to theirs, having heard stories of how "[he] would tear off his clothes and fall on his knees to make a point clearer, and nothing would calm him down," according to the account of one such visit.

Camille and Lucien Pissarro, perhaps the most regular callers at the brothers' apartment, once encountered Vincent on the rue Lepic coming back from a day of plein air painting. In a fit of eagerness to show his latest work, Vincent dropped his load of equipment in the middle of the busy sidewalk and lined the wet canvases up against the wall "to the great amazement of passersby," Lucien recalled. On the basis of this and, no doubt, other such incidents, Camille concluded that Vincent was almost surely on the road to madness. Guillaumin came to the same conclusion when Vincent visited his studio and immediately started criticizing his paintings of men unloading sand. "Suddenly he went wild," Guillaumin told an early chronicler, "shouting that the movements were all wrong, and he began jumping about the studio, wielding an imaginary spade, waving his arms, making what he considered to be the appropriate gestures." The scene reminded Guillaumin of a painting by Delacroix: *Tasso in the Madhouse.* But civility to a madman was a small price to pay for a chance to show on the *entresol.*

Meanwhile, Vincent obliviously pursued his vision of an "entourage of artists" guided and supported by the brothers Van Gogh. He made introductions, wrote letters, arranged exchanges, and dispensed relentless advice on how fellow artists could advance their careers. He hinted that Theo was prepared to

provide regular monthly stipends to some artists (just as he had to Vincent)—
the fantasy of every painter in the feast-or-famine world of living by the brush.
He urged them to "set aside petty jealousies" and summoned them to "unity
and strength," just as he had so often summoned his brother. "Surely the com-
mon interest is worth the sacrifice of that selfishness of every man for himself,"
he preached. Borrowing a coinage, probably from Lautrec, he tried to unite the
fractious group under a new name: artists of the *"petit boulevard"* (side street),
as opposed to successful Impressionists like Degas and Monet, who had already
won their place in the galleries of the *"grand boulevard."* It was the perfect cap-
tion from a man who lived by captions: rallying his fellows not to their divisive
art, but to their shared aspirations.

Hovering over every call to solidarity and sacrifice, of course, was the prom-
ise of reward: "If you work hard," he wrote Bernard, "I think you might end up
by having a certain stock of pictures, *some of which we shall try to sell for you.*" It

HENRI DE TOULOUSE-LAUTREC, *Portrait of Vincent van Gogh,*
1887, PASTEL ON CARDBOARD, 21³/₈ X 17³/₄ IN.

was that promise that kept Lautrec circling despite his inevitable disdain for the coarse and earnest Dutchman, so different from his smooth and subtle brother. On one outing to a café, Lautrec, a lightning draftsman, made a sketch of Vincent sitting alone in a booth with a glass of absinthe. Later, he took the sketch home and turned it into a pastel portrait, which he presented to the brothers. With typical Lautrecian drollery, he portrayed Vincent not frontally but in profile, cold-shouldering the observer, staring straight out over the already mixed absinthe on the table in front of him—perhaps deep in thought, perhaps in a huff at a sly insult or insufficient attention; but in any case, lost in his own world. In January 1888, Theo bought a painting of Lautrec's. After Vincent left Paris in February, he wrote Lautrec a letter. Lautrec never answered.

Sometime in October 1887, Vincent began to lay plans for an exhibition. It would be a *manifestation* not just of the "new school" of art, but also of Vincent's central role in the brothers' new enterprise. The proposal to Theo must have been both artistic and commercial: an exhibition would test the public's interest, raise awareness of their venture among artists and critics, audition art for the *entresol*, and, not least, give Vincent an opportunity to show his own work—something Theo could never do at the Goupil gallery.

Theo may have approved of the concept, but he surely disapproved of the venue Vincent chose. No one could have mistaken the Grand-Bouillon Restaurant du Chalet for an art gallery. With its immense, unadorned hall and lofty ceiling, it looked more like "a Methodist chapel," according to one visitor. And with its crowds of hungry, noisy working-class patrons, it sounded more like a train station. Nothing recommended it as a place to show art except that Vincent, who frequently ate there, knew the proprietor, Lucien Martin, and Martin needed *something* to put on his vast empty walls ("enough space to hang a thousand canvases," one observer estimated). Vincent may have been urged to the unconventional site by Bernard, whose impatience for notoriety drove him inevitably to insurgent venues; but, like other vanguard artists and dealers, Vincent probably had no better choice.

The show was a disaster. Indeed, it was hardly a show at all (Bernard later referred to it as merely "an attempt" at a show). No matter how vehemently he argued, Vincent could not bring the bitterly divided avant-garde art world together under the skylights of the Restaurant du Chalet. Bernard vetoed the inclusion of Neo-Impressionists like Signac and Seurat (frustrating Vincent's effort to reconnect with Signac, who returned to Paris in November). Vincent himself refused to include the Symbolists, like Redon, that Bernard pushed on him. Pissarro, a stout partisan of Seurat, took umbrage at the exclusion of Signac (he referred to Neo-Impressionism as "our common struggle") and refused to participate. His son Lucien followed suit. In the end, only Bernard and his Cormon comrades Lautrec and Anquetin agreed to contribute a few works—a

testament to Theo's backing and Goupil's allure. Guillaumin may have contributed for the same reason. (Theo made his first purchase of a Guillaumin painting about the time the show opened, and featured his works on the *entresol* soon after it closed.)

With so few artists participating, Vincent's plan for a joint exhibition, a show of "unity and strength," collapsed. To avoid an outright embarrassment—a comedy of inconsequence in Martin's huge hall—Vincent filled up the show with his own work. He lugged cartload after cartload of paintings from the rue Lepic to the restaurant on the avenue de Clichy a half mile away, virtually emptying his studio. He enlisted Arnold Koning, a young Dutch artist who happened to be visiting the brothers from Holland, to help him hang the fifty to one hundred canvases, almost all of them Vincent's.

Despite the Herculean effort, the exhibition foundered after only a few weeks. As at Le Tambourin, and everywhere else, Vincent fell into a dispute. The proprietor Martin was so eager to fill his bare walls that he began hanging "patriotic shields" alongside Vincent's precious paintings. The ensuing argument escalated until Martin summarily canceled the exhibition and ordered Vincent and his paintings out of the restaurant.

During the brief interval between late November and early December when the strange array of unframed images hung on the walls of Martin's cavernous eatery, hardly a soul noticed them. There was no catalogue, no announcement in the paper, no review. No "public" came. The restaurant's regular patrons "paid more attention to the dish of the day" than to the new décor, one visitor recalled, although some seemed "a little disconcerted by the forbidding aspect of the paintings." A few minor dealers dropped by, either earning or repaying favors. Some of the artists in the Van Gogh brothers' circle (Pissarro, Guillaumin) came; others (Lautrec, Anquetin) apparently stayed away. Surprisingly, Georges Seurat showed up one day and spoke briefly to Vincent.

Among the visitors was another artist whom Vincent had never met. He was a slight, suntanned man, just back from a long voyage to the Caribbean: Paul Gauguin.

BETWEEN PROSELYTIZING for the painters of the Petit Boulevard, strategizing and promoting the brothers' new enterprise, and preparing for the Restaurant du Chalet exhibition, Vincent had little time left for his own work. He later admitted doing only "a little painting" in the last months of 1887. It didn't help that the police had banned him from working in the streets—a consequence, no doubt, of public displays like the one the Pissarros witnessed. The cosmopolites of Paris, no less than the peasants of Nuenen, found his strange habits and vehement displays disruptive.

When he did go to the studio, it was inevitably to enlist his art in the brothers' new shared mission.

While Theo flattered and engaged artists with words, Vincent did the same with images. Driven by his vision of fraternal partnership, the mirage of collegiality, and his own protean imagination, Vincent opened a dialogue of imagery with each of the painters in the brothers' circle. Like an anxious host, he darted from artist to artist, from innovation to innovation, leaving a zigzag trail of images that would defy later efforts to order or categorize them.

For Pissarro, he already had stacks of pointillist works from his trips to Asnières to prove his engagement with Seurat's science of color and light. He answered Lautrec's pastel portrait of him with still lifes—one of a glass of absinthe—done in the same soft palette and feathery strokes. When Anquetin introduced him to the possibilities of monochrome canvases—works dominated by a single color—Vincent responded with a still life of apples all in yellow. When Guillaumin introduced violent colors and brutal contrasts into the argument over the future of Impressionism, Vincent fired back with canvases of blazing color and crashing complementaries. But when Signac returned to Paris in November, Vincent reached out to him with a very different conversation: still lifes of French novels, a motif he had undoubtedly seen in Signac's earlier work, done in the gay tonalities and restless pointillist brush the two had shared in the spring—an image as carefully crafted to please its recipient as Vincent's most polished letter.

Émile Bernard introduced Vincent, in both words and images, to a radically new direction in art. Intent on being a leader, not a follower, Bernard advocated an imagery that would *overturn* Impressionism, not merely "renew" it. Beginning in 1887, he developed a stylized art of flat planes of color and bold outlines arranged to maximum ornamental effect, and compositions reduced to the simplest possible geometries—in short, an art that defied the canons of Impressionism in all its forms, indicting equally the feckless vagaries of Monet and the faux precision of Seurat. Both had failed in art's greatest mission, he argued: to penetrate to the essence of life. Instead, they had rendered reality as insubstantial and meaningless—an evanescent stage effect, not *real* at all.

These ideas belonged originally to Anquetin, a fearless innovator; the imagery, to the reclusive Paul Cézanne. But Bernard advertised them to Vincent in the bold new language of the Symbolists—the language of Huysmans's *À rebours*. An image stripped of its temporal, scientific finery (Bernard called objective truth "an intruder in art"), reduced to color and design, possessed the same mysterious expressive power as pure sensation, he argued. Indeed, it *was* sensation. "What is the point of reproducing the thousand insignificant details that the eye perceives?" one critic summarized the rebellious new art. "One should grasp the essential characteristic and reproduce it—or, rather, *produce* it." (In

March 1888, the same critic coined a name for the new art: "Cloisonnism," invoking the mosaic-like segmented color used on enameled metalware.)

Like the Symbolists, Bernard claimed roots for his imagery in the iconography of the past, citing as precedents everything from medieval tapestries to Gothic stained-glass windows. In particular, he invoked the simplicity and directness of Japanese prints.

These humble, ubiquitous images, imported by the bale for decades, had only recently been swept up into the debate about the future of art. While the exoticism and refinement of Japanese aesthetics had transfixed artists like Whistler and Manet as early as the 1860s, it wasn't until the Exposition Universelle of 1878, with its dazzling Japanese pavilion, that *"japonisme"*—the mania for all things Japanese—began to grip the Paris art world. Stores specializing in Japanese arts opened on the city's most fashionable shopping streets, selling everything from porcelains to samurai swords, but mostly reams of prints. Monet collected both prints and fans, and famously painted his wife in a striking red kimono. Le Chat Noir incorporated the imagery of Japanese prints into its shadow plays, and comprehensive guides, like Louis Gonse's *L'art japonais*, unlocked the mysteries of their meaning. In 1886, only a few months after Vincent's arrival in Paris, a popular magazine, *Paris Illustré*, featured a Japanese print on the cover of a special issue devoted entirely to the art and culture of the floating kingdom.

Symbolists, especially, seized on the colorful, ubiquitous little prints as a model for the new art. Their prismatic color, exaggerated perspective, and stylized iconography represented the elemental expression of a "primitive" culture—that is, one uncorrupted by the bourgeois values and spiritual malaise of fin-de-siècle Europe. (In the same way, the cultures of medieval Europe, ancient Egypt, tribal Africa, and the Pacific islands were all deemed "primitive.") Like the madmen and eccentrics that the Symbolists heroized, these unspoiled cultures, and their creations, had remained closer to the elusive world of essences—the wellspring of all great art.

Vincent may have encountered Japanese art as early as childhood through a seafaring uncle who visited the island soon after it opened to the West and brought home its strange artifacts. Decades later, in The Hague and even in the wilderness of Nuenen, he had felt the rising tide of *japonisme* in the books he read, the prints he collected, and the Salon catalogues he consumed. It wasn't until he arrived in Antwerp in late 1885, however, after reading Edmond de Goncourt's celebration of Japanese art in *Chérie*, that he began to collect the cheap, colorful woodcuts that filled the shops of the maritime city.

They were called *crépons* for the thin, wrinkled paper, like crêpe, on which they were printed. Vincent was drawn especially to images of geishas (as he was to all depictions of pleasuring women) and to busy city scenes: detailed panora-

mas of a distant world that appealed both to his long obsession with perspective and to his natural window-gazing, eavesdropping curiosity. Even then, he saw them mainly as affordable collectibles, decorations for an artist's studio, and, in a pinch, a ready source of cash or exchange. His exhibition at Le Tambourin had been based on the belief—mistaken, it turned out—in the easy redeemability of his *crépon* collection.

It wasn't until late 1887, however, when Bernard introduced him to their symbolist secrets—their expressive code—that Vincent accepted the simple prints as lessons for his own art. Other artistic affinities drew him to this belated embrace. Already in Antwerp he had admired the luminous colors of stained-glass windows as well as the paintings of Henri de Braekeleer, with their patches of pure color and profound simplicity ("hardly anything, and yet a great deal").

But it took Bernard's advocacy to lure Vincent off the trodden path of Impressionism. The younger artist sealed the older's devotion with a claim—improbable but extravagantly flattering—that the Tambourin exhibition had influenced him and Anquetin in formulating their revolutionary imagery. Hungry for validation, especially from the young painter on whom he had set his brotherly eye, Vincent readily accepted Bernard's blandishments and rewarded them with a storm of appreciation for *crépons* as passionate as the one he had shared with Anthon van Rappard for black-and-white prints.

Informed by Gonse's guide and inflamed by a succession of celebratory exhibitions in Paris in the winter of 1887, Vincent descended on the premier retailer of Japanese art in the Western world, the emporium of Siegfried Bing. The store's bronze doors, only a few blocks from Theo's gallery, opened into a world of exotic artifacts and imagery, both Japanese and Chinese, in every medium and at every price: from authentic imperial pieces to reproductions crafted in Bing's own workshops. A combination of Goupil-like ambition and a genuine zeal for Asian art had lofted Bing, a German native, to the zenith of the French decorative arts (a perch from which, a decade later, he would launch the Art Nouveau movement).

With the fervor of a prospector, Vincent sifted through the "heaps" of images stored in Bing's cellar and attic—"ten thousand *crépons*," he exulted—poring over landscapes and figures; dozens of Mount Fujis and hundreds of geishas; pagodas and flowers and samurai fighters. "You're dazzled, there's so much of it," he confessed. He returned again and again, haggling with the manager over prices, offering to swap previous purchases, or even to exchange one of his own paintings for a bundle of the precious tissues. He used his connection to Goupil to persuade the store to give him prints on credit—a license that swelled the "stock" of *crépons* on the rue Lepic to more than a thousand and ran up a peril-

ous debt. He badgered Theo with elaborate plans for marketing the little prints and pleas to invest more in them. He battered other artists, especially Bernard and Anquetin, with exhortations to join him on his treasure hunts, or at least go and learn what wonders could be found in the dusty heaps.

It wasn't long before the fever swept into his studio. In a winter when little else was accomplished there, he spent hour upon hour tracing the exotic new images and transferring them to canvas. It was a madly elaborate process—almost an act of self-mortification for the voluble, impatient Vincent. He had to draw a grid on paper; then trace the little scenes—every blossom, every branch; then draw another, larger grid on the canvas, sometimes twice the size of the original; then transfer the tracing, square by square, line by line, onto the canvas grid.

Once the transfer was complete, however, the ferocity of his zeal could express itself. Seizing Bernard's notions of simplified forms and "plates" of color, he filled the penciled outlines with emerald greens, vivid oranges, and blazing yellows, creating black-bordered jigsaws of luminous color that doubled the originals in both size and intensity. A scene of pedestrians scurrying over a bridge on a gray rainy day was transformed into a bright yellow streak arching across a turquoise river, with a cobalt shore in the distance and a cerulean sky beyond. The gnarled limbs of a plum tree translated into a decorative calligraphy of dark veining set against a sunset reduced to a tricolor flag: green ground, yellow horizon, red sky.

Because his premade stretchers didn't match the elongated proportions of the prints he used, the transfers left borders of canvas beyond the image. Into these slender voids, Vincent poured his newfound fervor for prismatic color and ornamental effect, as well as Blanc's old gospel of complementaries. He painted frames within frames: red within orange, red within green within red again. Borrowing Japanese characters from other prints, he filled these frames with a decorative gibberish of signs, slashing green on orange or red on green, with unmixed paint directly from the tube.

These were rhetorical images: bold, demanding exhortations to the new art, not private meditations on favorite prints. The subjects he chose for this lavish aggrandizement—like the plum orchard and the rainy bridge from the series *One Hundred Famous Views of Edo* by Utagawa Hiroshige—were already-celebrated icons of *japonisme*, images as familiar to many Parisians as Millet's *Sower* or Manet's *Olympia*. He was advertising his allegiance to the new art in the only way he knew how: simultaneously shouting out the new ideas and celebrating his beloved *crépons* with an evangelical ardor; competing with Anquetin for the favor of his new *copain* Bernard; convincing his skeptical brother; and even, perhaps, currying a sale or exchange.

Tracing of the Cover of Paris Illustré, JULY–DECEMBER 1887,
PENCIL AND INK ON TRACING PAPER, 15^1/$_2$ X 10^3/$_8$ IN.,
and *Courtesan: After Eisen*, OCTOBER–NOVEMBER 1887,
OIL ON COTTON, 41^3/$_8$ X 24 IN.

In the last and largest of these polemics in color and form, Vincent looked beyond his collection of prints and chose as his subject the figure on the cover of *Paris Illustré*'s special *japonisme* issue: a sensuous courtesan beckoning all to enjoy the enchantments of her "primitive" island paradise. After transferring the figure to a larger canvas (almost four feet by two feet), he overlaid on this image of exotic allure a kaleidoscope of color. Ignoring the rich, subtle shadings of her dragon kimono, he robed her in jagged volutes of green and asterisks of red. He transformed the stiff folds of embroidered silk into a latticework of thick, crystalline color, much of it directly from the tube. He set the figure in a box of bright, gilded yellow and surrounded it with a broad border decorated with a different image entirely—a riverbank scene distilled to its barest essentials: green and yellow vertical stripes of bamboo, lavender and blue horizontal stripes of water, and, floating in between, pink balls of water lilies.

The so-called *japonaiserie* were not the only hortatory images that winter.

Vincent didn't go to the studio often, but when he did, he went on fire. He returned to a portrait of Tanguy from earlier in the year and began a new version according to the new gospel, rendering the old paint dealer this time as a Buddha in a cobalt-blue coat, set against a studio wall chockablock with *crépons*, each one rendered in faithful, furious abstraction and incandescent color. He revisited another previous portrait, probably of Agostina Segatori, and repainted her in a dazzling Italian costume that, like the geisha's kimono in *Courtesan: After Eisen*, gave free range to his fervor for simplicity, brilliant color, and decorative invention. He reduced everything—the design of her skirt, the folds in her blouse, the rejection on her face—to tesserae of pure pigment. In a thrill of ornamentation, he framed her on two sides with a border of tricolor stripes. He painted still lifes and self-portraits stripped down to no more than three or four colors and countable strokes of the brush.

Vincent couldn't help his vehemence. Every idea he ever seized, he seized to its furthest margin; every enthusiasm, wrung to its extremity. In his effort to capture "a sense of life's intensity," Bernard wrote of Vincent's painting, "he tortures the paint . . . He denies all wisdom, all striving for perfection or harmony." Whether making his arguments in paint or in person, whether at the rue Lepic or in another artist's studio, Vincent had to "tear off his clothes and fall on his knees." "When one has fire within oneself," he wrote his sister Wil at the end of 1887, "one cannot keep bottling [it] up—better to burn than to burst. What is in will out."

If anything, the foothold in reality he had finally gained in Paris—the long-sought joint enterprise with Theo, amity on the rue Lepic, the grudging deference of fellow artists, Bernard's fawning fraternity—only excited him to greater and greater exertions of advocacy, more and more vehement expressions, as if he had finally found the ministry to which he had always felt called.

And then, suddenly, he left.

NO ONE KNOWS why Vincent left Paris in February 1888. The real reasons are hidden, like so much else about his two years in Paris, behind the curtain of silence drawn over the brothers' relationship when cohabitation ended their correspondence in February 1886. When the letters resumed, Vincent claimed "a thousand reasons" for his sudden departure: from the most poetic ("looking for a different light [and] a brighter sky") to the most prosaic ("this terrible winter, which has lasted an eternity").

Sometimes, he laid the blame at the city's feet: the cold, the noise, the "damned foul wine" and "greasy steaks," all made life there "unbearable," he said. He complained about official harassment ("You can't sit down wherever you want") as well as the mist and smog that obscured the true colors of things.

He blamed the Parisians themselves—"changeable and faithless as the sea." In particular, he faulted the fickleness of his fellow artists and attributed his departure to exasperation with their endless rivalries and factional infighting.

At other times, he cast his leaving as an advance, not a retreat: an artistic quest for new subjects that would put "some youth and freshness" into his paintings—or at least give buyers "what they want in pictures nowadays." Or sometimes he explained it as a business venture: a bold sales trip to the provinces in search of unrecognized bargains (in particular, Monticellis in Marseille). Indeed, Vincent portrayed himself in a race with other dealers to be "first on the ground" in Monticelli's Mediterranean homeland.

The cloud of explanations that Vincent offered for his departure—shape-shifting with every gust of enthusiasm or self-justification—only confirms the fundamental inexplicability of it. After years of pining for a perfect union with his brother, after bewailing his loneliness and bitterly demanding companionship from the coal fields of the Borinage or the heaths of Drenthe, Vincent abandoned Theo at the very moment when his dream finally seemed fulfilled— abandoned him and returned to a life of loneliness in a remote, unfamiliar, and friendless region.

Of course, artists often left Paris for extended trips to picturesque, faraway places, in winter as well as summer. Cormon had traveled as far as Africa, as had Maupassant's *Bel-Ami*, Georges Duroy. Monet had profitably spent the fall of 1886 in Belle Île, and, by the time of Vincent's departure in February, had already embarked on a new expedition to Antibes. Bernard fled the city every summer to Normandy or Brittany, as did Signac and Pissarro. Anquetin had spent the previous winter (1886–87) on the Mediterranean coast. Gauguin had bested them all, traveling to Brittany in the summer of 1886, then to Panama the following spring, thence to Martinique for the summer and fall of 1887. The same month Vincent left Paris, Gauguin returned to Brittany, where Bernard planned to join him in April.

But this was different. This was not a fashionable winter flight to sunnier climes like Signac's or Pissarro's. Nor was it Monet's months-long sojourn to picturesque provinces like Normandy or the Riviera. And it certainly wasn't Gauguin's globe-spanning voyage in search of extreme experience and exotic imagery. Unlike Vincent, all these artists returned. Whether they stayed away for two months or six, they always intended to come back to the families, homes, studios, and friends they left behind.

When Vincent left the rue Lepic apartment in February 1888, on the other hand, he moved out "for good," he said. In his letters, at least, he never contemplated returning. Theo's report to their sister Wil soon after Vincent left rings with finality. "It is not easy to replace someone like Vincent," he wrote. "It still seems strange that he has gone." In fact, Vincent's departure was rooted not in

the endless escapades of his fellow painters, but in his own plan the previous April to return to Antwerp, driven from the brothers' apartment by rancor and the threat of exile—a break from which there was no going back.

Did they fight again? Had their joint enterprise once again fallen victim to the resentments that always plagued and often wrecked previous *ententes*? The winter of 1887–88 was filled with invitations to argument, no doubt. Money still flowed only one way on the rue Lepic. While Vincent ran up unseen debts at Bing's and Tanguy's, the entries in Theo's marbleized account book continued to document his total dependence. All his maneuverings and even Theo's Goupil connections had not yet produced a single sale. He had not yet been invited to participate in any of the huge group exhibitions for new art, many of them organized by artists he knew; much less the selective shows mounted by Theo's counterparts at other galleries.

If Theo objected to Vincent exhibiting his work at untraditional venues like Le Tambourin or the Restaurant du Chalet, Vincent undoubtedly lashed back with accusations about Theo's misguided refusal to make the *entresol* available for fear of "compromising" himself. Other artists could enjoy the privilege of Goupil's imprimatur, but not his brother? Even Paul Gauguin, a newcomer to the *frères* Van Gogh circle in December, earned a coveted place on the mezzanine only a few weeks after meeting Theo. Meanwhile, Vincent was left to display several of his unframed pictures in the foyer of a new experimental theater in a hodgepodge display promoted as "decorating with chic."

Through it all, however, the bonds of brotherhood held fast. If anything, the summer brought them even closer together as they plunged, hand in hand, into the bohemian demimonde of Paris. Haunted alternately by the prospect of early death and the fear of lifelong loneliness, they embraced the *nostalgie de la boue* (nostalgia for sordidness), the hallmark of avant-garde social life. From the cheap taverns of Montmartre to the sexual tourism of the Moulin de la Galette (succeeded the next year by the Moulin Rouge), the city offered endless opportunities to indulge the slumming appetites the brothers had always shared.

Vincent set the pace in drinking: absinthe in the afternoon, wine with dinner, free beer at the cabaret, and his personal favorite, cognac, anytime. He used its sweet "stupefaction" to treat his inevitable winter depression, arguing that it "stimulated blood circulation"—increasingly important as the weather turned bitter cold. By the time he left Paris, he later admitted, he was well on the road to being a "drunkard" and an "alcoholic."

As for the pleasures of whores and the dangers of syphilis, Vincent offered another license: "Once you've caught it," he said blithely, "you'll never catch it again." He effected the *fumistes'* fashionable "disdain for everything"—exactly the kind of soulless self-amusement that Pastor Dorus had so often deplored. "Enjoy yourself too much rather than too little," he advised his sister Wil that

winter, "and don't take art or love too seriously." Andries Bonger accused Vincent of *"Weltverachtung"*—"a morbid contempt of the world." Second-guessing his doctors, Vincent resisted Rivet's prescription of potassium iodide (the preferred treatment for tertiary syphilis) and urged Theo to do likewise. They both scoffed at Rivet's counsel of "sobriety and continence" as well as Gruby's more direct admonition: *"no* women."

Far from discouraging his brother's excesses, as in the past, Theo eagerly mimicked them. Freed temporarily from his fantasy of middle-class married life and lured by his new role as avant-garde tastemaker (a friend described him as "completely caught up in the bohemia of the young painters"), Theo threw off a lifetime of dutiful inhibitions and paternal warnings. He openly repudiated his former ambition to "work hard" and "get ahead." Dutch friends like Bonger, still on course to be married in March, recoiled in disappointment and sadness. "[Theo] is ruining his health," he reported, "and has adopted the kind of extreme lifestyle he is bound to regret later on." When the news reached Jo in Amsterdam, she despaired for Theo's fate and worried to her diary: "If I only knew whether I did the right thing!"

By the time Vincent departed, the brothers had achieved a euphoria of unity unseen since the Zundert parsonage. They celebrated the nostalgic rituals of Christmas together, and Vincent welcomed the new year with a big self-portrait: a bold assertion of his new life as a *frère* Van Gogh, complete with all the accoutrements of an avant-garde artist, confidently detailed down to the stained-glass mosaic of paint on his palette.

He described his last days with Theo in Paris as "unforgettable," and left the rue Lepic on February 19 not in anger or defeat, but in sadness. The day before, he hung some of his beloved *crépons* around the apartment "so that my brother will feel that I am still with him," he told Bernard. On the way to the train station, the brothers paid a visit to the studio of the remote *célèbre* Georges Seurat—an affirmation of their "joint enterprise" even as it uncoupled. Despondent after their parting, Theo wrote Wil: "When [Vincent] came here two years ago I had not expected that we would become so much attached to each other, for now that I am alone in the apartment there is a decided emptiness about me. . . . He has lately meant so much to me."

Only one force could have sundered this perfect union. Vincent would never have let go at his brother's demand—as Theo knew well—nor could any improvement in climate or scenery have pried him away from such a consummation of longing; he cared too little for comfort, or even for his own health. But Theo's health was a different matter. By February 1888, the afflictions of the previous winter had returned with a vengeance: frozen joints, disfiguring swelling, inexplicable exhaustion. The progressions of Theo's disease, the waves of relapsing symptoms and torments of treatment, were inexorable. But to Vin-

cent, and probably Theo, too, they seemed to come as punishment. In his later reports, Vincent blamed his brother's misery on *"notre névrose"* ("our neurosis") and claimed a shared fraternal destiny of illness and degeneration. Relentlessly romantic, he imagined that Theo suffered a *"maladie de coeur"* over the loss of Jo Bonger, just as he himself had suffered over Kee Vos.

But the ghost of the dead parson pointed the finger of blame in a different direction. It was Vincent's reckless pursuit of pleasure, his heedless surrender to temptation, and his encouragements for Theo to follow that had wreaked havoc on Theo's fragile constitution. He was killing his brother—just as he had killed his father.

The previous winter, at the lowest point in their relationship, Theo had told Vincent, "I only ask one thing: do me no harm." In a letter to Wil, Vincent explained his departure from Paris this way: "I thought I should do nobody harm if I went someplace." Isn't that what Gianni Zemganno did when his unthinking encouragements resulted in the terrible fall that brought his younger brother Nello to the edge of death? Like Gianni, who renounced the life of an acrobat and abandoned their high-flying partnership rather than bring his brother to ruin, Vincent left Theo for his own good, as a final act of brotherhood. It was the first in a succession of "withdrawals" (his word)—from Paris, from Arles, from life—that Vincent hoped might save his ailing brother. "If I come to grief myself in the attempt," he wrote after he left, specifically citing the Zemganno brothers' story as a warning, "it will hurt only me."

Two years later, only months before his death and with the clarity of madness, Vincent admitted the truth about his leaving:

> After Father was no more and I came to Theo in Paris, then he became so attached to me that I understood how much he had loved Father. . . . It is a good thing that I did not stay in Paris, for we, he and I, would have become too close.

A Mercenary Frenzy

~

W HY DID VINCENT CHOOSE TO BEGIN HIS SELF-IMPOSED EXILE FROM Paris in Arles, an ancient Provençal town of twenty thousand people twenty miles from the Mediterranean Sea? If he had come to the legendary South of France—the Midi—in search of warmer weather, surely he would have stayed on the train and continued farther south. (He had considered traveling as far as Tangier.) Instead, he stepped off into snow deep enough to cover his shoes, and trudged through the coldest winter in Arles in a decade, searching for a room to rent.

If he had come looking for the "brilliant Midi light" promised by Lautrec and Signac, he wouldn't have picked as the subject of his first painting a butcher shop on an Arles side street—a sunless, skyless urban vignette that he could have found anywhere in Montmartre. If he had come just for the women—the beautiful "Arlésiennes" celebrated in the writings of Michelet and Multatuli and everywhere in popular entertainments—he would have moved on to Marseille, only fifty miles farther down the track: the kind of raucous port town, like Antwerp, where women of every kind were always available.

Instead, he went straight to work. Neither the bitter cold nor the wild mistral wind could deter him from his interrupted task. By leaving Paris, Vincent had let go of his brother, but not his vision of *les frères* Van Gogh. If anything, the distance he put between them only intensified his devotion to the joint enterprise begun on the *entresol* and the rue Lepic. "I ask nothing more," he wrote Theo soon after arriving in Arles, "than that the business you began in the shop on the boulevard should go on and increase in importance." This task required no sun or sky, only paper and pen.

No sooner had he secured a room above the Restaurant Carrel than he launched a campaign of solidarity as furious as the wind that whistled at his

window. Writing in French—the language not just of art, but of commerce—he bombarded his brother with advice on their budding venture. In arguments alternately vehement and cynical, he deplored the soullessness of competing dealers and offered elaborate, Machiavellian plots to best them. He coached the young *gérant* in the minutest details of buying and selling, lecturing him on the fickleness of public tastes and urging him to stealth and ruthlessness in the search for competitive advantage.

Casting himself as Theo's *conseilleur extraordinaire*, he speculated on the effects of current events, like Kaiser Wilhelm's death, on the art market. He advised that the war with Germany that France's belligerent General Boulanger seemed bent on "might have a favorable influence on the picture trade." He borrowed the bellicose talk filling the papers and cafés to rally Theo to their shared mission. Other dealers "will steal a march on you," he warned, as he introduced his "plan of attack" and vowed to "return to the charge," assuring his brother of ultimate "victory."

Only hours after arriving, he struck out through the snow in search of "bargains" for the *entresol*, especially paintings by the brothers' favorite, Adolphe Monticelli. He pledged to make a trip to Marseille, Monticelli's hometown, to plant the Van Gogh flag before others could beat them to it. He reveled in news that Theo's old colleague Alexander Reid resented Vincent's preemptive strike in the Midi, and gloated that Reid's enthusiasm for Monticelli had driven up the prices of the five paintings Theo already owned. To help him capitalize on that windfall, Vincent vehemently pressed John Peter Russell, his former Cormon classmate, to buy a Monticelli from Theo. He compared the recently deceased artist to no less a figure than Delacroix, the giant of color. "[He] gives us something passionate and eternal," Vincent wrote Russell, promoting both the Marseille painter and himself, "the rich color and rich sun of the glorious South."

In addition to long, fawning letters to Russell, he sent salvos of advice and encouragement to "comrades" in the *frères* Van Gogh circle, especially Émile Bernard. He kept them closely informed of Theo's sales of Monet's works on the *entresol*, hinting that he could do the same for them. He used the promise of Theo's favor to solicit exchanges for his own works according to elaborate calculations of relative value and strategic placement. When he wrote his other Cormon classmate, Lautrec, he enclosed the missive in an envelope to Theo and asked him to hand-deliver it—a tactic that put the stamp of the Goupil *gérant* on every letter he sent. He also wrote to the brothers' young Dutch friend, Arnold Koning, exhorting him to "tell those fellows in Holland about what you've seen in Paris." Even in letters to his sister Wil, he reflexively flogged the brothers' joint venture. "Theo is doing his best for all the impressionists," he wrote. "He is quite different from the other dealers, who do not care the least bit about the painters."

Vincent's new mercantile zeal carried his thoughts inexorably to The Hague and the little back office of H. G. Tersteeg, scene of so many previous humiliations. In the chilly isolation of his hotel room, the prospect of reversing the judgments of the past once again seized his imagination. In a fever of enthusiasm, he imagined enlisting his former nemesis in a three-pronged "offensive" to extend the brothers' new business across the entire continent. With Tersteeg's help, he and Theo could organize a network of sympathetic dealers—dealers who "have the artist's interests at heart"—in England, Holland, and France. Tersteeg would introduce the painters of the Petit Boulevard in London and The Hague, Theo would showcase them on the *entresol,* and Vincent himself would push on to Marseille and "get hold of a window to show the impressionists."

Painters of all kinds would rally to this enlightened venture, Vincent imagined, merging his bold new entrepreneurial project with his old dream of a "combination" of artists. Out of "moral obligation," established painters of the Grand Boulevard, such as Degas and Renoir, would contribute paintings to their joint initiative, providing a stock of salable works that could be used to support the "lesser impressionists"—a term he now applied to himself and all the artists who aspired to the *entresol.* He imagined, for instance, that Georges Seurat would contribute three paintings: one for each of the three new permanent exhibition sites he planned in Paris, London, and Marseille.

But everything depended, as it always did, on the approval of the implacable *gérant* on the Plaats. "Tersteeg must be in it," he insisted. Tersteeg could act as a powerful ally in selling the new art in Holland and England, and his reputation would attract others to the brothers' cause. Vincent drafted a letter to his former boss and laid out his sweeping fantasy, including detailed advice on how to outmaneuver Reid in the English market and bold predictions of commercial success. "[You] could easily dispose of fifty or so [pictures] for us in Holland," he wrote, "in view of the low prices compared with the interest the pictures offer." He sent Theo the letter with instructions to add his own encouragements before passing it along. When he learned that Tersteeg would soon visit Paris, he urged Theo to press the plan by arranging a "grand tour" of the artists' studios, where Tersteeg would "see for himself that next year people will start talking, and will go on talking about the new school."

After sending his letter, Vincent sat in his freezing hotel room boiling with anticipation. "Has that confounded Tersteeg written you yet?" he demanded of Theo after only a few days. When two weeks went by without a word, he began plotting an elaborate scheme to force the wily *gérant's* hand. "If he doesn't answer," Vincent vowed darkly, "he will hear of us all the same." He convinced himself that Tersteeg could be won to their cause if he saw one of Vincent's paintings. To that end, he proposed dedicating a picture to Anton Mauve, who had died recently, and giving it to Mauve's widow Jet, Vincent's cousin. Not only

would Mauve's dear friend Tersteeg be likely to see the painting, but the gift would also give the brothers an opening to complain about Tersteeg's inaction. "We do not deserve to be treated as if we were dead," he grumbled.

Finally, after three weeks of waiting, Theo received a letter from Tersteeg, but it made no mention of Vincent, his letter, or his art. Biting his lip against the injuries of the past, Vincent brushed off the rebuff. "You'll see that he'll write me a line as soon as he has seen what I've done," he assured Theo. Reaffirming his vision of ultimate victory, he urged Theo to send Tersteeg one of his Paris paintings—a study from the previous spring in Asnières—and promised better to come. "We must get our place in the sun," he rallied his brother. "When I think of that, I get into a mercenary frenzy."

In March, when the snow melted and the trees began to bud, that frenzy burst onto canvas.

THEO HAD REIGNITED Vincent's commercial ambition in late February with an offer to submit some of his paintings to the fourth annual Salon des Indépendants, a premier showcase for avant-garde art. Coming so soon after the brothers' abrupt parting, the offer may have been prompted by guilt, or gratitude, or both. Theo may have hoped to make amends for not including any of Vincent's work in the show he mounted on the *entresol* in December and January—a show that included fellow Petit Boulevard painters like Pissarro and Guillaumin, as well as Gauguin, a newcomer to the brothers' circle.

He followed through on his offer not only by carefully selecting the paintings to be submitted, but also by showing Vincent's work—discreetly—to select customers in his gallery. One visitor to the *entresol* around this time recalled Theo "telling us that he had a brother who was a painter and who lived in the country. . . . He brought some unframed pictures from another room [and] stood modestly aside, observing the effect these canvases made on us." Such efforts were already promising fruit. A few months later, Theo received a note from a collector who had been to Tanguy's shop and wanted to see more of Vincent's paintings—perhaps even to buy one or two of them. He knew so little about this new artist that he referred to him in his note to Theo as "your brother-in-law."

Chasing this latest hope of success, Vincent had rushed into the blanched landscape even before the snow melted, in search of imagery. But "the gray days offer him little subject matter," Theo reported to Wil, and "the cold makes him sick." When he did find something to paint—a muddy, rutted road, or the Arles skyline from a distance—he reverted to the cool colors and stippled strokes of Signac and Seurat. At almost the same time, Theo made overtures in Paris to the same two artists. In March, he paid a visit to Signac's home, and later the same month, he purchased a Seurat painting. "I congratulate you," Vincent wrote

when he heard of the purchase; "with what I shall send you, you must try to arrange an exchange with Seurat as well."

But the real star of the *entresol* that winter and spring was Claude Monet. Boussod, Valadon & Cie had already begun to profit lavishly from their huge investment in Monet's series of rocky seascapes from Belle-Île the previous year. That success emboldened Theo to pursue further opportunities with the artist, who had gone for the winter to Antibes, on the Côte d'Azur near Nice, about a hundred miles east of Arles. From there, Monet sent reports of his work on a series of views of the Mediterranean coast, with its wind-twisted trees and shimmering sea. By March, Theo was already laying the groundwork for a large-scale purchase of the Antibes paintings and a solo exhibition on the *entresol* in June, the artist's first in a decade. Theo's anticipation of this show, his admiration for Monet's shrewd choice of subjects, and reports of their commercial success undoubtedly reached Vincent.

Long held at bay by snow and record-setting cold, spring came to Arles in a great rush that year. Color swept across the countryside in a wave of blooming. Orchards of apple, pear, peach, and plum trees exploded almost simultaneously into flower. A tide of buttercups and daisies spilled over the meadows. Hedgerows sprouted roses and roadsides, irises. It was a spring like none Vincent had ever seen—a sudden spectacle of fecundity compared to the parsonage garden's slow slip from winter's grip.

In this bounty of imagery, Vincent saw possibilities for paintings everywhere. The receding rows and endless variety of fruiting trees offered a perfect opportunity for the kind of signature series that had proved such a success for Monet. Every day that the changeable weather allowed, he carried his heavy load of equipment down the tree-lined road that led out of town into the flat, surrounding fields. With a discipline and deliberateness exceptional even for the methodical Vincent, he set his easel in front of every kind of fruit tree he could find, as if embarking on a horticultural survey of Provence. He painted the willowy apricot trees with their sprinkling of tiny pink blossoms, the wiry, blushing plum trees, and the stately pears with their clouds of yellow-white flowers. He painted apple and peach trees in their vast outdoor enclosures of cane fencing and tall cypresses—protection from the brutal mistral. He painted the densely flowered cherry and the elegantly spare almond.

To capture this catalogue of fruiting trees, Vincent mustered a catalogue of painting styles. All of the fierce "isms" circulating in Paris made an appearance in the orchards of Arles. In addition to the feathery impressionism of Monet and acolytes like Guillaumin, he employed the thin, chalky paint and moody tonalities of his Cormon classmate John Peter Russell. Russell had painted a series of orchard scenes on a trip to Sicily the previous year, and Vincent invoked that commonality to lure the rich Australian to the brothers' venture. "[I] am work-

ing at a series of blooming orchards," he wrote Russell in April, "and involuntarily I thought often of you because you did the same in Sicily. Some day I shall send some work to Paris and I hope you might exchange a Sicilian study with me." Nothing could have been further from Russell's Whistlerian tone poems, however, than the fevered dots and dashes that Vincent applied to a stand of peach trees that same month. Following the procedure (if not the theory) of Signac, Pissarro, and other devotees of Seurat's scientific color, he peppered the sky with blue and the trees with tiny pink blossoms.

For Bernard, Vincent painted the orchards as stained-glass windows—mosaics of pure color and dark outline—and dutifully documented his adherence to the Japonist gospel of primitive simplicity, recently dubbed "Cloisonnism," with elaborate descriptions and explanatory illustrations. "Here is another orchard," he wrote in April in a letter that included an outline sketch with color designations. "The composition is rather simple: a white tree, a small green tree, a square patch of green, lilac soil, an orange roof, a large blue sky." He accompanied these descriptions with earnest manifestos, pledging his allegiance to Bernard's revolt against Impressionist dogma:

> My brush stroke has no system at all. I hit the canvas with irregular touches of the brush, which I leave as they are. Patches of thickly laid-on color, spots of canvas left uncovered, here or there portions that are left absolutely unfinished, repetitions, savageries; in short, I am inclined to think that the result is so disquieting and irritating as to be a godsend to those people who have preconceived ideas about technique.

But no matter how loudly Vincent protested his shared bravado to the young rebel Bernard, he still cared dearly about the opinions of "those people who have preconceived ideas about technique"—one of them in particular. His letters to Theo that spring brimmed with arguments for the salability of his orchard paintings and affirmations of his intent to please. "You know this kind of subject delights everybody," he wrote. He imagined that his sunny orchards would "really break the ice in Holland" and finally win over the recalcitrant Tersteeg. He made repeated claims for their "enormous gaiety"—a code for all the changes in his art that Theo had urged for years. He traced his paintings' lineage to *entresol* bestsellers like Monticelli and Impressionist luminaries like Renoir in support of their colorful palette and commercial appeal.

To bolster his argument, he laid plans for an ambitious "scheme of decoration" to rival Monet's series of images from Belle-Île and the vast canvases of Seurat that the brothers had seen in the artist's studio in February. Vincent would paint not just individual images of orchards, but groups of related images. Calling upon a lifetime of cataloguing and ordering, he imagined creating

a series of triptychs: threesomes of "matching" orchard views, each consisting of one vertical image between two horizontal images, a scheme he illustrated in a letter to Theo.

Convinced that these groupings would prove more decorative and therefore more salable, he began "touching up" the paintings he had already done in order to "give them a certain unity," and laying plans for "a final scheme of decoration a great deal bigger": a series of nine canvases organized in threes. Under the spell of yet another vision of success, Vincent made extravagant promises to his partner in Paris. "Take these three for your own collection," he urged Theo concerning one of his triptychs, "and do not sell them, for they will each be worth 500 later on." "If we had fifty like these put aside," he wrote, the numbers inflating as his hopes spiraled upward, "then I should breathe more freely."

But his illusions were short-lived. No sooner had the last petals from the fruit trees fallen to the ground, idling his brush, than the demons of the past rushed into the void. Unrejuvenated by the southern clime, his health continued to deteriorate. Stomach disorders, fevers, and general weakness plagued him. Between mouth sores, toothaches, and digestive problems, he found eating "a real ordeal," he admitted, and he flirted yet again with self-starvation. He complained of absentmindedness and spells of mental fogginess that sent sparks of panic through his letters as he contemplated the fates of other painters, like De Braekeleer and Monticelli, reduced to "hopeless wrecks" by "diseases of the brain"—a code for the brothers' shared affliction, syphilis.

At first, he blamed the persistence of these "curses" on the "damnable winter" and the bad wine in Paris. When spring finally arrived, he had cut back on tobacco and alcohol, convinced that his blood no longer needed "stimulants" in the heady Mediterranean air. But that had produced disastrous results. "When I stopped drinking and smoking so much," he wrote, "I began to *think* again instead of trying not to think. Good Lord, the depression and the prostration of it!" For a while, he took to his bed over the Restaurant Carrel and demanded better food and, especially, better wine. "I was so exhausted and so ill," he wrote, "that I did not feel strong enough to live alone."

He missed Theo. Almost from the moment he stepped onto the train in Paris, he regretted leaving his brother, and consoled himself with visions of their happy reunion. "During my journey I thought of you at least as much as I did of the new country I was seeing," he wrote Theo the day after his arrival in Arles. "Only I said to myself that perhaps later on you will often be coming here yourself." Even as the snow fell outside the door of his hotel, he advertised Provence, as he had Drenthe, as the perfect place for a busy *gérant* to "recuperate and get one's tranquility and poise back." Once the snow cleared, the thrill of spring and his frenzy of work kept the emptiness at bay. But as soon as the blossoms began

to disappear, it returned. "Oh! It seems to me more and more that people are the root of everything," he wrote longingly in April. A month later, he added: "The appearance of things has changed and become much harsher."

As always, he sought solace in his imagination, taking up Guy de Maupassant's *Pierre et Jean*, the story of two half brothers. But if he was looking for the "lightheartedness" he so much admired in Maupassant, the author of his only laughter in Paris, or for the touching fraternity of *The Zemganno Brothers*, he must have been confounded by *Pierre et Jean*'s dark tone and unhappy ending. He did find consolation, however, in the book's preface, where Maupassant laid out a theory of art that defended Vincent's new exile as ringingly as Zola had defended the last one. In describing his artistic ideal, Maupassant claimed for every artist a right—indeed, a mandate—to see the world his own way: to create a personal "illusion of the world . . . according to his own nature," and then to "impose [his] particular illusion upon humanity." Vincent described Maupassant's ideas to his distant brother ("He explains the artist's liberty to exaggerate, to create in his novel a world more beautiful, more simple, more consoling than ours"), and then used those ideas to draw Theo, and all his former circle, into his own "illusion of the world"—a more consoling world of shared insurgency, shared sacrifice, and, most important, shared isolation. "You feel that you're alive when you remember that you have friends who are outside real life as much as you," he wrote.

Throughout the spring, he denied the reality of his solitude by clinging to this ghost of brotherhood and belonging on the rue Lepic. Less than a month after arriving, in a rare unguarded moment, he gave the illusion away. "I would rather fool myself than feel alone," he admitted. "I think I should feel depressed if I did not fool myself about everything."

CAUGHT UP IN his mercenary zeal and bound in every thought to his former home, Vincent closed himself off to the new one. He wrote almost nothing about the city of Arles, or its inhabitants, in his first months there. When the weather permitted, he plodded directly into the countryside from his hotel near the train station. Other days, he holed up in the Restaurant Carrel, or took his meals in his room. He made a few trips to the city's bullfighting arena (where he reported seeing "a toreador crush a testicle jumping the barricade") and, of course, he visited the local brothels (conveniently located just a block from his hotel). But even on these rare excursions, the brothers' enterprise on the *entresol* guided his eye. The injured toreador, "dressed in sky blue and gold," reminded him of a figure out of "our Monticelli"; and his description of one brothel offered up exactly the gay avant-garde palette that he had promised to find in the Midi:

Fifty or more military men in red and civilians in black their faces a magnificent yellow or orange (what hues there are in the faces here), the women in sky blue, in vermilion, as unqualified and garish as possible. The whole in a yellow light.

Too tied to the city he left behind, Vincent never registered the extraordinary city to which he had come. Continuously occupied since before the time of Alexander the Great, Arles had felt the footsteps of all the great civilizations whose progress Vincent had limned a hundred times in his studies and on his maps: Greek settlers, Phoenician traders, Roman legionnaires, Visigoth invaders, Byzantine governors, Saracen conquerors, Crusader armies. The Carthaginian Hannibal could spy Arles from the heights of the Alpilles, a rocky spur of the Alps less than ten miles to the north. The great Julius Caesar had rededicated Arles as "the Rome of Gaul" in 46 b.c. Not long afterward, according to legend, a group of Jesus' family and friends had sailed from Judea to escape the turmoil following his crucifixion, and landed miraculously on the coast nearby.

All of these, and many more, had left their marks on the city's narrow streets. The Romans, in particular, had bequeathed a legacy in stone. The huge bullfighting arena where Vincent admired "the great colorful multitudes piled up one above the other on two or three galleries" had been built in the first century a.d. by the emperor Vespasian. Nearby, the plundered remains of a Roman theater cast a looming shadow of history over the warren of medieval streets where Vincent single-mindedly trooped to work, passing tourists, like Henry James, who came from worlds away to see "the most charming and touching ruins I had ever beheld."

If Vincent had not been so preoccupied, he might also have seen in Arles's history just the kind of metaphor he found so consoling. For millennia, Arles had controlled the strategic junction of the Rhône River and the Mediterranean Sea. A virtual island, surrounded by water and marshland on every side, it sat at the apex of the river's vast, triangular delta, straddling the gateway to one of Europe's richest regions. But centuries of silt had clogged the estuary channels and filled in the marshes, pushing the sea southward, beyond the horizon. Deprived of its port, Arles had become a city stranded in place and time. Now, instead of overlooking busy quays and sparkling water, the old stones kept watch over a broad, lazy river and a vista of waving sea grass and wild horses.

But Vincent saw only decay. "This is a filthy town," he wrote Theo. "Everything has a blighted, faded quality about it now."

His disdain for the town extended to its citizenry. As on all his forays into the country, Vincent found the natives of Provence as strange and unapproachable as they found him. "[They] all seem to me to be creatures from another world," he reported a month after his arrival. Like the coal-mining Borins, the

Arlesians spoke a patois almost unintelligible to Vincent's ear, honed for two years on Parisian French. Their medieval customs, mystical Catholicism, and deep superstitions were objects of ridicule even among their own countrymen. By 1872, when Alphonse Daudet published the first in a series of comic novels about a hapless, blowhard Provençal named Tartarin from Tarascon, a real town only ten miles from Arles, the natives of Provence had become a national joke, mocked everywhere for their buffoonery and braggadocio.

Just as he had relied on a guidebook to learn about the Borins, Vincent took Daudet's caricature as a textbook on the "simple and artless folk" of Arles. He seemed both bemused and disconcerted that his only source for painting supplies was an amateur artist who doubled as the local grocer (who had access to an ample supply of egg yolks for sizing the canvas he sold). After a visit to the city's museum, Vincent assumed the airs of a condescending Parisian, dismissing it as "a horror and a humbug [that] ought to be in Tarascon."

The locals sensed his contempt and returned it. They recalled him as *"méfiant"* (mistrustful) and *"frileux"* (aloof). One of the townspeople later remembered that Vincent "always looked as if he were rushing away, without deigning to look at anyone." Like the miners of the Borinage and the peasants of Nuenen, they deplored his strange manner and bizarre dress. An eyewitness recalled Vincent years later as *"vraiment la laideur personnifiée"*—truly ugliness personified. As in those other places, he attracted the unwanted attentions of teenagers who "shouted abuse at [him] when he went past," one of them recounted, "[with] his pipe between his teeth, his big body a bit hunched, a mad look in his eye." In a sad confession, Vincent acknowledged his latest failure to find a home. "Up to the present I haven't made the least progress in people's affection," he wrote that summer. "Often whole days pass without my speaking to anyone, except to ask for dinner or coffee. And it has been like that from the beginning."

Vincent did, however, occasionally see other artists working in the area. Christian Mourier-Petersen, a twenty-nine-year-old Dane living outside Arles, was the next in a succession of younger artists whom Vincent attempted to tyrannize with instruction. "His work is dry, correct, and timid," he reported to Theo. "I talked to him a lot about the impressionists." As always, Vincent sent glowing accounts of social evenings and painting excursions with his pedigreed young companion. But after Mourier-Petersen left in May, Vincent's happy account dissolved into the usual wounded recriminations ("that idiot"), elliptical confessions of discord, and belated complaints about his student's resistance to reason.

Just as Mourier-Petersen was leaving, Vincent made the acquaintance of Dodge MacKnight, a twenty-seven-year-old American artist who had rented a studio in the nearby village of Fontvielle. Vincent never liked Americans, whom he considered boorish, and MacKnight confirmed his bias at their first encoun-

ter. "As an art critic, his views are so narrow that they make me smile," Vincent summed up their conversation. Only because MacKnight was a friend of John Peter Russell—the object of Vincent's commercial ambitions—did he hold his fire, putting off the inevitable dénouement at least for a few months.

The combination of unrequited longing for Theo and unrelieved loneliness triggered a wave of nostalgia. Vincent was often gripped by debilitating seizures of memory and remorse, especially when prevented from working by lack of materials or subjects. As the color drained from the orchards, he complained of "inward suffering" and vowed, "I must go and look for a new subject." Remembrances of things past rushed into the void, flooding his thoughts, his letters, his pen, and his brush.

The countryside around Arles was filled with reminders of his childhood and homeland: from the network of canals that crisscrossed the marshy boglands, to the mills that drained them. Tree-lined roads vanished at the horizon and grasslands stretched heathlike to the sea. Even the sky, arching over the chessboard of groves, grazing pastures, and stubbled fields, evoked the great Golden Age vistas of Ruisdael and Philips Koninck. But whether on the delta of the Rhône or the banks of the Thames, Vincent's imagination needed no prompting to drift back to the past. Indeed, like London, Provence reminded him of Holland both in its differences and its similarities. That they followed the same cycle of seasons,

The Road to Tarascon, JULY 1888, PENCIL AND INK ON PAPER, 9⁷/₈ X 13¹/₄ IN.

or fell under the same sun, was enough to return him to the plain of the Maas. "I keep thinking of Holland," he wrote, "and across the twofold remoteness of distance and time gone by, these memories have a kind of heartbreak in them."

In April, in a startling reversal, he set aside his paint box and took up his pencil and pen—the first instruments of his art—as if the years in Paris had never happened. He sent Theo two drawings made according to "a method that I had already tried in Holland some time ago," he announced. Instead of seeing the stony ruins all around him, or the rocky Alpine heights nearby, his eye lighted on scenes he had seen or drawn a hundred times: a pair of pollard willows, a lone farmhouse standing sentry in a wheat field, a single traveler on a tree-lined road to infinity. Toting his heavy perspective frame through the strange but familiar landscape, he made elaborate drawings, then took them back to his room for his pen to obsess over.

He used the sturdy reeds that he found growing wild on canal banks and roadsides. Cutting their tips at an angle "the way you would a goose quill," he deployed an astonishing variety of marks—hatchings, dots, and dashes, thin brushlike washes and stark black outlines—closely observing every idiosyncrasy of limb and leaf. In some images he raised the horizon almost to the top of the paper, focusing his gaze not on the Mediterranean sky but on the minute changes in grassy textures of an untended meadow. These were the images that he and Rappard had drawn together on the banks of the Passievaart swamp near Etten; the images that Theo had favored over Vincent's endless weavers and peasants; the images that had nursed his mother back to health in Nuenen. And they were the only images about which his unforgiving father had ever said a kind word.

Vincent returned again and again to one of these in particular.

In March, in his earliest wanderings around the countryside after the snow melted, he had come upon a familiar sight: a drawbridge. Constructed of huge timbers bleached as white as bone by the relentless sun, it spanned the canal connecting the Rhône to the port of Bouc, about thirty miles southeast of Arles. Vincent had seen similar skeletal contraptions everywhere in cities and towns in the watery matrix of his homeland. Indeed, the dozen or more bridges along the length of the same canal had been built by Dutch engineers to Dutch specifications. Known technically as a double-leaf bascule bridge (after the French *bascule*, for seesaw), it operated as simply as a child's toy. The timbered trusses, like gateways, on either side of the canal, supported frameworks of heavy beams connected by chains to the roadway "leaves" at one end, and laden with counterweights at the other. So precisely were these weights balanced that a casual heave could throw the whole great lumbered mechanism into motion, opening the way for boats to pass. With a loud creak like a ship docking, the road would split in the middle and rise to perpendicular on each bank, as the long counterweighted arms descended to the ground.

The Réginelle Bridge, spanning the road south from Arles to Port St. Louis on the coast, attracted him especially, even though getting to it from the Hotel Carrel, on the north side of the city, took some effort. He had first stumbled on the bridge in mid-March, just as the weather warmed enough for local women to start washing their clothes on the weedy canal bank nearby. The scene sent Vincent's imagination drifting backward. Not just the bridge, but the laboring figures echoed the art of his past—before Paris. The wild reeds and neglected waterline evoked the fields and ponds of Nuenen, not the playgrounds of Asnières. Against a bright blue sky, he rendered the bridge and its stone abutments in broken tones of tan and ocher that harked back to the parsonage garden and his father's Bible. The bridge itself he painted not in the bold color slashes of the *japonaiserie,* but in the painstaking detail of the weavers' looms. Using his cumbersome perspective frame for the first time since Paris, he recorded every complication of its workings: the reinforced pivots, the ropes and pulleys, the squiggles of draw-chains. Thrust upward on its massive abutments, high above the desiccated canal bank, the jostling peasant women, and the sweep of agitated water, it looms over the familiar landscape as indelibly as the tower over the churchyard where his father was buried.

For the next month, despite the onerous trek, Vincent returned again and again to this landmark of memory, bearing his perspective frame and his draftsman's pencil. He drew it from both sides of the canal: from the north bank, in front of the house of the *pontier* (bridgekeeper) Langlois, after whom the locals called the bridge; and from the steeper south bank, where the towpath hugged the waterline. He drew it from the west, looking toward the sea, and from the east, against the sunset; from the side, and from straight on, in dramatic foreshortening. With pencil and ruler, he labored like a schoolboy over precise renderings of the bridge's mechanism. He sent a bold sketch of it to Bernard, along with a description that hints at the long hours he spent lingering in its shadow. He described the "sailors with their sweethearts going up to the town . . . profiled against the strange silhouette of the drawbridge."

With every visit, every view, the past loomed larger and larger in his thoughts as well as on his easel. By the end of March, it took only a newspaper obituary of Mauve, enclosed in a letter from his sister Wil, to trigger tears of guilt and regret. "Something—I don't know what—took hold of me," Vincent reported, "and brought a lump to my throat." He had known of his cousin's death for two months. Only a month before, he had coldly calculated sending Mauve's grieving widow a painting in order to secure Tersteeg's attention. But weeks of loneliness and obsessing over the bridge had reopened all the old wounds. Theo's plan to visit their mother and sisters in Holland on the eve of his thirty-first birthday in May unleashed yet another wave of corrosive memories. Reverting

to the oldest family ritual, Vincent painted a birthday present: an orchard done in "a frenzy of impastos"; and achingly pictured his brother in Holland "seeing the same trees in flower on that very day."

Vincent fought the flood of reflection with a desperate new plan for vindication. Staring at the paintings and drawings that filled his little hotel room, he

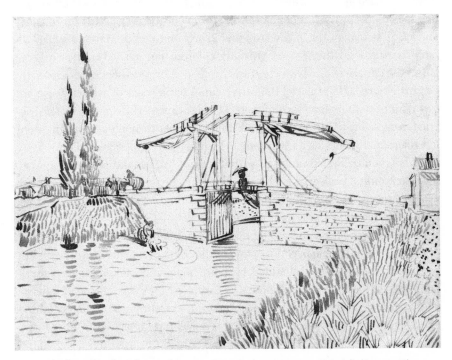

Drawbridge with Lady with Parasol, MAY 1888, INK AND CHALK ON PAPER, 24 X 12^{1}/$_{8}$ IN.

began to conceive an image that would put all the ghosts of Holland to rest and reverse his unending exile: a single image that would crown the brothers' enterprise on the *entresol,* seal his comradeship with fellow avant-garde painters, and finally "convince Tersteeg that I really am a true impressionist of the Petit Boulevard."

That image was the Langlois Bridge.

In a "continual fever" of determination, he returned to the familiar canal bank. On a large canvas, secured against the spring mistral, he laid on large areas of color: giant pieces in the simplest of jigsaws. "I want to get colors into it like stained glass windows," he wrote, echoing the new Cloisonnist gospel of Bernard, "and a good, bold design." He painted a sandy-white path streaking diagonally across the canvas, bejeweled with passersby in crystals of contrasting color. Under a rectangle of cerulean sky, two great lilac abutments shimmered in a triangle of emerald water. Above them, the bridge loomed in a bold callig-

raphy of timbers. On the horizon behind, a huge golden sun radiates its setting glow in stylized waves of white and yellow.

No sooner had he put these pieces together and prepared a sketch for Bernard than the wind and rain drove Vincent indoors, where, in the effort to finish the image from memory, he "completely ruined it," he lamented to Theo. Undeterred, he tried again and again. In April, when the weather failed to cooperate, he holed up in his hotel room and began a copy of the very first version he had done. But instead of the backward-looking broken tones of March, he filled the familiar outlines with the vivid, prismatic color he had learned on the rue Lepic. He set the canvas ablaze with contrasts: instead of orange-ocher, he painted the earth rusty red. He replaced the rangy canal bank reeds of winter bistre and spring mint with stylized fans of tropical forest green. The rippling water deepened from azure to ultramarine; the stone abutments modulated from gray to lavender; and the bridge itself sprang to life in bright, impossible yellow.

It was a dazzling summary—an image that finally connected his new art to the emotional wellspring of his imagination: the past. He knew immediately that he had created something new and exceptional—"an odd thing," he called it, "not like what I generally do."

Fueled now by the same redemptive passion that had driven him to the limits of endurance in the black country and to the brink of suicide in Antwerp, Vincent's mercenary fervor redoubled. He launched a fantastic scheme to rain his paintings on family and associates in Holland: one for sister Wil, one for his old companion George Hendrik Breitner, two for a museum in The Hague, and, of course, one for the implacable Tersteeg. "He *will* have a picture of mine," Vincent vowed. And that picture would be the Langlois bridge. "Tersteeg will not refuse that picture," he promised. "I have made up my mind." Only that picture could exact "revenge" on the haughty *gérant* for rejecting all the brothers' previous approaches. Only that picture could set the past right.

In an ecstasy of optimism, he crated it and shipped it to Theo. "It only needs a frame specially designed for it in royal blue and gold," he wrote—demanding for it the same splendid treatment he had demanded for *The Potato Eaters.* "As far as the Impressionists' cause is concerned, there is little fear now that we shall not win."

EVEN AS HIS art coalesced and his ambitions soared, Vincent's life resumed its unraveling. For all his mercenary zeal, almost nothing had changed. His endless scheming and elaborate pleading had produced not a single sale. Russell had not bought either of the two paintings (a Monticelli and a Gauguin) that Vincent pressed on him. When Theo sent a selection of "new school" paintings to The Hague in response to Tersteeg's request for "only those pictures that you your-

self think the best," he had left out both Bernard and Russell, rejecting Vincent's advocacy.

His own work had fared no better. Theo's efforts on the *entresol* had led nowhere. The one collector who had expressed an interest in his work failed to buy anything. The painting that Theo sent to Tersteeg in April was returned unsold in June. A self-portrait he shipped to a London dealer disappeared altogether. The three paintings that were exhibited at the Salon des Indépendants in March and April (two Montmartre landscapes and the still life *Parisian Novels*) narrowly escaped the dustbin when the exhibition closed while Theo was out of town and unable to retrieve them. Vincent had to make hurried arrangements for the young Dutchman Koning (who had moved into the rue Lepic apartment) to rescue them before they were hauled away. Vincent couldn't even persuade his fellow artists to exchange works with him. Seurat, Pissarro, Russell, Gauguin, Bernard, even the talentless Koning, all passed up opportunities to trade paintings, despite Vincent's persistent importuning.

If there was a silver lining, it was a tarnished one. At least one reviewer of the Independents' show, Gustave Kahn, had noticed the two landscapes and the still life by "M. Van Gogh." It was Vincent's first critical attention. Regarding the landscapes, Kahn accused the artist of not exercising "a great enough concern for the value and exactitude of his tones." He described *Parisian Novels* as "a polychromatic multitude of books" and dismissively cast it aside as "a fine motif for a study, perhaps, but not a pretext for a painting."

As the months passed without a success, either for the brothers' enterprise or for his art, Vincent sank under the same weight of guilt that had driven him out of Paris. Theo's money disappeared as quickly and inexplicably in the dusty streets of Arles as in the peat bogs of Drenthe. Contrary to Vincent's promises, the move to Provence had brought no savings at all. "Worse luck," he wrote soon after arriving, "I can hardly manage to live any cheaper here than in Paris." Theo not only sent the same 150 francs every month (at a time when teachers made 75 francs a month), he supplemented that with extravagant supplies of paint and canvas, as well as additional payments when Vincent complained loudly enough about being *"sans le sou."*

Soon enough, Vincent found himself making the same excuses for excessive consumption and promises of imminent success that had haunted him on the heaths of his homeland. "I must reach the point where my pictures will cover my expenses," he vowed in April, "and even more than that, taking into account how much was spent in the past. Well, it will come. I don't make a success of everything, I admit, but I'm getting on." The return to old habits of pleading and promising drained his confidence. After weeks of effervescing over his work in the orchards, he confessed to "not being so keen as all that on my pictures," and offered to relocate from Arles to Marseille in order to put more effort into dealing

and less into painting. He even bought new shoes and clothes in anticipation of the move, assuring Theo: "In view of the business I count on doing, I want to be well turned out."

The offer to leave also revealed the growing strains in Vincent's relations with his neighbors. In fact, mutual suspicion had already degenerated into outright antagonism. Gripped by paranoia, Vincent blamed the Arlesians for plotting to thwart and exploit him at every opportunity. "They consider it a duty to get whatever they can," he groused. He accused merchants of overcharging him, cooks of spiting him, clerks of cheating him, and officials of misleading him. When he challenged them ("It would be feeble of me to let myself be exploited"), he found them impervious to his complaints. "The indifference, the lazy happy-go-lucky ways of the people here are beyond belief," he fumed. Nothing enraged him more than being ignored, of course, and he admitted saying "foolish and vicious" things in the heat of argument. In letters to Theo, he denounced the locals in increasingly acid rants as "bores," "loungers," "loafers," and "swine." Even the prostitutes of Arles lost their allure, threatening Vincent's most reliable source of companionship and consolation, other than alcohol. He called them "worn-out" and "stupefied," and, like the city itself, "in their decadence." With every sou he paid out, whether to a whore or a shopkeeper, he complained bitterly about money "going into the hands of people whom one loathes."

By the end of spring, as surely as the flowers fell from the trees, his life in Arles had withered to a series of angry confrontations. He fought with booksellers and brothel keepers, with the grocer who supplied him paint and canvas, and with postal clerks over his awkward packages to Paris and their proper postage. He fought with restaurateurs over their refusal to make the foods his delicate stomach demanded and with the local teenagers who taunted him ("street arabs," he called them).

But mostly he fought with his landlord. As in every place he ever lived, Vincent waged a war of attrition against his keeper. In Arles, his fury was directed at Albert Carrel, owner of the hotel where he stayed. He complained about the terrible food and "regular poison" of wine that Carrel served in the restaurant downstairs and about the lack of heat and the "nest of microbes" in the toilet upstairs. He accused Carrel of playing "tricks" on him. "They're ruinous and they make me wretched," he wrote Theo. Despite the drumbeat of grievances, Carrel made a covered terrace available for Vincent to dry his paintings and to use as a fair-weather studio. But when Carrel tried to charge extra rent for the additional space, Vincent protested and counted one more reason to seek accommodations elsewhere.

Rejected and besieged at every turn, Vincent could feel his great enterprise in the sunny South spiraling toward yet another failure only two months after it

began. "I see [the future] bristling with difficulties," he wrote, "and sometimes I ask myself if they won't be too much for me." As in the past, he brooded on his misfortunes. He looked in the mirror and painted an aging thirty-five-year-old man with wrinkles and "ash-colored" hair—"stiff and wooden . . . considerably neglected and mournful." Vexed by an exchange with Bernard about Christian imagery, distressed by news from Paris that Theo had fallen ill again, and haunted by the continuing rebuff from Tersteeg, his thoughts turned in the darkest direction: to "death and immortality."

It was a path that led only to melancholy. "Loneliness, worries, difficulties, the unsatisfied need for kindness and sympathy—that is what is hard to bear," he wrote Theo, spilling out his despair in the effort to bolster his sick brother's spirits. "The mental suffering of sadness or disappointment undermines us more than dissipation—us, I say, who find ourselves the happy possessors of disordered hearts."

Having long since given up the "infectious foolishness" of religion, Vincent had only one place to seek consolation. As he had so often in the past, especially at times of crisis, he seized on the possibility of rebirth—redemption—through art. Only art, he said, "can lead us to the creation of a more exalting and consoling nature." Echoing Zola's messianic mandate in *L'oeuvre*, as well as his own early formulations of the sublime *"it,"* he summoned up a new vision of art's future—a vision that, like his evangelical Christianity, promised to transform his troubles into sacrifices and his torments into martyrdom. He preached to all his correspondents a coming "revolution" in art, and declared himself and the other painters of the *entresol* its avant-garde. "And so, if we believe in the new art and in the artists of the future," he wrote Theo,

> our faith does not cheat us. When good old Corot said a few days before his death—"Last night in a dream I saw landscapes with skies all pink," well, haven't they come, those skies all pink, and yellow and green into the bargain, in the impressionist landscapes? All of which means that there are things one feels coming, and they are coming in very truth.

Combining the comforting promise of the old faith and the thrilling promise of the new art, it was a model of redemption and resurgence uniquely Vincent's—a Michelet-like conception of apocalyptic reincarnation that simultaneously exalted the painters of the Petit Boulevard and vindicated his burning nostalgia for a bygone Eden in art and in his own life. The past would return—but purged and perfected by a new understanding of color and a deeper vision of "very truth."

—

AT THE END of April 1888, two events inspired Vincent to transform this desperate illusion into reality—to "impose it on humanity," as Maupassant preached. The first was a letter from Bernard bragging that he had taken an entire house in Saint-Briac on the Brittany coast. At almost exactly the same time, Vincent's fight with his landlord finally boiled over, sending him on a search through the hostile town for another room, even as he contemplated escaping to Marseille. Only a few blocks north of the Hotel Carrel, on the far side of a public park that he had passed often on his way to the countryside, he saw a dilapidated house— "shut up and uninhabited for a considerable time." It was painted yellow.

Le Paradou

~

THE FOUR ROOMS THAT VINCENT RENTED HARDLY LOOKED THE STUFF
of dreams. They occupied the two floors in one half of a building at the north-
east corner of the place Lamartine, a triangular park on the north side of Arles
between the old city walls and the train station. The space had long gone un-
rented, despite the bargain rate of fifteen francs a month. Years of neglect had
left its yellow stucco exterior bleached to ivory and its green shutters faded to a
eucalyptus gray.

It was a strange fragment of a building, squeezed onto a trapezoidal corner
lot. Its twin gables facing the park masked two unequal "halves": a deep and
spacious one on the left, occupied by a grocery store, and a shallow, cramped
one on the right—the one Vincent rented. The right side also suffered most from
the noise and dust of the avenue de Montmajour, a main thoroughfare that ran
along the east side of the building. The tortured floor plan allowed just one large
room downstairs, with a kitchen in back, and two tiny bedrooms upstairs ac-
cessible only via the common hall and stairway. All the rooms but the kitchen
faced south, but none had cross-ventilation—a formula for suffocatingly hot
summers, especially upstairs, and insufferably close winters. None of the rooms
had heat, gas, or electricity. There was no bathroom. The closest facilities were
the filthy public toilets in the hotel next door.

The neighborhood discouraged sorties at any hour. The abutting hotel and
an all-night café two doors down disgorged revelers, drunks, and transients day
and night. Trains arrived and departed from the station, belching and scream-
ing as they passed on elevated tracks less than a hundred feet away. On the park
side, a few scrawny trees offered only a lace of shade from the relentless sun,
but no relief from the choking dust. At night, dark figures rustled and moaned
in the bushes—overflow sexual traffic from the brothel district just on the other

side of the park. The combination of inhospitable rooms, noise and traffic, danger and decadence, had long deterred any sensible vendors or lodgers. To the townspeople who passed by every day to post a letter or buy groceries, or at night to fornicate in the park, the corner apartment at 2, place Lamartine had disappeared already, a victim of vacancy and vandalism, condemned inevitably to the fate that awaited it fifty years later when an Allied bomb exploded it to rubble.

THE YELLOW HOUSE, ARLES

But to Vincent, it was paradise. Where others saw an interior of peeling whitewash, rough brick floors, and unlivable rooms, Vincent saw a serene, churchlike space. "In this I can live and breathe, meditate and paint," he wrote. Rather than a seedy transient neighborhood, Vincent saw a garden of Eden where the greenery was always lush and the sky overhead always "intensely blue." He called the dusty park "delightful" and bragged to sister Wil that his windows "overlook[ed] a very pretty public garden from which one can see the sun rise in the morning." Instead of decay and depravity, Vincent saw Daumier caricatures, scenes from Flaubert novels, Monet landscapes, and, in the denizens of the all-night café, "absolute Zola."

Where others saw a blighted eyesore, Vincent saw a home. "I feel that I can make something lasting out of it," he wrote Theo in a rapture of anticipation. "The ground feels firmer underfoot, so let's go ahead." One visitor later remarked that Vincent had found his "dream house."

Without waiting for Theo's approval, he signed the lease and launched an extravagant campaign to bring the derelict building back to life. He had the in-

terior repaired and the exterior repainted—"the yellow color of fresh butter on the outside with glaringly green shutters," he reported. He fixed the doors and windows, installed gas, and otherwise spent lavishly to make the house habitable, all the time pleading poverty to his brother. (He told Theo that the landlord had agreed to underwrite the renovations.) Eager to move in as soon as possible, he marched his studio from the Hotel Carrel to the downstairs room. But when

122. — *Arles.* « Entrée de la Ville.

Collection J: Poirey.

PLACE LAMARTINE, ARLES

he demanded a commensurate reduction in his rent at the hotel, Albert Carrel balked, sparking a furious battle ("I've been swindled," he cried). Forced to ransom his remaining possessions from Carrel, who seized them when Vincent refused to pay his bill, Vincent had to rent a room over the all-night café nearby and take his dispute with Carrel to the local magistrate, setting a tone of antagonism that would embitter all his future dealings with his new neighbors.

But nothing could dim the beacon of the Yellow House. The prospect of a permanent studio had revived the oldest and most potent dream of all: companionship. For Vincent, home always meant an end to loneliness. As early as 1881, he had pleaded with Anthon van Rappard to come to Etten and join in his patriotic pursuit of "Brabant types." "I am going *in a definite direction*," he beckoned, "and not being contented with this, I want others to go along with me!" In The Hague, he laid plans to transform the Schenkweg studio into a "house of illustrators" where other black-and-white draftsmen (and a host of models) would join him, as in the glory days of *The Graphic*. In Drenthe, he imagined founding a studio on the heath where "a colony of painters might spring up." In Nuenen,

he consoled himself with visions of the Kerkstraat studio as a "pied-à-terre" for all the peasant-painting disciples of Millet. Even during his brief, tumultuous stay in Antwerp, he toyed with "founding a studio." And in Paris, he invited his Antwerp Academy classmate Horace Livens, a virtual stranger, to "share my lodgings and studio so long as I have any."

The same fantasy of artistic family followed him to Arles. Separated from his brother and from his fellow painters of the Petit Boulevard, Vincent longed more than ever for the companionship—the completion—that had always eluded him. "I should like to get some sort of little retreat," he wrote Theo soon after his arrival, "where the poor cab horses of Paris—that is you and several of our friends, the poor impressionists—could go out to pasture when they get too beat up."

Through a spring filled with loneliness, estrangement, and debilitating spasms of nostalgia, his thoughts returned again and again to this dream of domesticity. He fondly recalled previous glimpses of it (with Van Rappard in Brussels) and brooded over his failed attempts at it ("I reminded myself that in The Hague and Nuenen I tried to take a studio, and how badly it turned out!"). On a spring day sometime in mid-April, all these injuries from the past and longings for the future converged on the four rooms to let at 2, place Lamartine.

"I could quite well share the new studio with someone," he announced the same day he signed the lease, "and I should like to. Perhaps Gauguin will come south?"

PAUL GAUGUIN WAS NOT Vincent's first choice of companion. When illness temporarily ruled out his brother, he had turned first to nineteen-year-old Émile Bernard, his most tractable comrade on the rue Lepic. Apparently following up on an invitation he had extended while still in Paris, Vincent plied the young painter with glowing reports of the beauty and healthiness of life in the Midi ("a real advantage for artists who love the sun and color") and the allure of Arlesian women. He billed the south as a bargain over Brittany, where Bernard had planned to spend the summer again. ("I don't yearn for the grey sea of the North" was Vincent's acerbic rebuttal.)

To tantalize his Japanophile friend, Vincent reimagined the dusty Provençal landscape as a gallery of Japanese prints, filled with "blotches of a beautiful emerald," "rich blue landscapes," and "splendid yellow suns." He sent drawings and descriptions of his paintings that boldly advertised the Cloisonnist essence of a countryside "as beautiful as Japan for the limpidity of the atmosphere and gay color effects . . . such as we see in *crépons*." He sweetened the invitation with hints of advancement on the *entresol* and offers to sell Bernard's work in Marseille.

When Bernard demurred (claiming an obligation to do military service in North Africa, although he never did), Vincent turned his search closer to home.

Either shunning or shunned by the handful of French artists working in Arles at the time, he briefly considered inviting the Dane Mourier-Petersen to share a studio, despite his "spineless" art and his reluctance to join Vincent's frequent expeditions to the brothel district (or as he called it, "the street of kind girls"). In March, when Mourier-Petersen announced his plan to return home, Vincent's domestic ambitions turned to Dodge MacKnight, Russell's boorish American friend who lived in the nearby village of Fontvieille. "He is a Yankee," Vincent summed up, "and probably paints much better than most Yankees do, but a Yankee all the same."

Even before seeing MacKnight's work, Vincent wondered if he might "come to some arrangement" with the younger man to join him in the Yellow House. "Then the cooking could be done in one's own place," he imagined. "I think we should both benefit by it." Within a week, however, after Vincent trekked the five miles to MacKnight's studio in Fontvieille, that vision, like so many others, collapsed in a cloud of rancor. All summer long, Vincent sniped at his American neighbor: "a dry sort of person," "heartless," "dull," "common," "stultifying," "a slacker." Out of deference to their mutual friend John Peter Russell, the two continued to exchange "frosty" visits in which Vincent had to endure criticisms of his work, which he catalogued bitterly to Theo: "It makes too queer an impression," "a total abortion," "utterly repulsive." In retaliation, Vincent pronounced an even more damning judgment on the American: "[MacKnight] will soon be making little landscapes with sheep for chocolate boxes."

The match with Paul Gauguin was no more promising. In March, Vincent had faulted Gauguin for "not hav[ing] the kind of temperament that profits from hardships"—an aspersion on both his masculine and his artistic mettle. Vincent made the comment in response to a letter Gauguin had sent out of the blue from Pont-Aven, a small town on the Brittany coast, pleading ill health and penury. "He is on the rocks," Vincent related the contents to Theo. "He wants to know if you have sold anything for him, but he can't write to you for fear of bothering you." Vincent professed to be "deeply sorry for Gauguin's plight," and he did petition both Theo and Russell to buy some of his work. He also sent a solicitous reply to Pont-Aven (his first letter to Gauguin) decrying the curse of sickliness shared by all painters ("My God! Shall we ever see a generation of artists with healthy bodies!"). But he pointedly did not invite Gauguin to join him in the reparative South. Known for his prickliness and aloof self-regard, the forty-year-old Frenchman was no match for the attentive young Bernard, on whose companionship Vincent had by now fixed his sights. Nor was the older man's art, for all its exotic subject matter, as seductive as the younger's fiery new gospel of color and simplicity—especially after the March *Revue Indépendante* proclaimed Cloisonnism the crown jewel of avant-garde art.

Of course, Vincent had followed closely and no doubt enviously Gauguin's

meteoric success on the *entresol*. In December and January alone, Theo had bought almost a thousand francs' worth of Gauguin's work, including the Martinique canvas *Les négresses* that hung proudly over the sofa in the rue Lepic apartment. But the two artists remained barely connected after Gauguin left Paris in early February. When Gauguin wrote from his sickbed in March, he sent the letter to Paris, unaware that Vincent had moved on to Arles. He wrote a second plaintive letter only a week later. "He complains of the bad weather [and] is still ailing," Vincent summarized. "[He] says that of all the various miseries that afflict humanity, nothing maddens him more than the lack of money, and yet he feels doomed to perpetual beggary." Vincent forwarded the letter to Theo with a casual suggestion that he offer a Gauguin painting to Tersteeg, but didn't bother replying to it for a month.

By the end of that month, however, everything had changed. Mourier-Petersen had announced his departure; relations with MacKnight were careening toward a blowup; and the landlord Carrel had seized all Vincent's possessions. Bernard had ignored his entreaties and taken a house in Brittany, then invited Gauguin to join him there. Theo had returned from his trip to Holland as worrisomely sick as ever and immediately laid plans to visit Claude Monet in Giverny, where he would soon offer the Impressionist eminence the richest deal yet on the *entresol*. "You will see some lovely things there," Vincent wrote forlornly, "and you will think what I send very poor stuff in comparison."

Meanwhile, the Provençal landscape had turned hot and harsh as the summer mistral scoured it with dust. Flies and mosquitoes tormented every excursion. Color continued to drain from the fields, health from his body, money from his purse, and confidence from his brush. (As of May 1, he had still not sent a single work to Paris.) The Yellow House represented the sole "glimmer of hope" on a bleak horizon. But to bring his vision of an artistic Eden to life he had committed himself to ruinous debt without a word to Theo.

By mid-May 1888, Vincent had convinced himself that only one person could reverse this tide of misfortune: that only by bringing Paul Gauguin to Arles could he salvage his dream of artistic home and family. "We may be able to make up a bit for the past," he imagined. "I shall have a quiet home of my own [and] I should be a different man."

To impose that illusion on reality, Vincent mounted the campaign of a lifetime. As a bright new building emerged at 2, place Lamartine, a far grander edifice took shape in his imagination. Through months of elaborate, almost daily, pleading, exhortatory letters, he constructed the greatest of his glittering castle-in-the-air schemes for happiness. Combining the careful calculation of his brief on behalf of Sien and the Schenkweg studio, the breathless "join me" urgency of his pleas from Drenthe, and the evangelical ardor of his Millet conversion on the heaths of Nuenen, Vincent's campaign in the early summer of

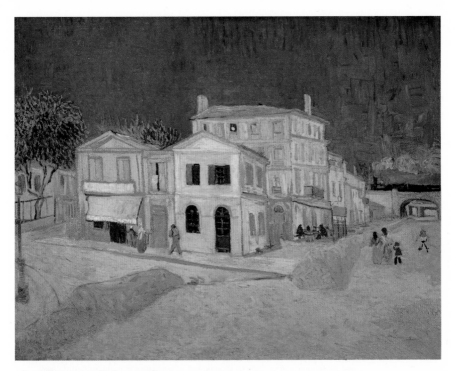

The Yellow House ("The Street"), September 1888, oil on canvas, 29 7/8 × 37 in.

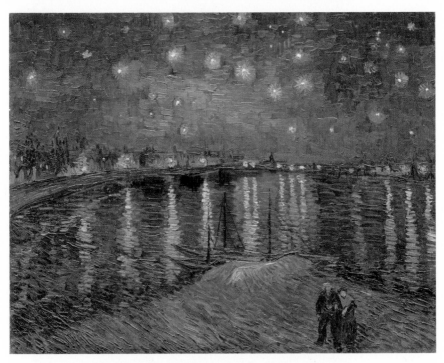

Starry Night over the Rhône, September 1888, oil on canvas, 11 1/8 × 36 1/8 in.

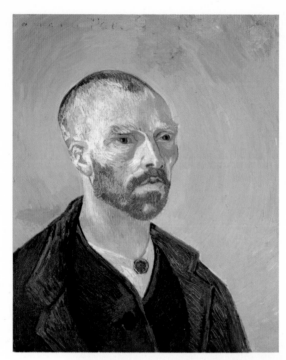

Self-Portrait (Dedicated to Paul Gauguin),
SEPTEMBER 1888,
OIL ON CANVAS,
24 $\frac{1}{4}$ X 20 $\frac{1}{2}$ IN.

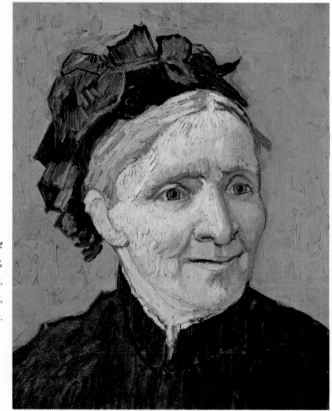

Portrait of the Artist's Mother,
OCTOBER 1888,
OIL ON CANVAS,
15 $\frac{7}{8}$ X 12 $\frac{7}{8}$ IN.

Public Garden with Couple and Blue Fir Tree: The Poet's Garden III, OCTOBER 1888,
OIL ON CANVAS, 28 7/8 X 36 1/8 IN.

Tarascon Diligence, OCTOBER 1888, OIL ON CANVAS, 28 3/8 X 36 1/8 IN.

*L'arlésienne: Madame
Ginoux with Books,*
November 1888
(or May 1889),
oil on canvas,
35 ¹/₄ x 28 ³/₈ in.

*Madame Roulin
Rocking the Cradle
(La Berceuse),*
January 1889,
oil on canvas,
36 ⁵/₈ x 29 ¹/₈ in.

Vincent's Chair with His Pipe, DECEMBER 1888, OIL ON CANVAS, 36 5/8 X 28 7/8 IN.

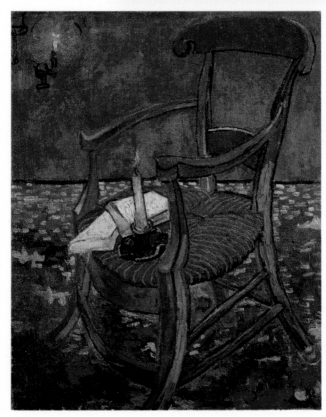

Gauguin's Chair, DECEMBER 1888, OIL ON CANVAS, 35 5/8 X 28 3/8 IN.

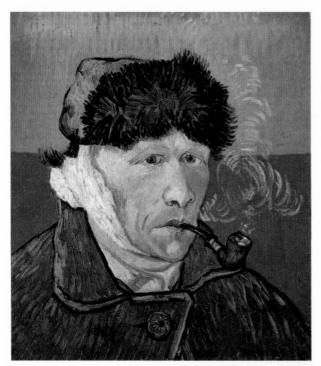

*Self-Portrait with
Bandaged Ear and Pipe,*
JANUARY 1889,
OIL ON CANVAS,
20 $^1/_8$ X 17 $^3/_4$ IN.

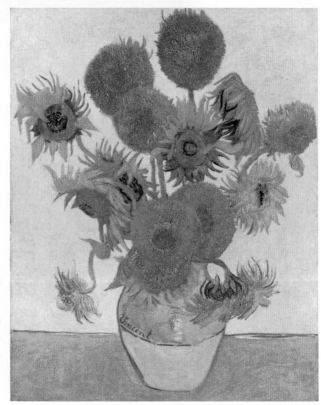

*Still Life: Vase with
Fifteen Sunflowers,*
AUGUST 1888,
OIL ON CANVAS,
36 $^5/_8$ X 28 $^3/_4$ IN.

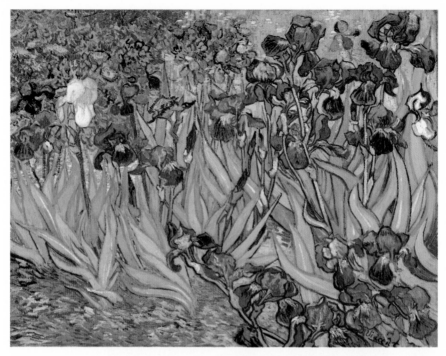

Irises, MAY 1889, OIL ON CANVAS, 28 X 36 5/8 IN.

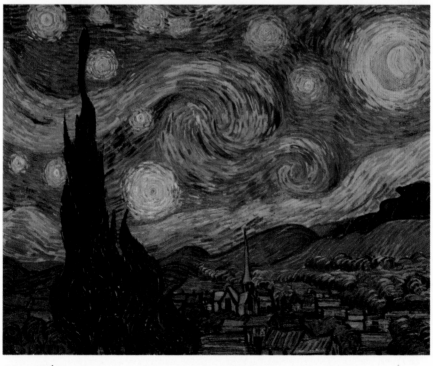

Starry Night, JUNE 1889, OIL ON CANVAS, 28 3/8 X 36 1/8 IN.

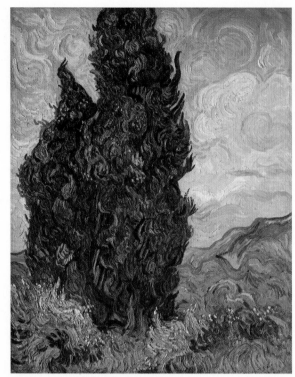

Cypresses,
1889,
OIL ON CANVAS,
37 1/4 X 28 3/4 IN.

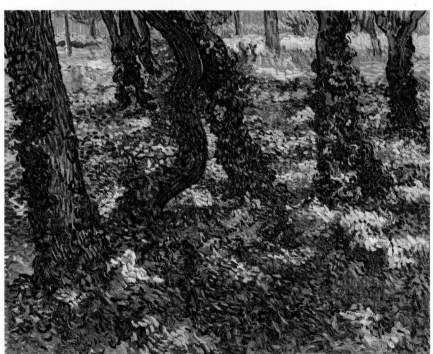

Tree Trunks with Ivy (Undergrowth), JULY 1889, OIL ON CANVAS, 29 1/8 X 36 1/8 IN.

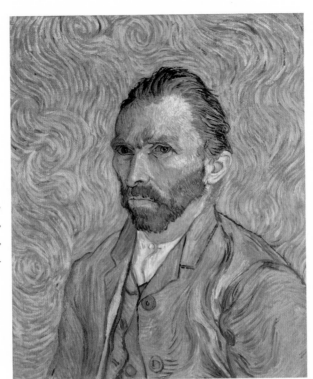

Self-Portrait,
SEPTEMBER 1889,
OIL ON CANVAS,
25 $\frac{5}{8}$ X 21 $\frac{3}{8}$ IN.

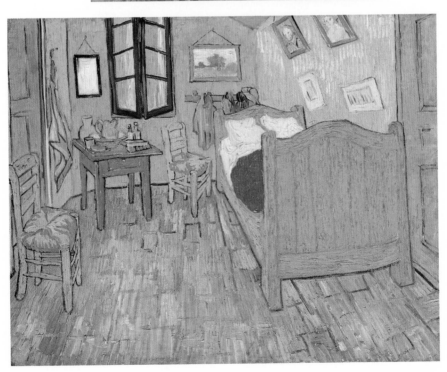

The Bedroom, EARLY SEPTEMBER 1889, OIL ON CANVAS, 28 $\frac{3}{4}$ X 36 $\frac{1}{8}$ IN.

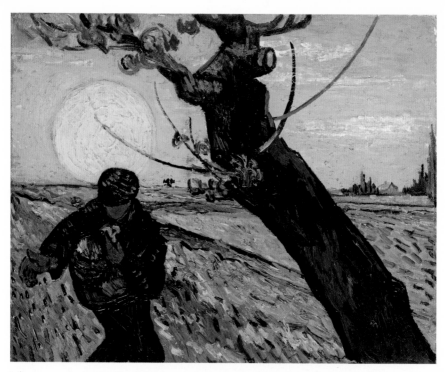

The Sower, NOVEMBER 1888, OIL ON CANVAS, 12 ⁵/₈ X 15 ³/₄ IN.

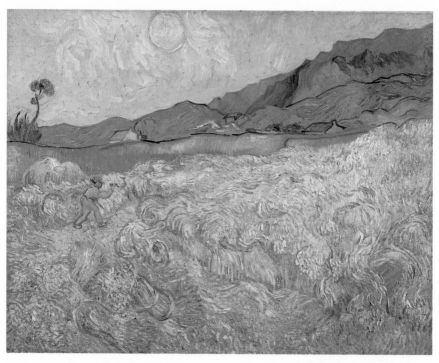

Wheat Fields with a Reaper, EARLY SEPTEMBER 1889, OIL ON CANVAS, 29 ¹/₈ X 36 ¹/₈ IN.

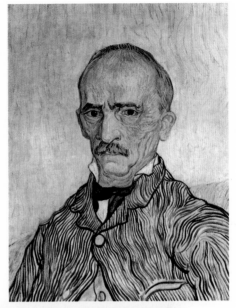

*Portrait of Trabuc,
an Attendant at
Saint-Paul Hospital,*
SEPTEMBER 1889, OIL ON
CANVAS, 24 X 18 1/8 IN.

*Trees in the Garden of
Saint-Paul Hospital,*
OCTOBER 1889, OIL ON
CANVAS, 35 1/4 X 28 3/4 IN.

Olive Picking, December 1889, oil on canvas, 28 ¾ × 35 in.

Noon: Rest from Work (after Millet), January 1890, oil on canvas,
28 ¾ × 35 ⅞ in.

Les Peiroulets Ravine, OCTOBER 1889, OIL ON CANVAS, 28 ³/₄ X 36 ¹/₈ IN.

Almond Blossom, FEBRUARY 1890,
OIL ON CANVAS, 28 ⁷/₈ X 36 ¹/₈ IN.

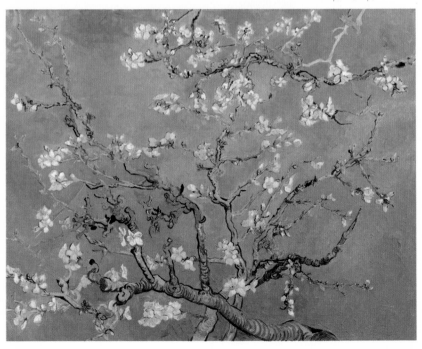

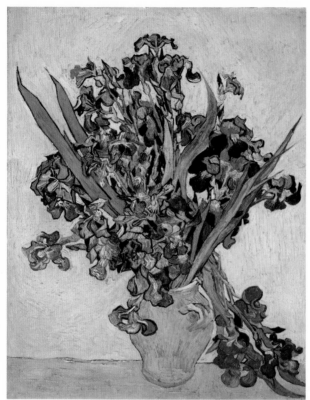

Irises,
MAY 1890,
OIL ON CANVAS,
36 1/8 X 28 7/8 IN.

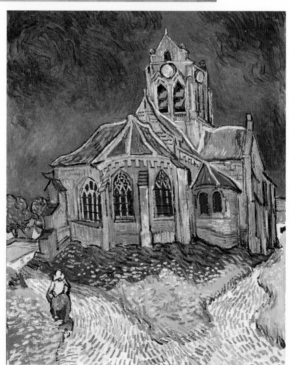

The Church at Auvers,
JUNE 1890,
OIL ON CANVAS,
37 X 29 1/8 IN.

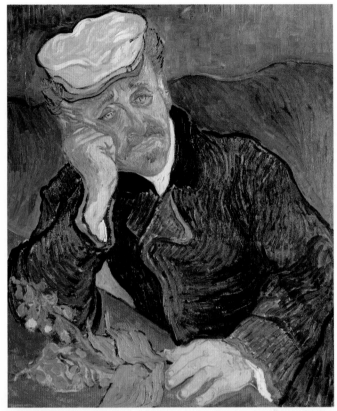

Portrait of Doctor Gachet, JUNE 1890, OIL ON CANVAS, 26 1/4 X 22 IN.

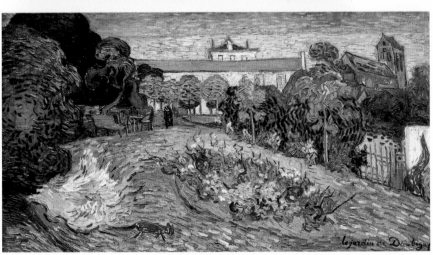

Daubigny's Garden, JULY 1890, OIL ON CANVAS, 19 5/8 X 40 IN.

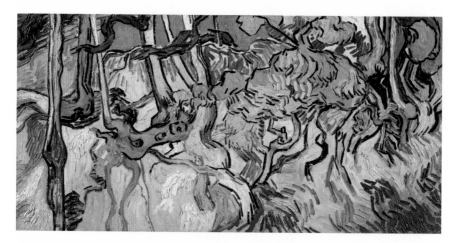

Tree Roots, JULY 1890, OIL ON CANVAS, 19 ¾ X 39 ¼ IN.

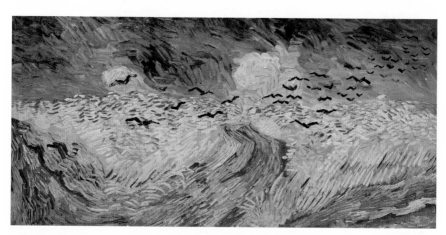

Wheat Field with Crows, JULY 1890, OIL ON CANVAS, 19 ⅞ X 39 ⅛ IN.

1888 staked everything on a heroic new vision of personal and artistic utopia—
a paradise of redemption and rebirth that shone even more brightly than its
counterpart in stucco and yellow paint. Subsequent accounts dubbed this final
fantasy "the Studio of the South"—a term that Vincent never used.

Vincent argued that Gauguin's coming would finally put the brothers' *en-
tresol* enterprise on a sound financial footing. Presenting his plan as a "plain
matter of business," he concocted elaborate budgets based on the oft-discredited
proposition that two could live as cheaply as one and the certainty that works
like Gauguin's *Les négresses* would "treble or quadruple" in value. If Theo would
only settle Gauguin's debts in Pont-Aven, pay for his travel to Arles, add a hun-
dred francs to the monthly stipend he sent, and demand one Gauguin work each
month, he would not only make back his money, Vincent concluded, "wouldn't
it even mean a profit?"

Such an arrangement would pay off in other ways, he promised Theo. An
association with Gauguin would attract other avant-garde painters and put
the brothers' venture "in a stronger position as far as reputation goes." On the
updraft of Gauguin's success, Vincent's work would begin to sell, too, he reck-
oned—at the rate of at least one or two, and perhaps as many as four, paintings
a month for a hundred francs apiece. "So I tell myself that bit by bit the expenses
will be balanced by the work," he assured Theo, eagerly foreseeing an end to his
long, corrosive dependence. Gauguin's coming might even help secure the com-
mercial backing of that eternal skeptic, H. G. Tersteeg, Vincent dared to imag-
ine. "If we have [Gauguin]," he boldly predicted, "we can't lose."

In late May, he penned an invitation:

My dear comrade Gauguin,

 I wanted to let you know that I have just rented a four-room house
here in Arles. And that it would seem to me that if I could find another
painter inclined to work in the South, and who, like myself, would be
sufficiently absorbed in his work to be able to resign himself to living like
a monk who goes to the brothel once a fortnight . . . it might be a good
job . . . My brother would send 250 francs a month for both of us which
we would share. . . . And you would give my brother one picture a month.

In addition to the hints of brothels filled with beautiful Arlésiennes, Vincent
sweetened his offer with compliments ("my brother and I greatly appreciate
your painting") and promises of sunnier weather ("working out-of-doors is pos-
sible nearly all the year round") and improved health ("I was ill when I came
here, but now I am feeling better"). But, Vincent insisted, "business must come
first." "My brother cannot send you money in Brittany and at the same time

send me money in Provence," he wrote bluntly in response to Gauguin's pleas for financial support. "But if we combine, there may be enough for both of us. In fact, I am sure of it." Finally, he warned the wily ex-banker against appealing to Theo directly for a better deal. "We have thought it over carefully," he emphasized, "and the *only* means we have found of coming to your aid in a more practical way is this combining."

In an unusual show of restraint, Vincent sent the drafted letter to Paris, presumably for Theo's approval. But his arguments never paused for a reply. In flights of yearning that soared past the dreary logic of business, he envisioned Gauguin's coming as not just a commercial coup but a boon to both their art. In the South, he claimed, "one's senses get keener, one's hand becomes more agile, one's eye more alert, one's brain clearer." He portrayed the Midi as the inevitable destination of *all* true Impressionists: a land bursting with the prismatic color and limpid light of Japanese art—the new grail of every vanguard artist—just waiting to be captured on canvas by a painter of faith, ambition, and "daring." In a crescendo of fervor, he broadened his invitation into a *L'oeuvre*-like challenge to all artists who loved *japonisme* and felt its influence: "Why not come to Japan, that is to say to the equivalent of Japan, the South?" Summoning the apocalyptic ardor of his days as a preacher, he prophesied the birth of a new religion in the Midi. "There is an art of the future," he imagined, "and it is going to be so lovely and so young . . . I feel it so strongly." He clothed this prophetic reverie in the rhetoric of revolution, with its calls for shared sacrifice, greater good, and utopian triumph.

And its promise of messianic return. Someday soon, he assured Theo, an artist from the "coming generation" would "rise up in this lovely country and do for it what the Japanese have done for theirs." This artist would lead the revolution for which Vincent saw himself merely "clearing the way." "I am not sufficiently ambitious for that fame to set a match to the powder," he insisted, "but such a one *will* come." Vincent dubbed this Messiah of the new art "the Bel-Ami of the Midi"—"a kind of Guy de Maupassant in painting" who would "paint the beautiful people and things here lightheartedly." He would rival Monticelli in color, Monet in landscape, and Rodin in sculpture (all stars of the *entresol*). He would be, Vincent declared in bold underline, *"a colorist such as has never yet existed."*

He refused to name this coming savior, but the comparison to Maupassant's Georges Duroy, a sly, sophisticated, sexual predator like Zola's Octave Mouret, spoke to Theo in deep fraternal code. It not only invoked the great French realist writers who had revolutionized literature, it promised the charming imagery that spelled commercial success on the *entresol*, and hinted at sexual wonders to be performed on the beautiful Arlésiennes. And it pointed the finger of destiny unmistakably at the worldly, ambitious, predatory painter who lay sick and broke on a bed in Pont-Aven.

Like all Vincent's utopian visions, this one looked simultaneously backward and forward. By combining, he and Gauguin would be following in the footsteps of previous artistic "brotherhoods": from the medieval guilds of artists who "loved one another like friends," to the Dutchmen of the Golden Age who "complemented one another"; from the writers and draftsmen of *The Graphic* who worked in their studios, shoulder to shoulder, creating together "something holy, something noble, something sublime," to the painters of the Barbizon who formed not just a colony of artists, but a noble community of kindred spirits sharing "their warmth, their fire, and their enthusiasm" in the Fontainebleau Forest.

Onto this dream of lost Edens, he layered the latest fashionable myth of artistic *fraternité:* Japanese Buddhist monks, known as *bonzes.* Vincent had read about these exotic religious brotherhoods in sources both serious (Gonse's *L'art japonais*) and sensational, especially Pierre Loti's wildly fictionalized travel account, *Madame Chrysanthème.* Now he cast his kinship with Gauguin in the image of these simple, self-abnegating priests of the primitive sublime, who "liked and upheld each other," according to Vincent, living together in "fraternal communities [where] harmony reigned." Comparing the *bonzes'* mystical union to the "fraternal marriage" (*unitas fratrum*) of the Moravian Brothers, whose eroticized communes dotted the Dutch heaths, Vincent summoned Gauguin to a monastic life of "cold water, fresh air, simple good food, decent clothes, [and] a decent bed"—the same spartan discipleship he had briefly shared with Harry Gladwell in a Montmartre garret more than a decade earlier.

He reached out to include not just Gauguin, but all the beleaguered artists of the avant-garde in his ambitions for the Yellow House—all those "poor devils, whose homes are cafés, who lodge in cheap inns and live from hand to mouth, from day to day." On behalf of all those painters "leading lives approximately comparable to the lives of street dogs," Vincent preached a great new shared mission. If Theo truly cared about "this vigorous attempt by the impressionists," Vincent wrote, he had a duty to "care about their shelter and daily bread." Reprising the soup-kitchen fantasy of the Schenkweg, he imagined offering succor to all the homeless cab horses of Paris who, like him, suffered for their art:

> We are paying a hard price to be a link in the chain of artists, in health, in youth, in liberty, none of which we enjoy, any more than the cab horse that hauls a coachful of people out to enjoy the spring. . . . You know you are a cab horse and that it's the same old cab you'll be hitched up to again: that you'd rather live in a meadow with the sun, a river and other horses for company, likewise free, and the act of procreation.

Inevitably, this vision of offering pasturage to neglected painters everywhere merged with Vincent's longtime ambition to create a "combination" of artists in

which the successful few would support the destitute many. Why should paint-ers be "chained to the opportunity of earning their own bread," he demanded, projecting his own sense of imprisonment onto all the painters of the Petit Bou-levard, "which means that in fact one is far from free." He rallied Theo to lead the fight against this great "injustice" by heading a new "Impressionist Society"—a partnership in which "the dealer will join hands with the artist, the one to take care of the housekeeping side, to provide the studio, food, paint, etc.; the other to create." In these sweeping exhortations to take up the cause of his suffering comrades, Vincent found the comfort he most needed. By transforming his long dependence on his brother into a moral right shared by *all* struggling artists, and Theo's years of support into a utopian mandate imposed on *all* successful dealers (and artists), this paradisiacal vision of the Yellow House promised to release him from his deepest guilt.

So powerful was this vision of redemption that the possibility of failure drove Vincent's thoughts into all the darkest places: sickness, madness, even death—intimations that foretold the future in ways he could not have intended. But for now, his feverish anticipation of Gauguin's companionship carried his imagi-nation past these doubts into a future sun-washed with dreams. "The dreams, ah! the dreams!" Bernard wrote, recalling the rush of visionary letters he, too, received that spring, "giant exhibitions, philanthropic phalansteries of artists, foundations of colonies in the Midi."

In June, those dreams burst onto canvas. Taking his arguments where words could not go, Vincent launched the most productive, most persuasive, and, ul-timately, most fateful campaign of imagery he would ever wage. From Drenthe, he had accompanied his fierce invitations with magazine illustrations of life in the peatland. From Nuenen, he had defended his home among the peasants with dark incantations of Millet and Israëls. From Provence, with two years of the new color in his eye and the new brushwork in his hand, he championed his plans for the Yellow House with some of the glories of Western art.

WITH THE SALTY SPRAY of the Mediterranean in his face, Vincent made a drawing of four fishing boats beached at the water's edge. He had come to the ancient village of Saintes-Maries-de-la-Mer at the end of May, traveling thirty rough miles in a high-wheeled diligence "to have a look at the *blue* sea and the *blue* sky." "At last I have seen the Mediterranean," he exulted. Fighting a wild wind from Africa, he had tried painting the little one-man boats as they battled their own ways through the surf. But he ended up spending most of his five days in Saintes-Maries wandering around the bright, bony village, sketching the crustaceous cottages, called *cabanes* ("whitewashed all over—the roof too"), in neat rows and in splendid isolation.

Street in Saintes-Maries, JUNE 1888, REED PEN AND INK ON PAPER, 12 X 18$^1/_2$ IN.

His thoughts were borne ceaselessly into the past. The sea reminded him of his sailor uncle Jan; the dunes, of Scheveningen; and the cottages, of the hovels in Drenthe. The same ghosts apparently kept him away from the battlements of the pilgrimage church from which the town derived its name. It was here, according to Provençal legend, that the Three Marys, including Mary Magdalene, had come ashore after their miraculous voyage from the Holy Land. Every year in late May, hundreds of pilgrims made the arduous journey across the salty marshland of the Camargue to celebrate the Festival of Saint Sarah, the servant girl who accompanied the Marys on their magical boat. Most were gypsies who had taken the dark-skinned Sarah as their patron saint. Vincent's trip to the sea at Saintes-Maries—rather than Marseille, where he had often promised to go— may have been inspired by the annual transit through Arles, only days earlier, of these ardent *gitans* in their colorful caravans.

But once he arrived, his eye returned again and again to the little boats on the beach. Every morning, he went to the shore and saw them there: "little green, red, blue boats, so pretty in shape and color that they made one think of flowers," he said. But every morning they put to sea before he could set up his equipment. "They dash off when there is no wind," he explained to Bernard, "and make for the shore when there's a bit too much of it." On the fifth morn-

ing, he rose early and hurried to the beach with only a sketchpad and a pen. He caught the group of four shallow-drafted barks still resting in the sand, awaiting the day's buffeting as serenely as the cab horses of Paris. Working without his perspective frame, he sketched them in all their neglected nobility: the one in front almost filling the sheet with its broad beam and sweeping prow, the other three arranged behind in the ragged row where their owners had left them: their masts leaning to and fro like the pollard birches of Nuenen, their long booms and fishing poles crisscrossing at crazy angles. Before their masters arrived to drag them to their duties, he made notes of their colors directly on his drawing.

That same day, Vincent, too, set off, abruptly cutting short his visit to the seashore after an unexplained intervention by the parish priest and a local gendarme. He returned over the wild Camargue, leaving behind all three of the canvases he had painted in Saintes-Maries because, he explained, "they are not dry enough to be submitted with safety to five hours' jolting in the carriage." He never did return to fetch them.

He did take his drawings, however. As soon as he arrived at the Yellow House, he sent a batch of them to Theo and took the others, including the "moored boats," to his studio, where he set to work transposing them into paintings. First, he rehearsed the colors he had annotated by testing them out in a watercolor exactly the same size as the sketch (15½ by 21 inches). Ignoring everything Mauve had taught him about drawing with color, he traced the boats' bold outlines in black with a broad reed pen, then filled between the lines with even daubs of bright, watery color: complementary red and green for the boats, orange and blue for the beach and beyond. Finally, he copied his drawing of brave little boats onto the left side of a larger canvas (25½ by 32 inches), leaving space on the right and at the top for more sea and sky. He broke the drawing into smaller and smaller pieces of pure, clear color: a maroon-and-cobalt hull with celadon railing; a moss-green prow with orange railing; an avocado cockpit with white ribbing; a yellow mast, lapis-lazuli rudder, robin's-egg-blue oars; and a rainbow of fishing poles.

But when he painted the sky and sea, his vision changed entirely. Instead of setting his bejeweled boats on the watercolor's contrasting plates of blue and orange, he transported them to a soft and dreamy world—a world of glowing sky and silvery light that Mauve or Monet would have recognized. White clouds dissolve into brushstrokes of soft blues and greens, arching over the spiky masts in a luminous vault. The beach shades from a gold-stippled taupe in the foreground, where the boats rest, to a sunny tan in the distance. White-tipped waves wet the sand in lavender. At the horizon, sea meets sky in a pastel kiss of powder blue and aquamarine. Against this gauzy dawn, the crystalline colors of the little boats leap off the canvas.

Vincent claimed that *Fishing Boats on the Beach* and the other paintings based on the sketches he brought back from Saintes-Maries—a virtual coloring book of imagery—proved that he had found "absolute Japan" in the South of France. "I am always telling myself *that I'm in Japan here*," he exclaimed. "I have only to open my eyes and paint what is right in front of me." He wrote Bernard and Gauguin boasting of the seashore's "amusing motifs," "naïve" landscapes, and "primitive" coloration. He professed his devotion to the new gospel of Cloisonnism, which he summarized as "simplification of color in the Japanese manner" and "put[ting] flat tones side by side, with characteristic lines marking off the movements and the forms."

To Theo, he trumpeted the salability of *Boats* and other works like it, comparing them to Japanese prints in their desirability as "decorations for middle-class houses." In terms that probably echoed Monet's pitch for his Antibes paintings (just then showing on the *entresol*), Vincent claimed that his brief time in the South had given him a new vision: "One sees things with a more Japanese eye," he wrote; "one feel colors differently." Indeed, hadn't Monet himself painted a scene of four brightly colored boats on a beach? With all these arguments and more, he pushed his brother to urge other dealers "to join in sending people who would work down here. In that case I think Gauguin would be *sure* to come."

He sent similar pleadings to Bernard and Gauguin, brushing past the former's demurrals and the latter's indecision. "Do you realize that we have been very stupid, Gauguin, you and I, in not going to the same place?" he scolded Bernard in mid-June. A few letters later, he pointed his friend to the same message hidden in the simple image of four medieval barks. "Life carries us along so fast that we haven't the time to talk and to work as well. That is the reason why, with unity still a long way off, we are now sailing the trackless deep in our frail little boats, all alone on the high seas of our time."

But the ultimate invitation was always directed at Theo. "I wish you could spend some time here," he wrote after returning from Saintes-Maries. "I think that once again you should steep yourself more and more in nature and in the world of artists." Echoing his pleas from Drenthe, he urged Theo to quit Goupil, or at least demand "a year's leave (on full pay)" during which he could recover his health, promote the brothers' enterprise, and "steep himself" in the serenity of the South. "I keep thinking of you and Gauguin and Bernard all the time wherever I go," he wrote. "It is so beautiful, and I so wish you were here."

With such reveries in his head, Vincent returned to the painting and inscribed a word in big letters on one boat: AMITIÉ—friendship. Then, on the empty expanse of aquamarine water, he painted four frail little boats, side by side, headed out to the trackless deep, the wind filling their sails, and nothing but glassy sea in front of them.

—

ONLY A WEEK LATER, Vincent traveled north toward Tarascon, home of Daudet's mythical clown, Tartarin. The road passed near the fabled ruins of the abbey church at Montmajour, a dizzying limestone escarpment rising a hundred and fifty feet straight up from the edge of the Rhône delta. For most of history, Montmajour had stood as a rocky island redoubt lapped by the waters of the Mediterranean. Sixth-century Christians sought safety on its forbidding heights, and gave thanks by hewing a sanctuary from the solid rock at its peak. Subsequent generations of monks had topped that first rough church with layer after layer of devotion in stone, from a Byzantine chapel to a medieval *donjon* to a Renaissance cloister to an eighteenth-century fortified palace and gardens. After the Revolution, all were left to crumble.

Using the road that ran up the less precipitous back slope, Vincent had climbed to Montmajour's rocky summit many times by midsummer 1888. A lifelong lowlander, he had marveled at the spectacular view from the abbey tower, looking south toward Arles across a plain known as the Crau. Here, at the foot of the high country, the Rhône had dropped its most fertile detritus, while washing the sea's salty deposits farther south to the Camargue. Early in the nineteenth century, a Dutch-style drainage project had reclaimed the Crau's rocky but arable soil for cultivation, especially vineyards. The result was a picturesque vista studded with limestone islands and tiny villages set amid fields and groves. In mid-May, when Theo invited Vincent to submit some drawings for an exhibition in Amsterdam, Vincent's imagination naturally returned to this aerial view. Over the course of a week, he made seven elaborate purple-ink drawings at Montmajour, including four sweeping panoramas of the Crau. But only days after completing the last one, his enthusiasm for them was replaced by the fervor for "Japanese" color that propelled him to Saintes-Maries at the end of May.

By the time he revisited the Crau in mid-June, however, the argument for the Yellow House had, like the Rhône, shifted course; and Vincent's eager eye had shifted with it. His return from Saintes-Maries was greeted with news that his old Cormon classmate Louis Anquetin had been crowned by the *Revue Indépendante* as "the leader of a new trend, in which the Japanese influence is even more apparent." Not long after that, Vincent learned of an even more enviable milestone: Anquetin had sold a painting. The buyer was the dealer Georges Thomas, a longtime target of Vincent's commercial ambitions, and the painting was a study called *The Peasant*.

Although Vincent disputed Anquetin's primacy in the new movement known as Cloisonnism (he thought his young protégé Bernard had "gone further in the Japanese style than Anquetin"), he could not argue with a sale—something neither he nor Bernard could boast. As the movement's anointed

leader, Anquetin now set the agenda. Within a few weeks, Gauguin announced his plan to paint a large scene of Breton peasants doing a harvest dance. Before the end of the summer, Bernard would join Gauguin in Pont-Aven and also undertake to paint the natives of that exotic, rocky province at the opposite end of France. Around the same time, Theo returned from Giverny with glowing reports of the shimmering landscapes he had seen in Monet's studio documenting the evanescent effects of light and season on the Île-de-France countryside.

Also in June, Vincent read a review of the exhibition of Monet's Antibes paintings then on view at Theo's gallery. In florid descriptions, the critic celebrated Monet's "intimacy" with nature and praised him for documenting with his sensitive, light-filled brush the elemental beauty of France's southern coast at Antibes, just as he had done earlier for the northern coast at Belle-Île. Proclaiming Monet the "poet and historian of the Midi" and the successor to Millet and Corot in elevating rural life to its rightful place in art, he urged his countrymen to embrace once again the sublime poetry of their own homeland. Why look to Pacific islands or ancient civilizations to find "primitive" imagery when such untouched Edens could still be found in France itself?

While Vincent was in Saintes-Maries, the author of that review, Gustave Geffroy, wrote Theo a letter expressing an interest in buying some of Vincent's work.

In Geffroy's article and overture; in Anquetin's choice of subject matter; and in the reports of new imagery from Paris, Pont-Aven, and Giverny, Vincent saw new opportunities to plead the cause of the Yellow House. His letters and art erupted with arguments. No one had a more "intimate knowledge" of nature or "loved the countryside" more than he did, he protested; no one was more deeply schooled in the simple life of peasants and their primitive bond to the land than he was; and no place was better suited than Arles for artists to reconnect with the uncontaminated poetry of nature. "[I] look round and see so many things in nature that I hardly have time to think of anything else," he wrote in direct response to Geffroy's challenge, "for just now it is harvest time." Abruptly canceling a return trip to Saintes-Maries, he loaded his painting equipment on his back and set off into the blazing sun and swirling mistral of the Crau.

In the next two weeks, he painted almost a dozen images in support of his Arcadian claims. He painted view after view of the Crau's golden wheat fields, raising the horizon higher and higher to focus his obsessive brush on the summer bounty of color. "The wheat has all the hues of old gold," he wrote as he painted, "copper, green-gold or red-gold, yellow-gold, yellow-bronze, red-green [and] flashing orange colors like a red-hot fire." He modulated the light from a blinding midday yellow to the russet tones of sunset, when the wheat shone "luminous in the gloom." He adjusted the sky, too, from cobalt to lavender to turquoise and finally to a yellow as unrelenting as the sun itself "in the full furnace

of the harvest at high noon." He painted unmowed fields churning in the wind awaiting the scythe; a thresher making his slow way through the high stalks, leaving sheaves of reaped wheat in his wake; and the huge mangy haystacks that filled the barnyards, offering impromptu beds to their exhausted builders.

Egged on by his own arguments and hounded by the fierce heat and furious wind, he raced from painting to painting, sometimes completing two in a single day, chasing his vision of a "painters' paradise" in Provence. "I have *seven studies of wheat fields*," he boasted to Bernard, "done quickly, quickly, quickly and in a hurry, just like the harvester who is silent under the blazing sun, intent only on his reaping."

One of these images in particular summed up Vincent's new view of an alluring rural utopia, simultaneously familiar and exotic, that beckoned all true artists to the Midi. On a spot of high ground just east of Arles, he set his perspective frame facing north, toward the Alpilles, and captured a spectacular panorama of the golden Crau. "I am working on a new subject," he reported to Theo, "fields green and yellow as far as the eye can reach." On a canvas more than two by three feet—bigger than any he had used previously in Arles—Vincent's imagination transformed the stony, sun-baked checkerboard of cultivation into a lush Shangri-La. The sunlight falls softly and evenly, leaving not a single shadow, burnishing the new-mown fields and saturating every corner of the mosaic plain in vivid color: white sandy paths, lavender reed fences, orange tile roofs, a spectrum of yellow and gold fields interlaid with mint-green shards of new growth. Forest-green groves, brakes, and copses stutter into the distance as far as the purple rocks of Montmajour and, at the horizon, the lilac Alpilles under a cloudless cerulean sky.

In a triumph of Cloisonnist gospel over the observable reality of haze and glare, the atmosphere is crystal clear all the way from the bristling cane enclosure in the foreground to the serrated line of mountains miles away. Every fragment of color, from the little blue hay cart at the center of the canvas to the white citadel of Montmajour's ruins near the horizon, shines translucently, unblurred by dust or distance. On this vast, serene landscape, tiny peasants go about their labors in a cartoon narrative of rural life: a reaper finishes his work in one field; a horse-drawn cart trots along the edge of another; a couple walk home in the distance while, not far away, a farmer stands on the back of his wagon and pitches wheat into his grain loft. In the foreground, the ancient artifacts of the harvest are arrayed in silent testimony: ladders against a haystack, the empty blue cart, and a spare set of wheels in brilliant red.

After completing the image in a single day under the burning sun, Vincent came home bursting with new confidence in his art ("this picture kills the rest") and new arguments for his mission in the Midi. "I am on the right track," he exclaimed. "If Gauguin were willing to join me . . . it would establish us squarely

as the explorers of the South." In a reverie of regression, he renewed his vow of solidarity with the peasants of Nuenen. "During the harvest my work was not any easier than what the peasants who were actually harvesting were doing," he insisted. "In the long run I think I shall come to belong to the country altogether."

To support the primitive bona fides of his new images, he recruited both the rustic icons of Millet and the "innocent and gentle beings" of Zola. Following Geffroy's nativist injunctions, he compared his simple images not to Japanese prints, but to the "naïve pictures out of old farmers' almanacs where hail, snow, rain or fine weather are depicted in a wholly primitive manner." He cited as direct inspiration a harvest painting that he had seen in Paris by the newly elevated Anquetin. He claimed a newfound kinship with Paul Cézanne, admired by both Gauguin and Bernard and artistic godfather to the Cloisonnist imagery that now united all three men. Just as Cézanne had become "absolutely part of the countryside" that he painted so often around Aix, only fifty miles away, Vincent claimed an ineffable connection to the Crau. "Coming home with my canvas, I say to myself, 'Look! I've got the very tones of old Cézanne!'" he wrote. "I work even in the middle of the day, in the full sunshine, without any shadow at all, in the wheat fields, and I enjoy it like a cicada."

To Theo, Vincent invoked a pantheon of shared favorites and Goupil bestsellers: from the skyscapes of Philips Koninck and Georges Michel to the Barbizon pastorals of Millet and Dupré to the landscapes of Monticelli. But mostly he invoked the current *entresol* star. A sunset over the Crau had "just the effect of that Claude Monet," he attested; "it was superb." Where Monet had the Mediterranean at Antibes, Vincent had the Crau—"stretching away toward the horizon" as "beautiful and infinite as the sea." Just as Geffroy had claimed for Monet's coastal vistas the power to lull the senses into a dreamlike state, Vincent claimed for his Elysian panorama the power to soothe the weary soul with contemplation of the infinite. "[In] that flat landscape," he wrote, "there [is] *nothing* but eternity."

To underscore that point, he returned in July to the heights of Montmajour and drew his beloved valley from an even loftier perspective. Had the walk from town not been so long or had the wind not blown so hard across the rocky hilltop, he probably would have painted the dizzying view from the abbey ruins. But even with just pen and paper, Vincent could summon up a vision of paradise. On two large sheets (19 by 24 inches), he drew a bird's-eye view of the entire valley. "At first sight it is like a map," he said.

From the limestone outcropping of the Mont de Cordes in the east to the banks of the Rhône in the west, spotted with villages, barns, and farmhouses and crisscrossed with fences, roads, and even a train track, he documented the view at his feet. Then, with an intensity and inventiveness astonishing even by

Vincent's standards, he filled the outline with an ecstasy of tiny pen strokes. No furrow, no fence picket, no stubble of wheat, no plug of grass, no change in texture, no matter how far away, went unrecorded by his obsessive quill. With endless dots and dashes, hash marks and hatchings, strokes and squiggles—each one an argument for the splendor and sublimity of the Crau—he transformed the maplike vista into a magical place. As soon as he finished, he mailed the two drawings to Theo as report, invitation, and plea. "Refresh your eyes with the wide-open spaces of the Crau," he enjoined his brother. "I so much want to give you *a true idea* of the simplicity of nature here."

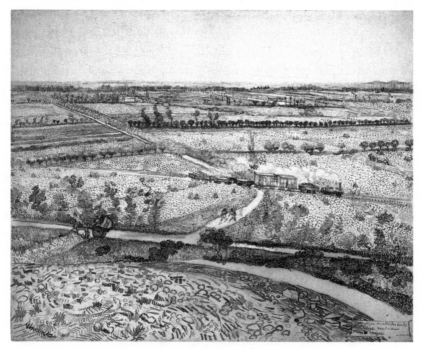

Landscape Near Montmajour with Train, JULY 1888,
INK AND CHALK ON PAPER, $19^3/_8$ X 24 IN.

BUT ONE THING was still missing both from Vincent's art and from his brief for the Midi. He had come to the country, as he always did, looking for models. Stymied for two years in Paris by the expense and the lack of a private studio, he arrived in Arles with his eye alert to the potential for figure painting and portraits in a region well known for its attractive natives. "People are often good-looking here," he confirmed to his sister Wil. On every walk in the streets, he said, he saw "women like a Fragonard or a Renoir," "girls who reminded one of Cimabue and Giotto," or "figures quite as beautiful as those of Goya or Velasquez." But except

for one old Arlesian woman that he painted soon after arriving, his luck had hardly improved from Paris.

The move to the Yellow House in May, which finally provided him with a place to take models other than his cramped hotel room, and the trip to the beach at Saintes-Maries, where he hoped to find bathers to pose for him, announced yet another burst of enthusiasm for "figures, figures, and more figures." "I shall make a furious onslaught on the figure," he declared, "[for] that is really what I aim at." As in Antwerp, he began to talk confidently about luring women to his new studio for portraits. "I am pretty sure they'd take the bait," he wrote leeringly.

But they didn't. In Saintes-Maries, he had come too early for the bathing season, and in Arles, the labor demands of the harvest deprived him of the models he needed to depict it. Nor could he persuade the suspicious peasants to freeze their gleaning or pitching long enough to sketch them in action. As a result, in painting after painting, the heroes of rural life barely feature. Unlike Millet's farmyard icons, the figures in Vincent's harvest paintings, small and roughly drawn, virtually disappear in the celebration of sun and wheat. All during June, he spoiled more than a few images by trying to freehand a figure for lack of a model to pose. "I *still feel* the want of my models," he wrote, recalling the obliging De Groots of Nuenen, "who seemed to be made for me, and whom I still adore; if only I had them here."

Finally, in desperation, he begged Wil to retrieve some of the prints that had been salvaged from his Kerkstraat studio. If he had to work from paper models, not flesh-and-blood, he wanted at least to work from the best. As in the past, he feverishly imagined that his failure to secure models—women especially—imperiled his whole artistic project. "Doing portraits has much more depth," he insisted. "It makes me cultivate whatever is best and deepest in me." Projecting this obsession onto his vision for the Yellow House, he prophesied in oracular tones that the coming artistic messiah—the "Bel Ami of the Midi"—"will be in figure-painting what Claude Monet is in landscape." Like Maupassant's hero, he imagined, the erotic conquistador Gauguin, tamer of wild negresses, would come to Provence and lure the legendary beauties of Arles into the studio that he would share with Vincent.

This vision of vicarious sexual and artistic conquest was only whetted by news that Gauguin had begun his painting of peasant girls dancing—an Arcadian fantasy out of Jules Breton. At the same time, twenty-year-old Bernard tormented Vincent with titillating tales of Parisian bordellos, accompanied by drawings of prostitutes and poems of erotic encouragement. Desperate not to be outdone, Vincent trawled the brothels and back alleys of Arles, just as he had in Antwerp, in search of "public women" to pose for him. That may be how

he found the "dirty little girl" who sat for a single portrait that summer, then disappeared. Vincent boasted of his discovery—a "mudlark with a head like a Monticelli"—to friends like Russell, who both appreciated a good street whore and, Vincent hoped, might support his great plans for the Midi. (He said nothing about her to Theo, however, having vowed abstinence from women for fear of another "petticoat crisis.")

In fact, the best advertisement for the sexual allure of Arles that Vincent could find—and could share with everybody—wasn't a woman at all. It was a man. In mid-June, just as the harvest was interrupted by a week of torrential rain, a striking figure strode into the Yellow House and straddled the chair in front of Vincent's easel. He wore a sleeveless scarlet tunic decorated with bold scrolls of gold and an embroidered collar. A rumpled red fez sat on his head, cocked at a rakish angle. A big black tassel dangled to the side. He straddled the small chair with his legs wide apart, as if on a horse, his hands on his thighs and his elbows akimbo. He stared at Vincent with his dark, deep-set eyes and impatiently chewed a pipe.

"I have a model at last," Vincent exulted, "a Zouave."

Originally recruited to the French army from the Zouaoua tribe of Algeria, the Zouaves had earned a place in the European imagination that reached far beyond the Berber highlands of North Africa. Untamed for centuries by the Ottoman beys, and rebellious against French colonization even into the 1870s, the Zouaves had become symbols of fierceness in battle and feral virility in sex. By the time Vincent encountered them in the brothels of Arles, however, the Zouaves' fame had enticed so many Frenchmen to their ranks that little was left of Africa except the exotic garb and the erotic mystique. Indeed, Vincent had probably been introduced to his young model by a lieutenant in the third regiment of the Zouaves named Paul-Eugène Milliet, whose unit was barracked not far from the brothel district. An estranged son of the middle class turned soldier of fortune, Milliet had come to Arles on leave after a long campaign in French Indochina. He spent his nights at the brothels, but his days indulging his other recreation: drawing. Vincent shared both of the lieutenant's pastimes and soon offered to tutor him in the latter.

But Milliet had a sweet face and refined features—not the image of animal fierceness and carnality that Vincent wanted to send to his confrères in Paris and Brittany. His young model, on the other hand, had "a bull neck and eyes like a tiger," he told Theo—a description that traded on the Zouaves' reputation for both fighting and fucking. On a dare or a bet, perhaps, or after being plied with liquor (as Vincent later confessed), the young soldier came at least twice to the Yellow House and sat broodingly for Vincent's fanatic eye.

To convey the brute sexuality he saw in his subject, Vincent applied thick strokes of saturated color in crashing complementaries: the red fez against a

slab of green with a flash of orange brick to the side, the decorative gold scrolls on his tunic set off by a broad waist sash painted in bright blue instead of its actual color, red. When the Zouave arrived for a second sitting wearing a pair of billowing red pantaloons, Vincent posed him sitting in front of a whitewashed wall with his legs spread wide, creating a huge triangle of vivid red draped over an orange-ocher tile floor and topped by the decorative blue-and-orange tunic and a sash now painted green. He slumps tensely on a bench, staring straight out with coal-black eyes, his sun-darkened skin even darker against the white wall. One large hand fidgets on his knee, the other rests in the blood-red hammock of his pantaloons, drawing attention to the wonders beneath.

Zouave Sitting, JUNE 1888, PENCIL AND INK ON PAPER, 20^1/$_2$ X 26 IN.

As boldly jagged and jarringly colored as these two portraits were, Vincent reported them to Theo and his friends in even starker terms: "That bronzed, feline head with the reddish cap, against a green door and the orange bricks, it's a savage combination of incongruous tones, not easy to manage." Claiming the inspiration of Delacroix, the famous painter of big cats who handled paint as ferociously as his subjects hunted their prey, he boasted of the image's "ugliness," "vulgarity," and "horrible harshness," and vowed to make others just like it because "it may pave the way for the future." The message to his mates was

clear enough. Only in the South, only in Arles, only in the Yellow House could they find the primitive sexuality they craved and the savage imagery their art demanded. As for models: Would a magnificent predator like his Zouave hunt anything but the finest game on anything but the richest range?

Finally, in July, Vincent was able to show the prize. Somehow he managed to persuade or pay a young Arlesian woman to sit for him. She was no beauty; nor was she a stranger to modeling. If the portrait that Mourier-Petersen painted of her earlier that year is any guide, she was a long-faced, raven-haired, thin-lipped, gimlet-eyed woman in her late teens or early twenties. But that is not what Vincent painted. In his fever to lure his companions to the place Lamartine, that is not what he saw.

Licensed by yearning, Vincent's imagination transformed Mourier-Petersen's pensive model into an ideal of sexual gratification that was, at that moment, enthralling men all across France: a *mousmé*. In his fairy-tale travelogue of Japan, *Madame Chrysanthème*, Pierre Loti had described in lurid detail his encounter with this exotic sexual species—a virgin in her early teens, flushed with the first pink bloom of womanhood, offered up by the natives of that most exotic land for the delectation of a white visitor—a prostitute, a mistress, a child bride, a sex doll, whose only purpose was pleasure. "Now if you know what a *'mousmé'* is," Vincent announced to Theo, who was, like all of the brothers' circle, entranced by Loti's recently published fantasy, "I have just painted one. It took me a whole week, and I haven't been able to do anything else."

In that week of exhausting effort, Vincent worked and reworked his portrait of the Provençal girl in an ardor of image-making reminiscent of *The Potato Eaters*. He narrowed her eyes, darkened her brows, and puckered her mouth to comply with Loti's descriptions. He tried especially hard to transform his model's slender face into the pleasing and docile "puffy little visage" that so beguiled Loti. He layered color after color on her hands and face, searching for the exact combination of yellow and pink—Nipponese exotic and feminine universal—that Loti, too, had struggled to reconcile. He dressed her in garish country-girl finery that owed less to Arles or Japan or even Loti's fancy of Japan than to Cloisonnist precepts of design and ornament: a red-and-violet-striped bodice with bright gold buttons, and a billowing skirt vividly polka-dotted in orange and blue. He sat her on an extravagantly curvilinear bentwood chair and set her against a background of pure celadon—a misty green, borrowed from oriental porcelain, that resisted the red stripes of her bodice and the scarlet bow in her hair even as it submitted to the royal blue of her skirt.

Finally, he placed in her hand a branch of oleander, a blossom that symbolized for Vincent both the allure and the thrilling danger of sex. Its pale pink blossoms could be poisonous. Its tender leaves could raise sores on tender skin. Even its enchanting fragrance, if inhaled too deeply, could kill. The hand that

holds this ambivalent bouquet rests, like the Zouave's, on her lap, in the bole of her colorful skirt, gesturing toward the treasures beneath.

With *La mousmé*, Vincent completed the narrative of primitive lust begun with the Zouave: the former's design for pleasure a pendant to the latter's savage appetite. With these images, advertised in elaborate drawings sent to all his friends, Vincent beckoned everyone—but especially Gauguin—to a land of exotic eroticism; a land filled with women of "shapely, firm breasts" and lamblike docility that matched anything in Loti's Japan or Gauguin's Martinique; a land of sexual adventurers and the child brides to amuse them; a land without inhibitions—sexual or artistic; an erotic nirvana of primitive sex and primitive art equal to anything in fiction or sailors' tales. It was a promise sure to lure even the Bel-Ami to the Midi.

WITH UTOPIAN VISIONS like these filling his head, Vincent waited in a reverie of anticipation for word from Pont-Aven. Accompanied by the Zouave lieutenant Paul Milliet, he made frequent sketching trips into the countryside in July and August, especially to his favorite spot, the rocky summit of Montmajour. Together they explored the craggy mountaintop and its mazelike ruins. It was on one of these fraternal expeditions that Vincent discovered the abbey's old garden, a crumbling enclosure neglected for a century, boisterously overgrown in the benevolent southern sun. "We explored it together and stole some excellent figs," Vincent reported, describing for Theo the garden's "great reeds, vines, ivy, fig trees, olives, pomegranates with lusty flowers of the brightest orange . . . and scattered fragments of crumbling walls here and there among the greenery."

In this word painting of the hidden paradise among the ruins of Montmajour, as in all things, Vincent's imagination was tutored by his reading. The abbey's untouched garden reminded him of the famous walled garden in Zola's *La faute de l'abbé Mouret* (*The Sins of Father Mouret*), a wonder of nature and neglect where Zola's hero finds both the unspoiled bounty and sensual abandon of the Garden of Eden. Zola described it as "a bit of paradise" where nature "frolicked wildly" and "offered herself strange bouquets, destined to be picked by no hand"; where flowers "stampeded into the walks" and "gamboled about with such exuberance, that it was now nothing but a riot, a bushy mob beating against the walls." Zola called this mystical garden, also abandoned for a century, *Le Paradou*.

Like Zola's amnesiac hero, Serge, who fell in love with the *Paradou*'s only inhabitant, a wild young blond girl named Albine, Vincent found a promise of happiness in the abbey's hidden garden. Rehearsing the longed-for arrival of another Paul from Pont-Aven, he walked among the garden's hundred-year-old trees, lichen-covered rocks, and profligate fruitings in the playful company

of the young soldier Milliet. "He is a handsome boy, very unconcerned and easy-going," Vincent wrote, "and very nice to me."

Vincent painted the approach to Montmajour, with its sentinel trees clinging to bare rock (taking up again the old hopeful theme of life springing miraculously from blight), and made elaborate drawings of the abbey *donjon* with its vertiginous view. But a fierce spell of mistral prevented him from painting or drawing in the garden where he and Milliet frolicked. To express these exquisite intimations of happiness on paper and canvas, he searched the side streets and surrounds of Arles for vignettes of nature's exuberance that he could incorporate into the vision of *Paradou* in his head. In image after image, in paint-

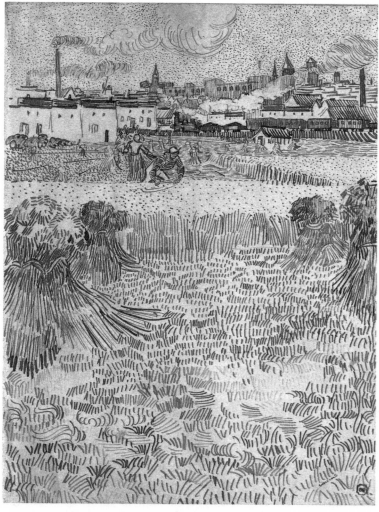

Wheat Harvest at Arles, 1888, INK ON PAPER, 12¼ X 9½ IN.

ings and drawings, he lavished his brush and pen on gardens in riotous bloom. So extravagantly fertile are these visions of liberated nature that their opulent verdure pushes the horizon almost out of view and overwhelms the enclosures that try to restrain it. Even in the sandy peninsula created by a looping path to the public bathhouse, Vincent saw a vision of nature unchained: an explosion of "lusty flowers of the brightest orange"—oleanders, just coming into bloom.

BUT PAUL GAUGUIN had his own ideas about paradise. And mostly they involved money. As a former stockbroker with a family of six to support, a censorious wife to appease, and serious material ambitions for his artistic career, Gauguin could not afford the luxury of Vincent's utopian dreams. In response to the invitation to Arles (which he described as "touching"), Gauguin offered a colorful image of artistic camaraderie that thrilled Vincent to the core: "He says that when sailors have to move a heavy load, or weigh anchor," Vincent told Theo, "they all sing together to keep them up to the mark and give them vim. That is just what artists lack!"

But this tantalizing conceit came accompanied by a dizzyingly ambitious scheme that dwarfed even Vincent's grand plans for the Van Gogh brothers' *entresol* enterprise. Gauguin proposed that Theo lead an effort to raise the astounding sum of six hundred thousand francs "to set up as a dealer in impressionist pictures." Vincent was so dumbfounded by the amount that he refused even to discuss the details of Gauguin's plan with his brother. Instead, he dismissed it as a *"fata morgana"*—a mirage of hope—and attributed it to Gauguin's debilitated condition. "The more destitute you are—especially if you are ill," he wrote, without a hint of irony, "the more you think of such possibilities. To me this scheme simply looks like another proof of his breaking down, and it would be better to get him away as quickly as possible."

The unexpected reply cast a cloud over Vincent's sunny plans for the Yellow House. In a fit of ire that combined vexation, indignation, and sibling rivalry, he denounced Gauguin's counterproposal as "nothing but a freak" and demanded its immediate retraction. He girded Theo against the Frenchman's blandishments, and suggested that Gauguin should butt out of the brothers' business affairs. "The most solid asset Gauguin has now is his painting," Vincent wrote, "and the best business he could do [is] his own pictures." Indeed, he turned Gauguin's experience at the Bourse into fodder for dark speculation about a possible conspiracy with "Jewish bankers" to undo the brothers. In a huff, he threatened to withdraw his invitation and find another, more grateful artist to share his studio in the South. In desperate straits, Gauguin finally backpedaled from his grand scheme and wrote Theo "replying categorically and affirmatively to the proposition you made me concerning going to Arles."

Vincent's spirits soared. "Your letter brings great news," he cheered. "Gauguin agrees to our plan. Certainly the best thing would be for him to come rushing here at once." But the elation lasted only a week before Gauguin delayed his departure yet again with more claims of financial distress (he needed travel money), more complaints of illness, and more punishing silences between letters. By mid-July, Vincent felt the need to mount yet another campaign to convince Theo that the combination with Gauguin made financial sense. Against his own better judgment, he pushed harder for Russell to buy a Gauguin painting; he sent his Montmajour drawings to the dealer Thomas and offered the proceeds from their sale to offset Gauguin's expenses; and he proposed to organize an exhibition for Gauguin in Marseille. In a stunning reversal, when Theo suggested that he might quit Goupil, Vincent not only pleaded with him to *stay*, for fear that quitting might jeopardize the plan for Gauguin, he even offered to go back to work for the firm himself. Finally, in an unprecedented gesture, he returned some of the money that Theo sent him.

By July 22, Vincent felt compelled to repeat a startling proposal he had first made in late June, the last time negotiations threatened to collapse. Setting aside all his dreams for the Yellow House and a studio in the Midi, he offered to go to Pont-Aven. "If Gauguin cannot pay his debts or his fare," he wrote Theo, "why shouldn't I go to him if we want to help him? . . . I lay aside all preference, either for the North or the South. Whatever plans one makes, there's always a root of difficulty somewhere." Only a few days later, however, his spirits rebounded when a letter arrived from Pont-Aven reporting Gauguin's improved health and closing on an optimistic note: "While waiting to be reunited affectionately, I offer you my hand." Vincent responded immediately, enclosing a sketch of his latest calling card for the Midi, *La mousmé*. But when weeks passed without another word—a form of torment by silence that Vincent knew well—his spirits sank again.

And so it went. Every surge of hope was followed by new obstacles, as Gauguin weighed his options and maneuvered to gain maximum advantage from the brothers' invitation. To Vincent, he sent complaints about his isolation in Brittany. "The band of boors who are here find me completely insane," he wrote, echoing back Vincent's defiant alienation, "and that pleases me because it proves that I am not." To Theo (whom he addressed with a mispelling, "Monsieur Van Gog"), he bewailed his "pestering creditors" and dangled promises of imminent sales, even as he solemnly pledged to Arles: "I am a man ready for sacrifices."

The mixed messages coming out of Pont-Aven were matched by doubts in Paris. Reading Vincent's urgent, exhortatory missives alongside Gauguin's cool, tactical communiqués, Theo began to have second thoughts. The Frenchman was already taken aback by Vincent's "intimidating" letters and lavish praise.

Were his brother's expectations too high? Would these two very different artists prove incompatible? Would his brother's overweening ardor collide with Gauguin's subtle self-advancement?

When these concerns inevitably leaked to Arles, Vincent reversed course completely. After months of mercenary frenzy, he disavowed any expectations of commercial success for the combination with Gauguin and offered up extravagant sermons on the folly of ambition and the perils of fame. The "treacherous public" would never warm to the "austere talent" of painters like Gauguin and himself, Vincent wrote, "[for] it likes only easy, pretty things." To expect more from his art than "*eternal* poverty," "social isolation," and a "siege of failure" would only be to invite misery, he professed. "I neither care about success for myself nor about happiness," he assured Theo, recanting his earlier excitement over Geffroy's expression of interest in his work. "What I do care about is the permanence of this vigorous attempt by the impressionists."

In mid-August, Vincent's worst fears seemed realized when Gauguin, ever vigilant for advantage, signaled that he might go to Paris instead of coming south. "Gauguin is hoping for success and cannot do without Paris," Vincent wrote despairingly. "He would feel that he was doing nothing if he were [here]." Only a few days later, a letter arrived from Bernard reporting on his visit with Gauguin in Pont-Aven. The letter included "not one syllable about Gauguin intending to join me," Vincent wrote in anguish, "and not a syllable either about wanting me to come there."

The ups and downs of these triangle negotiations cast Vincent into a perdition of anxiety. With every delay from Pont-Aven and every reservation from Paris, he felt his dreams of an artistic *Paradou* slip further from his grasp. Always one to see conspiracy instead of confusion, he sank deeper and deeper into rancor and depression—a state compounded by continued silence from Russell; perceived slights from MacKnight; more frustrations over models; another round of guilty spending; the resurfacing of old debts in Paris; and his reading of *L'année terrible* (*The Terrible Year*), Hugo's pitilessly depressing account of the Paris Commune. He quieted his fears with long, arduous days in the blazing summer sun; endless cups of coffee, sometimes laced with rum; and dreamy evenings of absinthe—even more popular in Arles than in Paris. "If I thought about, if I dwelled on the disastrous possibilities," he wrote, "I could do nothing, [so] I throw myself headlong into my work with abandon . . . If the storm within roars too loudly, I take a glass too many to stun myself." He punished himself with the usual exertion and starvation. He cut off his beard and shaved his head.

The months of uncertainty roiled his sleep, upended his stomach, and jangled his already frail nerves. "It has cost me a carcass pretty well destroyed," he admitted to Theo in an unguarded moment, and "my mind pretty well cracked."

His sole occasional companion, the lieutenant Milliet, described Vincent as racked by mood shifts as wild as the mistral: one minute seized by "hotheaded" fits of anger ("when he was mad, he seemed crazy"); the next, by "exaggerated sensitivity" ("sometimes reacting like a woman"). His letters skidded from exuberance to anger to resignation. He continued to wage furious battles against every objection and impediment even as his confidence collapsed in gasps of despair: "All that one hopes for, independence through work, influence on others, all comes to nothing," he cried, "nothing at all." He dolefully tallied the amount Theo had sent him over the years ("15,000 francs") and joked blackly that the money might have been better spent buying other artists' work. In a feisty moment, he blamed his plight not on Gauguin but on "an ungrateful planet"—"the worm-eaten official tradition" that left all avant-garde artists "isolated, poor, [and] treated like madmen."

In a spasm of optimism, he tacked up thirty of his canvases in the Yellow House, treating himself to an exhibition of his own work while he waited for the paint to dry so he could send them to Paris. "We have gone too far to turn back," he cheered his brother unconvincingly. "[I] swear to you that my painting will improve. Because I have nothing left but that." In bleaker moods, he saw the inescapable hand of fate—"[Perhaps] the hope of doing better is rather a *fata morgana*, too"—and acknowledged the cost of resisting it. "I do not feel I have strength enough left to go on like this for long. . . . I am going to pieces and killing myself." Still, he choked on the prospect of yet another failure. "You see that I have found my work," he wrote his sister and confidante, Wil:

> and you see too that I have not found all the rest that belongs to life. And the future? Either I shall become wholly indifferent to all that does not belong to the work of painting, or . . . I dare not expatiate on the theme.

But no act of will could prevent his thoughts from slipping into darker realms. With increasing frequency, he referred to himself as "mad" or "cracked" or "crazy"—sometimes in self-conscious jest, sometimes in deadly earnest. Being treated like a madman, he warned pointedly, can lead to "actually becoming so." Even after shaving his head, he looked in the mirror and saw the sunken cheeks and "stunned" expression of Hugo van der Goes, the "mad painter" famously depicted by Émile Wauters as hirsute, wild-eyed, and clutching himself—an image of artistic torment that had haunted Vincent's imagination since before he became an artist.

These demons were already loose in his head when word arrived at the end of July that Uncle Cent had died. At the age of sixty-eight, the venerable dealer had finally succumbed, outlasting all but one of his brothers despite decades of ill health. Although alerted in advance to Cent's imminent demise, Vincent took the

news like a hammer blow. All the ghosts of Holland descended on the stalemate with Gauguin. His letters filled up with long ruminations on death and mortality—surrogates for past mistakes, lost opportunities, and imminent failure.

Infuriated by Wil's report that the unyielding Cent had died in "peace and calm," he dismissed his uncle's—and his father's—comforting certainty of an afterlife as nothing more than the vanity of old women. But the possibility of an unforgiving void terrified him. To fill it, he threw up a teetering edifice of speculation on the possibility of other, "invisible" worlds. Combining his call for a rebirth of modern art with his unmet need for personal redemption—now further foreclosed by Cent's death—he wondered if there might be "another hemisphere" of life where artists were recognized for themselves, not just for their sales; where the burden of guilt was lifted; the sins of the past, forgiven. "It would be so simple," he imagined, "and would account so much for the terrible things in life, which now amaze and wound us so."

He took long walks at night, peering into the sky and pondering the new reports of distant planets and unseen worlds, imagining a paradise that he seemed unable to make in his own world. "I always feel I am a traveler," he wrote, "going somewhere and to some destination. If I tell myself that the somewhere and the destination do not exist, that seems to me very reasonable and likely enough." He compared life to "a one-way journey in a train": "You go fast, but cannot distinguish any object very close up, and above all you do not see the engine."

> Why, I ask myself, should the shining dots of the sky not be as accessible as the black dots on the map of France? If we take the train to get to Tarascon or Rouen, we take death to reach a star. One thing undoubtedly true in this reasoning is this: that while we are *alive* we *cannot* get to a star, any more than when we are dead we can take the train.

Caught in a maelstrom of dark musings, Vincent grasped for the only sure consolation he knew. On a large canvas, he sketched out a familiar image more comforting than any promise of paradise: a sower. The idea came to him during his work on harvest paintings in the Crau. It came as a vision, not as a vignette. In June, the fields were filled with reaping, not sowing, which would not start until the fall. Like his views of the Langlois Bridge, it sprang from a deep, burning nostalgia. "I am still enchanted by snatches of the past," he wrote at its conception, "and have a hankering after the eternal, of which the sower and the sheaf of corn are the symbols."

With no one to pose, he was forced to rely on his memory of Millet's iconic version of the subject, which he had seen only as a print and, briefly, in a pastel rendering. But no matter. The image of the proud, striding figure with the sack of seeds slung over his shoulder and his arm outstretched had haunted

him with hope since the depths of the Borinage. In the years since—in Etten, in The Hague, in Drenthe, in Nuenen—he had tried again and again to express the promise of redemption through persistence that his father preached, that Millet gave form, and that all the heroes of his imagination, from Eliot to Zola, confirmed. But every attempt had failed. "I have been longing to do a sower for such a long time," he lamented as he watched the harvest finish in Arles, "but [it] never comes off. And so I am almost afraid of it."

He attacked and retreated from the harrowing image in a struggle as furious and fraught as the parallel struggle with Gauguin and Theo over the future of the Yellow House. The battleground canvas recorded every surge and every rout of confidence. It began, like *The Boats at Saintes-Maries*, as another affirmation of the new Cloisonnist gospel, as he described to Bernard: in the foreground, "a definite purple" of plowed earth; at the horizon, a line of ripe wheat of "yellow ochre with a little carmine"; a giant sun in a sky "chrome yellow, almost as bright as the sun itself"; and a single sower in "blue smock and white trousers." Only a week later, his hopes for the image had spiraled upward toward something "done completely differently." Invoking the older complementary gospels of Blanc and Chevreul, and their messiah, Delacroix, he imagined painting his sower just as Delacroix had painted Christ on the Sea of Galilee: an icon of calm in the storm, of serenity in rejection, of reincarnation through suffering. "I am trying to get at something utterly heartbroken," he struggled to explain, "and therefore utterly heartbreaking."

He thrust himself deeper into the image with a vision of Christ as a "great artist" who spread the light-filled art of redemption just as the striding figure in the field spread the seeds of rebirth. "What a sower," he exclaimed, "what a harvest!" Around the same time, he painted a strange, impossible self-portrait depicting himself "on the sunny road to Tarascon"—the path to eternity—striding confidently and shouldering his load of sketchpads, canvases, pens, and brushes: the seeds of his new faith. "I consider making studies like *sowing*," he once said, "[and] I long for a harvest time."

Driven by such metaphysical ambitions, Vincent worked and reworked the simple image he described to Bernard. Channeling all his frustrations with the present and expectations for the future, he cast and recast the pose of the lone sower, bringing it more into line with his memory of Millet's talismanic figure. He layered and relayered the canvas with new colors, dashing green into the yellow sky to brighten the sun and accent its radiations; adding orange into the purple field, laying on thick shingles of paint in a votive obsession of Impressionist brushwork. He claimed for all these worried reworkings the same mandate he claimed for his worried dreams of the Yellow House: Corot's deathbed summons to a deeper truth. "I couldn't care less what the colors are in *reality*," he boasted to Bernard, as long as they satisfied his "hankering after the eternal."

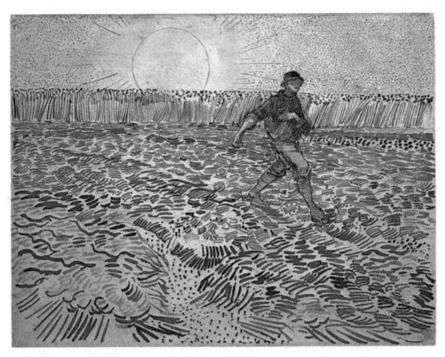

Sower with Setting Sun, AUGUST 1888, REED PEN AND INK ON PAPER, 9⅝ X 12⅝ IN.

But the image continued to confound him. He dismissed the result of all his hard work as merely an "exaggerated study"—yet another seed that failed to take root. He set it aside in his studio, "hardly daring to think about it." But it continued to "torment" him, he confessed, "making me wonder if I shouldn't attack it seriously and make a tremendous picture of it. My Lord I want to. But I keep asking myself if I have vigor enough to carry it off." In letters to Theo, he taunted himself with his own cowardice: "Could one paint the Sower in color . . . yes or no? Why, *yes.* Well, do it then." Finally, with a great heave of frustration, he consigned the image to the same uncertain fate as his dream for the Yellow House. "There is certainly a picture of this kind to be painted of this splendid subject," he wrote, "and I hope it will be done someday, either by me or by someone else."

IN MID-AUGUST, the terms of Uncle Cent's will were revealed. As expected, the old man left his impoverished nephew Vincent not a cent. Indeed, he had taken the opportunity to lash out one last time at his ne'er-do-well namesake. Even as he lavished large sums on family retainers and distant relatives, he disinherited Vincent not once, but twice. And not by discreet omission. "I want to make the

clear statement that it is my intention that Vincent Willem van Gogh, oldest son of my brother Theodorus van Gogh, will have no share of my estate," he scolded from the grave. Elsewhere, he excluded Vincent "and his progeny"—a spitting expression of the family's undying suspicion that Vincent had fathered Sien's infant son.

But he had also left special bequests to both Theo and his mother, as well as more than a quarter of his sizable estate to Dorus's children upon the death of Cent's wife Cornelia. The double legacy relieved Theo of both current and future financial burdens. But it also left him with a great weight of guilt. "It's a pity," he wrote to his mother on behalf of his rejected brother. (Anna was unmoved.) Within days, he wrote both Vincent and Gauguin promising to use Cent's legacy to "carry out [their] combination." He offered Gauguin the same favorable terms he had long provided his brother: a monthly stipend of one hundred and fifty francs in exchange for twelve paintings a year. He would also pay Gauguin's debts and travel expenses. Only a few days later, a letter arrived in Arles. "I have had a note from Gauguin," Vincent reported ecstatically. "He is quite ready to come South as soon as the opportunity arises."

By the twisted, hidden currents of Van Gogh family hearts, the unforgiving old dealer had thrown a lifeline to Vincent's most improbable bid for rehabilitation, and brought him within sight of his *Paradou*.

CHAPTER 32

The Sunflower and the Oleander

~

THE PETALS CAME LAST. WITH A FULL BRUSH AND A TURN OF THE WRIST, he applied the twisting yellow and orange strokes one at a time, one after the other. The pan-sized composite flowers, with their sunburst aureoles of ray florets and densely packed centers of multihued disc florets, opened the floodgates of Vincent's fevered imagination and manic brush. At their last blooming, a year before in Paris, he had brooded obsessively over the details of these giant flowers listing on their rigid stalks. But now, in Arles, on the eve of Gauguin's arrival, he saw only extravagant form and brilliant color.

Against a background of the most intense turquoise—a hue pitched perfectly between acid green and sublime blue—he sketched three huge flower heads. In a squall of tiny strokes, he transformed their spiraled discs into color wheels of complementaries: dashes of lavender for the yellow petals, cobalt for the orange. A slashing sortie draped a great floppy leaf over a lime-green vase, glazed and glistening in the bright light of his new studio. Another sortie, another leaf. He jabbed at the tabletop in a blaze of reds and oranges and then polished it with glancing strokes in every color on his palette.

He painted the way he talked: thrust and parry, assault and retreat. Barrages of brushwork swept across the canvas again and again, like summer storms. Furious exhortations of paint, as intense as fireworks, were followed by wary, ruminating reassessments as he recoiled from the image, arms folded, plotting his next volley. Then, just as suddenly, his brush would dart to his palette, dabbing and stirring, dabbing and stirring, searching for a new color; then rush to the canvas, bursting with new arguments and fresh fervor. "[He] became a fanatic as soon as he touched a paint brush," recalled the Zouave Milliet disapprovingly. "A canvas needs to be seduced; but Van Gogh, he, he raped it." Another witness described how Vincent attacked the canvas with both paint *and* words—

muttering and sputtering, coaxing and cajoling, bullying and railing—giving voice to his arguments even as his hand gave them form, texture, and color.

In both debates, he thrived on confrontation. If critics like Kahn and painters like MacKnight thought his colors too bright, he made them brighter. His wildflowers demanded a yellower yellow than the one in his tubes—a cruder, sunnier, "savage" yellow—and he searched his palette for just the right touch of green to make it shriek, or a deep complementary to make it pop. His goal, he said, was "to arrange the colors in a way that makes them vibrate." And if Theo criticized his work as too hasty, too "haggard," and urged him to slow down, he painted even faster—impossibly fast. He compared his painting style to the eating style of a local *paysan* ravenously slurping bouillabaisse, and claimed that the faster he worked, the better the results. Describing himself as a man "driven by a certain mental voracity," he despaired of "ever painting pictures that are peaceful and quietly worked out. . . ." "It will always be headlong," he lamented.

But, of course, it never was. Just as his campaigns of persuasion unfolded over many letters, and his letters sometimes went through multiple drafts, his paintings often gestated for weeks or months or even years before brush touched canvas. The image of a vase of sunflowers had been in his head since at least a year earlier, when he saw a bouquet of the huge flowers in the window of a Paris restaurant near Theo's gallery. At the time, he had painted a series of individual blossoms, arranged in a morbid narrative and depicted in the descriptive, backward-looking draftsman's style of The Hague. In the year since, however, Vincent had discovered the new testament of Cloisonnism, and the image of sunflowers in his head took new form and new color.

He practiced this new vision on a jug of early-blooming wildflowers in May, and then rehearsed it again in June with the boats on the beach at Saintes-Maries—"so pretty in shape and color that they make one think of flowers." All summer, as he raced from field to field in search of imagery and hunted from brothel to brothel for models, this vision of simple flowers haunted him. "I reproach myself for not painting flowers here," he wrote in early August. "Under the blue sky, the orange, yellow, red splashes of flowers take on an amazing brilliance, and in the limpid air, they look somehow happier, more lovely than in the North." When the first sunflowers appeared soon thereafter, the plan sprang back to life. "I am thinking of decorating my studio with half a dozen pictures of 'Sunflowers,'" he announced to Émile Bernard.

To the Symbolist Bernard, Vincent promised "effects like those of *stained-glass windows* in a Gothic church." To his dealer brother, he promised "a symphony in blue and yellow" that would rival Monet's Antibes paintings, as well as a huge "decorative scheme" (grown to a dozen panels) to match the ambitious projects of Seurat. Vincent himself was naturally drawn to the gawky, late-starting flowers that now dotted gardens everywhere in Arles, no doubt seeing his own story

in their glorious blooming, mad bounty, and sad decay. But his most important audience was the painter he expected to walk in the door of the Yellow House any day. "Now that I hope to live with Gauguin in a studio of our own," he wrote longingly, "I want to make decorations for the studio. *Nothing but large sunflowers.*"

But first he had to work them out. "Great things do not just happen by impulse," he had written early in his career, "but are a succession of small things linked together." He spent long days and sleepless nights planning the color "program" that would both differentiate and unite so many images. He described it to Bernard as "a decoration in which the raw or broken chrome yellows will blaze forth on various backgrounds—from the palest malachite green to royal blue." He plotted the variables until his head spun in a "damnably difficult mess" of combinations.

Having heard the criticism that Monet's Antibes paintings, for all their luscious atmosphere, suffered from a "total lack of construction," he pledged himself to the "logical composition" of Cézanne and the "reasoned color" of Dutch masters like Vermeer. Like these and other "scientific" painters, he claimed, he had prepared for his series of sunflowers with hours of careful calculations: calculations of everything from the size and orientation of each canvas to its exact color scheme and the amount of paint it would consume, color by color. Only through this kind of elaborate advance planning, with his mind "strained to the utmost," could he hope to produce "a quick succession of canvases quickly executed."

But no matter how much preparation he did, it never seemed enough. "Alas, alas," he wrote Bernard, "the most beautiful paintings are those which you dream about when you lie in bed smoking a pipe, but which you never paint."

By the time all Vincent's "calculations" burst onto canvas in late August, the giant heliotropes were the last blooms left in the gardens, and already beginning to fade. But, of course, with the new gospel of exaggeration animating his palette and brush, he barely needed to look at the vase of wilted sunflowers sitting on a table in the Yellow House. He may have skipped altogether the preliminary charcoal drawing that had always guided him in the past, and gone straight to paint. Roughing in just enough of the composition—the vase, a few flowers, and the tabletop horizon—he locked in to the Cloisonnist program and complementary logarithms that had kept him awake at night. Before long, he was working on three paintings simultaneously: two with three flowers apiece and one with at least a dozen huge blossoms in various states of eclipse. It was less an orderly progression than a rhetorical outburst. "I am working at it every morning from sunrise on," he reported to Theo, "for the flowers fade so soon, and the thing is to do the whole in one rush."

Inevitably, once his brush touched canvas, all Vincent's nights of careful planning collided with the impetuous rush of paint. For a man whose enthusi-

asms knew neither patience nor caution, the infinite permutations of color and stroke proved an irresistible lure to improvisation: a spontaneous eccentricity of line, a serendipitous clash of color, an ardor of impasto, a lyrical flight of brushwork. Every errancy, accident, or inspiration triggered a new round of calculations as the weeks of planning wrestled with his brush in a furious dialectic of purpose and effect. He compared his working sessions to a "fencing match," pitting "intensity of thought" against "tranquility of touch."

Vincent understood this contest well, and, at different times, championed both its contestants. One day he would insist on the necessity of speed, citing both the bestselling Monet and the immortal Delacroix. But when Theo questioned his consumption of paint or the hasty, unpredictable results, he insisted that every stroke and color choice had been determined beforehand, citing Monticelli—"the logical colorist, able to pursue the most complicated calculations, subdivided according to the scales of tones that he was balancing." Other times, he would blame the wild winds of the mistral for his turbulent brushwork, comparing himself to Cézanne, who also had to tame a "reeling easel."

But the real storm that shook Vincent's easel and trembled his hand was the one inside his head. Indeed, he worked best under the pressure of exigency, whether a tempest on the beach at Scheveningen, the raging mistral of the Crau, or the damning voices of the past. Only friction—between himself and the elements, between hope and experience, between elaborate planning and evangelical zeal, between the Cloisonnist mandate to simplify and his obsessive need to persuade—only friction could induce the "feverish state" of creativity from which, he believed, all his best work emerged. "I count on the exaltation that comes to me at certain moments," he wrote, "and then I let myself run on extravagances." He described the "terrible lucidity" that came over him in such moments, "when nature is so beautiful, I am not conscious of myself any more, and the picture comes to me as in a dream." He claimed as his model Japanese artists, with their "lightning" execution and absolute sureness of touch ("as simple as breathing"). He invoked Monticelli, too, defending the much-maligned Marseille painter, and himself, against charges of painting in a mad or drunken frenzy. "They call a painter mad if he sees with eyes other than theirs," he scoffed, daring any drunkard to attempt either man's acrobatic feats of color.

But Vincent had always preached the paradox of calm in the storm, joy in sorrow, comfort in pain. And he had already exalted his own inner turmoil by committing to memory a famous tribute to Delacroix: "Thus died—almost smiling—a painter of a noble race, who had a sun in his head and a thunderstorm in his heart." Bystanders like Milliet, who gaped at Vincent's assault on the canvas or mocked the manic theater of his dialogue with images, saw exactly the same exhausting and combustible choreography of certainty and doubt, of dervish intelligence and fanatic heart, that flamed through his writing. "Everyone

will think that I work too fast," he warned Theo self-knowingly. "Don't believe a word of it. Is not emotion, the sincerity of one's feeling for nature, what attracts us, and sometimes the emotions are so strong that one works without knowing one works, and the strokes come with a continuity and a coherence like words in a speech or a letter."

By the end of August, burning with anticipation of Gauguin's arrival, Vincent submitted yet another image of sunflowers to the "furnace of creation." This time, the logic of complementaries lost the battle to the "extravagance" of brilliant effect. The whiplashing mistrals of conception and execution further disentangled object from atmosphere, color from context, and image from reality. The result was "a picture all in yellow": yellow flowers on a yellow-green background in a yellow vase on a yellow-orange table. Vincent pronounced it "certainly different," and assigned it a very special role. Like the flowers themselves, which turned to the east every morning to salute the rising sun, Vincent's yellow canvas would greet the Bel-Ami due at the door any day. "The room you or Gauguin will have," he wrote Theo, merging his dreams of a new brotherhood in the Midi with memories of the last one in Paris, "will have white walls with a decoration of great yellow sunflowers."

THE THRILL OF anticipation at Gauguin's coming, and the promise of renewal that came with it, filled every corner of Vincent's life in Arles. He leaped out of bed early every morning, rushed to his studio, and worked until sunset. "I am vain enough to want to make a certain impression on Gauguin with my work," he confessed, "so I cannot help wanting to do as much work as possible before he comes." He ate heartily twice a day at the Café de la Gare, claiming that the better food there not only quieted his stomach, but also improved his work. He took "splendid walks" into the countryside, especially among the vineyards, where preparations for the fall harvest were already under way. He bought a fine new black velvet jacket and a new hat to greet his guest in style.

A special visitor also required special accommodations. By September, the Yellow House had been painted inside and out, but was still without gas. Vincent could work there during the daylight, but had to return every night to his room over the all-night café. He had never intended to use more than just the large studio downstairs: a single room for both painting and sleeping. The rest would serve as "storehouse for the campaign," he told Theo. But Gauguin's coming changed all that. Only a true *"maison d'artiste"*—"an artist's house . . . in an absolutely individual style"—would do to welcome his new partner.

Struck by a newspaper story about an "impressionist house" built of violet-colored glass bricks, Vincent spent long hours devising a "scheme of decoration" that would transform the plain commercial building at 2, place La-

martine into a studio that reflected the *new* new art—the art of Japan. "The real Japanese have nothing on their walls," he told Theo, drawing on his reading of Loti's *Madame Chrysanthème*. "The rooms there are bare, without decoration or ornaments." As if planning a Cloisonnist painting, he imagined a space defined by white walls, bright light, red tile floors, and squares of blue sky. "*Nothing precious,*" he vowed, nothing "commonplace": none of the curio-shop clutter of most artists' houses. "I am so set on making an artist's home . . . not a haphazard production, but a deliberate creation."

But like all Vincent's deliberate creations, the Yellow House was subjected to contrary currents. Loti's Japanese may have kept "the drawings and curiosities all hidden in the drawers," or placed only a single scroll or exquisite arrangement of flowers in a niche, but Vincent had a world of arguments to make and only one place to make them—where he had always made them—on his walls. Quickly scrapping the plan to hang only sunflowers, he framed dozens of his own paintings in oak and walnut and placed them throughout the house— especially in the small bedrooms upstairs where he and Gauguin would sleep. Rather than leave any wall empty, even in the kitchen, he hung "a great wealth of portraits and painted figure studies" along with the usual gallery of prints.

Then he filled the rooms with furniture. The Japanese model of "simple white mats" and his own pledges of "order and simplicity" could not long restrain Vincent's mania for homemaking. As in The Hague, when he prepared the Schenkweg studio for the return of Sien and her baby from the hospital, he went on a binge of furniture buying that included beds, mattresses, linens (lots of "bedding"), mirrors, dressing tables, chests of drawers, chairs, and unspecified "small necessities." Everything had to be bought in twos, of course, except for a single kitchen table and a frying pan big enough for two. In addition to the two bedrooms upstairs, he planned two studios downstairs: the big front room for Gauguin, the kitchen for himself. Finally, he bought two planters to put on either side of the front door, so blooming bushes would greet the newcomer.

When Theo objected to this spree of spending, Vincent defended every extravagance as necessary. "If Gauguin and I do not take the opportunity to fix ourselves up like this, we may drag on year after year in small lodgings where we cannot fail to go to seed," he argued tartly. "I have pretty well done that already." After a supplementary "loan" of three hundred francs disappeared, Vincent countered his brother's worried concern with buoyant promises of long-term savings, rich returns, improved health, "freer" work, and inevitable success. "And now you can tell yourself that you have a sort of country house," he added brightly, "though unfortunately rather far away."

In his fervor of scene-setting, Vincent refurbished not just his house in Arles, but his whole attitude toward the Midi. After the summer's battles with wind

and sun, the disappointment of models, and the contumely of neighbors, he embraced once again the "crude and casual" South of Tartarin. He painted for Theo (and Gauguin) an irresistibly inviting picture of a land where an artist could find the primitive simplicity, cosmic comedy, and sublime humanity of Daudet's clown. He portrayed himself as Voltaire's hapless hero, Candide, let loose in a land of impossible color and Daumier caricature. He extolled the artistic charm of provincial dullness by citing the two most famous dullards in French literature, François Bouvard and Juste Pécuchet, Flaubert's Laurel and Hardy of comic pretension and antic overreach.

He advertised this vision not just in his jaunty self-portrait as a traveler on the "sunny road to Tarascon," but in a playful study of a group of wagons camped beside the road. These rickety two-wheeled covered carts belonged to "the performers in a traveling fair," he reported to Theo as he spun an elaborate conceit of painting as a sideshow trick and himself as a carnival performer. "That's what I'm good at," he boasted in the spirit of Tartarin,

> doing a fellow roughly in one sitting. If I wanted to show off, my boy, I'd always do it, drink with the first comer, paint him, not in watercolor but in oils, on the spot in the manner of Daumier. If I did a hundred like that, there would be some good ones among them. I'd be more of a Frenchman and more *myself*, and more of a drinker. It does tempt me so—not drinking, but painting tramps.

No one played a more important role in this new, boisterously welcoming vision of the Midi than Joseph Roulin, a postal official at the Arles train station. Normally, Vincent would have reflexively loathed Roulin as just another petty bureaucrat. Indeed, he had already fought openly with the postal authorities over his awkward packages, and it may have been these altercations that first brought the strange Dutchman to Roulin's attention. Or they might have met at the all-night café, where both men ate and drank.

Almost six and a half feet tall, with a thick salt-and-chestnut beard—"a whole forest"—groomed to two points, a brow like an escarpment, and a perpetual drunken glow, the forty-seven-year-old Roulin could have stepped out of a Daudet novel. He drank, sang, and orated with gusto until the bars emptied, except for Vincent. He boasted his republican politics with the booming voice and bureaucratic flourish appropriate to his office, and paraded about at all hours in his heavy postal livery—a deep blue double-breasted coat with brass buttons, scrolling gold embroidery at the sleeves, and a stiff cap with POSTES emblazoned over the bill.

Vincent compared his face to Dostoyevsky's ("the look of a Russian"), his or-

atory to Garibaldi's ("he argues with such sweep"), and his drinking to Monticelli's ("a drinker all his life"). But it wasn't just alcohol—absinthe especially—that sealed their improbable bond. "[Roulin's] wife was delivered of a child today," Vincent announced at the end of July, "and he is consequently feeling as proud as a peacock, and is all aglow with satisfaction." Vincent loved babies and, in the past, had often used them to gain access into adopted families. And so it was with the newborn Marcelle and the family of Joseph Roulin—wife Augustine and teenage sons Armand and Camille—who lived in a dark government building wedged between two railroad bridges only a block from the Yellow House. Vincent attended Marcelle's christening and immediately laid plans to paint a portrait of the chubby infant. "A child in the cradle," he wrote in wonderment, "has the infinite in its eyes."

But first he had to paint the giant himself.

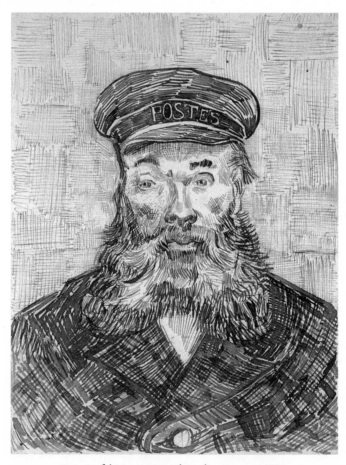

Portrait of the Postman Joseph Roulin, AUGUST 1888,
INK ON PAPER, 12¹/₄ X 9¹/₄ IN.

Vincent couldn't wait to share his astonishing discovery, this Tartarin among the mailbags of the Midi, with his comrades in Paris and Pont-Aven. Just as the *Zouave* and the *Mousmé* promised sexual exploits in the land of sun and passion, the postman Roulin would lure the world with the kind of lighthearted, larger-than-life character that could only be found in Daudet's South. With an offer to pay for food and drink that the bibulous Roulin could hardly refuse, Vincent coaxed his reluctant model into the studio. Roulin sat stiffly, impatiently, while Vincent raced to finish in a single session. He used a big canvas, nearly two by three feet, for his tall-tale subject, and posed him sitting in a chair like a proud Dutch burgher, his arms spread beyond the chair arms as if resting on an imaginary throne. He looks down his pug nose disdainfully as Vincent hurries to capture every detail of his blustery self-regard, from the great gilded coat to the carefully trimmed, twin-pointed beard. Whether in carelessness or in caricature, Vincent painted him with huge hands and heavy-lidded eyes. He placed him against a sky-blue background, both to reinforce the cobalt of his uniform and to highlight the gold ornaments on his sleeve, the double row of brass buttons, and the label on his cap: POSTES. "God damn it!" he boasted to Bernard when he finished, "what a motif to paint in the manner of Daumier, eh!"

By late August, the prospect of hosting Gauguin, and perhaps Bernard, too, had made Vincent acutely aware of the distance, artistic as well as physical, that separated him from his comrades in Pont-Aven. To close that gap, he wrote voluminous letters filled with pledges of unity and common purpose. As if swearing a loyalty oath to the new Cloisonnist cause, he renounced any affiliation with Monet's Impressionism ("I should not be surprised if the impressionists soon find fault with my way of working," he wrote) or Seurat's Neo-Impressionism (which he dismissed as "that school which would confine itself to optical experiment").

Citing a host of inspirations, from the giants of the Golden Age to the pariah Monticelli, from Richard Wagner to Christopher Columbus, Vincent repeatedly cast himself, Gauguin, and Bernard as a triumvirate of explorers blazing a trail toward "the final doctrine"—an art that would do nothing less than "embrace the whole of the epoch." Only as a team, he insisted again and again, could they reach this brave new art. "Paintings that achieve the serene summits of the Greek sculptors, the German musicians, and the writers of French novels are beyond the power of an isolated individual," he cautioned the firebrand Bernard. "They can only be created by groups of men combining to execute an idea held in common." When Theo suggested that his brother exhibit at the next show at the offices of the *Revue Indépendante*, despite Kahn's poor review the previous year, Vincent worried only that his work might present an "obstacle" to his confréres in Pont-Aven. "The honor of all three of us is at stake," he intoned. "None of us is working for himself alone."

Only a few days after Theo relayed the *Revue*'s invitation, Vincent packed up his painting gear and headed to the Place du Forum. By the time he arrived, night had fallen. The spectacle of an artist clattering his easel into place on the dark, pebbled square may have looked like a joke to the locals who strolled by or sat under the awning of the Grand Café du Forum (it was reported with amusement in the local paper). But, in fact, Vincent was protecting the "honor" of his comrades. Only a year earlier, Anquetin, the *Revue*'s designated champion, had painted a similar nocturnal scene: a crowded sidewalk outside a butcher's shop illuminated only by the gaslight within and two big gas lanterns hanging from its canopy. Other than the rank of patrons pressed near the orange glow of the windows, the image consisted almost entirely of purple-blue darkness, broken into fragments of hue as if viewed through a blue-glass prism. Anquetin's night painting (to which he gave the Seurat-like documentary title *Avenue de Clichy: Evening, Five O'clock*) became an instant icon of the new Japanese style.

Placing himself at exactly the same oblique angle that Anquetin had chosen for his painting, Vincent used the café's huge awning to create the same plunging perspective into the dark street and night sky beyond. He turned up the gaslight until it filled the covered patio with bright yellow and spilled across the Crau-stone pavement in ripples of complementary color. "I often think the night is more alive and more richly colored than the day," he wrote as he added wide swaths of orange (for the floors) and blue (for the doors) to his Anquetin tribute. He wrote endlessly of his Cloisonnist bona fides: his reliance on Japanese prints; his admiration for the speed and sureness of Japanese drawing; and, most of all, his devotion to Japanese color. "The Japanese artist ignores reflected colors," he wrote Bernard, as if reciting a catechism, "and puts the flat tones side by side, with characteristic lines marking off the movements and the forms."

Through letters and letter sketches from both Bernard and Gauguin, Vincent monitored the refinements to Anquetin's Japonist ideas that the two artists forged during their summer together in Pont-Aven. Despite having not seen either's work since the previous winter in Paris (when Gauguin, especially, was painting in a very different style), Vincent relentlessly pledged his allegiance to their unseen art and, based on Bernard's enthusiastic reports, proclaimed the older artist a leader of the new movement. (Bernard called Gauguin "a very great master and a man absolutely superior in character and intellect.")

Gauguin, after all, had painted negresses in Martinique who exactly matched Pierre Loti's description of his Japanese child bride. And were not the Caribbean, Japan, and Provence all regions of the same magical South, Vincent argued, "where so much more of life is spent in the open air"? He called Gauguin "such a great artist" and prized the letters he received from Gauguin as "things of extraordinary importance." To bring his art more and more into line with the path he imagined the Frenchman taking, Vincent embraced Gauguin's Symbol-

ist sympathies and promised to make his own images "more subtle—more like music." He began referring to his works as "abstractions," a word that bound music and art indistinguishably together.

He praised not only Wagner but another Symbolist favorite, the American poet Walt Whitman. He renounced naturalism ("I turn my back on nature") and dedicated himself to the new gospel of clarity, simplicity, and intensity. He vowed "to paint in such a way that everybody, at least if they have eyes, would see it." The sunflowers of late summer, with their determined "simplicity of technique" and "bright clear colors," announced the new mission as Vincent heard it from Pont-Aven: "Gauguin and Bernard talk now of 'painting like children.'"

To prove his new discipleship, Vincent painted a self-portrait. Not since Paris had he assayed himself in the mirror, and what he saw now looked nothing like the dapper entrepreneur or the avant-garde avatar that he had painted so often on the rue Lepic. Eschewing the small canvases and cardboard scraps to which so many Paris self-portraits had been relegated, he chose an imposing canvas almost two feet square. On it, he sketched out a gaunt head, turned slightly to one side to expose its nearly bald crown and highlight its bony cheek and brow. With soft hints of pink and yellow, he carefully modeled a sunken but untroubled face. His beard, more grown out than his hair, bristles in rust and gold, limning a jaw that is set but not clenched. The shortened whiskers reveal for the first time an upper lip, painted almost red, rising to two sharp peaks on either side of a deep philtrum. The head sits on a long neck, bare and featureless as the stem of an exotic flower, with only a large ornamental stud holding together his collarless shirt. A heavy rust-and-blue coat drapes his shoulders like a cloak. All around this austere figure shines a brilliant Veronese green, as bright as emerald but soft as menthol, radiating in halos of brushstrokes to the painting's edge. The same ineffable color fills the whites of his eyes (rendered with ocher irises for contrast) as they gaze not directly into the mirror but past it—past the viewer, into the distance, fixed on this brilliantly colored, better world.

In those same eyes, Vincent rededicated himself to the path forward. "I have made the eyes *slightly* slanting," he informed Theo, "like the Japanese." Indeed, not just the upward-slanting, almond-shaped eyes, but everything about the image—the shaved carapace, the long neck, the cloaklike coat, the ascetic gaze—evoked the descriptions and illustrations of Japanese monks that Vincent and his comrades all knew from Loti's *Madame Chrysanthème* and other accounts. "[I] conceived it as the portrait of a *bonze*," he told Gauguin, "a simple worshipper of the eternal Buddha." This was the transformation that awaited them in Provence, Vincent's image promised: from careworn painters beset by convention to priests of the sublime, living serenely in nature—"as if they themselves were flowers." "One cannot study Japanese art without becoming much happier and more cheerful," he assured them.

So eager was Vincent to share this beckoning, sunflower version of himself with his comrades in Pont-Aven that he wrote and urged them to make portraits of each other so that he could send them his "placid priest" in exchange. He imagined the trade as an initiation rite in the brotherhood of Midi *bonzes*. "Japanese artists often used to exchange works among themselves," he explained. "The relationship between them was evidently, and quite naturally, brotherly . . . The more we can copy them in this respect the better for us." And when he sent the painting to Gauguin in early October, he accompanied it with an oath, as solemn and summoning as his Japanese divine: "I should so much like to imbue you with a large share of my faith that we shall succeed in starting something that will endure."

LIKE ALL HIS DESPERATE bids for belonging, Vincent's campaign for membership in the brotherhood of "Japanese" artists carried the seeds of its own undoing. The same crosscurrents of devotion and antagonism, adhesion and aversion, that roiled his love for Theo and his friendship with Van Rappard quickly undermined his relations with Pont-Aven. No sooner had he accepted the new orthodoxy—even celebrated it—than he began to bridle against it. "I do not find it easy to think of changing my direction," he had grumbled to Theo in June. "It is better never to budge."

Throughout the summer, his letters to both Bernard and Gauguin squirmed between allegiance and resistance. Ringing declarations of "the final doctrine" and calls to unity and cooperation sat uneasily beside prickly defenses of independence and individuality. Vincent predicted that his comrades "will alter my manner of painting and I shall gain by it," but then added ruefully, "all the same I am rather keen on my decorations." Warm professions of fraternal solidarity were suffused with hints of competitive rancor and fits of resentment.

While Gauguin proved an erratic and unengaged correspondent, Bernard matched Vincent argument for argument, passion for passion, in a tug-of-war over the direction of the new movement. With Gauguin, who had a direct channel to Theo, Vincent struck an almost reverential tone ("I do not want to say depressing or dismal or malicious things to so great an artist," he told Theo). But with Bernard, who shared his letters with Gauguin, Vincent could dominate the three-way conversation while preserving the appearance of deference to the older artist. When Bernard seconded Gauguin's argument that the new art should find its imagery in the imagination—*"ex tempore"*—Vincent defiantly reaffirmed his determination to work from nature; chastised his young friend for "departing from the possible and the true"; and drew a sharp red line between "exaggeration" (what he did) and the Symbolists' dreamy "inventions."

He scolded Bernard's self-dramatizing Symbolist poetry (questioning its

"moral purpose") and privately mocked his drawings done in the Symbolist style ("à la Redon"), calling them "very strange." When Bernard defended Symbolism by charting its half-century rise from the scandals of Charles Baudelaire, an early champion of both Delacroix and Wagner, to the heights of the Parisian avant-garde, Vincent took up the gauntlet. In sweeping, vehement terms, he derided the Symbolists' images as "follies," "stupidities," and "sterile metaphysical meditations." He chastised them especially for turning their backs on the great artists of the Dutch Golden Age who "painted things just as they are." "Hammer into your head that master Frans Hals," he instructed Bernard; "hammer into your head the no less great and universal master . . . Rembrandt van Rijn, that broad-minded naturalistic man." The argument escalated to accusations of cultural plagiarism as Vincent dismissed two centuries of French art as nothing more than "Dutch paste solidly stuffed into vulgar French noodles."

Nothing about the Symbolist tutelage from Pont-Aven incensed Vincent more than the call for religious imagery. Bernard had first reopened these wounds in April by sending some religious poetry for Vincent's review. Fired by the Symbolist debates in Paris, newly befriended by Albert Aurier, a young Symbolist poet, and reawakened to his own Catholicism by a love affair in Brittany that spring, Bernard arrived in Pont-Aven with a portfolio of mystic religious imagery in one hand and a Bible in the other. Gauguin received the new ideas openly, and soon both artists were busily planning works to plumb the Good Book's deep well of mystery and meaning.

After such a warm reception, Bernard must have been shocked by the storm of protest that greeted his ideas in Arles. "How small-minded the old story really is!" Vincent fired back immediately. "My God! Does the world consist solely of Jews?" With inexplicable fury, he railed against "that deeply saddening Bible, which arouses our despair and indignation, which seriously offends us and thoroughly confuses us with its pettiness and infectious foolishness." Only the figure of Christ survived Vincent's wrath—he called it the "kernel" of consolation "inside a hard rind and bitter pulp." But he belittled Bernard's ambition to capture Christ's image as "artistic neurosis" and ridiculed his chances of succeeding. "Only Delacroix and Rembrandt have painted the face of Christ in such a way that I can feel him," he scoffed. "The rest rather make me laugh."

The rant spilled across letter after letter, to Paris as well as Pont-Aven. "Oh, my dear boy," he wrote Theo, "I can very well do without God both in my life and in my painting." He pounded Bernard with the crimes of Christianity, especially the "barbarity" of Catholic conversions in the New World, and mocked its modern-day hypocrisies. His months in Catholic Provence, with its medieval festivals and mystical devotions, had already roused childhood feelings of Protestant isolation and antipapist iconoclasm. (He described the Gothic church in Arles, St. Trophime, as "cruel and monstrous" and, worse, "Roman.") In July,

he undertook to reread the complete works of Balzac, as if to inoculate himself against the world of spirits and superstitions that surrounded him.

But the push from Pont-Aven was too strong, the obsession from the past too deep and unsettled, to resist for long. That same month, even as his letters filled up with bitter denunciations, Vincent tried his hand at the denounced imagery. He painted "a big study, an olive garden, with a figure of Christ in blue and orange, and an angel in yellow." It was the image that had haunted him through a lifetime of failures and campaigns for forgiveness: Christ in the Garden of Gethsemane. Only now he saw it in the vivid color of the new art: "Red earth, hills green and blue, olive trees with violet and carmine trunks, green-gray and blue foliage, [and] a citron-yellow sky." But the effort collapsed. In a fit of panic (he later called it "horror") that foretold the catastrophes to come, he angrily took a knife and scraped the offending image off. He kept his failure secret from Bernard and Gauguin. To Theo, he blamed it on the lack of models. "I must not do figures of that importance without models," he vowed. But surely he knew the block lay deeper.

The failed image triggered a fresh wave of resistance. He scolded his colleagues for resorting to the static, fabular world of the Bible, when the world of nature all around them—especially in Arles—offered so many subjects ripe with significance: sowers and sheaves, sunflowers and cypresses, suns and stars—all opportunities to "paint the infinite." "It is actually one's *duty* to paint the rich and magnificent aspects of nature," he declared, taking aim at the Symbolists' dry metaphysical exercises. "We are in need of gaiety and happiness, of hope and love." And why confront the terrible, perfect countenance of Christ, he demanded, when sublimity could be found in faces and figures everywhere? "Do I make myself understood?" he wrote Bernard fiercely. "I am just trying to make you see this single great truth: one can paint all of humanity by the simple means of portraiture."

In fact, the marginalization of Vincent's favorite genre was already well under way. Impressionism's glancing sight and playful light could never penetrate the inner life of a subject, only record the charming surface—while the new art, whether obsessed with science or essence, had little use for the random peculiarities of the human visage—as Vincent himself acknowledged.

To ensure a place for his beloved portraits (and models) in the art of the "next generation," Vincent fervently argued on behalf of the mystery and sanctity—the symbolist essence—of portraiture. A great portrait was "a complete thing, a perfection," he argued, "a moment of infinity." When the "metaphysical magician" Rembrandt painted saints or angels or Christ himself, he painted real people, not abstractions or "fantasies." For his own portraits, Vincent claimed the Symbolists' ambition to "say something comforting as music is comforting," and appropriated the religious mandate coming from Pont-Aven. "I want to

paint men and women with that something of the eternal which the halo used to symbolize," he wrote. All summer long, as he prepared for the arrival of the Bel-Ami of the Midi (who "will do in portraiture what *Claude Monet does in landscape*"), Vincent shouted out his recusant conviction that portraits represented "the thing of the future": "Ah! portraiture, portraiture with the thought, the soul of the model in it, that is what I think must come."

At the beginning of August, soon after the success of Anquetin's *The Peasant* triggered a rush to rustic imagery in both Pont-Aven and Arles, Vincent recruited an old gardener named Patience Escalier to model for him. He described Escalier as "a poor old peasant, whose features bear a very strong resemblance to Father, only coarser." Vincent painted him hurriedly, placing his deeply creased, sun-brazed face against a cobalt background and dressing him in a bright turquoise blouse and yellow straw hat much like those Vincent himself wore on his painting trips into the countryside. To Theo and the comrades in Pont-Aven, he advertised Escalier as an icon out of Millet or Zola ("a man with a hoe, a former drover of the Camargue"), a primitive antidote to "highly civilized Parisian" ways, as well as a Daumier caricature, like the amiable giant Roulin. "I dare believe that Gauguin and you would understand," he wrote Bernard. "You know what a peasant is, how strongly he reminds one of a wild beast, when you have found one of the true race."

Vincent quickly fell out with his model over payment terms, but the old man's image lingered in his eye throughout the arguments with Bernard over religious imagery. When he finally lured Escalier back into the studio at the end of the month, he posed the grizzled gardener leaning on a cane, his hands folded in an attitude of prayer. From under his wide-brimmed straw hat, his old eyes stare serenely into the distance with a sad, long-suffering, heaven-fixed gaze. Beyond his sloping blue shoulders, the world is filled with "flashing orange" representing the "furnace" of harvests past, Vincent said, as well as the "luminous gold" of the sunset to come, and the sunrise beyond.

Immediately after finishing his rustic saint, Vincent took up once again Bernard's ultimate challenge to evoke the mystical sublime. The opportunity presented itself when Eugène Boch visited the Yellow House in late August. Vincent had met the thirty-three-year-old Belgian artist in June, when he became Dodge MacKnight's studiomate in nearby Fontvieille. Vincent shared with the newcomer not only similar physiognomies ("a face like a razor blade, green eyes, and a touch of distinction"), but also similar bourgeois backgrounds with siblings involved in the art trade (Boch's sister Anna was both a collector of avant-garde art and an artist herself).

But Vincent lumped Boch together with the "slacker" MacKnight, and Boch shared MacKnight's dislike of Vincent's art and his distaste for Vincent's "moody and quarrelsome" nature. The two barely saw each other until MacKnight left

Arles at the end of August. In a single whirlwind week of camaraderie—a re-hearsal for Gauguin's imminent arrival—they took walks in the country, saw a bullfight in the arena, and talked late into the night about art. When Vincent learned that Boch intended to go to the coal region of his native Belgium and paint the miners of the Borinage, he swooned with solidarity, urging Boch to designate his new studio among the coal mines as a Yellow House of the North where he, Gauguin, and Boch could "change places" from time to time.

To memorialize this brief manna of friendship, Vincent persuaded Boch to sit for a portrait. Despite their previous antagonism, Vincent had been laying elaborate plans for this portrait for some time. "I should like to paint the portrait of an artist friend," he had written Theo after an encounter with Boch in early August, "a man who dreams great dreams, who works as the nightingale sings, because it is his nature." Despite Boch's dark hair, Vincent imagined painting him as "a blond man [with] orange tones, chromes and pale-yellow" highlights in his hair:

> Behind the head, instead of painting the ordinary wall of the mean room, I [will] paint infinity, a plain background of the richest, intensest blue that I can contrive, and by this simple combination of the bright head against the rich blue background, I [will] get a mysterious effect, like a star in the depths of an azure sky.

When Boch finally sat for him, Vincent faithfully rendered his subject's razor visage and dark hair (with blond highlights only in his mustache and beard). But he dressed him in a yellow-orange coat and stood him against a background of the deepest blue he could devise—just as he had imagined it. He crowned Boch's head with a thin corona of citron yellow—exactly the color of the "nim-bus" around the Savior's head in Delacroix's *Christ on the Sea of Galilee*—and flecked the dark void with stars shining yellow and orange from worlds beyond.

It was exactly the scheme he had tried and destroyed in his *Garden of Geth-semane:* "a figure of Christ in blue and orange."

Images like these, Vincent argued, expressed their transcendent truths not in the biblical finery that Bernard urged, but in a new and different garb: color. Whether through "the mingling of opposites" or "the vibrations of kin-dred tones," Vincent claimed he could address the deepest mysteries of life—the Symbolists' grail—without resorting to the follies of religion. He could speak directly to the heart "through the language of color alone." Thus, the sunset colors on Escalier's face expressed "the eagerness of a soul," while the light tone of Boch's figure against the night sky expressed "the thought of a brow" and "hope upon a star."

The right color combinations, he insisted, could arouse the full range of

human emotions: from the "anguish" of broken tones to the *"absolute rest-fulness"* of balanced ones; from the "passion" of red and green to the "gentle consolation" of lilac and yellow. In describing his colors, especially to Bernard, Vincent adopted the Symbolists' vocabulary (repeatedly invoking "the eternal," "the mysterious," "infinity," and "dreams"), but defiantly declared himself a "rational colorist" and boasted of the complicated calculations that guided his palette—Seurat-like terms anathema to the Symbolists' manifesto of sensation. And he rejected outright Cloisonnism's relegation of color to a mere element of design—a decorative deduction—rather than the "forceful expression" of "an ardent temperament."

That temperament expressed itself nowhere more forcefully, or defiantly, than in brushwork. In Pont-Aven, Vincent's comrades had been developing a paint surface that barely betrayed a brush at all. Following Anquetin's lead, they had pursued the Cloisonnist rhetoric about "plates" of color and the paradigm of stained glass to their logical conclusion. Where Cézanne had used brushy, thinly painted planes and brickworklike strokes to construct his faceted scenes, Gauguin and Bernard divided their images into areas of pure color and then filled each area with thinned paint applied in smooth, impassive strokes. Vincent surely knew of these innovations through his correspondence with both artists, and even occasionally tried them himself when the urge to solidarity overtook him.

But inevitably his manic brush rebelled. His letter sketches to Pont-Aven continued to show only the coloring-book dogma of blocks of pure color, each with its label of *"rouge"* or *"bleu."* But in his studio, unseen by his colleagues, his draftsman's hand tirelessly filled those blocks with flights of brushwork in a pattern book of textures and complex topographies of *enlever* paint. Some-times he followed the contours of his subjects with undulating trenches of color, faithfully tracing the spiky needles of a pine tree or the snaking branches of a vineyard. Other times, in the background or on the plates mandated by the new gospel, his brush would break into slathering riffs of strokes, turning a cloud-less sky into a churning sea or a plowed field into a scumbled battleground. In one particularly intense eruption of impasto—Vincent himself called such epi-sodes "violent"—he loaded his brush with paint and transformed a picturesque streamside mill into a castle of pigment, shattering every plane—walls, roof, sky, and stream—into defiantly visible paint strokes, each one a silent protest, a shake of his fist, against the orthodoxy issuing from Pont-Aven.

By the end of September, with Gauguin's arrival only weeks away, Vincent's balks, debates, and rebuffs had combined into a full-throated rebellion against his fellow triumvirs of the new art. "How preposterous it is," he wrote sister Wil seditiously, "to make oneself dependent on the opinion of others in what one does." In opposition to the decorative, cerebral imagery advocated in Brit-

tany, he had put forward the elements of a very different art: an art of portraits, not parables; figures, not fantasies; peasants, not saints; an art of impact, not enigma; of paint, not glass. But most of all, an art of feeling—"heartbroken, and therefore heartbreaking." Color, with its magic, musiclike power to arouse emotions, played a central role. "I use color . . . to express myself forcibly," he wrote. "That's it as far as theory goes." If color was his music, the brush was his instrument. Strokes could be "interwoven with feeling," Vincent maintained, to elicit a range of emotions: from the *"pain"* of impasto, to the exhilaration of stippling; from the serenity of smooth paint ("like porcelain"), to the sublimity of radiating strokes.

He accepted Cloisonnism's injunction to simplify, simplify, simplify—but not just for simplicity's decorative sake. Simplification and exaggeration, like color and brushwork, had to serve some deeper emotional truth. In describing how he painted the square in front of the Yellow House—a patch of ill-tended public real estate—Vincent sheepishly admitted to "leaving out some trees" and "some shrubs that are not in character. . . . To get at that character," he said, *"the fundamental truth of it."*

This was not "imagining," he hastened to add, rejecting the Symbolist term as Bernard and Gauguin used it. He imagined nothing, he insisted; only *looked* and *felt*. He neither ignored nature, nor slavishly followed it; he "consumed" it. "I do not invent the picture," he corrected Bernard; "on the contrary, I find it already there in nature; I just have to free it." When Rembrandt painted angels, Vincent explained, "[he] did not invent anything . . . he knew them; he *felt* them there." So, too, when Vincent looked at the trafficked square, he squinted his eyes and saw not the trompe l'oeil reality of overgrown pathways in un-Dutch neglect, but the riotously blooming oleander bushes—"loaded with fresh flowers, and quantities of faded blooms as well, their green continually renewing itself in fresh, strong shoots, apparently inexhaustibly"—an image of angelic consolation that bore no more relationship to reality, he argued, than reality bore to a colorless photograph.

This was the only theory that Vincent's refractory art could bear—the inevitable expression of a synthetic intelligence bound forever to a lunging heart. "When I am moved by something," he said, "these are the only things that appear to have any deep meaning." And painting those things "absorbs me so much," he confessed, "that I let myself go, never thinking of a single rule." Obsessively introspective and often alone, Vincent thought deeply about questions that preoccupied the writers, artists, and philosophers he read; but his personal theories on art, as on everything else, were neither coherent nor consistent. He never could command consistency from himself (not even within the same letter, much less between correspondents), nor could he keep his ideas isolated from the swirling currents of his emotions. Even within a single painting, his

palette and brush often skidded from theory to theory, from model to model, in pursuit of the emotion that seized him—the only dogma that mattered. "What do these differences matter," he wrote Bernard, declaring his independence by defending his deviations, "when the great thing after all is to express oneself strongly?"

Vincent's rebellious art opened the door to a century of "expressive" imagery and, as he foresaw, "even more personal and more original" visions. But, like all Vincent's great zeals, this one redeemed the past by championing the future. "What I learned in Paris is *leaving me*," he wrote Theo at the height of his summer insurrection in 1888. "I am returning to the ideas I had in the country before I knew the impressionists." His dissenting argument for exaggerated, "suggestive" color skipped the Impressionists altogether and invoked Charles Blanc's older gospel of simultaneous contrast; and, of course, its messiah, Delacroix. "My way of working . . . has been fertilized by Delacroix's ideas rather than by theirs," Vincent insisted. It was Delacroix, the hero of the Kerkstraat studio—not Monet or Seurat or Cézanne or Anquetin—who "spoke a symbolic language through color alone," he said, and through that language, expressed "something passionate and eternal." It was Delacroix, the artist-explorer of Africa, who had shown him the way South to the land of exaggerated color, and blazed the path to the Yellow House.

He gave no credit to the Symbolists, either. Years before hearing Wagner's music or Bernard's instruction, he reminded Theo, he had studied the relationship between color and music by taking piano lessons in Nuenen. And from the moors of Brabant he had written about how the great Barbizon painter Jules Dupré expressed an "enormous variety of moods" using "symphonies of color." He had sought his inspiration from within—through "instinct, inspiration, impulse, and conscience"—and rallied to Delacroix's cry *"Par coeur! Par coeur!"* long before Huysmans's *À rebours* roused avant-garde Paris.

Since his return to Nuenen from the Rijksmuseum in October 1885, his brush had been guided by the miracle of *enlever* paint and the mandate to work *"in one rush,"* as Rembrandt did, to achieve an image of "noble sentiment, infinitely deep." Liberated by the sight of Rembrandts and Halses that "did not have to be *literally* true," Vincent had already claimed his right "to idealize, to be a poet," and to let his colors "speak for themselves." In the Kerkstraat studio and in the tumbledown hut of the De Groot clan, he had already put that right to the test. The portraits he slashed out there—with loaded brush, in the dim light, in a single sitting—had pointed the way. Three years before Anquetin's *The Peasant*, Vincent had seized the example of Millet (in whose works "all reality is also at the same time symbolic," he said) and found the perfect imagery to express his subjects' stoic despair—and his own—in color and texture. By depicting his primitive family "as if painted in the soil that they sowed," and doing so "with

a *will*, with *feeling*, with *passion*, with *love*," he had already achieved the "truer truth" that his comrades in Pont-Aven only now aspired to.

In short, the world had come round to his lowly peasants. He called his portrait of Patience Escalier "an absolute continuation of certain studies of heads I did in Holland." The old gardener's radiant countenance marked the De Groots' passage—and Vincent's—out from the shadows of the heath and into the brilliant sun of the Midi. The years in Paris had merely brought to flower the seed of revolutionary art planted earlier in the dark loam of rhetoric that defended *The Potato Eaters*. His claims for the new art bristled with vindication of the old. If he had "kept the faith" of Nuenen, he told Theo, bitterly rebutting the judgments of the past, "I'd be a notable madman. Now I am just an insignificant one."

As in Nuenen, Vincent found an image that both expressed and inspired his resurgent contrarian vision. Like all of his self-justifications in paint, it sprang not from his imagination, but from his life. Every night that summer, when the Yellow House went dark, Vincent returned to the all-night Café de la Gare only a short block away. He ate a late supper in the bare barroom downstairs with its billiard table, hanging gas lamps, and looming clock. He occasionally shared a meal or an absinthe with Roulin at one of the marble-topped tables, but mostly sat by himself or drank standing up at the bar in back. Eventually, he climbed the narrow stairs to his small room and fell asleep over the never-sleeping scene below.

As one of the few establishments in Arles open after midnight—other than the brothels—the café attracted a rogues' gallery of drifters, hooligans, refugees, and homeless. Vincent called them *"rôdeurs de nuit"* (night prowlers)— those who "have no money to pay for a lodging, or are too drunk to be taken in," he catalogued. Cranks talking politics, crazies babbling to themselves, whorehouse patrons dragging their whores, rejected suitors nursing their wounds— all ended up in the mercurochrome light of the Café de la Gare. "They flop down at a table and spend the whole night thus," he told Bernard, describing his home-away-from-home as "a free-love hotel."

Vincent began his dissonant painting in a dissonant mood. He had fought his landlord, Joseph Ginoux, to a bargain: if Ginoux would forgive his tardiness in paying his rent, Vincent would paint a portrait of Ginoux's "dreary" establishment. "To revenge myself for paying him so much money for nothing," he reported to Theo, "I offered to paint the whole of his rotten joint." More bemused than persuaded, Ginoux agreed to the proposition and Vincent began immediately. He waited until after the clock downstairs chimed midnight, then set his easel and a huge canvas in the front corner of the barroom, next to the door, to get the best view of the nightly procession.

Most of his fellow patrons fled his brush, abandoning the scene, leaving coffee cups and drink glasses half full at their places and chairs pushed back in dis-

array. The few that remained, seated in the distant corners of the room, slumped and turned their faces away—accustomed, no doubt, to ignoring the unseemly goings-on in the café's nocturnal demimonde, or to being ignored. Only the proprietor Ginoux stood his ground. Unashamed, immune to any abuse, inured to any scandal, he stationed himself proudly beside the billiard table in white coat and apron, looking straight at Vincent, taking the full heat of the gaslight glare.

For three nights in a row, after sleeping through the day, Vincent returned to the perdition beneath his bed to capture in color and paint the feeling of isolation and marginalization he found there. Whatever colors Ginoux had chosen for the interior of his bar, Vincent saw only the pain of red and green. From the "blood-red" walls to the jade ceiling, from the malachite billiard table to its orange-red shadow, from the "soft tender Louis XV green" of the bar counter to the "delicate pink nosegay" of flowers that sat incongruously on it, every corner of the room was refracted through the lens of Vincent's tartan vision of inner torment. Green scuffs the floorboards while red leaches up through the cracks; turquoise infiltrates the marble tabletops and the porcelain stove while a single red ball sits on the green felt playing field. Glasses glint in pink next to absinthe-green bottles labeled in red. A woman at the back wears a green skirt and pink shawl. A shy tramp slumps away, but shines in emerald.

Over this battleground of "clashes and contrasts," Vincent cast a merciless yellow glow. Four hanging lanterns, radiating strokes of yellow, orange, and green, beat down like four suns on the denizens of this unnatural world, exposing them like a searchlight, casting only the single shadow of the billiard table in the middle of the room.

As in Nuenen, Vincent claimed the highest purpose for his lowly subjects huddled around a table by lamplight. "The café is a place where one can ruin oneself, go mad, or commit a crime," he explained to Theo, invoking both a Zola novel and a Tolstoy play. In describing *The Night Café*'s exaggerations of color and form, he used the same defiant language he had used for his previous cry of dissent from the wilderness. "This picture is one of the ugliest I have done," he wrote, as proudly unapologetic as the proprietor Ginoux. "It is the equivalent, though different, of the 'Potato Eaters.'" (To prove his pride, he sent Theo a watercolor of the image the next day.)

In a perfunctory bow to Pont-Aven, he affirmed the painting's "Japanese gaiety" and attributed to it the "good nature" of Daudet's Tartarin. But he also claimed for his insistently secular subject a mystery and "deep meaning" equivalent to any of Bernard's biblical fictions. "I have tried to express the terrible passions of humanity," he wrote, elevating his dingy café to the rank of Millet's *Sower.*

But the real subject, as always, was Vincent himself; the real passions, his

own. Unlike Zola or Daudet, Vincent could not report or imagine other lives, feel other pain or other mirth. Whether painting shoes or nests, beached boats, roadside thistles, or families at table, all his windows looked inward. "I always feel I am a traveler," he had written Theo in August when he first planned a painting of the Café de la Gare, "going somewhere and to some destination." Driven by the same fear, rootlessness, and disenfranchisement as his fellow *rôdeurs de nuit*, he had taken temporary refuge in the strange, inverted daylight of Ginoux's midnight café, just as he sought comfort in the midday darkness of the De Groots' hovel. On behalf of all his fellow outcasts, Vincent wondered hopefully if "those things that we pretty well do without—like native land and family—are perhaps more attractive in the imaginations of people such as us than they are in reality."

Unlike the others, however, Vincent had someplace to go. Every night, he could climb the stairs to his room, lie in bed, smoke his pipe, and dream of the visitor yet to come and the paintings yet to be painted.

The Poet's Garden

~

ONLY THE ANTICIPATION OF GAUGUIN'S ARRIVAL HELD VINCENT'S loneliness in check. When the Zouave lieutenant Milliet went on leave in August, Vincent missed their trips to the brothels, but he imagined that Gauguin would attract even more attention among the beautiful Arlésiennes on the rue des Récollets. After Eugène Boch's departure in early September, Vincent clung to their friendship with a chain of letters, a second portrait from memory, a push for Boch and Theo to meet in Paris, and even a fantasy scheme for Boch to marry his sister Wil. ("I always hoped that Wil would marry an artist," he wrote. "And besides, he isn't exactly penniless.") He passed the lonely nights by telling himself that Gauguin's presence in the Yellow House would inevitably lure other artists, like Boch, to his door. Indeed, Boch himself was "certain to return," he reassured Theo, once Gauguin settled in.

As his few acquaintances fled, only the prospect of Gauguin's companionship could protect him from the increasing hostility of his neighbors—a problem made worse when Vincent finally abandoned the Café de la Gare in mid-September and began sleeping in his new home. "The isolation of this place is pretty serious," he wrote Theo. He complained bitterly about being "treated like a madman" and "paralyzed" because "nobody likes [me] personally." He imagined that Gauguin would somehow both share his isolation and reverse it. When a gang of "hooligans" assaulted him on the street, squeezing his tubes onto the pavement as he tried to paint, Vincent laughed off the incident as a perverse comic prelude to the "fame" that he and Gauguin would enjoy in Arles.

He reached for the same consolation when models balked, refused to show up, haggled over terms, or took advances and never returned. Even the models he liked, Milliet among them, posed badly. The postman Roulin refused to let him paint the infant Marcelle. "Difficulties with models continue with exactly the

same tenacity as the mistral here," he wrote. "It is almost enough to make you lose heart." But Gauguin, the tamer of Martinique natives and Brittany peasants, would change all that. He would charm the reluctant models of the Midi into the Yellow House. He would stop the locals from laughing at Vincent's portraits or being "ashamed to let themselves be painted." He would win the "poor little souls" of Arles to the wonders of the new art.

Whenever the scorn of the Arlesians made Vincent "downhearted," whenever he lost faith in his own work (as he did when Theo asked him to exhibit at the *Revue Indépendante* show), whenever he "struggled to be something more than a mediocrity," Vincent thought of "the other fellows in Brittany, who are certainly busy doing better work than I," and of the "beautiful things still to be done" in the South. Whenever he worried that age and illness had taken an irreparable toll on his body, his mind, or his art, he thought of Gauguin and the coming opportunity to "make the most" of his remaining strength. "We may have the power to work today," he warned Theo, "but we do not know if it will hold out till tomorrow."

Gauguin held the key to his waning sex life, too. By September, Vincent had trouble luring to his bed (or his studio) even the "2-franc" whores that the Zouaves passed over. The problem wasn't money (he could always find a few coins for sex), or his strange art, or his assaultive personality. The problem was his desire—or, more precisely, his performance. Years of "running after the game," he revealed to Theo, had left him impotent—often unable to achieve erection. Unaware of the deeper mental and physical processes at work (chiefly syphilis), the thirty-five-year-old Vincent attributed his dysfunction to aging—"I am getting older and uglier than my interest demands"—or simple exhaustion.

To Bernard and Gauguin, however, he presented his chastity not as a sad fate, but as a bold choice, and urged them to follow suit. "If we want to be really potent males in our work," he insisted, "we must sometimes resign ourselves to not fuck much." To support this unexpected call, Vincent cited a pantheon of virile but abstemious artists: from the "well regulated" Dutchmen of the Golden Age, to the mighty Delacroix, who "did not fuck much, and only had easy love affairs so as not to curtail the time devoted to his work." Among the moderns, he cited the Impressionist Degas, who "does not like women because he knows that if he loved them and fucked them often, he would become an insipid painter," as well as the Cloisonnist favorite Cézanne, in whose work Vincent found "plenty of male potency."

He invoked the brothers' earliest tutor in love, Michelet, and their latest, Zola; as well as "that great and powerful" Balzac, who had famously emerged from an assignation complaining, "I lost a book this morning!" Vincent argued that "painting and fucking a lot don't go together, it softens the brain." Like the disciplined *bonzes*, he might visit a brothel every two weeks for "hygienic" rea-

sons, he told Bernard, but otherwise he, and they, should "pour out all our sap" into the creation of art, not waste it on common whores for whom "professional pimps and ordinary fools do better in the matter of satisfying the genital organs." Instead, they should make Art their mistress and Painting their sex, creating "spermatic" works in "headlong spurts." "Ah! My dear friends," he rallied them, "let us crazy ones feel orgasm all the same, through our eyes, no?"

Vincent renounced not just sex, but wife and family as well, in order to conserve all his "sap" for the coming artistic union with Gauguin. The less he felt a procreative drive, the more urgently he proclaimed this creative one. "The enjoyment of a beautiful thing is like coitus," he explained to Bernard, "a moment of infinity." Together, he and Gauguin would propagate a generation of new art. Fate had "defrauded [him] of the power to create physically," he conceded, but with Gauguin's help he would make paintings "in place of children."

Vincent had long argued for the power of sympathetic minds to beget great art. Almost from the beginning of his career, he had spoken of his own paintings as the progeny of just such a higher union: his brotherhood with Theo. "I swear that you will have created them as much as I," he reaffirmed in September. "We are making them together." But increasingly the vision of Gauguin as artistic spouse superseded all the images of partnership and pairing that had long obsessed his imagination.

In his letters, he took up the subject with an elaborate digression on one of the most famous creative couplings in Western history: Francesco Petrarch and Giovanni Boccaccio. After reading an article about the "friendship well beyond love" shared by these fourteenth-century poets, Vincent seized on their fertile bond as a model for the marriage he envisioned. (The article described it as "a constant devotion, a marvelous delicacy and a touching reciprocal indulgence [that] raised [them] above their time and themselves.") Even though it was Petrarch who had spent most of his life in Provence, Vincent saw himself as the dutiful helper Boccaccio, author of the sublimely vulgar *Decameron* ("a melancholy, rather resigned, unhappy man . . . the outsider") and cast Gauguin as the revered, reclusive master, proclaiming him "the new poet from these parts." Just as a benighted medieval world had been awakened to Humanism by the light that issued from Petrarch and Boccaccio's union, the Paris art world would marvel at the art spawned by his "combination" with Gauguin, Vincent imagined. "Art always comes to life again after inevitable periods of decadence," he wrote, predicting that another renaissance would soon spring from the Midi.

On his easel, he celebrated this sacred, fruitful bond in a rush of landscapes. Just as Petrarch's country house in Vaucluse (only forty miles northeast of Arles) had a garden retreat where he and Boccaccio could consummate their years of epistolary longing; the Yellow House, too, had a garden: the public park of the place Lamartine. There, among the eternal cypresses and the oleander

bushes that provided nightly cover for coarse doings worthy of the *Decameron*, Vincent set up his easel, squinted his eyes, and saw "a poet's garden." "This park has a fantastic character," he wrote both Theo and Gauguin, "which makes you quite able to imagine the poets of the Renaissance, Dante, Petrarch, Boccaccio, strolling among these bushes and over the flowery grass." Possessed by this reverie, Vincent painted almost a dozen versions of the disheveled park in the last weeks of September and early October, working from sunrise until after sunset when the gas lights were lit. In some, nature bursts in *Paradou*-like bounty and seclusion; in others, lovers stroll in the footprints of the dead poets.

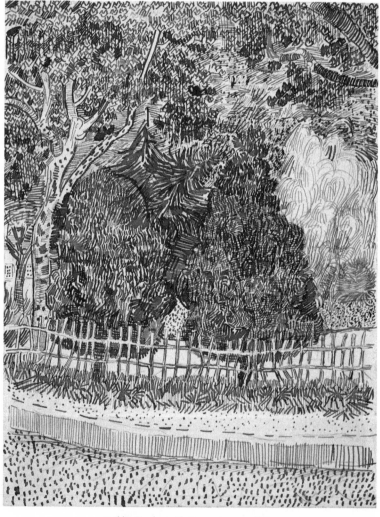

Public Garden with Fence, APRIL 1888,
PENCIL AND INK ON PAPER, 12⅝ X 9⅝ IN.

Conflating the fraternal and the fertile, the sexual and the spiritual, Vincent's fever for conjoining flooded past the reveries of the unkempt little park into every corner of his imaginative world. While his letters called the roll of creative couples (Rembrandt and Hals, Corot and Daumier, Millet and Diaz, Flaubert and Maupassant), his brush found copulation everywhere. From thistles to coaches, from sand barges to shoes, he saw pairs of objects that "complemented" each other as inevitably as red complemented green. "There are colors that cause each other to shine brilliantly," he wrote, "which form a *couple*, which complete each other like man and woman."

In late September, Vincent found a subject that invited him to layer all these intimations of coupling into a single image. The Zouave lieutenant Milliet re-

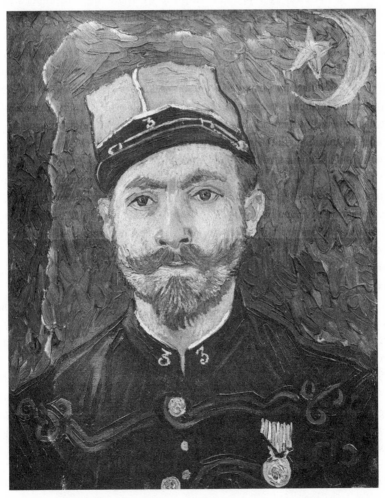

Portrait of Milliet, Second Lieutenant of the Zouaves, SEPTEMBER 1888,
OIL ON CANVAS, 23⅝ X 19⅜ IN.

turned briefly to Arles on his way to another tour of duty in Africa. Between packing up his barracks home and taking "tender leave" at every brothel in Arles, Milliet barely had time to sit for his former drawing teacher. When Vincent finally lured him into the Yellow House, he sat impatiently, fidgeting and criticizing as Vincent hurried to finish. The painting that emerged married thick paint and bold brushstrokes to some of Vincent's most careful rendering—not at all the caricature of Roulin, but not a true likeness either (as Vincent ruefully admitted).

The scarlet of the lieutenant's military cap invoked the legendary carnality of the bullnecked, tiger-eyed Zouave who had posed earlier that summer. But the jade background, as much blue as green, softened the "savage" contrast to express a masculinity more touching than threatening. In Milliet's handsome face, Vincent saw both the smooth lothario of Maupassant's *Bel-Ami* and the sentimental naïf of Milliet's favorite novel, *L'abbé Constantin* (*The Abbot Constantine*); both the calculating ambition of Gauguin and the open heart of his own brother. Like Theo, Milliet "completed" Vincent's awkward intensity with his "unconcerned and easy-going behavior"; with his youth ("he is only twenty-five, for Christ's sake"), and especially his potency. "Milliet is lucky," Vincent wrote, explaining why he and the young Zouave made a pair as perfect as red and green. "He has as many Arlésiennes as he wants, but then, he can't paint them; and if he were a painter, he wouldn't have them."

Vincent hung the portrait, which he called simply *The Lover*, on the wall of his new bedroom alongside the one of Boch, which he had dubbed *The Poet*. Together, they formed a fitting template for the even more perfect pairing to come. "My own bedroom will be extremely simple," he informed Theo about his decorations for the Yellow House, while Gauguin's room would be "pretty" and "dainty." "As much as possible," he wrote, "I shall try to make it like the boudoir of a really artistic woman."

Carried on images like these, Vincent's expectations soared. The combination with Gauguin would not only "complete" him, it would put him at the epicenter of a great new movement in art. The Yellow House would become a mecca for all true "colorists" who drew inspiration from the magical light of the South. He and Gauguin would school them in the new art, then send them out, like Boch, to seed the gospel across the Continent. He bought a dozen chairs to accommodate the "apostles" he expected to answer the call. Eventually, his dreams included a museum and a permanent *école* that would nourish generations of painters. Even the reclusive Seurat might be drawn into such a glittering vision of the future, he suggested, creating an alliance with Gauguin that would finally bring unity to the heirs of Impressionism. "Do you realize," he wrote Theo portentously, "we are at the beginning of a very great thing, which will open a new era for us."

Visions like these not only whetted his anticipation of Gauguin's arrival, they kept alive the dream of Drenthe: the dream that Theo, too, would join him someday in the Yellow House. "I tell myself that by myself I am not able to do sufficiently important painting to justify your coming South," he wrote his brother plaintively. "But if Gauguin came and if it was fairly well known that we were staying here and helping artists live and work, I do not see at all why the South should not become another native land to you as well as to me." References to the Zemganno brothers and their "daring" feats reappeared in his letters. He talked of "making a hit" in Paris and promised Theo to "earn back all the money you have been lending me for several years." He pictured his old nemesis H. G. Tersteeg hearing of his great Gauguin coup and imagined himself finally loosed from the long grip of the past.

Vincent brought these visions to life in paint. On a big canvas (more than two by three feet), he transformed the humble building at 2, place Lamartine into a monument in yellow. By positioning his little house in the middle of the canvas between two plunging perspectives, he rooted it in the sunny Midi as immovably as the old church tower in Nuenen was rooted in the black soil of the heath. Its "fresh butter" yellow and bright cobalt sky rejected the tower's monstrous grays and lowering clouds, just as the bustling street life on the avenue de Montmajour—couples with children, café drinkers—mocked the lifeless graves at the tower's base, including his father's. Beckoning and eternal, the Yellow House springs from the bright countryside like a shaft of light—a *rayon blanc* to the church tower's *rayon noir.*

On another big canvas, he painted the one place in the house where he could dream such dreams in peace: his bedroom. Even downstairs, he always found reality intruding: creditors hounded him, models rebuffed him, whores refused him, fellow painters rebuked him. But in his bedroom, he could close the door on all that and read about Tolstoy's ideas on religion or Wagner's music. "In the end," he mused, "we will all want to live more musically." Whether pondering such thoughts or humming hymns to himself as he did in England, he could lie awake until late at night, floating above the "cynicism, skepticism and humbug" of the world on clouds of pipe smoke and dreams.

To capture that music of serenity, he set his easel in the corner of the tiny room and filled the canvas with his inner sanctum. In the past, he had often drawn records of his living spaces, as well as views from inside them, to give to family members as "souvenirs" or keep as aides-mémoires. But now he had a new means of recording. "Color will do everything here," he boasted about the painting even before it was finished, "giving by its simplification a grander style to things." And he also had a new reason to record. Like his painting of the Yellow House, *The Bedroom,* with its oversized furniture and exaggerated perspective, transformed the mundane into the monumental. Simplified forms and saturated colors turned

a domestic vignette into a stained-glass shrine ("painted in free flat tints," he wrote, claiming the mantle of Cloisonnism)—a celebration in vivid complementaries and cartoon furnishings of the sanctity of inner life. "Looking at this picture ought to rest the brain," he said, "or rather the imagination."

In Nuenen, he had painted *The Bible* to vindicate his defiant life on the heath. In *The Bedroom*, he memorialized the limitless possibilities of his dreams in the Midi. The wood-plank floor opens like a book to show not his father's bleak text, but the *"joie de vivre"* of Zola's novel: a bed big enough for two, built of yellow-orange pine, as sturdy as a ship; and paired chairs with rush seats. On pegs above the headboard, his turquoise painter's smock and straw hat. Over the bed, the portraits of the missing Boch and the departing Milliet—whose painted images, he said, made the house "seem more lived-in." Yellow sunlight peeks through the closed shutters and casts a citron light on the pillowcases and sheets. The defiant streaks of color that he had used on the pages of *The Bible* spring from their prison of gray to fill the canvas with a tumult of contrasts: a blue washbasin on an orange toilet table; pink floorboards laced with green; yellow deal and lilac doors; a mint-green towel against a robin's-egg wall; and, on the bed, a splash of scarlet coverlet. At the back of the telescoped room, beside the window, a small shaving mirror hangs on the wall, reflecting not an image, but a color—the same serene Veronese green that radiated from the *bonze*'s shaved head and gleamed in his eyes.

But the higher Vincent flew, the harder he fell. In mid-September, after a long silence, Gauguin wrote another brief, cryptic note. One line stood out above all the others: "Every day I go deeper into debt, and the journey becomes more and more out of the question."

The letter sent Vincent into a tailspin of fury and hurt. He accused Gauguin of betraying the brothers' generosity, and he urged Theo to issue an ultimatum—"Ask Gauguin bluntly . . . 'Are you coming or not?'" If he continued to waver or delay, Vincent fumed, Theo should cut him off—withdraw his offer of assistance at once. "We must behave like the mother of a family," he scolded, displaying a sternness he never tolerated in his brother. "If one listened to him, one would go on hoping for something vague in the future . . . and go on living in a hell with no way out."

Seized by paranoia, he imagined that Gauguin had found a better "combination" with his friend Charles Laval, a young painter with family money who had accompanied Gauguin to Martinique the year before, and had recently joined him once again in Pont-Aven. "Laval's arrival has temporarily opened a new resource to him," Vincent concluded. "I think that he is hesitating between Laval and us." When a letter arrived from Bernard suggesting that *he* would come to Arles for the winter, Vincent immediately suspected a plot to wring yet more

money from his generous brother. "Gauguin is sending him as a substitute," Vincent wrote, warning Theo not to tolerate such treachery. "No arrangement of any sort with [Bernard]," he snapped; "he is too fickle."

Vincent tried everything to keep his hopes for the Yellow House alive. He flooded Theo with long, manic letters whiplashing between cynicism ("I feel instinctively that Gauguin is a schemer") and reassurance ("our friendship with him will endure," "we are on the right road"). He summoned Theo to ever grander visions of a studio in the Midi even as he advised Gauguin on the finer points of evading creditors (he suggested either suing his landlord or leaving the back rent unpaid). He thrust himself into the details of the stalled negotiations in an effort to break the impasse. Placating Theo one minute, Gauguin the next, he alternated sides at the table: now pushing his brother to accede to Gauguin's conditions (pay all his debts *and* travel expenses); now demanding new, impossibly onerous concessions from Gauguin (give Theo all his pictures *and* pay his own expenses). He vehemently pressed the commercial advantages of the combination even as he clung to the mandate of destiny. "All true colorists *must* come here," he insisted; "Impressionism *will* last." He bought more furniture for Gauguin's bedroom. In the same letter, he assured Theo of his readiness to go forward alone if the deal broke down ("solitude does not worry me," he said), and boldly proposed bringing *both* Gauguin and Laval to the Yellow House. "It is only fair since Laval is his pupil and they have already kept house together," he reasoned. "We could find some way of putting them both up."

In late September, when Theo gently urged him to move on from his plan for Gauguin, and even move out of the Yellow House, Vincent's confidence collapsed. He bravely parried his brother's calls to concentrate more on selling and less on decorating, to quit his quaint dream of a utopia where artists didn't have to pay their own way, and to abandon his grandiose plans for an institute of Impressionism in the hinterlands. He protested his ultimate commercial intent—"It is absolutely my duty to try to make money by my work"—and pledged himself yet again to "make progress." He retreated from any immediate intention to provide a soup-kitchen refuge to other artists, while wanly defending "the right to wish for a state of things in which money would not be necessary in order to live."

But the prospect of another catastrophic failure pushed him closer and closer to breakdown. Without his dreams of the combination to hold it back, a wave of guilt and self-reproach swept over him. The old defenses of the Schenkweg studio sprang into place: the extravagant promises of future success, the claims of turning a new leaf, the bids for brotherly solidarity. As in The Hague, contrite confessions were followed by pleas for more money in a spiral of guilt and offense.

Just when the burden of apology seemed too heavy to bear, news arrived from Paris that Theo had fallen ill again, as syphilis took its inevitable toll on his frail constitution. "Thinking and thinking these days how all these expenses of painting are weighing on you," Vincent wrote in a panic of remorse; "you cannot imagine how disquieted I am . . . horribly and continually tormented by this uneasiness." Answering old sins with old penance, he punished himself with unceasing labor, strict fasting, neglected ailments, and abusive drinking. He reimagined the extremes of Arlesian weather—the sulfurous sun and lashing mistral especially—as a kind of self-mortification. And when a letter arrived from Eugène Boch in the Borinage, Vincent immediately laid plans to return to the black country himself. "I love that dismal land so much," he wrote Boch the same day, eagerly embracing the torments of the past. "It will always remain unforgettable to me."

His thoughts turned inevitably to death and, worse, madness. For the first time, he recognized himself in Claude Lantier, the hero of Zola's *L'oeuvre*, a painter driven to suicide by crazed, self-annihilating ambition. He looked in the mirror and saw again the icon of artistic dementia, Émile Wauters's portrait of the mad painter-monk Hugo van der Goes. "I am again pretty nearly reduced to the madness of [that] picture," he confessed in October.

More and more, though, Vincent's darkest fears took the face and form of one man: Adolphe Monticelli.

Vincent had appointed the Marseille artist as spiritual godfather to the brotherhood of colorists he envisioned springing up in the Midi. It was Monticelli, after all, who had first spun great art (as well as commercial gold) from the southern sun. It was Monticelli who denied "local color or even local truth" in order to achieve "something passionate and eternal." The more Vincent's dreams for the Yellow House slipped toward failure, the more fiercely he clung to the lifeline of Monticelli's example. In flights of rhetoric increasingly unhinged, he claimed a virtual identity with the dead artist. He did not merely follow Monticelli, he said, he "resurrected" him. "I am continuing his work here," Vincent declared, "as if I were his son or his brother." He compared his sunflowers to Monticelli's paintings of the South—"all in yellow, all in orange, all in sulfur." He laid delusional plans for a joint exhibition to vindicate both himself and his predecessor in the eyes of a skeptical world, and elaborately imagined his triumphant "return" to Marseille. "It is my firm intention to go saunter in the Cannebière there," he wrote in a reverie of reincarnation, "dressed exactly like him . . . with an enormous yellow hat, a black velvet jacket, white trousers, yellow gloves, a bamboo cane, and with a grand southern air."

But Monticelli had died in a stupor of madness and drink, slumped over a café table, according to the stories circulating in the art world. While Vincent

acknowledged his hero's troubled mind—"a little cracked," he conceded, "or rather very much so"—he blamed it on the "harassment of poverty" and the hostility of a scorning public. "They call a painter mad if he sees with eyes other than theirs," he scoffed. If this was madness, it was the madness that comes from being "blasted" too much by the sun, Vincent argued—a madness of inspiration and fecundity. It was the madness of the plants in Zola's *Paradou*, or of the "raving mad" oleander bushes in the public garden outside his door, "flowering so riotously they may well catch locomotor ataxia." If this was madness, it was *his* madness—an admission he celebrated in paint with a still life of a vase of blooming oleander sitting on a table next to a copy of *La joie de vivre*.

But mad or not, the image of Monticelli's ignominious end haunted him. "My mind dwells on the stories going around about his death," he confessed. It was a mystery that both puzzled and frightened him. He tried to see his efforts in the Midi as redeeming his fallen hero. "We shall try to prove to the good people that Monticelli did not die slumped across the café tables of the Cannebière," he vowed, "but that the little fellow is still alive." But what if those efforts failed? What then? Who would redeem Monticelli's glorious legacy of color and light if not Vincent? And who would redeem Vincent?

With questions like these, his thoughts slipped back into the quicksand of religion. "When in a state of excitement," he confessed, "my feelings lead me to the contemplation of eternity and eternal life." He searched for answers in an article about Tolstoy's views on the future of faith, but found no comfort in the Russian's impossible call for a return to the simple belief of "common folk" and his bracing rejection of the afterlife. "He admits neither the resurrection of the body, nor even that of the soul," Vincent reported bleakly, "but says, like the nihilists, that after death there is nothing else." Unpersuaded by Tolstoy's prediction of "an inner and hidden revolution" that would "have the same consoling effect . . . as the Christian religion used to," Vincent lashed out at the failure of modern thinkers to answer the ultimate question, raising a cry that combined furious rebuke, anguished confession, and existential panic:

> I only wish that they would succeed in proving to us something that would tranquilize and comfort us so that we might stop feeling guilty and wretched, and could go on just as we are without losing ourselves in solitude and nothingness, and not have to stop at every step in a panic, or calculate nervously the harm we may unintentionally be doing to other people.

In his desperation, Vincent turned again to the most consoling image he knew: Christ in the Garden. He imagined Monticelli "passing through a regu-

lar Gethsemane" and cast himself as the martyr's resurrected spirit—"a living man arising immediately in the place of the dead man." He summoned himself to "take up the same cause again, continuing the same work, living the same life, dying the same death." In late September, he tried again to capture this vision of immortality in paint. "I have the thing in my head," he wrote, "a starry night; the figure of Christ in blue, all the strongest blues, and the angel blended citron-yellow." But again he failed. Crushed a second time by the weight of an image too heavily freighted with the past—"too beautiful to dare to paint"— Vincent again took a knife and "mercilessly destroyed" the canvas, offering up only the same timorous excuse: "the form had not been studied beforehand from the model."

But he immediately began another attempt. This time, he would leave out the fearful, unbearable figures of Christ and the angel, and paint only the starry night sky under which their sublime encounter played out.

IT WAS AN IMAGE as deeply embedded in the iconography of Vincent's imagination as sowers or sunflowers. "The lovely evening stars express the care and love of God for us all," Anna van Gogh had written to her teenage son. To Anna, stars represented God's promise "to make light out of darkness; and out of problems, good things." Vincent's father fondly recalled his late-night walks "under lovely starry skies," while his sister Lies saw in the stars "all the people I hold dear very near . . . urging me: 'Be brave.'" Andersen's magical night skies had beguiled Vincent's childhood, while Heine's Romantic starlight had guided his adolescence. The beckoning star of Conscience had called him to Christianity, while Longfellow's "tender star of love and dreams" had consoled his long exile. In Ramsgate, he looked into the starry night and saw both his family ("I thought of you all and of my own past years and of our home") and his shame. In Amsterdam, on his evening walks along the riverbank, he "heard God's voice under the stars," and he painted in words an elaborate picture of the comfort he felt in the "blessed twilight," when "the stars alone do speak."

In Paris, the city lights virtually extinguished the stars, but his imagination took flight on the "miraculous" fantasies of Jules Verne and the astronomical discoveries of Camille Flammarion, who mapped the night sky with new worlds and gave each speck of light its own new mystery, opening up a universe of infinite possibility. Or he could dream upon the starry nights he kept at his bedside in the books of Zola, Daudet, Loti, and especially Maupassant, author of *Bel-Ami*. "I love the night with a passion," Maupassant wrote in the summer of 1887. "I love it as one loves one's country or one's mistress, with a deep, instinctive, invincible love. . . . And the stars! The stars up there, the unknown stars

thrown randomly into the immensity where they outline those bizarre figures, which make one dream so much, which make one muse so deeply."

In Arles, Vincent rediscovered the stars. "At night, the town *disappears* and everything is *black*," he reported with delight, "much *blacker* than in Paris." He walked the city streets, the riverbanks, the country roads, the orchards, even the open fields, at night, drawn both by the opportunity to "muse deeply" and by the chance to go about unbothered. As much as the famous sun, the starry vault defined Vincent's experience of the Midi. Soon after arriving, he began to imagine painting it. "I must have a *starry* night," he wrote Theo in early April. "A starry sky is something I should like to try to do," he wrote Bernard, "just as in the daytime I am going to try to paint a green meadow spangled with dandelions." On his trip to the sea in May, a walk along the shore at night brought this ambition to a fever pitch. "It was beautiful," he wrote Theo.

The deep blue sky was flecked with clouds of a blue deeper than the fundamental blue of intense cobalt, and others of a clearer blue, like the blue whiteness of the Milky Way. In the blue depth the stars were sparkling, greenish, yellow, white, pink, more brilliant, more emeralds, lapis lazuli, rubies, sapphires.

On that dark shore, where both the inky water and the glittering sky invited reflection, Vincent's ambition to combine with Gauguin—still more dream than plan—merged with his view of the night sky. Just as he saw the ghosts of his past in the dunes and houses of Saintes-Maries, he saw his future in the stars over the Mediterranean. "To look at the stars always makes me dream," he wrote, "as simply as I dream over the black dots of a map." He returned to Arles with the image burning in his imagination. "When shall I ever get round to doing the starry sky," he wondered in mid-June, "that picture which is always in my mind?" Through all the trials of the summer, the up-and-down negotiations with Gauguin, the death of Uncle Cent, he saw in the nightly spectacle overhead not just a map to an impossibly distant world where life for painters might be easier, but the promise of a future almost within reach. "Hope is in the stars," he wrote. "But let's not forget that this earth is a planet too, and consequently a star."

In early September, he considered returning to the seashore to confirm and record the image in his head. "I absolutely want to paint a starry sky," he told his sister Wil. With a vehemence that betrayed months of looking and planning, he explained to her how the night was "more richly colored than the day; having hues of the most intense violets, blues and greens," and instructed her in the rainbow of starlight: "If only you pay attention you will see that certain stars

are citron-yellow, others have a pink glow, or a green blue and forget-me-not brilliance." To fix this vision in the firmament of Symbolist imagery, he invoked the poetry of Walt Whitman, whose embracing summons to a future filled with love and sex and work and friendship "under the great starlit vault of heaven" perfectly matched the image Vincent saw when he stared and squinted into the night sky.

He practiced this vision again and again throughout the summer and fall. He completed the portrait of Eugène Boch in early September by dabbing a constellation of multicolored "sparkling stars" onto the painting's deep blue background. At the same time, he gave the portrait its new title, *The Poet*—a designation that connected Boch's star-lighted visage with the new Petrarch of the Midi, Gauguin.

But just painting the stars wasn't enough; he longed to paint *under* the stars. "The problem of painting night scenes and effects on the spot and actually by night interests me enormously," he wrote. To satisfy that yen, he dragged his equipment to the Place du Forum and painted his nocturnal view of the café terrace with its gaslit awning and its plunging streetscape "stretching away under a blue sky spangled with stars." Unlike the seemingly random dots of the Boch portrait, the wedge of night sky in the *Café Terrace on the Place du Forum* reveals a universe of stars and planets arranged in solar systems of color. "Here you have a night picture without any black in it," he boasted, "done with nothing but beautiful blue and violet and green, and citron-yellow color." He compared it to a description from Maupassant's *Bel-Ami*, another touchstone of his dream for the Midi. He laid plans to paint a series of "starry night" paintings to rival the sunflowers of summer, including a plowed field under the night sky and, especially, the Yellow House, home to all his dreams. "Someday or other you shall have a picture of the little house itself," he promised Theo, "with the window lit up, and a starry sky."

When his similar attempt to depict Christ under a starry sky failed so miserably in late September, Vincent shouldered his equipment in the middle of the night and sought his subject directly under the stars. He picked a spot only a few blocks away, on a seawall overlooking the Rhône. To provide light, he set his easel under one of the gas lamps that lined the wall along the riverbank. Experience had shown him that its golden light was inadequate, even deceptive. "In the dark I may mistake a blue for a green," he admitted, "a blue-lilac for a pink-lilac, for you cannot rightly distinguish the quality of a hue." But the immediacy of the image mattered more than the accuracy, he insisted. And there was no other way to avoid "the poor sallow whitish light" of conventional night scenes.

Once set up, he turned his gaze south, looking downriver at the dark town. It stretched out along the great bend of the Rhône, curving and receding from

left to right, visible only by its necklace of gas lamps and its jagged dark profile on the horizon: the tower of the Carmelite convent at one side, the dome of St. Trophime in the middle, the spires of St. Pierre on the opposite shore. Only a handful of windows are lighted. Boats are moored in the black water below him. It is late.

But when he looked up, he saw a different sky than he had seen three months before on another shore. Or, rather, he saw it with different eyes. In June, his rocketing dreams for the combination with Gauguin had found inspiration in Daudet-inspired fantasies of train trips to distant stars and galaxies of better worlds. Now, as the prospect of Gauguin's coming receded like the sunset, Vincent searched the night sky for an older, deeper consolation. "I have a terrible need of—shall I say the word?—religion," he wrote, shuddering at the confession. "Then I go out at night to paint the stars."

As best he could, he deployed the palette of greens and blues with "citron" highlights that he had used in the failed Gethsemane—colors he had long connected to Christ—from Scheffer's *Christus Consolator* to Delacroix's *Bark*—and to those of his own paintings, from *The Potato Eaters* to *The Poet's Garden,* that portrayed "a different world from ours." He plunged the town itself into the blackest blue he could contrive. To make it even darker, he painted the string of streetlamps in bursts of "harsh gold." The ultimate subject may have been above him, but the river, too, drew his dreamy eye. The play of light on water—on rivers, on ponds or puddles—had always led Vincent to deep meditation on the mysteries of the infinite. Looking at the receding line of lanterns, he tracked their "ruthless reflections" in the choppy river water with hundreds of short, brooding strokes. For the small jetty at his feet, where the black boats bobbed in silence, he used yellow-green to show the reach of his own lantern, but he unsettled the foreground with highlights of mauve, a red-blue mix that added a mysterious other light.

In the sky, he started by dutifully laying out the stars of the Ursa Major constellation in the southern quadrant at the center of his big canvas—the seven stars of the Big Dipper most prominent of all. But the longer he looked, the more he saw and the more his brush wandered. He saw dots and smudges, perfect circles and misshapen fragments. He imagined some stars in the palest shades of pink and green, "sparkling" like hued gems in the dark void. He compared himself to a jeweler arranging precious stones "in order to enhance their value." To some, he added coronas of radiating strokes, like flower petals or distant fireworks, creating for each a citron aura like the nimbus that encircled the head of Delacroix's Christ. He rendered the Milky Way with the lightest touch of his brush—an impossible blush of pale blue on the cobalt vastness. With exquisite care, he laid the brushstrokes on the night sky in a rhythm of broad dashes, "firm and interwoven with feeling."

If he could achieve with his gentle brush and "harmonious" color the same consolation as the unapproachable image of Christ, if he could capture in paint "the feeling of the stars and the infinite high and clear above you," perhaps his loneliness might end—or at least be comforted. The never-dark night café provided its own kind of consolation, of course, to those like him "without native land or family." But for Vincent the transient balms of absinthe and gaslight could never suffice. Nor could he accept his own furtive argument that "the Arts, like everything else, are only dreams; that one's self is nothing at all." Inevitably his eyes returned to the starry night sky, where he saw another, truer, deeper consummation, however distant. With his plans for the Yellow House slipping toward failure, his yearning for that future poured onto the canvas as he labored more tenderly than ever before to express a transcendent truth through color and brushstroke: to capture the one human emotion shut out of the Café de la Gare, the most important one: the hope—no matter how faint or how far—of redemption. "Is this all," he asked despairingly, "or is there more besides?"

At the end, perhaps back in the studio, he added to the painting a shadowy couple standing on the shore: lovers arm in arm, wandered in from a distant star.

IN EARLY OCTOBER, Gauguin wrote Theo: "I will soon be joining [Vincent] . . . I shall leave for Arles toward the end of the month." At the same time, he sent to Arles the portrait that Vincent had requested as a token of brotherhood. "We have fulfilled your wish," he grandly announced. The news dropped Vincent to his knees. "Now at last," he wrote Theo the same day, "something is beginning to show on the horizon: Hope."

Even more thrilling than the news itself was Gauguin's description of the painting on its way. In a self-portrait, Gauguin had imagined himself as Hugo's famous outcast, Jean Valjean, with "the mask of a bandit" hiding an "inner nobility and gentleness." In this way, Gauguin explained, he meant to show not just his own features, but a portrait of all painters everywhere who felt "oppressed and outlawed by society." It was a vision of artistic ostracism and shared suffering that could have come from Vincent's own pen. "His description of himself moves me to the depths of my soul," Vincent wrote.

After months of torturous advances and retreats, all his expectations for the Yellow House burst forth at once in a flood of ecstatic, adulatory letters. He pledged himself to work tirelessly to provide the "very great master" Gauguin with "peace and quiet in which to produce, and to be able to breathe freely as an artist." Flinging aside all his previous reservations, he welcomed Bernard to join them, and Laval, too—and even two of Gauguin's other Pont-Aven protégés

whom Vincent had never met. All were welcome to the brotherhood of the Midi. "Union is strength," he cried.

But only one man could lead them. "There must be an abbot to keep order," Vincent insisted. "Gauguin and not I will be the head of the studio." Theo could serve as "first dealer-apostle," Vincent allowed; but he, too, owed this single allegiance. "You have committed yourself to Gauguin body and soul," he solemnly instructed his brother. Only in this way could they achieve the procreative triumph that Vincent had long envisioned. "I can see my own painting coming to life," he imagined. "And if we stick to it, all this will help to make something more lasting than ourselves."

But in Paris, Theo read Vincent's surge of giddy letters with increasing concern. After months of negotiations, he knew all too well Gauguin's Gallic egotism and fecklessness (his "final" commitment to go to Arles was conditioned on the payment of an additional hundred francs). And he knew even better his brother's heedless ardor. He had lived through all the great, fiery arcs of Vincent's passions: bugs and birds, brothels and bordellos, Christ and the benighted miners, Mauve and his magic brush, Herkomer and black-and-white illustrations, Millet and the heroic peasants, Delacroix and color: a succession of gospels and saviors. The self-advancing Gauguin must have seemed a particularly unsteady fulcrum for such a heavy load of expectation.

How heavy a load became clearer with every new expense (another binge of spending followed Gauguin's letter), every plea for more money, and every promise to pay it all back. (In October, Vincent proposed yet another fantastical plan to reimburse Theo for everything he had spent over the years.) Indeed, Vincent had come to see the combination with Gauguin as balancing the books of a lifetime. When sister Wil sent a recent photograph of their mother, Vincent immediately made a painting based on it, triumphantly rerendering the face of the past in the same "ashen coloring" and vibrant Veronese green as his *bonze* self-portrait.

But what if Gauguin *did* come? Even from a distance, he had found Vincent's tireless persuasion and endless demands for affirmation "intimidating." Theo knew better than anyone the trials of living with his brother: the insecurity and defensiveness, the alternating currents of guileless optimism and abyssal depression, the inner war of grand ambition and easy frustration. ("I am afraid of getting discouraged if I do not succeed at once," Vincent confessed that September.) How would Gauguin, a man of forty with multiple careers and a world of experience, respond to Vincent's devouring need to reshape the people and things closest to him because he could change so little else about his life? Even now, awaiting "the abbot's" arrival, Vincent was already lobbying to put off Bernard's coming and dictating the terms of Gauguin's happiness as sure-handedly

as he had planned Sien Hoornik's rehabilitation: "He must eat and go for walks with me in lovely surroundings," he wrote Theo, "pick up a nice girl now and then, see the house as it is and as we shall make it, and altogether enjoy himself."

In addition to his own experience, Theo had the reports of Lieutenant Milliet and Eugène Boch, both of whom had visited him recently in Paris with first-hand accounts of Vincent's embattled life under the southern sun. The Dane Mourier-Petersen (who later called Vincent "mad") had stayed with Theo briefly after leaving Arles, and Theo undoubtedly knew from both sides the story of Vincent's rancorous falling-out with Dodge MacKnight, his first candidate for a "combination" in the Yellow House. Vincent himself talked ominously of "madness" and the need to "beware of my nerves."

As if confirming Theo's worst fears, Vincent launched a preemptive assault on Gauguin only a week after receiving his final agreement to come. When the self-portrait Gauguin had described so thrillingly arrived in Arles, Vincent found the colors "too dark" and "too sad." "Not a shadow of gaiety," he complained. How could the Bel-Ami of the Midi paint such a "despairing" and "dismal" image? "He must not go on like this," Vincent sputtered. "He absolutely must cheer up. Or else . . ."

What would happen if this castle in the air collapsed, like so many before it? Theo had already pressured Vincent to move on: a pressure that would only intensify if Gauguin balked again. In a fury of denial, Vincent claimed that he would stay in Arles for ten years, living the unbothered life of a Japanese monk, "studying a single blade of grass" and "drawing the human figure" contentedly. But he had said the same thing in The Hague, before scandal and failure drove him home to Nuenen; and the same thing in Nuenen, before scandal and failure drove him to Theo in Paris.

In his darkest moments, Vincent must have considered returning to Paris; but even that road of shame was fraught with uncertainty. Not only was Theo's health precarious, but his heart was drawn in other directions. Alone in the rue Lepic apartment, "feeling emptiness everywhere," Theo complained of "a void" that Vincent could not fill. His thoughts had turned again to love and marriage and a family of his own.

IN HIS DELIRIUM of anticipation, Vincent ignored the signals from Paris that the net beneath his high wire might be removed. In a celebration of the perfect union to come, he painted another view of the public park outside his door— the "Poet's Garden" of Petrarch and Boccaccio. An immense fir tree spreads its shade over a winding gravel path and an island of luxuriant grass. Its feathery bulk blocks sun and sky, filling the upper half of the canvas with buoyant, radiating fronds of a deep and wondrous turquoise—a color exquisitely poised be-

tween blue and green: a perfect marriage; unfathomably lovely. In its Persian-fan shade, a couple walk hand in hand.

When it was dry, Vincent hung it in the tiny bedroom he had prepared for Gauguin along with the other paintings of the Poet's Garden and the sunflowers of summer as a harmonious chorus of welcome. At the same time, in the pots on either side of the front door of the Yellow House, he planted two oleander bushes—reminders of the fecundity of madness, and the toxicity of love.

Imaginary Savage

~

C HARLES LAVAL LOVED PAUL GAUGUIN SO MUCH THAT HE WOULD have followed him through Hell. And in April 1887, he did just that. Lying feverish and delusional on a seaweed-stuffed mattress in a hut built for negro slaves, shivering uncontrollably in a swamp of his own sweat, Laval never questioned his decision to come to Martinique with his friend and *maître* Paul Gauguin.

They had met the previous summer on the cool, rocky coast of Brittany—the same summer Vincent spent closeted in the rue Lepic apartment painting flowers. Gauguin had blown into the little artists' resort of Pont-Aven like a gust of tropical wind off the nearby Gulf Stream. The community of young painters—mostly British, American, and Scandinavian—hungry to make sense of the upheavals in Paris, flocked around him. Here was a man who had painted alongside the heroes of Impressionism, from Manet to Renoir, who had shown with them as early as the *refusé* days and as recently as the eighth and final Impressionist exhibition in May, only months before. In that show, Gauguin's work had shared the walls with Seurat's *Grande Jatte*—an image of electrifying newness. With his flamboyant dress, exotic background, and mysterious reserve, the thirty-eight-year-old Gauguin seemed to hold the key that would unlock all the art world's secrets. In a fever to win his favor, the young artists of Pont-Aven paid for his lodgings, attended him at table, and sat spellbound at his nightly audiences at the Gloanec Inn.

None competed more ardently or listened more enthralled than Charles Laval. Wearing the pince-nez of an aesthete and the wispy beard of an ascetic, the twenty-five-year-old Laval combined the refined sensibilities of his father, a Parisian architect, and the soulful yearnings of his Russian mother. He had come of age on the fringes of Impressionism, studied with Toulouse-Lautrec, and exhibited at the Salon while still a teenager. Financially secure but spiri-

tually thirsting, Laval, who had lost his real father at age eight, distinguished himself among all the young painters of Pont-Aven as Gauguin's most devoted acolyte.

Thus, it was no surprise when, the following winter, Laval accepted his master's invitation to join an expedition to the Caribbean in search of the erotic license and artistic truths known only to primitive cultures. Gauguin painted an irresistible picture of a "free and fertile" land where "the climate is excellent

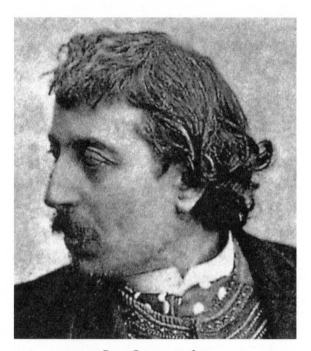

PAUL GAUGUIN, 1891

and one can live on fish and fruit which are to be had for the taking." It was an image ripped directly from the pages of Pierre Loti's fabulist account of his trip to Tahiti, *The Marriage of Loti.* Charles Laval, besotted like so many aimless sons of the bourgeoisie by Loti's vision of paradise on earth, could hardly refuse.

In fact, Laval had every reason to believe in Gauguin's seductive vision of a paradise in the Americas. As everyone at the Gloanec Inn knew, Gauguin traced his ancestry to the colonial Spanish rulers of Peru, where the young Paul had spent his early years. Sometimes he hinted at an even earlier, more primitive and noble lineage among the great native rulers of the New World, including perhaps the Aztec emperor Montezuma—a notion to which his dark skin and sharp features seemed to bear witness. He talked of wealthy family connections still in Lima, where he had lived a childhood pampered by tropical breezes and Chinese servants.

With stories like these, Gauguin cast their trip to the Caribbean more as a triumphal return than a careless adventure. Indeed, he had chosen their destination—a tiny island called Taboga—because of its proximity to his brother-in-law, a successful merchant who had recently returned to his native Colombia. In the northern part of that country, on a narrow isthmus called Panama, French companies had undertaken a massive construction project: a canal to connect the Atlantic and Pacific oceans. In the flood of money and matériel being poured into this remote region, his brother-in-law would make a fortune, Gauguin assured his young disciple, and could well afford to stake them to their piece of paradise in Taboga.

Laval, too, had a relative among the scores of companies that had rushed to Panama, but he knew nothing of money or business. On these matters, especially, he trusted Gauguin. After all, Gauguin had worked at the Paris stock exchange, the Bourse, for years before becoming an artist. As a broker and "liquidator," he had parlayed a respectable inheritance from a mysterious benefactor into a haut-bourgeois lifestyle of hired carriages and Sunday outings. He had acquired a family along the way as well, including a wife and five children, although its workings must have been deeply obscure to the conventional Laval. The one son who lived with Gauguin in Paris, Clovis, had been safely set aside in boarding school, seemingly no impediment at all to his father's long absences; the others remained with his Danish wife, Mette, in distant Copenhagen. Gauguin said little about any of them, and Laval dared not inquire. Like his unusual accent (Spanish was his first language), murky finances, and uncertain pedigree, such questions were all subsumed in the enigma that was Paul Gauguin.

His art only added to the mystery. From his grandmother's friendship with Delacroix to his own flirtation with Symbolism, Gauguin's art seemed always on the move, drawing from everywhere, promising everything, flinging itself from one latitude of the art world to another as freely as his ancestors (and Gauguin himself) traversed the tropics. As a stockbroker, he had bought the art and indulgence of the Impressionists. On his Sunday outings, he took up their brush and, under the tutelage of Pissarro, mastered their feathery style. By 1882, when his Bourse job vanished in the great stock crash that year, Gauguin felt sufficiently confident to turn his avocation for art into a full-time pursuit. To the horror of his status-conscious wife, who promptly left him and returned to Denmark, he took up the "vagabond life" of an artist and threw himself on the mercy of the art market. Unable to win critical attention or patronage (he admitted to offering himself "like a whore to the market and finding no takers"), Gauguin was soon forced to accept a sales job with a tarpaulin maker and rejoin his family in Copenhagen. After only six months, however, he abandoned them and returned to Paris, more determined than ever to make his mark in the art world. He took

only his son Clovis, Mette's favorite, with him—out of spite, some thought. In a tiny garret with little food and less heat, the six-year-old immediately fell sick with smallpox.

Meanwhile, Gauguin's art bounded from Impressionism to Symbolism. He drafted ambitious manifestos for a new kind of imagery—"spiritual, enigmatic, mysterious, and suggestive"—and took up a new champion, Cézanne. But before he could create an art to match this *L'oeuvre*-like mandate, the ground beneath him shifted again. In 1886, Seurat's *Grande Jatte* swept all before it. Gauguin's canvases were lost in the wake of the latest *succès de scandale,* his rhetoric drowned out by the deafening buzz over the "new" Impressionism. Almost immediately, he laid elaborate plans to ingratiate himself with the new hero Seurat, to whose banner many of Gauguin's former comrades, especially Pissarro, had rallied. But an unexplained "contretemps" with the ill-tempered Seurat in June 1886 brought that initiative to an abrupt end. Before long, he and his longtime sponsor Pissarro were trading insults. Gauguin denounced the Neo-Impressionists as makers of "petit-point tapestries" and cursed "those damn dots." Pissarro accused Gauguin of "bad manners" and dismissed his art as "a sailor's art, picked up here and there." "At bottom his character is anti-artistic," Pissarro sized up his former friend, "he is a maker of odds and ends." Degas called him "a pirate."

But Gauguin rebounded again. By the time Laval met him a few months later at the Gloanec Inn, he had found a new mentor, Félix Bracquemond; moved on to a new medium, ceramics; and assumed a new shape: a "savage from Peru." Advertising his "Indian" heritage, he fashioned clay figures that combined pre-Columbian forms and Symbolist suggestion into sexually freighted images: menacing snakes and swans with phallic goosenecks. He signed them "PGo"— French slang for "prick." He also refashioned himself as a brooding, volatile, alien "beast," trapped in the parlors and studios of France. Banishing his past as a bourgeois Sunday painter, stockbroker, and Impressionist hanger-on, he grew his hair long and dressed in operatic costumery (extreme dishevelment one day, swaggering capes the next, often bedecked in ostentatious jewelry). Friends worried about his strange appearance and theatrical moods. Some thought that he had slipped into megalomania. He cultivated rumors (started by the altercation with Seurat) about his quick temper and feral belligerence, even as he continued to woo and charm. "You must remember that two natures dwell within me," he explained ominously, "the Indian and the sensitive man. The sensitive being has disappeared and the Indian now goes straight ahead."

This was the Gauguin that Laval met and loved and devoted his life to: a man unconstrained by convention or good repute; a man of both enlightenment and mystery, cultivation and danger; a man, as Gauguin himself put it, "outside the limits that society imposes." He could be affable and gregarious one

minute, bullying and bellicose the next; now sardonic, now morose. In his lim-
pid green eyes, some saw "gentleness and warmth"; others, "scoffing" disdain;
others, "heavy-lidded sensuality."

In a profession defined by effeteness, in an era of irony and languor, Gauguin
boxed and fenced and did not flinch from physical confrontation—a reputation
that delighted his admirers and intimidated his adversaries. Although short even
by the standards of the period (five feet four), he was strong and solidly built. To
some, he radiated a "menacing power that seemed just barely held in check."
They called him *"malin"*—cunning. "Most people were rather afraid of him,"
wrote an English painter in Pont-Aven in 1886, "and the most reckless took no
liberties with his person. . . . He was treated as a person to be placated rather
than aroused." Those he could not intimidate, he seduced. By Gauguin's tell-
ing, men as well as women could taste the honey of his charms, and Laval was
by no means the only proof of such claims. Gauguin himself, despite his many
tales of amorous conquest, seemed to live beyond sex. He demanded chastity of
acolytes like Laval with the exhortation *"pas de femmes"* (no women) and exalted
androgyny above all other forms of sexual allure. By such various and variable
means, Gauguin won hearts like Laval's. "All the artists fear me and love me," he
boasted from Pont-Aven. "None can hold out against my theories . . . [They] ask
my advice, fear my critiques, and never challenge anything I do."

Paris, on the other hand, continued to resist him. By the time he returned
there in the fall of 1886, the break with Pissarro and Seurat had widened into a
chasm of mistrust and recrimination. No one would buy or sell or even show his
work. Estrangement, obscurity, poverty, a long hospitalization, and a full turn
from painting to pottery, combined to erase him from the avant-garde scene. By
January 1887, Pissarro could write with some relief, "Gauguin is gone . . . com-
pletely disappeared." One winter night, in his freezing apartment, warmed only
by his kiln, his frustration, and the stubborn adulation of a few Pont-Aven ac-
olytes like Laval, Gauguin presented his thrilling plan to thrust himself back
into the public eye: he would "rebaptize" himself in the tropics. "I am going to
Panama," he announced, "to live like a savage."

The long and miserable sea voyage, racked by storms and "packed like
sheep" in the third-class cabin, hinted at the horrors to come. But Laval saw
only his mentor's steadiness and seamanship on a crossing he had made many
times before. In his two years as a merchant seaman, Gauguin had acquired
not only steady legs, but also a talent for the shipboard ritual of storytelling.
A gifted raconteur (he bragged of being "an astonishing liar"), Gauguin spun
yarns more easily than truth. On their ocean journey, Laval may have heard for
the first time some of Gauguin's Candide-like tales: of earthquakes and ship-
wrecks, of royal ancestors and madmen chained to the roof of his childhood

home; of sexual awakening at the age of six and whores in every port; of action in the Franco-Prussian War and near court-martial for insubordination; of cloak-and-dagger doings in a failed plot to overthrow the Spanish king. In one of his most astonishing stories, Gauguin crossed paths with another prolific fabulist, Julien Viaud—a fellow artistic soul of ambiguous sexuality lost in a midshipman's uniform. A decade after their encounter, Viaud had become one of the era's most popular writers, taking the name of a character he had invented for his fantasy account of a voyage to the Pacific: Pierre Loti.

But no sailor's tale, or even Loti, could have prepared Laval for Panama and what he found in Colón, at the base of the great dig. A huge shantytown stretched as far as the eye could see: twenty thousand people crowded onto a finger of marshland jutting into the sea. Torrential rains, regular floods, and poor drainage had turned the low-lying town, swollen to ten times its original size in just a few years, into a hellhole of mud and misery—a "malarious swamp," Gauguin called it. Trash and sewage filled the streets, swirling into new patterns of rat-infested effluvia with each downpour or inundation. In the overcrowded, unpoliced town, "a sort of filthy, putrescent anarchy" reigned, according to one account. Convulsions of violence—by the indigenous population against the newcomers and among the workers—cut swaths of ashes and ruin across the shanty rows. Death hovered in the air. Mosquitoes carrying malaria and yellow fever swarmed over the muddy peninsula, infecting half the population. At the canal itself, three out of four diggers—almost all of them blacks recruited from the West Indies—perished in wave after wave of unchecked contagion. At Colón's only hospital, the death rate climbed even higher.

Gauguin's plans for work proved as illusory as his promise of paradise. His brother-in-law's "trading firm" in Panama City, on the Pacific side of the isthmus, turned out to be just a general store, where Gauguin found neither work nor money nor sympathy. He and Laval were forced to return to Colón, where, according to a newspaper account, "the sad spectacle of educated men starving in the streets" was common. Through Laval's contact, they found jobs as clerks at a construction company office, but only for two weeks. After that, Laval tried to raise money by painting portraits. Gauguin struck off into the countryside looking to buy land from the local Indians using what little money they had left. When that failed, he persuaded Laval to press on to Taboga, their original destination. Instead of an unspoiled Shangri-La, however, they found a tourist trap—a sham of costumed natives, Sunday trippers, and guided tours. The wily islanders demanded exorbitant prices for everything, especially their land. Frustrated, Gauguin immediately laid plans to travel to Martinique, a "genial and gay" French island in the eastern Caribbean where their ship had called briefly on the trip over. "We ought to have gone there," Gauguin fulminated, "where

living is cheap and easy and people affable." Trailed by the adoring Laval, he left the fetid isthmus, convinced that an "enchanting life" awaited them at the end of the thousand-mile voyage to Martinique.

They barely had time to find the little slave cabin, in the mountains overlooking the port of Saint-Pierre, before Laval was struck down by yellow fever. The disease pounced on its victims with savage suddenness, reducing healthy men to racking pain, trembling fevers, and convulsive nausea in a single day. The poison spread to every organ, impairing liver, kidneys, and lungs. Drenching sweats, dysentery, and bloody vomiting brought light-headedness, delusion, and delirium. Skin and eyes turned a bilious yellow. In his letters to family and friends, Gauguin made nothing of Laval's agony ("all's well that ends well," he wrote). While Laval lay in his sweat-stained bed, Gauguin explored the mango groves and watched the dark *porteuses* carrying their loads on their heads through the mountain passes. He reported painting "some good pictures . . . with figures far superior to my Pont-Aven period." Laval eventually recovered enough to join him on some of these painting excursions, at least around the perimeter of their little hut.

In July, Gauguin, too, fell sick, but not seriously enough to merit a mention in his letters. That changed a month later when word arrived that a collector in Paris had expressed some interest in his pottery. Suddenly, a new El Dorado beckoned. "I must get out of here," he wrote a friend, "otherwise I shall die like a dog." In a fury of letters that testified against its own account of debilitating illness, Gauguin pled for money to return home. "I am just a skeleton," he cried. "My head has become very weak, I have only a little strength in the intervals between delirium. Nervous crises almost every day and horrible shrieks, it is as if my chest were burning. I implore you . . . do all that is possible to send me 250 or 300 francs immediately." In a bold lie, he claimed that his work in the trenches of the canal ("break[ing] the earth from half past five in the morning until six in the evening under the tropical sun") had "poisoned" him. He described his "agonies in the stomach" and "atrocious pains." "My head is swimming," he wrote, "my face is covered with perspiration and I have shivers down my back." Every night he "expected to die," he said, and only a return to France would save him from death or a lifetime of "disease and fever."

Was Gauguin ever this sick? Or did he weave this vivid narrative from his friend's sufferings to bolster his case for funding? Although the course of the disease was mercifully short, recovery (if there was one) often took months. In October, when Gauguin finally succeeded in begging the money for passage back to France, Laval was still too weak to travel. Gauguin, on the other hand, bounded home, leaving his friend to convalesce on his own, no doubt defending his departure in the same terms he had used only six months earlier when he

abandoned his son Clovis in Paris: "I have *just* enough to pay my fare . . . my heart and mind are steeled against all suffering."

ALMOST EXACTLY ONE YEAR after returning from Martinique, Paul Gauguin knocked at the Yellow House door. He had not seen his wife or children once in the intervening year. Nor had the Paris art world fallen prostrate before the artist who now styled himself "a man of the tropics." True, he had sold three Martinique paintings to the newcomer Theo van Gogh (whose *entresol* gallery, he discovered, had become "the center for the Impressionists" in his absence), but nothing had come of it. He had returned from his exotic adventure expecting a triumph—to "hit everybody in the eye" the way Seurat's *Grande Jatte* had done. Instead, he found only Theo's cautious optimism and his strange brother's suffocating enthusiasm. "All I have brought back from the tropics arouses nothing but admiration," he wrote acidly in November 1887. "Nevertheless, I do not arrive."

Rather than suffer obscurity in Paris, Gauguin had returned to the scene of his first and, so far, only *succès*—Pont-Aven—at almost the same moment in February 1888 when Vincent struck out for the South. There, he had worked tirelessly to bolster his new identity as an artist of savage temperament and primitive essence. He talked endlessly of his "decisive" Martinique experiences and instructed his reassembled acolytes: "If one wants to know who I am . . . one must look for me in the works I brought back from there." He drew strained parallels between Brittany and Martinique, calling both "dark and primitive" places, whose natives bore the mark of "primitive times." Borrowing from yet another Loti fantasy, *Mon frère Yves*, he dressed like a Brittany sea captain in sailor's jersey and beret—a reminder to all of his exotic travels and of "the hidden savage" that Loti saw in every man who "inhabited the primitive world of the sea."

In this guise, Gauguin had revisited the triumph of two summers before. While currying Theo's support with humble letters addressed "*Cher Monsieur*," and repeatedly putting off Vincent's pleading invitations to Arles with a charade of imminent departure, he circulated among the holiday crowd in Pont-Aven, reprising the role of *chef d'école* to a circle of young painters who, he hoped, would carry the flame of celebrity back to Paris. He even reclaimed the adulation of young Laval, who finally limped home from Martinique in July 1888, eight months after Gauguin left him there. With the help of Émile Bernard, a new addition to this charmed circle, Gauguin had developed an art to accompany his new incarnation—an art of primitive "crudity" and spiritual intensity. The bold forms and colors of Anquetin's Cloisonnism and Bernard's reborn mystical Catholicism both perfectly suited Gauguin's self-portrait as savage. (The

self-portrait that he sent Vincent had a "fierce, blood-glutted face," he wrote, and "eyes like lava fires.") Gauguin not only dominated the young challenger Bernard (though the two would soon clash over authorship of the new art), he underscored his primitive primacy by seducing Bernard's seventeen-year-old sister Madeleine.

Not surprisingly, he had stayed in Pont-Aven as long as possible. Only after all the others had left, including Bernard and Madeleine; only after his money had run out entirely; and then only after Theo bought some of his ceramics, offered to show his Pont-Aven pictures on the *entresol,* and paid a final fifty-franc inducement, did Gauguin reluctantly board a train and begin the long journey to Arles. While Vincent waited breathlessly for the consummation of brotherhood to come (alerted by a trunk sent in advance), Gauguin coolly appraised Theo's—not Vincent's—plan for the future: "However much Van Gogh may be in love with me, he would not bring himself to feed me in the South for my beautiful eyes," he wrote a friend on the eve of his departure. "He has surveyed the terrain like a cautious Dutchman and intends to push the matter to the utmost of his powers . . . This time I really have my foot on solid ground."

With his sights so firmly fixed on relations in Paris, and ambivalent to the last minute, Gauguin failed to inform Vincent what day or what time he would arrive in Arles. When his train pulled into the station shortly after five in the morning on October 23, 1888, it was still dark—too early to intrude on a man he barely knew. So he stepped into a nearby café that was open, the Café de la Gare, to wait for the sunrise. "It's you," the manager called out, startling him. "I recognize you." In his excitement of anticipation, Vincent had shown Gauguin's self-portrait to the café owner.

A short time later, Vincent jolted awake at the sound of the long-awaited knock and rushed to the door.

There was more to the mix-up than irresolution or oversight. As an expert fencer and boxer, Gauguin knew the value of keeping an opponent off balance. "Wait for the first forward movement," he once advised an overmatched student at the fencing school where he taught. When he chose, he planned meticulously and acted decisively. When he sensed a weakness, he did not hesitate to attack. But the venture with Vincent was filled with unknowns, and Gauguin preferred not to put too much weight forward until he knew his opponent better.

Where Vincent saw a brotherhood, Gauguin saw a contest. "I have a need for struggle," he had announced before arriving, using a French term, *la lutte,* for the competition of wills that Gauguin saw in every exchange, whether with swords, fists, words, or images; "[I] slash away blow by blow." To underscore this *en garde,* he sent Vincent a drawing of a painting he had made. It showed two Breton youths locked in a tense, wrestlers' embrace. He described it as an image of primal combat "as seen through the eyes of a Peruvian savage."

La Lutte

~

THE FIRST BLOW FELL WHEN VINCENT OPENED THE YELLOW HOUSE door. Gauguin's months of pleading letters and claims of paralyzing illness had led Vincent to expect a sick and debilitated man. He had seen that image in the self-portrait Gauguin sent ahead: "Gauguin looks ill and tormented!!" he exclaimed when it arrived. But the man who stood in his doorway looked a picture of health and vigor: muscles on his bones, blood in his cheeks, fire in his eyes. "Gauguin has arrived in good condition," he wrote Theo, unmistakably startled. "He even seems to me better than I am."

In the days that followed, Vincent marveled at his guest's resilient stomach and hearty constitution—the two measures by which so many artists, Vincent included, often failed muster. With his ruddy complexion and robust health, Gauguin not only betrayed his self-portrait and belied months of complaints, he disarmed one of Vincent's most vehement arguments on behalf of the Midi. Again and again, he had promised Theo that the Provençal sun would help Gauguin recover his health, rejuvenate his spirits, and return him to the gaiety and color of his Martinique paintings. But the hale bantam wrestler at his door had no need of rescue. "We are without the slightest doubt in the presence of a virgin creature with savage instincts," Vincent reported in amazement.

The next blow fell only a few days later. Theo wrote that he had sold Gauguin's painting of peasant girls dancing, *Les bretonnes*, for a handsome sum. In his subsequent letter, he enclosed a money order for Gauguin in the amount of five hundred francs—more than he had ever sent Vincent. "So for the moment," he added cheerfully, "he will be quite well off." Vincent dutifully dubbed the sale "a tremendous stroke of luck" for "all three of us." But he couldn't disguise the wound it inflicted. Any congratulations he offered Gauguin were drowned out

in a cry of guilt to Theo. "I cannot help it that my pictures do not sell," he wrote forlornly in a long mea culpa the same day news of the sale arrived.

> I myself realize the necessity of producing even to the extent of being mentally crushed and physically drained by it, just because after all I have no other means of ever getting back what we have spent. . . . But my dear boy, my debt is so great that when I've paid it, which I think I'll succeed in doing, the hardship of producing paintings will, however, have taken my entire life, and it will seem to me that I haven't lived. . . . It is agonizing to me that there is no demand for [my pictures] now, because you suffer for it . . . I believe that the time will come when I too shall sell, but I am so far behind with you, and while I go on spending, I bring nothing in. Sometimes the thought of it saddens me.

Oblivious to his brother's pain, Theo followed up on the sale of *Les bretonnes* with a quick show of Gauguin's latest Breton work on the *entresol*. Only weeks after his arrival in Arles, Gauguin was receiving the glowing reports from Paris that Vincent had only dreamed about. "It will undoubtedly please you to learn that your pictures are having a great success," Theo wrote him in mid-November. "Degas is so enthusiastic about your works that he is speaking about them to a lot of people . . . Two [more] canvases have now been definitely sold." Theo used the opportunity to open negotiations with Gauguin about raising Goupil's commission "once we begin to sell your work more or less regularly." It was a conversation he had never had with Vincent. Within two months, Theo would sell five of Gauguin's paintings, plus some pottery, and send him almost fifteen hundred francs, in addition to his monthly stipend.

Vincent reeled under his guest's onslaught of success. Just as Gauguin's hearty condition foiled Vincent's argument that all true artists suffered for their art, Gauguin's successes on the *entresol* undermined years of excuses for why his own art had failed to sell. Forced by events to justify his work "from the financial point of view," Vincent could offer only a single, pathetic defense: "It is better that [the paint] should be on my canvas than in the tubes."

Reversing years of pleadings, he urged his brother to abandon any effort to sell his paintings and advised him instead to "keep my pictures for yourself." That way, he said, he could tell Gauguin and others that Theo treasured his works too much to sell them. "Besides," he added, "if what I am doing should be good, then we shall lose no money; for it will mature quietly, like wine in the cellar." He bolstered this wisp of hope with two familiar images. On his first trip into the countryside with Gauguin, he painted the scarified trunk of an old yew tree, an image that spoke in deep fraternal code of new life springing from the wreckage of the past. He immediately sent a sketch of the painting to Theo, ral-

lying him to their shared mission of a "great renaissance" of Impressionism in the Midi—a mission that transcended any single artist.

On the same trip, he began yet another version of the Sower. More than any other image, Millet's striding figure, making his rhythmic way through a vast field of turned earth in blues and yellows under a thin stripe of sea-blue sky, sounded the consoling notes of adversity overcome and persistence rewarded that Vincent most needed in this new trial by contrast.

Another blow fell when Gauguin picked the destination for their next painting excursion. Rejecting the barren fields and dusty barnyards of Vincent's beloved Crau, Gauguin led them instead into the romantic heart of Arles: the Alyscamps. In Roman times, a necropolis lay to the south and east of the city walls—named, like the great avenue in Paris, after the *Campi Elysii,* the Elysian Fields. Christianity had added a gloss of sanctity to the old pagan burial ground. Chapels were built, saints gave blessings, legends of miraculous doings went out, Christ appeared in a vision. By medieval times, relatives eager to assure a place at the Last Judgment could float their dead down the Rhône to Arles, confident that Christian duty would safeguard them to a favored spot in the Alyscamps.

LES ALYSCAMPS, ARLES

Over the centuries, a ramshackle city of the dead grew up. Thousands of sarcophagi, arranged as randomly as death, spread across the alluvial plain, each one making claims on eternity, both in stone and in words. But neither

antiquity nor sanctity stood in the way of industrial progress. By the time Vincent arrived, the railroad had blasted through the hallowed ground, churning up grave sites and discarding the marble detritus of death with furious disregard for the claims of *pacem* and *aeternam.* Belatedly, the city fathers collected some of the plundered discards and arranged them in a long alley connecting one of the cemetery's antique gates to the Romanesque chapel of Saint Honorat. They lined this facsimile of history with benches and poplars, and solemnly dubbed it the *"allée des tombeaux."*

The trees were still young and flaming with fall color when Gauguin led Vincent to the famous Alyscamps in late October 1888. He came partly as tourist (guidebooks devoted chapters to the "ancient" graveyard), but mostly as voyeur. For time had delivered one final insult to the displaced souls of the Alyscamps. In the allée's cul-de-sac privacy and shady interstices, young lovers had found a perfect haven. Generations of Arlésiennes had turned the old site of reckoning into a parade-ground of vanities: a lovers' lane limned in death. Here they could stroll in their exotic Sunday costumes for the gratification of tourists and the bid of bachelors, or even walk arm in arm with a beau, without causing scandal.

Because of their reputation for beauty (they were widely viewed as direct descendants of the "Roman virgins" that adorned the vases of antiquity), the Arlésiennes' perambulations among the tombs had achieved a romantic fame that reached far beyond Provence. Through popular stories and images, the Alyscamps had become the most celebrated lovers' lane in France, a collective Venusian fantasy of noble beauty, coquettish charm, and chaste love. When one local lovely threw her unwanted baby into a nearby canal, the fantasy showed its darker side: a busy nightlife of trysting among the sarcophagi and lovemaking among the shades.

Vincent had probably explored the Alyscamps sometime in his seven months in Arles, but he had never mentioned it, drawn it, or painted it. In general, he gave all the city's ruins a wide berth, avoiding both the tourists and the taunting immortality of the old stones. For feminine entertainments, he preferred the whorehouses of the rue des Récollets, near the Yellow House, where money was all that mattered. Egged on by Bernard, who sent both drawings and poems about brothels, Vincent took Gauguin on a tour of all his favorite spots, retracing his nightly rounds with the Zouave lieutenant Milliet (who left for Africa soon after Gauguin arrived), ostensibly for both recreation and "study."

Gauguin tolerated these early excursions to the charmless, heavily regulated *maisons de tolérance* (which, according to one account, catered primarily to "the proletariat of ugliness and infirmity"), but he preferred the more elusive prey and challenging game of the Alyscamps—the contest of wit and glance that Vincent had long since abandoned as futile. ("My body is not attractive enough

to women to get them to pose for me free for nothing," he lamented.) In these fabled precincts, Gauguin, on the other hand, flourished. With his hypnotic sensuality and menacing physicality, he seduced the beautiful and aloof Arlésiennes with an audacity—and lack of conscience—that left Vincent breathless with envy.

Gauguin's amorous successes dealt his host a special blow. They not only solidified Vincent's place among the hapless rejects of the rue des Récollets, they exploded the myth of abstinent, monklike artists, resigned "to fuck only a *little*," that he had devised to cover the shame of impotence. Here was an artist in whom the blessings of "blood and sex prevail[ed] over ambition" (or so Vincent thought); a man who did not need to preserve his sperm—indeed, spent it profligately—and still had plenty of "creative sap" left for his work. Already awestruck at Gauguin's five children (and, according to rumor, twice as many bastards), Vincent marveled that Gauguin had "found the means of producing children and pictures at the same time."

As if to press this crippling advantage, Gauguin immediately embarked on a reprise of his Martinique negresses—the touchstone of his artistic appeal and erotic authority for both Van Gogh brothers. On the Alyscamps, he painted three lovely Arlésiennes, in full local costume, posing indulgently on the bank of the canal that ran alongside the lane of graves. (Later, he turned to the Alyscamps's dark side, with a menacing scene, half hidden behind a tree, of an older man accosting a young girl, to which he gave the leering title *Your Turn Will Come, Pretty One.*) Vincent, as usual, could find no one to pose for him and was forced to staff his Alyscamps paintings with figures based on old drawings and eavesdropping glances. He defended himself in the only way he could: with a brothel scene showing a man and two women playing cards (a ubiquitous form of foreplay in whorehouses) surrounded by groping couples and bored, dark-skinned beauties in candy-colored ball gowns.

Gauguin soon turned his predatory eye on a woman closer to home. Marie Ginoux, wife of the Café de la Gare's owner Joseph Ginoux, had probably attracted Gauguin's attention from the moment he arrived in Arles and waited at the café before calling on Vincent. A handsome, raven-haired woman of forty (exactly Gauguin's age) with half-mast eyes and a "habitual smile," according to one admirer, Marie had married a man more than a decade her senior, resigning herself to a childless marriage and round-the-clock service to the café's family of regulars. Vincent, too, had been drawn to Marie's Mediterranean warmth and faded beauty, so reminiscent of Agostina Segatori, the café proprietress he had tried to woo in Paris. Like Henry James, who wrote admiringly of one "splendid mature Arlésienne" whom he found "enthroned" behind the counter of a café (an "admirable dispenser of lumps of sugar"), Vincent saw in Marie's oval face,

low brow, straight "Greek" nose, and long, elaborately coiffed hair the picture of Arlesian womanhood sung by poets from Ovid to Daudet—"intensely feminine" yet "wonderfully rich and robust and full of a certain physical nobleness."

Yet in the months Vincent had known this paragon, he had not painted her. For all his admiration of the legendary Arlésiennes, he had managed to coax only one old woman to sit for his brush. In August, he paid a young girl in advance to pose for him in local costume, but she never showed up. Either Marie Ginoux had refused his entreaties, or, fearing she would, he never asked. Paul Gauguin had no such fears. Less than a week after setting foot in Arles, he arranged for Marie to come to the Yellow House and pose. "Gauguin has already found his Arlésienne," Vincent wrote, astounded. "I wish I had got that far."

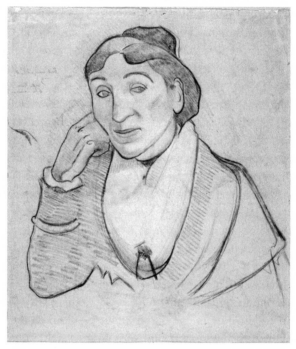

PAUL GAUGUIN, *Madame Ginoux (Study for "Night Café")*, 1888,
CHARCOAL ON PAPER, $36^{1}/_{8}$ X $28^{3}/_{4}$ IN.

She arrived in the full iconography of her kind: a long black dress with the distinctive white muslin *fichu* (shawl), her hair in a bun under a coquettish cap with a black ribbon dangling to her shoulder. She glided to a chair, laid down her parasol and gloves, then sat facing Gauguin and his sketchpad. When Vincent eagerly took up a position nearby, she put her hand up to her face, blocking his view and focusing her gaze on the beguiling newcomer, whom she called "Monsieur Paul." While Gauguin sketched languorously in charcoal, glancing from

his paper to engage his subject and capture her Mona Lisa smile, Vincent worked furiously in paint, slashing on a blue-black dress, scowling green face, and orange chair against a background of electric yellow in a race against the clock. Less than an hour later, Gauguin finished his drawing and Ginoux left. Fortunately, Vincent had finished his painting in time. To Theo, he gamely claimed a victory. "At last," he wrote, "I have an Arlésienne."

Over the next two weeks, a painting took form on Gauguin's easel that added artistic insult to sexual one-upmanship. The visage of Madame Ginoux lingered in the shared studio as Gauguin slowly transferred his drawing to a large canvas. He gave her even softer features and a more beguiling, flirtatious smile. He transformed the wooden studio table on which she leaned into the milky marble of the Café de la Gare, and placed in front of her the tools of her trade: a serving of absinthe, a bottle of soda water, and two lumps of sugar.

Behind her, he painted an uncanny replica of the scene in Vincent's *The Night Café*, seen from within—a low, patron's perspective rather than Vincent's high, all-seeing panorama. The green field of the billiard table fills the middle distance, stamping the floor with the same deep shade. Against the far wall—painted in the exact same fiery orange-red—a single oil lamp casts the same shadowless glare, and, under it, the same drunk slumps on a table, fast asleep. To fill out the crowd, Gauguin appropriated two of Vincent's most cherished images, his portraits of Milliet and Roulin, and painted them into the scene as patrons: the Zouave at the table with the dozing drunk, the postman with a trio of glum prostitutes, holding forth under sickly streamers of cigarette smoke. Finally, he added a tiny cat under the billiard table, a symbol of female licentiousness that boasted of sexual conquest.

This ambiguous tribute to Vincent's world—at once flattering and mocking—marked the first blow of an artistic siege: a battering of words and images and frustrated expectations that took Vincent completely by surprise. Despite months of beckoning advertisements like *La mousmé* and *Le Zouave*, Gauguin dismissed Vincent's magical Midi as "petty and shabby." He looked at the Crau and the Café de la Gare and saw not the bright hues and Zola life that Vincent saw, but only "scummy local color." He called Arles "the filthiest spot in the South" and continued to hold out Pont-Aven as the true artist's paradise. "He tells me about Brittany," Vincent reported dolefully only days after his guest's arrival, "[how] everything there is better, larger, more beautiful than here. It has a more solemn character, and especially purer in its tonality and more definite than the shriveled, scorched, trivial scenery of Provence."

Vincent wanted to paint; Gauguin wanted to draw. Vincent wanted to rush into the countryside at the first opportunity; Gauguin demanded a "period of incubation"—a month at least—to wander about, sketching and "learning the essence" of the place. Vincent loved to paint *en plein air;* Gauguin preferred to

work indoors. He saw their expeditions outside as fact-finding missions, opportunities to gather sketches—"documents," he called them—that he could synthesize into *tableaux* in the calm and reflection of the studio. Vincent championed spontaneity and serendipity ("those who wait for the calm or work quietly will miss their chance," he cautioned); Gauguin constructed his images slowly and methodically, trying out forms and blocking in colors. Vincent flung himself at the canvas headlong with a loaded brush and fierce intent; Gauguin built up his surfaces in tranquil sessions of careful brushstrokes. In their first few weeks in the Yellow House, Gauguin completed only three or four canvases; Vincent blazed through a dozen.

Vincent had imagined that Gauguin would share his *Paradou* fecundity once he felt the regenerative power of the Provençal sun. But Gauguin had just the opposite reaction. A man of the city, he found that bucolic life made him "lazy" in his personal habits and even more laconic in his approach to art, which he famously summed up: "One dreams, then paints calmly." His deliberativeness struck Vincent a mortifying blow. Since arriving in Arles, he had vehemently defended his speed and productivity (and copious consumption of paint) against Theo's repeated urgings to slow down and take more care with each painting. Every time Gauguin picked up a brush and began one of his slow transits across the canvas with short, scratching strokes, Vincent heard his brother's nagging complaints. Vincent reveled in the fury of work, bragging to Theo: "Our days are taken up with work and ever more work; in the evening we are shattered and go to the café, followed by an early night. Such is our existence." Gauguin wrote his wife scornfully: "Vincent is working himself to death."

Gauguin's elaborate programs and methodical brushwork also challenged Vincent's understanding of Cloisonnist theory. "Aren't we seeking intensity of thought rather than tranquility of touch?" he had written Bernard that summer. Vincent struggled to reduce his images to the fewest possible elements, arranged in bold mosaics of color—a campaign shared in dozens of color-labeled letter sketches; Gauguin endlessly adjusted line and tone, dissolving every surface into carefully modulated planes of interwoven, overlapping hues. Vincent answered the call to "crudity" and "ugliness" he heard in Anquetin's ideas and Bernard's rhetoric—the evidence of his audacity hung everywhere on the walls of the Yellow House; Gauguin sat at his easel in the front room and fashioned deft, delicate images filled with feathery strokes and discretions of color. Vincent enshrined the law of simultaneous contrast, the gospel of Blanc and Delacroix, at the heart of his art; Gauguin ridiculed the catechism of complementary colors as simplistic and monotonous. And as for the yellow that flooded the paintings in his bedroom—Gauguin could barely hide his exasperated contempt: "Shit, shit, everything is yellow: I don't know what painting is any longer!"

Vincent wanted them to grind their own colors; Gauguin hated Vincent's

paints and arranged to have his sent from Paris. Vincent typically finished his painting with varnish (egg white or resin); Gauguin preferred the unvarnished matte surface of the Impressionists. Vincent painted on commercially prepared canvases; Gauguin wanted a rougher surface and bought a bolt of jute, with the coarseness of burlap, which he cut, stretched, and primed himself. Vincent lavished paint on his images, dispensing it with a broad brush heavily loaded and quickly replenished, plowing it into deep contours and *enlever* peaks; Gauguin arranged the pigments on his palette in stiff dollops of color that he doled out stingily in an unchanging register of short, parallel hatches. Vincent reworked his strokes, reshaping his impasto again and again before the paint began to set, and sometimes after, in a tempest of inspiration; Gauguin, who rarely repainted, deplored the disorder and indecision of Vincent's method—a "mess" he called it. "He likes the accidents of thickly applied paint," Gauguin alerted Bernard. "I detest the worked-over surface."

Vincent championed Monticelli, another passionate sculptor of paint. When Vincent talked of Monticelli, Gauguin reported, "he wept." But Gauguin despised the Marseille eccentric and his sloppy paintings, too. He praised instead a different maestro of the southern light, Paul Cézanne. Ever since his previous incarnation as stockbroker and collector, Gauguin had admired Cézanne's serene, cerebral depictions of the countryside around Aix-en-Provence, not far from Arles. For him, Cézanne's dry palette and measured brush perfectly captured the Midi's distinctive play of color, dust, and glare. The previous summer, in his bid for Gauguin's favor, Vincent had claimed a special kinship with his fellow painter of the South ("Look! I've got the very tones of old Cézanne!"), but even then he couldn't help but criticize Cézanne's lack of energy or ardor—the defining qualities he celebrated in the martyred Monticelli, and in himself.

Vincent proposed another hero for the Yellow House: Honoré Daumier, the "great genius" of caricature who translated into images the sublime ridiculousness of Daudet's Tartarin and Voltaire's Candide. On the eve of Gauguin's arrival, Vincent had declared the Midi "superb, sublime country . . . [like] a Daumier come to life." Testaments to his conviction hung on every wall: from Daumier prints, to landscapes peopled with cartoon figures, to writ-large portraits of the postman Roulin and the peasant Escalier. But Gauguin saw only meanness and squalor in the people of Arles. "It's strange that Vincent feels the influence of Daumier here," he wrote Bernard in November, just as he put the finishing touches on his lampoon of Vincent's Daumier delusions in *The Night Café*.

Again, he countered with a different artist: Pierre Puvis de Chavannes, the creator of myth-like scenes filled with affectless figures in friezelike poses, painted with classical calculation in a cool, untraceable brush—the defining qualities Gauguin celebrated in his own work. In the streets he saw the future of art not in the caricatures of Daumier but in the goddesses of Puvis: "Women

here have a Greek beauty," he wrote Bernard, admiring the elaborate coifs and costumes of the Arlésiennes. "The girl passing along the street is as virginal in appearance as Juno . . . So there is a fountain of beauty here, *modern style.*"

And so it went, through Vincent's entire pantheon: every sortie of enthusiasm blocked by a parry of contradiction or disdain. Vincent admired the great Barbizon painters Daubigny, Dupré, and Rousseau; Gauguin "could not tolerate" them, and proposed as better models the great illusionists Ingres and Raphael—artists that Vincent "hated," according to Gauguin. Vincent praised the painters of *real* people, like Breton and Lhermitte and, of course, Millet; Gauguin countered with the "primitive" perfection of Giotto and Michelangelo and cared not a jot for Vincent's sainted painter of peasants. As for the moderns, Gauguin made a spirited case for his new sponsor, the master of contour, Degas—a choice that left Vincent "despairing." Even when they agreed, they disagreed. Vincent venerated Rembrandt for his moody tonalities and deep meaning; Gauguin, for his exquisite forms. To Vincent, Delacroix ranked as a "universal genius" for his expressive color, bravura brushwork, and godlike vision ("he paints humanity"); Gauguin admired his consummate draftsmanship. "Generally speaking," Gauguin reported drily to Bernard, "Vincent and I hardly see eye to eye, especially in regard to painting."

Behind Gauguin's attacks on Vincent's idols loomed another, far greater threat. Gauguin's mocking *Night Café* challenged Vincent's entire way of working. In creating *his* image, Gauguin never set his easel in the Café de la Gare; never painted in its harsh glare; never endured the skeptical shrugs or suspicious stares that Vincent did; never experienced the loneliness that bound the patrons together in the shared solitude of mercurochrome light. Through imagination alone, Gauguin had entered the world of Vincent's painting and constructed an imaginary scene glimpsed from an impossible angle—a scene as unreal as an angelic visitation. By doing so, he had raised again the argument that true art sprang not from the eye, but from the head—*"de tête."*

Mixing symbolist rhetoric and Zola's mandate to create a perfect "modern" art, Gauguin insisted that only images removed from reality—transformed through imagination, reflection, and memory—could capture the elusive essence of experience, the human quotient, that represented art's truest subject. "My artistic center is in my brain and not elsewhere," he would later insist. In his *Night Café,* as in his self-portrait sent in advance, Gauguin warned Vincent against the "childish trivialities" of technique, like brushstroke and impasto. Even paint itself represented a compromise with the Truth. As he had instructed all his disciples in Pont-Aven, an artist should pursue painting of pure thought (*"sans exécution"*), liberated from the interference of reality by a process of "abstraction" in which the artist synthesizes messy experience into pure *"idée."*

Vincent had already heard these lessons from one of those Pont-Aven dis-

ciples, Émile Bernard. During the summer, they had fought an epistolary battle over the mandate from *le maître* to forswear the accidents of technique and pursue the inner truth of imagination. Vincent had adopted Gauguin's vocabulary of musical "abstraction" and had even ventured a few *de tête* images—in particular, his two versions of Christ in the Garden of Gethsemane. But when both of those pictures failed so miserably, he recoiled from the new teaching. "I never work from memory," he wrote in early October. "My attention is so fixed on what is possible and really exists that I hardly have the desire or the courage to strive for the ideal." In his use of color, he was already following Gauguin's gospel of the unreal, he protested, "arranging the colors, exaggerating and simplifying." But "in the matter of form," he told Bernard, he would continue "doing what I am doing, surrendering myself to nature."

Why did Vincent draw this line in the sand? Why did he resist the mandate of *de tête* painting "in the matter of form" but not color? Despite his new sense of shared mission with Gauguin and Bernard, Vincent's imagination clung fiercely to the artistic ideals of old heroes like Millet and Monticelli and the studio practices he had learned from them. Like them, he was born into a world filled with religious metaphor and Victorian sentiment—lenses that revealed new layers of meaning in reality but never abandoned it. Romantic nature had enthralled his adolescence, and Naturalist observation had shaped his maturity. Like his brother, he had emerged into adulthood as a man of "logic and earthly things"—an artistic ward of the Frenchman banned from the Zundert parsonage, Émile Zola. When asked if Vincent resembled the *idée*-obsessed painter Claude Lantier depicted disparagingly in Zola's *L'oeuvre*, Theo responded: "That painter was looking for the unattainable, while Vincent loves the things that exist far too much to fall for that."

To accept Gauguin's world of pure imagination, Vincent would not only have to give up his beloved rituals of plein air painting, he would have to uproot an entire lifetime of engagement with reality (what he called the "hand-to-hand struggle with nature"). He would have to trade the world of models and portraits for a world peopled by chimeras and phantoms; to exchange the endless fascinations of the outer world—from birds' nests to starry nights—for the nameless terrors of memory and reflection.

In fact, Vincent's imagery, with its defiantly idiosyncratic craft and deeply personal symbolism, already answered Gauguin's call for an art of "individual intention and feeling"—answered it more forcefully and convincingly even than Gauguin's wrought-over constructions with their heavy-handed mysteries. Indeed, from the earliest days of his career, Vincent had used the language of *de tête* painting to define his art and defend his artistic prerogatives. A decade before, in one of his first adult works, he had drawn a scene from the Bible "as I imagined the place." In his furious arguments on behalf of *The Potato Eaters,* he

had championed the artist's right to transform reality into images "truer than the literal truth"—Gauguin's *idée*—and passionately seconded Delacroix's call for art created *"par coeur"* (by heart).

But Gauguin's ideas posed a threat to the delicate compromise buried at the core of Vincent's artistic project. Unlike his guest, Vincent could not draw free-hand. He depended on models, studio "tricks" like the perspective frame, and endless attempts to achieve anything like verisimilitude. Even then, the sure lines and graceful contours of Degas (or Gauguin) eluded him. He could use the new art's mandate to "exaggerate and simplify" as an excuse for his weak drafts-manship, just as he had used Delacroix's *par coeur* call to justify his errant lines, impetuous brush, and perpetual inability to render "likenesses." But without the opposition of reality, without the cover of defiant deviation, his weaknesses would be laid bare. There was no perspective frame for the imagination.

In his optimistic moments, Vincent imagined that time would close this gap, allowing him eventually to create the pure "inventions" that Gauguin de-manded. "I don't mean I won't do it after another ten years of painting stud-ies," he wrote. But until that day, Gauguin's license to "make up" images—to forswear nature's impediments and "just paint"—struck Vincent a paralyzing blow. "When Gauguin was in Arles," he recalled to Theo a year later, "I consid-ered abstraction an attractive method. But that was delusion, dear friend, and one soon comes up against a brick wall."

It was easy enough for Vincent to fend off Gauguin's ideas in letters to Ber-nard ("I am too afraid of departing from the possible and the true," he had told Bernard as recently as October). But the presence of the master himself—working in the Yellow House with him, painting at the easel next to him, sitting at the café table across from him—changed everything. Against Gauguin's com-manding certainty, his mastery of fashionable discourse, his superior French, and, especially, his persuasive art, Vincent's defenses failed him. (He later de-scribed Gauguin as "a genius" when explaining his theories.) Gauguin also held the high ground of caring less. He already had a confident foothold on the *en-tresol*. Theo owed him almost a thousand francs. For him, the consequences of failure in Arles hardly registered. For Vincent, they were unthinkable.

After an opening salvo of self-assertive imagery—the sower and the yew tree—Vincent quickly succumbed to Gauguin's overwhelming advantage. Within a week, his guest's ideas found their way into Vincent's brush. Working on Gauguin's coarse jute, he tamed his impasto, muted his color, and reached for the safe, shared models of Japanese prints and Puvis de Chavannes's ideal-ized settings. In one of his Alyscamps paintings, orange leaves drift down from the trees in Gauguin's dry, judicious hatches.

The official surrender came on the first Sunday of November, on a walk to

Montmajour. Passing the empty vineyards at the bottom of the mount, Vincent described to Gauguin the scene he had witnessed a month before when the grapes were harvested: the workers, mostly women, swarming over the fat, purpling vines, sweating in the still-intense southern sun. Moved by this vivid description, Gauguin challenged his host to paint the scene *from memory*. Gauguin offered to paint the same scene himself, based on nothing more than Vincent's telling—that is, from imagination. For Vincent, the intimacy of their wandering walk—so much like Petrarch and Boccaccio—and the "splendor" of the sunset over the vineyards proved an irresistible inducement. He accepted the challenge. "Gauguin gives me the courage to imagine things," he wrote.

Over the next week, confined to the studio by a spell of rain, both artists constructed their competing visions. Vincent relied on years of sketching fieldwork and on his trove of drawings to populate the empty vineyard with toiling women bending over the low-lying vines like the potato diggers of The Hague. He dressed them in purples and blues to contrast with the burning yellow sky under which they labor. Near the horizon, he put a signature Midi sun.

Gauguin responded with a completely different image. Eschewing Vincent's deep space and southern light, Gauguin zoomed in on a single worker—a mysterious, doleful figure with a masklike face and a dome of orange hair. As formidable as any Martinique negress, she sits exhausted on the ground with her chin propped on her fists, resting between bouts of work. Her large scale and deftly drafted pose contrast starkly with Vincent's awkward little figures crawling anonymously over the landscape. Her bare forearms and brooding pose radiate sexual energy, creating a portrait of the peasant's bestial essence entirely missing from Vincent's faceless crowd of pickers.

Gauguin's laborer wears the native costume of Brittany, not Provence—as much a rebuke as his rejection of complementaries in favor of "uniform tonalities." Unlike Vincent's workaday scene with its clustered figures, neat narrative, and postcard sunset, Gauguin's vision of the grape harvest abbreviates the task (two women are shown at work in the background), crops the foreground tightly, and poses more questions than it answers—Who is this woman? Why is she so desolate?—transforming Vincent's colorful vignette of country labor into a Symbolist meditation on the inaccessibility of inner life. Calling Gauguin's painting "very fine, very unusual" and "as beautiful as the Negresses," Vincent conceded defeat. "Things from the imagination certainly take on a more mysterious character," he acknowledged.

After his victory in the vineyard, Gauguin immediately turned to another image that bested Vincent in draftsmanship, eroticism, and mystery. Drawing on some tantalizing sketches he had made in Brittany before leaving, and on his love of Degas's bathers, Gauguin painted a peasant woman stripped to the

waist, seen from behind. "Gauguin is working on a very original nude woman in the hay with some pigs," Vincent reported in mid-November. "It promises to be very fine, and of great distinction."

The woman slumps exhausted over a stack of hay, baring her muscular back, the nape of her neck, and wisps of blond hair loosed from under her bonnet. With one half-tanned arm flung over the hay to grasp a hook, and the other providing a cushion for her bowed head, she could be resting or praying—or preparing for some sexual act—while the pigs she tends grunt and grub around her with the indifference of fellow beasts. Gauguin called the grouping simply *Les cochons*— *The Pigs*—and sent the painting to Theo with a salacious note: "[It is], to my mind, rather virile . . . Is it the southern sun that causes us to be in rut?"

The image routed Vincent's last defenses. "I am going to set myself to work from memory often," he wrote. "The canvases from memory are always less awkward, and have a more artistic look than studies from nature." He chose as his impossible image a scene he had witnessed months before: a bullfight in the great Roman arena at the center of Arles. He had loved the spectacle of it—the "colorful multitudes piled up one above the other," the "fine sight [of] sunshine and crowd." He had even considered making the arena the subject of his next series of paintings after the orchards of spring—to explore "the effect of sun and shade and the shadow cast by the enormous ring." Gauguin had seconded the idea in a letter that summer, listing the bullfight as the Provençal subject he most wanted to "interpret." But by the time he arrived in October, the season for blood sport had ended. So with only his memories to guide him, Vincent sat in the studio and unleashed his brush on a big piece of Gauguin's heavy jute.

Everywhere, his hand betrayed him. The far spectators turned into hash marks; those in the middle distance, into stick figures; those closer up, into awkward cartoons. He filled the foreground with people drawn loosely from his studies—Roulin, Ginoux, a couple from the Alyscamps—arranged in disjointed poses and jumbled perspective: some of their faces barely sketched, some rendered with odd care, some blank, some blotted out in frustration. The coarse jute smothered his boldest impasto and made permanent every errant risk of his brush. He never mentioned the painting to Theo.

Instead, he tried again. This time, he tapped the wellspring of all his truest art: the past. In mid-November, three letters arrived from Holland that sent him into a rapture of nostalgia. One came from Jet Mauve, his cousin and the widow of his former mentor. She thanked him for the *"mémoire"* painting he had sent through Theo, and "spoke of old times" in a way that opened his heart. Another came from his youngest sister, twenty-six-year-old Wil, who had long assumed the duty of caring for their aging mother. Her announcement that she had begun reading Zola's scandalous *Au Bonheur des Dames* struck him as a sign of

passing time. The third letter came (via Theo) from Anna van Gogh herself, who had not written him directly since Dorus's death. Her mood was melancholic.

Arriving almost simultaneously, the three missives triggered a wave of remembrance that found its way onto canvas. Vincent's mind traveled back to the last place where he had lived in peace under the same roof with his parents and siblings: Etten. Following Gauguin's program of asymmetric composition and tight cropping, he imagined a scene in the parsonage garden from which he had been expelled in 1881. In the sinuous contours that Gauguin had taught him, he filled the left foreground with two large female figures shown only from the waist up and only steps away from exiting the canvas. "Let us suppose that the two ladies out for a walk are you and our mother," he described the image to Wil.

To give his figures the air of mystery that Gauguin demanded, he shrouded one in a dark hood, like a mourner at a funeral, and the other in a high-bundled shawl. Using the photograph Wil had sent him, he gave the mourning figure his mother's features; the other he depicted with the naïve intensity of his Zola-reading sister, but with the eyes and nose of Madame Ginoux. Behind them, the winding path of the public garden snakes up toward the unseen horizon, interrupted only by the figure of a peasant woman, an unwanted ghost from Nuenen, thrusting her rump in the air in a way he had drawn a hundred times. In the background he saw both the twisting, flaming cypresses of the Midi gardens and the multicolored flowers that had filled all his mother's gardens.

The memories were his own, but the image belonged to Gauguin. From the muted tonalities to the labored brushwork, from the sensuous curves to the stylized composition, from the mysterious figures to the shadowless landscape, Vincent had yielded to the *maître*'s persuasion. He built up the image with the same layering of dry paint in short strokes that Gauguin used—an astonishing act of discipline for Vincent's impetuous brush.

But the absence of a model and the halting approach invited back all the demons of drawing—especially drawing the human figure—that had defeated him so often in the past: lifeless faces and grotesque hands; conflicting perspectives and skewed proportions. In his letter to Wil, which included a sketch of the painting, he defended his unnatural new work ("bizarre," he called it) with an appeal to Gauguin's mandate of the imagination. Rather than pursue "vulgar and fatuous resemblance," he had presented the scene "as seen in a dream," he insisted. "I know this is hardly what one might call a likeness," he apologized, "but for me it renders the poetic character and the style of the garden as I feel it."

At the same time, Vincent instructed Theo to refuse an invitation from the *Revue Indépendante* to exhibit his paintings in the magazine's next show, in the spring of the following year (1889). Gauguin had discovered a plot against him by the *"petits points"* crowd to use the *Revue* exhibition as a platform to attack

him and Bernard as "worse than devils who must be avoided like the plague." Rather than participate in this ambush, Vincent cast aside years of ambition and embraced the avant-garde factionalism he had so often decried. He called the *Revue*'s editor, Édouard Dujardin, "a scoundrel" and ridiculed his exhibition as "a black hole." "Please tell them curtly it's no go," he instructed Theo. "I am so disgusted at the idea." It was a small price to pay for his new brotherhood. "My friend Paul Gauguin, an impressionist painter, is now living with me," he boasted to Wil, "and we are very happy together."

BUT THE NEW BROTHERHOOD of art and ideas, like the old one of blood and family, was pulled by contrary currents. In a few short weeks, unable to achieve the mastery of form and line that Gauguin's art demanded, Vincent swung from submission to defiance. The compliant paint of the Etten garden barely had time to dry before he returned to the canvas and attacked it with his contradictory brush. He peppered the shrouded figure of his mother with jabs of red and black and the stooping peasant with a hail of blue, orange, and white dots. At a time when Gauguin was locked in combat with the Pointillists in Paris, Vincent's revisions announced an insurgency under the same roof.

Vincent had never completely capitulated to his mentor's unnatural methods. Even in the midst of his enthrallment to Gauguin's Puvis surfaces and Degas contours, he had continued to celebrate his own Daumier caricatures and Monticelli incrustations. Even as he obeyed Gauguin's instruction to wash the shine off his glistening impasto, he would return to his canvases afterward and touch them up to restore the brilliant, jewel-like color that he never stopped prizing. Even as he acknowledged Gauguin's criticism that he painted too quickly and contritely agreed to "make some alterations," he boasted to Theo of "doing some things *even more* hurriedly."

By the end of November, the great sea change in his own art that Vincent had predicted Gauguin would bring had been reduced to this grudging concession: "In spite of himself and in spite of me, Gauguin has more or less proved to me that it is time I was varying my work a little."

Vincent marked the pendulum's swing with a bold reassertion of self: a Sower. He tried it first on a small canvas, not Gauguin's jute, with Millet's striding figure placed forthrightly in the center of the picture, not off to the side or oddly cropped. He is dressed in the uniform of Cloisonnism, as Vincent understood it: fragments of pure color; and he treads a field as blue and glassy as a calm sea. The tokens of reality—a plowing horse, a farmhouse, the distant Arles skyline (including factories belching smoke)—frame the crystal figure in Zola's nature. A topography of impasto grounds it in paint. In another attempt only a few days later, Vincent "varied" the image by enlarging the familiar figure and

moving it to one side, but rooted it even more deeply in the landscape of his own art. In the middle of the canvas he placed a huge pollarded tree with fresh blossoms springing from old wounds, silhouetted against a pink-and-green Corot sky. Over the sower's head, an immense yellow sun sets into a stippled violet horizon—a shake of the fist in form, color, and stroke. "I allowed myself to be led astray," Vincent later described his Gauguin experiments, "and [then] I had my fill of that."

Next, he pressed the insurrection with portraits. He had imagined that Gauguin would lure a stream of models to the Yellow House and had fitted out the studio to accommodate a dozen models at a time. Vincent pictured the two painters coming home from a day in the fields "bringing along neighbors and friends, and, while chatting away, [painting] portraits of people in the light of a gas lamp." But after the brief session with Madame Ginoux, Gauguin had largely ignored Vincent's pleas on behalf of the "painting of the future." For almost a month, Vincent stood by, fulminating at the opportunities for models lost on account of Gauguin's devotion to the art of airy nothings. "If at the age of forty," he wrote, citing Gauguin's age and squandered advantages, "I do a painting of figures or portraits the way I feel it, I think that will be worth more than any present success."

At the end of November, Vincent struck out against the boycott of his favorite imagery. "I have made portraits of *a whole family*," he announced to Theo triumphantly. "You know how I feel about this, how I feel in my element . . . At least I shall have done something to my liking and something individual." After a long absence, the postman Roulin had reappeared in Vincent's life, and he brought his family with him: his sons Armand, seventeen, and Camille, eleven, and his wife, Augustine. Money probably played a role in their rapprochement. Vincent was so eager to paint portraits that he agreed to pay for every sitter provided by the postman, who supported his family on a mere hundred and thirty francs a month, half of what Theo sent. Even the infant Marcelle joined the line of Roulins that filed into the Yellow House.

Vincent tore through six portraits at the rate of one a day. After weeks of Gauguin's demands for invention and inward looking, he reveled in the sheer tactility of faces and postures and clothing. Rather than explore the dark recesses of his own mind, he gleefully recorded every nuance of his sitters' moods: Armand's glum resignation, Camille's fidgety distraction, Marcelle's squirming indifference in her mother's arms. He rushed from portrait to portrait (two of Armand, three of Camille), glorying in the reconnection with reality. He labored lovingly over facial features with some of the most faithful likenesses he had produced in a decade of trying. "I am completely swamped with studies, studies, studies," he wrote in an ecstasy of observation; "it makes such a mess that it breaks my heart."

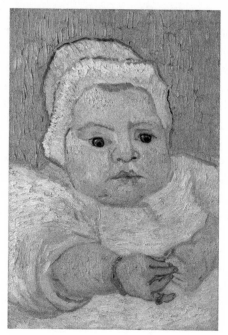

The Baby Marcelle Roulín, DECEMBER 1888,
OIL ON CANVAS, 13⁷/₈ X 9¹/₄ IN.

His next subject argued even more vehemently for the mess and marvel of real life. What could be further from Gauguin's phantoms and illusions than the wooden slats, stout legs, rush seat, and blunt feet of a sturdy pine chair? Vincent had bought a dozen of them in preparation for the acolytes he expected would follow Gauguin to his door. Now he picked one out of the crowd, set it in front of a big canvas, and *just looked.* Like birds' nests, tree trunks, and canal bridges, the simple, armless chair engaged Vincent's imagination in a way no *idée* could.

He rediscovered the fierce colors of *The Bedroom* in the red floor, blue door, pale blue walls, and brilliant yellow of the chair itself. Rejecting Gauguin's evasive curves and elusive space, he planted the square-jointed chair firmly on its four legs in careful perspective and declared forthrightly its place in *this* world by focusing his brush on knots in the wood and hinges on the door. He battled Gauguin's coarse jute to a triumph of impasto, crisscrossing every floor tile with its own signature fabric of paint. Working with defiant speed, he laid in great swaths of color and outlined each bone of the monumental chair, reclaiming the Midi for reality. This was the vision of the future of art that he had championed in paintings like *The Yellow House:* the Japanese gospel of simplicity and intensity to which he had sworn a sacred oath before his guest's arrival.

He had found his voice again.

Bursting with protest, he immediately grabbed a second big sheet of jute and began another image: Gauguin's chair. In the internal debates that always accompanied his ardors, Vincent often took up the arguments of his opponents, recasting them to suit his counterattacks and ensure his victory. He did the same with paint. In Nuenen, he had depicted his father's Bible in the heavy, lifeless grays of the *rayon noir* so he could assail it with a copy of Zola's *La joie de vivre* in a flash of sunny yellow. Now he picked another fight with another oppressive foe. This time, he used chairs, not books, as surrogates; and he staged their battle on separate canvases.

He had bought the chair specifically for Gauguin's bedroom. Its saber legs, curving arms, and voluted top-rail perfectly fit his ambition to create a "prettier" room for his refined guest. It also contrasted with the coarse, cheap pine of his own room, which he described in complementary terms of "solidity, durability and quiet." The same clash of opposites played out on the two canvases: humble naïveté versus showy elegance; Millet's sturdy forms versus Degas's languorous lines; Midi sun versus café gaslight; yellow-blue consolation versus red-green purgation.

Unable or afraid to recruit Gauguin to pose for him, Vincent piled all his pent-up grievances on the gaudy chair. He slashed its outline onto the resistant jute with such force that the foremost leg ran off the canvas. He filled its sensuous contours with the arguments of color that Gauguin rejected: orange and blue for the walnut chair, red for the floor, and a deep, acidic green for the wall. He imposed on it—in a way he could never impose on its absent sitter—not just the law of simultaneous contrast, but the crustaceous impasto of Monticelli, the cartoon simplicity of Daumier, and a quaint, nostalgic program of "day effect" and "night effect"—just the kind of straightforward picture making that the sophisticated Gauguin disdained. Finally, he placed on the seat of the chair a burning candle and a pair of books—a scolding of pink and yellow novels, icons of French Naturalism—as a rebuttal to Gauguin's Symbolist excesses and a call to eventual enlightenment, or inevitable reckoning.

While the bright peasant chair resurrected the dream of Daudet's magical South, Gauguin's abandoned throne summoned older and darker memories. Its empty embrace could not fail to evoke Luke Fildes's famous image of Charles Dickens's desk after his death, with its stilled pen, blank paper, and a vacant chair pushed back by the departing master. Years before, Vincent had cited the Fildes image to bewail the loss of courage and direction among modern artists. In 1878, after his father came to Amsterdam and put an end to his studies for the ministry, Vincent returned from the train station to his room and wept at the sight of his father's empty chair. A decade later, the same image of failure

LUKE FILDES, *The Empty Chair ("Gad's Hill, Ninth of June 1870")*, 1870, ENGRAVING

and abandonment resurfaced in the Yellow House. The true subject of *Gauguin's Chair*, Vincent later admitted, wasn't a chair at all. "I tried to paint 'his empty place,'" he wrote, "the absent person."

The Bel-Ami was slipping away.

HARDLY A DAY had passed without conflict at 2, place Lamartine. From the moment of Gauguin's arrival, the little blows of everyday life had never stopped driving a wedge deeper and deeper between host and guest. Gauguin not only rejected Arles and its people, he complained about the unseasonable cold, the ceaseless wind, and the miserable food. He was shocked at the cramped quarters and domestic disorder of the Yellow House, and he abhorred the "mess" of Vincent's studio. ("His box of colors barely sufficed to contain all those squeezed tubes, which were never closed up," he later recalled.) Displeased with some of the furniture in his carefully composed bedroom, Gauguin immediately bought a new chest of drawers and a long list of household goods. He threw out Vincent's elaborate bedding and had his own sheets sent from Paris. He had pottery, cutlery, silver, and etchings sent, too—each item a reproach to the perfect "artist's home" on which Vincent had lavished so much attention.

Everything about Gauguin frustrated Vincent's expectations: his low forehead (according to phrenology, a sign of imbecility), the strange fencing masks and foils he had inexplicably brought with him, the pictures of his five

children. The same opposing currents that buffeted their art invaded every corner of their daily life together. Despite Vincent's advance pledge "not to quarrel" with his guest, they clashed early over everything from household chores to restaurant choices. Gauguin took charge of the former (with assistance from Vincent's ancient charwoman), while the latter was resolved only when Gauguin volunteered to cook. Vincent, a creature of café and bistro, tried to learn—just as he tried *de tête* painting—but with similar results. "Vincent wanted to make a soup," Gauguin recalled, "but I don't know how he mixed it—no doubt like the colors on his paintings—in any event, we couldn't eat it." Thereafter, Gauguin did all the cooking and Vincent did the shopping. Duties were divided, not shared.

They clashed over money, too. Gauguin, the ex-stockbroker, found the household finances in the same shamble of disorder as Vincent's studio. He immediately established a regimen of bookkeeping as laborious as his brushwork. On a table in the front room, he set out two boxes with money inside: one was for food, the other for incidentals (liquor, prostitutes, tobacco) and "unforeseen expenses like rent." On a piece of paper, "each would inscribe honestly what he took from the till." Vincent, who could never abide a budget (Gauguin later referred to financial matters as "that great sensitivity of his"), rebelled against the arrangement by soliciting extra money from Theo.

Gauguin quickly sized up his adversary and set a strategy. "Your brother is indeed a little agitated," he wrote Theo a few days after arriving, putting a gloss of understatement on the storms of passion and persuasion that must have burst from Vincent after being bottled up for so long. "I hope to calm him down gradually." To accomplish that, rather than engage Vincent in his rants of enthusiasm (he had promised "day-long discussions"), Gauguin dodged and feinted. "He does not let himself get out of hand," Vincent wrote, puzzled, in his initial report to Theo. Where Vincent poured out past injuries and plans for the future, Gauguin entertained with tales from his sailor days. Where Vincent heaped flattery on his guest ("your brother is most indulgent," Gauguin wrote Theo blushingly), Gauguin reserved judgment. "I do not know yet what Gauguin thinks of my decorations in general," Vincent complained after a week of awkward silence.

The ardent Dutchman found this intricate choreography of appeasement and evasion deeply vexing. Always alert to slights, and wary of Gauguin's intentions after their drawn-out courtship, he imagined his guest as a stalking tiger "waiting for the right moment to make a leap forward." But when Vincent tried to goad him into debate, Gauguin only replied with a mocking salute—"Yes, sir, Sarge"—quoting a popular song about a policeman's muzzled contempt for his foolish boss.

Inevitably, this daily drubbing of caustic accommodation and veiled antagonism found its way onto canvas. Earlier that fall, Gauguin had drawn a caricature of Vincent sitting dangerously close to the edge of a cliff, looking up mesmerized at the sun, ignoring the peril at his feet. When Bernard sent the drawing to Vincent, he laughed it off, objecting, "I suffer from vertigo." After that humiliation, it is doubtful that Vincent posed for the portrait of him that Gauguin painted in early December. Gauguin's preparatory sketch looks candid: Vincent sits at his easel, caught midstroke, his eyes fixed on the canvas in front of him. His discomfort is palpable, and may account for the spareness and speed of Gauguin's drawing—hardly the fond eye-embrace of Madame Ginoux.

The image that emerged on Gauguin's big canvas over the following days brought the weeks of intimate combat to a head. With an instinct for the jugular, Gauguin depicted Vincent at work on his favorite subject: sunflowers. The last of the great blooms had long since disappeared from the gardens of Arles, but in Vincent's delusional world, Gauguin suggested, they never died. A vase of the ubiquitous flowers sits beside Vincent's easel. He stares at it intently, his eyes squinting and fluttering in the peculiar way he had of focusing his field of vision. His face is dulled and mirthless. His lips are tight, and his jaw protrudes in what could be a pout or could be a trace of the monkeylike features that Gauguin gave him in the preparatory sketch.

As in his version of *The Night Café*, Gauguin ruthlessly commandeered the icons of Vincent's imagination: not just the revered sunflowers but their palette, too. The distinctive mix of yellows and oranges leaches from the enormous blossoms into Vincent's coat and face and beard. The figure's long reach, low brow, and simian features inflict on Vincent the very Daumier caricature he had urged on Gauguin. The thumb sticking up through the palette on his lap belittles his manhood. "Perhaps my portrait does not bear him much resemblance," Gauguin coyly told Theo, "but it contains, I think, something of the intimate man."

Gauguin placed his helpless sitter under a huge painting done in *his* style: *de tête.* The invented landscape that looms over Vincent's shoulder—so big it almost transports him to his beloved plein air—celebrates the limitless world of the imagination on which he has turned his back. Rather than seize that path, Gauguin's Vincent fixes his eyes on the briefest of nature's ephemera: flowers. Like Darwin's monkey, he clings to the lowest rung of an inexorable climb to the fire and air of pure *idée.* To underscore this scornful message, Gauguin painted Vincent's brush poised ambiguously between the flowers he depicts and the image he paints, imposing a Symbolist mystery on the sincere but witless act of transcribing nature.

—

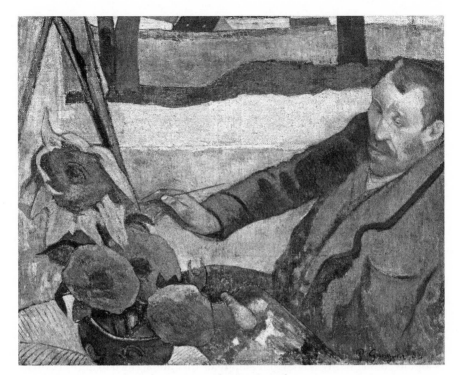

PAUL GAUGUIN, *Vincent van Gogh Painting Sunflowers,* NOVEMBER 1888,
OIL ON CANVAS, $28^3/_4$ X $35^7/_8$ IN.

IN MID-DECEMBER, Gauguin delivered the coup de grâce. "I am obliged to re-
turn to Paris," he wrote Theo. "Vincent and I absolutely cannot live side-by-side
any longer without friction because of the incompatibility of our temperaments
and because he and I both need tranquility for our work. He's a man of a re-
markable intelligence whom I hold in great esteem and leave with regret, but, I
repeat, it is necessary that I leave."

The Stranger

~

GAUGUIN HAD WANTED TO LEAVE EVEN SOONER. IN MID-NOVEMBER, only a few weeks after arriving, he wrote Bernard: "I am like a fish out of water." As the light shortened and the weather closed in, the days began to stretch out endlessly. When asked later how long he had stayed in the Yellow House, Gauguin could not say exactly, but admitted "the time seemed to me a century." He had arrived thinking he might remain a year (whereas Vincent had imagined he would stay forever). Then he began to talk of departing in a few months; then simply "soon." To another friend, he cast his circumstance in more dire terms, comparing it to a train "hurtling along at top speed." "[I] can foresee the end of the line," he wrote, "but I keep on coming up against the chances of going off the rails."

Initially, he kept the truth from Theo. "The good Vincent and the prickly Gauguin continue to make a happy couple," he wrote cheerfully at the same time he despaired to Bernard. Still financially insecure and determined "not to launch my attack before I have all the necessary materials in my hands," he hoped to endure by putting some distance between himself and his host. As often as he could, he left the house and disappeared into the night on his own, telling Vincent that he needed some "independence."

When bad weather condemned him to long spells in the living room that served as his studio, he buried his head in his work to avoid being trapped in the great debates that continuously raged in Vincent's head. But even this did not bring the "peace and quiet" he sought. "When I am painting," he complained, "[Vincent] is always finding me at fault with this, that or the other." Gauguin apparently succeeded in exiling his host to work in the kitchen, which had been fitted out as a separate studio. But they still intersected every evening over supper and every night when they retreated to their bedrooms (Gauguin could only

reach his by going through Vincent's). Even then, the walls of his tiny nook were crowded with sleepless arguments.

Inevitably, his thoughts fled the Yellow House long before he himself dared to. His enthusiasm wandered; his energy flagged. He left sketches undeveloped and paintings unfinished. He relied more and more on old drawings from Pont-Aven, or reprised previous paintings, or even borrowed from Vincent's work, rather than engage with a place and a people he despised. He rarely mentioned Vincent in his letters—the only form of privacy left to him. Feeling put-upon and purchased, he brooded resentfully. Only weeks after arriving, he began imagining his escape. A brief encounter with the Zouave lieutenant Milliet, who left for Africa at the beginning of November, reignited his plan for a return to Martinique the following year. He determined to stay in Arles only until he could save enough to set sail, he wrote a friend, "[then] I shall go to Martinique and surely produce some fine work there. . . . I will even buy a house there and establish a studio where friends could find an easy life for next to nothing."

Vincent tried at first to see Gauguin's plan for Martinique as an extension of his own great project for the South. "What Gauguin tells of the tropics seems marvelous to me," he wrote soon after his guest arrived. "Surely the future of a great renaissance in painting lies there." But with tensions mounting and Gauguin more disengaged every day (Vincent called him "homesick for the tropics"), any talk of departure threw Vincent into a panic of suspicion and anxiety that pushed their relations closer and closer to an open break. "Between the two of us," Gauguin later recounted, "the one entirely a volcano and the other also boiling, but inside, some sort of struggle was bound to occur."

Even as Vincent's behavior made Gauguin's stay in Arles increasingly intolerable, Theo's efforts in Paris made it increasingly unnecessary. In mid-November, when Gauguin's canvases finally arrived from Pont-Aven, Theo exhibited them on the *entresol* and diligently promoted them to collectors and critics. Sales of both paintings and pottery mounted; admirers multiplied. A fresh wave of money and praise washed over the Yellow House. Gauguin began keeping lists of his buyers. He boasted to Bernard of his distinguished "flatterers," especially Degas, and plotted to ensure that his disapproving family "got wind of my success." Theo sent letters enclosing hundreds of francs, elaborate plans for framing, and requests for Gauguin to approve pending sales. Other letters arrived filled with sycophantic praise ("the richness and abundance of your production astound me . . . You are a giant") and plans for exhibitions. He was invited to show his work with Les Vingt (The Twenty), an artists' society in Brussels that, through its connection with the influential review *L'Art Moderne*, had become a leading venue for avant-garde art.

Like Vincent, he declined an invitation to exhibit at the *Revue Indépendante* show in January, convinced that his enemies had laid a trap for him. Instead, he

began planning his own independent show—"a serious exhibition in opposition to the *petit point.*" Swollen with new confidence, he wrote to his wife, "My business affairs are heading in the right direction [and] my reputation is becoming firmly established." He sent friends a new photograph of himself showing off his "savage countenance," as if to announce his triumphant—and imminent—return from the wilderness.

Soon thereafter, the message reached Theo: "It is absolutely necessary that I leave."

VINCENT HAD SEEN the end coming. As early as mid-November, fear of it had begun to creep into his letters. "We are having wind and rain," he reported, "and I am very glad not to be alone." When Gauguin received the invitation to show with Les Vingt in Brussels, Vincent was seized by a paranoid suspicion that his housemate intended to move there. "Gauguin is already thinking of settling in Brussels," he imagined, "so he can see his Danish wife again." Perhaps to hide his anxieties from Theo, he wrote fewer and shorter letters, even as the nights grew longer and lonelier. He blamed the frictions in the Yellow House on weather and wind, or Gauguin's obligations to his family, or the usual strains of creative life. The truth was simply unacceptable. As soon as Gauguin announced his decision to leave, Vincent launched a furious campaign to reverse it, pretending to Theo that the decision had not been made. "I think myself that Gauguin was a little out of sorts," he explained. In a delusion of denial, he rented two additional rooms in the Yellow House.

Like Theo's refusal to come to Drenthe, or Rappard's criticism of *The Potato Eaters,* Gauguin's decision to leave Arles had to be undone—unsaid. Vincent would force him to "take it back." He told Gauguin: "Before doing anything . . . think it over and reckon things up again." Seeing doubt where there was none, he reopened all the arguments of the spring and summer—the "good reasons" why Gauguin's destiny lay in Arles—pressing them with fresh vehemence and an edge of desperation.

Despite the proof of his own eyes, he insisted that Gauguin had arrived there "in pain and seriously ill" and would fall sick again if he left the reparative embrace of the Yellow House. He warned that the success of Gauguin's art, too, depended on the magical Midi. He heaped praise on recent works like *The Grape Harvest* and *The Pigs,* calling them "thirty times better" than Gauguin's paintings from Pont-Aven. Turning against the plan for Martinique, he offered his own "calculations" to show that Gauguin needed far more money for his voyage than Gauguin himself had figured. Only if he stayed longer in the frugal South—with Theo looking after his pictures and Vincent looking after his

health—could he amass the funds he truly needed. Surely he owed that duty of caution to his wife and children, Vincent pleaded.

After exhausting all these arguments, he turned to the oldest argument of all: solidarity. He revealed to Gauguin his deepest secrets of failure—in family, in religion, in love—and drew from them a lesson that projected his own last hope for happiness onto his guest. "Gauguin is very powerful and strongly creative," he wrote Theo, "but just because of that he must have peace. Will he find it anywhere if he does not find it here?"

Inevitably, the pleadings found their way into paint. With tremendous care, he filled a large canvas with a scene that he and Gauguin had shared only a few weeks before: the ball at the Folies Arlésiennes. Vincent had always been drawn to crowds. From the fervent masses at the Metropolitan Tabernacle in London to the rowdy sailors' dances in Antwerp, the anonymity of large gatherings had made it possible for him to enjoy the human warmth that always eluded him in more intimate encounters. The annual winter ball at the Folies Arlésiennes, a huge theater that also hosted Christmas pageants and traveling zoos, outdid any celebration Vincent had seen in its naïve splendor and earnest high spirits. By the time he and Gauguin arrived on the night of December 1, the balconied theater was so packed that there was no room left for dancing. The festive chaos and infectious good cheer dispelled the claustrophobia of the Yellow House and the increasingly tense relations within it.

Thus it was no surprise, two weeks later, when Vincent summoned up this raucous evening of wine, women, and camaraderie to dissuade Gauguin from leaving Arles. Working in Gauguin's way, *de tête,* he captured the roiling sea of celebrants: women in Sunday hats and native bonnets, Zouave soldiers in their red regimental caps, both sexes bareheaded—an audacity of rustic esprit. Shoulder to shoulder, they surge across the ballroom floor and spill from the distant balconies under a galaxy of luminous Chinese paper lanterns.

The vast mosaic of figures and faces bursts with decorative motifs and patterns, some borrowed directly from Gauguin's Brittany work and from a Bernard painting that Gauguin had brought with him from Pont-Aven. The elaborate, geishalike hairdos of the Arlésiennes, seen from behind, fill the foreground with their sensuous curves of ribbons and curls. Beyond them, faces dissolve into featureless masks—rank after rank of Gauguin's mysterious phantoms, like revelers at a masquerade. Only the face of Madame Roulin stands out as a real person. In homage to the *maître,* Vincent also abjured the bright color contrasts of his own work and filled the heavily outlined elements with Gauguin's subtle *crépon* palette applied in judicious strokes. This was not the Folies ball they had witnessed; it was an *idée* of a ball.

The outing to the Folies proved successful enough that Gauguin proposed

a more extended day trip. The destination: Montpellier, a picturesque medieval city sixty miles southwest of Arles, not far from the Mediterranean coast. Gauguin chose the spot not for its rocky shoreline or its antique streets, but for its most famous treasure: the Musée Fabre. He had visited the museum years before, and he lured Vincent on the long train ride (a five-hour round-trip) with descriptions of the magnificent Delacroixs and Courbets that hung there as part of a collection given by Alfred Bruyas, a famous benefactor of the arts and friend to artists. In the lofty, skylighted Bruyas Gallery, the two painters passionately debated the paintings that crowded the walls. While Gauguin championed the muted tones of Delacroix, Vincent pleaded for his beloved portraiture—even defending the dozens of portraits of himself that Bruyas, a relentless narcissist, had commissioned from various artists.

After the trip, a tense peace descended on the Yellow House. In response to discussions like the one in the Bruyas Gallery, Gauguin painted a portrait of an old man leaning on a cane—a nod of approval to Vincent's Daumier-inspired country saint, Patience Escalier. Around the same time, he agreed to participate in another round of portraits of Madame Roulin, the postman's wife, a model of motherhood that had begun to obsess Vincent's imagination. The pair of portraits not only signaled an entente on the subject of portraiture, but also announced that the two artists had begun working together again in the front room. Gauguin even obliged Vincent's request that they exchange self-portraits—the ultimate pledge of artistic brotherhood. Like the Rashomon views of Augustine Roulin, the reciprocal self-portraits matched perfectly in size, orientation, and palette. For the background, Vincent adopted Gauguin's meticulous brushstrokes; Gauguin borrowed Vincent's *bonze* green.

Only days after returning from Montpellier, Gauguin withdrew his plan to leave Arles. "Please consider my journey to Paris as imaginary," he wrote Theo mysteriously, "and in consequence the letter I wrote you as a bad dream." Was Gauguin persuaded by Vincent's pleas to stay? Was he moved by the passion for art that Vincent showed in Montpellier? Did he take pity on Vincent's troubled past? Or did he simply fear that his housemate might come unhinged if he left?

Undoubtedly, Theo had intervened in the meantime. Knowing his brother's frantic needs and fragile spirits, he had surely begged in his careful way for Gauguin to reconsider and, if at all possible, remain. The combination of pity and pressure—whatever it was—proved persuasive even to the pirate Gauguin. "I owe a lot to Van Gogh and Vincent," he wrote his friend Émile Schuffenecker. "In spite of some discord, I am unable to hold it against a man with such a good heart who is ill, suffering, and calls for me." Indicating the threat he felt, he compared Vincent to Edgar Allan Poe, "who became an alcoholic as a result of his sorrows and neurotic state"; and he hinted at a darker cause: "I'll explain in detail later."

But nothing had changed. Where Vincent saw entente and rededication, Gauguin saw appeasement and delay. What Vincent took as a change of heart, Gauguin meant only as a recalculation. If he could maintain good relations in Paris and avoid an explosion in Arles by staying, Gauguin reckoned, he could bear life with Vincent a little longer. "I am staying put," he confided to Schuffenecker, "but my departure is always imminent."

To Theo, Vincent reported that all had returned to normal in the Yellow House. "This is how things stand," he wrote cheerfully. "Gauguin was saying to me this morning when I asked him how he felt 'that he felt his old self coming back,' which gave me enormous pleasure." But, in fact, he knew the truth. Even as he boasted of a new rapprochement and claimed Gauguin as "an excellent friend," he continued to fear the worst. "Up to the last days," he later confessed, "I saw only one thing, that [Gauguin] was working with his heart divided between the desire to go to Paris to carry out his plans, and the life at Arles." The uncertainty paralyzed him. Despite his claims of unceasing effort, his work ground to a halt. In a collapse of confidence reminiscent of The Hague, he asked Theo to return canvases from Paris and proposed not sending any more for at least a year. "It would certainly be better if I can refrain from sending them," he wrote forlornly. "For there is no need to show them at the moment, I know that well enough." Still, through all the premonitions of catastrophe, he protested his "absolute serenity" and confidence in the future.

As in Drenthe and Antwerp, the contradiction between his averred life and his real life drove Vincent into a spiral of guilt and self-reproach in the weeks before Christmas, his most vulnerable season. Gauguin undoubtedly saw the first cracks of the coming breakdown in Montpellier when, standing before Delacroix's portrait of Alfred Bruyas, Vincent launched into a bizarre discourse on the family resemblance between the bearded, redheaded Bruyas and himself. In twisted knots of association, he linked both Gauguin and Theo to Rembrandt portraits, creating a delusional brotherhood of look-alikes, and ended with a vision of himself as the brooding, demon-plagued poet Torquato Tasso, as Delacroix famously depicted him, imprisoned in an insane asylum.

As much as he could, Vincent hid from Theo the gathering storm in his head. He talked vaguely about "difficulties [that] are rather within ourselves than outside." He complained that his discussions with Gauguin left him "as exhausted as an electric battery after it has run down." Only later did he admit to multiple "nervous crises" and attacks of "delirium" in the last weeks of December. But even at the time, Theo must have noticed how Vincent's infrequent letters flitted distractedly from subject to subject, from image to image, as restless and disconnected as a ghost. He reported looking at paintings and seeing visions from the past. Delacroix's portrait of Bruyas triggered a particularly vivid reverie, he told Theo: a phantomlike figure from a favorite poem by Alfred de Musset—"a

wretch clad in black" that followed him silently wherever he went, watching as if from the other side of a mirror:

> *My ill-starred brother, clad in gloom*
> *As though arisen from the tomb.*

Religion, the most toxic of all subjects, had returned. From Musset's resurrected sibling, to the Christlike Tasso, to the "man of God" Delacroix, Vincent saw the ghosts of his own past in apparitions almost indistinguishable from real life. Among the many portraits of his "lost brother" Bruyas that he saw in Montpellier was one depicting the gaunt, redheaded collector posed as Christ with a crown of thorns. Steeling himself against the "siege" of Gauguin's success, Vincent invoked Saint Paul's injunction to be "sorrowful yet always rejoicing." He engaged in heated debates with Gauguin that explored the elusive, fraught boundaries between art, religion, delusion, and the supernatural. According to the latter's account, Vincent became so animated and emphatic in these arguments that he scribbled on the wall of the studio in yellow chalk *"Je suis Saint-Esprit"*—I am the Holy Spirit.

But no image of alienation or disintegration could have haunted Vincent more than the one in Guy de Maupassant's story "Le horla"—"The Stranger." The obscure, gothic term, taken from Norman dialect, perfectly suited Maupassant's account of a man driven to insanity by hallucinatory visions and paranoid fantasies. Vincent probably read "Le horla" while still in Paris. But his plan for the combination with Gauguin had no place in it for this dark diary of a mind possessed. The bright future and boundless optimism of *Bel-Ami* better suited his dreams for the Midi. When those dreams began to unravel in December, his thoughts turned to Maupassant's dreadful tale. Gauguin, an admirer of the supernatural, noted the story and its strange title in his sketchbook from Arles—a sign of its influence on their increasingly electrified life in the Yellow House—and Vincent later reported hallucinatory sightings of the *horla* itself.

Like Vincent, Maupassant's narrator suffered from sleepless nights, attacks of nerves, and strange visions. Over the course of a few months, recorded day by day in excruciating detail, he descends into madness. He comes to distrust his senses and fear his dreams ("this perfidious sleep"). He imagines himself the unwitting victim of a hypnotist or a sleepwalker living a mysterious double life. Gradually, he slips from vague unease into paranoid fear and then into terrifying delirium. He feels the constant presence of a menacing spirit—an "invisible being" determined to suck the life out of him, then plunge a knife into him while he sleeps. It stalks him, like Musset's black-clad wretch, drinking his water at night, turning the pages of his book, stealing his reflection in the mirror. He compares it to the "fairies, gnomes, and ghosts" of ancient lore, and especially

to the most frightening delusion that ever haunted men's minds: "the conception of God."

His hallucinatory visions grow stronger and stranger. He sees objects move in midair, as if guided by an unseen hand. He feels chained to his chair, unable to escape—"an enslaved and terrified spectator" at his own undoing. He fights off madness for as long as possible with the same brave pretense of logic and self-awareness that Vincent used as a bulwark against the disorder in his head. "I ask myself whether I am mad," he records in his diary. "I certainly should think that I was mad, absolutely mad, if I were not conscious that I knew my state, if I could not fathom it and analyze it with the most complete lucidity." But finally he succumbs. In a furious attack of paranoia, he tries to kill his invisible tormentor by trapping it in his room and setting fire to the building. When that plot fails, he turns his avenging terror on himself. "No—no—there is no doubt about it," he cries out at the end of the story, vowing to pursue his fight against the *horla* to its inevitable conclusion. "He is not dead. Then—then—I suppose I must kill MYSELF!"

In the Yellow House, too, events spiraled out of control. Vehement outbursts of debate punctuated every day. "Our arguments are *terribly electric*," Vincent told Theo. They argued "until our nerves were strained to the point of stifling all human warmth," he lamented. Gauguin tried to defuse his host's volcanic eruptions by ignoring them—a strategy that Vincent's father had used. But that only made them worse. The repeated explosions left the house charged with tension. The silences between them weighed so heavily that visitors like the postman Roulin felt an air of dread even during their truces. Like Maupassant's haunted hero, Vincent seemed at war with himself: seized by titanic passions one minute, brooding or nervous the next. "Horrible fits of anxiety" alternated with "feelings of emptiness and fatigue," he later admitted. Days of exhausting argument were followed by nights of wandering sleeplessness.

Gauguin noted the "contradictions" in Vincent's behavior and saw them as signs of a fierce inner struggle. "Vincent has been turning very strange," he reported to Bernard, "but fighting it." Years later, Gauguin recalled how suddenly and violently Vincent could change personalities: from "excessively abrupt and boisterous" to ominously silent, then back again. One minute he cogently made the case why Gauguin should stay in Arles and fondly laid plans for a joint exhibition; the next he angrily accused his guest of scheming mischief and hovered suspiciously after Gauguin went to bed, as if fearing a midnight flight. In a fit of mistrust, he seized the *bonze* self-portrait that he had given Gauguin as an invitation to the Midi and rubbed out the dedication (*"à mon ami"*) with paint solvent.

Of all the paranoid visions that filled Vincent's head, one terrified him more than any other. Since Gauguin's arrival in Arles, his relations with Theo had

changed. Their letters had grown not only shorter and less frequent, but less intimate as well. Theo had warmer words for the two young Dutch artists who were visiting him in Paris than for his distant, troubled brother. (He commented pointedly on how their "pleasant company" had improved life on the rue Lepic.) When the two artists left Paris for the countryside, Theo did not recommend they go to Arles, as Vincent had urged him to do.

It was only one of many signs that Theo's confidence in his brother's artistic project had begun to ebb. He seemed genuinely startled when Gauguin finally showed up in Arles—as if he doubted the combination's success all along. After Gauguin arrived, he abandoned the long and rancorous push for Vincent to make salable works, a push that had defined their relationship for almost a decade. Instead, he sent only patronizing assurances ("the condition I want you to arrive at is that you should never have any worries") and empty blandishments ("you are living like the great ones of the earth"), all signaling, it seemed, his acceptance of inevitable failure. "We must see to it that we don't take too much on our shoulders," he wrote, oddly unbothered by Vincent's plan not to send any paintings for a year. "We shall be able to go on for some time to come, even without selling anything."

For Gauguin, on the other hand, Theo saw only the brightest future. In letters filled with optimism and accolades, he sent news of Gauguin's *"grand succès"* in Paris and reports of more sales. He boldly predicted that Gauguin's reputation would be "bigger than anybody had thought"—bigger even than Monet's. He praised Gauguin's work not just for its salability but for its "strange poetry." "Gauguin whispers words of solace for those who are not happy or healthy," he wrote, usurping the language of consolation that Vincent had taught him. "In him nature itself speaks." But of all the flattery Theo heaped on Gauguin, none could have rankled his brother more than this: "He could go the same way as Millet."

Gauguin responded in kind, sending frequent, often long letters (in stark contrast to Vincent's) filled with upbeat reports, courtly gestures, cogent explanations of Symbolist theory, and incisive business suggestions. Where Vincent sent no paintings to Paris, Gauguin sent multiple shipments, complete with directions for framing and selling. In one of these batches, he included his mocking portrait of Vincent painting sunflowers, which he grandly presented to Theo as a gift. Theo hailed it as "a great work of art" and called it the "best portrait" ever painted of his brother "in terms of capturing his inner being."

Week after week of lopsided encomiums and unshared letters only intensified the sibling rivalry that had built up through the spring and summer. In the hothouse of paranoia on the place Lamartine, Vincent's early suspicions that Gauguin was "a schemer" with political designs on his brother slipped easily into delusions of betrayal. Why, for instance, had Vincent's relations with

Bernard come to such an abrupt, mysterious end shortly after his houseguest's arrival in Arles? Bernard continued to correspond with Gauguin, but Vincent's letters went strangely unanswered. Would his relations with Theo suffer the same fate? Was Gauguin another Tersteeg: another false brother luring Theo toward the *fata morgana* of conventional comfort and success?

Vincent had welcomed Gauguin as a lost sibling, like Bruyas. Had he unwittingly invited into their lives a stranger who, like Musset's "wretch," *looked* like a brother but brought only despair and ruin? In his attacks of inexplicable dread, every fear seemed plausible. For the first time, he started hoarding Theo's letters—as if clinging to something that he felt slipping away—and eavesdropped suspiciously on Gauguin's correspondence with Paris. Between Theo's upcoming Christmas trip to Holland, which inevitably included a visit with the invidious Tersteeg, and his blithe acceptance of Gauguin's invitation to Arles after years of resisting his brother's entreaties, Vincent could see the outlines of treachery. If Theo would come to the Yellow House for Gauguin, would he abandon it if Gauguin left?

Nothing made Vincent feel more disconnected from his family, whether real or imagined, than the coming of Christmas. Like Redlaw in *The Haunted Man*, Dickens's tale about a Christmas Eve reckoning with a phantom twin (a story that he reread every year), Vincent found nothing but dreaded reflection and regret in the joyful rituals of the season—a season that enveloped Arles starting in early December. Everywhere he turned, he saw plates of *"Sainte Barbe* corn" on windowsills—one of many local holiday customs that mixed Catholic mysticism with older pagan fertility rites. Soon, meat disappeared from meals and menus, special breads appeared, and desserts multiplied. Decorations of fruit and flowers filled the faded, dusty rooms throughout town—even the infernal Café de la Gare.

Then the crèches came out. Every family and business in Arles rehearsed the miraculous birth in little clay figurines, called *santons*, for which the Midi was famous. The same scene came to life and burst into song in the *pastorales* staged at the Folies Arlésiennes. These elaborate theatricals—part medieval mystery play, part musical revue—drew thousands to the theater, just as the parade of shepherds playing rustic instruments and leading a spotless lamb drew thousands into the streets, kneeling and crossing themselves as the sacred procession passed.

No matter the pageantry and piety outside his window, Vincent's Christmas could never escape the ghost of the man who had presided over all his Christmases past. The Nativity festival that Arlesians called Calendo was a time to celebrate family—both living and departed. Only the poorest, homeless wretches spent the holiday alone. But in his agitated state, Vincent needed no special prompting to conjure his disapproving father. In the weeks before Christmas, he

spun yet another illusory plan to reverse the judgments of the past. Once again, it involved the approval of his nemesis H. G. Tersteeg, the only man who still carried the torch of the *rayon noir.* Raising the stakes at the Yellow House even higher, Vincent imagined using Gauguin's recent successes to recruit Tersteeg's support for a joint exhibition in London. Thus, in a single stroke, he could placate the implacable *gérant and* put to rest his spectral holiday visitor.

But fantasies of redemption were not enough. In the week before Christmas, tortured by Gauguin's success and his own continued failure, terrified that Gauguin might leave and Theo might abandon him at any moment, and besieged by the usual demons of the season, Vincent withdrew to his studio in search of consolation. Over the next few days, an image took shape on his easel that had been gestating in his imagination since the previous summer: Madame Roulin and her infant Marcelle.

Since his own childhood of babies and cradles in a crowded parsonage, Vincent had been transfixed by the eternal tableau of mother and child— what Michelet called "the absolute of beauty and goodness, the acme of perfection." In the apartment that he shared with Sien Hoornik, he fawned over his make-believe children and was overtaken with emotion at the sight of Sien bending over the cradle—an image that he rendered again and again. Whether contemplating a favorite print, describing a visit with Kee Vos and her son, or painting a domestic scene in Paris, the image of mother and child invariably caused his "eyes to grow moist" and his "heart to melt." When he moved into the Yellow House in September, he planned to decorate his sturdy bedstead with the image of "a child in a cradle."

In the five months since Marcelle's birth, Vincent had painted the matronly Augustine several times—with and without her baby. When the photograph of his own mother arrived in September, his ambition redoubled. By mid-December, he had painted the postman's wife so many times that her patience for the strange painter from the North had apparently reached its limit: Vincent had to launch his latest attempt by tracing one of his previous portraits.

Layering his own family longings onto the ubiquitous image of the Holy Family—especially the Virgin and Child that gazed beatifically from every shrine and festival and fireside crèche in Provence—he filled a big canvas with the most consoling image he could imagine. "As one whom his Mother comforteth," he had written from England in 1876, at another moment of existential dread, "so I will comfort you, saith the Lord." In Isleworth, he had poured his heartbreak not into art, but into sermons ("the journey of our life goes from the loving breast of our Mother on earth to the arms of our Father in heaven") and into thousands of lines of poetry carefully transcribed into the guestbook of Annie Slade-Jones, another paragon of maternal fecundity and comfort. In 1882, abandoned by family and friends, he had dreamed a reverie of Sien and her newborn as "that

eternal poetry of Christmas night with the infant in the stable . . . a light in the darkness, a brightness in the middle of a dark night."

Just as he had turned Patience Escalier into a rustic saint, and himself into a *bonze* priest, he slowly transformed the coarse, harried postman's wife into an icon of motherhood. The great mountain of her bosom he rendered in flowing curves and full, fruitlike ripeness. He clothed her in a simple buttoned bodice, not the flimsy, wrinkled frock of previous portraits. He raised her forehead to match the Virgins of his memory, and slimmed her formidable jowls and prominent chin to a maidenly point. He transformed her lips from the raw flesh of previous attempts to a bright ruby red and made her eyes sparkle with irises of a sublime, otherworldly green. Her hair, before always loosely swept up and tousled by labor, now formed into a crown of braids, as perfect as a porcelain figurine.

He filled this Daumier cartoon of indomitable provincial maternity with the most consoling palette he could devise—"a lullaby of colors," he called it: for the bodice, a deep and somber green accented at the cuffs and collar with the tenderest baby blue; the broad, high-waisted skirt, light green against the earth-red chair and vermilion floor—a graduated scale of contrasts calculated to soothe the eye, not jolt it. "As an impressionist arrangement of colors," he wrote, "I have never devised anything better." For the face, he worked and reworked yellows and pinks to give her countenance light and life, and he crowned her with a halo of orange and yellow hair—like his own—the shining Delacroix nimbus that marked all his attempts to render the ultimate consolation of Christ.

In this simple portrait, Vincent summed up a lifetime of comforting imagery: from the Rembrandt etching of a candlelit cradle that had hung in the Zundert parsonage (and in the Schenkweg studio), to a Carlo Dolci Gethsemane, to his own *Starry Night*—all images that had showed him "a light in the darkness" at times of crisis. He saw in it both Daumier's simple truth and Corot's ineffable magic. He claimed it as a vindication for both his long love of "types" and his belief that portraits of everyday people ranked among the most sacred icons of the sublime. He championed it as a promise of artistic procreativity—a Midi fertility goddess that ensured the Yellow House would not be counted among the *"entreprises sans issue."*

The painting also resurrected the dream of The Hague—of magazine illustrations and of lithographic prints—the dream of reaching out directly to the masses, bypassing the hostile world of galleries and dealers, including his brother, to touch the hearts of the common people who hungered for his heartbroken art. Comparing his maternal talisman to "a chromolithograph from a cheap shop," he imagined it bringing the consoling gospel of color into their colorless lives, just as it had into his.

As always, Vincent bolstered his arguments with images from his reading.

Hadn't Tolstoy called for a return to a more humble, more human religion—more like the simple faith of "primitive Christians"? And didn't that simpler faith demand a simpler, earthier art? For sainthood in this new religion, Tolstoy had nominated his nursemaid—"a memorable exemplar of uncomplicated faith and wise naïveté"—the very image of Vincent's stolid earth mother with her crude form and almanac color. Zola's mystical *Le rêve*, which Vincent read that fall, echoed the same themes of rustic faith and secular sainthood in a story of medieval craftsmen seeking the sublime through their simple handiwork.

Vincent gave his Byzantine icon the title *La berceuse*, a term that applied to both the maternal figure who rocks the cradle and the lullaby she sings. He claimed that the image had been inspired by the great spinner of simple myths, Pierre Loti. In *Pêcheur d'Islande* (*Icelandic Fisherman*), Loti had described a faïence figurine of the Virgin Mary that accompanied the brave fishermen on their perilous voyages in the cold and violent North Atlantic. Affixed to the wall of the ship's cabin, this earthenware Mother, "painted in the most naïve style," heard the seamen's rough prayers, calmed their lonely distress, protected them through wind and storm, and rocked them to sleep at night in the cradle of their boat. "If one were to put this canvas just as it is in a fishing boat," Vincent boasted of his new portrait, "even one from Iceland, there would be some among the fishermen who would feel they were there, inside the cradle."

The "fisherman" Vincent most wanted to comfort with his brightly colored *Berceuse* was his housemate Gauguin, who claimed to have visited Iceland in his merchant marine days and still wore the sailor's beret described in *Pêcheur.* (Vincent had noted Gauguin's "affinity" with Loti's fishermen the moment he arrived.) From its subject matter to its painting style, *La berceuse* pleaded for Gauguin to stay in Arles. Like the Folies ball, the image of the postman's wife recaptured a moment of solidarity when Vincent and his guest had worked side by side in the front room of the Yellow House with Augustine Roulin as their shared model. Vincent imagined that Gauguin had, in fact, sired his icon of fecundity. "He and I were talking about the fishermen of Iceland and of their mournful isolation, exposed to all dangers, alone on the sad sea," he reported.

> Following those intimate talks of ours the idea came to me to paint a picture in such a way that sailors, who are at once children and martyrs, seeing it in the cabin of their Icelandic fishing boat, would feel the old sense of being rocked come over them and remember their own lullabies.

His brush took up the argument using Gauguin's heavy outlines, flat texture, and careful gradations of color. He borrowed elements from Gauguin's portrait and grandly seated his Madame Roulin in Gauguin's thronelike chair. Now working entirely *de tête*, he filled in the ground with Gauguin's unbroken

vermilion, and, despite the temptation presented by vast stretches of color, reined in his impetuous hand to prevent any hint of impasto from undermining his hope for reconciliation. On the wall behind the figure, that hope burst into great blooms of color as Vincent filled more than half the canvas with flowered wallpaper. Sprays of pink dahlias—the same flower that bedecked the dreamed scene of his mother and sister in the parsonage garden at Etten—burst against a blue-green background—a reverie of the wallpaper in his attic room in Zundert—speckled with orange and ultramarine in an ardent tribute to Cloisonnist ornament.

To enchant his simple figure with Gauguin-like mystery, Vincent planned not to depict the infant Marcelle, but only to *suggest* her presence by showing Augustine holding the rope that she used to rock the cradle. Her grip on the rope—firm yet tender—would capture the Symbolist essence of the magical mother-child bond. It would be, in short, a triumph of Gauguin's elliptical imagery. But once again Vincent's draftsmanship failed him. As he worked and reworked every other part of the big canvas in the week before Christmas, the icon's hands remained unfinished.

Vincent must have blamed the roadblock on his lack of models. The loving grip and tension on the rope presented a special challenge for an artist who always had trouble with hands. And he could hardly model the pose himself. But as the Yellow House spun deeper and deeper into delirium, and his own grip on reality grew more and more uncertain, the unfinished hands on his easel no doubt assumed in Vincent's fevered imagination a larger and darker significance. Surrounded by celebrations of family and images of belonging, he was losing the battle for connection—both in the world and within himself. Without a rope holding him fast, he would suffer the same fate as the poor seamen who trusted Loti's faïence Virgin: their boat capsized in a storm and all aboard perished.

VINCENT'S EFFORTS, TOO, came to grief.

On December 23, the last Sunday before Christmas, the moment he had long feared finally arrived. Whether Gauguin intended to leave Arles when he walked out of the Yellow House that evening isn't clear. But Vincent thought he did. In the previous few days, their life together had become unbearable. Bad weather had trapped them both inside: Vincent obsessing over his strange portrait of Madame Roulin; Gauguin idle and restless. When not working, Vincent spent his days in rambling arguments punctuated by outbursts of temper and voids of brooding silence. Gauguin, finally convinced of his host's true "madness," worried that at any moment "a fatal and tragic attack" might imperil his own safety—especially at night, when Vincent roamed the house menacingly. "I have been living with my nerves on edge," he reported to Bernard.

Gauguin may have left that evening just to get some air between downpours, or to dull his misery at the nearby Café de la Gare, or to visit a favorite prostitute in the brothel district across the place Lamartine—all escapes he had sought more often as the pressures built up in the Yellow House. He and Vincent had been arguing fiercely over newspaper reports about a famous Jack the Ripper–style killer who, while awaiting execution, was haunted by *horla*-like nightmares. Whatever Gauguin's reasons for leaving, Vincent heard the door close and thought it was for the last time.

Gauguin had barely reached the middle of the park before he heard familiar footsteps behind him. "Vincent ran after me," Gauguin recalled to a friend a few days later, "I turned round, for he had been very strange recently, and I did not trust him."

"You are going to leave?" Vincent demanded.

"Yes," Gauguin replied.

He may have meant only to reaffirm his ultimate intention (already well known to Vincent) or, unnerved by the threatening pursuit, he may have felt a sudden, urgent resolve to escape. Either way, Vincent took it as the final verdict he had long expected, and he came armed with a response. Without saying a word, he handed Gauguin a story torn from the day's newspaper and pointed to the last line: *"Le meurtrier a pris la fuite"*—the murderer has fled.

Gauguin turned and walked on. He heard Vincent running away into the darkness.

No one knows what happened next. Vincent's previous breakdowns left traces in his letters: trails of thoughts and images that followed his descents and recorded his crashes. In Drenthe, the desolate heath, regret over Sien, dwindling paint supplies, and snatches of disconsolate poetry limned a path toward the disastrous psychotic episode of September 1883. Less than three years later in Antwerp, a diagnosis of syphilis, the indignity of rotting teeth, the deception of his brother, the ridicule of prostitutes and models, and ubiquitous images of death and madness marked his spiral toward the abyss of "absolute breakdown." In both places, dismal weather, stubborn poverty, and abusive drinking combined to wear down Vincent's defenses against despair. In this heightened nervous state, even the slightest insult or setback could trigger apocalypse.

Three years later in Arles, it struck again. He said little about the "attack" (his word) this time. He professed to remember nothing about it except *horla*-like "mental fevers" and terrible hallucinations. As before, the stage was set. It had been raining for days in Arles—a cold winter rain. Vincent had been drinking again, too: not just wine and cognac, but the far more potent absinthe. After his confrontation with Gauguin in the square, he may well have fled to a café for a glass or two of the green consolation. And he was broke again. At one point that day, he reached into his pocket and found only a pitiful handful of change—

"one louis and 3 sous"—reminding him not only of his poverty at that moment, but of all the tens of thousands of francs Theo had sent over the years—all now gone.

The images swirling in his head on a Sunday night two days before Christmas included Maupassant's diabolical *horla*, Dickens's haunted Redlaw, Loti's drowned sailors, and especially the ghost of the man who dominated every Sunday and every Christmas of his life—all images of guilt, fear, failure, and death. When he returned to the darkened, empty Yellow House that night, he saw the detritus of his dream everywhere: on the walls, in the accusatory faces of the *bonze*, the Zouave, Patience Escalier, and all the rest of his rejected invitations to the magical South; on his easel, in the unforgiving, unfinishable *Berceuse*, now repudiated by the one man it was meant to please.

In the past, Vincent had always managed to pull himself out of the abyss: in the Borinage, by imagining a new life of artistic brotherhood with Theo; in Drenthe, by inviting Theo to join him on the heath; in Antwerp, by laying plans to join Theo in Paris. By Christmas 1888, however, all these routes of escape had been foreclosed. Two years of living together had almost killed his brother, and the weight of guilt had almost crushed him. Even now, the cautionary example of the Zemganno brothers, who separated in order to survive, still weighed on his conscience. He had left Paris to save Theo; he could not go back. Nor would Theo come to him. Whatever remained of that fantasy had been put to rest by the painful transfer of Theo's favor from Vincent's hopeless enterprise in the Midi to the *entresol*'s new star, Gauguin.

By December 23, news had reached Arles that only confirmed the abandonment Vincent already felt: Theo had proposed to Jo Bonger. The two had reunited again in Paris, apparently at Jo's initiative, and sought their parents' permission to marry. If the announcement did not wound him, the secrecy of their whirlwind courtship surely did. Vincent had always suspected that, in the end, Gauguin would be drawn away from the Yellow House by his wife and family. Now, for the same reasons, he knew Theo would never come.

Shipwrecked with no hope of rescue, delirious, disoriented, and probably drunk, he stumbled to his bedroom. He went to the corner where the washstand stood. From there he could see into Gauguin's room, which was still empty. When he turned around, he looked into the mirror that hung over the washstand. Instead of the familiar face he had painted dozens of times, he saw a stranger—an "ill-starred wretch" who had failed his family, killed his father, bled his brother of money and health, destroyed his dream of a studio in the South, and driven away his Bel-Ami. The failure was too overwhelming. The crime was too great. It had to be punished. But how?

Vincent had spent a lifetime inflicting discomfort and pain on the image in the mirror: from refusing food to sleeping on the ground in freezing huts and

beating himself with cudgels. But this crime demanded more. His fevered mind swam with images of punishments exacted for sin, from the sword wounds inflicted by the apostles on Christ's attackers at Gethsemane to the brutal exorcisms of Zola's *Le rêve* and mutilations in *La terre* and *Germinal*. The traitorous brother who dragged Zola's hero from the *Paradou* garden had had his ear chopped off.

Vincent picked up the straight razor that lay on the washstand and opened it. He grabbed the criminal's ear and pulled at the lobe as hard as he could. He brought his arm across his face and slashed at the offending flesh. The razor missed the upper ear, coming down at about the midpoint and slicing through to the jaw. The skin cut easily, but the rubbery gristle of cartilage demanded either savagery or persistence before the flesh between his fingers came loose. By then, his arm was covered in blood.

Jolted into reality, he tried almost immediately to stanch the fierce, arterial bleeding. The amount of blood must have surprised him, as he scurried to the kitchen in search of more towels, leaving a trail of crimson through the hall and studio. By the time the bleeding slowed, his mind was possessed by a new delusion. He would find Gauguin and show him the awful price that had been paid. Perhaps then he would reconsider. Vincent washed the small fan of flesh and carefully wrapped it, like a cut of meat, in a piece of newspaper. He dressed his wound and covered the bandage with a large beret, then set off into the darkness.

Twenty-four hours before Christmas on a rainy night, there were only a few places Gauguin could be. Vincent probably tried the brothels first. Gauguin's favorite, on the rue du Bout d'Arles, was only a few minutes' walk from the Yellow House. Vincent asked to see "Gaby," the *nom de théâtre* of a woman named Rachel, Gauguin's particular favorite. But the brothel keeper would not let him pass. Convinced, perhaps, that Gauguin was within, he surrendered his package to the "sentry" and asked him to convey it with a message: "Remember me."

He returned to the Yellow House, staggered up to his bloody bedroom, lay down dizzily on the scarlet blanket and closed his eyes, expecting—even welcoming—the worst.

Two Roads

~

T HEO COULDN'T BELIEVE HIS GOOD FORTUNE. JO HAD FINALLY SAID yes. Eighteen months after rejecting his marriage proposal, she had miraculously reentered his life and, in a whirlwind two weeks, transformed it. On December 21, Theo announced the "great news" to his mother, giving her the best possible Christmas present. "We have seen one another a great deal these last few days," he wrote. "She has told me she loves me too and that she will take me the way I am. . . . O Mother I am so inexpressibly happy."

His family celebrated the news in a chorus of holiday endorsements. "What good news, we are so happy with it!" sister Wil responded. "I'm so thankful that you won't be alone anymore because you're not that type of person." "We have been wishing it for you for such a long time," Lies added. His mother thanked "the good Lord for hearing my prayer." On Christmas Eve, Theo laid plans with Jo to travel to Holland and formally announce their engagement to both families. "This will be a turning point in my life," he predicted. "I am on cloud nine."

Later the same day, a courier arrived at the gallery with a telegram from Arles. Vincent had fallen "gravely ill." Theo needed to come at once. Gauguin offered few details. Theo imagined the worst. "Oh, may the suffering I dread be staved off," he scrawled in a note to Jo as he hurried out the door. "I shall keep my spirits up by thinking of you." At 7:15 that evening, as Christmas Eve candles, lamps, and electric lights were lit across Paris, he boarded a train for the 450-mile trip to Arles—a trip he had long avoided. Jo bid him farewell at the station.

On Christmas morning, the hospital in Arles was unusually empty. Staff and visitors and any patients who could walk filled the churches of Catholic Provence—one of them attached directly to the hospital—or joined family at home. Built in the sixteenth and seventeenth centuries, when any illness was a deadly, demonic business, the hospital looked like a prison, with high stone

walls pierced by small windows and few entries. Its builders had given it a name, carved over the main door, at once hopeful and helpless: Hôtel Dieu—God's house. Reminders of its spiritual license—crucifixes, plaques, inscriptions—filled the cavernous halls as Theo searched for his brother. He may have stopped first at the Yellow House, near the station, and asked Gauguin to be his guide. If he did, Gauguin refused. (Vincent had called out for his housemate many times after he regained consciousness, hoping to dissuade him from doing what he had already done: summon Theo.)

With so few staff and so many beds, finding Vincent could not have been easy. Since arriving twenty-four hours earlier, he may have already been re-moved from the "fever ward"—a huge, high-ceilinged room with dozens of beds separated by muslin curtains. The police had left him there, bleeding and un-conscious, the previous morning. But when he regained consciousness, he cried out incomprehensibly in a tumble of Dutch and French that unnerved both pa-tients and staff. Eventually, they moved him to an isolation cell—a tiny room with padded walls, barred windows, and a bed fitted with shackles.

By the time Theo found him, he had calmed down again and may have been returned to the ward—a round-trip he would make many times. "He seemed to be all right at first," Theo reported to Jo. At one point, he lay down in the bed beside his brother and they reminisced about their childhood together in the attic of the Zundert parsonage. "How poignant," their mother wrote when Theo related the scene to her, "together on a pillow." Theo asked if Vincent ap-proved of his plan to marry Jo. Vincent replied elusively: "marriage ought not to be regarded as the main object in life." But before long the demons descended again. "He lapsed into brooding about philosophy and theology," Theo reported. "It was terribly sad . . . From time to time all his grief would well up inside and he would try to weep, but couldn't."

If only Vincent had someone like Jo, Theo thought. "Poor fighter and poor, poor sufferer," he wrote her after his visit. "Had he just once found someone to whom he could pour his heart out, it might never have come to this."

And then he left.

After no more than a few hours at the hospital, with only a brief visit to the Yellow House, he returned to the station and took a train that left Arles at 7:30 that evening—only nine hours after he arrived. He was probably accompanied on the long ride back to Paris by Gauguin, who carried a load of Vincent's paint-ings as trophies of his two months in Arles. Struggling to explain his hasty flight from Vincent's bedside, Theo wrote Jo: "His suffering is deep and hard for him to bear," but "nothing can be done to relieve his anguish now."

In his brief time at the hospital, Theo managed to speak to one doctor: a twenty-three-year-old intern named Félix Rey. As the most junior member of the medical staff, Rey had drawn the short straw of holiday duty. An affable Midi

native, Rey had yet to earn his medical degree, but he could report to Theo the strange circumstances of Vincent's "accident" and the agony of his long first day in the hospital. All of the doctors at the Hôtel Dieu were astonished and perplexed by Vincent's case: the violence of his attack on himself, the vehemence of his agitation, the strangeness of his behavior. Not one of them had yet dared to propose a diagnosis. Clearly, his mind was unmoored. Anyone could see that. His wound and his fever they could treat, but some were already declaring him insane and urging his transfer to a lunatic asylum where he could receive more expert attention.

Rey, who was just completing his doctoral thesis on urinary tract infections, knew little about mental illness, but he brightly ventured his own reassuring prognosis to the patient's distraught brother. Vincent was merely suffering from "overexcitement," he said—the natural product of an "extremely hypersensitive personality." The symptoms would soon abate, he predicted confidently. "He will be himself again in a few days."

If Theo had stayed in Arles another day, he might have met the hospital's medical director or administrator and heard other, more dire opinions. But formal interviews would have entailed wrenching inquiries into family health secrets, both physical and mental: a routine part of the admitting process that both brothers dreaded. (Vincent's hospital records contained none of the background information that Theo could have provided.) Rey's opinion may have been hasty, inexperienced, or inexpert, but it gave Theo what he wanted most: permission to return to Paris. Just as his old life threatened to end, a new one beckoned. "The prospect of losing my brother," he wrote Jo, "made me realize what a terrible emptiness I would feel if he were no longer there. And then I imagined you before me."

It was a pattern that would be repeated again and again over the next five months as Vincent shuttled in and out of the hospital, in and out of padded cells, in and out of coherence: one brother suffering in silence and self-reproach, the other retreating into optimism and indecision; one haunted by the past, the other looking to the future; both grasping at every straw of hope, minimizing every dread, moving in contrary spirals of denial that pushed them further and further apart with each revolution. "Let's not exhaust ourselves in futile attempts at mutual generosity," Vincent wrote in a moment of grim clarity and resignation after Theo left. "You do your duty and I will do mine . . . and at the end of the road perhaps we will meet again."

AS SOON AS NEWS of Theo's departure pierced his consciousness, Vincent plunged into darkness again.

Vincent remembered little about his attacks ("I don't know anything about

what I said, what I wanted, or what I did," he wrote), but he remembered the darkness. It descended without warning. In an instant, "the veil of time and the fatality of circumstances seemed to be torn apart," he said—as if he had suddenly and inexplicably disappeared from the world. A witness at the hospital who saw him during an attack described him as "lost." In the darkness, nameless fears overwhelmed him. He felt waves of "anguish and terror" and "horrible fits of anxiety." He lashed out violently at the threats he saw everywhere, raging incoherently at doctors and chasing away anyone who approached his bed. When his rage was spent, he retreated to a corner or under the covers and cowered in fevers of "indescribable mental anguish." He trusted no one, recognized no one, doubted everything he heard or saw, took no food, could not sleep, would not write, and refused to talk.

In the darkness, shapeless shadows pursued him. *Horla*-like ghosts— "unbearable hallucinations"—appeared and disappeared like vapor, but as vivid and palpable as his own flesh. "During the crises themselves," he wrote, "I thought that everything I imagined was real." They spoke to him. They accused him of terrible crimes. They called him "a deplorable and melancholy failure," a "weak character," a "miserable wretch." He shouted back, desperately defending himself against the thin air. But he could not make himself heard. After a lifetime of arguing and persuading, he was trapped in his worst nightmare: a prisoner at the bar, gagged into silence. "I cried out so much during the attacks," he recalled; "I wanted to defend myself and couldn't do it." The unanswered accusations sent him spiraling into seizures of self-loathing and "atrocious remorse."

Vincent never identified his phantom accusers. But in his hours of "frightful suffering . . . when I was so far gone that it was more than a swoon," he called out names: Degas, whose easy, elegant lines eluded him; Gauguin, whose refusal to stay in Arles confirmed the failure of his great Midi dream; Theo, who came to Arles too late and for all the wrong reasons. And, of course, the damning parson who relentlessly tallied every failure and spied from every crucifix. "During my illness," Vincent wrote,

> I saw again every room of the house at Zundert, every path, every plant in the garden, the views from the fields round about, the neighbors, the graveyard, the church, our kitchen garden behind—down to the magpie's nest in a tall acacia in the graveyard.

In such hallucinatory "eruptions of memory," as Flaubert called them, Vincent revisited all the injuries of the past. "In my madness," he recalled, "my thoughts sailed over many seas." For him, memory had always been the imagination's sixth sense; nostalgia, a turbulent inland sea of inspiration. His delirium breached the dam between past and present. Flaubert, who suffered similar

mental seizures, described how images flooded in "like torrents of blood . . . everything in one's head bursting all at once."

Where others saw madness, Vincent saw memories. He climbed into bed with fellow patients, just as he had done with Theo in Zundert. He chased after nurses in his nightshirt, just as he had done with Sien in The Hague. He even blackened his face with coal, just as he had done in the Borinage. To Rey it looked like an act of lunacy—"he went to wash himself *in the coal bin*," the doctor reported incredulously. What Rey couldn't see, what only Vincent could see, was a past of ridicule and rejection by the wretched Borins and a familiar self-abasing ritual of solidarity with the miners who, like him, "walked in darkness."

Sometimes the darkness passed quickly—a sudden storm that blotted out the sun for a moment or an hour. Other times, it lingered for days as storm after storm battered his reason and seemed to banish the sun forever.

By December 30, the darkness had lifted. Or so it seemed. "His condition has improved," Rey wrote Theo that day, exactly a week after Vincent took up his razor. "I don't believe his life is in danger, at least for the moment." When he emerged, Vincent found himself imprisoned and alone. "Why do they keep me here like a convict?" he angrily demanded. Stripped of recollection, he felt only guilt. "He hides himself in absolute silence," one visitor reported, "covers himself with his bedclothes and at times cries without uttering a single word." Both his anger and his shame threatened to restart the cycle of madness. Another visitor described him as "calm and coherent" but so "amazed and indignant" at his situation ("kept shut up [and] completely deprived of his liberty") that another attack seemed inevitable. The anger fueled days of protests against his continued confinement. For a time, he refused to cooperate with his captors. "When he saw me enter his room," Rey wrote, "he told me that he wanted to have nothing to do with me."

The doctors increasingly saw only one path forward: commitment. During the worst of his attacks they had issued a "certificate of mental alienation" claiming that Vincent suffered "a generalized delirium" and attesting to his need for "special care" in one of the two public asylums in the region, in Aix and Marseille. Even Rey seemed convinced. He wrote Theo expressing his preference for the asylum in Marseille, where he had recently interned. The future seemed set until Vincent's sudden return from the darkness in late December. Paralyzed at the prospect of burdening Theo further, he argued fiercely for his freedom and recruited the postman Roulin to plead his case to hospital officials. But no display of calmness and coherence, no promises from Roulin to look after his friend, not even the speedy healing of the wound on Vincent's head, could persuade the doctors to release him. Even Rey, the most optimistic of them, feared the violent consequences of a relapse. Besides, the commitment process had already been set in motion.

In a desperate bid to head off a collision, Rey wrote Theo to propose a different path forward. "Would you like to have your brother in an asylum near Paris?" he inquired. "Do you have resources? If so, you can send for him."

BUT THEO HAD other matters on his mind. "Now tell me what we have to do according to Dutch custom," he wrote Jo Bonger the day Rey's letter arrived. "We could start sending the announcements, couldn't we?"

He had returned to Paris on the day after Christmas determined to recapture the perfect happiness interrupted by Arles. "I think of you and long so to be with you," he wrote Jo, who had left for Amsterdam only hours before his return. The thought of their future together carried him through the long days at the gallery during its busiest season and the long nights in the empty rue Lepic apartment. "I too often look at the corner of my room where we enjoyed such peace together," he wrote her. "When shall I be able to call you my little wife?"

The outpouring of congratulations from friends and family resumed immediately, separating Theo even further from the brief, otherworldly detour to Arles. "Bless your future life together," sister Lies wrote the day after his return. "For Ma it is like a ray of sunshine to know that your life won't be lonely anymore." Only the uncertainty of Vincent's fate (which hung over the holiday season like a "haze," he said) prevented him from racing to Holland to join his beloved, as they had planned before Christmas. "I shall not postpone it for a single day unless I absolutely *must*," he assured her. "I so long to be with you." In the meantime, he busied himself with preparations for his new life: printing the engagement announcements, planning a round of visits to friends, and looking for a new apartment—"the place where we shall build our nest."

As much as longing for Jo distracted him from his brother's fate, news from Arles confused him about it. "I've been wavering between hope and fear," he wrote. Rey's initial reports summarized Vincent's condition well enough, but with a clinical dispassion and professional caution that hardly captured the tempests of emotion Theo knew his brother was suffering. At one point, Rey, an aspiring gentleman, wandered far from the case by delicately suggesting that Theo introduce him into Paris society after he completed his medical degree. Through the fog of propriety and uncertainty ("it is very difficult to respond categorically to all of the questions that you ask of me," Rey demurred), Theo probably overlooked the hints that the young intern had already begun to earn Vincent's trust, and that Vincent had already begun to control the information Rey shared with him.

While in Arles, Theo had accepted Joseph Roulin's offer to look in on Vincent and report on his condition. In his letters and his art, Vincent had portrayed Roulin not just as a model but as a friend and a community leader of

some distinction. Theo apparently met the imposing postman at the hospital on Christmas Day and heard (probably from Roulin himself) of Roulin's role in rescuing Vincent from his blood-soaked bed the day before. His very presence in the hospital spoke of his concern for Vincent's welfare. When Roulin offered his services as *rapporteur* to the distinguished *gérant* from Paris (whose fine stationery and frequent money orders Roulin knew well), Theo gladly accepted, no doubt promising some form of compensation for his trouble.

But when Theo returned to Paris, Roulin's reports only compounded the distortions of distance. His penchant for tale-telling, dramatic overstatement, self-promotion, and florid language led Theo on a tortuous path. "I should have liked to have the honor of announcing an improvement in your brother's health," his first letter began. "Unfortunately I am not able to do so." Roulin reported Vincent near death one day and "quite recovered" the next; victimized by "terrible attacks" one day, "completely recovered" the next. In the space of a week, he endorsed the proposal to commit Vincent to an asylum as a sad necessity and condemned it as an unthinkable outrage.

By the end of December, after only a few days of Roulin's Tartarin reportage, Theo turned in frustration to a complete stranger for news of his brother. Frédéric Salles, a local pastor, served as unofficial chaplain to the hospital's occasional Protestant patients. Probably at the recommendation of Rey, Theo arranged for the forty-seven-year-old Salles to pay regular visits to Vincent's bedside and report on his progress. Worldly and energetic—requirements for an outpost preacher in lusty, Catholic Provence—Salles showed himself a diligent correspondent and conscientious caretaker. "I will do all I can to make your brother's life as bearable as possible," he assured Theo.

But Salles's sympathy and optimism proved no more helpful to Theo than Roulin's bluster. His reports, too, bounced from dark insinuations of "insanity" to sunny predictions of an imminent return to health. Salles offered prayers when Theo needed insights; scolding when he needed guidance; and faith when Vincent's fate hung on the finest balance of science and intuition. On the subject of committing Vincent to an asylum, Salles dutifully reported the doctors' indecision and conveyed Vincent's forceful objections, but ventured no opinion based on his own observations: a paralyzing reticence that paralleled Theo's own.

The absence of hard information and authoritative advice left Theo's heart free to despair. "There is little hope," he wrote Jo. "If he must pass away, so be it." Days after Rey had assured him of Vincent's improvement, he still dreaded the imminent arrival of a telegram from Arles summoning him to a deathbed, and talked as if Vincent were already gone. "I would have wanted him, whether near or far, to remain that same advisor and brother to both of us," he told Jo. "That hope has now vanished and we are both the poorer for it . . . We shall honor his memory."

In response to Theo's persistent, gloomy fatalism, Jo issued a stern rebuke. "Don't go thinking the worst." But she joined in the eulogizing all the same. "I'd have been delighted and very proud," she wrote, "if Vincent had wanted to be a brother to me as well." Other family members and friends responded with either conspicuous indifference or open relief. Most shared his mother's view that Vincent's death was both foretold and for the best. "I believe he has always been insane," Anna summed up coldly, "and that his suffering and ours was a result of it." Even Theo, for all his lamentation, could not disagree. "I almost dare not hope for his complete recovery," he confided to Jo, "because the attack was the culmination of a variety of things that had been pushing him in that direction over a long period of time. All one can hope for is that his suffering is brief."

But as the news from Arles brightened, as Roulin's fraught tales yielded to Salles's message of hope, Theo swung from despair to denial. "There is a chance that everything will come right again," he wrote to Jo on January 3. Vincent's "outbursts" might prove a blessing if they caused him to "stop making such extraordinary demands on himself." Turning from resignation to optimism, Theo adopted Rey's benign diagnosis of "hyperexcitement." Describing Vincent as "driven by his kindness and always full of good intentions," he dismissed the whole episode as "just blowing off steam." Perhaps all his brother needed was some time in the country, Theo suggested. "Once spring comes he will be able to work outdoors again and I hope that will give him some peace of mind. Nature is so invigorating."

The fixed star in this sudden reversal was Amsterdam. Whether through tragedy or denial, Theo would find his way to Jo. "Let's hope for the best," he wrote, blithely concluding one chapter and opening another. "There's no reason now to postpone my arrival any longer and I shall be overjoyed to be with you again."

Nothing was allowed to interrupt this narrative of new life. Through the long, dark nights of late December, Theo wrote letter after letter to Jo, but none to his brother. On New Year's Eve, Salles reported Vincent's "astonishment" that Theo had not written to him since their brief, dreamlike reunion on Christmas Day. "He even wanted me to send you a telegram to make you do it," Salles scolded. When Theo finally sent the obligatory New Year's greeting, he talked only of Jo and put to rest any hope of a return to the past. Not even Rey's urgent letter about sending Vincent to an asylum could break the hold of the future. Theo had told Jo that the final decision lay in the doctors' hands, not his. And he never told her about the letter suggesting that Theo take him back and place him discreetly in a Paris asylum. The day after Rey's letter arrived, he wrote Jo, "I keep thinking of you and what our life will be like." The day after that, with Rey's letter still unanswered, he boarded the overnight train for Amsterdam.

—

ON JANUARY 7, one day after Theo arrived in Holland, Vincent returned to the Yellow House. In less than a week, the momentum of commitment had been reversed. Efforts to "free" him had come from both the solicitous Salles, who believed Vincent had been miraculously cured, and from the amiable blowhard Roulin. The latter, of course, claimed the lion's share of the credit for the doctors' about-face. "I went to see the head of the hospital who is a friend of mine," he reported to Theo. "He replied that he would do as I wished." But the person truly responsible for Vincent's freedom was Vincent himself, who had finally joined the debate over his release on January 2. "My dear Theo," his letter began.

> So as to reassure you completely on my account, I write to you these few lines . . . I shall stay here at the hospital for a few more days, then I think I can count on quietly returning to the house. Now I only beg of you one thing, not to worry, because that would cause me too much of a worry.

Vincent awoke from his weeklong nightmare with this single purpose: to reassure his brother. To that end, he bent every fiber of his reemerging reason. Within days after his doctors signed the paperwork certifying him insane, he launched a desperate campaign to prove them wrong—to "take back" the events of the previous week and convince Theo that all had returned to normal.

The campaign started with Félix Rey, on whom Theo had settled such unquestioning trust. Rather than rail against the injustice of his confinement, as he had done in his delirium, Vincent instead wooed the young and impressionable intern—just as he had wooed Rappard, Bernard, and Theo himself—with erudition, flattery, deep discussion, hints of favor, and even flashes of humor. Rey invited Vincent to his office for what he called "entertaining chats." They took long walks around the hospital courtyard while Vincent talked endlessly and cogently of his artistic ambitions, the magic of complementary colors, the genius of Rembrandt, and the shared mission of artists and physicians to comfort and console. "I told him that I myself should always regret not being a doctor," Vincent wrote. "What men these modern doctors are!"

Rey described himself as "fond of painting." Vincent urged Rey to become a collector and offered to inaugurate his collection with a gift of *The Anatomy Lesson*, Rembrandt's famous paean to doctors. When Rey talked of the challenges he faced starting out in a new profession, Vincent promised him Theo's help in making connections in Paris.

Vincent befriended the other, more senior doctors as well. He discovered one

doctor in particular, a Parisian, who knew of Delacroix and appeared "very curious about impressionism." "I think I can hope to become better acquainted with him," Vincent wrote cheerfully. On January 5, he led a delegation of doctors, including Rey, to the Yellow House to show them his paintings. While there, he promised to do a portrait of the dapper young intern—to prove his mental "equilibrium"—just as soon as he was released. He also solemnly swore that "at the first sign of a serious symptom" he would return to the hospital and submit himself voluntarily to Rey's care.

It was one thing to transfer a raving madman—a Protestant Dutchman, no less—to a distant asylum. That seemed appropriate enough to Rey. But to condemn a thoughtful, sensitive artist to the company of lunatics because of a single seizure of passion? Once Vincent began to plead on his own behalf, to contest his confinement with calmness and clarity, in passable French, what else could Rey do but release him? "I am happy to tell you," he wrote Theo on the back of one of Vincent's letters, "this over-excitement has only been temporary. I strongly feel that he will be himself in a few days."

To be safe, he arranged for Vincent to take a day trip to the Yellow House on January 4, accompanied by Roulin and preceded by the charwoman who cleaned up the mess left by the crimes of Christmas. Rey's subsequent visit to the house allowed him not only to see Vincent's work but to assess personally his living situation—an appropriate precaution in the absence of family members to look after him. He may have had reservations, but with Vincent's pleadings in one ear and Theo's conspicuous silence in the other, foreclosing better alternatives, Rey signed the release papers.

Vincent's campaign to rewrite the past turned next to his brother. "My dear lad," he wrote Theo on his first day of freedom, "I am so terribly *distressed* at your journey. I should have wished you had been spared that, for after all no harm came to me, and there was no reason why you should put yourself to that trouble." Week after week, through the rest of a bleak, wintry January, Vincent poured out his guilt in shades of denial and delusion. He dismissed his injury as "such a trifle"—an accident that hardly merited Theo's attention; his breakdown as a mere indisposition; and his recovery as a foregone conclusion. Such incidents happened all the time "in this part of the world," he joked. "Everyone in this good Tarascon country is a trifle cracked." Other times, he explained it as simply an occupational hazard—"an artist's fit" that could have happened to any painter. Gauguin himself had "caught the very same thing," in Panama, Vincent insisted, "this excessive sensitivity."

In flights of fantasy, he claimed that he had checked himself into the hospital and that his stay there "in fact refreshed me considerably." He sent boasting reports of his hearty appetite, good digestion, and healthy blood—always

accompanied by emphatic instructions to "please quite deliberately forget your unhappy journey and my illness." He reassured Theo again and again that he had completely recovered and that "serenity returns to my brain day by day." He withdrew the defiant rhetoric about his own art that had filled his letters before Christmas. "If you want any pictures, certainly I can send you some," he wrote compliantly. "As to the *Indépendants* [exhibition], do what seems best to you, and what the others do."

No vow was too broad, no pretense too improbable, no prevarication too extreme, so long as it helped erase the past. He pretended that he and Gauguin were still friends, reporting brightly to Theo (who certainly knew better) that Gauguin "on the whole, got himself rested here." He imagined other painters coming to stay with him, now that he and Gauguin had worked out the kinks of joint housekeeping.

Fearing that Theo might force him to return to Paris—a prospect perhaps divulged by Rey—he argued with renewed fervor on behalf of his Midi dream, claiming a newfound kinship with the people of Arles, who in fact still mocked and spurned him. "Everyone here is kind to me," he protested, "kind and attentive as if I were at home." He compared himself to Voltaire's Candide, settled happily in the best of all possible worlds. He wrote glowing reports to friends in Holland with only joking references to "something the matter with my brains" before resuming the campaign for Tersteeg's favor. Unaware that Theo (and Roulin) had already shared the real story with his mother and sisters, Vincent sent them a letter that portrayed his hospital stay as a spa-like interlude ("not worth troubling to inform you about") that both refreshed his spirits and "provided the opportunity for getting acquainted with quite a number of people."

Gauguin, too, felt the onslaught of Vincent's unreality. Vincent had emerged from the hospital with his feelings toward his fellow painter in a haze of forgetfulness and regret. "Now, let's talk about our friend Gauguin," he inquired of Theo on January 2; "have I terrified him? Why hasn't he given me any sign of life?" But within days, Gauguin, too, was pressed into the project of reassurance and denial. "Look here," Vincent wrote him sternly from Rey's office two days later, "was my brother Theo's journey really necessary, old man?" In the same letter, he instructed Gauguin to "completely reassure everyone"—especially Theo—and warned him against "speaking ill of our poor little yellow house."

Upon his release from the hospital, Vincent immersed himself in the duties of a good host, arranging to send the studies and other belongings (including fencing equipment) that Gauguin had left behind in his unseemly haste. He wrote chatty letters addressed to "My dear friend Gauguin" inquiring about Paris, his work, and his plans for the future. To Theo, Vincent expressed benign admiration for Gauguin's paintings (even his mocking portrait of Vincent) and

"hearty approval" of his return to Martinique. "Naturally I regret it," he added good-naturedly, "but you understand that provided all goes well with him, that is all I want."

When Gauguin responded to Vincent's strange outreach by complimenting his sunflower paintings—two of which Gauguin had taken with him when he left Arles—Vincent seized on the evasive accolade ("it is a style essentially yours") to prove that his project in the South yet lived—if not in the Yellow House, at least in the hearts of those who had shared it. "I should very much like to give Gauguin a real pleasure," he wrote Theo. "And after all I should like to go on exchanging my things with [him]."

By the end of January, this delusion of reconciliation had overtaken Vincent's imagination. "One thing is certain," he wrote, toying with the unthinkable. "I dare say that basically Gauguin and I are by nature fond enough of each other to be able to begin again together if necessary." To Gauguin, he admitted that "perhaps I insisted too much that you stay on here," and "perhaps it was I who was the cause of your departure." Finally, he invited his former housemate to join him in rewriting the past. "Be that as it may," he ventured, "I hope we still like each other enough to be able, if need be, to start afresh."

To bolster this fiction of recovery and renewal, Vincent summoned all the story-making powers of his brush. The portrait of Dr. Rey, which he began virtually the moment he returned to the Yellow House, took up again the great *Bel-Ami* mandate—abandoned by Gauguin—to "do in portraiture what *Claude Monet does in landscape.*" He painted the goateed, pomaded intern in an orange-trimmed blue coat set against a decorative Provençal wallpaper of red-flecked green—a lesson in complementaries as well as a proof of his steady hand and collected mind.

To document his mental and physical recuperation, he painted a still life showing the remedies that made it possible. On a sun-washed drawing board (itself a pledge of productivity), he placed a copy of his new bible, F. V. Raspail's *Manuelle annuaire de la santé* (*Health Annual*), a popular manual of first aid, hygiene, and home remedies. Next to the thick, pocket-sized book, he set a plate of sprouting onion bulbs, one of the many healthful foods Raspail recommended (along with garlic, cloves, cinnamon, and nutmeg). To represent Raspail's most famous panacea, camphor (his prescription for everything from tuberculosis to masturbation), Vincent included a candle, probably camphor-scented, and a pot of camphor oil. (The bandage over Vincent's ear, which was changed every day at the hospital, was doused with camphor, too, thanks to Raspail's advocacy of the oil's antiseptic properties.) To complete this inventory of his new, healthy life, Vincent also placed on the table his pipe and tobacco pouch—a promise of serenity—and a letter from Theo—his

lifeline to the past. At the edge of the canvas, a drained wine bottle makes a pledge of moderation for the future.

His brush seconded the outreach to Gauguin as well. On the same day he returned from the hospital, he started a series of still lifes showing pairs of fishes and crabs that resumed the obsession with pairings and partnerships that had

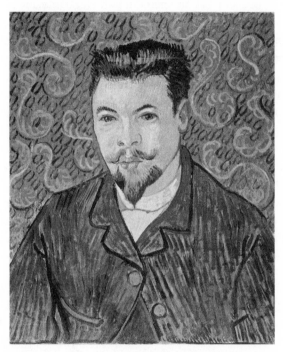

Portrait of Doctor Félix Rey, JANUARY 1889, OIL ON CANVAS, $25^{1}/_{8}$ X $20^{7}/_{8}$ IN.

marked the months leading up to Gauguin's arrival. Clinging to the compliment he imagined in Gauguin's letter, he also launched on a vast new project of sunflower paintings, beginning with exact replicas of the two images that hung in "Gauguin's room." "You know, Gauguin likes them extraordinarily," he boasted. "[He] is completely infatuated with my sunflowers." Embracing Gauguin's mocking portrait of him as "The Painter of Sunflowers," he claimed the summer flower as his signature image. "The sunflower *is* somewhat my own," he agreed. "[It] takes on a richness the longer you look at it." He changed the subject, but not the palette, in a still life of oranges and lemons that he painted around the same time. To Theo, he boasted that the electric-yellow image had "a certain chic"—code for the kind of painting he knew Gauguin approved.

Inevitably, the grail of Gauguin's favor led Vincent back to the image that sat on his easel at Christmastime: the unfinished *Berceuse.* Inspired by yet another

ambiguous compliment from his former housemate, he imagined completing his Loti-inspired maternal icon, the most conspicuous relic of their time together, by placing it between two sunflower paintings, creating a devotional triptych that combined his own Daumier vision of the South with Gauguin's chic bouquets of color. In flights of rhetoric touched by the missionary fire of the past ("we have a light before our feet and a lamp upon our path"), he imagined this marriage of imagery ultimately redeeming not just the failed combination with Gauguin but all his Midi suffering and sacrifice. "We have gone all out for the impressionists," he wrote Theo as he laid plans for a whole series of *Berceuse*-and-sunflower decorations, "and now as far as it's in my power I am trying to finish canvases which will undoubtedly secure me the little corner that I have claimed."

For his doctors, Vincent painted two self-portraits, both displaying his bandaged left ear and neat hospital dressing. In both, he showed himself bundled against the January chill in a deep-green coat and furry new hat: a pointed assurance to Rey and the others that he was following instructions (both theirs and Raspail's) to take walks and get plenty of fresh air. In both paintings, he stares out from the canvas with focus and calm. In one, he serenely smokes his pipe. In the other, he stands before his easel—a promise of hard work—and a Japanese print on the wall, laying claims to both artistic legitimacy and avant-garde bona fides for the benefit of his art-loving provincial doctors.

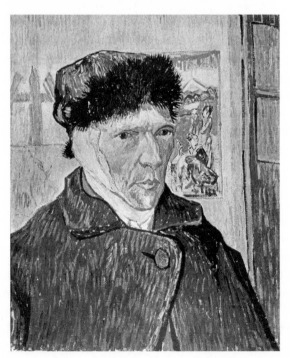

Self-Portrait with Bandaged Ear, JANUARY 1889, OIL ON CANVAS, 23⅝ X 19⅜ IN.

For Theo, however, Vincent saw a very different image in his mirror (and never mentioned the damaged, bandaged one). Done in the same small size and sunny palette as the many he painted in Paris when they lived together, the self-portrait for his brother shows Vincent from the other side—the healthy, youthful side (clean-shaven in the hospital), hiding completely the bandages and wounds that he displayed to his doctors. For Theo, he relegated recent events to the airy realm of humor. "As for me, being in this little country of mine, I have no need at all to go to the tropics," he wrote. "Personally I am too old and (especially if I have a *papier mâché* ear put on) too jerry-built to go there."

IN A LETTER TO Jo Bonger, Theo jokingly compared himself to "an oyster in its shell" and invited his now fiancée to pry him open. He had returned from his trip to Holland in a bliss of expectation. His week with Jo only perfected the desperate infatuation that had upended his staid existence in the weeks before Christmas. "You have no idea how you have changed my life," he wrote her immediately after his return. They had spent their "wonderful week" (as Jo called it) meeting families and friends, but mostly discovering each other. They talked of Shakespeare and Goethe, Heine, Zola, and Degas. She played Beethoven for him. He took her to galleries. They confessed their many flaws and protested their mutual unworthiness. "You bring sunshine into my life," he told her. "Am I truly your sunshine?" she blushingly replied.

The light Theo brought back from Holland changed his "somber world" in Paris from night to day. He found new pleasures in society: from intimate dinners with Jo's brother Andries to "grand soirées" with glittering strangers. (Jo playfully chided him for his "disgraceful gadding about.") At home, he enjoyed the companionship of the Dutch painter Meijer de Haan, who had taken Vincent's place in the rue Lepic apartment and listened every night as Theo unwound his love. Even being alone no longer frightened him. "[I] sometimes catch myself whistling or humming a tune," he told Jo. "It's your fault."

Whether late at night or during breaks in his workday, he found time to write letters—a Vincent-like flood of affirmation and affection ("I should like to lay my head in your lap and bask in your love"). Despite his busy schedule and preparations for another Monet show in February, a day rarely passed without a letter, sometimes two. He sent books (Michelet, the patron saint of lovers), photographs of himself, and even a portrait of him that De Haan had drawn. He wished he were a painter, he said, because "I can picture you so clearly that I would be able to paint you if I knew how." He longed to give Jo "the best and innermost part" of himself, and agreed with her that "softly and imperceptibly the ties that bound me to my old life are loosening, and I mostly live in the future."

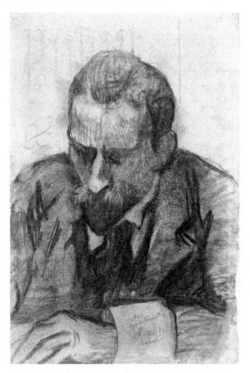

MEIJER DE HAAN, *Sketch of Theo van Gogh,* 1888,
CHALK ON PAPER, $8^1/_4$ X $5^1/_2$ IN.

In this bright future, there was little place for his troubled brother. In the three weeks after he returned from Holland, Theo wrote fifteen letters to Jo—fat letters filled with quotidian details, intimate inquiries, and pleadings of love. During the same period he sent three letters to Vincent, all of them to accompany payments. He enclosed no photographs. While Vincent responded promptly (sometimes twice in the same day) and at length (one letter filled twelve pages), Theo's missives lagged and dwelt on money matters. He answered Vincent's pleas of poverty after emerging from the hospital (because Theo had missed the first January payment) with a demand that Vincent prepare a budget for the year. Married life would put new burdens on his finances, he cautioned.

In the river of words that poured from Paris to Amsterdam after Theo returned from Holland, Vincent's name was rarely mentioned. Jo was forced to inquire: "You've told me nothing about [him] . . . is anything wrong?" More than a week later, Theo responded with a rambling parable comparing "people who want something passionately" to sunflowers. "It is impossible to stop them [from] turning to face the sun," he pondered, even though "it makes them wilt a little sooner!" Vincent, he wrote vaguely, "is certainly one of the people who have done the most and wishes to." For the literary Jo, he invoked the nobly

delusional Don Quixote, who, like his brother, possessed "an exceptionally kind heart." Then the subject quickly moved on to wedding plans and "kisses in thought."

For all the same reasons, Theo looked past the signs of new trouble in Arles. In response to Vincent's increasingly "agitated" and "overwrought" letters, he briskly advised resignation. Drawing in equal measure on his father's pious stoicism and his mother's precautious fatalism, he instructed Vincent "not [to] let oneself have any illusions about life" and "to accept the probably disastrous reality." He took Vincent's reports of continuing hallucinations and nightmares and fears of a relapse as "signs of improvement rather than symptoms of illness." They showed, he explained to Jo, that Vincent "understood his condition." Clinging to his wedding plans, his family's good name, and his own last chance for happiness, he continued to insist that his brother suffered only "an imperfect state of health" brought on by overwork and self-neglect.

Theo's self-preserving fatalism masked a double denial. Not only did Vincent's illness cast a shadow over his pending marriage (and the children he intended to father with Jo) at a time when insanity was widely regarded as hereditary, but Theo had health secrets of his own. He had not yet told Jo about his battle with syphilis—another threat to his vision of marital bliss. (It was widely believed at the time that syphilis could be passed not only to sexual partners but also to babies in utero.) When Theo mistakenly thought that Vincent had revealed the truth to Doctor Rey, he lashed out in a fierce rebuke that startled Vincent into an apology: "I did not think I was doing anything to compromise you."

But Theo's thoughts quickly moved on to a more uplifting subject: house hunting. "I spend all my free time looking at all kinds of ugly unattractive apartments in the most impossible houses with endless staircases," he wrote his sisters in late January while Rey's letter went unanswered and Vincent languished. After viewing more than a hundred potential homes, Theo reported to Jo at the beginning of February that he had finally found their "cozy nest." It was "close enough to the gallery to come home for dinner," he wrote happily, and had a garden view with "a lovely catalpa just under the window that will be beautiful when it's in bloom."

THREE DAYS LATER, the police arrived at 2, place Lamartine and dragged Vincent away from his beloved Yellow House. They took him to the Hôtel Dieu and left him there, shackled to a bed in an isolation cell. His charwoman rushed to Pastor Salles with the terrible news. Salles immediately went to the hospital and found Vincent cowering under his covers, refusing all offers of help, and choking back sobs. "I have just seen your brother," Salles reported to Theo the same day, "and got a very painful impression of the condition he is in."

From the moment Vincent left the hospital a month before, events had begun to spin out of control again. Theo's demand for a budget in mid-January triggered a paroxysm of guilt. Already distraught over the cost of his medical care (every bandage and bloodstained sheet was billed separately), Vincent came home to an eviction notice from his landlord after missing the January rent payment. Theo may have meant only to put his finances in order as he contemplated the expenses of a new house and family, but Vincent saw in his demand for an accounting a lifetime of chastisement. "What is to be done?" he cried out helplessly. "My pictures are valueless, it is true they cost me an extraordinary amount, perhaps even in blood and brains at times. I won't harp on it, and what am I to say to you about it?"

In a reflex of defense, he not only refused to give Theo the budget he requested but mustered all the arguments of the past to justify his expenditures, protest his economies, demand an *increase* in his stipend, and explain why his paintings didn't sell—but soon would. "I have set to work again with a nerve like iron," he wrote, estimating that his sunflowers would be worth as much as a Monticelli someday. "Let me work with all my strength . . . If I am not mad, the time will come when I shall send you what I have promised you from the beginning." If he failed, Vincent dared his brother, "[then] shut me up in a madhouse right away—I shan't oppose it."

January proved cruel, as well, to his fantasy of rapprochement with Gauguin. Vincent may or may not have known about Gauguin's efforts, starting only days after his flight from Arles, to parlay the events of December into self-aggrandizing myth (efforts that would ultimately backfire). But he had never fully trusted Gauguin's intentions, and he certainly knew by mid-January that his injunction to "refrain from speaking ill of our poor little yellow house" had been ignored. He worried especially about Gauguin's conversations with Theo, who continued to send Gauguin money and enthusiastically support his work after the debacle in Arles.

At first, Vincent seconded this outreach, hoping to appease Gauguin into silence. But when Theo hinted that Gauguin had accused the brothers of exploiting him and had demanded that Theo exclude his troubled brother from any further dealings, Vincent erupted in a fury of pent-up grievance. "I have seen him do things which you and I would not let ourselves do," he wrote acidly, "because *we* have consciences." He blamed Gauguin for the "disaster" at Christmastime, accusing him of deliberately sabotaging the Yellow House—betraying not just Theo's generosity but the cause of Impressionism itself. In scathing terms, he mocked Gauguin's reputation for physical bravery, describing him alternately as a coward and a buffoon. He ridiculed Gauguin's fencing gear as "toys" and belittled his bellicosity, calling him "the little Bonaparte

tiger of impressionism"—the "Little Corporal" who "always left his armies in the lurch." He angrily demanded that Gauguin return at least one of the sunflower paintings he had stolen from the studio and urged his brother to break off relations with the ungrateful, perfidious "deserter." By the end of the month, he had twisted Gauguin's sailor pretensions into an accusation of abandoning ship and darkly insinuated that the wrong painter had made the trip from the Yellow House to the mad ward in December.

Gauguin was only the first to reject Vincent's phantom of recovery. In late January, the postman Joseph Roulin moved to Marseille ("for a microscopic increase in pay," Vincent noted ruefully), leaving his family temporarily behind. He returned briefly at the end of the month, resplendent in his new uniform, and visited the Yellow House to hold forth on politics in the big city. But only a short time later, Augustine Roulin, the sitter for *La berceuse*, took her children and retreated to her mother's house in the country, later admitting that being around Vincent frightened her. Bereft of his facsimile of family, Vincent returned to the brothel on the rue du Bout d'Arles where he had left his gift of flesh on Christmas Eve. "Yesterday I went to see the girl to whom I had gone when I was off my head," he reported in early February. But even the prostitute Rachel, apparently, refused to see him.

At almost exactly the same time, a letter arrived from Theo. In yet another misbegotten attempt to set his financial affairs in order, he responded to Vincent's defiant demand for more money with an unblinking look into the future. In dire terms, he reported on the state of his own illness, which had apparently taken another turn for the worse (as it did every winter). He confirmed Vincent's fear that ill health would probably prevent him from ever coming to Arles again. The prospect of his own deterioration, its implications for his soon-to-be family, and Vincent's continuing plight had forced Theo to a grim reckoning. With a calmness and clarity that sent shock waves through Vincent's unreal world, he laid out the consequences if he should die. He reassured Vincent that his will, unlike Uncle Cent's, made "generous" provisions for Vincent's continued support, even apparently promising his brother a share in his business interests— just as Vincent had always given him a share in his painting enterprise.

Theo no doubt intended his sober, unvarnished talk to reassure his brother— a show of fraternal solidarity on the eve of his wedding. But it had just the opposite effect. Following so soon upon Gauguin's betrayal, Roulin's transfer, his wife's flight, and Rachel's rebuff, Theo's talk of debt and death dealt Vincent a crushing blow. "Why are you thinking about your marriage contract and the possibility of dying just now?" he wrote, horrified. In a long letter, he poured out his objections in a frantic mix of consolation and despair. He rejected his brother's dire speculations ("It'll all come all right in the end, believe me"), recanted

his previous demands, and dismissed all talk of sickness and death as the rantings of a disordered mind—not unlike his own—and therefore not to be trusted. "When I am in a delirium and everything I love so much is in turmoil," he wrote, "then I don't mistake that for reality, and I don't play the false prophet."

Any threat of abandonment—whether by death or by marriage—raised the specter of mortality, and its eternal companion, religion. "Illness or death holds no terror for me," Vincent declared, signaling by disavowal that the storms of Christmas had returned. "Ambition is not compatible with the callings we follow." In the first week of February, the nightmares—which had never stopped tormenting his sleep—leaped back into real life. He saw visions, ranted gibberish in the street, and followed strangers into their homes. "I have moments when I am twisted with enthusiasm or madness or prophecy," he admitted to Theo. He neglected to eat and drank to excess. Swaths of time disappeared from his memory.

To Theo, he continued to claim that the people of Arles treated him "kindly." "Everyone here is suffering either from fever, or hallucinations, or madness," he wrote, veiling his confession in humor. "We understand each other like members of the same family." But in reality, rumors about the events of December had turned his neighbors into gawking spectators or fearful spies. His increasingly rancorous relations in Arles, combined with his suspicion that Gauguin was spreading disparaging rumors about him, especially to Theo, spawned a paranoid fantasy that someone was trying to poison him. "He believes that he is being poisoned and is everywhere seeing nothing but poisoners and poisoned people," Vincent's terrified charwoman reported to Pastor Salles.

Battered by waves of failure, loneliness, and paranoia, Vincent clung like Loti's storm-wracked sailors to his lifeline of imagery: the faïence Virgin he called *La berceuse*. He painted her again and again, carefully copying every detail of her porcelain hair and frozen glare. Working "furiously . . . from morning till night," he traced and retraced the tracery of flowered wallpaper that filled the canvas behind her—a celebration of both the Midi (famous for its floral wallpaper) and the Cloisonnist gospel that he shared with the departed Bel-Ami. Every storm or setback, whether in his head or in life, sent him scurrying back to this icon of consolation.

When Theo talked about marriage and a new family, Vincent's thoughts retreated to his own childhood. He imagined "singing a lullaby of colors" to his infant brother in the attic room they shared in Zundert, and immediately made a "fresh start" on the *Berceuse* of Christmas. When Theo demanded a reckoning of his Midi project, Vincent saw in his unending Provençal wallpaper, which Monticelli had painted, new proof that "indeed, indeed we are following Monticelli's track," and began another *Berceuse*. When Vincent returned to the Folies

Arlésiennes, retracing his steps with Gauguin, he saw a *pastorale* that moved him to tears with its Rembrandt-like tableau of the "mystic crib" and an old peasant woman who sang to the child "with the voice of an angel"; and immediately went home to begin another *Berceuse*. When the Roulins briefly visited the studio for the last time at the end of January, Vincent gave them their choice of all the *Berceuses* he had made, then promptly began work on a copy of the one they chose, as if he could not bear to part with even one of the nearly identical images.

On February 7, all of Vincent's faïence Virgins watched serenely from their vivid floral otherworld as the police entered the Yellow House and wrestled Vincent away. (Alerted by neighbors who feared for their safety, gendarmes had been watching the house for days.) The same image stayed in his head for more than a week as Rey and the other doctors tried, unsuccessfully, to fathom the mystery of his illness. He didn't recognize them at first and for days refused to utter a single word. When he finally began to talk, the words came out in an incoherent babble. While in his cell at the hospital, he received a letter from his mother describing a snowstorm in Holland followed by a quick thaw and wishing that the "Lord of Nature" might work the same miracle in Vincent's life. When his condition improved enough to permit day trips, he returned to the Yellow House and set to work on yet another version, his fourth, of his maternal talisman, his Belle Dame of the Midi, enthroned in her wallpaper *Paradou*.

AT ALMOST THE same time, four hundred miles to the north, Theo had wallpaper on his mind, too. "I am enclosing a few samples of the wallpaper they're putting up for us," he reported to Jo as the hectic redecoration of their new apartment progressed, "although you do need to see it all in order to judge whether it's suitable." Only a few days before, he had sent samples of the "divine curtains" he had planned for the dining room. "People who like plush and satin would think them vulgar," he warned, "but anyone with a sense of color would find them gorgeous."

After a month of welcoming Vincent's delusional reassurances and ignoring the many unspoken signals of his brother's deterioration, Theo was startled by the latest news from Arles. That Vincent had been seized by police and forcibly confined horrified him especially. He omitted that part of Salles's report in his letter to Jo the same day. "Poor poor fellow, how hard his life is," he wrote. "What a sorry state of affairs, don't you agree, dearest. I know you will also be very concerned and that's a comfort to me." He shared with Jo the question (raised by Salles) whether Vincent should be sent to an asylum in Provence or Paris, but used it only as a prelude to a full-throated defense of his brother as a misunderstood Byronic hero:

That mind has for so long been preoccupied with things our society today has made impossible to solve and which he, with his kind heart and tremendous energy, nevertheless fought against. . . . He holds such sweeping ideas on questions of what is humane and how we should regard the world, that one first has to relinquish all one's conventional ideas in order to grasp what he means.

The letter soon wandered off into the beauties of art, especially Monet (whose show had just opened on the *entresol*), and a strange rumination on death, triggered by a Rodin sculpture, also in the show, depicting the head of John the Baptist on a platter. The saint's head, Theo said, "bears a striking resemblance to Vincent. . . . That furrowed and contorted brow betraying a life of reflection and asceticism." Like Vincent contemplating a portrait of his look-alike, Bruyas, Theo saw both his brother and himself in Rodin's image of mortality. "Death has left no sign of anguish on that face nor an aura of eternal peace," he wrote. "It has retained an air of tranquility and also an energetic concern with the future."

Over the next week, while Vincent weathered the storms of darkness in a stupor of isolation, Theo's thoughts stayed fixed on the "difficult matter" of decorating the apartment. At one point he sent a telegram to Dr. Rey requesting an update, but he left unanswered Salles's urgent call for Vincent to be removed to Paris. "Your brother should be watched continuously and should have the special attention which he can only receive in a mental hospital or in the family," the parson had written a week before. "Let me know whether you want him near you." Salles had even arranged for Vincent's loyal charwoman to accompany him on the long journey. "In any case, we must make a quick decision," he pressed; "we will not do anything until we have heard from you."

But before Theo had to decide, Rey telegraphed a reprieve of good news: "Vincent much improved, pending recovery we will look after him here, do not worry for the time being." A few days later, Vincent himself wrote, reporting his provisional (daylight only) return to the Yellow House and dismissing his affliction, yet again, as a mere "fever of the region." "You must not think too much about me, nor fret yourself," he wrote. "We cannot change much in our fate." Theo forwarded Vincent's reassuring letter to Jo (noting "he's on the right track"), along with samples of the wallpaper for the dining room.

The Real South

~

F IVE DAYS LATER, THE POLICE DESCENDED ON THE YELLOW HOUSE AGAIN and dragged Vincent away. He was too drunk to resist. This time, they closed the shutters, padlocked the door, and pasted official seals over it—as if they expected him never to return.

As Vincent suspected, the neighbors had indeed poisoned him. Not with potions or spells, but with a secret petition to the authorities. "The Dutch subject named Vood," they wrote, mangling his name, "has for some time and on several occasions furnished proof that he is not in full possession of his mental faculties. . . . He no longer knows either what he does or what he says." Because of Vincent's "excitement" and "instability," they said, they lived in fear, especially for their women and children. "In the name of public security," they demanded that Vincent be either "returned to his family as soon as possible," or committed to a mental asylum, "in order to prevent whatever misfortune which will certainly occur one day if vigorous measures are not taken."

Thirty of his neighbors had signed the petition—an overwhelming number. Their extraordinary protest represented the crest of a wave that had been building almost from the day Vincent arrived in Arles. Even before the events of Christmas, children had teased and badgered "the queer painter," as one of them later called him. After the calamities of December, adults, too, shunned and scorned him. When he passed in the street, they tapped their heads and muttered to each other *"fada"*—Midi dialect for "crazy." The brothel whores dubbed him *"fou roux"*—the mad redhead. His stalking gait, fluttering eyelashes, tirades of Dutch, and stuttering attempts at the local patois, all began to assume an alarming aspect.

Derision turned quickly to suspicion and fear in a community that still believed in demonic possession. His second hospitalization in February only cor-

roded civility further. Children threw stones now, not scraps of food. Vincent added fuel to the fire with drunken disdain for his antagonists, dismissing their fears as "absurdities" and them as superstitious provincials. Convinced that their backward prejudices against painters demanded a firm response, he hurled their taunts back at them. They had already done their worst, he said. "Where can I go that's worse than where I have twice been: the isolation cell?" A simmering dispute with his landlord (who owned other properties in the area) may have galvanized the neighbors into official action. By the end of February, Vincent had to send his charwoman on errands rather than venture into the street himself.

Once the petition was filed, months of rumor and private rancor boiled into public view. The chief of police, who had no doubt already identified Vincent as a troublemaker after his dispute with the innkeeper Carrel the year before, sent gendarmes door to door collecting testimonies to support the allegations in the petition (in the officialese of the mayor's order, "to establish the degree of Van Goghe's [*sic*] madness"). The witnesses (identified only by age, sex, and trade) poured a heady mix of fact, hearsay, and suspicion into the record. They reported that Vincent chased after children in the street with the intent of "doing them harm," that he drank too much, and that his speech rambled incoherently.

One woman, a dressmaker, complained of being "grabbed by the waist and lifted into the air." Others reported more generally that they had seen Vincent "indulging in touching women who live in the neighborhood" and "permitting himself to fondle them." One accused him of "making obscene remarks in the presence" of women. The grocer who shared the Yellow House, François Crevoulin, described how Vincent would "come into my store, insult my clients and touch women." More than one witness reported that Vincent had followed women home—even entered their houses—so that they felt "no longer safe." Mostly, they filled their affidavits with the verdict of the mob: cries of "lunatic" and "madman," diagnoses of "derangement," declarations of "public danger," and demands that he be "confined in a special institution," or simply "locked up."

From the familiar confines of the Hôtel Dieu, Vincent lashed out at his accusers in a letter to Theo. "What a staggering blow between the eyes it was to find so many people here cowardly enough to band themselves together against one man," he stormed, "and a sick one at that." He called them "meddlesome idiots" and "poisonous idlers"—a "pack of skunks and cowards" bent only on his undoing. He demanded, and may have received, a hearing before the mayor or other official in which he could make all the arguments that swirled in his head—a lifetime of arguments against the prejudices and conspiracies that forever thwarted him. He insisted that the events of December had been exaggerated, and mocked those who suggested that he posed a danger to anyone but himself.

I answered roundly that I was quite prepared, for instance, to chuck myself into the water if that would please these good folk once and for all, but that in any case if I had in fact inflicted a wound on myself, I had done nothing of the sort to them.

As for the strange behavior detailed in the petition, he claimed that he had been provoked by his accusers. "I would have remained more calm," he argued, "if the police had protected my liberty by preventing the children and even grown-ups from collecting round my lodgings and climbing up to my window as they have done (as if I were a strange animal)." Any other man would have taken a pistol and shot the "gawking idiots" dead, he cried. Turning the tables on his tormenters, he demanded reparations for the troubles they had caused him. "If these fellows here protest against me, I protest against them," he countered, "and all they have to do is to give me damages and interest . . . to pay me back what I have lost through their blunders and ignorance."

Claiming the mantle of martyrdom, he compared himself to heroes like Victor Hugo, condemned by a "mischievous opposition" to suffer calumny, imprisonment, or worse, as an "eternal example" to future generations. Whatever he had done, he said, he had done for the new art, which he called "the first and last cause of my aberration." And if that brought him pain or indignity at the hands of fools and cowards, so be it. "An artist is a man *at work*," he declared defiantly, "and it is not for the first idler who comes along to crush him for good." Besides, he added, "All this stir will ultimately be good for 'impressionism.'"

Vincent's feelings of betrayal and martyrdom were only sharpened when his doctors refused to come to his defense. From the beginning, he had agreed with Pastor Salles that "it should be the doctors and not the superintendent of police who ought to be the judges in a case like this." But Vincent's sudden, violent relapses had left all the doctors at the Hôtel Dieu confused and cautious. They could not agree on a diagnosis—they talked of cancer one minute, epilepsy the next—and dared not predict when or if his attacks would return. One of them, a Doctor Delon, had already provided the police with a report attesting to Vincent's "mental alienation" and supporting the petition to have him removed from the community. Not even Rey, who considered it "an act of cruelty to permanently lock up a man who has done nobody any harm," according to Salles, would contradict the official finding that Vincent constituted a potential "public danger." In any event, there was little the young intern could do against a determined police chief, an angry landlord, a pusillanimous mayor, and a fearful citizenry.

Over his enraged objections, Vincent spent the next month, from February 25 to March 23, in the Hôtel Dieu—almost all of that time "under lock and key," alone in an observation chamber. If anything, his indignation proved his undo-

ing. The more furiously he raged against the injustice of his confinement, the more he confirmed the verdict of "dangerous lunatic." He learned the hard way that even in isolation his jailers could punish him. They took away not just his flask, but his pipe and tobacco, too. He was not allowed even a book or a breath of fresh air. Salles brought him some paints and brushes from the Yellow House, but these "made him wild," the pastor reported, and were quickly removed. "I *miss* the work," he noted bleakly. "The work takes my mind off things, or rather keeps me in order." For weeks, he wrote no one, and no one wrote him. Except for Salles's rare visits, he had no company other than the doctors who "gnawed at" him like "wasps on a fruit," he said. Yet he had no privacy, either. Day and night, he was always watched.

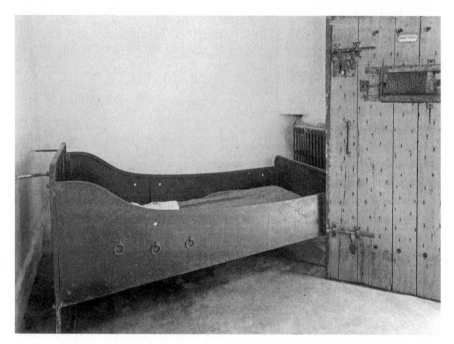

ISOLATION CELL, ARLES HOSPITAL

The indignity and injustice of it all triggered new storms of "indescribable anguish." He would emerge each time newly amazed and "revolted" at his plight. Waves of "deep remorse" and "loathing of life" washed over him. For long periods, he plunged into a terrified silence, awaiting the next attack. It was a harrowing cycle that left him all but stripped bare, shackled to his bed, staring into the darkness, holding his head in his hands, rearguing his case "in the secret tribunal of my soul," recalling the books and people he loved, imagining the art he would have made, and rehearsing all the failures that had brought him

to this dark place. "Everything for nothing," he despaired. "It is a shame . . . I would rather have died than have caused and suffered such trouble."

IN THE MONTH BEFORE his wedding on April 18, Theo's life was a whirligig of activity. The Monet show on the *entresol* proved a huge success, especially after the critic Octave Mirbeau unleashed a "torrent of enthusiasm" in *Le Figaro*. "What a daze I've been in," Theo wrote Jo. "We're rushed off our feet at work because of the exhibition." As often as his busy schedule allowed, he visited Jo's brother Andries and his wife Annie in the leafy, affluent suburb of Passy, where they took relaxing strolls in the woods. With friends in the city he spent long evenings that started with dinner, then a play or concert, then conversation and drinks at a boulevard café until long past midnight.

For Jo, he heard Beethoven's "lovely" Seventh Symphony. He saw Lecocq's *Le petit duc* (*The Little Duke*), too, an opéra-bouffe confection of naïve love and juvenile flirtation that reminded him of Jo in a different way. Out-of-town guests were always popping in, along with distant relatives wishing him well on his long-awaited nuptials. No matter how late his evenings, he never came home to an empty house, thanks to his roommate De Haan, who often entertained guests of his own at the rue Lepic apartment.

Somehow, in this crush of activity, Theo found time to make wedding plans. He picked out a dinner service, bargain-shopped for banquet facilities and tuxedo rentals, allocated cash gifts from relatives, arranged witnesses, and pondered honeymoon possibilities, while closely tracking Jo's parallel efforts in Holland. ("What does your wedding gown look like?" he inquired.)

No preparation, of course, was more important than the new apartment, which continued to consume vast efforts and generate frequent crises over furniture, fabric, and wallpaper. "The painters and decorators are finished," Theo announced on February 25, the day Vincent was seized by police the second time, "but unfortunately it turns out that not all the French have taste." Even as he began to hang paintings in the new apartment, Theo continued to dither over final arrangements, and samples of wallpaper continued to fly between Paris and Amsterdam. "I'm rather afraid it's going to be *too* nice," he fretted.

The commotion of daily life played out against a solid background of letters—sometimes three or four a week—reliving each day's events in the reality that mattered most: his love for Jo and their future together. "[I] am so grateful that I am no longer alone," he wrote her on March 7, "that my life is no longer aimless." On the first day of spring, he threw open the windows of the new apartment and a fresh breeze from the future blew over him. "All of a sudden a street musician started playing the guitar, accompanied by the voice of a girl of about ten," he de-

scribed his augury to Jo. "Her soft little voice shimmered in the air, singing words one could not distinguish about *printemps, amour, lumière.*" "Dearest," he wrote, "I have you to thank you for that moment." He called her "my pet," "sweet-pea," and "wife-to-be." She addressed him as "my dearest husband." Together, they counted down the days until they could be together again. Almost a month in advance— more than six weeks before the wedding day—he set a firm date for his return to Amsterdam.

By now, Vincent's name came up at least once in every letter: in a worried complaint from Theo ("no news from Arles"), or a polite inquiry from Jo ("No news from Vincent yet?"). Occasionally a black cloud obscured their shared sunlight, as when news arrived that Vincent had been taken to the hospital again in late February—"this time at the request of the neighbors," Theo wrote, "who were probably afraid of him." But by mid-March, the distant brother had been reduced to a shorthand—"And Arles?" "What a wretched flaw in an otherwise cloudless sky," Theo lamented.

Meanwhile, Salles's plea had become a clamor. "A decision must be taken," the pastor demanded as he informed Theo about Vincent's third involuntary hospitalization. "Is it your intention to have your brother come to you or do you intend to put him into an institution of your own choice or would you prefer to leave it in the hands of the police? On this point we should have a categorical reply."

For two months, Theo had successfully maneuvered around the repeated calls for Vincent to be moved to an asylum in Aix or Marseille where he could receive specialized care. Loath to impose a solution on his contrary brother ("It is not permissible for anyone, not even you or a doctor, to take such a step without consulting me," Vincent warned) and ever hopeful of a cure, Theo had returned again and again to a strategy of delay. Through downturn after downturn, his innate caution had found common cause with Salles's pious optimism, Rey's deferential indecision, and his brother's denial. ("Let me go quietly on with my work," Vincent shrugged; "if it is that of a madman, well, so much the worse.") The sudden oscillations of Vincent's affliction, whatever it was, had beaten back every sortie of resolve, casting Theo back and forth from hopefulness to hopelessness, sometimes in the same letter.

But if consigning his brother to a lunatic asylum was difficult, bringing him home was unthinkable. From the beginning, Theo had successfully stonewalled Rey and Salles on the subject, to the consternation of both. He had also beaten back a suggestion from his sister Wil that Vincent be brought to Breda, where Wil already tended their aging mother. "I wish Vincent could be home," she wrote. "It is so unnatural that others are taking care of him and that we don't do anything for him." Mother Anna opposed the idea, too. "[Vincent] is decidedly a poor wretch," she wrote as the fourth anniversary of her husband's untimely death approached and forgiveness eluded her.

But around the same time, Jo, who visited the Van Gogh women in February, took up the cause. "Theo dear," she inquired sweetly, "couldn't [Vincent] go home, like any ordinary person who was ill?" Taking to heart Theo's defense of his brother as "a noble, lofty spirit," Jo reasoned that Vincent might fare better in a "quiet, friendly environment" than in a hospital or on his own. "Wouldn't that calm his nerves, whereas solitude to my mind would cause him to lapse back into worrying again." And if not Breda, why not Paris? "If he were in Paris now," she ventured, "you could simply go and see him. As things are, he is all alone and so very far away."

Theo frantically listed reasons why, in this case, the obvious was unworkable. "If you knew him, you would appreciate twice as much how hard it is to solve the problem of what must and what can be done," he wrote. "From his style of dress and his demeanor you can see at once that he is different and for years everyone who sees him has said *C'est un fou* [he's a madman]." In an artist, such behavior might be understandable, Theo allowed, even advantageous ("many painters have gone insane yet nevertheless started to produce true art"), "but at home," he insisted, "it is *not* acceptable."

He retold the fiasco of Vincent's years in Paris, when models refused to pose for him, passersby harassed him, and the police ran him off the street when he tried to work. "By the end of it all he'd had more than enough of Paris," he said; and Paris, more than enough of him. "Even those with whom he is the best of friends find him difficult to get along with," Theo struggled to explain. "There's something in the way he talks that makes people either love him very dearly, or find him intolerable." He hinted at Vincent's pariah status among his fellow artists (referring enigmatically to "lots of enemies") and gently contradicted Jo's vision of recuperation in the quiet, welcoming bosom of family: "There's no such thing as a peaceful environment for him . . . He spares nothing and no one."

To bolster his case for turning his brother away, Theo finally sought the advice of Louis Rivet, the doctor who had treated Vincent in Paris and who continued to treat Theo for the "nervous condition" that masked his worsening syphilis. "Rivet says, and I agree with him, that [Vincent] would be better off in the worst hospital than looking after himself, even if he were well," Theo reported in early March. "He strongly advised me not to have him come here for the time being as he could be a danger to himself and others." And why not move him to a private asylum in or near Paris, where, as Jo pointed out, "you could simply go and see him"? Rivet had an answer for that, too, according to Theo: "As a rule, the institutions [in France] are excellently equipped and . . . patients who are looked after free of charge get the same nursing and treatment as those who pay."

Of course, Theo never mentioned money to Vincent, whose letters coursed with guilt for every franc spent on medical care and every day deprived of the

opportunity to work and repay his mounting debt. "If it is not absolutely necessary to shut me up in a cell," he wrote in January, "then I am still good for paying, at least in goods, what I am considered to owe." Theo touched on the subject in a letter to Jo, acknowledging the investment that both brothers had at stake. "Though he has no idea about money," Theo wrote (protecting the fiction, invented for Jo, of Vincent as a selfless free spirit), "he would be upset if all we have put into it were lost."

But money was never far from Theo's mind. As a man who considered marriage the ultimate fiscal responsibility, money informed every decision, or indecision. When his sisters Wil and Lies sent a part of their father's legacy to help pay for Vincent's care, Theo put the money in the bank instead, telling them, "There is no reason to make a change in his current treatment, which is free." If his sisters spent their legacy, Theo would be called on someday to replace it, either as a dowry in marriage or as a stipend in spinsterhood.

Guilt, no doubt, explains Vincent's rejection of the lukewarm invitation to Paris that Theo issued in late February, finally shamed into acting by Jo's guileless sympathy. He must have been relieved, but not surprised, when Vincent waved the offer away. "You are very kind to say I could come to Paris," he wrote only days before the police seized him a second time, "but I think the excitement of a big town would never do for me." To assuage his own guilt—and, again, to appease Jo, who had urged him to go to Arles if Vincent would not come to Paris—Theo proposed a different plan. He would send another artist to Arles to reignite Vincent's missionary zeal for the Midi. "That's the only thing I can think of that would really give him peace of mind," Theo explained.

At first he had considered only countrymen like Arnold Koning or Meijer de Haan, whose discretion he trusted. But Vincent recoiled at the idea in a fit of guilt and shame. "I do not dare persuade painters to come here after what has happened to me," he wrote; "they run the risk of losing their wits like me." The plan languished for a month, while the silence from Arles grew deeper and the details of the petition against Vincent became clearer. Finally, in mid-March, Theo prevailed on Paul Signac, who was about to embark on his annual summer holiday in Cassis, a picturesque seaside village about seventy-five miles from Arles. "Signac, an acquaintance of mine, is going to Arles next week and I hope he'll be able to do something," he informed Jo vaguely. "I'm almost inclined to go back there myself," he added, in another feint of appeasement, "but it would serve no purpose."

Instead, he left for Holland, exactly on schedule. He took the overnight train that departed on March 30—Vincent's thirty-sixth birthday.

—

SIGNAC AND VINCENT had to break down the door. To discourage intruders, the authorities had not only shuttered and sealed the Yellow House, they had jammed the lock. Some hostile neighbors tried to prevent the mad painter's return to the scene of the crime, causing a row that brought the police once again to Vincent's door. But Signac placated them—as persuasive in housebreaking as in art making. "He was so good and straightforward," Vincent wrote admiringly. "They began by refusing to let us do it, but all the same we finally got in."

The two artists had not seen each other or corresponded since their passing encounters on the banks of the Seine two summers before. Vincent wrote about their day together as if he were meeting the twenty-five-year-old Signac for the first time. "I found Signac very quiet, though he is said to be so violent . . . he strikes me as someone who has balance and poise." They met at the hospital, where Dr. Rey gave his blessing to their outing—Vincent's first in a month. Once inside the Yellow House, Vincent showed off his paintings, and gave one to the younger artist. They talked about everything—art, impressionism, literature, politics—as the month-long monologue of Vincent's solitude poured out.

He rained on Signac all the grievances and injuries that he had been saving up for a different visitor. He complained about the lack of privacy in the hospital and pressed the possibility of coming to Paris in a way he never could directly to Theo. He stewed over the expense of his hospitalization and lashed out at the authorities for continuing to imprison him—an unmistakable indictment of Theo for not rescuing him, for delegating his brotherly duties to a virtual stranger, and for choosing to go north instead of south. Such thoughts "unnerved" his host, Signac later recalled, attributing Vincent's volatility to a "frightful mistral" that rattled the windows. At one point, he grew so agitated that he reached for a bottle of turpentine—a desperate substitute for the alcohol so long forbidden to him—and started to drink it.

As the reality of Theo's marriage sank in, Vincent's fragile world unraveled. He had spent months denying it. When he returned to consciousness after the attack at Christmastime, he referred to it vaguely not as a marriage at all but as a welcome rapprochement with Andries Bonger. "How glad I am that you have made peace with the Bongers," he wrote from his hospital bed in January. When he finally came around to the truth, he offered Theo only halfhearted congratulations ("the house will not be empty any more") and steadfastly avoided using Jo's name (as he would until just days before the wedding). At one point, he openly advised Theo just to "screw the girl" instead of marrying her. "After all," he added in a snide reference to Theo's many mistresses, "that's normal practice in the North." Next, he belittled the marriage as merely the proper thing to do—a loveless function of "social position" and filial duty.

But Theo's endless reports on the new apartment and mooning letters about

Jo soon forced Vincent into the delusion that always overtook him when his brother threatened to marry. "A secure home for you is a great gain for me too," he wrote, proposing that the three of them live together. As in Drenthe, when he invited Theo's mistress Marie to join the brothers' mission on the heath, he imagined Jo as a partner in their work on behalf of the new art: "[She] will join with us in working with the artists." As in Paris (the first time Theo had planned a life with Jo), he fantasized that the newlyweds would buy a country house that he could fill with paintings. He pictured the imminent blessed union not as a marriage, but as a merger that would ensure the success of the brothers' joint enterprise far into the future. "In the spring, you and your wife will found a commercial house for several generations," he wrote. "And that settled, I only ask the position of a painting employee."

But his month in an isolation cell turned these fantasies to dust. When he emerged from the hospital at the end of March, his attitude toward the marriage had changed. A month of waiting in vain for Theo to rescue him, a month without a single letter from his brother, or Jo, had confirmed his worst fears. Marriage meant only one thing: abandonment. It didn't help that no one had shared any of the wedding plans with him. He knew neither the place nor even the date of the ceremony. It was as if they feared he might board a train and appear like a ghost at his brother's wedding, uninvited and unwelcome, to spoil his family's special day, as he had spoiled so many others.

Nor did it help that when Theo finally did write again, he urged Vincent to share his happiness by finding a wife of his own. He cruelly labeled this state of marital bliss "the *real* South." The suggestion prompted a paroxysm of despair as Vincent saw his brother disappearing down a path he could never follow. "I rightly leave [marriage] to men who have a more well-balanced mind, more integrity than I," he wrote. "I could never build an imposing structure on such a moldy, shattered past."

By the time Signac arrived—a final abdication of fraternal duty—Vincent had sunk into bitterness. He caustically instructed Theo not to bother with such trivial things as his imprisonment until *after* the wedding. "Leave me quietly here," he said. "Except for liberty . . . I am not too badly off." In one of the darkest and most despairing passages in all their correspondence, he abjured not only marriage but any hope that he could love someone without hurting them. "The best thing for me would certainly be not to live alone," he wrote, "but I would rather live in a cell forever than sacrifice another life to mine." His bitterness over Theo's marriage must have filled his conversations with Signac, too, as it certainly did his letter to the young artist immediately afterward:

> Goodness gracious—mustn't one pity the poor wretch who is obliged
> after having provided himself with the necessary documents, to repair

to a locality where, with a ferocity unequaled by the cruelest cannibals, he is married alive at a slow fire of receptions and the aforesaid funereal pomp.

But Signac's visit also showed Vincent a new path forward. The company of a fellow artist, the elevated discussions, the studio rituals, gave him another glimpse of the painter's life he had always longed for, but rarely known. Perhaps he could start again, he dared to imagine—on his own this time. With his health sturdy and his head clear (or so he thought), Vincent made a lunge at normal life. When Signac wrote from Cassis tepidly suggesting that Vincent "come do a study or two in this pretty country," Vincent briefly entertained the illusion that the two men might "find a place together" and form yet another brotherhood of painters under the southern sun.

He sent a fulsome letter filled with beckoning images—in both words and sketches—of a new home for *japonisme* on the Côte d'Azur. If he could not marry, at least he could have a *true* friend. "My best consolation, if not the best remedy, is to be found in deep friendships," he wrote Signac in a rebuke of his faithless brother, "even though they have the disadvantage of anchoring us more firmly in life than would seem desirable in the days of our great sufferings."

When the combination with Signac, like so many other illusions, failed to materialize, Vincent set his sights on a new life in Arles. Persuaded that he could never return to the place Lamartine for fear that the neighbors might provoke him again, he allowed Salles to search for an apartment in another part of town. "I must have my own fixed niche," he wrote, anticipating his imminent freedom; "then I could certainly make a trip as far as Marseille or further." But the only willing landlord the pastor could find was Doctor Rey, who agreed to rent Vincent two "very small rooms" in his mother's house. ("Nothing like as nice as the other studio," Vincent complained.) While laying plans to move out of the Yellow House by Easter (April 21)—the deadline imposed by his landlord— Vincent also persuaded the good doctor to let him practice his "handicraft" in and around the hospital grounds. At the end of March, he sent Theo an order for paint and went into town himself to buy other supplies.

He began with another round of mantric repetitions: his fifth *Berceuse* and one more portrait of the postman Roulin, who visited Arles not long after Signac, rekindling Vincent's Tartarin fantasies of the Midi as a land of jolly, carefree peasants with "strong constitutions" and irrepressible "high spirits." Next, he followed through on a pledge he had made in January, when a return to normalcy seemed just around the corner: "Soon the fine weather will be coming and I shall begin again on the orchards in bloom." First he painted a big *doux-pays* vista of a flowering peach orchard, invoking the magisterial Crau of the previous year; then a close-up view of a single twisted tree afloat in a sea of

emerald grass dotted with dandelions, affirming all his arguments for a Japan of the South.

Next, he reasserted his vision of a *Paradou* in Arles with both a drawing and a painting of the hospital's courtyard garden, its shaggy boxwood parterres rioting with new growth—"forget-me-nots, Christmas roses, anemones, buttercups, wallflowers, daisies," he listed them—a secret heart of life and bounty within the prison walls and dreary routine of dying.

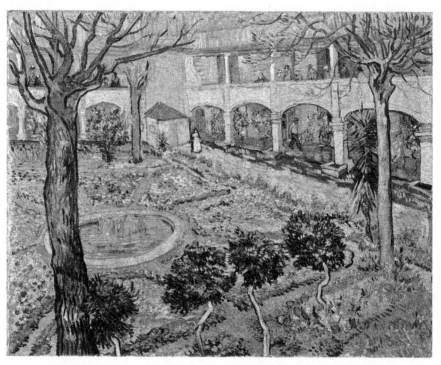

The Courtyard of the Hospital at Arles, APRIL 1889, OIL ON CANVAS, 28¾ x 36⅛ IN.

For his new life, Vincent struck a new pose of independence and inner peace. He solemnly informed Theo "I am on the high road to recovery," and professed to want nothing more than to stay on that road. Afraid that any aggravation might trigger a relapse, and convinced, as ever, that he could quell the storms in his head by sheer force of will, he addressed the future with Japanese serenity and a Voltairean cosmic laugh. "I am recovering a sort of calm in spite of everything," he told Theo, recalling both Father Pangloss and Flaubert's sublime clowns, Bouvard and Pécuchet. "The best we can do perhaps is to make fun of our petty griefs and, in a way, of the great griefs of human life too. Take it like a man." He repudiated the gritty reality of Naturalism and embraced the soothing, sentimental works of his youth: *Uncle Tom's Cabin* and Dickens's *Christmas Stories.* "I read in order to meditate," he told his sister Wil.

He *painted* to meditate, too. Imitating the Japanese monk who stilled his inner demons by studying "a single blade of grass" for a lifetime, Vincent painted vignettes of flowers and butterflies and swirling clumps of grass—images as close as botanical studies but as transfixed as pure abstraction—intimacies with nature that he had occasionally turned to in the past, especially to please Theo, but that now pointed his mind and his art in a new direction.

For models of serenity, he reached into the future as well as into the past. For the first time in his life, he found solace in science. Seizing on Dr. Rey's mischievous notion that love was caused by a microbe, Vincent imagined that even his attacks of melancholy and remorse "might possibly be caused by microbes too"—a theory that allowed him to think of his ordeal not as an inexorable martyrdom, but rather as a "simple accident" in an unjudging universe. "I am beginning to consider madness as a disease like any other and accept the thing as such," he wrote. "Almost everyone we know among our friends has something the matter with him."

But it didn't work. The hounds of failure, fault, and abandonment always found him. "Oh, if only nothing had happened to mess up my life!" he interjected abruptly in a description of his orchard paintings. "You see that I have no better luck in the South than in the North. It's pretty much the same everywhere." He complained of a "certain undercurrent of vague sadness difficult to define," and, surveying the future, saw "no prospect of any better luck anywhere." Apologies for his "weakness of character" and the "deplorable and melancholy failure" of the Yellow House slipped out before he could stop them. ("But we won't begin again," he caught himself.) He sent guilty reports of his expenditures, right down to new socks.

Paranoia, privacy, and the need to work drove him out of the hospital, but the prospect of living on his own terrified him. "I shall move out, of course," he wrote timidly, "as soon as I see how to manage it." Every time his head had "just about returned to its normal state," he had confided to Signac, he was hit again by "inner seizures of despair of a pretty large caliber," and the cycle of dread began again.

The potassium bromide he took to prevent such attacks dulled his enthusiasm and muddled his mind. "Not all my days are clear enough for me to write logically," he confessed to Theo. If he could not remember what month it was or felt too fatigued to write a letter, how could he live on his own? It didn't help that he couldn't resist the self-tranquilization of alcohol during his long outings from the hospital (despite his promise of "a very sober way of living"), or control the lightning in his head when his thoughts turned inevitably to the fateful events unfolding far away in Holland.

When he guessed that the deed was done, he finally wrote and admitted the inadmissible. He wished his brother well, thanked him for all his years of af-

fection and kindness, apologized one last time for having given him so little in return, and then released him. Henceforth Theo would seek his "kindness" and "comfort" elsewhere, Vincent acknowledged: the time had come to "transfer this affection as much as possible to your wife."

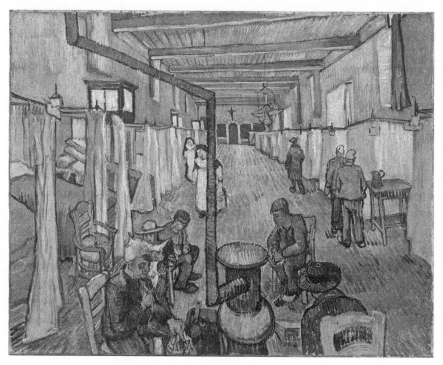

Ward in the Hospital at Arles, APRIL 1889, OIL ON CANVAS, 29¹/₈ X 36¹/₈ IN.

Only days before, on the eve of the wedding, Vincent had told Salles, "I am unable to look after myself and control myself. I feel quite different from what I used to be." He asked to go to an asylum "immediately."

The announcement surprised Salles, who had thought Vincent seemed "infinitely better"—"as if not a trace of the trouble remained." The doctors had agreed to release him from the hospital; the new apartment was arranged. The two men were on their way to sign the lease when something inside Vincent collapsed. "He suddenly confessed to me that for the time being he lacked the courage to stand on his own feet," Salles reported, "and that it would be infinitely wiser and very much better for him if he spent two or three months in a mental home."

In his letter to Theo announcing his decision, Vincent begged to be excused from explaining it. "Talking about it would be mental torture," he said. Yet, in the days that followed, he sent a sprint of letters filled with reasons for his sudden reversal: from the most prosaic ("I am absent-minded and could not direct

my own life just now") to the most heartrending: "I have been 'in a hole' all my life, and my mental condition is not only vague now, but has always been so, so that whatever is done for me, I cannot think things out so as to balance my life."

But the real reason was clear enough. He was doing it for Theo. "I wish to remain shut up as much for my own peace of mind as for other people's," he informed his brother. "I am sorry to give trouble to M. Salles, and Rey, and above all to you." But Salles reported to Theo a much more turbulent reality as the wedding day approached. "You would hardly believe how much your brother is preoccupied and worried by the thought that he is causing you inconvenience," the pastor wrote. Vincent worried especially about "scenes in public" if another attack struck after his release. What would Theo be forced to do? "My brother," he cried out to Salles, "who has always done so much for me and now to cause him more trouble!"

DESPITE MONTHS OF waiting for Vincent to choose his own fate, Theo balked when he finally did. The "repulsive" prospect of his brother entering a lunatic asylum, even for a few months, shattered his delusion of a hospital-based "convalescence," spoiled his narrative of Byron and Don Quixote, and cast a shadow over his family seed just as he began planning a family of his own. Nothing else but shame could explain Theo's frantic efforts to talk Vincent out of a decision over which he had agonized for so long. Theo not only repeated the reluctant invitation to Paris, where he and Jo had just arrived (having put off their honeymoon); he even suggested that Vincent might want to rejoin Gauguin in Pont-Aven for the summer—a notion of breathtaking folly.

He questioned Vincent's choice of asylum, too. At Salles's recommendation, Vincent had already picked out a small church-affiliated asylum in Saint-Rémy, a little town about fifteen miles northeast of Arles in the foothills of the Alpilles, the rocky ramparts of the Alps just visible on the horizon of the Crau. The choice of a small, private, and expensive institution came as a surprise to Theo after months of correspondence that focused solely on the larger, public (and less costly) asylums in Aix and Marseille. He belatedly suggested that Vincent further investigate conditions at those asylums and, in any event, that he wait for more information before making a final decision. And whether his destination was Saint-Rémy or some other place, he urged Vincent to shorten his stay there—from three months to one—and continued to speak of it more as a camplike retreat than a psychiatric confinement.

Even in the midst of his calls for reconsideration and further delay, Theo confirmed all the fears that had driven Vincent to his sudden reversal. He sent cheerful reports of the wedding ceremony and rapturously proclaimed the connubial bliss he had found with Jo. "We thoroughly understand each other, so we

feel such a complete mutual satisfaction," he wrote, inflicting the wound over and over with each unthinking exclamation. "All goes better than I have ever been able to imagine, and I never dared hope for so much happiness."

Theo's resistance and insensitivity only pushed Vincent into more extreme threats of withdrawal. "I could get out of this mess by joining the Foreign Legion for five years," he wrote at the end of April. "I think I should prefer that." Distraught by higher than expected fees at Saint-Rémy and initial reports that he might not be allowed to paint outside the asylum, Vincent imagined an escape to the *extreme* South: the deserts of Arabia. There he could find "supervision" for free, and perhaps be allowed to continue his work in the Legion barracks. There he could find the order and serenity of a hospital ward and, after five years, "might recover and be more the master of myself." There, most important, he could escape the guilt. "The money painting costs crushes me with a feeling of debt and worthlessness," he exclaimed in an outburst that jolted Theo to attention, "and it would be a good thing if it were possible that this should stop."

As horrified as Theo was by his brother's threat to join the Foreign Legion ("It is meant as an act of despair, isn't it?" he replied accusingly), he saw even darker threats in a newspaper article that Vincent sent him about an unknown Marseille artist who had committed suicide. "One catches a glimpse of Monticelli in it," Vincent hinted, invoking the Midi master whose ignominious death (and rumored suicide) haunted him even more since the failure of the Yellow House. "Alas, it's yet another deplorable story." If he himself had not failed so miserably, Vincent wondered, could he have saved this anonymous comrade? "For it was precisely to painters such as the poor wretch in the enclosed article that the studio could have been of use." All that remained of that dream now was "deep remorse," more expenses, and the faithful Theo. "If I were without your friendship," he cautioned his recalcitrant brother, "they would drive me remorselessly to suicide, and coward that I am, I should end by committing it."

In the end, Theo had no choice. He agreed to pay the extra money and wrote the required admission letter to Saint-Rémy (requesting the cheapest "third class" accommodations). But in a last gasp of denial, he reassured the asylum director that his brother's confinement was "required more to prevent a recurrence of previous attacks than because his mental condition is at present affected." For Vincent, he could find no better comfort than this: "From one point of view you are not to be pitied, though it may not seem so. . . . Be of good heart; your disasters will surely come to an end."

BY EARLY MAY, Vincent had finished packing up the Yellow House. It was an agonizing job. During his long absence, the heat had been turned off and the nearby river had flooded, bringing the waters of the Rhône almost to his

doorstep. In the cold, damp darkness, water and salt oozed from the walls and mold spread luxuriantly. Many drawings and paintings were ruined. "That was a blow," he admitted, "since not only the studio had come to grief, but even the studies that would have been reminders of it." Sifting through the wreckage, he salvaged what he could. The furniture, he stored over the Ginouxs' infernal night café. The paintings took weeks to sort and dry. One by one—the beloved *Berceuse*, the bedroom, the Sower, the chair, the starry night, the sunflowers—he removed them from their stretchers, interleaved them with newspaper, packed them, crated them, and sent them to Paris with apologetic instructions. "There are lots of daubs among them, which you will have to destroy . . . [Just] keep what seems passable to you."

As he packed, waves of remorse washed over him. He spent only a few nights in his new apartment before loneliness and nightmares drove him back to the hospital for his final days in Arles. "Certainly these last days were sad," he wrote Theo,

> but the thing I felt saddest about was that you had given me all these things with such brotherly love, and that for so many years you were always the one who supported me, and then to be obliged to come back and tell you this sorry tale.

He looked around the room and saw not a studio but "a graveyard," and pronounced a despairing epitaph: "Pictures fade like flowers." In his farewell letter from Arles, he reviewed his career as if his life were flashing before him. He reclaimed his Millet peasants and the "Dutch palette with its grey tones," and cautioned his brother, "do not become completely and exclusively impressionist. After all, if there is good in anything, don't let's lose sight of it." He listed artists he loved, but feared would be forgotten. As for himself, he said, "as a painter I shall never amount to anything important, I am absolutely sure of it."

Even as he considered giving up painting altogether, he managed to paint two more images before leaving. Both depicted roads. In one, a family frolics on a path in a park "splashed with light and shade" under a lush canopy of flowering chestnut trees. In the other, an empty road winds into the distance and disappears behind a wall. Its rutted, lonely route is lined by shaggy clumps of meadow grass and leafless pollarded willows, scarred and misshapen, as far as the eye can see.

Starry Night

~

T HE ASYLUM OF SAINT-PAUL-DE-MAUSOLE LAY IN A MOUNTAIN VALLEY that had enchanted visitors since the Romans. Some compared the hidden glen to the magical Swiss Alpine passes much higher up on the spine of Europe. Others saw in its green fields and olive groves the rolling countryside of Tuscany. "Pure Italy," composer Charles Gounod called it, "the most beautiful mountain valley that you could see anywhere." Some saw the Attic hills of ancient Greece—the original Arcadia.

The fearsome Visigoths had preferred the nearby rocky heights of Les Baux—an eagle's nest of a city carved out of solid rock and perched impossibly at the very edge of the Alps, where the mountains met the delta of the Rhône in a great wall of limestone. But the civilizing Romans found both security and an echo of their hilled homeland in the remote, fertile vale just beyond the rocky crest. So impressed were they by the secret serenity of the place that they built a small resort city, called Glanum, dedicated entirely to health and the restoration of the spirit.

By the tenth century, Glanum had been plundered to rubble to build the nearby town of Saint-Rémy, but the valley's regenerative powers found new expression in reports of a miracle (a staff, plunged into the ground, had burst into bloom) and the inevitable establishment of a monastery. In a merger of appreciation that reached across a millennium, the founders named it after the most prominent relic left by the Romans, a towering funerary monument. For the next eight hundred years, the cloister church of Saint-Paul-*de-Mausole* (of the mausoleum) welcomed thousands of pilgrims, especially those who sought succor for troubled minds and infirm spirits. Secure in its mountain redoubt, it survived all the waves of plague and destruction that brought so many of its

lowland cousins to ruin. At the beginning of the nineteenth century, the salubrious climate, serene vistas, and legends of healing power brought the old monastery, by now a sprawling complex of buildings, to its final incarnation: an asylum for the insane.

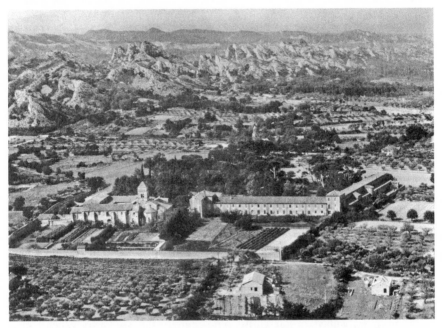

ASYLUM OF SAINT-PAUL-DE-MAUSOLE, SAINT-RÉMY

The Catholic heritage of Saint Paul must have given both Vincent and Theo pause. But the asylum's brochure (which both brothers read) hardly mentioned religion, emphasizing instead the older salvation, the pagan cure, of tree and grove and mountain air beneath a "jewel-enameled sky":

> Air, light, space, large and beautiful trees, drinkable waters—fresh, abundant, of good quality, originating from the mountains—and sufficient remoteness from all large population centers: such are the principal justifications for the learned founder's choice of location.

Of the monastic orders that had prayed under Saint Paul's Romanesque arches (Augustinian, Benedictine, Franciscan), all that remained were a small clutch of nuns who supplemented the staff; a routine as orderly as matins and vespers; and a pervasive, otherworldly calm. Indeed, after the tortuous two-hour train trip from Arles, climbing through the terrifying gorges known since Dante's time

as Hell's Gate, Vincent must have seen the low-lying asylum, with its tree-lined entrance, tended gardens, and verdant fields, exactly as so many previous pilgrims had seen it: an island of serenity in a craggy, perilous world.

In the restorative spirit of Glanum, Saint-Paul-de-Mausole operated more like a resort than an asylum. Other than the monastic routine of shared mealtimes and bathing hours, residents were generally left on their own, under distant but watchful supervision. No longer supported by the church, Saint Paul lured the moneyed middle class—eager to keep relatives out of crowded and repugnant public asylums—with promises of hygienic conditions, healthy food ("abundant, varied, and even rare"), frequent outings, scenic views, radiator heat, and modern medical treatment, which consisted of management by "gentleness and benevolence" (that is, without resort to shackles or straitjackets) and a program of "manual work and amusements."

Accommodations varied, of course, "according to the class of boarder," but the institution's Swiss cows provided "plentiful natural dairy foods" to all equally. Rooms were set aside for the manual work of women (sewing) and the amusement of men (billiards). A library provided access to "illustrated journals, books, and various games fit for recreation." Facilities allowed patients so inclined to play music, write, or draw. A parlor was available for visiting with family members. Boarders of "higher social rank" had secluded apartments of their own, attended by "domestics dedicated to their service."

Patients were encouraged to spend as much time as possible out-of-doors, strolling the long allées of tall, knotty pines, bent by the wind into graceful apostrophes, or the pathways bordered by a profusion of iris and laurel; or just to sit on one of the many stone benches that lined the arcaded courtyards and listen to the plashing of a fountain, or watch the swallows nesting beneath the ancient arches.

Even with these amenities, Saint Paul could not fill all the beds it had inherited from a previous era when charity alone paid the bills and mental afflictions called for the ministrations of a priest, not a doctor. Fewer than half the rooms were occupied. When Vincent arrived on May 8, he joined a cadre of ten male patients and about twice that number of women (madness being still seen as primarily a female affliction). Dwindling revenues had taken their toll on the "first-quality foods" and "well-planted gardens" described in the brochure. Vincent found the daily fare served in the refectory "a bit musty"—short on meat and heavy on beans—"as in a cockroach-infested restaurant in Paris, or in a boarding-house." The "neglected gardens" went for months without pruning or weeding, lending to the old stone buildings an air of decline hardly befitting a retreat dedicated to spiritual renewal.

At the helm of this listing enterprise stood Dr. Théophile Peyron, a fat, bespectacled widower with a quick temper and a gouty leg. The law required that

the asylum be captained by a doctor, not a priest, but did not yet credit the science of "mental alienation" enough to demand that the captain have any special training in it. Peyron, an ophthalmologist by trade and a navy doctor by experience, brought nothing to his retirement sinecure at Saint Paul other than a general knowledge of medicine, an officer's mania for order, and an accountant's eye for expenses. He demanded that a rigorous log be kept of all arrivals and departures, and relentlessly squeezed the budget. Outbursts of misbehavior were dealt with swiftly and summarily by sequestration in a secluded courtyard, or, in the worst cases, a distant, briglike ward, far from the rest of the "boarders."

In this measured, monitored, orderly world apart, Vincent thrived. "I think I have done well to come here," he wrote only days after his arrival. "I have never been so peaceful as here." For Theo, he described in loving detail the tidy, well-lighted space that he now called home. "I have a small room with greenish-gray paper with two sea-green curtains with a design of very pale roses," he wrote; "very pretty." He admired the old armchair as if it had been chosen especially for him: "[It] is covered in a tapestry speckled like a Diaz or a Monticelli in brown, red, pink, white, cream, black, forget-me-not blue and bottle green." The window was barred, of course, but it overlooked an enclosed wheat field—"a prospect like a Van Goyen"—and faced east, so that "in the morning, I watch the sun rise in all its glory."

In the asylum's cloistered calm, undisturbed by police, creditors, landlords, street boys, or spying neighbors, Vincent found the serenity he had always longed for. "Where I must follow a rule," he once said, "I feel at peace." Here he could eat regularly, if not well, and drink in moderation, without facing the temptations of the Café de la Gare. During the day, he could stroll the grounds, enjoying the aromatic plants and the clear air ("one can see so much farther here than at home"), or just sit and study the scenery. "I never get tired of the blue sky," he wrote.

Twice a week, he took a two-hour bath—a therapeutic ritual that "steadies me a lot," he said. At night, he could settle into his Monticelli armchair, read a book or newspaper, and smoke in peace. No paintings stared down from the walls—no ghosts from the past. All had been either sent to Theo or left in Arles. The great weights of ambition and expectation had been lifted from his shoulders. "We don't have to live for great ideas any longer," he wrote, "but, believe me, for small ones only. And I find that a wonderful relief." Because the money for his upkeep never passed through his hands, he could escape, temporarily at least, the "grinding daily task of earning a living"—or, worse, the "crushing feeling [of] debt and worthlessness." Even the mistral no longer tormented him. "Because there are mountains around," he marveled, "[it] seems much less tiresome than in Arles, where you always got it firsthand."

Other winds shifted in Vincent's favor, too. Compared to the people of Arles,

the patients at Saint Paul proved a model of civility and sympathy. "They say we must tolerate others so that the others may tolerate us," Vincent reported, "and we understand each other very well." For the first time in his career as an artist, he could draw and paint in public unmolested and unmocked. In the princely Hague, they spat on him; in Nuenen, they banished him; in Arles, they threw stones at him. But in the arcaded garden of Saint-Paul-de-Mausole, where he spent most of his time, he found the peace he needed to work and recover.

BATHS, ASYLUM OF SAINT-PAUL-DE-MAUSOLE

Nearby, games of *boules* and checkers went on undisturbed. Passersby might stop to watch, but always from a respectful distance. Unlike "the good people of Arles," he observed of his fellow boarders, "*they* have the discretion and manners to leave me alone." Indeed, he reveled in their innocent attentions, noting, "It has always been my great desire to paint for those who do not know the artistic aspect of a picture."

As Vincent reported, the patients at Saint Paul were, in general, a refined and courteous lot. The person playing *boules* while he painted, or sitting next to him at the refectory table, was as likely to be the victim of a family quarrel as a mental affliction (a "ruined rich person," in Vincent's parlance), or perhaps a misunderstood eccentric who insisted on dressing for travel (with hat, cane,

and coat) even when he went to bed. One was a frustrated law student who had "greatly overtired his brain" in preparing for examinations, according to asylum records; another, an accused pedophile. At least one was diagnosed as an "idiot" because he could only grunt and nod. Vincent found him an excellent listener. "I can talk with [him] because he is not afraid of me," he said. There were shouters, too, of course; and, at night, howlers. And some who, like Vincent, burst suddenly into fits of paranoia and hallucinatory panic. But when they did, other patients would rush to calm them—not flee in fear—even before the wardens arrived. "People get to know each other very well," Vincent wrote, "and help each other when their attacks come on."

Not even the worst cases could resist such solicitude, he believed, citing the example of a recent arrival, a young man who "smashes everything and shouts day and night, wildly tears his straitjackets, overturns his food, destroys his bed and everything else in his room." It was a "very sad" case, Vincent wrote, but he knew that his fellow inmates, especially the veterans, would "intervene to ensure that he does not harm himself" when an attack came on. "They will pull him through," he predicted confidently.

By the same twist of logic, every outburst, every maniacal fit, every howl in the night, calmed Vincent's own anxieties about the future. "By seeing the *reality* of the life of the various madmen and lunatics in this menagerie," he wrote, "I am losing the vague dread, the fear of the thing." And every intervention by his fellow patients made him feel part of a community, just as he did a decade earlier in the Borinage when injured miners nursed each other: a community not of idiots and outcasts, but of true fellowship and mutual consolation. "For though there are some who howl or rave a great deal," he noted, "there is *much* true friendship here."

Even as the routine and familiarity of Saint Paul imposed order on Vincent's daily life, his sessions with Dr. Peyron dispelled the shadows in his head. He had brought from the Arles hospital an official diagnosis of "acute mania with generalized delirium." It was during an attack of these symptoms in December, his admission report concluded, that Vincent had cut off part of his ear. But Dr. Rey had also passed along to Peyron his belief that Vincent suffered "a kind of epilepsy." Not the kind, known since antiquity, that caused the limbs to jerk and the body to collapse ("the falling sickness," as it was sometimes called), but a *mental* epilepsy— a seizing up of the mind: a collapse of thought, perception, reason, and emotion that manifested itself entirely in the brain and often prompted bizarre, dramatic behavior. Among Vincent's Arles doctors, only the young intern Rey knew much about this recently defined variant of the ancient and dreaded disease.

—

THE EXISTENCE OF a nonconvulsive epilepsy had been known to doctors in France and elsewhere for fifty years, but its causes and its elusive symptoms had long defeated positive identification. The names they gave it betrayed their frustration with defining it. They called it "latent epilepsy" or "larval epilepsy" for its long periods of dormancy between episodes, during which the sufferer could lead a relatively normal life, unaware that the incubus was forming within. They called it "masked epilepsy" for its hidden causes and various guises. Some doctors refused to consider it epilepsy at all, given its vague symptomology. Some called it the "intellectual disease" for its cruel targeting of higher brain functions, but tried to impose on its invisible seizures the same hierarchy of "grand mal" and "petit mal" applied to visible ones. Some, like Rey, called it simply "a kind of epilepsy" to bridge the conceptual chasm between the most extroverted of mental afflictions and its most introverted expression.

In Arles, Rey had already discussed his diagnosis with Vincent (who worried that the Foreign Legion might not take "an epileptic"), and even given him reassuring statistics on the prevalence and relative benignity of the broader disease. "There are 50,000 epileptics in France," Vincent cheerfully informed his brother in May, "only 4,000 of whom are confined, so it is not extraordinary." Rey explained how the mental seizures of latent epilepsy sometimes produced hallucinations—auditory, visual, and olfactory—that drove their victims to desperate acts of self-mutilation such as biting their tongues or cutting off their ears.

If Rey described to him the "epileptic character," as it had been limned by two generations of French doctors, Vincent undoubtedly saw a familiar figure in the mirror. With a "disposition to irritation or anger," latent epileptics astonished and frightened family and friends with their changeable moods, easy excitability, furious work habits, and "exaggerated mental activity." Even the most trifling offense could provoke a latent epileptic to anger—or worse, "epileptic fury," which the leading French psychiatrist had described in 1853 as "lightning condensed into terrible deeds." Latent epileptics were always on the move, as unstable in their lives as in their minds: never staying in any one place for long, as their wild, unpredictable outbursts irritated, alienated, and ultimately infuriated everyone around them.

The portrait matched so perfectly that Peyron, who probably heard it from Rey in advance, immediately credited the young intern's diagnosis, writing in the asylum register only twenty-four hours after Vincent's arrival: "I believe, in light of all the facts, that M. Van Gogh is subject to some epileptic fits from time to time now and then." (Vincent reported to Theo: "As far as I can make out, the doctor here is inclined to consider what I have had some sort of epileptic attack.") Over the following weeks, Peyron interviewed Vincent, taking details of his story and family history. A scrupulous, if unempathetic, observer, he found only confirmation of Rey's opinion. "I have every reason to believe," he wrote

Theo at the end of May, "that the attack which [Vincent] has had is the result of a state of epilepsy." Although an eye doctor by training, Peyron "nevertheless kept abreast of what was then known about mental illness," according to a colleague, and during his sessions with Vincent, he no doubt filled in the portrait of the latent-epileptic "type" that Rey had sketched.

The disease often showed itself first in childhood, in the form of "mischievous restlessness and irritability," according to one of the leading authorities on the subject in the 1880s. Attacks could be triggered by anything from excessive sun or alcohol, to disruptive emotions: especially feelings of guilt. The excitation of "profound mental suffering" was the most commonly reported prelude to an attack. Some patients described feeling suddenly trapped in a waking nightmare, or "falling into a chasm." Pangs of conscience were known to bring on attacks, especially in cases where the victim felt haunted by inexplicable or insurmountable misfortune. Painful memories could trigger attacks, as could religious obsessions, especially over sins perceived to be unremitted.

When attacks came, they were often accompanied by out-of-body sensations, as if the victim's psyche were divided or projected into other entities—entities that sometimes spoke with their own voices. Victims would babble gibberish and act "automatically"—without conscious control, or even recognition, of their actions. This marked the beginning of the seizure itself—the most dangerous period, especially for the victim. Its hallmarks were violence and paroxysmal rage. Both homicide and suicide were possible. An attack was almost always followed by loss of consciousness: a deep, troubled sleep from which the victim would awake with no memory of what had happened. The days and weeks that followed were marked by "epileptic stupor"—a twilight state of ill-tempered torpor, aimlessness, and crushing remorse.

For Peyron, the diagnosis was absolutely confirmed when Vincent revealed that there had been other cases of epilepsy in his family. The experts on latent epilepsy disagreed on many things, but on one point they stood unanimous: epilepsy, whatever its form, whatever its origin, could be inherited. Vincent's stories offered a veritable family tree of mental affliction. His grandfather, Willem Carbentus, had "died of a mental disease," according to an unusually candid note in the family chronicle. His mother's sister Clara had suffered epilepsy throughout her reclusive, spinster life. Another maternal uncle committed suicide. A paternal uncle, Hein, suffered his first "epileptic fit" at thirty-five, about Vincent's age. He retired early after repeated fits left him "half paralyzed," according to his sister's account, and died young in a conspiracy of family silence. Another uncle, Jan, the admiral, experienced unexplained "fits" at age forty, according to the same account. Among his many health problems, Uncle Cent had "seizures." And at least two of Vincent's cousins were victims of mental illness. One of them, Admiral Jan's son Hendrik, "suffered some bad epileptic fits," accord-

ing to Vincent's father, after which he was institutionalized and may have committed suicide. Peyron noted conclusively in Vincent's asylum record: "What happened to this patient would be only the continuation of what has happened to several members of his family."

Peyron's "eureka" echoed his profession's—and his era's—conviction that heredity held the key to understanding all human behavior. In 1857, two years before Darwin's *Origin of Species*, Bénédict Morel, the leading French expert on latent epilepsy, had published a treatise on mental illness that took pre-Darwinian theories of evolution in a much darker direction. He claimed that not just epilepsy but all mental deficiencies, from neurosis to cretinism (as well as physical imperfections and personality deviancies), resulted from gradual genetic deterioration, a process he called "degeneration." The destiny of a family—or an entire race—could be determined by the cumulative effect of these genetic pollutants, which were powerful enough to alter human anatomy.

In fin-de-siècle France, Morel's theory crystallized the millennial pessimism. After a century of Pyrrhic revolutions, failed empires, and especially the humiliating defeat of the Franco-Prussian War, Morel's identification of an enemy within, a cancer of weakness and flaw corroding the nation's vitality, gripped the public imagination. Peyron, along with most alienists and asylum directors in France, embraced Morel's theory, both because it enhanced their professional standing (making them protectors of the national genetic patrimony), and because it helped them in the long battle to wrest ultimate authority over the human mind away from priests, phrenologists, and sideshow hypnotists. "Before, I used to care for the eyes of the body," Peyron, the former ophthalmologist, once said; "now I care for the eyes of the soul; it is still the same job."

Morel's theory of degeneration—the final and most sinister expression of his century's fascination (and Vincent's) with "types"—would wreak an awful toll in the century that followed: from sterilization campaigns to extermination camps. But for Vincent, it proved a liberation. By giving the storms in his head a medical explanation, Peyron lifted the weight of the past off Vincent's shoulders. "My life has not been calm enough," he had written on the eve of his arrival; "all those bitter disappointments, adversities, changes keep me from developing fully and naturally in my artistic career." Now, in addition to relieving Vincent of the need to shift for himself (a task, he admitted, that "paralyzed" him), Peyron's diagnosis restored Vincent's sense of control over his own fate— what he called "my self-command"—something he had not felt since Christmas. "Once you know what it is," he explained to Theo, "then you can do something to prevent your being taken unawares by the anguish or the terror."

It also released him—temporarily, at least—from a lifetime of guilt. If his art failed to sell or he could not support himself, it was not his fault; he was merely the victim of a disease. "Unfortunately, we are subject to the circumstances and

the maladies of our time," he wrote, echoing Morel, "whether we like it or not." His was a disease like any other, no more blameworthy than "consumption or syphilis," he maintained. If there was blame, it rested not on *his* past, but on *generations* past: not on his shoulders—his flaws, his failures—but squarely on the shoulders of his accusing, unforgiving family.

To bolster this new vision of redemption, Vincent began to assemble an *asile imaginaire*—an imaginary asylum of artists who, like him, had suffered not failure or ignominy or madness, but only a "malady of the times." He summoned up a long list of the unjustly accused—Troyon, Marchal, Méryon, Jundt, Matthijs Maris, and, of course, Monticelli—and assured himself that his creative serenity would inevitably return, as theirs did. "There are so many among the artists who—notwithstanding nervous diseases or epileptic fits from time to time—nevertheless go ahead," he wrote, "and in a painter's life it seems to be enough to make paintings."

Once the weight of guilt was lifted, Vincent could embrace his new life. He had always been drawn to custodial institutions, whether searching for models in the orphanages and almshouses of The Hague or imagining himself founding a monastery of modern art in the Midi. (In 1882, he called the sight of "convalescent people" gathered together in places like these "beautiful, very beautiful.") He collected prints of hospital scenes, and fondly described his own visits to hospitals, even for the most grueling treatments. He often leaped at the chance to accompany others to the hospital, even virtual strangers, and as recently as Arles had considered becoming a hospital orderly himself. "Perhaps it is from the sick," he once said, "that one learns how to live."

He had fiercely opposed the plan to commit him to Gheel, but only because his father proposed it. Now, with the implacable pastor dead, and his ghost banished by medical science, Vincent could finally enjoy the monklike order and spartan simplicity he had always aspired to. His "treatment" consisted of little more than doses of bromide (a sedative), long soaks in a stone tub, regular meals (stingy on meat, which was considered a stimulant), moderate drink (wine only, in rationed amounts), and the soothing routine of daily life in the enchanted valley. Like the heroes and heroines of some of his favorite novels, he found a serenity in the cloistered asylum that he had never found in the world outside, and like them, he increasingly saw that other world as the true madhouse.

After a few days, he began sending Theo regular updates on his rebounding health, "tranquility," and "peace of mind." "My stomach is infinitely better," he announced, "my health is good, and as for my brain, that will be, let us hope, a matter of time and patience." He buoyed these encouraging reports with a blithe attitude toward his disease and even flashes of humor. He compared the doldrums in the asylum halls on a rainy day to "a third-class waiting room in some stagnant village," and he commented impishly that the menu of chick-

peas, haricot beans, and lentils created "certain difficulties" with digestion that resulted in patients "filling their days in a way as offensive as it is cheap." He called this collective gastric distress one of the institution's primary "daily distractions, along with *boules* and checkers."

By the end of May, less than a month after arriving, Vincent had decided: "I think my place is here." He had come imagining that he would stay, at most, three months. Now, as the prospect of a languid summer in the clear air stretched out before him, he could not imagine leaving. "It's been almost a whole month since I came here," he wrote Theo; "not once have I had the slightest desire to be elsewhere, only the wish to work is getting stronger."

INEVITABLY, VINCENT'S NEW serenity found its way into paint. Within days of arriving, he secured permission to set up a studio in a large room on the ground floor, one of many unused spaces in the half-empty dormitory. Its location next to the entrance gave him easy access to the garden and a place to dry his paintings in sun and air.

In the untended grounds and wandering paths right outside the door, he immediately resumed the series of "garden corners" begun in Arles. Only now his pen and brush could relax. Rather than make a vehement argument for his serenity (and sanity), as the previous works did, now he could just *look*. Drawings and paintings poured out. He filled big sheets of paper with vignettes of greenery seen in a languor of looking. He recorded every detail of ivy climbing up a tree, a bench nestled in tall grass, a lattice of shadow on the ground. A single mangy shrub could occupy a whole sheet in a tireless observation of texture, character, light, and air. Like the proverbial Japanese monk, he found a lone moth worth both pen and paint, and enough beauty in a single lilac bush to spread across a huge canvas.

The more his eyes meditated on these scenes of "nature in undress," the more Vincent's imagination returned to its earliest roots. He thought of Alphonse Karr's *A Tour Round My Garden*, his childhood guide to the mysteries of flowers and gardens, and especially of the Barbizon masters who had first shown him the magic to be found in the humblest shrub. "All those lovely canvases," he sighed; "it seems hardly probable that anyone will do better than that, and unnecessary besides." He reminded Theo how painters like Daubigny and Rousseau had "expressed all of nature's intimacy," as well as "all its vast peace and majesty," and, at the same time, "added a feeling so individual, so heart-breaking."

Compared to the worlds of imagery he saw in the shaggy garden of Saint Paul, the battles of Paris now seemed distant and absurd. "We shall always keep a sort of passion for impressionism," he wrote, "but I feel that I return more and more

to the ideas that I already had before I came to Paris." He neither heard from nor inquired about Gauguin or Bernard. When news reached him of an insurgent exhibition that Gauguin planned at the Exposition Universelle in Paris that summer, he could barely conceal his lack of interest. "So I am inclined to think that a new sect has again been formed," he sighed, "no less infallible than those already existing. . . . What storms in teacups." Later, he admitted that he spent the summer "doing little things after nature, without giving a thought to impressionism or whatever else."

One of those "little things" was a bed of irises. Nestled beside the much larger lilac bush, the little cluster of purple flowers barely rose to Vincent's knee. He must have prostrated himself in some way to see them as he did: filling the canvas from left to right in a procession of pointed leaves and towering blossoms. With no sky, little background, and only a corner of foreground, the big canvas compacts and monumentalizes all the exuberance and bounty of spring into a dozen out-of-step stalks, a blaze of leaves, and two bulbous clouds of blossoms. The looming little stand of flowers partakes of all the ardors of the past— a bit of Impressionist brushstroke, the outlined forms of Cloisonnism, a dash of contrasting marigolds—but argues none. "I have no ideas," Vincent professed. Rather than argue or think too much, he preferred "to go out and look at a blade of grass, the branch of a fir tree, an ear of wheat, in order to calm down."

The irises also announced the color of Vincent's new serenity: violet. As if his life were a painting, he picked the complementary of the yellow that had so dominated his sunburnt days in Arles to depict his monastic new life at Saint Paul. What better contrast to the strife and despair of the Yellow House than the calm and contentment of his mountain valley hideaway depicted in violet, lavender, lilac, or purple?

Those variations and dozens of others filled the first paintings that Vincent set in the doorway to dry. Depicting the view from his bedroom window, he saw nothing but a lavender sky, lavender hills, and a field of spring-green wheat— another *ton rompu* (broken tone) of blue. He himself told Theo that the painting's open vistas and cool harmonies made a perfect pendant to the inward-looking and intensely colored portrait of his previous home, *The Bedroom* in Arles. "What I dream of in my best moments," he wrote in a complete reversal, "is not so much striking color effects as once more the half tones." Whether staring into the deepest underbrush or directly into the sky, he saw shades of the same soothing mix of red and blue. In his letters, he struggled to differentiate them: "violet," "purplish blue," "lilac," "pale lilac," "tender lilac," "broken lilac," "plain lilac," "gray rose," "yellowish rose," "greenish rose," "violet rose."

To accompany these exquisitely poised half tones, Vincent found the perfect complement in images from the past. "I feel tempted to begin again with the simpler colors," he wrote Theo, "the ochres for instance." Leaping back decades and

centuries, he cited the sepia landscapes of the Golden Age giant Jan van Goyen and the maizy, fawnish hues of his longtime favorite Georges Michel, both of whom had transformed "delicate lilac skies" and ocher highlights into works of sublime serenity. He practiced it himself in a view of a garden path leading beside the ocher asylum façade under a canopy of ocher leaves against a deep lavender sky. When Peyron gave permission for him to venture beyond the garden (but not yet beyond the asylum walls), he set up his easel in the enclosed field outside his bedroom window, just in time to catch the green wheat turning golden. In a letter to his sister, he lovingly described how the ocher of the ripe grain, with "the warm tones of a bread crust," stood out against the "far-off violet hills and a sky the color of forget-me-nots."

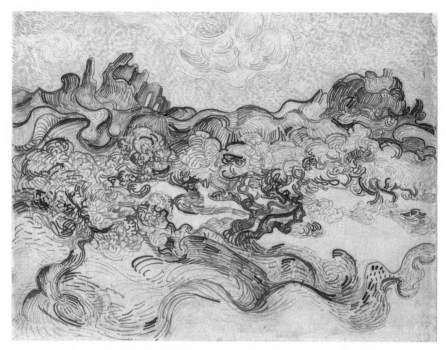

Olive Trees in a Mountain Landscape, JUNE 1889,
PENCIL AND INK ON PAPER, $18\frac{1}{2}$ x $24\frac{5}{8}$ IN.

The regimen of close looking and serene color worked so well that by early June Vincent was allowed to seek his subjects in the world outside the asylum gates. "As I find him entirely tranquil," Peyron informed Theo, "I have promised to let him go out in order to find scenery." To be sure, he could only take daylight trips, and had to be accompanied by a warden. But even this limited freedom liberated his brush. His walks in the orchards and fields beyond the walls invited his eye to explore the serrated horizon in a way impossible from the bedroom

window's frozen tableau or the garden paths where buildings blocked the view altogether.

The nearby Alpilles changed shape with every step. The craggy limestone escarpments, just fringed with green, jutted into the sky in odd shapes and gravity-defying curves. Beneath him, the ground undulated. Groves and meadows alternated with rocky barren patches, hollows with hillocks, as the valley rose to meet its stone ramparts.

In this peaceful, supple valley, far from the storms of Paris, surrounded by the fantastical shapes and meandering lines of the Alpilles, Vincent conceived a new notion of line and form. "When the thing represented is, in point of character, absolutely in agreement and one with the manner of representing it," he suggested after one of his first outings, "isn't it just that which gives a work of art its quality?" Not only should *color* express the essence of the subject depicted (earth tones for the peasants of Nuenen, red and green for the lonely denizens of the night café); so, too, the *form* should reflect the subject's true nature, not just its outward appearance. And what could be more "in agreement" with this enchanted valley and its fairy-tale mountains than an art of exaggerated forms and playful lines?

Exaggeration, of course, had long been a mandate of the new art, at least as Vincent first understood it from his correspondence with Bernard after leaving Paris. But Gauguin had brought a very different notion of modeling to the Yellow House: an insistence on precise line and idealized form that proved frustratingly elusive to Vincent's unruly hand. Now, finally, in the clarity and serenity of his alpine retreat, Vincent could set aside his useless perspective frame, unclench his fist, and let his brush find the truest image. "In the open air," he wrote, "one works as best one can, one fills one's canvas regardless. Yet that is how one captures the true and the essential—the most difficult part."

He found support for his serene new art in a most unexpected place. After reading an article about a display at the Exposition Universelle, he determined that the ancient Egyptians—another "primitive" race, like the Japanese—must have known the secret of true art that he had discovered in the hills and vales of the Midi. Recalling the granite images he had seen in the Louvre, he imagined that Egyptian artists, "working by feeling and by instinct," were able to express the "patience, wisdom, and serenity" of their potentates simply "by a few knowing curves and by the marvelous proportions." Vincent found the same "harmony" of subject and art in the still lifes of Chardin and in the Golden Age glories of Hals, Rembrandt, and Vermeer. But he wondered to Theo whether the Impressionists, or any of their noisy would-be successors, could make a similar claim.

Meanwhile, in his own little world, he found that harmony everywhere. On

his canvases, the valley's rocky parapets came to life in cartoons of huge boulders piled in precarious walls and impossible overhangs. Close up, the ground ripples like a choppy sea. In the distance, it piles up in a dizzying multiplication of horizons. The clouds overhead hover not as atmosphere or light, but as objects in space, as solid as the mountains beneath, only bulbous and buoyant. The moon rises as a huge crescent, fantastically big and bright in its enclosed patch of sky. On the ground, olive trees loosen their crooked limbs and seem to shake to life, like characters in an Andersen fairy tale. With trembling foliage and twisted roots, they spring from the rolling ground as spritely curls of smoke.

In this enchanted valley, everything has a life of its own. Even the stone wall that enclosed the field outside Vincent's window seems to merge into the living landscape. Its angles soften; its hard edges melt. Instead of hewing to its straight course, it wanders across the undulating ground like a country lane or a hedgerow, as much a part of the countryside as the furrows and fields it encloses. Vincent was convinced that his old comrades Bernard and Gauguin would approve his new, "more spontaneous drawing." "They do not ask the correct shape of a tree at all," he insisted. But, in fact, nothing could have been further from either Gauguin's ambitious striving after Degas's or Bernard's cerebrated ornamentalism than Vincent's tranquil, childlike world outside the world.

That world would not have been possible without brushstroke. "What an odd thing the touch, the stroke of the brush, is," he wrote in newfound wonderment. By altering the brushstroke "in keeping with the subject," he discovered, "the result is without doubt more harmonious and pleasant to look at, and one can add whatever serenity and happiness one feels." Freed from the "isms" that had chained it for so long, Vincent's hand now returned to his Hague quest (kept alive since in drawings and letter sketches) to find the perfect fit of subject, line, texture, and mood. He cited the great engravers Félix Bracquemond and Jules Jacquemart, who had transformed works of art from one medium (oil) to another (copper plate) and in the process given them new perfection. He would do the same for nature, using the distinctive marks of *his* medium: brushstroke.

To practice this "fit," he found the ideal subjects right in plain sight, where he had looked past them a thousand times: cypress trees.

They grew everywhere in the valley, some dating back to Roman times. They served as windbreaks and grave markers; they lined roads and marked boundaries; they stood in cohorts and in lonely sentinel. Once he *saw* them, their compact, "bottle-green" foliage and plain conical shape captivated him. He compared them in "beauty of line and proportion" to Egyptian obelisks. "The cypresses are always occupying my thoughts," he wrote. "I should like to make something of them like the canvases of the sunflowers, because it astonishes me that they have not yet been done as I see them."

He saw them not just as simple cones ("a splash of black in a sunny land-

scape"), but as constellations of strokes. Like an astronomer looking through a telescope, the more closely he looked, the more he saw—and the more his brush recorded. From a distance, the dense branches all curved toward the pointed tip, twisting and flickering upward like flames. But as he approached closer and closer, each quivering branch became a little spiral of color and motion. Some curled upward, advancing the tree toward the sky; others flung themselves outward into space. Branch by branch, spiral upon spiral, he patiently piled them up, transforming ancient monuments of nature into towering monuments of paint.

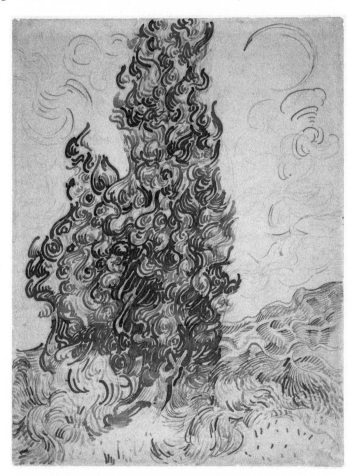

Cypresses, JUNE 1889, INK ON PAPER, 24⅝ X 18½ IN.

By the end of the month, Vincent was working on a dozen canvases at once—almost all of them featuring cypress trees. Another dozen sat in the dormitory doorway, drying in the June heat. One of these was a nighttime study of a single tree silhouetted against a strange celestial display. *"Enfin,"* he wrote Theo, "I have a new study of a starry sky."

—

VINCENT'S SEARCH TO express the serenity he felt led him inevitably to this familiar image. He was proud of the nightscape over the Rhône that he had painted in September the previous year (1888), on the eve of Gauguin's arrival. Theo had liked it, too. Only a week after his brother complimented that painting in late May, Vincent proposed submitting it to the *Revue Indépendante* show in September—"in order not to exhibit anything too mad." If not for the confinements of the Arles hospital—daylight-only releases, windowless isolation cells, bans on paints and brushes—he undoubtedly would have returned to the subject sooner.

At Saint Paul, the constraints had hardly loosened. He still could not venture out after dark to paint, as he preferred, directly under the stars. Brushes and paints remained in his studio downstairs, to which he had access only during the day. To paint a starry night, he could only watch from behind the bars of his bedroom window as the asylum lights blinked off, the sky darkened, and the stars assembled. He may have made drawings—and tested other, deeper inventions—while staring at the small quadrant of the eastern sky that filled his little window. Over the course of the night, he saw a waning moon and the constellation Aries, lying low in the east, just above the hilltops, its four bright stellar points arrayed in a rough arc over the faint blush of the Milky Way. In the predawn hours, Venus, the morning star, appeared prominently on the horizon, bright and white—a perfect companion to an early wakening or a sleepless night. He stared and stared at the light they each shone, and the sparkling darkness around them.

All this and more made its way onto Vincent's canvas in the daylight hours. To ground his celestial vision, he added a sleeping village in the middle distance. Earlier in June, he had taken a day trip into the town of Saint-Rémy, about a mile downhill from the asylum gates. On this visit, or on one of his other forays into the hills overlooking the town, he had made a careful sketch of the popular mountain resort, with its dense warren of medieval streets girdled by broad modern boulevards: famous birthplace of Nostradamus, astrologer and prophet, and still a watering hole for passing luminaries like Frédéric Mistral and Edmond de Goncourt.

For his painting, however, Vincent reduced the bustling town of six thousand to a sleepy village of no more than a few hundred souls—no bigger than Zundert or Helvoirt. The twelfth-century church of Saint Martin, which dominated the town with its fearsomely spiked stone bell tower, became a simple country chapel with a needlelike spire that barely pierced the horizon. Finally, he moved the town from the valley floor north of the asylum and placed it to the east, directly between

his bedroom window and the familiar serrated line of the Alpilles—a spot from which it, too, could witness the celestial spectacle about to begin.

With all these elements—cypress tree, townscape, hills, horizon—secured

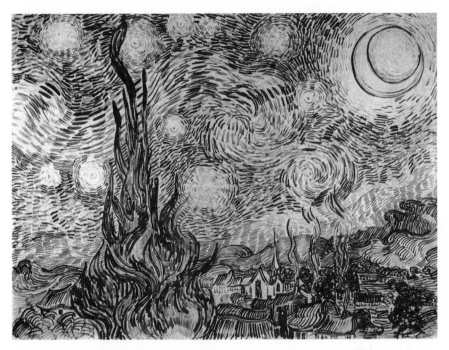

Starry Night, JUNE 1889, INK ON PAPER, 18^1/$_2$ X 24^5/$_8$ IN.

in his imagination, Vincent's brush launched into the sky. Unconstrained by sketches, unschooled by a subject in front of him, unbounded by perspective frame, unbiased by ardor, his eye was free to meditate on the light—the fathomless, ever-comforting light he always saw in the night sky. He saw that light refracted—curved, magnified, scattered—through all the prisms of his past: from Andersen's tales to Verne's journeys, from Symbolist poetry to astronomical discoveries. The hero of his youth, Dickens, had written of "a whole world with all its greatnesses and littlenesses" visible "in a twinkling star." The hero of his age, Zola, described the sky of a summer night as "powdered with the glittering dust of almost invisible stars":

> Behind these thousands of stars, thousands more were appearing, and so it went on ceaselessly in the infinite depths of the sky. It was a continuous blossoming, a showering of sparks from fanned embers, innumerable worlds glowing with the calm fire of gems. The Milky Way was whitening already, flinging wide its tiny suns, so countless and so

distant that they seem like a sash of light thrown over the roundness of the firmament.

In his reading, in his thinking, in his seeing, Vincent had long looked past the "real" night sky—the tiny, static specks and sallow light of the night paintings he detested—in search of something truer to the vision of limitless possibility and inextinguishable light—the ultimate serenity—that he found in Zola's blossoming, showering, glittering night.

To record this vision, he summoned his new palette of violet and ocher, the unstudied curves of his mountaintops, the swirling spirals of his cypress branches, and the odd, wondering brushstroke with which he could "add whatever serenity and happiness" he felt. Guided only by "feeling and instinct," like the ancient Egyptians, he painted a night sky unlike any the world had ever seen with ordinary eyes: a kaleidoscope of pulsating beacons, whirlpools of stars, radiant clouds, and a moon that shone as brightly as any sun—a fireworks of cosmic light and energy visible only in Vincent's head.

IN THE CENTURY after *Starry Night* was painted, scientists would discover that "latent" epileptic fits resembled fireworks of electrical impulses in the brain. William James called them "nerve storms"—"explosions" of abnormal neural discharges that could be triggered by just a few "epileptic neurons" in a brain made up of billions of neurons. These cascading surges of errant sparks often originated in, or took their heaviest toll on, the most sensitive areas of the brain, especially the temporal lobe and the limbic system: the seats of perception, attention, comprehension, personality, expression, cognition, emotion, and memory. The "bombardment" of an epileptic shower could shake any of these foundations of consciousness and identity.

The brain could weather these storms, researchers discovered, but it could never fully recover from them. Each attack lowered the threshold for the next attack and permanently altered the functions that had been shaken. The combination of fear (of another attack) and underlying neurological changes in the affected area of the brain created a pattern of behavior—a syndrome—associated with what came to be known as "temporal lobe epilepsy."

Seizures were usually followed by periods of extreme passivity—an apathetic haze in which victims showed little interest in the outside world, or in their own circumstances. Sexual appetite waned. To the untutored eye, and even to the victim, this passivity was often mistaken for serenity. Gradually, however, apathy yielded to its opposite: a state of heightened excitability. Obsessively alert to the outside world, the victim would be seized by intense feelings, deepened emotions (whether elation and euphoria or depression and paranoia), and towering

enthusiasms. This state of heightened reality—easily exacerbated by alcohol—led in many cases to cosmic visions and religious raptures. As the mind grew increasingly excited, irritability, impulsiveness, and aggressiveness—the hallmarks of latent epilepsy—reappeared. Emotional disturbances led, inexorably, to violent ones—the "paroxystic violence" of a seizure—and the cycle would begin again.

As for the ultimate cause—the origin of dysfunctional "epileptic" neurons in the brain—the answer remained a mystery. Some scientists, even as early as Vincent's time, thought brain injuries, tumors, or birth defects might be responsible. Heredity continued to be suspected. Research did succeed in identifying the immediate causes of attacks—the triggers that could push a sufferer from passivity to euphoria, to paranoia, to agitation, to violent seizure, sometimes in the space of a year, sometimes within a month, sometimes within a day of the previous attack.

Stress, alcohol, poor diet, vitamin deficiencies, emotional shocks, all could increase the brain's susceptibility to electrical storms. The intense enthusiasms that filled the epileptic mind could also paralyze it with *idées fixes*—parasitic ideas that bored into a victim's consciousness to the exclusion of all else, distorting perception and memory and alienating those around him to the point where friction and aggravation, the precursors of an attack, became inevitable. Any overstimulation of the affected areas of the brain—that is, disruptions of perception, cognition, or emotion—could open a pathway for bolts of neuronal "lightning." Seizures could be triggered by visual stimuli as varied as sunlight dappling through leaves, fluttering of the eyelids, even images summoned up by passages in a book. Vivid dreams, unexpected events, rejection by loved ones, derogation by strangers, ambushes of memory, eruptions of "intense meaningfulness" (whether from religious thoughts or metaphysical musings)—any or all could provoke the troubled brain to another attack.

Vincent's euphoric image of a swirling, unhinged cosmos signaled that his defenses had been breached.

EVEN LOCKED INSIDE his serene mountain retreat, Vincent could not escape the provocations that lurked everywhere—not least inside his own head. Letters arrived regularly from Paris and Holland, filled with his family's equivocal embrace. Theo wrote sweetly of art and artists for which the brothers had always shared affection, and solicitously of Vincent's hardships ("It can hardly be pleasant to be near so many lunatics"). But the pressures of married life both reduced the frequency of his letters and heightened his anxiety over the extra cost of the Saint Paul asylum.

Meanwhile, he remained steadfastly lukewarm about Vincent's works from

Arles. "In the course of time they will become very beautiful," he wrote evasively, "and they will undoubtedly be appreciated someday." He dubbed paintings like *La berceuse* "very curious" and could find only words like "vigorous" and "glaring" to describe their brushwork and color. As Vincent's strange, exaggerated landscapes began arriving from Saint-Rémy in June, Theo could not refrain from openly wondering why they "tortured the form" so, and seeing the answer in his brother's mental affliction. "Your last pictures have given me much food for thought on the state of your mind at the time you did them," he wrote. "How your brain must have labored, and how you have risked everything to the very limit, where vertigo is inevitable!"

Jo wrote, too, sometimes happily chiming into Theo's letters, sometimes venturing on her own into the darkness of Vincent's vulnerability. "Dear Brother," she began her first outreach in early May, "It is high time at last that your new little sister had a chat with you herself . . . now that we are really and truly brother and sister." She could have no idea of the wounds she inflicted with her portrait of her new role as "Madame van Gogh" and the domestic bliss she shared with Theo. "It's as if we had always been together," she wrote. "He always comes home at twelve o'clock for lunch and at half-past seven for dinner." Company, including family members, often joined them in the evenings, she reported. On Sundays—"so pleasant and cozy"—they spent the whole day together, just the two of them, sometimes visiting galleries, but sometimes staying home to "enjoy ourselves in our own way." Her schoolgirl hints of conjugal intimacies ("In general we are very tired at night, and we go to bed early") shook the foundations of Vincent's brotherhood and his manhood, just as her report that "hardly a day ever passes without our speaking of you" set off tremors of anxiety and guilt.

Vincent's sister Wil also flooded her brother with unthinking concern. Of all his siblings, his youngest sister had followed most closely in his tortured path. With no history of suitors and no prospects of any, Wil, like Vincent, seemed destined for a life of loneliness and introspection. His stay at the Saint Paul asylum licensed her to inquire about their shared lot. "Why are so many other people who try to make their way in life making more progress than I?" she wondered. Was she, like Vincent, the victim of some "fatal malady" that prevented her from enjoying a "regular life"? Talk of failed love and elusive happiness led inevitably to thoughts of Theo and his new life as husband and father. To frame her queries, Wil sent Vincent a copy of *Le sens de la vie* (*The Meaning of Life*), Édouard Rod's sentimental tale of a bourgeois lost soul who finds contentment and meaning in the arms of "a sweet and very devoted wife and his child" (as Vincent derisively summarized it). His mother wrote, too, celebrating Theo's latest triumph with an obtuse exuberance bordering on cruelty.

Books held dangers, too. Science may have pointed the accusing finger at his family, but in literature Vincent found that finger everywhere pointing back at him. Despite continuing to profess "boundless admiration" for the works of Naturalist writers like Zola and the Goncourts, he conspicuously abstained from reading them during his time at Saint Paul, fearing no doubt that their too-real temptations and look-in-the-mirror recriminations might bring on another attack. Instead, he turned to the philosophical melodrama of Ernest Renan's *L'abbesse de Jouarre,* a play about doomed lovers, stolid suffering, and a dutiful but loveless marriage. What could be less troubling than a stilted play about a defrocked nun making her way through the Terror?

Yet even here, provocations waited. Like Rod's anodyne morality tale of bourgeois conventionality and happy marriage, Renan's drama sanctified motherhood and portrayed loneliness as a fate worse than death. "The author finds consolation in the companionship of his wife," Vincent wrote ruefully, summing up both the Rod book and the Renan play. "It certainly is not very cheering . . . [and] it teaches me nothing about the 'meaning of life,' whatever is meant by that."

As in the Borinage, he sought escape in the distant world of Shakespeare, abstracted both by time and by language. He focused on the history plays—the only genre of the Bard's work that he had not yet explored—and no doubt found brave solace against adversity in *Richard II, Henry IV, Henry V,* and *Henry VI,* all of which he reported reading. But he also found tales of bad seeds and family degeneration, fraternal rivalry and filial betrayal, stolen or squandered birthrights, and heroes undone by immutable flaws.

Vincent defended himself against this gauntlet of unintended accusations and inadvertent provocations with a frantic mix of anger and denial. "With the number of precautions I am now taking," he assured his brother, "I am not likely to relapse." The most important precaution was to avoid the debilitating guilt that threatened to engulf him with each new letter from Paris. He parried Theo's financial anxieties with renewed pledges of hard work, campaigns of salable imagery (flowers and landscapes, especially), and elaborate schemes to resurrect business relations in England and Holland. He deflected Jo's hurtful intimacies by dismissing her as a sweet but superficial country girl.

He answered Theo's faint praise of his art with similarly tepid appreciations of Jo ("I dare say she will find the means to make life a bit more pleasant"), and filled his letters with private jokes, insider art talk, and paeans to Paris (which he knew Jo disliked), all insisting on his special place in Theo's life—a place that no wife, especially not the "plucky and brisk" Jo, could ever fill. He fended off his sister Wil's solicitude with a sharp attack on her naïve taste in reading matter ("good women and books are two different things," he sneered to Theo) and a

bleak counsel of hopelessness. "We have to resign ourselves to the obstinate callousness of the times and to our isolation," he wrote, predicting for her, as for himself, a life of "poverty, sickness, old age, madness and always exile."

He could counter Shakespeare's unfathomable fatality by reading the "mighty" Voltaire, who "at least gives a glimpse of the possibility that life may have some meaning," he noted. But nothing could protect him from the damning judgment he heard in his mother's joy. "I have not seen a letter of Mother's showing so much inner serenity and calm contentment—not for many years," he confessed to Theo. "And I am sure that this comes from your marriage. They say that pleasing your parents assures long life."

The ghosts of the Zundert parsonage had returned.

By mid-June, dangerous images were flooding into his imagination from every side. Obsessing about his mother and her delight over Theo's triumph, his thoughts returned again to the *Berceuse*, the icon of motherhood that had witnessed all his wretchedness in Arles. From the beloved *Berceuse*, his thoughts drifted to his long-frustrated love of figures and portraits, and the unfulfilled dream of the Bel-Ami of the Midi. "If I had someone like the woman who posed for 'La Berceuse,'" he wrote, "I'd do something very different yet." Soon, the familiar cry arose for subjects "with life in them"—human beings "transformed into something luminous and comforting, serene and pure," figures like those in Daumier's drawings or Zola's novels or Shakespeare's plays. "What has life in it too," he wrote, circling back to the original injury, "is that Mother is glad that you are married."

Before long, these old yearnings made the leap to canvas in a painting of the enclosed field below his bedroom window showing the lone figure of a reaper harvesting the golden wheat under a blazing yellow sky. He framed the luminous figure in a Shakespearean meditation that revealed the darker thoughts and deeper perils now loosed in his imagination:

> Aren't we, who live on bread, to a considerable extent like wheat, at least aren't we forced to submit to growing like a plant without the power to move, by which I mean in what way our imagination impels us, and to being reaped when we are ripe, like the same wheat?

Vincent had arrived in Saint-Rémy making light of religion (calling it "the rear end of some sort of Buddhism"), determined to avoid the obsessions that had upended his emotional world so often and with such catastrophic consequences in Arles. But both his letters and his art remained haunted by the quest to "prove that something very different exists as well," and he continued to muse vaguely about "the other side of life." Increasingly, he talked of art in the messianic terminology of a previous gospel. Artists, he said, exist "to give consolation

or to prepare the way for a painting that will give even greater consolation." He vainly protested that such thoughts represented "not a return to the romantic or to religious ideas, no." But his eye and his imagination said otherwise.

When Theo unthinkingly praised a Rembrandt drawing of an angel, Vincent began to see religious imagery everywhere: from the Delacroix "Pietà" on his wall to the other Rembrandt Bible scenes in his memory. Whether in Renan's stagy melodrama or Rod's sentimental claptrap, whether in Rembrandt's mysterious holy figures or Shakespeare's flawed heroes, he found "that heartbroken tenderness, that glimpse of a super-human infinitude" that led inexorably to thoughts of mortality and beyond. When Theo slipped again and mentioned Delacroix's *Education of the Virgin*, Vincent's thoughts returned to his own faïence virgin, the *Berceuse*, bringing the longing for family and the search for meaning together into a vortex of despair that could lead to only one place. Advising Wil in *her* moment of crisis, Vincent revealed where his had taken him: "I think it very brave of you, Sister, not to shrink from this Gethsemane." As if testing that sacred ground, he ventured into the olive groves around the asylum and painted the empty scene again and again, even as he admitted it was "too beautiful to dare to paint or be able to imagine."

Finally, in mid-June, he averted his eyes from the impossible, perilous figures in the grove by looking up and painting the starry night sky overhead. To do otherwise, he warned Theo, and himself, would "risk vertigo," and, with it, "a hopeless deluge of pain."

VINCENT'S FRAGILE DEFENSES (the "precautions" he bragged about to Theo) could barely withstand the threats that lurked everywhere in his own thoughts. Against the insults and indifference of the real world, they stood no chance at all. On his first excursion into the town of Saint-Rémy in early June, the old terror followed him as closely as his asylum escort. "The mere sight of people and things had such an effect on me that I thought I was going to faint and I felt very ill," he had reported to Theo after the trip. "There must have been within me some too powerful emotion to upset me like that, and I have no idea what can have caused it."

Peyron and his staff saw nothing of this dread as they watched Vincent puttering about his ground floor studio or bustling toward the asylum gates loaded with equipment on his daytime hikes into the countryside. Thus, when Vincent came to Peyron on July 6 and asked for permission to make a trip to Arles the next day, the doctor saw no reason to object, as long as an attendant accompanied him. Vincent talked about bringing his furniture back to the asylum and settling more permanently into his new home—apparently acquiescing to Peyron's recommendation that he extend his stay. "I must wait a year before think-

ing myself cured," he wrote Theo, "since the least little thing might bring on another attack."

Unknown to Peyron, that "little thing" had already happened. The very same day that Vincent asked to go to Arles, he received a letter from Paris with electrifying news: Jo was pregnant. "My dear brother," she wrote (in French for the first time), "I am now going to tell you a great piece of news . . . We're expecting a baby, a pretty little boy—whom we are going to call Vincent, if you will consent to be his godfather."

Jo's happy announcement did not summon up the lightning right away. Vincent collected himself and responded the same day with an effusive letter addressed to his "Dear brother and sister." "I congratulate you," he wrote. "I am very glad to hear it [and] I was much touched by your thought." But everywhere amid the cheery reassurances and hearty congratulations, black, charged clouds threatened. He complained of his "feeble health," crippling indebtedness, and feelings of remorse—all unchanged from the past; of his longings for alcohol, lack of companionship, and fears of mortality. Jo's news not only drove him to reverse his plan for a short stay in the asylum—agreeing with Peyron to another year at least—it also transformed his trip to Arles from a housekeeping chore (to retrieve some paintings for Theo) into a desperate lunge at a new life—a bid to undo the abandonment that now seemed sealed.

But he had no time and had laid no plans. At the end of the vertiginous train ride over the gorges, he found Arles virtually deserted of friends. He went to Pastor Salles's house but was told the parson had gone on a long vacation. He braved a visit to the Hôtel Dieu, where he had spent so many stormy nights, hoping to find Dr. Rey; but he, too, was gone. Someone said he had passed his examination and moved on to Paris; but the hospital porter, who undoubtedly recognized Vincent, would tell him nothing. He ended up spending most of the day in a café or brothel with a group that he described only vaguely as "former neighbors," suggesting that he did not see the Ginouxs either (his furniture remained in Arles), and that the only people who would sit with him were prostitutes and drinking companions that he had never dared name to Theo. With the asylum attendant looking on, apparently, he deadened his loneliness in the long-missed bliss of alcohol.

Even the detached Peyron noticed the change in Vincent after he returned from Arles. His agitated state and reports of his excesses while away may have prompted the director to cut Vincent's ration of both meat and wine in an effort to calm him. Even more ominous were the warning signs Peyron couldn't see: the waves of longing, regret, and self-reproach that poured from Vincent's pen in the days after his failed trip to Arles. Jo's announcement had plunged him deeper into the swoon of maternal feeling that began with his mother's letter in early July, beaming over Theo's marriage. In his congratulations, Vincent

struggled to console Jo's worries that Theo's persistent ill health portended a child with a weak constitution. He reminded her that the Roulins' baby Marcelle (whose portrait hung in Theo's new apartment) "came to them smiling and very healthy when the parents were in straits."

Talk of babies and images of motherhood, especially Madame Roulin, the model for *La berceuse*, wound Vincent ever more tightly into an obsession of maternal longing and identification. He compared parenthood to the "caressing but purifying" trials of the mistral that he knew so well, and predicted that becoming an uncle would help him "get back my interest in life." For the first time in years, he wrote his own mother a long and intimate letter ("I cannot tell you how happy I am with that letter!" Anna reported to Theo)—a letter burning with nostalgia for a homeland and a childhood that he had imagined, not lived. In a reverie of remembrance, he talked of Holland's moss-covered cottages, oak copses, beech hedges, and "the beautiful Nuenen birches" that he knew his mother loved. Under the guise of consoling her over the imminent departure of her youngest son, Cor, to the gold fields of the Transvaal in southern Africa, Vincent explored the most sensitive subject of all, their long estrangement, and even entertained fantasies of reconciliation. The "sorrow" of "separation and loss," he reminded her achingly, "helps us to recognize and find each other again later."

But everywhere he turned, he heard only the ghostly *horla*'s accusations: in Jo's reports of Theo's dire health and fears of the degeneracy he might pass on to their progeny; in his mother's even graver worries about Theo's frail constitution and the relentless demands placed on it, both past and future. Vincent defended himself with Panglossian nostrums ("illness sometimes heals us") and exhortations to patience and serenity: "A sickly condition is only the result of nature's efforts to right herself." But no words could comfort him; no arguments acquit him. In his mother's concern for Theo, he heard a defense of his old nemesis, Goupil; in his brother's bid for fatherhood, he saw the final victory of the unforgiving parson. When, in early July, news arrived that a Millet painting had sold in Paris for the astounding sum of half a million francs, Vincent felt not a vindication but an indictment. In the face of his own continued poverty and obscurity, he admitted, the sale caused him to suffer more, not less, from "the black need that always tortured Millet."

For days, he lived on a razor's edge of self-annihilating guilt. He heard accusatory voices even in the screeching cicadas outside his window at night. They spoke to him of a past and a future all now lost because "little emotions are the great captains of our lives, and we obey them without knowing it." The thought of Theo abandoning him, or dying, raised all the demons of the Yellow House. His mind fixed again on Monticelli, the mad Marseille painter of whom he had proclaimed himself the reincarnation. He discovered that a doctor at the asy-

lum had known Monticelli but considered him merely "an eccentric"—that is, only mad "a little . . . toward the end." Vincent found this strangely consoling. "Considering all the misery of his last years," he wrote, seeing himself and his own inevitable fate, "is there any reason to be surprised that he gave way under too heavy a load?"

He wrote a letter to Gauguin, the lone witness to his crimes, reaching out again for a pardon of normalcy. For Theo, he painted another of the garden vignettes that he knew his brother loved: an ivy-covered, sun-dappled corner of woodland shade that invoked not only old Barbizon favorites like Diaz, but also, in its luxurious paint and impossible mosaic of color, the madman Monticelli. In the studio, Vincent sorted through the paintings he had brought back from Arles and picked a few to send to Theo, tallying his failures with the grimness of the reaper that he watched from his window. "It is still hard for me to take courage again in spite of faults committed," he confessed in a letter that accompanied them.

Finally, beset by accusations on every side, he gave Theo permission to leave him. In a farewell letter so choked with emotion that it barely held his thoughts together, Vincent told his brother: "If you too find yourself faced with heavy responsibilities . . . honestly, don't let's be too much concerned about each other." Events had carried them "far from our youthful conceptions of an artist's life," he added inconsolably, and now Theo had his own family to care for. He ended his heartbroken adieu with a delusion of solidarity as vivid and haunting as any hallucination. Describing Theo as "an exile and stranger and poor man" like himself, Vincent sanctified their shared childhood on the heath ("it still remains with us, inexpressibly dear") and their brief "happy-go-lucky" partnership in Paris. That was a life they could now live "only in memory," he conceded. Past was past. The time had come to "meet our destinies."

Within days, if not hours, of writing that letter, Vincent was struck down by another attack. The explosion came on one of his painting trips in mid-July. Like all his encounters with nature, these excursions were fraught with peril. "The emotions that come over me in the face of nature can be so intense that I lose consciousness," Vincent later admitted. He had been warned. Only a day or two before, he had painted a view of the craggy Alpilles "with a dark hut at the bottom among some olive trees," he recorded. As he painted, a scene from Rod's *Le sens de la vie* bored into his thoughts: the little mountain cabin where Rod's hero found happiness with his wife and child—the "enchanted asylum," Rod called it. Vincent's imagination veered dangerously toward the image of Theo and Jo with "the child who is to come," and their tranquil life together—an image, he admitted, "that keeps haunting me."

But soon after, perhaps the next day, he found himself again confronting the fearful solitude of nature. He wandered even farther afield in search of "rather

wild places, where one has to dig one's easel in between the stones lest the wind should blow the whole caboodle over." His search took him to an old quarry, a jagged hole in the earth, abandoned for centuries—a lonely spot even on a bright summer day.

No sooner had he secured his easel and begun work than a furious gust of wind shot through the hollow like a cannon blast, scattering his canvas, easel, and paints. In a flash of metaphor, the wreckage of his little excursion became the wreckage of his life. Nature's crushing indifference rose over him; the quarry's biblical abyss opened beneath him. The consoling nature that "makes one feel more easily the ties that unite us all" suddenly turned cold and cruel as "a horrible feeling of loneliness overwhelmed me," he recalled. Then came a spell of dizziness. Then the darkness.

The Isolated One

~

*T*HIS TIME, THE DARKNESS LASTED FOR MORE THAN A MONTH.
From mid-July to the end of August, the attacks came again and again—"as much [as] if not worse than in Arles," Vincent later recalled. Spells of terrifying hallucinations were followed by faintness, vertigo ("at such times I don't know where I am"), and then unconsciousness. Each time, he awoke in a sea of amnesia and anguish. "I was so dejected," he said, "that I had no desire to see friends again or to work."

Each time he hoped would be his last. "A more violent attack," he feared, "could destroy my ability to paint for good." But instead, the attacks grew longer and fiercer; the intervals between them, shorter; his behavior, more bizarre and violent. Once, while in the garden, he scooped up a handful of dirt and began to eat it. Another time, he assaulted his asylum escort, accusing him of being a spy for the secret police.

With each escalation, the misery between attacks deepened and the leash of restrictions tightened. He was confined to the asylum; then to his dormitory; then to his room; then to his bed. He spent almost two months deprived of "open air." His throat swelled up with sores. He barely ate or spoke, and wrote no letters. At times, he longed for death, if only the next attack would be his last. "I hated the idea of regaining my health," he later recalled, "always living in fear of relapses . . . I preferred that there be nothing further, that this be the end."

For a while, he was allowed to work between attacks. He finished the quarry painting that had been blown away by the mistral. But each time, he had to ask for "permission to make pictures"—a humiliating ritual. Then the wardens caught him drinking kerosene from his lamp and eating the paint from his tubes. Fearing he had poisoned himself, they had to forcibly restrain him in order to administer an antidote. The doctors considered it a suicide attempt,

which is how Peyron reported it to Theo. They took his paints and brushes and locked him out of his studio. "Not being able to go to the room they have allotted me to do my painting in is almost unbearable," he wrote. When, in late August, he finally emerged from the storms of darkness long enough to lodge this grievance with Theo, he wrote it with a piece of chalk; they still did not trust him with sharp objects.

The attacks plunged Vincent into the netherworld of memory. "My mind has been *absolutely distraught,*" he wrote. In hallucinatory visions, he revisited places and images from his past. At least once, he imagined himself back in the Yellow House, pursued by the angry mob. He heard and saw (and may have spoken with) people he had known, read about, or seen in paintings—as in the Rembrandt portraits that forever reminded him of homeland and family. Figures had always crowded and conflated in his imagination—present and past, real and fictional—brought to life by aching nostalgia or the unrequited need for companionship. Now, fellow patients and asylum attendants took on the visages of the dead and the imagined. "During the attacks," he said, "the people I see are *entirely different* from what they are in reality, so much do I seem to see them in pleasant or unpleasant resemblances to people I knew in other times and places."

Religious figures, in particular, populated his visions. "The attacks tend to take an absurdly religious turn," he reported in September. "I get perverted and frightful ideas about religion." Vincent never described these spiritual apparitions and fits of hysteria, but throughout the summer, two images in particular obsessed his fevered thoughts.

By July, he had taken the print of Delacroix's Pietà down from his bedroom wall and pinned it close to his easel, as if to pin in his brain the image of a loving mother embracing her son's return from the dead. In the trials that followed, Delacroix's maternal icon took the place of the missing Berceuse. Between attacks, he riffled through magazines in search of other consoling images of motherhood, and sang songs from his childhood. At one point, he collected himself enough to write to the Roulins, the Berceuse's real family, merging memory, imagery, and delusion into a fantasy of redemption.

Before he was locked out of his studio, he tried to make a painted version of Delacroix's ineffably comforting scene, determined to "do portraits of saints and holy women." But in an unexplained stroke of "bad luck"—another attack, perhaps—he dropped the precious print, and others, "into some oil and paint," ruining the lot of them. "I was very sad about it," he noted grimly.

The other image that fixed itself in his mind that summer was of an angel. Theo had summoned it in June, setting off a tremor of self-accusation and remorse. Then, in late July, as Vincent was battered by wave after wave of attacks, a gift arrived from his brother: a print of Rembrandt's painting of the archangel

Raphael—a vision of benevolence and light, as radiant as any of Vincent's Midi suns, announcing not just the miraculous birth to Mary, but the divine consolation of motherhood to all. Unknown to Theo, however, Vincent saw in Rembrandt's angel not just a welcome messenger of comfort to the "broken-hearted and dejected in spirit," as he had written a decade earlier, but also the accusing image of his father (who preached with "the countenance of an angel"), warning of the reckoning to come.

In September, when Vincent was allowed to paint again (with a warden watching), among the first images that emerged out of the wreck of his head and his studio were the Delacroix Pietà and the Rembrandt angel—big color versions of the little gray prints that had buoyed and tormented him through the endless storms: the loving mother and the sublime nuncio. When he painted these images, he saw his own features in the face of the levitating Christ, and gave the colorless angel his own sunburnt hair. These two pictures—painted half in darkness, half in light—were as close as he would ever come to documenting the images that ravished and ravaged his mind that summer.

VINCENT EMERGED IN late August shaken, afraid, and alone. The attacks ended abruptly; an "interval" just like any other lengthened into days, then into weeks. But "everything remains in doubt," he cautioned Theo. "I myself am *counting* on it to return." The threat of another relapse haunted him. He still suffered spells of dizziness and paralyzing fits of dread. His days were still filled with "solitude and anguish," he said; his sleep, with "abominable nightmares." Despite the void of loneliness, he feared seeing anyone or going anywhere. The risks were too great. He clung to the safety of solitary confinement long after the doctors had given him permission to go outside again. Even a trip to his studio was fraught with perils. "I've tried to force myself to go downstairs," he confessed, "but in vain."

His fellow patients now terrified him. Months of hallucinatory visions and paranoid fantasies had shattered the solidarity he once felt for his "companions in misfortune." Now the very proximity of so many "queer souls" upset him, and their "vegetative" idleness, he suspected, threatened his recovery. He compared them to the "gawking idiots" who had driven him out of the Yellow House, and accused them, too, of secretly harboring superstitious ideas about painters and causing him "no end of pain." He vowed to "limit my relations [with them] for fear of falling ill again." His paranoia extended to staff members as well. He suspected them of cheating on his bills and poisoning his food. He blamed them for spreading false rumors about his bizarre behavior during the attacks that summer, and accused them, too, of bearing an implacable prejudice

against painters. He compared them to money-grubbing landlords—the lowest of the low—who needed to be told regularly to "go to hell."

Tapping the deep well of antipapism in his own past, Vincent insinuated that Catholic authorities, not Dr. Peyron, actually ran the asylum, and he singled out the handful of nuns on the staff as the agents of this dark, controlling power. "What disturbs me," he wrote, "is the constant sight of these good women, who both believe in the Virgin of Lourdes and make up that sort of thing." He began to see himself as a prisoner in an institution devoted to "cultivating unhealthy religious aberrations" rather than curing them. He cited the religious character of the attacks that summer as proof of this nefarious influence. Why else would a man of "modern ideas"—a man who admired Zola and abhorred religious exaggeration—have the "perverted and frightful ideas" of a superstitious peasant? he demanded.

Indeed, he was so "sensitive to [his] surroundings" that the prolonged stay in the old cloisters of Saint Paul (and before, that, the Hôtel Dieu) "would be enough to explain these attacks," he argued. Eventually, his paranoia embraced not just the asylum's patients and staff, but the surrounding countryside as well, and indeed the entire region. He saw "a general evil" lurking everywhere, waiting to ensnare him even if he wandered into the garden. When he finally dared a dash to his studio in mid-September, he locked the door behind him.

Escape seemed the only answer. Even in the midst of his attacks that summer, Vincent imagined fleeing Saint Paul. As the weeks passed without a relapse, his thoughts returned again and again to "giving the slip" to his jailers. "We must finish with this place," he wrote Theo anxiously. "In the long run I shall lose the faculty for work here, and that is where I draw the line." When Dr. Peyron refused "point-blank" to take him on a trip to Paris ("It was too sudden," Peyron told him), Vincent began drafting elaborate escape plans.

He seized on Theo's report about the hard luck suffered by Camille Pissarro, who had gone to live in the countryside near Paris. Vincent imagined moving in with the old man and his shrewish wife. Better that Theo's money go to "feed painters," he argued, than to support nuns. When Theo told him "it was not the right moment" to approach Pissarro, Vincent opened up the plan to any comers. Surely, "one or another of the artists who is hard up will agree to keep house with me," he pressed. As candidates, he listed artists he barely knew and some he knew too well. "What you say about Gauguin interests me very much," he ventured incredibly. "And I still tell myself that Gauguin and I will perhaps work together again."

If no one would take him, he threatened, then he would go *anyplace*—a prison, the army, the street—to escape the terrors of the asylum.

But leaving, too, terrified him. The prospect of confronting the real world

again, and the fear of what might happen if the next attack struck him in public, combined to freeze him in place. "To leave now," he wrote in early September, "would perhaps be too foolhardy." He begged off all his elaborate plans with pleas for just "another few months," and warnings of the unbearable dangers that awaited him in the outside world. "All in all," he concluded, "I *prefer* to be definitely ill like this than be the way I was in Paris when all this was brewing." As if to document the torment he felt, trapped between the terrors within and terrors without, he started a self-portrait as soon as he returned to his studio. He described it as a "thin and deathly pale" figure with sunken cheeks and haunted eyes. His yellow hair stands out against a radiating darkness, a *rayon noir,* of deep purple, and a ghastly green shadow crosses his face.

It was an image that he could never share with Theo. The child on the way made returning to Paris "impossible," he acknowledged. His first and only fraternal duty now was not to worry his brother. He had withheld news of his attacks that summer for as long as possible, and may have persuaded Peyron to do the same. His very first report in August, the one in chalk, began with an apology: "I hope it is not complaining too much if I tell you these details." After that, he tried in every way to minimize his plight. "I have been feeling better since I wrote you," his next letter began.

Every spontaneous outburst of pain ("I am in a very bad humor, things aren't going well") was followed quickly by soothing assurances of improvement ("Day by day my strength is returning") and even hope for ultimate success ("Perhaps my journey to the south will yet bear fruit"). When he heard that Peyron would visit Theo in Paris, he launched a frantic campaign to discredit the doctor and any distressing news he might bear. "The good M. Peyron will tell you heaps of things," Vincent warned, "probabilities and possibilities, and involuntary acts. Very good, but if he is more precise than that I shall believe none of it."

To bolster his message of reassurance, Vincent painted a second self-portrait, this one showing him poised and groomed like a faïence figurine, dressed in a crisp new linen suit of celadon green set against a background of powder-blue swirls as serene as a starry night. "Work is going very well," he wrote as he painted.

> I am discovering things I have sought in vain for years, and, aware of that, I am constantly reminded of that saying of Delacroix's you know, that he discovered painting when he had neither breath nor teeth left.

The difference between these two self-depictions—one to be shared, the other hidden—betrayed the gulf opening up between Vincent and his brother. Even before the attacks started in July, Theo had begun slipping away. His letters were always late, often unresponsive, and occasionally hurtful. He talked

of pleasant weekends in the country, interior decoration, and Jo's morning sickness. Not until weeks after Vincent stopped writing did he notice the silence from Saint-Rémy. Between problems at the gallery (Monet had taken his success to another dealer), the demands of a new wife, and the worries of a family to come, Theo's attention was focused elsewhere.

Vincent tried to retrieve it with a flood of multipage, diary-like letters in early September, but he had to wait longer and longer for each reply. For weeks, he argued his plan of escape from the asylum, even threatening to come to Paris after all. But Theo blocked every exit. No artist had room or desire to take Vincent in, he reported. Pissarro had rejected the idea outright. Brittany was even more dangerously religious than the Midi, which put Gauguin out of the question. Indeed, no place in the North was suitable because "you know how you suffer from the cold," Theo reminded him. Vincent could not be trusted to live alone, and any companionship threatened to "enervate" him. Finally, Theo put an end to the conversation with a stark instruction: "Do nothing imprudent . . . Stay under the supervision of a doctor."

Other family members, as always, followed Theo's lead. After months of largely ignoring Vincent's embarrassing confinement, his mother and sister Wil moved to Leiden from Breda, abandoning the Brabant of his childhood. At almost exactly the same time as Theo began his family in Paris, brother Cor left for Africa (without a word to Vincent), thus dissolving the last vestige of unity from the Zundert parsonage. In a desperate bid to hold it together, Vincent sent paintings and greetings (for his mother's seventieth birthday) and plaintive affirmations of their unbreakable bond. "I feel a nearly irresistible urge to send something of my work to Holland," he wrote Wil. "One goes on clinging to the affections of the past." He carefully allocated his paintings among family members and old friends (including Margot Begemann), yet urged the recipients to "keep them all together," as if he could bind the past in place with his art. "I certainly have a right," he said, acknowledging the flight away from him, "yes, a *right* to work from time to time for friends who are so far away that I shall probably never see them again."

ABANDONED BY FAMILY, afraid of the asylum staff, and threatened by every other human contact, Vincent escaped into his work. As always, he was convinced that only furious labor could restore his equilibrium and keep the demons of illness at bay. "Work distracts me infinitely better than anything else," he wrote. "[It] strengthens the will and consequently leaves these mental weaknesses less hold." As soon as the door to his studio was unlocked, he threw himself into it "with all my energy possible." Within the first week, he had begun a dozen canvases. He started with all the images that had burned themselves into

his imagination during his long solitude: the Pietà, the angel, the face in the mirror, and, especially, the view from his barred bedroom window.

Working as long as the wardens would let him—"morning, noon and night," he told Theo—he revisited canvases begun before the attacks, and retouched others he had considered finished. Proclaiming a new dawn and a ripe harvest, he started another version of *The Reaper*, depicting the little figure working tirelessly outside his window at sunrise. He used an identically huge canvas and completed it within days. Throughout his long ordeal, the painting of his Arles bedroom had sat in his studio. Right before the attacks, Theo had returned it for some repairs, but Vincent had left it rolled up, fearing it might further roil his troubled brain. Now he fearlessly unfurled it and began another version, on another big canvas.

He finished that one in the first week, too, and immediately laid plans to repaint a raft of favorite images from the Yellow House: the vineyards, the Crau, and "above all, that Night Café." Ordering vast new supplies of materials, he imagined painting reduced copies of all his "best canvases" to send to family members, and then starting a new series of "autumn effects"—all by the end of the month. It was the beginning of a stupendous outpouring of work—almost a painting every other day for the next eight months—racing to keep his hands busy and his mind distracted. "I am working like one truly possessed," he wrote, "more than ever I am in the grip of a pent-up fury of work, and I'm sure it will help to cure me."

As always, he longed most to do portraits. But his confinement to the asylum meant he could only recruit models from among his fellow patients ("an impossibility," he conceded) or from the staff. He apparently did succeed in persuading one befuddled, blank-eyed inmate to pose in his hospital robe for a quickly slashed portrait. But the only true sitters he could find were the two wardens who were paid to watch him while he painted. One was Jean-François Poulet, the young attendant who had often accompanied him on excursions outside the asylum. The other was Charles Trabuc, the elderly chief warden who lived with his wife in a house on the grounds.

Universalizing his tiny world of human companionship, Vincent painted both men as types: Poulet as the smiling local peasant boy in straw hat and colorful shirt, set forever in the outdoors he called home; Trabuc (known as "the Major") as a stiff, unsmiling grandee of authority. Dressed in his official black-and-white striped jacket, colorless and humorless, Trabuc becomes in Vincent's austere portrait a symbol of the rigidity and morbidity of the asylum, the church, the region, and life. "He has a military air and small, lively, black eyes," Vincent wrote, "a veritable bird of prey . . . very much a Southern type."

The limited palette, careful rendering, and heads-of-the-people ambition of the Trabuc portrait announced yet another front in Vincent's campaign of

work: the past. He had emerged from the summer, as he always did from attacks, "overwhelmed with memories as by an avalanche." Haunted equally by these hallucinatory visions and by the reality of his disintegrating family, Vincent fell into a reverie of regression. He reported feeling "homesick" and "swamped by over-melancholic nostalgia." To placate these ghosts, he immersed himself again in his scrapbook of the past: his portfolio of prints. The Delacroix Pietà and Rembrandt angel had cracked open a door, an escape hatch, into a previous obsession as consoling to him in his isolation at Saint Paul as it was in The Hague. In the first week of September, he sketched out a grand plan to transform his collection of beloved images into a studio full of color paintings. If he could not find models among the strangers that wandered about him all day, he would find them in the intimates of his *musée imaginaire*.

He began where his artistic journey had begun: with Millet. A decade earlier, when he escaped from the Borinage with nothing more than an ambition to be an illustrator, he had started by copying Millet's famous series depicting laborers in the fields, *Les travaux des champs.* In his little room in Cuesmes, perched on his rickety camp stool with his sketchpad on his knees, he had made copy after copy, laboring intently over the scenes of woodcutters and sheep shearers, threshers and sheaf binders. Now, once again, he reached out to Millet's rustic icons from the depths of the black country.

Using the skills of squaring and enlarging that he had honed on his Japanese

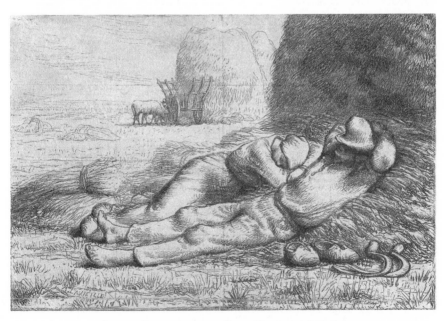

ADRIEN LAVIELLE AFTER JEAN-FRANÇOIS MILLET,
The Siesta, 1873, ENGRAVING, $5^5/_8$ X $8^3/_4$ IN.

prints in Paris, he drew a grid on the tiny black-and-white images and transferred them one by one to canvas. He lavished each with contrasting colors—mostly yellows and blues in broken tones—and flights of impasto. He varied the sizes from very small (15½ inches by 9½ inches) to very big (three feet by two feet—as big as *The Bedroom*), and never felt bound by Millet's uniform proportions. He took pains to fill in backgrounds and flesh out faces.

Within two weeks, he had finished seven of Millet's ten figures and started an eighth. By the end of a month, he had exhausted *Les travaux* and moved on to engravings of other artists' works—although he begged Theo to send him more Millet: in particular, *Les quatre heures de la journée* (*The Four Hours of the Day*). His plans stretched months into the future—to more Delacroix and more Rembrandt, and then to Doré and Daumier—until he had amassed a collection "large and complete enough to give the whole to a school," he said. And then he would attack the world beyond prints: drawings. Millet had done drawings that never made it onto canvas, after all, and painting them "might make Millet's work more accessible to the great general public," he imagined. "Perhaps I would be more useful doing that than doing my own painting."

Vincent gave various accounts of this bizarre, bottomless, backward-looking project. At first, he attributed it to the lucky "accident" of spoiling some prints and needing replacements as decorations. ("I don't especially like to see my own pictures in my bedroom," he explained.) As the task grew, he cited bad weather and lack of models as reasons for continuing it. Elsewhere, he defended it as essential to his recovery. The discipline of copying ensured a "clear mind" and "sure fingers," he told Theo. One day he described it as a drudging necessity—like his drawing in the Borinage—the only way to make up for lost time and past failures ("those ten years of unfortunate studies that didn't come off"). But another day, he claimed for his new direction a loftier artistic purpose. Rising to the rhetorical heights and evangelical fervor of The Hague, he argued that figures, far from being relics of a past art, pointed the way to Impressionism's future. By applying the new gospel of contrasting color to these venerated icons of the primitive, he could do for figure painting what Monet had done for landscape.

To justify this great turn backward in his imagination, this desperate "clinging to the affections of the past," Vincent insisted that he wasn't just copying these images, he was *"translating them into another tongue"*—much the way Jo translated books from English to Dutch. Instead of simply re-creating the palette of the original, he "improvised" the color in an effort to find "the vague consonance of colors that are at least right in feeling." Thus, the new work became *"my own* interpretation," he emphasized. "Isn't it like that in music?" he asked, piling up ever more elaborate and poetic reasons for his recherché imagery. "When a person plays Beethoven, he adds his own personal interpretation." Is that not what Jo did when she played the piano for Theo? Painting was the same

for him, he argued. "My brush goes between my fingers as a bow would on the violin, and absolutely for my own pleasure."

The real reason was clear enough; and Vincent eventually admitted it. "Because I am ill at present, I am trying to do something to console myself," he wrote. "I find that it teaches me things, and above all it sometimes gives me consolation." A decade earlier in the Borinage—the last time Theo sent him *Les travaux*—Vincent had climbed out of the darkness with a vision of fraternal solidarity in the "land of pictures." Now, only a fantasy of fraternal reunion could save him. The endless reworkings of Millet were just the most visible part of that fantasy. In search of comfort, his reveries took him back to Henri Conscience, the Belgian writer beloved of both brothers, whose evocations of life on the heaths "bucked me up," he said. He laid plans to move to a farm for a year and "live with the ordinary folk." As in Nuenen, he would take up the "virile and complete" life that could only be lived in the country.

Theo welcomed the return of Vincent's peasant delusions as a sign of recovery, and encouraged them by referencing the noble miners and puddlers of another Belgian, Constantin Meunier, along with images of farmers' daughters "as fresh as young cows" and paintings done with the "wholesomeness of brown bread." From these strands, Vincent wove a thrilling and consoling vision. Henceforth, he would live his life in mirror parallel with his brother: the rustic trueheart to Theo's urban sophisticate (the "wooden clogs" to Theo's "patent-leather boots"); the artist to his merchant; the monk to his married man; the creator to his procreator. On the mystic heaths of memory, laboring every day on images that "smelled of the earth" like Millet's peasants, he would take up the country life that he knew Theo, in his heart, longed for over the din and distraction of Paris. He would live for *both* of them, he imagined, experiencing the "simpler and truer nature" that they would always share—in art as well as in thought—in a place where Jo could never intrude. "Oh, my dear brother," he wrote, "a thing like that is not felt, nor even found, by any chance comer."

A DECADE EARLIER, Vincent had imagined his way out of the black country with a Barbizon-like fantasy and the promise of the Rijswijk road ("two brothers . . . feeling, thinking and believing the same"). At the asylum of Saint Paul, his new vision of a brotherhood of the imagination—a union more perfect than any marriage—lifted him out of the darkness. By mid-September, he reported "feeling completely normal" and "eating like a horse." In the studio, he devoured canvas, too, as image after image appeared at the asylum door, stacked to dry. He begged Theo for copious quantities of new materials and sent off bundles of paintings to signal his resurgent strength. Step by step, he ventured from the safety of the studio and returned to the outdoors, painting as he went: first to

the asylum garden; then to the enclosed field outside his window; and finally, as October began, to the world beyond the wall. "I have feasted upon the air in the hills and the orchards," he announced triumphantly.

He arrived just in time for fall. "We are having some superb autumn days," he wrote, "and I am taking advantage of them." Like a sailor on shore leave after a long voyage, he spent his brush profligately on the season's voluptuous color. He painted a pair of poplars by the road as two jets of flame shooting into a violet sky. He painted a simple mulberry tree—not much bigger than a shrub—as an orange-and-red Medusa with leafy ringlets filling an entire canvas. He tested his hand on all the styles of the past, from the thin paint and loose fabric of Paris to the sculptural impasto of Monticelli; from swarms of Impressionist brushstrokes to plates of Japanese color. He laid on paint with the lightest possible touch—mere glances of hue—to show the falling of leaves; then loaded his brush with spades of pigment to paint the serpentine web of bare tree limbs left behind. His palette, too, flexed all the ardors of the past: from the broken tones and quiet harmonies of Nuenen, to the pastel mirages of the Grande Jatte, to the pungent yellows and fathomless blues of Arles.

He tested his mind as well as his hand. On one of his first excursions outside the asylum walls, he ventured into an olive grove, a subject fraught with the perils of Gethsemane. He not only painted the rows of twisted trees and silvery leaves, he found someone to sit for a portrait. The hospital's chief warden, Trabuc, lived beside the grove, and his wife, Jeanne, agreed to Vincent's importunings. Not since Madame Roulin, the inspiration for *La berceuse,* had a woman modeled for him. With a confidence that seemed unthinkable only weeks before, he painted a careful likeness of her "tired, withered, sunburned face," using a panel, not a canvas, just as Monticelli had often done.

Before long, he ventured farther still—into the foothills of the Alpilles, where the winter wind already howled. It had been three months since that wind upended his easel and his sanity. "But never mind," he wrote his sister Wil, "now my health is so good that the physical part of me will gain the victory." He descended into a "very wild ravine" and somehow secured a huge canvas at the edge of the rocky stream that ran through it. He painted the looming cliffs "all in violet," with a hardy pair of hikers making their way through the shadowy gorge. Pleased with the result, he imagined himself strong enough to do a whole series of such "stern" alpen scenes, boasting "I am more up to it."

Next, he trekked to the edge of the quarries, not far from the site of his collapse in July. He anchored his easel with rocks and painted a sumptuous, defiant canvas of color and light. The bright Midi sun plays off the rocks in streaks of pink and blushes of blue. Light reaches to the very back of the cave, filling it with lilac and lavender. Out of its craggy mouth, a figure strides fearlessly forward, unfazed by loneliness or vertigo.

With every successful expedition, every safe return, every new canvas propped outside the studio to dry, the fear of another attack ebbed and his confidence surged. "I have become more master of myself," he crowed, "my health has steadied. . . . I have not got soft yet." His doctors, too, saw light at the end of the tunnel. When Peyron visited Theo in late September, he marveled that his patient seemed "absolutely healthy"—not yet ready to leave the asylum, perhaps, but clearly on that path. The good report to his brother elated Vincent and sent his own thoughts racing into the future. Theo boosted his spirits still higher with a report from Pissarro about a doctor in Auvers, a bucolic town north of Paris, who might take Vincent in when the time came. "What you say of Auvers is a very pleasant prospect," Vincent shot back, "we must fix on that."

In the same letter, Theo heaped praise on the latest paintings to arrive from Saint-Rémy, the fruits of Vincent's rehabilitation. They had, he said, "that unshakable something which nature has, even in her fiercest aspects." He also announced the arresting news that his friend Jozef Isaäcson planned to write an article about Vincent for a Dutch art review, *De Portefeuille* (*The Portfolio*). But this was only part of a curious pattern, Theo reported. More and more often, people in Paris were approaching him and asking to view Vincent's work. They had seen it at the fall *Indépendante* show, where both the first *Starry Night*—the one from Arles—and the *Irises* of May shared the walls with works by Seurat, Signac, and Toulouse-Lautrec. Or at Tanguy's. Or they had heard that Vincent was invited to show in January with the Belgian group Les Vingt (The Twenty)— the premier showcase for avant-garde art outside Paris. Only the year before, Gauguin had been invited to exhibit there, but not Vincent.

The good reports from both Theo and Peyron brought Vincent's ambitions bounding back. Only a month earlier, still shadowed by the weeks of attacks, he had almost withdrawn from the Vingt show. "I'm conscious of my inferiority," he had written then, wondering dolefully if the show's organizers would even remember that they had asked him to participate, and, indeed, if "it might be preferable if they did forget all about me." After months of shying away from his old comrades, he boldly wrote to both Gauguin and Bernard: chiding and cajoling, patronizing and browbeating, as if the storms of summer had never happened. "I intend to return to the charge," he told Bernard (whom he had not written in a year). Reasserting his rightful place in the vanguard of the new art, he proposed exchanges and requested updates on both artists' latest work. He flattered and joked and reaffirmed their shared commitment to the primitive beauty and truth of *japonisme*. Without revealing the demons of the summer, he vehemently warned them against using religious imagery in their work and summoned them instead to brotherly solidarity in the quest for the deeper truth—"something one has a firm faith in"—that he had found in Millet, not the Bible.

Vincent's new confidence also revived other, older aspirations. "If I again start trying to sell, to show, to make exchanges," he wrote Theo, empowered by the news of exhibitions and outreach to old comrades, "perhaps I shall succeed a little in being less of a burden to you." To prove his commercial bona fides, he immediately began a series of "autumn-effect" paintings: conventional scenes of shadowy forest canopies and tree-lined, leaf-strewn paths, all colored in muted tones and brushed with a schooled restraint. These overhead versions of the ivy-laced garden corners that Theo loved so much showed little of the imaginative freedom, extravagant brush, or spontaneous form of his Alpilles horizons or midnight visions of the summer sky. But they *were* salable, according to his dealer brother. "You are stronger when you paint *true* things," Theo wrote in late October, singling out the "the underbrush with ivy" as a particular favorite.

Vincent's new pursuit of sales eventually forced him to renounce the great visions of summer. Theo's advice also singled out the more recent *Starry Night*, the one painted in June, for special criticism. "The search for some style is prejudicial to the true sentiment of things," he wrote, dismissing all such "forced" images as the product of an errant "preoccupation." Gauguin's recent works had shown a similar trend toward abstraction, Theo lamented, using the word to refer to any image that had no basis in reality. As a result, the *entresol* storeroom was filling up with Gauguin paintings "less saleable than those of last year." Theo's disapproval extended not just to the biblical scenes that frightened Vincent, but to all the pretentious exertions of Symbolism. "Those things that satisfy one most," he said, "are the wholesome, true things without all that business of schools and abstract ideas."

Vincent not only agreed in principle ("it is better to attack things with simplicity than to seek after abstractions"), he confessed to having erred in the past with images like *La berceuse* and the second *Starry Night*, both of which he dismissed as "failures." "I allowed myself to be led astray into reaching for stars that are too big," he wrote, "and I have had my fill of that." To prove to Theo his determination to do better, he immediately followed the autumn scenes with a project of far grander commercial ambitions. What Monet had done in Antibes and Gauguin in Brittany, he would now do in the South. In a vast projected series of paintings he dubbed "Impressions of Provence," he would capture the primitive essence—"the true soil"—of the country.

The series would include images of sunrises and sunsets; of "the olive and the fig trees, the vineyards and the cypresses"; of "the scorched fields with their delicate aroma of thyme"; and of the Alpilles set against "the sun and the blue sky"—all painted with "their full force and brilliance." With images such as these, he imagined, he could "disentangle the inner character" of the place using not abstraction but simplicity, not "vaguely apprehended" symbols but "feeling and love." The scale and promise of the plan for success so possessed

him that he wrote Theo's friend Isaäcson urging him to delay his article until the new series was complete. Only then could he "feel the whole of the country," Vincent insisted, invoking the godfather of the new art: "isn't that what distinguishes a Cézanne from anything else?"

He began his grand new project with another round of paintings in the olive groves. Theo had already approved the subject, and in late September Vincent had announced his intention to "do a personal impression of them, like what the sunflowers were." Here amid the storied trees with their gnarled trunks and silvery leaves, he could both prove his strength against the demons of the past and demonstrate his allegiance to Theo's commercial imperatives of "wholesomeness" and "true sentiment"—of art without affectation.

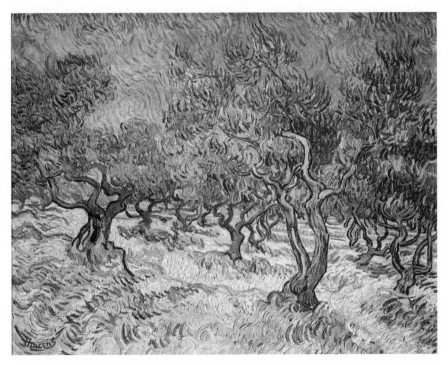

Olive Grove, JUNE 1889, OIL ON CANVAS, 28³/₈ X 36¹/₈ IN.

One after another, Vincent painted four big canvases in the first weeks of November, each one showing the ancient groves from a different angle, at a different time of day, in a different mood: against a rising sun and a setting sun; under a yellow sky, a green sky, and a pale blue sky. He painted them with a red-and-green ground, with a blue-and-orange ground, and against a lavender-and-yellow mountain vista. He painted them with their emerald foliage flaming like the cypresses, and with their silvery underleaves sparkling like stars. He painted not with the loaded brush of Arles (Theo disapproved of his

heavy impasto), but with a loose fabric of short strokes evoking the atmosphere of Seurat and the brushwork of Gauguin. In his descriptions to Theo, he stressed the roots of these images in "hard and coarse reality"—"[they] smell of the earth," he said—not in studio calculations.

But how could he capture the true essence of Provence without figures? Gauguin wrote alluringly about his studies of Breton peasant women working in the hemp fields and gathering seaweed. He boasted of his plan to paint fifty pictures that would "instill in these desolate figures a wild quality I perceive in them and also within me." Without figures, how could Vincent aspire to the primitive truth, fraternal approval, and inevitable commercial success of images like these? And how could he paint figures without models? What could be more real—less abstract—than flesh and blood? The Millet peasants that lined his studio mocked the ambitions of the Impressionists, he said. " 'But look here,' " he imagined them taunting him, " 'when shall we see these country men and women of yours?' " "As for myself," he replied abjectly. "I feel a disgrace and a failure."

Driven by thoughts like these, and bursting with new confidence, Vincent departed on a journey unthinkable only two months before: to Arles.

Securing permission to go had not been easy. Peyron still blamed the last trip to Arles in July for "provoking" the crisis that summer. He had told Theo in October that Vincent would have to "pass many tests" before he could be trusted to travel so far again. But as the days without a relapse accumulated, it became harder and harder to resist Vincent's pleas. In late October, Theo sent extra money for the journey. A few days later, Peyron gave his final approval. "[He] said that there is considerable improvement," Vincent reported, "and that he has good hopes for me." The trip that began two weeks later, in mid-November, seemed to confirm Peyron's optimism. This time, everything went according to plan. Vincent saw Pastor Salles and collected the money he had been holding for Theo. He boldly bought "a stock of paints" for the great venture that lay ahead.

But, most important, he saw Madame Ginoux.

Ever since he missed seeing her in July, Vincent had been fantasizing about his reunion with the proprietress of the Café de la Gare, who had posed for him and Gauguin exactly one year earlier. Theo's friend Isaäcson had seen Vincent's portrait of her and complimented it. "I am glad to hear that someone else saw something in that woman's figure," Vincent had written in June, "though I think that the merit is in the model and not in my painting." Since then, he had thought often about the statuesque Arlésienne with the raven ringlets and Mediterranean temperament. In October, he wrote Theo vaguely about "some people" in Arles "whom I felt, and again feel, the need for seeing"—the vagueness required to hide either a sudden spasm of desire or a long-simmering infatuation with a woman he barely knew.

It had happened before, as Theo knew too well: a friendly female face exaggerated by loneliness and maternal longing into a fantasy of fondness, and even intimacy—a delusion that could only lead to overreach and heartbreak. Just two years earlier, in Paris, when Theo first abandoned the rue Lepic apartment to woo Jo Bonger, Vincent had wandered into these dangerous waters with Agostina Segatori, another sensuous, sloe-eyed café proprietress. That episode had ended in disaster. To avoid those memories, Vincent cloaked his ardor, as he had so many times before, in artistic imperative. "I despair of ever finding models," he complained when he heard of Isaäcson's compliment. "Ah, if now and then I had someone like [Madame Ginoux] . . . I'd do something very different yet."

On his trip in November, Vincent not only found his model, but apparently persuaded her to pose for him. She may have stood for his pencil, or merely allowed him to sketch her as she went about her chores. But when Vincent returned to the asylum two days later, he immediately sat down and memorialized his visit by painting another olive grove and inserting his Dulcinea at the foremost tree, arms upstretched, plucking the ancient fruit. He dared not share his triumph with Theo, but only hinted at it between the lines of his report: "It is a good thing to show yourself there from time to time," he wrote about Arles, "they were very friendly, and even welcomed me."

In the days after his return, anything seemed possible. To Theo, Vincent couched his optimism in caution. "We will wait a little first to see if this journey will provoke another attack," he wrote. "I almost dare to hope it won't." But the long streak of good health capped by the successful trip was already steeling his confidence and catapulting his thoughts into the future. He imagined leaving the asylum and returning to Arles where, he claimed, "at present no one has any antipathy toward me." He talked of being "cured" and coming north in the spring when, he predicted, "we shall not even need the doctor at Auvers or the Pissarros." His mind even drifted to the images he would make when he returned to Paris and could focus his newfound strength, his truth-telling brush, and his clear southern color on the gray city that gave birth to the new art.

His ambitions raced forward and backward at the same time. He hatched plans for selling his paintings in England ("I know well enough what they look for there") and boldly wrote Octave Maus at Les Vingt listing the six works he expected to hang in the upcoming Brussels show—more than twice the allotment per artist. He imagined a world in which art could be brought to the common people by a means less expensive than oil paints and less cumbersome than "grandiose exhibitions." "Oh, we must invent a more expeditious method of painting," he wrote, rallying Theo, as he did in The Hague, to a world in which "a picture will become as commonplace as a sermon" and even the humblest worker "could have in his home some pictures or reproductions." He imagined

producing lithographs of his own canvases in order to make them "more accessible to the public"—turning on its head his Millet project of translating prints into paintings, and reviving the distant mirage of popularity.

With old ambitions and old ardors came old angers. Vincent returned from Arles and found two letters waiting for him, one from Gauguin and one from Bernard. Both contained alarming news. Gauguin's boasted of recently completing a picture of Christ in the Garden. "I think you will like it," he wrote; "it has vermilion hair." Bernard's reported a whole studio full of biblical images, including his own version of the scene at Gethsemane. Theo had visited his studio in Paris and sent Vincent a detailed description. It is "a kneeling figure surrounded by angels," he wrote, "very difficult to understand, and the search for a style lends to the figures a ridiculous quality." The report about Bernard, especially, infuriated Vincent. He replied immediately with a contemptuous echo of his brother's criticism. "Our friend Bernard has probably never seen an olive tree," he sneered. "Now he is avoiding getting the least idea of the possible, or of the reality of things, and that is not the way to synthesize—no."

A few days later, when Bernard sent photographs of the offending works, Vincent erupted in righteous indignation. "Those biblical paintings of yours are hopeless," he lashed out: "bogus," "spurious," "appalling"—a "nightmare," and, worse, "a cliché." In a tone that wavered between brotherly condescension and apoplectic derision, between *tu* and *vous*, he demanded that Bernard abandon his "medieval tapestries" and "tremble" before the one true God: the God of "what is possible." How dare he trade the "spiritual ecstasy" of the truth for the vagaries and falsities of imagined figures in dreamlike settings? "Can that really be what you mean to do?" he thundered. *"No!"* In terms as cataclysmic as his letter to Anthon van Rappard in defense of *The Potato Eaters,* Vincent called on Bernard to turn back from the "danger in those abstractions" and "immerse" himself once again in reality—as Vincent had done. "I ask you one last time," he raged, "shouting at the top of my voice: please try to be yourself again!"

This letter, like the earlier one, ended a friendship. The two artists never corresponded again. But far from regretting his outburst, Vincent immediately penned a similar scolding to Gauguin. He then wrote Theo boasting of his double blow against superstition and abstraction. "I have written to Bernard and Gauguin that our duty is thinking, not dreaming," he proudly reported, "[and] I was astonished at their letting themselves go like that." Artists must work "without artistic preoccupations," he insisted, planting himself firmly at his brother's side in the partisan wars raging in Paris reviews and cafés. Together, they would defend the art of the past against the audacities and sophistries of the Symbolists and their ilk, who pretended to see what they could not see and know what they could not know. "They don't just leave me cold," he sputtered, "they give me a painful feeling of collapse instead of progress."

In his imagination, however—and on his easel—a more subtle, searching debate was playing out. Throughout the fall and winter, away from Theo's sight and unmentioned in their correspondence, Vincent had been experimenting with the Symbolist license to invent. In letting his horizon lines wander, his mountaintops curl, his moons swell, and his clouds balloon, Vincent had been edging ever closer to the line between the real and the invented. In his quest for "the true and the essential," exaggeration and simplification quickly slipped toward something altogether different.

Painting a rocky gorge, he relegated the sky to a stalactite of green, the hillsides to dashes of orange, the looming mountains to broad strokes of violet and white. Looking down from an overhanging cliff, he saw no sky at all, just wavy stripes of furrowed ground, the green tops of a ragged grove interrupted here and there by an eruption of yellow—a plane tree in autumn. He painted the twisting olive groves so many times that they assumed an almost stenographic simplicity: black-and-green tangles of brushstrokes on hillsides reduced to cascades of multihued light and notations of violet-blue shadow. This is where the freedom to simplify led: to images of pure form, color, and texture—images to which later generations would refer using the word so much disparaged by Theo: abstraction.

In his endless encouraging, Theo had unknowingly given his blessing to these excursions from reality. "It is permissible to do a piece of nature exactly as one sees it," he wrote in early December. "The sympathy an artist feels for certain lines and for certain colors will cause his soul to be reflected in them." What Vincent had done for color in Arles—freeing it from the demands of reality and infusing it with personal meaning—he did for form in Saint-Rémy. Even as he pledged and repledged his allegiance to reality with coloring-book Millet peasants and pleasant autumn "effects," his contrary brush tested the limits of the freedom he decried, exploring how the real world could be portrayed in wild, unreal ways, and art could be uprooted from nature.

In the clear air and cloistered serenity of the asylum of Saint Paul, Vincent might have ventured farther down the road to pure abstraction—the road down which the next century of art would vanish from view. But, as in Arles, the darkness turned him back.

VINCENT NEVER SAID what triggered the renewed attacks that began in December 1889. But no season was more fraught with peril for him than Christmas—even before the dark events a year before in the Yellow House. Vincent himself had foreseen the danger. In September, just after recovering from the last series of attacks, he had predicted the next one with virtual certainty: "I shall continue to work without let-up, and then if I have another attack around

Christmas, we'll see, and when that's over . . ." To plan for any other outcome, he said, "would be too foolhardy."

The demons can be heard offstage in his letters leading up to the dreaded holiday. The hardening weather and shortening days of winter forced him to spend more hours in the asylum, where idleness and despair stalked the halls. He spoke of being "bored to death" and sometimes overcome with "a great depression." When the leaves fell in November, the bare countryside and the cold damp air reminded him more and more of "the North," and the people from whom he was separated. "I think of you and Jo very often," he wrote Theo, "feeling as though there were an enormous distance between here and Paris and it was years since I saw you." The distance made him feel both alone and helpless. He complained of being "without an idea for the future," and "feeling that I can do nothing about it." At times he questioned whether his own confidence was mere "pretension" and wondered if "fate itself is set on thwarting us."

As the holiday approached, his thoughts flooded with images of home and homecoming. He showered his mother and sister Wil with gifts of paintings to fill the walls of their new home in Leiden, and, in a family ritual of sharing, sent them a painting of his own new home—the view from his studio window. He pushed the dreary, institutional dormitory to the edge of the picture in order to show more of the parklike asylum garden with blooming flowers and a verdant canopy against a radiant sunset. In the foreground, one enormous old tree shows the wound where a huge limb has been recently sawed off. He called it "a somber giant, with its hurt pride," and explained how the image of "the great tree struck by lightning . . . gives an impression of anguish."

He also began another round of the Millet images that bound him to the past. One in particular, called *Evening*, tugged at the heartstrings of memory and remorse. It depicted a young peasant couple at the hearthside, bent over a baby in a cradle. Just as the asylum began to fill with the anticipation of Christmas and images of the Holy Family, Theo reported that Jo was "getting bigger" and "already feeling life" inside her. Vincent repainted Millet's little scene of sublime domesticity on a huge canvas and imagined sending it to Paris as a Christmas present. At the same time, he wrote to his mother pleading in advance for a holiday reprieve for the pain and bother he had inflicted on his brother—and, by extension, his family—over so many Christmases past. "I certainly agree with you," he wrote, "that it is much better for Theo now than before."

The guilt had never gone away. Vincent called it "the grief that gathers in our heart like water in a swamp." If anything, the hints from Paris of future success only underscored the failures of the past. "The more my health comes back to normal," he wrote in late October, "the more foolish it seems to me, and a thing against all reason, to be doing this painting which costs us so

much and brings in nothing." Theo didn't help. By writing so rarely, so reluctantly, and usually about money; by focusing relentlessly on sales—whether good news or bad—he left Vincent convinced yet again that only success could reclaim his place in his brother's and his family's favor.

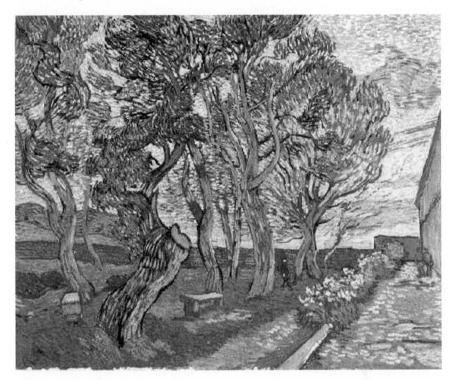

The Garden of Saint-Paul-de-Mausole, NOVEMBER 1889, OIL ON CANVAS, $28^7/_8$ X $36^1/_8$ IN.

With every shipment of paint and canvas from Paris, every apologetic accounting of expenses, and every report of Theo's deteriorating health ("[he] is still coughing—damn it—this does not please me at all"), Vincent slipped further into the swamp. "If I could one day prove that I have not impoverished the family," he wrote at Christmastime, "that would comfort me." Eventually, he could barely summon the courage to write at all. Speechless with guilt, he would start a letter again and again, he admitted, "without being able to finish it."

It didn't take much to tip this toxic mix of fear, longing, and regret into a spiral of despair. A week before Saint Nicholas Day, a package arrived in the mail for Vincent. Theo had sent him a wool coat.

It was a thoughtful, practical gift. Winter in the idyllic mountain valley of Saint-Rémy proved far harsher than in Arles. Vincent had complained of the cold, and Theo had asked, "Don't you want something warm?" But the humble

coat crystallized all the guilts and failures of the past. "How kind you are to me," Vincent wrote in thanks immediately, "and how I wish I could do something good, so as to prove to you that I would like to be less ungrateful."

In the first two weeks of December, he filled out this reproachful self-portrait in strokes of abject apology and collapsing confidence, setting himself on a path that could end only one way. He reacted to Isaäcson's praise with humility, even incomprehension ("There isn't anything worth mentioning about my work now"), while his attitude toward the upcoming Les Vingt exhibition slipped into frantic self-effacement—almost a terror of recognition. "We *must* work as much and with as few pretensions as a peasant," he admonished Theo, and himself. "Slow, long work is the only way, and all ambition and keenness to make a good show of it, false." Despite the freezing temperatures and the "unbearably harassing" winter wind, he redoubled his work effort, hurling himself into the hostile elements with such self-mortifying fervor that Theo felt obliged to pay extra for a fire in his studio to lure him in from the cold.

Only days after dismissing the need for a doctor in Auvers, or anywhere else, and imagining his return to Paris in the spring, Vincent wrote asking to stay at least another year in the asylum. "There is no hurry," he said, "for after all Paris only distracts." He promised and promised better work in the future—much better than the "hard," "harsh," "ugly" things he was sending—and begged Theo to let him finish his "Impressions of Provence," his portrait of the South, by "attacking the cypresses and mountains" again. On his hikes in the bitter weather, he had staked out many potential subjects for spring, and "good ideas are beginning to germinate," he assured his brother. Staying was not only better for his art and absolutely necessary for his health, he argued, but also cheaper. "If I leave here, I think there would be hardly any advantage from the point of view of expense," he pleaded, "and the success of my work is even more doubtful if I leave."

Or he could quit painting altogether. Even as he imagined an artistic redemption in the valley of the Alpilles and listed the paintings to be sent to Brussels, Vincent wondered if his life "would have been simpler if I had stayed quietly in North Brabant." Once again, he briefly entertained a fantasy that "if I gave up painting and had to lead a hard life, say, as a soldier in the East, it would cure me." As the fateful holiday approached, every path not taken haunted him. "I often think that if I had done as you did," he wrote Theo in a spasm of regret, "if I had stayed with Goupils, if I had confined myself to selling pictures, I should have done better."

By the week before Christmas, Vincent had worked himself into a fever of dread. "It is exactly a year ago that I had that attack," he wrote as the day approached. "It is to be feared that it will come back from time to time. And this leaves the head in a latent state of sensitivity." As if testing that sensitivity, let-

ters flew back and forth between Paris, Holland, even South Africa, as the Van Gogh family erupted in holiday rituals of greetings and gifts and professions of unity. Sister Wil fondly described her new home and announced plans to go to Paris in January to help Theo and Jo with the new baby. Mother Anna wrote unthinkingly of the joy she found in being surrounded by family, and promised to visit her sick sister in Breda. But nobody made plans to come south. Instead, they celebrated the blessed event due in Paris in a month—the perfect union of family and faith at Christmastime. "We received quite a batch of little things for the baby," Theo wrote cheerfully. "You will do its portrait as soon as you are here."

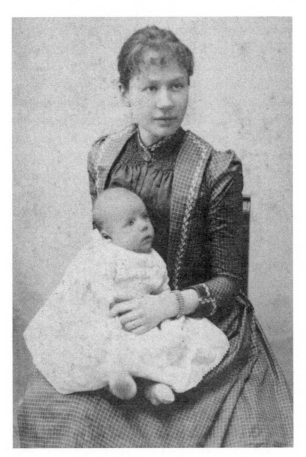

JO WITH SON VINCENT, 1890

Sitting alone in his barred bedroom, Vincent did his best to join in the holiday cheer. For Wil, he promised to paint a picture of the new house in Leiden and offered to arrange a match between her and his young painter friend Bernard—"a nice boy, very Parisian, very elegant." It would have been a fam-

ily Christmas present to rival Theo's gift of new life. To his mother, he inquired plaintively after his brother Cor, who had reported on the Transvaal to others, but not to him. But all his sorties of sympathy ended in bitterness ("I suppose your thoughts are often with Theo and Jo," he added). In the studio, meanwhile, he toiled over a melancholic holiday image of skeletal pine trees silhouetted against a setting sun.

Ever since his visit to Arles in November, Vincent had been laying delusional plans for a holiday return and, especially, a reunion with Marie Ginoux. To Theo, he spoke about her only in code, recalling a portrait by Puvis de Chavannes that they had seen together in Paris, which he dreamingly connected to a favorite passage from Michelet's *L'amour*, once both brothers' gospel of love: "There is no such thing as an old woman." As in the past, he spun a comment Marie had made—"When you are friends, you are friends for a long time"—into a motto as powerful as "she, and no other" or *"aimer encore"* (both also from Michelet). Madame Ginoux had "taken ill" at Christmastime the previous year, just when Vincent did, and he clung to that coincidence as a sign of fated togetherness. As the next holiday approached, he compared the alluring Arlésienne to Augustine Roulin, his icon of maternal love, and, months later, he confessed to seeing her often in his dreams.

To celebrate in paint his own Christmas story of fearful memories, frustrated love, and confused longings, Vincent returned to the olive groves. Whether he braved the punishing cold and loneliness and fixed his easel outdoors, or just worked from previous studies in his studio, it was a perilous imagery at a perilous time. Painting ceaselessly in the short advent days, he filled one big canvas after another with images of the "holy trees" being picked by women—one of them always portrayed with the distinctive black ringlets of the Arlésienne.

To please Theo, he eschewed all the affectations and exaggerations of the past, brushing each image in short, thoughtful strokes with a lightly loaded brush. ("I shall not do any more things in impasto," he pledged. "I am not so violent as all that.") He conjured up the softest color contrasts he could—silver-green leaves against a pink or citron sky—convinced that only such "mild," caressing hues could win a woman's heart or a family's favor. Instead of the savage complementaries and primitive subjects of the Yellow House, he talked of "discreet color" arranged in "exquisite lace." To his sister, he described the new work as "the most delicate thing I have painted yet." To Theo, he promised it would lend itself, like Monticelli's scenes, to color lithography—and, ultimately, to profit. Even harder hearts might be won, he imagined. Only days before Christmas, he wrote his mother, "I started still another big picture for you, of women gathering olives."

Like the *Berceuse*, this consoling image, painted again and again, showed Vincent the way out of the darkness: the way forward and the way back. "You

tell me not to worry *too much* and that better days will yet come for me," he wrote Theo as he began the copy for his mother and sister. "Those better days begin for me when I glimpse the possibility of completing my work and giving you a series of really sympathetic Provençal studies, which will somehow be linked, I hope, with our distant memories of our youth in Holland."

But the consolation of images and memories was never enough. On the day before Christmas Eve, Vincent sat down and wrote his mother. In a letter that alternately cried out with guilt, begged for forgiveness, and rhapsodized his maternal longing, he plunged toward his own undoing:

> I often feel much self-reproach about things in the past, my illness being more or less my own fault, in any case I doubt if I can make up for faults in any way. But reasoning and thinking about these things is sometimes so difficult, and sometimes my feelings overwhelm me more than before. And then I think so much of you and of the past. You and Father have been, if possible, even more to me than to the others, so much, so very much, and I do not seem to have had a happy character.

He blamed himself not only for his illness, but for not seeking treatment sooner and not recovering faster. He confessed to mistreating his father in Nuenen, leading his brother astray in Paris, and disappointing his mother by not producing a child. He tried one last time to convince her to like his art, but admitted being "powerless" to paint any other way. For all the sins of the past, he offered only a single, humble defense: "to err is human."

On the same day—exactly one year after the terrible events in the Yellow House—he was struck down again. The panic of the approaching anniversary no doubt played a self-fulfilling role in the Christmas attack of 1889. Vincent was painting yet another olive grove when the darkness descended. "I was working perfectly calmly," he recounted in January, "and suddenly, without any reason, the aberration seized me again."

After a week of "exaltation and delirium," of violence and disorientation, the cycle began again. Just as in the past, Vincent emerged from the shadows shaken, paranoid, and "overcome with discouragement." He woke to find his paints taken from him, after he had made another attempt to eat them. Of the whole week, he recalled only one moment; and even that might have been a dream. "While I was ill there was a fall of damp and melting snow," he wrote. "I got up in the night to look at the country. Oh, never, never had nature seemed to me so touching and so full of feeling."

Just as in the past, he immediately launched a campaign to reassure his brother that the storm had passed and left his little boat intact. "As for me, don't worry too much," he wrote as soon as he could be trusted with a pen. "Let's go

on working then as much as possible as if nothing had happened." He vowed a quick return to "my normal condition." Laying paranoid blame for the relapse on the "superstitious ideas" of those around him and the plight of painters in general, he rededicated himself to his work even before his paints were returned to him, and soothed his brother with a fantasy of the day when his illness would "pass away completely."

As in the past, he felt suddenly imprisoned and laid plans to escape—at least to an asylum where the patients could work in the fields and might pose for him. Or perhaps to Brittany to join Gauguin. Or perhaps to Paris. As in the past, a tide of guilt lapped at his feet as he fretted over new expenses and vainly imagined himself "doing a bit of business" as a dealer or "finding some other job." "Let's take the terrible realities for what they are," he wrote in mid-January, "and if it should be necessary for me to give up painting, I think I should do so."

Theo, too, played his familiar part. The news of Vincent's Christmas seizure caught him, again, by surprise. After months of laggard correspondence, he rushed letter after letter filled with fraternal concern, cautious advice, cheerful reports, and parsed praise. ("There is more atmosphere in these last works . . . due to your not laying on your paint so thickly everywhere.") He issued vague, hasty invitations to Paris ("we shall always be happy to have you with us"), then, on deeper reflection, withdrew or qualified them. When Vincent proposed moving to an asylum where he could work more freely, Theo unwittingly suggested Gheel, the communal asylum in Belgium where their father had tried to commit Vincent a decade earlier.

In the weeks after the Christmas attacks, the director of the Saint Paul asylum reprised his role, too. When Vincent was first struck down, Peyron wrote an alarmed letter to Theo describing his brother's latest attempt to poison himself by eating paint. On his way out the door for the New Year's holiday, the doctor hastily replied to Vincent's mail and banned any further painting. For almost a week, he disappeared from view—either sick, on vacation, or just inaccessible. When he reappeared, he found Vincent largely recovered and eager to "undo" the events of the previous week.

Negligent and distracted as always, and overly susceptible to his patient's persuasion, Peyron immediately withdrew the dire prognosis he had shared with Theo and returned to the usual treatment of bromide and nostrums. "He said to me, 'Let's hope that there will be no recurrence,' " Vincent reported, "exactly the same thing as ever." Peyron's vacillation and lax supervision (Vincent began painting long before the doctor lifted his ban) left Theo alone in urging his brother to avoid the "dangers" of color, at least for a while, and make drawings instead. Vincent, as always, rejected the warning. "Why should I change my means of expression?" he rejoined. "I want to go on as usual."

Soon after he returned to his studio, only a few weeks after the storms of

Christmas had passed, Vincent's imagination began building toward the next crisis of loneliness and longing. Confined to his studio by weather now too cold even for him, he began work on another Millet copy. Theo had praised *Evening*, the scene of new parents hovering over a cradle, and Vincent's thoughts were drawn yet again to the child due in Paris. "These are the things without which life would not be life," he responded to Theo's nervous reports on Jo's pregnancy, "and it makes one serious." Meanwhile, in the studio, he carefully squared up and transferred onto another big canvas Millet's image of a young peasant couple urging their child to take its first steps. Working in nothing but blues and greens—a reverie of muted tones and soothing harmonies—he dreamed "of Holland, of our youth in the past," and even imagined coming to Paris for the blessed event.

But those same thoughts led through Arles. Vincent had emerged from the attacks in the first days of 1890 already eager to return to his dark-eyed Arlésienne. At first, he did not expect he could make the trip until February. He wrote Theo obliquely about needing "to see my friends again, which always refreshes me." He devised elaborate plans involving the furniture he had stored at the Café de la Gare, all of which required his presence in Arles. As before, he hinted at his yearning in an urgent call for models. He proposed the trip as merely a "test" to see "whether I am capable of risking the journey to Paris." But as the image of happy parenthood took shape on his easel and the coming events in Paris transfixed his imagination, he could not wait any longer. On January 19, after buying a new suit, he set out again on the perilous trip over the cliffs to Arles.

He did not find the welcome he longed for. Madame Ginoux had fallen ill again—a foreboding sign. She may have been too sick to see him at all. He returned to the asylum after only a short stay, much of it probably spent elsewhere than at the Ginouxs', seeking other forms of solace. The furniture remained where it was. He had just enough time after his return to write two long and plaintive letters: one to the Ginouxs and one to his sister Wil. In the first, he poured out his feelings in the guise of solicitude. Endlessly conflating Marie Ginoux's flu with his own, darker illness, he summoned her to "rise up from her sickbed completely renewed." Like the sight of the pregnant Sien in The Hague or of his crippled mother in Nuenen, the image of his sick Dulcinea roused him to flights of consolation. "Diseases exist to remind us that we are not made of wood," he wrote, comforting himself as well as her, "and it seems to me this is the bright side of it all."

But in the letter to his sister—which he knew his mother would read—Vincent found no comfort and saw no bright side at all. He wrote of "life passing by more rapidly" and the urgency of "making up for lost time." "The future is more mysterious," he said, "and, dear me, a little more gloomy." Out of thin air, he conjured the image of his healthy mother dying, and the thought of that

irreversible foreclosure elicited a cry of despair: "I often think with a deep sigh that I ought to have been better than I am." He tried to arrest the thought—"Let me stop talking of it at once, or else it might discourage me"—but could not. "One cannot retrace one's steps," he concluded bleakly.

Two days later, the storms struck again. Theo received the news the following week from the dilatory Peyron: "I am writing to you in the place of M. Vincent who is once more the victim of another attack. . . . He is unable to do any work at all and only replies incoherently to any question put to him." Peyron's bland report hid a much harsher reality. Vincent not only could not paint, he could not read or write. When anyone approached him, or even tried to talk to him, he would recoil violently "as if it hurts him," a witness reported. All day long, day after day, he sat in his cold, barred room "with his head in his hands," alternately ranting to himself about his "sad and melancholy past," or lost in unreachable solitude.

IN PARIS, ON THE same day Peyron sent his sad news, Johanna van Gogh–Bonger penned a letter to her distant brother-in-law. She sat at the dining room table in the apartment that Theo had decorated so conscientiously. It was midnight, but she was not alone. Theo, his mother, and his sister Wil had all joined her. A doctor slept in the apartment, too; the baby was due soon—perhaps as soon as that night. Theo, exhausted, was dozing in the chair beside her. On the table in front of her lay a copy of the Paris paper *Mercure de France,* which Theo had brought home from work. In it was an article about Vincent. Everyone at the table had read it and "talked about you for a long time," Jo reported.

Indeed, everyone in Paris had read it and begun talking.

The title of the article, the first in a projected series, was "Les Isolés"—"The Isolated Ones."

"A Degenerate Child"

~

HOLIDAY SHOPPERS PASSING BY THE PAINT STORE OF JULIEN "PÈRE" Tanguy at Christmastime in 1889 saw something very strange in the window: two huge bouquets of sunflowers. Their distinctive aureoles of orange and yellow petals stood out starkly on the gray streets of Paris. But it wasn't just their unseasonal subject that struck passersby. It was their size, their gesticulating forms, and, most of all, their ferocious color. One pasted the giant flowers against a brilliant, pearly turquoise; the other, against a yellow so bright it almost hurt the eyes. Some were startled by this vision of summer in the wintry gloom; some, bemused; many, dismayed. "It was horrible," one passerby later recalled, "the rank glare of a sunflower."

But others came looking for it. They had read Jozef Isaäcson's article in *De Portefeuille* in September or registered the brief mention in *La Vogue* that same month; or they had seen the tantalizingly cryptic review by a pseudonymous columnist named "Le Flâneur"in the April *Le Moderniste Illustré* directing them to Tanguy's shop, where they could find "pictures fantastically spirited, intense, full of sunshine." Some heeded insider tips from among Theo's wide circle of acquaintances about the mysterious painter identified by both Isaäcson and Le Flâneur only by his first name, Vincent. Some had heard the stories already circulating in the Paris art world about Gauguin's bloody encounter a year ago with the strange Dutchman who had moved south and gone mad.

The images in Tanguy's window seemed to prove all this and more.

One of those who came to Tanguy's in search of the myth, as well as the art, was a young art critic named Albert Aurier. Like Vincent van Gogh (the subject of his first review in the *Mercure de France*), the twenty-four-year-old Aurier was riding the wave of history toward brief celebrity, early death, and

enduring fame. Unlike Vincent, he saw the wave coming. He arrived in Paris in 1883 as a law student and immediately succumbed to the high life and low morals of fin-de-siècle bohemia. A whirlwind of productivity in every area but his legal studies—poet, critic, novelist, playwright, painter—Aurier embraced each new "ism" as it emerged from the roiling, fermenting pot of intellectual fashion, and even invented one of his own: "*Sensationnisme.*" His first novel mimicked the ambition and Naturalism of Balzac. But Huysmans's *À rebours* electrified him—as it did an entire generation of young poets, thinkers, and artists—in the service of Symbolism. By the time he turned twenty, he had joined the Decadents; declared Baudelaire's *Les fleurs du mal* his "Bible"; the forbidden lovers Verlaine and Rimbaud, his heroes; and eccentricity ("a bizarre outlook"), the highest calling in art or life.

Aurier arrived in Paris as a *wunderkind* writer and critic. He published his first journal at age nineteen, wrote for *Le Chat Noir* by twenty, and caught Mallarmé's eye at twenty-one. His meteoric rise coincided exactly with the ascendance of the critic as the single most powerful voice in the art world. Upon the withdrawal of state sponsorship from the Salon system in 1881, artists of every stripe were thrown into the crowded, competitive world of private dealers, galleries, and auction houses. As the influence of the Salon's prizes waned, critics and reviews rushed into the vacuum of discernment, clamoring for the attention of bourgeois buyers bewildered by the dizzying array of choices now open to them.

Whereas the Salon had anointed single images, the new critics allied with private dealers to elevate artists, even whole movements, over individual works. One painting could not make a critic's reputation, fund a magazine, or support a dealer's family. Buyers had to be convinced that *any* painting by an approved artist, or within an approved style, was preferable to a work by any other artist or in any other style. The era of art franchises had begun. The model, of course, was Georges Seurat, whose distinctive Pointillist images had been championed by the critic Félix Fénéon not just as attractive decorations and masterpieces of craft, but as inevitable expressions of the zeitgeist. Fénéon's relentless advocacy in the *Revue Indépendante* launched an army of Neo-Impressionist painters and collectors. Art was no longer enough. In a culture besotted by words and fashion, art needed advocates to persuade and mobilize; and artists needed movements to succeed. Critics provided both.

Gauguin and Bernard had watched Seurat's startling rise and learned the lesson of the new era well. To be seen by the public, artists had to be shown by the galleries; to be shown by the galleries, they had to be talked about in the journals. Working in an uneasy alliance of self-interest (which would later collapse in a rancorous competition for credit), the two artists began jockeying for position in the scrum of avant-garde art. For his part, Bernard wooed potential sponsors among his friends who contributed to art reviews. During the long

summer of 1888, while Vincent flooded both his comrades in far-off Brittany with ringing calls to the new art of Japan, Bernard circulated among the holiday crowds in Pont-Aven using Vincent's ideas, and even some passages and drawings from his letters, to "sell" the new movement to influential critics like Gustave Geffroy. Another of his targets was the lanky twenty-three-year-old rising star Albert Aurier.

When the art world returned to Paris in the fall, Bernard's campaign followed. As Gauguin prepared to leave for Arles, Bernard pressed his case on Aurier with trips to Tanguy's paint store, Goupil's *entresol*, and even Theo van Gogh's apartment, in order to see works by Guillaumin, Gauguin, Vincent, and, of course, himself—all examples of this exciting new movement that lacked only an advocate.

Gauguin, meanwhile, plotted his own way to attract critical attention. From the depths of his entrapment in the Yellow House, he imagined mounting an insurgent attack on the avant-garde establishment, just as the Impressionists had done at the famous Salon des Refusés twenty-five years earlier. In a single coup de théâtre, he could showcase the still unnamed movement and steal a march on the "Neos" at the *Revue Indépendante* who had connived against him in preparing their January show. And what more appropriate place to stage his coup than at the upcoming Exposition Universelle that would open in Paris in May 1889? Like Bernard's gallery tours, Gauguin's *manifestation* would include enough of his fellow painters ("a little group of comrades," he later described them) to impress critics like Aurier with the strength and viability of the new movement. "Vincent sometimes calls me the man from afar who will go far," he rallied his comrade Bernard. "[But] we must work with each other and arrive holding hands together."

Only a few days later, on Christmas Eve 1888, Gauguin had fled the Yellow House. It was hardly surprising that, upon his arrival in Paris, he immediately contacted Bernard; or that the first person to whom Bernard reported the terrifying story was Albert Aurier.

> I am so sad that I need somebody who will listen to me and who can understand me. My best friend, my dear Vincent, is mad. Since I have found out, I am almost mad myself.

Bernard and Gauguin served up a Poe-like tale filled with Symbolist significance, religious overtones, and gothic frisson. Vincent believed "he was some kind of Christ, a God," Bernard wrote, "a being from the other side." His "powerful and admirable mind" and "extreme humanity" had been driven to madness by these strange visions. He had accused Gauguin of trying to "murder" him—an insane accusation that drove his stalwart friend away just as the horrible crime

was revealed: " 'The entire population of Arles was in front of our house,' " Bernard wrote, transcribing Gauguin's first-person account. " 'It was then that the gendarmes arrested me, for the house was full of blood.' " *They thought Gauguin had killed him!* Bernard's account dramatically implied. But in fact, Vincent had slashed off his own ear and given the bloody prize to a prostitute.

The letter launched Gauguin's campaign to portray himself as the innocent victim of Vincent's murderous madness, not the guilty provocateur. It also reached out to the fashionably decadent critic. Only six months before, Aurier had contributed to a debate in *Le Figaro* over the new science of criminal anthropology. The paper cited works by prominent Symbolists (with provocative titles like *Murder Considered as One of the Fine Arts*) defending murder as a natural instinct, not an abomination.

Aurier used the debate to comment on the most sensational story in the Paris papers at the time: the murder trial of Luis Carlos Prado, a handsome roué and confidence man accused of slitting the throat of a Paris prostitute. Like Gauguin, Prado had lived in Peru and worked in the stock market. The "Prado Affair" had brought to public view the Symbolists' obsession with deviant behavior, especially criminal behavior, and Aurier's review confirmed the stylish fascination with "sympathetic killers." Gauguin had already traded on the new vogue with his self-portrait as Hugo's Jean Valjean, the most famous criminal-hero in French literature. During Gauguin's stay in the Yellow House, the trial had flamed again in the headlines as a bloodthirsty public counted down the days to Prado's execution. (Gauguin, in fact, arrived back in Paris just in time to attend the public spectacle of his beheading.)

But the letter backfired. Indeed, Gauguin's campaign to acquit himself worked at cross purposes with his outreach for favor. To the true believer Aurier, champion of outcasts and deviants, Vincent van Gogh, not Paul Gauguin, emerged from Bernard's narrative as the truer artist. For Aurier, Vincent's unthinking fury—whether directed at Gauguin (as Gauguin later claimed) or at himself—represented exactly the kind of extreme experience, the orgasmic surrender to sensation, that Huysmans exalted in *À rebours.* What could be more primitive, more *essential*, than the murderous urge that Cain felt against Abel? Indeed, wasn't violence of any kind the ultimate rejection of bourgeois convention and thus the truest path to art?

Vincent's continued confinement in the Arles hospital and then the asylum of Saint-Paul-de-Mausole only enhanced the image of tortured genius that Aurier, like Huysmans, prized above all else. Had not the great Italian criminologist Cesar Lombroso only recently revealed the link between epilepsy, insanity, criminality, and genius? According to Lombroso, many of history's greatest artists—Molière, Petrarch, Flaubert, Dostoyevsky, the Goncourt brothers—had suffered epileptic fits. What was "creative genius" if not an altered, aberrant

state—an attack—of heightened feeling and perception? And was not this the same spiritual rapture that the great mystics and prophets felt when they saw visions and spoke God's words? Lombroso named Saint Paul among his "epileptoid geniuses," and saw in all of them the same "degenerative psychosis" as in born killers like Prado—a psychosis that he claimed he could document in the stigmata of their "savage" countenances.

Throughout 1889, while Gauguin and Bernard vied for the favor of the Catholic critic with increasingly hortatory images of Christ, Aurier's interest stayed fixed on the lonely figure locked away in a Midi asylum. In April of that year, writing under the pseudonym Le Flâneur, he first reported the miracle happening under the southern sun. Not even Gauguin's strange, improvisational show at the Exposition Universelle the following month could distract Aurier's gaze for long. In his desperation for a prominent venue, Gauguin had rented a vast, déclassé brasserie, the Café Volpini, just opposite the entrance to the official art exhibition. His and Bernard's paintings, over a dozen of each, competed with the pomegranate-red walls and a Russian all-woman band for the attention of fairgoers. Gauguin had invited Theo to show Vincent's work. But Theo withdrew his brother from the venture before it opened, convinced that in the vast, ugly eatery the art would show poorly. Aurier came, but finding no images by the strange, raving Dutchman with a single name, he gave the show only brief attention.

Instead, he returned again to Tanguy's, and to Theo's, to see the work of an artist who had broken through the illusion of reality and penetrated to the core of the human experience. What better subject for the inaugural issue of his new journal, *Mercure de France,* that would greet the New Year and the new decade in January 1890? What better way to rivet the art world's attention and secure his reputation than a profile of this pariah from the North, a pariah even among the pariahs of the avant-garde? With the public gorge still high over the severed head of Luis Prado, what better hero to carry the Symbolist banner of sensation in extremis into the new millennium than this mad Dutchman, this provincial trueheart who had slashed *himself* out of passion for life and art, this *poète maudit* of the Midi, this prophet and preacher, this seer and stranger?

By the time he put pen to paper at the end of the year, Aurier had worked himself into a fever of appreciation.

He opened with a blast of Baudelaire, invoking Symbolism's deepest roots in the century, *Les fleurs du mal:*

> *Everything, even the color black,*
> *Seemed furbished, bright, iridescent;*
> *The liquid encased its glory*
> *In the crystallized ray . . .*

From these opening trumpets, Aurier's article clamored with the thrill of discovery. He had found a genius—an "exciting and powerful," "profound and complex" artist—an "intense and fantastic colorist, grinder of golds and of precious stones"—"vigorous, exalted, brutal, intense"—"master and conqueror"— "unbelievably dazzling." The Symbolists exalted excess, and Aurier set out to show as well as tell. In a long, dense, delirious fusion of prose and poetry, he attempted to capture in words the *sensation* of seeing the images he described— the work of this newfound master. He piled up flights of description hundreds of words long, voluptuous cascades of imagery, strange extravagances of syntax and vocabulary, urgent imperatives and magisterial pronouncements, cries of recognition and exclamations of surprise and delight. In the paintings of Vincent van Gogh, he said, he had uncovered an art

> at once entirely realistic and yet almost supernatural, of an excessive nature where everything—beings and things, shadows and lights, forms and colors—rears and rises up with a raging will to howl its own essential song in the most intense and fiercely high-pitched timbre. . . . It is matter and all of Nature frenetically contorted in paroxysms, raised to the heights of exacerbation; it is form, becoming nightmare; color, becoming flame, lava and precious stone; light turning into conflagration; life, into burning fever. . . . Oh! how far we are—are we not?—from the beautiful, great tradition of art.

In Vincent's painting, Aurier saw "heavy, flaming, burning atmospheres . . . exhaled from fantastic furnaces," "countries of resplendence, of glowing sun and blinding colors," mountains that "arch their backs like mammoths," twisted trees that waved their "gnarled menacing arms . . . the pride of their musculature, their blood-hot sap," and "great dazzling walls made of crystal and sun."

Where did these strange "flaming landscapes" come from? Aurier invoked the giant Zola, who still bestrode the avant-garde world, and claimed for Vincent the frayed mantle of Naturalism. No one could doubt Vincent's "great love for nature and for truth," he wrote. "He is very conscious of material reality, of its importance and its beauty." But Vincent had gone further, Aurier proclaimed. He had revealed reality for the "enchantress" she was—an enchantress that kept most mortals under her spell using "a sort of marvelous language" that only artist-savants like Vincent could decipher. And he communicated that language to the world by the only means possible: symbols. "[Van Gogh] is, almost always, a Symbolist," Aurier announced, claiming the new genius as one of his own, "a Symbolist who feels the continual need to clothe his ideas in precise, ponderable, tangible forms, in intensely sensual and material exteriors."

To support this extraordinary claim, he portrayed Vincent's paintings as

dreamlike visions, his landscapes as "vain and beautiful chimeras," his flowers as conjuries from "some alchemist's diabolical crucible." His cypresses "exposed their nightmarish, flame-like, black silhouettes," and his orchards beckoned "like the idealizing dreams of virgins." Never had there been a painter, Aurier exclaimed, whose art appealed so directly to the senses: from the "indefinable aroma" of his sincerity to the "flesh and matter" of his paint, from the "brilliant and radiant symphonies" of his color to the "intense sensuality" of his line. What else but Symbolist ambition could explain the exuberant excesses of these paintings, their "almost orgiastic extravagances"? "He is a fanatic," Aurier concluded, "an enemy of bourgeois sobriety and minutiae, a sort of drunken giant. . . . What characterizes his work as a whole is its excess, its excess of strength, of nervousness, its violence of expression."

With every reference to orgiastic extravagance and bourgeois outrage, Aurier invoked the spirit of Huysmans's *À rebours,* the bible of his generation of artists and writers. For many, Huysmans's decadent hero, Des Esseintes, pointed the way to the coming millennium. Now Aurier had found him in real life. "Finally, and above all," he wrote, "[Van Gogh] is a hyper-aesthetic . . . who perceives with abnormal, perhaps even painful, intensities"—intensities "invisible to healthy eyes" and "removed from all banal paths. . . . His is a brain at its boiling point, irresistibly pouring down its lava into all of the ravines of art, a terrible and demented genius, often sublime, sometimes grotesque, *always at the brink of the pathological."*

Hinting at the rumors that some had heard, he talked vaguely of "ineluctable atavistic laws" and invoked the criminology of Lombroso with references to Vincent's "disquieting and disturbing display of a strange nature" and "brutally brilliant forehead." Anyone could *claim* Symbolist ideas or imagery, Aurier wrote, throwing down a gauntlet to any artist who aspired to Vincent's example. But only a privileged few could claim a true Symbolist temperament. And these few were chosen by nature, not affect; by instinct, not intellect. Only the few— the geniuses, the criminals, and the madmen—the savages among us—could see past the banal surface of bourgeois complacency to the "universal, mad and blinding coruscation of things." This is where the "strange, intense and feverish" Vincent van Gogh towered above the rest. Aurier called him "this robust and true artist, a thoroughbred with the brutal hands of a giant, the nerves of a hysterical woman, the soul of a mystic."

Indeed, Aurier claimed for Vincent the greatest prize of all—the crown of *L'oeuvre.* Ever since Zola's masterpiece appeared in 1885, on the eve of Vincent's arrival in Paris, its call for a new art for the new age had gone unanswered. The furious factional infighting since then had left every artist looking small just as the new century loomed large on the horizon. But the expectation of a galvanizing modern art had not died with the suicide of Zola's fictional mad genius,

Claude Lantier. Now, in this relentless, incandescent exhortation, a fiery young critic had anointed Vincent his successor.

Like Lantier, Van Gogh had worked too long in the noonday heat of truth— "insolent in confronting the sun head-on." He had gone to the sunny South in pursuit of enlightenment, Aurier wrote, recasting Vincent's exile as a Symbolist mission, "naively setting out to discover the direct translation of all these new sensations so original and so removed from the milieu of our pitiful art of today." Like Lantier, Vincent was "a dreamer, a fanatical believer, a devourer of beautiful Utopias, living on ideas and dreams." And, like Lantier, he had paid a heavy price for it. Indeed, only once before had anyone suffered so much for truth. Comparing Vincent to the subject that "haunted his brain," Millet's Sower, Aurier invoked on Vincent's behalf the ultimate "idée fixe" of redemption that neither Vincent nor the century could escape: "the necessary advent of a man, a messiah, a sower of truth, who would regenerate the decrepitude of our art and perhaps of our imbecile and industrialist society."

AS AURIER UNDOUBTEDLY expected, his article rocked the art world like an anarchist's bomb. Almost immediately, it catapulted him into the firmament of critics, lifted his new journal to eminence, and put the name "Vincent" on every lip. Few had seen his art, and fewer still had paid it any attention. For many, the exhibition of Les Vingt, opening in Brussels only a few weeks after the article appeared, offered their first glimpse of Aurier's new "genius." To bait public interest still further, Aurier wrote a condensed version of his paean, titled simply "Vincent van Gogh," for the January 19 issue of *L'Art Moderne*, the Belgian organ of Les Vingt, which appeared on the eve of the opening.

In the elegant galleries of the Palais des Beaux-Arts, Vincent's sunflowers, wheat field, orchard, and vineyard took their place for the first time beside works by Cézanne, Renoir, Toulouse-Lautrec, Signac, and Puvis de Chavannes. But the spotlight of Aurier's article cast all the others into shadow. Traditionalist critics, who had still not forgiven Les Vingt for introducing Seurat's dots to the world in 1887—and never hesitated to pronounce any deviation from Salon conventions "crazy"—were left speechless with incomprehension by Vincent's wild imagery.

But avant-garde artists and critics rallied to the double charge. They praised Vincent's "fierce impasto" and "powerful effects." "What a great artist!" they cried. "Instinctive . . . a born painter." Emotions ran so high that arguments broke out. At the official Vingt dinner, one member called Vincent "a charlatan," which brought Toulouse-Lautrec leaping to his stubby feet shouting "Scandal! Slander!" and demanding a retraction. To defend the honor of the "great artist" Vincent, he challenged his detractor to a duel. After settling the quarrel (forc-

ing the skeptic's resignation), Octave Maus, Les Vingt's founder, wrote Theo to report that Vincent's work had sparked many "animated discussions" and won "strong artistic sympathies" in Brussels.

But in the places that mattered to Vincent—Paris and Holland—all eyes were focused on a different Vincent van Gogh: Theo's newborn son. The news arrived at Saint Paul almost at the same time as the first copy of Aurier's article. The mail had piled up unread after the attack that followed Vincent's trip to Arles in January. He awoke to find Jo's heartbreaking midnight letter written before the birth, confiding her darkest fears to her distant brother-in-law. "If things should not turn out well," she wrote, "if I should have to leave him—then you must tell him—for there is nobody on earth he loves so much—that he must never regret that he married me, for he has made me, oh, so happy." Only a day later, Theo's triumphant announcement arrived. "Jo has brought into the world a beautiful boy, who cries a good deal, but who looks healthy." Together, the letters told a story of private anguish and tragedy averted—a roller coaster of emotion that dimmed the luster of Aurier's praise.

Long indisposed (and unaccustomed) to flattery, Vincent first responded to the article with blushing surprise and self-effacing denials. "I do not paint like that," he wrote Theo immediately, as if to cut off any borning expectations. "My back is not broad enough to carry such an undertaking." He recast Aurier's comments as general exhortations to *all* artists, not praise of any single one. "The article is very right as far as indicating the gap to be filled," he clarified. "The writer really wrote it more to guide, not only me, but the other impressionists as well." He dismissed Aurier's compliments, as he had dismissed Isaäcson's (and, before that, Gauguin's), as exaggerated and undeserved—or, at best, premature—and compared the article's stirring rhetoric and utopian vision to a political campaign song: more rallying cry than sober criticism. "[Aurier] indicates a thing to be done rather than a thing already done," he demurred. "We have not got there yet."

Beneath the reflex of humility, however, the article was already working its way into Vincent's deepest thoughts about the future. ("When my surprise wore off a little," he later admitted, "I felt at times very much cheered by it.") Like green shoots from a tree long blighted by drought, old dreams sprang back to life. In Aurier's deluge of praise, he saw not a personal triumph but an overdue vindication of the brothers' shared enterprise on the *entresol*—an announcement to all the world, he said, "that at present the artists had given up squabbling and that an important movement was silently being launched in the little shop on the Boulevard Montmartre." He immediately began plotting ways to translate Aurier's overheated prose into sales and exchanges. The article "will do us a real service against the day when we, like everybody else, shall be obliged

to try to recover what the pictures cost," he wrote Theo. "Anything beyond that leaves me pretty cold." He marked the rebirth of his mission in the Midi with an old icon of hope that now spoke in new layers of meaning: Millet's *The Sower.*

Vincent pressed his brother to send the Aurier article to the English dealer Alexander Reid, as well as to his uncle Cor in Amsterdam—even, perhaps, to his old nemesis H. G. Tersteeg—in order to "take advantage of it to dispose of something." He reopened a correspondence with his former Cormon classmate, John Peter Russell, after almost two years of silence. "My purpose," he wrote boldly, enclosing the article, "is to remind you of myself and my brother." He lured the wealthy Australian to Theo's gallery with the promise of a painting (implying, not specifying, an exchange) and tried to revive an old plan for Russell to put together a collection of the new art for his native country—a grand buying project that would require Theo's savvy as well as Vincent's art. And what better way to start than by buying one of the many Gauguins that filled the *entresol*'s storeroom, Vincent urged. "I assure you that I owe much to the things Gauguin told me on the subject of drawing," he wrote, transferring Aurier's imprimatur to his former housemate.

Within days, the article emboldened Vincent to imagine a reunion at the Yellow House. Gauguin had recently written bewailing conditions in Brittany and even threatening to quit painting altogether. He talked vaguely of another sojourn to an exotic land (this time, the French colony of Vietnam), but languished in Le Pouldu increasingly impecunious and desperate. Earlier in January he had brushed aside Vincent's preposterous offer to come stay with him on the coast. But a few days later, no doubt after reading Aurier's article, he had surprised Vincent with a proposal that they set up a studio together in Antwerp, claiming "Impressionism will not be truly accepted in France until it has returned from abroad."

Delirious at the prospect of reconciliation and renewed friendship, but frightened by the cost of furnishing a new studio in Antwerp "as established Dutch painters do," Vincent pressed his delusional plan for Gauguin to return to the South. "It seems a pity to me that he did not stay on here a little longer," he wrote Theo in a reverie of "what if." "Together we would have worked better than I have all by myself this year. And now we would have a little house of our own to live and work in, and could even put others up."

In pursuit of this vision of a resurrection in the Midi, Vincent sat down to write the one person who could make it come true: Albert Aurier. "Thank you very much for your article in the *Mercure de France*," he began humbly. "It seems to me that you paint with words; in fact, I encounter my canvases anew in your article, but better than they are in reality, richer, more meaningful." Vincent took no issue with Aurier's dense arguments and left unchallenged the strange, insupportable claim that he was "almost always a Symbolist."

Instead, he argued that Aurier had missed the two most important parts of the story: first, his art's unbreakable roots in the South; and second, his debt to Gauguin. Again and again, he invoked the dead Marseille master Monticelli, both for the intense "metallic, gem-like quality" of his color, and for his *"isolé"* credentials ("a melancholy, rather resigned, unhappy man . . . the outsider"). As for Gauguin—"that curious artist, that strange individual"—no one could rival the authenticity and "morality" of *his* art. They had "worked together for several months in Arles," Vincent wrote, "before my illness forced me to go into an asylum."

Reframing Aurier's article as "a study of the question of the future of 'art in the tropics,'" he insisted that these two artists—Monticelli and Gauguin—should be the primary focus of any such study and that his role would never be more than secondary. He aspired only to be a facilitator, a disciple, a witness—that is, to reprise the role he played during those precious two months in Arles. If Aurier would only set aside "sectarian thinking," he, too, would see the necessity of a return to that moment in time when the perfect artist, Gauguin, encouraged by the perfect companion, Vincent, worked together in the perfect place, Monticelli's South. If Aurier had doubts, he could see for himself the fruits of this too-brief three-way collaboration under the southern sun by visiting Theo's gallery on the *entresol*, where the gift of a new painting of cypresses— "so characteristic of the Provence landscape"—awaited him.

When the letter was finished, Vincent made a copy for Gauguin and sent the original to Theo to convey to the critic. In a separate note to his brother, he added a wistful hope that Aurier's article and his reply might convince Gauguin to "work together again here," and a thrill of anticipation that, if it did, Vincent might become the artist that Aurier described. "[It] would encourage me [to] let myself go and venture even further," he imagined, even to "drop reality and make a kind of music of tones with color."

If the Aurier article could revive the combination with Gauguin, perhaps it could heal more ancient wounds. From the beginning, when his first copy of the article arrived alongside the announcement of Theo's new son, Vincent had blurred these two triumphs into one. "The good news you have sent me and this article have made me feel quite well personally today," he wrote his brother. He proudly predicted that Aurier's praise would bring *both* of them "some sort of reputation" and celebrated their joint achievement with a single, hearty congratulation: "Bravo—how pleased Mother is going to be." He began to see the critic's paean, like Theo's son, as his long-delayed prodigal return. "I feel the desire to renew myself, and to apologize," he wrote his sister Wil as copies of the article flew to every family member, as ubiquitously—and at the same time—as Theo's announcement cards.

Dreams of family redemption and maternal longings led inevitably to the

manger scene in a Paris apartment. "Jo is nursing the baby, and has no lack of milk," Theo reported in early February. "At times the little one lies with his eyes wide open and his fists pressed against his face. Then he has an air of perfect well-being." Vincent drank in the reports of the baby's first days, and he reached out to Jo with a letter in Dutch—an intimacy he had loftily withheld—signed with a reciprocal "Your brother, Vincent." Theo indulged his brother's longing heart with loving descriptions of the new arrival ("he has blue eyes . . . and big round cheeks") and a touching insistence that the child take Vincent's name, saying, "I devoutly hope that he will be able to be as persevering and as courageous as you." Vincent saw in Theo's new mission of fatherhood "a new sun rising inside him," and laid plans to travel to Paris "when I am free again."

In the meantime, his heart lunged in a different direction: toward Arles. Since his aborted visit to see her in January, he had kept the image of his Arlésienne, Marie Ginoux, close by: not just in his imagination, but in the drawing that Gauguin had made of her more than a year earlier. The renewed correspondence with Le Pouldu and the prospect, however wishful, of Gauguin's return to the South drew the big charcoal drawing out of whatever place Vincent had secreted it. If Aurier's praise could lure the Bel-Ami back to the Midi, then surely it could persuade the reluctant Arlésienne to whatever consummation Vincent imagined. Among the first letters he sent announcing the article was one addressed to the Café de la Gare. "There have been articles on my pictures published simultaneously in Belgium and in Paris," he wrote like a proud but diffident child. "They speak far better of them than I myself could have wished." Other painters were now eager to come visit him, he said, and only recently "Mr. Paul" had written, and "it's possible I shall see him soon."

As if rehearsing that double fantasy, he carefully traced Gauguin's drawing of Marie Ginoux onto canvas. With every sinuous curve of her face, he drew closer to both of the elusive figures whose fates seemed intertwined with his: the disdainful bar matron Ginoux, who withheld her favor while passing out cubes of sugar, and the chameleon Gauguin, who issued rejections in the form of invitations. Vincent filled the sensuous forms with the tenderest shades of pink and green, laid on with the dry, careful brush of the *maître* himself—a reverie of the past and a preview of the reborn Studio of the South he envisioned. He had used this same blushing palette on the olive groves at Christmastime—the paintings he made for his mother and sister—colors so lovely, contrasts so delicate, no woman could resist them. As soon as he was done, he began another version, this one with more charged color and a more loaded brush: an urgency of affection and self-assertion that lingered with special care over the expression on her face, coaxing the hauteur of Gauguin's drawing toward a benign smile.

The same urgency transformed the books on the table in front of her. Instead of blank place-fillers, Vincent painted them as his own nostalgia-laden child-

hood favorites: Dickens's *Christmas Stories* and Stowe's *Uncle Tom's Cabin.* With the same meticulous care as his entries in Annie Slade-Jones's guestbook, he inscribed their covers and spines in paint. No sooner was the second version finished than a third began. Then a fourth, in a more maidenly palette—pink dress, citron shawl, and pale yellow wallpaper decorated with florets of impasto—as the new icon of womanhood oscillated in his imagination between urbane seductress and maternal comforter.

Like the fecund Berceuse that multiplied in his eye with each new iteration, the sultry café proprietress slowly peopled his studio. Working night and day, he finished five versions, feverishly preparing for the double reunion he foresaw any day, regardless of the perils it posed, all made possible by Albert Aurier's gift of praise.

BUT IT WAS ALL A FRAUD.

Almost from the moment he first read Aurier's article, Vincent had felt caught in a lie. "I *ought* to be like that," he said, "rather than the sad reality of what I feel myself to be." As he paraded his new success to family and friends, the deception of it weighed on him more and more heavily. "Pride, like drink, is intoxicating," he confessed. "When one is praised, and has drunk the praise up, it makes one sad." His lifetime of "weaknesses, diseases, and wanderings" mocked Aurier's fine words and seemed to invite a terrible reckoning. "As soon as I read the article in question," he later recalled, "I feared at once that I should be punished for it."

Everywhere he looked, he saw failure and fakery: in the ranks of unsold canvases that lined his studio no less than in the endlessly repeated faux intimacies of his portraits of Madame Ginoux, whose elegant Degas-like lines didn't belong to him any more than the sitter's seductive gaze. He was already having "scruples of conscience" about his entire project of Millet "translations" when the Sower on his easel refused to "come off." Suddenly, the grand ambition to bring these masterpieces to the masses began to look more and more like simple plagiarism. And now he was pouring his labors into another man's image of his inamorata—a kind of plagiarism of the heart. And what about the elusive Madame herself? Was she not just a fiction of love—an intimacy as false as the illness he invented or exaggerated to justify his repeated trips to Arles to visit her? Bored with his relentless protestations of affection, apparently, she had banned him from visiting, and would no longer even accept his letters.

Vincent's fear of a reckoning welled up from deep in his childhood. In the Zundert parsonage, his mother had taught that fate would always have its revenge against excess or falsity. Vincent had learned the lesson well. "I fear that after all the sunshine I enjoy," he wrote from London when he was twenty,

"there could be rain very soon." In February 1890, his letters filled up with the same dark forebodings of a price due for undeserved blessings. "You will foresee, as I do," he wrote Theo after his first reading of the Aurier article, "that such praise *must* have its opposite, the other side of the coin." The same dread led him to resist mightily Theo's plan to name the new baby after him. Vincent already feared for the child's family legacy—the seed of degeneracy that Vincent certainly carried and Theo probably shared. Why confuse and tempt the fates with another Vincent? He suggested naming the child Theo instead, "in memory of our father," and followed with grave concern every report of the baby's gloomy moods and "nervous disposition."

With each passing day, Vincent saw the reckoning approach. Theo mailed copies of the infamous article to family and friends, but conspicuously withheld comment or congratulations. ("It is necessary to get well known without obtruding oneself," he remarked obliquely.) Instead, he called Vincent's illness "the only cloud in the sky of our happiness," and complained that "Jo and I suffer too because we know you are ill"—expressions of sympathy that only added new weight to the impossible burden of guilt Vincent already carried.

The Aurier article—and the rumors that inevitably accompanied it—spawned a new terror: embarrassment. How would his family suffer as the details of his past "crime" and his commitment in Saint Paul began to be talked about openly? Would they be dragged through the "thorns and thistles" of public ridicule? Would his sister's marriage prospects be dimmed? Would the new child suffer? "You must beware of putting your young family *too much* into artistic surroundings," Vincent warned his brother. And all for what? In the month since the article appeared, no sales had materialized and not a soul had come to see him. An expected visit from a Marseille artist (arranged by Theo) was mysteriously canceled without a word, confirming Vincent's worst fears about the price of "pretension." Bernard maintained his stony silence, while Gauguin, too poor for honesty, hid his fury that Aurier had passed over him.

Sensing coldness on every side, Vincent retreated into his studio, returned to his furtive portraits of phantom love, and rejected Theo's latest invitation to Paris—"there is no hurry," he said—convinced that no one truly wanted him. "My pictures are after all almost a cry of anguish," he wrote to Wil in an entreaty meant for his mother's ears. "I feel that I have become a rather degenerate child."

In his pain, Vincent reached out to the only person who could make it better. He wrote a letter to his mother and began a new painting: "a blue sky with branches full of blossoms standing out against it."

Both his pen and his brush pleaded for forgiveness. He apologized again for Theo's decision to name his son Vincent—a second death for the dead parson. "I should have greatly preferred him to call the boy after Father," he wrote,

"of whom I have been thinking so much these days." In a desperate jumble of words, he tolled his sins: from a childhood of wandering too far on the heath to a lifetime of dependency, grief, and now illness. He confessed to violating "the bounds of pride and eccentricity" and being "soiled in the struggle for life."

His eye followed his thoughts back to Nuenen and his days of living "as the peasants do." On a walk outside, he saw an almond tree—its pink-and-white flowers the first blooms of spring. One particular old branch caught his eye: a gnarled, knotted, half-dead limb that twisted its way toward the sky. From this wounded relic, a shower of blossoms exploded.

It was an image of nature's redemption that had comforted Vincent since his days on the heaths and in the hovels of Brabant. To capture it, he returned to the intense looking and soulful imagery of the Kerkstraat studio—the imagery of birds' nests and battered shoes. Of all the drawings or paintings he had ever made, the only ones that his mother ever truly loved were the familiar scenes of nearby nature that he made for her during her convalescence in the Nuenen parsonage—especially the stand of sad, proud pollard birches. Now, with a brush instead of a pen, he focused his fanatic eye on another triumphant freak of nature.

On a big canvas, he plunged straight in, not even bothering to paint a background color before limning the bulbous branch and its delicate tracery of new life: every starburst flower, every wandering shoot, every tender pink bud. The bounty of it spread across the entire picture, to every edge and beyond—a promise in paint that even the oldest, humblest, most crooked, barren, and diseased branch could still produce the most glorious flowering in the orchard.

At the same time, he defended this vision of resurrection in words. To his mother, who had seen the Aurier article, he vehemently denied the accusations that it raised—nowhere more loudly than in Vincent's own head—of pretension, fraud, and degeneration. He invoked a fervent litany of artists who had worked at the very limits of love, spirituality, and sanity: Giotto, who wept when he painted; Fra Angelico, who painted on his knees; Delacroix, who worked "full of grief" but "nearly smiling." And surely none deserved the sainthood of sincerity more than the peasant-loving Millet, painter of the celebrated *Angelus*, who found divinity in "the quiet furrows of the fields." "Oh Millet! Millet!" he cried. "How he painted humanity and that *'quelque chose là-haut.'*"

How could his mother not embrace such exalted examples, such models of devotion and humility? Anna Carbentus had always criticized her son for not keeping "good company." What better companions could he have than these *copains imaginaires* in the new art—"we impressionists"? What better rebuttal to Aurier's charge of isolation and despair than these fellow disciples of the sublime, these tellers of truth and bringers of comfort no less than his preacher father?

To show his renewed commitment to this higher calling, this belief in something "that is not in ourselves," this shared faith in the ultimate forgiveness of the next world, he turned his eyes heavenward, placing his resurrected almond branch against a cloudless, clear blue sky: higher than the asylum walls, higher than the encircling hills, higher than any horizon—looking to the "other hemisphere of life" where art, religion, and family all reunited. Mixing and remixing an otherworldly blue, he painted around every tormented branch and brave blossom, filling every jagged void, every deformed crevice, with a rapture of brushstrokes in a color he called *"bleu céleste"*—heavenly blue.

Dizzy with maternal longing, Vincent struck out for Arles the next day, before the paint on his plea had dried. He took with him a different image of aspiration and desire, a portrait of Madame Ginoux. He may have thought to win his reluctant model with the exciting news from Brussels: one of his works in the Vingt show had sold. Anna Boch, sister of Eugène, the Belgian artist who posed for him in Arles, had bought his painting of the grape harvest, *The Red Vineyard*, for four hundred francs. ("Compared with other prices," he apologized to his mother, "this is little.") Still, he left the asylum clutching the announcement from Theo, no doubt hoping to impress the worldly, penurious Ginoux.

But something happened on the way. "My work was going well," he recalled a month later, "and the next day, down like a brute." Vincent never said what turned his dream of reconciliation into a nightmare. But only a month before, he had written Gauguin that his trips to Arles were always "disturbed by memories." "My illness makes me very sensitive now," he admitted to Theo. Despite continuing complaints of a "weak head" and "eccentric thoughts" after the last attack, he saw the trip as a test. "I shall try to make the trip to Arles again as a kind of trial," he wrote Wil the day before leaving, "in order to see if I can stand the strain of traveling out of ordinary life without a return of the attacks."

He couldn't. He was found the next morning wandering the streets of Arles, dazed and lost, unable to remember who he was, or where, or why. Both the painting he carried and the precious letter had disappeared. The authorities were contacted. Asylum personnel were dispatched to bring him back by carriage—a long and treacherous ride. The Ginouxs never said whether he had reached the Café de la Gare with his gift.

The day after he returned, Dr. Peyron wrote Theo reassuringly: "It will only be for a few days and he will regain his sanity as before."

BUT THIS TIME was different. This time, the demons would not release him. Day after day, week after week, he sat in his room seized by paralyzing fear and hallucinatory fevers. Wave after wave of despair washed over him. He could not read or write. No one dared to come near him, much less trust him with a pen or

pencil. Peyron banned him from the studio and forbid the use of paints. He held back the letters that arrived for Vincent, fearing they might contain fresh incitements. Now and then, the storms seemed to abate for brief interludes of dazed "stupefaction," loneliness, and pitiless self-reproach—periods in which Vincent could expound coherently on the nightmare in which he was trapped. But then, just as suddenly, the darkness would close in on him again, Peyron reported, and "the patient once more becomes despondent and suspicious and replies no more to the questions put to him."

Almost a month passed before he emerged long enough to write one single letter, and that one took several tries to complete. "Don't worry about me," he wrote Theo on March 15. "My poor boy, just take things as they come, don't be grieved over me, it will encourage and sustain me more than you think, to know that you are running your household well." He ended the short letter with a wan hope that "peaceful days will come again" and a promise to "write again tomorrow or the next day" when his head cleared. But no letter followed; his head did not clear. Instead, he plunged back into the darkness.

In another brief interlude, he managed to persuade his keepers to bring him a sketchpad, chalk, and pencil from his studio. With no models and a mind ravaged by memories, he filled sheet after sheet with drawings of figures—peasants digging and working the fields, parents with children, cozy cottages—deformed reveries of past and future, all drawn with the trembling hand of a frightened child, all as awkwardly posed and clumsily rendered as his earliest efforts in the black country. As if documenting the visions that afflicted him, he drew sowers and wanderers, empty shoes, parents with babies; endless versions of peasants eating around a table and empty chairs by the fireside.

And then he plunged back into the darkness.

Not even the surge of family attention that reached him in late March—on the occasion of his thirty-seventh birthday—could rescue him from the months of battering. If anything, the letters from the north only triggered dangerous new seizures of nostalgic longing. "Everything that reminds him of the past makes him sad and melancholy," Theo reported to his mother. With or without Peyron's permission, Vincent used his brief clearings of lucidity to paint a handful of images, all of which rehearsed the regressions that haunted his darker world. He painted scenes of his Brabant youth idealized into Andersen tales: filled with moss-covered cottages, quiet villages, and picturesque sunsets, all rendered in the "green soap" palette of *The Potato Eaters*. He called these nostalgic delusions "Reminiscences of the North," and laid plans for a much larger series, including new versions of his "Peasants at Dinner" and the old church tower in Nuenen. "I can make something better of them now from memory," he imagined. But his efforts to remake the past in paint only triggered new spasms of guilt, pushing him inexorably back into the abyss.

Finally, at the end of April, on the eve of Theo's birthday, he emerged from the darkness long enough to write another letter—only his second in two months. He meekly thanked his *waarde* brother for "all the kindness you have shown me," but offered only a cautious hope for his health ("I feel a bit better just now") before opening the floodgates of despair. "What am I to say about these last two months? Things didn't go well at all. I am sadder and more wretched than I can say, and I do not know at all where I have got to."

Two weeks later, he left the asylum for good.

WHAT HAPPENED? WHAT had changed? What gave Vincent (and Theo) the confidence to abandon the relative safety of Saint-Paul-de-Mausole after two months of relentless, devastating attacks—the worst yet—and dashed hopes for a lasting recovery?

Vincent awoke from his long nightmare as he always did: paranoid, angry, and determined to leave. "Really I have no luck," he wailed in his birthday greeting to Theo. "I must try to get out of here." He rehearsed old complaints about falling behind in his work (the blooming season in the orchards had already passed) and offered to go to an asylum in Avignon or Paris, reviving escape plans that had come and gone as often as his attacks. "I do not think I could be more shut up and more of a prisoner in the homes where they do not pretend to leave you free," he wrote bitterly about his "voluntary" confinement in the cloister of Saint Paul. "What one has to endure here is hardly bearable." He chastised Theo for allowing his previous deadlines for leaving to lapse, and propounded a preposterous theory—based on "observation of the other patients," he claimed—that he was too young and too energetic to fall victim to another attack for at least another year.

Within days, this delusion of invulnerability led him back to the plan, first proposed by Theo, of moving to the countryside outside Paris and living with a fellow artist, or on his own, near Paul Gachet, the doctor recommended by Pissarro. That plan had died once already, only to be revived in March when Theo reported meeting Gachet. "He gives the impression of being a man of understanding," Theo had written. "When I told him how your crisis came about, he said to me that he didn't believe it had anything to do with madness, and that if it was what he thought he could guarantee your recovery." Theo's letter, not read until the beginning of May, added a chimerical certainty of recovery to Vincent's determination to leave. "I am almost certain that in the North I shall get well quickly," he wrote, focusing the beam of obsession on the small town of Auvers, just north of Paris, where Gachet lived. "I dare to think that I shall find my balance in the North." He wanted to leave in "a fortnight at most," he announced impatiently, "although I'd be happier with a week."

But Theo had heard it all before. He had followed the ups and downs of Vincent's crises and weathered the inevitable urgent calls for rescue that followed each attack. He had watched many times as even the fiercest optimism yielded to dread, and then to silence. To fend off Vincent's demands to be released, he had counseled caution and proposed various "tests," all of which Vincent had failed. Horrified by the prospect of another public incident like the one at the Yellow House, Theo gently insisted that his brother remain "under the supervision of a doctor"—another impediment to a rash departure. To keep Vincent at least *near* the asylum, he tried (unsuccessfully) to find a painter willing to take a studio in Saint-Rémy for the winter. He issued dutiful invitations to Paris, of course, but always with conditions that provided a cordon of delay. (A year earlier, he had required five months without an attack before deeming a recovery secure.)

By the middle of March, after Peyron's dire report and another long silence, Theo had resigned himself to the inevitable cycle of Vincent's disease and urged his mother and sister to do the same. "Now that the crisis has lasted so long," he wrote them, "it will be more difficult for him to pull through." Vincent would never be "completely himself" again, he said, and to let him leave the asylum would be "irresponsible."

By early May, however, everything had changed.

By May, Vincent's predicament was no longer just a "sad situation"—a family embarrassment best left to doctors in a distant institution and the comfort of occasional letters filled with heartfelt but hollow encouragements. ("Cling to the hope that things will soon take a turn for the better," Theo wrote in March.)

By May, Vincent was a celebrity.

The Aurier article had lit the fuse. The explosion came in March, when the annual Salon des Indépendants opened in the splendor of the Ville de Paris pavilion on the Champs-Elysées. With Vincent locked in silent suffering, Theo selected the ten paintings that hung alongside works by Seurat, Lautrec, Signac, Anquetin, Pissarro, Guillaumin, and others. The president of France officiated at the opening on March 19, and in the weeks that followed, all of Paris's art world flooded through the pavilion doors. Many came specifically to see Aurier's tormented genius. Few left disappointed. "Your pictures are very well placed and make a good effect," Theo wrote, in a report that Vincent could not read until May. "A lot of people came to us and asked us to send you their compliments."

Vincent's work was dubbed *"le clou"*—the star—of the show, throwing even the new offerings of Seurat into the shadows. Collectors accosted Theo and "discussed your pictures even without my drawing their attention to them," Theo marveled. Artists returned again and again to see them; many made offers of exchanges. Painters stopped Theo on the street with congratulations for his brother: "Tell him that his pictures are highly remarkable," one of them said. Another artist came to Theo's apartment to express his "rapture" at Vincent's

imagery. "He said that if he had no style of his own," Theo reported, "he would change his course and go seek what you are seeking." Even Claude Monet, the monarch of Impressionism, pronounced Vincent's pictures "the best of all in the exhibition."

Critics ratified the triumph. In *Art et Critique,* Georges Lecomte praised Vincent's "fierce impasto," "powerful effects," and "vivid impression." In Aurier's magazine, *Mercure de France,* Julien Leclercq hailed Vincent's "extraordinary power of expression" and advanced Symbolism's claim to his art. "His is an impassioned temperament, through which nature appears as it does in dreams," Leclerq wrote, "or rather, in nightmares." He urged his readers to go and see for themselves these "fabulous" and "magnificent" new images: "ten paintings that bear witness to a rare genius."

But no review could have meant more to Vincent than the one sent by his former companion in the Yellow House (whose letter, like Theo's reports, languished unread in Peyron's office). "I send you my sincere compliments," Gauguin wrote. "Of the many artists on display, you are the most remarkable." He called Vincent "the only exhibitor who *thinks,*" and paid his work the ultimate tribute: "There is something in it as emotionally evocative as Delacroix." Gauguin, too, asked for an exchange.

It was one thing to seclude a troubled family member in the far-off mountain retreat at Saint-Rémy, away from the insults of daily life and public ridicule. It was quite another to imprison an artist that all of avant-garde Paris proclaimed a genius. As praise poured in and offers multiplied, as actual money appeared for the first time in Theo's account book (in March, he deposited the check from Anna Boch for *The Red Vineyard*), the awkward questions mounted. What a pity it was—a crime, almost—that Vincent was not free to paint as he wanted. Why was he so often deprived of his studio and paints? Why was he treated like a misbehaving child, not the great artist that he was?

Under the onslaught of questions and doubts, Theo quickly capitulated. Only weeks before, he had resigned himself to the tragic irony of Vincent's fate. "It is such a pity that just now his work is becoming very successful," he wrote his mother in mid-April. But on May 10, not even two weeks after the latest "recovery," Theo sent Vincent the hundred and fifty francs he needed for the journey north. Ever the pragmatist, he saw the commercial opportunities in his brother's sudden success, as well as the obstacles that his isolation posed to the full realization of that success. He shared Vincent's frustration at the long confinements and interrupted productivity. Business was slow (a broad economic downturn had dragged the entire art market into a slump), and the prospect of his brother finally supporting himself undoubtedly beckoned.

But Theo was a romantic, too. And just at the moment when he had finally resigned himself to the cruel inevitability of Vincent's exile, the triumph at the

Indépendante show allowed him to step back from the brink of fatalism and imagine a happy ending at last to his brother's long, sad journey. "I should like for you to feel better," he wrote Vincent with the simplicity of hope, "and for your fits of sadness to disappear."

Over the first two weeks of May, Theo's cautious fears fought a losing battle with his impetuous heart. He insisted that Vincent bear responsibility for his decision to leave Saint-Rémy (Vincent tried to characterize it as Theo's plan), and admonished him not to have "too many illusions about life in the North." He asked only that Vincent "act in conformity" with Peyron's advice—a knot of circularity, since Peyron, who opposed the release as premature, would not give his blessing without Theo's agreement. Over Vincent's furious objections, Theo argued that the asylum should provide an escort on the train trip all the way to Paris, pointedly recalling the absolute disaster of Vincent's unaccompanied excursion to Arles in February. On and on they went, in a duel of denial and delusion, indirection and defensiveness, thrashing toward a decision that neither wanted to claim.

But Vincent wasted no time. Convinced that his window of "complete calm" was closing fast (already reduced from a year to "three or four months" as the battle over his departure dragged on), he plunged back into painting. He had always come out of his attacks with a manic burst of belated energy and a profligate outpouring of paint, as if to make up for all the canvases forgone in his delirium. Never had the reservoir been so full. "I have more ideas in my head than I could ever carry out," he wrote. "The brush strokes come like clockwork."

He started in the garden, just as the early spring began to fade, with two of the "greenery nooks" that Theo prized: groundscapes of swirling, uncut grass and a carpet of dandelions among the gnarled tree trunks. But as he packed up his equipment in expectation of an imminent departure, he stayed more and more in the studio and confined his bursting brush to still lifes of flowers that he cut from the asylum garden: irises and roses—the last blooms of spring. He stuffed the already-listing flowers into ceramic vessels and, in a finish-line fury of work—"like a man in a frenzy"—filled one big canvas after another with expressions of his own impetuous heart and hope for the future.

The choice of subject wasn't just a matter of season or circumstance. His painting of irises from the previous spring had won many accolades since it first appeared at the *Indépendante* show in 1889—especially from his brother Theo. What more gorgeous display of gratitude could he devise—what more convincing argument for success—than these humble blossoms, misshapen but proud in their ephemeral glory? He painted them quickly, with the lavish brush and limber wrist of his serene mountain retreat. The same unique alchemy that had conjured the sunflowers of Arles—the impossible combination of urgency and care, calculation and ease ("packing seems to me more difficult than painting,"

he said)—now magically transformed the irises of Saint-Rémy into amethyst constellations of purple, violet, carmine, and "pure Prussian blue."

He painted them twice: once against the electric yellow of Arles, generating a jolt of contrast as striking as anything he had done under the Midi sun; and once against a serenity of pearly pink, glistening in the very gemlike colors and monumental forms praised by Aurier. He did the same with the roses, piling them into a simple jug until it spilled over with white blooms just barely tinged with reds and blues against a wavy background of *bonze* green; and then again as a towering cloud of blossoms in the tenderest pink, achingly poised against a wall of spring green, the color of new life.

By the end, only one subject remained. He had packed off his trunk and penned a farewell letter to the Ginouxs, leaving most of his furniture at the Café de la Gare as both a remembrance and a hope of return. But he held back enough canvas, paints, and brushes to keep working, and arranged to have any canvases not dry in time shipped after him. That left him alone with only a few finished paintings, which he would take as gifts, and a handful of prints. Theo had sent some of them earlier in May, at Vincent's request, and he had already turned two into grand paintings filled with color and meaning: Delacroix's *The Good Samaritan* and Rembrandt's *The Raising of Lazarus*. Because nothing terrified him more than idleness, he filled his last few days in the asylum—while he negotiated with Theo over the details of his travel—painting one final "translation" into color. He picked as his model not an image of rescue, like the Samaritan; or of rebirth, like the Lazarus. He chose instead a lithograph that he himself had made in The Hague in 1882. It showed an old man sitting by a fire with his head buried in his hands, overwhelmed by the woes and futility of life. It bore the legend he had lettered himself eight years earlier as another studio and another fantasy of family collapsed around him: "At Eternity's Gate." After all the protestations of health and hopes for the future, after all the bouquets of praise and plans for recovery, he still could not dispel the fear or escape the past. "I think of it as a shipwreck," he said of his southern journey.

In a mortification of despair, he painstakingly transferred the pitiful self-portrait to a big canvas and filled it with orange and blue and yellow—the colors of his shipwrecked enterprise in the Midi. "I confess to you that I leave with great grief," he wrote his brother. "Oh, if I could have worked without this accursed disease—what things I might have done."

The Garden and the Wheat Field

~

O N MAY 16, DR. PEYRON WROTE "CURED" ON VINCENT'S ASYLUM RECORD.
The next morning, his train pulled in to Paris's grand Gare de Lyon. Theo stood
on the platform to welcome him. Other than their fleeting, hazy reunion in the
Arles hospital, they had not seen each other in more than two years. They took
a horse-drawn cab through Haussmann's bright limestone canyons to Theo's
new apartment at 8, Cité Pigalle. A woman waved to them from a window. It
was Jo Bonger, the new Madame van Gogh. She met them at the door. It was his
first glimpse of her, and hers of him. "I had expected a sick person," she later
wrote, "but here was a sturdy, broad-shouldered man, with a healthy color, a
smile on his face, and a very resolute appearance."

Inside, the apartment greeted him with a ghostly procession from the past:
in the dining room, *The Potato Eaters* from Nuenen; in the living room, a view
of the Crau and the *Starry Night* from Arles. In the bedroom, a Midi orchard
bloomed above the bed that Theo and Jo shared. A flowering little pear tree stood
watch over the lace-draped cradle where three-and-a-half-month-old Vincent
lay. The brothers gazed silently at the sleeping child, Jo recalled, until tears
welled up in their eyes.

In the next two days, he whisked through gallery after gallery: from a mod-
est exhibition of Japanese prints to the grand halls of the Champs de Mars
where the spring Salon was still on view. Having seen nothing but his own
easel work for so long, he was overwhelmed by Puvis de Chavannes's gigan-
tic mural *Inter artes et naturam* (*Between Art and Nature*) with its marriage of
"primitive" archaic form and modern simplicity. "When one looks at it for a
long time," he wrote in a rapture, "one gets the feeling of being present at a
rebirth, total but benevolent, of all things one should have believed in, should
have wished for."

In the apartment, his paintings filled not just the walls, but the closets and drawers as well—painting after painting that he had packed up and sent off to his brother, sometimes before the paint had dried. "To the great despair of our housekeeper," Jo wrote, "there were huge piles of unframed canvases under the bed, under the sofa, under the cupboards in the little spare room." Pile by pile, Vincent dragged them onto the floor and into the light, studying each "with great attention," Jo recalled. He visited the storage room at Tanguy's, too, and reviewed the stacks of familiar images there, gathering dust along with a gallery of his fellow painters.

He had come promising a short stay, but dreaming of a long one. To allay Theo's fear of an attack far away from medical supervision, Vincent had talked of moving on to Auvers "as soon as possible" after arriving—perhaps even leaving his luggage at the station. But secretly he imagined "a fortnight" in Paris, at least—time enough to reconnect with his beloved brother and the young family he knew only from a photograph. "What consoles me," he had written Theo two weeks earlier, "is the great, the very great desire I have to see you again, you and your wife and child . . . as indeed I never cease thinking of them."

He carried proof of that great desire on his back: a heavy load of easel, canvas, stretchers, paints, and brushes. He had plans to take his equipment into the streets—starting "the day after my arrival"—and paint all the "essentially modern subjects" of Paris that had haunted his long exile. "Yes, there is a way of seeing Paris beautiful," he said. Then, perhaps, he would paint a portrait of Jo. Nothing could do him more good, he maintained, nothing could better protect him from the dangers of the outside world than "spending some days with you."

But on May 20—only three days after arriving—Vincent abruptly packed his things and returned to the station. He boarded the northbound train carrying the same burdens he had brought, with a few paintings from Saint-Rémy added to the load. His paint box hadn't been opened. He arrived in Auvers about an hour later. When the train pulled away, he was alone again. Paris had passed like a drunken revel or a dream: months of longing spent in a flash of hours. Stunned at his sudden solitude, he wrote Theo: "I hope that it will not be unpleasant to meet oneself again after a long absence."

Just as in the past, Vincent blamed his quick departure on Paris itself. "I felt very strongly that all the noise there was not for me," he explained after the fact from Auvers. "Paris had such a bad effect on me that I thought it wise for my head's sake to fly to the country." But his welcome in Paris had always been uncertain, and his ambitions for the visit always conflicted. He had pleaded with Theo to "insist" that Aurier not write any more articles about his painting. "I am too overwhelmed with grief to be able to face publicity," he wrote on the eve of leaving the asylum. "Making pictures distracts me, but if I hear them spoken of, it pains me more than he knows." Still, he made plans to see the critic while

in Paris (plans that fell through), and he despaired when neither Gauguin nor Bernard bothered to come see him, even though both were in Paris at the time.

Theo welcomed him heartily, even tearfully, but the years of sacrifice and secret illness had taken a terrible toll that Vincent saw etched in his brother's sunken face, pale complexion, and rattling cough. (Jo later admitted her shock at how much healthier Vincent looked when the two brothers stood side by side.) Despite their years apart, Theo spent most of Vincent's brief visit working long hours at Goupil, where a Raffaëlli show filled his mezzanine gallery and a strategy to recapture Monet as a client preoccupied his mind.

Not enough time had passed, however, to erase the stains of the past. Still feeling unwelcome at his brother's workplace, Vincent failed to attend the Raffaëlli show or even to see Gauguin's latest paintings from Brittany. Indeed, everything about Theo's new life in Paris seemed to scold or exclude him: from his brother's poor health to the piles of unsold paintings hidden away under beds and in Tanguy's bug-infested storeroom; from the bright bourgeois apartment on Cité Pigalle ("which is certainly better than the other one," Vincent admitted) to the Dutch that Jo insisted on speaking. Even in the baby's colicky wails, Vincent heard the judgment of his family and his past. "I can do nothing about my disease," he wrote guiltily from his banishment in Auvers.

> I do not say that my work is good, but it's the least bad that I can do.
> All the rest, relations with people, is very secondary, because I have no
> talent for that. I can't help it.

WHEN VINCENT AWOKE from his three-day dream of Paris, everything had changed and nothing had changed. He could walk the streets of Auvers without an escort, but all the faces still belonged to strangers and all still eyed him with suspicion. He could buy whatever food he wanted and choose the hotel where he stayed, but Theo still had to pay the bills. "Send me some money toward the end of the week," he wrote, already broke, the day after his arrival. "What I have will only last me till then." In his haste, he had left Paris without arranging new "terms" with his brother, so his very first letter plunged him back into the torment of dependency. "Is it 150 francs a month," he was forced to inquire, "paid in three installments, as before?"

In Auvers, Vincent could finally be treated by a doctor who understood artists. In his forty years of practice, Paul Gachet had tended to the afflictions, both physical and mental, of an avant-garde honor roll that included Manet, Renoir, and Cézanne, as well as Van Gogh colleagues like Pissarro and Guillaumin. But when Vincent went to see Gachet on the day of his arrival, he found the sixty-one-year-old doctor as detached and distracted as the ophthalmologist

Peyron. Surrounded by a house full of cats and dogs and a yard full of fowl, the dyed-blond Gachet greeted him with complaints about the medical profession, nostrums of encouragement ("he said that I must work boldly on"), and offers of a mysterious "booster" treatment if Vincent should fall prey to depression "or anything else became too great for me to bear." To Theo, Vincent bleakly dismissed any hope that Gachet could provide meaningful medical oversight—the hope that had drawn him to Auvers in the first place. "We must not count on Dr. Gachet at all," he wrote. "First of all, he is sicker than I am, I think . . . Now when one blind man leads another blind man, don't they both fall into the ditch?"

In Auvers, for the first time in years, Vincent could meet people at will—circulate, start fresh, without the terrible rumors that followed him everywhere in Arles. Paris lay only twenty miles over the pastoral horizon, and the cottage-lined streets bustled with cosmopolites—retired, seasonal, even weekend refugees who shared none of the superstitions or prejudices that had dogged his past ventures into the countryside. (In the summer, Auvers's population swelled from two to three thousand.) But Vincent brought his exile with him. Despite the beautiful scenery ("There is a great deal of color here," he wrote of the picturesque riverbank town), he laid plans to lock himself in his hotel room and redraw the Bargue *Exercices* yet again.

With unlimited access to pen and paper, he could write to anyone he wanted. But his mind wandered and his hand faltered. He started letters multiple times and left completed drafts unsent. With his work, too, freedom thwarted resolution. He talked hazily about painting some more "translations" of his old drawings and perhaps "working a little at the figure." "Some pictures present themselves vaguely to my mind," he reported listlessly, "which it will take time to get clear, but that will come bit by bit."

In Auvers, he could finally see the night sky without looking through a barred window. But the stars still spoke of loneliness and distant loved ones. Sitting alone in his empty hotel room (his trunk had been delayed), bereft of companionship, or even attention, Vincent's thoughts returned inexorably to the family he had left behind in Paris. "Often, very often I think of my little nephew," he wrote only a few days after arriving.

> Is he well? I take an interest in my little nephew and am anxious for his well-being. Since you were good enough to call him after me, I should like him to have a soul less unquiet than mine, which is foundering.

With this plaintive, confessional plea, Vincent began the last great campaign of his life. The days in Paris had been brief, but even the fleeting sight of his brother's wife and child had triggered a longing that overtopped all those

that preceded it. In the cell-like solitude of his Auvers hotel room, he dreamed a scheme—a final "castle in the air"—commensurate with that longing. He would bring Theo's family to Auvers and make it *his* family.

The idea had formed by the time he left Paris; perhaps even before then. It was the same vision of reunion that he had shouted from the wilderness of Drenthe when he demanded that Theo—and his mistress—"join me" in a cottage on the heath to form a "family of painters." It was the same vision that comforted him in 1887 when Theo first proposed to Jo Bonger and Vincent imagined the three of them sharing a "country house" filled with one brother's children and the other's paintings. With the same vision, he had beckoned Theo, in words and images, to make the Yellow House his home in the South so they could jointly foster the next generation of Impressionists.

But this time the family was real, not imaginary. Vincent had held the child in his arms only days before. It bore his name.

His first lonely days in Auvers turned that vision from a wistful dream into a driving obsession. When he first committed it to paper, in a letter addressed to Jo as well as Theo on May 24, it came out not as a plea but as an accusation. "At present it seems to me that while the child is no more than six months old yet, your milk is already drying up," he scolded his sister-in-law. "Already—like Theo—you are too tired. . . . Worries are looming too large, and are too numerous, and you are sowing among thorns." He chastised the young parents for shirking their duty to their child by staying in the city where all three were forever "on edge and worn out." If they continued on that reckless path, Vincent warned, "I foresee that the child will suffer later on for being brought up in the city." In short, they risked condemning their son to a life of "suffering" and "ruin"—a life, that is, like his uncle's.

Vincent never sent that letter. No doubt deeming it too harsh and too honest, he set it aside and drafted a different, less dire invitation: "Often, very often, I think of your little one and then I start wishing he was big enough to come to the country. For it is the best system to bring them up here." But the fire of obsession burned no less brightly in the weeks of persuasion that followed. "Auvers is very beautiful," he wrote, "really profoundly beautiful . . . decidedly very beautiful." He called it "the real country, characteristic and picturesque . . . far enough from Paris to be *real* country . . . an almost lush country [with] much well-being in the air." He compared it to Puvis's mural of a quiet, ancient, unstained Eden—only lovingly tended like a Dutch garden, not Zola's untamed *Paradou*—"no factories, but lovely greenery in abundance and well kept."

For Jo, he promised escape from the choking air and noise of the city, less pressure on her overworked husband, more "solid nourishment," and better health for all—especially the baby. "I honestly believe that Jo would have twice as much milk here," he wrote. Again and again, he appealed to the mother's

duty to her young child. "I often think of you, Jo, and the little one, and I no-
tice that the children here in the healthy open air look well." He sympathized
over the "terrible difficulty" of raising children in the city: of "keeping them safe
and sound in Paris on a fourth floor." He had heard the child's relentless wails
and seen the mother's exasperation at what she called his "hot-headedness": his
"screaming as if someone is killing him." All he needed, Vincent insisted, was
country air, better milk, the soothing distractions of animals and flowers, and
"even more, the little bustle of other children that a village has."

For Theo, Auvers needed no introduction. The medieval town along the Oise
River, a tributary of the Seine, had entered the French imagination as early as
the 1850s, when Charles Daubigny anchored his studio barge at the water's
edge and began to record its archetypal charms. Fixed in the rich alluvial mar-
gin between the river and the surrounding plateau, and dependent for centuries
on the fish-rich waters of the Oise, the town had grown along the riverbank like
a vine, not outward onto the surrounding plateau.

Only a few roads wide, but miles long, mixing clusters of thatched houses
and farm enclosures with vineyards and market gardens all along its winding
length, Auvers became a model for the postcard-perfect rural utopias depicted
again and again in the mania of nostalgia that accompanied the depredations
of industry. Once the railroad came, the same mania brought flocks of Pari-
sians, all looking for vestiges of the lost past. Artists like Corot, Cézanne, and
Pissarro followed Daubigny in capturing these pretty, rustic scenes for broader
consumption, and dealers like Theo van Gogh sold thousands of their images of
picturesque cottages, country lanes, and village folk, all advertising the repara-
tive power of country life.

But Vincent had a more specific promise for Theo. He had left his first en-
counter with Dr. Gachet discouraged, even scornful. But his new vision of family
changed all that. The eccentric doctor now had a critical role to play in bring-
ing Theo to Auvers. What better enticement to his sick brother than a repu-
table, sympathetic, attentive (and rich) physician? Vincent immediately shelved
the letter he had written dismissing Gachet ("the blind leading the blind") and
substituted a glowing account of their budding friendship. "[He] has shown me
much sympathy," Vincent wrote. "I may come to his house as often as I want."
Indeed, he had found in the dotty doctor yet another lost brother. "Father Ga-
chet is very, yes very like you and me," he wrote, slipping into the fraternal "we"
of earlier days. "I feel that he understands us perfectly, and that he will work
with you and me to the best of his power, without any reserve, for the love of art
for art's sake."

To prove this alluring vision to his brother, Vincent took his easel to Gachet's
big hillside house, set it in the garden amid the chickens, turkeys, and ducks, and
began a portrait of the strange man who had become both his bulwark against

the storms and his best chance for a family of his own. He painted him in a thoughtful pose: seated at a table with his head turned to one side and propped comfortably on his hand, as if listening to his neighbor at a dinner party. His attentive posture, open face, and big blue eyes, fretted with concern, invite confidences of both body and soul.

DR. PAUL GACHET

On the table in front of him, Vincent placed a glass with sprigs of foxglove, as both an emblem of Gachet's particular devotion to homeopathic remedies and a deeper promise of nature's curative powers. Next to the glass, Vincent painted two books, their titles carefully inscribed as a message for Theo: *Germinie Lacerteux* and *Manette Salomon*—both by Edmond and Jules de Goncourt, the great model for all artistic brotherhoods: one, a cautionary tale of illness and death in the city; the other, a story of salvation through art. Together, they reassured Theo that this eccentric country doctor, with his funny white cap and too-heavy-for-summer coat, fully embraced the modern world of the mind, even as he worked to cure its inevitable ills.

The portrait of Dr. Gachet marked the opening round in a fusillade of painted arguments for Auvers. In Drenthe, Vincent had sent magazine illustrations inviting Theo to share the "stern poetry" of the heath. In Arles, he had

summoned his *copains* to the primitive nobility of the Midi with monuments of color and light. Now, from a makeshift studio in a back room of his hotel, he dunned his brother (and Jo) with dozens of advertisements for the healthy, happy, family-friendly life that could only be found in the rural utopia of Auvers.

In a frenzy of work that began every morning at five and often left canvases, like letters, unfinished or loosely drafted, he painted the little village all up and down its length, devoting canvas after canvas to the quaint thatch-roofed cottages that were disappearing almost everywhere else on the Continent but still spoke eloquently of a simpler, steadier time. He painted Auvers's unique marriage of country and village. Because of its long reach, the town had no real center; houses alternated with vineyards and gardens all along its two main arteries. Nature broke in everywhere. Every house that he painted sat in its own park, enveloped in greenery—a promise that comfort and repair never lay more than steps away from any door.

So powerful was the spell of nature in Auvers that it transformed even the new middle-class "villas," which Vincent despised everywhere else, into "pretty country houses." He painted them, too: stately homes with regular façades and airy banks of windows—the kind of houses rich Parisians built, bought, or rented—houses fit for a prominent art dealer and his family. As if leading his brother on a tour of the neighborhood, Vincent painted glimpses down every thoroughfare and rutted back road of Auvers. He painted the great chestnut trees on the rue Boucher, the *maisons* of local notables, and the winding pedestrian paths up the riverbank, all lined and shaded by flowering trees, bushes, and wildflowers.

He climbed to the top of the high bank and showed Theo the winding Oise with its modern railroad bridge, putting Paris an easy commute away. From there, he only had to turn around to reveal the fertile plateau of the Île-de-France. The change from riverbank to plain was a dramatic one: from a sunken valley of lush verdure to an unbroken expanse of crop rows and furrows, plots and fields, as far as the eye could see. Vincent painted the sudden vista in all its Crau-like mosaic splendor. All this, he pledged in painting after painting, could be Theo's to share.

A magical land demanded magical inhabitants, and Vincent painted these, too: ambling the verdant paths and traffic-free streets, promenading along shaded walks with parasols or straw bonnets. Almost all were women, or girls, often in twos, leaning together in deep conversation—a promise of companionship to a Dutch girl stranded in Paris. No one in Vincent's enchanted Auvers works. Here and there, figures tend the little gardens or vineyards outside their doors, but they never stoop or kneel or use a tool. No onerous Millet labor mars the pristine beauty of the fields above Auvers, either, even in the middle of the harvest season.

Vincent painted one local girl posed in the midst of ripe wheat stalks. But she sits serenely in a long polka-dot dress, wearing a clean apron and a neatly knotted bow on her bonnet. Her red cheeks and full round breasts speak not of hard labor but of healthy living and wholesome milk. He painted children, too: chubby, smiling children, ensconced in nature, beaming with good health and humor. Finally, in a hint of the future, he painted a hearty young lad with a mop of Theo's signature red-blond hair. He clenches a cornflower rakishly in his teeth: a sign—a guarantee—of robust adolescent blood.

Like all Vincent's reveries of reunion, however, his campaign for Auvers argued more ardently for the past than the future. The thatched cottages of his advertisements for the Oise valley looked less like those he saw on his walks in the village than like the storybook cartoons that he had drawn and painted during his nostalgic delirium in Saint-Rémy earlier that spring: his "Reminiscences of the North." At that time, he intended to repaint all the dark images of his past, even *The Potato Eaters*, using the color of the South to transform them into icons for a new age. In Auvers, he resumed this project of personal redemption through artistic renovation. He filled canvas after canvas with familiar scenes of country life—as redolent of Brabant as Auvers—in the colors and forms of the new art: the luminous poppy fields of Monet, the gay riverbank of Renoir, the *doux pays* of Puvis. He found a modern villa that looked like the parsonage in Nuenen and painted it under the starry night sky of the Midi—exactly as he had intended to paint the Yellow House.

Fulfilling a specific vow he made to Theo in April, he carried his easel to the Gothic church that overlooked the town of Auvers and set his brush to the most difficult task of all: repainting the forbidding church tower in Nuenen where his father lay buried. Using an even bigger canvas, he transformed the gloomy stone hulk of the past into a glass palace of color. The twelfth-century walls and buttresses spring from the wildflower-strewn grass in bright shades of violet and ocher. The busy silhouette of transept, apse, and tower plays irrepressibly against the "simple, deep, pure cobalt" sky. A slab of bright orange roof jars the rambling old building to life. Below, a sandy path "with the pink flow of sunshine" surrounds and embraces it.

As soon as it was done, Vincent pronounced a triumphant verdict on all his efforts to reimagine the past and reclaim his brother: "Once again it is nearly the same thing as the studies I did in Nuenen of the old tower and the cemetery," he wrote, "only now the color is more expressive, more sumptuous."

Theo heard and saw his brother's pleas. But, as always, Vincent demanded too much. He had begun rationally enough (only a day after leaving Paris) with a simple "I'd be very glad if some time you were to come here one Sunday with your family." But soon his expectations had escalated to "a month of absolute rest in the country." Next, he pressed Theo to cancel his customary three-week

summer holiday in Holland and come to Auvers instead. Their mother would miss seeing the little one, he conceded, but she "would surely understand that it was really better for the baby." Finally, he imagined "living together for years." Theo managed, as always, to parry his brother's wilder schemes while never dashing his hopes entirely. He didn't write at all until early June, and even then he responded only vaguely to weeks of ardent invitation. "At some time or other I shall have to go there," he wrote, "and I shall be pleased to lend a willing ear to your proposal to come with Jo and the little one." He mulled the possibility of splitting the distant summer holiday (with a brief stop in Auvers on the way to Holland), but committed to nothing.

Then suddenly, he announced a visit. After all Vincent's exertions, it had taken only a casual invitation from Dr. Gachet, who dropped in at the Paris gallery, to make the impossible happen. "He told me that he thought you entirely recovered," Theo reported about Gachet's brief visit, "and that he did not see any reason for a return of your malady." Even after accepting the invitation, however, Theo refused to "absolutely promise" until the appointed day arrived, and wouldn't have gone at all if the weather hadn't been clear.

As it happened, Sunday, June 8, was a beautiful day, and Vincent spent a sublime afternoon with his brother's little family in the Eden of Auvers. He met them at the train station clutching the gift of a bird's nest for his four-month-old namesake. They had lunch on Gachet's terrace overlooking the Oise. Vincent insisted on carrying the baby into the yard and thrusting him at all its feathery inhabitants "to introduce him to the animal world," Jo recalled. The roosters, hens, and ducks scattered before him, raising an alarm that terrified the child. Vincent tried to calm him by imitating the sound of the crowing cock— "*cocorico*"—but that only made the baby scream louder. He took the family on a walking tour of the paradise that he had shown them so often on canvas and in dreams. Then they loaded the pram onto the train and left.

Theo no doubt hoped the brief excursion would appease his demanding brother. But it had just the opposite effect. If anything, the fleeting visit only emboldened Vincent's vision of a new family, together forever in the peaceful valley of the Oise. "Sunday has left me a very pleasant memory," Vincent wrote afterward; "you must come back soon." He immediately imagined a whole string of successive visits because "we live so much closer to each other now." He even ventured to commit his most precious wish to words: "I should very much like you two to have a pied à terre in the country along with me."

As in Drenthe, Vincent strained every sinew of his imagination to make that wish come true.

To allay Theo's fear that the attacks could return at any time, he never missed a chance to proclaim his good health. Bolstered by Gachet's oblivious optimism, he dismissed the previous two years as a bad dream from which he

had finally awoken. "My Northern brains were oppressed by a nightmare," he wrote, again blaming his affliction on "a malady of the South" and promising that "the return to the North will free me from it." Indeed, "the symptoms of the disease"—especially the nightmares—had "quite disappeared," he claimed. He wrote to Dr. Peyron as if discharging him ("I shall certainly never forget him"), and pleaded his recovery to his mother and sisters, recruiting them to his crusade for a second chance. "It makes me happy," sister Lies wrote Theo, "that Vincent is back again in an environment of healthy minds and can enjoy life more naturally."

Of all those healthy minds, none impressed Theo more than Paul Gachet. "I hope you [two] will become friends," he wrote enviously. "*I* should like very much to have a friend who is a doctor." In response, Vincent sent a crescendo of boasting reports about his relations with the good doctor. "I have found a true friend in Dr. Gachet," he wrote, "something like another brother, so much do we resemble each other physically and also mentally."

He claimed that Gachet showed "much sympathy" for his work and visited his little hotel studio two or three times a week "for hours to see what I am doing." "*The gentleman knows a good deal about painting,*" Vincent wrote, "and he greatly likes mine." Gachet had invited him to work in the villa garden and even to stay overnight if he wished. He took frequent meals at Gachet's elaborate table ("four- or five-course dinners," Vincent groaned) where he befriended the widower's two children: sixteen-year-old Paul *fils* and twenty-one-year-old Marguerite. To Theo, he described his evenings at the villa as reminders of earlier, fonder times: "those family dinners which we ourselves know so well."

Vincent sealed this inviting tableau of family *temps perdu* with paintings, starting with his portrait of *"père"* Gachet portrayed as both healer and sympathetic paternal ear, as well as rich patron of the new art. In late June, Vincent seemed to float the possibility of an even more direct family connection with the announcement that he had done a portrait of Gachet's daughter Marguerite. In its ambitious scale and careful rendering, the painting of a well-dressed young woman intently playing an upright piano gave rise to speculation—probably at the time and certainly later—of an unrevealed love on one side or the other.

But Vincent painted Marguerite less as an object of desire than as a sister: an earnest, cultured piano player like his sister-in-law Jo—the perfect partner for Beethoven *à quatre mains*—a different but no less potent promise of family connection and enlightened urbanity in the bosom of nature. "I imagine Jo would soon be friends with her," Vincent wrote. Only days after the portrait was done, he sent Theo a renewed invitation: "I think that it would be a good plan for you to come and stay here—with Gachet—with the little one."

—

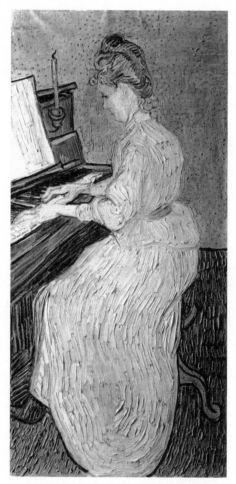

Marguerite Gachet at the Piano, JUNE 1890,
OIL ON CANVAS, 40¼ X 19¾ IN.

FOR ALL ITS ODDITIES, the Gachet house offered comfort, station, and artistic companionship—all the refinements of the city in addition to breathtaking views of the river valley. The family of Gustave Ravoux offered a different, more urgent version of the pastoral ideal. Vincent had come to Ravoux's little inn across from the town hall because of its low price. But in his narrative of perfect retreat, the Ravouxs—recent refugees from the city—exemplified the "enormous effect of country air." "The people at the inn here used to live in Paris, where they were constantly unwell, parents and children," he wrote Theo pointedly. "Here they never have anything wrong with them at all."

Ravoux's infant son "came when he was two months old," Vincent reported with special gravity, "and then the mother had difficulty nursing him, whereas

here everything came right almost at once." To bolster these arguments, he painted two more portraits: one, of the Ravouxs' thirteen-year-old daughter Adeline—pink-cheeked, ponytailed, and rendered in the deepest, most serene blues he could conjure; the other, of her young sister Germaine as a towheaded two-year-old fondling a fresh orange. "If you come with Jo and the little one," he summed up, "you could not do better than stay at this same inn."

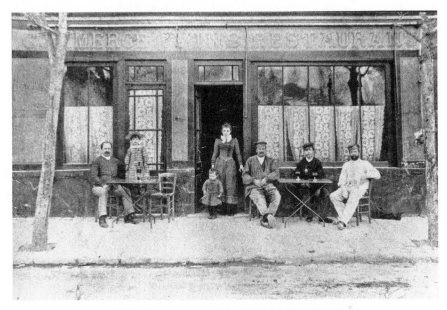

THE RAVOUX FAMILY IN FRONT OF THE RAVOUX INN

Vincent's portraits of the men, women, and children of Auvers sprang from the same invitation as his lavish landscapes of the Oise valley. "I am looking forward to doing the portraits of all of you in the open air," he wrote Theo in a rapture of anticipation: "yours, Jo's and the little one's." Like the paintings of his mother and father that he was forever imagining he would do, even in the darkest days of Drenthe and Nuenen, but never did, the unpainted portraits of his brother's family haunted all the images from Auvers with their conspicuous absence. In a letter to Wil, Vincent explained his undying love for portraiture in words that spoke with equal poignance of striving for artistic perfection and longing for human connection:

What impassions me most—much, much more than all the rest of my métier—is the portrait, the modern portrait. . . . I *would like* to paint portraits which would appear after a century to people living then as apparitions. By which I mean that I do not endeavor to achieve this by a photographic resemblance, but by means of our impassioned expres-

sions—that is to say, using our knowledge of and our modern taste for color as a means of arriving at the expression and intensification of character.

The portraits that increasingly lined Vincent's studio also announced his reborn ambitions to commercial success—without which no vision of paradise was complete. "In order to get some clients for portraits," he wrote in early June, "one must be able to show different ones that one has done. That is the only possibility I see of selling anything." Over the next month, while he labored relentlessly on his slideshow of rural utopia, he signaled his commercial determination by painting flowers (always sure sellers); planning a café exhibition in Paris; writing sales pitches to critics; imagining forays into new media, like posters and prints; and negotiating complex exchanges of his works (both for other artists' paintings and for services rendered). But he never stopped clinging to the delusion that had gripped him since Antwerp: that he could make money doing what he loved most—portraits.

Such thoughts drew him irresistibly back to Paul Gauguin, the Bel-Ami of the Midi that he had expected to usher in "a great revolution in portraiture." Of all Vincent's paintings the world had seen since January, Gauguin had expressed particular admiration for the *Arlésienne*—Vincent's portrait of Madame Ginoux based on Gauguin's own drawing of her. Still convinced that his commercial viability was tied to Gauguin and the "southern" imagery that they had pioneered together, Vincent reached out to his former housemate with groveling praise ("Dear *maître*"), tender affection ("since my return I have thought of you every day"), and urgent pleas for reconciliation. He even offered to join Gauguin in Brittany, where, he solemnly promised, "we will try to do something purposeful and serious, such as our work would probably have become if we had been able to carry on down there"—that is, in Arles.

Daydreams and smoky evenings filled with thoughts of portraits and models and memories of the Yellow House led Vincent inevitably, again, to the search for a studio. The Ravouxs had given him the use of a small room off the back hall of the little inn to spare him the long climb upstairs with his cumbersome kit. They had even set aside a place in the barn where he could dry his paintings. By the time Theo and his family visited in early June, however, Vincent was already talking about renting a house somewhere in the village.

He wrote to the Ginouxs requesting that they send the two beds from the Yellow House, still stored in their café attic, and began to militate for retrieving the paintings stacked so haphazardly both at Tanguy's and in Theo's apartment. He had to have a studio to prevent them from going to ruin, he argued, and to retouch those that needed it. "By keeping them in good condition," he

reminded Theo, pleading for himself as well as his paintings, "there will be a greater chance of getting some profit out of them." "Neglecting them," he sputtered, in an accusation that rang with personal grievance, "is one of the causes of our mutual penury."

By mid-June, only days after Theo's visit, he had found one particular house (for four hundred francs a year) and begun the long march of persuasion. "This is how it is. Here I pay 1 franc a day for sleeping, so *if I had my furniture,* the difference between 365 francs and 400 would be no great matter, I think." Somewhere along that road, his old dream of a studio merged with the larger quest for home and family. His search for a studio became a hunt for a house that all could share. He immediately began thinking about how to decorate this combined artist's studio and family home—the first since the Schenkweg—and fixed it in his imagination with a painting.

But even his biggest canvases proved too small for this double dream. He needed a new, larger size to paint his new, larger-than-life vision of home and family at last. He had seen many big, panoramic pictures over the years, but none more recent or more powerful than Puvis de Chavannes's magisterial mural at the Salon in Paris, *Between Art and Nature.* To achieve the same enveloping pictorial world—the embrace and escape of pictures like that—Vincent began working on a canvas almost three and a half feet wide and half as tall: as big a painting as he could balance on his easel.

On this vast horizontal blank, and others like it, Vincent made his last and most vehement pleas for Auvers.

No scene lent itself more perfectly to the new format than the fields above the rim of the river valley. Both Theo and Jo admired the view of the Crau that Vincent had painted in Arles—so much that they hung it in the living room of the Paris apartment. What better subject for his first beckoning panorama than this boundless vista of neatly tended plots in a receding puzzle of ripe yellow wheat and green potato plants, stacks of mown hay and furrows of freshly turned soil? He filled the broad foreground with a profusion of flowers, mostly poppies, painted in an ardor of pigment and brushstroke that grows freer, looser, and more fervent as it sweeps toward the viewer like a flood. The narrow strip of sky at the top he dispatched with a wide brush and a cloudless blue.

Next, he turned his wide-angle lens to the forest floor. Not the forest primeval, with its wild variation and untamed undergrowth, but a grove of mature poplar trees planted in neat rows—probably a formal *bois* on the grounds of the local château. He focused his eye on the carpet of wildflowers beneath: a *sous-bois* of "grass with flowers, pink, yellow, white and various greens." A golden light filters down through a canopy of leaves that hovers just above the painting but is nowhere visible. The ranks of trees show only their trunks—row after row of

violet stripes in plunging perspective, disappearing into a high, dark horizon of deeper and deeper woods. In the middle of this cultivated Elysian grove, as tame and touching as a stage set, Vincent placed a well-dressed couple on an intimate stroll. Such were the glowing moments of communion with nature that awaited Theo and Jo in the valley of the Oise.

And when they returned from their outings, they came home to the scene he painted on another big canvas. A dirt road winds toward a distant country house, standing half-hidden by trees on the far side of a parklike glen and fields of green wheat. Behind it, the setting sun fills the sky with brilliant color. The fading light etches a pair of nearby pear trees in dramatic silhouettes of Prussian blue, creating the kind of picturesque vignette, the surprise of beauty, that would always stop Dorus and Anna van Gogh on their walks around Zundert for a moment of silent appreciation. In the distance, he painted Auvers's famous château, nestled in greenery. But in Vincent's dreamlike vision, the elaborate castle—a vast amalgam of two centuries of building and planting, parterres and terraces—was reduced to a simple silhouette of forget-me-not blue: an image of home on the horizon, rest at journey's end, that summoned his brother to the best of both bourgeois comfort and rustic sublime.

If Theo's young family appeared nowhere in these visionary vistas of country life, they didn't have to. Theo, like Vincent, had seen Puvis's big painting at the Salon, and Vincent's mural-shaped invitations invoked that image wordlessly. In a letter to Wil, Vincent described Puvis's friezelike tableau of family life in Arcadia:

> On one side two women, dressed in simple long robes, are talking together, and on the other side men with the air of artists; in the middle of the picture a woman with her child on her arm is picking a flower off an apple tree in bloom.

In early July, Vincent made this vision of family and art his own with another inviting panorama. He chose as his subject not the Michel-like vista of the plateau, or the Gauguin-like mystery of the woods, or the Corot-like magic of a country sunset. Instead, he took his easel and paints and ungainly canvas to a house just a few steps from the Ravoux Inn: the house of Charles Daubigny.

Other than Millet, no painter of Vincent's lifetime had touched his heart or shaped his art more than Daubigny: hero of the Barbizon; champion of plein air painting; liberator of the brush from Salon rectitude; godfather of Impressionism; friend and mentor to generations of painters of nature, from Dupré and Corot to Cézanne and Pissarro. He had brought many of them to Auvers: first to his studio barge, *Le Botin*, then to a succession of houses that he built on the

verdant riverbank. The last and grandest of these was a long, narrow structure of pink stucco and blue roof tiles overlooking the river and a beautiful, parklike garden.

Daubigny died before he could enjoy this hillside paradise of fruit trees and flower beds, lilac hedges and rose-bordered paths. The tragedy of it reached as far as Amsterdam, where a twenty-four-year-old parson's son and failing pastoral candidate anxiously awaited the next turn of his fate. "I was downcast when I heard the news," Vincent wrote when he heard of Daubigny's death in 1878. "It must be good to die in the knowledge that one has done some truthful work and to know that, as a result, one will live on in the memory of at least a few."

Twelve years later, Daubigny's widow still lived in the big pink house near the station—an image of abandoned womanhood and faithful grief that transfixed Vincent's imagination. He had planned on painting the garden of her vigil from the moment he arrived in Auvers and heard the touching story. The public was admitted from time to time and still caught glimpses of the black-clad Sophie Daubigny-Garnier. Vincent had already made one study of the garden—so intent on doing so that he used a linen towel when he couldn't find a canvas.

This time he brought his big double-square canvas and filled it with all the gardens of a lifetime: the wandering paths of the Etten parsonage, as he had painted it for Gauguin; the shimmering leaves of the olive groves outside Arles; the swirling vortices of the night sky over the garden of Gethsemane. In Vincent's reverie, it was blooming season for every plant. Every leaf on every tree trembled with light. The yellow wildflowers of spring still dotted the grass, and manured flowerbeds radiated vivid lavender. Dull bushes came alive with swirls of color and vibrations of shade. Lime trees marched toward the distant house on impossibly thin trunks with wavy crowns of foliage in cloudlike formations.

Like the "poet's garden" outside the Yellow House, this garden had its ghosts, too, its Petrarch and Boccaccio. Not just the spectral figure of Madame Daubigny, which Vincent added in the background, wearing widow's weeds and standing forlornly next to an empty table and chairs—another echo of parsonage gardens past—but the dead artist himself, as "seen" in the empty lawn chair and in the mysterious cat that skitters across the foreground, but mostly in the great effusion of life all around: the rapture of nature that Daubigny had painted so often, and that even now resurrected him in memory.

But this beckoning image of the "lush country" and "lovely greenery in abundance" that Vincent promised in Auvers, of "the quiet like that of Puvis de Chavannes," spoke to Theo in a code deeper still. Daubigny had spent his final years not just with his wife and children, but also with a fellow artist, Honoré Daumier, the painter and immortal caricaturist, grown blind in old age. The *three* of them had sat together at a garden table under a vine arbor and filled

Daubigny's house with both great art and laughter. In this dream landscape, they had lived out their lives together—husband, wife, and afflicted confrère: a model for the home and studio, family and brotherhood, that Vincent imagined for himself and Theo and Jo in the Edenic valley of the Oise.

IT WAS A BEAUTIFUL, alluring vision—as much as paint and words could make it. But real life for Vincent in Auvers was anything but idyllic. He had arrived in May holding on by the thinnest thread: terrified by the possibility of another attack, still racked with guilt over the money diverted from Theo's new family, haunted by the stacks of unsold paintings in Paris. He poured his despair into a letter so bleak that he didn't dare to mail it: "I am far from having reached any kind of tranquility . . . I feel a failure . . . a lot that I accept and that will not change. . . . The prospect grows darker, I see no happy future at all."

The past never stayed in the past. The simple task of extracting his furniture from Arles turned into a torment of memory. Despite his repeated requests, and offers to pay the shipping charges, the Ginouxs prevaricated with absurd Tartarin tales (that Mr. Ginoux had been gored by a bull) and sheer disregard ("the traditional laziness," Vincent grumbled), threatening with each delay to resurrect the demons he had struggled to leave behind (what he called "that business which has been talked about so much in Arles").

Gauguin would not let him forget, either. He dismissed Vincent's offer to come to Britanny as "unrealizable" because his studio lay "quite some distance from the town," he explained, "and for a person who is ill and sometimes in need of a doctor, it could be risky." Besides, Gauguin had again set his sights on exotic climes—Madagascar, this time ("the savage will return to the wild," he explained). Bernard planned to accompany him there. Vincent briefly let himself dream of joining his comrades ("for you *must* go there in twos or threes"), but soon submitted to the truth. "Certainly the future of painting is in the tropics," he wrote Theo, "but I am not convinced that you, Gauguin or I are the men of that future."

The same resignation marked his personal life as well. He was too old not just for Madagascar, he said, but for wife and children, too. "I am—at least I feel—too old to retrace my steps or to desire anything different," he confessed. "That desire has left me, though the mental suffering of it remains." More and more, he complained about the limits on his time, on his work, on his energy; and brooded on the precariousness of both sanity and life. He imagined how differently he would have spent the previous decade—his entire artistic career— "knowing what I know now." He mourned the ebbing of his ambition as well as his manhood, and cried out like a man twice his age against the "desperately swift passing away of things in modern life." He looked in the mirror and saw a

"melancholy expression," which he called "the heart-broken expression of our time," and compared it to the face of Christ in the Garden.

In June, his mother sent another thunderbolt from the past. She had just returned from Nuenen, where she marked the fifth anniversary of her husband's death with a visit to his grave. She sent Vincent a devastating account of her pilgrimage ("I saw everything again with gratitude that once it was mine") that left him babbling with guilt and remorse. In a letter he wrote to console her, he reached out to a biblical passage that spoke more directly to his own feelings of inexplicable suffering and irreversible fate. "As through a glass, darkly," he wrote, invoking the passage from I Corinthians in which all burdens are made bearable by the promise of ultimate purpose, "so it has remained; life, the why or wherefore of parting, passing away, the permanence of turmoil—one grasps no more of it than that." "For me," he confessed, "life may well continue in solitude. I have never perceived those to whom I have been most attached other than as through a glass, darkly."

This sentence of solitude, the judgment of the past, had followed him even to the garden valley of Auvers. The ranks of beautiful places and happy faces that lined his studio walls could not hide the fact that he had no friends at all. By July, his relationship with Dr. Gachet had fallen into the familiar spiral of alienation and rancor. Vincent's unceasing demands and Gachet's high-strung detachment set the two on a collision course. The doctor's frequent absences from Auvers confirmed Vincent's fear that he could not be counted on in a crisis. Vincent's strange behavior and vehement views on art (and possibly his attentions to Marguerite Gachet) threw the doctor's household into an uproar. Gachet imposed prohibitions on painting in the house; Vincent hurled his napkin down and stalked away from the dinner table. The final break came in an argument over Gachet's refusal to frame a Guillaumin painting.

As an eccentric neurotic himself, Gachet showed some sympathy for Vincent's oddities of manner and dress. Others were less tolerant. Young Paul Gachet later described Vincent's "comic way of painting": "It was very odd to watch him," he recalled. "Every time he put his little strokes of paint on the canvas he would first lean his head back to look up with half-closed eyes . . . I had never seen anyone paint like that." Marguerite Gachet put off for a month Vincent's request to pose, and finally consented only to let him watch her while she played the piano. His request for a second sitting went unanswered. Vincent's intense exertions behind the easel bewildered and menaced Adeline Ravoux as well. "The violence of his painting frightened me," she later told an interviewer, and she described the portrait that resulted as "a disappointment, for I did not find it true to life." She, too, declined to grant a second sitting.

Indeed, the year in the asylum of Saint-Paul-de-Mausole had left an indelible mark on Vincent's demeanor—an anxious alertness to the possibility of

imminent collapse, visible in his vacant expression and fugitive gaze—that un-
nerved grown men, not just adolescent girls. "When you sat opposite him and
talked face-to-face," a witness in Auvers recalled,

> and someone came up to one side of him, he would not just turn his eyes
> to look to see who it was, his whole head would turn . . . If a bird came
> past when you were chatting with him, instead of just glancing at it, he
> would raise his whole head to see what sort of bird it was. It gave his eyes
> a sort of fixed, mechanical look . . . like headlights.

Anton Hirschig, a young Dutch painter, arrived at the Ravoux Inn in
mid-June, sent by Theo, like a draft replacement, to provide his brother with
the companionship of a fellow artist and the comfort of a countryman. The
twenty-three-year-old Hirschig found Vincent a nervous, twitching, frightened
man—"a bad dream," "a dangerous fool"—with a mind ominously unmoored.
"I still see him sitting on the bench in front of the window of the little café,"
Hirschig later wrote, "with his cut-off ear and his wild eyes in which there was
a crazed expression into which I did not dare to look."

Vincent had no better luck with the Spanish artist who took his meals at
the Ravoux Inn ("Who is the pig that did that?" he said when he first saw Vin-
cent's paintings); or another Dutch artist who worked in Auvers; or the fam-
ily of English-speaking artists who lived next door, "painting away, day in and
day out"; or the French artist who visited Auvers but successfully avoided any
contact at all. Even the brothers' old comrade from the rue Lepic, Pissarro, who
lived only six miles away, never came to see him. Vincent did briefly befriend one
of the neighbors, an artist named Walpole Brooke, but Brooke quickly disap-
peared down the same hole of mutual hostility as Hirschig, of whom Vincent
wrote, "He still has quite a few illusions about the originality of his way of see-
ing things . . . He won't come to much, I think."

Locals had even less tolerance for the visitor's bizarre ways. They avoided
him in the cafés and fled when he accosted them in the street with entreaties to
pose. One of them heard Vincent muttering to himself, "It's impossible, impossi-
ble!" as he stalked away from one such rejection. Most of the townspeople knew
nothing of the events in Arles or the asylum of Saint Paul, but they could see the
mutilated ear easily enough. "It was the first thing you noticed when you saw
him," one of them said, "and it was very ugly." Some compared it to "a gorilla's
ear." The residents of Auvers may not have shared the Arlesians' superstitions
or prejudices against painters, but they were still repulsed by Vincent's tramp-
like appearance, unkempt beard, self-trimmed hair, and indeterminate accent—
they guessed German or English—that spoke of rootlessness and rough living.
As in Arles—and everywhere else he went—Vincent attracted the attention of

teenage boys. Dressed in his peasant's rags and toting his strange bag of painting gear, he looked "like a scarecrow," one of them later told an interviewer. Local ruffians chased him through the streets shouting a familiar chant: *"fou"*—crazy. But some of the boys of Auvers were more sophisticated than the "street arabs" of Arles. Many were summer idlers from Paris schools, sons of the vacationing bourgeoisie. Their games with the strange vagabond were more inventive than throwing rotten vegetables; but no less cruel.

They pretended to befriend him—bought him drinks, invited him on outings—only to make him the butt of pranks. They put salt in his coffee and a snake in his paint box. (He nearly fainted when he found the snake.) When they noticed his habit of sucking on a dry paintbrush, they distracted him long enough to rub the brush with hot red pepper, then watched with glee as his mouth exploded. "How we used to drive poor Toto wild," one boy later boasted, using their patois pet name for the strange painter-man—yet another way of saying "crazy."

The leader of the summer boys was René Secrétan, the sixteen-year-old son of a rich pharmacist from Paris. The Secrétans had a holiday house in the area and arrived every June at the start of the fishing season. An avid outdoorsman who would readily skip class at his prestigious *lycée* for a chance to go hunting or fishing, and who admired paintings only if they depicted naked women, René Secrétan might never have crossed Vincent van Gogh's path if it had not been for his older brother Gaston, an aspiring artist. Nineteen-year-old Gaston—the sensitive, poetic polar opposite of his brother—found Vincent's stories of the new art and the Paris art world engaging in a way unfathomable to René, who kept expecting the authorities to haul Vincent away any day "because of his hare-brained ideas and the way he lived."

In his loneliness, Vincent accepted the abuse of the younger brother as the price of the older's companionship. He nicknamed René "Buffalo Bill," both for his strutting cowboy bravado and for the costume he had bought at Bill Cody's "Wild West Show" at the 1889 Exposition Universelle in Paris, complete with boots, fringed coat, and cowboy hat. But Vincent mispronounced the name—he called him "Puffalo Pill"—a mistake that only incited René to more aggressive taunts and greater extremes of ridicule. For an extra touch of authenticity and menace, he added a revolver to his ensemble, an antiquated .380-caliber "peashooter" that "went off when it felt like it," René recalled.

Although he agreed to pose at least once (fishing on the riverbank), René used his "chummy" proximity to Vincent primarily as a cover for more elaborate forms of mischief and provocation. "Our favorite game," said René, "was making him angry, which was easy." It was René, an athletic drinker, who bought the painter round after round of Pernod at the local poacher's bar. It was René who, after discovering Vincent's taste for the pornography that he and his

friends traded in, paraded his Parisian girlfriends in the painter's presence, fondling and kissing them to torment poor Toto, and encouraging the girls (some of them dancers from the Moulin Rouge) to tease and torment him by pretending to show amorous interest in him.

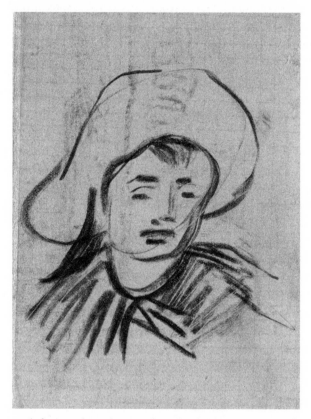

Head of a Boy with Broad-Brimmed Hat (probably René Secrétan),
JUNE–JULY 1890, CHALK ON PAPER, $5^3/_8$ X $3^3/_8$ IN.

But no adolescent prank or sexual humiliation could wound Vincent as deeply as the letter that arrived from Paris at the beginning of July. In a cri de coeur unlike anything else in their long correspondence, Theo described the hell his life had become. The baby was sick—"continuously crying, day and night." "We don't know what to do," he wrote, "and everything we do seems to aggravate his sufferings." Jo was sick, too—sick with worry: so terrified that her child might die that she "moaned in her sleep."

In all these woes, Theo saw one single cause: not enough money. "I work all day long but do not earn enough to protect that good Jo from worries over money matters," he confessed. He blamed his employers of seventeen years—"those rats"—for paying him so little and treating him "as though I just entered

their business." But mostly he blamed himself. In the ultimate test of man-hood—providing for his wife and child—he had failed miserably. The shame of it drove him, yet again, to the thought of quitting: of "taking the plunge" by setting up as an independent dealer. For the risk-averse Theo, it was tantamount to a threat of suicide.

In every cry of anguish, Vincent heard an accusation. When Theo listed Vincent among the mouths he had to feed, or portrayed himself as an exhausted draft horse pulling a heavy cart in which Vincent *rode,* or predicted "going through the world like a down-and-out beggar," the Furies of guilt swept back into Vincent's life with a vengeance. The entire letter cried out against the injus-tice of duty, familial and fraternal ("I spend nothing on extras and yet am short of money"). Theo even touched the most sensitive subject of all, his deteriorat-ing health, with a teary wish that he might live to see his son "grow up to be Somebody"—unlike his failed father and dissolute uncle.

In this paroxysm of bitterness and despair, Theo could not let his brother's pitiful delusions of family stand. "I hope from the bottom of my heart that you too will someday have a wife," he wrote. Only by that route would Vincent ever truly "become a man" and know the crushing burdens, and joys, of fatherhood. Dismissing any claim of a higher, transcendent bond from the past ("the daisies and the lumps of earth freshly cast up by the plow," he parodied), Theo affirmed his love for Jo as the sine qua non of *his* happiness and the true seed from which *his* family sprang. The message was clear enough: if Vincent wanted a family, he would have to make one of his own.

In Auvers, the letter struck a devastating blow. Both its substance and its tone filled Vincent with alarm. Jo may not have known the true nature of Theo's illness, but Vincent certainly did, and he knew better than anyone the terrible toll it took on one's wits and compass. He also saw how the plan to leave Goupil threatened his dream of a life together in Auvers. Without his job, without the *entresol,* Theo would need all the capital he could muster for his new venture as an independent dealer. There would be no money for a country retreat—no leisurely weekends, no long holidays.

At first, Vincent fought his instinct to catch the next train for Paris. "I should greatly like to come and see you," he wrote Theo the day the letter arrived, "[but] I am afraid of increasing the confusion by coming immediately." Instead, he sent another pleading invitation to the country—his most desperate yet—demanding "a full month at least" for the fresh air to have its full effect. He in-cluded sketches of his most alluring paintings and a delusional offer to trade places with Jo and the baby. They could have Vincent's room at the Ravoux Inn and he would come to Paris, he assured Theo, "so that you should not be too much alone."

But only days later, unable to wait, overcome by dread, and determined to

"unmake" his brother's disastrous decision, Vincent rushed to Paris. He arrived at Cité Pigalle unannounced and unexpected.

In his effort to undo a disaster, Vincent triggered a catastrophe.

The apartment was already primed for an eruption. In the five days since Theo had sent his troubled letter, the crises had only deepened. He had decided to confront his employers with an ultimatum: either they would give him a raise or he would resign. He had enjoyed some recent successes in selling, and Jo's brother Andries had agreed to help him find financing for an independent dealership. The combination had made him bold enough to risk everything. The baby's wails and Jo's worries had made him desperate enough.

But the implacable Jo worried even more about the brinkmanship of an ultimatum. Would Theo endanger his young family by quitting his job and "recklessly going into the unknown"? How certain could he be of success as an independent dealer? What would they do if they found themselves "without a penny of income"? Vincent arrived to find the couple "distressed" and "over-wrought" and locked in a bitter quarrel over a decision with the highest possible stakes—for Vincent as well as for them. "It was no slight thing when we all felt our daily bread was in danger," he recalled the ongoing dispute, which he quickly joined. "We felt that our means of subsistence were fragile." With Vincent's vulnerability and volatility added to the mix, the arguments soon escalated. He later described them as "violent."

When Andries Bonger arrived, the rancor turned in his direction. Vincent aggressively questioned his support for Theo's proposed venture, especially in light of his reneging on a similar pledge in the past. He may even have called for Theo to "break" with his brother-in-law there and then. But mostly he zeroed in on what he saw as the greatest threat: Theo's plan to move to the ground-floor apartment in the same building and share the garden with Andries and his wife. The move rejected all Vincent's fervent pleas for a house in the country and repair in nature. With a garden outside their door, Theo and his family would have no need for the glories of Auvers that Vincent had argued so ardently in paint. He saw his dream of a reunion on the heath dying.

In the furor that followed, Vincent's grievances against Jo as a negligent mother (for raising her baby in the city) and Jo's resentment over the money Theo spent on his idle brother apparently found their way into bitter words. "If only I'd been a bit kinder to him when he was with us!" Jo later wrote. "How sorry I was for being impatient with him." In one particularly acid exchange, brother and sister-in-law argued fiercely over the placement of a painting.

Vincent left the apartment, and Paris, the same day. He rushed off before a planned visit by an old acquaintance, Guillaumin. "The hours I shared with you were a bit too difficult and trying for us all," he wrote afterward. He described his brief—and last—visit to Paris with a single word: "agony."

So furious were the arguments that day that all the letters detailing the events of Sunday, July 6, were subsequently lost or destroyed. In their place, Jo later substituted a happy tale of a summer lunch and a parade of prominent visitors that left Vincent "overtired and excited"—the first (and only) sign of the terrible end three weeks later. But Vincent told a different story. He left Paris that day crushed in a different way. "I feared," he wrote Theo afterward, "that being a burden to you, you felt me to be rather a thing to be dreaded."

BACK IN AUVERS, Vincent's world changed. Pursued by the "sadness" and "storms" of Paris, he saw threats everywhere. When he climbed the riverbank to the fields above, he found the picturesque vistas of rural life replaced by a dark void of unfeeling wilderness. All trace of consolation had drained from the landscape, along with the promise of second chances and redemption.

He lugged two of his awkward double-width canvases up the hillside to record this new, threatening vision of nature. Where before he had painted a rolling mosaic of countryside, now he painted "vast fields of wheat under troubled skies"—a featureless desert of grain as bare and lonely as the heath. Nothing—not a tree, not a house, not a steeple—breaks the impossibly distant horizon. A slight rise in the middle suggests less a hill than the curve of the earth. Instead of a crystal-blue sky or a radiant sunset, he painted an ominous darkness and a roil of thunderclouds in deeper and deeper shades of blue.

On the other canvas, he plunged directly into the churning wheat, following a rutted reaper's lane to a fork in the middle of a field. Wind whips the ripe grain into heaving whirlpools of color and stroke—a lashing so violent that it frightens a coven of crows from their hiding place. They swoop and rise in a panic of escape from the remorselessness of nature. In both these ravishingly bleak vistas, he banished any view of rustic domesticity; not a person or a dwelling is visible for miles. Instead of advertising the consolations of country life, now he was using his brush, he said, "to express sadness and extreme loneliness." "My life is threatened at the very root," he wrote only days after returning to his former paradise. "My steps are wavering."

On July 15, Theo took his family directly from Paris to Holland. Only the true country air of home, he decided, could revive his wife and child. They did not stop in Auvers on the way, as Theo had once offered to do. Jo and the baby would stay in Holland for a month. Theo left after a few days and returned to Paris by a roundabout route, stopping to do business in The Hague, Antwerp, and Brussels on his way; but not in Auvers. Vincent sent a wounded letter of protest, raising yet another alarm about the terrible events of July 6. In a mix of anguish and supplication ("Have I done something wrong?"), he unburdened his heart of its darkest fears: about his role in Theo's "falling out" with Jo, about his continuing

need for money at such a difficult time, about the "grave danger" that he saw everywhere.

Theo announced his departure for Holland on July 14, Bastille Day. Only days before, Vincent had received a letter from his mother and sister, delighted at the prospect of Theo's imminent arrival with his wife and child. There would be a reunion on the heath after all. "I often think of you both," he replied forlornly, "and should very much like to see you once again." In response to his mother's recommendation that, for his health's sake, he should spend some time in a garden ("to see the flowers growing"), Vincent offered his darker, contrary view of nature: "I myself am quite absorbed in the immense plain with wheat fields against the hills, boundless as a sea."

Theo could help his mother in the garden; Vincent was fated to wander the lonely heath. "Good-bye for today," he wrote in his last words to his mother and sister. "I have to go out to work."

He only had to step outside the door of the Ravoux Inn to find an image of loneliness and abandonment. Directly across the street, the Auvers town hall, the Mairie, was bedecked with flags and garlands and Chinese lanterns, ready for the annual Fête Nationale of fireworks and celebration that night. But until then the square was deserted; the bleachers empty. Vincent painted it that way—with no throngs, no brass band, no fireworks, no dancing. The town hall—a stone cube—sits stolidly alone, in shrubless isolation, hung mirthlessly for festivities in which it, and he, will not participate. It bears an unmistakable, ghostly resemblance to the town hall on the Zundert Markt, directly across from the parsonage of his childhood.

When Theo returned to his Paris apartment on July 18, he did not invite his brother to join him, as Vincent had once offered to do. For more than a week, he did not even write. When he finally did, it was only to dismiss Vincent's worries with exclamations of incomprehension ("Where did you see these violent domestic quarrels?"), and dismiss as "a trifling matter" the stuff of his brother's nightmares.

Vincent dared not ask—and Theo did not share—the predictable outcome of his confrontation at work. His bosses had ignored his ultimatum, refused his demand for a raise, and treated his threat to quit with indifference. Desperately lonely for his family (he wrote to Jo daily) and desolate over his own future— his career, his health—Theo considered cutting the cord with his inconsolable brother. But, as always, duty restrained him. "One cannot drop him when he's working so hard and so well," he wrote Jo with a cry of exasperation. "When will a happy time come for him?"

Vincent sent an order for paints, hoping no doubt that Theo would bring them himself to Auvers, a mere twenty miles away. Theo breezily advised his

brother that if "there is something troubling you or not going right . . . drop in to see Dr. Gachet; he will give you something to make you feel better." Vincent pleaded in hints for more information ("I hope you have found those worthy gentlemen well disposed toward you") and left more drafts of letters unfinished and unsent. "There are many things I should like to write you about," he wrote in one of them, "but I feel it useless." Theo maintained his stony silence. It must have seemed to Vincent as if a continent separated them.

Nothing posed a greater threat to his stability—his sanity—than Theo's withdrawal. Since his return from Paris, the events of that day had haunted his thoughts like *horlas*. Other fears beset him as well, especially Theo's progressing illness—and his own. As the first anniversary of the terrible attack the previous summer in Saint-Rémy approached, another one seemed both inevitable and imminent. "I am risking my life," he wrote in one of his discarded drafts, "and my reason has half foundered." He complained of feeling "a certain horror" when he thought about the future. At times, he trembled with fear so violently that he had trouble writing, and could hardly hold a brush in his hand.

To steady his nerves, Vincent always had alcohol (whether Pernod at a poacher's bar with young René Secrétan, or absinthe at a roadside café with the local gendarme). But to chase the demons from his head, nothing beat the distraction of work. "I apply myself to my canvases with all my mind," he wrote Theo. Dr. Gachet had recommended the same remedy. "He tells me that in my case work is the best thing to keep my balance . . . that I ought to throw myself into my work with all my strength." The more the storms "weighed" on him, the more furiously Vincent applied paint to canvas. By the third week of July, he had begun a whole raft of new paintings, most of them on the vast double squares that had become the shape of his imagination. Only in an image this size could he lose himself—be swallowed up—in raptures of brushwork and eternities of looking.

He painted everything from panoramic countryside scenes of cottages under immense skies—in sun and in rain—to simple sheaves of wheat, arranged like the pollard birches of Nuenen, in shaggy ranks like old veterans. He painted haystacks that looked like houses transformed into hay by some rustic magic, and cottages that blended almost invisibly into the mosaic of fields around them. He stared transfixed at the exposed roots of a tree until he could fill one of his huge canvases with just a small corner of the scene: an intimate *sous-bois* writ as large as a forest. He focused his wide view so tightly on the gnarled old roots, vines, and shoots of new growth—eliminating the sky, the ground, even the tree itself—that the shapes and colors lose connection with reality and, like Vincent, enter a distant, deeper world, abstract and absorbing.

In this new fever of work, an old fantasy was reborn. The vast, exhorta-

tory images of rural life, the inviting cottages, the echoes of Nuenen and the heaths, the beloved greenery nooks—all hinted at the resurgent hope that Theo might join him in Auvers. Moved by the image of his brother sitting alone in a Paris apartment, Vincent set aside all the rancor and recrimination of their recent exchanges. He abandoned a letter that openly rejected Theo's version of the events of July 6 ("having seen the weal and woe of it for myself"), and sent instead a proposal that they "start again." To avoid despairing over Theo's neglect, he recast his plight as the plight of all artists. "Painters are fighting more and more with their backs to the wall," he wrote resignedly, and *any* "union" between artists and dealers was doomed to failure. The implacable marketplace had betrayed *all* Impressionists, he consoled his brother, and rendered even the sincerest "personal initiatives," like Theo's, "powerless."

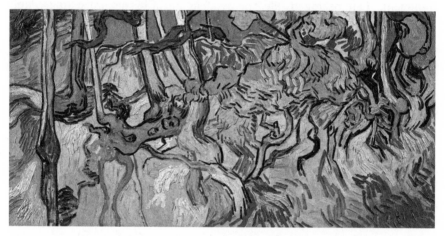

Tree Roots, JULY 1890, OIL ON CANVAS, $19^3/_4$ X $39^1/_4$ IN.

He included in his letter an ardor of sketches showing the reborn dream of country life and fraternal reunion. He turned one sheet on its side and drew a vehement sketch of his proudest invitation to this new life: *Daubigny's Garden.* Since painting his first view of it in early July, Vincent had probably returned many times to the storied garden only a few blocks from the Ravoux Inn. In the meantime, he had repainted his sumptuous image of the garden on another double-square canvas. Vincent had no doubt heard about the murals that filled the walls inside Daubigny's other studio in Auvers. All of the painter's family had contributed to them—an echo of Vincent's vision in Drenthe of "a family of painters" in a cottage on the heath. Indeed, the broad canvases that burst from Vincent's imagination in July also could have filled a country house with scenes of sublime rusticity.

For Vincent, whose eye always gravitated to paintings in groups—the se-

rial "decorations" of Seurat and Monet—these seamless panoramas may have formed just such a chorus of imagery. He wrote Theo as the double squares unfurled from his easel one after another: "I am trying to do as well as certain painters whom I have greatly loved and admired." There was no painter he loved and admired more than Charles Daubigny. And there was no image more inviting than the one of a garden that Daubigny might have shared with his wife and his comrade Daumier. "Perhaps you will look at this sketch of Daubigny's garden," he hinted in the letter that accompanied the drawing. "It is one of my most purposeful canvases."

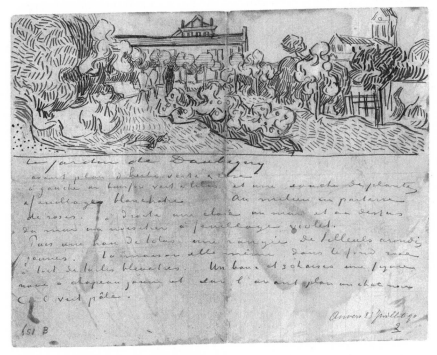

Daubigny's Garden, JULY 1890, LETTER SKETCH, PEN, 3 X 8⅝ IN.

In his first draft of that same letter, Vincent called his brother again to the procreative partnership that they had pledged each other on the road to Rijswijk eighteen years before. "I shall always consider you to be something more than a simple dealer," he wrote, echoing the summons of Drenthe. "Through my mediation you have your part in the actual production of some canvases, which will retain their calm even in catastrophe." In the draft he actually sent—his last letter to his *waarde* Theo—he replaced the overt plea with the beckoning image of the miraculous garden. "The truth is," he explained, "we can only make our pictures speak."

—

FOUR DAYS LATER, on Sunday, July 27, Vincent returned from a morning of painting to have his midday meal at the Ravoux Inn. When he was finished, he slung his bag of paints and brushes over his arm, reshouldered his easel, and returned to his labors, just as he had been doing almost every day for weeks. He could have been headed to Daubigny's garden nearby, or farther into the countryside with another double-square canvas added to his awkward load.

Hours later, after the sun had set, he staggered back to the Ravoux Inn without his bag or his easel or his canvas. The Ravouxs and their other boarders, who had taken dinner outdoors on a hot summer evening, were lingering on the café terrace. They saw him approach on the darkened street. "[He] was holding his belly and seemed to be limping," one of them later recalled. "His jacket was buttoned up"—odd on such a warm night. He passed them without a word and went straight to his room. Gustave Ravoux, concerned about his guest's strange behavior, listened from the bottom of the stairs. When he heard moaning, he climbed to Vincent's attic room. He found Vincent lying on his bed, curled up in pain. He asked what was wrong.

"Je me suis blessé," Vincent replied as he lifted his shirt and showed Ravoux the small hole under his ribs—"I wounded myself."

Illusions Fade;
the Sublime Remains

~

No ONE KNOWS WHAT HAPPENED IN THE FIVE OR SIX HOURS BETWEEN Vincent's midday meal at the Ravoux Inn on Sunday, July 27, and his return with a bullet in his stomach that night.* Both at the time and afterward, many theories were offered. The police briefly investigated. But no one ever stepped forward as a witness to any of Vincent's activities that day. No one could establish his whereabouts when the incident occurred. His easel, canvas, and painting kit disappeared. The gun was never found.

Fading in and out of consciousness, flashing between pain and shock, Vincent seemed at first confused about what had happened. He called for medical attention as if he had been the victim of an accident. Years later, one witness recalled him saying, "I wounded myself in the fields. I shot myself with a revolver there." A doctor was summoned. Vincent gave no explanation for why he had a gun or how he had come to shoot himself with it.

Whether it was an accident or something else remained unclear until the next morning when the police arrived to investigate rumors of a shooting. When they heard that Vincent had wounded himself, they immediately inquired, "Did you want to commit suicide?" Vincent replied vaguely, "Yes, I believe so." They reminded him that suicide was a crime—both against the state and against God. With strange, unprompted vehemence, Vincent insisted that he had acted alone. "Do not accuse anyone," he said; "it is I who wanted to kill myself."

Within hours, this abrupt claim became a story. "Vincent had gone toward the wheat field where he had painted before," Adeline Ravoux later told an in-

* For a full discussion of our views on what happened the day of the shooting, see "A Note on Vincent's Fatal Wounding," p. 869.

terviewer, recalling the account that her father had assembled from the bits and pieces he heard at Vincent's bedside:

> During the afternoon, in the deep path that lies along the wall of the château—as my father understood it—Vincent shot himself and fainted. The coolness of the night revived him. On all fours he looked for the gun to finish himself off, but he could not find it. Then Vincent got up and climbed down the hillside to return to our house.

The story accounted for some of the oddities of the missing hours, but by no means all. Vincent couldn't find the gun in the dark to "finish himself off," but how could it have fallen so far from his grasp? And why could no one else find it the next day—or ever—in the daylight? And what had become of the missing easel and canvas? How could he have lain unconscious for so long and bled so little? In his wounded, semiconscious state, how could he descend the steep, wooded slope that lay between the fields and the Ravoux Inn in the dark? Where and when had he gotten the gun? Why did he try to shoot himself? Why did he aim for his heart, not his head? Why did he miss?

Not that Vincent hadn't thought about suicide before. In troughs of despair as far back as Amsterdam, in 1877, he had mused longingly on the serenity and escape of death—on what it would be like to be "far away from everything." Occasionally he joked about it (reciting Dickens's "diet" for suicide). Occasionally, he threatened it. From the depths of the Borinage, he promised Theo he would "cease to be" if ever he felt "a nuisance or a burden to you or those at home—of no use to anyone."

But mostly, he inveighed against it. He called it "wicked" and "terrible"—an act of "moral cowardice"—a crime against the beauty of life and the nobility of art, as well as Christ's example. He cited Millet's famous dictum that suicide "was the deed of a dishonest man" and boldly insisted, "I really do not think I am a man with such inclinations." Yes, he had moments of "deep melancholy," of "emptiness" and "unutterable misery," he said—just as Theo did. But he disavowed any self-extinguishing intent, and urged his melancholic brother to do likewise. "Look here," he wrote from Drenthe, "as regards making oneself scarce or disappearing—now or ever—neither you nor I should *ever* do that, no more than commit suicide."

The events in Arles and the onset of his disease had tested this brave resolve, but not broken it. Through all the torments of both body and spirit—the isolation and confinement, the nightmares and hallucinations—he had kept his pledge to Theo. Dr. Peyron thought he saw a suicide attempt in Vincent's sucking his brushes, and once, when he felt his brother's love slipping away, Vincent lashed out with a desperate threat. "If I were without your friendship, they

would drive me remorselessly to suicide," he wrote in April 1889, "and coward that I am, I should end by committing it."

There were times when he welcomed death—even devoutly wished for it: times when the *"horror"* and "loathing of life" so overwhelmed him that he would gladly have embraced it. "I would rather have died," he wrote from his hospital cell in Arles, "than have caused and suffered such trouble." In Saint-Rémy, he painted a Reaper as radiant and "beautiful" as a rescuing angel, and instructed Theo: "There is no sadness in death." The trials had made him riper, readier to be reaped—even eager for the scythe. Battered by wave after wave of attacks and "always living in fear of relapses," he confessed, "I often said to myself that I preferred that there be nothing further, that this be the end." But as welcome as death would have been, he dared not deliver it himself. In all the haunted nights in the Yellow House, all the lonely walks around Saint-Rémy, Vincent had kept his pledge. He had not drowned himself in the Rhône, or leaped off an Alpilles cliff, or thrown himself under a Paris-bound train.

Indeed, he described himself as a man who had come too close to the heinous, cowardly deed ever to approach it again. "I am trying to recover," he wrote, "like someone who has meant to commit suicide, but then makes for the bank because he finds the water too cold."

Whether in the mountain valley of Saint-Rémy or the black country of the Borinage, whether in the Yellow House or the Schenkweg studio, whenever thoughts of suicide cleared the hurdles of conscience and entered Vincent's imagination, they came in one form only: drowning. When Kee Vos refused his pleas of love in 1882, he considered "jumping into the water" in despair. Later, he toyed with an exception to Millet's rule against self-slaughter: "I can understand people drowning themselves." A year after that, he warned Theo that Sien Hoornik might drown herself if he abandoned her. In Antwerp, he expressed sympathy for an anonymous consumptive "who will perhaps drown herself before she dies of any illness"; and in Arles he roundly declared to the mayor and his assembled accusers that he was "quite prepared to chuck myself into the water if that would please these good folk once and for all."

In Vincent's imagination, both artists and women always committed suicide by drowning because they shared the same intelligence, "delicacy," and "sensitivity to their own suffering." Artists "die the way women die," he wrote in Antwerp, "like women who have loved much, and been hurt by life." Margot Begemann had taken strychnine, and he knew others, both in life and in fiction, who had poisoned themselves. (Indeed, he knew a good deal about poison and could have used it effectively on himself.) But such people did not enjoy the same "consciousness of themselves" as artists did. Unlike him, they held life in contempt.

He had read Balzac's *Illusions perdues* (*Lost Illusions*) and heard Lucien Char-

don, the book's discouraged poet, musing on the gravity and method of suicide. "As a poet he wanted to make a poetic end," Balzac wrote, so he picked a "pretty spot" along the river and planned to fill his pockets with stones. Of course, Vincent had also read about jumping from heights as long ago as Michelet's *Jeanne d'Arc* and as recently as the Goncourts' *Germinie Lacerteux*. Flaubert's misbegotten heroes Bouvard and Pécuchet plotted to hang themselves—together, of course—but failed. Zola's Claude Lantier succeeded: "[He] hanged himself from the big ladder in front of his unfinished, unfinishable masterpiece." A character in Zola's *Au Bonheur des Dames* threw himself under an omnibus. Daudet's Evangelist chose a train.

In Vincent's reading, resort to firearms always ended badly—and often unsuccessfully. In Zola's *Pot-Bouille*, the dissolute lawyer Duveyrier tried to shoot himself with a small revolver but succeeded only in disfiguring himself for life. In Maupassant's *Pierre et Jean*, an accidental discharge produced a "frightful" stomach wound "through which the intestines protruded." In Vincent's own life, guns were exotic, alien devices, confined to wilderness adventures and calls to battle. When his brother Cor arrived in the Transvaal in 1889, Theo conveyed the "wildness" of the country by reporting that "one has to go about with a revolver all day long."

No one in Auvers (at the time) remembered seeing Vincent with a gun, and no one admitted to giving or selling or lending him one. Who, after all, would trust the *fou* Dutchman with a revolver—still a novelty in rural France. And what had become of it? In subsequent years, the mystery of Vincent's missing weapon invited a host of baseless claims: that he had borrowed it from the innkeeper Ravoux to "scare away the crows" in the fields; that he had threatened others with the same gun; that he had brandished a similar weapon earlier in his life.

But the doctor who arrived first on the scene, a Dr. Mazery, did not need to see the weapon to know that it was a small-caliber pistol. The wound just below Vincent's ribs was "about the size of a large pea" and bled only a trickle. Around the little circle of dark red, a purple halo had formed. Mazery concluded that the bullet had missed all the major organs and blood vessels. By probing Vincent's body, a painful process, he thought he located the bullet toward the back of the abdominal cavity. That meant it might have punctured a lung, grazed an artery, or lodged near the spinal cord—all mortal threats.

It had traveled an odd path. If Vincent had meant to hit his heart, his aim was inexplicably wide of the mark. The gun had been held too low and pointed downward, hurling the little bullet into a dangerous position, but far from its intended target. It looked like the crazy angle of an accidental shooting, not the studied straightness of a determined suicide. And another oddity: normally, a bullet fired at such close range, if it didn't hit bone, would have passed through

the soft tissue of the midsection and exited the other side. That it remained in his body indicated not only a small caliber with limited powder, but also that the gun had been fired from farther out—"too far out," according to the doctor's report—perhaps farther out than Vincent's reach.

At some point, Dr. Gachet arrived. He had gone fishing with his son and heard about the shooting from a passerby—an indication of how quickly the news was spreading. As Vincent's nominal custodian in Auvers, Gachet had much to answer for. He rushed to the Ravoux Inn, no doubt expecting the worst. He found Vincent surprisingly lucid—smoking his pipe—but demanding that someone remove the bullet from his stomach. "Will nobody cut my belly open for me?" one witness recalled him pleading.

Gachet examined the wound himself and consulted apart with Dr. Mazery. Neither dared to attempt surgery. Mazery was a Paris obstetrician on summer holiday; Gachet, an expert on nutrition and neurotics, not gunshot wounds. Moving Vincent to a Paris hospital presented even greater risks. With no symptoms to treat, they applied a dressing and hoped for the best. Undoubtedly over Vincent's protests, Gachet drafted a letter to Theo saying only that Vincent had "wounded himself." "I would not presume to tell you what to do," he wrote cautiously, "but I believe that it is your duty to come, in case of any complications that might occur."

To avoid the alarm of a telegram, Gachet planned to post the letter. But when he asked Vincent for Theo's address, Vincent refused to give it. Gachet decided to dispatch the young Dutch painter Hirschig to Paris the next morning to hand-deliver the letter to Theo at his gallery, where Gachet had visited him. After that, both doctors left the little attic room. Vincent smoked his pipe and waited. Every now and then, his body stiffened and his teeth clenched in pain. That night, Anton Hirschig, who occupied the room next to Vincent's, heard "loud screaming."

By the next morning, Auvers buzzed with rumors about the extraordinary events of the night before. Someone had seen Vincent, around dusk, enter a walled farmyard just off the main thoroughfare—far from the fields above the town. He appeared to be hiding behind a dunghill, as if for a rendezvous, or perhaps detained by unseen companions. It was here, the rumors said, that the fateful shot had been fired. Vincent could have dragged himself wounded over the level ground between the dunghill and the Ravoux Inn—less than half a mile—a far easier route than the steep, tricky slope of the riverbank. His easel and canvas, and the gun, could have been disposed of.

Revolvers were rare in Auvers, and in the days after the shooting, locals inventoried every one of them. Only one was missing—along with its owner. René Secrétan and his "Puffalo Pill" "peashooter" had left town—spirited away with his brother Gaston after the shooting by their pharmacist father in the middle

of the summer. The brothers eventually returned to Auvers, but the pistol was never seen again. Decades later, René Secrétan came forward to offer an explanation. After more than half a century of silence, he told an interviewer that Vincent had stolen it from him. "We used to leave it around with all our fishing gear," he said, "and that's where Vincent found it and took it."

But the verdict of rumor had long since been rendered. In the 1930s, when the great art historian John Rewald visited Auvers and interviewed the surviving witnesses of that midsummer night in 1890, he heard people say that some "young boys" had shot Vincent accidentally. The boys never came forward, he was told, because they feared being accused of murder; and Vincent chose to protect them as a final act of martyrdom.

THEO ARRIVED BY MIDDAY on the twenty-eighth, only hours after Hirschig appeared at the gallery. Even after all the thunderbolts of the past, the news from Auvers came as a shock. He had spent the previous week assaying the ground-floor apartment in his building, dreaming about his reunion in August with his wife and child in Holland, and planning, in the meantime, a weekend excursion to Passy—a summer watering spot outside Paris, not unlike Auvers. When he allowed himself to worry, it wasn't about Vincent, it was about his job. Since his aborted ultimatum, he had heard rumors that two of the firm's branches in Paris had been marked for closing—one of them, his.

Gachet's letter interrupted all that. On the train to Auvers, the old dread crashed in on him. Only a week before, he had dismissed such worries in words that must have haunted him as the train left Paris. "As long as he's not melancholic and heading for another crisis," he reassured Jo on July 20, "it was all going so well." Gachet's letter said that Vincent had "wounded himself." The last time Theo was summoned by news like that, he had arrived in Arles to find his brother lying mutilated and unmoored in a hospital bed. What new horror awaited him in Auvers? Hirschig may have mentioned the possibility of a suicide attempt—a scandalous charge that Gachet had discreetly omitted from his letter—raising yet another specter to torment the endless hour-long ride.

By the time he arrived at the Ravoux Inn, his face was "distorted by grief," Adeline Ravoux recalled. He rushed upstairs to Vincent's room. But instead of the deathbed scene he feared, he found Vincent sitting up in bed, smoking. "I found him better than I had expected," he wrote Jo later that day, "although he is indeed very ill." The brothers embraced, according to Adeline (who had followed Theo and her father to the room), and immediately fell into deep conversation in Dutch. The Ravouxs withdrew.

For the rest of the day and into the evening, they talked: Vincent on his low-slung iron bed, Theo in the lone straw chair that he drew up next to it. Al-

ternately agitated and enervated, taking short breaths and wincing with pain, Vincent thanked his brother for coming and giving them this opportunity to "be together constantly." He asked about Jo and the baby. How sweet for them, he said, to "have no inkling of all life's sadness." If Vincent claimed a suicide attempt—as he had to Ravoux and others—Theo surely raised questions. Why had he given no warning? His most recent letter had been filled with buoyant spirits ("good luck in business . . . handshakes in thought") and boisterous sketches of country life—even an order for more paint. Looking around the room Theo could see no signs of preparation for death—no tidying up, no farewell note. Discarded drafts and torn fragments of letters that Vincent clearly never intended to be read lay on his desk.

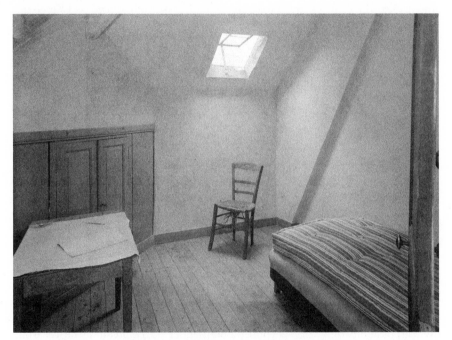

VINCENT'S BEDROOM AT THE RAVOUX INN

During one of their few breaks—perhaps while Vincent tried to sleep or take food, or lapsed into unconsciousness—Theo wrote Jo. He gave no hint of suicide, only surrender. "Poor fellow, he wasn't granted a lavish share of happiness," he wrote, "and he no longer harbors any illusions. He was lonely, and sometimes it was more than he could bear." He reassured Jo, and himself, with memories of Vincent's previous injuries and recoveries. "It was just as desperate before," he noted hopefully, "and the physicians were surprised by his strong constitution." He promised to return to Paris the next day "if he's better tonight."

But Vincent's wound would never heal, and there was only one treatment.

He had lost "faith in life," Theo concluded. Fate had given him this chance—whether by his own hand or another's—and he was choosing death. *"I would not expressly seek death,"* Vincent had written in Nuenen, *"but I would not try to evade it if it happened."*

As the sun set and the attic began to cool, both conversation and rest became more elusive. Vincent's breathing grew shallower and faster. His heart raced. Color and warmth drained from his skin. He had spells in which he seemed almost to be "suffocating," Theo recalled. By nightfall, the end seemed near. The spells came more often. They talked less.

With each panic of breathing, with each fond remembrance and each flush of tears, the subject of death hovered closer. The brothers had said little about suicide over the years—except to disavow it—but death had obsessed Vincent's letters from the beginning. The thought of death "warmed me and made my heart glow," he wrote from England in 1876. He lingered in graveyards and longed to draw corpses. He cherished images of funerals and plagues and portrayals of Death. He saw serenity in the faces of the dead and envied their freedom from "the burden of life, which we have to go on bearing." "Dying is hard," he had scolded a mourner at his father's funeral, "but living is harder still."

The years of failure, penury, guilt, loneliness, and finally madness had shown him a different face of death. Deprived of the comfort of religion by his father's death in 1885, he had failed ever since to fill the void it left. He tested everything from Tolstoy's nihilism to Voltaire's cosmic laugh, and found them all wanting. In the end, only art consoled. "My aim in life is to make pictures and drawings, as many and as well as I can," he wrote; "then, at the end of my life, I hope to pass away, looking back with love and tender regret, and thinking, 'Oh, the pictures I might have made!' "

But pictures alone were not enough. "Of the future life of artists through their works I do not think much," he wrote in Arles. "Yes, artists perpetuate themselves by handing on the torch . . . But is that all?" He could not live without the possibility of a world beyond—a place where he could finally be free from "the empty stupidity and the pointless torture of life." To keep alive the promise of a second chance, of starting over—for him, the indispensable consolation of religion—he had spent long hours constructing his own versions of an afterlife: glorious visions of distant orbs and "invisible hemispheres"—of trains to the stars and lifetimes as limitless as planets in the universe. Like his paintings, these elaborate conceits drew on the beauties of nature, the allure of science, the "deeply saddening Bible," and, especially, the transcendent power of art. "Illusions may fade," he wrote in Antwerp, "but the sublime remains."

Of all these consoling visions—some of which no doubt flitted through his thoughts as he felt the end approach—none was more glorious or more hopeful

or more comforting than the one he imagined in Arles, in 1888, r
the Yellow House for Gauguin's arrival:

> I feel more and more that we must not judge of God from this world.
> It's just a study that didn't come off. What can you do with a study that
> has gone wrong?—if you are fond of the artist, you do not find much
> to criticize—you hold your tongue. But you have the right to ask for
> something better. We should have to see other works by the same hand
> though; this world was evidently slapped together in a hurry on one of
> his bad days, when the artist didn't know what he was doing or didn't
> have his wits about him. All the same, according to what the legend says,
> this good old God took a terrible lot of trouble over this world-study of
> his. . . .
> I am inclined to think that the legend is right, but then the study is
> ruined in so many ways. It is only a master who can make such a blun-
> der, and perhaps that is the best consolation we can have out of it, since
> in that case we have a right to hope that we'll see the same creative hand
> get even with itself. And this life of ours, so much criticized, and for good
> and even exalted reasons, we must not take it for anything but what it is,
> and go on hoping that in some other life we'll see something better than
> this.

At half past midnight, on July 29, cradled in his brother's arms and strug-
gling for breath, Vincent uttered his last words to his *waarde* Theo: "I want to die
like this." He lay there for another half hour, one arm cast over the side of the
bed with his hand resting on the floor, his mouth agape and panting for air. A lit-
tle after one in the morning, with his eyes wide open, his fanatic heart stopped.

"He has found the rest he was longing for," Theo wrote his mother. "Life was
such a burden to him. . . . Oh Mother! he was so my own, own brother."

LATER THAT MORNING, Theo buried his grief in a new mission: to give Vin-
cent the dignity in death that he never had in life. Working with grim focus and
efficiency, he presented himself at the town hall and completed all the official
paperwork. He arranged with a printer to have both death notifications and fu-
neral invitations printed within hours. The invitations had to make the post in
time for delivery in Paris that same day or early the next morning, July 30—the
day of the funeral. He listed train departure times to ensure the largest possible
attendance. The ceremony would begin at the Auvers church "precisely" at
2:30 P.M., and would include a "funeral procession, service, and burial." Mean-

while, he engaged a carpenter to provide a coffin and an undertaker to stabilize the body in the sweltering summer heat.

While the mortician did his ghoulish work in the back room that Vincent used as a studio, Theo busied himself converting one of the inn's two public rooms into a mortuary chapel, using flowers and greenery in the Dutch way. Their countryman Hirschig, who knew the custom well, scoured the neighborhood for appropriate material. But Theo wanted art first. With unflinching bravery, he searched the studio and the shed in back where much of Vincent's recent work was stored, and selected a handful of paintings according to some painful calculus of the heart.

One by one, he nailed the canvases—some unstretched, some still wet—around the billiard-table bier: the portrait of Adeline Ravoux, the Auvers town hall, the lonely wheat fields, Daubigny's magical garden. He had barely finished when the undertaker and his minions lugged the casket into the room, hoisted it onto the billiard table, and covered it with a sheet. Ravoux had closed the shutters, and the smell of carbolic acid, an embalming fluid, filled the room. Impervious in his duty, Theo draped the coffin in greens and flowers—especially yellow flowers. He placed candles around the room and, finally, positioned Vincent's studio easel, palette, and stool at the foot of the casket.

But even in death, Vincent confounded him. The local curate would not permit a funeral service in the Auvers church. Theo's invitation had been too hasty. Whether because Vincent was a foreign Protestant or a suspected suicide, the abbot Tessier even forbade the use of the parish hearse. And not all Theo's Parisian politesse, or Gachet's influence, could change his mind. The most Tessier would allow was for Theo to purchase a plot in the sparsely populated new cemetery on the plateau above the town, far from the church Vincent had painted. It was a lonely spot—not much more than a bit of bare earth in a barren field. To Jo, and to himself, Theo put the best face he could on this final rejection. He called it "a sunny spot amid the wheat fields."

The next morning, July 30, a trickle of guests began. Tanguy, the grizzled old dealer and Communard, arrived early—as he had so often before. Lucien Pissarro came, but not his father Camille, who pleaded age and ill health. Émile Bernard brought Charles Laval, Gauguin's lackey, as a stand-in for the *maître* himself, who, despite his many debts to Theo, claimed not to have received his invitation in Brittany in time. (In fact, he later told Bernard that it was "idiotic" to allow himself to be associated with the madman Vincent.) Bernard entered the makeshift mortuary and immediately began rearranging the paintings. Dr. Gachet brought a retinue of locals, including some of the artists who had avoided Vincent in life. Andries Bonger came, too—for his sister and Theo, if not for Vincent. No one from Vincent's family came, except Theo.

One by one, the mourners filed past the casket. Some brought flowers. Tan-

guy wept. Theo played the perfect host. A lunch was served in the Ravoux Inn's dining room. Around three o'clock, the most able-bodied carried the coffin to a hearse that Hirschig and young Paul Gachet had fetched from a neighboring parish, and the procession set out toward the cemetery under a blazing summer sun. Andries Bonger and Theo led the small group.

At the graveside, the elder Gachet, at Theo's request, muttered some vague praise ("an honest man and a great artist") for a man he barely knew. Dazed by the heat and interrupted by tears, he left most people confused. Choked with emotion, Theo thanked him "with all my heart," but did not give a speech. The coffin was lowered into the ground. Theo and Bonger cast the first shovelfuls of dirt. The small group began to disperse: the Parisians drifting toward the train station or back to the inn, the locals evaporating into the countryside.

Theo stood on the heath and sobbed.

Ici Repose

~

VINCENT'S TORMENT HAD ENDED, BUT THEO'S HAD JUST BEGUN. BAT-
tered by storms of grief and regret, his frail constitution collapsed. The syphilitic
contagion that had congested his lungs and paralyzed his gait for years now
leaped into his brain. His weakened mind was possessed by a single idea: "He
will not be forgotten." The world had ignored Vincent's work—"these master-
pieces"—for too long, he said. People must know that he was a great artist; pos-
terity must honor him; the world must "grieve that he was taken from us so
soon." This was Theo's new mission. "I would hold myself to blame," he wrote
in a paroxysm of belated guilt, "I could never forgive myself if I did not do every-
thing in my power to bring this about."

Nothing else gave comfort. The condolences that started arriving almost
immediately made him alternately angry and ashamed. Artists and colleagues
who had ignored or ridiculed Vincent in life urged on him the consolation of
his brother's work in death. "As often happens," he wrote bitterly, "everyone is
now full of praise." In note after note, he found the same comfortless message:
Theo was better off without his troubled brother. Even his own family greeted
the news with unconcealed relief. Words intended only to console, like Wil's,
stabbed him in the heart: "What a strange coincidence," she wrote, "that he
had his wish to be and to live more like ordinary people, and was now so near
to you."

In the first weeks after the funeral, guilt turned to obsession. "Oh, how empty
it is everywhere," he wrote Jo from Paris. "I miss him so; everything seems to
remind me of him." He talked only about Vincent. On a trip to Holland in early
August, he spent whole days with his mother and Wil, deep in conversation
about Vincent. In Amsterdam, he reunited with his wife and child, but at night,
he admitted, the ghost of Auvers haunted his sleep. When he returned to Paris,

he wanted to see only people who had known Vincent. He invited them for din-
ners and long evenings "where Vincent was almost the only subject of conversa-
tion," he reported proudly. He clung especially to Paul Gachet, the doctor who
had known Vincent so briefly at the end. The old man's teary remembrances of
a patient he barely knew watered Theo's obsession at a time when the whole
world seemed set on forgetting.

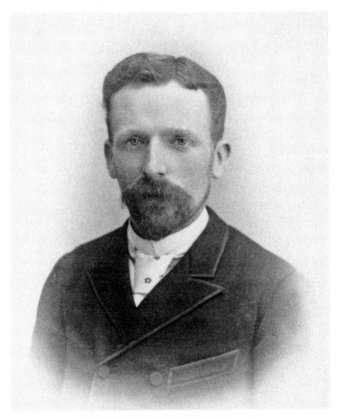

THEO VAN GOGH, 1890

He spent hours digging through the piles of Vincent's letters that he had
stuffed into a dining room cupboard—often with relief—along with all his other
correspondence. Alone with his brother again, he relived the years of trials and
tribulations, and a new resolve formed. "I find such interesting things in Vin-
cent's letters," he wrote his mother, "and it would be a remarkable book if one
could see how much thinking he did and how he remained true to himself."
Calling it "a book that *has* to be written," he first solicited Paul Gachet to write
it, but then set his sights higher: on the critic Albert Aurier. Angered by the few,
terse obituaries that had appeared (especially one that referred to Vincent's art
as the "expression of a sick mind"), he saw in Aurier's new eminence a chance

to immortalize an artist whom fame had barely glanced. "You were the first to appreciate him," he wrote the critic, "and by doing so you very clearly saw the man."

In this, as in everything, Theo honored his brother's memory by dreaming only big dreams. After a lifetime of cautious planning and incremental ambitions, he envisioned a panoramic memorial to Vincent: an exhibition at the gallery of the pioneer Impressionist dealer Durand-Ruel, accompanied by a vast illustrated catalogue with lithographs of Vincent's works and excerpts from his letters. He framed this comprehensive show exactly as Vincent would have—"it is essential for one to see a lot of it together because then one understands it better"—and pushed it with all Vincent's evangelical zeal. When Durand-Ruel balked at the "large space" Theo demanded ("to do him justice"), Theo reacted exactly as Vincent would have—by redoubling his demands and supporting them with elaborate accountings, extravagant details, and delusional promises. When anyone dared to challenge him, he lashed out—just as Vincent always did. "He is haunted by his brother's memory," Andries Bonger reported, "to such an extent that he resents anyone who does not share his views."

The mania of remembrance tore at his sense of identity. Like Vincent in Arles, Theo seemed pursued by an "ill-starred brother, clad in gloom / As though arisen from the tomb." By September, he was railing against his employers at Goupil, rallying the art world to a utopian "association of artists," and planning an exhibition at the café Le Tambourin, the long-defunct site of Vincent's first show in 1887, when the brothers lived together on the rue Lepic. In wild displays of defiance and rage—some of them directed at his wife and child—in attacks of paranoia, in spells of denial and magical thinking, in neglecting his health, his sleep, even his clothes, Theo mourned his brother by becoming his brother.

The transference came to a disastrous head in early October when Theo summarily quit Goupil—just as Vincent had always urged him to do—unleashing decades of accumulated grievances with a great Vincent-like show of shouting and slamming of doors. Virtually his last act as he left the firm where he had worked since adolescence was a defiant, delusional telegram to Gauguin: "Departure to tropics assured, money follows, Théo, Director."

Within days, the breakdown was complete. On October 12, 1890, Theo was admitted to a hospital in Paris. Two days later, he was transferred to a private asylum in Passy, the leafy suburb where he had vacationed the previous summer. After that, his path mostly followed Vincent's. There were some differences. Theo was physically far sicker than his brother when he surrendered his freedom. By now, the paralysis afflicted his whole body. At times, he could not walk at all. Far more frail than Vincent, in mind as well as in body, he suffered wilder and more dangerous bouts of delirium. He threw furniture and tore at

his clothes so violently that he had to be chloroformed into passivity. Instead of young interns like Félix Rey, the best doctors in France attended his case. The private asylum of Dr. Antoine Blanche *was* the spa that Vincent had imagined Saint Paul to be; and Passy, the glamorous resort that Glanum had once been. The alienist Blanche was not only the father of a prominent artist but also a colleague of Jean-Martin Charcot, the giant of French neurology and Freud's teacher.

Unlike Vincent's solitude in Arles and Saint-Rémy, Theo's confinement brought a flock of family and friends to his bedside. Wil traveled from Leiden, bearing their mother's unspeakable concern for her "crown and joy." H. G. Tersteeg, Vincent's implacable nemesis, rushed from The Hague. Only Gauguin remained aloof—fearing that the madness of both Van Gogh brothers would infect his own reputation and that of the movement he was still struggling to found. He complained to Bernard that Theo's insanity "is a rotten break for me," and began looking elsewhere for money to fund his latest idea for a triumph in the tropics: Tahiti.

But Bernard saw his fortune in the opposite direction—as Theo's grieving confrère, Vincent's champion, and both brothers' chief hagiographer. His plan to organize a retrospective of Vincent's work in Theo's memory drew a sharp rebuke from Le Pouldu ("What blundering!"), setting off a contest for credit that would preoccupy the rest of both artists' careers. Others in the avant-garde community who knew Theo shared Camille Pissarro's stunned lament: "No one can replace this poor van Gogh . . . It is quite a great loss for us all."

In addition to sympathizers, Theo had something else Vincent never had: an attentive, steadfast partner. Jo Bonger fought harder and longer than anyone else for her husband's health and reputation—a fight she would take far beyond his grave. She refused to believe the doctors at Blanche's asylum when they told her that both Theo's paralysis and his dementia were products of the same root disease: syphilis. She rejected the doctors' treatments, as well as their diagnosis. "[Jo] cannot accept what is being done," her brother Andries reported in distress, "and she constantly wants something else because she thinks she knows Theo better and knows what he needs most." She fought counsels of resignation and hopelessness from every side. Clinging to Theo's claim that sensitive "nerves" and grief over a lost brother were the source of all his woes, she imagined that hypnosis might help him. She enlisted the Dutch writer and psychologist Frederik van Eeden to visit him at the asylum. The young, charismatic Van Eeden preached a mystical gospel of brotherly love that gave hope in a faithless world. Vincent, too, had been drawn to it as the end approached.

After only a month in Passy, with Van Eeden's blessing, Jo arranged for Theo to be moved to an asylum in Utrecht, Holland. The long, sleepless train ride—

in a straitjacket, accompanied by guards—completed the return to the North that Vincent had often vowed. Jo rode the same train home, carrying her infant son. Within a few months, she would settle in the little town of Bussum, twenty miles north of Utrecht, where Van Eeden lived and later established a utopian commune. Theo arrived at the asylum on November 18, "in a wretched state": babbling in a mash of languages, disheveled, incontinent, and barely able to walk. He could not answer questions about who he was, where he was, or what day it was.

For the next two months, Theo lived the same life of confinement in Utrecht that his brother had lived in Arles and Saint-Rémy. Long days of delusion, delirium, and drug-induced stupor were followed by long nights of restless, haunted sleep, or no sleep at all. He sat for hours in his padded cell conducting fevered, incoherent monologues—arguments with himself—in multiple languages. His mood swung wildly from "cheerful and boisterous" to "dull and drowsy," according to the asylum reports. At other times, a sudden fury possessed his delicate body. He shook with tremors from head to toe in paralytic attacks indistinguishable from epileptic seizures. The look in his eyes, the timbre of his voice, his whole character, changed—as if commandeered by some other entity. In these transformations, the cultured art dealer of refined sensibilities clawed at his underclothes, ripped up the sheets on his bed, and tore the straw from his mattress. The wardens had to wrestle him into a straitjacket and tranquilize him.

Speech became increasingly difficult, as did walking, as the tremors invaded every part of his body. The muscles of his face twitched uncontrollably. He had trouble swallowing. Eating was a torment, and he vomited up most of what he ate. His bowels malfunctioned. Urination was painful, and attempts to insert a catheter failed. He couldn't feed himself or dress himself. After he was found asleep in the bath, he wasn't allowed to bathe himself for fear he might accidentally drown. He had to be placed in a covered, padded "crib" at night, so he could not harm himself.

Out of deference to Jo, no doubt, the doctors noted in Theo's record a benign diagnosis that his agonies were the result of "heredity, chronic illness, excessive exertion, and sadness"—a fitting benediction for either brother. But when Jo demanded to take her husband home, they rose up in unanimous opposition: "His general condition is such that he must be deemed to be absolutely unfit for normal intercourse and private care," they wrote in his record, describing his state as "appalling," "deplorable," and "lamentable in all respects."

In the end, even Theo seemed set against her. When she came to see him, he greeted her with either stony silence or eruptions of rage, as if blaming her for some offense his tongue could not name. Instead, he threw chairs and over-

turned tables. At Christmastime, when she brought him flowers, he seized them and tore them to shreds. He brooded for days after every visit, and eventually her presence was deemed too provocative.

Having heard the stories about the patient's artist-brother, one doctor tried to penetrate Theo's unreachable solitude by reading to him an article about Vincent that had appeared in a Dutch paper. But as he heard the familiar name repeated over and over, his eyes went vacant and his attention wandered to somewhere inside. "Vincent . . . ," he muttered to himself, "Vincent . . . Vincent . . ."

Like his brother, Theo died in a final haze of mystery. Not even the date of his death is certain. One report puts it on January 25, 1891, but hospital records show the body being removed on January 24. According to one account, he died after yet another visit by Jo. Defying the doctors to the end, she refused to allow an autopsy. Four days later, Theo was unceremoniously buried in a Utrecht public cemetery, in an ignominy of family silence that spoke louder than all Jo's protests.

There he waited for almost twenty-five years while Vincent's star ascended and the rest of the Van Gogh family disappeared in a vortex of tragedy. Ten months after Theo's death, in December 1891, sister Lies married her longtime employer, whose wife had died of cancer. In fact, Lies had already borne a child by her new husband, in secret, five years earlier, which she had abandoned to a peasant family in Normandy. The shame of it haunted her to her grave. The surviving brother, Cor, never returned from the Transvaal. After a brief, unhappy marriage, he joined the Boer fight against the British in 1900. Not long after, during a bout of fever, he shot himself and died. He was thirty-two years old. Two years later, sister Wil was committed to an insane asylum. She spent the rest of her life there—almost forty years. During most of that time, she never uttered a word and had to be force-fed. She made several suicide attempts.

Mother van Gogh absorbed every blow with invincible faith. "Trust in God who sees everything and knows everything," she maintained until her own death in 1907, "though His solution may be deeply sad." At least one of those sad solutions never rose to her notice. In 1904, Sien Hoornik, Vincent's prostitute lover and substitute wife in The Hague, threw herself into a canal and drowned, fulfilling the vow she had made to Vincent in 1883: "Yes, it's true I'm a whore, and the only end for me will be to drown myself."

BY 1914, JO BONGER had remarried and been widowed a second time. The first publication of Vincent's letters and the prominent sale of his works had brought her the attention of the world. To share that vindication with her dead

husband, and, no doubt, to wipe away the horrible events in Paris and Holland during the six months between the brothers' deaths, Jo had Theo's body brought from Utrecht. She buried him next to Vincent, overlooking the wheat

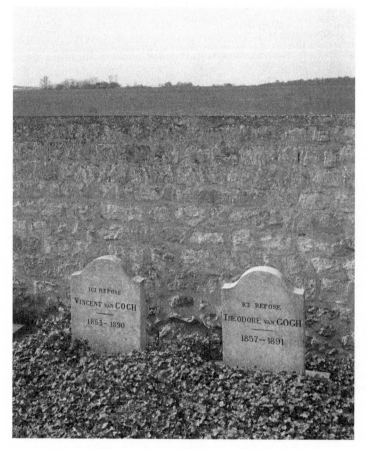

GRAVES OF VINCENT AND THEO VAN GOGH, AUVERS

fields above Auvers. She placed matching stones on the side-by-side graves, with matching inscriptions: ICI REPOSE (here rests) VINCENT VAN GOGH and ICI REPOSE THEODORE VAN GOGH.

Finally, Vincent had his reunion on the heath.

Appendix: A Note on Vincent's Fatal Wounding

*F*OR AN ACT OF SUCH FAR-REACHING SIGNIFICANCE AND SUBSEQUENT NOTORIETY, surprisingly little is known about the incident that led to Vincent van Gogh's death at the age of thirty-seven.

All that can be said with certainty is that he died of a gunshot wound that he sustained in or near the town of Auvers, about twenty miles north of Paris, on July 27, 1890. The injury occurred sometime after he had lunch at the inn where he was staying and then left on a painting excursion loaded down with equipment. He returned to the Ravoux Inn just after suppertime with a bullet hole in his upper abdomen. He called for medical assistance but the injury was fatally severe. He died approximately thirty hours later.

The two doctors who attended him during that time examined the wound and manually probed his midsection. They concluded: first, the bullet had not exited the body but had come to rest near the spinal column; second, the gun that inflicted the wound was a small-caliber pistol; third, the bullet had entered the body from an unusual, oblique angle (not straight on); and fourth, the gun had been fired at some distance from the body, not close up.[1]

No physical evidence of the shooting was ever produced. No gun was ever found. None of the painting equipment that Vincent took with him from the Ravoux Inn—easel, canvas, paints, brushes, sketchbooks—was ever recovered. The location of the shooting was never conclusively identified. No autopsy was performed. The bullet that killed him was not removed. No eyewitnesses to the shooting could be located. Indeed, no one stepped forward who could verify Vincent's whereabouts at any time during the roughly five-hour period during which the shooting occurred.

Within hours of Vincent's return to the Ravoux Inn, rumors had begun to circulate about the circumstances that had led to his fatal wounding. Those rumors quickly coalesced into a narrative about the events of July 27. According to this narrative, which was taken up in virtually all subsequent accounts, Vincent borrowed a revolver from Gustave Ravoux, the owner of the inn where he was staying, and took it with him on his regular afternoon painting expedition that day. He then climbed up the riverbank and walked some distance into the wheat fields that lay above and outside the town. There he put down his load and shot himself. The blow did not kill him (it missed his heart), but it did knock him out. By the time he regained consciousness, darkness had fallen and he could not find the gun. So he staggered back down the steep riverbank and returned to the Ravoux Inn seeking medical attention.

It was, and is, a satisfying narrative. It provides a suitably tragic end to an undeniably tragic life: a troubled, unappreciated artist seeks escape from the neglect of the world by

taking his own life. The story not only appeared early, it caught on quickly, and it played an important role in the meteoric ascent of Vincent's celebrity in the decades immediately after his death. By 1934, when it was immortalized in Irving Stone's bestselling novelization, *Lust for Life*, the story of Vincent's suicide in the wheat field had become firmly lodged in the artist's legend. Two decades later, in the 1950s, when the celebrity of Vincent van Gogh reached new heights with the centenary of his birth in 1953,[2] it was sealed in the mythology permanently with the release three years later of the Academy Award–winning movie adaptation of *Lust for Life*.

In our review of the available evidence, however, we could find little reliable, verifiable support for the narrative summarized above. The purpose of this note is to put forward an account of the events of July 27 that better fits the known facts about the incident and about the man; to examine the origins of the traditional account; and to explain why, in our opinion, that account falls short.[3]

IN THE SAME YEAR that the movie *Lust for Life* was released—1956—an eighty-two-year-old Frenchman named René Secrétan stepped forward to give his account of the strange painter he had known in Auvers in the summer of 1890. The son of a prosperous pharmacist who grew up in an exclusive Paris suburb, René was sixteen at the time of Vincent's death.[4] He was a student at Paris's famous Lycée Condorcet, the same school where Paul Verlaine and Marcel Proust studied and Stéphane Mallarmé and Jean-Paul Sartre taught.[5]

René and his brother Gaston came to Auvers every summer to fish and hunt at their father's villa on the bank of the Oise River.[6] René was a rambunctious, adventurous teenager who liked the outdoors far more than his prestigious school (where he often skipped classes). In this, he was completely unlike Gaston, a sensitive eighteen-year-old[7] who preferred art and music to fishing and shooting. It was through Gaston that René met Vincent van Gogh. René told Victor Doiteau, a French writer, during a series of interviews Doiteau conducted in 1956, that Gaston and Vincent had many conversations about art and that Vincent eventually sought out Gaston's company for these discussions.[8]

A self-proclaimed philistine,[9] René disdained their talk of art, but in his brother's company, he spent many hours observing the strange Dutchman. In his interviews with Doiteau, René painted an intimate portrait of Vincent with details that bespeak close and repeated contact, conform to descriptions from other sources that he would not have known, and bear no resemblance whatsoever to the hagiographic image of the artist then being propagated by *Lust for Life*. ("He compared Vincent's mangled ear to that of an angry cat, as well as a gorilla's."[10]) René described Vincent's clothes, his eyes,[11] his voice,[12] his gait, his taste in liqueurs,[13] and what it was like to share a café booth with him.[14]

Despite all this, René did not claim to be friends with the famous painter. Indeed, just the opposite. When he was not tagging along with his brother, René led a rowdy group of other boys: most of them, like the Secrétans, Parisian students vacationing in Auvers for the summer. With his natural bravado, adventurous spirit, and puckish sense of mischief, René was the one they all wanted to follow. A crack marksman, he took them on hunting expeditions for squirrels or rabbits or whatever else they could find in the woods and fields. He guided them to the richest fishing areas along the Oise. He also led them on amorous adventures.[15] Through his connections with the director's son, he regularly imported girls from the Moulin Rouge (René called them "our *cantinières* [canteen women]") and organized boating parties and picnics for the amusement of his fellows and their girlfriends.[16]

René also brought something else from Paris: a cowboy costume that he had bought when he saw Buffalo Bill's Wild West Show at the Universal Exposition the year before (1889).[17] It consisted of a fringed buckskin tunic, boots, and a rodeo hat with the front brim turned up. Its rakish outlaw look perfectly suited René's bumptious spirit, taste for risk, and love of high jinks.[18] To lend this outfit more authenticity (and, no doubt, an edge of genuine menace), he added to it a real gun. To Doiteau, René described the gun as an old .380 caliber pistol that was falling apart and worked only erratically.[19] But it worked well enough. When not playing Buffalo Bill fighting off an Indian attack, René used it to shoot squirrels and birds and any fish that came too close to his boat. With or without the cowboy getup, he kept it always close at hand in his rucksack. So it was not a toy, however much he may have treated it as one.

According to René, the gun was sold (or lent) to him by Gustave Ravoux, the innkeeper.[20]

When in town, René led his followers in another favorite pastime: playing pranks on Gaston's friend, the strange Dutchman named Vincent.[21] They put salt in his coffee and watched from a distance as he spat it out and cursed with anger. They put a grass snake in his paint box; when he discovered it, he almost blacked out, René recalled. René noticed that Vincent would sometimes suck on a dry paintbrush when he was thinking, so they rubbed the brush with chili pepper when he wasn't looking. It was all part of a campaign to "drive [Vincent] wild," René admitted.[22]

For his own reasons, Vincent chose not to take offense. Nor did the ever-escalating pranks turn René into an enemy. Vincent gave the sixteen-year-old his own nickname: "the terror of the smoked herring," a joking tribute to René's talents as a fisherman. Seeing him often in his Wild West outfit, Vincent also called him "Buffalo Bill." But, according to René, with Vincent's "strange accent," the name came out as "Puffalo Pill,"[23] setting off a round of mockery every time he said it.

Even though he avoided the gang of boys that René led[24] (just as he had avoided similar tormentors in virtually every place he ever lived), Vincent suffered René's abuses without complaint, even in good humor (he never mentioned them in letters to Theo). The two continued to share drinks at Ravoux's Inn and at an old poacher's bar on the bank of the Oise about a mile outside town— René called it "our favorite watering hole,"[25] Partly, Vincent tolerated the mischievous René to preserve his rare camaraderie with Gaston, whose ideas on painting Vincent considered advanced, according to René.[26] No doubt he also appreciated that the brothers always paid the bar tab.[27] The Secrétan brothers were also the right kind of company—sons of a respectable bourgeois family that could play an important role in Vincent's delusive plan to lure Theo and his family to Auvers.[28]

But René Secrétan also supplied Vincent with something he could not get any other way: women. (There was no brothel in Auvers.)[29]

René had noticed how enviously Vincent watched when the *cantinières* came from Paris. When René and his cohorts sat on the riverbank kissing and fondling their girlfriends, Vincent was both titillated and timorous as he watched from a distance. "[Van Gogh] would modestly look the other way, which seemed madly funny to our little chicks," René told Doiteau.[30] Always looking for new ways to torment his brother's friend, René encouraged the girls to try their wiles on the reticent painter—to "provoke him with their amorous attentions."[31]

When these attentions had no apparent effect on Vincent,[32] René began to think that "it wasn't only his ear that had been cut off,"[33] but then he caught Vincent with his pockets full of erotic photographs and books.[34] Once, René discovered the painter masturbating in

the woods.[35] This humiliating encounter offered new opportunities for even crueler forms of mockery and torment. René dubbed him with a new taunting sobriquet: "faithful lover to the Widow Wrist."[36] It became easier and easier to achieve the desired effect of driving Vincent wild. Increasingly, "he took it very badly," René recalled. "One day he became red with anger and wanted to kill everyone."[37]

This was the poisonous atmosphere that prevailed between Vincent and René Secrétan in July 1890.

Another witness came forward in the decade following Van Gogh's centenary. She was the daughter of a gentleman who, in 1878, had lived near one of Vincent's favorite painting spots in Auvers,[38] the former house and garden of the great French Barbizon painter Charles Daubigny. In the 1960s, when she gave an interview to the Van Gogh biographer Marc Tralbaut, she used only her married name, Madame Liberge. In 1890, she had been about twenty years old.[39]

Madame Liberge dismissed the traditional account of Vincent receiving his mortal wound in the wheat fields above the Auvers cemetery. She told Tralbaut:

> I don't know why people don't tell the true story. It was not over there, by the cemetery . . . [Van Gogh] left the Ravoux Inn in the direction of the hamlet of Chaponval. At the rue Boucher he entered a small farmyard. There he hid behind the dunghill. Then he committed the act that led to his death a few hours later.[40]

Madame Liberge said that her father, a prominent citizen, had told her this account years before. "These were my father's very words," she said. "Why should he have wanted to invent such an absurd story and falsify history? Anyone who knew my father could tell you that he was always to be trusted."[41]

Some years later, another Auvers resident named Madame Baize confirmed Madame Liberge's story when she told a different interviewer that her grandfather "saw Vincent leave the Ravoux Inn that day and walk in the direction of the hamlet of Chaponval."[42] The same witness reported seeing Van Gogh enter a small farmyard on the rue Boucher and then hearing a gunshot. After waiting some time, "he went into the farmyard himself," according to Madame Baize's account, "but there was no one to be seen. No pistol and no blood, just a dung heap."

The hamlet of Chaponval and the wheat fields behind the cemetery lay in opposite directions—the first to the west of the Ravoux Inn, the other to the east. The rue Boucher mentioned by Madame Baize intersects with the road to Chaponval less than half a mile west of the Ravoux Inn. At the time, the road to Chaponval (now called the rue Carnot) was lined with just the kind of walled farmyards described in both these accounts, which are separated by almost thirty years. Dung heaps were a common feature of such enclosures. Vincent often walked the Chaponval road to go to Pontoise, four miles away, where he took advantage of the better train service to have supplies sent from Paris and to dispatch his own work.[43] The Chaponval road also led directly to a bend in the Oise, halfway between Auvers and Pontoise, where René Secrétan could usually be found,[44] both because of the good fishing and because of the favorite bar.[45] From this spot, René often launched his expeditions in search of adventure, entering Auvers along the Chaponval road.

The shot that killed Vincent van Gogh was probably fired not in a wheat field, but in or near a farmyard on the road to Chaponval like the one described by Madame Liberge and Madame Baize. Moreover, the gun that delivered the fatal blow was probably

not brought into that farmyard by Vincent van Gogh, who knew nothing about guns and had no need of one, but by René Secrétan, who rarely went anywhere without his .380-caliber peashooter. The two may have encountered each other by accident on the Chaponval road, or they may have been returning from their favorite watering hole together. Gaston was almost certainly with them, as Vincent would have avoided René, whether alone or in the hostile company of his followers.

René had a history of teasing Vincent in a way intended to provoke him to anger. Vincent had a history of violent outbursts, especially when under the influence of alcohol. Once the gun in René's rucksack was produced, anything could have happened— intentional or accidental—between a reckless teenager with fantasies of the Wild West, an inebriated artist who knew nothing about guns,[46] and an antiquated pistol with a tendency to malfunction.

Wounded, Vincent must have stumbled into the street as soon as he was able and headed toward the Ravoux Inn, leaving behind whatever painting gear he had brought. At first, he may have had no idea how seriously he was hurt. The wound did not bleed profusely.[47] But once the initial shock wore off, the pain of his abdominal injury had to be excruciating.[48] The Secrétan brothers would have been terrified. Whether they tried to give Vincent assistance cannot be known. But they apparently had the time and presence of mind to collect the pistol and all of Vincent's belongings before hurrying off into the gathering dusk—so that when Madame Baize's grandfather showed up soon afterward to investigate (if he did), he found only an empty farmyard and a dungheap.

THIS HYPOTHETICAL RECONSTRUCTION of the events of July 27, 1890, resolves many of the contradictions, fills many of the gaps, and fits together many of the misshapen pieces of the traditional narrative of suicide that has dominated Van Gogh mythology since the day of the shooting.

• It explains the immediate and permanent disappearance of all the evidence surrounding the incident, despite a police investigation that began the very next day. In his wounded state, Vincent would never have been able to clean up so thoroughly afterward, and nobody other than a guilty accomplice would have had a reason to take, hide, or dispose of the mostly worthless gear that he left behind. In their hasty cover-up of the deed, with night falling, the Secrétan brothers may well have missed something—a spot of blood or a spent cartridge—but the police would never have found it, because they were searching the wheat fields far away, not the farmyards on the Chaponval road.

• It explains the oddities of Vincent's wound as reported by the doctors who examined it: that the shot was to the body, not to the head; that the bullet entered from an unusual, oblique angle—not straight on as one would expect in a suicide; and that the shot appeared to have been fired from "too far out" for Vincent to have pulled the trigger.[49]

• It explains how Vincent, in his wounded state, could have dragged himself from the site of the shooting to the Ravoux Inn despite the hole in his abdomen and the severe pain aggravated by each step. Even the relatively short half-mile trek from the rue Boucher to the inn—a direct route over flat roadway—must have required an agony of effort. A long descent from the wheat fields along a steep, uneven path down a forested riverbank in the waning light of dusk (as legend would later have it) would have been virtually impossible in his condition.

• It explains the sightings of Vincent on the Chaponval road by two separate witnesses on the evening of the incident. As far as is known, no independent witness came forward to place Vincent in the vicinity of the wheat field (on the other side of town) where legend locates the shooting. Nor did anyone testify to seeing him anywhere on the long route he would have had to take between the wheat field and the Ravoux Inn. On a warm summer night in July, many residents would have been outside after sunset, eating, drinking, smoking, and gossiping (just as the Ravouxs were). Given that all of the routes that Vincent could have taken from the wheat field to the inn would have included populated public streets, and given his conspicuous staggering gait, surely someone would have seen him passing along the purported route that night.

• It explains why Vincent left no suicide note, and why Theo could find no trace of a "farewell" when he searched Vincent's room and his studio in the days after the shooting. It explains why Vincent bothered to take a load of canvas and paint and other supplies on his expedition that day—something he would have been unlikely to do if he did not intend to return.

• It explains why he failed to "finish himself off" when his first (and only) shot went wrong, and chose instead to take the far more painful and embarrassing path back to his attic room at the Ravoux Inn.[50]

• It explains the strange disappearance of a haystack from the narrative of Van Gogh's suicide. The very first written account of the shooting (in a letter from a mourner at the funeral) reported that Vincent had "placed his easel against a haystack before shooting himself."[51] But the later retellings of the story omitted this detail, presumably because no haystacks appear in the painting that was widely, but wrongly, considered Vincent's last, *Wheatfield with Crows*. In fact, the "haystack" of the earliest reports was almost certainly the "dungheap" recalled by the later witnesses.

• It explains why the origin of the gun that inflicted the fatal wound was not revealed until seventy years later, even though it must have been known by a number of people at the time of the shooting. Auvers being a small town and revolvers being a rarity in rural France,[52] many friends of both Gustave Ravoux, who lived a very public life, and René Secrétan, who brandished the weapon openly, surely were familiar with the innkeeper's exotic firearm. Ravoux's daughter, Adeline, made no mention of the connection between her father and the fatal weapon in any of her early accounts of Vincent's death. When she finally admitted it, in the 1960s, she omitted René Secrétan from her narrative, instead maintaining that Vincent had obtained the gun directly from her father after asking for it in order to scare away crows—a cover story devised (probably by her father) to explain to the police how his pistol had come to be involved in the fatal shooting; to conceal his own culpability in putting a gun in the hands of a notoriously belligerent teenager; and to protect the Secrétan brothers (whose father was a rich and prominent patron) from a protracted and potentially embarrassing inquiry—even a trial—arising from what Ravoux almost certainly believed to be either an unfortunate accident or, at worst, an adolescent prank gone terribly wrong.

• Finally, this reconstruction explains why Vincent's "confessions" to a suicide attempt, as reported by witnesses at the time, were so hesitant, halfhearted, and oddly

hedged. When the police asked Vincent directly, "Did you want to commit suicide?" he answered with an indecisive "Yes, I believe so."[53] When they told him it was a crime to attempt suicide, he appeared more concerned that no one else should be blamed than that he himself might be charged with a crime. "Do not accuse anyone," he responded; "it is I who wanted to kill myself."[54] Why would Vincent vehemently volunteer that he acted alone when the natural inference in any suicide would have been solitary intention and execution? Why would he urge the officers not to "accuse anyone" of the shooting and insist on taking sole responsibility? Vincent's early and inexplicable defensiveness about the participation of others indicates an intent—indeed, a determination—to protect the Secrétan brothers from any implication of involvement in the incident.[55]

But why would Vincent go to such lengths to protect the Secrétan brothers, especially his tormentor René, from a police inquiry, or perhaps prosecution? Why would he repeatedly "confess" that he had shot himself with the intention of committing suicide when in fact he was the victim of a terrible accident, if not something worse?

The answer, we believe, is that Vincent welcomed death. "Poor fellow, he wasn't granted a lavish share of happiness," Theo wrote his wife from Vincent's bedside in the final hours. "If only we could give him more faith in life."[56] Émile Bernard, who came to Auvers for the funeral, reported that Vincent had expressed his "desire to die."[57] Dr. Paul Gachet, another witness at Vincent's deathbed, wrote Theo only two weeks after the funeral expressing his admiration for "the sovereign disdain that [Vincent] felt for life"[58] and comparing his end to a martyr's embrace of death. As Vincent himself had once written (and boldly underlined): "*I would not expressly seek death . . . but I would not try to evade it if it happened.*"[59]

In fact, whether by accident or negligence or malice, René Secrétan may have provided Vincent the escape that he longed for but was unable or unwilling to bring upon himself, after a lifetime spent disavowing suicide as "moral cowardice" and "the deed of a dishonest man."[60] Having just returned from a disastrous visit to Paris during which he had been made painfully aware of the burden he imposed on Theo and his young family, Vincent undoubtedly saw his chance to "withdraw"—just as he had withdrawn from Paris in 1888—and spare his brother further heartache (see chapter 29).

With so much to be gained, Vincent must have seen no reason, no benefit, in dragging the Secrétans—even the mischievous, careless René—into the glare of public inquiry and embarrassment simply for having done him this favor.

OUR RECONSTRUCTION RELIES heavily on the interviews that René Secrétan gave to Victor Doiteau in 1956 and in 1957, the year of his death at the age of eighty-three.[61] While his artistic older brother Gaston[62] went on to become a cabaret singer of some renown, writing songs for films in the twenties and thirties[63] and even appearing in a few of them,[64] René had lived his life far from the world of art. After his rambunctious adolescence, he settled down to become a rich and respected member of society. He had a long and distinguished career as a banker, businessman, and shooting champion.[65]

Despite his advanced age, René was an excellent witness. Doiteau, who met and corresponded with him often, described him as in good physical and mental condition until the end of his life.[66] Unlike so many witnesses, René gave his first account of Vincent's last days long after the painter had become famous. He came forward not in order to attach himself to the painter's legend or claim a piece of his immortality, but simply to set the record straight. He had seen a story in *Paris Match* about the release of the movie *Lust for*

Life that featured a picture of Kirk Douglas playing Vincent van Gogh. The image of the hale, handsome, wholesome Douglas so violated René's sense of duty to the truth that he could hold back his story no longer. The picture "bore no resemblance to our friend who always looked more like a tramp with shoes on his feet," he told Doiteau.[67] René's account to Doiteau, taken as a whole, not only runs counter to the projections of Stone and Hollywood that dominated the era, but is richly and convincingly detailed, internally consistent, sometimes independently verifiable, and not self-inflating or self-serving. Indeed, it is often self-indicting, both intentionally and unintentionally.

However, despite his astonishing frankness in revealing his own abusive, belligerent behavior toward Vincent, René never confessed to having any direct role in the painter's fatal shooting on July 27, 1890. Regarding the events of that day, René told Doiteau that Vincent had stolen the gun from his rucksack and recalled vaguely that both he and Gaston left for the family's villa in Normandy sometime in July and that he first learned of Vincent's death by reading about it in a major Paris daily newspaper,[68] although he could not remember which one, and no such article has surfaced since. But his denials lack the consistency and conviction of the rest of his account. As nowhere else in his many recollections, they betray the lawyerly caution of a man who knows he is speaking for the record. For example, he told Doiteau that he carried his rucksack (containing the heavy pistol) everywhere he went—yet he didn't notice that the gun was missing before he left for Normandy. Elsewhere, he implied that Vincent had stolen the pistol from him on the very day of the shooting, placing himself still in Auvers at the time.[69]

In these faltering denials, as much as in his many boisterous confessions, we hear the voice of a man who had kept the truth to himself for a lifetime but could not die without telling it—or at least most of it—to ease his conscience at the end.

THE STORY THAT VINCENT'S DEATH was the result of a botched suicide attempt took shape over a period of more than seventy years. The earliest accounts of the shooting— those written in the days immediately after the event—do not mention suicide. When Paul Gachet, one of the doctors treating Vincent, wrote Theo on July 28 to summon him to Auvers,[70] he said nothing about the circumstances or the nature of Vincent's injury except that he had "wounded himself."[71]

In his reports to Jo from Vincent's bedside, Theo, too, gave no hint that his brother had made a suicide attempt—or that he, Theo, suspected one.[72] He portrayed Vincent as sad ("Poor fellow, he wasn't granted a lavish share of happiness")[73] but not suicidal. Nothing in Vincent's room or studio indicated an intention to commit suicide. He had left no farewell note. He hadn't even straightened up.[74] His most recent letters had been filled with expressions of buoyant spirits[75] and inviting sketches of his new home in Auvers.[76] Indeed, only days before, he had placed a large order for new paints and other supplies— hardly the act of a man planning to end his life, especially one so sensitive about spending his brother's money.

Besides, as Theo knew well, Vincent had always rejected suicide in the most vehement terms. He called it "terrible" and "wicked."[77] He thought it cowardly[78] and dishonest.[79] Even on the verge of despair in the Borinage in 1881, he had assured Theo, "I really do not think I am a man with such inclinations."[80] From Drenthe, too, during another period of deep melancholy, he had made his feelings on suicide clear: "As regards making oneself scarce or disappearing—now or ever—neither you nor I should *ever* do that, no more than commit suicide."[81] (Emphasis in original.)

Theo also knew his brother well enough to know that if he ever did try to commit

suicide, he would not have used a gun, a device about which he knew virtually nothing.[82] On the other hand, he knew a great deal about poisons, and he could have used that knowledge to see himself off with far less bother and pain.[83] Of the various methods of suicide, drowning was the means Vincent had always considered the most "artistic"[84] and the only one he had ever threatened (once, in a moment of pique).[85]

The first commentator to raise the possibility that Vincent had attempted suicide was neither a witness to the shooting nor present at Vincent's deathbed. On July 30, Émile Bernard came to Auvers to attend Vincent's funeral. Two days later, he wrote a letter to the critic Albert Aurier—the same critic to whom Bernard had sent a sensationally fictionalized account of the ear incident in Arles two years earlier.[86] This letter contained the first recorded description of the shooting incident and the first suggestion of a suicide attempt: "On Sunday evening [July 27] [Van Gogh] went into the Auvers countryside, placed his easel against a haystack and went behind the château to shoot himself with a revolver."[87]

What was the basis of this account? Bernard claimed that he had heard the details from townspeople, especially Gustave Ravoux, the owner of the inn where Vincent died. But Bernard was a prolific and inventive fabricator,[88] Ravoux left no account of his own, and Auvers was abuzz with baseless rumors by the time of the funeral. The police had already begun investigating the shooting and interviewing witnesses. People who knew of Vincent's stay in an asylum and had seen his deformed ear were quick to assume a connection between self-mutilation and suicide—a connection debunked by later research.[89] Suspicion of suicide ran so high that the local abbot refused to allow Vincent's body to be carried by the parish hearse or buried near the church.[90]

A week later (August 7), a brief article in *L'Écho Pontoisien*, a local paper, rejected the sensational rumors of suicide and reported the incident in straightforward terms, leaving the possibility of an accident conspicuously open:

> On Sunday July 27, one van Gogh, aged thirty-seven, a Dutch painter staying at Auvers, shot himself with a revolver in the fields, but, being only wounded, returned to his room, where he died two days later.[91]

In fact, the gendarmes investigating the incident must have assumed at first that they were dealing with an accidental shooting.[92] They would quickly have learned from interviews that Vincent was not accustomed to firearms (he had never been seen with a gun),[93] that he drank heavily at times, that he took liquor with him on painting expeditions, and that he was clumsy and reckless in his manner and therefore prone to accidents.[94]

They surely knew from experience what subsequent studies have shown: that an overwhelming majority (98 percent) of suicides using guns involve a shot to the head, not to the chest or abdomen.[95] The fact that Vincent immediately sought medical care also pointed to an accidental shooting. A man truly bent on suicide would have finished himself off with a second shot rather than make the steep, difficult descent to the Ravoux Inn with a bullet in his belly.[96] Pulling the trigger again would have taken far less energy and caused far less pain. Also, Vincent's attending doctors had probably already told the officers that the fatal shot was fired from an odd angle and from "too far out,"[97] the first suggesting that it was an accidental discharge and the second that someone else might have pulled the trigger.

Indeed, the primary question for the police would have been not whether the shoot-

ing was a suicide or an accident, but whether others were involved in it—a possibility made more likely by the disappearance of the pistol and all of Vincent's painting equipment. When a thorough daylight search of the area failed to produce a single missing item (and nothing was turned in by locals), the inevitable assumption was that somebody had hidden or disposed of the evidence, either at the time of the shooting or immediately afterward.

But Bernard's dramatic tale of an artist driven to suicide had planted a seed in the Van Gogh legend that could not be uprooted by logic or lack of evidence. Even those with first-hand knowledge of the events of July 27, 1890, were subject to its allure. Anton Hirschig was a twenty-three-year-old Dutch artist who happened to be lodging at the Ravoux Inn the day Vincent was wounded. In 1912, twenty-two years later, when Hirschig first set down his recollections of the events he witnessed that night in 1890, he did not mention suicide. He recalled Vincent saying only, "Go and get me the doctor . . . I wounded myself in the fields . . . I shot myself with a revolver there"[98]—a statement that, like Gachet's, is as consistent with a careless accident as with an attempted suicide.

It was not until 1934—the same year that Irving Stone immortalized Bernard's sad version in *Lust for Life*—that Hirschig testified to Vincent's suicidal *intent* that day in July 1890, forty-four years earlier. "I can see him in his little bed in his little attic, in the grip of terrible pain," Hirschig told an interviewer. "'I couldn't stick it any longer, so I shot myself,' he said."[99]

The story that began with Bernard's letter—the story of a suicide attempt in the wheat field—was not fully fleshed out until the 1950s, when the centenary of Vincent's birth touched off a decade-long celebration of the painter's life and work. The person chiefly responsible for turning Bernard's slender tale into the definitive account of Vincent's final days was Adeline Ravoux, the daughter of the innkeeper Gustave Ravoux, a girl of thirteen at the time of the shooting. Over the course of the 1950s and 1960s, Adeline gave repeated interviews regarding Vincent's death, adding fresh details and heightening the drama with each telling.[100]

Adeline's accounts followed the broad outlines of Bernard's tale, and, like Bernard, she claimed her dead father as her ultimate source. For her versions of events that the innkeeper did not witness—such as the shooting itself—she claimed that Vincent had confided his story to her father in the hours before his death. By this process, events that had been shrouded in mystery for sixty years sprang suddenly into the record in full, rich detail. Here, for example, is Adeline's 1956 account—her first—of the day of the shooting:

> Vincent had gone toward the wheat field where he had painted before, situated behind the château of Auvers, which then belonged to M. Gosselin, who lived in Paris on the rue de Messine. The château was more than a half kilometer from our house. You reached it by climbing a rather steep slope shaded by big trees. We do not know how far away he stood from the château. During the afternoon, in the deep path that lies along the wall of the château—as my father understood it—Vincent shot himself and fainted. The coolness of the night revived him. On all fours he looked for the gun to finish himself off, but he could not find it. (Nor was it found the next day either.) Then Vincent got up and climbed down the hillside to return to our house.[101]

Adeline Ravoux's accounts seem unreliable for a number of reasons: (1) By her own telling, they are mostly hearsay:[102] that is, they involve recollections of what her

father told her he saw or heard, not what she actually witnessed or heard. (2) Her multiple accounts are often internally inconsistent as well as inconsistent with one another.[103] (3) Her accounts are distorted by her determination to prove her father's closeness to the famous artist (a project that became her life's work).[104] (4) Her later accounts are vastly more detailed than her earlier ones. In particular, she often added dialogue to enhance the drama of her stories,[105] sometimes conjuring whole scenes.[106] (5) She appears to have adjusted her accounts over time to respond to critics or to correct inconsistencies.[107]

Perhaps the best example of Adeline's fitting her account to the requirements of the moment was the startling admission in her last set of interviews (in the 1960s) that the revolver that killed Vincent van Gogh had belonged to her father[108]—a fact that neither she nor her father had volunteered for more than seventy years, despite intense inquiry throughout that time into where Vincent procured the fatal weapon and why.[109]

Adeline's new account confirmed René Secrétan's story that the pistol was her father's, but not René's alibi that Vincent had stolen the gun from his rucksack. Instead, she told the interviewer (Tralbaut) that Vincent had asked her father for the gun "in order to scare away crows"—a patent falsehood, since Vincent had no fear of birds and thought of crows in particular as good omens.[110] At the time Adeline told this story, however, it was widely believed that Vincent's last painting was *Wheatfield with Crows*,[111] thus lending both credibility to her story and extra poignancy to the painting. It is now known that *Wheatfield with Crows* was painted around July 10, two weeks before the fatal shooting.[112]

OUR RECONSTRUCTION OF the events of July 27, 1890, is based on an analysis of all the evidence, both direct and circumstantial, that is in the public record, and a weighing of all the witness testimonies that bear on the events of that day, from the multiple accounts of Adeline Ravoux to the deathbed confessions of René Secrétan.

It is also precisely the story that John Rewald heard when he went to Auvers in the 1930s and interviewed residents of the town who had been living there at the time of Vincent's death. Rewald, a scholar of unparalleled integrity and thoroughness, went on to become the ultimate authority on both Impressionism and Post-Impressionism, about which he wrote two magisterial surveys and many other books, including volumes on Cézanne and Seurat. The story he heard was that "young boys shot Vincent accidentally" and that "they were reluctant to speak up for fear of being accused of murder and that Van Gogh decided to protect them and to be a martyr."[113]

Fifty years later (in 1988), Rewald recounted this story to a young scholar named Wilfred Arnold, who included it in his 1992 book, *Vincent van Gogh: Chemicals, Crises, and Creativity*. Arnold openly attributed the story to Rewald, who died two years later. Other than in his conspicuous failure to "correct" Arnold's report, to our knowledge Rewald never directly confirmed or challenged the alternate version of Van Gogh's death that he had heard in Auvers. He did, however, revise his seminal overview of Post-Impressionism by citing Victor Doiteau's interview with René Secrétan in which it was first revealed that the weapon that killed Van Gogh was the pistol that young René had acquired from Gustave Ravoux.[114] A meticulous scholar, Rewald had to realize that René Secrétan's guilt-ridden story of teasing the painter to the point of "torture" and supplying him (willingly or not) with the weapon that killed him confirmed the rumors that he had heard two decades earlier about young boys accidentally causing the death of Vincent van Gogh.

Notes

1. For all the reports on Vincent's wound, see chapter 43.
2. Sjraar van Heugten, "Vincent van Gogh as a Hero of Fiction," in *The Mythology of Vincent van Gogh*, edited by Tsukasa Kôdera and Yvette Rosenberg (Philadelphia: John Benjamins, 1993), p. 162.
3. Much of the material in this note appears elsewhere in the text (primarily in chapter 43, "Illusions Fade; the Sublime Remains"), at those points where it is relevant to the narrative. We have brought it together here in order to present it as clearly and cogently as possible.
4. René Secrétan was born in January 1874. Victor Doiteau, "Deux 'copains' de Van Gogh, inconnus: Les frères Gaston et René Secrétan, Vincent, tel qu'ils l'ont vu" ["Two Unknown Pals of Van Gogh: The Brothers Gaston and René Secrétan, Vincent as They Saw Him"], *Aesculape* 40, March 1957, p. 57.
5. Doiteau, p. 39.
6. Paul Gachet, "Les Médecins de Théodore and de Vincent van Gogh" ["The Doctors of Theodorus and Vincent van Gogh"], *Aesculape* 40, March 1957, p. 38.
7. Gaston was born on December 18, 1871. Doiteau, p. 57.
8. Quoted in Doiteau, p. 40.
9. Doiteau, p. 40.
10. Quoted in Doiteau, p. 55.
11. Doiteau, pp. 55–56.
12. "He always spoke French with the indefinable accent I have already mentioned of those who've moved around a lot." Quoted in Doiteau, p. 56.
13. Specifically, 72° Pernod. Doiteau, p. 41.
14. Quoted in Doiteau, p. 40.
15. Doiteau, p. 42.
16. Quoted in Doiteau, p. 39.
17. According to René, Buffalo Bill was all the fashion among young people at the time. Doiteau, p. 45.
18. Quoted in Doiteau, p. 45.
19. Doiteau, p. 46.
20. Doiteau, p. 46.
21. Doiteau, p. 56.
22. Quoted in Doiteau, p. 42.
23. Quoted in Doiteau, p. 45.
24. Quoted in Doiteau, p. 41.
25. Quoted in Doiteau, p. 41.
26. Doiteau, p. 56.
27. Ibid.
28. See chapter 43.
29. Doiteau, p. 44.
30. Quoted in Doiteau, p. 42.
31. Quoted in Doiteau, p. 47.
32. Doiteau, p. 44.
33. Quoted in Doiteau, p. 42.
34. Doiteau, p. 42.
35. Quoted in Doiteau, p. 44.
36. Quoted in Doiteau, p. 42.
37. Quoted in Doiteau, p. 41.
38. See chapter 43.
39. Marc Edo Tralbaut, *Vincent van Gogh* (New York: Viking, 1969), p. 326. Tralbaut says

that Madame Liberge was "about Marguerite Gachet's age," which was twenty at the time of Vincent's death.

40. Quoted in Tralbaut, p. 326.
41. Quoted in Tralbaut, p. 326. Tralbaut comments: "The puzzle remains: why has this account, which is more than ninety years old, never appeared in any biography of Vincent?" (p. 326).
42. Quoted in Ken Wilkie, *In Search of Van Gogh* (Rocklin, Calif.: Prima, 1991), p. 124.
43. In his 1911 letter to Plasschaert, Hirschig reports accompanying Vincent on one such trip to Pontoise (b3023V/1983, "Hirschig, A. M." to "Plasschaert, A.," 9/8/1911, partly published in Jan van Crimpen, "Friends Remember Vincent in 1912," International Symposium (Tokyo 1988), p. 86.
44. Doiteau, pp. 42–43.
45. Doiteau, p. 41.
46. Vincent knew that René kept the revolver in his rucksack. He had seen it there often. Doiteau, p. 46.
47. Doiteau and Edgar Leroy, "Vincent van Gogh et le drame de l'oreille coupée" ["Vincent van Gogh and the Drama of the Severed Ear"], *Aesculape*, 1936, p. 280. See chapter 43.
48. "Hirschig, A. M." to "Bredius, A." (published in *Oud-Holland*, 1934). Quoted in Tralbaut, p. 328. See chapter 43.
49. Doiteau and Leroy, p. 280. See chapter 43.
50. In a late addendum to her account, Adeline Ravoux maintained that after he awoke from his faint, Vincent *did* try to shoot himself again, but he could not find the gun. Adeline Carrié-Ravoux, "Recollections on Vincent van Gogh's Stay in Auvers-sur-Oise," in *Les Cahiers de Van Gogh* in 1956, in *Van Gogh: A Retrospective*, edited by Susan Alyson Stein (New York: Hugh Lauter Associates and Macmillan, 1986), p. 214. That could be true; the Secrétans could already have taken it.
51. Quoted in Ronald Pickvance, *Van Gogh in Saint-Rémy and Auvers* (New York: The Metropolitan Museum of Art, 1986), p. 216.
52. Eugen Weber, *Peasants into Frenchmen: The Modernization of Rural France, 1870–1914* (Stanford: Stanford University Press, 1976), p. 40.
53. Quoted in Carrié-Ravoux, in Stein, p. 215.
54. Ibid.
55. Interestingly, when the gendarmes continued to press Vincent on the issue of the possible involvement of others in the shooting, it was Gustave Ravoux who intervened to stop that line of questioning. According to his daughter's account, after Vincent told them "Do not accuse anyone; it is I who wanted to kill myself," her father "begged the officers, somewhat harshly, not to insist any further." Quoted in Carrié-Ravoux, in Stein, p. 215. This intervention can be seen, as Adeline intended it, as an example of her father's solicitude toward Vincent—or as an effort to ensure that Vincent, in his unguarded delirium, did not implicate the Secrétan brothers in the shooting.
56. b2066 V/1982, "Gogh, Theo van" to "Gogh-Bonger, Jo van," 7/28/1890.
57. b6918 V/1996, "Bernard, Émile" to "Aurier, Albert," quoted in Bernard, "On Vincent's Burial," in Stein, p. 220.
58. b3266 V/1966, "Gachet, Paul-Ferdinand" to "Gogh, Theo van," c. 8/15/1890.
59. Johanna van Gogh–Bonger, *The Complete Letters of Vincent van Gogh* (Boston: Little, Brown, 1978), letter 355a, January 1885 (hereafter, BVG). Leo Jansen, Hans Luijten, and Nienke Bakker, *Vincent van Gogh: The Letters; The Complete Illustrated and Annotated Edition* (London: Thames and Hudson, 2009), letter 474, 12/10/1884 (hereafter, JLB): "If I were to drop dead—*which I shan't refuse if it comes but won't expressly seek*—you'd be standing on a skeleton—and—that would be a mightily insecure standpoint" (emphasis in original).
60. In a letter to Theo in 1882, from The Hague, Vincent quoted a maxim from his hero Millet: "*Il m'a toujours semblé que le suicide était une action de malhonnête homme.*" (It

has always seemed to me that suicide was the deed of a dishonest man.) BVG 212, 7/6/1882 (JLB 244, 7/6/1882). See chapter 15.

61. Doiteau, p. 57.

62. Gaston Secrétan died in 1943.

63. "Vitus en vitesse" from the *Lune Rousse* of 1927, http://100ansderadio.free.fr/HistoiredelaRadio/Radio-Vitus/RadioVitus-20.html.

64. "Il est charmant" (1932), "Avec le sourire" (1936), "L'habit vert" (1937), and "La fin du jour" (1939), http://www.omdb.si/index.php/ooseba/?i=636527.

65. Doiteau, pp. 57–58. p. 22. See chapter 42.

66. Doiteau, p. 57.

67. Quoted in Doiteau, p. 57.

68. Doiteau, p. 47.

69. Referring apparently to a swim in the river, René told Doiteau: "We left [the gun] on the spot with all our fishing stuff, haversacks . . . and even our trousers . . . as fate would have it, the day Van Gogh used it, it worked" (p. 46).

70. Dr. Paul Gachet to Theo, 7/27/1890, quoted in Distel and Stein, *Cézanne to Van Gogh* (New York: The Metropolitan Museum of Art, 1999): *The Collection of Doctor Gachet*, p. 265. Also see Bonger, *Memoir*, p. lii, in BVG. See chapter 43.

71. "With the greatest regret I must disturb your repose. Yet I think it my duty to write to you immediately . . . I was sent for by your brother Vincent, who wanted to see me at once. I went there [to the Ravoux Inn] and found him very ill. He has wounded himself." Quoted in BVG, p. lii.

72. "[Vincent] is indeed very ill. I shan't go into detail, it's all too distressing, but I should warn you, dearest, that his life could be in danger." b2066 V/1982, "Gogh, Theo van" to "Gogh-Bonger, Jo van," 7/28/1890, in *A Brief Happiness*, edited by Leo Jansen and Jan Robert (Zwolle: Waanders, 1999), p. 269.

73. b2066 V/1982, "Gogh, Theo van" to "Gogh-Bonger, Jo van," 7/28/1890, in Jansen and Robert, p. 269. This may have been Theo trying to protect the young mother Jo from the traumatic truth—or the family name from yet another embarrassment. But his report of Vincent's state is more convincing (and sounds more like Vincent) than the cliché of a bungled suicide already circulating on the streets of Auvers.

74. Vincent had left discarded drafts and torn fragments of letters that he clearly never intended Theo to read among the papers on his desk. See chapter 42.

75. See chapter 42.

76. Tralbaut, pp. 337–40.

77. "Ought I to have despaired then, jumped into the water or something? God forbid—I should have if I had been a wicked man" (BVG 193). See chapter 43.

78. Ibid. See chapter 43.

79. BVG 212 (7/6/1882). See note 60 above. See chapter 15.

80. Ibid. See chapter 15.

81. BVG 337 (10/31/1883). See Chapter 43.

82. Despite several posthumous efforts to put a gun in Vincent's hands prior to his death—by A. S. A. Hartrick in *A Painter's Pilgrimage Through Fifty Years* (Cambridge: Cambridge University Press, 1939), p. 42, and Paul Gauguin in *Intimate Journals* (*Avant et après*), translated by Van Wyck Brooks (Bloomington: University of Indiana Press, 1963), pp. 126–27, as well as by the Gachets (see n. 93 below)—Vincent made his ignorance of (and disdain for) firearms clear in a letter from Saint-Rémy: "I ought to have defended my studio better, . . . Others would have used a revolver in my place" (BVG 605; c. Sept. 1889). See chapter 43.

83. See note 48 above.

84. See chapter 43.

85. In Arles, Vincent defied the neighbors' petition to commit him to an asylum by telling the city's mayor that he was "quite prepared to chuck myself into the water if that would please these good folk once and for all." See chapter 38.

86. See chapter 41.

87. Quoted in Pickvance, p. 216. Inevitably, Bernard's story to Aurier heavily plays up the drama of the suicide. Before he died, Bernard wrote, Vincent had said that "his suicide was absolutely calculated and lucid" and had expressed "his desire to die." Indeed, in an especially dramatic gesture, Vincent had threatened to "do it over again" if he recovered from his wound, according to Bernard. In Bernard, in Stein, pp. 219–20. This irresistible red herring was picked up by subsequent chroniclers such as Tralbaut (p. 328): "Gachet told [Vincent] that he still hoped to cure him. Vincent at once replied: *I will do it all over again*" (emphasis in original).

88. In his account to Aurier, Bernard gave his version of the incident a twist of Christian martyrdom: "From the violence of the impact (the bullet passed under the heart) [Van Gogh] fell, but he got up and fell again three times and then returned to the inn where he lived . . . without saying anything to anyone about his injury." Bernard, in Stein, p. 220. See chapter 43. For Bernard's similarly bogus Christian gloss on the story of the ear incident in Arles, see chapter 41.

89. R. R. Ross and H. B. McKay, *Self-Mutilation* (Lexington, Mass.: Lexington Books, 1979). According to Ross and McKay, "There is in the action of the self-mutilator seldom an intent to die and often very little risk of dying. Although a self-mutilator could engender his own death by his behavior, in the vast majority of cases, this does not happen. His behavior is actually counter-intentional to suicide rather than suicidal" (p. 15). See also the important discussion of the issue in Barent W. Walsh and Paul M. Rosen, *Self-Mutilation: Theory, Research, and Treatment* (New York and London: Guilford Press, 1988), pp. 3–53. Walsh and Rosen argue, "The similarities between suicide and self-mutilation can be deceiving. Both forms of behavior are self-directed, and both result in concrete physical harm. Nonetheless, when the behaviors are analyzed using the framework of Shneidman's 10 commonalities, it is evident that the behaviors are different in many facets, and in several ways are even opposites" (p. 51).

90. Tralbaut, p. 335. See chapter 43.

91. See Tralbaut, p. 333.

92. Even Bernard's melodramatic account acknowledges as much: "The innkeeper told us all the details of the accident," he wrote to Aurier (b6918 V/1996, "Bernard, Émile" to "Aurier, Albert," in Bernard, in Stein, pp. 219–20).

93. In "La curieuse figure de Docteur Gachet" ("The Curious Case of Doctor Gachet") (pp. 278–79), Doiteau reports a later story circulated by the doctor's son, Paul, in 1957 that Vincent had threatened his father with a pistol after an argument over an unframed painting in the doctor's collection. We dismiss this as an audaciously inventive attempt to connect this argument to Vincent's death, by gunshot wound, shortly afterward. See chapter 42.

94. In the asylum at Saint-Paul-de-Mausole, Vincent reported dropping many of his prints into oil or paint, or spilling on them, thus ruining some of his favorites. See chapter 40.

95. In a study of 464 suicides by firearm, Di Maio found that only eight (2 percent) of the suicidal handgun wounds were in the chest or abdomen. Vincent J. M. Di Maio, *Gunshot Wounds: Practical Aspects of Firearms, Ballistics, and Forensic Technique* (Boca Raton, Fla.: CRC Press, 1999), chapter 14 (see Table 14.1), p. 358.

96. "You reached [the wheat field] by climbing a rather steep slope shaded by big trees." Carrié-Ravoux, in Stein, p. 215.

97. Paul Gachet, quoted in Doiteau and Leroy, pp. 169–92, quoted in Tralbaut, p. 327. See chapter 43.

98. "*Allez me chercher le docteur . . . je me suis blessé dans les champs . . . je me suis tiré un coup de revolver là.*" "Hirschig, A. M." to "Bredius, Dr., A.," 8/1911, b3023V/1983, partly published in Jan van Crimpen, "Friends Remember Vincent in 1912," p. 86. In assessing Hirschig's recollections, one has to allow for his notoriously poor French, described by Adeline Ravoux as "laughable" (Carrié-Ravoux, in Stein, pp. 211–12), and for Adeline's contrary account, that Vincent said nothing when he entered the inn that night (ibid.).

99. "Hirschig, [A. M.]" to "Bredius, Dr. A.," published in *Oud-Holland* in 1934, quoted in Tralbaut, p. 328.

100. Compare the three very different accounts Adeline gave of the same event (Vincent's return to the Ravoux Inn after the shooting) in the following sources: (1) Maximilien Gauthier, "La femme en bleu nous parle de l'homme à l'oreille coupée" ["The Woman in Blue Speaks to Us of the Man with the Severed Ear"], in *Les Nouvelles Littéraires*, April 16, 1953; (2) Carrié-Ravoux, in Stein, pp. 211–19; and (3) Tralbaut, pp. 325–26.

101. Carrié-Ravoux, in Stein, p. 214.

102. Adeline claimed to have been present at only "a majority" of the events she related. "Obviously," she told one interviewer, "I did not witness the agony of Van Gogh." Carrié-Ravoux, in Stein, p. 215. Hearsay evidence is generally considered unreliable in courts of law and therefore inadmissible. There are exceptions to this rule, such as deathbed statements and declarations against interest, but we do not believe that any of these exceptions apply to Adeline's accounts where they involve hearsay. An example is her account of the police interview with Vincent. Despite offering a word-for-word reconstruction of the interview, she does not claim to have been present in the room, and it is unlikely that, as a thirteen-year-old girl, she would have been invited to attend.

103. For example, in her first (1953) account, Adeline said that Vincent entered the inn and went up to his room "without saying a word." In her second (1956) account, she recalled that Vincent had a brief exchange with her mother on his way upstairs. In her third (1960s) account, she added this dramatic interlude to Vincent's passage to his room: "He leant for a few minutes against the billiard table in order not to lose his balance, and replied in a low voice: 'Oh nothing, I am wounded.'" Another example: In Adeline's first account, her father first hears the sound of moaning coming from Vincent's room. In a later account, it is Adeline herself who first hears Vincent's moans and summons her father to his aid.

104. Adeline filled her various accounts with examples of her father's kindness, attentiveness, and especially his protectiveness toward the painter during his final agony. For example: When the police came to question Vincent about the shooting, her father "preceded the officers into the room [and] explained to Vincent that French law prescribed in such cases an investigation, which the officers were coming to make." When the gendarme spoke to Vincent "in an unpleasant tone," her father "begged him to soften his manner."

105. In her first (1953) interview, Adeline gave only a brief summary of the interview that the police conducted with Vincent as part of their investigation into the shooting. In her second (1956) interview, however, she quoted the participants in lengthy word-for-word exchanges.

106. According to Adeline's first (1953) account, her father went to Vincent's room and found him wounded, at which point "[Vincent] showed him his wound and said that, this time, he really hoped he hadn't missed." In her second (1956) account, she gave the two men this extended interaction: " 'What's wrong with you?' asked Father. 'Are you sick?' Vincent then lifted his shirt and showed him a small wound in the area of the heart. Father exclaimed, 'You poor man, what did you do?' 'I wanted to kill myself,' answered Van Gogh." By the time of her third and final account (1960s), this exchange had grown into a complete dramatic scene: "The door was not locked, and my father went in and saw Monsieur Vincent lying on his narrow iron bedstead with his face turned to the wall. My father gently asked him to come and eat downstairs. There was no answer. 'What is the matter with you?' my father went on. Then Monsieur Vincent turned carefully over towards my father. *Look* . . . he began, and taking his hand he showed him the place on his body at the bottom of his chest where there was a small bleeding hole. Once again my father asked: 'But what have you done?' And this time Monsieur Vincent replied: 'I shot myself . . . I only hope I haven't botched it.' "

107. For example, in her second (1956) account, Adeline added the detail that Vincent fainted when the gun went off, apparently in order to explain why, if he intended suicide, he did not take a second shot. By the time he regained consciousness, night had fallen and he could not find the gun in the darkness—although he did make a search "on all fours," she clarified, still hoping to "finish himself off."
108. Tralbaut, pp. 325–26.
109. In subsequent interviews, Adeline explained why her father's connection to the gun had not come out before, first by saying that her father had simply forgotten it belonged to him (i.e., he was "so upset that he did not at once remember that he had lent his pistol to Monsieur Vincent" [quoted in Tralbaut, p. 326]), and then by saying that he had, in fact, revealed it to the police at the time (when the gendarme asked Vincent "Where did the pistol come from?" her father "hastened to explain that it was he who had lent it," and Vincent would neither confirm nor deny this, according to her account [quoted in Tralbaut, p. 329]).
110. In 1877, during his pastoral studies, Vincent noted with approval that the Romans believed that if a crow "landed on the head of anyone, it was a sign that heaven approved of them and blessed them" (BVG 114; 11/24/1887). For more on Vincent's lifelong love, knowledge, and fearlessness of birds, see also chapter 3.
111. JH2117.
112. In the new edition of the *Collected Letters*, the letter in which Vincent reports having completed the painting of crows in the wheatfield (JH2117) is dated July 10, 1890 (JLB Letter 898, n. 4.). See chapter 42.
113. Wilfred Arnold, *Vincent van Gogh: Chemicals, Crises, and Creativity* (Boston: Birkhaüser, 1992), p. 259.
114. See John Rewald, *Post-Impressionism from Van Gogh to Gauguin*, 3rd rev. ed. (New York: Museum of Modern Art, 1978), p. 403, n. 35. The footnoted text appears on page 380.

Acknowledgments

We are profoundly grateful to our many friends at the Van Gogh Museum who welcomed us into one of the most intellectually exciting and professionally rewarding scholarly institutions in the entire world of art. No artist other than Vincent van Gogh benefits from a dedicated research institution on a scale comparable to an American presidential library. This book would not have been possible without the decades of accumulated archival work, research, and scholarship of the Museum's extraordinary staff.

In particular we want to thank Leo Jansen, curator and editor of the *Complete Letters*, who, despite a mercilessly demanding schedule, read much of this book in manuscript and pointed out mistakes of both fact and nuance. Fieke Pabst and Monique Hagemann, the Museum's archivists, both generously shared with us their encyclopedic knowledge of Van Gogh and warmly embraced us as friends. Fieke also read the manuscript with enormous care, pointing out errors, recommending improvements, and even directing us to little-known photographs, some of which are making their first public appearance in this book. (With expert assistance such as this, it should be clear—but is worth emphasizing—that we have no one but ourselves to blame if any errors remain.) Rianne Norbart, the Museum's director of development, offered her infectious encouragement, astute advice, and vital support at every turn. Finally, we are grateful to Axel Rüger, the Museum's director, who extended his support and friendship from the moment he assumed the leadership of the Museum toward the end of our long project. Leo, Fieke, Monique, Rianne, and Axel were all generous enough to visit us at our home in Aiken, South Carolina (not a common tourist destination), and to extend their extremely warm hospitality during our stays in Amsterdam.

Also at the Museum, we benefited greatly from the expertise of curators Sjraar van Heugten, Louis van Tilborgh, and Chris Stolwijk, all of them major scholars in the study of Van Gogh's art and life. We thank them not only for sharing their scholarship but also for making us so welcome at the Museum. We will never forget the time we spent with Sjraar in the Museum's "Vault" opening one Solander box after another filled with Vincent's most glorious drawings. Heidi Vandamme, the Museum's director of publicity, has also been enormously supportive of our efforts, as have Maria Smith and Femke Gutter in the Rights and Permissions Department, without whom this book would not be the rich tapestry it is.

Hans Luijten and Nienke Bakker, Leo Jansen's colleagues in the Letters Project, also deserve our profuse thanks. Van Gogh studies have been permanently transformed by their remarkable, fifteen-year-long retranslation and annotation of Van Gogh's letters—a six-volume monument of scholarship which the *Guardian* rightly called "the book of the decade." During the decade we spent writing this book, it was a source of constant con-

sternation that we were working just ahead of their great scholarly project. Fortunately, the editors made their website available to us early and, in the last years, their work overtook ours, giving us the opportunity to take full advantage of this incredible resource in finalizing our book.

No list of acknowledgments would be complete without a word of thanks to Theo van Gogh and his wife, Johanna Bonger. All of Van Gogh scholarship owes a vast debt of gratitude to Theo for saving so many of Vincent's letters (and those of other family members); and to Johanna for safeguarding this treasure and undertaking the first publication and translation of Vincent's letters. Her English translation, while not literal or scholarly, still rings with the cadences of Vincent's Victorian voice and the authenticity of firsthand acquaintance. Jo and Theo's son, Vincent's godson and namesake, continued his parents' work by generously donating the letters along with many works of art to the Dutch nation for the enjoyment and enrichment of the world.

Several other people read the manuscript for us, and we want to express our gratitude to them as well. Marion and George Naifeh read an early draft, as did Elizabeth Toomey Seabrook. We are very grateful for their recommendations and profoundly saddened that Steve's father, George; Greg's parents, William and Kathryn Smith; and Liz Seabrook did not live to see their inestimable contributions come to fruition. Carol Southern, the editor of our biography of Jackson Pollock, also read the manuscript and gave it the same sage guidance that proved such a benefit to the previous book.

This book is built on a formidable foundation—a virtual library of books and articles created by an army of brilliant scholars and devoted aficionados who have given some part of their lives to Vincent van Gogh. The task of telling Van Gogh's life in this detail would have been impossible without this superb and at times astonishing body of research. During the past years we have had the pleasure of meeting and in a few cases forging friendships with some of the scholars outside the Van Gogh Museum who have made singular contributions to this corpus of knowledge, including Douglas Druick, Ann Dumas, Cornelia Homburg, Colta Ives, Debora Silverman, Susan Stein, and Judy Sund. We are grateful to all of them for their friendship, encouragement, and support.

Our previous experiences had not prepared us for the esprit de corps that exists throughout much of the Van Gogh community—a spirit of cooperation, we believe, that springs directly from Vincent and his embracing art, as well as from the museum that carries his missionary flame forward. (For a complete list of the scholars who have made important contributions to the Van Gogh literature, and thus to our book, see the Bibliography online at www.vangoghbiography.com.) We have also had the pleasure of meeting David Brooks, not only a conscientious contributor to Van Gogh research but also a tireless proselytizer on behalf of the artist's life and work.

We want to thank Robert and Elizabeth Kashey, David Wojciechowski, and Joseph Gibbon of the Shepherd Gallery in New York who taught us so much about the world of nineteenth-century art that Vincent both cherished and transcended. Dr. Gregory Greco, a surgeon and close friend, spoke with us at length about both the ear incident and Vincent's fatal wound, making it possible to better reconstruct the medical aspects of these incidents from the spare written record. Joseph Hartzler and Brad Brian, two prominent attorneys and friends whom we have known for decades (and, respectively, a prosecutor and a defense attorney), reviewed drafts of the "Note on Vincent's Wounding" and provided extremely wise counsel on a subject of historical sensitivity as well as evidentiary complexity.

One of the greatest challenges of researching this book was that neither of us reads Dutch. In the end, we were able to bridge that gap through the extraordinary efforts of eleven translators: Keimpe Andringa, Casandra Berkich, Jan Christianen, Isabel Daems, Frank Gabel, Pragito von Bannisseht, Nolly Nijenhuis, Huub van Oirschot, Mel Oppermann, Jan Sawyer, and Inge De Taeye. Thanks to their skills and dedication, we were able to absorb the vast literature of Dutch primary and secondary sources that had not previously been translated into English. In particular, we want to thank our primary translators Pim Andringa and Inge De Taeye for the hours they spent poring over books, articles, and other sources with us to determine what materials should be translated. For translations from German, we have Adrian Godfrey to thank. Although we can read French passably well, we had occasion to call on the services of French translators Jean-Pascal Bozso, Peter Field, Catherine Merlen, Christian Quilliot, and Karen Stokes where the original was difficult (e.g., archaic) or a formal translation was required. (All our translations will be made available through the Van Gogh Museum Archives.)

We also owe a huge debt of gratitude to the team of researchers and fact-checkers who made it possible to assemble what could well be the most extensive notes that have ever accompanied a biography. The team was led by the brilliantly capable Elizabeth Petit and her gifted colleague, Beth Fadeley. They were assisted by Kristin Barron, Brad Petit, Laura Storey, Ernest Wiggins, and Renée Zeide, all of whom worked with us through the two-year-long process of preparing the notes for online publication. Also of assistance were De'Andrea Youmans and Daniel Lutz. Despite our location far from a major research library, we were able to borrow books and articles from around the world thanks to the miracle of the inter-library loan program and the good offices of Bridget Smith, librarian at the University of South Carolina—Aiken.

At the inception of this project, surveying the scale of the enterprise we were undertaking, we commissioned special research-management software that mimicked the research methods we had used for all our previous books. This special application—which allowed us to digitize the library of source materials, create digital "index cards," and then organize those cards into an interactive outline—was built for us by Stephen Geddes and Jeremy Hughes, with help from Phillip Greer and Keith Beckman. The task of combining references, textual notes, illustrations, and photographs into a single, seamless website at the other end of the process was managed by Jeremy Hughes, Elizabeth Petit, and Beth Fadeley, with the assistance of Dr. Jennifer Guiliano of the Center for Digital Humanities at the University of South Carolina together with Jun Zhou, Aidan Zanders, and Shawn Maybay. This extraordinary technology allowed us to assimilate and access more than ten times the information available for our biography of Jackson Pollock, and compressed what might easily have been a thirty-year project into a mere decade.

That time-saving turned out to be more important than we ever imagined. The writing of this book was repeatedly interrupted by medical exigencies. There were times when it looked as if Greg might not make it to the finish line of our ten-year odyssey. An intractable brain tumor took him out from behind his computer for great stretches of uncertainty. Our research on Van Gogh began while we were at UCLA for a two-month session of radiation. As Vincent's meteoric career arced over us, we passed through major brain surgery, kidney surgery, and a program of receptor-mediated radiation therapy. Vincent died just as we were undergoing a series of cutting-edge chemotherapeutic regimens. Without the contributions of all these doctors, and others, this book would not have been written. We want to express our unnameable gratitude especially to Drs.

James Vredenburgh and Michael Morse of the Preston Robert Tisch Brain Tumor Center at Duke University Medical Center, and to Drs. Francis DiBona and Davor Sklizovic in our hometown of Aiken.

Our thanks also go to our remarkable agent at William Morris Endeavor, Mel Berger, who provided us with strong, patient support through this long effort.

Finally, in almost three decades of writing books, we have literally never had as much support from all levels of a publishing house as we have had at Random House. Our editor, Susanna Porter, has tolerated our delays, shaped our manuscript, and shepherded our book through the complicated publishing process with an enthusiasm, grace, and wonderful intelligence that will leave us always in her debt. The managing editorial team of Vincent La Scala, Benjamin Dreyer, and Rebecca Berlant, working with copy editor Emily DeHuff, brought a remarkable clarity and consistency to a vast and rangy manuscript. Art director Robbin Schiff and designers Anna Bauer (jacket) and Barbara Bachman (interior) created the elegant book that Van Gogh has always deserved and we had always hoped for. Then the production team of Sandra Sjursen and Lisa Feuer turned their vision into reality, and Ken Wohlrob gave it digital life. Meanwhile, marketing director Avideh Bashirrad and director of publicity Sally Marvin worked miracles to bring the product of all our labors to the attention of the public. From our editor's diligent assistant Priyanka Krishnan to our publishers Tom Perry, Susan Kamil, and Gina Centrello—all these people and more have participated significantly in the vast collaboration that is the book you hold in your hand.

A Note on Sources

It was originally our intention to include in this volume a complete set of notes so that the reader could precisely identify the source of all the factual material used in the text and so that we could share additional relevant information. Our biography of Jackson Pollock included almost one hundred pages of such ancillary material, consisting in roughly equal parts of source identification and commentary.

Not long after beginning this book, however, we realized that Vincent van Gogh's life and the vast literature it has inspired presented a far more daunting challenge for biographers bent on thorough documentation than the relatively undocumented life of Jackson Pollock. (Most of the research for that book consisted of interviews with people who had known the artist.)

There are a number of reasons for this. First and foremost, of course, are the thousands of letters that Vincent famously wrote. As invaluable as they have been to this (and every) Van Gogh biography, they also introduce a Gordian knot of research complications. The most fundamental of these, for the non-Dutch biographer at least, is translation. Until very recently, there was only one definitive English translation of Vincent's letters: the one produced by his sister-in-law, Theo's wife Johanna Bonger. Her translation is the one most familiar to English speakers and the one most available in the libraries of the English-speaking world. It was Bonger's translation that guided us through most of the writing of this book.

Recently, however, the Van Gogh Museum completed a fifteen-year project of re-translating Vincent's letters and the result is the monumental and indisputably definitive *Complete Letters* published in 2009 and available online at www.vangoghletters.org.

The existence of two translations—one more modern and scholarly but the other more familiar—had a substantial impact on a set of notes that aspired to completeness. Whenever we quote a short passage from the letters (or, as we often do, a single word), we felt an obligation to provide the fuller passage in the notes in order to inform the reader of the context from which the words were taken. With two translations, one making a claim on the past, the other a claim on the future, we felt obligated to include the contextual passages from *both* translations in our notes. This had the immediate effect of doubling their length.

A far larger problem than translation was interpretation—a problem that would have presented itself even if the letters had been originally written in English. Our biography differs from many previous biographies of Vincent van Gogh in at least this one important respect: we have not taken Vincent's letters as a necessarily reliable record of the events of his life, or even of his thinking at any given time—at least not directly. They are not entries in a diary or a journal, although they are often treated as such. They are not inner unburdenings intended only for their author. The corpus of Vincent's writings

consists almost entirely of letters that he wrote to his family and friends. Of these, the overwhelming majority were addressed to his brother Theo.

Theo occupied a unique position in Vincent's life. He was not only Vincent's sole friend through much of their correspondence, but also his sole sponsor and sole supporter. Theirs was a complicated relationship. Theo was his successful younger brother: beloved by his family where Vincent was lamented, celebrated where Vincent was scolded, embraced where Vincent was shunned, favored (by his rich uncles, in particular) where Vincent was shut out. In our opinion, all of the information and thoughts that Vincent shared with his brother in his letters must be viewed through these various potentially distorting prisms. At times, this requires questioning the accuracy of Vincent's accounts, even his veracity; sometimes, it requires reading between the lines of his letters for the truth that is being hidden or conveyed indirectly: for the conspicuous silence, the pregnant non sequitur, or the evasive ellipsis ("etc." was a favorite), all of which he used to conceal hurt, resentment, humiliation, and setback.

As much of his heart as he poured out in his letters to Theo, Vincent hid at least as much, for fear of alienating his brother, jeopardizing his financial support, or confirming his family's damning judgment of him. At the same time, he could wield these sensitivities as cudgels: threatening to undertake activities that would lead to fraternal disapproval or family embarrassment in order to coerce more money out of Theo, for example; or, by proposing then abjuring some reckless course of action, to win Theo's approval for another course that had been his intent all along. By these and a myriad of similar stratagems, Vincent used his letters to mold his brother's opinions and craft his reactions in the minutest ways. In at least a few cases, we have concrete evidence that Vincent wrote multiple drafts of his letters and there is extensive inferential evidence that this was not an uncommon practice, especially when the topic being discussed was important or sensitive.

On the human level, of course, it is profoundly sad that Vincent could not speak openly and spontaneously to the only person who truly cared about his inner life. For the biographer, this dance of indirection (and sometimes deception) presents a special challenge. To disregard, or even completely discredit, one of Vincent's accounts to Theo (as we do) requires copious explanation—if for no other reason than that readers (and scholars) can follow our reasoning and, if so inclined, dispute it. More than any other factor, it is this need to make transparent our readings of Vincent's letters that has had an inflationary impact on the notes to this book.

We have, of course, also used notes in their other traditional capacities: (1) to bring previous biographers and academic scholars into the discussion over controversial issues in the literature; the scale of the notes is, in part, a reflection of the volume and quality of the Van Gogh scholarship that preceded us; (2) to alert readers where we have taken a position that is contrary to the canon of Van Gogh scholarship and explain, often in detail, why we take the positions we take; (3) to expand on the text with additional information about secondary characters, locales, art-historical movements, particular artists, works of art, etc.; (4) to offer "sidebars" on interesting subjects that are touched on by the text but only tangential to the telling of Van Gogh's story.

As a result of all these factors, the notes ballooned to roughly five thousand typewritten pages—a length unmanageable in a single-volume biography and incompatible with our intent to reach general readers as well as specialists. The compromise we struck was to separate the notes from the text and put them all online, free of cost, at www.vangoghbiography.com.

This solution allows anyone to browse freely through the additional material, search by keyword, or go directly to the notes for a particular page in the book. It also allows us to enrich the notes with hundreds of additional illustrations and photographs, to facilitate cross-referencing through hyperlinks, and to solicit comments from readers.

Because notes also serve another, broader purpose for the general reader—to identify the body of research that formed the basis of a book and to direct interested readers to the leading sources—we have included in this volume the bibliography that follows. In it are listed all the books, exhibition catalogues, journal articles, and articles in edited books that are cited in the text. Information on additional sources cited in the text, including archival materials, dissertations, newspaper articles, and websites, can be found in the chapter-by-chapter bibliographies online at www.vangoghbiography.com. A large number of additional sources that are cited in the notes but not in the text, also appear at www.vangoghbiography.com.

Selected Bibliography

This bibliography includes only the books, exhibition catalogues, journal articles, and articles in edited books that are cited in the text of the printed book. Archival materials, dissertations, newspaper articles, and websites cited in the text appear in the chapter bibliographies online at www.vangoghbiography.com.

The large number of additional sources that are cited only in the textual notes, not in the book itself, appear only online at www.vangoghbiography.com.

Books and Exhibition Catalogues

Ackerman, Gerald M. *The Life and Work of Jean-Léon Gérôme: With a Catalogue Raisonné.* London: Sotheby's Publications, 1986.

Ackroyd, Peter. *London: The Biography.* London: Chatto and Windus, 2000.

Aglionby, William. *The Present State of the United Provinces of the Low-Countries as to the Government, Laws, Forces, Riches, Manners, Customs, Revenue, and Territory of the Dutch.* Collected by W. A. Fellow. London: John Starkey, 1669.

Alpers, Svetlana. *The Art of Describing: Dutch Art in the Seventeenth Century.* Chicago: University of Chicago Press, 1984.

Andersen, Hans Christian. *What the Moon Saw and Other Tales.* Translated by H. W. Dulcken. London: George Routledge and Sons, 1871.

Arikawa, Haruo, Han van Crimpen, et al. *Vincent van Gogh: International Symposium.* Tokyo: Tokyo Shimbun, 1988.

Arnold, Wilfred Neil. *Vincent van Gogh: Chemicals, Crises, and Creativity.* Boston: Birkhaüser, 1992.

Aurier, Gustave-Albert. *Oeuvres posthumes.* Paris: Mercure de France, 1893.

Baedeker, Karl. *Belgium and Holland: Handbook for Travelers.* London and Paris: Williams & Northgate and Haar & Steinbert, 1869.

———. *Paris and Environs.* Leipzig: Karl Baedeker, 1888.

Baena, Duke de. *The Dutch Puzzle.* The Hague: Boucher, 1966.

Bailey, Martin. *Van Gogh in England: Portrait of the Artist as a Young Man.* London: Barbican Gallery, 1992.

———. *Young Vincent: The Story of Van Gogh's Years in England.* London: Allison and Busby, 1990.

Balzac, Honoré de. *Lost Illusions (Illusions perdues).* Translated by Herbert J. Hunt. London: Penguin Books, 1837–43.

Barentsen, P. A. *Het Oude Kempenland.* Groningen: Noordhoff, 1935.

Baring-Gould, S. *In Troubadour-Land: A Ramble in Provence and Languedoc.* London: W. H. Allen & Co., 1891.

Bernier, Georges. *Paris Cafés: Their Role in the Birth of Modern Art.* New York: Wildenstein, 1985.

Billen, Claire, and Jean-Marie Duvosquel, eds. *Brussels.* Antwerp: Mercatorfonds, 2000.

Blanc, Charles. *Les artistes de mon temps.* Paris: Firmin-Didot, 1876.

Blanch, Leslie. *Pierre Loti: The Legendary Romantic; A Biography*. New York: Carroll and Graf, 1985.

Blom, J.C.H., and Emiel Lamberts, eds. *History of the Low Countries*. Oxford and New York: Berghahn Books, 1999.

Blumer, Dietrich, ed. *Psychiatric Aspects of Epilepsy*. Washington, D.C.: American Psychiatric Press, 1984.

Bonnet, Marcel. *Au coeur du vieux Saint-Rémy*. Saint-Rémy-de-Provence: Office de tourisme, 1979.

Bossenbroek, Martin, and Jan H. Kompagnie. *Het mysterie van de verdwenen bordelen: Prostitutie in Nederland in de negentiende eeuw*. Amsterdam: Bert Bakker, 1998.

Bossuet, Jacques-Bénigne. *Selections from the Funeral Orations of Bossuet*. Boston: D. C. Heath, 1907.

Botwinick, Michael, ed. *Belgian Art, 1880–1914 (Belgische Kunst, L'art belge)*. Brooklyn: Brooklyn Museum and Brussels: The Ministries of Communities of the Government of Belgium, 1980.

Bouyer, Raymond. *Anton Mauve: Sa vie, son oeuvre*. Paris: Ch. Soccard, 1898.

Brettell, Richard, et al. *The Art of Paul Gauguin*. Washington: National Gallery of Art and Chicago: Art Institute of Chicago, 1988.

Brouwer, Jaap W., Jan Laurens Siesling, and Jacques Vis. *Anthon van Rappard*. Translated by G. Kilburn and G. Schwartz. Amsterdam: Rijksmuseum Vincent van Gogh and Maarssen: Gary Schwartz, 1974.

Brown, Frederick. *Flaubert: A Biography*. Cambridge, Mass.: Harvard University Press, 2007.

Brugmans, I. J. *Stapvoets voorwaarts: Sociale geschiedenis van Nederland in de negentiende eeuw*. Bussum, The Netherlands: Fibula–Van Dishoeck, 1970.

Bulwer-Lytton, Edward. *Kenelm Chillingly and Godolphin*. Boston: Dana Estates, 1880.

Bunyan, John. *The Entire Works of John Bunyan*. Vol. 1. London: James S. Virtue, 1859.

———. *The Pilgrim's Progress*. Edited with an introduction by N. H. Keeble. Oxford: Oxford University Press, 1984.

Burchell, S. C. *Imperial Masquerade: The Paris of Napoleon III*. New York: Atheneum, 1971.

Byrne, Julia Clara (Busk). *Gheel: The City of the Simple*. London: Chapman and Hall, 1869.

Caird, Mona. *Romantic Cities of Provence*. London: T. Fisher Unwin, 1906.

Carlyle, Thomas. *The Complete Works of Thomas Carlyle*. Boston: Dana Estes and Charles E. Lauriat, 1884.

———. *On Heroes, Hero-Worship, and the Heroic in History*. Boston: Houghton Mifflin and Company, 1907.

———. *Sartor Resartus*. Edited by Archibald MacMechan. Boston: Ginn & Company, 1896.

Carpenter, Humphry, and Mari Prichard, eds. *The Oxford Companion to Children's Literature*. Oxford: Oxford University Press, 1999.

Carter, G. R., E. F. Flores, and D. J. Wise, eds. *A Concise Review of Veterinary Virology*. Ithaca, N.Y.: International Veterinary Information Service, www.ivis.org.

Cate, Phillip Dennis, and Mary Shaw, eds. *The Spirit of Montmartre: Cabarets, Humor, and the Avant-Garde, 1875–1905*. New Brunswick: Jane Voorhees Zimmerli Art Museum and Rutgers: The State University of New Jersey, 1996.

Cates, Michael, and Diane Chamberlain, eds. *The Maritime Heritage of Thanet*. Ramsgate: East Kent Maritime Trust, 1997.

Chapman, Joan M., and Brian Chapman. *The Life and Times of Baron Haussmann: Paris in the Second Empire*. London: Weidenfeld and Nicolson, 1957.

Chassé, Charles. *Gauguin et le groupe de Pont-Aven: Documents inédits*. Paris: H. Floury, 1921.

Chetham, Charles S. *The Role of Vincent van Gogh's Copies in the Development of His Art*. New York: Garland Publishing, 1976.

Chevalier, Louis. *Classes laborieuses et classes dangereuses à Paris pendant la première moitié du XIX siècle*. Paris: Plon, 1958.

Chevreul, Michel Eugène. *The Principles of Harmony and Contrast of Colors and Their Applications to the Arts*. New York: Reinhold, 1967.

Clark, T. J. *The Painting of Modern Life: Paris in the Art of Manet and His Followers.* New York: Alfred A. Knopf, 1985.

Clébert, Jean-Paul, and Pierre Richard. *La Provence de Van Gogh.* Aix-en-Provence: Édisud, 1981.

Clegg, Gillian. *Chiswick Past.* London: Historical Publications, 1995.

Clement, Russell T., and Annick Houzé. *Neo-Impressionist Painters: A Sourcebook on Georges Seurat, Camille Pissarro, Paul Signac, Théo Van Rysselberghe, Henri Edmond Cross, Charles Angrand, Maximilien Luce, and Albert Dubois-Pillet.* Westport, Conn.: Greenwood Press, 1999.

Cloake, John. *Richmond Past: A Visual History of Richmond, Kew, Petersham and Ham.* London: Historical Publications, 1991.

Conrad, Barnaby. *Absinthe: History in a Bottle.* San Francisco: Chronicle Books, 1988.

Cook, Theodore Andrea. *Old Provence.* 2 vols. New York: Charles Scribner's Sons, 1905.

Copley, Antony R. H. *Sexual Moralities in France, 1780–1980: New Ideas on the Family, Divorce, and Homosexuality.* London: Routledge, 1989.

Coquiot, Gustave. *Vincent van Gogh.* Paris: Ollendorff, 1923.

Corbin, Alain. *Women for Hire: Prostitution and Sexuality in France After 1850 (Les filles de noce: Misère sexuelle et prostitution aux 19e et 20e siècles).* Translated by Alan Sheridan. Cambridge, Mass.: Harvard University Press, 1990.

Craik, Dinah Maria. *Thirty Years, Being Poems New and Old.* London: Macmillan and Company, 1880.

Crissey, John Thorne, and Charles Lawrence Parish. *The Dermatology and Syphilology of the Nineteenth Century.* With an introduction by William B. Shelley. New York: Praeger, 1981.

Daudet, Alphonse. *The Evangelist (L'évangéliste).* Translated by W. P. Trent. New York: Society of English and French Literature, 1889.

de Brouwer, Ton. *Van Gogh en Nuenen.* 2nd rev. ed. Venlo, The Netherlands: Van Spijk, 1998.

Défossez, Marie-Paule. *Auvers, or the Painters' Eye (Auvers ou le regard des peintres).* Translated by Patricia Wallace Costa. Paris: Valhermeil, 1986.

Dejollier, René. *Charbonages en Wallonie, 1345–1984.* Namur: Éditions Érasme, 1988.

de Leeuw, Ronald, John Sillevis, and Charles Dumas, eds. *The Hague School: Dutch Masters of the 19th Century.* Paris: Grand Palais, London: Royal Academy of Arts, and The Hague: Haags Gemeentemuseum, in association with Weidenfeld and Nicolson, 1983.

Demory, Évelyne. *Auvers en 1900: Entre coteau et rivière.* Paris: Valhermeil, 1985.

Denvir, Bernard, ed. *The Impressionists at First Hand.* London: Thames and Hudson, 1987.

De Vries, Jan, and A. M. van der Woude. *The First Modern Economy: Success, Failure, and Perseverance of the Dutch Economy, 1500–1815.* Cambridge: Cambridge University Press, 1997.

Dickens, Charles. *The Centenary Edition of the Works of Charles Dickens: The Uncommercial Traveller.* Vol. 36. London: Chapman and Hall, 1911.

———. *Christmas Books and Stories.* New York: Doubleday & McClure Company, 1899.

———. *The Complete Works of Charles Dickens: Christmas Books.* Vol. 25. New York: Harper & Brothers, 1902.

———. *The Pickwick Papers.* New York: Books, Inc., 1868.

———. *A Tale of Two Cities.* Edited by Richard Maxwell. London: Penguin Books, 2000.

Dijk, Wout J., and Meent van der Sluis. *De Drentse tijd van Vincent van Gogh.* Groningen, The Netherlands: Boon, 2001.

Distel, Anne, and Susan Alyson Stein. *Cézanne to Van Gogh: The Collection of Doctor Gachet.* New York: The Metropolitan Museum of Art, 1999.

Doiteau, Victor, and Edgar Leroy. *La folie de Van Gogh.* Paris: Aesculape, 1928.

Dorn, Roland, George S. Keyes, and Joseph J. Rishel with Katherine Sachs et al. *Van Gogh Face to Face: The Portraits.* Detroit: Detroit Institute of Fine Arts, Boston: Museum of Fine Arts, and Philadelphia: Philadelphia Museum of Art, 2000.

Dowbiggin, Ian R. *Inheriting Madness: Professionalization and Psychiatric Knowledge in Nineteenth-Century France.* Berkeley: University of California Press, 1991.

Druick, Douglas, and Peter Zegers. *Van Gogh and Gauguin: The Studio of the South*. Chicago: Art Institute of Chicago and Amsterdam: Van Gogh Museum, 2002.

Drummond, Lewis. *Spurgeon, Prince of Preachers*. Grand Rapids, Mich.: Kregel Publications, 1992.

Dufwa, Jacques. *Winds from the East: A Study in the Art of Manet, Degas, Monet, and Whistler.* Stockholm: Almqvist and Wiksell International, 1981.

Dyos, H. J., and Michael Wolff, eds. *The Victorian City: Images and Realities*. 2 vols. Boston and London: Routledge and Kegan Paul, 1973.

Edwards, Tudor. *The Lion of Arles: A Portrait of Mistral and His Circle*. New York: Fordham University Press, 1964.

Eliot, George. *Adam Bede*. Edited by Stephen Gill. London: Penguin Books, 1980.

———. *Daniel Deronda*. London: Penguin Books, 1995.

———. *Felix Holt: The Radical*. Edited by Lynda Mugglestone. London: Penguin Books, 1995.

———. *Scenes of Clerical Life*. Edited by Jennifer Gribble. London: Penguin Books, 1998.

———. *Silas Marner: The Weaver of Raveloe*. Edited by David Carroll. London: Penguin Books, 1996.

Emerson, Ralph Waldo. *Essays*. Edited by Arthur Hobson Quinn. Whitefish, Mont.: Kessinger Publishing, 2008.

Engel, Louis. *From Handel to Hallé: Biographical Sketches; With Autobiographies of Prof. Huxley and Prof. Herkomer.* New York: Scribner and Welford, 1890.

Erckmann-Chatrian, Émile. *The Conscript: A Story of the French War of 1813 (Histoire d'un conscrit de 1813)*. New York: Charles Scribner's Sons, 1904.

Erpel, Fritz. *Van Gogh: The Self-Portraits (Vincent van Gogh: Lebensbilder, Lebenszeichen)*. Translated by Doris Edwards and with a preface by H. Gerson. Greenwich, Conn.: New York Graphic Society, 1968.

Favazza, Armando R., and Barbara Favazza. *Bodies Under Siege: Self-Mutilation in Culture and Psychiatry*. Baltimore and London: The Johns Hopkins University Press, 1987.

Fell, Derek. *Van Gogh's Women: Vincent's Love Affairs and Journey into Madness*. New York: Carroll & Graf, 2004.

Fénélon, François. *The Adventures of Telemachus, the Son of Ulysses (Les aventures de Télémaque, fils d'Ulysse)*. Edited by O. M. Brack, Jr., translated by Thomas Smollett, and with an introduction by Leslie A. Chilton. Athens, Georgia, and London: University of Georgia Press, 1997.

Flaubert, Gustave. *Madame Bovary*. Translated by Alan Russell. London: Penguin Books, 1950.

Forster, John. *The Life of Charles Dickens*. Philadelphia: J. B. Lippincott, 1897.

Foster, Julie, and Judy Simons. *What Kathy Read: Feminist Re-Readings of 'Classic' Stories for Girls*. Iowa City: University of Iowa Press, 1995.

Fromentin, Eugène. *The Old Masters of Belgium and Holland (Les Maitres d'Autrefois)*. With an introduction by Meyer Schapiro. New York: Schocken Books, 1963.

Gachet, Paul. *Deux amis des Impressionnistes: Le docteur Gachet et Murer.* Paris: Éditions des Musées Nationaux, 1956.

———, ed. *Lettres Impressionnistes*. Paris: Bernard Grasset, 1957.

———. *Souvenirs de Cézanne et de Van Gogh à Auvers: 1873–1890*. Paris: Les Beaux Arts, 1953.

Galbally, Ann. *The Art of John Peter Russell*. Melbourne: Sun Books, 1977.

Gauguin, Paul. *Intimate Journals (Avant et après)*. Translated by Van Wyck Brooks. Bloomington: University of Indiana Press, 1963.

———. *Letters to His Wife and Friends (Lettres de Gauguin à sa femme et à ses amis)*. Edited by Maurice Malingue, translated by Henry J. Stenning. Cleveland: World Publishing Co., 1949.

———. *Paul Gauguin: 45 Lettres à Vincent, Théo et Jo van Gogh*. Edited by Douglas Cooper. The Hague: Staatsuitgeverij, 1983.

———. *The Writings of a Savage: Paul Gauguin (Écrits d'un sauvage: Paul Gauguin)*. Edited by Daniel Guérin and translated by Eleanor Levieux. New York: Da Capo Press, 1978.

Gauzi, François. *Lautrec mon ami*. Paris: La Bibliothèque des Arts, 1992.

Gay, Peter. *The Naked Heart: The Bourgeois Experience; Victoria to Freud*. New York: W. W. Norton, 1995.

———. *Pleasure Wars: The Bourgeois Experience; Victoria to Freud*. New York: W. W. Norton, 1998.

———. *The Tender Passion: The Bourgeois Experience; Victoria to Freud*. New York: Oxford University Press, 1986.

Gedo, Mary Mathews. *Looking at Art from the Inside Out: The Psychoiconographical Approach to Modern Art*. Cambridge: Cambridge University Press, 1994.

Gigoux, Jean. *Causeries sur les artistes de mon temps*. Paris: Calmann Lévy, 1885.

Gilman, Sander L., et al. *Hysteria Beyond Freud*. Berkeley and Los Angeles: University of California Press, 1993.

Goldstein, Jan. *Console and Classify: The French Psychiatric Profession in the Nineteenth Century*. Chicago: University of Chicago Press, 2001.

Goldwater, Robert. *Symbolism*. New York: Harper and Row, 1979.

Goncourt, Edmond de. *Elisa (La fille Élisa)*. Translated by Margaret Crosland. New York: Howard Fertig, 1975.

———. *The Zemganno Brothers (Les frères Zemganno)*. Translated by Leonard Clark and Iris Allan. London: Mayflower-Dell, 1966.

——— and Jules de Goncourt. *French XVIII Century Painters: Watteau, Boucher, Chardin, La Tour, Greuze, Fragonard (L'art au dix-huitième siècle)*. Translated by Robin Ironside. London: Phaidon Press, 1948.

———. *Germinie (Germinie Lacerteux)*. Translated by Martin Tunnell. London: Weidenfeld and Nicolson, 1955.

———. *Paris and the Arts, 1851–1896: From the Goncourt Journal*. Translated and edited by George J. Becker and Edith Philips with an afterword by Hedley H. Rhys. Ithaca, N.Y., and London: Cornell University Press, 1971.

———. *Sister Philomène (Soeur Philomène)*. Translated by Laura Ensor. New York: Howard Fertig, 1975.

Goudsblom, Johan. *Dutch Society*. New York: Random House, 1967.

Gowers, William Richard. *Epilepsy and Other Chronic Convulsive Disorders, Their Causes, Symptoms and Treatment*. London: J & A Churchill, 1881.

Graetz, H. R. *The Symbolic Language of Vincent van Gogh*. New York: McGraw-Hill, 1963.

Gray, Christopher. *Armand Guillaumin*. Chester, Conn.: Pequot Press, 1972.

Groot, Reindert, and Sjoerd de Vries. *Vincent van Gogh in Amsterdam*. Amsterdam: Stadsuitgeverij, 1990.

Guiral, Pierre. *La vie quotidienne en Provence au temps de Mistral*. Paris: Hachette, 1972.

Hammacher, Abraham Marie. *Van Gogh en Belgique*. Translated by A. H. Wolters-Girard. Mons: Musée des Beaux-Arts de Mons, 1980.

Harsin, Jill. *Policing Prostitution in Nineteenth-Century Paris*. Princeton: Princeton University Press, 1985.

Hartrick, Archibald Standish. *A Painter's Pilgrimage Through Fifty Years*. Cambridge: Cambridge University Press, 1939.

Havard, Henry. *The Heart of Holland*. Translated by Mrs. Cashel Hoey. London: Richard Bentley & Son, 1880.

Hendriks, Ella, and Louis van Tilborgh. *Vincent van Gogh: Paintings, Volume 2: Antwerp and Paris, 1885–1888*. Zwolle: Waanders and Amsterdam: Van Gogh Museum, 2011.

Herbert, Eugenia. *The Artist and Social Reform: France and Belgium, 1885–1898*. New Haven: Yale University Press, 1961.

Herkomer, Hubert von. *The Herkomers*. 2 vols. London: Macmillan, 1910.

Homburg, Cornelia. *The Copy Turns Original: Vincent van Gogh and a New Approach to Traditional Artistic Practice*. Amsterdam and Philadelphia: John Benjamins, 1996.

———, Elizabeth C. Childs, John House, and Richard Thomson. *Vincent van Gogh and the Painters of the Petit Boulevard*. St. Louis: Saint Louis Art Museum and Rizzoli, 2001.

Howells, John G., ed. *World History of Psychiatry*. New York: Brunner/Mazel, 1975.

Hugo, Victor. *The Last Day of a Condemned Man and Other Prison Writings (Le dernier jour d'un condamné)*. Translated by Geoff Woollen. Oxford: Oxford University Press, 1992.

Hulsker, Jan. *The New Complete Van Gogh: Paintings, Drawings, Sketches*. Revised and enlarged edition. Amsterdam: John Benjamins; Meulenhoff, 1996.

———. *Vincent and Theo van Gogh: A Dual Biography*. Edited by James M. Miller. Ann Arbor, Michigan: Fuller Publications, 1990.

Hutchison, Sidney C. *The History of the Royal Academy: 1768–1968*. London: Chapman and Hall, 1968.

Inwood, Stephen. *A History of London*. New York: Carol and Graf Publishers, 1998.

Ives, Colta, Susan Alyson Stein, Sjraar van Heugten, and Marije Vellekoop. *Vincent van Gogh: Drawings*. New York: The Metropolitan Museum of Art, Amsterdam: Van Gogh Museum, and New Haven: Yale University Press, 2005.

Jackson, J. Hughlings. *Neurological Fragments. With a Biographical Memoir by James Taylor*. Oxford: Oxford University Press, 1925.

James, Henry. *A Little Tour in France*. Boston and New York: Houghton, Mifflin & Company, 1884. (Originally published under the title *En Province* in 1883–84, as a serial in *The Atlantic Monthly*.)

———. *Parisian Sketches: Letters to the New York Tribune, 1875–1876*. Edited by Leon Edel and Ilse Dusoir Lind. New York: Collier Books, 1961.

Jansen, Leo, Hans Luijten, and Nienke Bakker. *Vincent van Gogh: Painted with Words; The Letters to Émile Bernard*. New York: Rizzoli, 2007.

Jefferies, Richard. *The Story of My Heart: My Autobiography*. London: Longmans, Green, and Company, 1883.

Jerrold, Blanchard, and Gustave Doré. *London: A Pilgrimage*. New York: Dover Publications, 1970.

Jirat-Wasiutynski, Vojtech. *Paul Gauguin in the Context of Symbolism*. New York: Garland, 1987.

Jullian, Philippe. *Montmartre*. Translated by Anne Carter. Oxford: Phaidon, 1977.

Karr, Alphonse. *A Tour Round My Garden*. Revised and edited by John George Wood. London and New York: G. Routledge & Co., 1855.

Kearns, James. *Symbolist Landscapes: The Place of Painting in the Poetry and Criticism of Mallarmé and His Circle*. London: Modern Humanities Research Association, 1989.

Kempis, Thomas à. *The Imitation of Christ: In Three Books (De imitatione Christi)*. Translated and edited by Joseph N. Tylenda with a preface by Sally Cunneen. New York: Vintage Spiritual Classics, 1998.

The King James Bible.

King, Edward. *My Paris: French Character Sketches*. Boston: Loring, 1868.

Knippenberg, Hans. *Deelname aan het lager onderwijs in Nederland gedurende de negentiende eeuw*. Amsterdam: Koninklijk Nederlands Aardrijkskundig Genootschap voor Sociale Geografie, Universiteit van Amsterdam, 1986.

Kôdera, Tsukasa. *Vincent van Gogh: Christianity Versus Nature*. Amsterdam and Philadelphia: John Benjamins, 1990.

Kools, Frank. *Vincent van Gogh en zijn geboorteplaats: als een boer van Zundert*. Zutphen, The Netherlands: Walburg Pers, 1990.

Kraus, G. *The Relationship between Theo and Vincent van Gogh*. Translated by G. J. Renier. Otterlo: Kröller-Müller Stichting and Amsterdam: J. M. Meulenhoff, 1954.

Lanier, Dorris. *Absinthe: The Cocaine of the Nineteenth Century; A History of the Hallucinogenic Drug and Its Effect on Artists and Writers in Europe and the United States*. Jefferson, N.C.: McFarland and Company, 1995.

La Plante, Eve. *Seized: Temporal Lobe Epilepsy as a Medical, Historical, and Artistic Phenomenon*. New York: Harper Collins, 1993.

Lauzac, Henry. *Galerie historique et critique de dix-neuvième siècle: J.B.A. Goupil*. Paris: Bureau de la Galerie Historique, 1864.

Lavater, Johann Kaspar. *Essays on Physiognomy: For the Promotion of the Knowledge and the Love of Mankind*. Translated by Thomas Holcroft. London: G.G.J. and J. Robinson, 1789.

Legouvé, Ernest. *Les pères et les enfants au XIXe siècle.* Paris: J. Hetzel, 1910.

Lennox, William Gordon, and Margaret A. Lennox. *Epilepsy and Related Disorders.* 2 vols. Boston: Little, Brown, 1960.

Lesseps, Ferdinand de. *Recollections of Forty Years (Souvenirs de quarante ans).* Translated by C. B. Pitman. London: Chapman and Hall, 1887.

Lövgren, Sven. *The Genesis of Modernism: Seurat, Gauguin, Van Gogh, and French Symbolism in the 1880s.* Bloomington: Indiana University Press, 1971.

Loti, Pierre. *An Iceland Fisherman (Pêcheur d'Islande).* Translated by Guy Endore. New York: Alfred A. Knopf, 1946.

———. *Japan: Madame Chrysanthemum (Madame Chrysanthème).* Translated by Laura Ensor. London: KPI, 1985.

———. *Mon frère Yves.* Paris: Calmon Levy, 1884.

Lubin, Alfred J. *Stranger on the Earth: A Psychological Biography of Vincent van Gogh.* New York: Da Capo Press, 1972.

Lutjeharms, W. *De Vlaamse Opleidingsschool van Nicolaas de Jonge en zijn opvolgers.* Brussels: Société d'Histoire du Protestantisme Belge, 1978.

Luyendijk-Elshout, A. M. *Safe in the Performance of the Reproductive Duty: The Leyden Obstetricians.* Publisher unknown, 1979.

MacCormick Edwards, Lee. *Herkomer: A Victorian Artist.* Aldershot and Brookfield, Vermont: Ashgate, 1999.

Mackay, James Hutton. *Religious Thought in Holland During the Nineteenth Century.* London: Stodder and Houghton, 1911.

Mak, Geert. *Amsterdam: A Brief Life of the City (Een kleine geschiednis van Amsterdam).* Translated by Philipp Blom. Cambridge, Harvard University Press, 2000.

Malingue, Maurice, ed. *Lettres de Gauguin à sa femme et ses amis.* 2nd ed. Paris: Grasset, 1949.

Maré, Eric de. *Victorian London Revealed: Gustave Doré's Metropolis.* London: Penguin Books, 2001.

Masheck, Joseph, ed. *Van Gogh 100.* Westport, Conn.: Greenwood Press, 1996.

Mathews, Nancy Mowll. *Paul Gauguin: An Erotic Life.* New Haven: Yale University Press, 2001.

Mathijsen, Marita. *Het literaire leven in de negentiende eeuw.* Leiden: Martinus Nijhoff, 1987.

Maupassant, Guy de. *Bel-Ami.* Translated by Margaret Mauldon with an introduction by Robert Lethbridge. Oxford: Oxford University Press, 2001.

———. *Le Horla.* Edited by Paul Ollendorff. Paris: Paul Ollendorff, 1887.

———. *Pierre and Jean, Father and Son, Boitelle, and Other Stories (Pierre et Jean, Hautot père et fils, Boitelle, et autres histoires).* Translated by A. E. Henderson et al. London: P. F. Collier and Son, 1910.

Mauron, Charles. *Van Gogh: Études psychocritiques.* Paris: Librairie Joseph Corti, 1976.

Maus, Madeleine Octave. *Trente années de lutte pour l'art: 1884–1914.* Brussels: Librairie L'Oiseau Bleu, 1926.

Mayhew, Henry. *London Labour and the London Poor: Cyclopaedia of the Condition and Earnings of Those That Will Work, Those That Cannot Work, and Those That Will Not Work.* London: Griffin, Bohn, 1862.

Merlhès, Victor. *Correspondance de Paul Gauguin. Documents. Témoignages. Tome premier 1873–1888.* Paris: Fondation Singer-Polignac, 1984.

———. *Paul Gauguin et Vincent van Gogh, 1887–1888: Lettres retrouvées, sources ignorées.* Taravao, Tahiti: Avant et Après, 1989.

Meyers, Jan. *De jonge Vincent: Jaren van vervoering en vernedering.* Amsterdam: De Arbeiderspers, 1989.

Micale, Mark S. *Approaching Hysteria: Disease and Its Interpretations.* Princeton: Princeton University Press, 1995.

Michelet, Jules. *Love (L'amour).* Translated by John Williamson Palmer. New York: Rudd and Carleton, 1859.

———. *Woman (La femme).* Translated by John Williamson Palmer. New York: Rudd and Carleton, 1860.

————. *The People (Le peuple)*. Translated by John P. McKay. Urbana: University of Illinois Press, 1973.

Michon, Pierre. *Vie de Joseph Roulin*. Dijon: Verdier, 1988.

Mill, John Stuart. *On Liberty*. Edited by Currin V. Shields. Indianapolis and New York: Bobbs-Merrill, 1859.

————. *Utilitarianism*. London: Parker, Son, and Bourn, West Strand, 1863.

Milner, John. *The Studios of Paris: The Capital of Art in the Late Nineteenth Century*. New Haven and London: Yale University Press, 1988.

Monneret, Sophie. *Sur les pas des Impressionnistes: Les sites, les musées, les promenades*. Paris: Éditions de La Martinière, 1997.

Monroe, Russell R. *Creative Brainstorms: The Relationship Between Madness and Genius*. New York: Irvington Publishers, 1992.

Moore, George. *Confessions of a Young Man*. New York: Modern Library, 1925.

Morel, Bénédict-Auguste. *Traité des dégénérescences physiques, intellectuelles et morales de l'espèce humaine*. Paris: J. B. Baillière, 1857.

Morgan, Howard Gethin. *Death Wishes? The Understanding and Management of Deliberate Self-Harm*. Hoboken, N.J.: John Wiley and Sons, 1979.

Murger, Henry. *Le pays latin, Les buveurs d'eau, La scène de gouverneur*. Paris: Librairie Garnier Frères, 1855.

Murray, Gale Barbara. *Toulouse-Lautrec: The Formative Years, 1878–1891*. Oxford: Clarendon Press, 1991.

Nagera, Humberto. *Vincent van Gogh: A Psychological Study*. Madison, Conn.: International Universities Press, 1967.

Narmon, Francis. *Académie royale des beaux-arts de Bruxelles: 275 ans d'enseignement; Exposition placée sous le haut patronage de leurs Majestés le Roi et la Reine*. Brussels: Crédit Communal–Gemeentekrediet, 1987.

Newmark, Michael E., and J. Kiffin Penry. *Genetics of Epilepsy: A Review*. New York: Raven Press, 1980.

Nordenfalk, Carl. *The Life and Work of Van Gogh*. New York: Philosophical Library, 1953.

Nye, Robert. *Masculinity and Male Codes of Honor in Modern France*. New York and Oxford: Oxford University Press, 1993.

Oberthur, Mariel. *Cafés and Cabarets of Montmartre*. Salt Lake City, Utah: Peregrine Smith Books, 1984.

Ozanne, Marie-Angélique, and Frédérique de Jode. *Theo: The Other Van Gogh (L'autre van Gogh)*. Translated by Alexandra Bonfante-Warren. New York: Vendome Press, 2004.

Pabst, Fieke, ed. *Vincent van Gogh's Poetry Albums*. Zwolle: Waanders and Amsterdam: Rijksmuseum Vincent van Gogh, 1988. (Cahier Vincent 1.)

Pach, Walter. *Letters to an Artist: From Vincent van Gogh to Anthon Ridder van Rappard: 1881–1885*. New York: Viking Press, 1930.

Penry, J. Kiffin, ed. *Epilepsy: Diagnosis, Management, Quality of Life*. New York: Raven Press, 1986.

Peres, Cornelia, Michael Hoyle, and Louis van Tilborgh, eds. *A Closer Look: Technical and Art-Historical Studies on Works by Van Gogh*. Zwolle: Waanders and Amsterdam: Rijksmuseum Vincent van Gogh, 1988. (Cahier Vincent 3.)

Perrot, Michelle, ed. *A History of Private Life: From the Fires of Revolution to the Great War (Histoire de la vie privée: De la révolution à la grande guerre)*. Vol. 4. Translated by Arthur Goldhammer. Cambridge, Mass., and London: Harvard University Press, 1990.

Perruchot, Henri. *La vie de Van Gogh*. Paris: Hachette, 1955.

Pick, Daniel. *Faces of Degeneration: A European Disorder c. 1848–1918*. New York: Cambridge University Press, 1989.

Pickvance, Ronald. *English Influences on Vincent van Gogh*. Nottingham: University of Nottingham and London: The Arts Council of Great Britain, 1974–75.

————. *Van Gogh in Arles*. New York: The Metropolitan Museum of Art and Harry N. Abrams, 1984.

————. *Van Gogh in Saint-Rémy and Auvers.* New York: The Metropolitan Museum of Art and Harry N. Abrams, 1986.

Piérard, Louis. *The Tragic Life of Vincent van Gogh (La vie tragique de Vincent van Gogh).* Translated by Herbert Garland. London: J. Castle, 1925.

————. *Visage de la Wallonie.* Brussels: Labor, 1980.

Pinckney, David H. *Napoleon III and the Rebuilding of Paris.* Princeton: Princeton University Press, 1985.

Pissarro, Lucien. *Lettres impressionistes au Dr Gachet et à Murer.* Paris: B. Grasset, 1957.

Pollock, Griselda. *Vision and Difference: Femininity, Feminism and Histories of Art.* London and New York: Routledge, 1988.

———— and Alan Chong. *Art in the Age of Van Gogh: Dutch Paintings from the Rijksmuseum, Amsterdam.* Toronto: Art Gallery of Ontario, 1998.

Porter, Roy. *London: A Social History.* Cambridge, Mass.: Harvard University Press, 1994.

Quesne–van Gogh, Elisabeth Huberta du. *Personal Recollections of Vincent van Gogh (Persoonlijke herinneringen aan Vincent van Gogh).* Translated by Katharine S. Dreier. Boston and New York: Houghton Mifflin, 1913.

Quétel, Claude. *History of Syphilis (Le mal de Naples: Histoire de la syphilis).* Translated by Judith Braddock and Brian Pike. Baltimore: Johns Hopkins University Press, 1990.

Ransome-Wallis, P., ed. *Illustrated Encyclopedia of World Railway Locomotives.* New York and Toronto: Hawthorne Books and McClelland & Stewart, Ltd., 1959.

Renan, Ernest. *The Life of Jesus (La vie de Jésus).* Amherst, N.Y.: Prometheus Books, 1991.

Rewald, John. *The History of Impressionism.* 4th rev. ed. New York: Museum of Modern Art and Boston: New York Graphic Society, 1973.

————. *Post-Impressionism from Van Gogh to Gauguin.* 3rd rev. ed. New York: Museum of Modern Art and Boston: New York Graphic Society, 1978.

————. *Studies in Post-Impressionism.* Edited by Irene Gordon and Frances Weitzenhoffer. New York: Harry N. Abrams, 1986.

———— and Lucien Pissarro, eds. *Camille Pissarro: Letters to His Son Lucien (Lettres à son fils Lucien presentées avec l'assistance de Lucien Pissarro).* Translated by Lionel Abel. New York: Pantheon Books, 1945.

Ribot, Théodule. *Heredity: A Psychological Study of Its Phenomena, Laws, Causes and Consequences (L'hérédité psychologique).* New York: D. Appleton, 1895.

Richardson, Joanna. *La Vie Parisienne: 1852–1970.* London: Hamish Hamilton, 1971.

Rietbergen, P.J.A.N., G.H.J. Seegers, and M. E. Bennett. *A Short History of the Netherlands from Prehistory to the Present Day.* 4th ed. Amersfoort: Bekking, 1992.

Rod, Édouard. *Sens de la vie.* Paris: Librairie Académique Perrin, 1921.

Roessingh, Karel Hendrik. *Het modernisme in Nederland.* Haarlem: De Erven F. Bohn, 1922.

Rollet, Pierre. *La vie quotidienne en Provence au temps de Mistral.* Paris: Hachette, 1972.

Roskill, Mark. *Van Gogh, Gauguin and the Impressionist Circle.* Greenwich, Conn.: New York Graphic Society, 1970.

Salter, Elizabeth. *The Lost Impressionist: A Biography of John Peter Russell.* Pymble: Angus and Roberston, 1976.

Sanders, Piet. *Genealogie Van Gogh.* Geldrop: Genealogisch Tijdschrift voor Midden- en West-Brabant, n.d.

Schama, Simon. *The Embarrassment of Riches: An Interpretation of Dutch Culture in the Golden Age.* New York: Alfred A. Knopf, 1987.

Schapiro, Meyer. *Vincent van Gogh.* New York: Harry N. Abrams, 1983.

Schimmel, Herbert D. *The Letters of Henri de Toulouse-Lautrec.* With an introduction by Gale B. Murray. Oxford: Oxford University Press, 1991.

Schuchart, Max. *The Netherlands.* New York: Walker, 1972.

Scull, Andrew, ed. *Madhouses, Mad-Doctors, and Madmen: The Social History of Psychiatry in the Victorian Era.* Philadelphia: University of Pennsylvania Press, 1981.

Secrétan-Rollier, Pierre. *Van Gogh chez les gueules noires: L'homme de l'espoir.* Lausanne: Éditions L'Age d'Homme, 1977.

Sensier, Alfred. *Jean-François Millet: Peasant and Painter* (*Jean-François Millet: La vie et l'oeuvre de J.-F. Millet*). Translated by Helena de Kay. Boston and New York: Houghton, Mifflin and Company, 1880.

Sheppard, Francis Henry Walliston. *London: A History*. Oxford: Oxford University Press, 1998.

Sillevis, John. *Dutch Watercolors of the 19th Century from the Printroom of the Rijksmuseum Amsterdam* (*Hollandse aquarellen uit de 19de eeuw uit het Prentenkabinet Rijksmuseum Amsterdam*). Translated by Liesje Offerhaus and Anita Weston. Amsterdam: Prentenkabinet, Rijksmuseum Amsterdam, 1985.

Silverman, Debora. *Van Gogh and Gauguin: The Search for Sacred Art*. New York: Farrar, Straus and Giroux, 2000.

Souvestre, Émile. *An Attic Philosopher in Paris, or a Peep at the World from a Garret, Being the Journal of a Happy Man* (*Un philosophe sous les toits; journal d'un homme heureux*). New York: D. Appleton, 1901.

———. *Les derniers Bretons*. Paris: Michel Lévy Frères, 1858.

Stein, Susan Alyson, ed. *Van Gogh: A Retrospective*. New York: Hugh Lauter Levin Associates and Macmillan, 1986.

Stengers, Jean, and Anne van Neck. *Masturbation: The History of a Great Terror* (*Histoire d'une grande peur, la masturbation*). Translated by Kathryn A. Hoffman. New York: Palgrave, 2001.

Steven, Mary Anne, et al. *Émile Bernard, 1861–1941: A Pioneer of Modern Art*. Amsterdam: Rijksmuseum Vincent van Gogh and Zwolle: Waanders, 1990.

Stokvis, Benno J. *Nasporingen omtrent Vincent van Gogh in Brabant*. Amsterdam: S. L. Van Looy, 1926.

Stolwijk, Chris. *Uit de schilderswereld: Nederlandse kunstschilders in de tweede helft van de negentiende eeuw*. Leiden: Primavera Pers, 1998.

——— and Richard Thomson. *Theo van Gogh, 1857–1891: Art Dealer, Collector and Brother of Vincent*. Amsterdam: Van Gogh Museum and Zwolle: Waanders, 1999.

Stone, Irving. *Lust for Life: The Novel of Vincent van Gogh*. London: Longmans, Green, 1934.

Sund, Judy. *True to Temperament: Van Gogh and French Naturalist Literature*. Cambridge: Cambridge University Press, 1992.

Sweetman, David. *Paul Gauguin: A Life*. New York: Simon and Schuster, 1995.

Szymanska, Anna. *Unbekannte Jugendzeichnungen Vincent van Goghs und das Schaffen des Künstlers in den Jahren 1870–1880*. Berlin: Henschelverlag, 1968.

Taine, Hippolyte. *Taine's Notes on England*. Translated with an introduction by Edward Hyams. London: Thames and Hudson, 1957.

Temkin, Owsei. *The Falling Sickness: A History of Epilepsy from the Greeks to the Beginnings of Modern Neurology*. 2nd rev. ed. Baltimore and London: Johns Hopkins University Press, 1971.

Thompson, E. P. *The Making of the English Working Class*. New York: Vintage Books, 1966.

Thornton, Esther M. *Hypnotism, Hysteria and Epilepsy: An Historical Synthesis*. London: Heinemann Medical, 1976.

Torrey, Edwin Fuller. *Surviving Schizophrenia: A Family Manual*. New York: Harper and Row, 1983.

——— and Judy Miller. *The Invisible Plague: The Rise of Mental Illness from 1750 to the Present*. New Brunswick, N.J.: Rutgers University Press, 2002.

Tralbaut, Marc Edo. *Vincent van Gogh*. New York: Viking, 1969.

Trimble, Michael R., and Tom G. Bolwig, eds. *Aspects of Epilepsy and Psychiatry*. London: John Wiley, 1986.

Uhland, Johann Ludwig. *The Poems of Uhland* (*Die Gedichte von Uhland*). Translated and edited by Waterman T. Hewett. New York: Macmillan, 1896.

———. *The Songs and Ballads of Uhland* (*Die Lieder und Balladen von Uhland*). Translated by W. W. Skeat. London: Williams and Norgate, 1864.

van Bruggen, H.W.E., ed. *Théophile de Bock, schilder van het Nederlandse landschap*. Waddinxveen, The Netherlands: Stichting Documentatie Théophile de Bock, 1991.

van der Mast, Michiel, and Charles Dumas, eds. *Van Gogh en Den Haag*. Zwolle: Waanders, 1990.

Vanderlaan, Eldred C. *Protestant Modernism in Holland*. London: Humphrey Milford and Oxford University Press, 1924.

van Eekelen, Yvonne, ed. *The Magical Panorama: The Mesdag Panorama, an Experience in Space and Time*. Translated by Arnold and Erica Pomerans. Zwolle, The Netherlands: Waanders, 1996.

van Gogh, Theo, and Johanna van Gogh-Bonger. *Brief Happiness: The Correspondence of Theo van Gogh and Jo Bonger*. Edited and translated by Leo Jansen and Jan Robert with introduction and commentary by Han van Crimpen. Amsterdam: Van Gogh Museum and Zwolle: Waanders, 1999.

van Gogh, Vincent. *The Complete Letters of Vincent Van Gogh: With Reproductions of All the Drawings in the Correspondence (Verzamelde Brieven van Vincent van Gogh)*. Translated with a memoir by Johanna Gezina van Gogh–Bonger. 2nd ed. Boston: Little, Brown, 1978.

———. *Vincent van Gogh: The Letters; The Complete Illustrated and Annotated Edition*. 6 vols. Edited by Leo Jansen, Hans Luijten, and Nienke Bakker. Amsterdam: Van Gogh Museum, Den Haag: Huygens Instituut, and Brussels: Mercatorfonds, 2009.

———. *Verzamelde Brieven van Vincent van Gogh*. Edited by Johanna van Gogh–Bonger and V. W. van Gogh. Amsterdam: Vincent van Gogh Foundation/Rijksmuseum Vincent van Gogh, 1954.

———. *Verzamelde Brieven van Vincent van Gogh*. Edited by Johanna van Gogh–Bonger, with an introduction by V. W. van Gogh. Amsterdam and Antwerp: Wereldbibliotheek, 1955.

Vanhamme, Marcel. *Bruxelles: De bourg rural à cité mondiale*. Antwerp and Brussels: Mercurius, 1968.

van Heugten, Sjraar. *Vincent van Gogh: Drawings, Volume 1: The Early Years, 1880–1883*. Amsterdam: Van Gogh Museum and London: Lund Humphreys, 1996.

———. *Vincent van Gogh: Drawings, Volume 2: Nuenen, 1883–1885*. Amsterdam: Van Gogh Museum and London: Lund Humphreys, 1997.

———, Joachim Pissarro, and Chris Stolwijk. *Van Gogh and the Colors of the Night*. Amsterdam: Van Gogh Museum, Brussels: Mercatorfonds, and New York: Museum of Modern Art, 2008.

van Looij, L. Theo. *Een eeuw Nationaal Hoger Instituut voor Schone Kunsten te Antwerpen*. Antwerp: Nationaal Hoger Instituut en Koninklijke Academie voor Schone Kunsten, 1985.

van Rappard–Boon, Charlotte, Willem van Gulik, and Keiko Bremen-Ito. *Catalogue of the Van Gogh Museum's Collection of Japanese Prints*. Amsterdam: Rijksmuseum Vincent van Gogh and Zwolle: Waanders, 1991.

van Tilborgh, Louis. *The Potato Eaters by Vincent van Gogh*. With contributions by Dieuwertje Dekkers et al. Zwolle: Waanders, 1993. (Cahier Vincent 5.)

———, ed. *Van Gogh and Millet*. With contributions by Sjraar van Heugten and Philip Conisbee. Amsterdam: Van Gogh Museum and Zwolle: Waanders, 1988.

——— and Marije Vellekoop. *Vincent van Gogh: Paintings, Volume 1: Dutch Period: 1881–1885, Van Gogh Museum*. Amsterdam: Van Gogh Museum and London: Lund Humphries, 1999.

van Uitert, Evert. *Van Gogh in Brabant: Paintings and Drawings from Etten and Nuenen*. Zwolle: Waanders, 1987.

——— and Michael Hoyle, eds. *The Rijksmuseum Vincent van Gogh*. Amsterdam: Meulenhoff/Landshoff, 1987.

Veith, Ilza. *Hysteria: The History of a Disease*. Chicago: University of Chicago Press, 1970.

Vellekoop, Marije, and Sjraar van Heugten. *Vincent van Gogh: Drawings, Volume 3: Antwerp and Paris 1885–1888, Van Gogh Museum*. Amsterdam: Van Gogh Museum and London: Lund Humphries, 2001.

Vellekoop, Marije, and Roelie Zwikker. *Vincent van Gogh: Drawings, Volume 4: Arles, Saint-Rémy & Auvers-sur-Oise, 1888–1890, Van Gogh Museum*. 2 vols. Zwolle and Amsterdam: Van Gogh Museum, 2007.

Venture, Rémi. *Arles.* Marguerites: Éditions de l'Équinoxe, 1989.

Vergeest, Aukje. *The French Collection: Nineteenth Century Paintings in Dutch Public Collections.* Amsterdam: Amsterdam University Press, 2000.

Verlat, Charles. *Plan général des études à l'Académie Royale d'Anvers.* Antwerp: L'Académie Royale d'Anvers, 1879.

Vermeeren, Karel. *Eindhoven.* The Hague: Kruseman's Uitgeversmaatschappij, 1976.

Vollard, Ambroise. *Recollections of a Picture Dealer (Souvenirs d'un marchand de tableaux).* Translated by Violet T. Macdonald. Boston: Little, Brown, 1936.

Walsh, Barent W., and Paul M. Rosen. *Self-Mutilation: Theory, Research, and Treatment.* New York and London: Guilford Press, 1988.

Walther, Ingo F., ed. *Masterpieces of Western Art: A History of Art in 900 Individual Studies.* Cologne: Taschen, 1999.

Weber, Eugen. *France, Fin de Siècle.* Cambridge, Mass., and London: Harvard University Press, 1986.

Weiner, Dora B. *Raspail: Scientist and Reformer.* New York and London: Columbia University Press, 1968.

Weinreb, Ben, and Christopher Hibbert, eds. *The London Encyclopedia.* London: MacMillan, 1983.

Weisberg, Gabriel P., et al. *Japonisme: Japanese Influence on French Art, 1854–1910.* Cleveland: Cleveland Museum of Art, 1975.

———, ed. *Montmartre and the Making of Mass Culture.* With a foreword by Karal Ann Marling. New Brunswick, N.J.: Rutgers University Press, 2001.

Welsh-Ovcharov, Bogomila. *Van Gogh à Paris.* Paris: Musée d'Orsay, 1988.

———. *Vincent van Gogh and the Birth of Cloisonism.* Toronto: Art Gallery of Ontario, 1981.

———, ed. *Van Gogh in Perspective.* Englewood Cliffs, N.J.: Prentice-Hall, 1974.

——— and Philip Dennis Cate. *Émile Bernard (1868–1941): The Theme of Bordellos and Prostitutes in Turn-of-the-Century French Art.* New Brunswick, N.J.: Jane Voorhees Zimmerli Art Museum, Rutgers University, 1988.

White, Christopher, and Quentin Buvelot, eds. *Rembrandt by Himself.* London: National Gallery Publications and The Hague: Royal Cabinet of Paintings Mauritshuis, 1999.

White, Harrison C., and Cynthia A. Harrison. *Canvases and Careers: Institutional Change in the French Painting World.* New York: John Wiley and Sons, 1965.

Wildenstein, Daniel, and Sylvie Crussard. *Gauguin: A Savage in the Making. Catalogue Raisonné of the Paintings (1873–1888).* 2 vols. Milan: Skira, 2002.

Wilkie, Ken. *In Search of Van Gogh.* Rocklin, Calif.: Prima, 1991.

Young, George Malcolm, and George Kitson Clark. *Portrait of an Age: Victorian England.* Oxford: Oxford University Press, 1960.

Zeldin, Theodore. *France, 1848–1945.* Oxford: Clarendon Press, 1973–77.

Zemel, Carol M. *The Formation of a Legend: Van Gogh Criticism, 1890–1920.* Ann Arbor: UMI Research Press, 1980.

———. *Van Gogh's Progress: Utopia, Modernity, and Late Nineteenth-Century Art.* Berkeley: University of California Press, 1997.

Zola, Émile. *The Belly of Paris (Le ventre de Paris).* Translated by Ernest Alfred Vizetelly. Los Angeles: Sun and Moon Press, 1996.

———. *The Earth (La terre).* Translated by Douglas Parmée. London: Penguin Books, 1990.

———. *Germinal.* London: Penguin Books, 1885.

———. *A Love Affair (Une page d'amour).* Translated by Jean Stewart. London: Elek, 1957.

———. *The Masterpiece (L'oeuvre).* Translated by Roger Pearson. Oxford: Oxford University Press, 1993.

———. *My Hatreds (Mes haines).* Translated by Palomba Paves-Yashinsky and Jack Yashinsky. Lewiston, New York: Edwin Mellen Press, 1991.

———. *Pot Luck (Pot-Bouille).* Translated by Brian Nelson. Oxford: Oxford University Press, 1999.

————. *The Sin of Father Mouret* (*La faute de l'abbé Mouret*). Translated by Sandy Petrey. Englewood Cliffs, N.J.: Prentice-Hall, 1969.

————. *The Dream* (*Le rêve*). Translated by Eliza E. Chase. London: Chatto and Windus, 1893.

JOURNAL ARTICLES

Andersen, Wayne. "Gauguin and a Peruvian Mummy." *The Burlington Magazine*, vol. 109, no. 769: April 1967, pp. 238–42.

Arenberg, I. Kaufman, et al. "Van Gogh Had Menière's Disease and Not Epilepsy." *Journal of the American Medical Association*, vol. 264, no. 4: July 25, 1990, pp. 491–93.

Arnold, Wilfred Niels. "Vincent van Gogh's Birthday." *The Pharos*, Fall 1995, pp. 28–32.

Aurier, Gustave-Albert [Luc le Flâneur]. "En quête de choses d'art." *Le Moderniste Illustré*, vol. 1, no. 2: April 13, 1889, p. 14.

Bailey, Martin. "Memories of Van Gogh and Gauguin: Hartrick's Reminiscences." *Van Gogh Museum Journal* 2001, pp. 96–105.

————. "Theo van Gogh Identified: Lucien Pissarro's Drawing of Vincent and His Brother." *Apollo*, vol. 138, no. 388: 1994, pp. 44–46.

————. "Vincent's Other Brother: Cor van Gogh." *Apollo*, vol. 138, no. 380: October 1993, pp. 217–19.

————. "Vincent van Gogh, the Writer." *The Art Newspaper*, no. 35: February 1994, p. 16.

Bernard, Émile. "Lettre ouverte à M. Camille Mauclair." *Mercure de France*, vol. 14: June 1895, p. 334.

————. "Louis Anquetin, artiste-peintre." *Mercure de France*, vol. 239: November 1, 1932, pp. 590–607.

————. "Souvenirs sur Van Gogh." *L'Amour de l'Art*, vol. 5: December 1924, pp. 393–400.

————. "Vincent van Gogh." *Les Hommes d'Aujourd'hui*, vol. 7, no. 390: 1890, pp. 65–69.

————. "Julien Tanguy dit le 'Père Tanguy.'" *Mercure de France*, December 16, 1908, pp. 600–616.

Blumer, Dietrich. "Hypersexual Episodes in Temporal Lobe Epilepsy." *American Journal of Psychiatry*, no. 126: 1970, pp. 1099–1106.

————. "The Illness of Vincent van Gogh." *American Journal of Psychiatry*, vol. 159, no. 4: April 2002, pp. 519–26.

———— and A. Earl Walker. "Sexual Behavior in Temporal Lobe Epilepsy: A Study of the Effects of Temporal Lobectomy on Sexual Behavior." *Archives of Neurology* 16: 1967, pp. 37–43.

Boime, Albert. "Van Gogh's 'Starry Night': A History of Matter and a Matter of History." *Arts Magazine*, December 1984, pp. 86–103.

Bredius, A. "Herinneringen aan Vincent van Gogh." *Oud-Holland*, vol. 51, no. 1: 1934, p. 44.

Brekelmans, Franciscus Antonius. "Vincent van Gogh in Zundert." *De Oranjeboom*, no. 6: 1953, pp. 48–59.

Bronkhorst, H. "Wie was oom Cor?" *Baerne: Tijdschrift van de Historische Kring "Baerne,"* no. 2: June 1987, pp. 10–11.

Buss, A., and P. Lang. "Psychological Deficit in Schizophrenia." *International Journal of Abnormal Psychology*, no. 70: 1954, pp. 2–24.

Cassee, Elly. "In Love: Vincent van Gogh's First True Love." *Van Gogh Museum Journal*, 1996, pp. 108–17.

Cochin, Henry. "Boccace." *Revue des Deux Mondes*, no. 3: 1888, pp. 373–413.

Commission on Classification and Terminology of the International League Against Epilepsy. "Proposal for Revised Clinical and Electroencephalographic Classification of Epileptic Seizures." *Epilepsia*, no. 22: 1981, pp. 489–501.

Coyle, Laura. "Strands of Interlacing: Colour Theory, Education and Play in the Work of Vincent van Gogh." *Van Gogh Museum Journal* 1996, pp. 118–31.

Dagen, Philippe. "L'aliéné de la société (Review of 'La face humaine de Van Gogh')." *Le Mondes des Livres,* January 1, 2000, n.p.

Decaudin, M. "Aurier l'ignoré." *Dossiers Acénonètes du Collège de Pataphyisique,* no. 15: October 1961, pp. 41–46.

Dekker, Hendrick Adriaan Christiaan. "A. Mauve." *De Portefeuille,* vol. 1: 1888, pp. 237–39.

de Leeuw, Ronald. "George Henry Boughton and the 'Beautiful Picture' in Van Gogh's 1876 Sermon." *Van Gogh Museum Journal* 1995, pp. 48–62.

Destremau, Frédéric. "L'atelier Cormon (1882–1887)." *Bulletin de la Société de l'Histoire de l'Art Français* 1996, pp. 171–84.

Dewhurst, Orrin, and David Bear. "Varieties of Aggressive Behavior in Temporal Lobe Epilepsy." *British Journal of Psychiatry,* no. 117: 1970, pp. 497–507.

Dijk, Wout. " 'Dark and Dreary Days': Dating Van Gogh's Letters from Drenthe." *Van Gogh Museum Journal* 1996, pp. 102–7.

Dirven, Herman. "De kunsthandelaar Vincent van Gogh uit Prinsenhage." *Werkgroep Haagse Beemden,* no. 19: July 1977, pp. 4–80.

Doiteau, Victor. "La curieuse figure de Docteur Gachet." *Aesculape,* August-December 1923, pp. 169–73, 211–16, 250–54, 278–83; January 1924, pp. 7–11.

———. "Deux 'copains' de Van Gogh, inconnus: Les frères Gaston et René Secrétan, Vincent, tel qu'ils l'ont vu." *Aesculape,* vol. 40: March 1957, pp. 38–62.

——— and Edgar Leroy. "Vincent van Gogh et le drame de l'oreille coupée." *Aesculape,* no. 7: 1936, pp. 169–92.

Dorra, Henri. "Gauguin's Dramatic Arles Themes." *Art Journal,* vol. 30, no. 1: 1978, pp. 12–17.

Dufau, J. C. "De tout un peu: Textes sur Van Gogh: Van Gogh et la famille Rouline." Publisher unknown, n.d., pp. 4–5.

Dujardin, Édouard. "Aux XX et aux Indépendants: Le Closonisme." *La Revue Indépendante,* vol. 6: March, 1888, pp. 487–92.

Dumas, Ann. "The Van Gogh Literature from 1900 to Present: A Selective Review." *Van Gogh Museum Journal* 2002, pp. 40–51.

Ellison, James M. "Alterations in Sexual Behavior in Temporal Lobe Epilepsy." *Psychosomatics,* no. 23: 1982, pp. 499–509.

"En Borinage, là où vécut Van Gogh." *Nord-Éclair* (Lille), December 10, 1971, p. 11.

Fénéon, Félix. "Georges Seurat." *Bulletin de la Vie Artistique,* vol. 7: May 14, 1914, n.p.

Fabbri, Remo, Jr. "Dr. Paul-Ferdinand Gachet: Vincent van Gogh's Last Physician." *Transactions and Studies of the College of Physicians of Philadelphia,* vol. 33: 1966, pp. 202–8.

Fles, Etha. "Anton Mauve and the Modern Dutch School, 1838–88." *The Magazine of Art* 1896, pp. 71–75.

Fowle, Frances. "Vincent's Scottish Twin: The Glasgow Art Dealer Alexander Reid." *Van Gogh Museum Journal* 2000, pp. 90–99.

Franits, Wayne. "The Family Saying Grace: A Theme in Dutch Art of the Seventeenth Century." *Simiolus,* vol. 16, no. 1: 1986, pp. 36–49.

Gachet, Paul. "Les médecins de Théodore et de Vincent van Gogh." *Aesculape,* vol. 40: March 1957, pp. 4–37.

Gardner, A. R., and A. J. Gardner, "Self-Mutilation, Obsessionality and Narcissism." *The British Journal of Psychiatry,* vol. 127: 1975, pp. 127–32.

Gastaut, Henri. "Clinical and Electroencephalographical Classification of Epileptic Seizures." *Epilepsia,* no. 11: 1970, pp. 102–13.

———. "État actuel des conaissances sur l'anatomie pathologique des épilepsies." *Acta Neurologica et Psychiatrica Belgica,* no. 56: 1956, pp. 5–20.

———. "Interpretation of the Symptoms of Psychomotor Epilepsy in Relation to Physiological Data on Rhinencephalic Function." *Epilepsia,* no. 3: 1954, pp. 84–88.

———. "Mémoires originaux: La maladie de Vincent van Gogh envisageé a la lumière des conceptions nouvelles sur l'élepsie psychomotrice." *Annales Medico-psychologiques,* vol. 114: 1956, pp. 196–238.

——— and H. Collomb. "Étude du comportement sexuel chez les épileptiques psychomo-teurs." *Annual Médical de Psychologie*, no. 112: 1954, pp. 657–96.

———, G. Morin, and N. Lesèvre. "Étude du comportement des épileptiques psychomoteurs dans l'intervalle de leurs crises." *Annual Médical de Psychologie*, no. 113: 1955, pp. 1–27.

———, J. Roger, and N. Lesèvre. "Différenciation psychologique des épileptiques en fonc-tion des formes électroniques de leur maladies." *Revue de Psychologie Appliqué*, no. 3: 1953, pp. 237–49.

Geffroy, Gustave. "Chronique: Dix tableaux de Claude Monet." *La Justice*, vol. 9, no. 17: June 1888, no. 3077, pp. 1–2.

Gelfand, Toby. "Neurologist or Psychiatrist? The Public and Private Domains of Jean-Martin Charcot." *Journal of the History of the Behavioral Sciences*, vol. 36, no. 3: Summer 2000, pp. 215–29.

Godfrey, Caroline Durand-Ruel. "Paul Durand-Ruel's Marketing Practices." *Van Gogh Mu-seum Journal* 2000, pp. 82–89.

Gram, Johan. "De kunstverzameling Vincent van Gogh in Pulchri Studio." *Haagsche Stem-men*, vol. 2: 1889, pp. 371–82.

Green, Nicholas. "Dealing in Temperaments: Economic Transformation of the Artistic Field in France during the Second Half of the Nineteenth Century." *Art History*, vol. 10: March 1987, pp. 59–78.

Greer, Joan E. "A Modern Gethsemane: Vincent van Gogh's 'Olive Grove.'" *Van Gogh Mu-seum Journal* 2001, pp. 106–17.

Gronberg, Theresa Ann. "Femmes de brasseries." *Art History*, vol. 7: September 1984, pp. 328–44.

Hammacher, Abraham Marie. "Van Gogh and Italy." *Van Gogh Museum Journal* 2001, pp. 118–23.

Herkomer, Hubert von. "Drawing and Engraving on Wood." *The Art Journal*, 1882, pp. 133–36, 165–68.

Honeyman, T. J. "Van Gogh: A Link with Glasgow." *The Scottish Art Review*, vol. 2, no. 2: 1948, pp. 16–20.

Howard, Michael. "Toulouse-Lautrec and the Art of Japan." *Art Quarterly*, Autumn 1991, pp. 23–27.

Hulsker, Jan. "1878, a Decisive Year in the Lives of Theo and Vincent." Translated by J. van Hattum. *Vincent: Bulletin of the Rijksmuseum Vincent van Gogh*, vol. 3, no. 3: 1974, pp. 15–36.

———. "Critical Days in the Hospital in Arles." *Vincent: Bulletin of the Rijksmuseum Vincent van Gogh*, vol. 1, no. 1: 1970, pp. 20–31.

———. "The Elusive Van Gogh, and What His Parents Really Thought of Him." *Simiolus*, vol. 4: 1989, pp. 243–63.

———. "A New Extensive Study of Van Gogh's Stay in The Hague." *Vincent: Bulletin of the Rijksmuseum Vincent van Gogh*, vol. 3, no. 2: 1974, pp. 29–32.

———. "The Poet's Garden." Translated by J. van Hattum. *Vincent: Bulletin of the Rijks-museum Vincent van Gogh*, vol. 3, no. 1: 1974, pp. 22–32.

———. "Van Gogh's Dramatic Years in The Hague." Translated by J. van de Vathorst-Smit. *Vincent: Bulletin of the Rijksmuseum Vincent van Gogh*, vol. 1, no. 2: 1971, pp. 6–21.

———. "Van Gogh's Studio in The Hague identified." *Vincent: Bulletin of the Rijksmuseum Vincent van Gogh*, vol. 1, no. 2: 1971, pp. 2–5.

———. "Van Gogh's Threatened Life in St. Rémy and Auvers." Translated by J. van Hattum. *Vincent: Bulletin of the Rijksmuseum Vincent van Gogh*, vol. 2, no. 1: 1972, pp. 21–39.

———. "Van Gogh's Years of Rebellion in Nuenen." Translated by J. van Hattum. *Vincent: Bulletin of the Rijksmuseum Vincent van Gogh*, vol. 1, no. 3: 1971, pp. 15–28.

———. "Vincent's Letters to Anton Kerssemakers." *Vincent: Bulletin of the Rijksmuseum Vincent van Gogh*, vol. 2, no. 2: 1973, pp. 16–24.

———. "Vincent's Stay in the Hospitals at Arles and Saint-Rémy: Unpublished Letters from the Postman Joseph Roulin and the Reverend Salles to Theo van Gogh." Translated by

J. van Hattum. *Vincent: Bulletin of the Rijksmuseum Vincent van Gogh,* vol. 1, no. 2: 1971, pp. 24–44.

———. "What Theo Really Thought of Vincent." Translated by J. van Hattum. *Vincent: Bulletin of the Rijksmuseum Vincent van Gogh,* vol. 3, no. 2: 1974, pp. 2–28.

Jackson, J. Hughlings, and Charles E. Beevor. "Case of Tumour of the Right Temporosphenoidal Lobe Bearing on the Localisation of the Sense of Smell and on the Interpretation of a Particular Variety of Epilepsy." *Brain,* no. 11: 1889, pp. 345–57.

James, Henry. "'Les Maîtres d'Autrefois,' Review of *Les Maîtres d'Autrefois: Belgique—Hollande* by Eugène Fromentin." *The Nation,* July 13, 1876.

Jampoller, Lili. "Theo van Gogh and Camille Pissarro: Correspondence and an Exhibition." *Simiolus,* vol. 16: 1986, pp. 50–61.

Jansen, Leo, Hans Luijten, and Erik Fokke. "The Illness of Vincent van Gogh: A Previously Unknown Diagnosis." *Van Gogh Museum Journal* 2003, pp. 113–19.

Jansen, Leo, Hans Luijten, and Nienke Bakker. "Self-Portrait between the Lines: A Newly Discovered Letter from Vincent van Gogh to H. G. Tersteeg." *Van Gogh Museum Journal* 2003, pp. 99–111.

Jansen, Leo, Hans Luijten, and Fieke Pabst. "Paper Endures: Documentary Research into the Life and Work of Vincent van Gogh." *Van Gogh Museum Journal* 2002, pp. 26–39.

Jirat-Wasiutnyski, Vojtech. "A Dutchman in the South of France: Van Gogh's 'Romance' of Arles." *Van Gogh Museum Journal* 2002, pp. 78–89.

Juneja, Monica. "The Peasant Image and Agrarian Change: Representations of Rural Society in Nineteenth-Century French Painting from Millet to Van Gogh." *Journal of Peasant Studies,* vol. 15, no. 4: 1988, pp. 445–71.

Keefe, J. W. "Drawings and Watercolors of Anton Mauve." *Museum News* (Toledo Museum of Art), vol. 9: 1966, pp. 75–94.

Koldehoff, Stefan. "When Myth Seems Stronger than Scholarship: Van Gogh and the Problem of Authenticity." *Van Gogh Museum Journal* 2002, pp. 8–25.

Korn, Madeleine. "Collecting Paintings by Van Gogh in Britain Before the Second World War." *Van Gogh Museum Journal* 2002, pp. 120–35.

Krijt, Chris. "Young Vincent's Art Collection." *Vincent: Bulletin of the Rijksmuseum Vincent van Gogh,* vol. 4, no. 3: pp. 24–26.

Leroy, Edgar. "Le séjour de Vincent van Gogh à l'asile de Saint-Rémy-de-Provence." *Aesculape,* May–July 1926, pp. 16, 137–43, 154–58, 180–86.

Lesseps, Ferdinand de. "Souvenir d'un voyage au Soudan." *La Nouvelle Revue,* no. 26: 1884, pp. 491–517.

Lister, Kristin Hoermann. "Tracing a Transformation: Madame Roulin into La Berceuse." *Van Gogh Museum Journal* 2001, pp. 63–83.

Loyrette, Henri. "On the Occasion of the Reopening of the Museum Mesdag." *Van Gogh Museum Journal* 1996, pp. 41–43.

Luijten, Hans. "As It Came into My Pen: A New Edition of the Correspondence of Vincent van Gogh." *Van Gogh Museum Journal* 1996, pp. 88–101.

Maher, B. "The Scattered Language of Schizophrenia." *Psychology Today,* no. 2: 1968, pp. 6–30.

Mantz, Paul. "Jean-François Millet." *Le Magasin Pittoresque,* vol. 6, no. 2: 1888, pp. 399–402.

Menninger, Karl A. "A Psychoanalytic Study of the Significance of Self-Mutilations." *Psychoanalytic Quarterly,* vol. 4, no. 3: 1935, pp. 408–66.

Merkus, F.W.H.M. "Het medische dossier van Theo van Gogh." *Nederlands Tijdschrift voor Geneeskunde,* vol. 136, no. 43: 1992, p. 21–41.

Middag, Ineke. "Vincent van Gogh: The Graphic Work." *Van Gogh Museum Bulletin Three:* 1995, pp. 3, 6.

Monroe, Russell R. "Another Diagnosis for Van Gogh?" *Journal of Mental Disorders,* no. 179: 1991, p. 241.

———. "The Episodic Psychoses of Vincent van Gogh." *Journal of Mental Disorders,* no. 166: 1978, pp. 480–88.

Morel, Bénédict-Augustin. "D'une forme de délire, suite d'une surexcitation nerveuse se

rattachant à une variété non encore décrite d'épilepsie: l'épilepsie larvée." *Gazette Heb-domadaire de Médecine et du Chirurgie*, no. 7: 1860, pp. 773–75, 819–21, 836–41.

Murray, Ann H. " 'Strange and Subtle Perspective . . . ': Van Gogh, the Hague School, and the Dutch Landscape Tradition." *Art History*, vol. 3, no. 4: 1980, pp. 410–24.

Niedermeyer, Ernest. "Neurologic Aspects of the Epilepsies." *Psychiatric Aspects of Epilepsy* 1984, pp. 99–142.

Nonne, Monique. "Theo van Gogh: His Clients and Suppliers." *Van Gogh Museum Journal* 2000, pp. 38–51.

Op de Coul, Martha. "In Search of Van Gogh's Nuenen Studio: The Oldenzeel Exhibitions of 1903." *Van Gogh Museum Journal* 2002, pp. 104–19.

Orton, Fred. "Vincent van Gogh in Paris, 1886–87: Vincent's Interest in Japanese Prints." *Vincent: Bulletin of the Rijksmuseum Vincent van Gogh*, vol. 1, no. 3: 1971, pp. 2–12.

Perry, Isabella H. "Vincent van Gogh's Illness: A Case Record." *Bulletin of the History of Medicine*, no. 21: 1947, pp. 146–72.

Persinger, Michael A. "Religious and Mystical Experience as Artifacts of Temporal Lobe Function: A General Hypothesis." *Perceptual & Motor Skills*, no. 57: 1983, pp. 1255–62.

Piérard, Louis. "Van Gogh à Auvers." *Les Marges*, January-May 1914, pp. 47–53.

Pollock, Griselda. "Labour—Modern and Rural: The Contradictions of Representing Hand-loom Weavers in Brabant in 1884." *Australian Journal of Art*, vol. 6: 1987, pp. 25–44.

———. "Stark Encounters: Modern Life and Urban Work in Van Gogh's Drawings of the Hague, 1881–1883." *Art History*, vol. 6: September 1993, pp. 330–38.

———. "Van Gogh and the Poor Slaves: Images of Rural Labour as Modern Art." *Art History*, vol. 11: September 1988, pp. 408–32.

Priou, Jean-Noel. "Van Gogh et la Famille Roulin." *Beaux Arts*, August 31–September 6, 1955, pp. 5–6.

Rentchnick, Pierre. "Pathographie de van Gogh." *Médecine et Hygiène*, no. 45: 1987, pp. 1750–61.

Reynolds, Edward H. "Hughlings Jackson: A Yorkshireman's Contribution to Epilepsy." *Archives of Neurology*, no. 45: 1988, pp. 675–78.

Richard, Pierre. "Vincent van Gogh's Montmartre." Translated by Jan Hulsker and Barbara Potter Fasting. *Jong Holland*, vol. 4, no. 1: 1988, pp. 16–21.

Ritchie, Alick P. F. "The Antwerp School of Art." *The Studio*, vol. 1: 1893, pp. 141–42.

Roetemeijer, H.J.M. "De Bruinisten in Amsterdam." *Ons Amsterdam*, July 1969, pp. 194–201.

Rusic, Svetozar. "Biographie d'Albert Aurier." *Dossiers Acénonètes du Collège de Pataphysique*, no. 15: October, 1961, pp. 47–51.

Secrétan-Rollier, Pierre. "Looking through Vincent's Book of Psalms." Translated by J. van Hattum. *Vincent: Bulletin of the Rijksmuseum Vincent van Gogh*, vol. 2, no. 4: 1973, pp. 21–24.

Sheehy, Jeanne. "The Flight from South Kensington: British Artists at the Antwerp Academy, 1877–1885." *Art History*, vol. 20, no. 1: March 1997, pp. 124–39.

Sheon, Aaron. "Theo van Gogh, Publisher: The Monticelli Album." *Van Gogh Museum Journal* 2000, pp. 53–61.

Silverman, Debora. "Framing Art and Sacred Realism: Van Gogh's Ways of Seeing Arles." *Van Gogh Museum Journal* 2001, pp. 44–61.

Slagter, J. "Van Goghiana." *De Tafel Ronde*, vol. 11, nos. 8–9: April 30, 1955, p. 91.

Smee, Sebastian. "Is It a Bird? Is It a Plane? No, It's an Australian!" *The Art Newspaper*, no. 119: November 11, 2001, p. 13.

Spalding, Frances. "The Low Life and High Art of Toulouse-Lautrec." *Harpers and Queen*, October 1991, n.p.

Stevens, Janice R., and Bruce P. Hermann. "Temporal Lobe Epilepsy, Psychopathology, and Violence: The State of the Evidence." *Neurology*, no. 31: 1981, pp. 1127–32.

Stolwijk, Chris. "An Art Dealer in the Making: Theo van Gogh in The Hague." *Van Gogh Museum Journal* 2000, pp. 19–27.

———. "Un marchand avisé: La succursale hollandaise de la maison Goupil." Translated

by Jeanne Bouniort. *État des Lieux* (The Musée Goupil in Bordeaux), no. 2: 1999, pp. 73–96.

———. "'Our Crown and Our Honour and Our Joy': Theo van Gogh's Early Years." *Van Gogh Museum Journal* 1997–1998, pp. 42–57.

ten Brink, Jan, et al. "The Art Collection: Vincent van Gogh in the Pulchri Studio." *Hague Voices*, no. 31: March 30, 1889, pp. 371–82.

Thomas, W. L. "The Making of the 'Graphic.'" *The Universal Review*, no. 21: September–December 1888, pp. 80–93.

Thomson, Richard. "Trading the Visual: Theo van Gogh, the Dealer Among the Artists." *Van Gogh Museum Journal* 2000, pp. 28–37.

Tralbaut, Marc Edo. "Addendum bij de Antwerpse Periode." *Van Goghiana*, vol. 5: 1968, pp. 43–47.

———. "André Bonger: L'ami des frères Van Gogh." *Van Goghiana*, vol. 1: 1963, pp. 5–54.

———. "Feuillets de Bloc-Notes." *Van Goghiana*, vol. 7: 1970, pp. 71–102.

———. "In Vincent van Gogh's voetspoor te Antwerpen." *De Toerist*, vol. 34, no. 11: June 1955, pp. 361–71.

———. "Vincent van Gogh, épileptique ou schizophrène?" *Van Goghiana*, vol. 3: 1966, pp. 24–38.

Trapp, F. A. "The Art of Delacroix and the Camera's Eye." *Apollo*, April 1966, pp. 270–88.

van den Eerenbeemt, H.F.J.M. "The Unknown Vincent van Gogh, 1866–1868, (1) The Secondary State School at Tilburg." *Vincent: Bulletin of the Rijksmuseum Vincent van Gogh*, vol. 2, no. 1: 1972, pp. 2–12.

van Geertruy, Anieta. "De familie Van Gogh te Etten (1875–1882)." *Jaarboek van de Geschied—en Oudheidkundige Kring van Stad en Land van Breda, De Oranjeboom*, vol. 36: 1983, pp. 35–64.

van Lindert, Juleke. "'De aap van het sentiment': Dordrechts Museum herdenkt romanticus Ary Scheffer." *Vitrine*, vol. 8, no. 8: 1995, pp. 20–23.

van Tilborgh, Louis. "Letter from Willemien van Gogh." *Van Gogh Bulletin* 1992–1993, p. 21.

——— and Fieke Pabst. "Notes on a Donation: The Poetry Album for Elisabeth Huberta van Gogh." *Van Gogh Museum Journal* 1995, pp. 86–101.

Verkade-Bruining, A. "Vincent's Plans to Become a Clergyman (1)." Translated by J. van Hattum. *Vincent: Bulletin of the Rijksmuseum Vincent van Gogh*, vol. 3, no. 4: 1974, pp. 14–23.

———. "Vincent's plans to become a clergyman (2): Vincent in Belgium." Translated by J. van Hattum. *Vincent: Bulletin of the Rijksmuseum Vincent van Gogh*, vol. 4, no. 1: 1975, pp. 9–13.

Voskuil, P.H.A. "Het medische dossier van Theo van Gogh." *Nederlands Tijdschrift voor Geneeskunde*, vol. 136, no. 36: 1992, pp. 1777–79.

———. "Het ziektebeeld van Vincent van Gogh." *Some & Psyche*, vol. 16, no. 1: 1990, pp. 17–23.

———. "Het ziektebeeld van Vincent van Gogh." *Some & Psyche*, vol. 16, no. 2: 1990, pp. 25–30.

———. "Vincent van Gogh's Malady: A Test Case for the Relationship Between Temporal Lobe Dysfunction and Epilepsy?" *Journal of the History of the Neurosciences*, no. 1: 1992, pp. 155–62.

Webster, John. "Notes on Belgian Lunatic Asylums, Including the Insane Colony of Gheel." *Journal of Psychological Medicine and Mental Pathology*, no. 10: 1857, pp. 50–78, 209–47.

Weisberg, Gabriel P. "S. Bing and the Evolution of Art Nouveau." *National Gallery of Art: Center for Advanced Study in the Visual Arts, Center 3, Research Reports and Record Activities*, June 1982–May 1983, pp. 79–80.

Wester, J.P.J. "Het medische dossier van Theo van Gogh." *Nederlands Tijdschrift der Geneeskunde*, vol. 136, no. 49: 1992, p. 2443.

Whiteley, Linda. "Goupil, Delaroche and the Print Trade." *Van Gogh Museum Journal* 2000, pp. 74–81.

Wolinsky, Howard. "What Ailed Van Gogh?" *The Medical Post*, June 18, 1991, pp. 13–14.

Wylie, Anne Stiles. "An Investigation of the Vocabulary of Line in Vincent van Gogh's Expression of Space." *Oud Holland*, vol. 85, no. 4: 1970, pp. 210–22.

———. "Vincent and Kee and the Municipal Archives in Amsterdam." *Vincent: Bulletin of the Rijksmuseum Vincent van Gogh*, vol. 2, no. 4: 1973, pp. 2–7.

———. "Vincent's Childhood and Adolescence." *Vincent: Bulletin of the Rijksmuseum Vincent van Gogh*, vol. 4, no. 2: 1975, pp. 4–27.

Zemel, Carol M. "Sorrowing Women, Rescuing Men: Van Gogh's Images of Women and Family." *Art History*, vol. 10, no. 3: September 1987, pp. 351–68.

Zimmermann, Michael F. "'. . . which Dazzle Many an Eye': Van Gogh and Max Liebermann." *Van Gogh Museum Journal* 2002, pp. 90–103.

ARTICLES IN EDITED BOOKS

Books cited in this section are listed in the first section of this bibliography.

Aurier, Gustave-Albert. "The Isolated Ones: Vincent van Gogh" ("Les isolés: Vincent van Gogh," *Mercure de France*, January 1, 1890, pp. 24–29). In *Van Gogh*, edited by Stein, pp. 181–93.

Baseleer, Richard. "Vincent Van Gogh in zijn Antwerpse Periode" (*Richard Baseleer Reminiscences*). In Van Gogh, *Verzamelde Brieven van Vincent van Gogh* [1954 ed.], edited by Van Gogh–Bonger and Van Gogh). In *Van Gogh*, edited by Stein, pp. 70–71.

Bear, David M. "Behavioral Changes in Temporal Lobe Epilepsy." In *Aspects of Epilepsy and Psychiatry*, edited by Trimble and Bolwig, pp. 19–30.

Bear, David M., Roy Freeman, and Mark Greenberg. "Behavioral Alterations in Patients with Temporal Lobe Epilepsy." In *Psychiatric Aspects of Epilepsy*, edited by Blumer, pp. 197–227.

Bernard, Émile. "Émile Bernard on Vincent (1886–1887)" ("Vincent van Gogh," *La Plume*, vol. 3, no. 57: September 1, 1891). In *Van Gogh in Perspective*, edited by Welsh-Ovcharov, pp. 37–41.

———. "Les Hommes d'Aujourd'hui" ("Vincent van Gogh," *Les Hommes d'Aujourd'hui, Mercure de France*, vol. 8, no. 390: 1891, n.p.). In *Van Gogh*, edited by Stein, pp. 282–85.

———. "Julien Tanguy, Called Le Père Tanguy" ("Julien Tanguy dit le 'Père Tanguy,'" *Mercure de France*: December 16, 1908, pp. 600–616). In *Van Gogh*, edited by Stein, pp. 92–94.

———. "On Vincent's Burial" ("L'enterrement de Vincent van Gogh," *Art Documents*: February 1953, no. 29, pp. 1–2; see b3052 V /1985, "Bernard, Émile" to "Aurier, Gustave-Albert," 7/3/1891). In *Van Gogh*, edited by Stein, pp. 219–22.

Billen, Claire. "Episodes: The Socio-Economic Framework of a Capital City." In *Brussels*, edited by Billen and Duvosquel, pp. 108–25.

Block, Jane. "Les XX: Forum of the Avant-Garde." In *Belgian Art*, edited by Botwinick, pp. 17–40.

Blom, J.C.H. "The Netherlands Since 1830." In *History of the Low Countries*, edited by Blom and Lamberts, pp. 393–470.

Blumer, Dietrich. "Epileptic and Pseudoepileptic Seizures: Differential Diagnostic Considerations." In *Psychiatric Aspects of Epilepsy*, edited by Blumer, pp. 179–96.

———. "The Psychiatric Dimension of Epilepsy: Historical Perspective and Current Significance." In *Psychiatric Aspects of Epilepsy*, edited by Blumer, pp. 1–66.

Boele van Hensbroek, Pieter. "Uit." In *Verzamelde Brieven van Vincent van Gogh* (1955 ed.), edited by Van Gogh–Bonger and Van Gogh, pp. 334–35.

Boime, Albert. "Van Gogh, Thomas Nast and the Social Role of the Artist." In *Van Gogh 100*, edited by Masheck, pp. 71–111.

Bolwig, Tom G. "Classification of Psychiatric Disturbances in Epilepsy." In *Aspects of Epilepsy and Psychiatry*, edited by Trimble and Bolwig, pp. 1–8.

Bonger, Andries. "Letters and Art" ("Letteren en Kunst: Vincent," *Nieuwe Rotterdamsche Courant;* September 5, 1893). In *Van Gogh*, edited by Stein, p. 105.

"Brochure for the Asylum." Maison de Santé de Saint-Rémy-de-Provence, c. 1865. In *Van Gogh*, edited by Stein, pp. 147–50.

Brusse, M. J. "Vincent van Gogh as Bookseller's Clerk." In Van Gogh, *The Complete Letters of Vincent van Gogh*, pp. 107–14.

Cachin, Françoise. "Van Gogh and the Neo-Impressionist Milieu." In *Vincent van Gogh*, edited by Van Crimpen, pp. 225–37.

Cadorin, Paolo. "Colour Fading in Van Gogh and Gauguin." In *A Closer Look*, edited by Peres, Hoyle, and Van Tilborgh, pp. 12–19.

Cate, Phillip Dennis. "The Spirit of Montmartre." In *The Spirit of Montmartre*, edited by Cate and Shaw, pp. 1–94.

Childs, Elizabeth C. "Seeking the Studio of the South." In *Vincent van Gogh and the Painters of the Petit Boulevard*, edited by Homburg, pp. 113–52.

Christensen, Carol. "The Painting Materials and Technique of Paul Gauguin." In *The Art of Paul Gauguin*, edited by Brettell et al., pp. 63–104.

Collins, Philip. "Dickens and London." In *The Victorian City*, edited by Dyos and Wolff, pp. 537–58.

Cox, Kenyon. "The 'Modern' Spirit in Art: Some Reflections Inspired by the Recent International Exhibition" (*Harper's Weekly*, vol. 15, March 1913, p. 10). In *Van Gogh*, edited by Stein, p. 338.

Dam, Mogens, and Agnete Mouritzen. "Is There an Epileptic Personality?" In *Aspects of Epilepsy and Psychiatry*, edited by Trimble and Bolwig, pp. 9–18.

Dekkers, Dieuwertje. "The Frugal Meal." In *The Potato Eaters by Vincent van Gogh*, edited by Van Heugten and Van Tilborgh, pp. 75–84.

de Meester, Johan. "Vincent van Gogh" (*Algemeen Handlesblad*, December 31, 1890). In *Van Gogh*, edited by Stein, pp. 246–57.

Denis, Maurice. "From Gauguin and Van Gogh to Classicism" ("De Gauguin et de van Goghs au classicisme," *L'Occident*, 1909). In *Van Gogh*, edited by Stein, pp. 335–37.

de Winkel, Marieke. "Costumes in Rembrandt's Self Portraits." In *Rembrandt by Himself*, edited by White and Buvelot, pp. 58–74.

Distel, Anne. "Gachet, Father and Son." In *Cézanne to Van Gogh*, edited by Distel and Stein, pp. 3–25.

Dorn, Roland. "The Arles Period: Symbolic Means, Decorative Ends." In Dorn et al., *Van Gogh Face to Face*, pp. 134–71.

———. "Vincent van Gogh's Concept of 'Décoration.'" In *Vincent van Gogh*, edited by Van Crimpen, pp. 375–85.

du Tour, Willem. "De Amsterdammer" (*De Amsterdammer*, February 21, 1892). In *Van Gogh*, edited by Stein, pp. 286–87.

Eidelberg, Martin, and William R. Johnston. "Japonisme and French Deocrative Arts." In Weisberg et al., *Japonisme: Japanese Influence on French Art, 1854–1910*, pp. 141–56.

Fénéon, Félix. "The Fifth Exhibition of the Société des Artistes Indépendants" ("Salon des Indépendants, Paris, 1889," *La Vogue*, September 1889). In *Van Gogh*, edited by Stein, pp. 180–81.

Fenwick, Peter. "Aggression and Epilepsy." In *Aspects of Epilepsy and Psychiatry*, edited by Trimble and Bolwig, pp. 31–60.

Ferguson, Shirley M., and Mark Rayport. "Psychosis in Epilepsy." In *Psychiatric Aspects of Epilepsy*, edited by Blumer, pp. 229–270.

Fry, Roger. "Monthly Chronicle: Van Gogh" (*The Burlington Magazine*, December 1923). In *Van Gogh*, edited by Stein, pp. 353–55.

Gauguin, Paul. "Avant et après" (*Avant et après*, Paris: Les Éditions G. Crès, 1903). In *Van Gogh*, edited by Stein, pp. 123–28.

———. "Gauguin on Vincent (1888)" ("Natures Mortes," in *Essais d'Art Libre*, January 4, 1894, E. Girard, Editeur, Paris, pp. 273–75). In *Van Gogh in Perspective*, edited by Welsh-Ovcharov, pp. 42–49.

———. "On Van Gogh's Legacy" (letter from Gauguin to Bernard, January 1891; see

b1481 V/1962, Paul Gauguin to Émile Bernard, 1/1891). In *Van Gogh*, edited by Stein, p. 240.

——. "On Vincent's Death" (letter from Gauguin to Theo, c. August 2, 1890; see Malingue, *Lettres de Gauguin à sa femme et ses amis*, letter no.113). In *Van Gogh*, edited by Stein, p. 231.

——. "Still Lifes" ("Natures Mortes," *Essais d'Art Libre*, January 4, 1894, E. Girard, Editeur, Paris, pp. 273–75). In *Van Gogh*, edited by Stein, pp. 121–22.

—— and Vincent van Gogh. "On Working Together in Arles" (letters from Vincent and Gauguin, October–December 1888). In *Van Gogh*, edited by Stein, pp. 128–30.

Gauzi, François. "Lautrec et son Temps" (*Lautrec et son temps*, Paris: David Perret et Cie, 1954). In *Van Gogh*, edited by Stein, pp. 71–72.

Geshwind, Norman. "Dostoievsky's Epilepsy." In *Psychiatric Aspects of Epilepsy*, edited by Blumer, pp. 325–34.

Gilot, Françoise, and Carlton Lake. "Life with Picasso" (*Life with Picasso*, New York: McGraw-Hill, 1964). In *Van Gogh*, edited by Stein, pp. 379–80.

Görlitz, Paulus Coenraad. "Among the People" (letter from Görlitz to M. J. Brusse, "Onder de Menschen, Vincent van Gogh als Boekverkopersbediende," *Nieuwe Rotterdamsche Courant*, May 2 and June 2, 1914). In *Van Gogh*, edited by Stein, pp. 41–42.

——. "Vincent in Dordrecht (1877)" (letter from Görlitz to M. J. Brusse, in "Onder de Menschen, Vincent van Gogh als Boekverkopersbediende," *Nieuwe Rotterdamsche Courant*, May 2 and June 2, 1914). In *Van Gogh in Perspective*, edited by Welsh-Ovcharov, pp. 16–18.

—— and Frederik van Eeden. "Brief van P. C. Görlitz aan Frederik van Eeden." In *Verzamelde Brieven van Vincent van Gogh* (1955 ed.), edited by Van Gogh–Bonger and Van Gogh, pp. 327–35.

Gram, John. "Overgenomen uit." In *Verzamelde Brieven van Vincent van Gogh* (1955 ed.), edited by Van Gogh–Bonger and Van Gogh, pp. 299–301.

Grojnowski, Daniel. "Hydropathes and Company." In *The Spirit of Montmartre*, edited by Shaw, pp. 95–110.

H., A. "Les Vingt" ("Les XX," *La Wallonie*, no. 5, 1890). In *Van Gogh*, edited by Stein, pp. 207–8.

Hageman, Victor. "Van Gogh in Antwerp" (in Louis Piérard, "Van Gogh à Anvers," *Les Marges*, January 13, 1914, pp. 47–53). In *Van Gogh*, edited by Stein, pp. 68–70.

Hammacher, Abraham Marie. "Van Gogh's Relationship with Signac (1962)" (*Van Gogh's Life in His Drawings: Van Gogh's Relationship with Signac*, London: Marlborough Fine Art Ltd., May–June 1962). In *Van Gogh in Perspective*, edited by Welsh-Ovcharov, pp. 143–47.

Himmelhoch, Jonathon M. "Major Mood Disorders Related to Epileptic Changes." In *Psychiatric Aspects of Epilepsy*, edited by Blumer, pp. 271–94.

Hirschig, Anton. "Recollections of Vincent van Gogh" (letter from Hirschig to A. Bredius, in Bredius, "Herinneringen aan Vincent van Gogh," *Oud-Holland*, vol. 51, no. 1: 1934, p. 44). In *Van Gogh*, edited by Stein, pp. 210–11.

House, John. "Towards the Modern Landscape." In *Vincent van Gogh and the Painters of the Petit Boulevard*, edited by Homburg, pp. 159–98.

Hummelen, Ijsbrand, and Cornelia Peres. "The Painting Technique of *The Potato Eaters*." In Van Tilborgh, *The Potato Eaters by Vincent van Gogh*, pp. 49–57.

Jampoller, Lili. "Theo and Vincent as Collectors." In *The Rijksmuseum Vincent van Gogh*, edited by Van Uitert and Hoyle, pp. 30–37.

Jaspers, Karl. "Van Gogh and Schizophrenia (1922)" (*Strindberg und Van Gogh*, Leipzig: Ernst Bircher, 1922). In *Van Gogh in Perspective*, edited by Welsh-Ovcharov, pp. 99–101.

Jirat-Wasiutynski, Vojtech. "Painting from Nature Versus Painting from Memory." In *A Closer Look*, edited by Peres, Hoyle, and Van Tilborgh, pp. 90–102.

Kahn, Gustave. "Painting" ("Peinture: Expositions des Indépendants," *La Revue Indépendante*, no. 18: April 18, 1888, p. 163). In *Van Gogh*, edited by Stein, p. 176.

Kerssemakers, Anton C. "Reminiscences of Vincent van Gogh" ("Herinneringen aan Vin-

cent van Gogh," *De Amsterdammer: Weekblad voor Nederland*, April 14, 1912). In *Van Gogh*, edited by Stein, pp. 48–55.

Keyes, George S. "The Dutch Roots of Vincent van Gogh." In Dorn et al., *Van Gogh Face to Face*, pp. 20–49.

Kôdera, Tsukasa. "Christianity Versus Nature." In *Van Gogh 100*, edited by Masheck, pp. 227–49.

———. "Van Gogh and the Dutch Theological Culture of the Nineteenth Century." In *Vincent van Gogh and Millet*, edited by Van Tilborgh, pp. 115–34.

Korshak, Yvonne. "From 'Passions' to 'Passion': Visual and Verbal Puns in *The Night Café*." In *Van Gogh 100*, edited by Masheck, pp. 29–42.

Lagye, Gustave. "Chronicle of the Fine Arts at the Salon of Les Vingt" ("Chronique des Beaux-Arts, Salon des XX," *L'éventail*, March 1, 1891). In *Van Gogh*, edited by Stein, p. 266.

Lauzac, Henry. "Galerie historique et critique du dix-neuvième siècle, par Henry Lauzac." In *Verzamelde Brieven van Vincent van Gogh* (vol. 4, 1955 ed.), edited by Van Gogh–Bonger and Van Gogh, pp. 302–304.

Leclercq, Julien. "Vincent van Gogh" (*Mercure de France*, December 1890). In *Van Gogh*, edited by Stein, pp. 240–41.

———. "Fine Arts at the Indépendants" ("Beaux-Arts aux Indépendants," *Mercure de France*, May 1890). In *Van Gogh*, edited by Stein, p. 207.

Lecomte, Georges. "L'exposition des néo-impressionistes" (*Art et Critique*, March 29, 1890). In *Van Gogh*, edited by Stein, p. 207.

MacKnight, Dodge. "On Van Gogh in Arles" ("Lau's Dodge MacKnight," Archives of American Art). In *Van Gogh*, edited by Stein, p. 108.

Mauclair, Camille. "Galerie Le Barc de Boutteville" (*La Revue Indépendante*, no. 23, 1892). In *Van Gogh*, edited by Stein, pp. 294–303.

Meijer de Haan, Jacob. "On Vincent's Death" (letter from Jacob Meijer de Haan to Theo van Gogh, c. August 1, 1890). In *Van Gogh*, edited by Stein, p. 232.

Mendes da Costa, Maurits Benjamin. "Personal Reminiscences of Vincent van Gogh" ("Persoonlijke herinneringen aan Vincent van Gogh," *Het Handelsblad*, December 2, 1910). In *Van Gogh*, edited by Stein, pp. 43–45.

Minkowska, Françoise. "Van Gogh as an Epileptic (1922)" ("Van Gogh: les relations entre sa vie, sa maladie et son oeuvre," *L'Évolution Psychiatrique*, no. 3, 1933, pp. 53–76). In *Van Gogh in Perspective*, edited by Welsh-Ovcharov, pp. 102–4.

Mirabeau, Octave. "Le Père Tanguy" (*Des artistes*, Paris: Ernest Flammarion, February 1894). In *Van Gogh*, edited by Stein, p. 222.

Mourier-Petersen, Christian Vilhelm. "On Van Gogh in Arles" (letter from Mourier-Petersen to Johan Rohde, March 1988, in Rohde, *Den frie udstelling: Journal fra en I rejse 1892*, courtesy of H. P. Rohde). In *Van Gogh*, edited by Stein, p. 108.

Newton, H. Travers. "Observations on Gauguin's Painting Techniques and Materials." In *A Closer Look*, edited by Peres, Hoyle, and Van Tilborgh, pp. 103–111.

Niedermeyer, Ernst. "Neurologic Aspects of the Epilepsies." In *Psychiatric Aspects of Epilepsy*, edited by Blumer, pp. 99–142.

"Obituary" (*L'Écho Pontoisien*, August 7, 1890). In *Van Gogh*, edited by Stein, p. 219.

Op de Coul, Martha. "Nuenen and Its Environs in the Work of Vincent van Gogh." In *Van Gogh in Brabant*, compiled by Van Uitert, pp. 92–101.

Osborn, Max. "Der Bunte Spiegel" (*Der Bunte Spiegel*, New York: Verlag Frederich Krause, 1945). In *Van Gogh*, edited by Stein, p. 89.

Pabst, Fieke, and Evert van Uitert. "A Literary Life, with a List of Books and Periodicals Read by Van Gogh." In *The Rijksmuseum Vincent van Gogh*, edited by Van Uitert and Hoyle, pp. 68–84.

Parry-Jones, William L. "The Model of the Geel Lunatic Colony and Its Influences on the Nineteenth-Century Asylum System in Britain." In *Madhouses, Mad Doctors, and Madmen*, edited by Scull, pp. 201–17.

Pereira, Orlindo Gouveia. "The Role of Copying in Van Gogh's Oeuvre and Illness." In *Van Gogh 100*, edited by Masheck, pp. 159–72.

Peres, Cornelia. "An Impressionist Concept of Painting." In *A Closer Look*, edited by Peres, Hoyle, and Van Tilborgh, pp. 24–38.

Perrot, Michelle, and Anne Martin-Fugier. "The Actors." In *A History of Private Life IV*, edited by Perrot, pp. 95–338.

"Petition and Investigation Report" (The City of Arles vs. Vincent van Gogh, February–March 1889). In *Van Gogh*, edited by Stein, pp. 132–34.

Peyron, Théophile. "On His New Patient, Vincent" (letter from Peyron to Theo van Gogh, May 26, 1889). In *Van Gogh*, edited by Stein, pp. 152–153.

Pickvance, Ronald. "An Insatiable Appetite for Pictures: Vincent the Museumgoer." In *The Rijksmuseum Vincent van Gogh*, edited by Van Uitert and Hoyle, pp. 59–67.

Piérard, Louis. "Among the Miners of the Borinage" (*La vie tragique de Vincent van Gogh*, Brussels: Éditions Labor, 1939). In *Van Gogh*, edited by Stein, pp. 45–48.

Pierloot, Roland. "Proceedings of the 8th European Conference on Psychosomatic Research, Belgium, 1970." In *World History of Psychiatry*, edited by Howells, pp. 136–49.

Pissarro, Lucien. "On Van Gogh in Paris" (letter from Pissarro to Dr. Paul Gachet, January 26, 1928; see Pissarro, *Lettres impressionistes au Dr Gachet et à Murer*, pp. 54–56). In *Van Gogh*, edited by Stein, pp. 88–89.

Ravoux-Carrié, Adeline. "Recollections on Vincent van Gogh's Stay in Auvers-sur-Oise [1956]" ("Les Souvenirs d'Adeline Ravoux sur le séjour de Vincent van Gogh à Auvers-sur-Oise," *Les Cahiers de Van Gogh* I, pp. 7–17). In *Van Gogh*, edited by Stein, pp. 211–19.

"Register of Voluntary Commitments" (Maison de Santé de Saint-Rémy-de-Provence, 1889). In *Van Gogh*, edited by Stein, pp. 151–52.

Rey, Felix. "With Van Gogh's Friends in Arles" (interviewed by Max Baumann, "Bei Freunden Van Goghs in Arles," *Kunst und Künstler*, vol. 26: 1928). In *Van Gogh*, edited by Stein, pp. 131–32.

Robertson, Mary M. "Ictal and Interictal Depression in Patients with Epilepsy." In *Aspects of Epilepsy and Psychiatry*, edited by Trimble and Bolwig, pp. 213–34.

Rodin, Ernst. "Medical Treatment of Epileptic Patients." In *Psychiatric Aspects of Epilepsy*, edited by Blumer, pp. 143–78.

Roskill, Mark Wentworth. "Van Gogh at Auvers." In *Van Gogh 100*, edited by Masheck, pp. 321–34.

Salles, Frédéric. "On the Petition and Investigation Report" (letters from Salles to Theo van Gogh, March–April 1889; see Hulsker, "Vincent's Stay in the Hospitals at Arles and Saint-Rémy," pp. 24–44). In *Van Gogh*, edited by Stein, pp. 134–36.

Schapiro, Meyer. "On a Painting of Van Gogh" (*View: The Modern Magazine*, vol. 7, no. 1: October 1946, pp. 9–14). In *Van Gogh in Perspective*, edited by Welsh-Ovcharov, pp. 159–68.

Seurat, Georges. "On Van Gogh in Paris" (draft of a letter from Seurat to Maurice Beaubourg, August 28, 1890, private collection; see Fénéon, "Georges Seurat"). In *Van Gogh*, edited by Stein, p. 90.

Shackleford, George T. M. "Van Gogh in Paris." In Dorn, et al., *Van Gogh Face to Face*, pp. 86–125.

Sheon, Aaron. "Van Gogh's Understanding of Theories of Neurosis, Neurasthenia and Degeneration in the 1880s." In *Van Gogh 100*, edited by Masheck, pp. 173–91.

Signac, Paul. "Vincent van Gogh" (letter from Signac to Gustave Coquiot, in Coquiot, *Vincent van Gogh*). In *Van Gogh*, edited by Stein, p. 136.

———— and Vincent van Gogh. "On Signac's Visit to Arles" (letters from Signac and Vincent, March–April 1889; see Van Gogh, *The Complete Letters of Vincent Van Gogh*). In *Van Gogh*, edited by Stein, pp. 145–47.

Sillevis, John. "Van Gogh in the Hague Art World." In *Van Gogh en Den Haag*, edited by Van der Mast and Dumas, pp. 146–65.

Sonn, Richard D. "Marginality and Transgression: Anarchy's Subversive Allure." In *Montmartre and the Making of Mass Culture*, edited by Weisberg, pp. 120–41.

Soth, Lauren. "Fantasy and Reality in the Hague Drawings." In Dorn et al., *Van Gogh Face to Face*, pp. 60–79.

Sund, Judy. "Van Gogh's 'Berceuse' and the Sanctity of the Secular." In *Van Gogh 100*, edited by Masheck, pp. 205–25.

———. "Famine to Feast: Portrait Making at Saint-Rémy and Auvers." In Dorn et al., *Van Gogh Face to Face*, pp. 182–227.

Tardieu, Eugène. "The Salon of the Indépendants" (*Le Magazine Français Illustré*, April 25, 1891). In *Van Gogh*, edited by Stein, p. 280.

Tersteeg, H. G. "Brief van H. G. Tersteeg aan Theo van Gogh, The Hague, 7 Apr. 1890." In *Verzamelde Brieven van Vincent van Gogh* (1955 ed.), edited by Van Gogh–Bonger and Van Gogh, pp. 304–5.

Thomson, Richard. "The Cultural Geography of the Petit Boulevard." In *Vincent van Gogh and the Painters of the Petit Boulevard*, edited by Homburg, pp. 65–108.

Tonio. "Notes and Recollections" ("Notes et souvenirs: Vincent van Gogh," *La Butte*, May 21, 1891). In *Van Gogh*, edited by Stein, pp. 281–82.

Trublot, Paul Alexis. "At Midnight" (*Cri du peuple*, September 7, 1887). In *Van Gogh*, edited by Stein, p. 96.

Valadon, Suzanne. "Vincent van Gogh" (interviewed by Florent Fels, in Fels, *Vincent van Gogh*, Paris: Henry Floury, 1928). In *Van Gogh*, edited by Stein, p. 87.

van Crimpen, Han. "The Van Gogh Family in Brabant." In *Van Gogh in Brabant*, compiled by Van Uitert, pp. 72–91.

———. "Vincent van Gogh: Friends Remember Vincent in 1912." In *Vincent van Gogh*, edited by Arikawa, Van Crimpen, et al., n.p.

van der Heijden, Cor G.W.P. "Nuenen Around 1880." In *Van Gogh in Brabant*, compiled by Van Uitert, pp. 102–27.

van de Wetering, Ernst. "The Multiple Functions of Rembrandt's Self-Portraits." In *Rembrandt by Himself*, edited by White and Buvelot, pp. 10–37.

van Gogh, Theo. "On Vincent in Paris" (letters from Theo, 1886–1888; see Hulsker, "What Theo Really Thought of Vincent," pp. 2–28). In *Van Gogh*, edited by Stein, pp. 105–7.

——— and G.-Albert Aurier. "On Posthumous Tributes to Vincent" (letters from Theo and Aurier, August–September 1890; see Distel and Stein, *Cézanne to Van Gogh*, pp. 259–69). In *Van Gogh*, edited by Stein, pp. 232–36.

van Gogh, Vincent. "An Early Biography" (letter from Vincent to the Reverend Thomas Slade-Jones, June 17, 1876). In *Van Gogh*, edited by Stein, pp. 32–41.

———. "Lettres de Vincent van Gogh à Emile Bernard" (*Lettres de Vincent van Gogh à Emile Bernard*, Paris: Ambroise Vollard, 1911). In *Van Gogh*, edited by Stein, pp. 237–39.

———, Theo van Gogh and Paul Gauguin. "On Exhibition Plans and Responses to Vincent's Work" (letters from Vincent, Theo, and Gauguin, 1888–1890). In *Van Gogh*, edited by Stein, pp. 156–76.

van Gogh–Bonger, Johanna. "Memoir of Vincent Van Gogh by His Sister-in-law." In *Van Gogh, The Complete Letters of Vincent Van Gogh with Reproductions of All the Drawings in the Correspondence*, vol. I, pp. xv–lxvii.

van Tilborgh, Louis. "'A Kind of Bible': The Collection of Prints and Illustrations." In *The Rijksmuseum Vincent van Gogh*, edited by Van Uitert and Hoyle, pp. 38–44.

van Uitert, Evert. "Vincent van Gogh, Painter of Peasants." In *Van Gogh in Brabant*, compiled by Van Uitert, pp. 14–46.

Wagener, J. Frits. "Vincent of Zundert." In *Van Gogh 100*, edited by Masheck, pp. 195–203.

Weiller, Pierre. "Nous avons retrouvé le Zouave de van Gogh" (*Les Lettres Françaises*, March 24–31, 1955). In *Van Gogh*, edited by Stein, pp. 108–11.

Wenckebach, Ludwig "Willem" Reijmert. "Letters to an Artist" (see Pach, *Letters to an Artist*, pp. xiii–xiv). In *Van Gogh*, edited by Stein, pp. 66–67.

Werness, Hope B. "The Symbolism of Van Gogh's Flowers." In *Van Gogh 100*, edited by Masheck, pp. 43–55.

Wilson, Michael L. J. "Portrait of the Artist as a Louis XIII Chair." In *Montmartre and the Making of Mass Culture*, edited by Weisberg, pp. 180–204.

Zemel, Carol M. "The 'Spook' in the Machine." In *Van Gogh in Brabant*, compiled by Van Uitert, pp. 47–58.

Index

Page numbers in *italics* refer to illustrations.

Image Credits

622: © The J. Paul Getty Museum, Los Angeles;
641: © Stichting Kröller-Müller Museum. Photo credit: Foto Marburg/Art Resource, NY;
657: © Photographer: Apic, Getty Images;
670: © Fine Arts Museums of San Francisco, Memorial gift from Dr. T. Edward and Tullah Hanley, Bradford, Pennsylvania;
717: © Scala/Art Resource, NY;
718: © Pushkin Museum of Fine Arts, Moscow, Russia. Photo credit: Erich Lessing/Art Resource, NY;
738–740: © Collection Oskar Reinhart "Am Römerholz," Winterthur;
756: © The Museum of Modern Art/Licensed by SCALA/Art Resource, NY;
759: © Brooklyn Museum, Frank L. Babbott Fund and the A. Augustus Healy Fund;
761: © Kunsthalle Bremen—Der Kunstverein in Bremen/Photo: Sickelmann;
785: © Stichting Kröller-Müller Museum. Photo credit: Bildarchiv Preussischer Kulturbesitz/Art Resource, NY;
832: © Kunstmuseum Basel, Martin P. Buhler;
842: © Musée du Louvre. Photo credit: Réunion des Musées Nationaux/Art Resource, NY.

COLOR PLATES

View of the Sea at Scheveningen; Two Women in the Moor; Head of a Woman; The Potato Eaters; The Old Church Tower at Nuenen ("The Peasants' Churchyard"); Basket of Potatoes; Still Life with Bible; Torso of Venus; In the Café: Agostina Segatori in Le Tambourin; Caraf and Dish with Citrus Fruit; View from Theo's Apartment; Wheatfield with Partridge; Self-Portrait with Straw Hat; Flowering Plum Tree: after Hiroshige; Self-Portrait as a Painter; The Zouave; The Yellow House ("The Street"); Gauguin's Chair; Tree Trunks with Ivy (Undergrowth); The Sower; Wheat Fields with a Reaper; Les Peiroulets Ravine; Almond Blossom; Irises; Tree Roots; and *Wheat Field with Crows:* © Van Gogh Museum Amsterdam (Vincent van Gogh Foundation);
A Pair of Shoes: © The Baltimore Museum of Art: The Cone Collection, formed by Dr. Claribel Cone and Miss Etta Cone of Baltimore. Photo credit: Mitro Hood;
Vegetable Gardens in Montmartre: La butte Montmartre: © Collection Stedelijk Museum Amsterdam;
Interior of a Restaurant; and *Pink Peach Tree in Blossom (Reminiscence of Mauve):* © Stichting Kröller-Müller Museum;
Pink Peach Tree in Blossom (Reminiscence of Mauve); Starry Night Over the Rhône; Self-Portrait; Noon: Rest from Work (after Millet); The Church at Auvers; and *Portrait of Doctor Gachet:* © Musée d'Orsay, Paris. Photo credit: Réunion des Musées Nationaux/Art Resource, NY;
Self-Portrait; Madame Roulin Rocking the Cradle (La Berceuse); and *The Bedroom:* © The Art Institute of Chicago;
Portrait of Père Tanguy: © Musee Rodin, Paris, France. Photo Credit: Erich Lessing/Art Resource, NY;
The Langlois Bridge at Arles with Women Washing, and *The Café Terrace on the Place du Forum, Arles, at Night:* © Stichting Kröller-Müller Museum. Photo Credit: Erich Lessing/Art Resource, NY;
La mousmé, Sitting: © National Gallery of Art, Washington, DC;
Portrait of the Postman Joseph Roulin: © Museum of Fine Arts, Boston. Gift of Robert Treat Paine;
Portrait of Patience Escalier; Portrait of the Artist's Mother: © Norton Simon Art Foundation;
Still Life: Vase with Oleanders and Books; L'arlésienne: Madame Ginoux with Books; Cypresses; and *Olive Picking:* © The Metropolitan Museum of Art. Photo credit: The Metropolitan Museum of Art/Art Resource, NY;
The Night Café in the Place Lamartine in Arles: © Yale University Art Gallery. Photo credit: Yale University Art Gallery/Art Resource, NY;

Self-Portrait (Dedicated to Paul Gauguin): © Harvard Art Museums, Fogg Art Museum, Bequest from the Collection of Maurice Wertheim, Class of 1906. Photo credit: David Mathews © President and Fellows of Harvard College;

Public Garden with Couple and Blue Fir Tree: The Poet's Garden III: © Private Collection. Photo credit: Erich Lessing/Art Resource, NY;

Tarascon Diligence: © The Henry and Rose Pearlman; on long-term loan to Princeton University Art Museum. Photo credit: Bruce M. White;

Vincent's Chair with His Pipe; and *Still Life: Vase with Fifteen Sunflowers:* © The National Gallery, London. Photo credit: National Gallery, London/Art Resource, NY;

Self-Portrait with Bandaged Ear and Pipe: © Collection Niarchos;

Irises: © The J. Paul Getty Museum, Los Angeles;

Starry Night: © The Museum of Modern Art, New York, NY, U.S.A. Photo credit: Digital Image © The Museum of Modern Art/Licensed by SCALA/Art Resource, NY;

Portrait of Trabuc, an Attendant at Saint-Paul Hospital: David Brooks (www.vggallery.com);

Trees in the Garden of Saint-Paul Hospital: © The Armand Hammer Collection, Gift of the Armand Hammer Foundation, Hammer Museum, Los Angeles, California;

Daubigny's Garden: © Kunstmuseum Basel.

GREGORY WHITE SMITH and STEVEN NAIFEH graduated from Harvard Law School in 1977. Mr. Naifeh, who has written for art periodicals and worked at the National Gallery of Art, studied art history at Princeton and did his graduate work in fine arts at the Fogg Art Museum of Harvard University. Mr. Smith, who majored in English literature at Colby College, studied medieval and Renaissance music as a Watson Fellow in Europe and did graduate work at Harvard while serving as the assistant conductor of the Harvard Glee Club. He also wrote two television series, one on human behavior with Phil Donahue and one on the Supreme Court and the U.S. Constitution with Archibald Cox. The two men have written many books on art and other subjects, including four *New York Times* bestsellers. Their biography *Jackson Pollock: An American Saga* won the Pulitzer Prize in 1991 and was a finalist for the National Book Award. It was made into the Academy Award–winning 2000 film *Pollock* starring Ed Harris and Marcia Gay Harden and inspired John Updike's novel *Seek My Face*. Naifeh and Smith have been profiled in *The New Yorker, The New York Times, USA Today,* and *People,* and have appeared on *60 Minutes.* They live in Aiken, South Carolina, where they serve as chairmen of the Juilliard in Aiken Festival, which they helped found in 2009.